FoArO	Folk Art in Oklahoma
FoAroK	Folk Art of Kentucky
FoArRP	Folk Art of Rural Pennsylvania
FoArtC	The Folk Arts and Crafts of New England
FoPaAm	Folk Painters of America
FoScu	Folk Sculpture U.S.A.
FouNY	Found in New York's North Country.
FraJ	Frank Jones
Full	Fullspectrum
GalAmS	A Gallery of American Samplers
GalAmW	A Gallery of American Weathervanes and Whirligigs
GalAQ	Gallery of Amish Quilts
GifAm	The Gift of American Naive Paintings from the Collection of Edgar William and Bernice Chrysler Garbisch
GoMaD	God, Man, and the Devil
GraMo	Grandma Moses, the Artist Behind the Myth
GravF	Graven by the Fisherman Themselves
GravNE	Gravestones of Early New England and the Men Who Made Them, 1653-1800
HanWo	Hands to Work; Shaker Folk Art and Industries
HerSa	Heritage Sampler
HisCr	Hispanic Crafts of the Southwest
HoPip	Horace Pippin
HoKnAm	How to Know American Folk Art
HoFin	Howard Finster, the Man of Visions
HoFinV	Howard Finster's Visions of 1982
IlHaOS	Illustrated Handbook of Ohio Sewer Pipe Folk Art
InAmD	The Index of American Design
JaJ	J. and J. Bard: Picture Painters
JaJoB	James and John Bard: Painters of Steamboat Portraits
JoKaP	John Kane, Painter
JusMc	Justin McCarthy
KaKo	Karol Kozlowski, 1885-1969, Polish-American Folk Painter
KenQu	Kentucky Quilts, 1800-1900
LeViB	Let Virtue Be a Guide to Thee
LoCo	Local Color: A Sense of Place in Folk Art
McAmFA	Masterpieces of American Folk Art
MisPi	Missing Pieces: Georgia Folk Art, 1770-1976
MoBBTaS	Morgan B. Brainard's Tavern Signs: A Collection
MoBeA	Mourning Becomes America.
NaiVis	Naives and Visionaries
NeaT	Neat and Tidy
NewDis	New Discoveries in American Quilts
NinCFo	Nineteenth-Century Folk Painting
OneAmPr	101 American Primitive Watercolors and Pastels
OneMa	101 Masterpieces of American Primitive Painting
PaiNE	Paintings by New England Provincial Artists, 1775-1800
PeiNa	Peintres Nahifs: A Dictionary of Primitive Painters
PenDA	Pennsylvania Dutch American Folk Art
PenDuA	Pennsylvania Dutch Art
PenGer	The Pennsylvania-German Decorated Chest.
PicFoA	Pictorial Folk Art: New England to California
PicHisCa	Pictorial History
PieQu	The Pieced Quilt: A North American Design Tradition
PioArt	Pioneer Art in America
PioPar	Pioneers in Paradise
PlaFan	Plain and Fancy
PopA	Popular Art in the United States.
PopAs	Popular Arts of Spanish New Mexico
PrimPa	Primitive Painters in America, 1750-1950
QufInA	Quilts from the Indiana Amish.
QuiAm	Quilts in America
Rain	Rainbows in the Sky
RediJFH	Rediscovery: Jurgan Frederick Huge (1809-1878)
RuPoD	Rufus Porter Rediscovered
Scrim	The Scrimshander
ScriSW	Scrimshaw and Scrimshanders, Whales and Whalemen
SculFA	The Sculpture of Fred Alten
SerPa	Sermons in Paint
ShipNA	Shipcarvers of North America
SoAmP	Some American Primitives
SoFoA	Southern Folk Art
TenAAA	Ten Afro-American Artists of the Nineteenth Century
ThTaT	They Taught Themselves
ThrNE	Three New England Watercolor Painters
TinC	The Tinsmiths of Connecticut
ToCPS	To Cut, Pierce, and Solder
Trans	Transmitters: The Isolate Artist in America
TwCA	Twentieth Century American Folk Art and Artists
TYeAmS	200 Years of American Sculpture.
UnDec	"Underwater Decoys: Fish "
ViSto	Visions in Stone.
WaDec	Waterfowl Decoys of Michigan and the Lake St. Clair Region
WeaVan	Weather Vanes
WeaWhir	Weathervanes and Whirligigs.
WhaPa	Whalemen's Paintings and Drawings
WiFoD	Wild Fowl Decoys
WiScAM	Wilhelm Schimmel and Aaron Mountz: Woodcarvers
WinGu	A Winterthur Guide to American Needlework
WoCar	Wood Carvings: North American Folk Sculptures
WoScuNY	Wood Sculpture of New York State
YankWe	Yankee Weathervanes
YoWel	Your Wellwisher, J.B. Walker

Folk Artists
Biographical
Index

Folk Artists Biographical Index

A Guide to Over 200 Published Sources of Information on Approximately 9,000 American Folk Artists from the Seventeenth Century to the Present, Including Brief Biographical Information; a Full Bibliography of Sources; Art Locator, Ethnicity, Geographic, Media, and Type of Work Indexes; and a Directory of Nearly 300 Institutions Where the Works of the Artists Are Located.

FIRST EDITION

George H. Meyer,
Editor

George H. Meyer, Jr., and **Katherine P. White,**
Associate Editors

A Sandringham Press Book

Published in association with the Museum of American Folk Art
Foreword by Dr. Robert Bishop, Director

GALE RESEARCH COMPANY BOOK TOWER DETROIT, MICHIGAN 48226

Editor: George H. Meyer

Associate Editors: George H. Meyer, Jr.
Katherine P. White

Gale Research Company Staff

Project Coordinator: Annie M. Brewer
Senior Assistant Editor: Nancy Franklin
Assistant Editor: Marie Browne

Production Supervisor: Mary Beth Trimper
Production Assistant: Michael Vargas
Art Director: Arthur Chartow

Editorial Data Systems Director: Dennis LaBeau
Supervisor of Systems and Programming: Diane H. Belickas
Program Design: Donald G. Dillaman, Mary Ellen Cameron

Publisher: Frederick G. Ruffner
Editorial Director: Dedria Bryfonski
Associate Editorial Director: Ellen T. Crowley
Senior Editor, Research: Annie M. Brewer

Cover Photography by Paul Primeau.
Blue heron decoy. Lloyd Parker. Parkertown, New Jersey,
circa 1870; wood with traces of blue paint; length 29 inches.
Collection of George H. Meyer

Library of Congress Catalog Card Number 86-15029
ISBN 0-8103-2145-9

Copyright © 1987 by George H. Meyer

Computerized photocomposition by
DataServ
Bethesda, Maryland

Printed in the United States of America

Contents

Foreword .. vii

Introduction .. ix

Reading a Citation .. xv

Key to Bibliographic Source Codes .. xix

Key to Museum and Institution Codes xxix

Folk Artists Biographical Index ... 3

Art Locator Index ... 303

Ethnicity Index ... 315

Geographic Index .. 321

Media Index ... 379

Type of Work Index .. 435

Foreword

There is a pressing need for more research and scholarship in the field of American folk art. Museums, scholars, and knowledgeable collectors now rightfully insist on knowing all of the available information not only about a folk art object, but also about its creator and the context in which it was created.

This need is being increasingly recognized by new scholarly and research works and by museums such as my own Museum of American Folk Art, which has been rapidly expanding its research library and educational programs. However, never has information been compiled in a single work about the thousands of American folk artists of every kind.

Now, George Meyer and his associates have done this by systematically researching a great number of publications and then summarizing the information found about each artist in a structured format serving as a ready access to the published sources of the information. The task was time-consuming and formidable and, I suspect, nearly impossible without a computer. The result, *Folk Artists Biographical Index,* is a first-rate work of major importance with which the Museum is most pleased to be associated.

<div style="text-align: right;">
Dr. Robert Bishop, Director

Museum of American Folk Art
</div>

Introduction

The identity of many American folk artists once thought of as anonymous or forgotten is now known. The primary purpose of *Folk Artists Biographical Index* is to provide a source to locate references to American folk artists of the past and present in a number of publications that contain information about the artists.

What Constitutes Folk Art Is Disputed

It is necessary, of course, to have at least a working definition of the term folk art in order to decide who should—or should not—be included in a listing of American folk artists.

American folk art is now a recognized field of art. However recognition, which has occurred over the last fifty years or so, has not simply failed to produce an accepted definition of folk art, but has resulted in a sometimes acrimonious and still continuing controversy as to that definition. In this controversy, the emphasis has been placed sometimes on the word "art," sometimes on the word "folk," and sometimes on the claimed inconsistency between the two words.

There are many definitions and viewpoints as to what American folk art is—or is not. The magazine *Antiques* published a symposium on the subject in 1950 with thirteen experts and thirteen differing viewpoints.[1] The subject was vigorously debated at the 1977 Winterthur Conference on American Folk Art, and the gauntlet was flung down again as recently as a few months ago in an article in the *Maine Antique Digest*.[2]

However, rather than attempting to describe all of the varying and often conflicting definitional approaches to folk art, it will be sufficient for purposes of this book to discuss only two of these viewpoints: that of the traditionalist and that of the folklorist.

Perhaps the most generally accepted view of American folk art is that it is the work of an untrained or untutored artist. This outlook is reflected by the description of folk art as "naive," "primitive," "self-taught," "grass roots art," "nonacademic," or "the art of the common man." All of these descriptive terms would probably be accepted by the traditionalist.

The traditional viewpoint, which stresses the "art" in folk art, is well described in the oft-quoted remarks of Holger Cahill, one of the first scholars to write extensively on American folk art. Mr. Cahill said in his commentary to the Newark Museum exhibit of American folk art sculpture in 1931:

> . . . folk art in its truest sense . . . is an expression of the common people and not an expression of a small cultured class. Folk Art usually has not much to do with the fashionable art of its period. It is never the product of art movements, but comes out of craft traditions, plus that personal something of the rare craftsman who is an artist by nature if not by training. This art is based not on measurements or calculations but on feeling, and it rarely fits in with the standards of realism. It goes straight to the fundamentals of art—rhythm, design, balance, proportion, which the folk artist feels instinctively.[3]

Jean Lipman, a prominent author and scholar, refined and broadened Mr. Cahill's traditional viewpoint. More than 40 years after Mr. Cahill's observations, she wrote in the preface to *The Flowering of American Folk Art: 1776-1876:*

> No single stylist term, such as primitive, pioneer, naive, natural, provincial, self-taught, amateur, is a satisfactory label for the work we present here as folk art, but

collectively they suggest some common denominators: independence from cosmopolitan, academic traditions; lack of formal training, which may make for interest in design rather than optical realism; a simple and unpretentious rather than sophisticated approach, originating more typically in rural than urban places and from craft rather than fine-art traditions.[4]

A second point of view is that of the "new" folklorists, whose field of study now actively encompasses items of material culture and whose views differ substantially from the folk art traditionalists. The new folklorists' perspective was anticipated by a scholarly and controversial essay, written just prior to the aforementioned 1977 Winterthur Conference on American Folk Art. In this essay, Dr. Kenneth L. Ames, then a teaching associate at the Winterthur Museum and presently the Chairman of its Office of Advanced Studies, traced the folk art movement from its cultural context and challenged the traditionalists, pointing out that many of the underlying assumptions about American folk art (for example, that individuality is a characteristic of folk artists) were nothing but myths that "distort the integrity of both the [art] objects and the people associated with them."[5] Instead, Dr. Ames contended that folk art should be judged by the hallmarks of tradition, decoration, and competence, with tradition as the key. By stressing tradition but still remaining very much interested in "art," Dr. Ames was in a sense a bridge between the traditionalists and the new folklorists.

The current folklorists' viewpoint is itself typified by the views of John Michael Vlach, a leading scholar and writer in the field. Dr. Vlach, in a 1985 article in the *Journal of American Folklore,* contended that in deciding whether something is folk art or not, the focus should be on "the features of an artwork which make it 'folk' rather than those features which make it an art object."[6] Dr. Vlach would limit folk art to "artwork made by a member of a folk society according to the collective dictates of the group"[7] and he would specifically exclude work which is "singular, unique, personal, original and unprecedented."[8]

In other words, Dr. Vlach would exclude from American folk art many of the works that Mr. Cahill and Ms. Lipman would call the best examples of American folk art because of the very fact that they are so personal and original. Moreover, Dr. Vlach would also exclude many of the other favorites of traditionalists such as naive primitive paintings from nineteenth-century New England, calling them in some cases not "good folk art" but "imperfect or bad fine art."[9]

The Lipman approach, on the other hand, would generally exclude from folk art most American twentieth-century works (often called contemporary folk art), while the Vlach approach would probably include some of them, but only so long as they were part of a folk tradition.[10] However, both Ms. Lipman and Dr. Vlach would exclude many works that are now considered American folk art by other scholars, such as Dr. Robert Bishop, the Director of the Museum of American Folk Art. *Folk Art Painting, Sculpture and Country Objects,* one of the recent Knopf collectors' guides to American antiques, authored by Dr. Bishop, Judith Weissman, Michael McManus, and Henry Niemann, further extends the definition of American folk art:

> "Folk art" is today used as an umbrella term for numerous artistic forms and utilitarian objects in a wide variety of mediums and from every period of American history. It ranges from primitive paintings and sculpture to baskets, wooden kitchenware, factory-made weathervanes, and even modern-day outdoor "junk sculpture." It has been subject to many different definitions over the years, largely because it refers to a relatively new field in which discoveries are constantly being made.[11]

This description, and some of the folk art objects pictured in the Knopf book, includes many of the very items that Alice Winchester (co-author with Jean Lipman of *The Flowering of American Folk Art*) questioned in 1974, when she wrote:

> As folk art has become increasingly popular in recent years, its limits have grown more and more indistinct. To some people nowadays folk art includes every sort of household, farm, trade and shop equipment or product that has an unsophisticated or "country" character.[12]

The positions of the traditionalists and the new folklorists, and some of the deviations from these viewpoints, illustrate that there is a genuine and basic difference of opinion about what constitutes American folk art.[13] Moreover, as Dr. Ames and others have pointed out, considering the marketplace for works of art in this field, the debate is not merely academic.

Interestingly, at least for the purposes of this book, both of the groups I have described, but particularly the folklorists, emphasize the great need for more information about the creators of the art works.[14] As Dr. Vlach said, new American folk art scholarship should "focus more attention on [the] artist[s], their life histories, their creative intentions, and their actions."[15]

The Broadest Definition of Folk Art Is Used in This Book

I recognize the importance of this definitional dispute, but I also believe that the maximum usefulness of this publication both as a reference book and to assist in further scholarly research will be achieved if persons are included, not excluded. I have elected, therefore, to treat American folk art in its broadest sense, in effect defining it for purposes of this book as everything that is considered by an author, scholar, or other responsible person in the folk art community to be folk art. Or, as Louis C. Jones, Director Emeritus of the New York State Historical Association, stated in a somewhat different manner, "The term *folk art* is like a great circus tent under which a variety of acts are simultaneously taking place."[16] In this spirit, I leave to others both the debate and the decision as to whether a particular person found in this book is "truly" an American folk artist.

The Names of Many American Folk Artists Are Now Known

As mentioned, at one time the term "folk artist" was most likely to refer to an anonymous artist. There are certainly folk artists whose names may never be known, particularly those of the seventeenth, eighteenth, and early nineteenth centuries. But as increasing scholarly attention is given to the subject, even the names of some of these artists will be found. Already, however, there is a wealth of published material covering substantial numbers of nineteenth- and, certainly, twentieth-century American folk artists. This first edition of *Folk Artists Biographical Index* contains listings for some 9,000 of those artists, from the seventeenth century to the present, along with citations to over 200 publications in which further information about the artists appears.

Most of the listings are of individual artists, although some are of businesses, such as commercial potters and "factory" weathervane manufacturers, while still others are of craftsmen. The businesses and craftsmen listed made objects now considered to be folk art, such as weathervanes, decorated stoneware pots, and cigar store figures. A few listings are of persons who might be regarded primarily as "fine artists" or trained artists working in a "folk art" style or "popular artists." These artists are included because they too are considered folk artists by one or more cited sources. Only American artists are listed. For purposes of this book, an artist is considered to be American if the artist worked in this country.

The Publications Indexed

Many of the publications indexed were selected from my personal library, which stresses the areas of my collecting interests: American folk sculpture and painting. Most of the publications indexed are books rather than catalogs, pamphlets, or periodicals. No claim is made that this first edition of *Folk Artists Biographical Index* is an index of only current publications or of publications covering all areas of folk art, or that it contains all of the important publications in those areas that are covered. However, the publications indexed are in most cases among the important publications in the broad areas of folk art included in the book, such as painting, sculpture, pottery, and fabric.

Most, if not all, of these publications can be acquired from decorative arts book dealers and museum book stores or found in large libraries and institutions that specialize in the arts. The researcher is urged to seek out the publications themselves, since this book is intended to be a guide to the publications, not a substitute for them.

The Entire Contents of Each Publication Have Been Reviewed

The approach taken in compiling this book has been to review the entire contents of each publication, not just the index, since many publications have incomplete indexes or none at all. Thus, this book includes artists and information that would be extremely difficult and time-consuming for a researcher to obtain otherwise.

Concise Information Is Supplied in Each Entry

Each entry includes the artist's name, nickname, and pseudonyms or variant spellings, and, if found in one of the sources, the date and place of the artist's birth and death; the period and the geographical area where the artist flourished; the ethnic heritage of the artist; the media used and type of work the artist did; the names of museums containing the artist's work; any special remarks about the artist, such as relationships to other artists; and, of most importance, a reference to the publication(s) in which the artist is listed—and where, in almost all cases, additional information is available—and should be sought.

The information in the entries is based solely on that found in the sources researched (with only a few exceptions, such as a recent death), and so the absence of information—or incorrect information—does not necessarily mean that other information—or correct information—is not available, but only that it was not in the sources researched.

An effort was made to identify and correct the names of museums and to reconcile inconsistent information found both in and among the publications that were indexed, such as differences in the spelling of names and pseudonyms and the identification of family members and dates of birth or death. For example, in the case of nineteenth-century potters and tinsmiths, the names of a father, his son, and his grandson might well be the same. So where the family continued in the same work, an attempt was made in several cases to distinguish the generations. However, in some instances the same person may be listed in more than one entry when the researcher simply could not determine from the different sources whether the person referred to was the same person or not.

In a few cases an entry may not include all of the above-mentioned information about the artist, even though the information appears in one or more of the sources cited, because an editorial decision to increase the categories of information in the entries was made after some publications had been researched.

Special Indexes to Contents

By indexing the contents of each entry, I have been able to supply an Art Locator Index, which provides an alphabetical listing of the museums and institutions where the artists' works may be found; an Ethnicity Index, which lists the artists under their ascribed heritage; a Geographic Index, which lists the cities and states where the artists flourished; a Media Index, which lists the material used in the artists' works; and a Type of Work Index, which lists the kinds of work the artists did.

The information provided in each of these indexes is not complete as to all of the artists listed, since the index contains only the information found in the entries themselves which, in turn, reflects only the information stated in the cited sources. For example, there are probably many artists of German heritage who were not specifically identified as such in a cited source and so are not listed as German in either the entry itself or in the Ethnicity Index.

Some additional comment may be helpful in connection with the Media Index and the Type of Work Index. The format of the entries in these indexes was designed to show the variety of information found in the sources and to point out the diversity in the kinds of folk art created by the artists. It was not designed merely to index the information, which would have required a much more standardized and simplified approach. When the media and type of work information on the several thousands artists in the book was routinely collated and printed out by the computer, the categories and assembled information, as was expected, turned out in many cases to be disorganized, inconsistent, duplicative, and frustrating. But, unexpectedly, this presentation also turned out to be unusually interesting and just fun reading and, because of its open structure and lack of systemization, useful to a researcher in ways

that a more standardized format might not be. I therefore decided to add the Media Index and Type of Work Index and to do so "as is."

Future Editions

This project has proved to be much more difficult and time-consuming than I originally thought it would be. Reviewing an entire book for names and other information and entering that information in a notebook or even directly into a computer proved to be tedious and tended to "burn out" researchers. The book was compiled using a computer, but the computer program had to be developed as the project developed.

What was learned about researching and computerizing this first edition is now being applied to the work on the next edition, which will index additional publications, including those in other areas of folk art, list additional artists, provide supplemental information on artists already listed, and perhaps provide additional indexes.

Acknowledgments

A number of acknowledgments are in order. First, to my son, George, Jr., who spent two summers in New York between semesters at Oberlin College to take on the primary responsibility for developing the computer database format of the entries, researching the publications, and compiling the data. In the process he learned a great deal not only about folk artists but also about the vagaries of publications and computers and how best to carry a backpack filled with notes on the subway between his apartment, the New York Public Library, and the Museum of American Folk Art Library.

Acknowledgment should also be given to Kay White, who spent hours verifying the accuracy of the information on the computer printouts against many of the original sources and resolving inconsistencies between the entries and among the publications referenced. She said that at times this was like working on a huge, never-ending crossword puzzle. Further, I would like to recognize the important contributions of Peter Ruffner, Hank Hubbard, Dennis LaBeau, Don Dillaman, and Douglas Cale, who together set up a computer program to handle this work and to permit the constant revision of the work as it evolved. Particular thanks should be given to Fred Ruffner and Jim Ethridge for their encouragement and thoughts as to the format of the book, and to Michael Hall and Bert Hemphill, who introduced me to American folk art.

Finally, I would like to acknowledge my great indebtedness to the authors of the publications indexed by this book, each of whom has added to the understanding and knowledge of those who created American Folk Art.

Corrections

Although all reasonable efforts were made to insure correctness, responsibility for the accuracy of the information in the entries must be disclaimed. The book by its very approach, nature, and scope is bound to contain errors and offers room for improvement. I would welcome corrections and suggestions for the next edition.

<div style="text-align: right;">
George H. Meyer

June 15, 1986
</div>

Notes

1. "What is American Folk Art? A Symposium." *Antiques* 57, (May 1950) no.5:355-62. (The thirteen experts are among a substantial number of authorities in this field, most of whom, because of context and space limitations, I regret I have been unable to refer to by name.)

2. Miami University (Ohio) Professor Eugene W. Metcalf, Jr. said in his article entitled "The Problem of American Folk Art, Which Folk?":

> ... perhaps we have trouble defining folk art because as an artistic category "folk art" does not exist apart from the collection of it. If so, the real creators of "folk art" are not the 18th and 19th century craftsmen who made the objects, but the modern collectors and dealers who find old things and infuse them with new folk art meaning.

Maine Antique Digest, (April 1986) 14:no.4:34-8.

3. Cahill, Holger. *American Folk Sculpture: The Work of Eighteenth and Nineteenth Century Craftsmen.* Newark, NJ: Newark Museum, 1931, p. 13. (Exhibition Catalog)

4. Lipman, Jean, and Winchester, Alice. *The Flowering of American Folk Art: 1776-1876.* New York: Viking Press, 1974, p. 6.

5. Ames, Kenneth L. *Beyond Necessity: Art in the Folk Tradition.* Winterthur, DE: Winterthur Museum, 1977; New York: W.W. Norton, 1977, p. 21.

6. Vlach, John Michael. "The Emergence of Forgotten American Folk Artists." *Folklore* 96,no.1:115.

7. *Ibid.,* p 116.

8. *Ibid.,* p 116.

9. *Ibid.,* p 117.

10. Among the leading advocates of the position that there is genuine American folk art in this century are Herbert W. Hempill, Jr., and Michael and Julie Hall. Some of their many writings are indexed in this book. On the other hand, Howard A. Feldman, the President of the American Folk Art Society and a former trustee of the Museum of American Folk Art, strongly argued in a speech at the New York Historical Association Colloquium at Cooperstown, New York, in 1983 that there is no such thing as twentieth-century American folk art. Reprinted in *Antiques and the Arts Weekly* (September 16, 1983) 11, no.36:25.

11. Bishop, Robert; Weissman, Judith Reiter; Mcmanus, Michael; and Neimann, Henry. *Folk Art: Paintings, Sculpture & Country Objects.* New York: Alfred A. Knopf, Inc., 1983.

12. Lipman and Winchester, *The Flowering of American Folk Art: 1776-1875,* p. 9.

13. Dr. Bishop perhaps attempted to smooth the sharp differences between the traditionalists and folklorists, when he said of a 1983 American Folklife Center meeting in Washington, D.C.,

> The conference succeeds in its purpose of bringing together those who view the folk art object primarily as art and those who emphasize its artifactual context. Looking at both the "art" and the "folk" yields the fullest understanding and appreciation of the object.

Bishop, Robert. "Letter from the Director." *The Clarion,* Museum of American Folk Art, New York, Winter, 1983/1984, p. 13.

14. Dr. Tom Armstrong, however, cautioned against placing too much stress on biographical material over aesthetics:

> The lack of emphasis upon the aesthetic merits of American folk art ... [is] ... due to some extent to the continuous debate over proper nomenclature for this category of American art. The anecdotal material on folk art has so consistently displaced true aesthetic judgments that the various terms that have been assigned to describe it refer more to the life and character of the artist than to his work.

Armstrong, Tom. *The Innocent Eye: American Folk Sculpture; 200 Years of American Sculpture.* New York: David R. Godine, Publisher, in association with the Whitney Museum of American Art, 1976, p. 75.

15. Vlach, John Michael. *The Emergence of Forgotten American Folk Artists.* p. 119.

16. Andrews, Ruth, ed. *How to Know American Folk Art.* New York: E.P. Dutton, 1977, p. 2.

Reading a Citation

Citations have been designed to enable a researcher to locate quickly and efficiently information about an artist from specific sources.

The citation gives the artist's name as the name is listed in the published source(s), and if in the source(s): the date and place of the artist's birth; the date and place of the artist's death; the date(s) and place(s) where the artist flourished; the artist's ethnicity; the media used by the artist and the type of work the artist did; museums where the artist's works are located; remarks that may help to identify the particular artist; and, finally, the sources in which this information was found.

>**Day, Frank Leveva**
>**b.** 1902 Berry Creek, CA **d.** 1976 Carmichael, CA
>**Flourished:** 1960 California, New Mexico, Montana
>**Ethnicity:** American Indian
>**Type of Work:** Oil (paintings)
>**Museums:** 80
>**Remarks:** Konkau-Maidu Indian, painted pictures of Indian myths and traditions.
>**Sources:** *TwCA 142*; FoA 462; PioPar 15, 30-1, 36*, 63.*

The Name

The last name is followed by the first name or initials. Variations in the spelling of the last name are in square brackets and are listed underneath the main entry. Only names in square brackets have been cross referenced.

Example of main entry:

>**Osbon, Aaron C.**
>[Osburn; Osborne; Osborn]

Example of cross reference:

>**Osburn, Aaron C.**
>*See:* Osbon, Aaron C.

Also in square brackets is the company or business name with which the artist was associated, whether as the sole owner, a partner, or an employee.

Example:

>**Tempest, Michael**
>[Hamilton Street Pottery]

Where there was sufficient information about a company, an entry was created under the company name, and the names of the artists associated with the company were listed in square brackets.

Example:

>**Swan and States**
>[Joshua Swan and Ichabod States]

The names of companies are interfiled with the names of individual artists and follow the Library of Congress filing rules; e.g., when the first element is the same, the company name follows all surnames.

Example:
> **Tempest, Michael**
> **Tempest, Nimrod**
> **Tempest, Brockman and Company**

Company names that use a first name or initials are filed in strict alphabetical order.

Example:
> **T.J. White and Company**
> **T. Rigby and Company**
> **T. Sables and Company**
>
> **Thomas and Webster**
> **Thomas Brothers**
> **Thomas C. Smith and Sons**
> **Thomas China Company**

Where a variation in the spelling of the first name was found in different sources or when additional given names were found, the variant or added information is enclosed in parentheses.

Examples:
> **Bears, O.I. (Orlando Hand)**
> **Huge, Jurgan Frederick (Friedrick; Fredrick)**

Where initials have been used for the first name(s) in one source and the full name has been used in a different source, parentheses have been placed around the added information.

Example:
> **Smirth, J(ohn) N(athan)**

When the name given by a source is clearly a nickname, quotation marks have been set around the name.

Example:
> **Wiener, Isador "Pop"**

In some cases, it was not clear whether a name was a nickname.

Example:
> **Dexter, Nabby (Abigail).**

Birth, Death, and Flourished Information

The birth and death dates and the dates an artist flourished are often not determinable from the source(s), and the researcher may reflect this in the entry by the use of a question mark (?) or a "c" for "circa" or by the addition of "s" to the date, for example, 1890s to indicate 1890-1900. Where a single date is shown for the period an artist flourished, it is usually that of a dated work of art. The word "contemporary" is sometimes used where a date for flourished is not known. The actual dates an artist flourished are probably greater than those shown. When only the state was given in the source as a place of birth or death or as a place where the artist flourished, the name of the state is spelled out; otherwise the state abbreviation is used. The listing of states where an artist flourished is not in any particular order.

Ethnicity

The term ethnicity includes race, nationality, and religion. Ethnicity is not indicated unless it was expressly identified in the publication(s) indexed.

Museums

The museums are identified in the citation by a code number and are listed alphabetically by full name and address in the Key to Museum and Institution Codes. In a few cases, the address of the museum could not be found. This is indicated by the notation *"(No further information available)."*

This section includes other institutions, such as libraries and local historical societies, that contain the artist's work. No attempt was made to verify that a work was or still is in the particular museum or institution.

Media and Type of Work

The media—the materials that the artist used—are shown first, followed in parentheses by the type of work that the artist did. There is no particular order in the listing where an artist used more than one medium or did more than one type of work. For example, the first type of work listed in the entry may or may not be the work for which the artist is best known. Where the media used by the artist were not clear from the source(s), no media are shown. Neither the listing of the media nor the listing of the types of work is necessarily complete.

Remarks

Relationships among individuals with similar names are shown in this field as well as other information that might help a researcher identify a particular artist. *See* references are also used in this section to refer to other entries that contain additional information.

Sources

The alphabetic codes used to represent the sources are intended to reflect the title of the publications. The publications are listed with their full bibliographic citation in the Key to Bibliographic Source Codes. For the convenience of the user, the codes and brief forms of the titles also appear on the endsheets.

The source code is followed by the page or pages where information was found. An asterisk (*) following a page number indicates there is an illustration. When a source code appears with an asterisk (*) but no page citation, this indicates that there is an illustration, but that the pages in the book were not numbered. Abbreviations used are "fig," for figure, and "pl," for plate.

Key to Bibliographic Source Codes

AfAmA *Afro-American Art and Craft.* By Judith Wragg Chase. New York: Van Nostrand Reinhold Co., 1971.

A1AmD *The All-American Dog: Man's Best Friend in Folk Art.* By Robert C. Bishop. New York: Avon, in association with Museum of American Folk Art, 1977. (Exhibition Catalog)

AmBiDe *American Bird Decoys.* By William F. Mackey, Jr. Exton, PA: Schiffer Publishing; New York: Dutton, 1965.

AmCoB *American Copper and Brass.* By Henry J. Kauffman. Camden, NJ: Thomas Nelson, 1968.

AmCoTW *American Country Tin Ware, 1700-1900,* [*The History & Folklore*]. By Margaret Coffin. Galahad Books, a division of A & W Promotional Book Corporation, New York: by arrangement with Thomas Nelson. Camden, NJ: Thomas Nelson, 1968.

AmDecor *American Decorative Wall Paintings, 1700-1850.* By Nina Fletcher Little. Sturbridge, MA, Old Sturbridge Village, in cooperation with Studio Publications, New York, 1952. Enl. ed. New York: E.P. Dutton, 1972.

AmDecoy *American Decoys: Ducks, Eiders, Scoters, Geese, Brants, Shorebirds, From Peeps to Curlews, Gulls, Terns, Owls, Crows, Blackbirds, Heron, Loon, Fish and Other Unusual Decoys from 1865-1928.* By Quintana Colio. Ephrata, PA: Science Press, 1972.

AmEaAD *The American Eagle in Art and Design.* By Clarence P. Hornung. New York: Dover Publications, 1978.

AmFiTCa *American Figureheads and Their Carvers.* By Pauline A. Pinckney. New York: W. W. Norton, 1940. Port Washington, NY: Kennikat Press, 1969.

AmFoA *American Folk Art.* By Ellen S. Sabine. Princeton, NJ: Van Nostrand, 1958.

AmFoAr *American Folk Art; A Collection of Paintings and Sculpture, Produced by Little-Known and Anonymous American Artists of the 18th and 19th Centuries.* Williamsburg, VA: Colonial Williamsburg Foundation, 1940. (Exhibition Catalog)

AmFoArt *American Folk Art; Expressions of a New Spirit.* By Robert C. Bishop. England: Penshurst Press, 1983.

AmFokA *American Folk Art from the Traditional to the Naive.* By Lynette I. Rhodes. Cleveland: Cleveland Museum of Art; Bloomington: distributed by Indiana University Press, 1978. (Exhibition Catalog)

AmFokAr *American Folk Art in Wood, Metal and Stone.* By Jean Lipman. New York: Pantheon, 1948. Reprint. New York: Dover Publications, 1972.

AmFokArt *American Folk Art of the Twentieth Century.* By Jay Johnson and William C. Ketchum, Jr. New York: Rizzoli, 1983.

AmFokDe *American Folk Decorations.* By Jean Lipman and Eve Meulendyke. New York: Oxford University Press, 1951.

AmFoPa *American Folk Painters.* By John Ebert and Katherine Ebert. New York: Scribner, 1975.

AmFoPaCe *American Folk Painters of Three Centuries.* By Jean Lipman and Tom Armstrong, eds. New York: Hudson Hills Press, in association with the Whitney Museum of American Art, distributed by Simon & Schuster, 1980.

AmFoPaN *American Folk Painting.* By Mary C. Black and Jean Lipman. New York: Clarkson N. Potter, 1966.

Key to Bibliographic Source Codes

AmFoPaS — *American Folk Painting: Selections from the Collection of Mr. and Mrs. William E. Wiltshire, III.* By Richard B. Woodward, compiler. Richmond, VA: Virginia Museum, 1977. (Exhibition Catalog)

AmFoPo — *American Folk Portraits: Paintings and Drawings from the Abby Aldrich Rockefeller Folk Art Center.* Boston: New York Graphic Society, 1981.

AmFoS — *American Folk Sculpture.* By Robert C. Bishop. New York: E.P. Dutton, 1974.

AmFoSc — *American Folk Sculpture: The Work of 18th and 19th Century Craftsmen Exhibited October 20, 1931 to January 31, 1932.* Newark, NJ: Newark Museum, 1931. (Exhibition Catalog)

AmHo — *American Hooked and Sewn Rugs: Folk Art Underfoot.* By Joel Kopp and Kate Kopp. New York: E.P. Dutton, 1975.

AmNa — *American Naive Paintings from the National Gallery of Art.* Introduction by Mary Black. Washington, DC: National Gallery of Art, 1985. (Exhibition Catalog)

AmNe — *American Needlework; The History of Decorative Stitchery and Embroidery from the Late 16th to the 20th Century.* By Georgiana Brown Harbeson. New York: Coward-McCann, 1938.

AmNeg — *American Negro Art.* By Cedric Dover. Greenwich, CT: New York Graphic Society, 1960.

AmPaF — *American Painted Furniture, 1660-1880.* By Dean A. Fales, Jr. New York: E.P. Dutton, 1972.

AmPiQ — *American Pieced Quilts; an Exhibition.* New York editions des Messons, SA, 1972; New York: Viking, 1972. (Exhibition Catalog)

AmPoP — *American Potters & Pottery.* By John Ramsay. Originally published in Boston, MA: Hale, Cushman & Flint, 1939. Ann Arbor, MI: Ars Ceramica, 1976.

AmPrP — *American Primitive Painting.* By Jean Lipman. New York: Oxford University Press, 1942. Reprint. New York: Dover Publications, 1972.

AmS — *American Stonewares: The Art and Craft of Utilitarian Potters.* By Georgeanna H. Greer. Exton, PA: Schiffer Publishing, 1981.

AmSFo — *Americana: Folk and Decorative Art.* New York: Introduction by Mary Jean Madigan. Edited by Arts & Antiques, a division of Billboard Publications; Roundtable Press, 1982.

AmSFok — *America's Folk Art; Treasures of American Folk Arts and Crafts in Distinguished Museums and Collections.* By Robert L. Polley, ed. Waukesha, WI: Country Beautiful Corporation, 1971.

AmSFor — *America's Forgotten Folk Arts.* Fred & Mary Fried. New York: Pantheon Books, 1978.

AmSQu — *America's Quilts and Coverlets.* By Carleton L. Safford and Robert Bishop. New York: Weathervane Books, 1974; New York: Bonanza Books, 1985.

AnP — *Ammi Phillips: Portrait Painter, 1788-1865.* By Barbara C. Holdridge and Lawrence B. Holdridge. New York: Clarkson N. Potter for the Museum of American Folk Art, distributed by Crown, 1969.

AnPh — "Ammi Phillips, 1788-1865". By Barbara C. Holdridge and Lawrence B. Holdridge. *Connecticut Historical Society Bulletin,* 30, no. 4 (October, 1965): Special issue.

ArC — *Art, Crafts, and Architecture in Early Illinois.* By Betty I. Madden. Urbana: University of Illinois Press, 1974.

ArEn — *The Art of Enterprise, a Pennsylvania Tradition.* Harrisburg, PA: Pennsylvania Historical and Museum Commission in concert with Landis Valley Associates, 1983. (Exhibition Catalog)

ArtDe — *The Art of the Decoy: American Bird Carvings.* By Adele Earnest. New York: Clarkson N. Potter, 1965.

Key to Bibliographic Source Codes

ArtWe	*The Art of the Weathervane.* By Steve Miller. Exton, PA: Schiffer Publishing, 1984.
ArtWea	*The Art of the Weaver.* By Anita Schorsch, ed. New York: Universe Books, 1978.
ArtWo	*Artists in Aprons: Folk Art by American Women.* By C. Kurt Dewhurst, Betty MacDowell and Marsha MacDowell. New York: E.P. Dutton, 1979.
ArtWod	*Artists in Wood: American Carvers of Cigar-Store Indians, Show Figures, and Circus Wagons.* By Frederick Fried. New York: Clarkson N. Potter, 1970.
ASeMo	*The Arts and Architecture of German Settlements in Missouri: A Survey of a Vanishing Culture.* By Charles Van Ravenswaay. Columbia, MO: University of Missouri Press, 1977.
AshPo	*Asahel Powers; Painter of Vermont Faces.* By Nina Fletcher Little. Williamsburg, VA: Colonial Williamsburg Foundation, 1973.
BenS	*Benjamin J. Schmidt: A Michigan Decoy Carver, 1884-1968.* Lowell Jackson, ed. Birmingham, MI: Lowell Jackson, 1970. (Exhibition Catalog)
Bes	*Bespangled, Painted & Embroidered: Decorated Masonic Aprons in America, 1790-1850.* Lexington, MA: Scottish Rite Masonic Museum of Our National Heritage, 1980. (Exhibition Catalog)
BeyN	*Beyond Necessity: Art in the Folk Tradition.* By Kenneth L. Ames. Winterthur, DE: Winterthur Museum; New York: distributed by W.W. Norton, 1977.
BilT	*Bill Traylor.* New York: Hirschl & Adler Modern, 1985. (Exhibition Catalog)
BirB	*The Bird, the Banner, and Uncle Sam: Images of America in Folk and Popular Art.* By Elinor Lander Horwitz. Philadelphia: Lippincott, 1976.
BlFoAr	*Black Folk Art in America, 1930-1980.* By Jane Livingston and John Beardsley. Jackson, MS: University Press of Mississippi, 1982.
BlkAr	*The Blacksmith, Artisan Within the Early Community.* An Exhibition of his work at the Pennsylvania Farm Museum of Landis Valley, 1972-1973. By Vernon S. Gunnion and Carroll J. Hopf, eds. Harrisburg, PA: Pennsylvania Historical and Museum Commission, 1976. (Exhibition Catalog)
BoLiC	*The Border Limner and His Contemporaries.* By Robert C. Bishop. Detroit: Michigan Council for the Arts, 1975. Ann Arbor, MI: University of Michigan, Museum of Art, 1976-77. (Exhibition Catalog)
CaAn	*The Carousel Animal.* By Nina Fraley. Berkley. CA: Zephyr Press, 1983.
CelWo	*Celebrations in Wood: The Sculpture of John Scholl, 1827-1915.* By Katherine C. Grier. Harrisburg, PA: William Penn Memorial Museum, 1979. (Exhibition Catalog)
ChAmC	*A Checklist of American Coverlet Weavers.* By John W. Heisey, compiler, Gail C. Andrews and Donald R. Walters, eitors. Williamsburg, VA: Colonial Williamsburg Foundation, distributed by the University Press of Virginia, 1978.
CiStF	*Cigar Store Figures in American Folk Art.* By A.W. Pendergast and W. Porter Ware. Chicago: Lightner Publishing, 1953.
CoCoWA	*Collecting Country & Western Americana.* By Doreen Beck. London; New York: Hamlyn, 1975.
ColAWC	*Collection of American Water Colors and Drawings, 1800-1875.* By Martha and Maxim Karolik. Vol. 1. Boston: Museum of Fine Arts, 1962.
ConAmF	*Contemporary American Folk Artists.* By Elinor Lander Horwitz. Philadelphia: Lippincott, 1975.
CutM	*Cutting the Mustard.* By Miles B. Carpenter. Tappahannock, VA: American Folk Art Co., 1982.
Decor	*Decorated Stoneware Pottery of North America.* By Donald Blake Webster. Rutland, VT: Charles E. Tuttle, 1971.

Key to Bibliographic Source Codes
Folk Artists Biographical Index • 1st Ed.

Decoy	*Decoys at the Shelburne Museum.* By David S. Webster and William Kehoe. Shelburne, VT: Shelburne Museum, 1961.
DicM	*Dictionary of Marks: Pottery and Porcelain.* By Ralph M. Kovel and Terry H. Kovel. New York: Crown Publishing, 1953.
DutCoF	*The Dutch Country; Folks and Treasures in the Red Hills of Pennsylvania.* By Cornelius Weygandt. New York, London: Appleton-Century, 1939.
EaAmFo	*Early American Folk Pottery.* By Harold F. Guilland. Philadelphia: Chilton Books. 1971.
EaAmG	*Early American Gravestone Art in Photographs.* By Francis Y. Duval and Ivan B. Rigby. New York: Dover Publications, 1978.
EaAmI	*Early American Ironware, Cast and Wrought.* By Henry J. Kauffman. New York: Weathervane Books; Rutland, VT: C.E. Tuttle, 1966.
EaAmW	*Early American Wood Carving.* By Erwin O. Christensen. Cleveland: World Publishing. 1952; Reprint. New York: Dover Publications, 1952, 1972.
EaAmWo	*Early American Wooden Ware and Other Kitchen Utensils.* By Mary Earle Gould. Springfield, MA: Pond-Ekberg, 1942. Rutland, VT: C.E. Tuttle, 1962
Edgar	*Edgar Tolson: Kentucky Gothic.* Exhibition organized by Priscilla Colt. University of Kentucky Art Museum, 1981. (Exhibition Catalog)
Edith	*Edith Gregor Halpert Folk Art Collection.* By Christina Wohler, comp. New York: Terry Dinterfass, 1973. (Exhibition Catalog)
EdwH	*Edward Hicks: His Peaceable Kingdoms and Other Paintings.* By Eleanora Price Mather and Dorothy Canning Miller. New York, London & Toronto: Cornwall Books; Newark: University of Delaware Press, 1983.
EdwHPa	*Edward Hicks, Painter of the Peaceable Kingdom.* By Alice Ford, Philadelphia, PA: University of Pennsylvania Press, 1952. Millwood, NY: Kraus Reprint, 1973.
EraSa	*Erastus Salisbury Field, 1805-1900.* By Mary C. Black. Williamsburg, VA: Abby Aldrich Rockefeller Folk Art Collection, 1963. (Exhibition Catalog)
EraSaF	*Erastus Salisbury Field, 1805-1900.* By Mary C. Black. Springfield, MA: Museum of Fine Arts, 1984. (Exhibition Catalog)
EyoAm	*An Eye on America: Folk Art from the Stewart E. Gregory Collection.* New York: Museum of American Folk Art, 1972. (Exhibition Catalog)
FigSh	*Figureheads & Ship Carvings at Mystic Seaport.* By Edward A. Stackpole. Mystic, CT: Marine Historical Association, 1964.
FloCo	*Floor Coverings in New England Before 1850.* By Nina Fletcher Little. Sturbridge, MA: Old Sturbridge Village, 1967.
FlowAm	*The Flowering of American Folk Art, 1776-1876.* By Jean Lipman and Alice Winchester. New York: Viking Press, 1974.
FoA	*Folk Art: Paintings, Sculpture & Country Objects.* By Robert Bishop, Judith Reiter Weissman, Michael McManus, and Henry Neimann. New York: Knopf, 1983.
FoAF	*Folk Art Finder,* 7, no. 1 (Jan/Feb/Mar 1986).
FoAFa	*Folk Art Finder,* 6, no. 4 (Nov/Dec 1985).
FoAFb	*Folk Art Finder,* 6, no. 3 (Sep/Oct 1985).
FoAFc	*Folk Art Finder,* 6, no. 2 (May/Jun/Jul/Aug 1985).
FoAFd	*Folk Art Finder,* 6, no. 1 (Mar/Apr 1985).
FoAFe	*Folk Art Finder,* 5, no. 5 (Jan/Feb 1985).
FoAFf	*Folk Art Finder,* 5, no. 4 (Nov/Dec 1984).
FoAFg	*Folk Art Finder,* 5, no. 3 (Sep/Oct 1984).
FoAFh	*Folk Art Finder,* 5, no. 2 (May/Jun/Jul/Aug 1984).
FoAFi	*Folk Art Finder,* 5, no. 1 (Mar/Apr 1984).
FoAFj	*Folk Art Finder,* 4, no. 5 (Jan/Feb 1984).

FoAFk	*Folk Art Finder*, 4, no. 4 (Nov/Dec 1983).
FoAFl	*Folk Art Finder*, 4, no. 3 (Sep/Oct 1983).
FoAFm	*Folk Art Finder*, 4, no. 2 (May/Jun/Jul/Aug 1983).
FoAFn	*Folk Art Finder*, 4, no. 1 (Mar/Apr 1983).
FoAFo	*Folk Art Finder*, 3, no. 5 (Jan/Feb 1983).
FoAFp	*Folk Art Finder*, 3, no. 4 (Nov/Dec 1982).
FoAFq	*Folk Art Finder*, 3, no. 3 (Sep/Oct 1982).
FoAFr	*Folk Art Finder*, 3, no. 2 (May/Jun/Jul/Aug 1982).
FoAFs	*Folk Art Finder*, 3, no. 1 (Mar/Apr 1982).
FoAFt	*Folk Art Finder*, 2, no. 6 (Jan/Feb 1982).
FoAFu	*Folk Art Finder*, 2, no. 5 (Nov/Dec 1981).
FoAFv	*Folk Art Finder*, 2, no. 4 (Sep/Oct 1981).
FoAFw	*Folk Art Finder*, 2, nos. 2&3 (May/Jun/Jul/Aug 1981).
FoAFx	*Folk Art Finder*, 2, no. 1 (Mar/Apr 1981).
FoAFy	*Folk Art Finder*, 1, no. 6 (Jan/Feb 1981).
FoAFz	*Folk Art Finder*, 1, no. 5 (Nov/Dec 1980).
FoAFab	*Folk Art Finder*, 1, no. 4 (Sep/Oct 1980).
FoAFcd	*Folk Art Finder*, 1, no. 3 (Jul/Aug 1980).
FoAFef	*Folk Art Finder*, 1, no. 2 (May/Jun 1980).
FoAFgh	*Folk Art Finder*, 1, no. 1 (Mar/Apr 1980).
FoArA	*Folk Art in America: Painting and Sculpture.* By Jack T. Ericson, ed. New York: Mayflower Books, 1979.
FoArO	*Folk Art in Oklahoma; An Exhibition Presented by the Oklahoma Museums Association.* Oklahoma City, OK: Oklahoma Art Center's Arts Annex, 1981 (Exhibition Catalog)
FoAroK	*Folk Art of Kentucky: A Survey of Kentucky's Self-Taught Artists.* By Ellsworth Taylor. Lexington, KY: University of Kentucky Fine Arts Gallery, 1972. (Exhibition Catalog). There are no page numbers in the Catalog.
FoArRP	*Folk Art of Rural Pennsylvania.* By Frances Lichten. New York: Bonanza Books, 1946.
FoArtC	*The Folk Arts and Crafts of New England.* By Priscilla Sawyer Lord and Daniel J. Foley. Philadelphia: Chilton Books, 1965. Updated ed. Radnor, PA: Chilton Books, 1975.
FoPaAm	*Folk Painters of America.* By Robert C. Bishop. New York: E.P. Dutton, 1979.
FoScu	*Folk Sculpture U.S.A.* By Herbert W. Hemphill, Jr., ed. Brooklyn: Brooklyn Museum; New York: distributed by Universe Books, 1976.
FouNY	*Found in New York's North Country; The Folk Art of a Region.* With essays by Varick A. Chittenden and Herbert W. Hemphill, Jr. Utica, NY: Munson-Williams-Proctor Institute, 1982. (Exhibition Catalog)
FraJ	*Frank Jones.* By R.J. Hunt, ed. Dallas, TX: Atelier Chapman Kelly Art Gallery; Topeka, KS: Mulvane Art Center, 1974. (Exhibition Catalog)
Full	*Fullspectrum: Michigan Moderns, Contemporary American Folk Painting.* By Julie Hall, curator. Detroit, MI: Michigan Artrain, 1978. (Exhibition Catalog)
GalAmS	*A Gallery of American Samplers: The Theodore H. Kapnek Collection.* By Glee F. Krueger. New York: E.P. Dutton, in association with the Museum of American Folk Art, 1978.
GalAmW	*A Gallery of American Weathervanes and Whirligigs.* By Robert C. Bishop and Patricia Coblentz. New York: E.P. Dutton, 1981; New York: Bonanza Books: distributed by Crown, 1984.
GalAQ	*Gallery of Amish Quilts.* By Robert C. Bishop and Elizabeth Safanda. New York: E.P. Dutton, 1976.
GifAm	*The Gift of American Naive Paintings from the Collection of Edgar William and Bernice Chrysler Garbisch: 48 Masterpieces.* By Walter P. Chrysler, Jr. Norfolk, VA: Chrysler Museum, 1974.

Key to Bibliographic Source Codes

Folk Artists Biographical Index • 1st Ed.

GoMaD *God, Man and the Devil, Religion in Recent Kentucky Folk Art.* By Larry Hackley, curator, and James Smith Pierce, cataloger. Lexington, KY: Folk Art Society of Kentucky, Kentucky Folk Life Foundation, Rev. and Mrs. Alfred R. Shands, and History Department, Mint Museum, Charlotte, NC, 1984. (Exhibition Catalog) There are no page numbers in the catalog.

GraMo *Grandma Moses, the Artist Behind the Myth.* By Jane Kallir. New York: Clarkson N. Potter, distributed by Crown in association with Galerie St. Etienne, 1982.

GravF *Graven by the Fisherman Themselves: Scrimshaw in Mystic Seaport Museum.* By Richard C. Malley. Mystic, CT: Mystic Seaport Museum, 1983.

GravNE *Gravestones of Early New England and the Men Who Made Them, 1653-1800.* By Harriette Merrifield Forbes. New York: DeCapo Press, 1967.

HanWo *Hands to Work; Shaker Folk Art and Industries.* By Marian Klamkin. New York: Dodd Mead, 1972.

HerSa *Heritage Sampler: An Introduction to the Domestic Arts and Crafts of Central Pennsylvania, 1750-1900.* By W.S. Richard Jones. University Park, PA: Museum of Art, Pennsylvania State University, 1979. (Exhibition Catalog). There are no page numbers in the catalog.

HisCr *Hispanic Crafts of the Southwest.* By William Wroth, ed. Colorado Springs, CO: Taylor Museum of the Colorado Springs Fine Arts Center, 1977. (Exhibition Catalog)

HoPip *Horace Pippin: The Phillips Collection, Washington, DC, Feb. 25-March 27, 1977.* With an essay by Romare Bearden. Washington, DC: Phillips Collection, 1976. (Exhibition Catalog)

HoKnAm *How to Know American Folk Art.* By Ruth Andrews, ed. New York: E.P. Dutton, 1977.

HoFin *Howard Finster, the Man of Visions: The Garden and Other Creations.* By John E. Ollman, ed. Philadelphia, PA: Philadelphia Art Alliance, 1984. (Exhibition Catalog)

HoFinV *Howard Finster's Visions of 1982.* By Howard Finster. Sumerville, GA: Author, 1982.

IlHaOS *Illustrated Handbook of Ohio Sewer Pipe Folk Art.* By Jack E. Adamson. Barberton, OH: Author, 1973.

InAmD *The Index of American Design.* By Erwin O. Christensen. New York: MacMillan Co., 1950, 1959.

JaJ *J. and J. Bard: Picture Painters.* By A.J. Peluso, Jr. New York: Hudson River Press, 1977.

JaJoB *James and John Bard: Painters of Steamboat Portraits.* By Harold S. Sniffan and Alexander Crosby Brown. Newport News, VA: Mariners Museum, 1949.

JoKaP *John Kane, Painter.* By Leon Anthony Arkus, comp. Including reprints of *Sky Hooks, the Autobiography of John Kane* as told to Marie McSurgan. Philadelphia: Lippincott, 1938 and *A Catalogue Raisonné of Kane's Paintings.* Pittsburgh, PA: University of Pittsburgh Press, 1971.

JusMc *Justin McCarthy.* By Ute Stebich. Allentown, PA: Allentown Art Museum, 1985. (Exhibition Catalog)

KaKo *Karol Kozlowski, 1885-1969, Polish-American Folk Painter.* By Martha Taylor Sarno. New York: Summertime Press, 1984.

KenQu *Kentucky Quilts, 1800-1900.* Jonathan Holstein and John Finley. Louisville, KY: Kentucky Quilts Project, 1982. (Exhibition Catalog)

LeViB *Let Virtue Be a Guide to Thee: Needlework in the Education of Rhode Island Women, 1730-1830.* By Betty Ring. Providence, RI: Rhode Island Historical Society, 1983. (Exhibition Catalog)

LoCo	*Local Color: A Sense of Place in Folk Art.* By William R. Ferris. New York: McGraw-Hill, 1982.
MaAmFA	*Masterpieces of American Folk Art.* By Milton Bloch, Charles Lyle, and John Gordon. Monmouth, NJ: Monmouth County Historical Association, Monmouth Museum, 1975. (Exhibition Catalog)
MisPi	*Missing Pieces: Georgia Folk Art, 1770-1976.* By Anna Wadsworth organizer. Atlanta, GA: Georgia Council for the Arts and Humanities, 1976. (Exhibition Catalog)
MoBBTaS	*Morgan B. Brainard's Tavern Signs: A Collection.* By Morgan B. Brainard. Hartford, CT: Connecticut Historical Society, 1958. (Exhibition Catalog)
MoBeA	*Mourning Becomes America.* By Anita Schorsch. Harrisburg, PA: Pennsylvania Historical and Museum Commission; Clinton, NJ: Main Street Press, 1976. (Exhibition Catalog)
NaiVis	*Naives and Visionaries.* Walker Art Center, Minneapolis, MN. New York: E.P. Dutton, 1974.
NeaT	*Neat and Tidy: Boxes and Their Contents Used in Early American Households.* By Nina Fletcher Little. New York: E.P. Dutton, 1980.
NewDis	*New Discoveries in American Quilts.* By Robert C. Bishop. New York: E.P. Dutton, 1975.
NinCFo	*Nineteenth-Century Folk Painting: Our Spirited National Heritage; Works of Art from the Collection of Mr. and Mrs. Peter Tillou.* William Benton Museum of Arts. Storrs, CT: University of Connecticut, 1973. (Exhibition Catalog)
OneAmPr	*101 American Primitive Watercolors and Pastels.* By Edgar William Garbisch and Bernice Chrysler Garbisch. Washington, DC, National Gallery of Art, n.d. (Exhibition Catalog)
OneMa	*101 Masterpieces of American Primitive Painting.* By Edgar William Garbisch and Bernice Chrysler Garbisch. New York: American Federation of Arts, 1961.
PaiNE	*Paintings by New England Provincial Artists, 1775-1800.* By Nina Fletcher Little. Boston, MA: Museum of Fine Arts, 1976. (Exhibition Catalog)
PeiNa	*Peintres Nahifs: A Dictionary of Primitive Painters.* By Anatole Jakovsky. New York: Universe Books, 1967.
PenDA	*Pennsylvania Dutch American Folk Art.* By Henry J. Kauffman. Rev. and enl. ed. of the work originally published by American Studio Books in 1946. New York: Dover Publications, 1964.
PenDuA	*Pennsylvania Dutch Art.* By Ruth Adams. Cleveland, OH: World Publishing, 1950.
PenGer	*The Pennsylvania-German Decorated Chest.* By Monroe H. Fabian. New York: Main Street Press, Universe Books, 1978.
PicFoA	*Pictorial Folk Art: New England to California.* By Alice Ford. New York, London: Studio Publications, 1949.
PicHisCa	*Pictorial History of the Cabin Home and Garden of Eden of S.P. Dinsmoor.* By S.P. Dinsmoor. Lucas, KS: privately printed, n.d.
PieQu	*The Pieced Quilt: A North American Design Tradition.* By Jonathan Holstein. Toronto: McClelland and Stewart; Greenwich, CT: New York Graphic Society, 1973.
PioArt	*Pioneer Art in America.* By Carolyn Sherwin Bailey. New York: Viking Press, 1944.
PioPar	*Pioneers in Paradise: Folk and Outsider Artists of the West Coast.* By Susan Larsen-Martin and Lauri Robert Martin. Long Beach, CA: Long Beach Museum of Art; Seattle: Henry Art Gallery, University of Washington; San Jose, CA: Museum of Art, 1984. (Exhibition Catalog)

Key to Bibliographic Source Codes

Folk Artists Biographical Index • 1st Ed.

PlaFan — *Plain and Fancy: American Women and Their Needlework, 1700-1850.* By Susan Burrows Swan. New York: Holt, Rinehart and Winston, 1977.

PopA — *Popular Art in the United States.* By Erwin O. Christensen. London: Penguin Books, 1948.

PopAs — *Popular Arts of Spanish New Mexico.* By E. Boyd. (Elizabeth Boyd White Hall.) Santa Fe: Museum of New Mexico Press, 1974.

PrimPa — *Primitive Painters in America, 1750-1950.* By Jean Lipman and Alice Winchester. New York: Dodd Mead, 1950.

QufInA — *Quilts from the Indiana Amish: A Regional Collection.* By David Pottinger. New York: E.P. Dutton, 1983.

QuiAm — *Quilts in America.* By Patsy Orlofsky and Myron Orlofsky. New York: McGraw-Hill, 1974.

Rain — *Rainbows in the Sky: The Folk Art of Michigan in the Twentieth Century.* By C. Kurt Dewhurst and Marsha MacDowell. East Lansing, MI: Kresge Art Gallery, Michigan State University, 1978. (Exhibition Catalog)

RediJFH — *Rediscovery: Jurgan Frederick Huge (1809-1878).* By Jean Lipman. New York: Archives of American Art, 1973.

RuPoD — *Rufus Porter Rediscovered: Artist, Inventor, Journalist, 1792-1884.* By Jean Lipman. First ed. published under title *Rufus Porter, Yankee Pioneer.* New York: C.N. Potter, 1968. Rev. ed. New York: C.N. Potter, distributed by Crown, 1980.

Scrim — *The Scrimshander.* By William Gilkerson. Rev. ed. San Francisco: Troubador Press, 1978.

ScriSW — *Scrimshaw and Scrimshanders, Whales and Whalemen.* By E. Norman Flayderman. New Milford, CT: N. Flayderman, 1972.

SculFA — *The Sculpture of Fred Alten.* By Julie Hall. Lansing, MI: Michigan Artrain, 1978. (Exhibition Catalog)

SerPa — *Sermons in Paint: A Howard Finster Folk Art Festival.* By Ann Frederick Oppenhimer and Susan Hankla, eds. Richmond, VA: University of Richmond, 1984. (Exhibition Catalog)

ShipNA — *Shipcarvers of North America.* By M.V. Brewington. Barre, MA: Barre Publishing Co., 1962; New York: Dover Publications, 1972.

SoAmP — *Some American Primitives; A Study of New England Faces and Folk Portraits.* By Clara Endicott Sears. Boston: Houghton Mifflin, 1941; Port Washington, NY: Kennikat Press, 1968.

SoFoA — *Southern Folk Art.* By Cynthia Elyce Rubin, ed. Birmingham, AL: Oxmoor House, 1985.

TenAAA — *Ten Afro-American Artists of the Nineteenth Century.* By James Amos Porter. Washington, DC: Gallery of Art, Howard University, 1967. (Exhibition Catalog)

ThTaT — *They Taught Themselves: American Primitive Painters of the 20th Century.* By Sidney Janis. New York: Dial Press, 1942.

ThrNE — *Three New England Watercolor Painters.* By Gail Savage, Norbert H. Savage, and Esther Sparks. Chicago: Art Institute of Chicago, 1974. (Exhibition Catalog).

TinC — *The Tinsmiths of Connecticut.* By Shirley Spaulding DeVoe. Middletown, CT: Wesleyan Press, 1968.

ToCPS — *To Cut, Pierce, and Solder: The Work of the Rural Pennsylvania Tinsmith.* By Jeannette Lasansky. Lewisburg, PA: Oral Traditions Project of the Union County Historical Society, 1982.

Trans — *Transmitters: The Isolate Artist in America.* With a foreword by Elsa S. Weinar, preface by Maria Tucker, essay by Richard Flood, and dialogue by Michael and Julie Hall. Philadelphia: Philadelphia College of Art, 1981. (Exhibition Catalog)

TwCA	*Twentieth Century American Folk Art and Artists.* By Herbert W. Hemphill, Jr. and Julia Weissman. New York: E.P. Dutton, 1974.
TYeAmS	*200 Years of American Sculpture.* New York: David R. Godine, publisher in association with the Whitney Museum of American Art, 1976.
UnDec	"Underwater Decoys: Fish." By Gene Kangas. In *Decoys, North America.* Spring 1978, pp. 14-23. Spanish Fork, UT: Hillcrest Publications, 1978.
ViSto	*Visions in Stone: The Sculpture of William Edmondson.* By Edmond L. Fuller. Pittsburgh: University of Pittsburgh Press, 1973.
WaDec	*Waterfowl Decoys of Michigan and the Lake St. Clair Region.* By Clune Walsh, Jr. and Lowell G. Jackson. Detroit: Gale Graphics, 1983.
WeaVan	*Weather Vanes: The History, Design and Manufacture of an American Folk Art.* By Charles Klamkin. New York: Hawthorne Books, 1973.
WeaWhir	*Weathervanes and Whirligigs.* By Ken Fitzgerald. New York: Clarkson N. Potter, distributed by Crown, 1967.
WhaPa	*Whalemen's Paintings and Drawings: Selection from the Kendall Whaling Museum Collection.* By Kenneth R. Martin. Sharon, MA: Kendall Whaling Museum; Newark, DE: University of Delaware Press; London & Toronto: Associated University Presses, 1983.
WiFoD	*Wild Fowl Decoys.* By Joel Barber. Windward House, 1934; Reprint. New York: Dover Publications, 1954, 1963.
WiScAM	*Wilhelm Schimmel and Aaron Mountz: Woodcarvers.* By Milton E. Flower. Williamsburg, VA: Abby Aldrich Rockefeller Folk Art Collection, 1965.
WinGu	*A Winterthur Guide to American Needlework.* By Susan Burrows Swan. New York: Crown Publishers, 1976.
WoCar	*Wood Carvings: North American Folk Sculptures.* By Marian Klamkin and Charles Klamkin, New York: Hawthorne Books, 1974.
WoScuNY	*Wood Sculpture of New York State.* New York: Museum of American Folk Art, 1975. (Exhibition Catalog)
YankWe	*Yankee Weathervanes.* By Myrna Kaye. New York: E.P. Dutton, 1975.
YoWel	*Your Wellwisher, J.B. Walker: A Midwestern Paper Cut-Out Artist.* By C. Kurt Dewhurst and Marsha MacDowell. Lansing, MI: Michigan State University Museum, 1979. (Exhibition Catalog)

Key to Museum and Institution Codes

001
Abby Aldrich Rockefeller Folk Art Center
307 S. England St.
Williamsburg, VA 23185

002
Ackland Art Museum
University of North Carolina
Columbia and Franklin Sts.
Chapel Hill, NC 27514

003
Addison Gallery of American Art
Phillips Academy
Andover, MA 01810

Adirondack Center
See: Essex County Historical Society

004
Adirondack Museum
Blue Mountain Lake
NY 12812

005
Akwesasne Museum
Rte. 37
Hogansburg, NY 13655

006
Albany Institute of History and Art
125 Washington Ave.
Albany, NY 12210

007
Albright-Knox Art Gallery
1285 Elmwood Ave.
Buffalo, NY 14222

008
Allen County Museum
620 West Market Street
Lima, OH 45801

009
Allen Memorial Museum of Art
Oberlin College
Oberlin, OH 44074

010
American Antiquarian Society
185 Salisbury St.
Worcester, MA 01609

011
American Clock and Watch Museum, Inc.
100 Maple St.
Bristol, CT 06010

012
American Federation of Arts
41 East 65th Street
New York, NY 10021

013
American Museum of Britain
Bath
England

014
Anadarko Philomothe Museum
311 E. Main St.
Anadarko, OK 73005

015
Anglo-American Art Museum
Louisiana State University, Memorial Tower
Baton Rouge, LA 70803

016
Art Institute of Chicago
Michigan Ave. & Adams St.
Chicago, IL 60603

017
Ashy Museum
(No further information available)

018
Atlanta University
Atlanta
GA 30314

019
Aurora Historical Museum
305 Cedar St.
Aurora, IL 60506

020
Baltimore Museum of Art
Art Museum Drive
Baltimore, MD 21218

021
Bancroft Library
University of California
Berkeley, CA 94720

Barnum Museum, P.T.
See: P.T. Barnum Museum

022
Bedford Historical Society, Museum of the Village Green
Bedford, NY 10506

023
Bennington Museum
W. Main St.
Bennington, VT 05201

024
Bergen County Historical Society
1209 Main St.
River Edge, NJ 07661

025
Berks County Historical Society
940 Centre Ave.
Reading, PA 19601

026
Big World Memorial Library
(No further information available)

027
Bird Craft Museum
314 Unguowa Rd.
Fairfield, CT 06430

028
Bishop Hill State Historic Site
P.O. Box D
Bishop Hill, IL 61419

029
Bostonian Society
Old State House
206 Washington St.
Boston, MA 02109

030
Bourne Museum
Bourne
MA 02532

031
Brookline Society
347 Harvard St.
Brookline, MA 02146

Key to Museum and Institution Codes

032
Brooklyn Museum
200 Eastern Parkway
Brooklyn, NY 11238

033
Broome County Historical Society
30 Front St.
Binghamton, NY 13905

034
Brown University
79 Waterman Street
Providence, RI 02912

035
Bucks County Historical Society
Mercer Museum
Pine & Ashland Sts.
Doylestown, PA 18901

036
Calaveras County Historical Society
30 N. Main St.
San Andreas, CA 95249

Canfield Memorial Library, Martha
See: Martha Canfield Memorial Library

037
Cape Vincent Historical Rooms
Community House, Market St.
Cape Vincent, NY 13618

038
Carnegie Institute
4400 Forbes Ave.
Pittsburgh, PA 15213

Carter Museum, Amon
See: Amon Carter Museum

039
Center for the Study of Southern Culture
Oxford
MS 38655

040
Center of Southern Folklore
P.O. Box 40105
Memphis, TN 38104

041
Central Synagogue
New York
NY 10022

042
Centralia/Timberland Library
110 S. Silver St.
Centralia, CA 98531

043
Chehalis/Timberland Library
76 NE Park
Chehalis, WA 98532

044
Chicago Historical Society
Clark Street at North Ave.
Chicago, IL 60614

045
Children's Museum of Nashville
Cumberland Museum and Science Center
800 Ridley Rd.
Nashville, TN 37203

046
Cincinnati Art Museum
Eden Park
Cincinnati, OH 45202

047
Circus World Museum
426 Water St.
Baraboo, WI 53913

048
Cleveland Museum of Art
11150 East Blvd.
Cleveland, OH 44106

049
Clinton County Historical Museum
Gouverneur
NY 13642

050
Colby College Museum of Art
Mayflower Hill
Waterville, ME 04901

051
Columbia County Historical Society
16 Broad St.
Kinderhook, NY 12106

052
Columbus Museum of Arts and Crafts, Inc.
1251 Wynnton Rd.
Columbus, GA 31906

053
Concord Antiquarian Society
Concord Museum
200 Lexington Rd.
Concord, MA 01742

054
Connecticut Historical Society
1 Elizabeth St.
Hartford, CT 06105

055
Connecticut Valley Historical Museum
194 State St.
Springfield, MA 10128

056
Cooper-Hewitt Museum
Smithsonian Institution
National Museum of Design
2 East 91st St.
New York, NY 10003

057
Cooper Union Society
Cooper Square
New York, NY 10003

058
Corning Museum of Glass
Museum Way
Corning, NY 14830

059
Cortland County Historical Museum
25 Homer Ave.
Cortland, NY 13045

060
Creek Council House Museum
Town Square
Okmulgee, OK 74447

061
Dallas Museum of Arts
1717 N. Harwood
Dallas, TX 75201

062
Dartmouth College
Hanover
NH 03755

063
Daughters of the American Revolution Museum
1776 D. St., N.W.
Washington, DC 20006

064
Daughters of the Republic of Texas Library
Austin
TX 78701

065
Dauphin County Historical Society
219 S. Front St.
Harrisburg, PA 17104

066
Deerfield Academy
Deerfield
MA 01342

067
Delaware Historical Society
(No further information available)

068
Denver Art Museum
100 W. 14th Ave. Pkwy.
Denver, CO 80204

069
Department of the Interior Museum,
 United States
18th and C St., N.W.
Washington, DC 20240

070
Detroit Institute of Arts
5200 Woodward Ave.
Detroit, MI 48202

071
Detroit Public Library
5201 Woodward Ave.
Detroit, MI 48202

072
Drumwright Community Historical
 Association
Drumwright
OK 74030

du Pont Winterthur Museum, Henry
 Francis
 See: Henry Francis du Pont Winterthur Museum

073
Dwight Eisenhower's Birth Place
 Museum
208 E. Day
Denison, TX 75020

074
Dyer-York Library and Museum
Saco
ME 04072

075
Earlham College
Box E2
Richmond, IN 47374

076
Edwards County Historical Museum
Half Way Park
Kinsley, KS 67547

Eisenhower's Birth Place Museum,
 Dwight
 See: Dwight Eisenhower's Birth Place Museum

077
El Paso Museum of Art
1211 Montana Ave.
El Paso, TX 79902

078
Essex County Historical Society and
 Adirondack Center Museum
Court St.
Elizabethtown, NY 12932

079
Essex Institute
132 Essex St.
Salem, MA 01970

080
Everhart Museum of Natural History,
 Science, and Art
Scranton
PA 18510

081
Fall River Historical Society
451 Rock St.
Fall River, MA 02720

Fleming Museum, Robert Hull
 See: Robert Hull Fleming Museum

082
Flint Institute of Art
1120 E. Kearsley St.
Flint, MI 48503

083
Fogg Art Museum
Harvard University
32 Quincy St.
Cambridge, MA 02138

Ford Museum, Henry
 See: Henry Ford Museum and Greenfield Village

084
Fordham University
E. Fordham Road
New York, NY 10458

085
Frankenmuth Historical Society
613 S. Main
Frankenmuth, MI 48734

086
Franklin D. Roosevelt Library and
 Museum
Hyde Park
NY 12538

087
Frederic Remington Art Museum
303 Washington St.
Ogdensburg, NY 13669

088
Fruitlands Museum
R.R. 2, Box 87, Prospect Hill Road
Harvard, MA 01451

089
Galena Historical Museum
221 S. Bench St.
Galena, IL 61036

090
Georgia Department of Archives and
 History
330 Capitol Ave., S.E.
Atlanta, GA 30334

091
Georgia Historical Society
501 Whitaker St.
Savannah, GA 31499

092
Gouverneur Museum
30 Church St.
Gouverneur, NY 13642

Greenfield Village
 See: Henry Ford Museum and Greenfield Village

093
Hagley Museum
P.O. Box 3630
Wilmington, DE 19806

094
Hancock Shaker Village, Inc.
Rte. 20, Pittsfield Albany Rd.
Pittsfield, MA 01202

095
Harwinton Historical Society
Harwinton
CT 06791

096
Henry Ford Museum and Greenfield
 Village
20900 Oakwood Blvd.
Dearborn, MI 48121

097
Henry Francis du Pont Winterthur
 Museum
Winterthur
DE 19735

Key to Museum and Institution Codes

098
Hermann Museum
4th and Schiller Sts.
Hermann, MO 65041

099
High Museum of Art
1280 Peachtree St., N.E.
Atlanta, GA 30309

Hilson Gallery
 See: Deerfield Academy

100
Historic Deerfield, Inc.
The Street
Deerfield, MA 01342

101
Historic New Orleans Collection
533 Royal St.
New Orleans, LA 70130

102
Historical Association of South
 Jefferson
Adams
NY 13605

103
Historical Society
Denver
CO 80203

104
Historical Society of Cocalico Valley
249 W. Main St.
Ephrata, PA 17522

105
Historical Society of Early American
 Decoration
Cooperstown
NY 13326

106
Historical Society of Montgomery
 County
 (No further information available)

107
Historical Society of Old Newbury
98 High St.
Newburyport, MA 01950

108
Historical Society of Pennsylvania
1300 Locust St.
Philadelphia, PA 19107

109
Historical Society of Saratoga Springs
 Museum
Walworth Memorial Museum
The Casino, Congress Park
Saratoga Springs, NY 12866

110
Historical Society of York County
250 E. Market St.
York, PA 17403

111
Hudson River Museum
511 Warburton Ave.
Yonkers, NY 10701

112
Idaho State Historical Museum
610 N. Julia Davis Dr.
Boise, ID 83702

113
Illinois State Historical Library
Old State Capitol
Springfield, IL 62706

114
Illinois State Museum
Corner Spring and Edwards Sts.
Springfield, IL 62706

115
Indiana University
Bloomington
IN 47405

116
Indiana University Art Museum
Indiana University
Bloomington, IN 47405

117
Indiana University Museum of Anthropology
Bloomington
IN 47405

118
Indianapolis Museum of Art
1200 W. 38th St.
Indianapolis, IN 46208

119
Iron County Historical and Museum
 Society
Iron River
MI 49935

120
Jefferson County Historical Society
228 Washington St.
Watertown, NY 13601

121
Jewish Museum
1109 Fifth Ave.
New York, NY 10128

122
Johnstown Museum
Johnstown
PA 15901

123
Kendall Whaling Museum
27 Everett St.
Sharon, MA 02067

124
Kentucky Historical Society
Broadway at the St. Clair Mall, Box H
Frankfort, KY 40602

125
Kentucky Museum
Western Kentucky University
Bowling Green, KY 42101

126
Kiah Museum, A Museum for the
 Masses
505 W. 36 St.
Savannah, GA 31401

127
Ladies' Hermitage Association
Hermitage
TN 20540

128
Lake George Historical Association
 Museum
Canada St.
Lake George, NY 12845

129
Landis Valley Museum, Pennsylvania
 Farm
2451 Kissel Hill Rd.
Lancaster, PA 17601

130
Lebanon Public Library
Lebanon
PA 17042

131
Leicester Museum
 (No further information available)

Key to Museum and Institution Codes

132
Library of Congress
10 First St., S.E.
Washington, DC 20540

133
Litchfield Historical Society and
 Museum
On-the-Green
Litchfield, CT 06759

134
Long Beach Museum of Art
2300 E. Ocean Blvd.
Long Beach, CA 90803

135
Long Island Historical Society
Brooklyn
NY 11201

136
Louisiana State Museum
751 Chartres St.
New Orleans, LA 70116

137
Louisiana State University
Baton Rouge
LA 70803

138
Lyndon Baines Johnson Library and
 Museum
2313 Red River St.
Austin, TX 78705

139
Lyman-Allyn Museum
625 Williams St.
New London, CT 06320

140
Maine State Library
LMA Building
State House Sta. 64
Augusta, ME 04333-0064

141
Marblehead Historical Society
161 Washington St.
Marblehead, MA 01945

142
Mariner's Museum
Museum Dr.
Newport News, VA 23606

143
Martha Canfield Memorial Library
Arlington
VT 05250

144
Maryland Historical Society
201 W. Monument St.
Baltimore, MD 21201

145
Massachusetts Historical Society
1154 Boylston St.
Boston, MA 02215

146
Massachusetts Medical Library
Boston
MA 02215

147
Massillon Museum
212 Lincoln Way, E.
Massillon, OH 44646

148
Mattatuck Museum of the Mattatuck
 Society
119 W. Main St.
Waterbury, CT 06702

149
Mead Art Museum
Amherst College
Amherst, MA 01002

150
Memorial Art Gallery of the University
 of Rochester
490 University Ave.
Rochester, NY 14607

151
Metropolitan Museum of Art
5th Ave. at 82nd St.
New York, NY 10028

152
Michigan Historical Museum
208 N. Capitol Ave.
Lansing, MI 48918

153
Milwaukee Art Museum
750 N. Lincoln Memorial Dr.
Milwaukee, WI 53202

154
Milwaukee County Historical Society
910 N. Third St.
Milwaukee, WI 53203

155
Minnesota Historical Society
690 Cedar St.
St. Paul, MN 55101

156
Minneapolis Institute of Art
2400 Third Ave. So.
Minneapolis, MN 55404

157
Mint Museum of History
2730 Randolph Rd.
Charlotte, NC 28207

158
Mississippi State Historical Museum
North State and Capitol Sts.
Jackson, MS 39205

159
Missouri Historical Society
Lindell & De Baliviere
St. Louis, MO 63112

160
MIT Museum
265 Massachusetts Ave.
Cambridge, MA 02139

161
Monmouth County Historical
 Association
70 Court St.
Freehold, NJ 07728

162
Monroe Historical Society
320 Wheeler Rd.
Monroe, CT 06468

163
Montgomery County Historical Society
Rte. 5
Fort Johnson, NY 12070

164
Moravian Museum of Bethlehem
66 W. Church St.
Bethlehem, PA 18018

165
Moore College of Art
20th and the Parkway
Philadelphia, PA 19103

166
Mount Vernon Ladies Association of the
 Union
Mount Vernon
VA 22121

167
Mueller House Museum
 (No further information available)

Key to Museum and Institution Codes

168
Munson-Williams-Proctor Institute
310 Genesee St.
Utica, NY 13502

169
Musée d'Art Naïf de l'Île de France
Paris
France

170
Museum, Michigan State University
West Circle Drive
East Lansing, MI 48824

171
Museum of American Folk Art
125 W. 55th St.
New York, NY 10019

172
Museum of Appalachia
Box 359
Norris, TN 37828

173
Museum of Art, Rhode Island School of Design
224 Benefit St.
Providence, RI 02903

174
Museum of Art Brut
Lausanne
Switzerland

175
Museum of Early Southern Decorative Arts
924 S. Main St.
Winston-Salem, NC 27101

176
Museum of Fine Arts
465 Huntington Ave.
Boston, MA 02115

177
Museum of Georgia Folk Culture at Georgia State University
University Plaza
Atlanta, GA 30303

178
Museum of International Folk Art
Division of Museum of New Mexico
706 Camino Lejo
Santa Fe, NM 87501

179
Museum of Modern Art
11 W. 53rd St.
New York, NY 10019

180
Museum of Natural History
New York
NY 10024

181
Museum of New Mexico
113 Lincoln Ave.
Santa Fe, NM 87503

182
Museum of Northern Arizona
Fort Valley Road, Route 4, Box 720
Flagstaff, AZ 86001

183
Museum of Our National Heritage
33 Marrett Rd.
Lexington, MA 02173

Museum of the Bedford Historical Society
See: Bedford Historical Society, Museum of the

184
Museum of the City of New York
Fifth Ave. at 103rd St.
New York, NY 10029

185
Museum of Wood Carving
Spooner
WI 54801

186
Mystic Seaport Museum, Inc.
Greenmanville Ave.
Mystic, CT 06355

187
Nantucket Historical Association
Old Town Building, Union St.
Nantucket, MA 02554

188
Nassau County Museum
1864 Muttontown Rd.
Syosset, NY 11791

189
National Gallery of Art
4th St. & Constitution Ave., N.W.
Washington, DC 20565

190
National Museum of American Art
8th & G Sts., N.W.
Washington, DC 20560

191
National Museum of History and Technology
Washington
DC 20560

192
Natural History Museum of Los Angeles County
900 Exposition Blvd.
Los Angeles, CA 90007

193
Naval Asylum
Philadelphia
PA

194
New Bedford Whaling Museum
18 Johnny Cake Hill
New Bedford, MA 02740

195
New England Historic Genealogical Society
101 Newbury St.
Boston, MA 02116

196
New England Medical Center Hospital
171 Harrison Ave.
Boston, MA 02111

197
New Haven Colony Historical Society
114 Whitney Ave.
New Haven, CT 06510

198
New Jersey Historical Society
230 Broadway
Newark, NJ 07104

199
New Jersey State Library Collection
185 W. State St.
Trenton, NJ 08625-0520

200
New Jersey State Museum
205 W. State St.
Trenton, NJ 08625

201
New Orleans Museum of Art
Lelong Ave., City Park
New Orleans, LA 70119

202
New York Public Library
5th Ave. & 42nd St.
New York, NY 10018

203
New York State Historical Association
Fenimore House, Lake Rd.
Cooperstown, NY 13326

204
Newark Museum
49 Washington St.
Newark, NJ 07101

205
Newport Historical Society
82 Touro St.
Newport, RI 02840

Norwegian-American Museum
See: Vesterheim Norwegian-American Museum

206
Norwood Historical Association and Museum
39 N. Main St.
Norwood, NY 13668

207
Oakland Museum
1000 Oak St.
Oakland, CA 94607

208
Ohio Historical Society, Inc.
Columbus
Ohio 43211

209
Ohio State Archeological and Historical Society
Columbus
OH 43211

210
Ohio State Museum
240 Hopkins Hall
148 N. Oval Dr.
Columbus, OH 43210

211
Old Colony Historical Society
66 Church Green
Taunton, MA 02780

212
Old Dartmouth Historical Society
New Bedford
MA 02746

213
Old Gaol Museum
York
ME 03909

214
Old Slave Mart Museum
6 Chalmers St.
Charleston, SC 29401

215
Old Sturbridge Village
Sturbridge
MA 01566

216
Oneida Historical Society
318 Genesee St.
Utica, NY 13502

217
Onondaga County Historical Association
311 Montgomery St.
Syracuse, NY 13202

218
Oregon Historical Society
1230 S.W. 11th Ave.
Portland, OR 97205

219
Oswego County Historical Society
135 E. 3rd St.
Oswego, NY 13126

220
P.T. Barnum Museum
820 Main St.
Bridgeport, CT 06604

221
Peabody Museum of Salem
East India Square
Salem, MA 01970

222
Pejepscot Historical Society
159 Maine St.
Brunswick, ME 04011

223
Pennsylvania Academy of Fine Arts
Philadelphia
PA 19102

224
Pennsylvania Farm Museum of Landis Valley
2451 Kissel Hill Rd.
Lancaster, PA 17601

225
Pennsylvania Historical and Museum Commission
Harrisburg
PA 17120

226
Peoria Historical Society
942 N.E. Glen Oak Ave.
Peoria, IL 61603

227
Philadelphia Museum of Art
26th St. & Benjamin Franklin Parkway
Philadelphia, PA 19130

228
Philbrook Art Center
2727 S. Rockford Rd.
Tulsa, OK 74114

229
Phillips Collection
1600 21st St., N.W.
Washington, DC 20009

230
Pilgrim Hall
75 Court St.
Plymouth, MA 02360

231
Pilgrim John Howland Society
(No further information available)

232
Plains Indians and Pioneer Historical Museum
2009 Williams Ave.
Woodward, OK 73802

233
Plattsburgh Public Library
15 Oak St., P.O. Box 570
Plattsburgh, NY 12901

234
Pocumtuck Valley Memorial Association
Deerfield
MA 01342

235
Potsdam Public Museum
Civic Center
Potsdam, NY 13676

236
Potters Museum
(No further information available)

237
Pratt Museum of Natural History
Amherst College
Amherst, MA 01002

Key to Museum and Institution Codes

238
Princeton University
Princeton
NJ 08540

239
Reading Public Museum Art Gallery
500 Museum Rd.
Reading, PA 19611

240
Red Barn Museum
River Rd.
Morristown, NY 13664

Remington Art Museum, Frederic
 See: Frederic Remington Art Museum

241
Rhode Island Historical Society
110 Benevolent St.
Providence, RI 02906

242
Robert Hull Fleming Museum
University of Vermont
Colchester Ave.
Burlington, VT 05405

243
Rochester Museum of Art and Science
 Center
657 East Ave., Box 1480
Rochester, NY 14603

Rockefeller Folk Art Center, Abby
 Aldrich
 See: Abby Aldrich Rockefeller Folk
 Art Center

244
Rockford Historical Society Museum
Rockford
MI 49341

245
St. George School
Newport
RI 02840

246
St. Lawrence County Historical
 Association
3 East Main
Canton, NY 13617

247
St. Louis Art Museum
St. Louis
MO 63119

248
St. Michael's Church
New York
NY 10001

249
Salem Academy and College
Winston-Salem
NC 27108

250
San Antonio Museum Association
3801 Broadway
San Antonio, TX 78215

251
San Diego Historical Society
2727 Presidio Dr.
San Diego, CA 92103

252
San Diego Museum of Art
Balboa Park
San Diego, CA 92101

253
San Francisco Art Institute
800 Chestnut St.
San Francisco, CA 94133

254
San Francisco Maritime Museum
San Francisco
CA 94109

255
San Francisco Museum of Modern Art
401 Van Ness Avenue
San Francisco, CA 94102

256
Saratoga County Museum
Brookside
Ballston Spa, NY 12020

257
Schenectady County Historical Society
32 Washington Ave.
Schenectady, NY 12305

258
Seaman's Church Institute of New York
 and New Jersey
50 Broadway
New York, NY 10004

259
Shaker Museum
Shaker Museum Road
Old Chatham, NY 12136

260
Shelburne Museum, Inc.
U.S. Rte. 7
Shelburne, VT 05482

261
Sheldon Art Museum, Archaeological
 and Historical Society
1 Park St.
Middlebury, VT 05753

262
Sheldon Memorial Art Gallery
University of Nebraska
12th and R Sts.
Lincoln, NE 68588

263
Smithsonian Institute
1000 Jefferson Dr., S.W.
Washington, DC 20560

264
Springfield Art and Historical Society
Springfield
IL 62702

265
Springfield Museum of Fine Arts
49 Chestnut Street
Springfield, MA 01103

266
Stamford Historical Society, Inc.
1508 High Ridge Rd.
Stamford, CT 06903

267
State Historical Society
1300 Broadway
Denver, CO 80203

268
State Museum of Oklahoma
Wiley Post Historical Building
2100 N. Lincoln
Oklahoma City, OK 73105

269
Staten Island Historical Society
441 Clarke Ave.
Staten Island, NY 10306

270
Stonington Historical Society
Stonington
CT 06378

271
Strong Museum
One Manhattan Square
Rochester, NY 14607

Key to Museum and Institution Codes

272
Taylor Museum of the Colorado Springs Fine Arts Center
30 West Dale Street
Colorado Springs, CO 80903

273
Telfair Academy of Arts and Sciences, Inc.
121 Barnard St.
Savannah, GA 31401

274
Tennessee Department of Conservation, Archeology Div.
Nashville
TN 37219

275
Tennessee Fine Arts Center at Cheekwood
Forest Park Drive
Nashville, TN 37205

276
Tennessee State Museum
505 Deaderick St.
Nashville, TN 37219

277
Texas State Library
1201 Brazos St.
Austin, TX 78711

278
Thomas Gilcrease Institute of American History and Art
1400 Gilcrease Museum Road
Tulsa, OK 74127

279
Thomas Jefferson Memorial Foundation
Charlottesville
VA 22902

United States. Department of the Interior Museum
See: Department of the Interior Museum

280
United States Naval Academy Museum
Annapolis
MD 21402

281
University Art Museum
2626 Bancroft Way
Berkeley, CA 94720

282
University of Kansas Museum of Art
Lawrence
KS 66045

283
University of Kentucky Art Museum
Rose and Euclid Sts.
Lexington, KY 40506

284
University of Michigan Museum of Art
S. State and S. University Sts.
Alumni Memorial Hall
Ann Arbor, MI 48109

285
University of Tennessee
Knoxville
TN 37996

286
University of Texas at Austin, Winedale Historical Center
FM Road 1714
Round Top, TX 78954

287
Valentine Museum
1015 E. Clay St.
Richmond, VA 23219

288
Vatican Collection
Rome
Italy

289
Vermont Museum
109 State St., Pavilion Bldg.
Montpelier, VT 05602

290
Vesterheim Norwegian-American Museum
502 W. Water St.
Decorah, IA 52101

291
Vigo County Historical Society
(No further information available)

292
Vinland Museum
KS
(No further information available)

293
Virginia Historical Society
428 North Blvd.
Richmond, VA 23221

294
Virginia Museum of Fine Arts
Boulevard and Grove Ave.
Richmond, VA 23221

295
Viterbo College Museum
Fine Arts Building
815 S. 9th St.
La Crosse, WI 54601

296
Wachovie Historical Society
(No further information available)

297
Wadsworth Atheneum Museum
600 Main St.
Hartford, CT 06103

298
Washington State Capital Museum
211 W. 21st Ave.
Olympia, WA 98501

299
Washington State Historical Society
315 N. Stadium Way
Tacoma, WA 98403

300
Wayside Museum
Harvard
MA 01451

301
Webb-Deane-Stevens Museum
211 Main St.
Wethersfield, CT 06109

302
Wenham Historical Association and Museum, Inc.
132 Main St.
Wenham, MA 01984

303
Western Reserve Historical Society
10825 East Blvd.
Cleveland, OH 44106

304
Whaling Museum Society, Inc.
Main St., Box 25
Cold Spring Harbor, NY 11724

305
White County Historical Society
Rt. 3, Box 4
Cleveland, GA 30528

306
The White House
1600 Pennsylvania Ave.
Washington, DC 20500

307
Whitney Museum of American Art
945 Madison Ave.
New York, NY 10021

308
Willamette Valley Rehabilitation Center
Lebanon
OR 97355

309
William Penn Memorial Museum
Harrisburg
PA 17120

Winterthur Museum, Henry Francis du Pont
See: Henry Francis du Pont Winterthur Museum

310
Witte Memorial
San Antonio
TX 78209

311
Worcester Art Museum
55 Salisbury St.
Worcester, MA 01608

312
Wright Memorial Library
Orwell
VT 05760

313
Yale University Art Gallery
1111 Chapel St.
New Haven, CT 06520

314
Zanesville Art Center
620 Military Rd.
Zanesville, OH 43701

Folk Artists Biographical Index

A

A. and W. Boughner
Flourished: 1850 - 1890 Greensboro, PA
Type of Work: Redware (Pottery)
Sources: *AmPoP 68, 220*
See: Boughner, Alexander.

A. Hall and Sons
Flourished: c1866 Perth Amboy, NJ
Type of Work: Clay (Pottery)
Sources: *AmPoP 174.*

A. Jennings Pottery
Flourished: 1860 Dunleith County, IL
Type of Work: Clay (Pottery)
Sources: *ArC 194.*

A.A. Austin and Company
b. Commerce, MO
Flourished: 1850
Type of Work: Stoneware (Pottery)
Sources: *AmS22*.*

A.B. and W.T. Westervelt Company
Flourished: 1883-1890 New York, NY
Type of Work: Metal (Weathervanes, ornamental metal works)
Sources: *ArtWe 17; YankWe 143, 214.*

A.D. Richmond and Company
Flourished: c1859 New Bedford, MA
Type of Work: Copper (Copperware)
Sources: *AmCoB 35*
See: Richmond, A.D.

A.E. Smith and Sons
See: Smith, Asa E.

A.J. Butler and Company
Flourished: c1850 New Brunswick, NJ
Type of Work: Stoneware (Pottery)
Sources: *AmPoP 172; Decor 217.*

A.J. Harris and Company
[J. Harris and Sons]
Flourished: 1868-1882 Boston, MA
Type of Work: Metal (Weathervanes, ornamental metal works)
Remarks: Partner with Whim, John A.
Sources: *AmFokAr 51; GalAmW 19, 78*;
YankWe 142, 212*.*

A.L. Dyke and Company
Flourished: c1884-1891 Akron, OH
Type of Work: Stoneware (Pottery)
Sources: *AmPoP 207; Decor 218.*

A.L. Jewell and Company
Flourished: 1852-1867 Waltham, MA
Type of Work: Metal (Weathervanes, signs, ornamental metal works)
Sources: *ArtWe 13, 15*, 17, 23*, 25-6*,
37*, 52*, 61*, 65-6*; FoArA 151*;
GalAmW 19, 50-1*, 84*; HoKnAm 170*;
WeaVan 23-4*; YankWe 38*, 137*, 212*
See: Cushing and White.

A.W. Pollard and Company
See: Pollard, A.W.

Aaron, Jesse
b. 1887 Lake City, FL **d.** 1979 Gainesville, FL
Flourished: 1968-1979 Gainesville, FL
Ethnicity: Black American, American Indian
Type of Work: Wood (Sculptures)
Remarks: Seminole Indian
Sources: *AmFokArt 2-3*; BlFoAr 55-7*;
FoAF 18-9; FoAFk 8.*

Abbe, Frederick
Flourished: c1848-1850 Columbus, OH
Type of Work: Stoneware (Pottery)
Sources: *AmPoP 212; Decor 216.*

Abbe, John
Flourished: New York
Type of Work: Watercolor (Portraits)
Sources: *PrimPa 168.*

Abbot, J.C.
[Abbott]
Flourished: 1856 Belfast, ME
Type of Work: Wood (Ship carvings, ship figures)
Sources: *AmFiTCa 186; ShipNA 156.*

Abbott, Henry R.
Flourished: 1860s Boston, MA
Type of Work: Whalebone (Scrimshaw)
Museums: 186
Sources: *GravF 84*.*

Abig, Adolphus
Flourished: 1855 New York, NY
Type of Work: Wood (Ship carvings, ship figures)
Sources: *AmFiTCa 186.*

Abraham, Carl
Flourished: c1965
Type of Work: Acrylic (Paintings)
Museums: 297
Sources: *FoAFh 19*.*

Abraham Hews and Son
Flourished: c1810-1872 Weston, MA
Type of Work: Redware, stoneware (Pottery)
Sources: *AmPoP 204.*

Absalom
See: Stedman, Absalom, and Seymour.

Abston, U.C.
Flourished: 1850 Springfield, IL
Type of Work: Paint (Portraits)
Sources: *ArC 263.*

Ache, H.M.
Flourished: Pennsylvania
Type of Work: Watercolor, ink (Frakturs)
Sources: *AmFoPa 187*.*

Acheo Brothers
Flourished: c1920s Los Angeles, CA
Type of Work: Wood (Duck decoys)
Sources: *AmBiDe 230.*

Acheson, Eurphemia J.
Flourished: 1853 New York
Type of Work: Fabric (Embroidered pictures)
Sources: *AmNe 89, 91*.*

Achey, Mary E.
Flourished: 19th cent Washington
Type of Work: Oil (Scene paintings)
Remarks: Worked in the Washington State territory
Sources: *PioPar 12, 20*, 59.*

Acken, J.
Flourished: c1785 Elizabeth, NJ
Type of Work: Stone (Gravestones)
Sources: *EaAmG 129.*

Ackerman, H(enry) H(arrison)
b. 1890? Toronto, IA d. 1985
Flourished: 1920s-1985 Lincoln Park, MI
Type of Work: Wood (Duck decoys)
Sources: *AmFoS 292*; FoA 213; Rain 11, 30*-3*.*

Ackerman, Jacob
See: Ackerman and Brothers.

Ackerman, John
See: Ackerman and Brothers.

Ackerman and Brothers
Flourished: 1859-1860 Aurora, IL
Type of Work: Fresco (Paintings)
Remarks: John and Jacob Ackerman
Sources: *ArC 263.*

Ackley, R.D.
Flourished: early 20th cent Ann Arbor, MI
Type of Work: Wood (Sculptures)
Sources: *AmFoS 339*.*

Adam
Flourished: 1821 Greencastle, PA
Type of Work: Fabric (Weavings)
Sources: *AmSQu 276; ChAmC 31.*

Adam States and Sons
Flourished: c1767-1835 Stonington, CT
Type of Work: Stoneware (Pottery)
Sources: *Decor 224.*

Adams
See: Hill and Adams.

Adams, Abigail
Flourished: c1776 Massachusetts
Type of Work: Fabric (Samplers)
Remarks: Wife of U. S. president John Adams
Sources: *ArtWo 20-1, 24, 33.*

Adams, B.
Flourished: 1797 Milton, MA?
Type of Work: Stone (Gravestones)
Sources: *GravNE 127.*

Adams, Charlotte
Flourished: 1830 Amonia, NY
Type of Work: Velvet (Paintings)
Sources: *PrimPa 168.*

Adams, Enos
Flourished: c1859 Bennington, VT
Type of Work: Brownware, Rockingham (Pottery)
Sources: *AmPoP 188.*

Adams, Frank
b. 1871 d. 1944
Flourished: 1930-1940 West Tisbury, MA; Martha's Vineyard, MA
Type of Work: Wood (Duck decoys)
Sources: *AmBiDe 73; ArtDe 175*; FoA 217*, 460; WoCar 171*.*

Adams, Henry
Flourished: c1812 Hagerstown, MD
Type of Work: Redware (Pottery)
Sources: *AmPoP 168.*

Adams, James W.
Flourished: c1850
Type of Work: Brass (Brassware)
Sources: *AmCoB 64*.*

Adams, Joseph
Flourished: c1785 Rockingham, VT
Type of Work: Stone (Gravestones)
Sources: *EaAmG 129.*

Adams, Joseph
Flourished: c1790 Killingly, CT
Type of Work: Stone (Gravestones)
Sources: *EaAmG 127.*

Adams, Olive M.
Flourished: 1850 Middlesex, NY
Type of Work: Charcoal (Drawings)
Sources: *PrimPa 168.*

Adams, Sampson
Flourished: c1785 Rockingham, VT
Type of Work: Stone (Gravestones)
Sources: *EaAmG 129.*

Adams, Willis Seaver
Flourished: Springfield, MA
Type of Work: Oil (Portraits)
Sources: *PrimPa 168; SoAmP 288.*

Adams Brothers
Flourished: 1856-1872 East Liverpool, OH
Type of Work: Brownware, stoneware (Pottery)
Sources: *AmPoP 216; Decor 216.*

Adams Decoy Company
Flourished: c1920 Hickman, KY
Type of Work: Wood (Duck decoys)
Sources: *AmBiDe 230.*

Addison, E.A.
Type of Work: Fabric (Quilts)
Sources: *QuiAm 283.*

Adelman, Joseph E.
Flourished: 1860 Yorktown, VA
Type of Work: (Scene paintings)
Sources: *PrimPa 168.*

Adkins, J.R.
b. 1907 York County, SC d. 1973 Seffner, FL
Flourished: 1969 York County, SC; Seffner, FL
Type of Work: Oil (Genre, history, literary, landscape paintings)
Museums: 171
Sources: *AlAmD 78*; AmFokArt 4-5*; TwCA 164*.*

Adolf, Charles
b. c1815
Flourished: 1845-1870 Henry County, IN; Wayne County, IN; Osage County, KS
Ethnicity: French
Type of Work: Fabric (Weavings)
Remarks: Brother of George
Sources: *AmSQu 276; ChAmC 31.*

Adolf, George
b. c1822
Flourished: 1848-1851 Henry County, IN; Wayne County, IN
Ethnicity: French
Type of Work: Fabric (Weavings)
Remarks: Brother of Charles
Sources: *AmSQu 276; ChAmC 31.*

Adolf, Henry
b. c1815
Flourished: 1841-1878 Mahaska County, IA; Douglas County, KS; Noblesville, IN
Ethnicity: French
Type of Work: Fabric (Weavings)
Sources: *ChAmC 31.*

Aetna Fire Brick Company
Flourished: Oakhill, OH
Type of Work: Clay (Sewer tile sculpture)
Sources: *IlHaOS *.*

Aetna Furnace
Flourished: 1775 New Jersey
Type of Work: Iron (Fireback ironware)
Museums: 151
Sources: *EaAmI 22, 29*.*

Agner and Gaston
Flourished: 1884-1887 East Liverpool, OH
Type of Work: Yellow-ware (Pottery)
Sources: *AmPoP 218.*

Agner, Fouts and Company
Flourished: 1862-1884 East Liverpool, OH
Type of Work: Yellow-ware (Pottery)
Sources: *AmPoP 218.*

Ahrens, Otto
Flourished: 1877 Meriden, CT
Type of Work: Tin (Tinware)
Sources: *TinC 160.*

Aiken, Gayleen
Flourished: contemporary Barre, VT
Type of Work: Oil (Paintings)
Sources: *FoAFo 13-4*.*

Aikens, James
Flourished: 1817-1818 Newburgh, NY
Type of Work: Fabric (Weavings)
Sources: *ChAmC 31*
See: Alexander, James.

Ainslee, Henry Francis, Colonel
Flourished: 1842 Illinois
Ethnicity: English
Type of Work: Watercolor (Paintings)
Sources: *ArC 263*.

Akin, John F.
Flourished: 1843-1847 New Bedford, MA
Type of Work: Pencil, watercolor (Ship portraits)
Sources: *WhaPa 97*, 112*, 116-7*.

Akin, Phebe
Flourished: 1834 New York, NY
Type of Work: Fabric (Weavings)
Sources: *AmSQu 276; ChAmC 31*.

Akron Porcelain Company
Flourished: Akron, OH
Type of Work: Clay (Sewer tile sculpture)
Sources: *IlHaOS*.

Akron Pottery Company
[Merrill, Edwin and Henry]
Flourished: 1861-1888 Akron, OH
Type of Work: Stoneware (Pottery)
Sources: *AmPoP 205; Decor 221*
See: Merrill, Calvin.

Alanson Lyman & Declus Clark
Flourished: 1837-1841 Gardiner, ME
Type of Work: Stoneware (Pottery)
Sources: *AmS 194*; Decor 221*.

Alaska Silver and Ivory Company
Flourished: contemporary Alaska
Type of Work: Ivory (Jewelry)
Remarks: Richard Mullen is an employee craftsman artist
Sources: *Scrim 31**.

Alback, John
Flourished: 1855 New York, NY
Type of Work: Wood (Ship carvings, ship figures)
Sources: *AmFiTCa 186*.

Albany Stoneware Factory
Flourished: c1850s Albany, NY
Type of Work: Stoneware (Pottery)
Museums: 203
Sources: *Decor 211**.

Albert, Henry
Flourished: c1816-1825 Allentown, PA
Type of Work: Redware (Pottery)
Sources: *AmPoP 162*.

Alberts, Sylvia
b. 1928 New York, NY
Flourished: 1966
Type of Work: Oil, masonite (Still life paintings)
Sources: *AmFokArt 6-9**.

Albertson, Erick
Flourished: c1870 Mendocino, CA
Type of Work: Wood (Sculptures, carvings)
Sources: *FlowAm 216**.

Albright, Chester
[Toboggan Company]
Flourished: 1900 Philadelphia, PA
Type of Work: Wood (Carousel figures)
Sources: *CaAn 11*
See: Auchy, Henry.

Albro, T.L.
b. 1806 Portsmouth, RI
Flourished: Newport, RI
Type of Work: Whalebone (Scrimshaw)
Museums: 186
Sources: *GravF 31, 46-8*, 69*.

Ald, Henry
Flourished: 1870 Boles Township, MO
Type of Work: Tin (Tinware)
Sources: *ASeMo 428*.

Alden, G.
b. 1804 d. 1862
Flourished: Massachusetts
Type of Work: Oil (Portraits)
Museums: 088
Remarks: Member of the Prior-Hamblen School
Sources: *AmFoPa 76-81*; PrimPa 168; SoAmP 49**.

Alden, Noah
Flourished: 1830 Middleboro, MA
Type of Work: Oil (Portraits)
Sources: *PrimPa 168; SoAmP 192**.

Aldich, Mrs. Richard
Flourished: 1900 New York
Type of Work: Fabric (Embroidered pictures)
Sources: *AmNe 157*, 163*.

Aldridge
[Oldridge]
Flourished: c1808 Virginia
Type of Work: Charcoal, oil (Portraits)
Museums: 001
Sources: *AmFoPo 39**.

Alexander, F.M.
Flourished: 1848
Type of Work: Fabric (Weavings)
Sources: *AmSQu 276; ChAmC 31*
See: Alexander, Thomas M..

Alexander, Francis
b. 1800 Killingly, CT d. 1880
Flourished: Windham County, CT; Providence, RI; Boston, MA
Type of Work: Oil, watercolor, pastel (Portraits)
Museums: 189
Sources: *AmNa 12, 20, 36*; FoArtC 111; PrimPa 168; SoAmP 216*.

Alexander, Frank
Flourished: Windham County, CT
Type of Work: Oil (Portraits of fish, animals and people)
Sources: *FoArtC 113*.

Alexander, James
b. 1770 d. 1870
Flourished: c1805-1826 Little Britian, NY; Orange County, NY
Ethnicity: Scottish
Type of Work: Fabric (Coverlets)
Sources: *AmSQu 229; ArtWea 17; ChAmC 31, 51, 62*-3, 69*, 118*
See: Crothers, Samuel; Gibbs, John; Robinson, James; and Wilson, John.

Alexander, John
Flourished: 1825 New York
Type of Work: Fabric (Coverlets)
Sources: *AmSFo 96-7**.

Alexander, Robert
b. 1801 d. 1880
Flourished: 1850 Canfield, OH; Thompsonville, CT
Ethnicity: Scottish
Type of Work: Fabric (Coverlets)
Sources: *AmSQu 276; ChAmC 31, 49**.

Alexander, Stanley
Flourished: Michigan
Type of Work: Wood (Duck decoys)
Sources: *WaDec 159**.

Alexander, Thomas M.
b. c1813 Ohio
Flourished: 1848-1850 Wayne County, OH
Type of Work: Fabric (Weavings)
Sources: *ChAmC 31*
See: Alexander, F.M..

Alford
See: Nichols and Alford.

Alfred, Cynthia
Flourished: Harwinton, CT
Type of Work: Paint, stencils (Clock faces, panels)
Museums: 095
Remarks: Sister of Louisa
Sources: *TinC 157*.

Alfred, Louisa
b. 1808 d. 1897
Flourished: Harwinton, CT
Type of Work: Paint, stencils (Clock faces, panels)
Remarks: Sister of Cynthia
Sources: *TinC 157*.

Alfred, Nabby
b. 1845
Flourished: Harwinton, CT
Type of Work: Tin (Tinware)
Sources: *TinC 157*.

Allabach, Philip
Flourished: Michigan
Type of Work: Fabric (Weavings)
Sources: *AmSQu 276; ChAmC 31.*

Allcock, Cirendilla
Flourished: c1860 Drakes Creek, KY
Type of Work: Fabric (Quilts)
Sources: *KenQu 37, fig25-6.*

Allen, Abby (Abigail Crawford)
b. 1776 Providence?, RI? d. 1855 Providence?, RI?
Flourished: 1794 Providence, RI
Type of Work: Fabric (Samplers)
Museums: 173
Sources: *LeViB 128, 154*, 190.*

Allen, Abram
Flourished: 1837-1840 Hillsboro, OH; Wilmington, OH
Type of Work: Fabric (Coverlets)
Museums: 016,204
Sources: *AmSFo 94*, 97; AmSQu 276; ChAmC 32, 93*.*

Allen, B. Hausman
Flourished: 1839 Groveland, NY
Type of Work: Fabric (Coverlets)
Sources: *ChAmC 32.*

Allen, Caleb
Flourished: New England,
Type of Work: Copper (Ladles)
Sources: *AmCoB 121.*

Allen, Calvin
Flourished: 1836 Boston, MA
Type of Work: Wood (Ship carvings, ship figures)
Sources: *AmFiTCa 186.*

Allen, Edward
Flourished: 1829 New England,
Type of Work: Oil (Portraits)
Sources: *NinCFo 173.*

Allen, Elizabeth
Flourished: 1832 New England,
Type of Work: Watercolor, ink (Drawings)
Sources: *NinCFo 194.*

Allen, George
d. 1774
Flourished: 1716-1771 Rehoboth, MA; Rumford, RI
Type of Work: Stone (Gravestones)
Remarks: Son is George Jr.
Sources: *EaAmG 14*-5, 50*-1, 128; GravNE 99, 127.*

Allen, George, Jr.
b. 1742 or 1743
Flourished: c1799 Rehoboth, MA
Type of Work: Stone (Gravestones)
Remarks: Father is George
Sources: *EaAmG 126*, 128; GravNE 99, 127.*

Allen, George
Flourished: c1859-1863 Philadelphia, PA
Type of Work: Whiteware (Pottery)
Sources: *AmPoP 17, 176.*

Allen, James
Flourished: 1841 Reading, PA
Type of Work: Wood (Ship carvings, ship figures)
Sources: *AmFiTCa 186.*

Allen, Luther
Flourished: c1801 Enfield, CT
Type of Work: Paint (Paintings)
Sources: *AmDecor xix.*

Allen, Marie W.
Flourished: 1855 Illinois
Type of Work: Crayon (Drawings)
Sources: *ArC 263.*

Allen, Pelotiah
Type of Work: Tin? (Tinware?)
Sources: *TinC 160.*

Allen, Priscilla A.
Flourished: c1746 Boston, MA
Type of Work: Needlework (Samplers)
Sources: *WinGu 41, 46*.*

Allen, William
Flourished: c1855 South Amboy, NJ
Type of Work: Brownware, Rockingham (Pottery)
Sources: *AmPoP 180.*

Allen Herschell Company
See: Herschell, Allen.

Allentown Woolen Mill
See: Gabriel, Henry.

Alley, Nathaniel
Flourished: c1819 Boston, MA
Type of Work: Copper (Boxes)
Sources: *NeaT 48*.*

Allin, William
Flourished: 1757 Rhode Island
Type of Work: Wood (Ship carvings, ship figures)
Sources: *ShipNA 163.*

Allis, Ichabod
b. 17th century
Flourished: Hadley, CT; Hatfield, CT
Type of Work: Wood (Hope chests)
Sources: *AmPaF 19*
See: Allis, John.

Allis, John
b. 1642 d. 1691
Flourished: Hadley, CT; Hatfield, CT
Type of Work: Wood (Hope chests)
Museums: 048
Sources: *AmFokA 56*; AmPaF 19; EaAmW 86*
See: Allis, Ichabod.

Allison, Mary H.
b. 1826
Flourished: Henderson, KY
Type of Work: Fabric (Samplers)
Sources: *GalAmS 16.*

Allison, W.B.
See: W.B. Allison and Company.

Allison, Walter
Flourished: 1825 New York, NY
Type of Work: Wood (Ship carvings, ship figures)
Sources: *AmFiTCa 186.*

Allison and Hart
See: W.B. Allison and Company.

Allo, P.A.
Type of Work: Velvet (Paintings)
Sources: *EyoAm 26.*

Almini, Peter M.
Flourished: 1852 Chicago, IL
Ethnicity: Swedish
Type of Work: Fresco (Ornamental paintings)
Sources: *ArC 263.*

Almon, Leroy
b. 1938
Flourished: contemporary Columbus, OH; Georgia
Ethnicity: Black American
Type of Work: Wood (Relief carvings)
Remarks: Friend and collaborator with Pierce, Elijah
Sources: *FoAFc 14*.*

Alpaugh and McGowan
Flourished: 1880-1900 Trenton, NJ
Type of Work: Clay (Bone china)
Sources: *AmPoP 182.*

Alsop, Mary Wright
Flourished: 1774-1800 Middletown, CT
Type of Work: Fabric (Pin-cushions, embroidered pocketbooks)
Sources: *PlaFan 98, 116*.*

Alt, Godfried
Flourished: 1855 New York, NY
Type of Work: Wood (Ship carvings, ship figures)
Sources: *AmFiTCa 186.*

Alt, William
Flourished: 1859 New York, NY
Type of Work: Wood (Ship carvings, ship figures)
Sources: *AmFiTCa 186.*

Alten, Fred K.
b. 1872 Lancaster, OH d. 1945 Lancaster, OH
Flourished: early 20th cent Wyandotte, MI
Ethnicity: German
Type of Work: Wood, metal (Animal sculptures, carvings)
Museums: 096,171
Sources: *AlAmD 86*; AmFoArt 70-1*; AmFokA 97*; AmFokArt 10-1*; FoA 187*, 460; SculFA;Trans7, 16*-7*, 53.*

Alton Foundry
Flourished: late 19th cent Lancaster, OH
Type of Work: Metal, oil (Painted iron sculptures)
Sources: *AlAmD 72*.*

Ambrose, Edward
Flourished: c1975 Stephens City, VA
Type of Work: Wood (Sculptures, carvings)
Sources: *ConAmF 79-84*.*

Ambrose, Frederick
Flourished: 1811 Urbana, OH
Type of Work: Redware (Pottery)
Sources: *AmPoP 231.*

Ambrouse
Flourished: 1836 Greencastle, PA
Type of Work: Fabric (Weavings)
Sources: *ChAmC 32*
See: Bohn, Adam.

Amelung, John Frederick
[Amelung New Bremen Glass Works]
Flourished: 1784-1796 Frederick County, MD
Ethnicity: German
Type of Work: Glass (Glass works)
Museums: 058
Sources: *AmSFo 82, 84; AmSFok 123*; InAmD 100*.*

Amelung New Bremen Glass Works
See: Amelung, John Frederick.

Amend, Charles
Flourished: 1860 Osage County, MO
Type of Work: Wood (Furniture)
Sources: *ASeMo 391.*

American Art Ceramic Company
Flourished: 1901 Corona, NY
Type of Work: Clay (Pottery)
Sources: *DicM 162*.*

American Art China Works
Flourished: 1891 Trenton, NJ
Type of Work: Clay (Pottery)
Sources: *DicM 172*.*

American China Company
Flourished: c1896 Toronto, OH
Type of Work: Clay (Pottery)
Sources: *DicM 155*, 243*.*

American Crockery Company
Flourished: 1876 Trenton, NJ
Type of Work: Clay (Pottery)
Sources: *AmPoP 183; DicM 9*, 154*, 163*.*

American Encaustic Tiling Company
Flourished: 19th Century Zanesville, OH
Type of Work: Clay (Pottery)
Sources: *DicM 57*.*

American Porcelain Manufacturing Company
Flourished: 1854-1857 Gloucester, NJ
Type of Work: Clay (Porcelain)
Sources: *AmPoP 111, 168, 198, 252; DicM 11*.*

American Pottery (Manufacturing) Company
Flourished: 1833-1845 Jersey City, NJ
Type of Work: Clay (Pottery)
Sources: *AmPoP 104, 154, 170, 252; DicM 10*, 164*, 177*, 183*, 230**
See: D. and J. Henderson.

American Pottery Company
Flourished: 1865- Peoria, IL
Type of Work: Brownware, yellow-ware (Pottery)
Sources: *AmPoP 226; ArC 188-9.*

American Sewer Pipe Company
Flourished: Akron, OH
Type of Work: Clay (Sewer tile sculpture)
Sources: *IlHaOS *.*

American Tea Tray Works
Flourished: 1860-1878
Type of Work: Tin (Tinware)
Sources: *TinC 108.*

American Terra-Cotta Company
Flourished: 1886-1900 Chicago, IL
Type of Work: Clay (Pottery)
Sources: *AmPoP 209.*

Ames, Asa (Alexander)
b. 1824 d. 1851
Flourished: 1850 Buffalo, NY
Type of Work: Wood (Sculptures, carvings)
Museums: 171
Sources: *AmFoArt 86-7*; AmFokAr 21, fig181; AmFoSc 17*; FoA 127*, 460; ShipNA 161.*

Ames, Ezra
b. 1768 Framingham, MA d. 1836
Flourished: 1800-1820 Albany, NY
Type of Work: Oil, wood (Portraits, cigar store Indians, figures)
Museums: 006,202,238
Remarks: 500 portraits, worked in upper New York state
Sources: *ArtWod 16*; Bes 36, 40, 106; FoPaAm 81, 83, 92, 96; MoBeA fig49.*

Ames Plow Company
Flourished: Boston, MA
Type of Work: Metal (Weathervanes)
Remarks: Affiliated with Cushing and White
Sources: *YankWe 210.*

Amidon, Douglas
Flourished: 1975 Sandwich, MA
Type of Work: Wood (Sculptures, carvings)
Sources: *BirB 105*.*

Ammidown, C.L.
Flourished: 1826 Massachusetts
Type of Work: Pen, watercolor (Drawings)
Sources: *AmPrW 62*, 127*.*

Amos, William
Flourished: 1833-1837 Baltimore, MD
Type of Work: Stoneware (Pottery)
Sources: *AmPoP 163; Decor 216.*

Amthor, John
Flourished: 1859 New York, NY
Type of Work: Wood (Ship carvings, ship figures)
Sources: *AmFiTCa 186.*

Anchor Pottery Company
Flourished: c1890-1895 Trenton, NJ
Type of Work: Clay (Pottery)
Sources: *AmPoP 183, 247; DicM 10*, 19*, 149*, 176*, 180*.*

Andaries, Elizabeth
b. 1806
Flourished: 1818 New York
Type of Work: Fabric (Samplers)
Sources: *PlaFan 54*.*

Anders, Abraham
Flourished: 1805 Pennsylvania
Type of Work: Watercolor, ink (Frakturs)
Sources: *AmFoPa 187.*

Anders, Andrew
Flourished: 1787 Pennsylvania
Type of Work: Watercolor, ink (Frakturs)
Sources: *AmFoPa 187.*

Anders, Judith
Flourished: 1807 Pennsylvania
Type of Work: Watercolor, ink (Frakturs)
Sources: *AmFoPa 187.*

Andersen, Elder William
Flourished: 1883 Mount Lebanon, NY
Ethnicity: Shaker
Type of Work: Wood (Shaker chairs)
Sources: *HanWo 138*
See: Wagan, Robert; Collins, Sister Sarah

Anderson, Alonzo
Flourished: 1830 New York, NY
Type of Work: Wood (Ship carvings, ship figures)
Sources: *AmFiTCa 186.*

Anderson, Eleanor S.
Flourished: 1950 Hawaii
Type of Work: Fabric (Quilts)
Sources: *AmSQu 198*.*

Anderson, Jacob S.
[Jacob Anderson and Co.]
Flourished: 1830-1868 New York, NY
Type of Work: Wood (Sculptures, carvings)
Museums: 184,254
Remarks: Son is John W.
Sources: *AmFiTCa 131-2, 186; AmFoS 102*, 252; FigSh 4*; ShipNA 47, 63*, 66-7, 71, 162; WoScuNY*
See: Dodge, Charles J.; Jacob Anderson and Co.

Anderson, James
Flourished: c1812 Boston, MA
Type of Work: Wood (Sculptures)
Museums: 186
Sources: *FigSh 6*.*

Anderson, James
Flourished: 1859 New York, NY
Type of Work: Wood (Ship carvings, ship figures)
Sources: *AmFiTCa 187.*

Anderson, Jane
Flourished: 1877 New York, NY
Type of Work: Wood (Ship carvings, ship figures)
Sources: *AmFiTCa 187.*

Anderson, John W.
b. 1834 d. 1904
Flourished: 1855-1904 New York, NY
Type of Work: Wood (Cigar store Indians, ship figures)
Remarks: Father is Jacob S.
Sources: *AmFiTCa 132, 187; ArtWod 241-2; ShipNA 66, 162.*

Anderson, Lloyd, Captain
Type of Work: Ivory (Ship models)
Museums: 207
Remarks: Carved elephant ivory
Sources: *Scrim 29.*

Anderson, Maria
b. c1805
Flourished: 1817 Massachusetts
Type of Work: Fabric (Samplers)
Sources: *GalAmS 52*.*

Anderson, Peter
Flourished: 1835 Lowell, MA
Type of Work: Watercolor (Ship and townscape paintings)
Sources: *PrimPa 168.*

Anderson, Sarah Runyan
Flourished: New Yersey, KY
Type of Work: Fabric (Weavings)
Sources: *KenQu 45.*

Anderson, Sarah Runyan
Flourished: early 19th cent Kentucky
Type of Work: Fabric (Quilts)
Museums: 124
Sources: *KenQu 45, fig33.*

Anderson, William A.
Flourished: 1870-1880 Anderson's Landing, PA
Type of Work: Stoneware (Pottery)
Sources: *AmPoP 207; Decor 216.*

Andreas, Jacob
Flourished: Pennsylvania
Type of Work: Watercolor, ink (Frakturs)
Sources: *AmFoPa 187.*

Andrew Duche Pottery
See: Duche, Andrew; Duche, Anthony.

Andrew Meneely and Sons
Flourished: c1853 New York
Type of Work: Brass (Bells)
Sources: *AmCoB 172, 174.*

Andrews, Ambrose
Flourished: 1824-1859 Middletown, CT; Schuyville, PA; Gt. Barrington, NY
Type of Work: Oil, watercolor (Portraits, paintings)
Museums: 203,289
Remarks: Itinerant
Sources: *AmFoPaN 102, 131*; FoArA 59*, 100*; FouNY 65.*

Andrews, Asa
Flourished: 1802-1805 Farmington, CT
Type of Work: Tin (Tinware)
Sources: *TinC 117.*

Andrews, Bernard
Flourished: 1772 Boston, MA
Type of Work: Fabric (Embroidered Masonic aprons)
Sources: *Bes 104.*

Andrews, Burr
Flourished: 1845 Meriden, CT
Type of Work: Tin (Tinware)
Sources: *TinC 160.*

Andrews, Fanny
Flourished: 1835 Hartford, CT
Type of Work: Fabric (Weavings)
Sources: *AmSQu 281**
See: Rounds, Mary M.

Andrews, H.
Flourished: 1877 Meriden, CT
Type of Work: Tin (Tinware)
Sources: *TinC 160.*

Andrews, Jacob
Flourished: 1836-1837 East Hempfield Township, PA; Manor Township, PA
Type of Work: Fabric (Weavings)
Sources: *ChAmC 32.*

Andrews, Jane Margaret
b. c1792
Flourished: 1800 South Berwick, ME
Type of Work: Fabric (Samplers)
Sources: *GalAmS 35*.*

Andrews, M.
Flourished: 1838 Millstone, NJ
Type of Work: Fabric? (Weavings?)
Sources: *ChAmC 32.*

Andrews, S. Holmes
Flourished: 1855
Type of Work: Oil (Landscape paintings)
Museums: 155
Remarks: Worked in the Midwest
Sources: *FoPaAm 206*.*

Andross, Chester
Flourished: 1814-1816 Hartford, CT
Type of Work: Oil, wood (Signs)
Sources: *MoBBTaS 11.*

Andruss, Mrs. W.B.
Flourished: c1855 Amboy Township, IL
Sources: *ArC 263.*

Angell, John Anthony
d. 1756
Flourished: Providence, RI
Type of Work: Stone (Gravestones)
Sources: *EaAmG 129; GravNE 98, 127.*

Angell, Richard
Flourished: 1808 Providence, RI
Type of Work: Oil, wood (Signs)
Sources: *PicFoA 138*.*

Angstad, Benjamin
[Mount Pleasant Mills]
b. c1806 Pennsylvania d. 1863
Flourished: 1836-1850 Lewisburg, PA
Type of Work: Fabric (Weavings)
Sources: *ChAmC 32*
See: Schnee, Joseph.

Angstad, E.
Flourished: 1800 Pennsylvania
Type of Work: Tin (Tinware)
Museums: 189
Sources: *AmFoS 160*; FoArRP 158*.*

Angstad, Nathaniel
b. c1822
Flourished: c1850 Lewisburg, PA
Type of Work: Fabric (Weavings)
Sources: *ChAmC 32*
See: Angstad, Benjamin.

Animal Trap Company
Flourished: 1939 Lititz, PA; Pascagoula, MS
Type of Work: Wood (Duck decoys)
Remarks: Purchased equipment from the Pratt Company
Sources: *AmBiDe 229.*

Anna Pottery
Flourished: 1860-1890 Anna, IL; Lowell, IL
Type of Work: Stoneware (Pottery)
Remarks: Kirkpatricks' company
Sources: *AmPoP 207; AmS 58*, 144, 150, 152*, 163*; ArC 185*
See: Kirkpatricks.

Annis, Clark
b. 1805
Flourished: 1818
Type of Work: Fabric (Coverlets)
Sources: *AmSQu 67*.*

Anshutz, Philip
Flourished: 1820-1840 Carrollton, OH
Type of Work: Fabric (Coverlets)
Sources: *ChAmC 32.*

Anson, James
Flourished: 1804-1809 New Jersey
Type of Work: Watercolor, ink (Frakturs)
Sources: *AmFoPa 187.*

Anthony, Anne
b. 1776 Newport, RI **d.** 1796
Flourished: 1786 Newport, RI
Type of Work: Fabric (Samplers)
Museums: 176
Sources: *LeViB 75*.*

Antietam Factory
See: Baer, Gabriel.

Antres, Charles
Flourished: 1859 New York, NY
Type of Work: Wood (Ship carvings, ship figures)
Sources: *AmFiTCa 187.*

Antrim, Mary
Flourished: c1807 Burlington County?, NJ
Type of Work: Fabric (Samplers)
Sources: *MaAmSA.*

Apodaca, Manuelita
Flourished: c1880 Watrous, NM
Ethnicity: Hispanic
Type of Work: Fabric (Weavings)
Sources: *PopAs 237.*

Apple, Henry
Flourished: 1851 Philadelphia, PA
Type of Work: Wood (Ship carvings, ship figures)
Sources: *AmFiTCa 187.*

Apple, W.
Flourished: Philadelphia, PA
Type of Work: Copper (Mugs)
Sources: *AmCoB 119*.*

Appleton, Chris
Flourished: 1802 Philadelphia, PA
Type of Work: Wood (Ship carvings, ship figures)
Sources: *AmFiTCa 187.*

Appleton, George W.
Flourished: 1827 Otisville, ME
Type of Work: Oil (Portraits)
Remarks: Itinerant
Sources: *AmPrP 149; PrimPa 168; SoAmP 288.*

Appleton, Thomas
Flourished: 1824 Baltimore, MD
Type of Work: Wood (Ship carvings, ship figures)
Sources: *AmFiTCa 187; ShipNA 158.*

Appletown, William L.
Flourished: Nantucket, MA
Type of Work: (Baskets)
Sources: *ScriSW 288*.*

Ara
Flourished: Los Angeles, CA
Type of Work: Oil (Paintings)
Sources: *ThTaT 236*.*

Aragon, Jose
Flourished: 1825-1835 Chamisal, NM
Ethnicity: Spanish
Type of Work: Wood (Santeros, other religious carvings)
Museums: 272
Remarks: Rio Grande area
Sources: *PopAs 366-76**
See: Aragon, Jose Rafael.

Aragon, Jose Rafael (Miguel)
b. c1795 **d.** 1862
Flourished: 1830-1850 Cordova, NM
Ethnicity: Spanish
Type of Work: Wood (Santeros, other religious carvings)
Museums: 068,181
Sources: *AmFokA 76*; AmFoPaCe 47-51*; EaAmW 123; FoA 460; HoKnAm 73-4*; PopAs 144*; TYeAmS 78*.*

Aragon, Luis
b. 1899 Shoemaker, NM **d.** 1977 Albuquerque, NM
Flourished: 1965-1970 Albuquerque, NM
Ethnicity: Hispanic
Type of Work: Wood (Santeros, other religious carvings)
Museums: 178
Sources: *HisCr 54*, 97*.*

Aragon, Rafael
Flourished: 1840-1865 New Mexico
Type of Work: Wood (Santeros)
Sources: *FoA 460.*

Aram, E.
See: E. Aram Factory.

Archer, Dr.
Flourished: c1886 Milwaukee, WI
Type of Work: Wood (Decoys)
Sources: *EaAmW 110.*

Archuleta, Antonio
b. 1944 Taos, NM
Flourished: 1977 Taos, NM
Ethnicity: Hispanic
Type of Work: Wood (Furniture)
Remarks: Apprentice of Gonzales, Elidio
Sources: *HisCr 33*-5*, 101*.*

Archuleta, Felipe Benito
b. 1910 San Pedro, NM
Flourished: 1968- Tesuque, NM
Ethnicity: Hispanic
Type of Work: Wood (Sculptures, carvings)
Museums: 178
Sources: *AlAmD 99; AmFokA 105*; AmFokArt 12-3* 191 7, 14*-5*, 17, 53; FoScu 84*; HisCr 57*, 98*.*

Archuleta, Manuel
Flourished: 1850-1860 New Mexico
Ethnicity: Hispanic
Type of Work: Wood (Furniture)
Museums: 272
Sources: *HisCr 32*.*

Ardner, Jacob
b. c1817
Flourished: 1851-1859 Mt. Vernon, OH
Ethnicity: German
Type of Work: Fabric (Weavings)
Remarks: Brother is Michael
Sources: *AmSQu 276; ChAmC 34.*

Ardner, Michael
b. c1821
Flourished: 1851-1859 Mt. Vernon, OH
Ethnicity: German
Type of Work: Fabric (Weavings)
Remarks: Brother is Jacob
Sources: *AmSQu 276; ChAmC 34.*

Arend, Michael
Flourished: 1855 New York, NY
Type of Work: Wood (Ship carvings, ship figures)
Sources: *AmFiTCa 187.*

Armbruster, J.
Flourished: 1839 Miami County, OH
Type of Work: Fabric? (Coverlets?)
Sources: *ChAmC 34.*

Armbruster, M.
See: M. Armbruster and Sons.

Armijo, Frederico
b. 1948 Albuquerque, NM
Flourished: 1977 Albuquerque, NM
Ethnicity: Hispanic
Type of Work: Wood (Sculptures, carvings)
Sources: *HisCr 56*, 98*.*

Armitage, James
Flourished: North Tonawanda, NY
Type of Work: Wood (Carousel figures)
Sources: *CaAn 9*
See: Herschell, Allen.

Armitage-Herschell Company
Flourished: c1890 North Tonawanda, NY
Type of Work: Wood (Circus and carousel figures)
Sources: *CaAn 9, 16-7*; WoScuNY*
See: Herschell-Spillman Company.

Armstrong, Ann Johnson
Flourished: c1890 Hickman County, NY
Type of Work: Fabric (Quilts)
Sources: *KenQu fig3.*

Armstrong, J.H.
Flourished: 1844-1847 Erie County, OH
Type of Work: Fabric (Weavings)
Sources: *ChAmC 34.*

Armstrong, James L.
Flourished: 1840 Baltimore, MD
Type of Work: Wood (Ship carvings, ship figures)
Sources: *AmFiTCa 187.*

Armstrong and Wentworth
Flourished: 1814-1834 Norwich, CT
Type of Work: Clay (Pottery)
Sources: *AmPoP 199, 253; Decor 216, 224; DicM 7*, 11*, 41*; EaAmFo 168*.*

Armstrong Company
Flourished: c1940 Houston, TX
Type of Work: Wood (Duck decoys)
Museums: 260
Sources: *Decoy 15.*

Armstrong Stove and Foundry Company
Flourished: 1890-1949 Perryville, MD
Type of Work: Iron (Iron wing duck decoys)
Sources: *AmBiDe 32-3.*

Arning, Eddie
b. 1898 Kenney, TX
Flourished: 1965- Austin, TX
Type of Work: Crayon, pastel (Drawings)
Sources: *AmFokArt 14-6*; FoA 460; FoAFr 4*; FoPaAm 238, fig70; Full *; TwCA 200-1*.*

Arnold, A.
Flourished: 1860 New York
Type of Work: Oil (Village scene paintings)
Sources: *PrimPa 168.*

Arnold, Daniel
Flourished: 1828-1846 Chambersburg, PA
Type of Work: Fabric (Weavings)
Sources: *ChAmC 34.*

Arnold, Elizabeth
b. 1791 Warwick, RI d. 1877 Northboro?, MA?
Flourished: 1809
Type of Work: Embroidery (Mourning pictures)
Sources: *LeViB 218, 236*.*

Arnold, John James Trumbull
b. 1812 d. c1865
Flourished: c1841 York County, PA; Washington, DC
Type of Work: Oil (Portraits)
Museums: 001
Remarks: Itinerant
Sources: *AmFoPo 28*, 39-41*.*

Arnold, Lorenz
Flourished: Wheeling, IL
Type of Work: Fabric? (Coverlets?)
Sources: *ChAmC 34.*

Arnold, Thomas
Type of Work: Chalk (Paintings)
Museums: 176
Sources: *ColAWC 232*.*

Arsworth, Cynthia
Flourished: 1790 Baltimore, MD
Type of Work: Fabric (Quilts)
Museums: 227
Sources: *AmSQu 217*.*

Artman, Abraham
Flourished: 1830 Dansville, NY
Type of Work: Fabric (Weavings)
Sources: *AmSQu 276; ChAmC 34.*

Artz, William
Flourished: Osage County, MO
Type of Work: Wood (Furniture)
Sources: *ASeMo 379.*

Aschert Brothers
Flourished: c1920s Los Angeles, CA
Type of Work: Wood (Duck decoys)
Sources: *AmBiDe 230.*

Ashberry
Flourished: Chambersburg, PA
Type of Work: Oil (Paintings)
Sources: *PrimPa 168.*

Ashby, Steve
b. 1904 or 1907 Delaplane, VA d. 1980 Fauquier County, VA
Flourished: 1960-1980 Delaplane, VA; Fauquier County, VA
Ethnicity: Black American
Type of Work: Wood (Sculptures, carvings)
Sources: *AmFokA fig70, 104-5*; AmFokArt 17; BlFoAr 58-63*; FoAFt 1*.*

Ashe, Thomas
Flourished: 1859 New York, NY
Type of Work: Wood (Ship carvings, ship figures)
Sources: *AmFiTCa 187.*

Ashley, Clifford W.
Flourished: c1926
Type of Work: Whalebone, paint (Scrimshaw, whaling scene paintings)
Remarks: Author of "Yankee Whaler"
Sources: *GravF 20; ScriSW 14*, 86*.*

Ashley, Solomon
b. 1754 d. 1823
Flourished: 1792-1800 Deerfield, MA
Type of Work: Stone (Gravestones, other stoneworks)
Sources: *AmFokAr 21*, fig177; EaAmG 128; GravNE 111, 127.*

Ashmore, A.P.
Flourished: 1833 Philadelphia, PA
Type of Work: Wood (Ship carvings, ship figures)
Sources: *AmFiTCa 187.*

Ashmore, Abraham V.
Flourished: 1833 Philadelphia, PA
Type of Work: Wood (Ship carvings, ship figures)
Sources: *AmFiTCa 187.*

Ashmore, W.
See: Ashmore, A.P.

Ashworth, Helen
Flourished: 1956 Heuvelton, NY
Type of Work: Oil (Farm scene paintings)
Sources: *FouNY 67*.*

Astbury and Poulson
See: Millington, Astbury, and Poulson.

Atcheson, D.L.
Flourished: 1841-1850 Annapolis, IN
Type of Work: Stoneware (Pottery)
Museums: 118
Sources: *AmS 23*, 141*.*

Atcheson, H.S.(R.)
Flourished: 1841-1900 Annapolis, IN
Type of Work: Stoneware (Pottery)
Sources: *AmPoP 69, 207; Decor 216.*

Atencio, Patricio
Flourished: New Mexico
Type of Work: Wood (Santeros, other religious carvings)
Remarks: No known works; teacher was Jose Miguel Rodriguez
Sources: *PopAs 434.*

Atkins, A.D.W.
Flourished: Nantucket, MA
Type of Work: (Baskets)
Sources: *ScriSW 286*.*

Atkinson, Sarah Weber
Flourished: 1807 New Hampshire
Type of Work: Fabric (Samplers)
Sources: *AmNe 43*, 47-8.*

Atkinson, W.A.
Flourished: c1850 Baltimore, MD
Type of Work: Clay (Pottery)
Sources: *AmPoP 164.*

Atlantic Garden
Flourished: c1870-1880 New York, NY
Type of Work: Stoneware (Pottery)
Sources: *Decor 179*.*

Attlee, William
Flourished: c1795 Lancaster, PA
Type of Work: Copper (Copperware)
Sources: *AmCoB 132.*

Attwood, J.M.
Flourished: c1839 Chicago, IL
Type of Work: Oil (Sign and ornamental paintings)
Sources: *ArC 159.*

Atwater, Caleb
Flourished: 1830-1840 Atwater, OH
Type of Work: Stoneware (Pottery)
Sources: *AmPoP 207; Decor 216*
See: Atwater, Joshua.

Atwater, Joshua
Flourished: 1830-1840 Atwater, OH
Type of Work: Stoneware (Pottery)
Sources: *AmPoP 207; Decor 216*
See: Atwater, Caleb.

Atwood, Jeremiah
Flourished: Massachusetts
Type of Work: Oil (Portraits)
Sources: *PrimPa 168.*

Aube, Peter R.
Flourished: 1851 Philadelphia, PA
Type of Work: Wood (Ship carvings, ship figures)
Sources: *AmFiTCa 187.*

Auber, P.
Flourished: c1860 Birmingham (Pittsburgh), PA
Type of Work: Stoneware (Pottery)
Sources: *AmPoP 227; PrimPa 216.*

Aubry, Jean
Flourished: 1830-1840 Massachusetts
Type of Work: Oil (Portraits)
Sources: *PrimPa 168.*

Auburn State Prison
Flourished: 1845-1850 Auburn, NY
Type of Work: Fabric (Carpets, coverlets)
Sources: *ChAmC 34.*

Auchy, Henry
 [Toboggan Company]
Flourished: 1900 Philadelphia, PA
Type of Work: Wood (Carousel figures)
Sources: *CaAn 11*
See: Albright, Chester.

Audin, Anthony
Flourished: c1791 Charleston, SC
Ethnicity: French
Type of Work: Paint (Ornamental paintings)
Sources: *AmDecor 107.*

Auer, Nicolas (Ayer)
Flourished: c1796 Baltimore, MD
Type of Work: Redware? (Pottery)
Sources: *AmPoP 162.*

August Blanck Pottery
Flourished: c1890 California; Monteau County, MO
Type of Work: Clay (Pottery)
Sources: *ASeMo 463*.*

Augustus, Sampson
d. 1811
Flourished: c1786 Salem, MA
Ethnicity: Black American
Type of Work: Paint (Ornamental paintings)
Sources: *AmDecor 42.*

Auld, Wilberforce
Flourished: 1834 New York, NY
Type of Work: Wood (Ship carvings, ship figures)
Sources: *AmFiTCa 187.*

Aulisio, Joseph P.
b. 1910 Old Forge, PA d. 1974
Flourished: c1965 Stroudsburg, PA; Scranton, PA
Type of Work: Oil (Portraits)
Museums: 171
Sources: *AmFokArt 20-1*; FoA 30*, 460; FoPaAm fig49; TwCA 209*.*

Aulont, George
b. 1888
Flourished: 1936- New York, NY
Ethnicity: Greek
Type of Work: Oil (Genre paintings)
Sources: *PrimPa 168; ThTaT 192-95*; TwCA 113*.*

Ault
See: Foel and Ault.

Auman, Fletcher
Flourished: c1890 Montgomery County, NC
Type of Work: Stoneware (Jars)
Sources: *AmS 84*.*

Aust, Brother Gottfried
Flourished: 1773 Salem, NC; Bethabara, NC
Ethnicity: German
Type of Work: Clay (Pottery)
Museums: 296
Remarks: Chief potter at Moravian Pottery
Sources: *AmPoP 84; HoKnAm 51*; SoFoA 3*, 16*-17, 216-7*
See: Christ, Rudolf.

Austin, A.A.
See: A.A. Austin and Company.

Austin, Peter H.
Flourished: 1830 New York, NY
Type of Work: Wood (Ship carvings, ship figures)
Sources: *AmFiTCa 187.*

Austin, Roy
Flourished: Oklahoma
Type of Work: Wood (Whirligigs)
Sources: *FoArO 76*.*

Avera, John C.
Flourished: 1871 Crawford County, GA
Type of Work: Clay (Pottery)
Sources: *SoFoA 26, 28, 213*, 223.*

Avery, Gilbert
Flourished: Canaan, NY
Ethnicity: Shaker
Type of Work: Wood (Chairs)
Sources: *HanWo 138.*

Avery, John
b. 1790 Deerfield, NH
Flourished: 1820-1841 Waterboro, NH; Middletown, NH
Type of Work: Oil (Ornamental paintings)
Sources: *AmDecor 119-21*, 152; PrimPa 168.*

Avery, Mary
Flourished: 1722 North Andover, MA
Type of Work: Fabric (Hooked rugs, bed rugs)
Museums: 079
Sources: *AmSQu 16-7*; ArtWea 142*; NewDis 10.*

Avery, Mary
Flourished: c1800 Connecticut
Type of Work: Fabric (Mourning pictures)
Sources: *MoBeA fig124.*

Avon Pottery
Flourished: 1886- Cincinnati, OH
Type of Work: Clay (Pottery)
Sources: *DicM 12*.*

Ayer, Nicolas
See: Auer, Nicolas.

Ayrhart, Peter
b. c1836 Ohio
Flourished: c1850 Madison Township, OH
Type of Work: Fabric (Coverlets)
Sources: *ChAmC 34.*

B

Babb, Conrad
Flourished: 1765 Reading, PA
Type of Work: Tin (Tinware)
Sources: *AmCoTW 150.*

Babbitt, George F.
Flourished: 19th cent
Type of Work: Pen, ink (Drawings)
Sources: *Edith *.*

Babcock, Amory L.
Flourished: 1820
Type of Work: Watercolor (Still life paintings)
Sources: *PrimPa 168.*

Bach, Ferdinand
b. 1888 **d.** 1967
Type of Work: Wood (Decoys)
Sources: *WaDec 42-7*.*

Bach, George W.
Flourished: c1880-1900 Allentown, PA
Type of Work: Redware (Pottery)
Sources: *AmPoP 162.*

Bacheller, Celestine
b. c1850 **d.** 1900
Flourished: Wyoma, MA
Type of Work: Fabric (Quilts)
Museums: 176
Sources: *AmSQu 299*; ArtWo 103, 155, fig20; FoArtC 142*; NewDis 115*; QuiAm 262*.*

Bacheller, Lucinda
Flourished: 1840 Solon, ME
Type of Work: Fabric (Coverlets)
Museums: 310
Sources: *AmSFok 119*.*

Bachman, Anceneta
Flourished: 1864 Philadelphia, PA
Type of Work: Fabric (Coverlets)
Sources: *ChAmC 34.*

Bachman, Christian
Flourished: 1798 Pennsylvania
Type of Work: Watercolor, ink (Frakturs)
Sources: *AmFoPa 187.*

Backer, Hiram
Flourished: Upper Macungie Township, PA
Type of Work: Fabric (Coverlets)
Sources: *ChAmC 34*
See: Kuder, Solomon.

Backman, Henry G.
Flourished: 1874 Philadelphia, PA
Type of Work: Wood (Ship carvings, ship figures)
Sources: *AmFiTCa 187.*

Backus, Thaddeus
Flourished: 1830 Marietta, OH
Type of Work: Fabric (Weavings)
Sources: *ChAmC 34.*

Bacon
See: Foster, Holloway, Bacon and Company.

Bacon, George H.
b. 1861 **d.** 1925
Flourished: Burlington, VT
Type of Work: Wood (Duck decoys)
Museums: 260
Sources: *Decoy 61*, 44*.*

Bacon, Mary
Flourished: 1808 Woodbury, CT
Type of Work: Fabric (Embroidered pictures)
Museums: 133
Sources: *AmNe 87*.*

Bacon, Mary Ann
Flourished: 1850 Litchfield, CT
Type of Work: Oil (Landscape paintings)
Sources: *PrimPa 168.*

Bacon, Nathaniel
Flourished: 1818-1822
Type of Work: Tin (Tinware)
Sources: *TinC 161.*

Badami, Andrea
b. 1913
Flourished: c1969 Omaha, NE
Type of Work: Oil (Paintings)
Sources: *FoAFm 2; TwCA 212*.*

Baddler
Flourished: 1859 Aikens County, SC
Ethnicity: Black American
Type of Work: Clay (Face jugs)
Remarks: Worked for the Louis Miles Pottery
Sources: *AmNeg fig5; EaAmFo 166.*

Baden, C.
Flourished: 1844-1847 Montgomery County, OH
Type of Work: Fabric (Weavings)
Sources: *ChAmC 34.*

Badger
Flourished: Kennebunk, ME
Type of Work: Oil (Portraits)
Remarks: Itinerant
Sources: *SoAmP 287.*

Badger, Hiram
Flourished: 1833 Philadelphia, PA
Type of Work: Wood (Ship carvings, ship figures)
Sources: *AmFiTCa 187.*

Badger, Joseph
b. 1708 Charlestown, MA **d.** 1763
Flourished: 1733-1760 Boston, MA
Type of Work: Oil (Portraits, paintings, signs)
Museums: 001,189
Sources: *AmFoPa 24-5*; AmFoPaN 3, 14*; AmFoPo 22*, 41-3*; AmSFok 156*; FoA 460; FoArtC 114; OneAmPr 38*, 77, 140, 153; PlaFan 37*.*

Badger, Nancy
Flourished: 1834-1844 Warner, NH
Type of Work: Watercolor (Still life paintings)
Sources: *PrimPa 168.*

Badger, S.F.M.
Flourished: 1840s Boston, MA
Type of Work: Oil (Ship portraits)
Sources: *AmFoPa 112-4.*

Badger, Stephen
Flourished: 1825 Stoddard, NH; Amesbury, MA
Type of Work: Oil (Ornamental and landscape paintings)
Sources: *AmDecor 120, 152; PrimPa 168.*

Badger, Thomas
Flourished: 1836-1859 Boston, MA
Type of Work: Oil (Miniature paintings)
Sources: *SoAmP 286.*

Baecher, Anthony W.
Flourished: 1851-1889 Winchester, VA; Thurmont, MD
Type of Work: Clay (Pottery)
Sources: *AmPoP 50, 243; BeyN 52*, 114; SoFoA 16*, 112*, 217, 220.*

Baecher, J.W.
Flourished: 1853-1880 Thurmont, MD
Type of Work: Redware (Pottery)
Sources: *AmPoP 50, 181.*

Baer, Gabriel
Flourished: 1849-1856 Franklin County, PA
Type of Work: Fabric (Coverlets)
Remarks: Wove at the Antietam Factory
Sources: *ChAmC 34.*

Baer, Martin
Flourished: c1825 Ephrata, PA
Type of Work: Watercolor, ink (Frakturs)
Sources: *MaAmFA *.*

Bagaly and Ford
Flourished: c1843 Philadelphia, PA
Type of Work: Redware (Log cabin banks, pottery)
Sources: *AmPoP 176.*

Baggott, S.
Flourished: 1853-1895 East Liverpool, OH
Sources: *AmPoP 75, 215.*

Baggott, W.
See: Baggott, S.

Bagley, S.
Flourished: 1840 Pekin, NY
Type of Work: Fabric? (Coverlets?)
Sources: *ChAmC 35.*

Bagnall, George
[Bagnell]
Flourished: c1870-1875 Newcomerstown, PA
Type of Work: Stoneware (Pottery)
Sources: *AmPoP 225; IlHaOS *; Decor 216.*

Bagnell, George
See: Bagnall, George.

Bahin, Louis Joseph
b. 1813 d. 1857
Flourished: 1848 Mississippi
Type of Work: Oil (Portraits, genre and landscape paintings)
Museums: 001
Sources: *AmFoPo 44-5*.*

Bailey, Abner
Flourished: Bristol, CT
Type of Work: Tin (Tinware)
Sources: *TinC 161.*

Bailey, Charles
Flourished: c1800 Hardwick, VT
Type of Work: Redware (Pottery)
Sources: *AmPoP 192.*

Bailey, Eldren
Flourished: c1964 Atlanta, GA
Type of Work: Cement (Sculptures)
Sources: *BirB 151*; MisPi 14, 107*.*

Bailey, I. Clarence, Captain
Flourished: c1910 Kingston, MA
Type of Work: Wood (Duck decoys)
Sources: *AmBiDe 85; ArtDe 135*; EyoAm 4.*

Bailey, James Bright
b. 1908 North Carolina
Flourished: Marshville Township, NC
Type of Work: Wood (Sculptures)
Sources: *FoAFs 12-3*.*

Bailey, Mary
Flourished: early 19th cent Coweeta County, GA
Type of Work: Fabric (Quilts)
Sources: *InAmD 118*.*

Bailey, William
Flourished: 1772-1792 York, PA
Type of Work: Copper, tin (Copperware, tinware)
Sources: *AmCoB 72, 113, 251-60*; AmCoTW 151-2; ToCPS 4.*

Bailly, Alexis J.
Flourished: 1855 New York, NY
Type of Work: Wood (Ship carvings, ship figures)
Sources: *AmFiTCa 187.*

Baily, Joseph
Flourished: c1734-1760 Cincinnati, OH; Newbury, MA
Type of Work: Clay (Pottery)
Sources: *AmPoP 79, 196.*

Baird
See: Myers, Baird, and Hall.

Baird, G.
Flourished: 1850-1870 Huron County, OH
Type of Work: Clay (Pottery)
Sources: *EaAmFo 251*.*

Baird, James
b. c1788
Flourished: 1830 Switzerland County, IN
Ethnicity: Irish
Type of Work: Fabric (Weavings)
Sources: *AmSQu 276; ChAmC 35.*

Baird, James
Flourished: 1851 Philadelphia, PA
Type of Work: Wood (Ship carvings, ship figures)
Sources: *AmFiTCa 187.*

Baker
See: Torbert and Baker.

Baker
See: Cornelius and Baker.

Baker, Daniel, Jr.
b. 1820 d. 1905 Washington Township, PA
Flourished: 1841-1850 Carroll Township, PA
Type of Work: Fabric (Weavings)
Sources: *ChAmC 35.*

Baker, David
b. 1816 Virginia
Flourished: 1843-1851 Columbus, OH
Type of Work: Fabric (Weavings)
Sources: *ChAmC 35*
See: Baker, John.

Baker, Dorothy
Flourished: late 18th cent Charlottesville, VA
Type of Work: Fabric (Quilts)
Sources: *QuiAm 277*.*

Baker, Eliza Jane
Flourished: Chicago, IL
Type of Work: Fabric (Weavings)
Sources: *ChAmC 35.*

Baker, Emily
See: Eastman, Emily.

Baker, J.W.
Type of Work: Watercolor (Historical paintings)
Museums: 176
Sources: *ColAWC 232-3*.*

Baker, John
Flourished: 1843-1844 Columbus, OH
Type of Work: Fabric (Weavings)
Sources: *ChAmC 35*
See: Baker, David.

Baker, John B.
Flourished: 1846 Menard County, IL
Type of Work: Watercolor, ink? (Frakturs)
Museums: 114
Sources: *ArC 84*, 263.*

Baker, Joseph
[Balar]
Flourished: c1796 Philadelphia, PA
Type of Work: Tin (Tinware)
Sources: *AmCoTW 153; ToCPS 6.*

Baker, Mary Canfield Benedict
See: Benedict, Mary Canfield (Baker).

Baker, Michael
Flourished: c1835-1860 White Hall, IL
Type of Work: Clay (Pottery)
Sources: *ArC 190.*

Baker, Nancy
b. 1795 Warren, RI d. 1837 Rehoboth?, RI?
Flourished: 1803 Warren, RI
Type of Work: Fabric (Samplers)
Museums: 241
Sources: *LeViB 215, 229, 230*-1.*

Baker, P.
Flourished: 1860 New Bedford, MA
Type of Work: Metal (Ornamental works)
Sources: *AmFoS 131*.*

Baker, Samuel Colwell
b. 1874 d. 1964
Flourished: Shenandoah, IA
Type of Work: Oil (Landscape, scene, religious paintings)
Museums: 262
Sources: *TwCA 118*.*

Baker, Thomas
Flourished: c1750 St. Mary's, MD
Type of Work: Redware (Pottery)
Sources: *AmPoP 50, 180.*

Baker, Tom
Flourished: 1960-1975 Oklahoma
Type of Work: Wood (Sculptures, carvings)
Museums: 014
Sources: *FoArO 84.*

Baker, Warren W.
Flourished: 1847-1849 New Bedford, MA
Type of Work: Pen, watercolor (Whaling scene paintings)
Museums: 123
Sources: *WhaPa 19*, 66*, 155.*

Baker, W(ilbur) A.
b. 1895 d. 1968
Flourished: 1941- Uhrichsville, OH; Gnadenhutten, OH
Type of Work: Clay (Sewer tile sculpture)
Remarks: Partner is Spenser, Herman
Sources: *IlHaSO *.*

Baker, William
Flourished: 1835 Painesville, OH
Type of Work: Wood (Ship carvings, ship figures)
Sources: *AmFiTCa 187.*

Baker-Lockwood
Flourished: Kansas City, MO
Type of Work: Oil (Circus banners)
Sources: *AmSFor 198.*

Bakewell, H.N.
Flourished: 1831-1841 Wellsburg, WV
Type of Work: Stoneware (Pottery)
Sources: *AmPoP 232; Decor 216.*

Balantyne
Flourished: 1845 Indiana
Type of Work: Fabric (Weavings)
Sources: *AmSQu 276.*

Balantyne, Abraham
b. 1835 Pennsylvania d. 1904
Flourished: c1845-1847 Lafayette, IN
Type of Work: Fabric (Weavings)
Remarks: Father is Samuel
Sources: *ChAmC 35.*

Balantyne, John
b. c1812
Flourished: c1850 Eel Township, IN
Ethnicity: Scottish
Type of Work: Fabric (Weavings)
Sources: *ChAmC 35.*

Balantyne, Samuel
b. 1808 d. 1861 White County, IN
Flourished: c1832-1850 Canonsburg, PA; Lafayette, IN; White County, IN
Ethnicity: Scottish
Type of Work: Fabric (Weavings)
Remarks: Son is Abraham
Sources: *ChAmC 35.*

Balar, Joseph
See: Baker, Joseph.

Balch, Clarissa
b. 1772
Flourished: 18th century
Type of Work: Fabric (Samplers)
Sources: *AmNe 43*.*

Balch, Mary
b. 1762 Newport, RI d. 1831
Flourished: 1773-1794 Newport, RI
Type of Work: Fabric (Samplers)
Museums: 241
Remarks: Was a teacher at a young ladies school
Sources: *LeViB 17, 71, 97-117, 155*, 158-166, 174, 192, 257-8.*

Balch, Sarah Eaton
Flourished: early 19th cent Boston area, MA; Dedham, MA
Type of Work: Wood (Furniture)
Remarks: Painted worktable
Sources: *AmPaF 183*; ArtWo 74*.*

Baldauf, Joseph
Flourished: 1870 Philadelphia, PA
Type of Work: Wood (Ship carvings, ship figures)
Sources: *AmFiTCa 187.*

Balderson and Pace
Flourished: c1875 Roseville, OH
Type of Work: Brownware, stoneware (Pottery)
Sources: *AmPoP 229; Decor 216.*

Baldwin
Flourished: Stratford, CT
Type of Work: Wood (Duck decoys)
Sources: *AmBiDe 71.*

Baldwin
See: Johnson and Baldwin.

Baldwin, Asa
Flourished: c1795 Dorset, VT
Type of Work: Stone (Gravestones)
Sources: *EaAmG 129.*

Baldwin, Frank
Flourished: 20th century Pittsburgh, PA; New Hampshire
Type of Work: Oil (Religious paintings)
Sources: *FoPaAm fig21.*

Baldwin, H.
Flourished: Medina, OH
Type of Work: Fabric (Coverlets)
Sources: *ChAmC 36.*

Baldwin, Hannah
Flourished: 1741
Type of Work: Fabric (Bed rugs)
Sources: *NewDis 12*.*

Baldwin, Henry
Flourished: 19th century Hudson River Area, NY
Type of Work: Charcoal, chalk (Farm scene drawings)
Sources: *NinCFo 200.*

Baldwin, John Lee
b. 1868 d. 1938
Flourished: Long Island, NY
Type of Work: Wood (Duck decoys, miniature duck carvings)
Sources: *AmBiDe 98-100*.*

Baldwin, Michael
b. 1719 d. 1787
Flourished: New Haven, CT
Type of Work: Stone (Gravestones)
Sources: *EaAmG 127.*

Baldwin, S.R.
Flourished: c1800-1850
Type of Work: Pen, ink (Drawings)
Sources: *FoA 103*.*

Baldwin, V.
Flourished: mid-1870s Ashtabula, OH
Type of Work: Metal (Weathervanes)
Sources: *GalAmW 98*.*

Baldwin, William
Type of Work: Wood (Duck decoys)
Remarks: Used Holmes, Benjamin patterns
Sources: *ArtDe 159.*

Baley, Sarah
b. 1727 Middletown, RI **d.** 1750
Flourished: 1738 Newport?, RI
Type of Work: Fabric (Samplers)
Museums: 205
Sources: *LeViB 60, 66**.

Baliot, Abraham
Type of Work: Fabric? (Coverlets?)
Sources: *ChAmC 36*.

Ball, H.H.
Flourished: 1830 Orange County, NY
Type of Work: Fabric (Weavings)
Sources: *AmSQu 276; ChAmC 36*.

Ball, John
Flourished: 1777
Type of Work: (Powderhorns)
Sources: *HoKnAm 8**.

Ball, Nelson
Flourished: c1831-1837 Cincinnati, OH
Type of Work: Clay (Pottery)
Sources: *AmPoP 210*.

Ball, Silas
Flourished: 1797-1808 Townshend, VT
Type of Work: Wood (Boxes)
Sources: *NeaT 65, 72, 101, 160, 183, 194*.

Ballard, A.K.
Flourished: c1856-1872 Burlington, VT
Type of Work: Stoneware (Pottery)
Museums: 260
Sources: *AmPoP 190; Decor 74*, 216, 222*.

Ballard, O.L.
See: Ballard, A.K.

Ballard Pottery
See: Woolworth F.

Balsh, Conrad
Flourished: 1765 Reading, PA
Type of Work: Tin (Tinware)
Sources: *ToCPS 4*.

Balzer, John
b. 1899
Flourished: contemporary Oklahoma
Type of Work: Wood (Sculptures, carvings)
Sources: *FoArO 77-8*, 86*.

Bancroft, G.F.
Flourished: 1848
Type of Work: Oil (Portraits)
Sources: *SoAmP 286*.

Bandel, Frederick
Flourished: 1809-1818 Ohio
Type of Work: Watercolor, ink (Frakturs)
Sources: *AmFoPa 187*.

Baner, Barbara A.
b. c1793 York, PA
Flourished: 1812 Harrisburg, PA
Type of Work: Fabric (Samplers)
Sources: *GalAmS 2*, 48**.

Bangor Stoneware Works
See: Pierson, Andrew.

Banker, Elizabeth
Flourished: 1799 New York
Type of Work: Fabric (Embroidered chairseats, samplers)
Sources: *AmS 44*; PlaFan 155**.

Banker, Martha Calista Larkin
Flourished: c1885 Clinton County, NY
Type of Work: Seeds (Wreaths)
Museums: 049
Sources: *FouNY 66**.

Bannon, S.S.
Type of Work: Oil (Scene paintings)
Sources: *PrimPa 169*.

Banta, John W.
Flourished: 1855 New York, NY
Type of Work: Wood (Ship carvings, ship figures)
Sources: *AmFiTCa 187*.

Banton, S.
Flourished: 1815 New England,
Type of Work: Watercolor (Portraits)
Sources: *NinCFo 185*.

Banvard, David
Flourished: 1820 New York, NY
Type of Work: Wood (Ship carvings, ship figures)
Sources: *AmFiTCa 187*.

Banvard, John
b. 1815
Flourished: Louisville, KY
Type of Work: Oil (Panoramic paintings)
Sources: *PicFoA 19-20*.

Barbee, W.T.
Flourished: c1890 Chicago, IL; Lafayette, IN
Type of Work: Metal (Weathervanes, ornamental metal works)
Sources: *YankWe 210*.

Barber, A.H.
Flourished: Civil War
Type of Work: Wood (Sculptures, carvings)
Sources: *WoCar 88**.

Barber, Betsy
Flourished: Connecticut
Type of Work: Tin (Japanned tinware)
Sources: *TinC 157*.

Barber, James
Flourished: 1841 Connecticut
Type of Work: Tin (Tinware)
Sources: *TinC 161*.

Barber, Joel
b. 1877 **d.** 1952
Flourished: Wilton, CT
Type of Work: Wood (Duck decoys)
Museums: 260
Remarks: Author and collector as well as carver
Sources: *ArtDe 165*; Decoy 6, 14*, 22*, 50*; EdwH;WiFoD 130**.

Barber, John W(arner)
b. 1798 **d.** 1885
Flourished: c1856-1860 Galena, IL
Type of Work: Pen, ink (Drawings)
Sources: *AmFoPa 124; ArC 263*.

Barber, Joseph
b. 1731 **d.** 1812
Flourished: West Medway, MA
Type of Work: Stone (Gravestones)
Sources: *EaAmG 128; GravNE 127*.

Barber, T.G.
Flourished: 1841 Connecticut
Type of Work: Tin? (Tinware?)
Sources: *TinC 161*.

Barber, Titus
Flourished: 1841 Simsbury, CT
Type of Work: Tin (Tinware)
Sources: *TinC 161*.

Barbier, D.
Flourished: 19th century
Type of Work: Oil (Landscape paintings)
Museums: 159
Sources: *PicFoA 99**.

Bard, James
b. 1815 New York, NY **d.** 1897 White Plains, NY
Flourished: 1831-1890 New York, NY
Type of Work: Oil, watercolor (Ship paintings)
Museums: 142,184,189,263
Remarks: Twin brother is John
Sources: *AmFoPaCe 52-8*; AmFoPaS 94*; AmNa 11-2*, 17-8, 20, 37*; AmSFok 165*; FoA 61*, 460; FoPaAm 104*; JaJ *; JaJoB *; NinCFo 165, 182, 195, figs115, 137, 145, 150; PrimPa 121-31*, 169*.

Bard, Johannes
Flourished: 1824-1832 Pennsylvania
Type of Work: Watercolor, ink (Frakturs)
Sources: *AmFoPa 187*.

Bard, John
b. 1815 New York, NY **d.** 1856 Roosevelt Island, NY
Flourished: 1831-1850 New York, NY
Type of Work: Oil, watercolor (Ship paintings)
Remarks: Twin brother is James
Sources: *AmNa 17; FoA 61, 460; InAmD 165, 182, fig115; JaJ *; JaJoB *; PrimPa 121-31*, 169*.

Bardick, Lewis
Flourished: 1870 New York
Type of Work: Oil (Paintings)
Sources: *PrimPa 169*.

Barela, Patrocinio
b. 1908 Bisbee, AZ d. 1969 Taos, NM
Flourished: 1931- Taos, NM
Ethnicity: Hispanic
Type of Work: Wood (Santeros, other religious carvings)
Museums: 020,179,181,272
Sources: *FoA* 460; *HisCr* 55*, 99*; *TwCA* 126*; *WoCar* 204.

Barkelow, Lou
b. c1870s d. c1950s
Flourished: Barnegat, NJ; Forked River, NJ
Type of Work: Wood (Decoys)
Sources: *AmBiDe* 119-20*; *AmDecoy* 71*.

Barker, Elizabeth Ann
Flourished: 1800 New York, NY
Type of Work: Fabric (Embroidered architectural, still life pictures)
Sources: *AmNe* 88-90*.

Barker, Harriett Petrie
Flourished: 1865-1870 Morristown, NY; St. Lawrence County, NY
Type of Work: Fabric (Quilts)
Museums: 240
Sources: *FouNY* 63*.

Barker, Peter
Flourished: c1760 Montville, CT
Type of Work: Stone (Gravestones)
Sources: *EaAmG* 127.

Barkley, Hugh
Flourished: 1792 Baltimore, MD
Type of Work: Paper (Wallpaper designs)
Sources: *AmDecor* 81.

Barley and Winters
Flourished: c1850-1890 Crooksville, OH
Type of Work: Clay (Pottery)
Sources: *Decor* 217; *DicM* 22*.

Barlow, Miss Lydia
Flourished: Brooklyn, NY
Type of Work: Fabric (Embroidered religious pictures)
Sources: *AmNe* 168.

Barlow, Myron
Flourished: Detroit, MI
Type of Work: Wood (Figures)
Sources: *CiStF* 21.

Barna, William
Flourished: 1855 New York, NY
Type of Work: Wood (Ship carvings, ship figures)
Sources: *AmFiTCa* 187.

Barnabus Edmonds and Company
[Edmonds and Company]
Flourished: 1812-1905 Charlestown, MA
Type of Work: Stoneware (Pottery)
Sources: *AmPoP* 190; *Decor* 167*, 218; *DicM* 17*
See: William Burroughs.

Barnard, Ebenezer
Flourished: c1772 Dorchester, MA
Type of Work: Stone (Gravestones)
Sources: *GravNE* 55.

Barnard, Lucy
Flourished: 1860 Dixfield Common, ME
Type of Work: Fabric (Hooked rugs, bed rugs)
Museums: 151
Sources: *ArtWo* 55*, 155.

Barnes, Blakeslee
Flourished: Berlin, CT
Type of Work: Tin (Tinware)
Sources: *TinC* 44, 93, 161.

Barnes, Edward
d. 1871
Flourished: 1845-1871 Bristol, CT
Type of Work: Tin (Tinware)
Sources: *TinC* 161.

Barnes, Henry
Flourished: Philadelphia, PA
Type of Work: Wood, paper (Bandboxes)
Sources: *AmSFo* 129*.

Barnes, Lucius
Flourished: 1810-1839 Middletown, CT
Type of Work: Oil (Portraits)
Museums: 001
Sources: *AmFoAr* 26; *AmFoPo* 45*; *PrimPa* 169.

Barnes, R.
Flourished: 1891 Virginia
Type of Work: Oil (Historical paintings)
Sources: *OneAmPr* 134*, 149, 153.

Barnes, Samuel T.
Flourished: 1890 Havre de Grace, MD
Type of Work: Wood (Duck decoys)
Museums: 260
Sources: *AmFokAr* 182, fig124; *Decoy* 52*, 98-9*; *WiFoD* 135-6*.

Barnes, William
Flourished: 1830 New York, NY
Type of Work: Wood (Ship carvings, ship figures)
Sources: *AmFiTCa* 187.

Barnhardt, John
Flourished: 1822-1823 Baltimore, MD
Type of Work: Wood (Furniture)
Sources: *AmPaF* 136*
See: Renshaw, Thomas.

Barnhott, Margaret
b. 1819
Flourished: 1831 Pennsylvania
Type of Work: Fabric (Samplers)
Sources: *AmNe* 59, 61*.

Barnum, E.T.
Flourished: 1870-1912 Detroit, MI
Type of Work: Metal (Weathervanes, ornamental metal works)
Sources: *YankWe* 210.

Barnum, Julia Fuller
Flourished: Kent, CT
Type of Work: Oil (Landscape paintings)
Sources: *PrimPa* 169.

Barr, Eliza
Flourished: 1900 Carroll County, GA
Type of Work: Fabric (Quilts)
Sources: *MisPi* 80*.

Barr, James
Flourished: c1815-1847 Pittsburgh, PA
Type of Work: Redware, stoneware (Pottery)
Sources: *AmPoP* 227.

Barrett
Flourished: c1850 Howard, PA
Type of Work: Fabric (Weavings)
Sources: *ChAmC* 36.

Barrett, Edward P.(T.)
Flourished: 1866 Williamsport, PA; Philadelphia, PA
Type of Work: Tin (Tinware)
Sources: *ToCPS* 41*-2.

Barrett, Jonathan
Flourished: 1810-1811 Connecticut
Type of Work: Tin? (Tinware?)
Sources: *TinC* 161.

Barrett, M.
See: M. Barrett and Brother.

Barrett, Salley
Type of Work: Watercolor (Mourning paintings)
Museums: 176
Sources: *ColAWC* 208*.

Barrett and Debeet
Flourished: 1860 Baltimore, MD
Type of Work: Wood (Ship carvings, ship figures)
Sources: *AmFiTCa* 187.

Barrow, John Sutcliff
Flourished: 1793-1804 Hartford, CT; Middletown, CT
Type of Work: Wood (Signs)
Sources: *MoBBTaS* 11.

Barrows, Asahel
Flourished: Berlin, CT
Type of Work: Tin? (Tinware?)
Sources: *TinC* 161.

Barry, Thomas
Flourished: 1835 New York, NY
Type of Work: Wood (Ship carvings, ship figures)
Sources: *AmFiTCa* 187.

Barry and Losea
Flourished: 1855 New York, NY
Type of Work: Wood (Ship carvings, ship figures)
Sources: *AmFiTCa* 92-4, 100-1, 187, 190, figxx; *ShipNA* 161.

Barsto Furnace
Flourished: 1766-1854 Burlington County, NJ
Type of Work: Iron (Stove plates)
Museums: 199
Sources: *EaAmI 22**.

Barstow, Salome
Flourished: 1820 Massachusetts
Type of Work: Velvet (Paintings)
Sources: *PrimPa 169*.

Bart, Daniel
Flourished: 1797 Pennsylvania
Type of Work: Watercolor, ink (Frakturs)
Sources: *AmFoPa 187*.

Bart, Susanna
Flourished: 1793 Pennsylvania
Type of Work: Watercolor, ink (Frakturs)
Sources: *AmFoPa 187*.

Barta, Joseph Thomas
b. 1904 Algonquin, IL d. 1972
Flourished: Spooner, WI
Type of Work: Wood (Sculptures, carvings)
Museums: 185
Sources: *AmFoS 198**; *FoAFz 14-5**.

Barth, Andrew
Flourished: 1843-1844 Columbus, OH
Type of Work: Fabric (Weavings)
Sources: *ChAmC 36*.

Barth, Bartholomew
Flourished: 1859 St. Louis, MO
Type of Work: Wood (Ship carvings, ship figures)
Sources: *AmFiTCa 187*.

Barth, Louis
Flourished: Meriden, CT
Type of Work: Tin (Tinware)
Sources: *TinC 161*.

Barth, Otto
Flourished: c1840 Galena, IL
Type of Work: Paint (Landscape paintings)
Sources: *ArC 263*.

Bartholomew, Jacob, Jr.
Flourished: 1804 Bristol, CT
Type of Work: Tin (Tinware)
Sources: *TinC 161*.

Bartholomew, Samuel
Flourished: Connecticut
Type of Work: Tin (Tinware)
Sources: *TinC 161*.

Bartlam, John
Flourished: 1770 Charleston, SC
Type of Work: White earthenware (Porcelain)
Sources: *AmPoP 85, 237*; *AmSFok 139*.

Bartleman
Flourished: c1840-1850 Plumstead, PA
Type of Work: Redware (Pottery)
Sources: *AmPoP 177*.

Bartler, Joseph
Flourished: North Georgetown, OH
Type of Work: Fabric (Coverlets)
Sources: *ChAmC 36*.

Bartlet, Jerusha
Flourished: 1855
Type of Work: Fabric (Weavings)
Sources: *AmSQu 276*; *ChAmC 36*.

Bartlett, Gershom
b. 1723 d. 1798
Flourished: 1766 East Hartford, CT
Type of Work: Stone (Gravestones)
Sources: *EaAmG 43*, 127*.

Bartlett, I.
Flourished: c1850 Kentucky
Type of Work: Oil (Paintings)
Sources: *AmFoAr 28*.

Bartlett, Jonathan Adams
b. 1817 d. 1902
Flourished: South Rumford, ME
Type of Work: Oil (Portraits)
Museums: 001
Sources: *AmFoPo 46-7**; *FoPaAm 43*, fig28*.

Bartlett, Lucy
Flourished: 1830 Massachusetts
Type of Work: Velvet (Memorial paintings)
Sources: *AmFoAr 36*; *AmPrP 149*; *PrimPa 169*.

Bartlett, W.H.
Flourished: mid 19th cent
Type of Work: Oil (Landscape paintings)
Sources: *AmPrP 15**.

Bartol, William Thompson
See: Bartoll, William Thompson.

Bartoll, William Thompson
b. 1817 d. 1859
Flourished: 1840-1850 Marblehead, MA
Type of Work: Oil, fresco (Landscape paintings, portraits)
Museums: 001,096,141,203
Remarks: Itinerant
Sources: *FlowAm 49**; *FoA 460*; *FoPaAm 39**; *PrimPa 169*; *SoAmP 188*, 192**.

Barton, Ann Maria
b. 1788 Providence, RI d. 1868 Providence?, RI?
Flourished: 1800 Providence, RI
Type of Work: Embroidery (Mourning pictures)
Museums: 241
Sources: *LeViB 135, 168*, 174*; *MoBeA*.

Barton, Major
Flourished: 19th century Illinois
Type of Work: Wood (Sculptures, carvings)
Sources: *AmFoS 116**.

Barton, Philura
b. c1812
Flourished: 1824 Chatham, CT
Type of Work: Fabric (Samplers)
Sources: *GalAmS 62**.

Barton, William
Type of Work: Metal (Sleighbells)
Sources: *AmCoB 180**.

Bascom, Ruth Henshaw
b. 1771 Leicester, MA d. 1848 Ashby, MA
Flourished: 1819-1837 Franklin County, MA; Fitswilliam?, NH
Type of Work: Pastel, crayon, pencil (Portraits)
Museums: 001,017,053,131,176,215
Sources: *AmFoPo 49-50**; *ArtWo 6, 32, 59-60*, 155-6*; *ColAWC 119, 121**; *Edith**; *EyoAm 21*; *FoA460*; *FoArtC 114*; *FoPaAm 38**; *NinCFo fig82*; *OneAmPr 92-3*, 134**; *PicFoA 15, 84**; *PrimPa 31-8*, 169*; *SoAmp 286*.

Basye, Joyce
b. 1947
Flourished: c1981 Bowie, MD; Baltimore, MD
Type of Work: Oil (Landscape paintings)
Sources: *FoA 54*, 460*.

Batchelder, Miss Christine
See: Bacheller, Celestine.

Batchelder Pottery
Flourished: c1850-1880 Menasha, WI
Type of Work: Stoneware (Pottery)
Sources: *Decor 216*.

Bates, A.S.
Flourished: 1842 Chicago, IL
Type of Work: Wood (Furniture)
Sources: *ArC 175**.

Batson, Mary Jane
Flourished: mid 19th cent Richmond, VA
Type of Work: Fabric (Quilts)
Sources: *ArtWo 54*, 156**.

Bauch, Stan, Dr.
Flourished: New York
Type of Work: Oil (Paintings)
Sources: *ThTaT 236**.

Bauders, F.
Flourished: c1841 Pittsburgh, PA
Type of Work: Stoneware (Pottery)
Sources: *AmPoP 227*; *Decor 216*.

Bauer, A.J.
Flourished: c1886-1900 Paducah, KY
Type of Work: Redware, brownware (Pottery)
Remarks: Paducah Pottery
Sources: *AmPoP 240.*

Bauer, Andeas B.
Flourished: 1832 Pennsylvania
Type of Work: Watercolor, ink (Frakturs)
Sources: *AmFoPa 187.*

Bauer, William
Flourished: pre-1863 Martinsburg, WV
Type of Work: Fabric (Coverlets)
Sources: *ChAmC 36.*

Baughman, John
Flourished: Lexington, OH
Type of Work: Fabric (Coverlets)
Sources: *ChAmC 36.*

Baum, J.H.
Flourished: c1880-1895 Wellsville, OH
Type of Work: White Granite (Pottery)
Sources: *AmPoP 232; DicM 232*.*

Baum, Mark
b. 1903
Flourished: New York, NY
Type of Work: Oil (Landscape, scene paintings)
Sources: *PrimPa 169.*

Bauman, August
Flourished: 1900 Pennsylvania
Type of Work: Watercolor, ink (Frakturs)
Sources: *AmFokDe 144; AmFoPa 187.*

Bauman, Leila T.
Flourished: 1860-1870 New Jersey
Type of Work: Oil (Landscape paintings)
Sources: *ArtWo 103, 105*, 156*.*

Baumann, S.
Flourished: 1876 Racine, WI
Type of Work: Metal (Ornamental works)
Sources: *InAmD 93*.*

Baumback, Theodore
Flourished: 1855 New York, NY
Type of Work: Wood (Ship carvings, ship figures)
Sources: *AmFiTCa 187.*

Baumgartner, Doc
Flourished: Michigan
Type of Work: Wood (Decoys)
Sources: *WaDec 156*.*

Baurichter, Fritz
d. 1937
Flourished: Warren County, PA
Type of Work: Wood (Sculptures, carvings)
Sources: *ASeMo 404*.*

Bause, K.F.
Flourished: mid 19th cent
Type of Work: Pen, ink (Calligraphy drawings)
Sources: *NinCFo 201.*

Bayard, Jacob
Flourished: North Lima, OH
Type of Work: Fabric (Coverlets)
Sources: *ChAmC 36.*

Bayer, Michael
Flourished: 1835 New York, NY
Type of Work: Wood (Ship carvings, ship figures)
Sources: *AmFiTCa 187.*

Bayley, Charles
Flourished: 1860s New Bedford, MA.
Type of Work: Whalebone, ivory (Carved canes)
Museums: 186
Sources: *GravF 91*-2.*

Bazan, Ignacio Ricardo
Flourished: Santa Fe, NM
Type of Work: Fabric (Weavings)
Museums: 263
Remarks: Son is Joaquin
Sources: *PopAs 199*, 200-1, 204-5.*

Bazan, Joaquin
d. 1871
Flourished: Belen, NM; Tome, NM
Type of Work: Fabric (Weavings)
Museums: 182
Remarks: Father is Ignacio Ricardo
Sources: *PopAs 200-1.*

Bdogna, Frank
Flourished: c1914
Type of Work: Oil (Paintings)
Sources: *FoAFm 2.*

Beach, Chauncey
Flourished: 1841 Connecticut
Type of Work: Tin? (Tinware?)
Sources: *TinC 161.*

Beadle, Edward
Flourished: 1855 New York, NY
Type of Work: Wood (Ship carvings, ship figures)
Sources: *AmFiTCa 187.*

Beadle, Leaman
b. 1680 Salem, MA d. 1717
Flourished: Salem, MA
Type of Work: Wood (Ship carvings, ship figures)
Sources: *ShipNA 6-7, 160.*

Beall-Hammond, Jemima Ann
Flourished: c1800 Frederick, MD
Type of Work: Fabric (Candlewick spreads)
Museums: 263
Sources: *SoFoA 199, 201*, 223.*

Beam, Caroline
Flourished: 1840 New England,
Type of Work: Charcoal (Drawings)
Sources: *ArtWo viii*, frontcover.*

Bean, Mrs.
Flourished: Medina County, OH
Type of Work: Fabric (Coverlets)
Sources: *ChAmC 36.*

Bean, W.P.
Flourished: 1865 Boston, MA
Type of Work: Wood (Ship carvings, ship figures)
Sources: *AmFiTCa 187.*

Beard, M.
Flourished: 1842
Type of Work: Fabric (Coverlets)
Sources: *ChAmC 36.*

Beard, William
Flourished: Dunlevy, OH
Type of Work: Fabric (Coverlets)
Sources: *ChAmC 36.*

Bears, O.I. (Orlando Hand)
Flourished: 1835 New London, CT
Type of Work: Oil (Portraits)
Remarks: Itinerant
Sources: *AmNa 14; PrimPa 169; SoAmP 287.*

Beatly, Spencer
Flourished: 1830 Boston, MA
Type of Work: Wood (Ship carvings, ship figures)
Sources: *AmFiTCa 187.*

Beatty
See: Norwich, Beatty and Company.

Beatty, Gavin I.
Flourished: c1798-1811 Harrisburg, PA
Type of Work: Fabric (Coverlets)
Sources: *ChAmC 36.*

Beatty, Spencer
d. 1853
Type of Work: Wood (Ship carvings, ship figures)
Remarks: Apprentice of Fowle, Isaac
Sources: *ShipNA 42.*

Beauchamp, William Millet
Flourished: 1830-1865 Skaneateles, NY
Type of Work: Pencil, watercolor (Landscape drawings)
Sources: *PrimPa 16.*

Beaujoy, Dennis
Flourished: 1851 Philadelphia, PA
Type of Work: Wood (Ship carvings, ship figures)
Sources: *AmFiTCa 187.*

Beauregard, C.G.
Flourished: 1840 Massachusetts
Type of Work: Oil (Portraits)
Sources: *PrimPa 169; SoAmP 287.*

Beaver, Chief
Flourished: 19th century New York
Type of Work: Oil (Landscape paintings)
Sources: *NinCFo 181.*

Beaver Clay Manufacturing Company
Flourished: New Galilee, PA
Type of Work: Clay (Sewer tile sculpture)
Sources: *IlHaSO *.*

Beaver Falls Art Tile Company
Flourished: 1888-1800 Beaver Falls, PA
Type of Work: Clay (Tile)
Sources: *AmPoP 208.*

Becham, Washington
Flourished: 1870-1880 Georgia
Type of Work: Clay (Pottery)
Sources: *MisPi 86-7*; SoFoA 36*, 218.*

Bechtel, John
Flourished: Springfield Township, PA
Type of Work: Fabric (Coverlets)
Sources: *ChAmC 37.*

Beck, A.M.
Flourished: 1882-1884 Evansville, IN
Type of Work: Clay (Pottery)
Sources: *AmPoP 219.*

Beck, Augustus
Flourished: Quincy, IL
Type of Work: Fabric (Weavings)
Sources: *ChAmC 37.*

Beck, Jesse
Flourished: c1850 Wrightstown, PA
Type of Work: Redware (Pottery)
Sources: *AmPoP 185.*

Becker
See: Tourpet and Becker .

Becker, A.H.
Flourished: 1859 Quincy, IL
Type of Work: Oil? (Frescos, ornamental, sign paintings)
Sources: *ArC 263.*

Becker, Barbara
b. 1774 d. 1850
Flourished: 1806 Shenandoah County, VA
Type of Work: Watercolor, ink (Frakturs)
Sources: *AmFoPaS 40*; FoPaAm 159*.*

Becker, J.M.
Flourished: 1829 Pennsylvania
Type of Work: Watercolor, ink (Frakturs)
Sources: *AmFoPa 187.*

Becker, Joseph
b. 1841 d. 1910
Flourished: Sacramento, CA
Ethnicity: Shaker
Type of Work: Oil (Paintings)
Museums: 278
Sources: *AmFoPaN 104, 140*; AmPrP backpage; HanWo 6*; PrimPa 169.*

Beckert, L.
Flourished: 1858 Chicago, IL
Type of Work: Fresco (Paintings)
Sources: *ArC 263.*

Beckett, Francis A.
b. c1829
Flourished: 1868-1885 Stockton, CA
Ethnicity: West Indian
Type of Work: Oil (Paintings)
Museums: 189
Sources: *AmNa 20, 38.*

Beckham, Julia Wickliffe
Flourished: c1870 Queensboro, KY
Type of Work: Fabric (Quilts)
Sources: *KenQu fig17.*

Beckley, John
Flourished: Meriden, CT; Wallingford, CT
Type of Work: Tin (Tinware)
Sources: *TinC 161.*

Beckley, Luther
See: Buckley, Luther .

Beckting Brothers
See: Becting Brothers .

Beckwith, Benjamin
Flourished: Berlin, CT
Type of Work: Wood, paint (Chairs)
Sources: *TinC 161.*

Beckwith, Israel
Flourished: Connecticut
Type of Work: Tin? (Tinware?)
Sources: *TinC 161.*

Becting Brothers
[Beckting Brothers]
Flourished: c1870-1900 Huntington, IN; Evansville, IN
Type of Work: Stoneware (Pottery)
Sources: *AmPoP 220-1; Decor 216.*

Bedell, Prudence
b. 1829
Flourished: 1840-1845 New Baltimore, NY
Type of Work: Watercolor, pencil (Drawings)
Museums: 001
Sources: *AmFoPo 55-7*.*

Bedger, Carl
See: Boettger, Carl .

Bedwell, Elias J.
Flourished: 1850- Boonville, MO
Type of Work: Stone (Gravestones, other sculptures)
Sources: *ASeMo 440*
See: Boonville Marble works .

Beech, Ralph Bagnall
Flourished: 1846-1852 Philadelphia, PA
Type of Work: Redware, Rockingham, white clay (Porcelain, pottery)
Sources: *AmPoP 46, 82, 104, 176; DicM 110*.*

Beecham Pottery
Flourished: Dent, GA
Type of Work: Clay (Pottery)
Sources: *AmPoP 237.*

Beecher, Laban S.
b. 1805 Connecticut d. 1876
Flourished: c1834 Boston, MA; Charlestown, MA; Wisconsin
Type of Work: Wood (Ship carvings, ship figures)
Museums: 148
Remarks: His apprentice is Bellamy, John
Sources: *AmFiTCa figxiv, 99-100, 187; AmFoS 5, 82*, 168; FoArtC 103; InAmD 188*; ShipNA 44-5*, 50, 88, 95, 128*, 131, 136, 145, 159, 164.*

Beecher and Lantz
Flourished: 1863-1883 Akron, OH
Type of Work: Stoneware (Pottery)
Sources: *AmPoP 205; Decor 216.*

Beekman, Miss Florence
Flourished: 1894 New York
Type of Work: Fabric (Embroidered veils)
Museums: 248
Sources: *AmNe 168*.*

Beeman, S.
Flourished: 1841 Connecticut
Type of Work: Tin (Tinware)
Sources: *TinC 162.*

Beerbauer, L.S.
See: Beerbower, L.S. .

Beerbaur, L.S.
See: Beerbower, L.S. .

Beerbower, L.S.
[Beerbauer; L.S. Beerbauer & Company]
Flourished: 1879 Elizabeth, NJ
Type of Work: Clay (Pottery)
Sources: *AmPoP 49, 62, 167, 254*; DicM 156*, 170*, 177**
See: Pruden, John; Leake, William .

Beerbower, William
Flourished: 1837 Steubenville, OH
Type of Work: Fabric (Weavings)
Sources: *ChAmC 37.*

Beers, Martha Stuart
Flourished: 1830 New Lebanon, NY
Type of Work: Velvet (Paintings)
Sources: *PrimPa 169.*

Begerly, Levi
Flourished: 1894 Strasburg, VA
Type of Work: Clay (Pottery)
Remarks: Employed at Eberly Pottery
Sources: *AmFoS 223**
See: Fleet, Theodore .

Behn, Andrew
Flourished: 1857-1877 Cincinnati, OH
Type of Work: Yellow-ware (Pottery)
Sources: *AmPoP 211.*

Behn, George Peter
Flourished: 1857-1900 Cincinnati, OH
Type of Work: Redware (Pottery)
Sources: *AmPoP 211.*

Beiber, C.G.
Flourished: 1865 Boston, MA
Type of Work: Wood (Ship carvings, ship figures)
Sources: *AmFiTCa 187.*

Beichler, Ed
b. 1906
Flourished: 1972 Greenville, OH
Type of Work: Wood, oil (Sculpture, landscape paintings)
Sources: *FoAFt 13-4*.*

Beiderlinden, Nicol
Flourished: 1855 New York, NY
Type of Work: Wood (Ship carvings, ship figures)
Sources: *AmFiTCa 187.*

Beidler, C.Y.
Flourished: 1847 Pennsylvania
Type of Work: Watercolor, ink (Frakturs)
Sources: *AmFoPa 187.*

Beidler, Mary Ann Yost
Flourished: 1834 Reading, PA
Type of Work: Fabric (Samplers)
Sources: *GalAmS 76*.*

Beil, B.
Flourished: 1846
Type of Work: Fabric (Weavings)
Sources: *AmSQu 276.*

Beil, David
b. c1811 Pennsylvania
Flourished: 1843-1868 New Hamburg, PA
Type of Work: Fabric (Coverlets)
Sources: *ChAmC 37.*

Beitel, Josiah
Flourished: c1800 Nazareth, PA
Type of Work: Watercolor (Mourning paintings)
Sources: *MoBeA.*

Belcher, M.D.
Flourished: 1830 Greenfield, MA
Type of Work: Watercolor (Landscape paintings)
Sources: *PrimPa 169.*

Belcher, Mary
Flourished: 1808
Type of Work: Fabric (Samplers)
Sources: *AmNe 48.*

Belcher, Sally Wilson
Flourished: 1790-1800 Connecticut
Type of Work: Fabric (Embroidered pictures)
Museums: 297
Sources: *AmNe 86*-7.*

Belden, Aziel
Flourished: 1813 Connecticut
Type of Work: Tin (Tinware)
Sources: *TinC 162.*

Belden, Horace
Flourished: Berlin, CT
Type of Work: Tin? (Tinware?)
Sources: *TinC 162.*

Belden, Joshua
Flourished: 1810-1816 Connecticut
Type of Work: Tin (Tinware)
Sources: *TinC 162.*

Belden, Sylvester
Flourished: 1810-1811 Connecticut
Type of Work: Tin (Tinware)
Sources: *TinC 162.*

Belding
See: Hastings and Belding.

Belding
See: Orcutt, Belding and Company.

Belding, David
Flourished: c1830-1840 Whateley, MA
Type of Work: Stoneware (Pottery)
Sources: *AmPoP 204.*

Belding, Samuel, Jr.
Flourished: Hadley, CT; Hatfield, MA
Type of Work: Wood (Hope or Hadley chests)
Sources: *AmPaF 19.*

Belknap, Zedakiah
b. 1781 d. 1858
Flourished: 1810-1840 Townsend, MA
Type of Work: Oil (Portraits)
Remarks: Itinerant in New England
Sources: *AmFoPa 47, 50-1*; AmFoPaS 62*; AmFoPo 57-60*; Edith *, FoA 2*, 460; NinCFo 165, 173, fig90; PrimPa 169; SoAmP 164*.*

Bell
See: Leisinger and Bell.

Bell, Charley
Flourished: 1865 Waynesboro, PA; Chambersburg, PA
Type of Work: Clay (Pottery)
Remarks: Worked at John Bell Pottery
Sources: *AmPoP 44, 50, 86; EaAmFo 258*.*

Bell, John
[John Bell Pottery]
Flourished: 1833-1881 Waynesboro, PA; Chambersburg, PA
Type of Work: Redware (Pottery)
Remarks: Father is Peter; brothers are Samuel and Solomon; son is John W.
Sources: *AlAmD 104*; AmFokAr 19, fig145; AmPoP 44, 50, 86, 165, 184-5; BeyN 44*, 46, 48-50*, 82*, 106, 121; Decor 72*, 175*, 216; DicM 70*; EaAmFo 258; MaAmFA *; SoFoA 17*, 33*, 39*, 217-8.*

Bell, John W.
Flourished: 1881-1895 Waynesboro, PA; Chambersburg, PA
Type of Work: Clay (Pottery)
Remarks: Father is John
Sources: *AmPoP 185; DicM 73*-4*.*
See: Bell, Charley.

Bell, Joseph
Flourished: 1827-1850 Putnam, OH
Type of Work: Stoneware (Pottery)
Sources: *AmPoP 228; DicM 74*.*

Bell, Joseph "Joe"
b. 1920
Flourished: 1965- Staunton, VA
Type of Work: Wood (Weathervanes, whirligigs)
Sources: *ConAmF 103-7*.*

Bell, Peter
Flourished: c1813-1824 Winchester, VA; Hagerstown, MD
Ethnicity: German
Type of Work: Clay (Pottery)
Remarks: Father of Samuel, John, and Solomon
Sources: *AmPoP 44, 50, 86, 168; DicM 105*; SoFoA 17.*

Bell, Richard Franklin
Flourished: 1885-1890 Strasburg, VA
Type of Work: Clay (Pottery)
Sources: *BeyN 23*.*

Bell, Samuel
Flourished: 1843-1883 Strasburg, VA
Type of Work: Clay (Pottery)
Remarks: Brother of Solomon and John; son of Peter
Sources: *AlAmD 109*; AmPoP 86, 241; DicM 19*, 116*, 119*, 123*.*

Bell, Solomon
[S. Bell and Sons Pottery]
Flourished: 1852-1908 Strasburg, VA
Type of Work: Clay (Pottery)
Museums: 175
Remarks: Brother of Samuel and John; father is Peter
Sources: *AlAmD 10, 107*, 111*; AmFoAr 48; AmFoS 218*; BeyN 40*, 113, 118; DicM 119*, 123*; EaAmFo 272*, 284*; SoFoA 8*, 17*, 31-2*, 217-8.*

Bell, Upton
Flourished: c1895 Waynesboro, PA
Type of Work: Clay (Pottery)
Sources: *AmPoP 44, 50, 86, 185; DicM 133*.*

Bell Pottery
See: Bell, John.

Bellamy, John Hales
b. 1836 Kittery Point, ME d. 1914 Portsmouth, NH
Flourished: until 1902 Kittery Point, ME; Charlestown, MA; Portsmouth, NH
Type of Work: Wood (Ship carvings, ship figures)
Museums: 096,142,189,221
Remarks: Apprentice of Beecher, Laban S.
Sources: *AmEaAD 20*; AmFokAr 31, 187, fig27; AmFoS 5, 92*, 171-3*; AmFoSc 14; AmSFok 21; BirB42*; EaAmW 34; Edith *; FigSh 112-3*; FoA 203*, 460; FoArA 129-34*; FoArtC 103*;InAmD 55, 187*; PicFoA 26*; ShipNA 88-90*, 161.*

Belleville Clay and Mining and Pottery Company
See: Reay, Charles.

Bellman, Henry
Flourished: Lebanon, PA
Type of Work: Fabric (Weavings)
Sources: *ChAmC 37.*
See: Meily, Emanuel, Jr.

Bellmark Pottery Company
Flourished: 1893 Trenton, NJ
Type of Work: Clay (Pottery)
Sources: *DicM 233*.*

Bells, T.
Flourished: c1880-1900 Ledgedale, PA
Type of Work: Redware (Pottery)
Sources: *AmPoP 222.*

Benabides, Jose Manuel
Flourished: 19th century Santa Cruz de la Canada, NM
Type of Work: Wood (Santeros, other religious carvings)
Sources: *PopAs 384-5, 401-2.*

Benavides, Rafael, Father
Flourished: 18th century Albuquerque, NM
Type of Work: Wood (Santeros, other religious carvings)
Sources: *PopAs 429.*

Bendele, Louis
b. 1806-1889
Flourished: 1838-1870 Boonville, MS
Type of Work: Wood (Furniture)
Sources: *ASeMo 381-2.*

Bender, A.S., Major
Flourished: 1844 Galena, IL
Type of Work: Oil? (Landscape paintings)
Sources: *ArC 263.*

Bender, David
b. 1824
Flourished: 1846-1874 Johnson County, IA
Type of Work: Fabric (Weavings)
Museums: 178
Sources: *ChAmC 37.*

Benedict, Mary Canfield (Baker)
Flourished: 1850s Arlington, VT
Type of Work: Fabric (Quilts)
Sources: *FoArtC 133*.*

Bennet, Cordelia Lathan
b. 1798
Flourished: c1807 New York
Type of Work: Fabric (Samplers)
Sources: *GalAmS 44*.*

Bennet, Daniel
See: Bennett, Daniel.

Bennet, Edwin
See: Bennett, Edwin.

Bennet, James S.
See: Bennett, James S..

Bennett, Miss
See: Dunham, John.

Bennett, Mrs.
Flourished: c1824 Berlin, CT; Baltimore, MD
Type of Work: Tin (Painted tinware)
Sources: *AmCoTW 81; TinC 157.*

Bennett, Alice
b. 1895 Mount Pleasant, MI
Flourished: c1915- Mount Pleasant, MI
Ethnicity: American Indian
Type of Work: Wood, dye (Baskets)
Remarks: Chippewa Indian tribe; worked on the reservation; son is Russell
Sources: *Rain 19*-21*.*

Bennett, Caroline
Flourished: 1835 Lunenburg, MA
Type of Work: Watercolor (Theorems)
Museums: 096
Sources: *FoPaAm 45*.*

Bennett, Daniel
Flourished: 1849-1860
Ethnicity: English
Type of Work: Yellow-ware, brownware (Pottery)
Remarks: Brothers are James, Edwin, and William
Sources: *AmPoP 75, 227.*

Bennett, E.V.
Flourished: Maine
Type of Work: Oil (Paintings)
Remarks: Member of the Rufus Porter school
Sources: *AmFoPa 141.*

Bennett, Edwin
[Edwin Bennett Pottery Co.]
Flourished: 1846-1900 Baltimore, MD; Pittsburgh, PA; Troy, IN
Ethnicity: English
Type of Work: Clay (Pottery)
Remarks: Brothers are William, James, and Daniel
Sources: *AmPoP 51, fig86, fig12, 75, 82, 164, 227; Decor 216; DicM 170*, 178*, 198*, 205*-6*, 240*, 251*-2*, 259*, 38*, 41*.*

Bennett, Elizabeth K.
Flourished: 1809 Connecticut
Type of Work: Fabric (Mourning pictures, samplers)
Sources: *AmNe 82*.*

Bennett, F.R.
Flourished: 1875 California; Oregon
Type of Work: Oil (Landscape paintings)
Museums: 203
Sources: *FoPaAm 213*.*

Bennett, James S.
[Bennet's Pennsylvania Pottery]
d. 1862 Pittsburgh, PA
Flourished: c1840 Moultonboro, NH; Baltimore, MD; Birmingham (Pittsburgh), PA
Ethnicity: English
Type of Work: Yellow-ware, brownware (Pottery)
Remarks: Brothers are Edwin, William, and Daniel
Sources: *AmPoP 49, 62, 74-75, 196, 214, 227; DicM 71*, 75*.*

Bennett, John
Flourished: c1875 New York, NY
Type of Work: Clay (Pottery)
Sources: *DicM 70*.*

Bennett, R.
Flourished: 1852-1853 Monroeville, OH
Type of Work: Fabric (Weavings)
Sources: *ChAmC 37.*

Bennett, Russell
b. 1926 Mount Pleasant, MI
Flourished: 1942- Mount Pleasant, MI
Ethnicity: American Indian
Type of Work: Wood, dye (Baskets)
Remarks: Chippewa Indian tribe; mother is Alice
Sources: *Rain 11, 22*-3*.*

Bennett, S.A.
Flourished: 1833 New York
Type of Work: Fabric (Weavings)
Sources: *ChAmC 37.*

Bennett, Thomas
Flourished: 1855 New York, NY
Type of Work: Wood (Ship carvings, ship figures)
Sources: *AmFiTCa 187.*

Bennett, William
Flourished: 1844-1849 Birmingham (Pittsburgh), PA
Ethnicity: English
Type of Work: Yellow-ware, brownware (Pottery)
Remarks: Brothers are Edwin, Daniel, and James
Sources: *AmPoP 74, 227; Decor 216.*

Bennett and Chollar
Flourished: 1843 Homer, NY
Type of Work: Clay (Pottery)
Sources: *DicM 19*.*

Bennett Brothers
Flourished: 1844- Pittsburgh, PA
Type of Work: Yellow-ware, brownware (Pottery)
Remarks: William, Daniel, James, and Edwin
Sources: *AmPoP 227.*

Bennett Haynes and Company
See: Haynes, Bennett and Company.

Bennington and Norton
See: J. and E. Norton.

Bensing, Dirick
[Benson]
Flourished: c1698 New York, NY
Type of Work: Redware (Pottery)
Sources: *AmPoP 53, 196.*

Benson, Dirick
See: Bensing, Dirick.

Benson, Frank
Flourished: 1801 Norfolk, VA
Type of Work: Wood (Ship carvings)
Sources: *ShipNA 164.*

Benson, Henry
Flourished: c1732 New York, NY
Type of Work: Redware (Pottery)
Sources: *AmPoP 196.*

Bent, Everett
Flourished: 1856 Watertown, MA
Type of Work: Wood (Ship carvings, ship figures)
Sources: *AmFiTCa 187.*

Bent, Samuel
See: Samuel Bent and Sons.

Bentley, E.W.
Flourished: c1840 Lanesboro, MA
Type of Work: Stone (Gravestones)
Sources: *EaAmG 128.*

Bentley, J.
See: J. Bentley Sons.

Benton, G.
Flourished: c1818 Hartford, CT
Type of Work: Clay (Pottery)
Sources: *DicM 51*
See: Stewart, L..

Benton, Jared
Flourished: 1823 Connecticut
Type of Work: Tin (Tinware)
Sources: *TinC 162.*

Benton and Steward Pottery
See: Goodale, Daniel, Jr..

Bereman, John
Flourished: Sullivan, WI
Ethnicity: Irish
Type of Work: Wood (Religious carvings)
Sources: *EaAmW 117.*

Berg's Mill
Flourished: c1968 Texas
Type of Work: Stoneware (Pottery)
Sources: *AmS 49*.*

Berge, Benjamin
See: Bergey, Benjamin.

Bergen, Johanna
Flourished: 1825-1829 Bergen's Island, NY; Flatlands Bay, NY
Type of Work: Fabric (Quilts)
Sources: *ArtWea 133*.*

Berger, L.D.
See: L.D. Berger Brothers Manufacturing

Berger Manufacturing Company
Flourished: 1889-1895 Canton, OH
Type of Work: Metal (Weathervanes)
Sources: *YankWe 210.*

Bergey, Benjamin
Flourished: 1830-1840s Montgomery County, PA
Type of Work: Clay (Pottery, sgraffito plates)
Museums: 227
Sources: *AmPoP 186; FlowAm 262*; FoArRP 43*.*

Bergey, Joseph K.
Flourished: 1803 Pennsylvania
Type of Work: Watercolor, ink (Frakturs)
Sources: *AmFoPa 187.*

Bering, Thomas G.
Flourished: 1860 Philadelphia, PA
Type of Work: Wood (Ship carvings, ship figures)
Sources: *AmFiTCa 187.*

Bernhardt, Peter
Flourished: 1789-1819 Keezletown, VA
Type of Work: Watercolor, ink (Frakturs)
Sources: *AmFoPa 187; AmFoPaS 39*; SoFoA 82*-3*, 86-7, 219.*

Bernier
Flourished: 1919 Saco-Biddeford, ME
Type of Work: Wood (Wood sculptures, carvings)
Sources: *AmFoS 5*, 173*, 284*.*

Berresford, Benjamin
Flourished: 1843 Alton, IL
Ethnicity: English
Type of Work: Stoneware (Pottery)
Sources: *ArC 190.*

Berry
Flourished: Bluff Springs, IL
Type of Work: Fabric (Weavings)
Sources: *ChAmC 37.*

Berry, Hans
Flourished: Cross Island, ME
Type of Work: Fabric (Samplers)
Sources: *WoCar 136*.*

Berry, James
b. 1805 d. 1877 Vandalia, IL
Flourished: c1843 Vandalia, IL
Type of Work: Oil (Portraits)
Museums: 044
Sources: *ArC 90*, 152-4, 157*.*

Berry, Jonnie E.
Flourished: 1865
Type of Work: Pastel (Portraits)
Sources: *PrimPa 169.*

Bert L. Daily Scenic Studio
Flourished: Dayton, OH
Type of Work: (Advertising drops for theaters, motion pictures, etc.)
Sources: *AmSFor 198.*

Berthalemy, Jacob
Flourished: New Berlin, OH
Type of Work: Fabric (Coverlets)
Sources: *ChAmC 37.*

Bertoncini, John
Flourished: c1904 San Francisco, CA
Type of Work: Pen, watercolor (Whaling scene paintings)
Museums: 123
Sources: *WhaPa 24-5*, fig, 29*, 33*, 67*, 71*, 77*, 79*, 93-4*, 111*, 121*.*

Besner, Fred M.
Flourished: Madrid, NY
Type of Work: Oil (Paintings)
Sources: *FouNY 66.*

Best Duck Decoy Company, Inc.
Flourished: c1920s New York, NY
Type of Work: Wood (Duck decoys)
Sources: *AmBiDe 230.*

Betsch, M.
Flourished: 1849 New York, NY
Type of Work: Oil (Fire engines, fire station art)
Sources: *AmFoS 264*.*

Beverburg, Lorenz
Flourished: 1860 Augusta, MO
Type of Work: Wood (Furniture)
Sources: *ASeMo 332*.*

Bevier, Ellen Bange
Flourished: 1806 Ulster County, NY
Type of Work: Fabric (Samplers)
Sources: *AmNe 81-2**.

Bewford, Elias
b. c1819 Pennsylvania
Flourished: c1850 Union Township, PA
Type of Work: Fabric (Coverlets)
Sources: *ChAmC 37*.

Bezold, George Adam
d. 1848
Flourished: 1839 Hermann, MO
Type of Work: (Drawings of furniture)
Sources: *ASeMo 386**.

Bianchi, John
Flourished: Ashville, NC
Type of Work: (Theatrical and banner art)
Sources: *AmSFor 57*.

Bias
Flourished: 1795 Philadelphia, PA
Type of Work: Wood (Ship carvings, ship figures)
Sources: *AmFiTCa 187*.

Bias, Joseph
Flourished: 1796 Baltimore, MD
Type of Work: Wood (Ship carvings, ship figures)
Sources: *ShipNA 158*.

Bichel, W.
[Bickel; Buechel]
Flourished: 1843 Newark, OH; Logan, OH
Type of Work: Fabric (Weavings)
Sources: *AmSQu 276; ChAmC 37*.

Bick, John
b. c1822
Flourished: 1850-1853 Rome, OH
Ethnicity: German
Type of Work: Fabric (Weavings)
Sources: *ChAmC 37*.

Bickel, George
Flourished: 1855 New York, NY
Type of Work: Wood (Ship carvings, ship figures)
Sources: *AmFiTCa 187*.

Bickel, W.
See: Bichel, W.

Bicknell, Charlotte
b. 1792 Cumberland, RI d. 1848
Flourished: 1808 Providence, RI
Type of Work: Embroidery (Mourning pictures)
Museums: 173
Sources: *LeViB 176**.

Bickner, Sam
Flourished: c1672 Charlestown, MA
Type of Work: Stone (Gravestones)
Sources: *GravNE 21*.

Bicksler, Jacob S.
Flourished: 1829 Pennsylvania
Type of Work: Watercolor, ink (Frakturs)
Sources: *AmFoPa 187*.

Bickstead, A.E.
Flourished: Lisbon, NY
Type of Work: Wood (Wood sculptures, carvings)
Sources: *FouNY 64**.

Biddle, Beulah
Flourished: 1783 Philadelphia, PA
Type of Work: Embroidery (Sewing cases)
Sources: *PlaFan 102**.

Biddle, Robert W.
Flourished: Tuscarawas County, OH
Type of Work: Clay (Sewer tile sculpture)
Remarks: Identification mark: R.W.B.
Sources: *IlHaOS **.

Bids
Flourished: 1819 Philadelphia, PA
Type of Work: Wood (Ship carvings, ship figures)
Sources: *ArtWod 119; ShipNA 163*.

Bidwell, Elizabeth Sullivan
Flourished: c1880 McLean County, KY
Type of Work: Fabric (Quilts)
Sources: *KenQu fig9*.

Bidwell, Titus
Flourished: Farmington?, CT
Type of Work: Tin (Tinware)
Sources: *TinC 162*.

Bierman, Fred
Flourished: 1877 Meriden, CT
Type of Work: Tin (Tinware)
Sources: *TinC 162*.

Biesecker, Jacob, Jr.
b. 1806 Pennsylvania d. 1865
Flourished: 1839-1852 Franklin Township, PA
Type of Work: Fabric (Weavings)
Sources: *AmSQu 276; ChAmC 37*.

Bigelow, P.W.
Flourished: Long Island, NY
Type of Work: Wood (Duck decoys)
Sources: *ArtDe 165*.

Bigger, Peacock
Flourished: c1738 Philadelphia, PA
Type of Work: Tin (Tinware)
Sources: *AmCoB 47, 72, 87*.

Bijotat, Simon
Flourished: 1800 New York, NY
Type of Work: Wood, paper (Bandboxes)
Sources: *AmSFo 126*.

Billings, Pheobe
b. 1690 d. 1775
Flourished: 1741
Type of Work: Fabric (Hooked rugs, bed rugs)
Museums: 003
Remarks: Identification mark: EPB
Sources: *ArtWo 4, 156*, pl.1; NewDis 10**.

Billings, William
Flourished: 1791 Providence, RI
Type of Work: Pewter (Pewterware)
Sources: *AmCoB 34-6, 121*.

Binckley, George
See: Binkley, George.

Bingham, David
b. 1788 Lancaster County, PA d. 1847
Flourished: c1815-1844 Hamilton, OH
Type of Work: Fabric (Weavings)
Sources: *ChAmC 38*.

Bingman, Samuel Harrison
b. 1835 d. 1922
Flourished: 1854-1914 Laurelton, PA
Type of Work: Tin (Tinware)
Sources: *ToCPS 24-30*, 43, 49*.

Bingman, Yost
b. 1812 d. 1889
Flourished: Laurelton, PA
Type of Work: Tin (Tinware)
Sources: *ToCPS 29, 43*.

Binkley, George
Flourished: 1826-1840 Canton, OH; Kendall, OH
Type of Work: Stoneware (Pottery)
Sources: *AmPoP 209, 222; Decor 216*.

Binney and Ronaldson
Flourished: c1809 Philadelphia, PA
Type of Work: Clay (Teapots, pottery)
Sources: *AmPoP 175*.

Birch, S.A.
Flourished: Morristown, OH
Type of Work: Fabric (Coverlets)
Sources: *ChAmC 38*.

Birch, Thomas
b. 1779 d. 1851
Flourished: 1812-1851 Philadelphia, PA
Ethnicity: English
Type of Work: Paint (Naval engagement, ship paintings)
Sources: *AmFoPa 100, 109, 125*.

Bird, C.H.
Flourished: c1905 Bolton, GA
Type of Work: Clay (Pottery)
Sources: *MisPi 94**.

Bird, Charles
Flourished: 1830 New York, NY
Type of Work: Wood (Ship carvings, ship figures)
Sources: *AmFiTCa 187*.

Birdsall, Jess, Captain
Flourished: Barnegat, NJ
Type of Work: Wood (Duck decoys)
Museums: 260, 269
Sources: *AmBiDe* 123-4*.

Birmingham Glass Works
[Ihmsen, Charles]
Flourished: 1813 Pittsburgh, PA
Type of Work: Glass (Glass works)
Museums: 023, 058
Sources: *AmSFok* 126*.

Bisco, Adaline
Flourished: late 18th cent
Type of Work: Watercolor, ink (Frakturs)
Sources: *Edith* *.

Bish, W.H.
Flourished: 1893 Climax, PA
Type of Work: Clay (Sewer tile sculpture)
Sources: *IlHaOS* *.

Bishop, Abby
b. 1781 Rehoboth, RI d. 1812 Providence?, RI?
Flourished: 1796 Providence, RI
Type of Work: Fabric (Samplers)
Museums: 176
Sources: *LeViB* 117, 131*-2, 150, 163-4, 256.

Bishop, Nathaniel
Flourished: 1800-1810 Red Stone Hill, CT
Type of Work: Tin (Tinware)
Sources: *TinC* 117, 162.

Bishop, P.
Flourished: 1846 Fayetteville, PA
Type of Work: Fabric (Weavings)
Sources: *ChAmC* 38.

Bishop, Sally Foster
b. 1785 Providence, RI d. 1842 Providence, RI
Flourished: 1801 Providence, RI
Type of Work: Fabric, pencil, embroidery (Still life pictures)
Sources: *LeViB* 153, 163*-5.

Bishop, Uri
Flourished: Connecticut
Type of Work: Tin (Tinware)
Sources: *TinC* 162.

Bissell, Thomas
Flourished: 1650-1700 Hartford County, CT
Type of Work: Wood (Carved boxes)
Sources: *NeaT* 5*.

Bisset, William
b. 1822 d. 1888
Flourished: Auburn, NY; Franklin, IN; Chillicothe, MO
Ethnicity: Scottish
Type of Work: Fabric (Weavings)
Sources: *AmSQu* 276; *ChAmC* 38.

Bissett, Asher
Flourished: 1800-1815 Old Bridge, NJ
Type of Work: Stoneware (Pottery)
Sources: *Decor* 216.

Bivenouer, M.
[Bivenour, M.]
Flourished: 1842
Type of Work: Fabric (Weavings)
Sources: *AmSQu* 276; *ChAmC* 38.

Bivenour, M.
See: Bivenouer, M.

Bixler, Absalom
Flourished: 1826 Berks County, PA
Type of Work: Clay (Pottery)
Sources: *BeyN* 124.

Bixler, Absalom
Flourished: c1878 Denver, PA
Type of Work: Wood (Wood sculptures, carvings)
Sources: *BeyN* 125*.

Bixler, David
Flourished: 1824-1848, 1849-1862 Ephrata, PA
Type of Work: Watercolor, ink (Frakturs)
Sources: *AmFoPa* 187; *NinCFo* 186; *PrimPa* 169.

Black, Calvin
b. 1903 Tennessee d. 1972
Flourished: c1953 Yermo, CA
Type of Work: Wood, paint (Costumed wooden dolls in an environment)
Remarks: Wife is Ruby; created "Possum Trot" with its "Fantasy Doll Show"
Sources: *AmFokArt* 22-3*; *FoA* 460; *PioPar* 9, 14, 18-9, 21*-2, 61; *TwCA* 130-1*.

Black, Charles
Flourished: Bordentown, NJ
Type of Work: Wood (Duck decoys)
Sources: *AmBiDe* 138-9*; *AmSFo* 25.

Black, Daniel (David)
Flourished: 1821-1856 Easton, PA
Type of Work: Tin (Tinware)
Remarks: Son of James
Sources: *ToCPS* 24-8, 33-4*, 41.

Black, David
See: Black, Daniel.

Black, G.
Flourished: 1843 Springfield, OH
Type of Work: Fabric (Weavings)
Sources: *ChAmC* 38.

Black, James
Flourished: 1821-1856 Easton, PA
Type of Work: Tin (Tinware)
Remarks: Father of Daniel
Sources: *ToCPS* 24-7, 32-5*.

Black, James
Flourished: 1846 Philadelphia, PA
Type of Work: Wood (Ship carvings, ship figures)
Sources: *AmFiTCa* 187.

Black, Minnie
b. 1899 Laurel County, KY
Flourished: 1955-1985 East Bernstadt, KY
Type of Work: Wood, gourds (Sculpture)
Museums: 172
Sources: *FoAFt* 13-4*; *GoMaD* *.

Black, Robert
Flourished: 1870 Philadelphia, PA
Type of Work: Wood (Ship carvings, ship figures)
Sources: *AmFiTCa* 188.

Black, Ruby
b. c1915 Georgia d. 1980
Flourished: c1953 Yermo, CA
Type of Work: Fabric (Costumed wooden dolls in an environment)
Remarks: Husband is Calvin; created "Possum Trot" with its "Fantasy Doll Show"
Sources: *AmFokArt* 22-3*; *FoA* 460; *PioPar* 9, 14, 18, 21*-2, 61; *TwCA* 130-1*.

Black, Willaim
Flourished: 1868 Ohio
Type of Work: Fabric (Weavings)
Sources: *ChAmC* 38.

Blackburn, Joseph
b. c1700 d. 1765
Flourished: New England,
Type of Work: Oil (Portraits)
Sources: *FoA* 460.

Blackman, George
Flourished: c1853 Hillsboro, IL
Type of Work: Wood (Furniture)
Sources: *ArC* 253*.

Blackstone, Eleanor
Flourished: 1880-1890 Macon, IL
Type of Work: Fabric (Hooked rugs, bed rugs)
Museums: 096, 151
Remarks: 6 rugs
Sources: *AmHo* 72*; *ArtWo* 56*, 156.

Blair, Fred
b. c1901-1973
Flourished: Woodbury, TN
Type of Work: Wood (Wood sculptures, carvings)
Sources: *FoScu* 62*.

Blair, J.B.
Flourished: 1856 Alton, IL; Milwaukee, WI
Type of Work: Oil (Paintings, panoramas)
Sources: *ArC* 263, 209*.

Blair, John
Flourished: 1865-1910 Philadelphia, PA; Elkton, MD; Delaware
Type of Work: Wood (Duck decoys)
Museums: 260
Sources: *AmBiDe 138*; AmDecoy 6*, 23*; AmFokAr 18*, fig123; AmSFo 25; ArtDe 163*; Decoy 25*;FoA 460; WiFoD 6*, 138*.*

Blair, Streeter
b. 1888
Flourished: Cadmus, KS; Los Angeles, CA
Type of Work: Oil (Paintings)
Sources: *PeiNa 114*.*

Blair, Sylvester
Flourished: 1825-1836 Cortland, NY
Type of Work: Clay (Pottery)
Sources: *AmPoP 191; Decor 216; DicM 20*, 31*.*

Blake, E.W.
Flourished: 1830
Type of Work: Oil (Portraits)
Remarks: Itinerant
Sources: *PrimPa 169; SoAmP 287.*

Blake, S. and J.
Flourished: 1877 Meriden, CT
Type of Work: Tin (Painted tinware)
Sources: *TinC 162.*

Blakely
See: Woodward, Blakely, and Company.

Blakeslee Stiles and Company
Flourished: 1849 Meriden, CT
Type of Work: Tin (Tinware)
Sources: *TinC 162.*

Blaney, Justus
Flourished: 1825-1854? Lookstown, PA
Type of Work: Clay (Pottery)
Sources: *EaAmFo 22*.*

Blank, Elizabeth
Flourished: 1851 Pennsylvania
Type of Work: Fabric (Samplers)
Sources: *AmNe 53*, 56.*

Blankensee, John
Flourished: 1856 Chicago, IL
Type of Work: Wood (Ship carvings, ship figures)
Sources: *AmFiTCa 188.*

Blatter, Jacob
Flourished: Greenville, IL
Type of Work: Wood (Beds)
Sources: *ArC 151*.*

Blauch, Christian
Flourished: 1854 Johnstown, PA
Type of Work: Wood (Decorated chests)
Museums: 096
Sources: *AmPaF 270*; PenGer 182*.*

Blayney, William Alvin
b. 1917 Claysville, PA
Flourished: Pittsburgh, PA
Type of Work: Oil (Religious paintings)
Sources: *Trans 6, 9, 41, 46*-7*, 53.*

Bleecher, Margaret
Flourished: 1805 New Albany, NY
Type of Work: Needlework (Mourning pictures)
Sources: *BeyN 39*, 110.*

Blent, John
Flourished: 1830
Type of Work: Oil (Landscape paintings)
Sources: *PrimPa 169.*

Blin, Peter
b. 1639-1725
Flourished: Wethersfield, CT
Type of Work: Wood (Furniture)
Museums: 096
Sources: *AmFoS 148*; AmPaF 19.*

Bliss, Aaron
b. 1730 d. 1810
Flourished: c1757 Longmeadow, MA
Type of Work: Stone (Gravestones)
Sources: *EaAmG 128, 30*-1; GravNE 127.*

Bliss, H.
Flourished: c1825
Type of Work: Watercolor (Scene paintings)
Sources: *Edith *.*

Bliss, Roswell E.
Flourished: Stratford, CT
Type of Work: Wood (Duck decoys)
Museums: 260
Remarks: Copied patterns from Shang Wheeler
Sources: *ArtDe 178; Decoy 67*.*

Blizzard, Georgia
Flourished: contemporary
Ethnicity: American Indian and Irish
Type of Work: Clay (Sculptures)
Remarks: Apache tribe
Sources: *FoAFc 5*.*

Blocher, S. (B.)
Flourished: 1848 Bolivar, OH
Type of Work: Fabric (Coverlets)
Sources: *ChAmC 38*
See: Flocher, S. .

Block, Andrew
b. 1879 d. 1969 Sobang, CA
Flourished: 1950s-1960s
Ethnicity: Danish
Type of Work: Oil (Paintings)
Sources: *PioPar 22-4*.*

Block, William
Flourished: 1854-1862 Brooklyn, NY
Type of Work: Clay (Porcelain)
Sources: *AmPoP 112, 198; AmSFok 141*
See: Union Porcelain Works.

Blocksma, Dewey Douglas
b. 1943 Amarillo, TX
Flourished: c1979 Holland, MI; Amarillo, TX
Type of Work: Wood, various materials (Sculpture constructions)
Sources: *AmFokArt 24-6*.*

Blood, M.I.
Flourished: c1840-1850 Galesburg, IL
Type of Work: Pastel (Portraits)
Sources: *ArC 263.*

Bloor, William
Flourished: 1862 Trenton, NJ
Type of Work: Clay (Pottery)
Sources: *AmPoP 49, 76, 78, 183, 215; DicM 252*.*

Bluebird Pottery
Flourished: c1890 Crooksville, OH
Type of Work: Stoneware (Pottery)
Museums: 208
Remarks: Edwin Worstall was one of their potters.
Sources: *AmS 213*.*

Blunt, John Samuel
b. 1798 d. 1835 or 1837
Flourished: 1821-1835? New Bedford, MA; Boston, MA; Portsmouth, NH
Type of Work: Oil (Landscape paintings, portraits)
Museums: 001,083,096,194,284
Sources: *AmFoPo 60-1; Bes 36, 40-1, 62-3; BoLiC;FoA 460; FoArA 49, 120-7; FoPaAm 31-3, fig17;HoKnAm 116.*

Blyderburg, S.
Flourished: 1799 Hartford, CT
Type of Work: Paint, wood (Signs)
Sources: *MoBBTaS 12.*

Blyth, Benjamin
b. 1737 d. 1803
Flourished: 1770-1780s Salem, MA
Type of Work: Pastel, oil (Paintings)
Museums: 079
Sources: *PaiNE 52-5*.*

Blythe, David
Flourished: 1835
Type of Work: Wood (Ship carvings, ship figures)
Sources: *AmFiTCa 188.*

Blythe, David Gilmour
b. 1815 d. 1865
Flourished: Uniontown, PA; East Liverpool, OH
Type of Work: Wood (Wood sculptures)
Sources: *AmFokA 28*; EaAmW 71.*

Boalt, James
b. c1820
Flourished: c1850 Washington County, PA
Type of Work: Fabric (Weavings)
Sources: *ChAmC 38.*

Board
See: Green and Board.

Boardman, E.
Flourished: c1832
Type of Work: Fabric? (Coverlets?)
Sources: ChAmC 38.

Boas, Jacob
Flourished: c1801-1828 Harrisburg, PA
Type of Work: Tin (Tinware)
Sources: FoAFn 156-7; ToCPS 13.

Bobb, "Hickory Stick Vic"
See: Bobb, Victor "Hickory Stick Vic".

Bobb, Victor "Hickory Stick Vic"
b. 1892 Vicksburg, MS **d.** 1978
Flourished: 1918 Vicksburg, MS
Type of Work: Wood (Carved canes)
Sources: LoCo xviii, 1*-31.

Bochero, Peter "Charlie"
b. c1895 **d.** 1962
Flourished: Leechburg, PA
Ethnicity: Armenian
Type of Work: Oil, housepaint (Religious and mystic paintings)
Sources: AmFokArt 27-9*; FoA 82*, 460; FoPaAm 13, 141*-2; Trans 6, 24*-5*, 53; TwCA 124*.

Bock, Mrs. William N.
Flourished: c1860 Logan County, IL
Type of Work: Fabric (Coverlets)
Sources: ArC 140*.

Boden, C.
See: Baden, C..

Bodenbuhl, Peter
Flourished: 1863-1870 Akron, OH
Type of Work: Stoneware (Pottery)
Sources: AmPoP 206; Decor 216.

Bodine, J.
Flourished: c1836-1843 Putnam, OH
Type of Work: Stoneware (Pottery)
Sources: AmPoP 228; Decor 216.

Bodine, R.H.
Flourished: 1878-1900 Zanesville, OH
Type of Work: Clay (Pottery)
Sources: AmPoP 234.

Boerner, Shapley and Vogt
[Massilon Stoneware Company]
Flourished: 1882-1900 Massillon, OH
Type of Work: Stoneware (Pottery)
Sources: AmPoP 223; Decor 216.

Boeshor, Heinrich
Flourished: 1819
Type of Work: Fabric (Weavings)
Sources: ChAmC 38.

Boettger, Carl
[Bedger]
b. 1823 **d.** 1900 Macungie, PA
Flourished: c1860 Millerstown, PA
Ethnicity: German
Type of Work: Fabric (Carpets, coverlets)
Sources: ChAmC 38
See: Fliehr, Charles B.

Boggs Pottery
Flourished: 1890-1900 Randolph County, AL
Type of Work: Stoneware (Jars)
Sources: AmS 86-7*, 94*.

Boghosian, Nounoufar
b. 1894
Flourished: 1967 Pasadena, CA
Ethnicity: Armenian
Type of Work: Oil (Memory paintings)
Museums: 012,189
Sources: FoAFg 7*; FoAFx 2; FoAFab 1*, 4-5*; FoPaAm 237*; TwCA 147*.

Bogun, Maceptaw, Reverend
b. 1917
Flourished: New York, NY
Type of Work: Oil (Portraits, landscape paintings)
Sources: HoKnAm 188*; TwCA 193*.

Bohacket, Albert
Flourished: 19th century New York
Type of Work: Wood (Sculptures)
Museums: 150
Sources: WoScuNY *.

Bohlken, Johann H.
Flourished: 1850-1860 Missouri
Type of Work: Wood (Furniture)
Sources: ASeMo 337*.

Bohn, Adam
b. c1808 Pennsylvania
Flourished: 1836-1850 Greencastle, PA; Antrim Township, PA
Type of Work: Fabric (Coverlets)
Sources: ChAmC 38
See: Ambrouse .

Bohn, Jacob W.
Flourished: 1846 Greencastle, PA
Type of Work: Fabric (Coverlets)
Sources: ChAmC 39.

Boize, Charles
Flourished: 1859 New York, NY
Type of Work: Wood (Ship carvings, ship figures)
Sources: AmFiTCa 188.

Bokee, John
Flourished: 1797 New York, NY
Type of Work: Wood (Ship carvings, ship figures)
Sources: AmFiTCa 188.

Bolander, Joseph
Flourished: contemporary Ordenville, UT
Type of Work: Oil (Landscape and historical paintings)
Sources: FoAFn 7*.

Bolden, Robert H.
Flourished: 1840 New York, NY
Type of Work: Wood (Ship carvings, ship figures)
Sources: AmFiTCa 188.

Bolen, Maria
Flourished: 1816 Philadelphia, PA
Type of Work: Fabric (Samplers)
Sources: AlAmD 135*; GalAmS 51*.

Boler, Daniel
Flourished: 1847 New Lebanon, OH
Ethnicity: Shaker
Type of Work: Pen, ink (Spirit drawings)
Museums: 303
Sources: PicFoA 145*.

Bolkcom, Betsey
Flourished: c1810
Type of Work: Embroidery (Mourning pictures)
Museums: 227
Sources: MoBeA fig34.

Bolland, Martin
Flourished: 1811 Philadelphia, PA
Type of Work: Wood (Ship carvings, ship figures)
Sources: AmFiTCa 188.

Bolles, John, Captain
Flourished: 1845-1847 New London, CT
Type of Work: Pencil (House portraits)
Museums: 123
Sources: WhaPa 130*.

Bollinger, Leslie
Flourished: c1840-1850 Pennsylvania
Ethnicity: Black American
Type of Work: Wood, paint (Chairs)
Sources: HerSa *.

Bologna, Frank
Flourished: 1914 Corona, NY
Type of Work: Oil (Paintings)
Sources: TwCA 50*.

Bolton, Thomas
Flourished: 1824 Brookville, IN
Type of Work: Fabric (Weavings)
Sources: ChAmC 39.

Bolton, William
Flourished: 1840 Philadelphia, PA
Type of Work: Wood (Ship carvings, ship figures)
Sources: AmFiTCa 188.

Bond, Caleb
Flourished: Connecticut
Type of Work: Tin? (Tinware?)
Sources: TinC 162.

Bond, Charles V.
b. Marshall, MI
Flourished: 1844-1864 Boston, MA; Detroit, MI; Chicago, IL
Type of Work: Oil (Portraits, landscape paintings)
Museums: 189
Sources: *AmNa* 21, 39*; *ArC* 263; *PrimPa* 169.

Bond, Milton
b. 1918 New York, NY
Flourished: c1963 Fairfield, CT
Type of Work: Oil on glass (Scenes, paintings)
Sources: *AmFokArt* 30-2*.

Bond, Peter Mason "PEMABO"
b. c1880 **d.** 1971
Flourished: 1960s San Francisco, CA
Ethnicity: Australian
Type of Work: Oil (Paintings)
Museums: 253
Remarks: Created "Peace Garden of Peter Mason Bond"
Sources: *FoA* 460; *FoPaAm* 238-9*; *PioPar* 14, 23, 25*, 62; *TwCA* 121*.

Bone, Elihu
Flourished: Menard County, IL
Type of Work: Fabric (Weavings)
Sources: *ChAmC* 39.

Bonin and Morris
See: Morris, George A.

Bonin, Gousse
Flourished: c1769 Philadelphia, PA
Type of Work: White earthenware (Pottery)
Sources: *AmPoP* 45, 99, 174
See: Morris, George A.

Bonnell, William
Flourished: 1830 New York
Type of Work: Oil (Portraits)
Sources: *PrimPa* 169.

Bonnin and Morris
See: Morris, George A.

Bontager, Mrs. Clara
[Bontrager]
Flourished: 1926 Haven, KS
Ethnicity: Amish
Type of Work: Fabric (Quilts)
Sources: *QuflnA* 34*, 60*.

Bontrager, Mrs. Clara
See: Bontager, Mrs. Clara.

Bontrager, Mrs. Eli
Flourished: 1934-1935 Shipshewana, IN
Ethnicity: Amish
Type of Work: Fabric (Quilts)
Sources: *QuflnA* 42*, 56*.

Bontrager, Mrs. Lydia
Flourished: 1920-1930 Middlebury, IN; Honeyville, IN
Ethnicity: Amish
Type of Work: Fabric (Quilts)
Sources: *QuflnA* 40*, 55*, 69*.

Bontrager, Polly
Flourished: 1913 Yoder Corner, IN
Ethnicity: Amish
Type of Work: Fabric (Quilts)
Sources: *QuflnA* 83*.

Bontrager, Mrs. Rudy
Flourished: 1948 Shipshewana, IN
Ethnicity: Amish
Type of Work: Fabric (Quilts)
Sources: *QuflnA* 88*.

Boone, Benjamin
Flourished: 1846-1863 Brooklyn, NY
Type of Work: Stoneware (Pottery)
Sources: *Decor* 216.

Boone, J.G.
[T.G. Boone and Sons]
Flourished: 1839-1845 Brooklyn, NY
Type of Work: Stoneware (Pottery)
Sources: *Decor* 216; *DicM* 129*.

Boone, Thomas E.
Flourished: 1858-1864 Brooklyn, NY
Type of Work: Stoneware (Pottery)
Sources: *Decor* 216.

Boonville Marble Works
Flourished: 1850 Boonville, MO
Type of Work: Stone (Gravestones, other stoneworks)
Sources: *ASeMo* 440
See: Bedwell, Elias J.

Boonville Pottery
Flourished: 1833-1909 California, MO
Type of Work: Clay (Pottery)
Sources: *ASeMo* 459*; *EaAmFo* 253*.

Boos, John
Flourished: 1859 New York, NY
Type of Work: Wood (Ship carvings, ship figures)
Sources: *AmFiTCa* 188.

Booth, Roger
d. 1849
Flourished: Bennington, VT
Type of Work: Stone (Gravestones)
Sources: *EaAmG* 129; *GravNE* 127.

Booth, Salmon
Flourished: 1821 Connecticut
Type of Work: Tin (Tinware)
Sources: *TinC* 162.

Booth, Thomas
Flourished: c1768 New York, NY
Ethnicity: English
Type of Work: Paint (Ornamental paintings)
Sources: *AmDecor* 9.

Booth Brothers
Flourished: c1858-1865 East Liverpool, OH
Type of Work: Stoneware (Pottery)
Sources: *AmPoP* 216; *Decor* 216.

Borden, Delana
b. 1801 Freetown, MA **d.** 1863 Fall River?, MA?
Flourished: 1818 Providence, RI
Type of Work: Embroidery (Mourning pictures)
Museums: 081
Sources: *LeViB* 181*, 258.

Border, Ann Amelia Mathilda
b. 1875
Flourished: 1839 Pennsylvania
Type of Work: Fabric (Samplers)
Sources: *GalAmS* 81*.

Bordner, Daniel
b. 1807 **d.** 1842
Flourished: 1839-1843 Millersburg, PA
Type of Work: Fabric (Weavings)
Sources: *AmSQu* 276; *ChAmC* 39
See: Klinger, Absalom.

Borkowski, Mary K.
b. 1916 Sulpher Springs, OH
Flourished: 1965 Dayton, OH
Type of Work: Needlework, string (Embroidered pictures)
Museums: 171
Sources: *AmFoArt* 123*; *AmFokArt* 33-4*; *ArtWo* 137-8*, 156-7; *BirB* 32*; *Full* *; *NewDis* 119*, 125*; *QuiAm* 145*; *TwCA* 156*.

Borton, Mary Ann
Flourished: 1832 Pennsylvania
Type of Work: Fabric (Samplers)
Sources: *GalAmS* 74*.

Boschert, Bernard
Flourished: 1860 St. Charles, MO
Type of Work: Tin (Tinware)
Sources: *ASeMo* 428.

Bosio, Louie
Flourished: Tuscarawas County, OH
Type of Work: Clay (Sewer tile sculpture)
Sources: *EaAmI* *.

Boss Brothers
Flourished: c1874 Akron, OH
Type of Work: Stoneware (Pottery)
Sources: *AmPoP* 207, 255; *Decor* 216; *DicM* 21*.

Boston Earthenware Factory
See: Mear, Frederick.

Boston Fancy Wood Carving Company
Flourished: 1865 Boston, MA
Type of Work: Wood (Ship carvings, ship figures)
Sources: *AmFiTCa* 188.

Boston Pottery Company
Flourished: 1878-1900 Boston, MA
Type of Work: Stoneware (Pottery)
Sources: *AmPoP 189; Decor 216.*

Bosworth
See: Seymour and Bosworth.

Bosworth, Sala
Flourished: 1828-1830 Ohio
Type of Work: Oil (Portraits)
Museums: 209
Sources: *PicFoA 70*; PrimPa 169.*

Bosworth, Stanley
Flourished: c1870-80s Hartford, CT
Type of Work: Stoneware (Pottery)
Museums: 203,215
Remarks: Identification mark: S.B.
Sources: *Decor 94*.*

Bothman
Flourished: c1850 Boonsboro, MD
Type of Work: Redware (Pottery)
Sources: *AmPoP 165.*

Bott, Hammersley and Company
Flourished: c1875 Richmond, IN
Type of Work: Clay (Pottery)
Sources: *AmPoP 229.*

Boucher, Doris
Flourished: c1885 Paducah, KY
Type of Work: Fabric (Quilts)
Sources: *KenQu fig18.*

Boudro(u), Alexandr(e)
Flourished: 1850s Philadelphia, PA; Bristol Township, PA
Type of Work: Oil (Scene paintings)
Sources: *AmFoAr 23; AmFoPaN 97, 112*; PrimPa 169.*

Boughner, A. and W.
See: A. and W. Boughner.

Boughner, Alexander
Flourished: 1812-1850 Greensboro, PA
Type of Work: Redware (Pottery)
Sources: *AmPoP 68, 220; DicM 9*.*

Boughner, Daniel
Flourished: 1800s Greensboro, PA
Type of Work: Stoneware (Sculptures)
Museums: 097
Sources: *AmSFo 48*.*

Boulanger, John F.
Flourished: 1794 Philadelphia, PA
Ethnicity: French
Type of Work: Wood (Ship carvings, ship figures)
Sources: *AmFiTCa 188.*

Boulter, Charles
Flourished: 1858-1900 Philadelphia, PA
Type of Work: Clay (Pottery)
Sources: *AmPoP 104, 175.*

Boulton, William
Flourished: 1860-1875 New York, NY
Ethnicity: English
Type of Work: Wood (Cigar store Indians, figures)
Sources: *ArtWod 238-9, 267.*

Bounell, W.
Flourished: 1826
Type of Work: Oil (Portraits)
Sources: *MaAmFA *.*

Bourguianon and Britt
Flourished: 1865 Boston, MA
Type of Work: Wood (Ship carvings, ship figures)
Sources: *AmFiTCa 188.*

Bourne, Mercy
Flourished: 1781 Barnstable, MA
Type of Work: Needlework (Chimney pieces)
Sources: *AmDecor 24, 32*.*

Boush, Elizabeth
b. c1753 Norfolk, VA
Flourished: 1768 Norfolk, VA
Type of Work: Fabric (Mythological embroidered pictures)
Museums: 175,289
Sources: *LeViB 38-9*; SoFoA 179, 218*, 223.*

Bouton, S.S.
Flourished: 19th cent
Type of Work: Pen, ink (Drawings)
Sources: *Edith *.*

Boutwell
Flourished: 1850 Groton, MA
Type of Work: Oil (Murals, frescos pictures)
Sources: *PrimPa 169.*

Bouve, S.R.
Type of Work: Oil, wood (Signs)
Sources: *EyoAm 14, 16*.*

Bowditch, Eunice
b. c1707
Flourished: 1718 Salem, MA
Type of Work: Fabric (Samplers)
Museums: 079
Sources: *AmNe 43*, 46; FoArtC 51*.*

Bowen, Ashley
Flourished: 1780-1790
Type of Work: Watercolor (Ship paintings)
Sources: *AmFoPa 107.*

Bower, George
Flourished: c1831 Albion, IL
Ethnicity: German
Type of Work: Stoneware (Pottery)
Sources: *ArC 189.*

Bower, L.
Flourished: New Springfield, OH
Type of Work: Fabric (Coverlets)
Sources: *ChAmC 39.*

Bower, Mary
Flourished: c1807 New Jersey
Type of Work: Fabric (Embroidered pictures)
Sources: *PlaFan 71*.*

Bower, W.M.
Flourished: c1838
Type of Work: Whalebone (Scrimshaw)
Sources: *ScriSW 169*.*

Bowers, E.
Flourished: 1858
Type of Work: Oil (Paintings)
Sources: *SoAmP 287.*

Bowers, Ezekial
Flourished: 1830 New York, NY
Type of Work: Wood (Ship carvings, ship figures)
Sources: *AmFiTCa 188.*

Bowers, J.
Flourished: 19th century
Type of Work: Pastel (Still life paintings)
Sources: *NinCFo fig133.*

Bowers, Joseph
Flourished: 1860 New York, NY
Type of Work: Wood (Ship carvings, ship figures)
Sources: *AmFiTCa 155, 188; ShipNA 162.*

Bowers, Reuben
Flourished: 1832 Shenandoah County, VA
Type of Work: Watercolor, ink (Frakturs)
Sources: *SoFoA 86*, 219.*

Bowles, Amanda A.
Flourished: 1833 Chesterfield County, VA
Type of Work: Fabric (Samplers)
Sources: *GalAmS 74*.*

Bowles, Joshua
b. 1720 d. 1794
Flourished: 1760 Boston, MA
Type of Work: Wood (Ship carvings, ship figures)
Sources: *AmFiTCa 188; ShipNA 6, 158.*

Bowman, Henry B.
d. 1863 Providence, PA
Flourished: c1840-1860 Neffsville, PA; Providence, PA
Type of Work: Fabric (Coverlets)
Sources: *ChAmC 39.*

Bowman, William
Flourished: 1890-1900 Long Island, NY; Lawrence, NY; Bangor, ME
Type of Work: Wood (Duck decoys, weathervanes, miniature duck carvings)
Museums: 171,260
Sources: *AmDecoy 15*, 40*, 68-9*; AmFoArt 94*; AmSFo 25; Decoy 107*, 109*; HoKnAm 40*; WoScuNY.*

Bowne, Catherine
Flourished: 1815-1839 Cheesequake, NJ
Type of Work: Stoneware (Pottery)
Sources: *Decor 216.*

Boyd, Ann
Flourished: 1804 Baltimore, MD
Type of Work: Fabric (Samplers)
Sources: *AmNe 48.*

Boyd, George
b. 1873 d. 1941
Flourished: c1890-1910 Seabrook, NH
Type of Work: Wood (Duck decoys)
Sources: *FoA 224*, 460; WoCar 150*.*

Boyd, James
Flourished: 1830-1836 Boston, MA
Type of Work: Leather (Boxes)
Sources: *NeaT 36-39*.*

Boyden
See: Van Horn and Boyden.

Boyer, John
Flourished: c1810 Schuylkill County, PA
Type of Work: Clay (Pottery)
Sources: *DicM 73*.*

Boyle, Ferdinand T.L.
b. 1820 d. 1906
Flourished: St. Louis, MO; New York, NY
Type of Work: Oil (Portraits)
Sources: *SoAmP 87.*

Boyle, M.
Flourished: 1850 Carlisle, PA
Type of Work: Oil (Historical and still life paintings)
Sources: *PrimPa 169.*

Boyley, Daniel
Flourished: 1764-1795 Newburyport, MA
Type of Work: Clay (Pottery)
Museums: 263
Sources: *FoArtC 43.*

Boynton
Flourished: 1870-1872 Red Wing, MN
Type of Work: Stoneware (Pottery)
Sources: *AmPoP 228; Decor 216.*

Boynton, C.
See: C. Boynton and Company.

Boynton and Farrar
Flourished: c1860 St. Albans, VT
Type of Work: Stoneware (Pottery)
Sources: *Decor 216.*

Brace, Deborah Loomis
b. 1752 d. 1839
Flourished: 1772
Type of Work: Fabric (Bed rugs)
Museums: 313
Sources: *NewDis 12*.*

Brackbill, Eliza Ann
Flourished: 1847 Pennsylvania
Type of Work: Fabric (Embroidered show towels)
Sources: *FoArRP 58*.*

Bracken, Thomas
See: Bracken and James.

Bracken and James
[Bracken, Thomas; James, Thomas R.]
Flourished: 1800-1825 Pittsburgh, PA
Type of Work: Redware (Pottery)
Sources: *AmPoP 67, 227.*

Bradburg, Harriett
Flourished: 1876 Charlestown, NH
Type of Work: Fabric (Quilts)
Museums: 263
Sources: *QuiAm 228*.*

Bradbury, Gideon
Flourished: 1850-1875 Salmon Falls, ME
Type of Work: Oil (Paintings)
Sources: *PrimPa 169.*

Bradford, Benjamin W.
Flourished: 1830s Bristol, RI
Type of Work: Whalebone (Scrimshaw)
Museums: 186
Sources: *GravF 48*.*

Bradford, Esther S.
Flourished: 1807 Montville, CT
Type of Work: Fabric (Weavings, quilts)
Museums: 096
Sources: *AmSQu 150*; FlowAm 269*.*

Bradford, Joseph
Flourished: c1720 Boston, MA
Type of Work: Tin (Tinware)
Sources: *ToCPS 4.*

Bradford, William
b. 1823-1892
Flourished: New Bedford, MA
Type of Work: Oil (Ship paintings)
Sources: *AmFoPa 106, 109.*

Bradley, I. (John)
d. 1874
Flourished: 1831-1847 New York, NY; Staten Island, NY
Type of Work: Oil (Portraits, miniatures)
Museums: 001,189,281
Remarks: Identification mark: I.H.J.
Sources: *AmFoPaN 57, 79*; AmFoPo 61-5*; AmPrP 150, fig18; AmPrW 56-7*, 126*; EyoAm 10*, 18; FlowAm 30*; FoA 8*, 460; NinCFo 165, 173, fig62; OneAmPr 77, 106*, 146, 153; PrimPa 169.*

Bradley, Mary
Flourished: 1830 Lee, MA
Type of Work: Velvet (Paintings)
Sources: *PrimPa 169.*

Bradley, Thomas
Flourished: c1796 Philadelphia, PA
Type of Work: Tin (Tinware)
Sources: *AmCoTW 153; ToCPS 6.*

Brady, Hiram
Flourished: 1835 Meriden, CT
Type of Work: Tin (Tinware)
Sources: *TinC 162.*

Brady, Walter
d. 1940
Flourished: until 1918 Virginia
Type of Work: Wood (Duck decoys)
Sources: *AmBiDe 156-7*.*

Brahm, B.
Flourished: Rock Island, IL
Type of Work: Oil (Paintings)
Remarks: Worked with Wirig, Nicholas
Sources: *FoPaAm 206.*

Braidt, Frohica
Flourished: c1820 Pennsylvania
Type of Work: Needlework (Samplers)
Sources: *WinGu 24.*

Brailer, Augustin
Flourished: 1847
Type of Work: Fabric (Coverlets)
Sources: *ChAmC 124.*

Brainard, Isaac
Flourished: 1780 Middletown, CT
Type of Work: Stone (Gravestones)
Sources: *EaAmG 127.*

Branchard, Emile Pierre
b. 1881 d. 1938
Flourished: 1912-1938 New York, NY
Type of Work: Oil (Landscape paintings)
Sources: *AmFokArt 35-6*; AmFoSc 123*; PrimPa 169; ThTaT 196-9*; TwCA 83*.*

Brand, D.
Flourished: 1838
Type of Work: Fabric? (Weavings?)
Sources: *AmSQu 276; ChAmC 39.*

Brandt, Mrs. Henry
Flourished: till 1940
Type of Work: (Baskets)
Sources: *ASeMo 411*
See: Weinland, Henry; Weinland, Nicholas.

Brannan, Daniel
Flourished: c1860 San Antonio, CA
Type of Work: Stoneware (Churns)
Museums: 263
Sources: *AmS 25*.*

Brasher, Rex
Flourished: 20th century Connecticut
Type of Work: Wood? (Weathervanes, sculptures, carvings)
Sources: *WeaVan 154*.*

Bratton, Phebe
Flourished: 1805 Lancaster, PA
Type of Work: Fabric (Samplers)
Sources: *PlaFan 53**.

Braun, C.W.
Flourished: 1860-1877 Buffalo, NY
Type of Work: Stoneware (Jugs)
Sources: *AmS 76*; Decor 217*.

Brayton Kellogg and Doolittle
Flourished: 1827-1840 Utica, NY
Type of Work: Stoneware, redware (Pottery)
Sources: *AmPoP 204; Decor 217*.

Bready, Eliza Ely
Flourished: Philadelphia, PA
Type of Work: Fabric (Quilts)
Sources: *WinGu 110**.

Brearley, Stephens and Tams
[Greenwood Pottery]
Flourished: 1861-1865 Trenton, NJ
Type of Work: White Granite (Pottery)
Sources: *AmPoP 182*.

Breastbein, Peter N.
See: Breeswine, Peter N.

Brechall, Martin
Flourished: 1783-1823 Berks County, PA
Ethnicity: German
Type of Work: Watercolor, ink (Frakturs)
Museums: 189
Sources: *AmFokA 47*; AmFokDe 144; AmFoPa 187; FoArRP 204*; HerSa;NinCFo 187*.

Breck, Joseph
See: Joseph Breck and Sons.

Breed, Mary
Flourished: 1770 Boston, MA
Type of Work: Fabric (Crewel bedspreads)
Museums: 151
Sources: *AmNe 32*; AmSQu 59**.

Breeswine, Peter N.
[Breastbein]
b. c1816 d. 1895
Flourished: c1850-1888 West Manchester Township, PA; York, PA
Ethnicity: German
Type of Work: Fabric (Coverlets)
Sources: *ChAmC 39*.

Brehm, Henry
Flourished: 1835-1837 Womelsdorf, PA
Type of Work: Fabric (Weavings)
Sources: *AmSQu 276; ChAmC 40*.

Breidenthal, P.
Flourished: 1839-1841 Wayne County, OH
Type of Work: Fabric (Coverlets)
Sources: *ChAmC 40*.

Breininger, Barbara
Flourished: 1972 Pennsylvania
Type of Work: Clay (Pottery)
Remarks: Identification mark: LBB, JM Robesonia
Sources: *AlAmD 115**
See: Breininger, Lester.

Breininger, Lester
Flourished: 1972 Pennsylvania
Type of Work: Clay (Pottery)
Remarks: Identification mark: LBB, JM Robesonia
Sources: *AlAmD 115**
See: Breininger, Barbara.

Breit, Peter
Flourished: 1880-1903
Type of Work: Wood (Circus and carousel figures)
Remarks: Worked for John Sebastian
Sources: *InAmD 154**.

Breneman, Martin B.
b. 1803 Lancaster County, PA d. 1889
Flourished: 1831-1861 York County, PA
Type of Work: Fabric (Coverlets)
Sources: *AmSQu 276; ChAmC 40, 75**.

Bresswine, Peter N.
See: Breeswine, Peter N.

Brett, Lady Dorothy
Flourished: 20th century Taos, NM
Type of Work: Tempera on tin (Paintings)
Sources: *FoAFm 2; FoPaAm 236**.

Brewer
See: Ott and Brewer.

Brewer
See: Otter and Brewer.

Brewer
Flourished: New Hampshire; Vermont
Type of Work: Oil (Children's portraits)
Sources: *PrimPa 169; SoAmP 285*.

Brewer, Daniel
b. 1699 d. 1763
Flourished: Middletown, CT
Type of Work: Stone (Gravestones)
Sources: *EaAmG 127*.

Brewer, J.A.
See: Brewer and Tempest.

Brewer, J.D.
Flourished: c1870-1900 Bogart, GA
Type of Work: Stoneware (Pottery)
Sources: *AmPoP 236*.

Brewer, Tunis
See: Brewer and Tempest.

Brewer and Tempest
Flourished: 1854-1869 Cincinnati, OH
Type of Work: Yellow-ware, Rockingham (Pottery)
Sources: *AmPoP 211*.

Brewster, Elisha C.
Flourished: Bristol, CT
Type of Work: Tin (Painted tinware)
Sources: *TinC 162*.

Brewster, John, Jr.
b. 1766 Hampton, CT d. 1854 Maine
Flourished: c1795 Buxton, ME; New York; Connecticut
Type of Work: Oil (Portraits)
Museums: 054,074,107,176,215
Remarks: Deaf-mute New England itinerant
Sources: *AmFoPaCe 18-25*, 45; AmFoPo 65-7*; EyoAm 21; FoA 18*, 460; FoPaAm 29*; GifAm 36*-7*; HoKnAm 92; MaAmFA *; NinCFo 165, 173, fig42; PaiNE 17, 56-63*, 158; PrimPa 169; SoAmP 291*.

Brewster and Sleight
Flourished: c1808 Hartford, CT
Type of Work: Clay (Pottery)
Sources: *AmPoP 193*.

Brice, Bruce
b. 1943
Flourished: 1963 New Orleans, LA
Ethnicity: Black American
Type of Work: Acrylic (Street genre paintings)
Sources: *ConAmF 65-71; FoA 460; FoPaAm 171, 174-5, 183*; TwCA 230-1**.

Brichdel, Christian
Flourished: c1767 Tulpehocken Township, PA
Type of Work: Redware (Pottery)
Sources: *AmPoP 183*.

Brick, Zena
Flourished: 1833
Type of Work: Fabric (Weavings)
Sources: *AmSQu 276; ChAmC 40*.

Brickner, John
Flourished: 1842-1848 Albany, NY
Type of Work: Stoneware (Pottery)
Sources: *Decor 217*.

Bridges, Charles
Flourished: 1735-1740 South Carolina
Type of Work: Oil (Portraits)
Museums: 096
Sources: *AmSQu 27*; FoA 460*.

Bridport, Hugh
Flourished: 1820 Massachusetts
Type of Work: Oil (Portraits)
Sources: *PrimPa 169*.

Brieschaft, Joseph
Flourished: 1804 Baltimore, MD
Type of Work: Wood (Ship carvings, ship figures)
Sources: *ShipNA 158*.

Briggs, Amos
Flourished: 1800s Connecticut; Philadelphia, PA
Type of Work: Tin (Tinware)
Remarks: Worked for Filley
Sources: *TinC* 73, 162; *ToCPS* 76.

Briggs, Cornelius
Flourished: 1816 Boston, MA
Type of Work: Wood (Ship carvings, ship figures)
Sources: *AmFiTCa* 188.

Briggs, John H.
Flourished: c1850-1860 Lew-Beach, NY
Type of Work: Stoneware (Pottery)
Sources: *Decor* 217.

Briggs, L.A.
Flourished: 1850 Boston, MA
Type of Work: Watercolor (Ship paintings)
Sources: *PrimPa* 169.

Briggs, Martha
b. c1785
Flourished: 1797 Halifax, MA
Type of Work: Fabric (Samplers)
Sources: *GalAmS* 34*.

Bright, Pete
[Sebastian Wagon Company]
Flourished: 1884 New York, NY
Type of Work: Wood (Circus and carousel figures)
Sources: *AmFokAr* 16, fig94
See: Sebastian, John .

Brinckerhoff, John P.
Flourished: 1830 New York, NY
Type of Work: Wood (Ship carvings, ship figures)
Sources: *AmFiTCa* 188, 199.

Brink, R.J.
Flourished: 1832 New York
Type of Work: Fabric? (Coverlets?)
Sources: *ChAmC* 40.

Brinker, George Henry
Flourished: 1830-1860 Franklin County, MO; Gasconade County, MO
Type of Work: Wood (Furniture)
Sources: *ASeMo* 354*, 362*.

Brinkman, Henry
b. c1806
Flourished: c1850 Hopewell Township, OH; Bascom, OH
Ethnicity: German
Type of Work: Fabric (Coverlets)
Sources: *ChAmC* 40.

Brinley, William R.
b. 1917
Flourished: 1930-
Type of Work: Various materials (Circus figures)
Museums: 220
Remarks: Made 50,000 pieces
Sources: *FoAFy* 6*-7*, 18*; *WoCar* 59-64*.

Brinton, Eleanor
Flourished: 1809 Philadelphia, PA
Ethnicity: Quaker
Type of Work: Fabric (Samplers)
Sources: *AmNe* 52*, 54.

Briscoe, Thomas "Ol' Briscoe"
Flourished: 1803 Stevens Plains, ME
Ethnicity: English
Type of Work: Tin (Tinware)
Sources: *AmCoTW* 92-3, 103, 105; *FoArtC* 83.

Britt
See: Bourguianon and Britt .

Brittin, Sanford
Flourished: 1852 Detroit, MI
Type of Work: Wood (Ship carvings, ship figures)
Sources: *AmFiTCa* 188.

Britton, William
Flourished: c1920 Germantown, PA
Type of Work: Oil (Townscape paintings)
Sources: *OneAmPr* 71*, 77, 143, 153.

Broad Gauge Iron Works
Flourished: 1892-1915 Boston, MA
Type of Work: Metal (Weathervanes)
Sources: *YankWe* 210.

Broadbent, Samuel, Dr.
b. 1759 d. 1828
Flourished: 1800-1825 Wethersfield, CT; New York
Type of Work: Oil (Portraits, landscape paintings)
Sources: *AmFoPo* 67-9*; *FoA* 460; *PrimPa* 169.

Brock, Harriet E.
b. 1825 d. 1850
Flourished: Old Brock Farm, VT
Type of Work: Fabric (Quilts)
Sources: *FoArtC* 130*.

Brockman
See: Tempest Brockman and Company .

Brockman Pottery Company
Flourished: 1863- Cincinnati, OH
Type of Work: Clay (Pottery)
Sources: *DicM* 155*.

Bromfield, Catherine
Flourished: 1850
Type of Work: Watercolor (Paintings)
Sources: *PrimPa* 169.

Bromley, William
Flourished: 1842-1870 Cincinnati, OH
Type of Work: Stoneware (Pottery)
Sources: *AmPoP* 77, 210-1; *Decor* 217.

Bromley and Son
See: Bromley, William .

Bronesky, S.S.
Flourished: Chicago, IL
Type of Work: Oil (Paintings)
Sources: *ThTaT* 236*.

Bronson, Asahel
Flourished: 1785 Berlin, CT
Type of Work: Tin (Tinware)
Sources: *TinC* 163.

Bronson, J.
Flourished: 1817 Utica, NY
Type of Work: Fabric (Coverlets)
Remarks: Brother is R. Bronson
Sources: *AmSQu* 276; *ChAmC* 40.

Bronson, Oliver
[Brunson]
Flourished: 1806-1822 Bloomfield, CT
Type of Work: Tin (Tinware)
Sources: *AmSFo* 42; *TinC* 73, 77; *ToCPS* 48.

Bronson, R.
Flourished: 1817 Utica, NY
Type of Work: Fabric (Coverlets)
Remarks: Brother is J. Bronson
Sources: *AmSQu* 276; *ChAmC* 40.

Bronson, Samuel
[Brunson]
Flourished: Berlin, CT
Type of Work: Tin (Tinware)
Sources: *TinC* 163.

Bronson, Silas
Flourished: Connecticut
Type of Work: Tin (Tinware)
Sources: *TinC* 73, 75*, 163.

Brook, Miss M.
Flourished: c1800 New Orleans, LA
Type of Work: Watercolor (Paintings)
Sources: *FoPaAm* 159*.

Brooks, Hervey
Flourished: c1753 Litchfield, CT
Type of Work: Redware (Pottery)
Sources: *AmPoP* 195.

Brooks, James A.
b. 1869 New York, NY d. 1937 Tampa, FL
Flourished: 1897-1937 New York, NY; Chicago, IL
Type of Work: Wood (Cigar store Indians, figures)
Remarks: Father is T(homas) V.
Sources: *ArtWod* 183, 193, 268; *HoKnAm* 164.

Brooks, James A.
Flourished: 1850 New York, NY
Type of Work: Wood (Ship carvings, ship figures)
Sources: *AmFiTCa 188.*

Brooks, Newton (N.)
Flourished: Massachusetts; New Hampshire
Type of Work: Oil (Portraits)
Sources: *PrimPa 169; SoAmP 291.*

Brooks, Noah
b. 1830 **d.** 1903
Flourished: 1859 Dixon, IL
Type of Work: Paint (Paintings)
Sources: *ArC 263.*

Brooks, Samuel Marsden
b. 1816 **d.** 1892 San Francisco, CA
Flourished: c1841 Chicago, IL
Type of Work: Oil (Portraits)
Museums: 044
Sources: *ArC 167*-8.*

Brooks, T(homas) V.
b. 1828 New York, NY **d.** 1895 Chicago, IL
Flourished: 1840-1890 New York, NY; Chicago, IL
Type of Work: Wood (Sculptures, cigar store Indians, ship figures)
Museums: 203,260,294
Remarks: Son is John
Sources: *AmFiTCa 188; AmFoS 102*, 256*, 341*; ArtWod 23, 81-2, 87, 93-4, 178, 181-93*, 202, 213*, 243; CiStF 29; EaAmW 42; HoKnAm 160-1, 164; ShipNA 162.*

Brooks and White
Flourished: 1871 New York, NY
Type of Work: Wood (Ship carvings, ship figures)
Sources: *AmFiTCa 188.*

Broome, Isaac
Flourished: 1880- Trenton, NJ
Type of Work: Clay (Pottery)
Sources: *DicM 12*, 22*, 234*.*

Broome and Morgan
Flourished: 1882-1900 Dayton, OH
Type of Work: Stoneware (Pottery)
Sources: *AmPoP 213; Decor 217.*

Brosey, John, Jr.
b. c1812 Pennsylvania
Flourished: 1835-1854 Manheim, PA
Type of Work: Fabric (Weavings)
Remarks: Father is John Sr.
Sources: *AmSQu 276; ChAmC 40.*

Brosey, John, Sr.
b. c1790 Pennsylvania
Flourished: c1850 Manheim, PA
Type of Work: Fabric (Coverlets)
Remarks: Son is John Jr.
Sources: *ChAmC 40.*

Brosey, W.
Flourished: 1847
Type of Work: Fabric (Weavings)
Sources: *AmSQu 276.*

Brosey, William
d. 1884
Flourished: 1846-1860 Manheim, PA
Type of Work: Fabric (Coverlets)
Remarks: Father may be John Jr.
Sources: *ChAmC 40.*

Broson, J. and R.
See: Bronson, J.; Bronson, R.

Brotherton
See: Brotherton and North.

Brotherton, E.
Flourished: Lancaster, PA
Type of Work: Copper, tin (Copperware, tinware)
Sources: *AmCoB 36.*

Brotherton and North
Flourished: 1859 New York, NY
Type of Work: Wood (Ship carvings, ship figures)
Sources: *AmFiTCa 188.*

Brower, J.F.
Flourished: c1875 Randolph County, NC
Type of Work: Stoneware (Pottery)
Sources: *AmS 140*.*

Brown, Angeline
b. 1821
Flourished: 1829
Type of Work: Fabric (Samplers)
Museums: 287
Sources: *AmSFok 110*.*

Brown, Caspar
Flourished: 1852 Detroit, MI
Type of Work: Wood (Ship carvings, ship figures)
Sources: *AmFiTCa 188.*

Brown, Catherine
[C. Brown and Company]
Flourished: 1834-1837 Baltimore, MD
Type of Work: Redware, stoneware (Pottery)
Sources: *AmPoP 51, 163.*

Brown, Charles
b. 1846 New York, NY **d.** 1917 Brooklyn, NY
Flourished: 1872-1917 New York, NY; Brooklyn, NY
Type of Work: Wood (Cigar store Indians, ship carvings, ship figures)
Museums: 260
Sources: *ArtWod 243-6*, 267.*

Brown, Charles
Flourished: 1859 New York, NY
Type of Work: Wood (Ship carvings, ship figures)
Sources: *AmFiTCa 188.*

Brown, David
b. c1819 Pennsylvania
Flourished: 1841-1850 Mount Joy, PA; Tulpehocken Township, PA
Type of Work: Fabric (Weavings)
Sources: *ChAmC 40.*

Brown, David E.
Flourished: 1873 Oswego, NY
Type of Work: Oil (Battle scene paintings)
Museums: 219
Sources: *FouNY 67.*

Brown, Edmond
Flourished: c1900 St. Johnsbury, VT
Type of Work: Wood (Carousel figures)
Sources: *TYeAmS 104*.*

Brown, Elinor
Flourished: 1753 Delaware
Type of Work: Fabric (Embroidered pocketbooks)
Sources: *PlaFan 97*.*

Brown, G.
Flourished: 1830s Sterling, MA
Type of Work: Wood (Windsor furniture)
Sources: *AmPaF 248*.*

Brown, George H.
Flourished: 1840 New Haven, CT; Fairhaven, CT
Type of Work: Wood (Ship carvings, ship figures)
Sources: *AmFiTCa 188.*

Brown, George R.
Flourished: 1863
Type of Work: Pen, watercolor (Paintings)
Museums: 176
Sources: *ColAWC 232.*

Brown, Hannah
Flourished: early 19th cent
Type of Work: Watercolor, ink (Mourning pictures)
Museums: 001
Sources: *MoBeA fig63.*

Brown, Isaac
b. c1799 Pennsylvania
Flourished: 1840-1850 Ashland, OH
Type of Work: Fabric (Weavings)
Remarks: Brother is W.W. Brown
Sources: *ChAmC 40.*

Brown, J.
Flourished: 1800-1835 New York;Massachusetts
Type of Work: Oil, watercolor (Portraits)
Museums: 203
Sources: *AmFoPo 67-72*; AmNa 13; EyoAm 18-9*; FoA 17*, 460; FoPaAm 28*; HoKnAm 92-3*; PrimPa 169.*

Brown, James
Flourished: 1883-1891 Philadelphia, PA
Type of Work: Wood (Cigar store Indians, figures)
Sources: *AmFiTCa 188; ArtWod 122, 268.*

Brown, James
Flourished: c1799-1807 Baltimore, MD
Type of Work: Redware? (Pottery)
Sources: *AmPoP 163*.

Brown, Jane
b. 1743
Flourished: 1758 Massachusetts
Type of Work: Fabric (Embroidered hatchments)
Sources: *PlaFan 156**.

Brown, John
Flourished: 1789-1804 Philadelphia, PA; Baltimore, MD
Type of Work: Wood (Ship carvings, ship figures)
Sources: *AmFiTCa 80-1, 188; ArtWod 119, 125; ShipNA 158, 163*
See: Rush, William.

Brown, John
Flourished: c1796 Baltimore, MD
Type of Work: Redware (Pottery)
Sources: *AmPoP 162*.

Brown, John
Flourished: 1843 New York
Type of Work: Fabric (Weavings)
Sources: *ChAmC 40; GalAmW 276*.

Brown, Jon
Flourished: 1802 Baltimore, MD
Type of Work: Wood (Ship carvings, ship figures)
Sources: *AmFiTCa 188*.

Brown, Jon
Flourished: c1830 West Charlton, NY
Type of Work: Watercolor, ink (Mourning pictures)
Sources: *MoBeA fig65*.

Brown, Joseph
b. 1840
Flourished: 1870 Salem, MA
Type of Work: Wood (Cigar store Indians, figures, sculptures, carvings)
Museums: 079
Sources: *AmFoS 236*; FoArtC 29**.

Brown, Joseph, Jr.
Flourished: Windsor, CT
Type of Work: Tin (Tinware)
Sources: *TinC 117, 127-8*, 163*.

Brown, M(andivilette) E(lihu) D(earing)
b. 1810
Flourished: Portsmouth, NH; Utica, NY; Philadelphia, PA
Type of Work: Watercolor (Apron paintings, portraits, landscape paintings)
Sources: *Bes 63**.

Brown, Margaret
b. c1780
Flourished: 1790 Chester County, PA
Type of Work: Watercolor, ink (Mourning pictures)
Sources: *AmPoP 215, 218; FlowAm 178*, 180*, 253-4*, 256**.

Brown, Mary
Flourished: c1875 Idaho
Type of Work: Oil (Paintings)
Museums: 112
Sources: *ArtWo 101-2**.

Brown, Moses
Flourished: 1807 Berlin, CT
Type of Work: Tin (Tinware)
Sources: *TinC 163*.

Brown, Nathan
Flourished: 1819 Connecticut
Type of Work: Tin? (Tinware?)
Sources: *TinC 163*.

Brown, Mrs. Nicholas E.
Flourished: c1936 Newport, RI
Type of Work: Fabric (Commemorative samplers)
Sources: *AmNe 174*, 177*.

Brown, O.F.
Flourished: 19th century
Type of Work: Pen, ink (Drawings)
Sources: *Edith **.

Brown, Olive W.
Flourished: 1852 Providence, RI
Type of Work: Watercolor, ink (Memorial drawings)
Sources: *MoBeA;NinCFo 197*.

Brown, R.
Flourished: c1841 Wellsburg, WV
Type of Work: Redware (Pottery)
Sources: *AmPoP 232*.

Brown, S.H.
Flourished: c1869-1900 Harmony, IN
Type of Work: Stoneware (Pottery)
Sources: *Decor 217; AmPoP 221*.

Brown, Sally
Flourished: 1841 Connecticut
Type of Work: Tin (Painted tinware)
Sources: *TinC 157*.

Brown, Samuel
Flourished: Connecticut
Type of Work: Tin (Painted tinware)
Remarks: Worked for Oliver Filley
Sources: *TinC 163*.

Brown, Samuel
Flourished: 1795
Type of Work: (Portraits)
Sources: *Bes 41-2, 49*.

Brown, W.H.
Flourished: 1842 Meridan, MA
Type of Work: Wood (Ship carvings, ship figures)
Sources: *ShipNA 160*.

Brown, W.H.
Flourished: 1886-1887 Binghamton, NY
Type of Work: Oil (Paintings)
Museums: 189
Sources: *AmNa 15, 21, 40**.

Brown, W.W.
Flourished: 1840-1850 Ashland, OH
Type of Work: Fabric (Weavings)
Remarks: Brother is Isaac
Sources: *ChAmC 41*.

Brown, William
Flourished: 1808
Type of Work: Pen, ink (Drawings)
Sources: *Edith **.

Brown, William Elliot
Flourished: 1860 Manchester, CT
Type of Work: Pen, ink (Penmanship, calligraphy drawings)
Sources: *NinCFo 201*.

Brown, William H.
Flourished: 1847 Boston, MA
Type of Work: Wood (Ship carvings, ship figures)
Sources: *AmFiTCa 188; ArtWod 5; ShipNA 159*.

Brown, William Henry
b. 1808 Charleston, SC d. 1883 Charleston, SC
Flourished: 1820s-1850s Charleston, SC; Vicksburg, MS
Ethnicity: Black American
Type of Work: Paper, watercolor (Silhouettes, collages)
Museums: 101
Remarks: Itinerant
Sources: *FoPaAm 169, 172*; SoFoA 64, 68*, 218*.

Brown and Crooks
Flourished: c1863 Ohio
Type of Work: Stoneware (Jars)
Museums: 208
Sources: *AmS 109**.

Brown and McKenzie
Flourished: c1870-1890 East River, WV
Type of Work: Stoneware (Pottery)
Sources: *AmPoP 219; Decor 217*.

Brown and Tweadwell
Type of Work: Wood (Ship carvings, ship figures)
Sources: *AmFiTCa 188*.

Brown Brothers
Flourished: 1813-1904 Huntington, NY
Type of Work: Stoneware (Pottery)
Remarks: S.C. Brown is believed to be a brother
Sources: *AmPoP 194; Decor 217; EaAmFo 8, 105**.

Browne
See: Miller and Browne.

Browne, George
Flourished: c1940 Norfolk, CT
Type of Work: Wood (Duck decoys)
Museums: 260
Sources: *Decoy 50**.

Browne, John H.
Flourished: 1830 New York, NY
Type of Work: Wood (Ship carvings, ship figures)
Sources: *AmFiTCa 188*.

Browne, John S.
Flourished: 1845 New York, NY
Type of Work: Wood (Ship carvings, ship figures)
Sources: *AmFiTCa 188*.

Browne, William
Flourished: pre 1850 New York
Type of Work: Watercolor (Landscape paintings)
Sources: *PrimPa 169*.

Brubacher, Abraham
Flourished: 1795-1806 Pennsylvania
Type of Work: Watercolor, ink (Frakturs)
Sources: *AmFoPa 187*.

Brubacher, Hans Jacob
Flourished: 1789-1801 Pennsylvania
Type of Work: Watercolor, ink (Frakturs)
Remarks: Identification mark: HIBB
Sources: *AmFoPa 187*.

Brubacher, Johannes
Flourished: 1795 Pennsylvania
Type of Work: Watercolor, ink (Frakturs)
Sources: *AmFoPa 187*.

Brubaker, A.
Flourished: 1847
Type of Work: Fabric (Weavings)
Sources: *AmSQu 276; ChAmC 41*.

Brubaker, Isaac
d. 1887
Flourished: 1832-1838 New Holland, PA
Type of Work: Fabric (Weavings)
Sources: *ChAmC 41*.

Bruce, John M.
Flourished: c1850 Baltimore, MD
Type of Work: Copper (Stills, kettles)
Sources: *AmCoB 113**.

Bruce, Joseph
Flourished: 1878-1883 Brooklyn, NY; New York, NY
Type of Work: Oil (Circus banners)
Sources: *AmSFor 44*, 198; FoPaAm 101**.

Bruce, Sophronia Ann
Flourished: c1880 Henry County, KY
Type of Work: Fabric (Quilts)
Sources: *KenQu 50-1, fig40*.

Bruer, Stephen T.
Flourished: 1828-1830 New London, CT
Type of Work: Stoneware (Pottery)
Sources: *Decor 217*.

Bruere, Theodore
Flourished: mid 19th cent Warren County, MO
Type of Work: Watercolor (Portraits)
Sources: *ASeMo 489*.

Brumman, David W.
Flourished: Shreve, OH
Type of Work: Fabric (Coverlets)
Sources: *ChAmC 41*.

Brunk, David
Flourished: c1831-1855 Cotton Hill, IL
Type of Work: Redware, stoneware (Pottery)
Sources: *ArC 189*.

Brunner, Hattie Klapp
b. c1890
Flourished: c1950-1973 Reinhold, PA
Type of Work: Watercolor, oil (Genre, memory scene paintings)
Sources: *AmHo 4*; ConAmF 53-7*; QuiAm 341**.

Brunson, Oliver
See: Bronson, Oliver.

Brunson, Samuel
See: Bronson, Samuel.

Brunt, William
See: William Brunt Pottery Company.

Brunt, Bloor, and Martin
Flourished: 1875 Liverpool, OH
Type of Work: Clay (Pottery)
Sources: *AmPoP 215, 218; DicM 178*, 180*, 253*, 254*, 256**.

Brunton, Richard
d. 1832
Flourished: c1800 East Granby, CT
Ethnicity: English
Type of Work: Oil (Portraits)
Museums: 054
Sources: *FoA 460; FoPaAm 29, fig2; PaiNE 8*, 11, 64-7**.

Brusgaeger, J. George
Flourished: 1815-1826 Pennsylvania
Type of Work: Watercolor, ink (Frakturs)
Sources: *AmFoPa 187*.

Bryant, Julian Edwards
Flourished: c1855 Princeton, IL
Type of Work: Oil (Landscape paintings)
Sources: *ArC 212**.

Bryne, Joseph
Flourished: 1865 Baltimore, MD
Type of Work: Wood (Ship carvings, ship figures)
Sources: *AmFiTCa 188*.

Bryne and Company
Flourished: 1860 Baltimore, MD
Type of Work: Wood (Ship carvings, ship figures)
Sources: *AmFiTCa 188*.

Bubier and Company
Flourished: 1872-18 Boston, MA
Type of Work: Metal (Weathervanes, ornamental metal works)
Sources: *YankWe 210*.

Buchanan, Mrs. John
b. 1774 **d.** 1830
Flourished: Nashville, TN
Type of Work: Fabric (Weavings)
Museums: 276
Sources: *ArtWea 87**.

Buchanan, Thomas
Flourished: c1850 Columbus, OH
Type of Work: Stoneware (Pottery)
Sources: *AmPoP 212; Decor 217*.

Buchman
Flourished: 1930-1950(?) Mount Clemens?, MI
Type of Work: Wood (Fish decoys)
Sources: *UnDec 20*.

Buchwalder, A.
Flourished: 1845
Type of Work: Fabric (Weavings)
Sources: *ChAmC 41*.

Buck, George H.
Flourished: 1845 New York, NY
Type of Work: Wood (Ship carvings, ship figures)
Sources: *AmFiTCa 188; ShipNA 162*.

Buck, William H.
Flourished: 1878
Type of Work: Oil (Landscape paintings)
Sources: *PrimPa 170*.

Buckingham, David Austin
Flourished: 1839 Watervliet, NY
Type of Work: Watercolor, ink, pen (Drawings)
Museums: 006
Sources: *FouNY 64*.

Buckingham, Susannah
Flourished: 1829
Type of Work: Fabric (Quilts)
Museums: 144
Sources: *QuiAm 237**.

Buckland, Peter
b. 1738 d. 1816
Flourished: c1762 East Hartford, CT
Type of Work: Stone (Gravestones)
Sources: *EaAmG 127, 39*; GravNE 127.*

Buckland, William, Jr.
b. 1727 d. 1795
Flourished: East Hartford, CT
Type of Work: Stone (Gravestones)
Sources: *EaAmG 127.*

Buckley, Justus
Flourished: 1823 Connecticut
Type of Work: Tin (Tinware)
Remarks: J. and W. Buckley Company
Sources: *TinC 163.*

Buckley, Luther
[Beckley]
Flourished: 1839 Connecticut
Type of Work: Tin? (Tinware?)
Sources: *TinC163.*

Buckley, Mary Ann
Flourished: 1800s Stevens Plains, ME; New York
Type of Work: Tin (Tinware)
Remarks: Father is Oliver
Sources: *AmCoTW 105; AmSFo 41-2.*

Buckley, Moses
Flourished: 1815-1818 Connecticut
Type of Work: Tin (Tinware)
Remarks: Perhaps worked for Peck
Sources: *TinC 164.*

Buckley, Oliver
b. 1781 Connecticut d. 1872 Maine
Flourished: 1800s Stevens Plains, ME; Wethersfield, CT
Type of Work: Tin (Tinware)
Remarks: Daughter is Mary Ann
Sources: *AmCoTW 66, 68, 93, 97*, 105-6; AmSFo 39*, 41-2; CoCoWA 59*; FoArtC 83; TinC 66*, 164.*

Buckley, Orrin
Flourished: Connecticut
Type of Work: Tin (Tinware)
Sources: *TinC 164.*

Buckley, Patrick
Flourished: 1859 Salem, MA
Type of Work: Wood (Ship carvings, ship figures)
Sources: *AmFiTCa 188.*

Buckley, William, Jr.
[Bulkeley]
b. Berlin, CT
Flourished: 1846-1861 Connecticut
Type of Work: Tin (Tinware)
Sources: *TinC 164.*

Buckman, John
Flourished: Berlin, CT
Type of Work: Tin (Tinware)
Sources: *TinC 164.*

Buckshot, Michele
See: Mackosikwe.

Budd, Alice M. (Mrs. Kenneth)
Flourished: 1924-1936 Newport Habor, NY
Type of Work: Fabric (Embroidered bay scene pictures, samplers)
Remarks: Great-grandmother is Wells, Lydia; daughter is O'Donnell, Mrs. J. Oliver
Sources: *AmNe 86, 111, 169*, 170-2*, 178*, 182.*

Budd, Edward
Flourished: 1668-1689 Boston, MA
Type of Work: Wood (Ship carvings, ship figures)
Sources: *ShipNA 158, 214.*

Budd, Mrs. Kenneth
See: Budd, Alice M.

Buddington, J.
[Budington]
b. 1779 d. 1823?
Flourished: 1798-1812 New York
Type of Work: Oil (Portraits)
Museums: 054
Remarks: May be the same artist as Budington, Jonathan
Sources: *PaiNE 68-73*; PrimPa 169.*

Budington, Jonathan
Flourished: 1792-1812 New York; Connecticut
Type of Work: Oil (Portraits, landscape paintings)
Remarks: May be same artist as Buddington, J.,
Sources: *AmFoPaS 34*; FoA 460; FoPaAm fig25.*

Buehler, John George
Flourished: 1843-1887 Leesport, PA
Ethnicity: German
Type of Work: Clay (Pottery)
Museums: 239
Sources: *AmPoP 170; FoArRP 34*.*

Buell, Benjamin
Flourished: c1760 New London, CT
Type of Work: Stone (Gravestones)
Sources: *EaAmG 127.*

Buell, S.J.
Flourished: late 19th Cent New Jersey
Type of Work: Fabric (Quilts)
Sources: *QuiAm 280*.*

Buell, William
d. 1681
Flourished: 1650s Dorchester, MA; Windsor, CT
Ethnicity: English
Type of Work: Wood (Carved boxes)
Museums: 216
Sources: *NeaT 6-7*.*

Buffalo Pottery Company
Flourished: c1905 Buffalo, NY
Type of Work: Clay (Pottery)
Sources: *DicM 152*.*

Bulger and Worcester
Flourished: 1875-1888 East Liverpool, OH
Type of Work: Yellow-ware (Pottery)
Sources: *AmPoP 218.*

Bulkeley, George
Flourished: Forestville, CT
Type of Work: Tin (Tinware)
Sources: *TinC 164.*

Bulkeley, William
See: Buckley, William, Jr.

Bull, Miss Elizabeth
Flourished: 1731 Boston, MA
Type of Work: Fabric (Embroidered wedding dresses)
Sources: *AmNe 65-6*.*

Bull, John, Captain
b. 1734 Newport, RI d. 1808 Middletown, RI
Flourished: 1767 Newport, RI; Middletown, RI
Type of Work: Stone (Gravestones)
Sources: *EaAmG 47*, 51*, 68-9*, 126*, 129; GravNE 97, 127.*

Bull, John C.
[Janes and Bull]
Flourished: 1800 Hartford, CT
Type of Work: Paint, wood (Coach, sign paintings)
Sources: *FoA 12*
See: Janes, Alfred; Janes, Almarin.

Bullard, A.
Flourished: 1850 Westerly, RI
Type of Work: Pastel (Portraits)
Sources: *PrimPa 169.*

Bullard, C.
Flourished: 1830
Type of Work: Velvet (Paintings)
Sources: *PrimPa 169.*

Bullard, Joseph O.
Flourished: c1870-1909 Allston, MA
Type of Work: Stoneware (Pottery)
Sources: *Decor 217*
See: Scott, Alexander F.

Bullock, W.
Flourished: c1870-1885 Roseville, OH
Type of Work: Stoneware (Pottery)
Sources: *AmPoP 229; Decor 217; DicM 141*.*

Bulluck, Panthed Coleman
Flourished: 1860 Greene County, AL
Type of Work: Fabric (Quilts)
Sources: *SoFoA 182, 217*, 223.*

Bulman, Mary
Flourished: 1745 York, ME
Type of Work: Fabric (Crewel bed assemblies)
Museums: 213
Sources: *AmSQu 53*; ArtWo 7, 156, fig2; FoArtC 61; InAmD 106**.

Bulsterbaum, John
Flourished: end 19th cent Brooklyn, NY
Type of Work: Oil (Circus banners)
Sources: *AmSFor 50*, 52*, 57*, 60*, 198*.

Bulyn, Mary
Flourished: 1730 Kensington, PA
Type of Work: Fabric (Samplers)
Sources: *AmNe 52*.

Bundy, Hiram
Flourished: 1831 Connersville, IN
Type of Work: Fabric (Weavings)
Sources: *ChAmC 41*
See: Van Vleet, Abraham.

Bundy, Horace
b. 1814 Hardwich, VT d. 1883 Concord, NH
Flourished: 1837-1859 Vermont; New Hampshire; Boston, MA
Type of Work: Oil (Portraits, paintings)
Museums: 189
Sources: *AmFoPa 47, 57-8*; AmFoPaN 84, 89; AmNa 15, 21, 41*; FoArtC 114; NinCFo 165, 173, fig91, 94; OneAmPr 77, 101*, 145, 153; SoAmP 87**.

Bunn and Brother
Flourished: 1870 Philadelphia, PA
Type of Work: Wood (Ship carvings, ship figures)
Sources: *AmFiTCa 188*.

Bunting, J.D.
Flourished: 1840-1850 Pennsylvania
Type of Work: Oil (Portraits)
Museums: 176
Sources: *FoPaAm 130**.

Burch, John
Flourished: c1773 New York, NY
Ethnicity: English
Type of Work: Tin (Japanned tinware)
Sources: *AmCoTW 77, 109, 111*.

Burchfield, A.N.
Flourished: c1860 Pittsburgh, PA
Type of Work: Stoneware (Pottery)
Sources: *AmPoP 227; Decor 217*.

Burd, Eliza Howard
Flourished: 1840 Philadelphia, PA
Type of Work: Watercolor (Scene paintings)
Sources: *PrimPa 170*.

Burden, Portia Ash
See: Trenholm, Portia Ash Burden.

Burdett, Edward
b. 1805 Nantucket, MA
Flourished: 1840s
Type of Work: Whalebone (Scrimshaw)
Museums: 123,186,221
Sources: *AmSFo 34; GravF 31, 43-4**.

Burford Brothers Pottery Company
Flourished: 1875-1900 East Liverpool, OH
Type of Work: Clay (Pottery)
Sources: *AmPoP 219; DicM 22*, 39*, 175*, 179*, 230*, 288**.

Burger, John
Flourished: 1854-1867 Rochester, NY
Type of Work: Stoneware (Pottery)
Sources: *Decor 217; HoKnAm pl11*.

Burgess, Ed
Flourished: c1890 Church's Island, VA
Type of Work: Wood (Duck decoys)
Sources: *WoCar 150**.

Burgess, Everard
Flourished: 1876 Medford, MA
Type of Work: Wood (Ship carvings, ship figures)
Sources: *AmFiTCa 188*.

Burgess and Campbell
Flourished: 1879 Trenton, NJ
Type of Work: Clay (Pottery)
Sources: *AmPoP 182, 255; DicM 17*, 67*, 114*, 175*-6*, 205*, 216**.

Burgess, Webster and Viney
Flourished: 1867-1869 East Liverpool, OH
Type of Work: Stoneware (Pottery)
Sources: *AmPoP 218; Decor 217*.

Burgum, John
Flourished: 1875 Concord, NH
Type of Work: Oil (Portraits)
Sources: *PrimPa 170*.

Burk, Eldon
Flourished: Oklahoma
Type of Work: Oil (Barn paintings)
Sources: *FoArO 100**.

Burke, Edgar, Dr.
Flourished: 1943 Ocracoke, NC
Type of Work: Wood, cork (Duck decoys)
Museums: 260
Sources: *Decoy 32**.

Burke, Michael
Flourished: 1877 Meriden, CT
Type of Work: Oil (Carriage paintings)
Sources: *TinC 164*.

Burke-Rand, Ravinia
Flourished: 1850
Type of Work: Pastel (Scene paintings)
Museums: 176
Sources: *ColAWC 190, 192**.

Burkerd, E.
Flourished: 1845 La Porte County, IN
Type of Work: Fabric (Coverlets)
Sources: *AmSQu 276; ChAmC 41*
See: Burkerd, Peter.

Burkerd, Peter
b. 1818 Pennsylvania
Flourished: 1843-1850 Fulton County, OH; La Porte County, IN
Type of Work: Fabric (Weavings)
Sources: *ChAmC 41*
See: Burkerd, E.

Burkfeldt, August
Flourished: 1859 New York, NY
Type of Work: Wood (Ship carvings, ship figures)
Sources: *AmFiTCa 188*.

Burkhardt, P.H.
Flourished: 1831 Canal Dover, OH
Type of Work: Fabric (Weavings)
Sources: *ChAmC 41*.

Burkholder, Isaac
b. c1801 Pennsylvania
Flourished: c1825-1850 Brookville, IN
Type of Work: Fabric (Weavings)
Sources: *ChAmC 41*.

Burkholder, J.P.
Flourished: early 20th cent Ephrata, PA
Type of Work: Paint, wood (Signs)
Museums: 104,224
Sources: *ArEn 50, 55*.

Burkholder, Lydia
Flourished: 1930 Indiana
Ethnicity: Amish
Type of Work: Fabric (Quilts)
Sources: *QuInA 21**.

Burley, John
Flourished: c1840-1850 Mt. Sterling, OH
Type of Work: Stoneware (Pottery)
Sources: *AmPoP 224; Decor 217*.

Burley, Lazalier
Flourished: c1846 Crooksville, OH
Type of Work: Stoneware (Pottery)
Sources: *AmPoP 212; Decor 217*.

Burlingame, Elder Philip
Flourished: Enfield, CT
Ethnicity: Shaker
Type of Work: Wood (Shaker chairs)
Sources: *HanWo 138*.

Burman, Augustus
Flourished: 1859 New York, NY
Type of Work: Wood (Ship carvings, ship figures)
Sources: *AmFiTCa 188*.

Burnap, Daniel
Flourished: East Windsor, CT
Type of Work: Brass (Brassware)
Sources: *AmCoB 241-6**.

Burnet
See: Remmey and Burnet.

Burnett, Henry
Flourished: 1750 Charleston, SC
Ethnicity: English
Type of Work: Wood (Ship carvings, ship figures)
Sources: *AmFiTCa* 188; *ShipNA* 2, 163.

Burney, J.M.
See: J.M. Burney and Sons.

Burnham, Aaron L.
Flourished: 1856 Essex, MA
Type of Work: Wood (Ship carvings, ship figures)
Sources: *AmFiTCa* 188.

Burnham, Mary Dodge
Flourished: 1725-1760 Boston, MA; Newburyport, MA
Type of Work: Fabric (Crewel needlepoint works)
Sources: *BeyN* 109; *PlaFan* 144*; *WinGu* 87*.

Burns, James
b. c1819 Virginia
Flourished: 1831-1850 St. Clairsville, OH; Chillicothe, OH
Type of Work: Fabric (Weavings)
Sources: *ChAmC* 41.

Burns, Martin
Flourished: 1851 West Virginia
Type of Work: Fabric (Weavings)
Sources: *AmSQu* 276; *ChAmC* 41.

Burns, W.F.
Flourished: c1850-1874 Atwater, OH
Type of Work: Stoneware (Pottery)
Sources: *AmPoP* 208; *Decor* 217.

Burnside, John
b. c1784
Flourished: 1844-1850 Cincinnati, OH
Ethnicity: Irish
Type of Work: Fabric (Carpets, coverlets)
Sources: *ChAmC* 41.

Burpee, Jeremiah
Flourished: c1804 Boscawen, NH
Type of Work: Clay (Pottery)
Sources: *AmPoP* 189; *EaAmFo* 135*.

Burpee, Sophia (Constant)
Flourished: 1788-1814 Sterling, MA; Amherst, NH
Type of Work: Watercolor, oil (Paintings)
Sources: *ArtWo* 68*, 156-7*; *PrimPa* 170.

Burr, A.
Flourished: Connecticut
Type of Work: Tin? (Tinware?)
Sources: *TinC* 164.

Burr, C.
Flourished: Connecticut
Type of Work: Tin? (Tinware?)
Sources: *TinC* 164.

Burr, Charles H.
Flourished: 1841 Connecticut
Type of Work: Tin? (Tinware?)
Sources: *TinC* 164.

Burr, Cynthia
b. 1770 Providence, RI d. 1848
Flourished: 1786 Providence, RI
Type of Work: Fabric (Samplers)
Museums: 173
Sources: *LeViB* 14*, 121*.

Burr, E(lisha)
Flourished: c1880-1890 Duxbury, MA; Hingham, MA
Type of Work: Wood (Duck decoys)
Museums: 176
Sources: *AmBiDe* 40, 87-8*; *AmDecoy* 72*; *ColAWC* 324.

Burr, Emerson
Flourished: Connecticut
Type of Work: Tin? (Tinware?)
Sources: *TinC* 164.

Burr, Jason
Flourished: Connecticut
Type of Work: Tin (Tinware)
Sources: *TinC* 73, 164.

Burr, John P.
Flourished: mid 1800s Philadelphia, PA
Ethnicity: Black American
Type of Work: Oil (Paintings)
Sources: *AfAmA* 96.

Burr, Julia
Flourished: 1825 Stratford, CT
Type of Work: Watercolor (Memorial paintings)
Sources: *PrimPa* 170.

Burr, Leonard
Flourished: 1840 Massachusetts
Type of Work: Oil (Portraits)
Sources: *PrimPa* 170; *SoAmP* 149*.

Burr, M.
Flourished: Connecticut
Type of Work: Tin? (Tinware?)
Sources: *TinC* 164.

Burr, Russ
Flourished: Hingham, MA
Type of Work: Wood (Miniature duck carvings, duck decoys)
Museums: 260
Remarks: Used Joseph Whiting Lincoln's patterns
Sources: *ArtDe* 176*; *Decoy* 120*.

Burridge
Flourished: 1865 St. Louis, MO
Type of Work: Oil (Genre paintings)
Sources: *PrimPa* 170.

Burrill, Hannah
b. 1758 Newport, RI d. 1786
Flourished: 1770 Newport, RI
Type of Work: Fabric (Samplers)
Museums: 205
Sources: *LeViB* 60, 69*.

Burris, J.C. "Jack"
b. 1928 North Carolina
Flourished: contemporary San Francisco, CA
Ethnicity: Black American
Type of Work: Wood (Puppets)
Remarks: Professional musician who uses puppets in act
Sources: *FoAFk* 12*.

Burrough, Mark
Flourished: 1836-1850 Camden, NJ
Type of Work: Fabric (Weavings)
Sources: *ChAmC* 41.

Burroughs, Sarah A.
Flourished: 1830 Norwich, CT
Type of Work: Watercolor (Landscape paintings)
Sources: *PrimPa* 170.

Burroughs and Mountford
[Montfort; Mountfort]
Flourished: 1879-1882 Trenton, NJ
Type of Work: Clay (Pottery)
Sources: *AmPoP* 183, 256; *DicM* 16*, 178*, 197*.

Burrows, Esther
Flourished: 1840- Connecticut
Type of Work: Fabric (Embroidered pictures)
Sources: *AmNe* 110-1*.

Burt, Mary Jane Alden
Flourished: 1830-1840 Bridgewater, CT
Type of Work: Fabric (Needlepoint)
Sources: *WinGu* 128*.

Burtis, Jacob H.
Flourished: 1825 New York, NY
Type of Work: Wood (Ship carvings, ship figures)
Sources: *AmFiTCa* 189.

Burton, John
Flourished: c1887 Roseville, OH
Type of Work: Stoneware (Pottery)
Sources: *AmPoP* 229; *Decor* 217.

Burton, Rebecca
Flourished: 1808 Pennsylvania
Type of Work: Fabric (Samplers)
Sources: *GalAmS* 46.

Burton, William
Flourished: 1870-1875 East Liverpool, OH
Type of Work: Yellow-ware, Rockingham (Pottery)
Sources: *AmPoP* 219.

Bury, Daniel
b. c1802 Pennsylvania
Flourished: 1830-1851 Youngstown, OH; Cornersburg, OH; New Portage, OH
Type of Work: Fabric (Weavings)
Sources: *ChAmC 41-2*.

Buschman, Frederick
Flourished: c1850 St. Charles, MO
Type of Work: Tin (Tinware)
Sources: *ASeMo 428*.

Buschong, W.F.
Flourished: 1835
Type of Work: Fabric? (Coverlets?)
Sources: *ChAmC 42*.

Buschor, Charles
Flourished: 1876 Philadelphia, PA
Type of Work: Wood (Ship carvings, ship figures)
Sources: *AmFiTCa 189*.

Bush, John A.
b. 1836 d. 1865
Flourished: 1859 Peoria, IL
Type of Work: (Masonic paintings)
Sources: *ArC 264; Bes 39*.

Bush, W.
Flourished: 1840 Bucks County?, PA; Montgomery County?, PA
Type of Work: Fabric (Coverlets)
Sources: *ChAmC 42*.

Bushby, Asa
Flourished: 1840 Danvers, MA
Type of Work: Oil (Portraits)
Sources: *PrimPa 170; SoAmP 291*.

Busketter, Barbara
See: Falk, Barbara.

Bussell, Joshua H.
Flourished: 1850 Alfred, ME
Type of Work: Watercolor (Cityscape paintings)
Sources: *BeyN 72*, 123*.

Butler, A.J.
See: A.J. Butler and Company.

Butler, Aaron
Flourished: Brandy Hill, NY
Type of Work: Tin (Tinware)
Remarks: Father of Ann, Minerva, and Marilla; son of Abel
Sources: *AmCoTW 17, 85, 115*, 131-34, 207-8; AmSFo 42*.

Butler, Abel
Flourished: c1799 East Greenville, NY
Type of Work: Tin (Tinware)
Remarks: Son is Aaron; grandchildren are Ann, Marilla, and Minerva
Sources: *AmCoTW 128-34*, 146, 207-8*, fig8; FoArtC 85*.

Butler, Ann
b. 1813
Flourished: East Greenville, NY; Brandy Hill, NY
Type of Work: Tin (Tinware)
Remarks: Sisters are Minerva, Marilla; father is Aaron
Sources: *AmCoTW 132-3, 142*-4, 198*; AmFokDe 66; AmSFo 36, 40-3*; ArtWo 27, 157*; FoA 460*.

Butler, Catherine
Flourished: c1806 Hartford, CT
Type of Work: Fabric, oil (Mourning pictures)
Sources: *PlaFan 149**.

Butler, David
b. 1898 Saint Mary Parish, LA
Flourished: 1940- Patterson, LA
Ethnicity: Black American
Type of Work: Metal (Ornamental works)
Museums: 171,201
Sources: *AmFokArt 37*; BlFoAr 65-9*; GalAmW 110**.

Butler, Esteria
Flourished: 1820 Maine
Type of Work: Oil (Miniature portraits)
Sources: *PrimPa 170*.

Butler, J.B.
Flourished: 1855
Type of Work: Pen, ink (Penmanship, calligraphy drawings)
Museums: 139
Sources: *AmFoPa 171**.

Butler, Marilla
Flourished: East Greenville, NY; Brandy Hill, NY
Type of Work: Tin (Tinware)
Remarks: Sisters are Minerva and Ann; father is Aaron
Sources: *AmCoTW 13; AmFokDe 84; AmSFo 42*.

Butler, Martha
b. 1717
Flourished: 1729 Boston, MA
Type of Work: Fabric (Samplers)
Museums: 056
Sources: *LeViB 37**.

Butler, Minerva (Miller)
b. 1821 d. 1912
Flourished: East Greenville, NY; Brandy Hill, NY
Type of Work: Tin (Tinware)
Remarks: Sisters are Marilla and Ann; father is Aaron
Sources: *AmCoTW 115*, 130*-1, 133, 143; AmFokDe 84; AmSFo 42; ArtWo 27, 64-5; FoA 466*.

Butler, Nellie
b. 1925 Newark, NJ
Flourished: 1970s San Francisco, CA
Type of Work: Acrylic (Paintings)
Sources: *FoAFd 12*-3**.

Butler, Reuben
See: Butler, Abel.

Butler, Thomas
Flourished: 1839 Berlin, CT
Type of Work: Tin (Tinware)
Sources: *TinC 165*.

Butler, Thomas C.
Flourished: Connecticut
Type of Work: Tin (Tinware)
Remarks: May be the same as Butler, Thomas
Sources: *TinC 165*.

Butler, Timothy
Flourished: 1839 Berlin, CT
Type of Work: Tin? (Tinware?)
Sources: *TinC 165*.

Butler, W. and L.
Flourished: 1850s Rockville, CT
Type of Work: Tin (Tinware)
Sources: *TinC 101, 165*.

Butler, William
Flourished: Connecticut
Type of Work: Tin (Tinware)
Remarks: Possibly W. and L. Butler
Sources: *TinC 165*.

Butterfield, J.
Flourished: New Hartford, NY
Type of Work: Fabric (Weavings)
Sources: *AmSQu 276; ChAmC 42*.

Butterfield, Samuel
Flourished: c1835-1855 New Hartford, NY
Type of Work: Fabric (Carpets, coverlets)
Sources: *ChAmC 42*.
See: Cunningham, James.

Buttersworth, James E.
b. 1817 d. 1894
Flourished: mid 19th cent New York; West Hoboken, NJ
Ethnicity: English
Type of Work: Oil (Paintings)
Sources: *AmFoPa 106-7*, 111; FoA 59*, 462*.

Buttling, Avery
Flourished: 1859 New York, NY
Type of Work: Wood (Ship carvings, ship figures)
Sources: *AmFiTCa 189*.

Buttre, William
Flourished: 1805-1814 New York, NY
Type of Work: Wood (Furniture)
Museums: 151
Sources: *AmPaF 166-7**.

Butts, F.A.
Type of Work: Whalebone (Scrimshaw)
Sources: *ScriSW 59**.

Butz, Mary
Flourished: 1842 Kutztown, PA
Type of Work: Fabric (Samplers)
Sources: *GalAmS 85**.

Buxton, Hannah P.
Flourished: 1820 New York
Type of Work: Velvet (Paintings)
Sources: *Edith *; PrimPa 170*.

Buyer, Alfred
Flourished: 20th century Needham, MA
Type of Work: Wood (Sculptures, carvings)
Sources: *WoCar 200**.

Bybee Pottery
Flourished: 1865-1900 Richmond, KY
Type of Work: Stoneware (Pottery)
Sources: *AmPoP 240*.

Byberin, Barbara
Flourished: c1808 Pennsylvania
Type of Work: Fabric (Embroidered linens)
Sources: *FoArRP 47*.

Byerley, Edwin
Flourished: 1859 New York, NY
Type of Work: Wood (Ship carvings, ship figures)
Sources: *AmFiTCa 189*.

Byerley and Ely
Flourished: 1859 New York, NY
Type of Work: Wood (Ship carvings, ship figures)
Sources: *AmFiTCa 189*.

Byington, Martin
Flourished: Bristol, CT
Type of Work: Tin, glass (Tin mirrors)
Sources: *TinC 165*.

Bykeepers, C.
See: C. Bykeepers, and Sons.

Byles, Abigail
b. c1746
Flourished: 1757 Boston, MA
Type of Work: Fabric (Samplers)
Sources: *GalAmS 25**.

Bynum, B.
Flourished: 1846 Belleville, IL
Type of Work: Paint (Portraits)
Sources: *ArC 264*.

Byrd Pottery
Flourished: c1930-1940 Tyler, TX
Type of Work: Stoneware (Pitchers)
Sources: *AmS 104*, 125*, 172**.

Byrley, Frank J.
b. 1906 Lexington, NC
Flourished: 1971- Kentucky; Aiken, SC
Type of Work: Wood (Carvings)
Remarks: Friend of woodcarver Cress, Edward
Sources: *GoMaD **.

Byrne and Kiefer Company
Flourished: late 1800s Pittsburgh, PA
Type of Work: Tin (Tinware)
Sources: *ToCPS 42, fig*.

Bysel, Phillip
Flourished: 1839-1846 Shanesville, OH; Holmes County, OH
Type of Work: Fabric (Weavings)
Sources: *ChAmC 42*.

C

C.A. Jackson and Company
Flourished: 1871 Boston, MA
Type of Work: Wood (Ship carvings, ship figures)
Sources: *AmFiTCa 194.*

C. Boynton and Company
Flourished: c1860 Troy, NY
Type of Work: Stoneware (Pottery)
Sources: *AmPoP 203; Decor 216.*

C. Brown and Company
See: Brown, Catherine.

C. Bykeepers and Sons
Flourished: 1894-1897 Brooklyn, NY
Type of Work: Clay (Pottery)
Sources: *EaAmFo 134*.*

C.C. Smith Co.
Flourished: Michigan
Type of Work: Wood (Decoys)
Sources: *WaDec xxl, 143, 148*.*

C.C. Thompson Pottery Co.
Flourished: c1888-1895 East Liverpool, OH
Type of Work: Yellow-ware, Rockingham (Pottery)
Sources: *AmPoP 218; DicM 84*, 92*, 126*, 131*, 152*, 178*, 258*.*

C. Dillon and Company
Flourished: 1834-1840 Albany, NY
Type of Work: Stoneware (Pottery)
Sources: *Decor 220; DicM 27**
See: Henry, Jacob; Selby, Edward; Dillon and Porter.

C. Foster and Company
Flourished: 1870 Worcester, MA
Type of Work: Metal (Weathervanes)
Remarks: Outlet for Cushing vanes
Sources: *YankWe 211.*

C.G. Brunncknow Company
Flourished: 1921 Providence, RI
Type of Work: Metal (Weathervanes)
Sources: *WeaVan 13*
See: Hallberg, Charles; Leibo, Jacob.

C. Goetz, Smith, and Jones, Slago Pottery
Flourished: 1850 Zanesville, OH
Type of Work: Clay (Pottery)
Sources: *BeyN 79*.*

C(harles) Hart and Company Pottery
Flourished: c1841-1866 Ogdensburg, NY; Shelburne, NY
Type of Work: Stoneware (Pottery)
Museums: 203
Sources: *AmS 86*; Decor 125*, 148*, 212*, 220; FouNY 63*
See: W. Hart Pottery; J.J. Hart Pottery.

C. Herman Company Pottery
Flourished: 1855 Milwaukee, WI
Type of Work: Clay (Pottery)
Sources: *EaAmFo 255*.*

C. Oppel and Company
Flourished: 1850 Zoar, OH
Type of Work: Fabric? (Weavings?)
Sources: *AmSQu 277; ChAmC 93.*

C. Potts and Sons
See: Christopher Potts and Sons.

C.W. Hasenritter
See: Hasenritter, Carl William.

C.W. Stevens Factory
Flourished: 1880 Weedsport, NY
Type of Work: Wood (Duck decoys)
Sources: *ArtDe 137*; WiFoD 89, 71*, 76**
See: H.A. Stevens.

C. Webster & Son
Flourished: 1850-1857 Hartford, CT
Type of Work: Stoneware (Pottery)
Sources: *AmPoP 193.*

Cabanis, Ethan T.
Flourished: c1845 Springfield, IL
Type of Work: Oil, daguerreotypes (Portraits)
Sources: *ArC 154*.*

Caberey
Flourished: 1850s Chicago, IL
Type of Work: (Masonic regalia)
Remarks: Manufacturer
Sources: *Bes 39.*

Cable, Henry K.
Type of Work: Fabric (Coverlets)
Sources: *ChAmC 18*.*

Cabot, Mrs. Samuel
Flourished: 1936 Boston, MA
Type of Work: Fabric (Embroidered prayerbook covers)
Sources: *AmNe 168*, 202.*

Cachel, John
See: Kachel, John.

Cadmus, Abraham
Flourished: c1850 South Amboy, NJ
Type of Work: Clay (Pottery)
Sources: *AmPoP fig31, 180, 256; DicM 7**
See: Congress Pottery; Price, G.; Hancock, William H.

Cadwell, A.
Flourished: Connecticut
Type of Work: Tin? (Tinware?)
Sources: *TinC 165.*

Cadwell, I.
Flourished: Connecticut
Type of Work: Tin? (Tinware?)
Sources: *TinC 165.*

Cadwell, L.
Flourished: Connecticut
Type of Work: Tin? (Tinware?)
Sources: *TinC 165.*

Cady
See: Lewis and Cady.

Cady, Almira
b. 1804 Pomfret?, CT? **d.** 1827 Providence, RI
Flourished: c1818 Providence, RI
Type of Work: Embroidery (Genre pictorials)
Sources: *LeViB 197-9*, 254-5*.*

Cady, Emma Jane
b. 1854 d. 1933
Flourished: 1890 New Lebanon, NY; East Chatham, NY; Grass Lake, MI
Type of Work: Watercolor (Still life paintings)
Museums: 001
Remarks: Originally thought to have flourished c1820
Sources: *AmPrP fig79, 150; ArtWo 81*, 157-8*; PrimPa 170.*

Cahoon, Hannah
See: Cohoon, Hannah.

Cahoon, Ralph
Flourished: 1930- Osterville, MA
Type of Work: Various materials, oil (Decorated objects, nautical theme paintings)
Sources: *FoPaAm 64*.*

Cain, Abraham
Flourished: c1826 Sullivan County, TN
Type of Work: Earthenware (Pottery)
Sources: *SoFoA 25*, 217.*

Cain, John
See: Kane, John.

Cain, Martin
Flourished: c1826 Sullivan County, TN
Type of Work: Earthenware (Pottery)
Sources: *SoFoA 25*, 217.*

Caire, Adam
See: Reidinger and Caire.

Caire, Frederick J.
Flourished: 1854-1863 Huntington, NY
Type of Work: Stoneware (Pottery)
Sources: *Decor 217; DicM 47*.*

Caire, Jacob
Flourished: 1842-1852 Poughkeepsie, NY
Type of Work: Clay (Pottery)
Sources: *AmPoP 201; Decor 217; DicM 69*, 170**
See: Caire Pottery.

Caire, John P.
Flourished: 1840-1842 Poughkeepsie, NY
Type of Work: Redware, stoneware (Pottery)
Sources: *AmPoP 201; Decor 217*
See: Caire Pottery.

Caire Pottery
[Caire, John P; Caire, Jacob]
Flourished: 1840-1878 Poughkeepsie, NY
Type of Work: Stoneware (Pottery)
Sources: *Decor 196*; EaAmFo 201*; InAmD 89*.*

Caldwell, Booth
b. 1803 d. 1872
Flourished: Pennsylvania
Type of Work: Wood (Carved canes)
Sources: *AmFokA 34*.*

Caldwell, James
b. Kentucky
Flourished: 1801 Cincinnati, OH
Type of Work: Earthenware (Pottery)
Sources: *AmPoP 67, 210.*

Caldwell, Robert
See: Caldwell, James.

Caldwell, Sarah S.
Flourished: 1806 South Carolina
Type of Work: Fabric (Samplers)
Sources: *AmNe 59.*

Calister, James C.
Flourished: 1853 Jefferson County, NY
Type of Work: Fabric (Weavings)
Sources: *AmSQu 276; ChAmC 42.*

Call, H.
Flourished: 1876
Type of Work: Oil (Pastoral scene paintings)
Sources: *AmNa 42*.*

Callaham, Richard
Flourished: 1868-1875 Baltimore, MD
Type of Work: Wood (Ship carvings, ship figures)
Sources: *ShipNA 158.*

Callahan, Richard
See: Callanan, Richard.

Callahan, William
Flourished: c1837 Martin's Ferry, OH
Type of Work: Redware, stoneware (Pottery)
Sources: *AmPoP 223; Decor 217.*

Callanan, Richard
[Callahan]
Flourished: 1867-1901 Baltimore, MD
Type of Work: Wood (Cigar store Indians, figures)
Sources: *AmFiTCa 189; ArtWod 134, 263.*

Caln Pottery
See: Thomas Vicker and Sons.

Calvert, Margaret Younglove
Flourished: c1870 Bowling Green, KY
Type of Work: Fabric (Quilts)
Museums: 125
Sources: *KenQu fig19.*

Cambell, Anna D.
Flourished: c1814 Philadelphia, PA
Type of Work: Fabric (Family register samplers)
Sources: *GalAmS 50*.*

Cambridge Art Pottery Company
Flourished: 19th century Cambridge, OH
Type of Work: Clay (Pottery)
Sources: *DicM 212*.*

Cameron, Glen, Judge
Flourished: Chillicothe, IL
Type of Work: Wood (Duck decoys)
Sources: *AmBiDe 190.*

Cameron, Mary Elizabeth
Flourished: 1835 Philadelphia, PA
Type of Work: Fabric (Samplers)
Sources: *GalAmS 78*.*

Camiletti, Edmund
Flourished: 1828 Massachusetts
Type of Work: Watercolor (Ship portraits)
Sources: *FoArA 144*.*

Camp, Emily
Flourished: 1852 Connecticut
Type of Work: Tin (Tinware)
Sources: *TinC 157.*

Camp, Lucy
Flourished: Harwinton, CT
Type of Work: Tin (Tinware)
Sources: *TinC 157.*

Camp and Thompson
Flourished: c1870-1880 Akron, OH
Type of Work: Stoneware (Pottery, sewer tile sculpture)
Sources: *AmPoP 206; Decor 217; DicM 26*; IlHaOS *.*

Camp Cook and Company
Flourished: 1863-1880 Cuyahoga Falls, OH
Type of Work: Stoneware (Pottery)
Sources: *AmPoP 212; Decor 217.*

Campbell, Daniel
Flourished: 1839-1856 Bridgeport, WV; Pennsylvania
Ethnicity: French
Type of Work: Fabric (Coverlets)
Museums: 171
Sources: *AmFoArt 134; AmSQu 276; ChAmC 42.*

Campbell, Elizabeth Gratia
See: Miner, Elizabeth Gratia Campbell.

Campbell, James
Flourished: 1851-1900 Baltimore, MD; Mystic, CT; Newark, NJ
Type of Work: Wood (Ship carvings, ship figures, cigar store Indians, figures)
Sources: *AmFiTCa 189; ArtWod 134, 263, 265; ShipNA 72, 155, 158*
See: Campbell and Colby.

Campbell, James
b. c1810
Flourished: c1846-1854 New Philadelphia, OH
Ethnicity: Irish
Type of Work: Fabric (Weavings)
Sources: *ChAmC 42.*

Campbell, John
Flourished: c1832-1859 Syracuse, NY
Ethnicity: Scottish
Type of Work: Fabric (Coverlets, weavings)
Sources: *AmSFo 93; ChAmC 42.*

Campbell, Justin
Flourished: 1826-1840 Utica, NY
Type of Work: Stoneware (Pottery)
Museums: 203
Sources: *AmPoP 204; Decor 97*, 217.*

Campbell, Larry
b. 1947 Jackson, KY
Flourished: contemporary Kentucky
Type of Work: Metal, wood (Saws)
Sources: *GoMaD *.*

Campbell, Pryse
Flourished: 1770
Type of Work: Oil (Portraits)
Sources: *PrimPa 170.*

Campbell, Thomas
Flourished: c1769 New York, NY
Type of Work: Redware (Pottery)
Sources: *AmPoP 197.*

Campbell and Colby
Flourished: 1877 Mystic, CT
Type of Work: Wood (Ship carvings, ship figures)
Sources: *AmFiTCa 189*
See: Campbell, James.

Campbell and Greig
Flourished: 1835 New York, NY
Type of Work: Wood (Ship carvings, ship figures)
Sources: *AmFiTCa 189.*

Canade, Vincent
b. 1880? d. 1961
Flourished: New York, NY
Type of Work: Oil (Portraits, landscape and still life paintings)
Sources: *PrimPa 170.*

Candee, G.E.
Flourished: 1850 Connecticut
Type of Work: Oil (Paintings)
Sources: *PrimPa 170.*

Canfield
Flourished: 1857-1869 Midford Center, OH
Type of Work: Stoneware (Pottery)
Sources: *AmPoP 223; Decor 217.*

Canfield, Abijah
b. 1769 d. 1830
Flourished: c1800 Chusetown, CT
Type of Work: Gouache on reverse glass (Paintings)
Museums: 096
Sources: *FoA 74*, 462; FoPaAm fig8.*

Canfield, Betsey
Flourished: 1810 New London, CT
Type of Work: Fabric (Bedcovers)
Museums: 032
Sources: *AmNe 37.*

Canfield, Caroline
Flourished: 1830 Litchfield, CT
Type of Work: Fabric (Wedding veils)
Sources: *AmNe 71, 77.*

Cannelton Sewer Pipe Company
Flourished: Cannelton, IN
Type of Work: Clay (Sewer tile sculpture)
Sources: *IlHaOS *.*

Cannon, Hugh
Flourished: 1848 Philadelphia, PA
Type of Work: Wood (Ship carvings, ship figures)
Sources: *AmFiTCa 189.*

Capalano, Anthony
Flourished: 1824 Baltimore, MD
Type of Work: Wood (Ship carvings, ship figures)
Sources: *AmFiTCa 189.*

Capen, Azel
Flourished: 1840 Maine
Type of Work: Oil (Portraits)
Sources: *PrimPa 170.*

Capron, Elizabeth W.
Flourished: 1840
Type of Work: Velvet (Paintings)
Sources: *AmFoPa 144*.*

Capron, William
Flourished: 1800-1808 Albany, NY
Type of Work: Stoneware (Pottery)
Sources: *Decor 217.*

Carey, Joseph
Flourished: 1785 Salem, MA
Type of Work: Oil (Scene paintings)
Sources: *PrimPa 170.*

Cariss, Samson
See: Samson Cariss and Company.

Carlin, John
Flourished: c1842 Nauvoo, IL
Type of Work: Stoneware (Pottery)
Sources: *ArC 190.*

Carll, E.S.
Flourished: 1856 Salem County, NJ
Type of Work: Pen, watercolor (Landscape paintings)
Sources: *OneAmPr 139*, 114*.*

Carlyle and McFadden
Flourished: 1850-1853 Freeman's Landings, WV
Type of Work: Stoneware (Pottery)
Sources: *AmPoP 220; Decor 217.*

Carmel, Charles
Flourished: 1910-1916 Brooklyn, NY
Type of Work: Wood (Circus and carousel figures)
Museums: 171
Sources: *AmFoArt 65*; AmSFor 130*; CaAn 10, 34-5*; FoA 201*, 462.*

Carmen, Caleb
Flourished: c1800 South Haven, NY
Type of Work: Wood (Duck decoys)
Sources: *ArtDe fig.*

Carmen, Elizabeth (Mrs. Caleb)
b. 1818 d. 1875
Flourished: Trousdale County, TN
Type of Work: Fabric (Weavings)
Sources: *ArtWea 88*.*

Carmen, T.
b. 1860
Flourished: c1900 Amityville, NY
Type of Work: Wood (Duck decoys)
Sources: *AmBiDe 101; AmDecoy 40*.*

Carpenter, Miss
Flourished: 1830
Type of Work: Watercolor (Miniature portraits)
Sources: *PrimPa 170.*

Carpenter, Frederick
Flourished: 1801-1827 Charlestown, MA; Boston, MA
Type of Work: Stoneware (Pottery)
Museums: 160
Remarks: Worked for Edwards Pottery
Sources: *AmS 165*, 180; BeyN 27*, 121; Decor 217*
See: Fenton and Carpenter.

Carpenter, Miles B.
b. 1889 Lititz, PA d. 1985 Waverly, VA
Flourished: 1949-1984 Waverly, VA
Type of Work: Wood (Sculptures, carvings)
Sources: *AmFokArt 38-9*; AmFoS 10*, 178*, 202*, 321*; ConAmF 73-8*; CutM *; FoA 462; FoAFa 2; FoAFc 19; FoAFt 15*; FoScu 42-3*; Trans 7, 38*-9*, 53; TwCA 218-9*.*

Carr, Henry A.
Flourished: mid 19th cent
Type of Work: Watercolor, ink (Portraits)
Sources: *NinCFo 198.*

Carr, James
[Carr and Locker; Carr and Morrison]
Flourished: 1852-1860 South Amboy, NJ; New York, NY
Type of Work: Rockingham (Pottery)
Sources: *AmPoP 48-9, 61, 63-5, 112, 180, 198, 257; DicM 25*, 126*, 231*, 248*-9**
See: partner Greatbach, Daniel.

Carr, Mary
b. 1772 Newport, RI
Flourished: Newport, RI
Type of Work: Fabric (Samplers)
Sources: *LeViB 74.*

Carretta, Frank
Flourished: 1920 Germantown, PA
Type of Work: Wood (Cigar store Indians, circus, other figures)
Sources: *AmSFor 18*, 20*-1*.*

Carroll, Tessie
Flourished: 1950- Oklahoma
Type of Work: Wood (Sculptures, carvings)
Sources: *AmSFor 18*, 20-1*.*

Carroll, Thomas
Flourished: 1860 San Francisco, CA
Type of Work: Wood (Ship carvings, ship figures)
Sources: *ShipNA 91, 155*
See: Gereau, William; Earl, Tarleton B.

Carson, William
Flourished: c1828 Harrisburg, PA
Type of Work: Tin (Tinware)
Sources: *AmCoTW 156.*

Carswell, Mrs. N.W.
Flourished: 1887 Waterbury, CT
Type of Work: Fabric (Quilts)
Museums: 111, 148
Sources: *AmSQu 302*; QuiAm 280*.*

Carter, A.G.
Flourished: 1930 Appalachia, VA
Type of Work: Oil (Landscape paintings)
Sources: *FoAFk 2; TwCA 77*.*

Carter, Achsah
b. 1820
Flourished: 1830 Smithfield, OH
Type of Work: Fabric (Samplers)
Sources: *GalAmS 72*.*

Carter, Bob Eugene
b. 1928 Turley, OK
Flourished: c1973 Oroville, CA
Type of Work: Acrylic, oil (Genre, memory paintings)
Sources: *AmFokArt 40-1*; FoAFab 3*, 18*.*

Carter, David
b. 1930
Flourished: Savannah, GA
Type of Work: Wood (Furniture)
Sources: *MisPi 62*.*

Carter, Elias
Flourished: Thompson Village, CT
Type of Work: Paint (Ornamental paintings)
Sources: *AmDecor 113.*

Carter, J.
Flourished: c1815
Type of Work: Oil, wood (Signs)
Sources: *PicFoA 138*.*

Carter, John W.
Flourished: 1890 Jamaica Bay, NY
Type of Work: Wood (Bird decoys)
Sources: *EyoAm 4, 7*.*

Carter, Rebecca
b. 1778 Providence, RI d. 1837
Flourished: 1788 Providence, RI
Type of Work: Fabric (Samplers)
Sources: *LeViB 22, 51, 96, 111, 122-3*.*

Carter, Thomas
Flourished: 1877 Meriden, CT
Type of Work: Tin (Tinware)
Sources: *TinC 165.*

Cartledge, William Ned
b. 1916 Cannon, GA
Flourished: Atlanta, GA
Type of Work: Wood (Social and political genre carvings)
Museums: 099, 138
Sources: *AmFokArt 42-3*.*

Cartlidge, Charles
Flourished: 1848 Greenpoint, NY
Type of Work: Clay (Porcelain)
Sources: *AmPoP 65, 197-8.*

Cartwright and Brothers
Flourished: 1880-1890 East Liverpool, OH
Type of Work: Clay (Pottery)
Sources: *AmPoP 217; DicM 11*, 22*, 39*, 128*, 183*.*

Carty, John, Sr.
Flourished: c1796-1845 Lexington, KY
Type of Work: Redware (Pottery)
Sources: *AmPoP 87, 239.*

Carver, Jacob
Flourished: 1813 Philadelphia, PA
Type of Work: Wood (Ship carvings, ship figures)
Sources: *AmFiTCa 189.*

Carver, James
Flourished: Havre de Grace, MD
Type of Work: Wood (Duck decoys)
Sources: *AmBiDe 144, 146.*

Cary, Mary
Flourished: c1753 New York
Type of Work: Fabric (Needlework)
Sources: *WinGu 25.*

Case, E.H.
Flourished: Connecticut
Type of Work: Tin? (Tinware?)
Sources: *TinC 165.*

Case, H.H.
Flourished: Connecticut
Type of Work: Tin? (Tinware?)
Sources: *TinC 165.*

Case, Robert
Flourished: Connecticut
Type of Work: Tin? (Tinware?)
Sources: *TinC 165.*

Case, T.
Flourished: Connecticut
Type of Work: Tin (Tinware)
Sources: *TinC 165.*

Casebeer, Aaron
b. c1825 Pennsylvania
Flourished: 1848-1850 Somerset Township, PA
Type of Work: Fabric (Weavings)
Remarks: Father is Abraham
Sources: *ChAmC 42*
See: Zufall, Moses; Menser, David; Hoffman.

Casebeer, Abraham
Flourished: Somerset County, PA
Type of Work: Fabric (Weavings)
Remarks: Son is Aaron
Sources: *ChAmC 42.*

Casebier, Jerry
b. 1942
Flourished: 1970 North Little Rock, AR
Type of Work: Wood (Furniture)
Sources: *TwCA 209*.*

Caseel, Hester
b. 1814
Flourished: 1828 Marietta, PA
Type of Work: Fabric (Samplers)
Sources: *GalAmS 70*.*

Caspori
b. 1812 d. 1886
Flourished: Coldwater, MI
Type of Work: Wood (Sculptures, carvings)
Sources: *AmFoS 31*.*

Cass, David
b. c1825 New York
Flourished: 1850 Lodi, NY
Type of Work: Fabric (Weavings)
Remarks: Father is Josiah; brother is Nathan
Sources: *ChAmC 45.*

Cass, Josiah
b. c1798 New Hampshire
Flourished: 1830s-1880 Lodi, NY
Type of Work: Fabric (Carpets, coverlets)
Remarks: Sons are David and Nathan
Sources: *ChAmC 45.*

Cass, Nathan
b. c1820 New York d. 1888
Flourished: 1850-1880 Lodi, NY
Type of Work: Fabric (Weavings)
Remarks: Brother is David; father is Josiah
Sources: *ChAmC 45.*

Cassel, Joseph H.
b. c1819 Pennsylvania
Flourished: 1846-1859 Skippack, PA; East Lampeter Township, PA; Strasburg, PA
Type of Work: Fabric (Weavings)
Sources: *ChAmC 45.*

Cassell, Christian
Flourished: 1771-1772 Pennsylvania
Type of Work: Watercolor, ink (Frakturs)
Sources: *AmFoPa 187.*

Cassell, Huppert
Flourished: 1763-1773 Pennsylvania
Type of Work: Watercolor, ink (Frakturs)
Sources: *AmFoPa 187.*

Cassell, Joel D.
Flourished: 1841-1846 Pennsylvania
Type of Work: Watercolor, ink (Frakturs)
Sources: *AmFoPa 187.*

Cassini, Frank
Flourished: Galesburg, IL
Type of Work: Wood (Duck decoys)
Sources: *ArtDe 76**.

Castelnau, Francis
Flourished: c1842 Chicago, IL
Ethnicity: French
Type of Work: Pen, ink (Sketches)
Sources: *ArC 163*.

Castle, James
b. 1900
Flourished: 1969 Idaho
Type of Work: Soot on paper (Drawings)
Sources: *TwCA 170**.

Castles, Mrs. John W. (Elizabeth Eshleman)
Flourished: 1910-1937 Convent, NJ
Type of Work: Fabric (Samplers)
Sources: *AmNe 181-2, 178*, 218-9**.

Caswell, Zeruah Higley Guernsey
Flourished: 1832-1835 Castleton, VT
Type of Work: Fabric (Weavings)
Museums: 151
Remarks: Made the Caswell Carpet
Sources: *AmHo 34*; AmNe 95*; ArtWo 55, 158*; FoArtC 91-2; InAmD 94-5**.

Cather, David
Flourished: 1793-1806 Philadelphia, PA
Type of Work: Wood (Ship carvings, ship figures)
Sources: *AmFiTCa 189; ShipNA 163*.

Catlett, Lucy Tucker
Flourished: c1855-1865 Anderson, SC
Type of Work: Fabric (Quilts)
Sources: *SoFoA 193*, 222*.

Catlin, Betsy
Flourished: c1811-1815 Litchfield, CT
Type of Work: Watercolor on silk (Mourning pictures)
Museums: 133
Sources: *MoBeA fig37*.

Catterson
See: Deval and Catterson.

Cavalla, Marcel
b. 1890 d. 1972 Los Angeles, CA
Flourished: 1950- Los Angeles, CA
Ethnicity: Italian
Type of Work: Oil (Paintings)
Museums: 134
Sources: *FoAFd 5*-6*; PioPar 23, 28*-9*, 62*.

Ceeley, Lincoln J.
Flourished: Nantucket, MA
Type of Work: Wood (Weathervanes, sculptures, carvings)
Sources: *FoArtC 70*.

Cellarinus, Ferdinand
Flourished: 1859 New York, NY
Type of Work: Wood (Ship carvings, ship figures)
Sources: *AmFiTCa 189*.

Central New York Pottery Company
Flourished: c1875-1900 Utica, NY
Type of Work: Stoneware (Pottery)
Sources: *Decor 217*.

Ceramic Art Company
Flourished: 1879-1906 Trenton, NJ
Type of Work: Clay (Pottery)
Sources: *AmPoP 113, 183; DicM 67*, 176*, 181**.

Cerere, Pete
b. 1940
Flourished: Virginia
Type of Work: Wood (Sculptures)
Sources: *FoAFw 32**.

Cernigliaro, Salvatore
Flourished: 1903 Philadelphia, PA
Type of Work: Wood (Circus and carousel figures)
Sources: *AmSFor 20**.

Cervantes
Flourished: 1874 New Mexico
Type of Work: Oil (Religious paintings)
Sources: *PopAs 85**.

Cervantez, Pedro
b. 1915
Flourished: New Mexico
Type of Work: Oil (Paintings)
Sources: *PeiNa 136**.

Cerveau, Fermin
See: Cerveau, Joseph Louis Firman.

Cerveau, Joseph Louis Firman (Fermin)
b. 1812 d. 1896
Flourished: Savannah, GA
Type of Work: Tempera (Cityscape paintings)
Museums: 091
Sources: *FoPaAm 166-7*. MisPi 5*

Ceutsch, J.H.
Flourished: 1860 Philadelphia, PA
Type of Work: Wood (Ship carvings, ship figures)
Sources: *AmFiTCa 189*.

Cezeron
Flourished: 1810 Ohio; Pennsylvania
Type of Work: Oil (Portraits)
Sources: *PrimPa 170*.

Chace, B.C.
See: Chace, L..

Chace, L.
Flourished: c1850 Somerset, MA
Type of Work: Redware (Pottery)
Sources: *AmPoP 202; Decor 217*
See: Somerset Pottery.

Chadwick, H(enry) Keyes
b. 1868 d. 1959
Flourished: c1880 Martha's Vineyard, MA
Type of Work: Wood (Duck decoys)
Remarks: Crowell, Elmer often finished painting Chadwick's decoys
Sources: *AmBiDe 73-5*, 85, 250; AmSFo 24; ArtDe 174-5*.

Chain
Flourished: 1881 San Juan Pueblo, NM
Type of Work: Oil (Murals)
Sources: *PopAs 67**.

Chalker, Walter H.
Flourished: 1877 Meriden, CT
Type of Work: Tin (Tinware)
Sources: *TinC 165*.

Chaloner, Holman Waldron
b. 1851 East Machias, ME
Flourished: c1870s-1895 East Machias, ME
Type of Work: Wood (Ship carvings, ship figures)
Sources: *AmFiTCa 189; ShipNA 98-101, 157*.

Chamberlain, C.B.
Flourished: 1885-1887 Norwich, CT
Type of Work: Stoneware (Pottery)
Sources: *AmPoP 199*.

Chambers, Joseph T.
Flourished: 1858 Chicago, IL
Sources: *ArC 264*.

Chambers, Thomas
b. c1808 d. c1865
Flourished: 1834-1865 New York, NY; Boston, MA; Albany, NY
Ethnicity: English
Type of Work: Oil (Portraits, landscape paintings)
Museums: 156,189
Sources: *AmFoPa 17, 100, 109-11*, 122, 132-3*; AmFoPaS 79*; AmNa 17, 21, 43-6*; EyoAM 26, 31*; FoA 36*, 462; FoPaAm fig28; MaAmFA;NinCFo fig124; OneAmPr 78, 107, 113*; PeiNa 140*;PicFoA 19*, 26*, 99*, 103*, 113*; PrimPa 106-12*, 170*.

Chambers, Thomas
Flourished: c1910 Michigan
Type of Work: Wood (Decoys)
Sources: *WaDec 89*, 10*, 90*, 92*, 94-5*, 98*, 100-1*, 110*, 112*, fig16*.

Chambers, Tom
Flourished: 1938 Michigan
Type of Work: Wood (Duck decoys)
Museums: 260
Sources: *Decoy 56**.

Champion, Richard
Flourished: 1784-1791 Camden, SC
Type of Work: Hardpaste (Porcelain)
Sources: *AmPoP 85, 92, 237*.

Chance, A.I.
Flourished: 1853
Type of Work: Fabric (Quilts)
Sources: *AmSQu 193**.

Chanceaulier, Martin
Flourished: 1831 Baltimore, MD
Type of Work: Wood (Ship carvings, ship figures)
Sources: *AmFiTCa 189*.

Chandler
See: Trapp and Chandler.

Chandler, Daniel
b. 1729 d. 1790
Flourished: East Hartford, CT
Type of Work: Stone (Gravestones)
Sources: *EaAmG 127*.

Chandler, Daniel, Jr.
b. 1764 d. 1853
Flourished: East Hartford, CT
Type of Work: Stone (Gravestones)
Sources: *EaAmG 127*.

Chandler, Joseph Goodhue
b. 1813 South Hadley, MA d. 1884
Flourished: Boston, MA
Type of Work: Oil (Portraits)
Museums: 026,062,100,149,176,189,234
Remarks: Wife is Chandler, Lucretia Ann Waite
Sources: *AmNa 22, 47*; AmPrP 150; FoArA 49, 72-8*; NinCFo fig113; PrimPa 170; SoAmP 81**.

Chandler, Lucretia Ann Waite
b. 1820 d. 1868
Type of Work: Oil (Portraits, paintings)
Remarks: Husband is Chandler, Joseph Goodhue
Sources: *FoArA 73*.

Chandler, Thomas
Flourished: c1845-1850 Edgefield, SC
Type of Work: Stoneware (Jugs, pitchers)
Sources: *AmS 43*, 84*, 94*, 104*, 108*, 169*, 207, 257*; SoFoA ix*, 28, 216*.

Chandler, William
Flourished: c1800 Lebanon, NH
Type of Work: Stone (Gravestones)
Sources: *EaAmG 129*.

Chandler, Winthrop
b. 1747 Woodstock, CT d. 1790 Worcester, MA
Flourished: 1785-1790 Worcester, MA; Woodstock, CT
Type of Work: Oil (Portraits)
Museums: 031,189,260
Sources: *AmDecor 9-10*, 28, figiv, 53-6*, 70*, 150; AmFokDe xil, 98*; AmFoPaCe 26-34*, 45; AmFoPaS 16*; AmNa 22, 48*-9*; AmPrP 150; FoA 26, 462; FoArtC 113-4; FoPaAm 23, 27*, 29-30*; MaAmFA *; OneAmPr 46*, 47*, 78, 141, 153; PaiNE 10-1, 13, 27, 75*-83*; PicFoA 57**.

Chapin, Alpheus
b. 1787 Massachusetts d. 1870 Boston, MA
Flourished: Vermont; New York, NY; Boston, MA
Type of Work: Watercolor (Portraits)
Museums: 176
Sources: *ColAWC 120*.

Chapin, Mary S.
Type of Work: Watercolor (Paintings)
Museums: 176
Sources: *ColAWC 161, 163**.

Chaplin, J.G.
Flourished: mid 1800s Philadelphia, PA
Ethnicity: Black American
Type of Work: (Paintings)
Sources: *AfAmA 96*.

Chapman, A.
Flourished: 1849 Portland, ME
Type of Work: Wood (Ship carvings, ship figures)
Sources: *ShipNA 157*.

Chapman, Ernst
Flourished: Clark's Falls, CT
Type of Work: Fabric (Coverlets)
Sources: *ChAmC 45*.

Chapman, Hicks David
Flourished: 1939 Cape Vincent, NY
Type of Work: Wood (Cape Vincent terminal models)
Museums: 037
Sources: *FouNY 68*.

Chapman, J(osiah)
Flourished: c1810-1819 Troy, NY
Type of Work: Stoneware (Pottery)
Sources: *Decor 217; DicM 184**.

Chapman, Nathan
Flourished: 1834 Portland, ME
Type of Work: Wood (Ship carvings, ship figures)
Sources: *AmFiTCa 189; ShipNA 157*.

Chapman, T.A.
Flourished: 19th century Richwood, OH
Type of Work: Wood (Sculptures)
Museums: 208
Sources: *AmFoS 326**.

Chapman and Hastings
Flourished: 1854 Boston, MA
Type of Work: Wood (Ship carvings, ship figures)
Sources: *AmFiTCa 137, 189, figiv; ShipNA 159*.

Chapman, Upson, and Wright Manufacturers
Flourished: 1865 Middlebury, OH
Type of Work: Clay (Pottery)
Sources: *AmFokA 91*; Decor 93**.

Chappelear, Mary
Flourished: 1856
Type of Work: Fabric (Weavings)
Sources: *AmSQu 276; ChAmC 45*.

Chappell, William
Flourished: 1855 New Bedford, MA
Type of Work: Whalebones, wood (Scrimshaw sculptures)
Remarks: Sailor
Sources: *FoA 284*.

Charles, the Painter
Flourished: Keene, NH
Type of Work: Oil (Portraits)
Sources: *SoAmP 288*.

Charles Wingender and Brother
Flourished: c1890 Haddonfield, NJ
Type of Work: Clay (Pottery)
Sources: *DicM 59**
See: Wingender, Charles, Sr.

Charlestown Massachusetts Pottery
Flourished: c1804 Charlestown, MA
Type of Work: Stoneware (Pottery)
Museums: 215
Sources: *AmS 119*, 157-8*; Decor 166**.

Charlie, Peter
See: Bochero, Peter Charlie.

Charlton, F.
Flourished: 1851 Philadelphia, PA
Type of Work: Wood (Ship carvings, ship figures)
Sources: *AmFiTCa 189*.

Charlton, Frederic
Flourished: 1836 Boston, MA
Type of Work: Wood (Ship carvings, ship figures)
Sources: *AmFiTCa 189*.

Charlton and Williams
Flourished: 1860 Philadelphia, PA
Type of Work: Wood (Ship carvings, ship figures)
Sources: *AmFiTCa 189*.

Chase, Elijah
Flourished: c1845 Nantucket, MA
Type of Work: Pen, watercolor (Ship portraits)
Museums: 123
Sources: *WhaPa 108**.

Chase, Joseph T., Captain
Flourished: 1848-1851 New Bedford, MA
Type of Work: Pen, watercolor (Ship portraits)
Museums: 123
Sources: *WhaPa 107**.

Chase, L. and B.G.
See: L. and B.G. Chase.

Chase, Phineas
Flourished: c1850 Amesbury, MA
Type of Work: Redware (Pottery)
Sources: *AmPoP 187*.

Chatham's Run Factory
Flourished: c1849 Clinton County, PA
Type of Work: Fabric (Weavings)
Sources: ChAmC 45
See: Rich, John.

Chatterson, Joseph
Flourished: 1840 Philadelphia, PA
Type of Work: Wood (Ship carvings, ship figures)
Sources: AmFiTCa 189.

Chatterson, Joseph
Flourished: 1845 New York, NY
Type of Work: Wood (Ship carvings, ship figures)
Sources: AmFiTCa 189
See: Chatterson and Higgins.

Chatterson and Higgins
Flourished: 1845 New York, NY
Type of Work: Wood (Ship carvings, ship figures)
Sources: AmFiTCa 189
See: Chatterson, Joseph.

Chattin, Benjamin
Flourished: 1850
Type of Work: Fabric? (Coverlets?)
Sources: ChAmC 45.

Cheever, Miss Mary
Flourished: 1795 Massachusetts
Type of Work: Embroidery (Still life pictures)
Museums: 079
Sources: AmNe 89-90*.

Cheever, Sarah F.
Flourished: 1825 Salem, MA
Type of Work: Velvet (Paintings)
Sources: PrimPa 170.

Chelmsford Foundry Company
Flourished: 1859-1913 Chelmsford, MA; Boston, MA; Cambridge, MA
Type of Work: Metal (Weathervanes, ornamental metal works)
Sources: AmSQu 19; YankWe 210.

Chelsea China Company
Flourished: 1888-1893 New Cumberland, WV
Type of Work: White earthenware (Pottery)
Sources: AmPoP 224; DicM 258*.

Chelsea Keramic Art Works
Flourished: 1875-1889 Chelsea, MA
Type of Work: Clay (Pottery)
Sources: AmPoP 190-1; DicM 25*, 29*, 212*.

Chemical Stoneware
See: Knight, Maurice A.

Chenne, Joseph
Flourished: Nauvoo, IL
Type of Work: Fabric (Weavings)
Sources: ChAmC 45.

Cherrill, Adolphus
Flourished: 1838-1847 Jacksonville, IL; Augusta, IL; Carthage, IL
Type of Work: Watercolor (Paintings)
Sources: ArC 264.

Cheseboro
See: Hubbell and Cheseboro.

Chester, Rebecca
Flourished: 1810 Jonesboro, TN
Type of Work: Watercolor (Paintings)
Museums: 276
Sources: SoFoA 211*, 223.

Chester, Sarah Noyes
Flourished: 1740 Wethersfield, CT
Type of Work: Fabric (Weavings)
Museums: 151
Sources: AmSQu 58*.

Chester Pottery Company
Flourished: c1880- Phoenixville, PA; Chester, PA
Type of Work: Clay (Pottery)
Sources: AmPoP 166; DicM 32*, 252*.

Chew, Ada
Flourished: 1820
Type of Work: Fabric (Weavings)
Sources: AmSQu 80*.

Chief
See: Willey, Philo T.

Child, Thomas
Flourished: mid 17th century Boston, MA
Type of Work: Oil (Paintings)
Sources: HoKnAm 85.

Childers, Russell
b. 1915 Wamic, OR
Flourished: 1938- Lebanon, OR
Type of Work: Wood (Carvings)
Museums: 292, 308
Remarks: Deaf, mute, institutionalized
Sources: FoAFd 4-5*; PioPar 15, 26*-7.

Childs, Hannah
Flourished: 1815
Type of Work: Fabric (Quilts)
Sources: BirB 41*.

Chipman
Flourished: c1825-1850
Type of Work: Oil (Still life paintings)
Sources: AmNa 50*; PrimPa 170.

Chism, Mrs. Charles
Flourished: Albion, IL
Type of Work: Oil (Paintings)
Sources: ArC 108, 264.

Chittenango Pottery Company
Flourished: c1900 Chittenango, NY
Type of Work: Clay (Pottery)
Sources: AmPoP 190; DicM 31*-2*, 179*.

Choate, John C.
Flourished: 1860 Essex, MA
Type of Work: Wood (Ship carvings, ship figures)
Sources: AmFiTCa 189.

Choate and Silvester
Flourished: 1856 New Bedford, MA
Type of Work: Wood (Ship carvings, ship figures)
Sources: AmFiTCa 189.

Chollar, Thomas D.
See: Thomas D. Chollar; Chollar and Darby.

Chollar and Bennett
See: Thomas D. Chollar.

Chollar and Darby
[Thomas D. Chollar]
Flourished: c1845 Homer, NY
Type of Work: Clay (Pottery)
Sources: AmPoP 191, 194; DicM 30*.

Chore, L.
Flourished: 1838 Lisbon, OH
Type of Work: Fabric? (Coverlets?)
Sources: ChAmC 45.

Choris, Louis
Flourished: 1816 California
Type of Work: Oil (Paintings)
Sources: FoPaAm 230*.

Christ, Rudolph
Flourished: 1810-1830 Salem, NC
Ethnicity: Moravian
Type of Work: Clay (Pottery)
Remarks: At various Moravian settlements
Sources: BeyN 34*; HoKnAm 51; SoFoA 7*, 16-7*, 216-7
See: Aust, Brother Gottfried.

Christensen, Carl Christian Anton
b. 1831 d. 1912
Flourished: Utah
Type of Work: Oil (Panoramic paintings)
Sources: FoPaAm 207, fig58.

Christenson, Lars
b. 1839 d. 1910
Flourished: 1880-1890 Benson, MN
Type of Work: Wood (Religious, other carvings)
Museums: 290
Sources: AmFoS 189*; EaAmW 125*; FoAFa 6*; InAmD 24*.

Christian, Nancy
Flourished: 1818 Rockbridge County, VA
Type of Work: Fabric (Embroidered bedspreads)
Museums: 263
Sources: SoFoA 199, 201*, 223.

Christie, Bernard
Flourished: c1918 Au Gres, MI
Type of Work: Wood (Decoys)
Sources: WaDec 130*, 138*, 150*.

Christie, Henry
See: Christie, Bernard.

Christie, I.
[Chrisy]
Flourished: 1834-1843 Bergen County, NJ
Type of Work: Fabric (Coverlets)
Sources: ChAmC 45.

Christie, William
See: Christie, Bernard.

Christman, G.
Flourished: 1842-1844 Hereford Township, PA
Type of Work: Fabric (Weavings)
Sources: ChAmC 45.

Christmas, W.F.
Flourished: Allentown, PA
Type of Work: Fabric (Coverlets)
Sources: ChAmC 45.

Christner, Mrs. John
Flourished: c1910 Honeyville, IN
Ethnicity: Amish
Type of Work: Fabric (Quilts)
Sources: QuInA 35*.

Christopher Potts and Sons
Flourished: 1796-1816 Norwich, CT
Type of Work: Stoneware (Pottery)
Sources: AmPoP 199; Decor 223; EaAmFo 200*.

Church, Hannah
b. 1733
Flourished: 1747 Little Compton, RI
Type of Work: Fabric (Samplers)
Sources: GalAmS 23*.

Church, Henry, Jr.
b. 1836 d. 1908
Flourished: 1878- Chagrin Falls, OH
Type of Work: Various materials (Portraits, still life paintings, sculptures)
Sources: AmFokA 15*; AmFoPaCe 175-81*; FoA 462; FoAFw 6-9*; HoKnAm 186; PrimPa 170; ThTaT99-109*; TwCA 27*.

Churchill, Lemuel
Flourished: 1802 Baltimore, MD
Type of Work: Wood (Ship carvings, ship figures)
Sources: AmFiTCa 189.

Chute, Bill
b. 1929 Brooklyn, NY
Flourished: c1969 New Rochelle, NY
Type of Work: Oil (Railroad paintings)
Sources: AmFokArt 44-5*.

Chwalinski, Joe Moore
Flourished: 1950-1964 Oklahoma
Type of Work: Wood (Sculptures, carvings)
Sources: FoArO 73*, 89.

Cincinnati Art Pottery Company
Flourished: 1879 Cincinnati, OH
Type of Work: Clay (Pottery)
Sources: AmPoP 210; DicM 78*, 172*, 183*
See: Francisco, James F.

City Pottery Co.
Flourished: c1860-1900 Trenton, NJ
Type of Work: White Granite, cream-colored ware (Pottery)
Sources: AmPoP 182-3; DicM 241*.

Claesen, Dirick
Flourished: c1657 New York, NY
Type of Work: Redware? (Pottery)
Sources: AmPoP 196.

Claire
See: Riedinger and Caire.

Claire Pottery
See: Caire Pottery.

Clapham, J.
Flourished: 1849 Union County, PA
Type of Work: Fabric (Coverlets)
Remarks: Inscription West Buffaloe Factory Union Co. Penn 1849
Sources: ChAmC 45.

Clapperton, William R.
Flourished: c1850 Chicago, IL
Type of Work: (Ornamental and landscape paintings)
Sources: ArC 264.

Clark
See: Fenton and Clark.

Clark, Abna
Flourished: Connecticut
Type of Work: Tin? (Tinware?)
Sources: TinC 165.

Clark, Alvan
b. 1804 d. 1864
Flourished: Massachusetts; Rhode Island
Type of Work: Oil (Miniature paintings)
Sources: PrimPa 170; SoAmP 286.

Clark, Ann Eliza
b. Providence?, RI? d. 1860
Flourished: 1791 Bristol, RI
Type of Work: Pencil (Genre drawings in a letter)
Museums: 241
Sources: LeViB 94-5, 110, 122, 139, 209-11, 213*, 216-7, 220.

Clark, Anson
b. 1783 Connecticut
Flourished: 1825 West Stockbridge, MA
Type of Work: Wood (Painted picture frames)
Sources: FlowAm 252*; NeaT 30*.

Clark, Benjamin
Flourished: 1850-1879 Lyndeboro, NH
Type of Work: Redware (Pottery)
Remarks: Son of William Clark
Sources: AmPoP 195.

Clark, Charles
Flourished: 1877 Meriden, CT
Type of Work: Tin (Tinware)
Sources: TinC 165.

Clark, Decius W.
b. Bennington, VT
Flourished: 1859-1865 Peoria, IL
Type of Work: Yellow-ware, white-ware, Rockingham (Pottery)
Sources: ArC 194.

Clark, Elisha
Flourished: Connecticut
Type of Work: Tin (Tinware)
Sources: TinC 165.

Clark, Elizabeth Potter
Flourished: 1830 New London, CT
Type of Work: Velvet (Paintings)
Sources: PrimPa 170.

Clark, Emily
b. c1820
Flourished: 1832 New Haven?, CT?
Type of Work: Fabric (Samplers)
Sources: AmNe 62.

Clark, Enos
Flourished: c1800 East Poultney, VT
Type of Work: Stone (Gravestones)
Sources: EaAmG 129.

Clark, F.C.
Flourished: 1845
Type of Work: Watercolor (Landscape paintings)
Sources: PrimPa 170.

Clark, Floyd
b. 1913 Mulberry Springs, TX
Flourished: 1970s- Jefferson, TX
Type of Work: Acrylic (Paintings)
Remarks: Also made frames of various materials for wife's (Clark, Mildred Foster) works
Sources: FoAFj 12*-3*.

Clark, Frances
b. 1835 d. 1916
Type of Work: Oil (Paintings)
Museums: 203
Sources: ArtWo 108*, 158.

Clark, Mrs. Frank T.
Flourished: 19th century Cheshire, CT
Type of Work: Fabric (Embroidered pictures)
Sources: AmNe 108; PrimPa 170.

Clark, G.W.
Flourished: c1855 Chicago, IL
Type of Work: (Portraits)
Sources: ArC 264.

Clark, George S.
Flourished: c1846-1849 Nantucket, MA
Type of Work: Pen, watercolor (Whaling scene paintings)
Museums: 123
Sources: *WhaPa fig.*

Clark, Harry A.
Flourished: 1855 Chicago, IL
Type of Work: Crayon (Drawings)
Sources: *ArC 264.*

Clark, Irene
Flourished: 1927 Washington, DC
Ethnicity: Black American
Type of Work: Paint (Portraits, scene paintings)
Sources: *AmNeg 24, 45*-6, 72, pl49, 100.*

Clark, Isaac
Flourished: c1831-1837 Cincinnati, OH
Type of Work: Redware (Pottery)
Sources: *AmPoP 210.*

Clark, J.
See: J. Clark and Company.

Clark, Jacob N.
Flourished: 1835 Richland County, OH; Newark, OH
Type of Work: Fabric (Weavings)
Sources: *ChAmC 45.*

Clark, John
Flourished: 1815 Waltham, MA
Type of Work: Metal (Weathervanes)
Sources: *YankWe 211.*

Clark, John W.
Flourished: 1859 New York, NY
Type of Work: Wood (Ship carvings, ship figures)
Sources: *AmFiTCa 189.*

Clark, Leon "Peck"
b. 1906 Miltonville, MS
Flourished: 1949- Sharon, MS
Ethnicity: Black American
Type of Work: Wood (Baskets)
Sources: *LoCo xviii-xix, 33*-51.*

Clark, Levin P.
Flourished: 1851 Baltimore, MD
Type of Work: Wood (Ship carvings, ship figures)
Sources: *AmFiTCa 189.*

Clark, Mary Ann
Flourished: 1812 Woodbury, NJ
Type of Work: Fabric (Samplers)
Sources: *PlaFan 65*.*

Clark, Mason
Flourished: 1850s Princeton, IL
Type of Work: Pen, watercolor, oil (Paintings)
Sources: *ArC 264.*

Clark, Mildred Foster
b. 1923 Avinger, d. c1980 Texas
Flourished: 1970s Jefferson, TX
Type of Work: Acrylic (Paintings)
Remarks: Husband is Floyd
Sources: *FoAFj 12*-3*.*

Clark, Minerva
Flourished: c1825-1840
Type of Work: Oil (Paintings)
Sources: *Edith *; PrimPa 170.*

Clark, N.
See: N. Clark and Company.

Clark, Nathan
See: Nathan Clark Pottery.

Clark, Nathan, Jr.
Flourished: 1843-1892 Athens, NY
Type of Work: Clay (Pottery)
Sources: *Decor 217; EaAmFo 105*, 266**
See: Nathan Clark Pottery.

Clark, Nathaniel
Flourished: 1817-1823 Connecticut
Type of Work: Tin (Tinware)
Sources: *TinC 165.*

Clark, Patrick
Flourished: 1813 Meriden, CT
Type of Work: Tin (Tinware)
Remarks: Stedman and Clark
Sources: *TinC 165.*

Clark, Peter
Flourished: 1775 Lyndeboro, NH; Braintree, MA
Type of Work: Clay (Pottery)
Remarks: Son is William
Sources: *AmPoP 189, 195; FoArtC 43.*

Clark, Peter, III
Flourished: c1800-1820 Lyndeboro, NH
Type of Work: Redware (Pottery)
Remarks: Son of William Clark
Sources: *AmPoP 195.*

Clark, R.
See: R. Clark and Company.

Clark, Samuel
Flourished: 1819-23 Bloomfield, CT; Lansingburgh, NY
Type of Work: Tin (Tinware)
Sources: *TinC 165-6.*

Clark, W.M.A.
See: W.M.A. Clark's Superior Friction Matches.

Clark, William
Flourished: c1826-1855 Lyndeboro, NH
Type of Work: Redware (Pottery)
Remarks: Father is Peter; son is Benjamin
Sources: *AmPoP 195*
See: Southwick, John.

Clark and Company Pottery
Flourished: 1814-1837 Rochester, NY; Athens, NY; Lyons, NY
Type of Work: Stoneware (Pottery)
Sources: *AmSFo 47; Decor 23; EaAmFo 128*.*

Clark and Fox
Flourished: 1828-1850 Athens, NY
Type of Work: Redware, stoneware (Pottery)
Sources: *AmPoP 187, 258; AmS 79-80*; EaAmFo 105*, 266*; InAmD 85**
See: Nathan Clark Pottery.

Clark and Lundy
Flourished: 1825-1826 Troy, NY
Type of Work: Stoneware (Churns)
Sources: *AmS 94*.*

Clark and Risely
Flourished: 1859 New York, NY
Type of Work: Wood (Ship carvings, ship figures)
Sources: *AmFiTCa 189.*

Clark Leonard and Company
Flourished: 1871 Charlestown, MA
Type of Work: Wood (Ship carvings, ship figures)
Sources: *AmFiTCa 195.*

Clarke, David
Type of Work: Watercolor (Paintings)
Sources: *PrimPa 170.*

Clarke, Harriet B.
Flourished: 1820 New York
Type of Work: Velvet (Paintings)
Sources: *PrimPa 170.*

Clarke, Laura Etta
Flourished: 1902 Barrington, NH
Type of Work: Fabric (Hooked rugs, bed rugs)
Sources: *AmHo 95*.*

Clarke, S.S.
Flourished: 1838-1868 Meriden, CT
Type of Work: Tin (Tinware)
Remarks: Employed about 60 people
Sources: *TinC 166.*

Clarke, Warren
Flourished: 1839 Berlin, CT
Type of Work: Tin (Tinware)
Sources: *TinC 166.*

Classic Woodcarving Company
Flourished: c1920s New York, NY
Type of Work: Wood (Duck decoys)
Sources: *AmBiDe 229, 279.*

Clayman, Susan
Flourished: Pennsylvania
Type of Work: Fabric (Bed rugs)
Sources: *FoArRP 187*.*

Clayton, Theodore
b. 1934 Hart County, KY
Flourished: 1971 Kentucky
Type of Work: Metal (Sculptures)
Sources: FoAroK *.

Clearfield Textile Mill
Flourished: 1849 Knox County, OH
Type of Work: Fabric (Coverlets)
Sources: ChAmC 45.

Cleaveland, Mrs. Mary
Flourished: 1850 Massachusetts
Type of Work: Fabric, various materials (Genre scene sculptures)
Museums: 079
Sources: AmNe 38*, 40.

Cleaveland, Nathan
Flourished: 1810-1826 Franklin, MA
Type of Work: Wood (Boxes)
Sources: NeaT 101, 112, 134, 194.

Cleever, John
Flourished: 1843-1855 Forks Township, PA; Easton, PA
Type of Work: Fabric (Weavings)
Sources: ChAmC 45.

Clein, Mathias
See: Klein, Mathias.

Cleland, Jennie
Flourished: 1861 Pennsylvania
Type of Work: Fabric (Quilts)
Sources: HoKnAm pl30.

Clemens, Johannes
Flourished: 1816 Pennsylvania
Type of Work: Watercolor, ink (Frakturs)
Sources: AmFoPa 187.

Clements, Seth
Flourished: 1851 Baltimore, MD
Type of Work: Wood (Ship carvings, ship figures)
Sources: AmFiTCa 189.

Cleveland, Mrs.
Type of Work: Husks (Corn husk toy)
Sources: AmSQu 176*.

Cleveland, William
Flourished: 1800-1814 Norwich, CT
Type of Work: Stoneware (Pottery)
Sources: AmPoP 199; Decor 224.

Cleveland and Company
Flourished: c1839 Chicago, IL
Type of Work: Oil (Sign and ornamental paintings)
Sources: ArC 159.

Cleveland Glass Works
Flourished: 1870 Cleveland, OH; Oswego County, NY
Type of Work: Glass (Glass works)
Museums: 219
Sources: FouNY 63.

Clews, James
[Clews Indiana Pottery]
Flourished: 1837-1838 Troy, IN
Type of Work: Clay (Pottery)
Sources: AmPoP 74, 77, 88, 231.

Clews Indiana Pottery
See: Clews, James.

Clifford, Edward M.
Flourished: c1846 Chicago, IL
Type of Work: Oil? (Portraits)
Sources: ArC 168.

Clifford, Robert
Flourished: contemporary Brewster, MA
Type of Work: Wood (Decorative duck decoys)
Sources: WoCar 170*.

Cline, Elizabeth Ann
Flourished: 1865 Denver, CO
Type of Work: Fabric (Quilts)
Museums: 068
Sources: AmSQu 186*, 194*; FlowAm 269*.

Clinton, George H.
Flourished: 1860 New Haven, CT
Type of Work: Wood (Ship carvings, ship figures)
Sources: AmFiTCa 189.

Cloister, Ephrata
Flourished: 1728 Lancaster County, PA
Type of Work: Tin (Tinware)
Sources: AmFokDe 143-4.

Clough, Ebenezer
Flourished: 1800-1818 Boston, MA
Type of Work: Wood (Wallpaper designs)
Museums: 057
Sources: AmSFok 153; NeaT 48-50*.

Clough, Calhoun and Company
Flourished: 1842-1848 Portland, ME
Type of Work: Stoneware (Pottery)
Sources: Decor 217.

Cluczs, H.
Flourished: 1876 Detroit, MI
Type of Work: Oil (Ship portraits)
Sources: FoPaAm 212*.

Coab, Joseph
Flourished: Berlin, CT
Type of Work: Paint (Carriage paintings)
Sources: TinC 166.

Coaxum, Bea
Flourished: contemporary Mount Pleasant, SC
Ethnicity: Black American
Type of Work: Grass (Baskets)
Sources: FoAFcd 9*.

Cobb, Anna C.
Type of Work: Charcoal (Still life paintings)
Museums: 176
Sources: ColAWC 232-4*.

Cobb, Arthur A(lbert)
Flourished: c1880 Cobb's Island, VA
Type of Work: Wood (Duck decoys)
Remarks: Brothers are Nathan and Elkenah
Sources: AmBiDe 153; AmDecoy 37*; ArtDe 164.

Cobb, Cyrus
b. 1834 d. 1905
Flourished: Malden, MA
Type of Work: Oil (Portraits)
Sources: SoAmP 287.

Cobb, Darius
b. 1834 d. 1919
Flourished: Malden, MA
Type of Work: Oil (Portraits)
Sources: SoAmP 287.

Cobb, E(lkenah), Captain
b. 1852 d. 1943
Flourished: c1870 Cobb's Island, VA
Type of Work: Wood (Duck decoys)
Museums: 260
Remarks: Brothers are Arthur and Nathan
Sources: AmBiDe 152-3; AmDecoy 37*; ArtDe 164; Decoy 47*; WiFoD 142-3*.

Cobb, Elijah
Flourished: c1860 Cobb's Island, VA
Type of Work: Wood (Duck decoys)
Museums: 260
Sources: Decoy 60*.

Cobb, N(athan), Jr.
Flourished: c1860 Cobb's Island, VA
Type of Work: Wood (Duck decoys)
Museums: 260
Remarks: Brothers are Elkenah and Arthur
Sources: AmBiDe 17, 30, 151-2, figvii; AmDecoy xii, 25*, 36-7*, 67*; AmFoS 298*; AmSFo 25; ArtDe 129; Decoy 67*, 94*, 113*.

Coble, Henry K.
Type of Work: Fabric (Coverlets)
Sources: ChAmC 45
See: Keener, Henry or Jacob.

Cochran, Hazel
Flourished: 1952 Oklahoma
Type of Work: Fabric
Sources: FoArO 92.

Cochran, Robert
Flourished: c1862-1877 Orrville, OH
Type of Work: Stoneware (Pottery)
Sources: AmPoP 226; Decor 219
See: Hall, Amos.

Cockefair Mills
Flourished: c1816-1911 Harmony Township, IN
Type of Work: Fabric (Coverlets)
Museums: 096
Sources: ChAmC 45.

Codman, Charles
Flourished: 1800-1825 Portland, ME
Type of Work: Oil (Masonic, sign and ornamental paintings)
Sources: *AmDecor 138, 140*; Bes 36, 106.*

Codman, William P.
Flourished: 1805 Boston, MA
Type of Work: Oil (Portraits)
Sources: *PrimPa 170.*

Codner, Abraham
d. 1750
Flourished: Boston, MA
Type of Work: Stone (Gravestones)
Remarks: Father is William; brother is John
Sources: *EaAmG 128; GravNE 61, 127.*

Codner, John
d. c1770
Flourished: c1760 Boston, MA
Type of Work: Stone (Gravestones)
Remarks: Father is William; brother is Abraham
Sources: *EaAmG 128; GravNE 61, 127.*

Codner, William
b. 1709 **d.** 1769
Flourished: 1715-1768 Boston, MA
Type of Work: Stone (Gravestones, other stoneworks)
Remarks: Sons are John and Abraham
Sources: *AmFokAr 173, fig170; AmFoSc 95*; EaAmG 41*, 128; GravNE 56, 59-61, 127.*

Coe, Clark
Flourished: early 20th cent Killingworth, CT
Ethnicity: Black American
Type of Work: Wood, metal (Sculptures, carvings)
Remarks: Killingworth "images", animated figural group of life-sized images in a waterway
Sources: *AmFokArt 46-7*; AmFoS 364*; FoAFm 2; FoScu 37*; TwCA 36*.*

Coe, Elias V.
Flourished: 1840 Warwich, NY
Type of Work: Oil (Portraits)
Sources: *PrimPa 170.*

Coffin, Henry
Flourished: 1865 Boston, MA
Type of Work: Wood (Ship carvings, ship figures)
Sources: *AmFiTCa 189.*

Coffin, William A.
Type of Work: Oil (Portraits)
Sources: *PrimPa 170.*

Cogburne and Massey
Flourished: c1820 Washington County, GA
Type of Work: Stoneware (Jugs)
Sources: *AmS 108*.*

Coggeshall, Eliza
b. 1773 Newport, RI
Flourished: 1784 Newport, RI
Type of Work: Fabric (Samplers)
Remarks: Half-sister is Esther
Sources: *LeViB 61, 84*-5, 215.*

Coggeshall, Esther
b. 1764 Newport, RI
Flourished: 1774 Newport, RI
Type of Work: Fabric (Samplers)
Museums: 054
Remarks: Half-sister is Eliza
Sources: *LeViB 61, 83*, 87.*

Coggeshall, Martha
See: Coggeshall, Patty.

Coggeshall, Mary
See: Coggeshall, Polly.

Coggeshall, Patty
b. 1780 Bristol, RI **d.** 1797
Flourished: 1790-1795 Bristol, RI
Type of Work: Fabric (Samplers)
Museums: 151
Sources: *AmNe 43*, 47; ArtWo 15*; LeViB 213, 222*, 225-6.*

Coggeshall, Polly
b. 1777 Bristol, RI
Flourished: 1790 Bristol, RI
Type of Work: Fabric (Samplers)
Sources: *LeViB 220, 222*.*

Cohen, Alfred
Flourished: 1830's Woodford County, KY
Ethnicity: French
Type of Work: Fresco (Ornamental paintings)
Remarks: Born in Marseilles
Sources: *AmDecor 121.*

Cohen, F.E.
Flourished: 1840-1850 Detroit, MI; Oberlin, OH
Type of Work: Oil (Paintings)
Museums: 096
Sources: *FoPaAm 188-9*.*

Cohen, Gideon
b. 1895
Flourished: 1965- Arlington, MA
Type of Work: Oil (Paintings)
Sources: *NinCFo 38-42*.*

Cohoon, Hannah
[Cahoon]
b. 1788 **d.** 1864
Flourished: 1845 Hancock, MA
Ethnicity: Shaker
Type of Work: Watercolor, ink (Religious drawings)
Museums: 094
Sources: *AmFoPaCe 58-65*; AmFoPaN 173, 182*; ArtWo 94-5, 97*, 158-9; FoA 462.*

Coist, P.F.
Flourished: 1880-1890
Type of Work: Wood? (Boxes?)
Sources: *NeaT fig24*, 187.*

Colburn, Paul
b. 1761 **d.** 1825
Flourished: Sterling, MA
Type of Work: Stone (Gravestones)
Sources: *EaAmG 128; GravNE 127.*

Colby
See: Campbell and Colby.

Colby, John
Flourished: Mystic, CT
Type of Work: Wood (Ship carvings, ship figures)
Sources: *ShipNA 72, 155.*

Colby, Emery and Company
Flourished: 1868 Bucksport, ME
Type of Work: Wood (Ship carvings, ship figures)
Sources: *ShipNA 156.*

Colclough, Jim "Suh Jim"
b. 1900? Portsmouth, AR
Flourished: 1960- Westport, CA
Type of Work: Wood (Sculptures, carvings)
Sources: *ConAmF 92-7*; PioPar 27, 32*.*

Colclough, William
Flourished: c1875- East Liverpool, OH
Type of Work: Rockingham (Pig banks, clay pipes)
Sources: *AmPoP 219.*

Cole, A.
Flourished: 1850
Type of Work: Watercolor (Historical paintings)
Sources: *PrimPa 170.*

Cole, A.C.
Flourished: c1839 Chicago, IL
Type of Work: Oil (Sign and ornamental paintings)
Sources: *ArC 159.*

Cole, Abraham
Flourished: 1835-1840 New York
Type of Work: Wood, paint (Clocks)
Remarks: Brother is Rufus
Sources: *FouNY 62.*

Cole, Anthony
Flourished: 1840-1844 Cincinnati, OH
Type of Work: Fabric (Carpets, coverlets)
Sources: *ChAmC 45.*

Cole, Charles Octavius
Flourished: 1830-1840 Newburyport, MA
Type of Work: Oil (Portraits)
Sources: *PrimPa 170.*

Cole, Dexter K.
Flourished: 1833 Darien, CT
Type of Work: Wood (Ship carvings, ship figures)
Sources: *ShipNA 155.*

Cole, J.C.
Flourished: 1861 Vernon Township, OH
Type of Work: Fabric (Weavings)
Sources: *AmSQu 276; ChAmC 46.*

Cole, John
Flourished: Berlin, CT
Type of Work: Tin? (Tinware?)
Sources: *TinC 166.*

Cole, Joseph Greenleaf
b. 1803 **d.** 1858
Flourished: 1826 Ellsworth, ME
Type of Work: Oil (Portraits)
Sources: *SoAmP 164*.*

Cole, Lyman Emerson
Flourished: 1830-1840 Newburyport, MA
Type of Work: Oil (Portraits)
Sources: *PrimPa 171.*

Cole, Major
Flourished: 1810 New Hampshire
Type of Work: Oil (Portraits)
Sources: *PrimPa 171.*

Cole, Maria
Flourished: 1830 Cheshire, MA
Type of Work: Velvet (Paintings)
Sources: *EyoAm 26; PrimPa 171.*

Cole, Richard
b. 1932 Portland, OR **d.** 1971 Stevenson, WA
Flourished: 1968-
Type of Work: Wood, stone (Carvings)
Sources: *PioPar 15, 27*, 30, 63.*

Cole, Rufus
b. 1804 Broadalbin, NY
Flourished: 1835-1840 Montgomery County?, NY
Type of Work: Wood, paint (Clocks)
Remarks: Brother is Abraham
Sources: *FouNY 62.*

Cole Pottery
Flourished: 1890-1900 Seagrove, NC
Type of Work: Stoneware (Pottery)
Sources: *AmPoP 241.*

Coleman
Flourished: 19th century
Type of Work: Chalk (Whaling scene paintings)
Museums: 176
Sources: *ColAWC 190, 193*; FoPaAm 228*.*

Coleman, Alvin
Flourished: 1836- New Bedford, MA
Type of Work: Wood (Ship carvings, ship figures)
Sources: *AmFiTCa 147, 187; ShipNA 160.*

Coleman, Hezekiah
Flourished: 1836 New Bedford, MA
Type of Work: Wood (Ship carvings, ship figures)
Sources: *AmFiTCa 147, 187; ShipNA 160.*

Coleman, Sarah Whinery
Flourished: 1840 Columbus, OH
Type of Work: Fabric (Weavings)
Sources: *ArtWea 233*.*

Coleman, William, Captain
Flourished: 1844-1846 Nantucket, MA
Type of Work: Pencil, pen, watercolor (Flag guide drawings)
Museums: 123
Sources: *WhaPa 127*, 155.*

Coles, John, Jr.
Flourished: 1807-1820 Boston, MA
Type of Work: Oil (Portraits)
Sources: *PrimPa 171.*

Collie, S.
Flourished: 1865-1870 Jefferson County, NY
Type of Work: Watercolor (Paintings)
Museums: 102
Sources: *FouNY 67.*

Collier, Richard
Flourished: c1779 Norwich, CT
Type of Work: Copper (Warming pans)
Sources: *AmCoB 86-7*.*

Collings, S.
Flourished: 1834
Type of Work: Fabric (Weavings)
Sources: *AmSQu 276; ChAmC 46.*

Collins
See: Train and Collins.

Collins, Abraham
Flourished: 1810 Philadelphia, PA
Type of Work: Wood (Ship carvings, ship figures)
Sources: *AmFiTCa 189; ShipNA 162.*

Collins, Benjamin
b. 1691,1722 Lebanon, CT **d.** 1759
Flourished: c1734 Lebanon, CT
Type of Work: Stone (Gravestones)
Remarks: Son is Zerubbabel
Sources: *EaAmG 127; GravNE 105, 127.*

Collins, C.
Flourished: 1810 South Hadley, MA
Type of Work: Watercolor (Memorial paintings)
Sources: *PrimPa 171.*

Collins, Julius
b. 1728 **d.** 1758
Flourished: Lebanon, CT
Type of Work: Stone (Gravestones)
Sources: *EaAmG 127.*

Collins, Nicholas E.
b. 1838
Flourished: 1850-1878 New York, NY
Type of Work: Wood (Cigar store Indians, figures)
Remarks: Partner of Brown, Charles
Sources: *ArtWod 242-3; CiStF 29*
See: Collins and Brown.

Collins, Samuel, Sr.
Flourished: c1847 Essex, CT
Type of Work: Wood (Duck decoys)
Museums: 260
Sources: *AmBiDe 71; Decoy 39*, 76*.*

Collins, Samuel, Jr.
Flourished: Essex, CT
Type of Work: Wood (Duck decoys)
Museums: 260
Sources: *Decoy 69*.*

Collins, Sister Sarah
Flourished: 1800-1900s Mount Lebanon, NY
Ethnicity: Shaker
Type of Work: Fabric (Rugs)
Museums: 259
Sources: *HanWo 103, 138*
See: Andersen, Elder William; Wagan, Robert.

Collins, Thomas
Flourished: 1775 New York, NY
Ethnicity: English
Type of Work: Wood (Ship carvings, ship figures)
Sources: *AmFiTCa 189.*

Collins, William
Flourished: Albany, NY
Type of Work: Oil (Paintings)
Sources: *SoAmP 81.*

Collins, Zerubbabel
b. 1733 Lebanon, CT **d.** 1797
Flourished: 1786-1794 Lebanon, CT; Bennington, VT; Shaftsbury, VT
Type of Work: Stone (Gravestones)
Remarks: Father is Benjamin
Sources: *EaAmG 127, viii, 76*; GravNE 111, 127.*

Collins and Brown
[Nicholas E. and Charles]
Flourished: 1871 New York, NY
Type of Work: Wood (Ship carvings, ship figures)
Sources: *AmFiTCa 189; ArtWod 243, 245*.*

Collis, Miss
Flourished: 1830 Rhode Island
Type of Work: Watercolor (Paintings)
Sources: *PrimPa 171.*

Collis, S.C.
Flourished: Philadelphia, PA
Type of Work: Copper (Stencils)
Sources: *AmCoB 118*.*

Collot, George Henri Victor
Flourished: 1796 Illinois
Type of Work: Pen, ink (Sketches)
Sources: *ArC 26-7*, 49*.*

Collyer, Thomas
Flourished: 1850 New York, NY
Type of Work: Wood (Ship carvings, ship figures)
Sources: *AmFoS 127*; Edith *.*

Colman, Peter
Flourished: 1851-1854 Chesterville, OH; Thornville, OH
Type of Work: Fabric (Weavings)
Sources: *AmSQu 276; ChAmC 46.*

Colton, Lucretia
b. 1788
Flourished: c1800 Longmeadow, MA
Type of Work: Fabric (Embroidered religious samplers)
Sources: *AmNe 83.*

Colton, S.
Flourished: 1841
Type of Work: Tin? (Tinware?)
Remarks: May have worked for Filley
Sources: *TinC 166.*

Columbian Art Pottery
Flourished: 1875 Trenton, NJ
Type of Work: Clay (Pottery)
Sources: *DicM 31*, 239*.*

Columbian Pottery
Flourished: c1830-1835 Perth Amboy, NJ
Type of Work: Stoneware (Pottery)
Sources: *AmPoP 175; Decor 217*
See: Warner, William E.

Combs, Frank
See: Coombs, Frank.

Commeraw, Thomas H.
See: Commeraw's Pottery.

Commeraw's Pottery
[Commeraw, Thomas H.]
Flourished: 1802-1820 Corlears Hook, NY
Type of Work: Stoneware (Pottery)
Sources: *AmPoP 197; AmS 34*, 84*, 155; Decor 217; DicM 31*; EaAmFo 106*, 150*, 191*, 249*, 252*.*

Commiller, Lewis
Flourished: 1850 St. Charles, MO
Type of Work: Tin (Tinware)
Sources: *ASeMo 428.*

Comstock, Mary
Flourished: 1810 Shelburne, VT
Type of Work: Fabric (Bed rugs)
Museums: 260
Sources: *AmHo 10-11*; ArtWo 4*.*

Cona
Flourished: c1865 Grane? County, KY
Type of Work: Fabric (Quilts)
Sources: *KenQu fig20.*

Conant, Maria T.
Flourished: 1840 Cambridge, NY
Type of Work: Oil (Portraits)
Sources: *PrimPa 171.*

Conant, S.
Flourished: c1846 Springfield, IL
Type of Work: Wood (Furniture)
Sources: *ArC 175*.*

Concklin
Flourished: 1809 Washington, DC
Type of Work: Wood (Ship carvings, ship figures)
Sources: *ShipNA 155.*

Condy, Mrs.
Flourished: c1738 Boston, MA
Type of Work: Needlepoint (Chimney pieces)
Sources: *AmDecor 24.*

Congdon, Catharine
b. 1763 Newport, RI d. 1833
Flourished: 1773 Newport, RI
Type of Work: Fabric (Samplers)
Museums: 056
Sources: *LeViB 17, 40-1*, 70*.*

Conger, Daniel
b. c1813 New York
Flourished: c1850-1856 Wolcott, NY
Type of Work: Fabric (Weavings)
Sources: *ChAmC 46*
See: Spencer, William; Huntington, Edwin.

Conger, J.
Flourished: 1839 New York
Type of Work: Fabric (Weavings)
Sources: *AmSQu 276*
See: Conger, Jonathan.

Conger, John
Flourished: 1827-1835 New York, NY
Type of Work: Wood (Cakeboards)
Sources: *BeyN 120.*

Conger, John
Flourished: 1830 New York, NY
Type of Work: Wood (Ship carvings, ship figures)
Sources: *AmFiTCa 189.*

Conger, Jonathan
Flourished: 1834-1839 Groton, NY; Southport, NY
Type of Work: Fabric (Carpets, coverlets)
Sources: *ChAmC 46*
See: Detterich, George; Conger, J.

Congress Pottery
Flourished: 1828-1854 South Amboy, NJ
Type of Work: Stoneware (Pottery)
Sources: *AmPoP 180; Decor 218*
See: Hancock, William H.; Cadmus, Abraham; Price, G.

Conian, P.T.
Flourished: 1865 Boston, MA
Type of Work: Wood (Ship carvings, ship figures)
Sources: *AmFiTCa 189.*

Conklin, Ananias
Flourished: 1639 Salem, MA; Peabody, MA
Type of Work: Clay (Pottery)
Sources: *AmPoP 56, 200.*

Conklin, Hurley
Flourished: contemporary Manahawkin, NJ
Type of Work: Wood (Duck decoys)
Sources: *WoCar 135*, 149*.*

Conklin, Roy
Flourished: Alexandria Bay Area, NY
Type of Work: Wood (Duck decoys)
Sources: *FouNY 27*, 64.*

Conner, C.S.
Flourished: 1839
Type of Work: Fabric (Weavings)
Sources: *AmSQu 276; ChAmC 46.*

Conner, Morris
Flourished: 1830 Henniker, NY
Type of Work: Watercolor, ink (Frakturs)
Sources: *PrimPa 171.*

Conner, William M.
Flourished: 1870 Philadelphia, PA
Type of Work: Wood (Ship carvings, ship figures)
Sources: *AmFiTCa 189.*

Conoly, David
Flourished: 1838 Farmington, OH
Type of Work: Fabric (Weavings)
Sources: *ChAmC 46.*

Conover, Henry
Flourished: 1810-1830 Monmouth County, NJ
Type of Work: Pastel (Portraits)
Sources: *PrimPa 171.*

Conrad, Ann
Flourished: 1829 Philadelphia, PA
Type of Work: Fabric (Embroidered pictures)
Sources: *AmNe 90, 83*.*

Constant, Sophia
See: Burpee, Sophia.

Contis, Peter A.
b. 1890
Flourished: 1950 Pittsburgh, PA
Type of Work: Tempera (Cityscape paintings)
Sources: *FoA 462; FoPaAm 111*; FouNY 55*, 67; TwCA 170*.*

Convay, John B.
Flourished: 1844 Peoria, IL
Type of Work: Clay (Pottery)
Sources: *ArC 190.*

Converse, Hannah
Flourished: early 19th cent Vermont
Type of Work: Ink (Mourning pictures)
Museums: 263
Sources: *MoBeA fig26.*

Cook
See: Weeks, Cook and Weeks.

Cook, Mr.
Flourished: 1840 Stepney, CT
Type of Work: Wood (Weathervanes)
Sources: *YankWe 68*.*

Cook, Eunice W.
Flourished: 19th century Vermont
Type of Work: Fabric (Quilts)
Museums: 189
Sources: *ArtWo 47-8*; InAmD 130*.*

Cook, G.W.E.
Flourished: 1855 Lacon, IL
Type of Work: Pencil (Drawings)
Sources: *ArC 264.*

Cook, Harvey
Flourished: 1851 West Virginia
Type of Work: Fabric (Weavings)
Sources: *AmSQu 276; ChAmC 46.*

Cook, Jermima Ann (Jermina)
[Mrs. Philip Drury Cook]
b. Virginia
Flourished: 1860 Union County, SC
Type of Work: Fabric (Weavings, quilts)
Sources: *AmNe 37, 39*; AmSQu 76; QuiAm 190-2*.*

Cook, John
Flourished: 1840-1851 Ohio
Type of Work: Fabric (Weavings)
Sources: *ChAmC 46.*

Cook, Mehitable J.
Flourished: 1830 Maine
Type of Work: Oil (Portraits)
Sources: *PrimPa 171.*

Cook, Phebe
Flourished: 1872 Mt. Gilead, OH
Type of Work: Fabric (Quilts)
Museums: 208
Sources: *QuiAm 342*.*

Cook, R.K.
b. 1892 Bay City, MI d. 1963
Flourished: 1920s Lansing, MI
Type of Work: Wood, cement (Mummy cases, carvings)
Sources: *Rain 64*, 65*.*

Cook, Ransom
b. 1892 Bay City, MI
Flourished: 1920s- Lansing, MI
Type of Work: Wood, cement (Mummy cases, carvings)
Museums: 105
Sources: *Rain 64*-5*.*

Cook, S.
Flourished: Chatham, CT
Type of Work: Iron (Waffle irons)
Sources: *EaAmI 50*.*

Cook, Valentine
[Koch]
b. c1820 d. 1869 Hanover, PA
Flourished: c1850-1869 Hanover, PA
Type of Work: Fabric (Coverlets)
Sources: *ChAmC 46*
See: Kump, Andrew.

Cook, William
Flourished: 1804-1815 New York, NY
Type of Work: Wood (Ship carvings, ship figures)
Sources: *AmFiTCa 190; ShipNA 161.*

Cook and Richardson
[Fairbank Cook and Company]
Flourished: 1869-1887 Akron, OH
Type of Work: Stoneware (Pottery)
Sources: *AmPoP 206; Decor 218.*

Cook Pottery Company
[J. Cook Pottery Company]
Flourished: 1895-1900 Trenton, NJ
Type of Work: Clay (Pottery)
Sources: *AmPoP 183; DicM 156*, 168*, 212*, 232*.*

Cooke, Captain
Flourished: 1910-1915 Miami, FL; New Bedford, MA
Type of Work: Oil (Ship paintings)
Sources: *FoA 58*, 462; TwCA 42*.*

Cooke, George
b. 1793 d. 1849
Flourished: 1830-1842 Columbus, GA
Type of Work: Oil (Indian portraits)
Museums: 273
Sources: *ArC 113; MisPi 36*.*

Cooley, William H.
Flourished: 1860 Springfield, MA
Type of Work: Wood (Ship carvings, ship figures)
Sources: *AmFiTCa 190.*

Coolidge, E.B.
Flourished: 19th cent
Type of Work: Fabric, paint (Mourning pictures)
Sources: *Edith *.*

Cooly
Flourished: 1846 Springfield?, MA
Type of Work: Oil? (Portraits, daguerreotypes)
Remarks: Partner with Stock, Joseph Whiting
Sources: *AmFoPa 87-8.*

Coombs, Frank
[Combs]
Flourished: Alexandria Bay Area, NY
Type of Work: Wood (Duck decoys)
Sources: *AmBiDe 106, 108*; ArtDe 190; FouNY 26*, 63; WoScuNY.*

Coon, Clara
Flourished: 1920 Kansas
Ethnicity: Amish
Type of Work: Fabric (Quilts)
Sources: *QuIInA 62*.*

Coon, Phillip
Flourished: 1970 Oklahoma
Type of Work: Sandstone (Sandstone works)
Museums: 060
Sources: *FoArO 93.*

Cooper, Ann Eliza
b. c1815
Flourished: 1822 Long Island, NY
Type of Work: Fabric (Samplers)
Sources: *GalAmS 59*.*

Cooper, James
Flourished: 1836 Cincinnati, OH
Type of Work: Wood (Ship carvings, ship figures)
Sources: *AmFiTCa 190.*

Cooper, Peter
Flourished: 1720 Pennsylvania
Type of Work: Oil (Paintings)
Sources: *FoPaAm 114-5*.*

Cooper, Richard P., Reverend
b. 1938 Pittsburg, PA
Flourished: 1975 Creekside, PA
Type of Work: Oil, collage, acrylic (Religious and landscape paintings)
Museums: 122
Sources: *AmFokArt 48-51*.*

Cooper, Teunis
Flourished: 1831 Englewood, NJ
Type of Work: Fabric (Weavings)
Sources: *ChAmC 46.*

Cooper, Thomas
Flourished: c1831 Wanborough, IL
Type of Work: Stoneware (Pottery)
Sources: *ArC 189.*

Cooper, William
Flourished: 1836 Cincinnati, OH
Type of Work: Wood (Ship carvings, ship figures)
Sources: *AmFiTCa 190.*

Cope, Enos
Flourished: c1825-1875 Frederick, PA
Type of Work: Redware (Pottery)
Sources: *AmPoP 167.*

Cope, Thomas
[Cope, Witmer and Brothers]
Flourished: 1874-1920 Lincoln University, PA
Type of Work: Clay (Pottery)
Sources: *AmPoP 43, 170.*

Cope, Witmer and Brothers
See: Cope, Thomas.

Coppola, Alphonse
b. 1938
Type of Work: Oil? (Paintings)
Remarks: Painted in a mental institution
Sources: *FoAFe 9**.

Corbin
Flourished: 1850-1860 Centerville, IN
Type of Work: Wood (Sculptures, carvings)
Museums: 001
Sources: *AmFoS 121**.

Corbin, Hannah
Flourished: Woodstock, CT
Type of Work: Fabric (Weavings)
Sources: *ArtWea 86**.

Corbit, Mary Pennell
Flourished: c1823 Odessa, DE
Type of Work: Needlework (Samplers)
Museums: 265
Sources: *WinGu 16**.

Cordero, Helen
b. 1916 Cochiti Pueblo, NM
Flourished: 1964- Cochiti Pueblo, NM
Type of Work: Clay (Pottery)
Museums: 069
Sources: *FoAF 13; FoAFx 2; TwCA 143**.

Cordery, William
Flourished: 1860 New York, NY
Type of Work: Wood (Ship carvings, ship figures)
Sources: *AmFiTCa 190*.

Cordier, David
Flourished: 1815 Pennsylvania
Type of Work: Watercolor, ink (Frakturs)
Sources: *AmFoPa 187*.

Cordova, Alfredo
b. 1918 Truchas, NM
Flourished: 1953- Truchas, NM
Ethnicity: Hispanic
Type of Work: Fabric (Weavings)
Remarks: Started the Cordova Weaving Shop; wife is Grabielita; son is Harry
Sources: *HisCr 19*, 99**.

Cordova, Gloria Lopez
b. 1943 Cordova, NM
Flourished: contemporary Cordova, NM
Ethnicity: Hispanic
Type of Work: Wood (Sculptures, carvings)
Remarks: Husband is Herminio; grandfather is Lopez, Jose Dolores
Sources: *HisCr 53*, 100**.

Cordova, Grabielita
b. 1918 Chimayo, NM
Flourished: 1933- Truchas, NM
Ethnicity: Hispanic
Type of Work: Fabric (Weavings)
Remarks: Husband is Alfredo R.; son is Harry; associated with Cordova Weaving Shop
Sources: *HisCr 19*, 99**.

Cordova, Harry
b. 1948 Truchas, NM
Flourished: 1969 Truchas, NM
Ethnicity: Hispanic
Type of Work: Fabric (Weavings)
Remarks: Cordova Weaving Shop, parents are Alfredo and Grabielita
Sources: *HisCr 19*, 99**.

Cordova, Herminio
b. Cordova, NM
Flourished: Cordova, NM
Ethnicity: Hispanic
Type of Work: Wood (Sculptures, carvings)
Remarks: Wife is Cordova, Gloria Lopez
Sources: *HisCr 53*, 100*.

Cordova Weaving Shop
See: Cordova, Alfredo, Grabielita, and Harry.

Cordrey, Isaac
Flourished: c1869 Brazil, IN
Type of Work: Stoneware (Pottery)
Sources: *AmPoP 208*.

Corey, Walter
Flourished: 1841-1850 Portland, ME
Type of Work: Wood (Furniture)
Sources: *AmPaF 202**.

Corick, Joshua
b. c1820 Maryland
Flourished: Middletown, MD
Type of Work: Fabric (Weavings)
Sources: *ChAmC 46*.

Corne, Michele Felice
b. 1752 d. 1838
Flourished: 1799-1822 Boston, MA; Newport, RI; Salem, MA
Ethnicity: Italian
Type of Work: Oil (Portraits, landscape, mural and fresco paintings)
Museums: 079,221
Sources: *AmDecor 18, 42-46*, 68-9*, 118-9*, 150; AmFokDe 97; AmFoPa 100, 102, 107-8*, 140; AmFoPo 73-7*; PaiNE 11, 84-5*; PicFoA 18**.

Cornelius, John
Flourished: c1893 Forked River, NJ
Type of Work: Wood (Decoys)
Remarks: Made heron decoys
Sources: *AmBiDe 55*.

Cornelius, Robert
Flourished: 19th century Philadelphia, PA
Type of Work: Tin (Lamps)
Sources: *ToCPS 48*.

Cornelius and Baker
Flourished: c1810 Philadelphia, PA
Type of Work: Brass (Candlesticks)
Sources: *AmCoB 240**.

Cornell, James
Flourished: 1860 Decatur, IL
Type of Work: Earthenware (Pottery)
Sources: *ArC 194*.

Cornell, John V.
Flourished: 1838-1849 New York, NY
Type of Work: Oil (Ship portraits)
Sources: *AmFoPa 116; AmFoPaS 86**.

Cornett, Chester
b. 1913 Letcher County, KY d. 1981 Fort Thomas, KY
Flourished: 1947 Dwarf, KY
Type of Work: Wood (Crosses, chairs, 20 foot boat)
Sources: *FoAroK *; GoMaD **.

Cornish, H.
Flourished: 1841 Connecticut
Type of Work: Tin? (Tinware?)
Remarks: May have worked for Filley
Sources: *TinC 166*.

Cornwall
Flourished: c1812 New York
Type of Work: Stoneware (Jugs, flasks)
Museums: 243
Sources: *AmS 188*, 226**.

Cornwell, Stephen
Flourished: 1812 New York, NY
Type of Work: Wood (Ship carvings, ship figures)
Sources: *AmFiTCa 190*.

Corrigan, William
Flourished: 1877 Meriden, CT
Type of Work: Tin (Tinware)
Sources: *TinC 166*.

Cortez, Maxine
Flourished: 1937 Oklahoma
Type of Work: Various materials (Sculptures)
Sources: *FoArO 92*.

Cortrite, Antoinette
See: Cortrite, Nettie.

Cortrite, Nettie (Antoinette)
Flourished: 1887 Detroit, MI
Type of Work: Oil (Paintings)
Sources: *ArtWo 104*, 159*.

Cortwright, J.D.
Flourished: 1840 Lowell, MA
Type of Work: Tempera (Portraits)
Sources: *PrimPa 171*.

Corwick, Andrew
b. c1790 d. 1863 Middletown, MD
Flourished: Middletown, MD
Type of Work: Fabric (Weavings)
Sources: *ChAmC 46*.

Corwin, Salmon W.
Flourished: 1829-1855 Ottisville, NY
Type of Work: Oil (Paintings)
Museums: 001,203
Sources: *AmFoPo 75**.

Corwin, Wilbur A.
Flourished: Bellport, NY
Type of Work: Wood (Duck decoys)
Remarks: Father is Wilbur R.
Sources: *AmBiDe 104.*

Corwin, Wilbur R., Captain
Flourished: 1850s-1890 Bellport, NY
Type of Work: Wood, cork (Duck decoys)
Museums: 260
Remarks: Son is Wilbur A.
Sources: *AmBiDe 104; ArtDe 120*; Decoy 16*; WiFoD 44*, 144*.*

Cosley, Dennis
b. 1816 **d.** 1904
Flourished: 1846-1859 Xenia, OH
Type of Work: Fabric (Weavings)
Museums: 016,189,278
Remarks: Brother is George
Sources: *AmSQu 276; ArtWea 139, 240*; ChAmC 49*
See: Cosley, D.

Cosley, G(eorge)
Flourished: 1851 Xenia, OH
Type of Work: Fabric (Weavings)
Sources: *AmSQu 276; ChAmC 49.*

Cossett, M.
Flourished: 1841 Connecticut
Type of Work: Tin? (Tinware?)
Remarks: May have worked for Filley
Sources: *TinC 166.*

Cote, Adelard
b. 1889 **d.** 1974 Biddeford, ME
Flourished: 1940 Biddeford, ME; Saco, ME
Ethnicity: Canadian
Type of Work: Wood (Sculptures)
Sources: *FoAFh 7*-9*.*

Cote, Claude
Flourished: 1867-1912 Chicago, IL
Type of Work: Wood (Cigar store Indians, figures)
Remarks: Worked in Quebec (1867-1869) and in Chicago (1883-1912).
Sources: *ArtWod 166-7, 264-5, 169*.*

Cothead, Phoebe
Flourished: 1812 New York
Type of Work: Fabric (Weavings)
Museums: 203
Sources: *AmSQu 287*.*

Cotten and Statler
Flourished: 1796 Charleston, SC
Type of Work: Wood (Ship carvings, ship figures)
Sources: *AmFiTCa 190; ShipNA 163.*

Cotton, Dorothy
Flourished: 18th century
Type of Work: Wool (Needlepoint)
Sources: *AmSFok 111*.*

Cotton, Shubael Banks
Flourished: after 1830 Middletown, CT
Type of Work: Tin (Tinware)
Sources: *TinC 166.*

Coudon, Joseph
Flourished: 1870-1875 Aiken, MD
Type of Work: Wood (Duck decoys)
Museums: 260
Sources: *ArtDe 93; Decoy 125*; WiFoD 135*.*

Couloy, Isadore
Flourished: c1850-1855 Nauvoo, IL
Ethnicity: French
Type of Work: Clay (Pottery)
Sources: *ArC 193-4, 207.*

Coulter, George
Flourished: 1851 West Virginia
Type of Work: Fabric (Weavings)
Sources: *AmSQu 276; ChAmC 49.*

Coultry, P.L.
Flourished: 1874-1900 Cincinnati, OH
Type of Work: Yellow-ware, Rockingham, artware (Pottery)
Sources: *AmPoP 211.*

Counce, Harvey P.
[R.H. Counce and Company]
b. 1821 Thomaston, ME
Flourished: 1840-1880 Thomaston, ME
Type of Work: Wood (Ship carvings, figures)
Sources: *AmFiTCa 138-9; ShipNA 88, 157.*

Counce, R.H.
See: R.H. Counce and Company.

Counts, Charles
Type of Work: Fabric (Quilts)
Sources: *AmSQu 308*.*

Court, Lewis
Flourished: 1860 New York, NY
Type of Work: Wood (Ship carvings, ship figures)
Sources: *AmFiTCa 190.*

Coutis, T.W.
Flourished: 1722 Kittery, ME
Type of Work: Wood (Ship carvings, ship figures)
Sources: *AmFiTCa 190; ShipNA 157.*

Covart, W.A.
Flourished: 1860-1864
Type of Work: Ivory, wood (Carved animals, boxes)
Sources: *SoFoA 97*, 219.*

Cover, Sallie
Flourished: 1880-1890 Garfield County, NE
Type of Work: Oil (Paintings)
Sources: *ArtWo 101, 150-1, 159, fig16.*

Covey, Harriet
Flourished: 1840 New York
Type of Work: Fabric (Weavings)
Sources: *AmSQu 276; ChAmC 49.*

Covill, H.E.
Flourished: 1885 New England,
Type of Work: Oil (Genre paintings)
Museums: 203
Sources: *AmFokDe xii*; PicFoA 121*; PrimPa 171.*

Coville, A.M.
Flourished: Oklahoma
Type of Work: (Drawings)
Sources: *FoArO 27, 84.*

Cowam, Donald
Flourished: 1820 Switzerland County, IN
Type of Work: Fabric (Weavings)
Sources: *AmSQu 276; ChAmC 49.*

Cowan, Robert
b. 1762 **d.** 1846
Flourished: 1791-1837 Salem, MA
Ethnicity: Scottish
Type of Work: Oil? (Ornamental paintings)
Sources: *AmDecor 40, 68, 110, 150.*

Coward, Eleanor L.
Flourished: New Jersey
Type of Work: Velvet (Paintings)
Sources: *AmFoAr 36; PrimPa 171.*

Cowden and Wilcox
Flourished: c1850-1890 Harrisburg, PA
Type of Work: Stoneware (Pottery)
Sources: *AmPoP 169; AmS 96*; AmSFok 137*; Decor 146*, 148*, 218; DicM 44*, 47*; EaAmFo 5, 236*, 248*.*

Cowell, Benjamin
Flourished: c1840-1850 Staunton, IL
Type of Work: Wood (Furniture)
Sources: *ArC 253*.*

Cowles, Calvin
Flourished: c1880-1900 Wilkes County, NC
Type of Work: Stoneware (Pottery)
Sources: *AmPoP 243.*

Cowles, Elisha
Flourished: 1815 Berlin, CT
Type of Work: Tin? (Tinware?)
Sources: *TinC 166.*

Cowles, Elisha
b. 1750 **d.** 1799
Flourished: Meriden, CT
Type of Work: Stone (Gravestones)
Sources: *EaAmG 127.*

Cowles, Josiah
Flourished: 1790 Marion, CT
Type of Work: Tin (Tinware)
Remarks: Apprenticed at the Pattison shop; partner with Upson, James
Sources: *AmSFo 37*; TinC 166.*

Cowles, Seth
b. 1766 d. 1843
Flourished: Kensington, CT
Type of Work: Stone (Gravestones)
Sources: *EaAmG 127.*

Cowles, Thomas
Flourished: Connecticut
Type of Work: Tin? (Tinware?)
Sources: *TinC 166.*

Cox, Henry F.
Flourished: c1824 New York
Type of Work: Wood (Molds)
Sources: *EaAmW 99.*

Cox, Susanna
Flourished: 1802 Westtown, PA
Type of Work: Fabric (Samplers)
Sources: *AmNe 54.*

Cox, W.A.
Flourished: 1910 Cattaraugus, NY
Type of Work: Pen, ink (Drawings)
Sources: *TwCA 39*.*

Coxe, Daniel
Flourished: 1684 Burlington, NJ
Type of Work: Redware, sgraffito (Pottery)
Sources: *AmPoP 8, 39-40, 165.*

Coxon and Company
Flourished: c1875 Trenton, NJ
Type of Work: Clay (Pottery)
Sources: *AmPoP 182; DicM 243*.*

Coxon and Thompson
Flourished: c1875-1880 Trenton, NJ
Type of Work: Cream-colored ware (Pottery)
Sources: *AmPoP 182.*

Coyle, Carlos Cortes
b. 1871 d. 1962
Flourished: 1930s Leesburg, FL; Seattle, WA; San Francisco, CA
Type of Work: Oil (Paintings)
Sources: *FoA 462; FoAroK *; TwCA 92*.*

Coyle, James
Flourished: Massachusetts
Type of Work: Oil (Portraits)
Remarks: Itinerant
Sources: *PrimPa 171; SoAmP 288.*

Cozzens, Eliza
b. 1785 Providence?, RI? d. 1885 Providence?, RI?
Flourished: 1796 Providence, RI
Type of Work: Fabric (Samplers)
Museums: 241
Sources: *LeViB 117, 131, 150*.*

Crabb and Minshall
Flourished: Baltimore, MD
Type of Work: Copper (Saucepans)
Museums: 065
Sources: *AmCoB 96*.*

Crafft, R.B.
Flourished: 1836-1866 Indiana; Kentucky; Tennessee
Type of Work: Oil (Portraits)
Museums: 001
Sources: *AmFoPo 12*, 75-7*.*

Craft, William
Flourished: Macon, GA
Ethnicity: Black American
Type of Work: Wood (Cabinets)
Sources: *AfAmA 73.*

Crafts, Caleb
Flourished: 1815-1854 Whateley, MA; Troy, NY; Portland, ME
Type of Work: Stoneware (Pottery)
Sources: *Decor 218.*

Crafts, Edward A.
[Wells, Crafts and Wells]
Flourished: 1849-1851 Whateley, MA
Type of Work: Stoneware (Pottery)
Sources: *Decor 218.*

Crafts, Elbridge
See: Crafts, Thomas .

Crafts, Martin
Flourished: 1834-1861 Portland, ME; Nashua, NH; Whateley, MA
Type of Work: Stoneware (Pottery)
Remarks: Son of Thomas
Sources: *AmPoP 196, 258; Decor 218; DicM 90*.*

Crafts, Mary S.
b. 1788
Flourished: 1805
Type of Work: Fabric (Embroidered religious pictures)
Sources: *PlaFan 179*.*

Crafts, Thomas
Flourished: 1750-1775 Roxbury, MA
Type of Work: Oil? (Ornamental paintings)
Sources: *AmDecor 8.*

Crafts, Thomas
Flourished: c1830 Whateley, MA
Type of Work: Clay (Pottery)
Sources: *AmPoP 204; DicM 128*.*

Crafts, Thomas
Flourished: 1833-1861 Whateley, MA
Type of Work: Stoneware (Pottery)
Remarks: Son is Martin
Sources: *AmPoP 59, 204, 259; Decor 218.*

Craghead, Elizabeth
Flourished: Revolutionary War period
Type of Work: Fabric (Embroidered Bible covers)
Museums: 310
Sources: *AmSFok 111*, 115.*

Craig, Burlon
Flourished: 1980 Lincoln County, NC
Type of Work: Stoneware (Pottery)
Sources: *SoFoA 4*-6, 35*, 216-7.*

Craig, James
b. 1823 South Carolina d. 1889
Flourished: 1846-1855 Floyd County, IN; Andersonville, IN; Greensburg, IN
Type of Work: Fabric (Weavings)
Sources: *AmSQu 276; ChAmC 49-50.*

Craig, James
b. 1819 d. 1896 Brazil?, IN?
Flourished: c1852 Canton, IN
Ethnicity: Scottish
Type of Work: Fabric (Coverlets)
Sources: *ChAmC 49*
See: Young, Matthew .

Craig, John
b. c1828
Flourished: c1850 Cincinnati, OH
Type of Work: Fabric (Carpets, coverlets)
Sources: *ChAmC 50.*

Craig, Robert
b. c1802
Flourished: c1850 Bethehem Township, NJ
Type of Work: Fabric (Weavings)
Sources: *ChAmC 50.*

Craig, William, Sr.
b. 1800 d. 1880
Flourished: 1842-1863 Greensburg, IN; Franklin County, IN; Milford, IN
Type of Work: Fabric (Weavings)
Museums: 016
Sources: *AmSQu 276; ChAmC 50; YankWe 239*
See: Gilchrist, Hugh .

Craig, William, Jr.
b. 1824 South Carolina
Flourished: 1850-1852 Greensburg, IN
Type of Work: Fabric (Weavings)
Sources: *AmSQu 276; ChAmC 50.*

Cramer, Chalkly
d. 1929
Flourished: New Gretna, NJ
Type of Work: Wood (Duck decoys)
Sources: *AmBiDe 131-2*.*

Cramlet, C.
Flourished: 1925 Ohio
Type of Work: Clay (Sewer tile sculpture)
Sources: *IlHaOS *.*

Crane
See: Smith and Crane .

Crane, Mr.
Flourished: 1830 Warren, ME
Type of Work: Wood (Weathervanes)
Sources: *YankWe 65*.*

Crane, Harry
Flourished: Lansingburgh, NY
Ethnicity: Black American
Type of Work: Tin (Tinware)
Sources: *TinC 117.*

Crane, Jacob B.
Flourished: 1840 New York, NY
Type of Work: Wood (Ship carvings, ship figures)
Sources: *AmFiTCa 190.*

Crane, James
b. 1900 Ellsworth, MN **d.** 1972
Flourished: 1960s Ellsworth, ME
Type of Work: Oil, oilcloth (Ship portraits, seascape paintings)
Sources: *AmFokArt 52-3*; FoA 64*, 462; FoPaAm 62, fig22; Full *; TwCA 161*.*

Crane, Margaret Smyser
Flourished: 1969 New York, NY
Type of Work: Paper (Paper works)
Sources: *TwCA 183*.*

Cranford, Ralph M.
Flourished: c1923 Babylon, NY
Type of Work: Wood, cork (Duck decoys)
Museums: 260
Sources: *AmBiDe 103; Decoy 21*; WiFoD 54*.*

Cranston, Thomas
b. c1835 **d.** 1899
Flourished: 1855-1881 Switzerland County, IN; Lowell, MA; Shelby Township, IN
Ethnicity: Scottish
Type of Work: Fabric (Weavings)
Sources: *AmSQu 276; ChAmC 50.*

Craven, I.W.
See: I.W. Craven and Company.

Craven, John A.
Flourished: 1855 Randolph County, NC
Type of Work: Stoneware (Pottery)
Sources: *SoFoA 11*, 18, 217.*

Craven, Peter
Flourished: c1770 Steeds, NC
Type of Work: Clay (Pottery)
Sources: *AmPoP 241.*

Craven, Thomas W.
Flourished: c1855 Randolph County, NC
Type of Work: Stoneware (Pottery)
Sources: *SoFoA 18-9*, 217.*

Crawford, Abigail
See: Allen, Abby.

Crawford, Alphia
Flourished: 1850
Type of Work: Oil (Portraits)
Sources: *PrimPa 171.*

Crawford, Cleo
b. 1892 **d.** 1939
Flourished: 1937 Haverstraw, NY
Ethnicity: Black American
Type of Work: Oil (Landscapes, genre paintings)
Sources: *AmNeg pl11; FoA 462; PrimPa 171; ThTaT 233-5*; TwCA 39*.*

Creamer, Susan
Flourished: c1827 Emmitsburg, MD
Type of Work: Fabric, watercolor (Mourning pictures)
Sources: *SoFoA 178*, 222.*

Crecelius, Ludwig
Flourished: 1830 Berks County, PA
Type of Work: Watercolor, ink (Frakturs)
Sources: *AmFoPa 187*; AmPrW 75*, 130*; BeyN 124*.*

Cree, Matilda
Flourished: 1855
Type of Work: Fabric (Quilts)
Sources: *QuiAm 269*.*

Creech, Homer E.
b. 1948 Laurel County, KY
Flourished: contemporary Corbin, KY
Type of Work: Wood, pencil (Clocks, set of praying hands)
Sources: *GoMaD *.*

"Creek Charlie"
See: Fields, Charlie.

Crehore, S.
Flourished: 1806 Boston, MA
Type of Work: Oil (Paintings)
Sources: *PrimPa 171.*

Creiger, Augustus
Flourished: 1820 New York, NY
Type of Work: Wood (Ship carvings, ship figures)
Sources: *AmFiTCa 190.*

Cresent Pottery Company
Flourished: 1881- Trenton, NJ
Type of Work: Clay (Pottery)
Sources: *DicM 92*, 173*, 177*, 179*, 238*-40*, 243*.*

Cress, Edward
b. 1906 Pulaski County, KY
Flourished: Squib, KY
Type of Work: Wood (Carvings)
Sources: *FoAroK *.*

Creus, William
Flourished: c1690-1695 Philadelphia, PA
Type of Work: Clay (Tobacco pipes)
Sources: *AmPoP 174.*

Cribbs, Daniel
Flourished: c1860 Tuscaloosa, AL
Type of Work: Stoneware (Pottery)
Sources: *AmS 24*.*

Cribbs, Peter
Flourished: 1875 Bedford, AL
Type of Work: Stoneware (Pottery)
Sources: *AmPoP 235.*

Crider, Susy A.
Flourished: 1801 Lancaster County, PA?
Type of Work: Fabric (Samplers)
Sources: *GalAmS 38*.*

Cridland, Charles E.
Flourished: 1855 Cincinnati, OH; Chicago, IL
Type of Work: Paint (Landscape paintings)
Sources: *ArC 264.*

Cripe, Jack "Sailor Jack"
Flourished: 1930 Tampa, FL
Type of Work: Paint (Circus banners)
Remarks: Partner in Sigler Sign Service
Sources: *AmSFor 61, 198*
See: Sigler, Jack.

Crisman, W.H.
Flourished: 1850s Strasburg, VA
Type of Work: Stoneware (Pottery)
Sources: *AmS 139.*

Crispell, John H.
Type of Work: Watercolor, crayon (Scene paintings)
Museums: 176
Sources: *ColAWC 233, 235*.*

Crite, Allan Rohan
b. 1910 Plainfield, NJ
Flourished: 1936 Boston, MA
Ethnicity: Black American
Type of Work: Oil (Genre street scene paintings)
Sources: *AmNeg 31, 48, pl53.*

Crites, Cyrus
Flourished: 1840
Type of Work: Metal (Ornamental works)
Museums: 008
Sources: *AmSFok 53.*

Crock, Charles
Flourished: c1880 Santa Fe, IL
Type of Work: Stoneware (Pottery)
Sources: *AmPoP 230; Decor 218.*

Crocker, Ephraim
Flourished: 1820 New York, NY
Type of Work: Wood (Ship carvings, ship figures)
Sources: *AmFiTCa 190.*

Crockett, Otto
Flourished: Tuscarawas County?, OH?
Type of Work: Clay (Sewer tile sculpture)
Sources: *IlHaOS *.*

Crofoot, Joseph
Flourished: 1821 Berlin, CT
Type of Work: Tin? (Tinware?)
Sources: *TinC 166.*

Crolius, Clarkson, I
b. 1773 **d.** 1843
Flourished: 1794-1837 New York, NY; Manhatten Wells, NY
Type of Work: Clay (Pottery)
Museums: 203
Sources: *AmPoP 17, 51, 55-6, 196-7; AmSFo 46*; CoCoWA 61*; DicM 27*; EaAmFo 46*, 245*, 287*; HoKnAm 56*.*

Crolius, Clarkson, II
b. 1806 d. 1887
Flourished: 1825-1870 New York, NY
Type of Work: Stoneware (Pottery)
Sources: *AmPoP* 55-6, 197; *AmS* 82*, 94*, 139*, 167*, 252; *Decor* 48*, 167*, 181-2*, 218; *EaAmFo* 146*, 245*, 287*.

Crolius, George
Flourished: New York, NY
Type of Work: Clay (Pottery)
Sources: *AmPoP* 55, 197.

Crolius, John
Flourished: 1762-1790 New York, NY
Type of Work: Stoneware, clay (Punchbowls, pottery)
Remarks: Son of William
Sources: *AmPoP* 54-5, fig29?, 196, 259; *AmS* ii*; *DicM* 64; *EaAmFo* 255*.

Crolius, Peter
Flourished: 1732-1762 New York, NY
Type of Work: Clay (Pottery)
Remarks: Brother is William
Sources: *AmPoP* 196; *HoKnAm* 53.

Crolius, William
b. 1700
Flourished: 1732-1762 New York, NY
Type of Work: Stoneware, clay (Pottery)
Remarks: Brother of Peter, father of John
Sources: *AmPoP* 196; *AmS* 18-9*, 156*, 185*; *EaAmFo* 40.

Croll, John
Flourished: 1860 New York, NY
Type of Work: Wood (Ship carvings, ship figures)
Sources: *AmFiTCa* 190.

Cromwell, John L. (S.)
b. 1805 d. 1873
Flourished: 1831-1869 Williamsburg, NY; New York, NY
Type of Work: Wood (Cigar store Indians, ship figures, other figures)
Sources: *AmFiTCa* 190; *AmFokAr* 74; *ArtWod* 23, 178-81*, 183, 243; *CiStF* 29; *HoKnAm* 159; *ShipNA* 162.

Cromwell, Stephen
Flourished: 1810 New York, NY
Type of Work: Wood (Ship carvings, ship figures)
Sources: *AmFiTCa* 190.

Cromwell and Harold
Flourished: 1841-1852 New York, NY
Type of Work: Wood (Ship carvings, ship figures)
Sources: *AmFiTCa* 190; *ShipNA* 162.

Crongeyer, Theodore
Flourished: 1872-1890 Detroit, MI
Ethnicity: German
Type of Work: Wood (Cigar store Indians, figures)
Museums: 096
Sources: *ArtWod* 150-1*, 265; *CiStF* 27.

Cronk, T.J.
Flourished: mid 19th cent
Type of Work: Pen, ink (Calligraphy drawings)
Sources: *AmFokDe* ix*, 10*; *AmPaF* 39; *NeaT* 17-8*.

Crooks
See: Brown and Crooks.

Crooks, Floyd
Flourished: Tomrun, MI
Type of Work: Wood (Decoys)
Sources: *WaDec* 117*.

Crooksville China Company
Flourished: late 19th cent Crooksville, OH
Type of Work: Clay (Pottery)
Sources: *DicM* 162*.

Crosby, William
b. 1764 d. 1800
Flourished: Chatham, CT
Type of Work: Stone (Gravestones)
Sources: *EaAmG* 127.

Crosman, Robert
b. 1707 d. 1799
Flourished: Taunton, MA
Type of Work: Wood (Carved boxes, furniture)
Museums: 151
Sources: *AmFokDe* ix*, 10*; *AmPaF* 39; *NeaT* 17-8*.

Cross, J.E.
Flourished: Pennsylvania
Type of Work: Tin (Tinware)
Museums: 097
Sources: *ToCPS* 47*.

Cross, J. George
Flourished: c1859 Aurora, IL
Type of Work: Pen, ink (Calligraphy drawings)
Sources: *ArC* 245*, 264.

Cross, John
b. 1935 Dover, NJ
Flourished: New York, NY
Type of Work: Wood (Genre carvings)
Sources: *MoBeA* 54-7*.

Cross, Peter
Flourished: c1810 Hartford, CT
Type of Work: Clay (Pottery)
Sources: *AmPoP* 193; *DicM* 105*.

Cross, Peter
Flourished: c1805 Steubenville, OH
Type of Work: Redware (Pottery)
Sources: *AmPoP* 231.

Crossley, Robert
Flourished: c1850 Springfield, OH
Type of Work: Fabric (Weavings)
Remarks: Apprentice is Stephenson, Daniel
Sources: *ChAmC* 51.

Crossman, G.
Type of Work: Wood (Signs, paintings)
Sources: *MoBBTaS* 17*.

Crothers, Samuel
Flourished: c1811 Orange County, NY
Type of Work: Fabric (Coverlets, carpets, blankets)
Remarks: Employer is Alexander, James
Sources: *ChAmC* 31, 51.

Crouch, Henry
Flourished: c1760 Annapolis, MD
Type of Work: Wood (Ship carvings, ship figures)
Sources: *ShipNA* 88, 158.

Crow, J.N.
See: Crow, S.N.

Crow, S.N.
Flourished: 1863
Type of Work: Wood (Sculptures, carvings)
Sources: *WoCar* 79*.

Crowell, A.E(lmer)
b. 1862 d. 1952
Flourished: until 1915 East Harwich, MA
Type of Work: Wood (Weathervanes, duck decoys, shore bird decoys, other carvings)
Museums: 048, 184, 260
Sources: *AmBiDe* 36, 40, 43*, 73-4*, 77-84*, figii, iii; *AmDecoy* xii, xiii, 12-13*, 48-51*, 73*, 93*; *AmFoArt* 94*; *AmFoS* 5-6, 180-1*; *AmSFo* 24; *AmSFok* 26*-7; *ArtDe* 133, 165*; *ArtWe* 104*; *CoCoWA* 98*; *Decoy* 23*, 49*, 56*, 107*, 119-20*.

Crowell, A.E(lmer) (Continued)
Sources: *EyoAm* 9; *FoA* 223*, 462; *HoKnAm* 39*; *MaAmFa* *; *WiFoD* 70*, 87.

Crowell, Andrew (Andres)
Type of Work: Metal (Weathervanes)
Remarks: Worked for Kenneth Lynch and Sons
Sources: *WeaVan* 25.

Crowell, Kleon
See: father Crowell, A. Elmer.

Crowley, J.M.
Flourished: 1835 New York
Type of Work: Paint (Portraits)
Museums: 176
Sources: *ColAWC* 122.

Crown Pottery Company
Flourished: c1891-1900 Evansville, IN
Type of Work: Clay (Pottery)
Sources: *AmPoP* 220, 261; *DicM* 9*, 32*, 62*-3*, 71*, 112*, 154*, 198*, 200*.

Crowningshield, Hannah
[Crowninshield]
b. 1789 d. 1834
Flourished: 1815-1820 Salem, MA
Type of Work: Oil, wood, paint (Portraits, furniture, boxes)
Museums: 221
Remarks: Sister is Maria
Sources: *AmPaF 101*; AmPiQ 153; FoPaAm 55*; NeaT 116-7*, 138*, 140; PrimPa 171.*

Crowningshield, Maria
[Crowninshield]
Flourished: 1814
Type of Work: Wood (Furniture)
Remarks: Sister is Hannah
Sources: *AmPaF 170*.*

Crowninshield, Hannah
See: Crowningshield, Hannah.

Crowninshield, Maria
See: Crowningshield, Maria.

Croxall, John W.
See: John W. Croxall and Sons.

Croxall, Thomas
See: Thomas Croxall and Brothers.

Croxall and Cartwright
See: Thomas Croxall and Brothers.

Croxton, Walter
Flourished: 1850 Barnbridge Township, IL
Type of Work: Clay (Pottery)
Sources: *ArC 193.*

Croylas, William
Flourished: 1698 New York, NY
Type of Work: Clay (Pottery)
Sources: *AmPoP 53-5, 196.*

Crozier, John
Flourished: 1830-1845 Cadiz, OH
Type of Work: Fabric (Weavings)
Sources: *AmSQu 276; ChAmC 51.*

Crumb, Charles H., Captain
b. 1840
Flourished: until 1920 Dyster, VA
Type of Work: Wood (Duck decoys)
Sources: *AmBiDe 154.*

Crygier, Ealli
Flourished: 1734 New York
Type of Work: Fabric (Samplers)
Sources: *GalAmS 22*.*

Cudgell, Henry
See: Gudgell, Henry.

Culin, Elizabeth B.
Flourished: c1820 Wilmington, DE
Type of Work: Fabric (Samplers)
Sources: *WinGu 18*.*

Culver, R.I.
Type of Work: Wood (Duck decoys)
Remarks: Used Holmes, Benjamin patterns
Sources: *ArtDe 159.*

Cumberland, Mary Alexander
Flourished: c1880 Cumberland County, KY
Type of Work: Fabric (Quilts)
Sources: *KenQu fig22.*

Cumbie
Flourished: c1840s Alamo?, IN
Type of Work: Fabric (Weavings)
Sources: *ChAmC 51.*

Cummings, C.W.
Type of Work: Pen, ink (Calligraphy drawings)
Sources: *AmFoPa 172*.*

Cummings, Frank
Flourished: Harsens Island, MI
Type of Work: Wood (Decoys)
Sources: *WaDec 126-7*.*

Cummings, J.C.
Flourished: 1870
Type of Work: Oil (Paintings)
Sources: *PrimPa 171.*

Cunning, Susan
Flourished: 1827 New England,
Type of Work: Fabric (Samplers)
Sources: *AmNe 59-61*.*

Cunningham, Earl
b. 1893 Edgcombe, ME d. 1978
Flourished: c1960 St. Augustine, FL
Type of Work: Oil (Seascape paintings)
Museums: 152
Sources: *AmFokArt 58-61*; FoA 55*, 462; FoAFm 2; FoPaAm 183*.*

Cunningham, James
b. c1797
Flourished: 1834-1848 New Hartford, NY; Oneida County, NY
Ethnicity: Scottish
Type of Work: Fabric (Coverlets)
Sources: *AmSQu 276; ArtWea 252*; ChAmC 51, 121**
See: Butterfield, Samuel.

Curlett, Thomas
Flourished: 1842 Baltimore, MD
Type of Work: Oil (Fire engines, fire station art)
Sources: *BirB 82*.*

Curran
See: Ives and Curran.

Currier, Alexander
Flourished: Hallowell, ME
Type of Work: Wood (Ship carvings, ship figures)
Sources: *ShipNA 156.*

Curry, Sam
Flourished: c1850s Scott County, KY; Fayette County, KY; Bourbon County, KY
Type of Work: Fabric (Coverlets)
Sources: *ChAmC 51.*

Curtis, Anne
b. Plymouth, MA?
Flourished: Farmington, CT
Type of Work: Tin (Painted tinware)
Sources: *TinC 157.*

Curtis, Charles
Flourished: 1820 Worcester, MA
Type of Work: Oil (Portraits)
Sources: *PrimPa 171; SoAmP 289.*

Curtis, Daniel
Flourished: Meriden, CT; Philadelphia, PA
Type of Work: Tin (Tinware)
Remarks: Worked for Filley in Philadelphia
Sources: *TinC 166.*

Curtis, Emory
Flourished: 1821 Berlin, CT
Type of Work: Tin? (Tinware?)
Sources: *TinC 166.*

Curtis, H.B.
Flourished: 1840 New York, NY
Type of Work: Oil (Paintings)
Sources: *PrimPa 171.*

Curtis, Isaac A.
See: Earnest, Joseph.

Curtis, John
Flourished: 1790-1822 Philadelphia, PA
Type of Work: Clay (Pottery)
Sources: *AmPoP 45, 175.*

Curtis, Thomas S.
Flourished: Berlin, CT
Type of Work: Tin? (Tinware?)
Sources: *TinC 166.*

Curtis Houghton and Company
Flourished: 1842-1864 Dalton, OH
Type of Work: Stoneware (Pottery)
Sources: *AmPoP 213; Decor 220*
See: Houghton, Edwin; Houghton, Eugene.

Curtiss, H.W.
Flourished: 1845 Meriden, CT
Type of Work: Tin (Tinware)
Remarks: Employed up to 8 people
Sources: *TinC 166.*

Curtiss, Lucy
See: Root, Lucy.

Cushing, Henry
See: Henry Cushing and Company.

Cushing, Jere C.
Flourished: 1859 Camden, ME
Type of Work: Wood (Ship carvings, ship figures)
Sources: *AmFiTCa 190*.

Cushing, Jeremiah C.
Flourished: 1859 Camden, ME
Type of Work: Wood (Ship carvings, ship figures)
Sources: *ShipNA 156*.

Cushing, Levi L.
b. Boston, MA
Flourished: 1830 Boston, MA
Type of Work: Wood (Ship carvings, figures)
Sources: *AmFiTCa 134*, 190; ShipNA 159*.

Cushing, Mrs. Thomas
Flourished: 1822
Type of Work: Velvet (Paintings)
Museums: 176
Sources: *ColAWC 256*.

Cushing and White
[L.W. Cushing and Sons]
Flourished: 1865-1933 Waltham, MA
Type of Work: Copper (Weathervanes)
Museums: 096,260,263
Sources: *AmFoS 62*, 68*, 72-3*, 264*; ArtWe 14*, 36*, 38-42*, 46-7*, 53-4*, 57*, 64*, 78*, 113-4*, 130*, 132*, 137*, 140-3*; FoA 462; FoArA 151-8*; GalAmW 17*, 19*, 39*, 48*, 58*, 67*, 83*, 98; WeaVan 23-4, 47, 49-50, 185; WeaWhir 136*; YankWe 41**
See: A. L. Jewell and Company.

Cushman, Mary
Flourished: 1800 Rhode Island
Type of Work: Watercolor (Memorial paintings)
Sources: *AmFoAr 28; PrimPa 171*.

Cushman, Noah
b. 1745 **d.** 1818
Flourished: Middleboro, MA
Type of Work: Stone (Gravestones)
Sources: *EaAmG 128*.

Cushman, Paul
b. Albany, NY
Flourished: c1805-1825 Albany, NY
Type of Work: Stoneware, clay (Jugs, pottery)
Museums: 006,097
Sources: *AmPoP fig37, 59, 186, 261; AmS 76*, 159*, 194; Decor 108-9, 133*, 137*, 164-5*, 218; DicM104*-5*; EaAmFo 178**.

Cushman, Warren S.
d. 1926
Flourished: c1895 Woodstock, OH
Type of Work: Stone (Gravestones)
Sources: *EaAmG 124*, 129*.

Cushman, William
b. 1720 **d.** 1768
Flourished: Middleboro, MA
Type of Work: Stone (Gravestones)
Sources: *EaAmG 128*.

Cusie, Ray
b. 1937 New York, NY
Type of Work: Various materials (Architectural constructions)
Sources: *AmFokArt 62-3**.

Custis, Nelly
Type of Work: Fabric (Embroidered bookmarks)
Sources: *AmNe 129-130*.

Cutbush, Edward
d. 178?
Flourished: 1770-1790? Philadelphia, PA
Ethnicity: English
Type of Work: Wood (Ship carvings, ship figures)
Remarks: Taught Rush, William
Sources: *AmFiTCa 57-8, 190; ArtWod 116; ShipNA 163*.

Cutbush, Samuel
Flourished: 1783-1785 Philadelphia, PA
Type of Work: Wood (Ship carvings, ship figures)
Sources: *AmFiTCa 190; ShipNA 163*.

Cutts, Elizabeth
b. 1787
Flourished: 1800 Berwick, ME
Type of Work: Fabric (Samplers)
Sources: *GalAmS 36**.

D

D.A. Sackett and Company
Flourished: c1843-1848 Galena, IL
Type of Work: Redware (Pottery)
Sources: *ArC 190*
See: Sackett, David A.

D. and J. Henderson
[Jersey City Pottery]
Flourished: 1829-1833 Jersey City, NJ
Type of Work: Brownware (Pottery)
Remarks: Also American Pottery Manufacturing Company
Sources: *AmPoP 20, 34, 48-9, 63, 169, 264, fig81; DicM 168*, 184*.*

D.E. McNichol Pottery Company
Flourished: 1870-1892 East Liverpool, OH
Type of Work: Rockingham, yellow-ware (Pottery)
Sources: *AmPoP 217.*

D.F. Haynes and Company
Flourished: 1879- Baltimore, MD
Type of Work: Clay (Pottery)
Sources: *AmPoP 167; DicM 125*, 168*, 171**
See: F. Haynes and Company.

D.G. Schofield and Company
Flourished: c1877-1893 New Brighton, PA
Type of Work: Stoneware (Pottery)
Sources: *AmPoP 225; Decor 223.*

D.N. Train and Collins
See: Train and Collins.

Dabney, Mrs. Charlotte
Flourished: 1799 Dorchester, MD
Type of Work: Fabric (Quilts)
Museums: 046
Sources: *AmSQu 174*.*

"Daddy Bill"
See: Dorsey, W.F.

Daggett, Clarissa
b. 1784 Attleboro, MA? **d.** 1816 Attleboro, MA?
Flourished: 1799 Providence, RI
Type of Work: Fabric (Samplers)
Museums: 034,173
Sources: *LeViB 134*-5*.*

Dalee, Justus
Flourished: 1826-1847 Cambridge, NY
Type of Work: Watercolor (Paintings)
Museums: 001
Sources: *AmFoAr 32; AmFoPo 77-9*; PrimPa 171.*

Dallas, Frederich
Flourished: 1865-1882 Cincinnati, OH
Type of Work: Clay (Pottery)
Sources: *AmPoP 78, 211.*

Dalton Pottery Company
Flourished: 1875 Dalton, OH
Type of Work: Clay (Pottery)
Sources: *DicM 35*.*

Dalzell, M.J.
Type of Work: Watercolor (Genre paintings)
Sources: *PrimPa 171.*

Daman, Desire Ells
Flourished: 1804 Scituate, MA
Type of Work: Fabric (Samplers)
Sources: *GalAmS 42.*

Daman, Ruth Tilden
Flourished: 1807 Scituate, MA
Type of Work: Fabric (Samplers)
Sources: *GalAmS 44*.*

Dambock, Adam
Flourished: 1779 Lancaster, PA
Type of Work: Watercolor, ink (Frakturs)
Sources: *BeyN 89*.*

Damitz, Ernst
b. 1805 **d.** 1883
Flourished: Warren County, IL
Ethnicity: German
Type of Work: Watercolor (House pictures)
Museums: 016
Sources: *FoPaAm 199*.*

Damon
See: Low and Damon.

Damon, Benjamin
See: Low and Damon.

Dan's Duck Factory
Flourished: c1920s Quincy, IL
Type of Work: Wood (Duck decoys)
Sources: *AmBiDe 229.*

Dana, Lucinda
b. 1792 **d.** 1826
Flourished: Princeton, MA
Type of Work: Fabric (Needlework pictures)
Museums: 088
Sources: *AmFoPa 144*.*

Dana, Sara H.
Flourished: 1825-1840 New England,
Type of Work: Watercolor (Paintings)
Museums: 215
Sources: *AmPrW 86*, 133*; ArtWo 67*.*

Danas, John
Flourished: c1840 Martin's Ferry, OH
Type of Work: Stoneware (Pottery)
Sources: *AmPoP 223; Decor 224*
See: Stevens, Joseph P.; Harris, James.

Dangler, John
See: Dengler, John.

Dangler, Samuel
Flourished: 20th century Long Island, NY
Type of Work: (Letter openers)
Sources: *WoScuNY.*

Danhouse, F.
Flourished: 1862
Type of Work: Fabric (Weavings)
Sources: *ChAmC 51.*

Daniel, Holy
Flourished: 1850s Illinois
Type of Work: Watercolor (Landscape paintings)
Sources: ArC 264; PrimPa 171.

Dannenburg, C.F.
Flourished: 1805-1832 Boston, MA; Newburyport, MA
Type of Work: Oil (Ship paintings)
Sources: AmFoPa 108-9.

Danner, Philip
Flourished: 1830-1840 Canton, OH
Type of Work: Fabric (Weavings)
Sources: ChAmC 51.

Dannert, Henry
b. c1790
Flourished: c1850 Allentown, PA
Type of Work: Fabric (Weavings)
Sources: ChAmC 51.

Danvers Pottery
Flourished: Danvers?, MA
Type of Work: Clay (Pottery)
Museums: 079
Sources: AmSFok 130.

Darby, Henry F.
b. 1831
Type of Work: Oil (Portraits)
Museums: 176
Sources: FoArA 44*, 61*.

Dare, Charles W.F.
Flourished: 1884-1896 New York
Type of Work: Wood (Circus and carousel figures)
Museums: 001
Sources: AmFoS 233*; CaAn 9.

Dare, Robert
b. c1800 d. c1839
Flourished: 1842-1847? Union County, IN; Fairfield, IN
Type of Work: Fabric (Coverlets)
Sources: ChAmC 52.

Darger, Henry
b. 1892 Chicago, IL d. 1973 Chicago, IL
Flourished: Chicago, IL
Type of Work: Watercolor (Fantasy paintings of children)
Sources: Trans 6-7, 22, 28*-9*, 53.

Darling, Robert
Flourished: 1835 New England,
Type of Work: Oil (Portraits)
Museums: 203
Sources: AmFoPaS 75*.

Darling, Sanford
b. 1894 Santa Barbara, CA d. 1973 Santa Barbara, CA
Flourished: 1960-1973 Santa Barbara, CA
Type of Work: Housepaint (Painted panels, furniture)
Remarks: Painted "House of a Thousand Paintings"
Sources: PioPar 14, 30, 33*, 63.

Darneille, Benjamin
Flourished: Loami, IL
Type of Work: Wood (Furniture)
Sources: ArC 252*.

Daroche, Frank
Flourished: 1871 Boston, MA
Type of Work: Wood (Ship carvings, ship figures)
Sources: AmFiTCa 190.

Daron, Jacob
b. c1805 Pennsylvania
Flourished: 1837-1848 Strinestown, PA
Type of Work: Fabric (Weavings)
Sources: ChAmC 52.

Darrow, Elijah
Flourished: c1833- Bristol, CT
Type of Work: Tin painted (Clock faces)
Sources: TinC 166.

Darrow, J.M.
Flourished: c1832-1833 Ithaca, NY?
Type of Work: Fabric (Weavings)
Sources: ChAmC 52.

Darrow, John
Flourished: 1860-1874 Baldwinsville, NY
Type of Work: Stoneware (Pottery)
Sources: Decor 218; MaAmFA *.

Darrow, Mrs. Newton
Flourished: 1860
Type of Work: Fabric (Quilts)
Sources: AmSQu 206*; Decor 218.

Darton, W.D.
Flourished: c1920's Portland, ME
Type of Work: Wood (Duck decoys)
Sources: AmBiDe 230.

Dash, John Baltus
Flourished: c1765 New York, NY
Ethnicity: German
Type of Work: Tin (Tinware)
Sources: AmCoTW 108.

Daugherty, S.
Flourished: c1840 Pittsfield, MA
Type of Work: Stone (Gravestones)
Sources: EaAmG 128.

Daugherty Brothers Tent and Awning Company
Flourished: St. Louis, MO
Type of Work: Oil (Theater and sideshow scenes)
Sources: AmSFor 198.

Dave
Flourished: 1858-1862 Edgefield, SC
Ethnicity: Black American
Type of Work: Clay (Pottery)
Remarks: Worked in Louis Miles Pottery
Sources: AmNeg fig5; AmS 87-8*, 139*; EaAmFo 166*; SoFoA 9*, 20*, 217.

Daveler, Joseph
See: Deavler, Joseph.

Davenport, A.F.
Flourished: 19th cent
Type of Work: Pen, ink (Drawings)
Sources: Edith *.

Davenport, Maria
Flourished: 1836 Berlin, CT
Type of Work: Watercolor (Miniature portraits)
Sources: PrimPa 171.

Davenport, Patrick Henry
b. 1803 Danville, KY
Flourished: c1830-1840 Indiana; Sumner, IL; Kentucky
Type of Work: Oil? (Portraits)
Remarks: Itinerant
Sources: ArC 89*.

Davenport, William, Captain
b. 1738
Flourished: 1762 Newburyport, MA
Type of Work: Wood (Ship carvings, ship figures)
Sources: AmFiTCa 140, 190; ShipNA 160.

David, Hannah
See: Davis, Hannah.

David C. Sanford Company
Flourished: c1920s Bridgeport, CT
Type of Work: Wood (Duck decoys)
Sources: AmBiDe 230.

David Parr and Company
See: Parr, David.

Davidson, Archibald
Flourished: 1830-1848 Ithaca, NY
Ethnicity: Scottish
Type of Work: Fabric (Carpets, coverlets)
Remarks: Master weaver for the Ithaca Carpet Factory
Sources: ArtWea 249*; ChAmC 13, 15*-6*, 52*, 54*, 57*.

Davidson, Betsy W.
Flourished: 1806 Charleston, SC
Type of Work: Fabric (Samplers)
Museums: 151
Sources: AmNe 62.

Davidson, George, Captain
Flourished: 1790 Massachusetts
Type of Work: Oil (Portraits)
Sources: PrimPa 171.

Davidson, J.
Flourished: 1834-1835
Type of Work: Fabric (Coverlets)
Sources: ChAmC 52.

Davidson, J.M.
Flourished: 1836-1840 Lodi, OH; Ovid, OH
Type of Work: Fabric (Coverlets)
Sources: AmSQu 252*, 276; ChAmC 52, 80*.

Davidson, Seth
Flourished: 1850 Scott County, IL
Type of Work: Clay (Pottery)
Sources: *ArC 193.*

Davidson, William
Flourished: 1836 Buffalo, NY
Type of Work: Wood (Ship carvings, ship figures)
Sources: *AmFiTCa 190.*

Davies, Albert Webster
b. 1889 Salem Depot, NH d. 1967
Flourished: c1960 New Hampshire
Type of Work: Oil (Historical, genre, landscape paintings)
Sources: *FoA 69*, 462.*

Davies, Thomas J.
Flourished: 1861-1865 Bath, SC
Type of Work: Brownware (Face jugs)
Sources: *AmPoP 235.*

Davis, Alfred "Shoe"
b. 1880 Taylor County, KY d. 1967 New Albany, IN
Flourished: 1902 Louisville, KY
Ethnicity: Black American
Type of Work: Oil (Landscape, still life, religious paintings)
Sources: *FoAroK *.*

Davis, Ben, Captain
Flourished: 1865 Monhegan Island, ME
Type of Work: Wood (Duck decoys)
Sources: *WiFoD pl73, 113.*

Davis, Betsy (Betsey?)
Flourished: 1797 Providence, RI
Type of Work: Fabric (Samplers)
Museums: 176
Sources: *LeViB 144*.*

Davis, Charles
Flourished: 1860 New York, NY
Type of Work: Wood (Ship carvings, ship figures)
Sources: *AmFiTCa 190.*

Davis, E.
Flourished: 1832
Type of Work: Fabric? (Coverlets?)
Sources: *ChAmC 124.*

Davis, E(ben) P(earson)
b. 1818 Byfield, MA d. 1902 Worcester, MA
Flourished: 1820-1850s Byfield, MA
Type of Work: Watercolor, oil (Portraits)
Museums: 001,176,203
Sources: *AmFoAr 27*; AmPrP 152; AmPrW 138*, 111*; ColAWC 122-3*; PicFoA 16; PrimPa 171.*

Davis, Ed
Flourished: 1935 New York
Type of Work: Wood (Sculptures, carvings)
Sources: *AmFoS 322*; FoAFm 2; FoScu 27*; TwCA 99*.*

Davis, Ellsworth
d. 1970
Flourished: 1968 Pennsylvania
Type of Work: Various materials (Sculptures)
Remarks: Deaf, mute
Sources: *FoAFm 2; TwCA 146*.*

Davis, George
b. 1808 d. 1855
Flourished: Chicago, IL
Type of Work: Paint (Scene paintings)
Sources: *ArC 126*.*

Davis, Gilbert, Captain
Flourished: 1870 Annisquam, MA
Type of Work: Watercolor (Portraits)
Sources: *WiFoD pl41, 47*.*

Davis, Gwyn
Flourished: 1936 Oklahoma
Type of Work: Oil (Paintings)
Sources: *FoArO 26-8, 81-2*, 72-3*, 103.*

Davis, Hannah
[David]
Flourished: 1825-1855 East Jaffrey, NH
Type of Work: Wood (Hat boxes, other decorated boxes)
Museums: 056
Sources: *AmDecor 31-2*; AmSFo 129-30*; AmSFok 150; NeaT 97*, 106-7*.*

Davis, Isaac
Flourished: 1872-1879 Trenton, NJ
Type of Work: Clay (Pottery)
Sources: *AmPoP 181.*

Davis, J.
Flourished: c1850
Type of Work: Fabric (Coverlets)
Sources: *ChAmC 124.*

Davis, James
Flourished: 1803-1828 Boston, MA
Type of Work: Brass (Andirons)
Sources: *AmCoB 153.*

Davis, James
Flourished: 1844 Peoria, IL
Type of Work: (Portraits)
Sources: *ArC 264.*

Davis, J(ane) A.
Flourished: 1827-1855 Massachusetts; Rhode Island
Type of Work: Watercolor (Portraits)
Museums: 001,171
Sources: *AmFoArt 13*; AmFoPa 48, 58, 61-2; AmFoPaS 91*; AmFoPo 79-82; FoA 29*, 462; FoArA 79-82; FoPaAm 49, 52, 57-9*, 62, 112; NinCFo fig104, 166, 184; ThrNE 42-53*, 66-7.*

Davis, Joseph H.
Flourished: 1832-1837? Massachusetts; New Hampshire; Maine
Type of Work: Oil, watercolor, pencil (Portraits)
Museums: 001,020,176,179,189,203,215
Remarks: The left handed painter
Sources: *AlAmD 24*; AmFoPa 48, 58-62*; AmFoPaCe 66-9*; AmFoPo 83-7*; AmPaF 197*; AmPrW 98*, 135*; AmSFok 160*; BoLiC 77-8; ColAWC 122-6*, 129*; EyoAm 21, 28; FoA 462; FoArA41*, 62-65*; FoArtC 116*; FoPaAm 49, 52, 58-9*, 62, 112*; HoKnAm 112*; MaAmFA *.*

Davis, Joseph H. (Continued)
Sources: *NinCFo 166, 185, fig57, 60-2; PicFoA 16, 80-1*; PrimPa 97-105*, 117; ThrNE fig, 22-41, 57-65.*

Davis, M.O.
Flourished: 1820-1830 Newburgh, NY
Type of Work: Velvet (Paintings)
Sources: *PrimPa 171.*

Davis, Martha
See: Davis, Patty.

Davis, Patty (Martha)
b. 1771 Newport, RI d. 1850
Flourished: 1793 Newport, RI
Type of Work: Fabric (Samplers)
Museums: 241
Sources: *LeViB 215, 228*-9, 260.*

Davis, S(amuel)
Flourished: 1811-1812 Lancaster, PA
Type of Work: Tin (Tinware)
Remarks: Apprenticed under Eicholtz, Jacob
Sources: *AmCoTW 155; ToCPS 36, 42, 45, 48-9.*

Davis, Ulysses
b. 1914
Flourished: Savannah, GA
Ethnicity: Black American
Type of Work: Wood (Sculptures, carvings)
Museums: 126
Remarks: Son is Virgil
Sources: *BlFoAr 70-5*; MisPi 64-5*.*

Davis, Vestie
b. 1903 Baltimore, MD d. 1978 New York, NY
Flourished: c1947-1964 New York, NY; Brooklyn, NY
Type of Work: Oil (Portraits, genre and cityscape paintings)
Sources: *AmFokArt 64-6*; FoA 105*, 462; FoPaAm 108*; HoKnAm 188; TwCA 196*.*

Davis, Virgil
Flourished: 1956
Ethnicity: Black American
Type of Work: Wood (Sculptures, carvings)
Remarks: Father is Ulysses
Sources: *MisPi 65*.*

Dawes, Thomas, Captain
b. 1731 d. 1809
Flourished: Boston, MA
Type of Work: Stone (Gravestones)
Sources: GravNE 127.

Dawkins, Henry
Flourished: 1775
Type of Work: Watercolor (Portraits)
Sources: PicFoA 56*; PrimPa 171.

Dawson, John
d. 1959
Flourished: 1900 Ducks Island, NJ; Trenton, NJ
Type of Work: Wood (Duck decoys)
Sources: AmBiDe figvi, 139-40*; AmDecoy 7*, 23*; AmSFo 25; HoKnAm pl6.

Dawson, Joseph
Flourished: Trenton, NJ
Type of Work: Wood (Duck decoys)
Sources: ArtDe 133*.

Dawson, R.W.
Flourished: 1859-1860 Batavia, IL
Sources: ArC 264.

Dawson, Tube
Flourished: Putnam, IL
Type of Work: Wood (Duck decoys)
Sources: AmBiDe 190; WoCar 147*.

Dawson, William
b. 1901 Huntsville, AL
Flourished: 1960s-1973 Chicago, IL
Ethnicity: Black American
Type of Work: Wood, oil (Sculptures, carvings, totem poles, paintings)
Sources: AmFokArt 67-8*; BlFoAr 76-9*; FoAFm 13-4*.

Day
See: Bolles and Day.

Day, Elizabeth
Flourished: 1845 New Haven, CT
Type of Work: Fabric (Needlework slipper cases)
Sources: AmNe 67*.

Day, Frank Leveva
b. 1902? Berry Creek, CA d. 1976 Carmichael, CA
Flourished: 1960 California; New Mexico; Montana
Ethnicity: American Indian
Type of Work: Oil (Paintings)
Museums: 069
Remarks: Konkau-Maidu Indian, painted pictures of Indian myths and traditions
Sources: FoA 462; PioPar 15, 30-1, 36*, 63; TwCA 142*.

Day, Nathan
Flourished: Windsor, CT
Type of Work: Tin (Tinware)
Sources: AmCoTW 53.

Day, Thomas
Flourished: 1820-1870 Milton, NC; Charleston?, SC?
Ethnicity: Black American
Type of Work: Wood (Cabinets)
Sources: AfAmA 74; AmNeg 18.

Dayton, B.
Flourished: late 1800s
Type of Work: Metal (Signs)
Sources: Edith *.

De Forest, J.H.
b. 1776 d. 1839
Flourished: 1833 Pittsfield, NY?
Type of Work: Stencils (Ornamental paintings)
Sources: AmDecor 147.

de Freest, Mrs. Daniel L.
Flourished: New York, NY
Type of Work: Fabric (Needlepoint stool tops)
Sources: AmNe 112*.

De Groot, Ann
Flourished: mid 19th cent New Jersey
Type of Work: Fabric (Quilts)
Sources: QuiAm 277*.

De Laclotte, Jean Hyacinthe
b. 1766 d. 1829
Flourished: 1811-1818 New Orleans, LA
Ethnicity: French
Type of Work: Oil (Battle scene paintings)
Museums: 201
Sources: OneAmPr 62*, 78, 142, 153; SoFoA 62*-3, 218.

De Lee, Francis H.
Flourished: Saratoga Springs, NY
Type of Work: Watercolor (Paintings)
Museums: 109
Sources: FouNY 65.

De Mejo, Oscar
b. 1911
Flourished: 1950?
Ethnicity: Italian
Type of Work: Oil, acrylic (Historic scene paintings)
Sources: AmFokArt 69-71*.

Deady, Stephen
Flourished: mid 19th cent Illinois
Type of Work: Wood (Sculptures, carvings)
Sources: WoCar 157-8.

Dealer, Joseph
See: Deavler, Joseph.

Dean, Abigail "Abby"
b. 1789 Providence?, RI? d. 1854
Flourished: 1797, 1803 Providence, RI
Type of Work: Embroidery (Mourning pictures)
Sources: LeViB 88*-9*, 165, 170-1*, 189, 256.

Dean, Emeline
Flourished: 1850-1865 East Orange, NJ
Type of Work: Fabric (Quilts)
Museums: 204
Sources: QuiAm 89*.

Dean, Frances E.
b. 1826c Newport, RI
Flourished: 1834 Newport, RI
Type of Work: Fabric (Samplers)
Museums: 205
Sources: LeViB 61, 86*.

Dean, Polly C.
Flourished: 1820 Massachusetts
Type of Work: Velvet (Paintings)
Sources: AmFoAr 36; AmPrP 151; PrimPa 171.

Dean, Thomas
Flourished: 1876 Philadelphia, PA
Type of Work: Wood (Ship carvings, ship figures)
Sources: AmFiTCa 190.

Deans, Sarah Ann Curry
b. c1802 Providence?, RI? d. 1860 Providence?, RI?
Flourished: 1815 Providence, RI
Type of Work: Embroidery (Literary and mythical pictures)
Museums: 241
Sources: LeViB 202*-3.

Deavler, Joseph
[Daveler; Devler; Dealer; Deuler; Doebler]
b. 1809 Pennsylvania d. 1886 Kissel Hill, PA
Flourished: 1838-1843 Lititz, PA; Warwick Township, PA
Type of Work: Fabric (Weavings)
Sources: AmSQu 276; ChAmC 52.

DeBault, Charles
Flourished: 1853 Nauvoo, IL
Type of Work: (Portraits)
Sources: ArC 264.

Debeet
See: Barrett and Debeet.

Decker
See: Starckloff and Decker.

Decker, Charles F.
Flourished: 1872-1906 Washington County, TN
Ethnicity: German
Type of Work: Stoneware (Pottery)
Museums: 276
Remarks: Made gravemarkers, yard ornaments, inkwells, banks, as well as the usual pottery
Sources: SoFoA v*, 14*-5*, 21*-2*, 216-7.

Decker, Evan
b. 1912 Wayne County, KY d. 1981 Delta, KY
Flourished: 1941- Delta, KY
Type of Work: Wood (Sculptures)
Sources: *FoAFo 15; FoAroK* *.

Decker, Fritz
Flourished: Philadelphia, PA
Type of Work: Wood (Cigar store Indians, figures)
Sources: *CiStF 31*.

Decker, Louis
Flourished: 1830 New York, NY
Type of Work: Wood (Ship carvings, ship figures)
Sources: *AmFiTCa 190*.

Decker, Robert M.
Flourished: 1857 Salem, MA
Type of Work: Wood (Ship carvings, ship figures)
Sources: *AmFiTCa 190*.

DeCoe, G.
Flourished: Marine City, MI
Type of Work: Wood (Decoys)
Sources: *WaDec 119**.

Dedham Pottery
Flourished: 1897 Dedham, MA
Type of Work: Clay (Pottery)
Sources: *DicM 151*; FoArtC 43*.

Dee, William M.
Flourished: Chicago, IL
Type of Work: Clay (Sewer tile sculpture)
Sources: *IlHaOS* *.

Deeble, Florence
b. Lucas, KS
Flourished: contemporary Lucas, KS
Type of Work: Various materials (Environmental sculptures)
Remarks: Lives one-half block from Dinsmore, S.P.
Sources: *FoAFd 11**.

Deeds, William
b. c1808 Pennsylvania
Flourished: c1850-1859 Miami County, IN
Type of Work: Fabric (Weavings)
Sources: *ChAmC 52*
See: Snider, J.

Deegan, Bill
Flourished: Martha's Vineyard, MA
Type of Work: Wood (Duck decoys)
Sources: *AmBiDe 73*.

Deene, John
Flourished: 1834 New York, NY
Type of Work: Wood (Ship carvings, ship figures)
Sources: *AmFiTCa 190*.

Deering, William
b. 1706
Flourished: Portsmouth, NH
Type of Work: Wood (Ship carvings, ship figures)
Sources: *ShipNA 14, 161*.

Deering, William, Jr.
b. 1741 Kittery, ME
Flourished: 1763-1799 Portsmouth, NH; Salisbury, MA; Kittery, ME
Type of Work: Wood (Ship carvings, ship figures)
Sources: *AmFiTCa figvi, 69, 78-80, 190; ShipNA 14, 161*.

Degenhardt, Henry
Flourished: c1757 Reading, PA
Type of Work: Tin (Tinware)
Sources: *AmCoTW 150; ToCPS 4*.

Degge, Mary Frances
Flourished: c1851 Petersburg, IL
Type of Work: Fabric (Quilts)
Museums: 114
Sources: *ArC 104**.

Degrasse, Aug.
Flourished: 1866 New Orleans, LA
Type of Work: Wood (Ship carvings, ship figures)
Sources: *AmFiTCa 190*.

Dehart, John, Jr.
b. c1808 Pennsylvania
Flourished: c1850 Harrisburg, PA
Type of Work: Fabric (Carpets, coverlets)
Museums: 025
Sources: *ChAmC 52*.

Dehate, Abraham
b. 1890-1968
Flourished: Mount Clemens, MI
Ethnicity: French
Type of Work: Wood, metal (Fish decoys)
Sources: *AmFokA 43*; UnDec 19**.

Deitsch, Andrew
Flourished: c1850 Myerstown, PA
Ethnicity: German
Type of Work: Fabric (Weavings)
Sources: *ChAmC 52*
See: Ney, William.

Deker, Francis Jacob
d. 1924
Flourished: 1888-1898 Philadelphia, PA
Ethnicity: Austrian
Type of Work: Wood (Cigar store Indians, figures)
Sources: *ArtWod 268, 124*.

Delano, Joseph
Flourished: 1836 Boston, MA
Type of Work: Wood (Ship carvings, ship figures)
Sources: *AmFiTCa 190*.

Delano, Milton
Flourished: contemporary
Type of Work: Whalebone (Scrimshaw)
Sources: *Scrim 24**.

Delano, Temperance
Flourished: 1806 New Bedford, MA
Type of Work: Watercolor (Flower paintings)
Sources: *NeaT 120-1*; PrimPa 171*.

Delanoy, Abraham
b. 1742 New York, NY d. 1795 West Chester County, NY
Flourished: 1784 New Haven, CT
Type of Work: Oil (Portraits, signs, ornamental paintings)
Sources: *AmDecor xix; AmNa 11; MoBBTaS 12; PaiNE 11, 86-7**.

Delaware Pottery Company
Flourished: 1884 Trenton, NJ
Type of Work: Clay (Pottery)
Sources: *DicM 184*, 186**.

Delgado, Francisco
Flourished: 1935 Santa Fe, NM
Ethnicity: Hispanic
Type of Work: Tin (Tinware)
Sources: *HisCr 75**.

Delgado, Fray Carlos Joseph
Flourished: c1720-1740 New Mexico
Type of Work: Oil (Paintings)
Sources: *FoPaAm 226*, 234*.

Delgado, Maria Luisa
See: Roybal, Maria Luisa Delgado.

Dellaway, Thomas
[Dilloway]
Flourished: 1799 Boston, MA
Type of Work: Wood (Ship carvings, figures)
Sources: *AmFiTCa 80, 190; ShipNA 159*.

Delmont, David
Flourished: 1825 New York, NY
Type of Work: Wood (Ship carvings, ship figures)
Sources: *AmFiTCa 190*.

Demeriett, Elizabeth J.
Flourished: early 19th cent Rochester, NH?
Type of Work: Fabric (Samplers)
Sources: *GalAmS 5*, 49**.

Deming, Horace
Flourished: 1816-1819 Lansingburgh, NY
Type of Work: Tin (Tinware)
Sources: *TinC 85, 166*.

Deming, Levi
Flourished: Berlin, CT
Type of Work: Tin? (Tinware?)
Sources: *TinC 167*.

Deming, Luther
Flourished: 1815- Lansingburgh, NY
Type of Work: Tin (Tinware)
Remarks: Worked for Filley
Sources: *TinC 167.*

Deming, Roger
Flourished: 1810 Berlin, CT
Type of Work: Tin? (Tinware?)
Sources: *TinC 167.*

Demuth, William
See: William Demuth and Company.

Dengler, J.
Flourished: 1870 New York, NY
Type of Work: Wood (Cigar store Indians, figures)
Sources: *ArtWod 268.*

Dengler, John
[Dangler]
b. c1812
Flourished: 1850 Newry, PA?
Ethnicity: German
Type of Work: Fabric (Weavings)
Sources: *AmSQu 276; ChAmC 52.*

Denholm, John
Flourished: 1837-1861 Pennsylvania
Type of Work: Fabric (Weavings)
Museums: 016
Sources: *AmSFo 93*; AmSQu 261*, 276; ChAmC 52.*

Denig, Ludwig
Flourished: 1784 Chambersburg, PA
Type of Work: Watercolor, ink (Frakturs)
Sources: *FoA 462; FoPaAm 120, fig33-4.*

Denison, Harriet
Flourished: 1800 Connecticut
Type of Work: Watercolor, fabric (Embroidery pictures)
Sources: *AmNe 83*-4.*

Denison, Marcia
b. 1825
Flourished: after 1838
Type of Work: Fabric (Family register samplers)
Sources: *AmNe 62.*

Denison, Nancy Noyes
Flourished: 1770 Mystic, CT
Type of Work: Fabric (Embroidered sewing baskets)
Museums: 234
Sources: *AmNe 146, 149*.*

Denler, Joseph
See: Deavler, Joseph.

Denlinger, David
Flourished: 1830 Pennsylvania
Type of Work: Watercolor, ink (Frakturs)
Sources: *AmFoPa 187.*

Denman, David
Flourished: 1830 New York, NY
Type of Work: Wood (Ship carvings, ship figures)
Sources: *AmFiTCa 190.*

Dennett, Olive
Flourished: 1870 Newburyport, MA
Type of Work: Fabric (Quilts)
Sources: *FoArtC 132.*

Dennis, S.A.
Flourished: c1900 Illinois
Type of Work: Pen, ink (Drawings)
Sources: *ArC 6*.*

Dennis, Thomas
b. 1638 d. 1706
Flourished: 1660-1706 Ipswich, MA
Ethnicity: English
Type of Work: Wood (Furniture)
Museums: 097,176
Sources: *AmPaF 11*; AmSFok 88*; EaAmW 85-6; HoKnAm 108, pl19; MaAmFA *; NeaT 3-4*.*

Dennis, William
Flourished: c1825 Illinois
Type of Work: Pen, ink (Drawings)
Sources: *ArC 3.*

Denny, Samuel
d. 1935
Flourished: c1920s-1930s Jefferson County, NY
Type of Work: Wood (Duck decoys)
Sources: *AmBiDe 106-7; FouNY 63; WoScuNY.*

Denny, Sara
Type of Work: Fabric (Hooked rugs, bed rugs)
Museums: 260
Sources: *AmSQu 18*.*

Dentzel, Gustav A.
d. 1909
Flourished: c1867-193 Philadelphia, PA
Ethnicity: German
Type of Work: Wood (Circus and carousel figures)
Remarks: Employed by Salvatore Cernigliaro; son is William
Sources: *CaAn 8-9, 62-7, 72-3, 76, 85*, 94-5*, 118*, 121*; WoCar 72.*

Dentzel, William
d. 1928
Flourished: Philadelphia, PA
Type of Work: Wood (Carousel, other figures)
Remarks: Father is Gustav A.
Sources: *CaAn 11, 88-9*, 110-2*.*

Derby, Madame
Flourished: 1780s Salem, MA
Type of Work: Paint (Ornamentals)
Sources: *AmDecor 40.*

Dering, William
Flourished: 1735-1751 Williamsburg, VA; Gloucester, VA; South Carolina
Type of Work: Oil (Portraits)
Sources: *AmFoPo 86-90; FoPaAm 145*-6.*

Derlom, Francis
Flourished: 1860 New York, NY
Type of Work: Wood (Ship carvings, ship figures)
Sources: *AmFiTCa 190.*

Derry China Company
Flourished: 19th century Derry Station, PA
Type of Work: Clay (Pottery)
Sources: *DicM 241*.*

Desaville, William W.
Flourished: 1860 New York, NY
Type of Work: Wood (Ship carvings, ship figures)
Sources: *AmFiTCa 190.*

Descillie, Mamie
b. c1920
Flourished: contemporary New Mexico
Ethnicity: American Indian
Type of Work: Mud, fabric (Dolls, toys)
Remarks: Navajo tribe
Sources: *FoAF 12-3*.*

Deshon, Thomas
Flourished: Stevens Plains, ME
Type of Work: Tin (Tinware)
Sources: *FoArtC 89.*

Detterich, George
Flourished: 1831 Groton, NY
Type of Work: Fabric (Weavings)
Sources: *ChAmC 53.*

Detweiler, John H.
Flourished: Pennsylvania
Type of Work: Watercolor, ink (Frakturs)
Sources: *AmFoPa 187.*

Detweiller, Martin M.
Flourished: 1765 Pennsylvania
Type of Work: Watercolor, ink (Frakturs)
Sources: *AmFoPa 187.*

Deuel, Elizabeth
Flourished: c1790 Saratoga, NY
Type of Work: Fabric (Weavings)
Sources: *ChAmC 53.*

Deuler, Joseph
See: Deavler, Joseph.

Deval and Catterson
Flourished: c1870 Shoals, IN
Type of Work: Stoneware (Pottery)
Sources: *AmPoP 230; Decor 218.*

Devler, Joseph
See: Deavler, Joseph.

Devol
See: Deval and Catterson.

DeWees, George M.
Flourished: 1875
Type of Work: Wood (Sculptures, carvings)
Museums: 096
Sources: *AmFoS 31**.

Dewey
See: Johnson and Baldwin.

Dewey, Ormand Sales
Flourished: 1783 St. Lawrence County, NY
Type of Work: Charcoal, pencil (Drawings)
Museums: 235
Sources: *FouNY 66*.

Dexter, Abby (Abigail G.)
Flourished: 1801 Providence, RI
Type of Work: Fabric (Samplers)
Sources: *LeViB 162**.

Dexter, Nabby (Abigail)
b. 1775 Providence, RI **d.** 1826
Flourished: 1785 Providence, RI
Type of Work: Fabric (Samplers)
Sources: *FlowAm 102*; LeViB 122, 139*-141, 246-7**.

Dey, John William "Uncle Jack"
b. 1915(?)
Flourished: 1955- Richmond, VA
Type of Work: Airplane enamel (Paintings)
Museums: 171,178
Sources: *AmFokArt 72-4*; ConAmF 31-4*; FoPaAm 180, fig55; Full *; TwCA 236-7**.

Deyarmon, Abraham
Flourished: 1825 Lexington, KY
Type of Work: Fabric (Weavings)
Sources: *AmSQu 276; ChAmC 53*.

Dibble, Philo
Flourished: Nauvoo, IL
Type of Work: Stone (Masks)
Sources: *ArC 205**.

Dibblee, Henry
Flourished: Chicago, IL
Type of Work: Wood (Cigar store Indians)
Sources: *CiStF 49*.

Diblee
See: Gould Brothers and Diblee.

Dick, Jacob
Flourished: c1830-1840 Tuscarawas County, OH
Type of Work: Stoneware (Pottery)
Sources: *AmPoP 234; Decor 218; DicM 70*-1**.

Dick, Mrs. Mary Low Williams
Flourished: 1932 Connecticut
Type of Work: Fabric (Crewel samplers)
Sources: *AmNe 174-5*, 187**.

Dickerman, Edwin S.
Flourished: Connecticut
Type of Work: Tin? (Tinware?)
Sources: *TinC 167*.

Dickinson, Russel
Flourished: early 19th cent Berlin, CT
Type of Work: Tin (Tinware)
Sources: *TinC 167*.

Dickson, W.
Flourished: 1900 California
Type of Work: Oil (Paintings)
Sources: *PrimPa 171*.

Dicus, Ellen
Flourished: Greenfield, MO
Ethnicity: Black American
Type of Work: Fabric (Quilts)
Sources: *QuiAm 269**.

Dieckhaus, Franz
Flourished: 1860-1880 Dutzow, Warren County, MO
Type of Work: Wood (Furniture)
Sources: *ASeMo 343*, 375**.

Diefendorter, John
Type of Work: Wood (Puppets)
Sources: *EaAmW 64*.

Diehl, George
Flourished: 1832-1915 Rock Hill, PA
Type of Work: Redware (Pottery)
Sources: *AmPoP 44, 178*.

Diehl, William
See: Diehl, George.

Dieter, Charlie
b. 1922 Little Jap, PA
Flourished: Carbon County, PA
Type of Work: Pen, ink (Landscape drawings)
Museums: 171,263
Sources: *AmFokArt 75-6**.

Dille, Susann
Flourished: 1832 Pennsylvania
Type of Work: Fabric (Stitched linens)
Sources: *FoArRP 47*.

Diller, P.
Flourished: 1843-1846
Type of Work: Fabric (Weavings)
Sources: *ChAmC 53*.

Dillinham, John E.
Flourished: 1855 Chicago, IL
Type of Work: Pencil (Drawings)
Sources: *ArC 264*.

Dillon, Charles
See: Dillon and Porter.

Dillon and Porter
[Dillon, Charles]
Flourished: 1825-1842 Albany, NY
Type of Work: Stoneware (Pottery)
Museums: 006
Sources: *Decor 180*, 218*
See: C. Dillon and Company; Jacob, Henry; Selby, Edward.

Dilloway, Thomas
See: Dellaway, Thomas.

Dilly, John
Flourished: Long Island, NY
Type of Work: Wood (Shorebird decoys)
Sources: *AmSFo 25*.

Dimond, C.C.
Flourished: 1871 Boston, MA
Type of Work: Wood (Ship carvings, ship figures)
Sources: *AmFiTCa 190*.

Dinsmoor, S.P.
b. 1843 Coolville, OH **d.** 1932 Lucas, KS
Flourished: 1907-1927 Lucas, KS
Type of Work: Cement (Environmental sculptures)
Remarks: Created "The Garden of Eden"
Sources: *AmFoS 12, 185*; FoAFd 11; FoAFq 16*; HoKnAm 188; NaiVis 8*, 32-41*, 97*; PicHisCa;RuPoD;Trans 41; TwCA 81**.

Dinyes, Mary Ann
b. c1826
Flourished: 1841 Stouchsburg, PA
Type of Work: Fabric (Samplers)
Sources: *GalAmS 85**.

Dippel, Ferdinand
Flourished: 1860 New York, NY
Type of Work: Wood (Ship carvings, ship figures)
Sources: *AmFiTCa 190*.

Dipple, A.G. Curtain
Flourished: c1890-1900 Lewisburg (Lewistown), PA
Type of Work: Clay (Pottery)
Sources: *AmPoP 170, 259; DicM 8**.

Dipple, Anna Margretta
Flourished: 1885-1897 Lewistown, PA
Type of Work: Clay (Pottery)
Sources: *ArtWo 29-30**.

Dirdorff, Abraham
Flourished: 1780-1781 Pennsylvania
Type of Work: Watercolor, ink (Frakturs)
Sources: *AmFoPa 187*.

Disbrow, Charles
Flourished: c1950 Stratford, CT
Type of Work: Wood (Duck decoys)
Museums: 260
Sources: *AmBiDe 73; Decoy 23**.

Ditmars, Peter
Flourished: 1838 Pennsylvania
Type of Work: Watercolor, ink (Frakturs)
Sources: *AmFoPa 187; Edith.*

Ditzler, Jacob
Flourished: c1840 Adams County, PA
Type of Work: Redware (Pottery)
Sources: *AmPoP 186.*

Dixon, J.F.
Flourished: 1912 Massachusetts
Type of Work: Oil (Harbor paintings)
Sources: *FoAFm 2; TwCA 43*.*

Dixon, Thomas Fletcher
Flourished: c1784 Baltimore, MD
Type of Work: (Decorative wall paintings)
Sources: *AmDecor 8*.*

Dize, Elwood
Flourished: Crisfield, MD
Type of Work: Wood (Duck decoys)
Sources: *AmBiDe 147-8*.*

Doane, Mr.
Flourished: 1800 Somers Point, NJ
Type of Work: Wood (Duck decoys)
Museums: 260
Sources: *AmSFok 24; Decoy 109*.*

Doane, George
Flourished: 1840-1860 Louisville, KY
Type of Work: Stoneware (Churns)
Sources: *AmS 94*, 164*.*

Doane, James
Flourished: c1831-1838 Cincinnati, OH
Type of Work: Yellow-ware (Pottery)
Sources: *AmPoP 210.*

Dober, Virginia
b. Ohio
Flourished: c1958, 1975- Blacksburg, VA
Type of Work: Oil (Memory paintings)
Sources: *FoAFn 12*-3*.*

Dobson
[Dubson]
Flourished: 1902 Adirondack Mountains, NY
Type of Work: Oil (Paintings)
Museums: 004
Sources: *FouNY 66.*

Dobson
b. 1891
Flourished: Massachusetts
Type of Work: Oil (Portraits)
Sources: *AmPrP 151; PrimPa 171; SoAmP 184*.*

Dobson, Isaac
Flourished: 1832 Berlin, CT
Type of Work: Tin (Japanned tinware)
Sources: *TinC 167.*

Dock, Christopher
d. 1771
Flourished: Montgomery County, PA
Type of Work: Watercolor, ink (Frakturs)
Sources: *AmFoPa 187; PenDuA 52.*

Dockum, S.M.
Flourished: 1868 Portsmouth, NH
Type of Work: Wood (Ship carvings, ship figures)
Sources: *ShipNA 143, 161.*

Dockum, Samuel M.
Flourished: 1845
Type of Work: Wood (Ship carvings, ship figures)
Sources: *AmFiTCa 190.*

Dodge, Asa
Flourished: c1819 Exeter, NH
Type of Work: Redware (Pottery)
Remarks: Son of Samuel
Sources: *AmPoP 191.*

Dodge, Charles J.
[Dodge and Son; Dodge and Anderson]
b. 1806 d. 1886
Flourished: 1828-1870 New York, NY; Brooklyn, NY
Type of Work: Wood (Cigar store Indians, ship carvings, ship figures)
Museums: 135,184,203,260
Remarks: Father is Jeremiah
Sources: *AmFiTCa 190; AmFoS 86*, 252*; ArtWod 5, 8, 83, 173-6*, 239, 241; ShipNA 47, 162; TwCA 8*; TYeAmS 80*, 93*, 339; WoScuNY*
See: Anderson, Jacob S.

Dodge, Eliza Rathbone
Flourished: 1850 Connecticut
Type of Work: Fabric (Needlework pictures)
Sources: *AmNe 119-120.*

Dodge, Ephraim J.
Flourished: 1850s New Bedford, MA
Type of Work: Whalebone (Scrimshaw)
Museums: 186
Sources: *GravF 45-6*, 52.*

Dodge, Jabesh
Flourished: 1800-1806 Exeter, NH
Type of Work: Redware (Pottery)
Remarks: Son is Samuel
Sources: *AmPoP 191.*

Dodge, Jasper N.
d. 1907 Detroit, MI
Flourished: c1900 Detroit, MI
Type of Work: Wood (Duck decoys)
Museums: 260
Sources: *Decoy 43*, 56*; WaDec 48-9, 51, 54*, 56, 61*, 70*, 91, 175*
See: J.N. Dodge Decoy Company.

Dodge, Jeremiah
Flourished: 1804-1839 New York, NY
Type of Work: Wood (Ship carvings, ship figures)
Remarks: Son is Charles J.
Sources: *AmFiTCa 92-3, 100-1, 190; ArtWod 5, 18, 83, 173-5;ShipNA 47-8*, 161*
See: Dodge and Sharpe; Skillin and Dodge.

Dodge, Nathan
Flourished: 1851 Philadelphia, PA
Type of Work: Wood (Ship carvings, ship figures)
Sources: *AmFiTCa 190.*

Dodge, Rufus
Flourished: c1849-1900 Exeter, NH
Type of Work: Redware (Pottery)
Remarks: Son is Asa
Sources: *AmPoP 191.*

Dodge, Samuel
Flourished: 1806-1819 Exeter, NH
Type of Work: Redware (Pottery)
Remarks: Father is Jabesh
Sources: *AmPoP 191.*

Dodge and Anderson
[Charles Dodge and Jacob S. Anderson]
Flourished: 1836-1870 New York, NY
Type of Work: Wood (Ship carvings, figures)
Sources: *AmFiTCa 190; ArtWod 266; ShipNA 47, 162.*

Dodge and Sharpe
Flourished: 1815-1821 New York, NY
Type of Work: Wood (Ship carvings, ship figures)
Sources: *AmFiTCa figXX, 92-94, 100-1, 190; ShipNA 47, 161*
See: Dodge, Jeremiah; Sharp, C(ornelius)

Dodge and Son
[Jeremiah Dodge, Jr.; Charles Dodge]
Flourished: 1800's New York, NY
Type of Work: Wood (Ship carvings, ship figures)
Museums: 280
Sources: *AmFiTCa figxiv, 92-3, 100-101, 114, 124, 190.*

Dodge Decoy Factory
See: J.N. Dodge Decoy Factory.

Dodson, Mrs. Priscilla
Flourished: 1845 Cambridge, MA
Type of Work: Fabric (Quilts)
Museums: 227
Sources: *AmSQu 202*.*

Dodson, W.K.
Flourished: 1855 New York, NY
Type of Work: Wood (Ship carvings, ship figures)
Sources: *AmFiTCa 190.*

Doebler, Joseph
See: Deavler, Joseph.

Doggett, Lydia
b. c1775
Flourished: 1783 Newburyport, MA; Attleboro, MA
Type of Work: Fabric (Samplers)
Sources: *GalAmS* 27.

Doherty, Joseph J.
Flourished: 1872-1908 Boston, MA
Type of Work: Wood (Ship carvings, ship figures)
Sources: *ShipNA* 159.

Doherty, Joseph J.
Flourished: 1860 East Boston, MA
Type of Work: Wood (Ship carvings, ship figures)
Sources: *AmFiTCa* 190.

Dolan, James
Flourished: 1860 New York, NY
Type of Work: Wood (Ship carvings, ship figures)
Sources: *AmFiTCa* 191.

Dolph, Charles
b. 1776 **d.** 1815
Flourished: Saybrook, CT
Type of Work: Stone (Gravestones)
Sources: *EaAmG* 127.

Dominy, Nathaniel, V
Flourished: 1800-1810 East Hampton, NY
Type of Work: Various materials (Yarn winders)
Sources: *PlaFan* 168*.

Domke, Paul
b. 1887 Michigan
Flourished: 1931- Ossineke, MI
Type of Work: Cement (Sculptures)
Remarks: Created "Paul Domke's Garden and Prehistoric Zoo"
Sources: *Rain* 12, 107*-9*.

Donahue Pottery
Flourished: 1874-1900 Parkersburg, WV
Type of Work: Stoneware (Pottery)
Sources: *AmPoP* 226; *Decor* 218.

Donaldson, Hugh
Flourished: c1839 Pittsburgh, PA
Type of Work: Stoneware (Pottery)
Sources: *AmPoP* 227; *Decor* 218.

Donegan, James
Flourished: 1860 New York, NY
Type of Work: Wood (Ship carvings, ship figures)
Sources: *AmFiTCa* 191.

Donkle, George
Flourished: North Carolina
Type of Work: Stoneware (Pottery)
Museums: 132
Sources: *AmS* 36, 40*-1*
See: Reems-Creek Pottery.

Donnahower, Michael
Flourished: 1860 Cooperstown, IL
Type of Work: Stoneware (Pottery)
Sources: *ArC* 194.

Doolittle
See: Brayton, Kellogg and Doolittle.

Doolittle
Flourished: 1877
Type of Work: Oil (Paintings)
Sources: *PrimPa* 171.

Doolittle, Amos
b. 1754 **d.** 1832
Flourished: 1776-1810 Connecticut; Boston, MA
Type of Work: Watercolor (Paintings)
Museums: 001
Sources: *AmFoAr* 30; *PicFoA* 25, 108*, 113.

Door, Edward
Flourished: 1812 Salem, MA
Type of Work: Wood (Ship carvings, ship figures)
Sources: *ShipNA* 160.

Doran
See: Mott and Doran.

Doran, John B.
Flourished: 1845 New York, NY
Type of Work: Wood (Ship carvings, ship figures)
Sources: *AmFiTCa* 191.

Doran and Miller
Flourished: 1845 New York, NY
Type of Work: Wood (Ship carvings, ship figures)
Sources: *AmFiTCa* 191.

Dorchester Pottery Works
Flourished: c1850-1900 Boston, MA; Dorchester, MA
Type of Work: Stoneware (Pottery)
Sources: *AmS* 143*; *Decor* 218; *FoArtC* 43.

Dorendorf, D.
Flourished: 1890 New York, NY
Type of Work: Metal? (Weathervanes)
Sources: *YankWe* 211.

Doriani, William
b. 1891
Flourished: c1931- New York, NY
Type of Work: Oil (Paintings)
Museums: 020,179
Sources: *BirB* 54*; *MaAmFA* *; *PrimPa* 171; *ThTaT* 40-52*; *TwCA* 90*-1*.

Dornbach, Samuel
b. c1796 Pennsylvania
Flourished: 1844-1851 Sugarloaf, PA
Type of Work: Fabric (Coverlets)
Sources: *ChAmC* 53
See: Turnbaugh, Samuel.

Dorsey, Miss Edith
Flourished: 1929
Type of Work: Clay (Sewer tile sculpture)
Sources: *IlHaOS* *.

Dorsey, Henry
d. 1962
Flourished: 1962 Oldham County, KY
Type of Work: Various materials (Environmental sculptures)
Remarks: Created a 150 foot automated assemblage
Sources: *FoAroK* *.

Dorsey, Tarp (Joseph Tarplin)
b. 1847 **d.** 1925
Flourished: Mossy Creek District, GA
Type of Work: Clay (Pottery)
Museums: 177
Sources: *MisPi* 87*.

Dorsey, W.F. "Daddy Bill"
Flourished: 1910-1920 Mossy Creek, GA
Type of Work: Clay (Pottery)
Sources: *MisPi* 95*.

Dorsey, William H.
Flourished: mid 1800s Philadelphia, PA
Ethnicity: Black American
Type of Work: (Paintings)
Sources: *AfAmA* 96.

Dorward, John
b. c1812 Pennsylvania **d.** c1861
Flourished: 1850-1862 Washington Township, PA
Type of Work: Fabric (Weavings)
Remarks: Son is Joshua
Sources: *ChAmC* 53.

Dorward, Joshua
b. c1835
Flourished: 1850-1862 Washington Township, PA
Type of Work: Fabric (Weavings)
Remarks: Father is John
Sources: *ChAmC* 53.

Dotter, Cornelius
Flourished: 1826 Chestnut Hill Township, PA
Type of Work: Watercolor, ink (Frakturs)
Sources: *BeyN* 24*, 116.

Dotterer, Charles
Flourished: 1846 Boston, MA
Type of Work: Wood (Ship carvings, ship figures)
Sources: *AmFiTCa* 191.

Doud, Delia Ann
b. 1837 Gainsville, NY **d.** 1926 Portland, OR
Flourished: 1857 Portland, OR
Type of Work: Oil (Paintings)
Museums: 218
Sources: *PioPar* 31*, 34, 59.

Doughty, John H.
Flourished: 1834 Boston, MA
Type of Work: Wood (Ship carvings, ship figures)
Sources: *AmFiTCa 191.*

Douglas, Charles
Flourished: 1838-1841 Brownsville, PA
Type of Work: Fabric (Coverlets)
Sources: *ChAmC 53*
See: Packer, J.

Douglas, Lucy
Flourished: 1810 New England,
Type of Work: Watercolor (Allegorical drawings)
Sources: *AmFoPaN 172, 178*; AmPrP fig90, 151; MaAmFA *; PrimPa 171.*

Douglas, Marya
Flourished: 1829 Cambridge, MA
Type of Work: Fabric (Mourning samplers)
Sources: *MoBeA.*

Douglass, Robert M., Jr.
b. 1809 Philadelphia, PA d. 1887
Flourished: 1800s Philadelphia, PA
Ethnicity: Black American
Type of Work: Oil? (Portraits, miniatures)
Sources: *AfAmA 96, 98-9, 102.*

Dousa, Henry
b. 1820 Lafayette, IN d. 1885? Lafayette, IN
Flourished: 1875 New Castle, IN
Type of Work: Oil (House portraits, farm scene paintings)
Museums: 176
Sources: *AmFoPaS 100*; ColAWC 233, 236*; FoPaAm fig60.*

Dow, John
b. 1770 Kensington, NH d. 1862
Flourished: Kensington, NH
Type of Work: Oil (Domestic scene paintings)
Sources: *AmDecor 49.*

Dowler, Charles Parker
b. 1841 d. 1931 Providence, RI
Flourished: 1869-1919 Providence, RI
Ethnicity: English
Type of Work: Wood (Cigar store Indians, figures)
Museums: 001
Sources: *AmFiTCa 191; AmFokAr 15, fig78; ArtWod 154-6*, 269; CiStF 22*; EyoAm 9, 15*.*

Downer, Ruth
Flourished: early 19th cent Massachusetts
Type of Work: Watercolor (Paintings)
Museums: 173
Sources: *ArtWo 69*.*

Downes, P.S.
Flourished: 1890s New York
Type of Work: Watercolor (Boat portraits)
Sources: *FoPaAm 105*; NinCFo 201.*

Downes, Peter B.
Flourished: 1854 Charlestown, MA
Type of Work: Wood (Ship carvings, ship figures)
Sources: *AmFiTCa 191*
See: Downes and Sargent.

Downes and Sargent
Flourished: 1854 Charlestown, MA
Type of Work: Wood (Ship carvings, ship figures)
Sources: *AmFiTCa 191*
See: Downes, Peter B.

Downing, Mary
Flourished: c1819 Downingtown, PA
Type of Work: Fabric (Needlework pictures)
Sources: *WinGu 102*.*

Downs, P.T.
Flourished: 1856 Charlestown, MA
Type of Work: Wood (Ship carvings, ship figures)
Sources: *AmFiTCa 191.*

Doyle, B.
Flourished: 1825 Connecticut
Type of Work: Pastel (Portraits)
Sources: *AmPrW 129*, 67*.*

Doyle, John M.
Flourished: 1870 Boston, MA
Type of Work: Wood (Ship carvings, ship figures)
Sources: *AmFiTCa 191.*

Doyle, Sam "Uncle Sam"
b. 1906 d. 1985 Saint Helene Island, SC
Flourished: Frogmore, SC
Ethnicity: Black American
Type of Work: Wood (Sculptures, carvings)
Sources: *BlFoAr 80-5*; FoAF 2*.*

Doyle, William G.
Flourished: 1832 Springfield, IL
Type of Work: Wood (Furniture)
Sources: *ArC 110*.*

Doyle, William M.S.
Flourished: 1820-1835 Massachusetts
Type of Work: Pastel (Portraits)
Sources: *AmPrP 151; Edith *; PrimPa 171; SoAmP 117*.*

Drach, Rudolf
Flourished: 1790-1798 Bedminster, PA; Northampton County, PA
Type of Work: Clay (Pottery)
Sources: *AmPoP 164; BeyN 117; DicM 111*.*

Drake, Ebenezer
b. 1729?
Flourished: c1770 Windsor, CT
Type of Work: Stone (Gravestones)
Sources: *EaAmG 127; GravNE 127.*

Drake, Nathaniel, Jr.
Flourished: c1765 Windsor, CT
Type of Work: Stone (Gravestones)
Sources: *EaAmG 128.*

Drake, Samuel Gardiner
Flourished: 1837 New Hampshire
Type of Work: Oil? (Indian paintings)
Remarks: Author of "The Book of The Indians of North America" (1837)
Sources: *ArC 54*, 114.*

Drake, Silas
Flourished: c1765 Windsor, CT
Type of Work: Stone (Gravestones)
Sources: *EaAmG 128.*

Draper, Augusta
Flourished: 1846 Brookline, MA
Type of Work: Oil (Paintings)
Sources: *PrimPa 172.*

Drawbridge, William S.
Flourished: 1830 New York, NY
Type of Work: Wood (Ship carvings, ship figures)
Sources: *AmFiTCa 191; ShipNA 161.*

Dreese, Thomas
Flourished: Pennsylvania
Type of Work: Tin (Spice boxes)
Remarks: Identification mark: T.D.
Sources: *ToCPS 46*.*

Dreschel, Alfred
Flourished: Michigan
Type of Work: Wood (Decoys)
Sources: *WaDec 153*, 157*.*

Dresden Pottery
Flourished: 1875-1892 East Liverpool, OH
Type of Work: White Granite (Porcelain)
Sources: *AmPoP 218.*

Dressel, John
See: Drissell, John

Dresser, Harvey
b. 1789 Charlton, MA d. 1835
Flourished: Thompson Village, CT
Type of Work: Paint (Ornamental paintings)
Sources: *AmDecor 113.*

Dressler, S.O.
Flourished: 1850s Pennsylvania
Type of Work: Watercolor, ink (Frakturs)
Sources: *AmFoPa 187.*

Drew
Flourished: 1860 Calais, ME
Type of Work: Wood (Ship carvings, ship figures)
Sources: *AmFiTCa 191.*

Drew, Alvin
Flourished: 1856 Hallowell, ME
Type of Work: Wood (Ship carvings, ship figures)
Sources: *AmFiTCa 191; ShipNA 156.*

Drew, Clement
b. 1806 d. 1889
Flourished: 1838-1873 Kingston, MA
Type of Work: Oil (Ship, seascape, lighthouse paintings)
Sources: *AmFoPa 106, 109-10*; PrimPa 172.*

Drew, W.H.
Flourished: 1850s Buffalo, NY
Type of Work: (Masonic regalia)
Sources: *Bes 39.*

Drexel, Anthony
Flourished: 1824-1830 Massachusetts
Type of Work: Oil (Portraits)
Sources: *AmPrP 151; GifAm 44*-5*; PrimPa 172.*

Drey, John
See: Dry, John.

Drinker, Elizabeth
Flourished: c1761 Philadelphia, PA
Type of Work: Embroidery (Needlework)
Sources: *PlaFan 127.*

Drinker, John
b. Philadelphia, PA
Flourished: 1789-1805 Shenandoah Valley, VA
Type of Work: Oil (Portraits)
Museums: 293
Sources: *SoFoA 50-1*, 218.*

Drinker, Philip
Flourished: 1635 Charlestown, MA
Ethnicity: English
Type of Work: Clay (Pottery)
Sources: *EaAmFo 14; HoKnAm 48.*

Drinkhouse, John N.
Flourished: 1830-1864 Easton, PA
Type of Work: Tin (Tinware)
Remarks: Father of William H.
Sources: *ToCPS 36, 40-2*.*

Drinkhouse, William H.
Flourished: Easton?, PA
Type of Work: Tin (Tinware)
Remarks: Son of John N.
Sources: *ToCPS 41-2.*

Drissell, John
[Dressel]
Flourished: c1797 Bucks County, PA
Type of Work: Wood (Decorated salt boxes)
Museums: 189
Sources: *AmFokDe;BeyN 75*, 117; FoArRP 102*; NeaT 145*.*

Drowne, Deacon Shem
b. 1683 d. 1774 Boston, MA
Flourished: Boston, MA
Type of Work: Metal (Weathervanes, tinware)
Museums: 010
Remarks: Son is Thomas
Sources: *AmCoTW 36, 38-42, 49, 56; AmFiTCa 49-50, 191; AmFokAr 49-50, fig30, 79; AmFoS 47*; AmSFok 21; ArtWod 14; EaAmI 136; FoArtC 66*; GalAmW 7*; HoKnAm 168; InAmD 54, 77*; ToCPS 4, 26, 44; WeaWhir 7*, 11-5, 50-3*, 72*, 74-5, 121-5*; YankWe 10*.*

Drowne, Thomas
Flourished: 1760s-1768 Boston, MA
Type of Work: Metal (Weathervanes)
Remarks: Son of Shem
Sources: *AmCoTW 36, 40; FoArtC 67; WeaWhir 124-5*; YankWe 22-23*.*

Drummond, M.J.
Flourished: 1850s New York, NY
Type of Work: (Masonic regalia)
Sources: *Bes 39.*

Drummond, Rose Emma
Flourished: 1835
Type of Work: Oil (Portraits)
Sources: *PrimPa 172.*

Dry, Daniel
Flourished: c1850-1880 Dryville, PA
Type of Work: Clay (Pottery)
Museums: 096
Remarks: Dryville Pottery; father is John
Sources: *AmFoS 219*; AmPoP 166; DicM 36*.*

Dry, John
[Drey]
Flourished: c1825 Dryville, PA
Type of Work: Clay (Pottery)
Remarks: Sons are Lewis, Daniel, and Nathaniel
Sources: *AmPoP 166; DicM 33*.*

Dry, Lewis
Flourished: 1875 Dryville, PA
Type of Work: Clay (Pottery)
Remarks: Dryville Pottery; father is John
Sources: *AmFoS 219*; AmPoP 166.*

Dry, Nathaniel
See: Dry, Daniel.

Dryville Pottery
See: Dry, Lewis; Dry, Daniel.

Dubbs, Isaac
Flourished: 1863-1867 Bethel, PA
Type of Work: Redware (Pottery)
Sources: *AmPoP 164.*

Duble, Jonathan
Flourished: before 1863 Martinsburg, WV
Type of Work: Fabric? (Coverlets?)
Sources: *ChAmC 53.*

Dubors, Oliver
Flourished: 1821 Zanesville, OH
Type of Work: Clay (Pottery)
Sources: *EaAmFo 180*.*

Dubrul
See: Miller, Dubrul and Peters Manufacturing Company.

Duchamp, Helen
Flourished: 1850
Type of Work: Fabric (Quilts)
Museums: 020,179
Sources: *QuiAm 278*.*

Duche, Andrew
Flourished: 1738 Savannah, GA; Charleston, SC; Philadelphia, PA
Type of Work: Clay (Pottery)
Remarks: Father is Anthony
Sources: *AmPoP 83, 85, 96-7, 241; AmSFo 44; Decor 21, 31*; MisPi 26.*

Duche, Anthony
Flourished: 1700-1762 Philadelphia, PA
Ethnicity: French Huguenot
Type of Work: Clay (Pottery)
Remarks: Son is Andrew
Sources: *AmPoP 174; Decor 21, 31*; EaAmFo 39-40, 44; MisPi 26.*

Duddleson, C.
Flourished: Upper Sandusky, OH
Type of Work: Fabric (Coverlets)
Sources: *ChAmC 53.*

Dudley, Lee
b. 1860 d. 1940
Flourished: c1892- Knotts Island, VA; North Carolina
Type of Work: Wood (Duck decoys)
Museums: 260
Remarks: Identification mark: LD
Sources: *AmBiDe 14*, 168-70*; AmDecoy xii, 1*; ArtDe 129*; Decoy 52*, 71*; WiFoD 2**
See: Dudley, Lem.

Dudley, Lem
b. 1861 d. 1932
Flourished: 1892 North Carolina
Type of Work: Wood (Duck decoys)
Sources: *AmBiDe 14*, 168-70*; AmDecoy xii, 1**
See: Dudley, Lee.

Dudley, Samantha Charlotte
Flourished: 1830 Roxbury, MA; Kentucky
Type of Work: Fabric (Coverlets)
Sources: *ChAmC 53; InAmD 112*.*

Dudson
See: Dodson.

Dulheuer, Henrich
Flourished: 1773-1886 Pennsylvania
Type of Work: Watercolor, ink (Frakturs)
Sources: *AmFoPa 187.*

Dullen, C.
Flourished: c1830 Bath, ME
Type of Work: Stone (Gravestones)
Sources: *EaAmG 128.*

Dumbay, Harriet
Flourished: 1760
Type of Work: Fabric (Embroidered wool bed covers)
Museums: 297
Sources: *AmSQu 64*.*

Dunbar, H.
Flourished: 1841 Connecticut
Type of Work: Tin? (Tinware?)
Remarks: May have worked for Filley
Sources: *TinC 167.*

Duncan, M.L.
Flourished: c1850 Cincinnati, OH
Type of Work: Wood (Frames)
Sources: *EaAmW 91*.*

Duncan, O.P.
Flourished: 1960s Oklahoma
Type of Work: Wood (Sculptures, carvings)
Sources: *FoArO 89.*

Dundy, H.
Flourished: 1850 Vermont
Type of Work: Oil (Portraits)
Sources: *PrimPa 172.*

Dunham, John
Flourished: 1812- Berlin, CT
Type of Work: Tin (Tinware)
Sources: *TinC 167.*

Dunham, Solomon
Flourished: c1776 Berlin, CT
Type of Work: Tin (Tinware)
Remarks: Taught son-in-law Porter, Abel
Sources: *TinC 167.*

Dunlap, William S.
Flourished: 1831 Richmond, IN
Type of Work: Fabric (Carpets, coverlets)
Sources: *ChAmC 53.*

Dunlavey, Martha
b. c1805
Flourished: 1820 New York, NY
Type of Work: Fabric (Samplers)
Sources: *GalAmS 55*, 91.*

Dunlop
See: Dunn, Ezra .

Dunn
See: Van Schaik and Dunn .

Dunn, C.F.
Flourished: 1850 North Litchfield, ME
Type of Work: Watercolor (Landscape paintings)
Sources: *AmPrP 159; PrimPa 172.*

Dunn, Ezra
[Dunn, Dunlop and Company]
Flourished: 1852-1859 Middlepoint, NJ
Type of Work: Stoneware (Pottery)
Sources: *Decor 225*
See: Van Schoik, Joseph .

Dunn, Helen (Helen Viana)
b. 1914 New York, NY
Flourished: c1968 New York, NY
Type of Work: Loom-art (Scene paintings)
Sources: *TwCA 165*.*

Dunn, Justus
Flourished: 1826-1831 Cooperstown, NY; Utica, NY
Type of Work: Wood (Boxes)
Sources: *NeaT 101, 112, 194.*

Dunn, Mary
Flourished: 1971 Campton, KY
Type of Work: Fabric (Quilts)
Sources: *AmSQu 306*.*

Dunn, Dunlop and Company
See: Dunn, Ezra .

Dunscombe, Hannah
Flourished: c1850 Warren County, OH
Type of Work: Stoneware (Pottery)
Sources: *AmPoP 235; Decor 218.*

DuPee, Isaac
Flourished: 1758 Boston, MA
Type of Work: Wood (Ship carvings, ship figures)
Sources: *ShipNA 159.*

Dupue
Flourished: 1820 Clark County, KY
Type of Work: Watercolor (Portraits)
Sources: *FoArA 56*; FoPaAm 155*.*

Duran, Damian
Flourished: 1865-1870 Los Pinos, CO
Type of Work: Fabric (Blankets)
Museums: 103
Sources: *PopAs 237.*

Durand, Helen
Flourished: 1858 Elizabethtown, NY
Type of Work: Pen, ink (Penmanship, calligraphy drawings)
Museums: 078
Sources: *FouNY 24, 37*, 65.*

Durand, John
Flourished: 1766-1782 New York, NY; New Haven, CT; Virginia
Ethnicity: French
Type of Work: Oil (Portraits)
Museums: 151,184,203
Sources: *AmFoPa 26-7*, 31; FoA 462; FoPaAm 28, 80-1*; GifAm 26; OneAmPr 40*, 42*, 78-9, 150, 153; PaiNE 10, 92-7*; PrimPa 13-4*, 172.*

Durfee, George H.
Flourished: 1865 New York
Type of Work: Watercolor (Paintings)
Sources: *AmPrP 151; PrimPa 172.*

Durrell, Jonathan
b. Philadelphia, PA
Flourished: 1753-1774 New York, NY
Type of Work: Redware (Pottery)
Sources: *AmPoP 54, 197.*

Dutye, Henre
Flourished: 1784 Pennsylvania
Type of Work: Watercolor, ink (Frakturs)
Sources: *AmFoPa 187.*

Duvall, Flo
Flourished: Flint Hill, VA
Type of Work: Fabric (Needlepoint squares)
Sources: *BirB 65*.*

Duyckinck, Gerardus I.
Flourished: 1722 New York, NY
Type of Work: Oil (Portraits)
Sources: *FoA 462; FoPaAm 68, 78.*

Duyckinck, Gerret
b. 1660 d. 1710
Flourished: 1690-1710 New York, NY
Type of Work: Oil (Portraits)
Museums: 097
Sources: *ArtWea 159*; FoA 462; FoPaAm 68, 73*.*

Duyckinck, I. Evert
Flourished: New York
Type of Work: Oil (Paintings)
Sources: *HoKnAm 85.*

Dwight, John
b. 1740 Boston, MA d. 1816
Flourished: c1771 Shirley, MA
Ethnicity: English
Type of Work: Stone (Gravestones)
Remarks: Worked at Fulham
Sources: *EaAmG 128; GravNE 79, 127.*

Dwight, Samuel
Flourished: 1796 Shaftsbury, VT
Type of Work: Stone (Gravestones)
Sources: *EaAmG 79*-81*, 129.*

Dwight, Stephen
Flourished: 1755-1763 New York, NY
Type of Work: Wood, oil (Historical portraits, paintings, ship carvings, ship figures)
Sources: *AmFiTCa 191; ArtWod 171; FoPaAm 79, 81; ShipNA 161.*

Dwinell, Hezekiah
Flourished: 1860 Danvers, MA
Type of Work: Wood (Ship carvings, ship figures)
Sources: *AmFiTCa 191.*

Dwyer, William J.
b. 1911 New Haven, CT
Flourished: 1960-1966
Type of Work: Oil (Paintings)
Remarks: Painted while a patient in a mental institution
Sources: *FoAFj 4*-6**.

Dye, Ben, Captain
Flourished: 1880 Havre de Grace, MD
Type of Work: Wood (Duck decoys)
Museums: 260
Sources: *AmBiDe 144-5*; Decoy 51*; WiFoD 14*, 134*.

Dyer, Benjamin
b. 1778 **d.** 1856
Flourished: Shaftsbury, VT
Type of Work: Stone (Gravestones)
Sources: *EaAmG 129*.

Dyer, Candace
Flourished: 1797 West Simsbury, CT
Type of Work: Pen, ink (Drawings)
Sources: *ArtWo 11*; MaAmFA 22*, 26*.

Dyer, Henry
Flourished: Connecticut
Type of Work: Tin (Tinware)
Remarks: May have worked for Filley
Sources: *TinC 167*.

Dyer, Sophia
b. c1805
Flourished: 1819 Portland, ME
Type of Work: Fabric (Samplers)
Sources: *GalAmS 59*.

Dyke, A.L.
See: A.L. Dyke and Company.

Dyke, Samuel
See: Samuel Dyke and Company.

Dyker, Henry
Flourished: 1900 Grandville, OH
Type of Work: Wood (Sculptures, carvings)
Sources: *AmFoS 336**.

E

E.A. Jegglin
See: Jegglin Pottery.

E. and L.P. Norton
See: Norton Pottery.

E. Aram Factory
Flourished: 1836 Bethany, NY
Type of Work: Fabric? (Coverlets?)
Sources: *ChAmC 32.*

E.E. Souther Iron Company
Flourished: 1900 St. Louis, MO
Type of Work: Metal (Weathervanes)
Sources: *YankWe 213.*

E.G. Washburne and Company
Flourished: 1853 - present Danvers, MA; New York
Type of Work: Metal (Weathervanes)
Sources: *GalAmW 19; WeaVan 23-4, 37, 47, 49-50, 87, 95, 97, 168, 195; WeaWhir 90, 94*, 129*, 136*, 186; YankWe 143, 214*
See: Kessler, Charles.

E.J. Hayden and Company
Flourished: 1905 Brooklyn, NY
Type of Work: Oil (Banner paintings)
Sources: *AmSFor 30, 44, 198.*

E. Norton and Company
Flourished: 1881-1883 Bennington, VT
Type of Work: Stoneware (Pottery)
Sources: *AmPoP 188, 273; AmSFo 44-5*.*

E. Swasey and Company
Flourished: Portland, ME
Type of Work: Stoneware (Jars)
Sources: *AmS 257*.*

Eagle Foundry
Flourished: Lebanon, PA
Type of Work: Iron (Cast iron kettles)
Sources: *EaAmI 39*.*

Eagle Pottery
Flourished: 1844-1890 Greensboro, PA
Type of Work: Stoneware (Pottery)
Sources: *AmPoP 68, 221, 262; AmS 174, 176*, 187*, 252*
See: Hamilton, James.

Eagle Pottery
Flourished: c1880-1891 Macomb, IL
Type of Work: Stoneware (Pottery)
Sources: *AmPoP 223; Decor 218.*

Eagle Pottery Company
Flourished: 1882-1895 Trenton, NJ
Type of Work: White Granite (Pottery)
Sources: *AmPoP 183.*

Eardley, John
See: John Eardley's Pottery.

Eardley Brothers Pottery
Flourished: 1855 St. George, UT
Type of Work: Clay (Pottery)
Sources: *EaAmFo 202*.*

Earl, Ralph
b. 1751 Worcester County, MA **d.** 1801 Bolton, MA
Flourished: 1780-1801 Worcester County, MA; New York, NY; Litchfield, CT
Type of Work: Oil (Portraits, paintings)
Museums: 007,133,265,311,313
Remarks: Son is Ralph E.W.
Sources: *AmDecor 53, 17; AmFoPa 18, 27-36*; AmFoPaS 31*; AmPaF 85*; ArtWea 29*; FloCo 46*; FoA 462; FoArtC 114*; GifAm 19; 32*-3*; OneAmPr 57*-8*, 79, 142, 154; PaiNE 11, 13, 98-105*; PicFoA 18*, 25, 113*; PrimPa 11-12*.*

Earl, Ralph E.W.
b. 1788 **d.** 1838 Nashville, TN
Flourished: 1815-1838 Nashville, TN
Type of Work: Oil (Portraits)
Museums: 189
Remarks: Son of Ralph; painted portraits of Andrew Jackson
Sources: *AmNa 22, 53*; OneAmPr 79.*

Earl, Tarleton B.
Flourished: 1860-1870 San Francisco, CA
Type of Work: Wood (Ship carvings, ship figures)
Sources: *ShipNA 91, 155*
See: Gereau, William; Carroll, Thomas.

Earle, James, Captain
Type of Work: Ivory? (Carved canes)
Museums: 186
Remarks: Could be owner or artist
Sources: *GravF 94-5*.*

Earle, James
Flourished: 1840 Philadelphia, PA
Type of Work: Wood (Ship carvings, ship figures)
Sources: *AmFiTCa 191.*

Earnest, Joseph
Flourished: 1820 Mount Holly, NJ
Type of Work: Fabric (Weavings)
Sources: *ChAmC 54.*

Eash, Lydia
Flourished: 1930 Middlebury, IN
Ethnicity: Amish
Type of Work: Fabric (Quilts)
Sources: *QuInA 48*.*

Easson, James
Flourished: 1830 New York, NY
Type of Work: Wood (Ship carvings, ship figures)
Sources: *AmFiTCa 191.*

East End Pottery Company
Flourished: 19th and 20th centuries East Liverpool, OH
Type of Work: Clay (Pottery)
Sources: *DicM 9*, 153-4*, 205*.*

East Liverpool Pottery Co.
Flourished: c1900 East Liverpool, OH
Type of Work: Clay (Pottery)
Sources: *AmPoP 217; DicM 242*.*

East Morrisania China Works
Flourished: late 19th cent New York, NY
Type of Work: Clay (Pottery)
Sources: *DicM 162*.*

East Trenton Pottery Company
Flourished: 1888 Trenton, NJ
Type of Work: Clay (Pottery)
Sources: *DicM 154*, 156*.*

Easter, Jacob
Flourished: c1850 Cumberland, MD
Type of Work: Redware (Pottery)
Sources: *AmPoP* 166.

Eastman, Emily (Baker) (Eastman Louden)
b. 1804 Louden, NH
Flourished: c1820-1830 Louden, NH
Type of Work: Watercolor (Portraits)
Museums: 176
Sources: *AmPrP* fig88, 154; *ArtWo* 90*, 159; *ColAWC* 237-8*; *FoPaAm* 58*; *MaAmFA* *; *NinCFo* fig27, 166, 185; *PrimPa* 172.

Eastman, Seth
b. 1808 d. 1875
Flourished: c1848 Washington, DC; West Point, NY
Type of Work: Watercolor (Paintings)
Sources: *ArC* 48*, 220*-1*.

Easton, Elizabeth (Rousmaniere)
b. 1783 Newport, RI d. 1868 Providence, RI
Flourished: 1795 Newport, RI
Type of Work: Fabric (Samplers)
Museums: 151
Sources: *LeViB* 54, 76*.

Easton, Mary
b. 1721 d. 1737
Flourished: 1732 Newport, RI
Type of Work: Fabric (Samplers)
Sources: *LeViB* 60, 64, 66.

Eaton, J.N.
Flourished: 1800-1845 Greene County, NY
Type of Work: Oil (Portraits)
Sources: *AmFoPaN* 207, 215*; *AmPrP* fig13, 151; *PrimPa* 172.

Eaton, Jacob
Flourished: c1818-1845 Washington, NJ
Type of Work: Stoneware (Pottery)
Sources: *Decor* 218
See: Stout, Samuel.

Eaton, Mary
Flourished: 1764 Newbury, NH
Type of Work: Fabric (Crewel and embroidered purses)
Sources: *InAmD* 107*.

Eaton, Moses, Sr.
b. 1753 d. 1833
Flourished: 1800-1830 Dublin, NH; Hancock, NH
Type of Work: Oil (Room interior and overmantel paintings)
Museums: 171
Sources: *AmFoArt* 50-1*; *AmFokDe* x, 96*; *AmFoPa* 140; *AmSFok* 149*; *Edith* *; *MaAmFA* *; *PicFoA* 21.

Eaton, Moses, Jr.
b. 1796 Hancock, NH d. 1886
Flourished: c1820 Dublin, NH; Hancock, NH
Type of Work: Oil (Boxes, overmantels, firebuckets, signs)
Sources: *AmDecor* 101-6*, 121, 145*, 147, 153; *AmFoPa* 140; *FoA* 264*, 462.

Eaton, W.P.
Flourished: 1845 Boston, MA
Type of Work: Wood (Stenciled chairs)
Sources: *AmFokDe* 12.

Eberle, Mark
Flourished: 1860 New York, NY
Type of Work: Wood (Ship carvings, ship figures)
Sources: *AmFiTCa* 191.

Eberley, Jacob J(eremiah)
Flourished: c1870-1905 Strasburg, VA
Type of Work: Redware (Pottery)
Sources: *DicM* 75*, 125*; *SoFoA* 9*, 17*, 29*-30*, 216-7.

Eberly, Jacob (J.)
See: Eberley, Jacob J(eremiah).

Eberly Pottery
See: Fleet, Theodore; Begerly, Levi.

Ebey, George
b. Ohio
Flourished: c1828-1860 Cotton Hill, IL; Manchester, IL; Winchester, IL
Type of Work: Stoneware, redware (Pottery)
Sources: *ArC* 189-90.

Ebey, John Neff
b. Huntington County, PA d. White Hall, IL
Flourished: c1826-1843 Sangamon County, IL; Greene County, IL; Manchester, IL
Type of Work: Redware, stoneware (Pottery)
Sources: *ArC* 189-90, 181-4*.

Echols, Alice
Flourished: 1951 Oklahoma
Type of Work: Fabric (Sculptures)
Sources: *FoArO* 90*.

Echstein, John
Flourished: 1788
Type of Work: Oil? (Group portraits)
Museums: 176
Sources: *FloCo* 48*.

Eckert, Gottlieb
b. c1809
Flourished: 1834-1836 Franklin County, IN
Ethnicity: German
Type of Work: Fabric (Weavings)
Sources: *ChAmC* 54.
See: Vogel, August; Walter, Jacob; G.W. Kimble Woolen Factory.

Eckhart, L.
Flourished: 1860 Baltimore, MD
Type of Work: Wood (Ship carvings, ship figures)
Sources: *AmFiTCa* 191.

Eckler, Henry
b. c1815
Flourished: c1850 New Chambersburg, OH
Ethnicity: German
Type of Work: Fabric (Weavings)
Sources: *ChAmC* 54.

Economite Potters
[Economy Pottery]
Flourished: 1834-1880 Economy, PA; Beaver Falls, PA
Type of Work: Stoneware, redware (Pottery)
Sources: *AmPoP* 208; *Decor* 218; *EaAmFo* 207*.

Economy Pottery
See: Economite Potters.

Eddy, Abby (Abigail)
b. 1800 Providence, RI d. 1880
Flourished: 1813 Providence, RI
Type of Work: Embroidery (Mourning pictures)
Museums: 204
Sources: *LeViB* 194*-5*, 258.

Eddy, Jesse
Flourished: 1812-1817 Berlin, CT
Type of Work: Tin (Tinware)
Sources: *TinC* 167.

Edes, Jonathan W.
b. 1751
Flourished: 1789-1803 Waltham, MA; Revere, MA
Type of Work: Oil (Harbor scene, overmantel paintings)
Sources: *AmDecor* 34*, 150; *FoArA* 31*; *PaiNE* 106-7*.

Edgerly, D.S.
b. 1852
Flourished: Northwood, NH
Type of Work: Fabric (Dolls)
Sources: *FoArtC* 240*.

Edgington, James McCallister
b. 1862 d. 1942
Flourished: Ohio
Type of Work: Wood (Miniature figures)
Sources: *WoCar* 128, 130-1*, 182-6*.

Edlefson
See: Farren and Edlefson.

Edmonson, William
b. 1883 Nashville, TN d. 1951 Nashville, TN
Flourished: 1934-1947 Nashville, TN
Ethnicity: Black American
Type of Work: Stone (Gravestones, other stoneworks)
Museums: 001,045,150,171,263,275,285
Sources: *AfAmA* 120-1*, 132; *AmFokArt* 77-9*; *AmFoPaCe* 120-1*, 132; *AmFoS* 193*; *AmNeg* 47, pl16; *BlFoAr* 87-91*; *FoA* 462; *FoScu* 65*; *HoKnAm* 188; *MaAmFA* *; *SoFoA* 124, 131*, 220; *Trans* 6-7, 48*-50, 53; *TwCA* 94*; *ViSto* *.

Edmunds and Company
See: Barnabus Edmunds and Company.

Edson, Almira
Flourished: 1830 Halifax, VT
Type of Work: Watercolor, ink (Frakturs)
Sources: *PrimPa* 172.

Edward Norton and Company
See: Norton, Edward.

Edward Selby and Son
Flourished: c1876 West Troy, NY
Type of Work: Stoneware (Pottery)
Sources: *Decor* 224.

Edwards Pottery
See: Carpenter, Frederick.

Egan, John J.
Flourished: c1844 Illinois
Type of Work: Paint (Paintings)
Museums: 247
Sources: *ArC* 228*.

Egelmann, Carl Friederich
Flourished: 1821-1831 Pennsylvania
Type of Work: Watercolor, ink (Frakturs)
Sources: *AmFoPa* 189.

Eggen, Jacob
Flourished: 1835 Highland, IL
Ethnicity: Swiss
Type of Work: Redware? (Pottery)
Sources: *ArC* 190.

Egoff, Daniel
Flourished: 1860-1876 Virginsville, PA; Mohrsville, PA
Type of Work: Redware (Pottery)
Sources: *AmPoP* 171, 184.

Ehn, John
b. 1896
Flourished: 1955-1970 Los Angeles, CA
Type of Work: Cement (Sculptures)
Sources: *TwCA* 166*.

Ehrler, Charles
Flourished: 1867 New Haven, CT
Type of Work: Wood (Ship carvings, ship figures)
Sources: *AmFiTCa* 191.

Eichenlaub, Valentine
Flourished: 1855-1857 Cincinnati, OH
Type of Work: Stoneware (Pottery)
Sources: *AmPoP* 211; *Decor* 218.

Eichert, Peter
Flourished: c1877-1900 Orrville, OH
Type of Work: Stoneware (Pottery)
Sources: *AmPoP* 226; *Decor* 218.
See: Fleckinger, Jacob.

Eichler, Maria
Flourished: early 19th cent Lititz, PA
Type of Work: Fabric, paint (Mourning pictures)
Sources: *MoBeA*.

Eichman, Michael
Flourished: 1831-1860 Juniata County, PA
Type of Work: Fabric (Weavings)
Sources: *ChAmC* 54.

Eicholtz, George
Flourished: 1800s Lancaster, PA
Type of Work: Tin (Tinware)
Remarks: Brother is Jacob; father is Leonard
Sources: *ToCPS* 29.

Eicholtz, Jacob
b. 1776 Lancaster, PA d. 1842
Flourished: 1804-1842 Lancaster, PA; Philadelphia, PA; Delaware
Type of Work: Oil, tin, copper (Portraits, tinware, copperware)
Remarks: Brother is George; father is Leonard
Sources: *AmCoTW* 154-6, 166-7; *AmFoPo* 91-2*; *ArEn* 36; *DutCoF* 1; *GifAm* 40*-1; *ToCPS* 10, 24-6, 28-9, 32-5*, 42, 76.

Eicholtz, Leonard
Flourished: c1790s-1800s Lancaster, PA
Type of Work: Tin (Tinware)
Remarks: Sons are Jacob and George
Sources: *ToCPS* 28-9.

Eidenbries, John
Flourished: 1833 Philadelphia, PA
Type of Work: Wood (Ship carvings, ship figures)
Sources: *AmFiTCa* 191.

Eights, James
Flourished: 1850 Albany, NY
Type of Work: Oil (Landscape paintings)
Sources: *AmPrP* 152; *PrimPa* 172.

Eisemann, Philip
Flourished: Lancaster, PA
Type of Work: Clay (Pottery)
Sources: *AmSFo* 79.

Eisenhauer, Jacob
Flourished: Pennsylvania
Type of Work: Watercolor, ink (Frakturs)
Sources: *AmFoPa* 188.

Eisenhause, Peter
Flourished: 1776 Berks County, PA
Type of Work: Iron (Forks)
Sources: *BeyN* 78*, 115.

Eisenhower, Mrs. Ida Elizabeth Stover
Flourished: Denison, TX
Type of Work: Fabric (Quilts)
Museums: 073
Remarks: Mother of President Dwight D. Eisenhower
Sources: *QuiAm* 30*.

"El Diadlo"
Flourished: Canton, OH
Type of Work: Clay (Sewer tile sculpture)
Sources: *IlHaOS* *.

Elderkin, E.B.
Flourished: 1877 Meriden, CT
Type of Work: Tin (Tinware)
Sources: *TinC* 167.

Eldredge, William Wells
Flourished: 1876 New Bedford, MA
Type of Work: Pen, crayon (Illustrated manuscripts)
Museums: 123
Sources: *WhaPa* 137*.

Elephant Joe
See: Josephs, Joseph.

Elethorp, Robert
Flourished: 1960-1970 Hammond, NY
Type of Work: Wood (Maple sugaring scenes)
Sources: *FouNY* 68.

Elfe, Thomas
Flourished: 18th century Charleston, SC
Type of Work: Wood (Furniture)
Sources: *AmPaF* 82.

Elgin Windmill Power Company
Flourished: c1880-1910 Elgin, IL
Type of Work: Iron (Mill weights)
Sources: *FoA* 208*.

Eli La Fever Pottery
Flourished: 1900-1925 Putnam County, TN
Type of Work: Stoneware (Vases)
Sources: *AmS* 115*.

Eliaers, Augustus
Flourished: 1865 Boston, MA
Type of Work: Wood (Ship carvings, ship figures)
Sources: *AmFiTCa* 191.

Eliot, John, Reverend
Flourished: mid 17th cent
Type of Work: Blocks (Block prints for decorations)
Sources: *AmSFo* 120.

Elizabeth Furnace
See: Stiegel, Baron Henry Wilhelm.

Ellenbass, Theodore
Flourished: 1860 New York, NY
Type of Work: Wood (Ship carvings, ship figures)
Sources: *AmFiTCa 191*.

Ellenville Glass Works
Type of Work: Glass (Flasks)
Sources: *AmSFo 85**.

Ellinger, David
Flourished: 1940-1980 Pennsylvania
Type of Work: Oil, watercolor, velvet (Theorems, frakturs)
Sources: *FoA 96*, 462; FoPaAm 137**.

Elliot, John
Flourished: c1720 Boston, MA
Type of Work: Tin (Tinware)
Sources: *AmCoTW 41*.

Elliot, Nathan
Flourished: Catskills, NY
Type of Work: Tin (Tinware)
Sources: *AmCoTW 55*.

Elliot, R.P.
Flourished: 1814 New England,
Type of Work: Oil (Cat paintings)
Sources: *NinCFo 184*.

Ellis
See: Sharpe and Ellis.

Ellis, A.
Flourished: 1830-1832 Exeter, NH
Type of Work: Oil (Portraits)
Museums: 203
Sources: *FoPaAm 38*; NinCFo 49, fig50, 166, 173*.

Ellis, Clarence
b. 1934 d. 1971 Kentucky
Flourished: Henderson Settlement, KY
Type of Work: Wood, paint (Religious paintings, sculptures)
Sources: *FoAroK **.

Ellis, Freeman
Flourished: 1850-1860 Potsdam, NY
Type of Work: Paper (Silhouettes)
Museums: 235
Sources: *FouNY 65*.

Ellis, John
Flourished: 1812 New York, NY
Type of Work: Wood (Ship carvings, ship figures)
Sources: *AmFiTCa 191*.

Ellis, John, Jr.
Flourished: 1825 New York, NY
Type of Work: Wood (Ship carvings, ship figures)
Sources: *AmFiTCa 191*.

Ellis, John
Flourished: 1839 Berlin, CT
Type of Work: Tin? (Tinware?)
Sources: *TinC 167*.

Ellis, Levi
Flourished: Franklin City, VA
Type of Work: Wood (Duck decoys)
Museums: 176
Sources: *ColAWC 324*.

Ellis, Lucebra
Flourished: c1850 Franklin, IL
Type of Work: Fabric (Tablecloths)
Museums: 114
Sources: *ArC 170**.

Ellis, Rachel E.
Flourished: 1820 Franklin, NY
Type of Work: Watercolor (Memorial paintings)
Museums: 176
Sources: *AmPrP 152; ColAWC 209*-10; PrimPa 172*.

Ellison, Orrin B.
Flourished: 1880 Amesbury, MA
Type of Work: Oil (Paintings)
Sources: *PrimPa 172*.

Elliston, Robert A.
b. 1849 d. 1915
Flourished: Bureau, IL
Type of Work: Wood (Duck decoys)
Sources: *AmBiDe 180-1*; ArtDe 185*; HoKnAm 43; WoCar 145*, 147*.

Ellsworth, James
Flourished: 1841
Type of Work: Tin? (Tinware?)
Remarks: May have worked for Filley
Sources: *TinC 167*.

Ellsworth, James Sanford
b. 1802 Windsor, CT d. 1874 Pittsburgh, PA
Flourished: 1835-1855 Hartford, CT; Massachusetts; New York
Type of Work: Oil, watercolor (Miniatures, portraits)
Museums: 055, 176
Sources: *AmFoPa 48, 62-3*; AmFoPaCe 70-3*; AmFoPo 92-3*; ColAWC 126*; EyoAm 21, 25*; FoA 462; PicFoA fig38, 147; PrimPa 67-71*, 172*.

Elmer, Edwin Romanzo
b. 1850 d. 1923
Flourished: Ashfield, MA
Type of Work: Oil (Portraits)
Sources: *PeiNa 171**.

Elmer, W.
Type of Work: Oil (Dog portraits)
Sources: *AlAmD 18-9**.

Elverson, Thomas
Flourished: 1862-1880 New Brighton, PA
Type of Work: Yellow-ware, Rockingham (Pottery)
Sources: *AmPoP 225*.

Elverson and Sherwood
[Sherwood Brothers Company]
Flourished: c1870 New Brighton, PA
Type of Work: Stoneware (Pottery)
Sources: *AmPoP 225; AmS 218*.

Elvins, George D.
Flourished: Franklin County, MO
Type of Work: (Baskets)
Sources: *ASeMo 412**.

Elwell, Samuel, III
Flourished: 1869 Gloucester, MA
Type of Work: Wood (Ship carvings, ship figures)
Sources: *AmFiTCa 191; ShipNA 160*.

Elwell, William S.
b. 1810 d. 1881
Flourished: 1839- Springfield, MA
Type of Work: Oil (Portraits)
Museums: 083
Sources: *AmPrP 151; PrimPa 172; SoAmP 80**.

Ely, Miss
Flourished: 1840 New Jersey
Type of Work: Oil (Paintings)
Sources: *AmFoAr 32*.

Ely, Abraham
Flourished: 1860 New York, NY
Type of Work: Wood (Ship carvings, ship figures)
Sources: *AmFiTCa 191*.

Ely, Edwin
Type of Work: Fabric? (Coverlets?)
Sources: *ChAmC 124*.

Ely, John
b. 1735
Flourished: East Springfield, MA
Type of Work: Stone (Gravestones)
Sources: *EaAmG 128; GravNE 127*.

Ely, John
Flourished: c1790 Pittsfield, MA
Type of Work: Stone (Gravestones)
Sources: *EaAmG 128*.

Ely, Sarah Weir
Flourished: mid-19th ent
Type of Work: Fabric (Quilts)
Museums: 260
Sources: *FoArtC 138*; ThTaT 117*.

Emens, Homer
Flourished: 1886
Type of Work: Oil (Scenes for the America Opera Company)
Sources: *AmSFor 198*.

Emerson, I.L.
Type of Work: Oil (Paintings)
Sources: *AmPrP 151; PrimPa 172*.

Emery
See: Colby, Emery and Company.

Emery, Charles
Flourished: 1859 Salem, MA
Type of Work: Wood (Ship carvings, ship figures)
Sources: *AmFiTCa 191.*

Emery, L.
Flourished: c1840 Bucksport, ME
Type of Work: Stone (Gravestones)
Sources: *EaAmG 128.*

Emigh, Mary
Flourished: 1848 Washington
Type of Work: Fabric (Coverlets)
Sources: *AmSQu 274*.*

Emmaline
b. 1836
Flourished: 1850s-1900s
Ethnicity: Black American
Type of Work: Fabric (Dolls, weavings)
Sources: *AfAmA 90*.*

Emmes, Henry
b. 1716?
Flourished: c1750-1760 Boston, MA; Newport, RI
Type of Work: Stone (Gravestones)
Remarks: Father is Nathaniel; brother is Joshua
Sources: *EaAmG 128-9, viii, 126*; GravNE 59, 127.*

Emmes, Joshua
b. 1719 d. 1772
Flourished: Boston, MA
Type of Work: Stone (Gravestones)
Remarks: Father is Nathaniel; brother is Henry
Sources: *EaAmG 128, viii; GravNE 59, 127.*

Emmes, Nathaniel
b. 1690 d. 1750
Flourished: c1717-1750 Boston, MA
Type of Work: Stone (Gravestones)
Remarks: Sons are Henry and Joshua
Sources: *EaAmG 128, viii; GravNE 56-9, 127.*

Emmons, Alexander Hamilton
b. 1816 d. 1879 East Haddam, CT
Flourished: 1850 Norwich, CT
Type of Work: Oil, watercolor (Miniatures, portraits, paintings)
Sources: *AmPrP 151; PicFoA 17; PrimPa 172; SoAmP 215*.*

Emmons, Mary
b. 1736
Flourished: 1749 Boston, MA
Type of Work: Fabric (Samplers)
Sources: *LeViB 20*.*

Emory, Ella
Flourished: 1878 Hingham, MA
Type of Work: Oil (Interior scene paintings)
Sources: *ArtWo 107*, 159; PicFoA 80*; PrimPa 172.*

Empire Pottery Company
Flourished: 1875 Trenton, NJ
Type of Work: Clay (Pottery)
Sources: *AmPoP 203; DicM 154*, 180*.*

Emsinger, A.
Flourished: 1828-1840 Jonathan Creek, OH
Type of Work: Stoneware (Pottery)
Sources: *AmPoP 222; Decor 218.*

Enders, Henry
b. 1828 d. 1902
Flourished: 1855-1876 Sidney, OH
Ethnicity: German
Type of Work: Fabric (Weavings)
Sources: *AmSQu 276; ChAmC 54.*

Endriss, George
Flourished: mid 19th cent Williamsport, PA; Philadelphia, PA
Type of Work: Tin (Tinware)
Museums: 097
Sources: *ToCPS 42.*

Endy, Benjamin
b. 1811 Berks County, PA d. 1879 Oley Township, PA
Flourished: 1834-1843 Friedensburg, PA
Type of Work: Fabric (Carpets, coverlets)
Museums: 025
Sources: *ChAmC 54.*

Engel, G.
[Engle]
Flourished: 1830-1855 Newark, OH
Type of Work: Fabric (Coverlets)
Sources: *ChAmC 56.*

England, Ann E.
Flourished: 1820 Newcastle County, DE
Type of Work: Fabric (Samplers)
Sources: *GalAmS 57*, 91.*

Engle, G.
See: Engel, G.

Engle, Sarah Ann
Flourished: 1827 Easton, PA
Type of Work: Fabric (Samplers)
Sources: *GalAmS 67*.*

Englehart, Nick
Flourished: Pekin, IL
Type of Work: Wood (Duck decoys)
Sources: *AmDecoy 39*.*

English, Dan
Flourished: 19th century New Jersey; Delaware
Type of Work: Wood (Duck decoys)
Sources: *ArtDe 163.*

English, John
Flourished: Delaware Bay Area, DE
Type of Work: Wood (Duck decoys)
Sources: *AmDecoy 6.*

English, Mark
Flourished: Northfield, NJ
Type of Work: Wood (Duck decoys)
Sources: *AmBiDe 134-5*.*

Enkeboll Art Company
Flourished: Omaha, NE
Type of Work: Oil (Theater and sideshow scenes)
Sources: *AmSFor 198.*

Ennin, Joseph G.
Flourished: 1850 Fairfield, CT
Type of Work: Oil (Paintings)
Sources: *PrimPa 172.*

Eno, Chester
Flourished: 1841 Connecticut
Type of Work: Tin? (Tinware?)
Remarks: May have worked for Filley
Sources: *TinC 167.*

Eno, Ira
Flourished: Connecticut
Type of Work: Tin? (Tinware?)
Remarks: May have worked for Filley
Sources: *TinC 167.*

Eno, Reuben
Flourished: 1808 Connecticut
Type of Work: Tin (Tinware)
Remarks: May have worked for Filley
Sources: *TinC 168.*

Eno, William
b. 1795 or 1796 d. 1838
Flourished: Simsbury, CT
Type of Work: Tin? (Tinware?)
Museums: 227
Remarks: May have worked for Filley; could be owner, peddler or decorator of coffeepot
Sources: *AmCoTW 83, 190*; TinC 168.*

Enos, John
Flourished: Provincetown, RI
Type of Work: Oil (Paintings)
Sources: *ThTaT 236*.*

Ensign, Moses
Flourished: Simsbury, CT
Type of Work: Tin? (Tinware?)
Sources: *TinC 168.*

Enterprise Pottery Company
Flourished: c1880-1900 Fallston, PA; Trenton, NJ
Type of Work: Stoneware (Pottery)
Sources: *AmPoP 220; Decor 218; DicM 40*.*

Eppler, George
b. 1828
Flourished: Gasconade County, MO
Type of Work: Wood (Furniture)
Sources: *ASeMo 378.*

Erbest, John
Flourished: 1877 Meriden, CT
Type of Work: Tin (Tinware)
Sources: *TinC 168.*

Erceg, Rose "Ruza"
b. 1898
Flourished: 1961 Portland, OR
Ethnicity: Yugoslavian
Type of Work: Watercolor (Landscape and memory paintings)
Sources: *FoAFd 6-7*; PioPar 34*-5, 63.*

Ernest, Mrs. Austin
Flourished: 1858 Paris, IL
Type of Work: Fabric (Quilts)
Museums: 044
Sources: *FlowAm 269*.*

Ernst, Carl
Flourished: 1891 Philadelphia, PA
Type of Work: Wood (Ship carvings, ship figures)
Sources: *AmFiTCa 191.*

Esputa, Susan Adel
Flourished: Washington, DC
Type of Work: Fabric (Quilts)
Museums: 263
Sources: *QuiAm 120*.*

Esquibel, Felix
Flourished: 1880 San Pablo, CO
Type of Work: Fabric (Blankets)
Museums: 103
Sources: *PopAs 238.*

Esteline, Martha
Flourished: 1840 Hershey, PA
Type of Work: Watercolor (Portraits)
Sources: *PrimPa 172.*

Esten, Edwin
Flourished: 18th century Ohio
Type of Work: Metal (Grills)
Museums: 008
Sources: *AmSFok 44*, 48.*

Esterbrucks, Richard
Flourished: c1722 Boston, MA
Type of Work: Tin (Tinware)
Sources: *AmCoTW 41-2; ToCPS 4.*

Esteves, Antonio
b. 1910 **d.** 1983
Flourished: 1973 Brooklyn, NY; New York, NY
Ethnicity: Brazilian
Type of Work: Oil, acrylic (Paintings)
Museums: 032,171
Sources: *AmFokArt 80-2*; FoA 104*, 462.*

Etner, Reuben
Flourished: Richland County, OH
Type of Work: Fabric (Coverlets)
Sources: *ChAmC 56.*

Etter, Elizabeth Davidson
Flourished: Maroupin County, IL
Type of Work: Fabric (Coverlets)
Museums: 114
Sources: *ArC 101*.*

Ettinger, Emanuel
b. 1801 Pennsylvania **d.** 1889 Aaronsburg, PA
Flourished: 1834-1863 Aaronsburg, PA; Centre County, PA; Haines Township, PA
Type of Work: Fabric (Weavings)
Sources: *AmSQu 276; ChAmC 56; HerSa**
See: Folk, John.

Ettinger, John
Flourished: 1837 Springfield, OH
Type of Work: Fabric? (Coverlets?)
Sources: *ChAmC 56.*

Ettinger, William
b. c1825 Pennsylvania
Flourished: c1850 Shrewsbury, PA
Type of Work: Fabric (Coverlets)
Remarks: Probably different than the weaver from Aaronsburg PA
Sources: *ChAmC 56.*

Ettinger, William (Henry)
Flourished: c1863-1867 Aaronsburg, PA; Haines Township, PA
Type of Work: Fabric (Weavings)
Remarks: Probably a different weaver than the Shrewbury PA weaver
Sources: *ChAmC 56.*

Eubele, M.
Flourished: Berks County, PA
Type of Work: Tin (Coffee pots)
Museums: 189
Sources: *FoArRP 158*.*

Euler and Sunshine
Flourished: c1860 Pittsburgh, PA
Type of Work: Stoneware (Pottery)
Sources: *AmPoP 227; Decor 218.*

Eureka Steam Machine Carving Company
Flourished: 1871 New York, NY
Type of Work: Wood (Ship carvings, ship figures)
Sources: *AmFiTCa 191.*

Eutatse, John
Flourished: c1728 New York, NY
Type of Work: Redware (Pottery)
Sources: *AmPoP 197.*

Eval and Zom
Flourished: c1830 Berlin, PA
Type of Work: Redware (Tobacco pipes)
Sources: *AmPoP 208.*

Evans
See: Rittenhouse, Evans and Company.

Evans
See: Holmes and Evans.

Evans, Daniel
Flourished: 1838-1840 Hallowell, ME; Augusta, ME
Type of Work: Paint (Boxes)
Sources: *NeaT 69*-70*, fig15.*

Evans, J.
Flourished: 1825-1855 Portsmouth, NH; Boston, MA; Roxbury, MA
Type of Work: Watercolor (Portraits)
Museums: 050,088,176,189,203
Sources: *AmFoPa 48, 58, 61-2; AmPaF 191*; AmPrW 137*, 105*; FoA 462; FoArA 66-71*; FoPaAm 59*; NinCFo fig84, 166, 185.*

Evans, J.M.
Flourished: 1850 Poughkeepsie, NY
Type of Work: Oil (Paintings)
Sources: *PrimPa 172; ThrNE 10-21*, 54-6*, fig.*

Evans, James Guy
Flourished: 1838-1862 New Orleans, LA
Type of Work: Oil (Marine and historical paintings)
Sources: *AmFoPa 111.*

Evans, James I.
Flourished: 1827-1854 New York
Type of Work: Oil (Ship portraits)
Sources: *OneAmPr 118*, 154.*

Evans, John
Flourished: 1880 Boston, MA
Type of Work: Wood (Ship carvings, ship figures)
Sources: *AmFiTCa 191.*

Evans, John T.
Flourished: 1809-1833? Philadelphia, PA; Boston, MA
Type of Work: Watercolor (Portraits, landscape paintings)
Museums: 176
Remarks: Itinerant artist
Sources: *ColAWC 130-2*.*

Evans, Minnie
b. 1892 Long Creek, NC
Flourished: 1930- Airlie Gardens, NC; Wilmington, NC
Ethnicity: Black American
Type of Work: Oil, pen, ink, crayon, collages (Biblical, fantasy drawings)
Sources: *AfAmA 125*, 132; AmFokArt 83-5*; ArtWo 134, 136, 152-3, 160, fig24; FoAFz 9*; HoKnAm191; TwCA 152*.*

Evans, Robert
Flourished: 1810 Berlin, CT
Type of Work: Tin? (Tinware?)
Sources: *TinC 168.*

Evans, W.D.
Flourished: c1860 Kernersville, NC
Type of Work: Wood, paint (Chests of drawers)
Sources: *SoFoA 146-7*, 157*, 221.*

Evans, Walter
[Evans Decoy Factory]
b. 1872
Flourished: until 1932 Ladysmith, WI
Type of Work: Wood (Duck decoys)
Sources: *AmBiDe 228-9*, 250.*

Evans, William B.
Flourished: 1859
Type of Work: Watercolor (Paintings)
Museums: 176
Sources: *ColAWC 237.*

Evans Decoy Factory
See: Evans, Walter.

Evans Pipe Company
Flourished: Uhrichsville, OH
Type of Work: Clay (Sewer tile sculpture)
Sources: *IlHaOS *.*

Evans Pottery
b. Dexter, MO
Flourished: c1900
Type of Work: Stoneware (Pottery)
Sources: *AmS 48*.*

Eveling, Frederick
Flourished: 1860 St. Charles, MO
Type of Work: Tin (Tinware)
Remarks: Native of Brunswick
Sources: *ASeMo 428.*

Ewen, John, Jr.
Flourished: late 18th cent
Type of Work: Oil (Paintings)
Sources: *AmPrP 151; PrimPa 172.*

Excelsior Pottery
See: Schenkle, William.

Excelsior Works
See: Hewett, Isaac.

Exley, F.
Flourished: 1907
Type of Work: Clay (Sewer tile sculpture)
Sources: *IlHaOS *.*

Eyer, Johann Adam
Flourished: 1788 Bucks County, PA
Type of Work: Watercolor, ink (Frakturs)
Sources: *HoKnAm 150, pl31.*

Eyman, Earl
Flourished: 1935-1975 Oklahoma
Type of Work: Wood (Sculptures, carvings)
Museums: 072
Sources: *AlAmD 88*, 91*; FoArO 13, 75*, 80*, 85-6*, 94, 101.*

Eyre, John
Flourished: 1840-1844 Cincinnati, OH
Type of Work: Fabric (Carpets, coverlets)
Sources: *ChAmC 56.*

Eyster, Elizabeth
Flourished: 1776 Manchester Township, PA
Type of Work: Watercolor, ink (Frakturs)
Sources: *FoPaAm fig36.*

F

F. Haynes and Company
[D.F. Haynes and Company]
Flourished: 1880 Baltimore, MD
Type of Work: White Granite (Pottery)
Sources: *AmPoP 164, 263; DicM 183*, 185*, 205*, 240, 252*, 254**
See: D.F. Haynes and Company.

F.J. Knapp
Flourished: c1874 Summit County, OH
Type of Work: Stoneware (Pottery)
Remarks: A factory
Sources: *AmS 253.*

F.T. Wright and Son
Flourished: c1860 Tauton, MA
Type of Work: Stoneware (Jugs)
Sources: *AmS 75*.*

F.W. Weeks
Flourished: 1890 Akron, OH
Type of Work: Stoneware (Jugs)
Sources: *AmS 78*.*

Faber, Wilhelmus Antonius
Flourished: 1787-1818 Pennsylvania
Type of Work: Watercolor, ink (Frakturs)
Sources: *AmFoPa 188; Edith *.*

Fabian, Caroline Broughton
Flourished: 1803 Georgia
Type of Work: Fabric (Samplers)
Sources: *SoFoA 174*, 222.*

Fabian, Gisela
b. 1943
Flourished: c1972 New York, NY
Ethnicity: German
Type of Work: Acrylic (Paintings)
Sources: *AmFokArt 86-7*.*

Fagley, S.
Flourished: 1872
Type of Work: Pen, ink (Drawings)
Sources: *FoA 102*.*

Fahr, Abraham
See: Fehr, Abraham.

Fahre, Abraham
See: Fehr, Abraham.

Faience, Grueby
See: Grueby Faience Company.

Faience Manufacturing Company
Flourished: 1880-1892 Greenpoint, NY
Type of Work: Clay (Pottery)
Sources: *AmPoP 198, 260; DicM 203**
See: Vance Faience Company.

Fair, Hannah
Flourished: 1796 Pennsylvania
Type of Work: Ink, watercolor (Portraits)
Sources: *NinCFo fig1.*

Fair, Henry
Flourished: c1870-1891 Mt. Etna, PA
Type of Work: Redware (Pottery)
Sources: *AmPoP 171.*

Fairbank Cook and Company
See: Cook and Richardson.

Fairbanks, Sarah
Flourished: 1820 Francestown, NH
Type of Work: Watercolor (Paintings)
Museums: 176
Sources: *ColAWC 237.*

Fairbrothers, William
b. c1800 d. 1876
Flourished: 1850-1860 Henry County, IN; Ohio
Ethnicity: English
Type of Work: Fabric (Weavings)
Sources: *AmSQu 276; ChAmC 56.*

Fairfield, Hannah
Flourished: 1839- Windham County, CT
Type of Work: Oil (Portraits)
Sources: *ArtWo 91*, 160*.*

Fairman, Edward
Type of Work: Pen, crayon (Landscape drawings)
Museums: 176
Sources: *ColAWC 160-1.*

Falk, Barbara (Busketter)
b. Los Angeles, CA
Flourished: c1975 Tucson, AZ
Type of Work: Acrylic (Paintings)
Sources: *AmFokArt 88-91*.*

Fallston Pottery Company
Flourished: c1875-1900 Fallston, PA
Type of Work: Stoneware (Pottery)
Sources: *AmPoP 220; Decor 218.*

Fare, Thomas
See: Fehr, Thomas.

Farmer
See: Marks, Farmer, Manley, and Riley.

Farmer, Josephus, Reverend
b. 1894 Trenton, TN
Flourished: late 1960s Milwaukee, WI
Ethnicity: Black American
Type of Work: Wood (Religious and historic carvings)
Sources: *AmFokArt 92-3*; FoAFl 1*, 4-6*.*

Farmington, Silas
Flourished: 1841
Type of Work: Tin? (Tinware?)
Remarks: May have worked for Filley
Sources: *TinC 168.*

Farnham, Henry
Flourished: 1820 New York, NY
Type of Work: Wood (Ship carvings, ship figures)
Sources: *AmFiTCa 191.*

Farnham, John D.
Flourished: 1871 New York, NY
Type of Work: Wood (Ship carvings, ship figures)
Sources: *AmFiTCa 191.*

Farrand, Stephen
Flourished: 1834 New York, NY
Type of Work: Wood (Ship carvings, ship figures)
Sources: *AmFiTCa 191.*

Farrand and Omensetter
Flourished: 1860 Philadelphia, PA
Type of Work: Wood (Ship carvings, ship figures)
Sources: *AmFiTCa 191.*

Farrand and Stuart
Flourished: 1834 New York, NY
Type of Work: Wood (Ship carvings, ship figures)
Sources: *AmFiTCa 191*.

Farrar
See: Boynton and Farrar.

Farrar, Caleb
Flourished: 1815-1850 Middlebury, VT
Type of Work: Redware, stoneware (Pottery)
Sources: *AmPoP 195*.

Farrar, Ebenezer L.
Flourished: c1850-1871 Burlington, VT
Type of Work: Stoneware (Pottery)
Sources: *AmPoP 192; Decor 218*.

Farrar, George W.
See: Farrar, Isaac Brown.

Farrar, H.W.
Flourished: Bennington, VT; Jersey City, NJ; Kaolin, SC
Type of Work: Clay (Pottery)
Sources: *AmPoP 49, 88, 238*.

Farrar, Isaac Brown
Flourished: c1815-1855 Fairfax, VT
Type of Work: Stoneware (Pottery)
Remarks: George and J.H. took over business
Sources: *Decor 218*; DicM 66**.

Farrar, J.H.
See: Farrar, Isaac Brown.

Farrar, S.H.
Flourished: 1856-1863 Fairfax, VT
Type of Work: Rockingham, Flint Enamel, brownware (Pottery)
Sources: *AmPoP 192*.

Farrar, William H.
See: William H. Farrar.

Farrar and Stearns
Flourished: 1850-1856 Fairfax, VT; Middlebury, CT
Type of Work: Stoneware (Pottery)
Sources: *AmPoP 59, 192; Decor 219*.

Farrell, John
Flourished: 1868-1870 San Francisco, CA
Type of Work: Wood (Ship carvings, ship figures)
Sources: *ShipNA 155*.

Farren and Edlefson
Flourished: 1860 Richmond, ME
Type of Work: Wood (Ship carvings, ship figures)
Sources: *AmFiTCa 191*.

Farrington, Anna Putney
Flourished: 1857 Katonah, NY; Baltimore, MD
Type of Work: Fabric (Quilts)
Sources: *AmBiDe 125*; AmSQu 180-1*; FlowAm 266**.

Farrington, Daniel
b. 1733 d. 1807
Flourished: Wrentham, MA
Type of Work: Stone (Gravestones)
Sources: *EaAmG 128; GravNE 127*.

Farrington, E.W.
Flourished: c1880 Elmira, NY
Type of Work: Stoneware (Pottery)
Sources: *Decor 219*.

Fasanella, Ralph
b. 1914 New York, NY
Flourished: New York, NY; Ardsley, NY
Type of Work: Oil (Political paintings)
Museums: 203
Remarks: Protest of social injustices
Sources: *AmFokArt 94-8*; ConAmF 60*; FoA 462; FoAFg 6*; FoPaAm 108*, 110; HoKnAm 188; TwCA181**.

Fash, William B.
Flourished: 1834 New York, NY
Type of Work: Wood (Ship carvings, ship figures)
Sources: *AmFiTCa 191*.

Fasig, A.
Flourished: 1853-1854 Clark County, IL
Type of Work: Fabric (Coverlets)
Sources: *ChAmC 56*.

Fasig, Christian
b. c1825
Flourished: 1853 Clark County, IL
Type of Work: Fabric (Weavings)
Sources: *ChAmC 58*.

Fasig, William
b. c1801 Lebanon County, PA
Flourished: c1824?-1858 Wayne County, OH; Missouri; Martinsville, IL
Type of Work: Fabric (Coverlets)
Sources: *ChAmC 58*.

Fatsinger, Adam
Flourished: 1843 Lehigh County, PA
Type of Work: Fabric (Weavings)
Sources: *ChAmC 58*.

Favorite, Elias
b. c1796 Maryland
Flourished: c1850 Dalton Township, IN
Type of Work: Fabric (Weavings)
Remarks: May have worked for the Test Woolen Mills
Sources: *ChAmC 58*
See: Hoover, John; Jordan, Thomas.

Fayette, Shavalia
Flourished: c1832 Utica, NY
Type of Work: Stoneware (Pottery)
Sources: *Decor 219*.

Feege and Feege
Flourished: ?-1862 Wrightstown, PA
Type of Work: Redware (Pottery)
Sources: *AmPoP 185*.

Fees, C.
Flourished: 19th cent
Type of Work: Oil (Portraits)
Sources: *Edith **.

Fehr, Abraham
[Fahr; Fahre]
b. c1822 Pennsylvania
Flourished: 1850-1860 Emmaus, PA; Salisbury Township, PA
Type of Work: Fabric (Coverlets)
Remarks: Worked with Fehr, Thomas
Sources: *ChAmC 58*.

Fehr, C.
Flourished: 1836-1845 Emmaus, PA
Type of Work: Fabric (Coverlets)
Sources: *AmSQu 276; ChAmC 58*.

Fehr, Thomas
[Fare]
b. c1815 Pennsylvania
Flourished: 1838-1850 Lower Saucon Township, PA
Type of Work: Fabric (Coverlets)
Remarks: Worked with Fehr, Abraham
Sources: *ChAmC 58*.

Fehr and Keck
Flourished: 1843-1848 Emmaus, PA
Type of Work: Fabric (Coverlets)
Sources: *ChAmC 58*
See: Keck.

Feke, Robert
b. 1707 d. 1752
Flourished: 1741 Boston, MA
Type of Work: Oil (Portraits)
Museums: 083
Remarks: Daughter is Sarah
Sources: *ArtWea 138*; FloCo 40**.

Feke, Sarah
b. c1749 Newport, RI d. before 1772
Flourished: 1762 Newport, RI
Type of Work: Fabric (Samplers)
Museums: 205
Remarks: Daughter of Robert
Sources: *LeViB 22, 60-1, 80*, 82, 250*.

Fell and Thropp Company
Flourished: 19th century Trenton, NJ
Type of Work: Clay (Pottery)
Sources: *DicM 151*, 156*, 243**.

Fellini, William
d. 1965
Flourished: New York, NY
Type of Work: Oil (Still life, landscape paintings)
Sources: *AmFokArt 99-101*; FoA 462; TwCA 153**.

Fellows and Meyers
Flourished: 1718 Pennsylvania
Type of Work: Brass (Brassware)
Sources: AmCoB 185.

Felski, Albina
b. 1925
Flourished: 1963 Chicago, IL
Type of Work: Oil (Paintings)
Sources: ArtWo 149*, 160; TwCA 223*.

Feltner, Jim
b. 1908 London, KY
Flourished: 1975- Kentucky
Type of Work: Wood, paper, plastic beads, coins (Boxes, hearts, beaded crosses)
Sources: GoMaD *.

Felton, Ebenezer
d. c1741
Type of Work: Stone (Gravestones)
Sources: GravNE 127.

Fenimore, Janice
b. 1924
Flourished: 1978 Madison, NJ
Type of Work: Wood (Whirligigs)
Sources: FoA 161*, 462.

Fenn
Flourished: Plymouth, CT?
Type of Work: Tin painted (Clock faces)
Sources: TinC 168.

Fennell, Michael
[Pennell]
b. c1826
Flourished: 1846-1851 Indiana; Salem Township, PA
Type of Work: Fabric (Coverlets)
Sources: ChAmC 58.

Fenton
See: Lyman, Fenton Company.

Fenton, C.L.
Flourished: 1850 Dover, NH
Type of Work: Oil (Portraits)
Sources: PrimPa 172.

Fenton, Christopher Webber
[Fenton Works]
b. Bennington, VT
Flourished: 1844-1865 Peoria, IL; Bennington, VT
Type of Work: Stoneware, Rockingham (Pottery)
Museums: 171
Remarks: Son of Jonathan; patented Fenton's Enamel Ware
Sources: AmFoArt 100-1*; AmPoP 21-2, 48, 59-64, 69, 78, 110-1, 117, 188, 260*; AmS 20; ArC 194; NeaT 52
See: Norton, Julius.

Fenton, J.H.
Flourished: c1854-1875 Mogadore, OH
Type of Work: Stoneware (Pottery)
Sources: AmPoP 224; Decor 219.

Fenton, Jacob
Flourished: c1790-1801 New Haven, CT; Burlington, NY
Type of Work: Stoneware (Pottery)
Sources: AmPoP 189; Decor 219.

Fenton, Jonathan
Flourished: 1794-1840 Boston, MA; Walpole, NH; Dorset, VT
Type of Work: Stoneware (Pottery)
Museums: 097
Remarks: Son is Christopher
Sources: AmPoP 191, 203; Decor 67*, 105*, 137*, 164*, 219; DicM 73*
See: Fenton and Carpenter.

Fenton, L(eander) W.
Flourished: 1800-1850 Dorset, VT; Burlington, VT; St. Johnsbury, VT
Type of Work: Stoneware, brownware (Pottery)
Sources: AmPoP 59-60, 203, 260; DicM 86*.

Fenton, Richard L.
Flourished: East Dorset, MA
Type of Work: Stoneware (Pottery)
Sources: AmS 20-1*, 180, 231*.

Fenton, Richard Webber
Flourished: 1808-1859 St. Johnsbury, VT
Type of Work: Stoneware (Pottery)
Remarks: Son is L(eander) W.; brother is Jonathan
Sources: AmPoP 203; Decor 219.

Fenton, T.H.
Flourished: c1850-1880 Tallmadge, OH
Type of Work: Stoneware (Pottery)
Sources: AmPoP 231; Decor 219.

Fenton and Carpenter
[Jonathan Fenton and Fredrick Carpenter]
Flourished: 1793-1797 New Haven, CT
Type of Work: Clay (Pottery)
Sources: AmS 20*, 76*.

Fenton and Clark
Flourished: 1859-1865 Peoria, IL
Type of Work: Clay (Pottery)
Sources: AmPoP 226.

Fenton and Hancock
Flourished: 1859-1870 St. Johnsbury, VT
Type of Work: Stoneware (Pottery)
Sources: AmPoP 203; DicM 46*.

Fenton Works
See: Fenton, Christopher Webber.

Ferg, Henry
Flourished: 1876 Philadelphia, PA
Type of Work: Wood (Ship carvings, ship figures)
Sources: AmFiTCa 191.

Ferguson
See: Simms and Ferguson.

Ferguson, Mrs.
Flourished: 1865 Pleasant Hill, GA
Type of Work: Fabric (Quilts)
Museums: 099
Sources: MisPi 78*.

Ferguson, Adaline M.
b. c1809
Flourished: 1822 Portsmouth, NH
Type of Work: Fabric (Samplers)
Sources: GalAmS 59*.

Ferguson, Frederica
Flourished: 1819-1823? Boston, MA
Type of Work: Fabric (Decorative apron trims)
Sources: Bes 36.

Ferguson, Sarah
b. 1828 d. 1900
Flourished: 1840-1845 Jones County, MS
Type of Work: Watercolor (Theorems)
Sources: SoFoA 78, 90*, 219.

Fernandez, Gilbert
b. 1922 Valdez, CO
Flourished: 1975 Weston, CO
Ethnicity: Hispanic
Type of Work: Fabric (Weavings)
Sources: HisCr 20*, 101*.

Fernberg, Samuel
Flourished: Mendota City, IL
Type of Work: Fabric (Weavings)
Sources: ChAmC 58.

Ferran, Joseph
Flourished: 1859 Salem, MA
Type of Work: Wood (Ship carvings, ship figures)
Sources: AmFiTCa 191.

Ferrell
See: Power and Ferrell.

Fetter, E.
Flourished: 1840
Type of Work: Fabric? (Coverlets?)
Sources: ChAmC 58.

Fewkes, E.
See: Fewkes, J.

Fewkes, J.
Flourished: 1856 Watertown, MA
Type of Work: Wood (Ship carvings, ship figures)
Sources: AmFiTCa 191.

Fibich, R.
Flourished: 1850-1860
Type of Work: Oil (Landscape paintings)
Sources: AmFoPaN 100, 124*; AmPrP fig53, 151; PrimPa 172.

Field, Erastus Salisbury
b. 1805 Leverett, MA **d.** 1900 Sunderland, MA
Flourished: 1824-1890 Sunderland, MA; Hartford, CT; New York, NY
Type of Work: Oil (Portraits, paintings)
Museums: 001,171,176,234,260,265
Remarks: Studied under Morse, Samuel Finley Breese
Sources: *AmFoPa* 7, 10-11*, 40, 42, 45, 47, 63-5*, 137-9*; *AmFoPaCe* 45, 74-81*, 142; *AmFoPo* 32-3*, 93-102*; *AmNa* 13, 18, 23, 54*-7*; *AmPaF* 189*; *BoLiC* 64-7; *CoCoWA* 104; *Edith* *; *EraSa* *; *EraSaF* *; *EyoAm* 18, 23*; *FoA* 16*, 464; *FoArA* 49.

Field, Erastus Salisbury (Continued)
Sources: *FoPaAm* 36*, 48-9, 52, 96, 98, 116, 169, 189 *GifAm* 48*; *NinCFo* 166, 173-4, fig66, 67, 77, 78, 105, ; *OneAmPr* 75*, 79-80, 110*, 144, 146, 154; *PrimPa* 72-9*, 172.

Field, J.A.
Flourished: 1851 Nauvoo, IL
Sources: *ArC* 264.

Field, L.F.
Flourished: c1865 Utica, NY
Type of Work: Clay (Pottery)
Sources: *AmPoP* 204; *DicM* 85*.

Field, Rebecca
Flourished: 1801 Dutchess County, NY
Type of Work: Fabric (Samplers)
Sources: *GalAmS* 37.

Fields, Charlie "Creek Charlie"
b. 1883 **d.** 1966
Flourished: 1928-1966 Lebanon, VA
Type of Work: Oil (House painted in patriotic colors)
Remarks: Painted in red, white and blue oils
Sources: *ConAmF* 118-26*; *FoAFv* 4*.

Fields, Leonard
b. 1910 Louisville, KY
Flourished: Louisville, KY
Ethnicity: Black American
Type of Work: Oil (Morality paintings)
Sources: *FoAroK* *.

Fieter, Michael
Flourished: 1760 Pennsylvania
Type of Work: Watercolor, ink (Frakturs)
Sources: *AmFoPa* 188.

Fife
See: Smith, Fife and Company.

Fifield, Daniel
Flourished: 1854 Charlestown, MA
Type of Work: Wood (Ship carvings, ship figures)
Sources: *AmFiTCa* 191.

Fifield, Mary Thurston
Flourished: 1711-1714 Boston, MA
Type of Work: Fabric (Quilts, crewel embroidered bedspreads)
Museums: 176
Sources: *AmNe* 32*, 34; *AmSQu* 56*.

Figley, Joseph
Flourished: c1850 Newport, OH; New Philadelphia, OH
Type of Work: Stoneware (Pottery)
Sources: *AmPoP* 225; *Decor* 219; *DicM* 71*.

Filcher, Thomas J.
Flourished: 1843 Nauvoo, IL
Ethnicity: English
Type of Work: Clay (Pottery)
Sources: *ArC* 190.

Filker, John
Flourished: 1877 Amherst, OH
Type of Work: Fabric (Hooked rugs, bed rugs)
Sources: *AmHo* 55*.

Filley, Augustus
b. 1789 **d.** 1846
Flourished: c1810 Lansingburgh, NY
Type of Work: Tin (Tinware)
Remarks: Cousin of Oliver
Sources: *AmCoTW* 59, 64, 66-7, 83-5, 112-8, 121; *TinC* 15-7, 19, 77, 138, 168.

Filley, Giles
Flourished: St. Louis, MO
Type of Work: Tin (Tinware)
Remarks: Brother is Oliver
Sources: *ASeMo* 423.

Filley, Harvey
Flourished: 1820-1850 Bloomfield, CT; Lansingburgh, NY; Philadelphia, PA
Type of Work: Tin (Tinware)
Remarks: Younger brother of Oliver
Sources: *AmCoTW* 59, 66, 75-6, 80-1, 166; *AmSFo* 41; *TinC* 17, 138, 168.

Filley, I.A.
Flourished: 1841 Connecticut
Type of Work: Tin? (Tinware?)
Sources: *TinC* 168.

Filley, Jay Humphrey
d. 1883
Flourished: Bloomfield, CT
Type of Work: Tin (Tinware)
Remarks: Son of Oliver
Sources: *TinC* 20, 168.

Filley, Marcus Lucius
Flourished: Lansingburgh, NY; Troy, NY
Type of Work: Tin (Tinware)
Remarks: Son of Oliver
Sources: *AmCoTW* 59; *TinC* 20, 168.

Filley, Oliver
b. 1784 **d.** 1846
Flourished: early 19th cent Windsor, CT; Bloomfield, CT
Type of Work: Tin (Tinware)
Sources: *AmCoTW* 50, 53-55, 58-9, 63-5, 75-77, 87*, 117, 147; *AmSFo* 37*, 39-41*; *ASeMo* 423*; *FoArtC* 84; *TinC* 11-21, 37, 41, 53, 73, 81, 88, 93-94*, 97, 106*, 114, 117, 138, 147, 149, 153, 168; *ToCPS* 7, 10, 12, 48, 75-6.

Filley, Oliver (Dwight)
d. 1881
Flourished: Bloomfield, CT; St. Louis, MO
Type of Work: Tin (Tinware)
Remarks: Son of Oliver
Sources: *AmCoTW* 59, 64-5; *TinC* 17-20, 168.

Fillman, Michael
Flourished: c1815 Tylersport, PA
Type of Work: Clay (Pottery)
Sources: *AmPoP* 186.

Finch, E.E.
Flourished: 1832-1850s Augusta, ME
Type of Work: Oil (Portraits)
Sources: *AmPrP* 151; *NinCFo* fig65, 165, 174; *PrimPa* 172.

Finch, John
Flourished: Michigan
Type of Work: Wood (Decoys)
Sources: *WaDec* 126*, 131*, 154*.

Finch, Nathaniel
Flourished: 1834 New York, NY
Type of Work: Wood (Ship carvings, ship figures)
Sources: *AmFiTCa* 192.

Finch, Ruby Derd
b. 1804 **d.** 1866
Flourished: New Bedford, MA; Westport, MA
Type of Work: Watercolor (Minatures, paintings)
Museums: 001
Sources: *AmFoPo* 102-105*; *ArtWo* 93*-4, 160-1, fig14.

Finchour, Joseph
[Finchow]
Flourished: 1796 Philadelphia, PA
Type of Work: Tin (Tinware)
Sources: *AmCoTW* 153; *ToCPS* 6.

Finchow, Joseph
See: Finchour, Joseph.

Findlay, Robert
Flourished: 1844 Cincinnati, OH
Type of Work: Fabric (Carpets, coverlets)
Sources: *ChAmC* 58.

Finger, Henry
Flourished: 1841-1863 Marissa, IL
Ethnicity: German
Sources: *ArC* 264.

Fink, Willie Sharpe
Flourished: c1875 Mercer County, KY
Type of Work: Fabric (Quilts)
Museums: 125
Sources: *KenQu 73, fig62*.

Finkel, Bill (William)
Flourished: 1930s St. Clair Flats, MI
Type of Work: Wood, metal (Fish decoys)
Sources: *UnDec 18*; WaDec 133*, 147**.

Finlay, Hugh
Flourished: 1803-1833 Baltimore, MD
Type of Work: Wood (Furniture)
Sources: *AmPaF 132-3**.

Finlay, John
Flourished: 1803-1830 Baltimore, MD
Type of Work: Wood (Furniture)
Sources: *AmPaF 132-3**.

Finn, Marvin
b. 1917 Clio, AL
Flourished: 1966 Louisville, KY
Ethnicity: Black American
Type of Work: Wood (Sculptures)
Sources: *FoAroK **.

Finnerard, M.T.
Flourished: 1860 Roxbury, MA
Type of Work: Wood (Ship carvings, ship figures)
Sources: *AmFiTCa 192*.

Finney, Elizabeth
Flourished: 1807 Harrisburg, PA
Type of Work: Fabric (Samplers)
Sources: *FlowAm 101**.

Finster, Howard, Reverend
b. 1916 Valley Head, GA
Flourished: 1961-present Pennville, GA; Summerville, GA
Type of Work: Oil, wood, plexiglass (Biblical scene paintings, environmental, other sculptures, carvings)
Sources: *AmFokArt 102-3*; FoA 81*, 464; FoAFj 14-5; FoAFs 17*; FoAFv 2, 7; FoAFz 8-9*; FoAFcd 1*; FoPaAm 177*, 180, 182; HoFin;HoFinV;MisPi 5, 11, 104-6*; SerPa;Trans 6, 38, 41-3*, 49, 54*.

Firth, E.F.
Flourished: 1829 New England,
Type of Work: Watercolor (Marriage and birth certificate drawings)
Museums: 096
Sources: *FoPaAm 49**.

Fische, William
See: William Fische Pot Factory.

Fischer, Albert
b. 1792 d. 1863
Flourished: Boston, MA
Type of Work: Oil (Portraits)
Sources: *AmPrP 151; PrimPa 172; SoAmP 288*.

Fischer, Charles
Flourished: 1860 Hermann, MO
Ethnicity: German
Type of Work: Tin (Tinware)
Sources: *ASeMo 426*.

Fischer, Charles
Flourished: 1860 New York, NY
Type of Work: Wood (Ship carvings, ship figures)
Sources: *AmFiTCa 192*.

Fischer, Charles Henry
Flourished: 1860 Newark, NJ
Type of Work: Oil (Paintings)
Sources: *AmPrP 152; PrimPa 172*.

Fischer, Samuel
Flourished: 1835 Upper Bern Township, PA
Type of Work: Fabric (Coverlets)
Sources: *ChAmC 58*.

Fish, C.
[Swan Hill Pottery]
Flourished: 1849-50 South Amboy, NJ
Type of Work: Stoneware (Pottery)
Sources: *AmPoP 180; Decor 219*.

Fish, Eliza R.
Flourished: 1860 Mystic, CT
Type of Work: Fabric (Religious embroidered pictures)
Sources: *AmNe 109, 111**.

Fisher
Flourished: 19th century York, PA
Type of Work: Iron (Weathervanes)
Museums: 110
Sources: *EaAmI 133**.

Fisher, Daniel
b. c1822 Pennsylvania
Flourished: 1845-1857 South Bend, IN
Type of Work: Fabric (Coverlets)
Remarks: Brother is Levi
Sources: *ChAmC 19*, 58*.

Fisher, Eleanor
b. 1829
Flourished: 1839 Rush, PA
Type of Work: Fabric (Samplers)
Sources: *GalAmS 82**.

Fisher, J(acob)
Flourished: 1878-1900 Lyons, NY
Type of Work: Stoneware (Pottery)
Sources: *AmS 143*; Decor 219; EaAmFo 96**.

Fisher, J.C.
Flourished: c1810 Hartford, CT
Type of Work: Clay (Pottery)
Sources: *AmPoP 193, 260; Decor 219; DicM 71**.

Fisher, J.C.
Flourished: 1787-1808 Steubenville, OH
Type of Work: Redware (Pottery)
Sources: *AmPoP 68, 231*.

Fisher, Jacob
Flourished: c1850 Haines Township, PA
Type of Work: Fabric (Coverlets)
Sources: *ChAmC 58*
See: Ettinger, Emanuel.

Fisher, Jeremiah
Flourished: c1765 Wrentham, MA
Type of Work: Stone (Gravestones)
Sources: *EaAmG 128; GravNE 128*.

Fisher, John
b. 1740 d. 1805
Flourished: c1776 York, PA
Type of Work: Wood (Cigar store Indians, figures)
Museums: 110
Sources: *AmFoS 257*; EaAmW 74; FoArRP 113**.

Fisher, John
Flourished: c1879 Cambria County, PA; Cincinnati, OH
Type of Work: Stoneware (Pottery)
Sources: *AmPoP 162, 212, 235; Decor 219*.

Fisher, Jonathan, Reverend
b. 1768 d. 1847
Flourished: Blue Hill, ME
Type of Work: Oil (Portraits, landscape and still life paintings)
Sources: *AmFoPa 154*; AmFoPaCe 82-7*; AmPrP 152; FoA 464; PrimPa 172*.

Fisher, Levi
b. c1829 Pennsylvania
Flourished: 1845-1855 South Bend, IN
Type of Work: Fabric (Coverlets)
Remarks: Brother is Daniel
Sources: *ChAmC 58*.

Fisher, Michael B.
Flourished: 1891-1900 Mt. Etna, PA
Type of Work: Redware (Pottery)
Sources: *AmPoP 171*.

Fisher, Robert
Flourished: 1800-1810 Baltimore, MD
Type of Work: Wood (Furniture)
Sources: *AmPaF 135**.

Fisher, Samuel
b. 1732 d. 1816
Flourished: c1768 Wrentham, MA
Type of Work: Stone (Gravestones)
Sources: *EaAmG 128; GravNE 87, 128*.

Fisher, Samuel, Jr.
b. 1768 d. 1815
Flourished: Wrentham, MA
Type of Work: Stone (Gravestones)
Sources: *EaAmG 128; GravNE 128*.

Fisher, Thomas
Flourished: c1808-1825 Steubenville, OH
Type of Work: Stoneware (Pottery)
Sources: *AmPoP 231; Decor 219*
See: Fisher and Tarr.

Fisher and McLain
Flourished: c1810-1840 Hillsboro, OH
Type of Work: Stoneware (Pottery)
Sources: AmPoP 221; Decor 219.

Fisher and Tarr
[Thomas Fisher]
Flourished: c1820 Steubenville, OH
Type of Work: Stoneware (Pottery)
Sources: AmPoP 231; Decor 219.

Fisk, Lorenza
Flourished: c1811 Concord, MA; Lexington area, MA
Type of Work: Needlework (Genealogical samplers)
Sources: PlaFan 84*; WinGu 17*.

Fiske, J.W. (John)
See: J.W. Fiske (Ironworks).

Fiske and Smith
Flourished: c1822-1830 Springfield, OH
Type of Work: Stoneware (Pottery)
Sources: AmPoP 69, 230; Decor 219.

Fitch, Isaac
Flourished: c1791 Lebanon, CT
Type of Work: Wood (Boxes)
Sources: NeaT 64.

Fitch, Simon, Captain
b. 1758 Norwich, CT d. 1835
Flourished: 1802 Lebanon, CT; Goshen, CT
Type of Work: Oil (Portraits)
Museums: 297
Sources: AmFoPaN 21-2*, 41*; AmNa 11; AmPaF 86*; FloCo 60*; HoKnAm 92; PaiNE 17, 108-111*.

Fitzgerald, Mrs. Joshua
Flourished: 1850
Type of Work: Fabric (Quilts)
Sources: AmSQu 158*.

Flagg, Abijah
Flourished: Berlin, CT
Type of Work: Tin? (Tinware?)
Sources: TinC 168.

Flagg, Edwin H.
Flourished: Los Angeles, CA
Type of Work: Oil (Theater and sideshow scenes)
Sources: AmSFor 198.

Flanagan, John
Flourished: 1877 Meriden, CT
Type of Work: Tin (Tinware)
Sources: TinC 168.

Flanagan, Thomas Jefferson, Reverend
b. 1896 Georgia
Flourished: 1950-1970 Atlanta, GA
Ethnicity: Black American
Type of Work: Oil (Paintings)
Museums: 018,052
Sources: AmNeg pl13, 47; BirB 142*; FoPaAm 171, 178*; MisPi 48-9*.

Flandrow, Joseph B.
Flourished: 1834 New York, NY
Type of Work: Wood (Ship carvings, ship figures)
Sources: AmFiTCa 192.

Flanigan, George
b. c1798 d. 1874 Salona, PA
Flourished: c1850?-1863? Mill Hall, PA
Type of Work: Fabric (Weavings)
Sources: ChAmC 58.

Flax, Walter
b. 1900
Flourished: Yorktown, VA
Type of Work: Various materials (Battleship fleet sculptures)
Sources: ConAmF 113-7*.

Fleck, Joseph
b. c1825
Flourished: c1850-1860 English Township, OH
Ethnicity: German
Type of Work: Fabric (Weavings)
Sources: ChAmC 61.

Fleck, William
Flourished: 1860 Findlay, OH
Type of Work: Fabric (Weavings)
Sources: ChAmC 61.

Fleckinger, Jacob
Flourished: 1877-1900 Orrville, OH
Type of Work: Stoneware (Pottery)
Sources: AmPoP 226; Decor 218
See: Eichert, Peter.

Fleeson, Plunket
Flourished: c1739 Philadelphia, PA
Type of Work: Paper (Wallpaper)
Remarks: The first American manufacturer of wallpaper
Sources: AmDecor 81, 113.

Fleet, Mary
Flourished: 1745 Boston, MA
Type of Work: Fabric (Embroidery)
Museums: 176
Sources: ArtWo 14*.

Fleet, Theodore
Flourished: 1894 Strasburg, VA
Type of Work: Clay (Pottery)
Remarks: Connected with Eberly Pottery
Sources: AmFoS 223*
See: Begerly, Levi.

Fleetwood, Abigail
See: Fleetwood, Miles.

Fleetwood, Miles
Flourished: 1654
Type of Work: Fabric (Samplers)
Sources: AmNe 46.

Fleming, James Adam
Flourished: c1785 New York, NY
Type of Work: Wood (Hat boxes)
Sources: NeaT 98.

Flemings, Isabella
Flourished: c1885 Paducah, KY
Type of Work: Fabric (Quilts)
Sources: KenQu fig18.

Flentke
See: Morley, Goodwin, and Flentke.

Fletcher
Flourished: New Hampshire; Vermont
Type of Work: Oil (Portraits)
Sources: AmPrP 151; PrimPa 172; SoAmP 285.

Fletcher, Aaron Dean
b. 1817 d. 1902
Flourished: Essex, NY; Clinton, NY
Type of Work: Oil (Paintings)
Sources: AmFoPo 106-7*; FouNY 65.

Fletcher, Alex
Flourished: Greensburg, PA
Type of Work: Oil (Paintings)
Sources: ThTaT 236*.

Fletcher, Eric
Flourished: Mill Valley, CA
Type of Work: Ivory, silver (Belt buckles)
Remarks: Made with elephant ivory
Sources: Scrim 34*.

Fletcher, Marianne
Flourished: Mill Valley, CA
Type of Work: Scrimshaw (Boxes)
Sources: Scrim 29*.

Fleury, Elsie
Flourished: 1855 Nauvoo, IL
Type of Work: (Drawings)
Sources: ArC 264.

Fliehr, Charles B.
b. c1824 d. 1885 Emmaus, PA
Flourished: 1845-1863 Millerstown, PA; Weissport, PA
Ethnicity: German
Type of Work: Fabric (Carpets, coverlets)
Sources: ChAmC 61.

Flieman
Flourished: Michigan
Type of Work: Wood, metal (Fish decoys)
Sources: UnDec 20.

Flocher, S.
Flourished: 1840-1848 Bolivar, OH
Type of Work: Fabric (Weavings)
Sources: ChAmC 61
See: Blocher, S..

Floote, Mrs. A.A.
Flourished: mid 19th cent Louisiana
Type of Work: Pastel (Building portraits)
Sources: FoPaAm 176*.

Flory, John
Flourished: c1788 Pennsylvania
Type of Work: Wood (Decorated chests)
Sources: PenGer 154-6*, 200*.

Florys, William
Flourished: 19th and early 20th cent Stroudsburg, PA
Type of Work: Tin (Tinware)
Museums: 162
Sources: *ToCPS 42.*

Flower, Ann
Flourished: c1763 Philadelphia, PA
Type of Work: Embroidery (Hatchments)
Sources: *WinGu 137*.*

Flower, George
b. 1787 d. 1862
Flourished: c1820-1830 Albion, IL
Type of Work: Watercolor (Genre paintings)
Museums: 113
Sources: *ArC 66-72, 87*, 90.*

Flower, Mary Elizabeth
Flourished: c1840-1848 Hazel Hill, IL
Type of Work: Wood (Ornamental carvings)
Museums: 076
Sources: *ArC 78*.*

Flowers, Peter
b. c1805 Pennsylvania
Flourished: c1850 Newark, OH; Reading Township, OH
Type of Work: Fabric (Coverlets)
Sources: *ChAmC 61.*

Floyd, Caleb
Flourished: 1799-1807 Fells Point, MD
Type of Work: Redware (Pottery)
Sources: *AmPoP 162.*

Floyd, Thomas and Caleb
Flourished: c1896 Fells Point, MD
Type of Work: Redware (Pottery)
Sources: *AmPoP 162.*

Fodor, Richard L.
b. 1946 Jefferson, OH
Flourished: 1975- Kentucky
Type of Work: Sawdust, clay (Constructions)
Sources: *GoMaD *.*

Foel and Ault
Flourished: c1860 Birmingham (Pittsburgh), PA
Type of Work: Stoneware (Pottery)
Sources: *AmPoP 227; Decor 219.*

Fogg, Mary
See: Fogg, Mercy.

Fogg, Mercy (Mary)
Flourished: Massachusetts
Type of Work: Fabric (Samplers)
Museums: 083
Sources: *AmNe 43*, 47.*

Fogle, Lewis
Flourished: c1850 Bucyrus, OH
Ethnicity: German
Type of Work: Fabric (Weavings)
Sources: *ChAmC 61*
See: Slaybaugh, Samuel.

Foglesong, Christopher
Flourished: c1825 Lewisburg, WV
Type of Work: Stone (Gravestones)
Sources: *SoFoA 125*, 220.*

Foley, Nicholas
Flourished: 1825 Connecticut
Type of Work: Oil (Paintings)
Sources: *AmPrP 151; PrimPa 172.*

Foley, Theodore H.
Flourished: 1865 Boston, MA
Type of Work: Wood (Ship carvings, ship figures)
Sources: *AmFiTCa 192.*

Folger, David
Flourished: 1840s Nantucket, MA
Type of Work: Whalebone (Scrimshaw)
Sources: *ScriSW 236*.*

Folger, George
b. 1927
Flourished: 1979 Connecticut
Type of Work: Watercolor, chalk, magic marker (Paintings of toys)
Remarks: Painted while a patient in a nursing home
Sources: *FoAFq 7.*

Folger, R.
Type of Work: Straw (Baskets)
Sources: *ScriSW 286*.*

Folk, John
Flourished: c1850 Haines Township, PA
Ethnicity: German
Type of Work: Fabric (Weavings)
Sources: *ChAmC 61*
See: Ettinger, Emanuel.

Follet, Mary
b. 1790 Marblehead?, MA?
Flourished: 1802 Bristol, RI
Type of Work: Fabric (Samplers)
Museums: 056
Sources: *LeViB 214, 222, 226-7*.*

Follett, T.
Flourished: c1970 New York, NY
Type of Work: Oil (Building portraits)
Sources: *FoA 45*.*

Folsom, Mrs.
Type of Work: Charcoal (Drawings)
Sources: *AmFoPa 155*.*

Folsom, Clara M.
Flourished: c1860
Type of Work: Oil (Portraits)
Sources: *Edith *.*

Folson, Abraham
Flourished: 1840 Dover, NH
Type of Work: Oil (Portraits)
Sources: *PrimPa 172.*

Foltz, Harry
Flourished: Lititz, PA
Type of Work: Fabric (Weavings)
Sources: *ChAmC 61.*

Foot(e), Abigail
Flourished: c1770s Colchester, CT
Type of Work: Fabric (Bed rugs)
Museums: 100
Remarks: Sisters are Elizabeth and Mary
Sources: *PlaFan 147.*

Foot(e), Elizabeth
Flourished: c1770s Colchester, CT
Type of Work: Fabric (Bed rugs)
Museums: 054
Remarks: Sisters are Abigail and Mary
Sources: *BeyN 120; PlaFan 147.*

Foot(e), Mary
Flourished: c1778 Colchester, CT
Type of Work: Fabric (Bed rugs)
Remarks: Sisters are Elizabeth and Abigail
Sources: *AmSQu 22*; BeyN 120; PlaFan 146*.*

Foot, D.
Flourished: late 19th cent New York
Type of Work: Wood (Three-footed tables)
Remarks: Worked in the north country of NY state
Sources: *FouNY 62.*

Foot, F.H.
Flourished: 1851 Rhode Island
Type of Work: Pen, ink, watercolor (Penmanship, calligraphy drawings)
Sources: *AmPrW 113*, 138*.*

Foot, Fanny
b. 1811
Type of Work: Fabric (Samplers)
Museums: 310
Sources: *AmSFok 110*, 114-5.*

Foot, Lewis
b. 1789 d. 1831
Flourished: c1811 Bristol, CT; Farmington, CT
Type of Work: Tin (Tinware)
Museums: 054
Sources: *TinC 168.*

Foot, Lucy
Flourished: 1816 Colchester, CT
Type of Work: Fabric (Trapunto coverlets)
Museums: 266
Sources: *AmSFo 98-9*; AmSQu 83*.*

Foote, Abigail
See: Foot, Abigail.

Foote, Elizabeth
See: Foot, Elizabeth.

Foote, Jim
Flourished: Michigan
Type of Work: Wood (Decoys)
Sources: *WaDec 169**.

Foote, Lewis
Flourished: Connecticut; Georgia
Type of Work: Tin (Tinware)
Remarks: Related to Foot, Lewis
Sources: *TinC 168*.

Foote, Mary
See: Foot, Mary.

Foraner, Robert
Flourished: contemporary
Type of Work: Wood (Bird sculptures, carvings)
Sources: *WoCar 153**.

Forbes, Hannah Lucinda
Flourished: 1825
Type of Work: Velvet (Paintings)
Sources: *PicFoA 130*; PrimPa 172*.

Forbes, Jack
b. Muscay, CA
Flourished: c1930s San Francisco, CA
Type of Work: Oil, acrylic (Paintings)
Sources: *FoAFs 6*-7**.

Ford, J.S.
Flourished: 1837-1838 Hennepin, IL
Type of Work: Wood (Chairs)
Sources: *ArC 150**.

Ford, Saddie
Flourished: 1882 West Hope, OH
Type of Work: Fabric (Quilts)
Sources: *AmSQu 117**.

Ford City Company
Flourished: late 19th cent. Ford City, PA
Type of Work: Clay (Pottery)
Sources: *DicM 175**.

Forden, E.
See: Fordenbach, E.

Fordenbach, E.
Flourished: 1843
Type of Work: Fabric? (Coverlets?)
Remarks: Could be a weaver or client
Sources: *AmSQu 261, 276; ChAmC 61*.

Fordham, H.
Flourished: Springfield, MA
Type of Work: Oil (Portraits)
Sources: *AmPrP 151; PrimPa 172; SoAmP 288*.

Foreman, Mary Lou
Ethnicity: Black American
Type of Work: Grass (Baskets)
Sources: *AfAmA 58-9**.

Foreman, Regina
Ethnicity: Black American
Type of Work: Grass (Baskets)
Sources: *AfAmA 58-9**.

Forg, P.
Flourished: 1865 Boston, MA
Type of Work: Wood (Ship carvings, ship figures)
Sources: *AmFiTCa 192*.

Forman, Irene B.
Flourished: 1853 New York, NY
Type of Work: Fabric (Quilts)
Museums: 189
Sources: *ArtWea 134*; QuiAm 270**.

Forney, Henry
Flourished: 1831
Type of Work: Watercolor (Still life paintings)
Sources: *Edith **.

Forrer, Johann
Flourished: Pennsylvania
Type of Work: Watercolor, ink (Frakturs)
Sources: *AmFoPa 188*.

Forrer, Martin
b. c1815 Pennsylvania d. 1890
Flourished: c1857 Massillon, OH; Hamilton County, IN
Type of Work: Fabric (Coverlets)
Sources: *ChAmC 61*
See: Klein, John.

Forrester, Laura Pope (Mrs. Pope)
Flourished: 1940-1950s Meigs, GA
Type of Work: Various materials (Petrified statues, lace-like walls, concrete arches)
Sources: *MisPi 14*.

Forry, Rudolph
b. 1827 d. 1914 Springettsbury Township, PA
Flourished: 1847 Windsor Township, PA
Type of Work: Fabric (Weavings)
Sources: *ChAmC 61*.

Forster, William
Flourished: 1857 Marion County, OH
Type of Work: Fabric (Weavings)
Sources: *ChAmC 61*.

Fort Edward Pottery Company
Flourished: c1860-18880 Washington, NY; Fort Edward, NY
Type of Work: Stoneware (Pottery)
Museums: 203
Sources: *Decor 126*, 144-5*, 219; EaAmFo 110**.

Fortner, Myrtle M.
Flourished: 1934 California
Type of Work: Fabric (Quilts)
Sources: *QuiAm 281**.

Fossbender, N.
Flourished: 1860-1875 Mogadore, OH
Type of Work: Stoneware (Pottery)
Sources: *AmPoP 224; Decor 219*.

Foster, C.
See: C. Foster and Company.

Foster, Hopestill
b. 1701 d. 1773
Flourished: c1749 Dorchester, MA
Type of Work: Stone (Gravestones)
Sources: *EaAmG 128, viii; GravNE 55, 128*.

Foster, James
b. 1651 d. 1732
Flourished: 1690s-1722 Dorchester, MA
Type of Work: Stone (Gravestones)
Remarks: Son is James; grandson is James
Sources: *GravNE 52-55*.

Foster, James, Jr.
b. 1698 d. 1763
Flourished: 1727- Dorchester, MA
Type of Work: Stone (Gravestones)
Remarks: Father is James; grandfather is James
Sources: *EaAmG 128, viii; GravNE 51-5, 128*.

Foster, James, III
b. 1732 d. 1771
Flourished: Dorchester, MA
Type of Work: Stone (Gravestones)
Remarks: Son is James; father is James
Sources: *EaAmG 128, viii; GravNE 51-5, 128*.

Foster, John
Flourished: 1670
Type of Work: Oil, wood (Portraits, woodcuts)
Sources: *PicFoA 8, 52**.

Foster, Mary Ann Kelly
Flourished: c1844 Carmi, IL
Type of Work: Fabric (Coverlets)
Museums: 305
Sources: *ArC 170**.

Foster, Rebecah
Flourished: 1808 Nashville, TN
Type of Work: Fabric (Quilts)
Sources: *QuiAm 179**.

Foster, Washington
Flourished: 1840s Mystic, CT
Type of Work: Whalebone (Scrimshaw)
Museums: 186
Sources: *GravF 62-3*, 69*.

Foster and Rigby
Flourished: 1857-1860 East Liverpool, OH
Type of Work: Yellow-ware (Pottery)
Sources: *AmPoP 216*.

Foster, Holloway, Bacon, and Company
Flourished: 1815 Berlin, CT
Type of Work: Tin? (Tinware?)
Sources: *TinC 168.*

Fothergill, Emily
b. c1827
Flourished: 1838 New York, NY
Type of Work: Fabric (Samplers)
Sources: *GalAmS 80*.*

Foulke
Flourished: 1784-1800 Morgantown, WV
Type of Work: Redware (Pottery)
Sources: *AmPoP 67, 223.*

Fouth, Jacob
Flourished: Piketon, OH
Type of Work: Fabric (Coverlets)
Sources: *ChAmC 61.*

Fouts
See: Agner, Fouts and Company.

Fouts, Edward
Flourished: 1944 Tuscarawas County, OH
Type of Work: Clay (Sewer tile sculpture)
Sources: *IlHaOS *.*

Fowle
See: Raymond and Fowle.

Fowle, Isaac
d. Massachusetts
Flourished: 1800-1853 Boston, MA
Type of Work: Wood (Ship carvings, figures)
Museums: 029
Remarks: Sons are John D. and William H.
Sources: *AmFiTCa figx, 124, 181, 192; AmFoS 80*, 85*; AmSFok 21; ArtWod 18, 78; EaAmW 52, 73; FoA 464; InAmD 54*; ShipNA 40*-2, 71, 93, 159*
See: Raymond, Edmund.

Fowle, John D.
d. 1869
Flourished: 1832-1869 Boston, MA
Type of Work: Wood (Ship carvings, figures)
Remarks: Father is Isaac; brother is William
Sources: *AmFiTCa 131, 192; ShipNA 42, 93, 98, 136, 159.*

Fowle, Robert
Flourished: c1765 Salem, MA
Type of Work: Stone (Gravestones)
Sources: *EaAmG 128.*

Fowle, William H.
[Isaac Fowle and Company]
d. 1862 Lexington, MA
Flourished: 1800s Massachusetts
Type of Work: Wood (Ship carvings, ship figures)
Remarks: Father is Isaac; brother is John D.
Sources: *AmFiTCa 131, 192; ShipNA 42, 93, 136.*

Fowler, Elizabeth Starr
b. c1824
Flourished: 1832 New England,
Type of Work: Fabric (Samplers)
Sources: *AmNe 60.*

Fowler, O.K.
Flourished: 1838
Type of Work: Oil (Portraits)
Sources: *Edith *.*

Fowler and McKenzie
Flourished: 1870-1900 Vanport, PA
Type of Work: Stoneware (Pottery)
Sources: *AmPoP 232; Decor 219.*

Fox
See: Nathan Clark Pottery; Clark and Fox.

Fox, Anne Mary B.
Flourished: c1850
Type of Work: Fabric (Samplers)
Museums: 227
Sources: *MoBeA.*

Fox, E.S.
Flourished: 1838-1843 Athens, NY
Type of Work: Stoneware (Pottery)
Sources: *Decor 217, 219.*
See: Clark, Nathan.

Fox, Francis
Flourished: 1846 Philadelphia, PA
Type of Work: Wood (Ship carvings, ship figures)
Sources: *AmFiTCa 192.*

Fox, Gustavus
See: Fox, Harmon.

Fox, H.
Flourished: c1850-1875 Seagrove, NC
Type of Work: Stoneware (Jars)
Sources: *AmS 85*-6*.*

Fox, Harmon
Flourished: c1840-1860 Newcomerstown, OH
Type of Work: Stoneware (Pottery)
Sources: *AmPoP 225; Decor 219.*

Fox, John
Flourished: McCuthenville, OH
Type of Work: Fabric (Coverlets)
Sources: *ChAmC 61.*

Fox, N.
Flourished: c1870-1900 Seagrove, NC
Type of Work: Stoneware (Jars)
Sources: *AmS 85*.*

Fox, Haag and Company
Flourished: 1869-1900 Reading, PA
Type of Work: Redware (Vases)
Sources: *AmPoP 178.*

Foy, P.
Flourished: 1838 New Orleans, LA
Type of Work: Wood (Ship carvings, ship figures)
Sources: *AmFiTCa 192.*

Fracarossi, Joseph
b. 1886 d. 1970 Covington, RI
Flourished: New York, NY
Ethnicity: Italian
Type of Work: Oil (Cityscape paintings)
Remarks: Born in Trieste
Sources: *FoPaAm 106*, 108; HoKnAm 188; TwCA 172-3*.*

Frailey, Michael
b. c1799 Pennsylvania
Flourished: 1835-1860 Hummelstown, PA
Type of Work: Fabric (Coverlets)
Sources: *ChAmC 61.*

France, Joseph
Flourished: 1814 Rhode Island
Type of Work: Fabric (Weavings)
Sources: *AmSQu 276; ChAmC 61.*

Frances
Flourished: 1850 Switzerland County, IN
Type of Work: Fabric (Weavings)
Sources: *AmSQu 276; ChAmC 61.*

Francis, Edward
Flourished: Bloomfield, CT; Philadelphia, PA
Type of Work: Tin (Painted tinware)
Remarks: Worked in the Filley shops
Sources: *AmCoTW 82-3; AmSFo 41; TinC 117, 169.*

Francis, J.P.
Flourished: 1895 West Cornwall, CT
Type of Work: Oil (Paintings)
Sources: *PrimPa 172.*

Francis, John F.
Flourished: 1828 Pennsylvania
Type of Work: Oil (Still life paintings)
Sources: *HerSa.*

Francisco, James F.
Flourished: 1831-1837 Cincinnati, OH
Type of Work: Redware (Pottery)
Remarks: Affiliated with Cincinnati Art Pottery
Sources: *AmPoP 210.*

Frank, Mrs. Gustav
Flourished: c1860 Jefferson, TX
Type of Work: Fabric (Quilts)
Sources: *QuiAm 287*.*

Franklin, Mary M.
Flourished: c1808 Pleasant Valley, NY
Type of Work: Fabric (Samplers)
Sources: *WinGu 20**.

Franklin, Mary Mac
b. Tennessee
Flourished: c1959-1974
Type of Work: Fabric (Hooked rugs, bed rugs)
Sources: *AmHo 120-1**.

Franklin Pottery Company
Flourished: c1880 Franklin, OH
Type of Work: Clay (Pottery)
Sources: *DicM 44**.

Franklin Woolen Factory
Flourished: c1838 Fayetteville, PA
Type of Work: Fabric (Weavings)
Sources: *ChAmC 61*.

Frantz, Henry
Flourished: c1865-1886 Tulpehocken Township, PA
Type of Work: Redware (Pottery)
Remarks: Brother is Isaac
Sources: *AmPoP 184*.

Frantz, Isaac
Flourished: 1870-1873 Tulpehocken Township, PA
Type of Work: Clay (Tobacco pipes)
Remarks: Brother is Henry
Sources: *AmPoP 184*.

Frantz, Sara L'Estrange Stanley "Sali"
b. 1892 Detroit, MI d. 1967 Gettysburg, PA
Flourished: Saginaw, MI
Type of Work: Watercolor, gouache (Fantasy and whimsical paintings)
Museums: 070
Sources: *Rain 89*-90*; TwCA 122*.

Franz, Michael
Flourished: 1839-1851 Miami County, OH
Type of Work: Fabric (Weavings)
Sources: *AmSQu 276; ChAmC 61*.

Fraser, John
Flourished: 1852 New York, NY
Type of Work: Wood (Ship carvings, ship figures)
Sources: *AmFiTCa 192; ShipNA 162*.

Frazer, Hiram
Flourished: 1836 Cincinnati, OH
Type of Work: Wood (Ship carvings, ship figures)
Sources: *AmFiTCa 192*.

Frazer, Nate
Flourished: Tuckerton, NJ
Type of Work: Wood (Duck decoys)
Sources: *AmBiDe 134*.

Frazer, Thomas
Flourished: Connecticut
Type of Work: Tin (Tinware)
Remarks: May have worked for Filley
Sources: *TinC 169*.

Frazie, J.
Flourished: 1861 Casey, IL
Type of Work: Fabric (Weavings)
Sources: *AmSQu 276; ChAmC 61*.

Frazier, Mrs.
Flourished: 1800 Red Bank, NJ
Type of Work: Fabric (Needlework pictures)
Sources: *AmFoPa 37**.

Frazier, Stephen
Flourished: 1813
Type of Work: Tin? (Tinware?)
Remarks: May have worked for Filley, Oliver
Sources: *TinC 169*.

Fredenburg, George
Flourished: 1830
Type of Work: Watercolor (Paintings)
Sources: *AmPrP 152; PrimPa 172*.

Frederick
See: Woodcocke.

Frederick, Henry K.
Flourished: 1846 Cumberland County, PA
Type of Work: Fabric (Coverlets)
Sources: *ChAmC 102*, 108**.

Frederick, Henry T.
b. c1813 Pennsylvania
Flourished: 1847-1852 South Middleton Township, PA
Type of Work: Fabric (Coverlets)
Sources: *ChAmC 61*.

Frederick, John
Flourished: c1875-1893 Chapel, PA
Type of Work: Redware (Pottery)
Sources: *AmPoP 166*.

Frederick, Schenkle, Allen and Company
Flourished: 1881- East Liverpool, OH
Type of Work: Yellow-ware, Rockingham (Pottery)
Sources: *AmPoP 219*.

Freeland, Anna C.
Flourished: late 19th cent Three Oaks, MI
Type of Work: Oil (Interior scene paintings)
Museums: 170
Sources: *FoPaAm 215**.

Freeland, Henry C.
Flourished: Texas
Type of Work: Oil (Signs)
Museums: 250
Sources: *SoFoA 89*, 219*.

Freeman, Mr.
Flourished: 1816 Cooperstown, NY
Type of Work: Watercolor (Portraits)
Museums: 203
Sources: *AmFoPaN 101, 127*; AmSFok 160**.

Freeman, Joseph L
Flourished: 1836-1839 New Bedford, MA
Type of Work: Wood (Comb boxes)
Remarks: Worked at Paper Hanging Manufactory
Sources: *AmSFo 128*; NeaT 100*, 108*.

Freeman, Thomas
Flourished: c1825 Pittsburgh, PA
Type of Work: Redware (Pottery)
Sources: *AmPoP 227*.

Freleigh, Margaret Ann
Flourished: 1828 Clinton County, NY
Type of Work: Velvet (Still life paintings)
Sources: *FouNY 65*.

Frell, John
See: John Frell and Company.

French, Asa
Flourished: 1815- Philadelphia, PA
Type of Work: Tin (Tinware)
Remarks: Apprentice to Filley, Oliver
Sources: *AmCoTW 111; TinC 169*.

French, B.
Flourished: 1835-1840 Clinton, NY; Waterville, NY; Cazenovia, NY
Type of Work: Fabric (Weavings)
Museums: 001
Sources: *AmSQu 276; ChAmC 61, 59**.

French, C.
Flourished: 1810 Massachusetts
Type of Work: Oil (Portraits)
Sources: *AmPrP 152; PrimPa 172*.

French, Daniel Chester
Flourished: New York?, NY
Type of Work: Clay (Sculptures)
Sources: *AmPoP 65*.

French, Eben
Flourished: c1837-1845 Chatfield Corners, OH
Type of Work: Stoneware (Pottery)
Sources: *AmPoP 209; Decor 219*.

French, P.
Flourished: 1832 Bethany, NY
Type of Work: Fabric? (Coverlets?)
Sources: *ChAmC 61*.

French, William B.
Flourished: 1830 New York, NY
Type of Work: Wood (Ship carvings, ship figures)
Sources: *AmFiTCa 192*.

Fresquis, Pedro Antonio
b. 1749 d. 1831
Flourished: c1807-1831 Las Truchas, NM; Chamita, NM; Nambe, NM
Ethnicity: Mexican
Type of Work: Oil (Altar paintings)
Museums: 068,181,272,288.
Sources: HoKnAm 71*-73; PopAs 86*.

Fretz, J.
Flourished: c1814 Pennsylvania
Type of Work: Clay (Sculptures)
Museums: 227
Sources: FoArRP 36*.

Fretzinger
Flourished: Blandon, PA
Type of Work: Tin (Cookie cutters)
Sources: ToCPS fig42.

Frey, Abraham
d. c1860
Flourished: c1855-1859 Mount Joy, PA
Type of Work: Fabric (Coverlets)
Sources: ChAmC 61.

Frey, Christian
b. 1811 d. 1888
Flourished: 1844-1852 Baltimore, MD; Fairfield, PA
Ethnicity: German
Type of Work: Fabric (Coverlets)
Museums: 110
Sources: ChAmC 61.

Frey, George
Flourished: c1830-1872 Freystown, PA
Type of Work: Redware (Pottery)
Sources: AmPoP 167.

Frey, Samuel B.
d. c1871
Flourished: 1855-1871 Mount Joy, PA
Type of Work: Fabric (Coverlets)
Sources: ChAmC 62.

Freytag, Daniel
Flourished: c1810- Philadelphia, PA
Type of Work: White earthenware (Pottery)
Sources: AmPoP 101, 175.

Fricke, John Frederick
Flourished: 1840-1860 Gasconade County, MO
Type of Work: Wood (Glass cupboards)
Sources: ASeMo 339*.

Fridley, Abraham
b. Pennsylvania
Flourished: c1850 Steuben County, IN
Type of Work: Fabric (Coverlets)
Sources: ChAmC 62
See: Enos, Michael.

Friedel, Robert
b. c1827
Flourished: 1870 Mount Joy, PA
Ethnicity: German
Type of Work: Fabric (Coverlets)
Sources: ChAmC 62.

Friedlein, Paul
b. 1889 d. 1984
Flourished: c1950 Gutenberg, IA
Type of Work: Stone (Monuments)
Remarks: Built "Inspiration Point"
Sources: FoAFc 1*, 8*-9*.

Friedrich, Johann
b. 1828 d. 1899
Flourished: Drake, MO
Ethnicity: German
Type of Work: Wood (Furniture)
Sources: ASeMo 389.

Fries
Flourished: Salem, NC
Type of Work: Watercolor, paper (Cutouts)
Sources: SoFoA 86*, 219.

Fries, Isaac
Flourished: 1825 Pennsylvania
Type of Work: Watercolor, ink (Frakturs)
Sources: AmFoPa 188.

Frinck, O.E.S.
See: Frink, O.E.S.

Frink, L.W.
Flourished: 1871 New York
Type of Work: Pen, ink (Penmanship, calligraphy drawings)
Sources: FlowAm 106*.

Frink, O.E.S.
[Frinck]
Flourished: Medford, MA
Type of Work: Oil (Portraits, paintings)
Sources: AmPiQ 151; PrimPa 172; SoAmP 188*.

Frisbie
Flourished: Connecticut
Type of Work: Tin (Tinware)
Remarks: Worked for Filley
Sources: TinC 169.

Frischwasser, Ben
Flourished: 20th cent Bronx, NY
Type of Work: Wood (Carved canes)
Museums: 086
Sources: ColAWC.

Frishmuth, Sarah
Flourished: 1743 Wilmington, DE
Type of Work: Fabric (Samplers)
Sources: GalAmS 22*-3, 89.

Fritz, Gilbert
See: Gilbert, Fitz W.

Fritz, Jacob
Flourished: 1809 Pennsylvania
Type of Work: Clay (Pottery)
Sources: AmFokAr 20, fig157.

Fritzinger, Jared
See: Fritzinger, Jerret.

Fritzinger, Jerret (Jared)
b. c1819 Pennsylvania
Flourished: 1844-1850 Allentown, PA
Type of Work: Fabric (Weavings)
Sources: ChAmC 62
See: Seidenspinner, John.

Fromfield, William
Flourished: 1821 Pennsylvania
Type of Work: Watercolor, ink (Frakturs)
Sources: AmFoPa 188.

Frost
See: Vodrey and Frost.

Frost, J(ohn) O(rne) J(ohnson)
b. 1852 Marblehead, MA d. 1928
Flourished: 1923- Marblehead, MA
Type of Work: Oil (Historical paintings)
Museums: 141
Sources: AmFokArt 104-5*; AmFoPaCe 182-5*; AmFoS 130*; FoA 464; FoPaAm 53*, 62; HoKnAm 181-4; PeiNa 185*; PrimPa 172, 166*; TwCA 62*.

Frothingham, James
b. 1786 d. 1864
Flourished: Boston, MA; Salem, MA; New York, NY
Type of Work: Oil (Portraits)
Museums: 221
Sources: AmPaF 97*; AmPrP 152; FoArtC 111; PrimPa 173; SoAmP 240*.

Frouchtben, Bernard
b. 1870
Flourished: New York, NY
Type of Work: Oil (Paintings)
Sources: PrimPa 173; ThTaT 154-9*.

Frune, George W.
Flourished: 1858 Chicago, IL
Sources: ArC 264.

Fry, George
Flourished: 1820 Philadelphia, PA
Type of Work: Wood (Windsor chairs)
Museums: 204
Sources: AmPaF 248*.

Fry, John
Flourished: 1778 Germantown, PA
Type of Work: Tin (Tinware)
Sources: ToCPS 24, 26, 28-8, 33-5*.

Fry, John
Flourished: 1768-1784 Reading, PA
Type of Work: Redware (Pottery)
Sources: AmPoP 178.

Fry, William H.
b. 1830 d. 1929
Flourished: c1851 Cincinnati, OH
Type of Work: Wood (Furniture)
Sources: EaAmW 91.

Frye, Mary
Flourished: 1925 Haven, KS
Ethnicity: Amish
Type of Work: Fabric (Quilts)
Sources: QufInA 45*.

Frye, William
b. 1821 **d.** 1872
Flourished: 1845 Louisville, KY; Huntsville, AL
Ethnicity: Austrian
Type of Work: Oil (Portraits, landscape paintings)
Sources: *SoFoA 63-5*, 218.*

Fryer, Flora
b. 1892 St. Paul, MN
Flourished: 1962- Seattle, WA
Type of Work: Oil (Paintings)
Sources: *TwCA 217*.*

Fryer, James
Flourished: 1865 Baltimore, MD
Type of Work: Wood (Ship carvings, ship figures)
Sources: *AmFiTCa 192.*

Frymier, Jacob
See: Frymire, Jacob.

Frymire, Jacob (J.)
[Frymier]
b. 1765-1774 Lancaster, PA **d.** 1822
Flourished: 1790s-1816 Shippensburg, PA; Alexandria, VA; Woodford County, KY
Type of Work: Oil (Portraits)
Museums: 044
Sources: *FoA 464; FoPaAm 123*, 125, 128; PrimPa 173; SoFoA 51-3*, 218.*

Fuentes, Lucas
Flourished: 1800 New York, NY
Type of Work: Wood (Ship carvings, ship figures)
Sources: *AmFiTCa 192.*

Fulham
See: Dwight, John.

Fulivier, James
Flourished: 1825 Pennsylvania
Type of Work: Tin painted (Coffee pots)
Museums: 096
Sources: *FlowAm 261*.*

Fuller, Augustus
b. 1812 **d.** 1873 or 1876
Flourished: Deerfield, CT
Type of Work: Oil (Portraits)
Museums: 265
Remarks: New England artist; deaf, mute
Sources: *PicFoA 17*, 77*; PrimPa 173.*

Fuller, Elijah K.
Flourished: 1846 Nauvoo, IL
Type of Work: Queensware (Pottery)
Sources: *ArC 190.*

Fuller, George
b. 1822 Deerfield, MA
Flourished: 1841 Deerfield, MA; Boston, MA; New York, NY
Type of Work: Oil on shell (Portraits)
Sources: *SoAmP 289.*

Fuller, John
Type of Work: Copper (Copperware)
Remarks: Author of "The Art of Coppersmithing"
Sources: *AmCoB 40, 49, 68-70*, 90-1*, 94*, 97*, 99*, 101*, 128, 130-1*, 133-4*.*

Fuller, Nathaniel
b. 1687 **d.** 1750
Flourished: c1740 Plympton, MA; Barnstable, MA
Type of Work: Stone (Gravestones)
Sources: *EaAmG 27*-8, 128.*

Fullerton, Hugh
Flourished: 1860 Moline, IL
Type of Work: Stoneware (Pottery)
Sources: *ArC 194.*

Fulper, Abraham
See: Fulper Brothers Pottery.

Fulper Brothers Pottery
[Fulper, Abraham]
Flourished: 1805-1890s Flemington, NJ
Type of Work: Stoneware, redware (Pottery)
Museums: 203
Sources: *AmPoP 48, 167, 261; Decor 147*, 219; DicM 48*, 253*-6*, 78*; EaAmFo 236*.*

Funk, Abraham
Flourished: 1936 Rockingham County, VA
Type of Work: Clay (Sewer tile sculpture)
Sources: *IlHaOS *.*

Funk, E.H.
Flourished: 1868 Toledo, OH
Type of Work: Wood (Box churns)
Museums: 096
Sources: *AmSFok 11.*

Funk, J.S.
Flourished: c1840 Quincy, IL
Type of Work: Wood (Furniture)
Sources: *ArC 173-4.*

Funkhouser, L.D.
Flourished: 1900 Strasburg, VA
Type of Work: Clay (Pottery)
Sources: *AmPoP 242; DicM 83*.*

Furman, Noah
Flourished: 1846-1856 South Amboy, NJ; Cheesequake, NJ
Type of Work: Stoneware (Pottery)
Sources: *Decor 219; DicM 97*.*

Furnass, John Mason
Flourished: 1785 Massachusetts
Type of Work: Oil (Portraits)
Sources: *AmPrP 152; PrimPa 173.*

Furnier, V.H.
Flourished: c1850-1890
Type of Work: Pen, ink, watercolor (Drawings)
Sources: *FoA 100.*

G

G. Adley and Company
Flourished: 1860-1880 Ithaca, NY
Type of Work: Stoneware (Pottery)
Museums: 080
Sources: *Decor 87*, 216.*

G. and F. Harley
Flourished: Philadelphia, PA
Type of Work: Copper (Fish kettles)
Museums: 035
Sources: *AmCoB 83*.*

G.B. McLain and Company
Flourished: 1842-1856 Bath, ME; Haverhill, MA
Type of Work: Wood (Ship carvings, ship figures)
Sources: *AmFiTCa 196; ShipNA 156, 160.*

G.V. Keen and Company
Flourished: 1850 Baltimore, MD
Type of Work: Tin (Lanterns)
Sources: *ToCPS 49.*

G.W. Kimble Woolen Factory
Flourished: c1836 Franklin County, IN
Type of Work: Fabric (Weavings)
Sources: *ChAmC 75*
See: Vogel, August; Walter, Jacob; Eckert, Gottlieb.

Gabriel, Henry
[Henry Gabriel Woolen Mill]
b. 1812 **d.** 1887
Flourished: c1836-1887 Millerstown, PA; Allentown, PA
Ethnicity: German
Type of Work: Fabric (Weavings)
Remarks: Operated Allentown Woolen Mill
Sources: *ChAmC 62*
See: Weil, George P.

Gabriel, Romano
b. 1888 **d.** 1977 Eureka, CA
Flourished: c1940-1970 Eureka, CA
Ethnicity: Italian
Type of Work: Wood (Environmental sculpture)
Museums: 134
Remarks: Created the Romano Gabriel Garden
Sources: *FoAFd 8*; FoAFo 8; PioPar cover*, 9, 13, 35.*

Gaebler, Carl Frederick (William)
Flourished: 1840-1880 Gasconade County, MO
Type of Work: Wood (Chairs, tables)
Sources: *ASeMo 322*, 329*.*

Gaebler, William
See: Gaebler, Carl Frederick.

Gage, Martha
Flourished: early 19th cent
Type of Work: Velvet (Paintings)
Sources: *Edith *.*

Gage, Nancy
b. 1787 **d.** 1845
Flourished: Bradford, MA
Type of Work: Oil (Paintings)
Sources: *PrimPa 173.*

Gager, Oliver A.
Flourished: 19th c Bennington, VT; New York, NY
Type of Work: Clay (Pottery)
Sources: *AmPoP 61, 188*
See: United States Pottery Company; Fenton, Christopher.

Gahery, Gendrot
See: Gendrot Gahery and Company.

Gahman, John
Flourished: 1806 Pennsylvania
Type of Work: Watercolor, ink (Frakturs)
Sources: *AmFoPa 188.*

Gale, F.A.
Flourished: 1845 Meriden, CT
Type of Work: Tin (Tinware)
Remarks: Employed two persons
Sources: *TinC 169.*

Gallatin, Almy Goelet Gerry
Flourished: 1890 East Hampton, NY
Type of Work: Fabric (Needlepoint pictures)
Sources: *AmNe 163-4*.*

Gallegos
Flourished: 1867 Colorado
Type of Work: Fabric (Blankets, jergas)
Museums: 103
Sources: *PopAs 238, 435*.*

Gallegos, Celso
d. 1943
Flourished: Agua Fria, NM
Type of Work: Wood (Santeros, other religious carvings)
Sources: *EaAmW 124*; PopAs 433*.*

Galley, Jacob
b. 1803 **d.** 1829 Tyrone Township, PA
Flourished: c1827 Tyrone Township, PA
Type of Work: Fabric (Coverlets)
Sources: *ChAmC 62.*

Gallier, Edward
Flourished: 1859 St. Louis, MO
Type of Work: Wood (Ship carvings, ship figures)
Sources: *AmFiTCa 192.*

Galloway, Ed
Flourished: 1940- Grand Lake, OK
Type of Work: Wood (Sculptures, carvings)
Sources: *FoArO 89*, 65*, 67*, 72*, 101.*

Galloway, Lyle
Flourished: contemporary San Francisco, CA
Type of Work: Whalebone (Scrimshaw)
Sources: *Scrim 33*.*

Galloway and Graff
Flourished: 1868 Philadelphia, PA
Type of Work: Clay (Pottery)
Sources: *AmPoP 177; DicM 51**.

Gally, Thomas J.
Flourished: 1833 Philadelphia, PA
Type of Work: Wood (Ship carvings, ship figures)
Sources: *AmFiTCa 192*.

Gambel, J.
See: Gamble, J.

Gamber, M.G.
Flourished: 1840-1844
Type of Work: Fabric (Coverlets)
Sources: *ChAmC 62*.

Gamble, J.
[Gambel]
Flourished: 1834
Type of Work: Fabric (Coverlets)
Museums: 068
Sources: *AmSQu 245*, 276; ChAmC 62*.

Gamble, J.A.
Flourished: 1833-1860 Mifflin County, PA; Edgemont, PA
Ethnicity: Scottish
Type of Work: Fabric (Weavings)
Sources: *ChAmC 62*.

Gamble, Sam
Flourished: 1830-1844 Glasgow, KY
Type of Work: Fabric (Coverlets)
Sources: *AmSQu 276; ChAmC 62*.

Gamble, Sarah E.
Flourished: c1820s Pennsylvania; New Jersey
Type of Work: Fabric, paint (Mourning pictures)
Sources: *MoBeA fig70*.

Gannett
See: Parker and Gannett.

Gans, H.
Flourished: c1870 Lancaster, PA
Type of Work: Clay (Pottery)
Sources: *DicM 61**.

Ganse Pottery
Flourished: c1870 Ronk, PA
Type of Work: Redware (Pottery)
Sources: *AmPoP 179*.

Gantz, Frederick
Flourished: 1834 New York, NY
Type of Work: Wood (Ship carvings, ship figures)
Sources: *AmFiTCa 192*.

Garber, C.
Flourished: 1840-1851 Ruffs Creek, PA; Washington County, PA
Type of Work: Fabric (Weavings)
Sources: *AmSQu 276; ChAmC 62*.

Garber, Jonathan
Flourished: 1839-1843 Beaver Dams, MD
Type of Work: Fabric (Coverlets)
Sources: *ChAmC 62*.

Garcia
Flourished: 1880-1890 La Isla, CO
Ethnicity: Hispanic
Type of Work: Fabric (Blankets)
Sources: *PopAs 237*.

Garcia, Fray Andres
Flourished: 1747-1777 Albuquerque, NM; Santa Fe, NM; Santa Cruz, NM
Ethnicity: Mexican
Type of Work: Wood (Santeros, other religious carvings)
Sources: *HoKnAm 72; PopAs 401*.

Garcia, Pablo
Flourished: Conejos, CO
Ethnicity: Hispanic
Type of Work: Fabric (Blankets)
Museums: 103
Sources: *PopAs 238*.

Gardiner, John
Flourished: 1870 Philadelphia, PA
Type of Work: Wood (Ship carvings, ship figures)
Sources: *AmFiTCa 192*.

Gardner
See: Lewis and Gardner.

Gardner, Andrew
Flourished: 1850 Buffalo, NY
Type of Work: Wood (Ship carvings, ship figures)
Sources: *AmFiTCa 192*.

Gardner, John
Flourished: 1850 Buffalo, NY
Type of Work: Wood (Ship carvings, ship figures)
Sources: *AmFiTCa 192*.

Gardner, Lester
Flourished: 1915 Amityville, NY
Type of Work: Wood (Duck decoys)
Sources: *ArtDe 165*.

Gardner, William
Flourished: 1799 Charleston, SC
Type of Work: Wood (Ship carvings, ship figures)
Sources: *AmFiTCa 192; ShipNA 163*.

Gardner, Xavier
See: Gerthner, Xavier.

Gardnier, Sally
Flourished: 1836 Nantucket, MA
Type of Work: Oil (Portraits)
Sources: *PrimPa 173*.

Garing, Christian
Flourished: 1845 New York, NY
Type of Work: Wood (Ship carvings, ship figures)
Sources: *AmFiTCa 192*.

Garis, John
b. c1810
Flourished: 1849-1852 Valparaiso, IN
Type of Work: Fabric (Weavings)
Sources: *ChAmC 63*.

Garmons, William
Flourished: 1790-1800's Baltimore, MD
Type of Work: Wood (Ship carvings, figures)
Sources: *AmFiTCa 142, 192*.

Garner, Jacob
[Garver]
Flourished: c1848-1850 Strasburg, OH
Type of Work: Fabric (Coverlets)
Sources: *ChAmC 63*.

Garr, Sarah Crain
b. 1862
Flourished: 1883 Hillsboro, KY
Type of Work: Fabric (Quilts)
Sources: *KenQu 65, fig52-3, 11*.

Garret, Thomas
See: Garrett, Thomas.

Garrett, Carlton Elonzo
b. c1900 Georgia
Flourished: 1980
Type of Work: Wood (Carvings)
Museums: 099,178
Sources: *AmFokArt 106-7**.

Garrett, Mary Hibberd
Flourished: 1820 Chester County, PA
Type of Work: Fabric (Samplers)
Sources: *GalAmS 56**.

Garrett, Thomas
[Garret]
Flourished: 1804 Hagerstown, MD
Type of Work: Fabric (Coverlets)
Sources: *AmSQu 276; ChAmC 63*.

Garver, Jacob
See: Garner, Jacob.

Gary, Mrs. James A. (L.W.) (Daisy)
Flourished: 1865-1888 Baltimore, MD
Type of Work: Fabric (Embroidered pictures, screens)
Remarks: Daughter is Taylor, Lillian Gary
Sources: *AmNe 105*, 110, 160, 164**.

Gaskill, Tom
b. 1879 d. 1932
Flourished: Barnegat Bay, NJ
Type of Work: Wood (Duck decoys)
Sources: *AmBiDe 115-6**.

Gasner, George
b. 1811 d. 1861
Flourished: Massachusetts
Type of Work: Oil (Portraits)
Sources: *AmPrP 152; PrimPa 173; SoAmP 289.*

Gaspari, P(ierre) G.
Flourished: 1861 Baltimore, MD
Type of Work: Wood (Cigar store Indians, figures)
Sources: *AmFiTCa 192; ArtWod 134, 263.*

Gast, Henry
Flourished: c1825-1890 Lancaster, PA
Type of Work: Redware (Tobacco pipes)
Sources: *AmPoP 170.*

Gastal, J.
Flourished: 1866 New Orleans, LA
Type of Work: Wood (Ship carvings, ship figures)
Sources: *AmFiTCa 192; ShipNA 156.*

Gaston
See: Agner and Gaston.

Gates, Erastus
Flourished: Plymouth, VT
Type of Work: Paint (Ornamental paintings)
Sources: *AmDecor 102.*

Gatewood, Jane Warwick
Flourished: 1795 West Virginia
Type of Work: Fabric (Quilts)
Sources: *QuiAm 165*.*

Gatto, (Victor) Joseph
b. 1890 New York, NY d. 1965
Flourished: c1935 New York, NY; Miami, FL
Type of Work: Oil (Fantasy, landscape, genre scene paintings)
Museums: 184, 307
Sources: *AmFokArt 108-10*; FoA 464; ThTaT 236*; TwCA 136-7*.*

Gaud, John
d. 1693
Flourished: Boston, MA
Type of Work: Stone (Gravestones)
Sources: *EaAmG 128; GravNE 56, 128.*

Gauss, George
Flourished: 1847-1868 Belleville, IL
Ethnicity: German
Type of Work: Fabric (Carpets, coverlets)
Museums: 114
Sources: *ArC 140*, 171-2; ChAmC 63.*

Gavrelos, John J.
b. 1893
Flourished: 1919 Beaumont, TX
Ethnicity: Greek
Type of Work: Wood, oil (Sculptures, carvings, paintings)
Sources: *TwCA 75*.*

Gawthorn, Ann
b. c1793
Flourished: 1800
Type of Work: Fabric (Samplers)
Sources: *AmNe 61.*

Gay, Amos
Flourished: c1829 Utica, NY
Type of Work: Stoneware (Pottery)
Sources: *Decor 219.*

Gay, Pocahontas Virginia
Flourished: c1900 Fluvanna County, VA
Type of Work: Fabric (Quilts)
Museums: 263
Sources: *QuiAm 280*.*

Geb, L.R. (John)
Flourished: 1846 Maytown, PA
Type of Work: Fabric (Weavings)
Sources: *ChAmC 63.*

Gebhart, John R.
b. c1804 Pennsylvania
Flourished: 1840-1849 Maytown, PA
Type of Work: Fabric (Weavings)
Sources: *AmSQu 276; ChAmC 63.*

Geddes Stoneware Pottery Company
Flourished: 1883-1887 Geddes, NY; Syracuse, NY
Type of Work: Stoneware (Pottery)
Sources: *Decor 219*
See: Hubbell and Cheseboro.

Geggie, William W.
Flourished: 1957 Newport, VA
Ethnicity: Scottish
Type of Work: Wood (Ship carvings, figures)
Museums: 142
Sources: *AmFoS 98*.*

Geidt, Anthony E.
Flourished: 1860 New York, NY
Type of Work: Wood (Ship carvings, ship figures)
Sources: *AmFiTCa 192.*

Geiger, Jacob
Flourished: 1860 New York, NY
Type of Work: Wood (Ship carvings, ship figures)
Sources: *AmFiTCa 192.*

Geiger, Margaret
b. 1861 Delhi, OH
Flourished: 1899 Campbell County, KY
Type of Work: Fabric (Quilts)
Sources: *KenQu 46-7.*

Geistweite, George, Reverend
Flourished: 1794-1804 Centre County, PA
Type of Work: Watercolor, ink (Frakturs, religious paintings)
Museums: 227
Sources: *AmFoPa 188; AmFoPaN 192, 199*; FoArRP 200*, 263*; FoPaAm 121*.*

Geller, Adam
b. c1804
Flourished: c1856 Somerset County?, PA; Bedford County?, PA
Type of Work: Fabric (Weavings)
Sources: *ChAmC 63.*

Gelston, Thomas
Flourished: c1900 Long Island, NY
Type of Work: Wood (Duck decoys)
Sources: *AmBiDe 98-9*; AmDecoy i*, 52; AmFoS 301*; AmSFo 25; ArtDe 165*; EyoAm 4, 13*; HoKnAm 40-1*; WiFoD 51*; WoScuNY.*

Gendrot Gahery and Company
Flourished: 1860 Roxbury, MA
Type of Work: Wood (Ship carvings, ship figures)
Sources: *AmFiTCa 192.*

Gentilz, Theodore
b. 1819 d. 1906
Flourished: Texas
Type of Work: Oil (Genre paintings)
Museums: 064
Sources: *FoPaAm 225*, 238.*

Gentner, George Henry
Flourished: 1850-1860 Missouri
Type of Work: Wood (Glass cupboards)
Sources: *ASeMo 341*.*

George Morley and Brothers
Flourished: c1870 Madison County, IL
Type of Work: Earthenware (Pottery)
Sources: *AmPoP 235.*

George Murphy Pottery Company
Flourished: 19th Century East Liverpool, OH
Type of Work: Clay (Pottery)
Sources: *DicM 200*.*

George Scott and Sons
See: Scott, George.

Gepfert, A
Flourished: 1846
Type of Work: Fabric (Coverlets)
Sources: *ChAmC 63.*

Gephart, S.S.
Flourished: 1860 Pittsburgh, PA
Type of Work: Oil (Paintings)
Sources: *PrimPa 173.*

Gerbrich, Conrad
Flourished: c1870- Hamburg, PA
Type of Work: Redware (Pottery)
Sources: *AmPoP 169.*

Gerbry, M.Y.
Flourished: 1847-1852 Piqua, OH
Type of Work: Fabric (Coverlets)
Sources: *ChAmC 62.*

Gereau, William
d. c1878
Flourished: 1858 San Francisco, CA
Type of Work: Wood (Ship carvings, ship figures)
Remarks: Nephew is Lovejoy, Edward Bell
Sources: *ShipNA 91, 93, 155*
See: Carroll, Thomas; Earl, Tarleton B.

Geret, Jacob
Flourished: 1837
Type of Work: Fabric? (Coverlets?)
Sources: *ChAmC 63.*

Gerhardt, George
Flourished: 1818 Pennsylvania
Type of Work: Watercolor, ink (Frakturs)
Sources: *AmFoPa 188.*

Gerlach, C.
Flourished: Pennsylvania
Type of Work: Clay (Pottery)
Sources: *AmPoP 186.*

German, Henry
b. 1830 d. 1884
Flourished: Hermann, MO
Ethnicity: German
Type of Work: Wood, oil (Sculptures, carvings, portraits)
Sources: *ASeMo 389, 401*.*

Gernand, J.B.
Flourished: Maryland
Type of Work: Fabric (Weavings)
Sources: *AmSQu 276.*

Gernand, Jacob B.
Flourished: c1836 Graceham, MD
Type of Work: Fabric (Weavings)
Sources: *ChAmC 63.*

Gernand, W.H.
Flourished: 1855-1879 Westminster, MD
Type of Work: Fabric (Weavings)
Sources: *AmSQu 276; ChAmC 63.*

Gernerick, Emelia Smith
b. 1754 d. 1826
Flourished: 1805-1810 Charleston, SC
Type of Work: Watercolor (Theorems)
Sources: *SoFoA 78*, 218.*

Gerrick, Sarah
Flourished: c1730 Boston, MA
Type of Work: Needlework (Headcloths)
Sources: *WinGu 67*.*

Gerrish, Woodbury
d. 1868
Flourished: 1844-1853 Portsmouth, NH; Charlestown, MA
Type of Work: Wood (Hobby horses, ship carvings, ship figures)
Museums: 193
Sources: *AmFiTCa 86-7, 192, figxv; AmFokAr 118; ShipNA 71*-2, 160-1.*

Gerry, Samuel Lancaster
b. 1813 d. 1891
Type of Work: Oil (Paintings)
Sources: *FoArA 103*.*

Gerstung, John
Flourished: 1870-1890 Logantown, PA
Type of Work: Stoneware (Pottery)
Sources: *HerSa *.*

Gerthner, Xavier
[Gardner]
Flourished: 1807 New York
Ethnicity: German
Type of Work: Fabric (Coverlets)
Sources: *ChAmC 63.*

Getty, A.
Flourished: Lockport, NY
Type of Work: Fabric (Weavings)
Sources: *AmSQu 276; ChAmC 63.*
See: Hay, Ann.

Getty, J.A.
Flourished: 1839 Auburn, IN; New York
Type of Work: Fabric (Weavings)
Sources: *AmSQu 276; ArtWea 250*; ChAmC 63.*

Getty, James
Flourished: Lockport, NY
Type of Work: Fabric (Weavings)
Sources: *ChAmC 63.*

Getty, John
Flourished: Lockport, NY
Type of Work: Fabric (Weavings)
Sources: *ChAmC 63.*

Getty, Marshall
Flourished: 1979 Oklahoma
Type of Work: Fabric (Quilts)
Sources: *FoArO 91.*

Getty, Robert
Flourished: 1870 Philadelphia, PA
Type of Work: Wood (Ship carvings, ship figures)
Sources: *AmFiTCa 192.*

Getty and Sapper
Flourished: 1860 Philadelphia, PA
Type of Work: Wood (Ship carvings, ship figures)
Sources: *AmFiTCa 192.*

Getz
Flourished: c1880-1900 Dayton, OH
Type of Work: Stoneware (Pottery)
Sources: *AmPoP 213; Decor 219.*

Getz, John
Flourished: Lancaster, PA
Type of Work: Copper (Copperware)
Sources: *AmCoB 52*, 67*.*

Geyer, Henry Christian
d. c1793
Flourished: c1761-1775 Boston, MA; Milton, MA
Type of Work: Stone (Gravestones)
Remarks: Son is John Just.
Sources: *EaAmG 50*-1, 54*, 128; GravNE 56, 62-4, 128.*

Geyer, John Just.
Flourished: c1786-1790 Boston, MA
Type of Work: Stone (Gravestones)
Remarks: Father is Henry Christian
Sources: *EaAmG 128; GravNE 64, 128.*

Gibble, John
Flourished: c1865 Manheim, PA
Type of Work: Redware (Indian-head tobacco pipes)
Sources: *AmPoP 171.*

Gibbs, Ezekial
b. 1889
Flourished: 1977-1981 Houston, TX
Ethnicity: Black American
Type of Work: Oil, pastel (Paintings)
Sources: *FoAFr 6*-7*.*

Gibbs, H.R.
Flourished: 1865 Shelburn, MA
Type of Work: Watercolor (Paintings)
Sources: *PrimPa 173.*

Gibbs, James
Flourished: 1848 Louisville, KY
Type of Work: Wood (Ship carvings, ship figures)
Sources: *AmFiTCa 192.*

Gibbs, John
d. Newburgh, NY
Flourished: 1818- Newburgh, NY; Balmville, NY
Ethnicity: Irish
Type of Work: Fabric (Weavings)
Sources: *ChAmC 31, 63*
See: Alexander, James.

Gibbs, Sarah
Flourished: 1749 Newport, RI
Type of Work: Fabric (Samplers)
Sources: *LeViB 64.*

Gibson, Charles S.
Type of Work: Oil (Portraits)
Sources: *AmPrP 152; PrimPa 173; SoAmP 287.*

Gibson, Mary L.
Flourished: c1865 St. Lawrence County, NY
Type of Work: Fabric (Quilts)
Museums: 235
Sources: *FouNY 63.*

Gibson, Page
Flourished: Connecticut
Type of Work: Tin? (Tinware?)
Remarks: May have worked for Filley
Sources: *TinC 169.*

Gibson, Sybil
b. 1908 Dora, AL
Flourished: 1963- Miami, FL; Birmingham, AL; Jasper, GA
Type of Work: Paint (Paintings)
Sources: *FoAFb 15-6**.

Giddings, C.M.
Flourished: 1840 Cleveland, OH
Type of Work: Oil (Paintings)
Sources: *AmPrP 152, fig.62; PrimPa 173.*

Gideon Crisbaum and Company
Flourished: 1853-1854 Poughkeepsie, NY
Type of Work: Stoneware (Pottery)
Sources: *AmPoP 202; Decor 219.*

Gier, David
Flourished: 1960s Michigan
Type of Work: Oil (Landscape paintings)
Sources: *FoA 464; FoAFm 2; FoPaAm 209*, 214-5.*

Gies, Joseph
Flourished: Detroit, MI
Type of Work: Wood (Figures)
Sources: *CiStF 21.*

Gifford, M.T.
Flourished: 1855-1859 New Bedford, MA
Type of Work: Pencil (Genre drawings)
Museums: 123
Sources: *WhaPa 73*.*

Gifford, Stephen B.
Flourished: 1832 Dartmouth, MA
Type of Work: Watercolor, ink (Frakturs)
Sources: *AmFoPa 166*.*

Gilbert, A.V.
Flourished: c1830 Winthrop, ME
Type of Work: Fresco (Landscapes)
Sources: *AmDecor 20.*

Gilbert, Archie
Flourished: 1940 Landoff, NH
Type of Work: Wood (Sculptures, carvings)
Sources: *AmFoS 291*.*

Gilbert, C.A.
Flourished: 1838 Bethany, NY
Type of Work: Fabric? (Coverlets?)
Sources: *ChAmC 63.*

Gilbert, Daniel
Flourished: 1826-1833 Pottsgrove Township, PA
Type of Work: Tin (Tinware)
Museums: 025
Sources: *ToCPS 39*-41, 48, 73, 76, fig.*

Gilbert, David
Flourished: 1815 Berlin, CT; Pottstown, PA
Type of Work: Tin (Tinware)
Museums: 189
Sources: *AmCoTW 161; FoArRP 158*; TinC 169.*

Gilbert, E.J.
Flourished: 1850 Maine
Type of Work: Fresco (Paintings)
Remarks: Follower of Rufus Porter
Sources: *AmFoPa 141; AmPrP 152; PrimPa 173.*

Gilbert, Fitz W.
[Fitz-Gilbert]
d. 1889
Flourished: late 19th cent Belfast, ME
Type of Work: Wood (Ship carvings, ship figures)
Sources: *AmFiTCa 141-2, 192; ShipNA 156.*

Gilbert, I.
Flourished: 1838 New Bedford?, MA?
Type of Work: Oil (Portraits)
Sources: *NinCFo 166, 174, fig85, 86.*

Gilbert, J.
Flourished: New Bedford, MA
Type of Work: Oil (Portraits)
Sources: *AmPrP 152; PrimPa 173; SoAmP 286.*

Gilbert, Mordecai
Flourished: c1788 Philadelphia, PA
Type of Work: Redware (Pottery)
Sources: *AmPoP 175.*

Gilbert, Samuel
b. c1802
Flourished: 1843-1860 Trappe, PA
Type of Work: Fabric (Weavings)
Sources: *ChAmC 63.*

Gilbert and Worcester
Flourished: 1853-1889 Belfast, ME
Type of Work: Wood (Ship carvings, ship figures)
Sources: *AmFiTCa 192; ShipNA 156.*

Gilberth, J.H.
Flourished: Pennsylvania
Type of Work: Tin (Coffee pots)
Sources: *ToCPS 36, 42.*

Gilchrist, Catherine Williams
Flourished: 1850 New York
Type of Work: Fabric (Crib quilts)
Sources: *FouNY 63.*

Gilchrist, Hugh
b. c1806 d. 1857
Flourished: 1869 Franklin County, IN; Massachusetts; Connecticut
Ethnicity: Scottish
Type of Work: Fabric (Weavings)
Remarks: Brother is William
Sources: *AmSQu 276; ChAmC 63.*

Gilchrist, James
b. 1687 d. 1722
Flourished: Boston, MA
Type of Work: Stone (Gravestones)
Sources: *EaAmG 128; GravNE 128.*

Gilchrist, William
b. 1803
Flourished: 1832-1850 Mount Carmel, IN
Ethnicity: Scottish
Type of Work: Fabric (Weavings)
Remarks: Brother is Hugh
Sources: *ChAmC 63*
 See: Craig, William, Sr.

Gilcrest, Helen
Flourished: 1850 Hill's Grove, IL
Type of Work: Fabric (Appliques)
Museums: 114
Sources: *ArC 88*.*

Giles, J.B.
Flourished: 1850 Vermont
Type of Work: Pen, ink (Portraits)
Sources: *PrimPa 173.*

Giles, Polly
Flourished: c1825 Groton, MA
Type of Work: Fabric (Family register samplers)
Sources: *GalAmS 65*.*

Gilkerson, Robert
b. 1922 Oakland, CA
Type of Work: Wood, tin, paint, canvas (Sculptures, constructions)
Sources: *PioPar 15, 35, 38*, 64.*

Gill
Flourished: Pennsylvania
Type of Work: Tin (Cookie cutters)
Sources: *ToCPS 36, 42.*

Gill, Ebenezer
b. 1678 d. 1751
Flourished: Middletown, CT
Type of Work: Stone (Gravestones)
Sources: *EaAmG 128.*

Gillam, Charles
Flourished: 1727 Guilford, CT; Saybrook, CT
Type of Work: Wood (Painted chests)
Sources: *AmPaF 24.*

Gillespie, J.H.
Flourished: 1828-1838 New England,
Type of Work: Watercolor, pencil (Miniature portraits)
Museums: 001
Sources: *AmFoPo 106-8*.*

Gillette, Susan Buckingham
Flourished: 1876 Milford, CT
Type of Work: Fabric (Quilts)
Sources: *QuiAm 276*.*

Gillingham, James
Flourished: Philadelphia, PA
Type of Work: Wood (Chairs)
Sources: *EaAmW 87.*

Gilman, J.F.
Flourished: 1870
Type of Work: Pen, wash (Drawings)
Sources: *PrimPa 173.*

Gilmore, Gabriel
[Gilmour]
b. 1800 d. 1843
Flourished: 1838-1842 Union County, IN; Decatur County, IN
Type of Work: Fabric (Coverlets)
Remarks: Brothers are Thomas, Joseph, and William
Sources: *AmSFo 95*; AmSQu 276; ChAmC 64.*

Gilmore, Joseph
[Gilmour]
b. c1805
Flourished: 1838-1842 Dunlapville, IN; Missouri
Type of Work: Fabric (Coverlets)
Museums: 016
Remarks: Brothers are Thomas, William, and Gabriel
Sources: *AmSFo 95*; AmSQu 276; ArtWea 237*; ChAmC 64.*

Gilmore, Thomas
[Gilmour]
b. c1813
Flourished: 1826 Union County, IN; Franklin County, IN
Ethnicity: Scottish
Type of Work: Fabric (Coverlets)
Remarks: Brothers are Joseph and William
Sources: *AmSFo 95*; AmSQu 276; ChAmC 64.*

Gilmore, William
[Gilmour]
b. c1807
Flourished: 1838-1858 Union County, IN; Oskaloosa, IA
Ethnicity: Scottish
Type of Work: Fabric (Coverlets)
Remarks: Brothers are Joseph and Thomas
Sources: *AmSFo 95*; AmSQu 276; ChAmC 64.*

Gilmour, Gabriel
See: Gilmore, Gabriel.

Gilmour, Joseph
See: Gilmore, Joseph.

Gilmour, Thomas
See: Gilmore, Thomas.

Gilmour, William
See: Gilmore, William.

Gilpin, A.W.S.
Type of Work: Watercolor (Still life paintings)
Sources: *AmPrP 152; PrimPa 173.*

Gingerich, Zach
Flourished: c1875 Jonestown, PA
Type of Work: Redware (Pottery)
Sources: *AmPoP 169.*

Ginn, Robert
b. 1805
Flourished: c1822-1846 Philadelphia, PA; Steubenville, OH; Piqua, OH
Ethnicity: Irish
Type of Work: Fabric (Weavings)
Sources: *ChAmC 64.*

Ginther, R(oland) D(ebs)
b. 1907 d. 1969 Seattle, WA
Flourished: 1920s-1930s Washington
Type of Work: Watercolor (Political and social paintings)
Museums: 299
Sources: *PioPar 38-9*, 61.*

Gise, Henry
Flourished: 1846 Pennsylvania
Type of Work: Watercolor, ink (Frakturs)
Sources: *AmFoPa 188.*

Gish, S.M.
Flourished: 1852
Type of Work: Fabric? (Coverlets?)
Sources: *ChAmC 64.*

Gitt, Wilhelm
Flourished: 1784 Hanover, PA
Type of Work: Watercolor, ink (Frakturs)
Sources: *NinCFo 167, 187, fig5.*

Glad, George H.
Flourished: 1865 Boston, MA
Type of Work: Wood (Ship carvings, ship figures)
Sources: *AmFiTCa 192.*

Gladding, Benjamin
Flourished: 1810 Providence, RI
Type of Work: Oil (Paintings)
Sources: *AmPrP 152; PrimPa 173.*

Gladding, Lydia
b. Providence, RI d. before 1828 Cleveland?, OH
Flourished: 1796 Providence, RI
Type of Work: Fabric (Samplers)
Sources: *GalAmS 33*, 190; LeViB 142-3*.*

Gladding, Susan Cary
b. 1800 Providence?, RI? d. 1873 Providence?, RI?
Flourished: Providence, RI
Type of Work: Fabric (Samplers)
Sources: *LeViB 201.*

Gladding, T.
Flourished: 1819 Albany, NY
Type of Work: Oil (Portraits)
Sources: *AlAmD 27*.*

Glaes, Abraham
Flourished: c1840-1867 Freystown, PA
Type of Work: Redware (Pottery)
Remarks: Son is John G.
Sources: *AmPoP 167, 173.*

Glaes, John G.
Flourished: c1870-1900 Passmore, PA
Type of Work: Redware (Pottery)
Remarks: Son of Abraham
Sources: *AmPoP 167, 173.*

Glaes, William
Flourished: c1850 Montgomery County, PA
Type of Work: Redware (Pottery)
Sources: *AmPoP 162.*

Glaser, Elizabeth
Flourished: 1830-1840 Baltimore, MD
Type of Work: Watercolor (Portraits, genre paintings)
Sources: *AmFoPaS 66*; FoA 12*, 464.*

Glasgow Pottery Company
See: John Moses and Sons.

Glassen, John
Flourished: 1860 Chicago, IL
Type of Work: Earthenware (Pottery)
Sources: *ArC 194.*

Glassey, Joseph
b. c1839 Pennsylvania
Flourished: c1870 Mount Joy, PA
Type of Work: Fabric (Coverlets)
Sources: *ChAmC 65.*

Glassir and Company
Flourished: c1872 Washington, MO
Type of Work: Stoneware (Pottery)
Sources: *AmPoP 233; Decor 219.*

Glassley, John
b. c1831 Pennsylvania
Flourished: c1870 Mount Joy, PA
Type of Work: Fabric (Coverlets)
Sources: *ChAmC 64.*

Glazier, Henry
Flourished: Huntingdon, PA
Type of Work: Stoneware (Pottery)
Sources: *HerSa *.*

Gleason
See: McIntyre and Gleason.

Gleason, Benjamin A.
[S.W. Gleason and Sons]
Flourished: 1800s Boston, MA
Type of Work: Wood (Ship carvings, ship figures)
Remarks: Son of S.W. Gleason
Sources: *AmFiTCa 126, 192.*

Gleason, Charles
Flourished: contemporary Richmond, VA
Type of Work: Oil (Genre, town scene paintings)
Sources: *ConAmF 35-7*.*

Gleason, Henry (Herbert)
Flourished: 1871-1896 Boston, MA
Type of Work: Wood (Ship carvings, ship figures)
Sources: *AmFiTCa 40, 129, 136-7*, 147, 192; ShipNA 67, 77-8, 80*, 159*
See: Gleason and Henderson; Hastings and Gleason.

Gleason, Mrs. L.
Flourished: Pennsylvania
Type of Work: Watercolor, pen (Scene paintings)
Museums: 176
Sources: *ColAWC 161-2*.*

Gleason, Samuel W(illiam)
See: S.W. Gleason and Sons.

Gleason, W.G.
Flourished: 1854 Boston, MA
Type of Work: Wood (Ship carvings, ship figures)
Sources: *ShipNA 159.*

Gleason, William B.
[S.W. Gleason and Sons]
b. 1800 Dorchester, MA
Flourished: c1853 Boston, MA
Type of Work: Wood (Ship carvings, ship figures)
Remarks: Son of S.W. Gleason
Sources: *AmEaAD 24*; AmFiTCa 120, 124, 126-9, 147, 183-4, 192, figxix; EaAmW 29*; ShipNA 67, 143.*

Gleason and Company
Flourished: 1800s Boston, MA
Type of Work: Wood (Ship carvings, ship figures)
Sources: *AmFiTCa 149.*

Gleason and Hastings
See: Hastings and Gleason.

Gleason and Henderson
Flourished: 1856 Boston, MA
Type of Work: Wood (Ship carvings, ship figures)
Sources: *AmFiTCa 129, 192.*

Glen, Hugh
Flourished: c1832 Middlefield, NY
Ethnicity: Scottish
Type of Work: Fabric (Weavings)
Sources: *ChAmC 65.*

Glenn, William
Flourished: 1860 Ripley, IL
Type of Work: Stoneware (Pottery)
Sources: *ArC 194.*

Glenn and Hughes
Flourished: 1860 Ripley, IL
Type of Work: Stoneware (Pottery)
Sources: *ArC 194.*

Glick, Herman
b. 1895
Flourished: 1970-1980 Havana, IL
Type of Work: Wood (Decoys)
Sources: *FoA 222*, 226*, 464.*

Globe Factory
Flourished: c1850 Middle Woodbury Township, PA
Type of Work: Fabric (Weavings)
Sources: *ChAmC 65*
See: Keagy, John.

Globe Pottery Company
Flourished: 1888 East Liverpool, OH
Type of Work: Clay (Pottery)
Sources: *AmPoP 219; DicM 63*, 89*, 178*, 203*, 232*, 258*.*

Glover, Elizabeth
b. 1824 d. 1845
Flourished: Sag Harbor, NY
Type of Work: Fabric (Quilts)
Museums: 304
Sources: *ArtWea 134*.*

Glover, John
Flourished: c1890 Duxbury, MA
Type of Work: Wood (Shorebird decoys)
Museums: 171
Sources: *AmFoArt 95*.*

Gminder, Gottlieb
Flourished: 1877 Meriden, CT
Type of Work: Tin (Tinware)
Sources: *TinC 169.*

Godbold
See: Treadwell and Godbold.

Goddard, Mary
b. 1801 Newport, RI d. 1883
Flourished: 1811 Newport, RI
Type of Work: Fabric (Samplers)
Museums: 205
Sources: *LeViB 61, 77*.*

Godfrey, Mary Greene
b. 1773 Newport, RI d. 1841 Newport, RI
Flourished: 1785 Newport, RI
Type of Work: Fabric (Samplers)
Sources: *LeViB 54, 56-8, 75-6*, 212.*

Godie, Lee
Flourished: contemporary Chicago, IL
Type of Work: Mixed media (Drawings)
Remarks: A so-called bag lady
Sources: *FoAFj 1*, 7-8*.*

Godshalk, Enos
Flourished: 1820 Pennsylvania
Type of Work: Watercolor, ink (Frakturs)
Sources: *AmFoPa 188.*

Godshall, M.
Flourished: 1835 Pennsylvania
Type of Work: Watercolor, ink (Frakturs)
Sources: *AmFoPa 188.*

Godwin, Abigail
Flourished: 1775-1800
Type of Work: Fabric (Quilts)
Sources: *WinGu 105*.*

Goebell, Henry
Flourished: 1841 Berks County?, PA
Type of Work: Fabric (Weavings)
Sources: *ChAmC 65.*

Goff, G.
Flourished: 1930 Oklahoma
Type of Work: Various materials (Sculptures)
Museums: 268
Sources: *FoArO 92.*

Goins, Luther
Flourished: 1895 Maryland
Type of Work: Wood (Chandelier)
Museums: 263
Sources: *SoFoA 113, 122*, 220.*

Golcher, James
Flourished: New England,
Type of Work: Brass (Lock plates)
Sources: *AmCoB 186*; MaAmFA *.*

Gold, Thomas
b. 1733 d. 1800
Flourished: New Haven, CT
Type of Work: Stone (Gravestones)
Sources: *EaAmG 128.*

Golder, C.H.
Flourished: 1880 New England,
Type of Work: Oil (Paintings)
Sources: *AmPrP 151; MaAmFA *; PrimPa 173.*

Goldin, Elizabeth Ann
Flourished: 1829 New York, NY
Type of Work: Fabric (Embroidered maps)
Sources: *AmNe 94*.*

Golding, John
Flourished: 1844 Hartford, CT
Type of Work: Wood (Ship carvings, ship figures)
Sources: *AmFiTCa 192.*

Golding, William O.
b. 1874 d. 1943
Flourished: Savannah, GA
Ethnicity: Black American
Type of Work: Watercolor, crayon (Boat portraits)
Sources: *FoA 464; FoPaAm 178*; MisPi 44-5*; TwCA 43*.*

Goldsborough, Moria T.
Flourished: 1820 Maryland
Type of Work: Watercolor (Memorial paintings)
Sources: *AmPrW 50*, 125*.*

Goldsmith, Deborah (Throop)
b. 1808 North Brookfield, NY **d.** 1836 Hamilton, NY
Flourished: 1820-1832 Hamilton, NY
Type of Work: Oil, watercolor (Portraits)
Museums: 001
Sources: *AmFoPaN 102, 129*; AmFoPo 108-110*; AmPaF 243*; ArtWo 85, 87, 88-89*, 161*, fig11; EyoAm 21, 24*; FoA 464; HoKnAm pl24, 114-5; PicFoA 15, 152; PrimPa 173, 90-6*.*

Goldsmith, Oliver B.
Flourished: 1845
Type of Work: Pen, ink (Penmanship, calligraphy drawings)
Sources: *AmFoPa 169*.*

Goldstein, Harry
Flourished: Brooklyn, NY
Type of Work: Wood (Carousel figures)
Sources: *CaAn 10, 28-31**
See: Stein and Goldstein.

Goldthwaite, William
Flourished: c1763-1808 Peabody, MA
Type of Work: Redware (Pottery)
Sources: *AmPoP 200.*

Golonko, Joe
Flourished: early 20th cent Youngstown, OH
Type of Work: Wood (Sculptures, carvings)
Sources: *AmFoS 345*.*

Gonzales, Elidio
b. 1923 Cimarron, NM
Flourished: 1934 Taos, NM
Ethnicity: Hispanic
Type of Work: Wood (Furniture)
Sources: *HisCr 33*, 101*.*

Gonzales, Jose de Garcia
Flourished: 1860s-1883 Las Trampas, NM
Ethnicity: Mexican
Type of Work: Oil (Altar paintings, santeros)
Sources: *HoKnAm 75; PopAs 343-9*.*

Good, Jacob
b. c1800
Flourished: c1867 Leitersburg, MD; Ohio
Type of Work: Fabric (Coverlets)
Sources: *ChAmC 65.*

Good Intent Woolen Factory
[Heikes Woolen Factory]
Flourished: 1847-1872 Bermudian Creek, PA
Type of Work: Fabric (Weavings)
Sources: *ChAmC 65.*

Goodale, Daniel, Jr.
[Benton and Steward Pottery; Goodale and Stedman]
Flourished: 1818-1830 Hartford, CT
Type of Work: Stoneware (Pottery)
Museums: 096
Sources: *AmPoP 193, 204; Decor 142*, 219; DicM 36*; EaAmFo 254*.*

Goodale and Stedman
[Goodale, Daniel, Jr.]
Flourished: 1822 Hartford, CT
Type of Work: Clay (Pottery)
Sources: *DicM 53*.*

Goodall, Premella
Flourished: 1790 Buffalo, NY
Type of Work: Fabric (Coverlets)
Museums: 096
Sources: *AmSQu 66*; FlowAm 268*.*

Goodell, Ira Chaffee
b. 1800 Belchertown, MA **d.** 1875
Flourished: Massachusetts; New York, NY
Type of Work: Oil (Portraits)
Museums: 001
Sources: *AmFoPo 110-1*; EraSaF 60.*

Goodell, J.C.
Flourished: 1825-1832 Malden Bridge, NY
Type of Work: Oil (Portraits)
Sources: *AmPrP 152; NinCFo 167, 179, fig39; PrimPa 173.*

Gooding, Charles Gustavus
b. 1834 **d.** 1903
Flourished: Yarmouth, ME
Type of Work: Wood (Ship carvings, ship figures)
Sources: *FoArA 150*.*

Gooding, William T.
Flourished: 1870 New London, CT
Type of Work: Oil (Ship and harbor paintings)
Museums: 139
Sources: *AmFoPa 120*.*

Goodman, Daniel
b. c1800 Pennsylvania
Flourished: 1842-1850 Nescopeck, PA
Type of Work: Fabric (Weavings)
Sources: *ChAmC 65.*

Goodman, H.K.
Flourished: 1845
Type of Work: Oil (Portraits)
Sources: *NinCFo 167, 179, fig89.*

Goodman, Hezekiah
Flourished: Connecticut
Type of Work: Tin? (Tinware?)
Sources: *TinC 169.*

Goodman, J. Reginald
Flourished: 1856 Chicago, IL
Type of Work: Watercolor (Street scene paintings)
Sources: *ArC 265.*

Goodman, John S.
b. Pennsylvania
Flourished: 1830-1851 Black Creek, PA
Type of Work: Fabric (Weavings)
Sources: *AmSQu 276; ChAmC 65.*

Goodman, Peter
b. c1783
Flourished: 1832-1854 Black Creek Township, PA; Delaware Township, PA; Danville?, PA?
Type of Work: Fabric (Weavings)
Sources: *ChAmC 65.*

Goodpastor, Denzil
b. c1908
Flourished: 1970 Ezel, KY
Type of Work: Wood (Carved canes)
Sources: *FoAF 10*.*

Goodrich, Asahel (Asohet)
Flourished: Connecticut; Lansingburgh, NY
Type of Work: Tin (Tinware)
Remarks: Worked for Filley, Oliver and Augustus
Sources: *AmCoTW 114-5; TinC 39, 73, 75*, 97, 103*, 169.*

Goodrich, Asaph
Flourished: Berlin, CT
Type of Work: Tin (Tinware, footstoves)
Sources: *TinC 169.*

Goodrich, Henry O.
b. 1814 **d.** 1834
Flourished: Deerfield, NH
Type of Work: (Ornamental paintings)
Sources: *AmDecor 101.*

Goodrich, John J.
Flourished: c1813 Berlin, CT
Type of Work: Tin (Tinware)
Sources: *TinC 169.*

Goodrich, Mahala
Flourished: c1835 Troy, NY
Type of Work: Fabric (Shawls)
Sources: *AmNe 71.*

Goodrich, Nathan
See: Goodrich, Ives and Rutty Co.

Goodrich, Samuel
Flourished: Berlin, CT
Type of Work: Tin (Tinware)
Sources: *TinC 170.*

Goodrich, Seth
Flourished: Connecticut
Type of Work: Tin (Tinware)
Sources: *TinC 44.*

Goodrich, Walter
b. 1802 Wethersfield, CT **d.** 1869
Flourished: 1820-1850 Berlin, CT; Lynn, MA; Stevens Plains, ME
Type of Work: Tin (Tinware)
Remarks: Formed a partnership Goodrich and Thompson
Sources: *AmFokDe 66; FoA 290*; FoArtC 84; TinC 170.*

Goodrich and Thompson
See: Goodrich, Walter.

Goodrich, Ives and Rutty Co.
[Nathan Goodrich]
Flourished: 1852-1864 Meriden, CT
Type of Work: Tin (Tinware)
Sources: *TinC 87*, 93, 97, 101, 107*, 169.*

Goodwin
See: Morley, Goodwin, and Flentke.

Goodwin, E.W.
Flourished: 1830s Auburn, NY
Type of Work: Oil (Miniature paintings)
Sources: *PicFoA 17.*

Goodwin, F.W.
Flourished: 1830 New York
Type of Work: Oil (Portraits)
Sources: *AmPrP 152; PrimPa 173.*

Goodwin, Harmon
Flourished: Maine
Type of Work: Fabric (Weavings)
Sources: *AmSQu 276; ChAmC 65.*

Goodwin, Harvey
Flourished: 1827-1870 West Hartford, CT
Type of Work: Stoneware (Pottery)
Remarks: Uncles are Goodwin, Seth and Goodwin, Horace
Sources: *AmPoP 193.*

Goodwin, Horace
Flourished: 1810-1867 Hartford, CT
Type of Work: Stoneware (Pottery)
Remarks: Brother of Seth
Sources: *AmPoP 193; Decor 97*, 219*
See: Webster, Mack.

Goodwin, John
Flourished: c1672 Charlestown, MA
Type of Work: Stone (Gravestones)
Sources: *GravNE 21.*

Goodwin, John
Flourished: 1844-1853 Liverpool, OH
Ethnicity: English
Type of Work: Yellow-ware, Rockingham (Pottery)
Sources: *AmPoP 75, 82, 215; DicM 53*, 153*, 162*, 169*, 175*.*

Goodwin, Russell F.
Flourished: 1859-1860 Dundee, IL
Sources: *ArC 265.*

Goodwin, Seth
Flourished: 1752-1828 Hartford, CT
Type of Work: Clay (Pottery)
Remarks: Brother is Horace; nephew is Harvey
Sources: *AmPoP 59, 82, 193; DicM 121*; EaAmFo 90*.*

Goodwin, Thomas (O'Hara)
Flourished: c1850 Hartford, CT
Type of Work: Clay (Pottery)
Sources: *AmPoP 193; DicM 131*.*

Goodwin, Webster
Flourished: 1818-1830 Hartford, CT
Type of Work: Stoneware (Jars)
Sources: *AmS 84*, 233*.*

Goodwin, William
Flourished: 1880 New London, CT
Type of Work: Oil (Paintings)
Sources: *PrimPa 173.*

Goodwin, William F.
Flourished: Berlin, CT
Type of Work: Paint (Painted tin toys)
Sources: *TinC 170.*

Goodwin and Webster
Flourished: c1825 Hartford, CT
Type of Work: Stoneware, brownware (Pottery)
Sources: *AmPoP 59, 82, 193; DicM 53*.*

Goodwin Brothers
Flourished: 1876-1893 East Liverpool, OH
Type of Work: Cream-colored ware (Pottery)
Sources: *AmPoP 216.*

Goodwin Pottery Company
Flourished: 1893-1900 East Liverpool, OH
Type of Work: Whiteware (Pottery)
Sources: *AmPoP 216.*

Gookin, William S.
Flourished: 1835-1860 Dover, NH
Type of Work: Oil (Paintings)
Sources: *PrimPa 173.*

Goose Lake Stoneware Manufacturings Company
Flourished: 1860 Grundy County, IL
Type of Work: Stoneware (Pottery)
Sources: *ArC 194.*

Goram, J.
Flourished: c1844 Nantucket, MA
Type of Work: Watercolor (Seascape paintings)
Museums: 123
Sources: *WhaPa 61-2*, 67-8*, 92*, 96*, 102*, 113**
See: Gould, George.

Gorbut, Robert
Flourished: 1846 Philadelphia, PA
Type of Work: Wood (Ship carvings, ship figures)
Sources: *AmFiTCa 193.*

Gordon, L.
Flourished: 1840 Bedford County, PA
Type of Work: Fabric (Weavings)
Remarks: Worked at the Keagy Factory
Sources: *ChAmC 65.*

Gordon, Theodore
b. 1924 Louisville, KY
Flourished: 1950s San Francisco, CA
Type of Work: Pen, ink, crayon (Drawings, paintings)
Museums: 174, 263
Sources: *PioPar 39, 42*, 64.*

Gordon, Thomas Clarkson
b. 1841 d. 1922
Flourished: 1880s Indiana
Type of Work: Oil (Panoramic paintings)
Museums: 096
Sources: *FoPaAm 200*, 210, 212, 214.*

Gordy, D.X.
Flourished: 1975 Westville, GA
Type of Work: Clay (Pottery)
Museums: 177
Sources: *MisPi 103*.*

Gordy, William J.
Flourished: 1935-1938 Cartersville, GA
Type of Work: Clay (Pottery)
Sources: *MisPi 8*, 99*.*

Gordy, William Thomas Belah
Flourished: 1920 Alvaton, GA
Type of Work: Clay (Pottery)
Museums: 177
Sources: *MisPi 98*.*

Gordy Pottery
Flourished: c1865-1900 Cartersville, GA
Type of Work: Stoneware (Pottery)
Sources: *AmPoP 237.*

Gore, John
Flourished: 1750-1775 Boston, MA; Roxbury, MA
Type of Work: Oil, fabric (Painted carpets)
Sources: *AmDecor 8; AmFokDe 84.*

Gore, Joshua
Flourished: 1860
Type of Work: Watercolor (Portraits)
Sources: *PrimPa 173.*

Gore, Samuel
Flourished: 1750-1775 Roxbury, MA
Type of Work: Oil? (Ornamental paintings)
Sources: *AmDecor 8.*

Gorham, Bethiah
b. 1789 Providence, RI d. 1821 Providence?, RI?
Flourished: 1800 Providence, RI
Type of Work: Fabric (Samplers)
Museums: 231
Sources: *LeViB 156*.*

Gorham, Jemima
b. 1775 Bristol, RI d. 1798 Bristol, RI
Flourished: 1790 Bristol, RI
Type of Work: Fabric (Samplers)
Museums: 263
Sources: *LeViB 220-1*, 208, 213.*

Gorham, Joshua
Flourished: 1852-1870 Illinois City, IL
Type of Work: Clay (Pottery)
Sources: *ArC 193.*

Gossett, Amariah
Flourished: c1810-1840 Hillsboro, PA
Type of Work: Stoneware (Pottery)
Sources: *AmPoP 221; Decor 219.*

Gossett, Henry
Flourished: 1891 Philadelphia, PA
Type of Work: Wood (Ship carvings, ship figures)
Sources: *AmFiTCa 193.*

Gottfried Kappel and Company
Flourished: 1845-1871 Zoar, OH
Type of Work: Fabric (Weavings)
Sources: *AmSQu 277; ChAmC 73*.*

Gottier, Edward
Flourished: 1806 Washington, DC
Type of Work: Wood (Ship carvings, ship figures)
Sources: *ShipNA 155.*

Gotwals, M.
Flourished: 1841 New Britain Township, PA
Type of Work: Fabric? (Coverlets?)
Sources: *ChAmC 65.*

Gould, George A.
Flourished: c1844 Nantucket, MA
Type of Work: Watercolor (Seascape paintings)
Museums: 123
Sources: *WhaPa 61-2*, 67-8*, 92*, 96*, 102*, 113**
See: Goram, J.

Gould, M.H.
Flourished: 20th century Cape Cod, MA
Type of Work: Wood (Fish decoys)
Sources: *WoCar 173, 177*.*

Gould and Hazlett
Flourished: 1840s Charlestown, MA; Boston, MA
Type of Work: Iron (Weathervanes)
Sources: *CoCoWA 111*; GalAmW 80*; YankWe 70*, 211.*

Gould Brothers and Diblee
Flourished: 1875 Chicago, IL
Type of Work: Metal (Weathervanes)
Sources: *YankWe 211.*

Goulette, Abe
Flourished: 1930s New Baltimore, MI; Goulette's Point, MI
Type of Work: Wood, metal (Fish decoys)
Sources: *UnDec 21*.*

Gouverneur, Maria Monroe
Flourished: c1830 New York
Type of Work: Fabric (Quilts)
Remarks: Daughter of U.S. President James Monroe
Sources: *QuiAm 91*.*

Gove, Jane
Flourished: 1845 Wiscasset, ME
Type of Work: Fabric (Hooked rugs, bed rugs)
Museums: 192
Sources: *ArtWo 56-7*, 161.*

Gove, Mary Breed
b. c1814
Flourished: 1827 Weare, NH
Type of Work: Fabric (Samplers)
Sources: *GalAmS 68*, 92.*

Grace, Daniel
Flourished: c1850 Canton, OH
Type of Work: Stoneware (Pottery)
Sources: *AmPoP 209.*

Gracey, William
Flourished: 1860 Philadelphia, PA
Type of Work: Wood (Ship carvings, ship figures)
Sources: *AmFiTCa 193.*

Graff
See: Galloway and Graff.

Graff, J.
Flourished: 1873-1880 Beaver Falls, PA
Type of Work: Yellow-ware (Pottery)
Sources: *AmPoP 208.*

Gragg, Samuel
Flourished: 1808-1830 Boston, MA
Type of Work: Wood (Chairs)
Museums: 016,097,176
Sources: *AmPaF 112-3*.*

Graham, B.
Flourished: 1841 Connecticut
Type of Work: Tin? (Tinware?)
Remarks: May have worked for Filley
Sources: *TinC 170.*

Graham, Charles
Flourished: 1886
Type of Work: Oil (Scenes for the America Opera Company)
Sources: *AmSFor 198.*

Graham, Francis
Flourished: c1796 Philadelphia, PA
Type of Work: Tin (Tinware)
Sources: *AmCoTW 153; ToCPS 6.*

Graham, John
b. c1798
Flourished: 1853-1855 Morris Township, OH; Mt. Vernon, OH
Ethnicity: Irish
Type of Work: Fabric (Weavings)
Sources: *AmSQu 276; ChAmC 65.*

Graham, John
d. 1805 New York, NY
Flourished: 1770-1786 New York, NY
Type of Work: Tin (Tinware)
Sources: *AmCoTW 108-9.*

Graham, Samuel
b. 1805 d. 1871
Flourished: 1843-1860 New Castle, IN; Henry County, IN
Ethnicity: English
Type of Work: Fabric (Coverlets)
Museums: 068
Sources: *AmSQu 250*, 276; ChAmC 34*, 38*, 44*, 65.*

Graham, Thomas
Flourished: 1846 Philadelphia, PA
Type of Work: Wood (Ship carvings, ship figures)
Sources: *AmFiTCa 193.*

Gramalich, John
See: Gramlyg, John.

Gramlic, John
See: Gramlyg, John.

Gramlyg, John
[Kramlich; Gramalich; Gramlic]
b. c1805
Flourished: 1853-1888 Allentown, PA; Anthony Township, PA
Type of Work: Fabric (Weavings)
Sources: *ChAmC 65*
See: Wiand, Charles.

Grand Ledge Sewer Pipe Factory
b. Grand Ledge, MI
Flourished: 1900-1925
Type of Work: Stoneware (Doorstops, pottery)
Sources: *AmS 53.*

Grandma Moses
See: Moses, Anna Mary Robertson.

Grandy, A.
b. 1890 d. 1951
Flourished: c1915 Back Bay, NC
Type of Work: Wood (Duck decoys)
Sources: *AmBiDe 172-3*.*

Granger, Charles H.
Flourished: 1840 Maine
Type of Work: Oil (Portraits)
Sources: *PrimPa 173.*

Granold, J. George
Flourished: 1852-1853 Sidney, OH
Type of Work: Fabric (Weavings)
Sources: *ChAmC 65.*

Grant, Henry
b. 1860 d. 1924
Flourished: c1870 Barnegat, NJ; Delaware
Type of Work: Wood (Duck decoys)
Museums: 260
Remarks: Son is Stanley
Sources: *AmBiDe 120-1; AmDecoy xii; ArtDe 163; Decoy 12*, 77*.*

Grant, Percy
Flourished: c1900 Osbornsville, NJ
Type of Work: Wood (Duck decoys)
Museums: 260
Sources: *Decoy 14*, 19**.

Grant, Stanley
Flourished: Barnegat, NJ
Type of Work: Wood (Duck decoys)
Remarks: Father is Henry
Sources: *AmBiDe 121*.

Grant, William
b. 1694 **d.** 1726
Flourished: Boston, MA
Type of Work: Stone (Gravestones)
Sources: *EaAmG 128; GravNE 128*.

Grant, William
Flourished: 1865 Boston, MA
Type of Work: Wood (Ship carvings, ship figures)
Sources: *AmFiTCa 193*.

Grape
Flourished: c1838 Lamar Township, PA
Type of Work: Fabric (Weavings)
Sources: *ChAmC 65, 84*
See: March, J. H.

Graves, Bert
d. 1944
Flourished: c1936 Peoria, IL
Type of Work: Wood (Duck decoys)
Sources: *AmBiDe 185-87*; ArtDe 189*; WoCar 146-7**.

Graves, David Isaac
[Grave]
b. c1803 Pennsylvania **d.** 1864
Flourished: 1836-1849 Morgan County, IN; Ohio
Type of Work: Fabric (Weavings)
Sources: *AmSQu 276; ChAmC 65*.

Gray, Mr.
Flourished: 1885
Type of Work: Wood (Weathervanes)
Sources: *YankWe 90**.

Gray, Grace
Flourished: 1971 Georgia
Type of Work: Fabric (Quilts)
Sources: *AmSQu 308**
See: Moore, Mrs. Roy.

Gray, William
Flourished: 1794-1795 Salem, MA
Type of Work: Oil? (Ornamental paintings)
Sources: *AmDecor 42*.

Gray and Todd
Flourished: 1817 Philadelphia, PA
Type of Work: Fabric (Printed handkerchiefs)
Sources: *Bes 30**.

Graziani, Reverend Dr.
b. 1885-
Flourished: New York
Type of Work: Oil (Paintings)
Sources: *FoPaAm 101**.

Gre(en?), G.
Flourished: 1880 Albany, NY
Type of Work: Clay (Pottery)
Sources: *AmFoS 217**.

Greatbach, Daniel
[Americican Pottery Company]
Flourished: c1837-1860 Bennington, VT; South Amboy, NJ; Peoria, IL
Ethnicity: English
Type of Work: Ceramic (Bottles, pottery)
Remarks: Partners are Moore, Enoch; Carr, James
Sources: *AmPoP 48-9, 63, 82, 180; ArC 188-9; NeaT 52*.

Greatbach, Hamlet
Flourished: 1854-1856 Cincinnati, OH
Type of Work: Yellow-ware (Pottery)
Sources: *AmPoP 211*.

Greble, Benjamin
Flourished: 1837-1850 Baltimore, MD
Type of Work: Stoneware (Pottery)
Sources: *AmPoP 163; Decor 219*.

Greco, John
b. 1895 Waterbury, CT
Flourished: 1956 Waterbury, CT
Type of Work: Cement (Environmental sculptures)
Remarks: Made "Holyland USA"
Sources: *FoAFg 3; FoAFj 2*; FoAFz 12-3**.

Greef, Adolph
b. 1807 **d.** 1863
Flourished: St. Louis, MO
Ethnicity: German
Type of Work: Wood (Furniture)
Sources: *ASeMo 378*.

Greeley, John
Flourished: 1886 Philadelphia, PA
Type of Work: Wood (Ship carvings, ship figures)
Sources: *AmFiTCa 193*.

Green, Adam
Flourished: 1840-1880 New Brunswick, NJ
Type of Work: Stoneware (Pottery)
Sources: *Decor 219*.

Green, Branch
Flourished: c1820 Philadelphia, PA
Type of Work: Stoneware (Pottery)
Sources: *AmPoP 175*.

Green, Charles E.
Flourished: 19th century Philadelphia, PA
Type of Work: Tin (Lamps)
Sources: *ToCPS 48*.

Green, G.
See: Gre(en?), G.

Green, George W.
Flourished: 1874 Philadelphia, PA
Type of Work: Wood (Ship carvings, ship figures)
Sources: *AmFiTCa 193*.

Green, Elder Henry
Flourished: 1884 Alfred, ME
Ethnicity: Shaker
Type of Work: Wood (Furniture)
Sources: *HanWo 124*.

Green, J.D.
Flourished: 1832 Pennsylvania
Type of Work: Wood (Clocks)
Sources: *AmPaF 238**.

Green, John H.
Flourished: 1861 Oswego, NY
Type of Work: Wood (Pull toys)
Sources: *FouNY 49*, 68*.

Green, Virginia
Flourished: 1937 Saluda, NC; Bronxville, NY
Type of Work: Fabric (Samplers)
Sources: *AmNe 179*-180*.

Green and Board
Flourished: New York, NY
Type of Work: Brass (Door locks)
Sources: *AmCoB 247**.

Greenawalt, Katie
Flourished: 1915 Emma, IN
Ethnicity: Amish
Type of Work: Fabric (Quilts)
Sources: *QufInA 28**.

Greene, E. De Chois
Flourished: 1920 Adams, NY
Type of Work: Wood (Weathervanes)
Sources: *FouNY 63*.

Greene, Samuel
Flourished: 1840-60 New London, CT
Type of Work: Whalebone (Scrimshaw)
Museums: 186
Sources: *GravF 130**.

Greenland, N(orval) W.
Flourished: c1885-1900 Cassville, PA
Type of Work: Stoneware (Pottery)
Sources: *AmPoP 209; Decor 219; HerSa **.

Greenleaf, Benjamin
b. 1786 **d.** 1864
Flourished: Phippsburg, ME; Massachusetts
Type of Work: Oil (Portraits)
Museums: 146
Sources: *AmPrP 152; FoArA 50-2*; PrimPa 173; SoAmP 132*.

Greenless, Kenneth
Flourished: Burlington, IA
Type of Work: Wood (Duck decoys)
Sources: *AmBiDe 181, 190*.

Greenwald, John W.
[Grunewald]
b. c1812 Pennsylvania **d.** 1865 Albany Township, PA
Flourished: 1845 Greenwich Township, PA; Lobachsville, PA; Albany Township, PA
Type of Work: Fabric (Weavings)
Sources: *ChAmC 65.*

Greenwalt, Maria B.
Flourished: 1822 Lehigh Valley?, PA?; Frederick County?, MD?
Type of Work: Fabric (Samplers)
Sources: *GalAmS 60*, 91.*

Greenwich Pottery
See: Smith, W.

Greenwood, Ethan Allan
b. 1779 Hubbardston, **d.** 1856
Flourished: 1801- Boston, MA
Type of Work: Oil (Portraits)
Sources: *SoAmP 205.*

Greenwood, John
b. 1727 **d.** 1792
Flourished: 1750s New England,
Type of Work: Oil (Portraits)
Museums: 176
Sources: *FoA 464; FoArtC 113*
See: Mason, David .

Greenwood Pottery Company
Flourished: 1864 Trenton, NJ
Type of Work: White Granite (Porcelain, pottery)
Sources: *AmPoP 182; DicM 53*-4*, 177*, 243*.*

Greer, Exell
Flourished: c1900 Waynesville, NC
Type of Work: Wood (Sculptures)
Sources: *SoFoA 102*, 219.*

Greer, James
Flourished: 1840 Philadelphia, PA
Type of Work: Wood (Ship carvings, ship figures)
Sources: *AmFiTCa 193.*

Greer, R.
Flourished: 1790 Norwich, CT
Type of Work: Fabric (Hooked bed rugs)
Museums: 032
Sources: *AmSQu 21*.*

Gregory Brothers
See: Wallace and Gregory Brothers .

Greig
See: Campbell and Greig .

Greiseiner Pottery
Flourished: c1800-1865 Hereford, PA
Type of Work: Redware (Pottery)
Sources: *AmPoP 169.*

Grice, Elias
d. 1684
Flourished: 17th century Boston, MA
Type of Work: Stone (Gravestones)
Sources: *EaAmG 128; GravNE 31, 128*
See: Mumford, William .

Grider, Nancy Miller
Flourished: c1800? Russell County, KY
Type of Work: Fabric (Quilts)
Sources: *KenQu fig1.*

Grider, Rufus A.
Flourished: 1879 Canajoharie, NY
Type of Work: Watercolor (Paintings)
Museums: 203
Sources: *PicFoA 140*.*

Gridley, George
Flourished: 1857 Norwich, CT
Type of Work: Wood (Ship carvings, ship figures)
Sources: *AmFiTCa 193.*

Gridley, R.
Flourished: Berlin, CT
Type of Work: Tin (Japanned tinware)
Sources: *TinC 93, 102*.*

Griest, David
See: Griest Fulling Mill .

Griest Fulling Mill
[David Griest]
Flourished: c1851 Adams County, PA
Type of Work: Fabric (Weavings)
Sources: *ChAmC 65.*

Griffin, Edward Souther
b. 1834 **d.** 1928
Flourished: 1851-1900 Portland, ME
Type of Work: Wood (Ship carvings, ship figures)
Sources: *AmFiTCa 193; EaAmW 34; ShipNA 83, 87, 157.*

Griffin, G.J.
Flourished: 1886 New England,; Freeport, ME
Type of Work: Oil (Cityscape paintings)
Sources: *FoPaAm fig20.*

Griffin, John
Flourished: 1840 Portland, ME
Type of Work: Wood (Ship carvings, ship figures)
Sources: *AmFiTCa 193.*

Griffin, Mark
Flourished: 1850 Gardiners Island, NY
Type of Work: Wood (Duck decoys)
Sources: *InAmD 137*.*

Griffin, Smith and Hill
Flourished: c1880 Phoenixville, PA
Type of Work: Clay (Pottery)
Sources: *AmPoP 109, 177, 262; DicM 41*, 168*.*

Griffing, Martin
Flourished: 1806 Berkshires, NY; Vermont
Type of Work: Paper (Silhouettes)
Sources: *FoArtC 174*, 178.*

Griffith, Thomas
Flourished: 19th century Pennsylvania
Type of Work: Tin (Tinware)
Sources: *ToCPS 76.*

Griffith, William
Flourished: 1793 Philadelphia, PA
Type of Work: Wood (Ship carvings, ship figures)
Sources: *ShipNA 163.*

Griffith Brothers
Flourished: c1815 Pittsburgh, PA
Type of Work: Redware (Pottery)
Sources: *AmPoP 227.*

Grim, T.
Flourished: 1866-1890 Strasburg, VA
Type of Work: Clay (Pottery)
Sources: *EaAmFo 232*.*

Grimes, John
Flourished: 1794-1797 Hartford, CT
Type of Work: Wood (Signs)
Sources: *MoBBTaS 13.*

Grimes, Leslie
d. 1968
Flourished: 1950s Los Angeles, CA; Fresno, CA; Tucson, AZ
Ethnicity: Australian
Type of Work: Wood (Western mural sculptures, carvings)
Sources: *TwCA 138-9*.*

Grimes, William
Flourished: Pennsylvania
Type of Work: Watercolor, ink (Frakturs)
Sources: *AmFoPa 188.*

Grimm, Curt
Flourished: St. Louis, MO
Type of Work: Paint (Decorated mugs)
Remarks: Worked in the Koken Company decorating department
Sources: *AmSFo 79-80.*

Grimm, Peter
b. 1832 Ohio **d.** 1914
Flourished: 1840-1867 Loudonville, OH
Type of Work: Fabric (Carpets, coverlets)
Museums: 096
Sources: *AmSQu 265*, 276; ChAmC 66.*

Grindstaff, William
Flourished: 1841?-1900? Knox County, TN
Type of Work: Stoneware (Hunting horns, churns)
Museums: 274
Sources: *AmS 135*, 186*.*

Grinniss, Charles
Flourished: Connecticut
Type of Work: Oil (Portraits)
Sources: *AmPrP 152; PrimPa 173; SoAmP 289.*

Griscom, Rachel Denn
b. 1808 Salem, NJ
Flourished: 1821 Chester County, PA
Type of Work: Fabric (Samplers)
Sources: *GalAmS 59*.*

Grist, Thomas
Flourished: 19th century Philadelphia, PA
Type of Work: Tin (Lamps)
Sources: *ToCPS 48.*

Griswold, George
b. 1633 d. 1704
Flourished: Windsor, CT
Type of Work: Stone (Gravestones)
Sources: *EaAmG 128.*

Griswold, Lucy
Flourished: 1805 Massachusetts; Connecticut
Type of Work: (Mourning pictures)
Museums: 301
Sources: *MoBeA.*

Griswold, Matthew, Sr.
d. 1698
Flourished: Lyme, CT
Type of Work: Stone (Gravestones)
Remarks: Son is Matthew, Jr.
Sources: *EaAmG 128.*

Griswold, Matthew, Jr.
b. 1653 d. 1715
Flourished: Lyme, CT
Type of Work: Stone (Gravestones)
Remarks: Father is Matthew, Sr.
Sources: *EaAmG 128; GravNE 128.*

Grocott, J.
b. Iowa
Flourished: 1843 Nauvoo, IL
Type of Work: Earthenware (Pottery)
Sources: *ArC 190.*

Groff, Joseph
Flourished: 1815-1832 Franconia, PA
Type of Work: Redware, stoneware (Pottery)
Remarks: Successor to Leidy, John
Sources: *AmPoP 44, 167.*

Grommes and Ulrich
Flourished: c1860 Chicago, IL
Type of Work: Stoneware (Pottery)
Sources: *ArC 194.*

Grosh Pottery
Flourished: 1880-1900 Bacon Hill, MD
Type of Work: Redware (Pottery)
Sources: *AmPoP 162.*

Gross, Catherine
Flourished: 1860 White Deer, PA
Type of Work: Fabric (Quilts)
Sources: *HerSa *.*

Gross, Isaac
Flourished: 1830 Pennsylvania
Type of Work: Watercolor, ink (Frakturs)
Sources: *AmFoPa 188.*

Gross, Jacob
Flourished: Pennsylvania
Type of Work: Watercolor, ink (Frakturs)
Sources: *AmFoPa 188.*

Gross, Magdalena
Flourished: 1829 Pennsylvania
Ethnicity: German
Type of Work: Fabric (Show towels)
Sources: *InAmD 10*.*

Gross, William
Flourished: 1860 Missouri; Washington
Ethnicity: German
Type of Work: Tin (Tinware)
Sources: *ASeMo 426.*

Grout, J.H.
Type of Work: Oil (Portraits)
Remarks: Itinerant
Sources: *AmPrP 152; PrimPa 173; SoAmP 291.*

Grubbs Manufacturing Company
Flourished: c1920s Pascagoula, MS
Type of Work: Wood (Duck decoys)
Sources: *AmBiDe 230.*

Grube, Emanuel
b. 1832 Pennsylvania d. 1914 Kissel Hill, PA
Flourished: c1835-1860 Warwick Township, PA
Type of Work: Fabric (Weavings)
Sources: *ChAmC 66.*

Grueby Faience Company
Flourished: 1897 Boston, MA
Type of Work: Clay (Pottery)
Sources: *DicM 54*, 211*.*

Gruenig
Flourished: 1849 Belleville, IL
Type of Work: Stoneware (Pottery)
Sources: *ArC 193.*

Grunewald, John W.
See: Greenwald, John W.

Gudgell, Henry
[Cudgell]
b. 1826 Kentucky d. 1899
Flourished: 1863 Livingston County, MO
Ethnicity: Black American
Type of Work: Wood (Carved canes)
Museums: 313
Sources: *AfAmA 60*; AmNeg 18, fig6; BlFoAr 29*.*

Gudy, Ernest
Flourished: 1927
Type of Work: Clay (Sewer tile sculpture)
Sources: *IlHaOS *.*

Guernsey, James
Flourished: Connecticut
Type of Work: Tin (Japanned tinware)
Remarks: Took over Hiram Mygatt's shop
Sources: *TinC 170.*

Guhle, Charles
Flourished: 1888 Detroit, MI
Type of Work: Wood (Cigar store Indians, figures)
Sources: *ArtWod 265, 152.*

Guiffer, D.
Flourished: Dartmouth, NH
Type of Work: Pastel (Landscape paintings)
Museums: 176
Sources: *ColAWC 191, 194*.*

Guisewite, Reverend
Flourished: Pennsylvania
Type of Work: Watercolor, ink (Frakturs)
Sources: *HerSa.*

Guiterman, Gustave
Flourished: New York, NY
Type of Work: Wood (Ship carvings, ship figures)
Sources: *ShipNA 162.*

Guldin, Mahlon
Flourished: 1850-1875 Exeter Township, PA
Type of Work: Redware (Pottery)
Sources: *AmPoP 167.*

Gullager, Christian
b. 1759 d. 1826 Philadelphia, PA
Flourished: 1786-1805 Newburyport, MA; Gloucester, MA; Boston, MA
Ethnicity: Danish
Type of Work: Oil (Portraits, landscape, decorative paintings)
Museums: 311
Sources: *AmDecor 49; PaiNE 11, 13, 112-5*.*

Gurney, P. Thompson
Flourished: 1854
Type of Work: Fabric (Quilts)
Sources: *NewDis 82-3*.*

Gurney, Thomas
Flourished: 1815
Type of Work: Watercolor (Memorial drawings, valentines)
Sources: *AmPrP 152; PrimPa 173.*

Guthrie, Elwood
Flourished: contemporary Worcester, MA
Type of Work: Wood (Sculptures, carvings)
Sources: *WoCar 202.*

Guthrie, Woody
Flourished: Oklahoma
Type of Work: Pen, ink (Drawings)
Remarks: Woody is the famous folk singer
Sources: *FoArO 62-4, 84.*

Guy, Francis
　d. 1820
Flourished:　1800 Baltimore, MD; Brooklyn, NY
Type of Work:　Oil (Landscape paintings)
Sources:　*AmFoPa 127.*

Gyory, Esther
　b. 1944
Flourished:　1975 New York, NY
Ethnicity:　Hungarian
Type of Work:　Oil, acrylic (Paintings)
Sources:　*MoBeA 111-114*.*

H

H.A. Stevens Factory
[Stevens Decoy Factory]
Flourished: 1866-1880 Weedsport, NY
Type of Work: Wood (Duck decoys)
Museums: 260
Sources: *AmBiDe 106, 215-8*; AmDecoy xi*, 24*; Decoy 34*, 60*; WaDec 48*
See: C.W. Stevens Factory.

H.L. Washburn and Company
Flourished: 1868
Type of Work: Metal (Weathervanes)
Sources: *ArtWe 13-4*, 56*.*

H. Wilson and Company
Flourished: c1875 Guadalupe, TX
Type of Work: Stoneware (Jugs)
Sources: *AmS 77*.*

Haag, Jacob
b. c1812
Flourished: 1847-1863 Emmaus, PA; Salisbury Township, PA; Stephenson County, IL
Ethnicity: German
Type of Work: Fabric (Weavings)
Sources: *ChAmC 66.*

Haag, Jonathan
Flourished: 1842
Type of Work: Fabric? (Coverlets?)
Sources: *ChAmC 66.*

Haas, Peter
Flourished: 1866-1875 Eagle Point, PA; Noxatawney Township, PA
Type of Work: Redware (Pottery)
Sources: *AmPoP 166, 173.*

Habecker, David
b. 1800 **d.** 1889
Flourished: 1846? Pekin?, NY
Type of Work: Fabric (Coverlets)
Sources: *ChAmC 66.*

Haberland, Benno
Flourished: 1860 New York, NY
Type of Work: Wood (Ship carvings, ship figures)
Sources: *AmFiTCa 193.*

Hackman, L.
Flourished: 1845
Type of Work: Fabric? (Coverlets?)
Sources: *ChAmC 66.*

Hadden, Elias W.
Flourished: 1850s
Type of Work: Wood (Cigar store Indians, figures)
Remarks: Partner of Hamilton, Charles J.
Sources: *ArtWod 22, 135-6.*

Haden Company
Flourished: 1900 New York, NY
Type of Work: Wood (Ship carvings, ship figures)
Sources: *AmFiTCa 164.*

Hadley, Sara
Flourished: 1850 Wilton, NH
Type of Work: Oil (Paintings)
Sources: *PrimPa 173.*

Hadsell, Ira
b. c1813 New York
Flourished: 1851-1866 Palmyra, NY
Type of Work: Fabric (Coverlets)
Sources: *AmSQu 276; ArtWea 251*; ChAmC 66.*

Haehnlen, Louis A.
Flourished: 1859 San Francisco, CA
Type of Work: Wood (Ship carvings, ship figures)
Sources: *ShipNA 91, 155.*

Haertel, Harold
Flourished: 1970s East Dundee, IL
Type of Work: Wood (Decorative duck decoys)
Sources: *AmBiDe 193*; AmDecoy v*; WoCar 160-3*.*

Haeseler, H.
Flourished: 1841-1843 Orwigsburg, PA
Type of Work: Fabric (Coverlets)
Sources: *ChAmC 66.*

Haff, John
Flourished: Cobb's Island, VA
Type of Work: Wood (Duck decoys)
Sources: *AmBiDe 153-4.*

Haffly, Joseph
Flourished: 1824 Belleville, PA
Type of Work: Pen, ink, watercolor (Drawings)
Sources: *HerSa.*

Hafline, Mary
Flourished: 178? Pennsylvania
Type of Work: Fabric (Samplers)
Sources: *GalAmS 26*, 90.*

Hagen, Horace Henry
Flourished: 1900 Oklahoma
Type of Work: Oil (Portraits)
Museums: 268
Sources: *FoArO 81.*

Hahnle, Egidius
Flourished: 1860 New York, NY
Type of Work: Wood (Ship carvings, ship figures)
Sources: *AmFiTCa 193.*

Haidt, John Valentine
b. 1700 **d.** 1780
Flourished: Bethlehem, PA
Ethnicity: German
Type of Work: Oil (Religious portraits, paintings)
Sources: *FoPaAm 120*, 160.*

Haig, James
Flourished: 1833-1890 Philadelphia, PA
Type of Work: Clay (Pottery)
Remarks: Worked with Haig, Thomas
Sources: *AmPoP 45-6, 175*
See: Haig, Thomas, Sr.

Haig, Thomas, Sr.
Flourished: 1812-1890 Philadelphia, PA
Type of Work: Stoneware (Pottery)
Museums: 097
Sources: *AmPoP 45-6, 175; Decor 185*; DicM 129*.*

Haig, Thomas
See: Haig, James.

Hailey, Molly (Mrs. George)
Flourished: 1890 Buffalo, TN
Type of Work: Fabric (Quilts)
Sources: *ArtWea 90*.*

Hain, Peter L.
b. 1834 d. 1882
Flourished: 1860 Heidelberg Township, PA
Type of Work: Fabric (Weavings)
Sources: ChAmC 66.

Haines, Rebecca M.
b. 1801 Evesham, NJ
Flourished: 1809 Westtown, PA
Type of Work: Fabric (Samplers)
Sources: GalAmS 47*.

Hainsdorf, Henry
Flourished: 1776 Charleston, SC
Type of Work: Wood (Ship carvings, ship figures)
Sources: ShipNA 163.

Haldeman, John M.
Flourished: 1840-1844 New Britain Township, PA
Type of Work: Fabric (Weavings)
Sources: ChAmC 66.

Halduman, Jacob
Flourished: 1800 Lancaster County, PA
Type of Work: Pen, ink, watercolor (Drawings)
Sources: NinCFo 167, 187, fig4.

Hale, Eliza Camp Miller
Flourished: 19th cent
Type of Work: Velvet (Still life paintings)
Sources: Edith *.

Haley, John C.
Flourished: 1874 Philadelphia, PA
Type of Work: Wood (Ship carvings, ship figures)
Sources: AmFiTCa 193.

Halkett, A.
Flourished: 1850
Type of Work: Pencil (Drawings)
Sources: PrimPa 173.

Hall
Flourished: 1869
Type of Work: Fabric? (Weavings?)
Sources: AmSQu 276; ChAmC 66.

Hall
See: Myers, Baird, and Hall.

Hall, A.
See: A. Hall and Sons.

Hall, Abida
See: Hall, Abija.

Hall, Abija
b. 1772 Providence, RI d. 1864 Rehoboth, RI
Flourished: 1785 Providence, RI
Type of Work: Fabric (Samplers)
Sources: LeViB 126, 138*.

Hall, Amos
Flourished: c1862-1877 Orrville, OH
Type of Work: Stoneware (Pottery)
Sources: AmPoP 226; Decor 219
See: Cochran, Robert.

Hall, Anna
See: Hall, Nancy.

Hall, Basil, Captain
b. 1788 d. 1844
Flourished: c1827 Illinois
Ethnicity: English
Type of Work: Pen, ink (Sketches)
Remarks: Traveled extensively in the East, South and Midwest
Sources: ArC 76*-8*.

Hall, Betsy
b. 1790 Norton, MA d. Brunswick?, ME?
Flourished: 1810 Providence, RI
Type of Work: Embroidery (Mourning pictures)
Museums: 222
Sources: LeViB 188*.

Hall, E.B.
Flourished: c1858 Newtown Township, OH; Tuscarawas County, OH
Type of Work: Stoneware (Elaborate jugs)
Museums: 032,096,314
Sources: AmFoS 216*; AmPoP fig54-5, 68, 73, 226; AmS 256*; AmSFok 135*; CoCoWA 52; Decor 155*.

Hall, George Henry
b. 1825 d. 1913
Type of Work: Oil (Portraits)
Museums: 001,032
Sources: AmFoPo 111*.

Hall, Hannah
Flourished: c1730-1740 Connecticut
Type of Work: Fabric (Hatchments)
Sources: WinGu 135*.

Hall, Irene
Flourished: 1970s Eufaula, OK
Type of Work: Various materials (Environmental sculptures)
Sources: FoArO 14, 93, 70-1*, 98*, 102-3.

Hall, James
b. 1793 d. 1868
Flourished: c1820-1827 Pennsylvania
Type of Work: Paint (Indian paintings)
Sources: ArC 117.

Hall, Joseph P.
Flourished: Connecticut; Lansingburgh, NY
Type of Work: Tin (Tinware)
Remarks: Employee of Filley, Augustus
Sources: AmCoTW 114; TinC 170.

Hall, Margaret L. (Mrs. George)
Flourished: c1934 Westport, CT
Type of Work: Fabric (Samplers)
Sources: AmNe 181, 179*.

Hall, Nancy (Anna)
b. 1776 Providence, RI d. 1863 Providence?, RI?
Flourished: 1788 Providence, RI
Type of Work: Fabric (Samplers)
Remarks: Sister is Abija
Sources: LeViB 126-7*, 154.

Hall, Sally
b. 1795
Type of Work: Fabric (Family register samplers)
Sources: AmNe 61.

Hall, Sylvester
b. 1774 Wallingford, CT
Flourished: 1798-1804 Wallingford, CT; New Haven, CT
Type of Work: Oil (Ornamental paintings)
Sources: AmDecor 98, 151; AmPrP 152; PrimPa 178.

Hallack, Jane E.
Flourished: 1840
Type of Work: Fabric (Coverlets)
Sources: AmSQu 273*.

Hallam, David
Flourished: 1870-1872 Red Wing, MN
Type of Work: Stoneware (Pottery)
Sources: AmPoP 228; Decor 220.

Hallberg, Charles
Flourished: 1921
Type of Work: Metal (Weathervanes)
Remarks: Worked for C.G. Brunncknow and Company
Sources: WeaVan 13.

Halliday, Thomas
Flourished: 1834 New York, NY
Type of Work: Wood (Ship carvings, ship figures)
Sources: AmFiTCa 193.

Hallowell, William, Dr.
Flourished: 1865 Norristown, PA; New Jersey
Type of Work: Pen, ink (Drawings)
Museums: 203
Sources: AmFoPaN 176, 189*; PrimPa 173.

Halsall, William Formsby
Flourished: mid 19th cent Boston, MA
Type of Work: Oil (Ship paintings)
Sources: AmFoPa 112.

Halstead, Israel T.
Flourished: 1843-1846 New Bedford, VA
Type of Work: Pencil (Landscape and mythical drawings)
Museums: 123
Sources: WhaPa 131*, 134*.

Haman, Barbara Becker
b. 1774
Flourished: c1806 Shenandoah County, VA
Ethnicity: German
Type of Work: Watercolor, ink (Frakturs)
Sources: *FoA 84*, 464.*

Hamas, Elias
Flourished: 1848 Cleveland, OH
Type of Work: Fabric (Weavings)
Sources: *ChAmC 66.*

Hamblen, Sturtevant J.
Flourished: 1837-1856 Portland, ME; Boston, MA
Type of Work: Oil (Portraits)
Museums: 001,059,171,189
Remarks: Brother-in-law of Prior, William Matthew; member of the Prior-Hamblen School
Sources: *AmFoArt 18*; AmFoPo 27*, 112-7*; AmNa 15, 60*; BoLiC 72-3; FoPaAm 40, 42, 46, 57, 115*;NinCFo 167, 175, fig95-6, 101, 107-112.*

Hamblett, Theora
b. 1895 Paris, MS d. 1977
Flourished: Oxford, MS
Type of Work: Oil (Genre, religious paintings)
Museums: 020,179
Sources: *ArtWo 135*, 137, 161, 162*; FoA 464; FoAFef 3*, 12*; LoCo xviii-xxvii, 69*-100*.*

Hamblin, L.J.
Flourished: 1840 Boston, MA
Type of Work: Oil (Portraits)
Sources: *AmPrP 152; PrimPa 173.*

Hamelton, John
Flourished: 1836-1856 Machenoy, PA; Jackson Township, PA; Lanark?, IL?
Type of Work: Fabric (Coverlets)
Remarks: May be the same as Hamilton, John
Sources: *ChAmC 66; HerSa *.*

Hamilton
See: Richey and Hamilton.

Hamilton, Amos
Flourished: 1830 Massachusetts
Type of Work: Oil (Portraits)
Sources: *AmPrP 152; PrimPa 173.*

Hamilton, Charles J.
b. 1832 Philadelphia, PA
Flourished: 1845 Charleston, SC; Philadelphia, PA; Washington, DC
Type of Work: Oil, watercolor, wood (Cityscape paintings, portraits, cigarstore figures)
Museums: 001
Remarks: Partner with Hadden, Elias W.
Sources: *ArtWod 22-3, 80, 82, 135-7, 268; FoPaAm 166*.*

Hamilton, Clem
Flourished: c1870 Tuscarawas County, OH
Type of Work: Stoneware (Pottery)
Sources: *AmPoP 235; Decor 220.*

Hamilton, Elizabeth Robeson
Flourished: early 19th cent
Type of Work: Fabric (Mourning pictures)
Museums: 204
Sources: *MoBeA fig62.*

Hamilton, James
b. 1832
Flourished: 1860-1870 Washington, DC; Philadelphia, PA
Type of Work: Wood (Cigar store Indians, figures)
Museums: 001
Sources: *FoA 155*, 464.*

Hamilton, James
[James Hamilton and Company]
Flourished: 1844-1890 Greensboro, PA; Philadelphia, PA
Type of Work: Stoneware (Pottery)
Sources: *AmPoP 68, 221; AmS 174*; Decor 220; DicM 38*, 70*; EaAmFo 217**
See: Eagle Pottery.

Hamilton, John
Flourished: 1850 Lanark, IL; Northumberland County?, PA
Type of Work: Fabric (Weavings)
Sources: *AmSQu 276; ChAmC 66.*

Hamilton, Mary
b. 1794 Antrim County,
Flourished: 1812
Type of Work: Fabric (Samplers)
Sources: *AmNe 63.*

Hamilton, Rebexy Gray
Flourished: c1850 Waynesbury, PA
Type of Work: Fabric (Quilts)
Museums: 016
Sources: *QuiAm 111*.*

Hamilton, Sophie
Flourished: 1820 New York
Type of Work: Watercolor (Landscape paintings)
Museums: 176
Sources: *ColAWC 161, 165*; PrimPa 173.*

Hamilton, W.L.
Flourished: c1837 Bridgewater, PA
Type of Work: Stoneware (Pottery)
Sources: *AmPoP 208; Decor 220.*

Hamilton and Jones Pottery
Flourished: c1870 Greensboro, PA
Type of Work: Stoneware (Pottery)
Museums: 097
Sources: *AmPoP 221; AmSFo 46-7*; Decor 220; DicM 59*; EaAmFo 256*.*

Hamilton Brothers
Flourished: c1840 West Bridgewater, PA
Type of Work: Stoneware (Pottery)
Sources: *AmPoP 233; Decor 220.*

Hamlin, Isaac
b. 1742 d. 1810
Flourished: Barnstable, MA
Type of Work: Stone (Gravestones)
Sources: *GravNE 178.*

Hamlin, John
b. 1658 d. 1733
Flourished: Middletown, CT
Type of Work: Stone (Gravestones)
Sources: *EaAmG 128; GravNE 128.*

Hamlin, Samuel E.
b. 1771 d. 1841
Flourished: c1809 Providence, RI
Type of Work: Metal (Weathervanes, brassware)
Sources: *AmCoB 14*; YankWe 78*, 212.*

Hamlyn, George
Flourished: c1835-1870 Bridgeton, NJ
Type of Work: Stoneware (Pottery)
Sources: *AmPoP 165; Decor 220; DicM 38**
See: Hamlyn II, George.

Hamlyn, George, II
Flourished: c1870-1900 Bridgeton, NJ
Type of Work: Stoneware (Pottery)
Sources: *AmPoP 165; Decor 220*
See: Hamlyn, George.

Hamm, Lillian
Flourished: 1850
Type of Work: Pen, ink, watercolor (Calligraphy paintings)
Museums: 171
Sources: *AmFoArt 40*.*

Hamman, Elias
See: Hammen, Elias.

Hammatt, Fanny Rand
b. c1801
Flourished: 1809 Boston, MA
Type of Work: Fabric (Samplers)
Sources: *GalAmS 46*, 91.*

Hammell, Guarner
b. 1840 d. 1939
Flourished: Pleasantville, NJ
Type of Work: Wood (Duck decoys)
Sources: *AmBiDe 134.*

Hammen, Elias
[Hamman]
Flourished: 1806 Virginia
Type of Work: Watercolor, ink (Frakturs)
Sources: *AmFoPa 188.*

Hammersley
See: Bott, Hammersley and Company.

Hammond, Denton
d. 1850
Flourished: Johnsville, MD
Type of Work: Fabric (Weavings)
Sources: *ChAmC 66*
See: Hammond, John.

Hammond, H.W.
Flourished: 19th cent
Type of Work: Papermache (Animals)
Sources: *Edith **.

Hammond, John
b. 1823 d. 1871 Johnsville, MD
Flourished: 1857 Johnsville, MD
Type of Work: Fabric (Weavings)
Sources: *ChAmC 66*
See: Hammond, Denton.

Hampshire Pottery Company
See: J.S. Taft and Co..

Hampton, James
See: Hampton, John.

Hampton, John (James)
b. 1909 Elloree, SC d. 1964 Washington, DC
Flourished: 1950-1964 Washington, DC
Ethnicity: Black American
Type of Work: Various materials (Sculptures)
Museums: 190,263
Remarks: Created Throne of the Third Heaven of the Nation's Millennium General Assembly
Sources: *AmFokA 22*; AmFoS 201*; BlFoAr 92-5*; ConAmF 127-32*; FoAFz 7*, 15*; NaiVis 9*-12; TwCA 108-9*; TYeAmS 100*-1*, 109, 277-8*.

Hance, Ben
b. 1857 d. 1928
Flourished: Bay Head, NJ
Type of Work: Wood (Duck decoys)
Sources: *AmBiDe 113-4*.

Hancock
See: Norton and Hancock.

Hancock, Frederick
See: Norton and Hancock.

Hancock, Herbert
Flourished: Martha's Vineyard, MA
Type of Work: Wood (Duck decoys)
Sources: *AmBiDe 73*.

Hancock, John
Flourished: c1829-1840 South Amboy, NJ
Type of Work: Stoneware, yellow-ware (Pottery)
Sources: *AmPoP 180*.

Hancock, John
[Congress Pottery]
Flourished: 1828-1854 South Amboy, NJ
Type of Work: Stoneware (Pottery)
Sources: *Decor 220*
See: Hancock, William.

Hancock, Miles
Flourished: Chincoteague, VA
Type of Work: Wood (Duck decoys)
Sources: *AmBiDe 159-60*.

Hancock, Nathaniel
Flourished: 1790-1808 Boston, MA; Salem, MA
Type of Work: Oil (Portraits)
Sources: *AmPrP 152; PrimPa 173*.

Hancock, Russell
Flourished: Martha's Vineyard, MA
Type of Work: Wood (Duck decoys)
Sources: *AmBiDe 73*.

Hancock, William
[Congress Pottery]
Flourished: 1828-1854 South Amboy, NJ
Type of Work: Stoneware (Pottery)
Sources: *Decor 220, 218*
See: Hancock, John; Cadmus, Abraham; Price, G.

Hanelsack, Daniel
Flourished: 1874-1880 Zanesville, OH
Type of Work: Clay (Pottery)
Sources: *AmPoP 234*.

Haney, Clyde
b. 1910
Flourished: Bowling Green, KY
Type of Work: Oil (Paintings)
Sources: *Full **.

Hanford, Isaac
Flourished: c1795-1805 Hartford, CT
Type of Work: Stoneware (Pottery)
Sources: *AmPoP 193; Decor 220*.

Hankes, Master
b. c1828
Flourished: New England,
Type of Work: Paper (Silhouettes)
Sources: *FoArtC 178-9*.

Hankins, Ezra
Flourished: until 1925 Pleasant Point, NJ
Type of Work: Wood (Duck decoys)
Sources: *AmBiDe 114-5*.

Hanlen, Bernard
Flourished: c1775-1780 Trenton, NJ
Type of Work: Stoneware (Pottery)
Sources: *Decor 220*.

Hann, W.F.
Flourished: 1880-1900 Trenton, SC
Type of Work: Stoneware (Jugs)
Sources: *AmS 222**.

Hansbury, John
Flourished: 1846 Philadelphia, PA
Type of Work: Wood (Ship carvings, ship figures)
Sources: *AmFiTCa 193*.

Hansee, Willard S.
Flourished: c1850
Type of Work: Pen, ink (Drawings)
Sources: *Edith **.

Hansenclever, Peter
Flourished: Cortland, NY
Type of Work: Iron (Iron forges)
Sources: *EaAmI 22*.

Hanson
Type of Work: Oil (Portraits)
Remarks: Itinerant
Sources: *SoAmP 160*.

Harbeson, Benjamin
Flourished: 1794
Type of Work: Brass (Tea kettles)
Sources: *AmCoB 64, 72, 234*, 235*.

Harbeson, Georgiana Brown
Flourished: 1924-1937 New York, NY
Type of Work: Fabric (Embroidered pictures)
Remarks: Artist and author of needlework books
Sources: *AmNe 165*, 172*, 174*, 177, 183*-5, 187*, 195*-6, 210*-11*, 216**.

Harch, J.
Flourished: Hanover?, PA?
Type of Work: Fabric (Weavings)
Sources: *AmSQu 276; ChAmC 66*
See: Kump, Andrew.

Hardcastle, Henry
Flourished: 1759 New York, NY
Type of Work: Wood (Ship carvings, ship figures)
Sources: *ShipNA 161*.

Hardee, Rodney
b. 1954 Lakeland, FL
Flourished: c1975
Type of Work: Acrylic (Paintings)
Sources: *FoAFg 14-5**.

Hardin, Esther McGrew
Flourished: 1975 San Antonio, TX
Type of Work: Fabric (Appliqued pictures)
Sources: *BirB 57**.

Harding, Chester
b. 1792 Conway, MA d. 1866
Flourished: Northampton, MA; Pittsburgh, PA; St. Louis, MO
Type of Work: Oil (Portraits)
Sources: *AmFokDe 129; AmFoPa 87; EdwH 51; EraSaF 9-10; FoArtC 111; PicFoA 10, 67*; SoAmP 247**.

Harding, Jane
Flourished: 1811 Nashville, TN
Type of Work: Fabric (Samplers)
Sources: *SoFoA 169*, 222*.

Harding, Jeremiah L.
Flourished: 1840 Massachusetts
Type of Work: Oil (Portraits)
Sources: *AmPrP 152; PrimPa 173; SoAmP 86**.

Harding, John T.
Flourished: 1840 New York, NY
Type of Work: Wood (Ship carvings, ship figures)
Sources: *AmFiTCa 193.*

Harding, Richard H.
Flourished: 1834 New York, NY
Type of Work: Wood (Ship carvings, ship figures)
Sources: *AmFiTCa 193.*

Harding, Samuel
Flourished: 1754-1758 Philadelphia, PA
Type of Work: Wood (Ship carvings, ship figures)
Sources: *ShipNA 163.*

Hardman, Mrs. Edwin
Flourished: c1860
Type of Work: Fabric (Quilts)
Sources: *QuiAm 315*.*

Hardy, Jeremiah P.
Flourished: 1840 Maine
Type of Work: Oil (Portraits)
Sources: *PrimPa 174.*

Hare Pottery
Flourished: 1800 New Castle, DE
Type of Work: Clay (Pottery)
Sources: *EaAmFo 136*.*

Haring, David
[Harring]
Flourished: 1826-1866 Nockamixon, PA
Type of Work: Clay (Pottery)
Sources: *AmPoP 173; EaAmFo 244*; FoArRP 34*.*

Haring, David D.
d. 1889
Flourished: 18O0?-1842? Norwood, NJ
Type of Work: Fabric (Coverlets)
Museums: 016,024
Sources: *ArtWea 242*; ChAmC 53*, 55*, 66-7, 71*, 91*, 95*, 97*, vi*.*

Haring, James A.
Flourished: 1825 Norwood, NJ
Type of Work: Fabric (Weavings)
Sources: *ChAmC 67.*

Haring Pottery
See: Haring, David.

Harker, Benjamin
Flourished: 1840-1844 East Liverpool, OH
Type of Work: Clay (Pottery)
Sources: *AmPoP 75, 214.*

Harker Pottery Comapny
Flourished: 1890 East Liverpool, OH
Type of Work: Clay (Pottery)
Sources: *AmPoP 214; DicM 159*-160*, 169*.*

Harker, Taylor and Company
[George Harker; James Taylor]
Flourished: 1847-1851 East Liverpool, OH
Type of Work: Clay (Pottery)
Sources: *AmPoP 63, 214, 263*.*

Harkins, Mrs. A.
Flourished: 1920s Oklahoma
Type of Work: Clay (Pottery)
Museums: 268
Sources: *FoArO 14, 92.*

Harley
Flourished: South Carolina
Ethnicity: Black American
Type of Work: Watercolor (Paintings)
Sources: *AfAmA 96.*

Harley, G. and F.
See: G. and F. Harley.

Harley, Mrs. George
See: Hailey, Molly.

Harley, Steve
[S.W. Harley, The Invincible]
b. 1863 Michigan d. 1947
Flourished: Scottsville, MI
Type of Work: Oil (Landscape paintings)
Museums: 001
Remarks: Also worked on the west coast
Sources: *AmFoPaCe 186-8*; FoPaAm 213-4*; Rain 11, 40*-2*; TwCA 72*.*

Harley Pottery
Flourished: 1875-1900 Nashville, TN
Type of Work: Stoneware, brownware (Pottery)
Sources: *AmPoP 240.*

Harlme, David D.
See: Harlmz, David D.

Harlmz, David D.
[Harlme]
Flourished: 1833
Type of Work: Fabric (Coverlets)
Sources: *AmSQu 247*, 276.*

Harmon, Christian
Flourished: c1825-1840 Salem, OH
Type of Work: Stoneware (Pottery)
Sources: *AmPoP 230; Decor 220.*

Harmon, P.
Flourished: 1855-1890 Green County, TN
Type of Work: Stoneware (Bowls)
Sources: *AmS 96*.*

Harned, Henry
Flourished: 1851 Philadelphia, PA
Type of Work: Wood (Ship carvings, ship figures)
Sources: *AmFiTCa 193.*

Harnell
See: Smyth and Harnell.

Harness, Martha
Flourished: 1817 Moorefield, VA
Type of Work: Fabric (Wedding veils)
Sources: *AmNe 91.*

Harold
See: Cromwell and Harold.

Harold and Randolph
Flourished: 1835 Baltimore, MD; Fells Point, MD
Type of Work: Wood (Ship carvings, ship figures)
Sources: *AmFiTCa 120-1, 193; ShipNA 158*
See: Randolph, James T.

Harper, Cassandra Stone
b. 1844
Flourished: Wilkes County, GA
Type of Work: Hair (Wreaths)
Sources: *MisPi 56*.*

Harper, William
Flourished: 1839-1850 Bridgeport, WV
Type of Work: Fabric (Coverlets)
Sources: *AmSQu 276; ChAmC 67.*

Harring, David
See: Haring, David.

Harrington
Flourished: 1852-1854 Rochester, NY
Type of Work: Stoneware (Bowls)
Sources: *AmS 99*.*

Harrington, Addie A.
Flourished: 1863
Type of Work: Oil (Paintings)
Sources: *AmFoPa 165*.*

Harrington, Ellen T.
Flourished: c1840 Charlestown, MA
Type of Work: Oil, watercolor, pencil, pastel (Portraits, paintings)
Sources: *FoA 72*; PrimPa 174.*

Harrington, Lyman
Flourished: c1835 West Hartwick, NY
Type of Work: Tin (Tinware)
Sources: *AmCoTW 63.*

Harrington, Thomas
Flourished: 1840-1872 Lyons, NY; Hartford, CT
Type of Work: Stoneware (Pottery)
Museums: 203
Sources: *AmPoP 193; Decor 102*, 111*, 220.*

Harrington, Thompson
Flourished: mid 19th cent Lyons, NY
Type of Work: Clay (Pottery)
Sources: *EaAmFo 103*.*

Harris, A.J.
See: A.J. Harris and Company.

Harris, Al
Flourished: c1890-1920 Nantucket, MA
Type of Work: Wood (Duck decoys)
Sources: *AmFoS 305*; Decoy 110*.*

Harris, Albert
Flourished: 1760s Mystic, CT
Type of Work: Whalebone (Scrimshaw)
Museums: 186
Sources: *GravF 87-8*.*

Harris, Daniel, Captain
Flourished: 1840-1860's
Type of Work: Wood (Ship carvings, figures)
Sources: *AmFiTCa 152.*

Harris, Elihu
Flourished: 19th century
Type of Work: Pen, ink (Penmanship, calligraphy drawings)
Museums: 142
Sources: *PicFoA 116*; PrimPa 174.*

Harris, George
Flourished: 1766 Charleston, SC
Type of Work: Wood (Ship carvings, ship figures)
Sources: *ShipNA 163.*

Harris, Harriet A.
Flourished: 1880
Type of Work: Oil (Paintings)
Sources: *AmPrP 152; PrimPa 174.*

Harris, James
Flourished: c1840 Martin's Ferry, OH
Type of Work: Stoneware (Pottery)
Sources: *AmPoP 223; Decor 224*
See: Stevens, Joseph P.; Danas, John.

Harris, Ken
Flourished: Woodville, NY
Type of Work: Wood (Duck decoys)
Sources: *FouNY 64.*

Harris, Thomas
Flourished: 1863-1900 Cuyahoga Falls, OH
Type of Work: Stoneware (Pottery)
Sources: *AmPoP 212, 263; Decor 220; DicM 131*.*

Harris, W.P.
Flourished: c1828-1856 Newtown Township, OH
Type of Work: Stoneware (Pottery)
Sources: *AmPoP 226; Decor 220; DicM 39*; EaAmFo 259**
See: Hall, E.B.

Harris and Company
Flourished: 1868-1882 Boston, MA; Brattleboro, VT
Type of Work: Copper (Weathervanes)
Remarks: Son's firm is A.J. Harris and Company
Sources: *ArtWe 17-9*, 22*, 34*, 39*, 48*, 51*, 53*, 82-3*, 125*, 134-5*, 138*, 151-9*; FoA 172*, 464;InAmD 79*; WeaVan 23, 47; YankWe 46*-7, 138, 142-3, 145, 149, 158, 165-6*, 173, 204, 212.*

Harrisman, Mehitable
Flourished: 18th century Hill, NH
Type of Work: Fabric (Coverlets)
Sources: *InAmD 108*.*

Harrison, Benjamin J.
Flourished: c1845
Type of Work: Watercolor (Scene paintings)
Sources: *QuiAm 28*.*

Harrison, C.R.
Flourished: c1858 Upper Alton, IL
Type of Work: Stoneware (Pottery)
Sources: *ArC 194.*

Harrison, Fielding T.
Flourished: 1850 Upper Alton, IL
Type of Work: Stoneware (Pottery)
Sources: *ArC 193.*

Harrison, Henry
Flourished: 1855 Baltimore, MD
Type of Work: Wood (Ship carvings, ship figures)
Sources: *AmFiTCa 193.*

Harrison, John
Flourished: mid 19th cent Bennington, VT
Ethnicity: English
Type of Work: Clay (Parian sculptures)
Sources: *AlAmD 67*; AmPoP 110.*

Harrison, Mary
Flourished: 1830 Alexandria, VA
Type of Work: Fabric (Samplers)
Museums: 263
Sources: *SoFoA 175*, 222.*

Harrison, Robert
Flourished: c1820-1834 Cahokia, IL; Upper Alton, IL; Winchester, IL
Type of Work: Redware (Pottery)
Sources: *ArC 189.*

Harrold, John "Spotter Jack"
b. Winchester, MA d. 1980
Flourished: 1950-1968 El Reno, OK
Type of Work: Oil (Paintings)
Sources: *FoArO 27-8, 81*, 103.*

Harrop, James A., Jr.
Flourished: contemporary Bedford, MA
Type of Work: Wood (Sculptures, carvings)
Sources: *WoCar 204*.*

Hart
Flourished: 1851
Type of Work: Fabric (Weavings)
Sources: *AmSQu 276.*

Hart
See: W. Hart Pottery.

Hart, Anna S.
Flourished: c1870 Battle Creek, MI
Type of Work: Oil (Paintings)
Museums: 001
Sources: *ArtWo 103, 106*, 141, 162.*

Hart, E.J.
Flourished: c1865 Clark County, KY
Type of Work: Fabric (Coverlets)
Sources: *KenQu fig7.*

Hart, J.
Flourished: 1845-1851 Wilmington, OH
Type of Work: Fabric (Coverlets)
Museums: 016
Sources: *ArtWea 241*; ChAmC 67.*

Hart, James
Flourished: 1832-1858 Oswego Falls, NY; Oswego, NY; Shelburne, NY
Type of Work: Stoneware (Pottery)
Remarks: Worked with Hart, Samuel
Sources: *Decor 220; EaAmFo 238*.*

Hart, Samuel
See: Hart, James.

Hart Pottery
See: S. Hart Pottery.

Harting, Peter
[Hartung]
b. 1799 d. 1864 West Cocalico Township, PA
Flourished: 1832-1834 Vera Cruz, PA
Type of Work: Fabric (Coverlets)
Sources: *ChAmC 67.*

Hartley, Florence
Flourished: c1859
Type of Work: Fabric (Needlework)
Remarks: Author of "The Ladies' Hand-Book of Fancy Ornamental Work"
Sources: *WinGu 63.*

Hartman, Christian B.
Flourished: 1846 Pennsylvania
Type of Work: Watercolor, ink (Frakturs)
Sources: *AmFoPa 188.*

Hartman, John
b. c1805
Flourished: 1837-1857 La Fayette, OH; Wooster, OH; Milton Township, OH
Ethnicity: German
Type of Work: Fabric (Weavings)
Remarks: Brother is Peter
Sources: *AmSQu 276; ChAmC 67.*

Hartman, Peter
Flourished: 1837-1845 Wooster, OH; La Fayette, OH
Ethnicity: German
Type of Work: Fabric (Weavings)
Remarks: Brother is John
Sources: *AmSQu 276; ChAmC 67.*

Hartman, Sarah Ann
b. c1807
Flourished: 1823 Mount Holly, NJ
Type of Work: Fabric (Samplers)
Sources: *GalAmS 60-1*.*

Hartmann, Charles G.
Flourished: Shelbyville, IL; Effingham, IL
Type of Work: Fabric (Coverlets)
Sources: *ChAmC 68.*

Hartshorn, John
Flourished: c1720 Norwich, CT
Type of Work: Stone (Gravestones)
Sources: *EaAmG 128.*

Hartshorn, John
b. 1650 d. 1734
Flourished: 1717-1730 Haverhill, MA; Rowley, MA; Connecticut
Type of Work: Stone (Gravestones)
Sources: *EaAmG 128, viii, 16*.*

Hartshorn, Jonathan
Flourished: c1775 Newbury, MA
Type of Work: Stone (Gravestones)
Sources: *EaAmG 128.*

Hartshorn, Samuel
b. 1725 d. 1784
Flourished: Franklin, CT
Type of Work: Stone (Gravestones)
Sources: *EaAmG 128; GravNE 128.*

Hartshorn, Stephen
b. 1737
Flourished: Providence, RI
Type of Work: Stone (Gravestones)
Sources: *EaAmG 129.*

Hartsoe, Sylvanus
Flourished: 1850-1900 Lincoln, NC
Type of Work: Stoneware (Jugs)
Sources: *AmS 206*.*

Hartung
See: Kessel and Hartung.

Hartung, Peter
See: Harting, Peter.

Hartwell, Alonzo
Flourished: 1835 Massachusetts
Type of Work: Oil (Portraits)
Sources: *AmPrP 152; PrimPa 174.*

Hartwell, George G.
b. 1815 d. 1901
Flourished: Auburn, MA; Bridgewater, MA
Type of Work: Oil (Portraits)
Museums: 088
Remarks: Member of the Prior-Hamblen School
Sources: *AmFoPa 47, 76, 80-1*; PrimPa 174.*

Hartz, Daniel
Flourished: 1836
Type of Work: Fabric? (Coverlets?)
Sources: *ChAmC 68.*

Hartzel, John, Jr.
Flourished: 1815 Pennsylvania
Type of Work: Watercolor, ink (Frakturs)
Sources: *AmFoPa 188.*

Harvey, Bill
Flourished: Oklahoma
Type of Work: Metal (Weathervanes)
Sources: *FoArO 76*, 100*.*

Harvey, George
b. 1874 d. 1962
Flourished: 1885 Rumson, NJ
Type of Work: Wood (Duck decoys)
Museums: 260
Sources: *Decoy 43*, 78*, 80*, 90*, 112*.*

Harvey, Isaac A.
Flourished: 1859-1869 Beaver Falls, PA; East Liverpool, OH
Type of Work: Rockingham, brownware (Pottery)
Sources: *AmPoP 208*
See: Knowles, Isaac W.

Harvey, M.T.
Type of Work: Chalk (Paintings)
Museums: 176
Sources: *ColAWC 191*, 195*.*

Harvey, Sarah E.
b. 1835 d. 1924
Flourished: New York
Type of Work: Oil (Paintings)
Sources: *AmFoPa 146.*

Harvey, Thomas
Flourished: 1842 Salem, MA
Type of Work: Wood (Ship carvings, ship figures)
Sources: *AmFiTCa 193.*

Hasenritter, C(arl) W(illiam)
d. 1878
Flourished: Hermann, MO
Ethnicity: Prussian
Type of Work: Wood (Furniture)
Remarks: Son is Robert Hermann
Sources: *ASeMo 389.*

Hasenritter, Robert Hermann
d. 1892
Flourished: 1860-1880 Hermann, MO
Type of Work: Wood (Glass cupboards)
Remarks: Father is Carl William
Sources: *ASeMo 342*.*

Hassler, Sven
Flourished: c1860 Marine, MN
Type of Work: Wood (Pipes)
Sources: *EaAmW 106.*

Hasslock, Charles
Flourished: 1860 New York, NY
Type of Work: Wood (Ship carvings, ship figures)
Sources: *AmFiTCa 193.*

Hasson, Sallie E.
Flourished: c1870 Rogersville, TN
Type of Work: Fabric (Quilts)
Sources: *SoFoA 186*, 222.*

Hastings
See: Chapman and Hastings.

Hastings, Daniel
b. 1749 Newton, MA
Flourished: 1770- Newton, MA; Boston, MA
Type of Work: Stone (Gravestones)
Sources: *AmFokAr 20, fig171; EaAmG 128; GravNE 56, 67-8, 128.*

Hastings, E.W(arren) (Warren E.)
d. 1896
Flourished: 1865-1878 Salem, MA
Type of Work: Wood (Ship carvings, ship figures)
Museums: 221
Sources: *AmFiTCa figiv, xxiii, 41, 136*-7, 149, 193; ShipNA 50, 67, 77-8, 159*
See: Hastings and Gleason.

Hastings and Belding
Flourished: 1850-1856 South Ashfield, MA
Type of Work: Stoneware (Pottery)
Sources: *AmPoP 60, 187, 263; Decor 220; DicM 11*, 60*; EaAmFo 196*.*

Hastings and Gleason
[Gleason and Hastings]
Flourished: 1850's Boston, MA
Type of Work: Wood (Ship carvings, figures)
Museums: 038
Sources: *AmFiTCa figiv, xxiii, 136*, 149, 193; ShipNA 67, 77-8*
See: Gleason, Herbert; Hastings, E.W.

Hatch, Edbury
b. 1849 Damariscotta, ME d. 1935
Flourished: c1877 Newcastle, ME; Portland, ME; Bath, ME
Type of Work: Wood (Ship carvings, ship figures)
Museums: 186,194
Sources: *AmFiTCa figv, 31, 140, 193; AmFokAr 18, fig131; EaAmW 22-3, 81-3*, 112; FigSh;FoA 464;ShipNA 83-6*, 156.*

Hatch, Elisha
Flourished: 1840 Canaan, NY
Type of Work: Watercolor (Portraits)
Sources: *AmPrP 152; PrimPa 174.*

Hatch, Sara
Flourished: 1828
Type of Work: Fabric (Mourning pictures)
Museums: 224
Sources: *AmFokArt.*

Hatfield, Joseph
Flourished: 1830 New York, NY
Type of Work: Wood (Ship carvings, ship figures)
Sources: *AmFiTCa 193.*

Hathaway, C.H.
Flourished: 1870 Connecticut
Type of Work: Oil (Paintings)
Sources: *PrimPa 174.*

Hathaway, Charles E.
Flourished: 1882-1900 Somerset, MA
Type of Work: Stoneware (Pottery)
Sources: *Decor 220.*

Hathaway, Rufus, Dr.
[Hatheway]
b. 1770 Freetown, MA d. 1822 Duxbury, MA
Flourished: 1790-1795 Duxbury, MA; Taunton, MA
Type of Work: Oil (Portraits, landscape paintings)
Museums: 001,151,195,211
Sources: *AmDecor 37-8*, 151; AmFoPaCe 35-40*; AmFoPo 23*; AmFoPaS 27*; 117-22*; AmPrP 152; FoA 28*, 464; FoPaAm 28-9*, 16*; OneAmPr 53*, 80, 141, 154; PaiNE 11, 14*, 116-123*; PrimPa 174.*

Hatheway, Rufus
See: Hathaway, Rufus.

Hattersley, Charles
Flourished: 1853-1856 Trenton, NJ
Type of Work: Redware, brownware (Pottery)
Remarks: Built the City Pottery
Sources: *AmPoP 46, 113, 181.*

Haukins, W.W.
Flourished: 1860 Ripley, IL
Type of Work: Clay (Pottery)
Sources: *ArC 194.*

Hausel, Martin
Flourished: 1860 New York, NY
Type of Work: Wood (Ship carvings, ship figures)
Sources: *AmFiTCa 193.*

Hausel, William
Flourished: 1860 New York, NY
Type of Work: Wood (Ship carvings, ship figures)
Sources: *AmFiTCa 193.*

Hauser, Joseph
Flourished: 1851 Philadelphia, PA
Type of Work: Wood (Ship carvings, ship figures)
Sources: *AmFiTCa 193.*

Hausgen, Frederick
Flourished: 1860-1870 Missouri; Washington
Type of Work: Wood (Bookcases)
Sources: *ASeMo 361*.*

Hausman, Allen B.
Flourished: 1839 Groveland, NY
Type of Work: Fabric (Weavings)
Sources: *AmSQu 276; ChAmC 68.*

Hausman, B(enjamin)
b. c1799 Pennsylvania
Flourished: 1838-1848 Allentown, PA; York County, PA
Type of Work: Fabric (Coverlets)
Sources: *AmSQu 258*, 276; ChAmC 68.*

Hausman, Ephrain
b. c1813 Pennsylvania d. 1901 Trexlertown, PA
Flourished: 1850-1872 Trexlertown, PA
Type of Work: Fabric (Weavings)
Sources: *AmSQu 276; ChAmC 68.*

Hausman, G.
Flourished: 1836 Trexlertown, PA
Type of Work: Fabric (Weavings)
Sources: *ChAmC 68.*

Hausman, Jacob, Sr.
b. 1788 Pennsylvania d. 1863 Lobachsville, PA
Flourished: 1834-1857 Lobachsville, PA; Trexlertown, PA
Type of Work: Fabric (Weavings)
Remarks: Son is Jacob, Jr.
Sources: *ChAmC 68.*

Hausman, Jacob, Jr.
b. 1808 Pennsylvania
Flourished: 1842-1859 Lobachsville, PA; Friedensburg, PA; Rockland, PA
Type of Work: Fabric (Weavings)
Remarks: Father is Jacob, Sr.; son is Tilgham
Sources: *AmSQu 276; ChAmC 68.*

Hausman, Joel
b. c1826 Pennsylvania
Flourished: Upper Macungie Township, PA
Type of Work: Fabric (Coverlets)
Sources: *ChAmC 68*
See: Hausman, Solomon.

Hausman, Solomon
b. c1794 Pennsylvania d. 1866
Flourished: 1836-1848 Trexlertown, PA
Type of Work: Fabric (Weavings)
Sources: *AmSQu 276; ChAmC 68*
See: Hausman, Joel.

Hausman, Tilgham (Tilghman)
b. 1832 Pennsylvania d. 1917 Lobachsville, PA
Flourished: 1868 Lobachsville, PA; Oley Township, PA
Type of Work: Fabric (Weavings)
Remarks: Father is Jacob Jr.
Sources: *AmSQu 276; ChAmC 68.*

Havens, George
Flourished: Long Island, NY
Type of Work: Wood (Duck decoys)
Sources: *ArtDe 165.*

Havens, Samuel
Flourished: c1836-1846 Putnam, OH
Type of Work: Stoneware (Pottery)
Sources: *AmPoP 228; Decor 220.*

Haviland, Matilda A.
Type of Work: Velvet (Paintings)
Sources: *AmPrP 152; PrimPa 174.*

Haviland Company
Flourished: 1930s New York, NY
Type of Work: Clay (Pottery)
Sources: *DicM 130*.*

Havins, N.
Flourished: 1775 New York
Type of Work: Stoneware (Pottery)
Remarks: May be maker or client
Sources: *Decor 98*.*

Hawes, Sarah E.
Flourished: 1810 Massachusetts
Type of Work: Watercolor (Memorial paintings)
Sources: *AmPrP 152; PrimPa 174.*

Hawkes, Elizabeth Jane
b. c1852
Flourished: c1865 Salem, NC
Type of Work: Fabric (Samplers)
Sources: *GalAmS 86*.*

Hawkes, Mary Lou
b. c1853
Flourished: c1865 Salem, NC
Type of Work: Fabric (Samplers)
Sources: *GalAmS 87*; SoFoA xiv*, 177*, 222.*

Hawkins, Ben
Flourished: 1800 Bellport, NY
Type of Work: Wood (Duck decoys)
Museums: 260
Sources: *AmSFok 24*; ArtDe 154; Decoy 109*; WiFoD 37*.*

Hawkins, D.W.
Flourished: 1859-1860 Geneva, IL
Sources: *ArC 265.*

Hawks, George W.
Flourished: 1856 Chicago, IL
Type of Work: Wood (Ship carvings, ship figures)
Sources: *AmFiTCa 193.*

Hawks, John
Flourished: 17th century Hatfield, CT; Deerfield, CT
Type of Work: Wood (Hope chests)
Sources: *AmPaF 19.*

Hawks, Mary
Type of Work: Fabric (Rugs)
Sources: *AmNe 96.*

Haxstun and Company
[Ottman Haxstun and Company]
Flourished: c1870-1900 Fort Edward, NY
Type of Work: Stoneware (Pottery)
Sources: *AmPoP 192; Decor 220; DicM 61*.*

Hay, Ann
Type of Work: Fabric? (Coverlets?)
Sources: *ChAmC 69*
See: Getty, A.

Hay, T.
b. 1892 Clinton County, KY
Flourished: 1972 Jamestown, KY
Type of Work: Various materials (Environmental sculptures)
Sources: *FoAroK *.*

Hay Weaving Shop
Flourished: 1845 Batavia, OH
Type of Work: Fabric (Weavings, coverlets)
Sources: *ChAmC 69, 105*.*

Hayden, E.J.
See: E.J. Hayden and Company.

Hayden, Hiram
Flourished: c1851 Waterbury, CT
Type of Work: Brass (Kettles)
Remarks: Patented a machine for spinning brass
Sources: *AmCoB 77-8*, 79.*

Hayden, J.
Flourished: 1861 New York
Type of Work: Whalebone, ivory (Carved whale teeth)
Museums: 184
Sources: *AmFoS 109*.*

Hayes, George A.
Flourished: c1860 New York
Type of Work: Oil (Genre paintings)
Sources: *OneAmPr 125*, 148, 154.*

Hayes Brothers
Flourished: 1874 Cincinnati, OH
Type of Work: Metal (Weathervanes)
Sources: *YankWe 212.*

Haynes, D.F.
See: D.F. Haynes and Company.

Haynes, F.
See: F. Haynes and Company.

Haynes, Bennett and Company
Flourished: 1890-1900 Baltimore, MD
Type of Work: Whiteware (Pottery)
Sources: *AmPoP 164, 263.*

Hays, George
Flourished: 1860
Type of Work: Oil (Genre paintings)
Sources: *AmFoPaN 103, 134*.*

Hays, J.M.
See: J.M. Hays Wood Products Company.

Hays, Robert
Flourished: 1840 Baltimore, MD
Type of Work: Wood (Ship carvings, ship figures)
Sources: *AmFiTCa 193.*

Hays and Morse
Flourished: 1860 Baltimore, MD
Type of Work: Wood (Ship carvings, ship figures)
Sources: *AmFiTCa 193.*

Hayse, Martha S.
Flourished: 1810 Massachusetts
Type of Work: Watercolor (Paintings)
Sources: *AmPrP 153; PrimPa 174.*

Hayward, Nathan
b. 1720 d. 1794
Flourished: Bridgewater, MA
Type of Work: Stone (Gravestones)
Sources: *EaAmG 128.*

Haywood, Thomas
[Hayward]
Flourished: c1806-1820 Woodstock, CT
Type of Work: Tin (Tinware)
Sources: *AmCoTW 22, 158.*

Hazard, Mary
Flourished: 1840s
Ethnicity: Shaker
Type of Work: Watercolor (Spirit drawings)
Museums: 094
Sources: *AmFoPaN 180*; NinCFo 167, 202, fig103.*

Hazlett
See: Gould and Hazlett.

Hazlitt, John
b. 1767 d. 1837
Flourished: 1780s Hingham, MA; Weymouth, MA
Ethnicity: English
Type of Work: Oil (Portraits, paintings)
Sources: *AmDecor 37, 39-40*, 131, 151; AmPrP 153; PrimPa 174.*

Headley, Joseph H.
See: Hidley, Joseph H.

Headley, Somers G.
Flourished: 1951 Wilmington, DE
Type of Work: Wood (Duck decoys)
Museums: 260
Sources: *Decoy 103*.*

Headman, Andrew
Flourished: 1793-1808 Rock Hill, PA; Bucks County, PA
Type of Work: Redware (Pottery, sgraffito plates)
Museums: 035,096,189
Remarks: Brother is John; son is Charles
Sources: *AmPoP 43, 178; AmSFok 130, 136*; FoArRP 44-5*.*

Headman, Charles
Flourished: 1825-1870 Bucks County, PA; Rock Hill, PA
Type of Work: Clay (Pottery)
Museums: 227
Remarks: Father is Andrew
Sources: *AmPoP 178, 264; DicM 24*, 29*; PenDA 126*; PenDuA 28*.*

Headman, John
Flourished: 1800 Rock Hill, PA
Type of Work: Redware (Pottery)
Museums: 096
Remarks: Brother is Andrew; son is Peter
Sources: *AmPoP 43, 178, 264; AmSFok 130.*

Headman, Peter
Flourished: 1830-1870 Rock Hill, PA
Type of Work: Redware (Pottery)
Remarks: Son of John
Sources: *AmPoP 178.*

Healy, Nathaniel
Flourished: c1776
Type of Work: Whaletooth (Scrimshaw)
Sources: *AmSFo 30; ScriSW 90*.*

Heath, Mrs. John
Flourished: 1758 Brookline, MA
Type of Work: Fabric (Quilts)
Museums: 176
Sources: *QuiAm 207.*

Heath, Samuel
Flourished: 1825 New York, NY
Type of Work: Wood (Ship carvings, ship figures)
Sources: *AmFiTCa 193.*

Heath, Susan
b. 1798
Flourished: Brookline, MA
Type of Work: Watercolor (Paintings)
Sources: *ArtWo 103-104*, 162*.*

Heath, William
Flourished: 1820-1835 Upper Alton, IL; White Hall, IL
Type of Work: Redware (Pottery)
Sources: *ArC 189.*

Hechler, Samuel
Flourished: 1826-1828 Pennsylvania
Type of Work: Fabric (Coverlets)
Museums: 025
Sources: *ChAmC* 69.

Hecht, Abslam
Flourished: 1849 Maryland
Type of Work: Fabric (Weavings)
Sources: *AmSQu* 276; *ChAmC* 69.

Heckmann, John H.
Flourished: 1840-1860 Hermann, MO
Type of Work: Wood (Wardrobes)
Sources: *ASeMo* 365*.

Hedden, Martha
Flourished: 1835 New York
Type of Work: Fabric (Coverlets)
Museums: 016
Sources: *AmSFo* 95*.

Hedderly and Riland
Flourished: 1819 Philadelphia, PA
Type of Work: Pewter (Spoons)
Sources: *AmCoB* 199.

Hedges, Joe
Flourished: 1979 Oklahoma
Type of Work: Wood (Sculptures, carvings)
Sources: *FoArO* 89.

Hedian
See: Meyers and Hedian.

Hedian, T.
Flourished: 1860 Baltimore, MD
Type of Work: Wood (Ship carvings, ship figures)
Sources: *AmFiTCa* 193.

Hedicaugh, William
Flourished: c1870-1900 Baxter, TN
Type of Work: Stoneware, brownware (Pottery)
Sources: *AmPoP* 235.

Hedley, Joseph H.
See: Hidley, Joseph H.

Heebner, David
Flourished: 1810s Pennsylvania
Type of Work: Watercolor, ink (Frakturs)
Sources: *AmFoPa* 188.

Heebner, John
Flourished: 1831 Pennsylvania
Type of Work: Watercolor, ink (Frakturs)
Sources: *AmFoPa* 188.

Heebner, Maria
Flourished: 1840 Pennsylvania
Type of Work: Watercolor, ink (Frakturs)
Sources: *AmFoPa* 188.

Heebner, Susanna
Flourished: c1807 Montgomery County, PA
Type of Work: Watercolor, ink (Frakturs)
Sources: *ArtWo* 83, 162, pl.9.

Heebneren, Susanha
b. 1797 d. c1879
Flourished: 1828 Montgomery County, PA
Type of Work: Fabric (Samplers)
Sources: *GalAmS* 13*, 20.

Heeling, John
Flourished: 1854 Maine
Type of Work: Oil (Historical paintings)
Sources: *FoPaAm* 61*.

Heerlein, W.
Flourished: 1880 Sharpsburg, PA
Type of Work: Oil (Building portraits)
Museums: 096
Sources: *AmFoS* 163*; *FoPaAm* 130*.

Heffner
Flourished: 1856 Muncie, IN
Type of Work: Fabric (Coverlets)
Sources: *ChAmC* 124.

Hefner, George
b. c1806 Pennsylvania d. 1878
Flourished: 1844-1845 Greentown, OH; Plain Township, OH
Type of Work: Fabric (Coverlets)
Sources: *ChAmC* 69
See: Petna, George.

Heifner, J. Philip
Flourished: 1844-1860 Perry Township, OH; Hayesville, OH; Olney, OH
Type of Work: Fabric (Weavings)
Sources: *ChAmC* 69.

Heighshoe, S.E.
Flourished: c1850 Somerset, OH
Type of Work: Stoneware (Pottery)
Sources: *AmPoP* 230; *Decor* 220; *DicM* 120*.

Heikes Woolen Factory
See: Good Intent Woolen Factory.

Heilbronn, George
Flourished: 1843-1855 Lancaster, OH; Basil, OH
Type of Work: Fabric (Weavings)
Sources: *AmSQu* 276; *ChAmC* 69.

Heilbronn, J(ohn) J.
d. c1842 Basil?, OH?
Flourished: 1839-1842 Basil, OH; Adelphi, OH; Lancaster, OH
Type of Work: Fabric (Coverlets)
Sources: *AmSQu* 276; *ChAmC* 69-70.

Heiligmann and Brother
Flourished: 1870 Philadelphia, PA
Type of Work: Wood (Ship carvings, ship figures)
Sources: *AmFiTCa* 193.

Hein, John
Flourished: 1860 New York, NY
Type of Work: Wood (Ship carvings, ship figures)
Sources: *AmFiTCa* 193.

Heiser, William L.
Flourished: Chillicothe, OH
Type of Work: Fabric (Coverlets)
Sources: *ChAmC* 70.

Heiss, Balthus
Flourished: 1860 New York, NY
Type of Work: Wood (Ship carvings, ship figures)
Sources: *AmFiTCa* 193.

Heiss, William
Flourished: Philadelphia, PA
Type of Work: Copper (Copperware)
Sources: *AmCoB* 53*, 72.

Heitzie, Christian
Flourished: 1850 Jersey County, IL
Type of Work: Earthenware (Pottery)
Sources: *ArC* 193.

Hellick, Ann
b. c1822
Flourished: 1832 Pennsylvania; New Jersey
Type of Work: Fabric (Samplers)
Sources: *GalAmS* 74*.

Hemenway, Asa
b. 1810 Shoreham, VT d. 1892 Manchester, VT
Flourished: 1889 Middlebury, VT
Type of Work: Watercolor (Paintings)
Museums: 176
Sources: *ColAWC* 237, 239*; *PrimPa* 174.

Hemon, James
Flourished: Circleville, OH
Type of Work: Fabric (Coverlets)
Sources: *ChAmC* 70.

Hemp, Robert
b. 1916
Flourished: Virginia
Ethnicity: Black American
Type of Work: Oil (Paintings)
Sources: *FoPaAm* 178-9*.

Hemphill, Joseph
Flourished: c1835 Philadelphia, PA
Type of Work: Clay (Pottery)
Sources: *AmPoP* 45, 102, 176, 261; *DicM* 74*, 138*, 90*.

Hemphill, Judge
See: Tucker and Hemphill.

Hempstead, Joshua
b. 1678 d. 1758
Flourished: c1720-1758 New London, CT
Type of Work: Stone (Gravestones)
Sources: *GravNE* 102-5, 128.

Henderson
See: Gleason and Henderson.

Henderson, D. and J.
See: D. and J. Henderson; Jersey City Pottery.

Henderson, Frank K.
Flourished: 1892? Kalamazoo, MI
Type of Work: (Masonic regalia)
Sources: *Bes 39**.

Henderson, George, Jr.
b. c1804 Pennsylvania
Flourished: 1836-1850 Green Township, PA
Type of Work: Fabric (Coverlets, diapers, carpets)
Sources: *ChAmC 70*.

Henderson, John
Flourished: c1847-1857 East Liverpool, OH
Type of Work: Yellow-ware, Rockingham (Bird whistles, toys, pottery)
Sources: *AmPoP 215*.

Henderson, Joseph
Flourished: 1860-1870 Portsmouth, NH; Cambridge, MA
Type of Work: Wood (Ship carvings, ship figures)
Sources: *AmFiTCa 193; ShipNA 161*.

Henderson Pottery
Flourished: c1880 Henderson, TX
Type of Work: Stoneware (Bowls)
Sources: *AmS 141*, 143**.

Hendricks, J.P.
Flourished: c1920's Santa Barbara, CA
Type of Work: Wood (Duck decoys)
Sources: *AmBiDe 230*.

Henis, William
Flourished: Philadelphia, PA
Type of Work: Metal (Weathervanes)
Sources: *ArtWe 63**.

Henkel, Ambrose
Flourished: 1812-1827 New Market, VA
Type of Work: Watercolor, ink (Frakturs)
Sources: *SoFoA 82*-3*, 219*.

Henne, Daniel P.
Flourished: c1860-1870 Shartlesville, PA
Type of Work: Redware (Pottery, especially toys and modeled pieces)
Remarks: Son is Joseph K.
Sources: *AmPoP 179*.

Henne, J.S.
Flourished: 1800 Shartlesville, PA
Type of Work: Clay (Pottery)
Sources: *DicM 182**.

Henne, Joseph K.
Flourished: c1870-1880 Shartlesville, PA
Type of Work: Redware (Pottery)
Remarks: Son of Daniel P.
Sources: *AmPoP 179*.

Henning, A.
Flourished: 1847 Sucer Creek, OH
Type of Work: Fabric? (Coverlets?)
Sources: *ChAmC 124*.

Henning, Herman D.A.
Flourished: c1875 Baltimore, MD
Type of Work: Wood (Figures)
Museums: 227
Sources: *EaAmW 71*.

Hennis, John
Flourished: 1858-1879 West Fallowfield, PA
Type of Work: Tin (Tinware)
Sources: *ToCPS 24-5, 28, 32-5**.

Henrie, John
Flourished: 1877 Meriden, CT
Type of Work: Tin (Tinware)
Sources: *TinC 170*.

Henrill, Hermann
Flourished: 1843-1845 Ephrata, PA; Cloisters, PA
Type of Work: Watercolor (Townscape paintings)
Sources: *NinCFo 167, 194, fig123*.

Henry, David H.
Flourished: 1851 Philadelphia, PA
Type of Work: Wood (Ship carvings, ship figures)
Sources: *AmFiTCa 193*.

Henry, Jacob
Flourished: 1827-1834 Albany, NY
Type of Work: Stoneware (Pottery)
Sources: *Decor 220*
See: C. Dillon and Company.

Henry, Samuel C.
Flourished: 1833 Philadelphia, PA
Type of Work: Wood (Ship carvings, ship figures)
Sources: *AmFiTCa 193*.

Henry Cushing and Company
Flourished: 1832-1844 Providence, RI
Type of Work: Cardboard (Boxes)
Museums: 097
Sources: *AmSFo 129; NeaT 108**.

Henry Gabriel Woolen Mill
See: Gabriel, Henry.

Henry Pettie and Company
Flourished: c1860 Pittsburgh, PA
Type of Work: Stoneware (Pottery)
Sources: *AmPoP 228; Decor 222*.

Herberling
Flourished: c1838 Quincy, IL
Type of Work: Iron (Cast ironware)
Sources: *ArC 172*.

Herbert
See: Thompson and Herbert.

Herbert(?)
Flourished: c1865 Louisville, KY
Type of Work: Fabric (Quilts, needleworks)
Remarks: Butler at the Brown family residence
Sources: *KenQu 70-71, fig59-60*.

Hereford Furnace
See: Maybury, Thomas.

Herff, Charles Adelbert
b. 1853 d. 1943
Type of Work: Watercolor (Genre paintings)
Museums: 286
Sources: *PicFoA 124**.

Hering
Flourished: 1785-1817 New Jersey
Type of Work: Oil (Portraits)
Sources: *AmPrP 153; PrimPa 174*.

Herman, C.
See: C. Herman Company Pottery.

Herman, John
Flourished: c1855 Butler County, OH; Ripley County, IN
Type of Work: Fabric (Coverlets)
Sources: *ChAmC 70*.

Herme, Daniel
Flourished: c1860-1880 Upper Bern Township, PA
Type of Work: Redware (Pottery)
Sources: *AmPoP 184*.

Heron, James
[Herron]
Flourished: 1830 New York, NY
Type of Work: Wood (Ship carvings, ship figures)
Remarks: Partner in Heron and Macy; Heron and Weedon
Sources: *AmFiTCa 193; ShipNA 162*.

Heron and Macy
[Herron and Macy]
Flourished: 1830 New York, NY
Type of Work: Wood (Ship carvings, ship figures)
Sources: *AmFiTCa 193; ShipNA 162*.

Heron and Weeden
[Herron and Weedon]
Flourished: 1825 New York, NY
Type of Work: Wood (Ship carvings, ship figures)
Sources: *AmFiTCa 193; ShipNA 161*.

Herp, Charles Adelbert
b. 1853 d. 1943
Flourished: Texas
Type of Work: Watercolor (Paintings)
Sources: *PrimPa 174*.

Herr, Anna
Flourished: 1828 Pennsylvania
Type of Work: Watercolor, ink (Frakturs)
Sources: *AmFoPa 188*.

Herr, Anna
Flourished: 1833 Pennsylvania
Type of Work: Fabric (Embroidered towels)
Museums: 151
Sources: *AmNe 53*, 56*.

Herr, David
Flourished: Pennsylvania
Type of Work: Watercolor, ink (Frakturs)
Sources: *AmFoPa* 188.

Herr, Elizabeth R.
Flourished: 1876
Type of Work: Fabric (Samplers)
Museums: 227
Sources: *MoBeA*.

Herr, Henry
Flourished: 1825 Massachusetts
Type of Work: Pen, watercolor (Portraits)
Sources: *AmPrW* 71*, 130*.

Herr, John
Flourished: 1860 New York, NY
Type of Work: Wood (Ship carvings, ship figures)
Sources: *AmFiTCa* 193.

Herrera, Antonio
Flourished: San Luis, NM
Ethnicity: Hispanic
Type of Work: Wood (Santeros, other religious carvings)
Sources: *PopAs* 434.

Herrera, Jose Inez (Ines)
Flourished: 1890-1910 El Rito, NM
Ethnicity: Hispanic
Type of Work: Wood, various materials (Sculptures)
Museums: 068
Sources: *HoKnAm* fig13; *TYeAmS* 79*, 188, 341.

Herrera, Miguel
Flourished: 1880 Arroyo Hondo, NM
Ethnicity: Hispanic
Type of Work: Wood (Santeros, other religious carvings)
Sources: *PopAs* 408, 432, 434.

Herreter and Sweitzer
Flourished: 1872 Little Marsh Creek, PA
Type of Work: Fabric (Weavings)
Sources: *ChAmC* 70
See: Kepners Woolen Mill; Sweitzer.

Herrick, Robert A.
Flourished: c1833-1860 Beverley, MA
Type of Work: Redware (Pottery)
Sources: *AmPoP* 188.

Herring, J.
Flourished: 1820 Massachusetts
Type of Work: Oil (Portraits)
Sources: *PrimPa* 174.

Herring, James
b. 1794 **d.** 1867
Flourished: New York, NY
Type of Work: Oil (Portraits)
Museums: 001
Sources: *AmFoPo* 123-5*.

Herrmann, Charles A.
Flourished: Champaign County, IL
Type of Work: Fabric (Weavings)
Sources: *ChAmC* 70.

Herrmann, P(eter)
Flourished: c1850-1872 Baltimore, MD
Type of Work: Stoneware (Bowls)
Sources: *AmS* 96*, 97*.

Herron, James
See: Heron, James.

Herron and Macy
See: Heron and Macy.

Herron and Weedon
See: Heron and Weedon.

Herschberger, Mrs. Manuel
Flourished: 1930 Topeka, IN
Ethnicity: Amish
Type of Work: Fabric (Quilts)
Sources: *QuiInA* 51*.

Herschell, Allen
Flourished: c1920- North Tonawanda, NY
Type of Work: Wood (Carousel figures)
Sources: *CaAn* 9-10, 18-19*
See: Armitage, James.

Herschell-Spillman Company
Flourished: 1912-1916 North Tonawanda, NY
Type of Work: Wood (Circus and carousel figures)
Museums: 188
Sources: *AmSFor* 18, 20*; *CaAn* 10, 70-1, 90-3*
See: Armitage-Herschell Co.

Hersey, Edmond
Flourished: 1850 Hingham, MA
Type of Work: Wood (Woodenware)
Remarks: Associated with the Hingham Wooden Ware factory
Sources: *EaAmWo* 162.

Hersey, Joseph
Flourished: 1843 Provincetown, MA
Type of Work: Pen, pencil, ink, watercolors (Drawings, calligraphy)
Museums: 123
Sources: *WhaPa* 8-9, 18*, 42*-5*, 78*-9*, 104*, 106*, 110*, 119*, 126*, 156.

Hersey, Samuel
Flourished: 1850-1875 Hingham, MA
Type of Work: Wood (Boxes)
Sources: *NeaT* 152*, 157.

Hersh, H.S.
Flourished: 19th cent
Type of Work: Wood, iron (Decorated tool box)
Sources: *BlkAr* 52*.

Hersh, Henry
b. 1808 Pennsylvania **d.** 1882 Lancaster, PA
Flourished: 1846-1950 Leacock Township, PA
Type of Work: Fabric (Carpets, coverlets)
Sources: *ChAmC* 70
See: Ressler, Rudolph.

Herstine, Cornelius
Flourished: c1785 Nockamixon, PA
Type of Work: Redware (Pottery)
Remarks: Sons are Daniel and David; grandson is Daniel
Sources: *AmPoP* 43, 173.

Herstine, Daniel
Flourished: c1810-1844 Nockamixon, PA
Type of Work: Redware (Pottery)
Remarks: Father is Cornelius; brother is David
Sources: *AmPoP* 43, 173.

Herstine, Daniel
Flourished: c1875-1910 Nockamixon, PA
Type of Work: Redware (Pottery)
Remarks: Grandfather is Cornelius
Sources: *AmPoP* 43, 173.
See: Daniel and David.

Herstine, David
Flourished: c1844-1875 Nockamixon, PA
Type of Work: Redware (Pottery)
Remarks: Father is Cornelius; brother is Daniel
Sources: *AmPoP* 43, 173.

Herter Sporting Goods Company
Flourished: c1920s Wauseca, MN
Type of Work: Wood (Duck and owl decoys)
Sources: *AmBiDe* 229; *WoCar* 141*.

Herzog, James J.
Flourished: 1871 Baltimore, MD
Type of Work: Wood (Ship carvings, ship figures)
Sources: *AmFiTCa* 193.

Heshe, Henry
Flourished: Poplar, OH
Type of Work: Fabric (Coverlets)
Sources: *ChAmC* 70.

Hesse, D.
Flourished: 1860 Logan, OH
Type of Work: Fabric (Coverlets)
Sources: *ChAmC* 70.

Hesse, F.E.
b. c1827
Flourished: c1860-1862 Logan Village, OH
Ethnicity: German
Type of Work: Fabric (Weavings)
Sources: *ChAmC* 70, 124.

Hesse, L.
Flourished: 1838-1860 Somerset, OH
Ethnicity: German
Type of Work: Fabric (Weavings)
Sources: *AmSQu 276; ChAmC 70.*

Hesselius, Gustavus
b. 1682 d. 1755
Flourished: Pennsylvania; Maryland
Type of Work: Oil (Portraits)
Sources: *FoA 464.*

Hesselius, John
b. 1728 Philadelphia, PA d. 1778 Annapolis, MD
Flourished: c1745 Annapolis, MD
Type of Work: Oil (Portraits)
Remarks: Taught Peale, Charles Willson
Sources: *OneAmPr 36*, 80, 140, 154.*

Hessin, Christina
Flourished: c1815 Pennsylvania
Type of Work: Fabric (Samplers)
Sources: *WinGu 22*.*

Hetzell, George J.
Flourished: 1870 Philadelphia, PA
Type of Work: Wood (Ship carvings, ship figures)
Sources: *AmFiTCa 194.*

Heuling, Martha
Flourished: 1809 Moorestown, NJ
Type of Work: Fabric (Samplers)
Sources: *AmNe 53.*

Hewell, Will
Flourished: 1910-1920 Mossy Creek, GA
Type of Work: Clay (Pottery)
Remarks: Worked for Dorsey, W.F.
Sources: *MisPi 95*.*

Hewes, Clarence "Charlie"
b. 1894 Mason, MI d. 1970 Lansing, MI
Flourished: 1929? Lansing, MI
Type of Work: Oil (Murals, paintings)
Remarks: Painted murals in pumping station of Lansing Board of Water and Light
Sources: *FoPaAm 216*; Rain 119*-126.*

Hewes Pottery
Flourished: Cambridge, MA
Type of Work: Clay (Pottery)
Sources: *FoArtC 43.*

Hewett, Isaac
[Hewitt]
Flourished: c1870-1880 Price's Landing, PA
Type of Work: Stoneware (Pottery)
Remarks: Owned Excelsoir Works.
Sources: *AmPoP 87, 228, 264; Decor 220; DicM 67**

Hewins, Amasa
Flourished: 1837 Dedham, MA
Type of Work: Oil (Portraits)
Sources: *AmPrP 153; Edith *; PrimPa 174; SoAmP 182.*

Hewins, Philip
b. 1806 d. 1850
Flourished: Hartford, CT
Type of Work: Oil (Portraits)
Museums: 083
Sources: *AmPrP 153; PrimPa 174; SoAmP 183.*

Hewit, Charles
Flourished: 1840s Lyme, CT
Type of Work: Whalebone (Scrimshaw)
Museums: 186
Sources: *GravF 55*.*

Hewitt, Isaac
See: Hewett, Isaac.

Hews, Abraham
Flourished: 1765-1810 Weston, MA
Type of Work: Redware (Pottery)
Sources: *AmPoP 204.*

Hewson, John
d. 1822 Pennsylvania
Flourished: c1774-1811 Philadelphia, PA
Ethnicity: English
Type of Work: Fabric (Bedcovers)
Museums: 046,096,097,110,227,263,282
Remarks: Wife is Smallwood, Zibiah
Sources: *AmNe 40; AmSQu 40*; NewDis 24-5*; QuiAm 25*, 41-4*, 46-7*.*

Hewson, Martha N.
Flourished: 1830 Kensington, PA
Type of Work: Fabric (Samplers)
Sources: *AmNe 52-3, 60*.*

Hext, Elizabeth
b. c1734
Flourished: 1743 Charleston, SC
Type of Work: Fabric (Samplers)
Sources: *GalAmS 23*, 89; SoFoA 172*, 222.*

Hey and Luckens
Flourished: 1860 Philadelphia, PA
Type of Work: Wood (Ship carvings, ship figures)
Sources: *AmFiTCa 194.*

Heyde, Charles Louis
b. 1822 d. 1892
Type of Work: Oil (Paintings)
Museums: 143
Sources: *FoArA 98*.*

Heydrich, Balzer
b. 1762 d. 1845
Flourished: 1784-1845 Pennsylvania
Type of Work: Watercolor, ink (Frakturs)
Sources: *AmFoPa 188.*

Heye, Frederick
d. 1881
Flourished: 1860 St. Charles, MO
Ethnicity: German
Type of Work: Tin (Tinware)
Sources: *ASeMo 428.*

Heyman, F.B.
Flourished: 1865 New York; Pennsylvania
Type of Work: Pen, ink (Penmanship, calligraphy drawings)
Sources: *FlowAm 107*.*

Heyne, Johann Christopher
Flourished: 1754-1780 Lancaster County, PA
Type of Work: Pewter (Pewterware)
Museums: 032
Sources: *PenDA 101*.*

Heyser, W.
Flourished: Chambersburg, PA
Type of Work: Brass (Kettles)
Sources: *AmCoB 76*, 125*.*

Heywood, Manie
Flourished: c1900 Killpevil, NC
Type of Work: Wood (Duck decoys)
Museums: 260
Sources: *Decoy 100*.*

Hiatt, James
Flourished: 1870 Boeuf Township, MO
Type of Work: Wood (Cabinets)
Sources: *ASeMo 384.*

Hicks, Edward
b. 1780 Langhorne, PA d. 1849 Newtown, PA
Flourished: 1820-1849 Milford, PA; Bucks County, PA
Ethnicity: Quaker
Type of Work: Oil (Paintings)
Museums: 001, 020, 032, 035, 179, 189, 229, 246, 311
Sources: *AmFoAr 21-2*; AmFokA 85*; AmFokDe xi, 129*; AmFoPaCe 88-99*, 163, 193, 218, 221; AmNa15-6, 23, 61*-4*; AmPrP 147, fig57, 65, 69; AmSFo 6, 8-15* AmSFok 166*; BeyN 52-3, 96, 106; CoCoWA 100*, 104; Edith *; EdwH *; EdwHPa *; FoA xi*, 464; FoArA 22*, 26*.*

Hicks, Edward (Continued)
Sources: *GraMo 32*, 34, 43, 63, 79; HoKnAm 84, 95pl18; MaAmFA *; OneAmPr 73*, 80, 87*, 109*; PeiNa 215*; PicFoA 21-4, 98*, 106*-7*, 112*, 126, 161-2; PrimPa 39-49*, 174.*

Hicks, Elizabeth
b. c1734
Flourished: c1760-1817
Type of Work: Fabric (Embroidered pocketbooks)
Museums: 110
Sources: *PlaFan 92*.*

Hicks, Harriet
Flourished: 1802-1812 Champlain, NY
Type of Work: Fabric (Rugs)
Museums: 151
Sources: *AmNe 97, 95**
See: Moore, Ann; Moore, Sophie.

Hicks, Samuel
b. 1804 Lebanon County, PA **d.** 1888 Ovid, IN
Flourished: 1834-1838 Millerstown, PA; Chambersburg, OH; Ovid, IN
Type of Work: Fabric (Weavings)
Sources: *ChAmC 70.*

Hicks, Walter
Flourished: 1825 New York, NY
Type of Work: Wood (Ship carvings, ship figures)
Sources: *AmFiTCa 194.*

Hicks, William
b. 1821 **d.** 1903
Flourished: c1850 Madison County, IN
Type of Work: Fabric (Coverlets)
Sources: *AmSQu 276; ChAmC 70.*

Hidley, Joseph H.
[Hedley; Headley]
b. 1830 Poestenkil, NY **d.** 1872
Flourished: 1840-1860 Poestenkil, NY; Troy, NY
Type of Work: Oil (Landscape paintings)
Museums: 001,203
Sources: *AmFoPaCe 98-102*; AmPrP 147, fig40*-2*; AmSFok 164*; FoA 464; OneAmPr 81, 126*; PicFoA 105*; PrimPa 174, 132-8*.*

Hieatt, Martha Tribble
d. 1901
Flourished: c1875 Henry County, KY
Type of Work: Fabric (Quilts)
Sources: *KenQu 54-5, fig9, 43-4.*

Hiester, Catherine
Flourished: 1786 Berks County, PA
Type of Work: Fabric (Samplers)
Sources: *GalAmS 28*.*

Higgin, Peter
Flourished: c1835 Boston, MA
Type of Work: Paper (Hat boxes)
Sources: *NeaT 105*.*

Higgins
See: Chatterson and Higgins.

Higgins, A.D.
Flourished: c1837-1850 Cleveland, OH
Type of Work: Stoneware (Pottery)
Sources: *AmPoP 212, 264; Decor 220; DicM 8*.*

Higgins, Stephen
Flourished: 1871 Portland, ME
Type of Work: Wood (Ship carvings, ship figures)
Sources: *AmFiTCa 194.*

Higgins, W.G.
See: W.G. Higgins.

Higgs, Harriet W.
Flourished: 1841 Halifax County, NC
Type of Work: Fabric (Samplers)
Sources: *SoFoA 175*, 222.*

Hild, Michael
Flourished: 1871 Newark, NJ
Type of Work: Wood (Ship carvings, ship figures)
Sources: *AmFiTCa 194.*

Hildebrand, Frederick
Flourished: c1825-1845 Tylersport, PA
Type of Work: Redware (Pottery)
Sources: *AmPoP 184.*

Hildreth, Herbert L.
Flourished: 1891 Maine
Type of Work: Oil (Farm scene paintings)
Sources: *NinCFo 181.*

Hiler, Pere
Flourished: San Francisco, CA
Type of Work: Oil (Paintings)
Sources: *ThTaT 236*.*

Hilker, Frederick
Flourished: 1840-1860 Augusta Community, MO
Type of Work: Wood (Cribs)
Sources: *ASeMo 375*.*

Hill
See: Griffin, Smith and Hill.

Hill, Asa
b. 1719 **d.** 1809
Flourished: Farmington, CT
Type of Work: Stone (Gravestones)
Sources: *EaAmG 128.*

Hill, Cad
Flourished: early 20th cent Providence, RI
Type of Work: Oil (Circus banners)
Sources: *AmSFor 52.*

Hill, George
Flourished: Plainville, CT
Type of Work: Tin (Tinware)
Sources: *TinC 120.*

Hill, Harriet
b. 1790 Providence, RI **d.** 1817 Bristol?, RI?
Flourished: 1799 Providence, RI
Type of Work: Fabric (Samplers)
Sources: *LeViB 115, 117, 140, 153*, 249.*

Hill, Henry
Flourished: Pennsylvania
Type of Work: Watercolor, ink (Frakturs)
Sources: *AmFoPa 188.*

Hill, Ithuel
b. 1769 **d.** 1821
Flourished: Farmington, CT
Type of Work: Stone (Gravestones)
Sources: *EaAmG 128.*

Hill, Lovice
b. 1793 **d.** 1849
Flourished: 1815 Providence, RI
Type of Work: Embroidery (Mourning pictures)
Museums: 225
Sources: *LeViB 186*; MoBeA fig33.*

Hill, Phinehas
b. 1778
Flourished: Harwinton, CT
Type of Work: Stone (Gravestones)
Sources: *EaAmG 128.*

Hill and Adams
Flourished: 1868? Akron, OH
Type of Work: Stoneware, sewer-pipe (Pottery)
Sources: *AmPoP 206; Decor 220*
See: Hill, Powers and Company.

Hill, Foster and Co.
Flourished: 1849-1851 Akron, OH
Type of Work: Stoneware (Pottery)
Sources: *AmPoP 205; Decor 220*
See: Hill, Powers and Co.; Hill and Adams.

Hill, Merrill and Company
Flourished: 1851-1855 Akron, OH
Type of Work: Stoneware (Pottery)
Sources: *AmPoP 205; Decor 220*
See: Hill, Foster and Company.

Hill, Powers and Company
Flourished: 1859-1868 Akron, OH
Type of Work: Stoneware (Pottery)
Sources: *AmPoP 206; Decor 220*
See: Hill and Adams.

Hillard, E.
Flourished: 1877 Meriden, CT
Type of Work: Tin (Ornamental tinware)
Sources: *TinC 171.*

Hillegas, Jacob
Flourished: 1811 Pennsylvania
Type of Work: Watercolor, ink (Frakturs)
Sources: *AmFoPa 188.*

Hilliard, Philip H.
Flourished: 1835-1846 Mount Bethel Township, PA; Northampton County, PA
Type of Work: Fabric (Coverlets)
Sources: *ChAmC 70, 94*.*

Hillings, John
d. 1894
Flourished: c1854 Bath, ME
Type of Work: Oil (Historical paintings)
Sources: *FoA 67*, 464.*

Hillman, Richard S.
Flourished: 1855 Springfield, IL
Type of Work: (Sign and decorative paintings)
Sources: *ArC 265.*

Hillyer, William, Jr.
Flourished: 1832-1864 New Jersey
Type of Work: Oil (Portraits)
Museums: 001
Sources: *AmFoAr 18; AmPrP 153; PrimPa 174.*

Hilton Pottery Company
Flourished: c1880-1925 Hickory, NC
Type of Work: Stoneware (Pitchers)
Sources: *AmPoP 238; AmS 169*.*

Hinchco, Benjamin
Flourished: c1865-1885 Troy, IN
Type of Work: Rockingham, brownware (Pottery)
Sources: *AmPoP 232.*

Hindes, John M.
Flourished: 1860 Philadelphia, PA
Type of Work: Wood (Ship carvings, ship figures)
Sources: *AmFiTCa 194.*

Hines
See: Towson and Hines.

Hingham Wooden Ware
Flourished: c1840 Hingham, MA
Type of Work: Wood (Woodenware, buckets)
Remarks: A factory
Sources: *EaAmWo 161*
See: Hersey, Edmund.

Hinkel, C(hristian) K.
Flourished: 1813-1899 Shippensburg, PA
Type of Work: Fabric (Coverlets)
Sources: *AmSQu 252*, 276; ChAmC 70.*

Hinsdale, Samuel
b. 1722 d. 1787
Flourished: Medfield, MA
Type of Work: Stone (Gravestones)
Sources: *EaAmG 128; GravNE 178.*

Hinshillwood, Robert
b. c1798
Flourished: c1848-1850 Salem, OH; Franklin Township, OH
Ethnicity: Scottish
Type of Work: Fabric (Weavings)
Sources: *ChAmC 70.*

Hinson, John
b. 1938 Lancaster, SC
Flourished: contemporary Lancaster, SC
Type of Work: Wood (Whirligigs)
Sources: *FoAFf 13-4*.*

Hipp, Sebastian
b. c1830
Flourished: 1853-1854 Mount Joy, PA; Mifflin Township, OH
Ethnicity: German
Type of Work: Fabric (Weavings)
Sources: *ChAmC 70*
See: Shearer, Henry.

Hippert, Samuel
Flourished: 1833-1840 Mount Joy, PA; Elizabethtown, PA
Type of Work: Fabric (Weavings)
Sources: *ChAmC 70.*

Hiram Swank and Sons
Flourished: c1865-1900 Huntington, PA; Johnstown, PA
Type of Work: Stoneware (Pottery)
Sources: *AmPoP 221; Decor 224; DicM 63*.*

Hirsch, Cliff
Flourished: contemporary Woodbury, CT
Type of Work: Scrap material (Weathervanes)
Sources: *WeaVan 26.*

Hirshfield, Morris
b. 1872 d. 1946
Flourished: 1936 Brooklyn, NY; New York, NY
Ethnicity: Polish
Type of Work: Oil (Paintings)
Museums: 020,179
Sources: *AlAmD 73*; AmFokArt 115-7*; AmFoPaCe 189-97*; FoA 464; FoAFef 6*, 11; FoPaAm 106, 108-9*; GraMo 14, 44*, 79; HoKnAm 181, 184*-5*; MaAmFA *; PeiNa 216*; PrimPa 174, 163*; ThTaT 14-39*; Trans 4, 6, 8-11*, 29, 54; TwCA 2*.*

Hirzel, William
Flourished: 1901 Rochester, NY
Type of Work: Clay (Sewer tile sculpture)
Sources: *AlAmD 108*.*

Hoadley, David
b. 1774 d. 1839
Flourished: 1800-1810 Naugatuck?, CT?
Type of Work: Wood (Signs)
Museums: 054
Sources: *MoBBTaS 30*.*

Hoag
Flourished: Michigan
Type of Work: Wood (Fish decoys)
Sources: *UnDec 20.*

Hoagland, James S.
[Hogeland]
b. c1820 Virginia
Flourished: c1854-1857 Lafayette, IN
Type of Work: Fabric (Coverlets)
Sources: *ChAmC 71*
See: Jackson, Thomas.

Hobart, Abigail Adams
b. 1793 Abington, MA d. 1844 East Bridgewater?, MA?
Flourished: 1802 Providence, RI
Type of Work: Fabric (Samplers)
Museums: 034
Sources: *LeViB 115, 137*.*

Hobart, Salome
b. 1783 Abington, MA d. 1861 Stamford, CT
Flourished: 1803 Providence, RI
Type of Work: Embroidery (Mourning pictures)
Sources: *LeViB 137, 172*, 258.*

Hobbs, G.W., Reverend
Flourished: 1784 Baltimore, MD
Ethnicity: Black American
Type of Work: Oil (Portraits, paintings)
Sources: *AfAmA 96; AmNeg 22, fig8; FoPaAm 156-7.*

Hobbs, John, Jr.
Flourished: 1860 Hallowell, ME
Type of Work: Wood (Ship carvings, ship figures)
Sources: *AmFiTCa 194.*

Hobbs, John E.
Flourished: 1859 Salem, MA
Type of Work: Wood (Ship carvings, ship figures)
Sources: *AmFiTCa 194.*

Hobdy, Ann F.
Flourished: Kentucky
Type of Work: Fabric (Samplers)
Sources: *AmNe 179*.*

Hochstetter, Katie
Flourished: c1940 Nappanee, IN
Ethnicity: Amish
Type of Work: Fabric (Quilts)
Sources: *QuInA 66*.*

Hochstetter, Mrs. Manas (Mary)
Flourished: 1901-1937 Honeyville, IN
Ethnicity: Amish
Type of Work: Fabric (Quilts)
Sources: *QuInA 64*, 43*.*

Hocusweiler, Jacob
Flourished: 1815-1856 Pittsburgh, PA
Type of Work: Redware (Pottery)
Sources: *AmPoP 227.*

Hodge, Mack
b. 1937 Elys, KY
Flourished: 1973- Kentucky
Type of Work: Wood (Models of churches, boxes, carvings)
Sources: *GoMaD.*

Hodges, Susana
Flourished: c1820 Kennebunk, ME
Type of Work: Fabric (Mourning pictures)
Sources: *MoBeA.*

Hodgetts, Sam
Flourished: c1889 Wallingford, CT
Type of Work: (Ornamental paintings)
Sources: *AmDecor 87.*

Hodgkins, Nathaniel
b. 1761 d. 1839
Flourished: Hampton, CT
Type of Work: Stone (Gravestones)
Sources: *EaAmG 128.*

Hoerr, Adam
b. c1812
Flourished: 1848-1856 Old Economy, PA
Ethnicity: German
Type of Work: Fabric (Coverlets)
Sources: *AmSQu 245*, 267*; ChAmC 71.*

Hoff, John
b. c1888 d. 1973 El Cajon, CA
Flourished: San Diego, CA
Type of Work: Various materials (Environmental sculptures)
Sources: *PioPar 14, 42, 61.*

Hoffman
Flourished: 1848 Somerset County?, PA
Type of Work: Fabric (Weavings)
Sources: *ChAmC 71*
See: Casebeer, Aaron .

Hoffman, Alexander
Flourished: 1860 Baltimore, MD
Type of Work: Wood (Ship carvings, ship figures)
Sources: *AmFiTCa 194.*

Hoffman, C.W. (Charles L.)
[Hofmann]
b. 1820 d. 1882
Flourished: 1860, 1872-1878 Berks County, PA; Montgomery County, PA
Ethnicity: German
Type of Work: Oil, watercolor (Paintings)
Museums: 001,106,189
Sources: *AmFoPaCe 103-9*; AmNa 17, 24, 65*; AmPrW 81, 133; FoA 40*, 464; FoPaAm 132*, 143; MaAmFA *; OneAmPr 81, 133*, 149, 154; PrimPa 174.*

Hoffman, Christopher
Flourished: 1839-1860s Pittsburg, MO; Hermann, MO
Ethnicity: German
Type of Work: Wood (Furniture)
Sources: *ASeMo 389.*

Hoffman, Gustav
Flourished: 1859 St. Louis, MO
Type of Work: Wood (Ship carvings, ship figures)
Sources: *AmFiTCa 194.*

Hoffman, Johannes
Flourished: 1811 Pennsylvania
Type of Work: Watercolor, ink (Frakturs)
Sources: *AmFoPa 188.*

Hoffman, John
Flourished: 1860 New York, NY
Type of Work: Wood (Ship carvings, ship figures)
Sources: *AmFiTCa 194.*

Hoffman, Leonard
Flourished: 1820 New York, NY
Type of Work: Wood (Ship carvings, ship figures)
Sources: *AmFiTCa 194.*

Hoffman, William
Flourished: Doylestown, PA
Type of Work: Tin (Tinware)
Sources: *ToCPS 6*.*

Hoffman and Maurer
Flourished: 1853-1860 New York, NY
Type of Work: Wood (Ship carvings, ship figures)
Sources: *AmFiTCa 194; ShipNA 162.*

Hoffmaster, Charles A.
Flourished: 1860 New York, NY
Type of Work: Wood (Ship carvings, ship figures)
Sources: *AmFiTCa 194.*

Hofmann, Anna
Flourished: Pennsylvania
Type of Work: Fabric (Samplers)
Sources: *PlaFan 62-3*.*

Hofmann, Charles L.
See: Hoffman, C.W.

Hogeland, J.S.
See: J.S. Hogeland and Son .

Hogue, Samuel
Flourished: 1860 Montgomery County, MO
Type of Work: Wood (Pie safes)
Sources: *ASeMo 352*
See: Vermillion, John .

Hohulin, Gottlich
[Gottlieb]
Flourished: 1861 Goodfield, IL
Type of Work: Fabric (Weavings)
Sources: *AmSQu 276; ChAmC 71.*

Hoit, Albert Gallatin
b. 1800 d. 1856
Flourished: Boston, MA
Type of Work: Oil (Portraits)
Sources: *AmPrP 153; PrimPa 174; SoAmP 185*.*

Hoke, George
Flourished: West Brookfield, OH
Type of Work: Fabric (Coverlets)
Sources: *ChAmC 71.*

Hoke, Martin
b. 1815 d. 1893 York, PA
Flourished: 1833-1847 Dover, PA; York County, PA
Ethnicity: German
Type of Work: Fabric (Coverlets)
Sources: *AmSQu 276; ChAmC 71, 111*.*

Holcomb, Allen
b. 1782 d. 1860
Flourished: New Lisbon, NY
Type of Work: Wood (Chairs)
Sources: *AmPaF 188.*

Holcomb, Sarah
Flourished: 1847 Lancaster County, PA
Type of Work: Fabric (Quilts)
Sources: *NewDis 84*.*

Holden, H.
Flourished: 19th cent
Type of Work: Watercolor (Still life paintings)
Sources: *Edith.*

Holden, Jesse
Flourished: c1830 Steubenville, OH
Type of Work: Stoneware (Pottery)
Sources: *AmPoP 231; Decor 220.*

Holden, Katharine
b. 1717 Warwick, RI d. 1807 Cranston, RI
Flourished: 1733 Newport, RI
Type of Work: Fabric (Samplers)
Museums: 241
Sources: *LeViB 65*, 216, 248.*

Holden, Oliver
Flourished: Charlestown, MA
Type of Work: Wood (Ship carvings, ship figures)
Sources: *ShipNA 160.*

Holingsworth, Mary
[Hollingsworth]
Flourished: c1675 Massachusetts
Type of Work: Fabric (Samplers)
Museums: 079
Sources: *AmNe 43*, 46; FoArtC 52*.*

Holland, James
Flourished: c1820 Lumberton, NJ
Type of Work: Fabric (Weavings)
Sources: *ChAmC 71*
See: White, Abel.

Holland, John Frederick
Flourished: Salem, GA
Type of Work: Clay (Pottery)
Sources: *MisPi 26-7; SoFoA 7*, 216.*

Holler, J.
Flourished: 1839
Type of Work: Fabric? (Coverlets?)
Sources: *ChAmC 71.*

Holliman, John
[Holman]
b. 1704 d. c1744
Flourished: c1738 Salem, MA; Boston, MA; Essex County, MA
Type of Work: Oil, stone (Interior paintings, gravestones)
Sources: *AmDecor 8, 40, 151; AmPaF 44; EaAmG 128; GravNE 89, 128.*

Hollinger, Lizzie
Flourished: 1885 Henderson, KY
Type of Work: Fabric (Quilts)
Sources: *KenQu 66-7, fig54-6.*

Hollingsworth, Mary
See: Holingsworth, Mary.

Hollinshead, Mary Ann
b. c1812
Flourished: 1827 Pennsylvania
Type of Work: Fabric (Samplers)
Sources: *GalAmS 70*.*

Hollister, W.R.
Flourished: c1840 Belpre, VA
Type of Work: Stone (Gravestones)
Sources: *EaAmG 129.*

Holloway
See: Foster, Holloway, Bacon and Company.

Holloway, Isabella
Flourished: c1800 New York
Type of Work: Fabric (Embroidered baby dresses)
Sources: *AmNe 78.*

Holly, Ben, Captain
Flourished: c1865 Havre de Grace, MD
Type of Work: Wood (Duck decoys)
Museums: 260
Sources: *Decoy 30.*

Holly, William
Flourished: 1833 Philadelphia, PA
Type of Work: Wood (Ship carvings, ship figures)
Sources: *AmFiTCa 194.*

Holman, John
See: Holliman, John.

Holman, Jonas W.
Flourished: 1833 Boston, MA
Type of Work: Oil (Portraits)
Sources: *PrimPa 174.*

Holmes, Allen E.
Flourished: 1877 Meriden, CT
Type of Work: Tin (Tinware)
Sources: *TinC 171.*

Holmes, Anna Maria
Flourished: 1820 New England,
Type of Work: Ink, needlework (Memorial drawings)
Museums: 215
Sources: *FlowAm 86*.*

Holmes, Benjamin
b. 1843 Stratford, CT d. 1912
Flourished: c1870-1890 Kingston, MA; Stratford, CT
Type of Work: Wood (Sculptures, duck decoys, carvings)
Museums: 176,260
Remarks: Was taught by Albert Laing
Sources: *AmBiDe 66-8*, 207*; AmDecoy xii, 9, 11*; 24*; AmFoS 130*; AmSFo 26; AmSFok 24*; ArtDe 133*; ColAWC 324; Decoy 18*, 41*, 63*; HoKnAm 40; WiFoD 7*, 55*, 97*; WoCar 140, 145.*

Holmes, Bettie
See: Holmes, Mrs. Christian R.

Holmes, Mrs. Christian R. (Bettie)
Flourished: 1936
Type of Work: Fabric (Samplers)
Sources: *AmNe 175*, 178.*

Holmes, Eleazer
Flourished: 1877 Meriden, CT
Type of Work: Tin (Tinware)
Sources: *TinC 171.*

Holmes, Flora Virginia
Flourished: Richmond, VA
Type of Work: Fabric (Samplers)
Museums: 287
Sources: *GalAmS 16.*

Holmes, John
b. 1695
Flourished: Woodstock, CT
Type of Work: Stone (Gravestones)
Sources: *EaAmG 128.*

Holmes, L.W.
Flourished: c1839 Chicago, IL
Type of Work: Tin, copper (Tinware, copperware)
Sources: *ArC 159.*

Holmes, Lothrop T., Captain
b. 1824 d. 1899
Flourished: c1890 Kingston, MA
Type of Work: Wood (Duck decoys)
Sources: *AmBiDe 88-9*; AmSFo 26, 24*; ArtDe 150*; FlowAm 166*; FoA 464; HoKnAm 38*-9.*

Holmes, Obediah
Flourished: 1639 Salem, MA; Peabody, MA
Type of Work: Clay (Pottery)
Sources: *AmPoP 56, 200.*

Holmes and Evans
Flourished: Fisherville, NH
Type of Work: Copper (Copperware)
Sources: *AmCoB 125*.*

Holmes and Roberts
Flourished: 19th century Robertsville, CT
Type of Work: Wood (Chairs)
Sources: *AmPaF 188.*

Holt, Elias
Flourished: Meriden, CT
Type of Work: Tin? (Tinware?)
Remarks: Partner with Lewis, Patrick
Sources: *TinC 171.*

Holton, Chancy
Flourished: c1852 Avon, IL
Type of Work: Wood (Furniture)
Sources: *ArC 150*.*

Holy Mother Wisdom
Ethnicity: Shaker
Type of Work: Ink, watercolor (Spirit drawings)
Sources: *HanWo 172*, 176.*

Holzer, Julius
Flourished: 1870 Philadelphia, PA
Type of Work: Wood (Ship carvings, ship figures)
Sources: *AmFiTCa 194.*

Homer, John
b. 1727 d. c1803
Flourished: 1758-1797 Boston, MA
Type of Work: Stone (Gravestones)
Remarks: Son is William
Sources: *EaAmG 128; GravNE 56, 65-7, 128.*

Homer, William
d. 1822
Flourished: Boston, MA
Type of Work: Stone (Gravestones)
Remarks: Father is John
Sources: *GravNE 65.*

Homer Laughlin China Company
[Laughlin Brothers]
Flourished: 1872-1874 East Liverpool, OH
Type of Work: Clay (Pottery)
Sources: *AmPoP 219; DicM 83*, 107*, 162*, 170*, 176*.*

Honey, John
Flourished: 1860 New York, NY
Type of Work: Wood (Ship carvings, ship figures)
Sources: *AmFiTCa 194.*

Honeywell, Martha Ann
b. 1787 d. 1848
Flourished: 1806-1848 Lampster, MA
Type of Work: Paper (Silhouettes)
Sources: *AmFoPo 126-128*; ArtWo 83, 84*, 85*, 162-3; BoLiC 74-5.*

Hoockey, Hannah
b. 1711
Flourished: 1728 Newport, RI
Type of Work: Fabric (Samplers)
Museums: 205
Sources: *LeViB 60, 62-3*, 248.*

Hood, E.R.
Flourished: Portsmouth, NH
Type of Work: Oil (Landscape paintings)
Sources: *AmPrP 153; PrimPa 174.*

Hood, Washington
Flourished: 1835
Type of Work: Oil (Paintings)
Sources: *PrimPa 174.*

Hook, Solomon
Flourished: 1875-1882 Ono, PA
Type of Work: Redware (Pottery)
Remarks: Son-in-law to Wiley, Martin
Sources: *AmPoP 173.*

Hook, Susan
Flourished: 1835 New England,
Type of Work: Velvet (Theorems)
Sources: *FoPaAm 142, fig9.*

Hooker, Asahel
Flourished: Bristol, CT; Plainville, CT
Type of Work: Tin (Tinware)
Remarks: Sons Ira and Bryan worked with him
Sources: *TinC 171.*

Hooker, Bryan, Captain
Flourished: Bristol, CT
Type of Work: Tin (Tinware)
Remarks: Associated with his father Asahel
Sources: *TinC 171.*

Hooker, Ira
Flourished: Bristol, CT
Type of Work: Tin (Tinware)
Remarks: Worked with his father Asahel
Sources: *TinC 171.*

Hoopes, Lydia
Flourished: 1774 Chester County, PA
Type of Work: Fabric (Samplers)
Sources: *GalAmS 26*.*

Hoopes, Milton
Flourished: 1842-1864 Downingtown, PA
Type of Work: Clay (Pottery)
Sources: *BeyN 126.*

Hooton, Martha C.
b. c1814
Flourished: 1827 Burlington County, NJ?; Pennsylvania
Type of Work: Fabric (Samplers)
Sources: *FlowAm 103*; GalAmS 69*, 92.*

Hoover, Andrew
b. 1802 d. 1877
Flourished: 1837-1849 Hanover, PA
Type of Work: Fabric (Weavings)
Sources: *ChAmC 71.*

Hoover, John
Flourished: Hagerstown, IN
Type of Work: Fabric (Weavings)
Sources: *ChAmC 71*
 See: Test Woolen Mills; Favorite, Elias; Jordan, Thomas .

Hoover, M.
Flourished: Canton, OH
Type of Work: Fabric (Weavings)
Sources: *ChAmC 71.*

Hope, James
b. 1818 or 1819 d. 1892
Type of Work: Oil (Paintings)
Sources: *FoArA 101*.*

Hopeman
Flourished: New York
Type of Work: Fabric (Weavings)
Sources: *AmSQu 276; ChAmC 71.*

Hopkins, John
Flourished: 1834-1840 Seneca County, OH
Type of Work: Stoneware (Pottery)
Sources: *AmPoP 234; Decor 220; DicM 73*; EaAmFo 166*.*

Hopkins, Lucy M.
Flourished: Litchfield, CT
Type of Work: Fabric (Samplers)
Museums: 133
Sources: *AmNe 44.*

Hoppe, Louis
Flourished: 1863 Texas
Type of Work: Watercolor, ink (Frakturs)
Sources: *SoFoA 78*-9*, 218.*

Hopper, Annie
b. 1904
Flourished: c1955-1985 North Carolina
Type of Work: Driftwood, putty (Biblical sculptures)
Sources: *FoAFc 4-5*.*

Hoppin, Davis W.
b. 1771 Providence, RI d. 1882 Providence, RI
Flourished: 1793 Providence, RI
Type of Work: Oil (Masonic and portrait paintings)
Sources: *Bes 41, 48*, 49.*

Hopps, David Vernon
Flourished: 1962 Hogansburg, NY
Type of Work: Beads (Beadwork map of New York)
Museums: 005
Sources: *FouNY 11*, 24, 67.*

Hord, Jacob
b. 1702 d. 1758
Flourished: Boston, MA
Type of Work: Whalebone (Scrimshaw)
Museums: 097
Sources: *ScriSW 200*.*

Horgos, William "Bill"
Flourished: San Francisco, CA
Type of Work: Whalebone (Scrimshaw)
Sources: *Scrim 28*, 106.*

Horn
See: Pierson and Horn .

Horn, Daniel Stephen
Flourished: 1839 Pennsylvania
Type of Work: Watercolor, ink (Frakturs)
Sources: *AmFoPa 188.*

Horn, John
Flourished: c1815 Pittsburgh, PA
Type of Work: Tin (Tinware)
Sources: *AmCoTW 156; ToCPS 7.*

Horn, Samuel
Flourished: c1825-1835 Allentown, PA
Type of Work: Redware (Pottery)
Sources: *AmPoP 162.*

Hornaday, William T.
Flourished: 19th cent
Type of Work: Clay (Statues)
Sources: *Edith.*

Hornbreaker, Henry
Flourished: 1830 St. Clairsville, OH
Type of Work: Fabric (Weavings)
Sources: *ChAmC 71.*

Horner, Gustavus Richard Brown
Flourished: 1852-1865 Warrenton, KY
Type of Work: Oil, watercolor (Paintings)
Sources: *SoFoA 214*, 218*, 223.*

Horner, Nathan Rowley
See: Horner, Roland .

Horner, Roland (Nathan Rowley)
Flourished: c1910 Manahawkin, NJ
Type of Work: Wood (Duck decoys)
Sources: *AmBiDe 28-9*, 130, ; AmDecoy 15*, 41*.*

Horner and Shiveley
Flourished: c1831-1841 New Brunswick, NJ
Type of Work: Flint stoneware (Pottery)
Sources: *AmPoP 172.*

Horsefall, Henry
Flourished: New Lisbon, OH
Type of Work: Fabric (Coverlets)
Sources: *ChAmC 72.*

Horsfield, Israel
[Horsfell]
Flourished: c1816 Windsor, CT
Type of Work: Tin (Tinware)
Remarks: Apprentice to Filley, Oliver; later worked for Augustus
Sources: *AmCoTW 53-55; TinC 171.*

Horshack, Jay
Flourished: 1980- Birmingham, MI
Type of Work: Wood (Duck decoys)
Sources: *WaDec 18.*

Horton, Daniel
Flourished: 1830 New York, NY
Type of Work: Wood (Ship carvings, ship figures)
Sources: *AmFiTCa 194.*

Horton, James
Flourished: 1846 Philadelphia, PA
Type of Work: Wood (Ship carvings, ship figures)
Sources: *AmFiTCa 194.*

Hortter, Amanda Malvina
b. 1818 Philadelphia, PA
Flourished: 1829 Germantown, PA
Type of Work: Fabric (Samplers)
Sources: *GalAmS 71*, 92.*

Hosfield, F
Flourished: Allentown, PA
Type of Work: Fabric (Weavings)
Sources: *ChAmC 72.*

Hosmer, Elizabeth Janes
Flourished: 1822 New York?, NY
Type of Work: Fabric (Samplers)
Sources: *AmNe 62.*

Hosmer, Joseph, Captain
Flourished: 1798-1800 Norwich, CT
Type of Work: Stoneware (Pottery)
Sources: *AmPoP 199; Decor 224.*

Hosmer, Lydia
Flourished: 1810-1820 Concord, MA
Type of Work: Velvet (Mourning paintings)
Sources: *AmNe 83-4*; AmPrP 153; PrimPa 174.*

Hosterman, Anna
Flourished: 1828 Pennsylvania
Type of Work: Fabric (Show towels)
Sources: *HerSa *.*

Hostetler, Nina D.
Flourished: 1925 Emma, IN
Ethnicity: Amish
Type of Work: Fabric (Quilts)
Sources: *QuIInA 47*.*

Hotz, Martin
Flourished: 1882 Philadelphia, PA
Type of Work: Wood (Ship carvings, ship figures)
Sources: *AmFiTCa 194.*

Hough, Catharine Westcot
Flourished: 1839 Bozrah, CT
Type of Work: Fabric (Samplers)
Sources: *GalAmS 83*.*

Hough, E.K.
Flourished: 1850 Vermont
Type of Work: Pastel (Drawings)
Sources: *PrimPa 174.*

Houghenon, Dorothy
Flourished: 1820 Montgomery County, NY
Type of Work: Watercolor (Paintings)
Museums: 163
Sources: *FouNY 65.*

Houghton, Curtis
See: Curtis Houghton and Company.

Houghton, Edward
Flourished: 1800's Bennington, VT; Dalton, OH
Type of Work: Brownware, stoneware (Pottery)
Remarks: Started Curtis Houghton and Company
Sources: *AmPoP 69, 213, 264.*

Houghton, Edwin
Flourished: 1864-1890 Dalton, OH
Type of Work: Stoneware (Pottery)
Remarks: Occasional mark "Dalton Pottery"
Sources: *AmPoP 213, 264; Decor 220; DicM 35**
See: Curtis Houghton and Company.

Houghton, Eugene
Flourished: 1890-1900 Dalton, OH
Type of Work: Stoneware (Pottery)
Sources: *AmPoP 213; Decor 220*
See: Houghton, Edwin; Curtis Houghton and Company.

Housman
Flourished: 1839-1845
Type of Work: Fabric (Weavings)
Remarks: Probably one of the Hausmans
Sources: *AmSQu 276; ChAmC 72.*

How, Joseph
Flourished: 1833 Philadelphia, PA
Type of Work: Wood (Ship carvings, ship figures)
Sources: *AmFiTCa 194.*

Howard
See: Starkey and Howard.

Howard, A.
Flourished: 1855-1862 Columbus, OH
Type of Work: Stone (Gravestones)
Sources: *EaAmG 118*-121, 129.*

Howard, B.
Flourished: 1850 Rumford Point, ME
Type of Work: Pastel (Drawings)
Sources: *PrimPa 174.*

Howard, Bill
Flourished: 1806-1810 New York, NY
Type of Work: Clay (Pottery)
Remarks: Worked for both Crolius and Remmey Potteries
Sources: *EaAmFo 154*.*

Howard, Freeman
Flourished: 1815c Berlin, CT
Type of Work: (Carriage paintings)
Sources: *TinC 171.*

Howard, J.
Flourished: early 19th cent Bridgewater, MA
Type of Work: Metal (Weathervanes)
Sources: *GalAmW 34*, 55*, 69*, 74*, 78*, 89*.*

Howard, Jesse
b. 1885 Shamrock, MO **d.** 1983 Fulton, MO
Flourished: 1953 Fulton, MO
Type of Work: Oil (Signs, bible paintings)
Sources: *FoAFi 3; NaiVis 60-9*; Trans 38, 44*5*, 54; TwCA 162*.*

Howard, Jonathan
See: Jonathan Howard and Company.

Howard, Mary Ann Eliza
b. 1822 **d.** 1874
Type of Work: Oil (Portraits)
Sources: *MisPi 38*.*

Howard, Rebecca F.
Flourished: 1850 Walpole, NH
Type of Work: Pencil (Landscape drawings)
Sources: *PrimPa 174.*

Howard, Thomas
Flourished: 1840 Chester County, PA
Type of Work: Iron (Bar iron banner signs, weathervanes)
Remarks: Brother is William
Sources: *AmFoS 42*-3*; FoScu 36*.*

Howard, William
Flourished: 1840 Chester County, PA
Type of Work: Iron (Bar iron banner signs, weathervanes)
Remarks: Brother is Thomas
Sources: *AmFoS 42*-3*; FoScu 36*.*

Howard and Rodgers
Flourished: c1837 Pittsburgh, PA
Type of Work: Copper (Kettles)
Sources: *AmCoB 82*.*

Howard and Son
Flourished: c1870-1900 Bell City, KY
Type of Work: Stoneware, brownware (Pottery)
Sources: *AmPoP 235.*

Howe, Louise
Flourished: Hadley, MA
Type of Work: Fabric (Quilts)
Museums: 257
Sources: *QuiAm 278*.*

Howell, Elias L.
Flourished: Meriden, CT
Type of Work: Tin (Japanned tinware)
Sources: *TinC 93, 171.*

Howland, Charity
Flourished: 1825
Type of Work: Watercolor (Paintings)
Sources: *PrimPa 174.*

Howland, E.D.
Flourished: 1856 Chicago, IL
Type of Work: Wood (Ship carvings, ship figures)
Sources: *AmFiTCa 194.*

Howland, John
Flourished: 1830s Nantucket, MA
Type of Work: Whalebone (Scrimshaw)
Museums: 186
Sources: *GravF 128**.

Howland, Lucinda
Flourished: 1830 Lisle, NY
Type of Work: Fabric (Weavings)
Museums: 059
Sources: *AmSQu 295**.

Howlett, Dick
Flourished: 1850-1860 Chesapeake Bay, MD
Type of Work: Wood (Duck decoys)
Sources: *AmBiDe 143-4**.

Howson, Bernard
Flourished: 1846-1853 Zanesville, OH
Type of Work: Yellow-ware, Rockingham (Pottery)
Sources: *AmPoP 77, 233-4*.

Howson, John
Flourished: 1846-1874 Zanesville, OH
Type of Work: Yellow-ware (Pottery)
Sources: *AmPoP 234*.

Hoy, David
Flourished: 1840 Walton, NY
Type of Work: Wood (Sculptures, carvings, show wagons, biblical stories)
Museums: 096
Sources: *AmFoS 276*-7**.

Hoyt, Esther
Flourished: 1789 Stamford, CT
Type of Work: Fabric (Coverlets)
Museums: 266
Sources: *AmSQu 238**.

Hoyt, Henry E.
Flourished: 1890 New York
Type of Work: Oil (Theater and sideshow scenes)
Sources: *AmSFor 198*.

Hoyt, Mary Ann
Flourished: 1834 Reading, PA
Type of Work: Fabric (Quilts)
Museums: 097
Sources: *AmSQu 293*; PlaFan 204*; QuiAm 113**.

Hoyt, Thomas
Flourished: 1850 Bangor, ME
Type of Work: Oil (Portraits)
Sources: *AmPrP 153; PrimPa 174*.

Hoyt, Thomas R., Jr.
Flourished: 1835-1845 New Hampshire
Type of Work: Watercolor (Paintings)
Sources: *PrimPa 174*.

Hubard, William James
b. 1807 d. 1862
Flourished: Boston, MA
Type of Work: Paper (Silhouettes)
Sources: *AmPaF 116**.

Hubban, E.A.
Flourished: 1855 Illinois
Type of Work: (Still life paintings)
Sources: *ArC 265*.

Hubbard
Flourished: 1818-1840 Boston, MA; New York
Type of Work: Oil (Portraits)
Sources: *AmPrP 153; PrimPa 174; SoAmP 288*.

Hubbard, Enoch
Flourished: 1877 Meriden, CT
Type of Work: Tin (Tinware)
Sources: *TinC 171*.

Hubbard, John
Flourished: c1812 Berlin, CT; Bloomfield, CT; Rochester, NY
Type of Work: Tin (Tinware)
Remarks: Worked for Filley and J. E. North
Sources: *AmCoTW 81, 114; TinC 171*.

Hubbard, Maria Cadman
b. 1769
Flourished: 1848 Nebraska
Type of Work: Fabric (Quilts)
Sources: *NewDis 32**.

Hubbard, Paul
Flourished: 1876-1877 San Francisco, CA
Type of Work: Wood (Ship carvings, ship figures)
Sources: *ShipNA 93, 155*.

Hubbard, Samuel
Flourished: 1840 Baltimore, MD
Type of Work: Wood (Ship carvings, ship figures)
Sources: *AmFiTCa 194*.

Hubbard, Tryphena Martague
b. 1757
Flourished: Sunderland, MA
Type of Work: Fabric (Quilts)
Museums: 076
Sources: *QuiAm 107-8**.

Hubbard and Root
[Hubbard, John; Root, Lewis]
Flourished: 19th century
Type of Work: Tin (Tinware)
Sources: *TinC 172*.

Hubbard Girls
Flourished: Berlin, CT; Rochester, NY
Type of Work: Tin (Japanned tinware)
Remarks: Daughters of John
Sources: *TinC 158*.

Hubbart, Samuel
Flourished: 1840-1852 Baltimore, MD
Type of Work: Wood (Ship carvings, ship figures)
Sources: *ShipNA 78, 158*.

Hubbell and Cheseboro
Flourished: 1866-1883 Geddes, NY
Type of Work: Stoneware (Pottery)
Museums: 189
Sources: *AmSFo 46*; Decor 208, 220; EaAmFo 211**
See: Geddes Stoneware Pottery.

Hubbs, W.W.
Flourished: c1850 Ripley, IL
Type of Work: Stoneware (Pottery)
Sources: *ArC 193*.

Hubener, Georg(e)
[Huebner]
Flourished: 1787 Montgomery County, PA; Vincent, PA
Type of Work: Clay (Pottery)
Museums: 151,189,227
Sources: *AmPoP 184-5, 264; BeyN 117*; FoArRP 201*; InAmD xviii; PenDA 112*, 114*, 94-5*; PenDuA 28**.

Huber, Damus
Flourished: 1840-1850 Dearborn County, IN
Ethnicity: German
Type of Work: Fabric? (Weavings?)
Remarks: Brother is John
Sources: *AmSQu 276; ChAmC 72*.

Huber, John
b. c1807
Flourished: 1840-1850 Dearborn County, IN
Ethnicity: German
Type of Work: Fabric (Weavings)
Remarks: Brother is Damus
Sources: *AmSQu 276; ChAmC 72*.

Hudders, J.S.
Flourished: 1849 Bucks County, PA
Type of Work: Fabric (Weavings)
Sources: *AmSQu 276; ChAmC 72*.

Hudson, Ira
b. 1876 d. 1949
Flourished: c1925-1940 Chincoteague, VA
Type of Work: Wood (Duck decoys, sculptures, carvings)
Museums: 260
Sources: *AmBiDe 17, 38, 40, 160-3*; AmDecoy xii, 18*, 58*, 95*; AmFoArt 93*; AmFoS 298*; ArtDefig; Decoy 26*, 69**.

Hudson, Samuel Adams
b. 1813 d. 1894
Type of Work: Oil (Paintings)
Sources: *FoArA 96**.

Hudson, William, Jr.
Flourished: 1820-1830 Boston, MA
Ethnicity: English
Type of Work: Oil (Portraits)
Sources: *AmPrP 153; NeaT 119*; PrimPa 174*.

Hudson Decoy Plant
Flourished: c1920s Pascagoula, MS
Type of Work: Wood (Duck decoys)
Sources: *AmBiDe 229.*

Hudson River Pottery
Flourished: c1830 New York, NY
Type of Work: Clay (Pottery)
Sources: *AmPoP 54, 197; EaAmFo 181*.*

Huebner, Abraham
b. 1772 d. 1818
Flourished: Pennsylvania
Type of Work: Watercolor, ink (Frakturs)
Sources: *AmFoPa 188.*

Huebner, George
See: Hubener, George.

Huebner, Henrich
Flourished: 1843 Pennsylvania
Type of Work: Watercolor, ink (Frakturs)
Sources: *AmFoPa 188.*

Huebner, Susanna
Flourished: 1806-1828 Pennsylvania
Type of Work: Watercolor, ink (Frakturs)
Sources: *AmFoPa 188.*

Huff, Celesta
Flourished: 1875-1889 Norway, ME
Type of Work: Oil (Portraits)
Museums: 050
Sources: *ArtWo 108*, 163; NinCFo 167, 181, fig47.*

Huffman, Barry G.
b. 1943 Georgia
Flourished: Hickory, NC
Type of Work: Oil (Paintings)
Sources: *FoAFn 15*.*

Huge, I.F.
See: Huge, Jurgan Frederick.

Huge, Jurgan Frederick (Friedrick; Fredrick)
b. 1809 d. 1878
Flourished: 1838-1878 Bridgeport, CT
Ethnicity: German
Type of Work: Oil, watercolor (Ship portraits, scene paintings)
Museums: 142
Sources: *AmFoPa 109, 111, 116, 119, 128; AmFoPaCe 110-5*; AmPrP 153; FoA 464; HoKnAm 160*; NinCFo 167, 195, fig144; PicFoA 118*; PrimPa 174; RediJFH.*

Huggins, Samuel, Jr.
Flourished: 1830s Nantucket, MA
Type of Work: Whalebone (Scrimshaw)
Museums: 186
Sources: *GravF 43.*

Huggins and Company
Flourished: c1870-1880 Lakenan, MO
Type of Work: Redware (Pottery)
Sources: *AmPoP 222; Decor 220.*

Hughes
Flourished: c1850 Granville, OH
Type of Work: Stone (Gravestones)
Sources: *EaAmG 129.*

Hughes, Charles Edward, Jr.
Flourished: 1899 Lakeland, KY
Type of Work: Colored pencil (Drawings)
Sources: *SoFoA 71*, 218.*

Hughes, Daniel
Flourished: c1780 Elk Ridge Landing, MD
Type of Work: Clay (Pottery)
Sources: *AmPoP 167.*

Hughes, Robert Ball
Flourished: 1830 Boston, MA
Type of Work: Oil (Portraits)
Sources: *AmPrP 153; PrimPa 174; SoAmP 291.*

Hughes, Thomas
Flourished: 1812-1825 Salem, OH
Type of Work: Stoneware (Pottery)
Sources: *AmPoP 68, 230; Decor 220.*

Hught, E.
Flourished: c1850 Hebron, OH
Type of Work: Stone (Gravestones)
Sources: *EaAmG 129.*

Huguenin, George
d. 1882
Flourished: Newfoundland, PA
Type of Work: Wood (Figures)
Sources: *EaAmW 105.*

Hull, John L.
Flourished: 19th century Killingworth, CT
Type of Work: Wood (Chairs)
Sources: *AmPaF 188.*

Hull, Lee
Flourished: South Royalton, VT
Type of Work: Oil (Paintings)
Sources: *FoAFm 2.*

Hull, Lewis
Flourished: 1831 New Holland, PA
Type of Work: Fabric (Weavings)
Sources: *ChAmC 72.*

Hull, Mathias
Type of Work: Fabric (Weavings)
Sources: *AmSQu 276; ChAmC 72.*

Hull and Stafford
Flourished: 1850s Clinton, CT
Type of Work: Tin (Tinware)
Sources: *TinC 81, 139*, 143*, 172.*

Hulme
See: Tucker and Hulme.

Humble, John
Flourished: c1840 Cincinnati, OH
Type of Work: Stone (Gravestones)
Sources: *EaAmG 129.*

Hume, Joseph
Flourished: c1850-1876 Bernville, PA
Type of Work: Redware (Pottery)
Sources: *AmPoP 164.*

Humistown and Walker
Flourished: 1826-1835 South Amboy, NJ
Type of Work: Stoneware (Pottery)
Sources: *AmPoP 180.*

Humiston, Orcutt and Company
See: Orcutt, Humiston and Company.

Humphrey, Harrison
Flourished: 1907-1912 Monhegan Island, ME
Type of Work: Metal (Ornamental works)
Sources: *AmFoS 322*.*

Humphrey, Hiram
Flourished: 1822 Bloomfield, CT
Type of Work: Tin (Tinware)
Remarks: Worked for Filley, Oliver
Sources: *AmCoTW 59; TinC 172.*

Humphrey, Maria Hyde
Flourished: 1840 Ohio
Type of Work: Watercolor (Paintings)
Sources: *PrimPa 174.*

Humphreys, Jane
b. c1759
Flourished: 1771 Philadelphia, PA
Type of Work: Fabric (Samplers)
Sources: *AmNe 53.*

Humphreys, S.
Flourished: 1835 Bethany, NY
Type of Work: Fabric (Weavings)
Sources: *AmSQu 276; ChAmC 72.*

Humsicker, Christian
Flourished: c1800 Hamburg, PA
Type of Work: Redware (Pottery)
Sources: *AmPoP 169.*

Hundley, Joe Henry
Flourished: c1920 Axton, VA
Type of Work: Wood (Carved fiddle)
Sources: *SoFoA 124*, 220.*

Hunneman, William C.
Flourished: c1798-1845 Boston, MA
Type of Work: Copper (Warming pans)
Sources: *AmCoB 88, 129, 153, 155-156*, 207.*

Hunt, Ben
Flourished: 1900 Duxbury, MA
Type of Work: Wood (Duck decoys)
Museums: 260
Sources: *AmFokA 41*; Decoy 75*.*

Hunt, Content
b. 1791 Norton, MA d. 1816 Norton?, MA?
Flourished: 1799 Warren, RI
Type of Work: Fabric (Samplers)
Sources: *LeViB 215, 232*.*

Hunt, D.W. Lewis
Flourished: 1845 East Boston, MA
Type of Work: Wood (Ship carvings, ship figures)
Sources: *ShipNA 160.*

Hunt, Elisha
Flourished: 1855 Bloomington, IL
Type of Work: Paint (Portraits)
Sources: *ArC 265.*

Hunt, John
Flourished: 1890-1900 Rusk County, TX
Type of Work: Stoneware (Jars)
Sources: *AmS 86*, 98*.*

Hunt, Peter "Pa"
b. 1870 d. 1934
Flourished: 1912 Provincetown, MA
Type of Work: Oil (Cityscape paintings)
Museums: 171
Sources: *FoPaAm 100*; PrimPa 175; ThTaT 224-6*.*

Hunt, William
Flourished: 1734-1737 Philadelphia, PA
Type of Work: Wood (Ship carvings, ship figures)
Sources: *AmFiTCa 47, 194; ShipNA 6, 163.*

Hunter, Clementine
b. 1885 Natchitoches, LA
Flourished: Natchitoches Parish, LA
Ethnicity: Black American
Type of Work: Oil (Genre, memory paintings)
Museums: 015,137
Sources: *AmFokArt 118-9*; ArtWo xii, 134-5*, 163; FoA 464; FoAFc 16; FoAFw 14-5*, 33*; FoPaAm 174-5, 184*; HoKnAm 190-1; TwCA 63*.*

Huntington, Caleb
b. 1749 d. 1842
Flourished: Norwich, CT
Type of Work: Stone (Gravestones)
Sources: *EaAmG 128.*

Huntington, Dyer
Flourished: -1851 New York
Type of Work: Watercolor (Paintings)
Museums: 120
Sources: *FouNY 66.*

Huntington, Edwin
b. c1829 New York
Flourished: Wolcott, NY
Type of Work: Fabric (Weavings)
Sources: *ChAmC 72*
See: Conger, Daniel .

Huntington, J.C.
Flourished: 1920- Sunbury, PA
Type of Work: Watercolor (Paintings)
Sources: *FoPaAm 141-2*; TwCA 140*.*

Huntington, John
b. 1705 d. 1777
Flourished: Lebanon, CT
Type of Work: Stone (Gravestones)
Sources: *EaAmG 128.*

Huntington, Julie Swift
Flourished: 1830 Windham, CT
Type of Work: Fabric (Bedcovers)
Sources: *AmNe 42*.*

Huntting, Marcy
b. 1781
Flourished: 1800 East Hampton, NY
Type of Work: Fabric (Coverlets)
Sources: *ArtWea 132*.*

Hupendon, Ernest
Flourished: Valton, WI
Type of Work: Paint (Murals)
Sources: *FoAFl 4.*

Hurd, Jacob
Flourished: 1730-1740
Type of Work: Gold (Boxes)
Museums: 272
Sources: *NeaT 83.*

Hureau, Madame E.
Flourished: 1889 New Orleans, LA
Ethnicity: French
Type of Work: Fabric (Embroidery and applique on capes)
Museums: 137
Sources: *AmNe 135*, 137.*

Hurley, George
Flourished: 1810 New York, NY
Type of Work: Wood (Ship carvings, ship figures)
Sources: *AmFiTCa 194.*

Hurst, John W.
b. 1905 Maldrum, KY
Flourished: 1959- Kentucky
Type of Work: Wood (Carvings)
Sources: *FoAroK *; GoMaD *.*

Hurst, T.W.
b. 1899 Bell County, KY
Flourished: 1960- Kentucky
Type of Work: Wood, paint (Carvings, paintings)
Sources: *FoAroK *.*

Hurxthal, Isabel Hall
Flourished: 1835
Type of Work: Fabric (Appliqued linens)
Museums: 147
Sources: *AmSFok 114*.*

Hustace, Maria
b. 1803
Flourished: 1825 New York, NY
Type of Work: Fabric (Wedding veils)
Museums: 184
Sources: *AmNe 70-1*.*

Hutchinson, Ebenezer
Flourished: c1815 Lyndeboro, NH; Vermont
Type of Work: Redware (Pottery)
Sources: *AmPoP 195.*

Hutchinson, John A.
Flourished: 1887
Type of Work: Clay (Sewer tile sculpture)
Sources: *IlHaOS *.*

Hutchinson, William
Flourished: c1815 St. Johnsbury, VT
Type of Work: Redware (Pottery)
Sources: *AmPoP 202.*

Huth, Abraham
Flourished: 1820-1840 North Lebanon, PA
Type of Work: Watercolor, ink (Frakturs)
Sources: *AmFoPa 188*; BeyN 124.*

Hutson, Charles Woodward
b. 1840 d. 1935?
Flourished: New Orleans, LA
Type of Work: Oil (Paintings)
Sources: *PrimPa 174; ThTaT 160-5*; TwCA 63*.*

Hutton, Christopher
Flourished: 1777 Oneida County, NY
Type of Work: Bone (Powderhorns)
Museums: 163
Sources: *FouNY 62.*

Hyde de Neuville, Baroness
Flourished: 1810
Type of Work: Watercolor (Street scene paintings)
Museums: 202
Sources: *ArtWod 15-6*; HoKnAm 157-9*.*

Hyssong, C.B.
Flourished: c1870-1900 Cassville, PA
Type of Work: Stoneware (Pottery)
Sources: *AmPoP 209; Decor 220.*

I

I.M. Meed and Company
Flourished: 1840-1850 Atwater, OH
Type of Work: Stoneware (Pottery)
Sources: *AmPoP 208; Decor 221; DicM 67**.

I. Meed and Company
See: I.M. Meed and Company.

I. Seymour and Company
See: Seymour, Israel.

I.W. Craven and Company
Flourished: 1855 Red Mound, TN
Type of Work: Stoneware (Pottery)
Sources: *SoFoA 21*, 217*.

Ide, Mary
b. 1790 Seekonk, MA d. 1817 Hopkinton?, MA?
Flourished: 1808 Providence, RI
Type of Work: Embroidery, paint (Mourning pictures, portraits)
Museums: 173
Sources: *LeViB 108, 204-5, 259*.

Ideal Pottery
Flourished: c1930 Dallas, TX
Type of Work: Stoneware (Churns)
Sources: *AmS 94**.

Ihmsen, Charles
See: Birmingham Glass Works.

Iler, William
Flourished: c1819 Cincinnati, OH
Type of Work: Clay (Pottery)
Sources: *AmPoP 67, 210*.

Iliff, Richard
Flourished: 1806-1820 Hillsboro, OH; Eagle Springs, OH
Type of Work: Stoneware (Pottery)
Sources: *AmPoP 213, 221; Decor 220*.

Illions, Marcus Charles
Flourished: 1888-1928 Brooklyn, NY
Type of Work: Wood (Carousel, other figures)
Sources: *AmSFor 18*, 22*, 24*, 185*; CaAn 9-10, 38-43**.

Immon Markell and Company
See: Markell, Immon and Company.

Impson, Jacob
Flourished: 1832-1845 Cortland County, NY
Type of Work: Fabric (Coverlets)
Sources: *AmSQu 276; ChAmC 72*.

Imsweller, Henry
Flourished: 1804-1805 York, PA
Type of Work: Fabric (Coverlets)
Sources: *ChAmC 72*.

Inabet, Mike
Flourished: Maiden Rock, WI
Type of Work: Wood (Cigar store Indians, figures)
Sources: *CiStF 27*.

Ingalls, C(yrus) A.
Flourished: 1856-1871 Bath, ME; Hoboken, NJ
Type of Work: Wood (Ship carvings, ship figures)
Sources: *AmFiTCa 194; ShipNA 156*.

Ingalls, Walter
b. 1805 New Hampshire d. 1874
Flourished: 1850s New Hampshire; Chicago, IL
Type of Work: Oil (Portraits, still life and scene paintings)
Remarks: Itinerant
Sources: *AmPrP 153; AmSFo 44; ArC 265; MisPi 26; PrimPa 175*.

Ingell, Jonathan W.
Flourished: c1830-1850 Taunton, MA
Type of Work: Stoneware (Pottery)
Sources: *Decor 220*.

Inger, J. Fritz
[J. Fritzinger]
Flourished: 1845 Allentown, PA
Type of Work: Fabric (Weavings)
Sources: *ChAmC 72*.

Ingersoll, John
b. 1788 d. 1815
Flourished: Haverhill, MA
Type of Work: Watercolor (Paintings)
Sources: *PrimPa 175*.

Ingersoll, John Gage
b. 1815
Flourished: Bradford, MA
Type of Work: Oil (Paintings)
Sources: *PrimPa 175*.

Ingersoll, W.S.
Flourished: c1845 Cincinnati, OH
Type of Work: Stone (Gravestones)
Sources: *EaAmG 129*.

Ingham, David
b. 1800 d. c1891 Tioga County, PA
Flourished: 1841-1868 Bradford County, PA
Ethnicity: English
Type of Work: Fabric (Weavings)
Sources: *AmSQu 277; ChAmC 72*
See: Monroeton Woolen Factory.

Ingles, Thomas
Flourished: c1844-1860 Manchester, NH
Type of Work: Clay (Artware pottery)
Sources: *AmPoP 195*.

Ingraham, Mary L.
Flourished: 1810 Massachusetts
Type of Work: Oil (Paintings)
Sources: *AmFoAr 29; AmPrP 153; PrimPa 175*.

Ingraham, Peggy
b. 1778 Providence, RI d. 1818 Providence?, RI?
Flourished: 1790 Bristol, RI
Type of Work: Fabric (Samplers)
Sources: *LeViB 213-4, 220, 223**.

Inman, Henry
b. 1801 d. 1846
Type of Work: Paint (Landscape paintings)
Sources: *ArC 213*.

International Pottery Company
Flourished: 1870 Trenton, NJ
Type of Work: Clay (Pottery)
Sources: *DicM 18**.

Irish, Tom
b. 1950 Springville, NY
Flourished: 1969- New York
Type of Work: Oil (Paintings)
Sources: *FoAFf 12*-3**.

Irvin, James
[Irwin]
Flourished: c1838-1854 Pulaski, NY
Type of Work: Fabric (Weavings)
Sources: *ChAmC 73*
See: Irwin, L.

Irvine, Eldon
b. 1909 Rusell County, KY
Flourished: contemporary Kentucky
Type of Work: Wood (Whirligigs, yard art)
Sources: *FoAroK **.

Irving, Clarabelle
Flourished: 1934 Albuquerque, NM
Ethnicity: American Indian
Type of Work: Fabric (Samplers)
Remarks: Member of the Hopi Indian tribe
Sources: *AmNe 175*, 178*.

Irving, George
Flourished: c1870
Type of Work: Wood (Puppets)
Sources: *EaAmW figxi**.

Irwin, Harvey
b. Ohio
Flourished: 1844 Ripley, IL
Type of Work: Clay (Pottery)
Sources: *ArC 190*.

Irwin, Joseph
Flourished: 1860 Philadelphia, PA
Type of Work: Wood (Ship carvings, ship figures)
Sources: *AmFiTCa 194*.

Irwin, L.
Flourished: c1838-1859 Pulaski, NY
Type of Work: Fabric (Weavings)
Sources: *AmSQu 277; ChAmC 73*
See: Irvin, James.

Isaac Fowle and Company
See: Fowle, Isaac.

Isaac Smith and Thomas Lee
Flourished: New Britain, CT
Type of Work: Tin (Tinware)
Remarks: Co-owned a tin shop; brothers-in-law
Sources: *TinC 173, 181*.

Isaac Wright and Company
Flourished: 1828-1838 Hartford, CT
Type of Work: Wood (Cabinets, chairs)
Museums: 054
Sources: *AmPaF 224**.

Isham, John
b. 1757 d. 1834
Flourished: Middle Haddam, CT
Type of Work: Stone (Gravestones)
Sources: *EaAmG 128*.

Isherwood, Henry
Flourished: c1837 Chicago, IL
Type of Work: Paint (Scene paintings)
Sources: *ArC 160*.

Isroff, Lola K.
b. 1920 New York, NY
Flourished: New York, NY; Akron, OH
Type of Work: Oil (Scene paintings)
Sources: *AmFokArt 120-1**.

Ithaca Carpet Factory
See: Davidson, Archibald.

Ives
See: Goodrich, Ives and Rutty Co.

Ives, Chauncey B.
Flourished: 1836 Boston, MA
Type of Work: Wood (Ship carvings, ship figures)
Sources: *AmFiTCa 194*.

Ives, Ira
Flourished: Red Stone Hill, CT
Type of Work: Tin (Tinder boxes)
Sources: *TinC 172*.

Ives, Julius
Flourished: c1849 Meriden, CT
Type of Work: Iron (Inkstands)
Remarks: Employed 3 people
Sources: *TinC 172*.

Ives and Curran
Flourished: 1854 Springfield, IL
Type of Work: Wood (Furniture)
Sources: *ArC 175**.

Ivy, Virginia Mason
Flourished: 1856 Russellville, KY
Type of Work: Fabric (Quilts)
Museums: 263
Sources: *QuiAm 57-8, 187-89**.

J

J.A. and L.W. Underwood
Flourished: c1860-1880 Fort Edward, NY
Type of Work: Stoneware (Pottery)
Museums: 203
Sources: *Decor 110*, 225.*

J. and E. Norton
[Bennington and Norton; J. and K. Norton]
Flourished: 1839-1894 Bennington, VT
Type of Work: Stoneware (Jugs)
Museums: 097,203,260
Remarks: Great grandsons of Captain John
Sources: *AmPoP 188, 273; AmS 34*, 59*; AmSFo 47, 51; BeyN 121; Decor 82*, 85*, 101*, 125*, 131*, 145*, 210*, 222;DicM 70*.*

J. and K. Norton
See: J. and E. Norton .

J.B. and G.L. Mesker and Company
Flourished: 1877-1891 Evansville, IN; St. Louis, MO
Type of Work: Metal (Weathervanes)
Sources: *YankWe 212.*

J.B. Owens Pottery Company
Sources: *DicM 62*, 100**
See: Owens, J.B.

J. Bentley Sons
Flourished: Philadelphia, PA
Type of Work: Copper (Saucepans)
Sources: *AmCoB 95*.*

J.C. Waelde Pottery
Flourished: 1851-1876 North Bay, NY
Type of Work: Clay (Pottery)
Sources: *FouNY 63.*

J. Clark and Company
Flourished: c1840-1850 Troy, NY
Type of Work: Stoneware (Pottery)
Sources: *Decor 139, 217.*

J. Cook Pottery Company
See: Cook Pottery Company .

J.E. Bolles and Company
Flourished: 1884 Detroit, MI
Type of Work: Metal (Weathervanes)
Sources: *YankWe 210.*

J.E. Jeffords and Company
Flourished: c1868-1875 Philadelphia, PA
Type of Work: Rockingham (Pottery)
Sources: *AmPoP 46, 177, 265; DicM 252*.*

J.E. North
See: Hubbard, John .

J. Harris and Sons
See: A.J. Harris and Company .

J.J. Hart Pottery
Flourished: 1869-1872 St. Lawrence, NY; Ogdensburg, NY
Type of Work: Clay (Pottery)
Sources: *FouNY 63*
See: W. Hart Pottery; C. Hart and Company Pottery .

J.L. Mott Iron Works
Flourished: 1875-1939 New York, NY
Type of Work: Metal (Weathervanes)
Sources: *AmFokAr 51; ArtWe 17, 32*; ArtWod 59, 75; YankWe 180*, 212.*

J.M. Burney and Sons
Flourished: 1850-1870 Jordan, NY
Type of Work: Stoneware (Pottery)
Museums: 217
Sources: *Decor 102*, 217.*

J.M. Hays Wood Products Company
Flourished: c1920s Jefferson County, MO
Type of Work: Wood (Duck decoys)
Sources: *AmBiDe 230.*

J.N. Dodge Factory
[Dodge Decoy Factory]
Flourished: 1869-1899 Detroit, MI
Type of Work: Wood (Duck decoys)
Museums: 260
Sources: *AmBiDe 206*, 209-15*; AmDecoy xi*; ArtDe 137*; Decoy 43*, 56*; WiFoD 89*
See: Dodge, Jasper N.

J. Patterson and Company
Flourished: c1887 Wellsville, OH
Type of Work: Yellow-ware (Pottery)
Sources: *AmPoP 232.*

J.S. Anderson and Son
Flourished: 1857-1858 New York, NY
Type of Work: Wood (Ship carvings, ship figures)
Remarks: Son is John
Sources: *ShipNA 66, 162*
See: Anderson, Jacob S.

J.S. Hogeland and Son
Flourished: 1856 Lafayette, IN
Type of Work: Fabric (Weavings)
Sources: *AmSQu 276.*

J.S. Taft and Company
[Hampshire Pottery]
Flourished: c1875 Keene, NH
Type of Work: Clay (Pottery)
Sources: *AmPoP 194, 281; DicM 59*, 75*, 169**
See: Taft, James Scholly .

J. Sage and Company
Flourished: c1870 Cortland, NY
Type of Work: Stoneware (Pottery)
Sources: *AmPoP 191; Decor 223.*

J. Swank and Company
Flourished: c1870 Johnstown, PA
Type of Work: Stoneware (Pitchers)
Sources: *AmS 104*, 169*.*

J(ohn) W. Banta and Company
Flourished: 1855 New York, NY
Type of Work: Wood (Ship carvings, ship figures)
Sources: *AmFiTCa 187.*

J.W. Fiske (Ironworks)
Flourished: 1870-1893 New York, NY
Type of Work: Metal (Weathervanes)
Museums: 260
Sources: *AlAmD* 56*; *AmFoS* 55*, 62*, 144*, 260; *ArtWe* 17-8, 32-3*, 49*, 59*, 114*, 139-40*; *CoCoWA* 110*, 119; *FoA* 170*, 464; *GalAmW* 18*, 73*, 78*; *HoKnAm* 171*; *InAmD* 74, 77*; *WeaVan* 10-1, 23, 47-50, 87, 95, 115, 123, 133-5, 175-6*, 185.

J.W. Fiske (Ironworks) (Continued)
Sources: *WeaWhir* 71, 90*, 135-6*, 186; *YankWe* 38*, 211.

J.W. Gleason and Sons
See: Gleason, Benjamin A.

Jabez Peck and Company
Type of Work: Tin (Tinware)
Remarks: Two brothers, Oliver and Jabez ran company
Sources: *TinC* 177.

Jackson, Anne Wakely
Flourished: c1834 Jacksonville, IL
Type of Work: Pen, ink (Sketches)
Sources: *ArC* 108*.

Jackson, C.A.
See: C.A. Jackson and Company.

Jackson, Charles Thomas
b. 1805 d. 1880
Type of Work: Watercolor (Paintings)
Museums: 140
Sources: *FoArA* 91*.

Jackson, Henry
Flourished: Chicago, IL
Type of Work: Poster paint (Drawings of Christ)
Sources: *FoAFm* 2; *TwCA* 156*.

Jackson, J.
Flourished: c1840 Chicago, IL
Type of Work: Pen, ink (Sketches)
Sources: *ArC* 163*.

Jackson, John Hamilton
[Hamelton]
Flourished: 1840, 1859 Pennsylvania
Type of Work: Fabric? (Weavings?)
Remarks: Could be John Hamilton of Jackson County PA
Sources: *AmSQu* 277; *ChAmC* 73.

Jackson, Joseph
Flourished: 1830 New York, NY
Type of Work: Wood (Ship carvings, ship figures)
Sources: *AmFiTCa* 194.

Jackson, Joseph H.B.
Flourished: 1845 New York, NY
Type of Work: Wood (Ship carvings, ship figures)
Sources: *AmFiTCa* 194.

Jackson, Mary
Flourished: 1788 Reading, PA
Ethnicity: Quaker
Type of Work: Fabric (Samplers)
Sources: *AmNe* 53, 60*.

Jackson, Samuel
Flourished: 1820 Pennsylvania
Type of Work: Watercolor, ink (Frakturs)
Sources: *FoPaAm* 134*.

Jackson, Samuel
Flourished: 1800-1830 Montgomery County, NY
Type of Work: Wood (Windsor rockers)
Museums: 163
Sources: *FouNY* 62.

Jackson, Samuel
Flourished: 1868-1879 East Liverpool, OH
Type of Work: Clay (Pottery)
Sources: *AmPoP* 219.

Jackson, Thomas
b. c1815
Flourished: 1850 Lafayette, IN
Ethnicity: English
Type of Work: Fabric (Weavings)
Sources: *ChAmC* 73
See: Hoagland, James S.

Jackson, Thomas
Flourished: 1843-1847 New Brighton, PA
Type of Work: Redware (Pottery)
Sources: *AmPoP* 225.

Jacob, K.S.
Type of Work: Watercolor (Paintings)
Museums: 176
Sources: *ColAWC* 230-1*.

Jacob Anderson and Company
Flourished: 1830-1833 New York, NY
Type of Work: Wood (Ship carvings, ship figures)
Sources: *AmFiTCa* 186; *ShipNA* 162
See: Anderson, Jacob; J.S. Anderson and Son.

Jacobi, J.C.
Flourished: 1851
Type of Work: Watercolor (Scene paintings)
Museums: 176
Sources: *ColAWC* 161.

Jacobs, A. Douglas
Flourished: Long Island, NY
Type of Work: Whalebone (Scrimshaw)
Museums: 123
Sources: *Scrim* 28*.

Jacobsen, Antonio
b. 1849 d. 1921
Flourished: c1870 New York, NY; Hoboken, NJ
Ethnicity: Danish
Type of Work: Oil (Ship paintings)
Museums: 006,203
Sources: *AmFoPa* 1, 114-6*; *AmSFo* 7, 16-21*; *FoA* 62*, 464.

Jaeckel, Christoph
Flourished: 1772 Pennsylvania
Type of Work: Watercolor, ink (Frakturs)
Sources: *AmFoPa* 188.

Jaeger, Michael
Flourished: Southbury, CT
Type of Work: Wood (Bird sculptures, carvings)
Sources: *WoCar* 165-7*.

Jaegglin, E.A.
Flourished: 1880-1896 Booneville, MO
Type of Work: Stoneware (Jugs)
Remarks: May be the same as Jegglin Pottery
Sources: *AmS* 76*.

Jager, Joseph
Flourished: 1857-1882 Peoria, IL
Type of Work: Stoneware (Pottery)
Sources: *ArC* 194.

Jakobsen, Kathy (Katherine)
b. 1952? Wyandotte, MI
Flourished: 1978- Ishpeming, MI; New York, NY
Type of Work: Acrylic, oil (Paintings)
Museums: 096,171,263
Sources: *AmFokArt* 122-6*; *FoA* 43*, 464; *FoPaAm* 215, fig63.

James, Boyd
Flourished: 1830-1836 Boston, MA
Type of Work: Leather (Boxes)
Sources: *NeaT* 36-9*.

James, D.C.
Flourished: c1860-1880 Greensboro, PA
Type of Work: Stoneware (Sculptures)
Museums: 097
Sources: *Decor* 189*.

James, Isaac
Flourished: 1851 Baltimore, MD
Type of Work: Wood (Ship carvings, ship figures)
Sources: *AmFiTCa* 194.

James, Rachel
Flourished: 1811 Philadelphia, PA
Type of Work: Fabric (Samplers)
Sources: *GalAmS* 47*, 91.

James, Ruth
Flourished: 1800 Westtown, PA
Type of Work: Fabric (Samplers)
Sources: *GalAmS* 35*.

James, Sarah H.
Flourished: 1820 Westtown, PA
Ethnicity: Quaker
Type of Work: Fabric (Samplers)
Sources: *AmNe 52*, 54.*

James, Thomas R.
See: Bracken and James.

James, Webster
Flourished: 1782-1788 Norwich, CT; Hartford, CT
Type of Work: Paint (Sign and miniature paintings)
Sources: *MoBBTaS 13.*

James E. Jones and Brother
See: Jones, James E.

James Hamilton and Company
See: Hamilton, James.

James Robertson and Sons
Flourished: c1872-1880 Chelsea, MA
Type of Work: Redware (Pottery)
Sources: *AmPoP 190; DicM 113*.*

Jamison, J.S.
Flourished: 1843 Pennsylvania
Type of Work: Watercolor, ink (Frakturs)
Sources: *AmFoPa 188.*

Janes, Alfred
Flourished: 1805 Hartford, CT
Type of Work: Paint, wood (Signs)
Remarks: Worked with Janes, Almarin
Sources: *MoBBTaS 12*
See: Bull, John C.

Janes, Almarin
See: Janes, Alfred.

Janes and Bull
See: Bull, John C.

Janey, Jacob
Flourished: c1794 Nockamixon Township, PA
Type of Work: Clay (Pottery)
Museums: 189
Sources: *DicM 70*; FoArRP 24*.*

Jansen, Frederick William
Flourished: 1835-1840 Quincy, IL
Ethnicity: German
Type of Work: Wood (Furniture)
Sources: *ArC 135, 172*.*

Janvier, George Washington
Flourished: 1820-1840 Delaware
Type of Work: Watercolor, ink (Historical drawings)
Sources: *BeyN 123.*

Jaramillo, Juanita
b. 1949 Taos, NM
Flourished: 1977 Taos, NM
Ethnicity: Hispanic
Type of Work: Fabric, oil (Weavings, murals)
Sources: *HisCr 23*, 102*.*

Jardalla, Joseph
Flourished: 1802 Philadelphia, PA
Type of Work: Wood (Ship carvings, ship figures)
Sources: *AmFiTCa 194.*

Jarvie, Unto
b. 1908
Flourished: 1971- Auburn, KY
Ethnicity: Finnish
Type of Work: Wood (Carvings)
Sources: *FoAroK *; GoMaD *.*

Jas. Hamilton Company
See: Hamilton, James.

Jeffers, James T.
Flourished: 1854 Charlestown, MA
Type of Work: Wood (Ship carvings, ship figures)
Sources: *AmFiTCa 194.*

Jefferson, Mannie Holland
Flourished: 1860 Emerson, GA
Type of Work: Fabric (Quilts)
Sources: *MisPi 77*.*

Jefferson, Thomas
b. 1743 Albemarle (Goochland) County, VA d. 1826 Albemarle County, VA
Flourished: after 1796 Monticello, VA
Type of Work: Wood, metal (Wind indicators, compasses)
Museums: 279
Remarks: Third President of the United States
Sources: *GalAmW 14*; WeaWhir 5, 58*.*

Jeffords, J.E.
See: J.E. Jeffords and Company.

Jeffries, David
Flourished: c1765 Elizabeth, NJ
Type of Work: Stone (Gravestones)
Sources: *AmFoS 16*; EaAmG 126*, 129.*

Jeffries, Deborah Hunt
Flourished: c1791 Wilmington, DE
Type of Work: Fabric (Linen baby caps)
Sources: *PlaFan 29*.*

Jeffries, Theodore
Flourished: early 20th cent Newark, OH
Type of Work: Wood (Sculptures, carvings)
Sources: *AmFoS 120*.*

Jeffries, W.P.
Flourished: c1840 Cincinnati, OH
Type of Work: Stone (Gravestones)
Sources: *EaAmG 129.*

Jegglin Pottery
[E.A. Jegglin]
Flourished: 1867?-1896? Boonville, MO
Type of Work: Clay (Pottery)
Remarks: May be the same as Jaegglin, E.A.
Sources: *ASeMo 462*, 464*.*

Jeliff, John
b. 1813 d. 1893
Flourished: Newark, NJ
Type of Work: Wood (Sculptures, carvings)
Sources: *AmFoS 170*.*

Jenison, J.
Flourished: Stark County, OH
Type of Work: Fabric (Coverlets)
Sources: *ChAmC 73.*

Jenkins, A.
Flourished: c1840-1850 Columbus, OH
Type of Work: Stoneware (Pottery)
Sources: *AmPoP 212; Decor 220.*

Jenkins, H.
Flourished: 1850
Type of Work: Oil (Portraits)
Sources: *AmPrP 153; PrimPa 175.*

Jenner, Augie
Flourished: 1950s Mount Clemens, MI
Type of Work: Wood (Fish decoys)
Remarks: Father is Jenner, Hans, Sr.; brother is Hans, Jr.
Sources: *UnDec 18*.*

Jenner, Hans, Sr.
Flourished: 1930s Mount Clemens, MI
Type of Work: Wood (Fish decoys)
Remarks: Sons are Augie and Hans
Sources: *UnDec 16*, 20*, 22*, 19*.*

Jenner, Hans, Jr.
Flourished: 1950s Mount Clemens, MI
Type of Work: Wood (Fish decoys)
Remarks: Brother is Augie; father is Hans
Sources: *UnDec 20.*

Jenney, N.D.
Flourished: 1850 Portland, ME
Type of Work: Oil (Portraits)
Sources: *AmPrP 153; PrimPa 175.*

Jennings, A.
See: A. Jennings Pottery.

Jennings, J.S.
Flourished: 1850 New Hudson, NY
Type of Work: Oil (Paintings)
Sources: *AmPrP 153, fig44; PrimPa 175.*

Jennison, Mary
b. c1755
Flourished: 1773 Salem, MA
Type of Work: Fabric (Samplers)
Sources: *EaAmI 64*.*

Jennys, Richard
Flourished: 1750s, 1766-1799 Boston, MA; Connecticut
Type of Work: Oil (Portraits)
Museums: 010, 054, 139, 176, 223
Sources: *AmFoPaN 22; AmNa 22; FoA 464; GifAm 30*-1*; MaAmFA *; PaiNE 10, 16*, 142-137*; PrimPa 17-8, 175.*

Jennys, William
Flourished: c1750s,1790-1807 New England,
Type of Work: Oil (Portraits)
Remarks: Itinerant
Sources: *AmFoPaN 22-3*; 42-3*; AmFoPo 128-32*; AmNa 22; EyoAm 19*, 21; FoA 464; GifAm 30*-1*; NinCFo 167, 175, fig7, 11, 12; PrimPa 18-9*, 175.*

Jeremenko, Theodore
b. 1938
Flourished: New York, NY
Ethnicity: Yugoslavian
Type of Work: Acrylic (Architectural paintings)
Sources: *AmFokArt 127-9*.*

Jeremiah Dodge and Son
Flourished: 1833-1870 New York, NY
Type of Work: Wood (Cigar store Indians, figures)
Sources: *ArtWod 266, 5, 18, 83, 173-5; ShipNA 162*
See: Dodge, Jeremiah.

Jersey City Pottery Company
Flourished: 1825-1847 Jersey City, NJ
Type of Work: White earthenware (Pottery)
Sources: *AmPoP 48, 74-5, fig83, 169; AmSFok 132; DicM 62*, 168*.*

Jessup, James
Flourished: 19th century Fairfield, IL
Type of Work: Fabric (Weavings)
Sources: *ChAmC 73.*

Jessup, Jared
b. Southampton, NY d. 1812
Flourished: 1800-20 Bernardston, MA; Old Lyme, CT
Type of Work: Oil (Overmantel paintings)
Museums: 234
Remarks: Is probably the same person who signed "E. Jones" in one house.
Sources: *AmDecor 55, 97*, 58*, 72, 75*, 86-93*, 152; FlowAm 196*; FoA 464; FoPaAm 27*.*

Jester, Doug (S.D.M.)
Flourished: 1900-1948 Chincoteague, VA
Type of Work: Wood (Duck decoys)
Museums: 001,260
Sources: *AmBiDe 163-4*; AmDecoy 19*; AmFoS 304*; Decoy 80*.*

Jevne, Otto
Flourished: c1860 Chicago, IL
Type of Work: Fresco (Ornamental paintings)
Sources: *ArC 265*
See: Almini, Peter M.

Jewell, A.L.
See: A.L. Jewell and Company.

Jewell, D.B.
Flourished: 19th cent
Type of Work: Pen, ink (Drawings)
Sources: *Edith *.*

Jewett, Amos
b. 1753 d. 1834
Flourished: New Lebanon, NY
Ethnicity: Shaker
Type of Work: Wood (Clocks)
Sources: *HanWo 182-3.*

Jewett, Frederick Stiles
b. 1819 d. 1864
Flourished: Hartford, CT
Type of Work: Oil (Paintings)
Sources: *AmPrP 153; PrimPa 175.*

Jewett, George
b. 1820
Flourished: Danbury, NH
Type of Work: Wood (Boxes, coffins)
Sources: *NeaT 113-4*.*

Jewitt, Clarissa
Flourished: 1830 Middlebury, VT
Type of Work: Pen, ink (Penmanship, calligraphy drawings)
Museums: 260
Sources: *AmFoPa 170*.*

Jewsson, George
Flourished: 1825 New York, NY
Type of Work: Wood (Ship carvings, ship figures)
Sources: *AmFiTCa 194.*

Job
Flourished: early 19th cent Freehold, NJ
Ethnicity: Black American
Type of Work: Wood (Carvings, figures)
Museums: 203
Sources: *AfAmA 70*-1; AmFokAr 14*, fig54; FlowAm 154*.*

Joder, Jacob
Flourished: 1800 Berks County, PA
Type of Work: Clay (Pottery)
Sources: *BeyN 113, 76*.*

Joe
Flourished: 1850 Milwaukee, WI
Ethnicity: Black American
Type of Work: Oil (Portraits)
Museums: 154
Sources: *AfAmA 96*; FoPaAm 210*.*

Joe
Flourished: 1800s Marine City, MI
Type of Work: Wood (Ship carvings, ship figures)
Museums: 096
Sources: *AmFiTCa 153, figxxix.*

Joe, Pappy
b. Ohio
Flourished: contemporary Clinton, AR
Type of Work: Wood (Chainsaw sculptures)
Sources: *FoAFq 14-5*.*

John A. Whim
Flourished: c1850 Boston, MA
Type of Work: Metal (Weathervanes)
Sources: *AmFokAr 51.*

John Bell Pottery
See: Bell, John.

John Eardley's Pottery
Flourished: 1860 St. George, UT
Type of Work: Clay (Pottery)
Sources: *EaAmFo 202*.*

John Frell and Company
Flourished: c1860 Pittsburgh, PA
Type of Work: Stoneware (Pottery)
Sources: *AmPoP 228; Decor 219.*

John M. Wilson Pottery
See: Wilson, John M.

John Maddock and Sons
Flourished: c1894 Trenton, NJ
Type of Work: Clay (Pottery)
Sources: *DicM 212*.*

John Mellinger and Sons
b. c1800 Pennsylvania d. 1888 Lebanon, PA
Flourished: 1834-1853 Seneca County, PA; Millerstown, PA; Warwick Township, PA
Type of Work: Fabric (Coverlets, carpets)
Remarks: Brothers are Daniel and Samuel
Sources: *AmSQu 277; ChAmC 86.*

John Moses and Sons
[Glasgow Pottery Company]
Flourished: c1875 Trenton, NJ
Type of Work: Clay (Pottery)
Sources: *AmPoP 182, 271; DicM 19*, 52*-3*, 72*, 119*, 132*, 136*, 162*, 169*, 172*, 174*-6*, 180*, 203*, 251*.*

John Pierson and Company
Flourished: 1860 Athens, IL
Type of Work: Clay (Pottery)
Sources: *ArC 194.*

John Vickers and Son
Flourished: 1822-1850 Lionville, PA
Type of Work: Redware (Pottery)
Sources: *AmPoP 171*
See: Vickers, Thomas; Vickers, John.

John W. Croxall and Sons
Flourished: 1898-1900 East Liverpool, OH
Type of Work: Yellow-ware, Rockingham (Pottery)
Sources: *AmPoP 215.*

Johnson, Mr.
Flourished: 1825-1837 Columbia County, NY
Type of Work: Oil (Portraits)
Sources: *FoArA 57*.*

Johnson, Alfred
Flourished: 1877 Meriden, CT
Type of Work: Tin (Tinware)
Sources: *TinC 172.*

Johnson, Ann
Flourished: 1810-1825 Connecticut
Type of Work: Watercolor (Paintings)
Sources: *AmFoAr 29*; AmPrP 153; PrimPa 175.*

Johnson, Catherine
Flourished: 1846
Type of Work: Fabric (Embroidered check black wool blankets)
Sources: *AmSQu 72*.*

Johnson, Charles M.
Flourished: 1862 New York, NY
Type of Work: Oil (Portraits, paintings)
Sources: *PrimPa 175; ThTaT 220-3*.*

Johnson, D.P.
Flourished: 1848 Orleans County, NY
Type of Work: Fabric (Coverlets)
Sources: *ChAmC 73.*

Johnson, Fanny
Flourished: c1830's Frederick, MD
Type of Work: Fabric (Quilts)
Sources: *PlaFan 207*.*

Johnson, Fred G.
b. 1892 Chicago, IL
Type of Work: Oil (Circus banners)
Sources: *AmSFor 46-52.*

Johnson, Hamlin
Flourished: 1845 Litchfield, CT
Type of Work: Oil (Portraits)
Sources: *PrimPa 175.*

Johnson, Hannah
b. 1770 d. 1818
Flourished: 1796
Type of Work: Fabric (Bed rugs)
Museums: 016
Sources: *NewDis 10*.*

Johnson, Isaac
Flourished: 1875-1900 Waddington, NY
Type of Work: Wood (Chairs)
Sources: *FouNY 68.*

Johnson, James E.
b. 1810 d. 1858
Flourished: Spencertown, NY
Type of Work: Oil (Portraits)
Museums: 051
Sources: *FoPaAm 86*.*

Johnson, Jarred
Type of Work: Wood (Stenciled chairs)
Sources: *AmFokDe 12.*

Johnson, John
Flourished: 1870 Chartette Township, MO
Type of Work: (Baskets)
Sources: *ASeMo 412*.*

Johnson, John
Flourished: 1860 New York, NY
Type of Work: Wood (Ship carvings, ship figures)
Sources: *AmFiTCa 194.*

Johnson, John
Flourished: c1793 Staten Island, NY
Type of Work: Stoneware (Pottery)
Sources: *Decor 220.*

Johnson, Joseph
b. 1698
Flourished: Middletown, CT
Type of Work: Stone (Gravestones)
Sources: *EaAmG 128.*

Johnson, Joseph
Flourished: 1830-1865 Langhorne, PA
Type of Work: Redware (Pottery)
Sources: *AmPoP 170.*

Johnson, Joshua
[Johnston]
b. 1765 d. 1830
Flourished: c1796-1824 Baltimore, MD
Ethnicity: Black American
Type of Work: Oil (Portraits)
Museums: 144,175,189
Sources: *AfAmA 94-5, 97*-8; AmFoPo 132-4*; AmNa 11, 24, 66-9*; AmNeg fig7; AmSFok 162*; CoCoWA 104; FoAFc 15*; FoPaAm 155-6*; MaAmFA *; NinCFo 167, 175, fig13; OneAmPr 60*-1*, 812, 154; PrimPa 175, 20*; SoFoA 52, 54*, 218; TenAAA 10*, 8, 24-5*.*

Johnson, Lewis
See: Lewis Johnson Pottery.

Johnson, Lloyd
Flourished: 1920 Bay Head, NJ
Type of Work: Wood (Duck decoys)
Museums: 260
Sources: *AmDecoy 43*, 81*; ArtDe 73*; Decoy 32*.*

Johnson, Mary Myers
b. 1732
Flourished: 1793 Connecticut
Type of Work: Fabric (Wedding gowns, quilts)
Museums: 097,297
Sources: *FoArtC 60*; PieQu 27*; QuiAm 110*.*

Johnson, Melvin
Flourished: contemporary Point Arena, CA
Type of Work: Ivory (Fantasy snuff boxes)
Remarks: Used elephant tusks as medium
Sources: *Scrim 30.*

Johnson, Persis
Flourished: 1819 Holliston, MA
Type of Work: Fabric (Family register samplers)
Sources: *PlaFan 64*.*

Johnson, Philip
Flourished: 19th century Methuen, MA
Type of Work: Wood (Sculptures)
Museums: 176
Sources: *ColAWC 324; MaAmFA *.*

Johnson, R.
b. 1898 d. 1977
Flourished: Bronx, NY
Type of Work: Oil (Ship portraits)
Sources: *ColAWC 324; FoPaAm 104*.*

Johnson, Ray
b. 1883 Horton, MI d. 1974 Michigan
Flourished: 1958-1974 Michigan
Type of Work: Enamel (House and barn paintings)
Museums: 170
Sources: *Rain 61-3*.*

Johnson, S.D.
Flourished: 1820
Type of Work: Watercolor (Paintings)
Sources: *AmPrP 153; PrimPa 175.*

Johnson, Sargent
Flourished: 20th century
Type of Work: Wood (Sculptures, carvings)
Museums: 255
Sources: *AmFoS 321*.*

Johnson, Taylor
b. 1863 d. 1929
Flourished: c1890 Bay Head, NJ
Type of Work: Wood (Duck decoys)
Sources: *AmBiDe 113-4*, 117*; AmDecoy 19*.*

Johnson, Theodore
Flourished: 1866-1878 Portland, ME
Type of Work: Wood (Ship carvings, ship figures)
Sources: *AmFiTCa 194; ShipNA 157.*

Johnson, Thomas
b. 1690 d. 1761
Flourished: Middletown, CT
Type of Work: Stone (Gravestones)
Sources: *EaAmG 128; GravNE 128.*

Johnson, Thomas, Jr.
b. 1718 d. 1774
Flourished: Cromwell, CT
Type of Work: Stone (Gravestones)
Sources: *EaAmG 128.*

Johnson, Thomas
b. 1750 d. 1789
Flourished: Middletown, CT
Type of Work: Stone (Gravestones)
Sources: *EaAmG 128.*

Johnson, William R.
See: William R. Johnson Company Inc.

Johnson, Zachariah
Flourished: c1804 Bristol, CT
Type of Work: Tin (Tinware)
Sources: *TinC 172.*

Johnson and Baldwin
[Whitmore Johnson and Company]
Flourished: 1857-1865 Akron, OH
Type of Work: Stoneware (Pottery)
Museums: 096
Remarks: Became Johnson and Dewey (1860-c1875)
Sources: *AmPoP 206; Decor 156*, 220.*

Johnson and Mason
Flourished: c1803 Baltimore, MD
Type of Work: Redware (Pottery)
Sources: *AmPoP 163.*

Johnston, Effie
b. 1868 Paradise Gulch, CA **d.** 1964 San Andreas, CA
Flourished: 1895 San Andreas, CA
Type of Work: Pen, ink, colored pencil (Drawings)
Museums: 036
Sources: *PioPar 12*, 43, 60.*

Johnston, Henrietta (Mrs.)
d. 1728
Flourished: Charleston, SC
Ethnicity: English
Type of Work: Pastel (Portraits)
Museums: 313
Sources: *FoPaAm 148, 150*; SoFoA 466.*

Johnston, John
Flourished: 1790 York, ME
Type of Work: Oil (Portraits)
Sources: *AmPrP 153; PrimPa 175.*

Johnston, John
[Rea and Johnston]
Flourished: 1752-1818 Boston, MA
Type of Work: Paint (Ornamental paintings)
Museums: 010,196,54
Remarks: Daniel Rhea was his brother-in-law; elder half-brother is William
Sources: *AmDecor 6, 8, 76; PaiNE 17, 138-141*.*

Johnston, Joshua
See: Johnson, Joshua.

Johnston, L.
Flourished: 1835 New England,
Type of Work: Oil (Farm scene paintings)
Sources: *AmFoPaS 75*.*

Johnston, Thomas
Flourished: 1740 Boston, MA
Type of Work: Oil, stone (Paintings, gravestones, other stoneworks)
Sources: *FoArtC 113.*

Johnston, Thomas
Flourished: 1825 Massachusetts
Type of Work: Watercolor (Paintings)
Sources: *PrimPa 175.*

Johnston, William
b. 1732 Boston, MA **d.** 1772
Flourished: c1760-1772 Portsmouth, NH; New London, CT; New Haven, CT
Type of Work: Oil (Portraits)
Museums: 054
Remarks: Younger half-brother is John
Sources: *PaiNE 142-5*.*

Joiner, Charles
See: Joyner, Charles.

Jonathan Howard and Company
Flourished: 1850-68 West Bridgewater, MA
Type of Work: Metal (Weathervanes)
Sources: *ArtWe 13, 17, 20-1*, 37*, 80*, 113*, 115*, 126*, 129*, 135*, 142*.*

Jones
See: Southworth and Jones.

Jones (of Conn.)
Flourished: 1850 Connecticut
Type of Work: Watercolor (Portraits)
Sources: *AmPrP 153; PrimPa 175.*

Jones, A.W.
Flourished: 1830 New York, NY
Type of Work: Wood (Sculptures, carvings)
Museums: 184
Sources: *AmFoS 268*.*

Jones, Anthony W.
Flourished: 1820 New York, NY
Type of Work: Wood (Ship carvings, ship figures)
Sources: *AmFiTCa 194.*

Jones, Arthur
b. 1945 New York, NY
Flourished: 1971 Lexington, KY
Type of Work: Mixed media (Sculpture, relief paintings)
Sources: *FoAroK *.*

Jones, E.
See: Jessup, Jared.

Jones, Eliza
Flourished: 1810 Pennsylvania
Ethnicity: Quaker
Type of Work: Fabric (Embroidered maps)
Sources: *AmNe 93.*

Jones, Emery
b. 1827 Pownall, ME **d.** 1908
Flourished: 1885 Freeport, ME; Brunswick, ME; Damariscotta, ME
Type of Work: Wood (Ship carvings, ship figures)
Museums: 142
Sources: *AmFiTCa figxxiv, 142, 165, 194; AmFokAr 12, fig17; AmSFok 23*; ShipNA 79, 82-3*, 156*
See: Southwork, William.

Jones, Emily Edson
Type of Work: Fabric (Candlewick spreads)
Museums: 096
Sources: *AmSQu 288*.*

Jones, Evan R.(B)
Flourished: 1850-1900 Pittston, PA
Type of Work: Stoneware (Jugs)
Sources: *AmPoP 177, 265; AmS 191*; Decor 220; DicM 41; EaAmFo 102*.*

Jones, Frank
b. 1901 Texas **d.** 1969
Flourished: Huntsville, TX
Ethnicity: Black American, American Indian
Type of Work: Colored pencil (Drawings)
Museums: 171
Remarks: Work done while in prison
Sources: *FraJ;TwCA 171*.*

Jones, George
Flourished: 1867-1900 Wellsville, OH
Type of Work: Terra-cotta, redware (Pottery)
Sources: *AmPoP 232.*

Jones, Gershom
Flourished: New England,
Type of Work: Copper (Ladles)
Sources: *AmCoB 121.*

Jones, Harriet Dunn
b. 1792 Providence, RI **d.** 1874 Providence?, RI?
Flourished: 1802 Providence, RI
Type of Work: Fabric (Samplers)
Museums: 241
Sources: *LeViB 157*, 163.*

Jones, Henry A.
Flourished: 1865 Boston, MA
Type of Work: Wood (Ship carvings, ship figures)
Sources: *AmFiTCa 194.*

Jones, James E.
James E. Jones and Brother]
Flourished: 1834-1840 Baltimore, MD
Type of Work: Redware (Pottery)
Sources: *AmPoP 163.*

Jones, L.
Flourished: 1849 Cornersburg, OH
Type of Work: Fabric (Weavings)
Sources: *ChAmC 73.*

Jones, M.D.
See: M.D. Jones and Company.

Jones, N.S.
Flourished: 1824-1832 Baltimore, MD
Type of Work: Redware, stoneware (Pottery)
Sources: *AmPoP 163.*

Jones, Reuben, Captain
Flourished: c1802-1806 Newburyport, MA
Type of Work: Pen, watercolor (Whaling scene paintings)
Museums: 123
Sources: *WhaPa 28*, 57*, 84*, 128*.*

Jones, Samuel D.
Flourished: 1870 Philadelphia, PA
Type of Work: Wood (Ship carvings, ship figures)
Sources: *AmFiTCa 194.*

Jones, Shields Landon
b. c1901 Franklin County, VA
Flourished: 1970 Pine Hill, WV
Type of Work: Wood, watercolor (Sculptures, figural carvings, paintings)
Museums: 171,263
Sources: *AlAmD 92-3*; AmFokArt 130-2*; FoAFcd 12*; Trans 7, 36*-7*, 54.*

Jones, Wealthy P.S.
Flourished: 1815 Bath, ME
Type of Work: Wood (Furniture)
Museums: 097
Sources: *AmPaF 178*.*

Jones, William
Flourished: 1819 Cincinnati, OH
Type of Work: Wood (Ship carvings, ship figures)
Sources: *AmFiTCa 194.*

Jordan, Samuel
b. 1803 d. 1831
Flourished: 1830 New York; Boston, MA
Type of Work: Oil (Portraits)
Museums: 001
Sources: *AmFoPo 135-6*; AmPrP 153; PrimPa 175.*

Jordan, Thomas
b. c1825 Ohio
Flourished: 1850 Hagerstown, IN
Type of Work: Fabric (Coverlets)
Sources: *ChAmC 73*
See: Test Woolen Mills; Favorite, Elias; Hoover, John .

Jorgenson
Flourished: Michigan
Type of Work: Wood (Fish decoys)
Sources: *UnDec 20.*

Joseph, Charles
Flourished: 1917-1918 New Bedford, MA
Type of Work: Pen, ink (Doodles)
Museums: 123
Sources: *WhaPa 144*.*

Joseph Breck and Sons
Flourished: 1893-1916 Boston, MA
Type of Work: Metal (Weathervanes)
Sources: *YankWe 210.*

Joseph Meeks and Sons
Flourished: 1825 New York
Type of Work: Wood (Secretaries)
Museums: 151
Sources: *AmPaF 164*.*

Joseph Wilson and Son
See: Wilson, Joseph .

Josephs, Joseph "Elephant Joe"
b. 1826 New York, NY d. 1893
Flourished: 1869 Buffalo, NY
Type of Work: Oil (Circus banners, frescos, signs)
Museums: 203
Sources: *AmSFor 44, 87-9*.*

Jotter, Jacob
Flourished: Monroe, OH
Type of Work: Fabric (Coverlets)
Sources: *ChAmC 73.*

Joy, Caroline
Flourished: 1830 New England,
Type of Work: Watercolor (Paintings)
Museums: 001
Sources: *ArtWo 71*.*

Joy, Charles
Flourished: Martha's Vineyard, MA
Type of Work: Wood (Duck decoys)
Sources: *AmBiDe 73.*

Joy, Josephine
b. 1860 or 1869?
Flourished: Los Angeles, CA
Type of Work: Oil (Paintings)
Sources: *PrimPa 175; ThTaT 201-3*.*

Joyner, Charles
[Joiner]
Flourished: 1940s Betterton, MD
Type of Work: Wood (Duck decoys)
Sources: *AmBiDe 33, 146 :166 57.*

Judd, Norman L.
Flourished: 1800-1820 Rome, NY
Type of Work: Stoneware (Pottery)
Sources: *AmPoP 189, 202; Decor 221.*

Jugtown Pottery
Flourished: 1925-1950 Seagrove, NC
Type of Work: Stoneware (Jugs)
Sources: *AmS 81*.*

Jukes, Benjamin
Flourished: 1837
Type of Work: Fabric (Coverlets)
Sources: *ChAmC 73.*

June, Benjamin
b. c1790 Massachusetts
Flourished: 1846-1850 Brunswick, OH
Type of Work: Fabric (Coverlets)
Sources: *ChAmC 73.*

Jungkurth, J.W.
Flourished: c1840 Lithopolis, OH
Type of Work: Stone (Gravestones)
Sources: *EaAmG 129.*

K

Kabotie, Fred
Flourished: New Mexico
Ethnicity: American Indian
Type of Work: Oil (Indian festival paintings)
Remarks: Hopi Indian tribe
Sources: *PicFoA 47.*

Kachel, John
[Cochel]
b. 1809 Pennsylvania **d.** 1889
Flourished: 1838-1857 Robeson Township, PA
Type of Work: Fabric (Weavings)
Sources: *ChAmC 73.*

Kahle, Mathew S., Captain
Flourished: 1840s Lexington, VA
Type of Work: Wood (Sculptures)
Remarks: Carved sculpture of George Washington for Washington and Lee University
Sources: *SoFoA 112, 121*, 220.*

Kaiffer, Frederick W.
Flourished: 1860-1892 New York, NY
Type of Work: Wood (Cigar store Indians, figures)
Sources: *ArtWod 65, 268.*

Kaley, John
Flourished: 1836-1840
Type of Work: Fabric (Weavings)
Sources: *ChAmC 73.*

Kane, Andy
b. 1956
Flourished: 1970s New York, NY
Type of Work: Oil, acrylic (Scene paintings)
Museums: 171
Sources: *AmFokArt 133-5*; FoA 466; FoAFm 2; FoPaAm 112*.*

Kane, John
[Cain]
b. 1870 **d.** 1934 Pittsburgh, PA
Flourished: 1910 Pittsburgh, PA; Akron, OH
Ethnicity: Scottish
Type of Work: Oil (Paintings)
Museums: 020,038,179,229
Sources: *AmFokArt 136; AmFoPaCe 198-202*, 216; FoA 466; FoPaAm 142, 148; GraMo 14-5, 39-44; HoKnAm 181; JoKaP;MaAmFA *; PeiNa 237*; PicFoA 163; PrimPa 161*, 175; ThTaT 77-98*; Trans 8; TwCA 77*.*

Kanoff, W.H.
Flourished: 1862 Ogdensburg, NY
Type of Work: Pen, ink (Penmanship, calligraphy drawings)
Sources: *FouNY 65.*

Kapp, Christof
Flourished: 1839 Warwick Township, PA
Type of Work: Fabric (Weavings)
Sources: *ChAmC 73.*

Kappel, Gottfried
See: Gottfried Kappel and Company.

Karsner, Clark
b. 1916 Monterey, KY **d.** 1971
Flourished: 1952 Kentucky
Type of Work: Glass (Neon signs)
Sources: *GoMaD *.*

Kasling, "Driftwood Charlie"
b. 1901
Flourished: Yuma, AZ
Type of Work: Dirt, stone, wood (Sculptures)
Sources: *TwCA 202*.*

Kassel, Georg
Flourished: 1800 Pennsylvania
Type of Work: Watercolor, ink (Frakturs)
Sources: *AmFoPa 188.*

Katchum, Captain
See: Ketchum, C.K., Sr.

Kauffman, Daniel
Flourished: 1825 Pennsylvania
Type of Work: Watercolor, ink (Frakturs)
Sources: *AmFoPa 188.*

Kauffman, Samuel
Flourished: 1825 Pennsylvania
Type of Work: Watercolor, ink (Frakturs)
Sources: *AmFoPa 188.*

Kauffman, Zoe
Flourished: 1763
Type of Work: Watercolor, ink (Frakturs)
Sources: *AmFokDe xii.*

Kaufman, Jacob
Flourished: 1860 New York, NY
Type of Work: Wood (Ship carvings, ship figures)
Sources: *AmFiTCa 194.*

Kaufman, John
Flourished: 1837-1846 Bucks County, PA
Type of Work: Fabric (Coverlets)
Sources: *AmSQu 277; ChAmC 73.*

Kay, Edward A.
b. c1900 Mount Clemens, MI
Flourished: 1930s Mount Clemens, MI
Type of Work: Wood (Totem poles)
Museums: 170
Sources: *AmFokA 99-101*; Rain 82*-5*.*

Keagy, Abraham, I
b. 1786 Pennsylvania **d.** 1867
Flourished: 1813-1850 Morrison's Cove, PA
Type of Work: Fabric (Weavings)
Remarks: Sons are John and Samuel; grandson is Abraham II
Sources: *ChAmC 74.*

Keagy, Abraham, II
Flourished: 1849-1879 Woodberry, PA; Morrison's Cove, PA
Type of Work: Fabric (Weavings)
Remarks: Father is John; grandfather is Abraham, I
Sources: *ChAmC 74*
See: Globe Factory.

Keagy, I.
Flourished: 1849 Woodberry, PA
Type of Work: Fabric (Coverlets)
Remarks: Could be John Keagy
Sources: *ChAmC 74*.

Keagy, John
b. 1811 Pennsylvania d. 1890
Flourished: 1849-1879 Woodberry, PA; Morrison's Cove, PA
Type of Work: Fabric (Weavings)
Remarks: Son is Abraham, II; father is Abraham, I
Sources: *ChAmC 74*
See: Globe Factory.

Keagy, Samuel
b. 1837
Flourished: 1879 Morrison's Cove, PA
Type of Work: Fabric (Weavings)
Remarks: Father is John; brother is Abraham II
Sources: *ChAmC 74*.

Kean, Carl Lewis
Flourished: 1840-1860 Scott County, KY; Louisville, KY
Ethnicity: German
Type of Work: Fabric (Coverlets)
Remarks: Brother is Frederick A.
Sources: *AmSQu 277; ArtWea 138*; ChAmC 74*.

Kean, Frederick A.
b. c1811 d. 1893
Flourished: 1840-1847 Terre Haute, IN; Louisville, KY
Ethnicity: German
Type of Work: Fabric (Weavings)
Remarks: Brother is Carl Lewis
Sources: *AmSQu 277; ArtWea 139; ChAmC 74*.

Kears, Mark
Flourished: c1900 Somers Point, NJ
Type of Work: Wood (Duck decoys)
Museums: 260
Sources: *Decoy 79**.

Keck
Flourished: 1843-1848 Emmaus, PA
Type of Work: Fabric (Coverlets)
Sources: *ChAmC 74*
See: Fehr and Keck.

Keebler, Julius
Flourished: 1882 Philadelphia, PA
Type of Work: Wood (Ship carvings, ship figures)
Sources: *AmFiTCa 194*.

Keegan, Marie
b. 1941 New York, NY
Flourished: Stockholm, NJ
Type of Work: Oil (Scene paintings)
Sources: *AmFokArt 138-141**.

Keeler, Benjamin
Flourished: c1825-1827 Huntington, NY
Type of Work: Redware (Pottery)
Sources: *AmPoP 194*.

Keen, G.V.
See: G.V. Keen and Company.

Keen, Palmyra M.
Flourished: 1818 North Branford, CT
Type of Work: Fabric (Samplers)
Sources: *AmNe 62*.

Keen, Sarah
Flourished: 1762
Type of Work: Fabric (Lace cutwork samplers)
Sources: *PlaFan 50**.

Keena, John
Flourished: 1860 New York, NY
Type of Work: Wood (Ship carvings, ship figures)
Sources: *AmFiTCa 194*.

Keener, Henry
Flourished: c1839-1844 Womelsdorf, PA
Type of Work: Fabric (Coverlets, weavings)
Museums: 129
Sources: *ChAmC 74; FoArRP 69**
See: Coble, Henry K.

Keener, Jacob
Flourished: 1857 Lancaster, PA
Type of Work: Fabric (Coverlets)
Sources: *ChAmC 74*
See: Coble, Henry K.

Keener, John
b. c1808
Flourished: c1854-1866 Mount Joy, PA
Type of Work: Fabric (Carpets, coverlets)
Sources: *ChAmC 74*
See: Manning and Wantz.

Keep, George
Flourished: c1835 Sheffield, MA
Type of Work: Stone (Gravestones)
Sources: *EaAmG 128*.

Keeper, Heinrich
Flourished: Pennsylvania
Type of Work: Watercolor, ink (Frakturs)
Sources: *AmFoPa 188*.

Keffer, William
Flourished: 1848
Type of Work: Fabric (Coverlets)
Sources: *ChAmC 74*.

Kehm, Anthony
Flourished: 1824 Pennsylvania
Type of Work: Watercolor, ink (Frakturs)
Sources: *AmFoPa 188*.

Keid, Andrew
d. 1802
Flourished: Boston, MA
Type of Work: Stone (Gravestones)
Sources: *GravNE 128*.

Keifer, Louis
Flourished: 1835 Canton, OH
Type of Work: Fabric (Weavings)
Sources: *ChAmC 75*.

Keipner, William
See: Kepner, William.

Keith, Charles F.
Flourished: c1852-1853 Mattapoisett, MA
Type of Work: Pencil, watercolor (Ship portraits)
Museums: 123
Sources: *WhaPa 106*, 116**
See: Luce, Shubael H.

Keith, Charles W.
b. Indiana
Flourished: 1849-1969 Ripley, IL
Type of Work: Stoneware (Pottery)
Sources: *ArC 193*.

Kell, D.
Flourished: Jackson County, OH
Type of Work: Fabric (Weavings)
Sources: *ChAmC 75*.

Keller, Adam
Flourished: 1880 Adams County, PA
Type of Work: (Hat boxes, other decorated boxes)
Museums: 008
Sources: *AmSFok 17*.

Keller, Conrad
Flourished: c1796-1800 Philadelphia, PA
Type of Work: Tin (Tinware)
Sources: *AmCoTW 153-4; ToCPS 6*.

Keller Pottery Company
Flourished: c1880-1900 Norristown, PA
Type of Work: Redware (Pottery)
Sources: *AmPoP 173*.

Kelley, Asahel A.
Flourished: 1874 Philadelphia, PA
Type of Work: Wood (Ship carvings, ship figures)
Sources: *AmFiTCa 195*.

Kelley, Peter
Flourished: c1840 Philadelphia, PA
Type of Work: Clay (Pottery)
Sources: *AmPoP 176, 265; DicM 105**.

Kellie, Ed
Flourished: Monroe, MI
Type of Work: Wood (Decoys)
Sources: *WaDec 108-9**.

Kellner, Anthony
Flourished: 1866 Santa Fe, NM
Type of Work: Oil (Cityscape paintings)
Museums: 181
Sources: *PopAs 37**.

Kellogg
See: Brayton, Kellogg and Doolittle.

Kellogg, Mrs. Francis Leonard
Flourished: New York, NY
Type of Work: Fabric (Needlepoint sofa panels)
Sources: *AmNe 165*, 168*.

Kellum, Frank
b. 1865 d. 1935
Flourished: 1890 Babylon, NY; Long Island, NY
Type of Work: Wood (Duck decoys)
Sources: *AmBiDe* 101; *ArtDe* fig165; *WiFoD* 127, 122-3*.

Kelly
Flourished: Michigan
Type of Work: Wood (Fish decoys)
Sources: *UnDec* 20.

Kelly, Ann E.
Flourished: 1825 Harrisburg, PA
Type of Work: Fabric (Samplers)
Sources: *AmNe* 63.

Kelly, James
Flourished: c1829 Baltimore, MD
Type of Work: Redware (Pottery)
Sources: *AmPoP* 162.

Kelly, John
Flourished: c1796-1807 Baltimore (Old Town), MD
Type of Work: Redware (Pottery)
Sources: *AmPoP* 162.

Kelly, Mary F.
Flourished: c1830
Type of Work: Paint (Boxes)
Sources: *NeaT* 50, fig13*.

Kelly, W.H.
Flourished: 1870
Type of Work: Oil (Paintings)
Sources: *AmPrP* 153; *PrimPa* 175.

Kelsey, Samuel
Flourished: c1813 Berlin, CT
Type of Work: Tin (Tinware)
Sources: *TinC* 172.

Kelson, James R.
b. 1888 d. 1968
Flourished: 1912 Detroit, MI
Ethnicity: Canadian
Type of Work: Wood (Decoys)
Sources: *WaDec* 32-35*.

Kemmelmeyer, Frederick
Flourished: 1788-1816 Baltimore, MD; Annapolis, MD; Alexandria, VA
Type of Work: Watercolor (Miniatures, landscapes, historical paintings)
Museums: 097,151
Sources: *AmNa* 12, 24, 70*; *AmPrP* fig67, 153; *BeyN* 45-7*; *FoA* 466; *FoArA* 12*; *FoPaAm* 156*, 170; *OneAmPr* 52*, 55*, 82, 141-2, 154; *PrimPa* 175; *SoFoA* 55, 58*, 218.

Kemmon, Joseph
Flourished: 1860 New York, NY
Type of Work: Wood (Ship carvings, ship figures)
Sources: *AmFiTCa* 195.

Kemp, A.
Flourished: 1891 Philadelphia, PA
Type of Work: Wood (Ship carvings, ship figures)
Sources: *AmFiTCa* 195.

Kemp, D.
Flourished: 1840 Pennsylvania
Type of Work: Oil (Paintings)
Sources: *PrimPa* 174.

Kemp, Frederick
Flourished: 1860 New York, NY
Type of Work: Wood (Ship carvings, ship figures)
Sources: *AmFiTCa* 195.

Kemper, Christopher
See: Kemper, Simon.

Kemper, Edward
Flourished: 1902 Gasconade County, MO
Type of Work: Wood (Furniture)
Sources: *ASeMo*.

Kemper, Simon
Flourished: 1840-1870 Missouri
Type of Work: Wood (Benches, cupboards)
Remarks: Worked with Kemper, Christopher
Sources: *ASeMo* 313*.

Kempton, Samuel
Flourished: c1786 New York, NY
Type of Work: Tin (Tinware)
Sources: *AmCoTW* 109.

Kendall, Loammi
Flourished: 1836-1870 Chelsea, MA
Type of Work: Stoneware (Pottery)
Sources: *Decor* 221.

Kendall, Miles
Flourished: c1740 Peabody, MA
Type of Work: Redware (Pottery)
Sources: *AmPoP* 200.

Kendall, Uriah
[Kendall and Sons]
Flourished: 1834-1850 Cincinnati, OH
Type of Work: Stoneware (Pottery)
Sources: *AmPoP* 77, 210; *Decor* 221.

Kendall and Sons
See: Kendall, Uriah.

Kenedy, Sarah
Flourished: early 19th century
Type of Work: Fabric (Quilts)
Sources: *QuiAm* 269*.

Kennard, William J., Jr.
Flourished: 1860 Baltimore, MD
Type of Work: Wood (Ship carvings, ship figures)
Sources: *AmFiTCa* 195.

Kennecott Copper Workshop
Flourished: 1931 Woodside, CA
Type of Work: Metal (Weathervanes)
Sources: *GalAmW* 101*.

Kennedy, David
Flourished: c1829-1832 Steubenville, OH
Type of Work: Fabric (Carpets, coverlets, weavings)
Sources: *ChAmC* 16*, 75.

Kennedy, Mary
b. 1789
Flourished: 1803 Wilmington, DE
Type of Work: Fabric (Samplers)
Sources: *GalAmS* 40*.

Kennedy, Samuel
Flourished: 1840 New York, NY
Type of Work: Wood (Ship carvings, ship figures)
Sources: *AmFiTCa* 195.

Kennedy, Terence J.
b. 1820
Flourished: 1840 Auburn, NY
Type of Work: Oil (Paintings)
Sources: *AmFoPaN* 97, 111*; *PrimPa* 175.

Kennedy, William W.
b. 1818 New Hampshire d. 1870
Flourished: 1845 New Bedford, MA; Baltimore, MD; Berwick, ME
Type of Work: Oil (Portraits, symbolic scene paintings)
Remarks: Member of the Prior-Hamblen School
Sources: *AmFoPo* 136-8*; *AmPrP* 153; *PrimPa* 175.

Kenneth Lynch and Sons
Flourished: mid 19th century to present Wilton, CT
Type of Work: Metal (Weathervanes)
Sources: *GalAmW* 19*-20; *WeaWhir* 52, 126; *YankWe* 151.

Kent, A.D.
b. 1898-
Flourished: 1970 Maine
Type of Work: Oil (Fishing boat paintings)
Sources: *FoPaAm* 52*.

Kentz, Joseph
Flourished: 1877 Meriden, CT
Type of Work: Tin (Tinware)
Sources: *TinC* 172.

Kepner, Absalom B.
Flourished: 1833 Covington, OH
Type of Work: Fabric (Coverlets)
Sources: *ChAmC* 75.

Kepner, Isaac
Flourished: 1836-1843 Pottstown, PA
Type of Work: Fabric (Weavings)
Sources: *AmSQu* 277; *ChAmC* 75.

Kepner, William
[Keipner]
Flourished: c1815 Pittsburgh, PA
Type of Work: Tin (Tinware)
Sources: *AmCoTW 156; ToCPS 7.*

Kepners Woolen Mill
Flourished: 1872 Little Marsh Creek, PA
Type of Work: Fabric (Weavings)
Sources: *ChAmC 75*
See: Herreter; Sweitzer.

Kerns, William
b. Pennsylvania
Flourished: 1847-1858 Wabash Township, IN
Type of Work: Fabric (Coverlets)
Sources: *AmSQu 277; ChAmC 75.*

Kertell, George
Flourished: 1860 New York, NY
Type of Work: Wood (Ship carvings, ship figures)
Sources: *AmFiTCa 195.*

Kessel and Hartung
Flourished: 1857 New York, NY
Type of Work: Wood (Ship carvings, ship figures)
Sources: *ShipNA 162.*

Kessler, Charles
b. 1883
Flourished: 1916-1956 New York, NY
Type of Work: Metal (Weathervanes)
Sources: *WeaVan 24*
See: E.G. Washburne and Company.

Keszler, Henry
b. 1818 d. 1906
Flourished: 1860 Pacific, MO
Ethnicity: German
Type of Work: Wood (Daybeds)
Sources: *ASeMo 327*.*

Ketcham, Al, Captain
b. c1840 d. 1910
Flourished: Copiague, NY
Type of Work: Wood (Duck decoys)
Sources: *AmBiDe 101.*

Ketchum, C.K., Sr.
[Captain Katchum]
Flourished: 1860 Copiague, NY
Type of Work: Wood (Duck decoys)
Museums: 260
Sources: *ArtDe 152-3*; Decoy 101*; WiFoD 44*.*

Kett, John F.
Flourished: 1886 Philadelphia, PA
Type of Work: Wood (Ship carvings, ship figures)
Sources: *AmFiTCa 195.*

Ketterer, J(ohn) B.
b. 1796
Flourished: 1870 Berks County, PA; Bedminster Township, PA
Ethnicity: German
Type of Work: Tin (Coffee pots, tinware)
Museums: 097,189,227
Sources: *AmCoTW 161; FoArRP 158*; ToCPS 18*, 38*-40, 43, 48-9, 73, 76.*

Kettle, Johnathan
Flourished: c1730 Peabody, MA
Type of Work: Redware (Pottery)
Sources: *AmPoP 200.*

Key, Charles B.
Flourished: 1815
Type of Work: Oil (Genre paintings)
Sources: *AmPoP 18.*

Key and Swope
Flourished: 1879-1900 Zanesville, OH
Type of Work: Clay (Pottery)
Sources: *AmPoP 234.*

Keyes, Caroline
d. 1810
Flourished: Salisbury, CT
Type of Work: Watercolor (Genre paintings)
Sources: *PrimPa 175.*

Keys, Jane
Flourished: 1825 Troy, NY
Type of Work: Oil (Paintings)
Sources: *AmPrP 153; PrimPa 175.*

Keys, Mary
Flourished: 1832 Lockport, NY
Type of Work: Watercolor (Paintings)
Sources: *AmFoPaN 145, 156*; ArtWo 103, 117*.*

Keytone Pottery Company
Flourished: 19th century Trenton, NJ
Type of Work: Clay (Pottery)
Sources: *DicM 181*.*

Kichline, Christine S.
Flourished: early 19th cent Quaker Hill, PA
Type of Work: Fabric (Quilts)
Museums: 164
Sources: *QuiAm 203.*

Kichline, Euphemia
Flourished: 1838 Pennsylvania
Type of Work: Fabric (Patchwork show towels)
Sources: *AmSQu 101*.*

Kidd, Joseph
Flourished: c1769 Williamsburg, VA
Type of Work: Oil? (Chimney board paintings)
Sources: *AmDecor 66.*

Kidder, O.G.
Flourished: 1850s
Type of Work: Wood (Pipes)
Sources: *WoCar 84*.*

Kiefer
See: Byrne and Kiefer Company.

Kieff, John
Flourished: c1750 Williamsburg, VA
Ethnicity: English
Type of Work: Paint (Landscape paintings)
Sources: *AmDecor 17.*

Kiehl, Benjamin
b. 1807 d. 1895
Flourished: 1822-1846 Berks County, PA; Lancaster County, PA
Type of Work: Fabric (Weavings)
Sources: *ChAmC 75.*

Kiehn, David
Flourished: 1847 Pennsylvania
Type of Work: Watercolor, ink (Frakturs)
Sources: *AmFoPa 188.*

Kier, S.M.
Flourished: 1867-1900 Pittsburgh, PA
Type of Work: Stoneware (Pottery)
Sources: *AmPoP 228; Decor 221.*

Kikoin, Aaron
b. 1896
Flourished: 1970 New York, NY
Ethnicity: Russian
Type of Work: Oil (Religious paintings)
Sources: *TwCA 210*.*

Kilbourne, William
Flourished: 1870
Type of Work: (Drums)
Sources: *WoScuNY.*

Killalea, Thomas
Flourished: 1860 New York, NY
Type of Work: Wood (Ship carvings, ship figures)
Sources: *AmFiTCa 195.*

Killcup, George, Jr.
Flourished: 1760-1768 Boston, MA
Type of Work: Oil, fabric (Painted carpets)
Sources: *AmFokDe 84; FloCo 18.*

Killens, B.
Flourished: c1841
Type of Work: Tin (Tinware)
Remarks: Worked for Filley
Sources: *TinC 172.*

Killeran, Rebecca
Flourished: 1796 Boston, MA
Type of Work: Fabric (Samplers)
Sources: *GalAmS 32*.*

Killian, Abraham
Flourished: 1800-1810 Pennsylvania
Type of Work: Watercolor, ink (Illustrated bookplates)
Sources: *NinCFo 187.*

Kilpatrick, Henry
Flourished: c1920s-1930s Barnegat, NJ
Type of Work: Wood (Duck decoys)
Sources: *AmBiDe* 121, 131*; *WiFoD* 130*.

Kilpatrick, R.L., Captain
Flourished: 1869 Oswego, NY
Type of Work: Watercolor (Army base life paintings)
Museums: 096
Sources: *FoPaAm* 85*.

Kilsey, Edward A.
Flourished: 1877 Meriden, CT
Type of Work: Tin (Tinware)
Sources: *TinC* 172.

Kimball, Chester
b. 1763 **d.** 1824
Flourished: Lebanon, CT
Type of Work: Stone (Gravestones)
Sources: *EaAmG* 128.

Kimball, Elizabeth O.
Flourished: 1871 Olympia, WA
Type of Work: Oil (Paintings)
Sources: *PioPar* 12, 59.

Kimball, Lebbeus
b. 1751 **d.** 1832
Flourished: c1785 Pomfret, CT
Type of Work: Stone (Gravestones)
Remarks: Relative of Richard
Sources: *EaAmG* 64-5*, 128.

Kimball, Mary Ann
Flourished: 1825 Pennsylvania
Type of Work: Velvet (Memorial paintings)
Sources: *AmFoAr* 36 23 153; *PrimPa* 175.

Kimball, Mary G.
Flourished: 1822 New York
Type of Work: Fabric (Mourning samplers)
Sources: *MoBeA*.

Kimball, Mary Grove
Flourished: 1808 Haverhill, MA
Type of Work: Fabric (Samplers)
Sources: *GalAmS* 45.

Kimball, Richard
b. 1722 **d.** 1810
Flourished: Pomfret, CT
Type of Work: Stone (Gravestones)
Remarks: Relative of Lebbeus
Sources: *EaAmG* 128.

Kimball, H.C. and Company
Flourished: 1858-1860 Chicago, IL
Type of Work: Paint (Landscape paintings)
Sources: *ArC* 265
See: Rasmussen, Nils.

Kimble, G.W.
See: G.W. Kimble Woolen Factory.

Kimmel
Flourished: 1860-1880 Hermann, MO
Type of Work: Wood (Bureau chests)
Sources: *ASeMo* 368*.

Kindall, George
Flourished: 1836 Harvard, MA
Type of Work: Ink, watercolor (Map drawings)
Museums: 088
Sources: *AmFoPa* 160*.

Kinderlen, Conrad
Flourished: early 20th cent Warren County, MO
Ethnicity: German
Type of Work: (Baskets)
Sources: *ASeMo* 416*.

King, Charles Bird
b. 1785 **d.** 1862
Flourished: 1850 Maine
Type of Work: Oil (Portraits)
Sources: *AmPrP* 153; *ArC* 113, 117; *PrimPa* 175.

King, Daniel
Flourished: c1767 Suffolk, MA; Philadelphia, PA
Type of Work: Iron, brass (Door latches, andirons)
Museums: 097,110
Sources: *AmCoB* 152*, 158*, 163, 177, 191-4*, 196, 211, 214-5; *EaAmI* 70*.

King, Daniel
b. c1828 **d.** 1888 Sugar Creek Township, OH
Flourished: 1856-1859 Stark County, OH
Type of Work: Fabric (Weavings)
Sources: *ChAmC* 75.

King, Joe
b. 1835 **d.** 1913
Flourished: Parkertown, NJ
Type of Work: Wood (Duck decoys)
Sources: *AmBiDe* 133.

King, Joseph
Flourished: 1839-1855 Morristown, OH
Type of Work: Fabric (Weavings)
Sources: *ChAmC* 75.

King, Josiah Brown
b. Florida, MA
Flourished: 1850 Connecticut
Type of Work: Watercolor (Miniature paintings)
Remarks: Itinerant; handicapped
Sources: *AmPrP* 153; *PicFoA* 10, 16-7; *PrimPa* 175.

King, Martha Ellen
Flourished: 1875 Georgia
Type of Work: Fabric (Weavings)
Sources: *MisPi* 84*.

King, Mary
Flourished: 1754 Pennsylvania
Type of Work: Fabric (Embroidered pictures)
Sources: *PlaFan* 81*; *WinGu* 75*.

King, Samuel
b. 1748/49 Newport, RI **d.** 1819
Flourished: 1770-1810 Newport, RI
Type of Work: Wood, oil (Figures, signs, portraits)
Museums: 066,194,241,313
Sources: *FlowAm* 159*; *PaiNE* 146-151*.

King, Samuel B.
Flourished: c1842 Peoria, IL; Elizabeth, IL
Type of Work: Redware, stoneware (Pottery)
Sources: *ArC* 186*, 190.

King, William
Flourished: c1780s-1816 Salem, MA; Boston, MA; Portsmouth, NH
Type of Work: Pen, ink, wood (Silhouettes, drawings, furniture)
Sources: *AmDecor* 42; *FoArtC* 174-5.

Kingman, Mary Dunham
Flourished: c1890 Brockton, MA
Type of Work: Fabric (Quilts)
Sources: *QuiAm* 204*.

Kings, Martha Y.
Flourished: 1834
Type of Work: Fabric (Samplers)
Museums: 227
Sources: *MoBeA*.

Kingsbury, Mary
Flourished: 1841 Connecticut
Type of Work: Tin (Tinware)
Sources: *TinC* 158.

Kingsley, Addison
Flourished: 1860
Type of Work: Oil (Landscape paintings)
Sources: *AmPrP* 153; *PrimPa* 175.

Kingsley, Mary
Flourished: early 19th cent
Type of Work: Ink, linen (Decorated handkerchiefs)
Sources: *MoBeA* fig42.

Kinney, Charles
b. 1906 Lewis County, KY
Flourished: contemporary Kentucky
Type of Work: Clay, acrylic, poster paint (Puppets, carvings)
Remarks: Brother is Noah
Sources: *GoMaD*.

Kinney, Noah
b. 1912 Lewis County, KY
Flourished: 1968 Kentucky
Type of Work: Wood (Carvings)
Remarks: Brother is Charles
Sources: *FoAroK* *; *GoMaD*.

Kinsey, Abraham K.
Flourished: 1864 Pennsylvania
Type of Work: Watercolor, ink (Frakturs)
Sources: *AmFoPa 188*.

Kinstler, W.
Flourished: c1900 Lancaster County, PA
Type of Work: Paint, wood (Signs)
Sources: *ArEn 50, 56**.

Kintner, Jacob
Flourished: c1780-1840 Nockamixon, PA
Type of Work: Redware (Pottery)
Sources: *AmPoP 173*.

Kinzie
See: Moore and Kinzie.

Kinzie, John
Flourished: c1797 Chicago, IL; Detroit, MI
Type of Work: Silver (Jewelry)
Sources: *ArC 46-7*.

Kinzie, Juliette M.
Flourished: 1831 Chicago, IL
Type of Work: (Sketches)
Sources: *ArC 265*.

Kip, Henry D.
Flourished: 1856 Canton, NY
Type of Work: Oil (Paintings)
Sources: *FouNY 65*.

Kirk, Elisha
Flourished: Yorktown, PA
Ethnicity: Dutch
Type of Work: Pewter (Pewterware)
Museums: 032
Sources: *PenDA 82**.

Kirkpatrick
[Anna Pottery]
Flourished: c1860-1900 Anna (Lowell), IL
Type of Work: Stoneware (Pottery)
Remarks: Large family of potters
Sources: *AmPoP 222; Decor 221*.

Kirkpatrick, Alexander
b. Pennsylvania
Flourished: 1857-1859 Mound City, IL
Type of Work: Stoneware (Pottery)
Sources: *ArC 194*.

Kirkpatrick, Andrew
b. Pennsylvania
Flourished: 1837-1857 Vermilionville, IL
Type of Work: Stoneware (Pottery)
Sources: *ArC 184, 190*.

Kirkpatrick, Cornwall E.
Flourished: c1850-1900 Anna, IL; Mound City, IL
Type of Work: Clay (Pottery, fanciful jugs, pipes)
Museums: 203
Remarks: Worked at Anna Pottery
Sources: *AmFoS 217*; AmPoP 222; AmS 152*, 162; ArC 184-5*, 194*
See: Kirkpatrick, Wallace V.

Kirkpatrick, Murray
b. Ohio
Flourished: c1840-1850 Vermilionville, IL; Mound City, IL
Type of Work: Clay (Pottery)
Sources: *ArC 190, 193-4*.

Kirkpatrick, Wallace (V.)
b. Pennsylvania
Flourished: 1857-1900 Mound City, IL; Anna, IL
Type of Work: Stoneware (Pottery, fanciful jugs)
Sources: *AmPoP 222; AmS 163*; ArC 184, 194; EaAmFo 227**
See: Kirkpatrick, Cornwall E.

Kirschbaum, Joseph, Sr.
b. 1829 Berlin, Germany, d. 1926
Flourished: Nauvoo, IL
Type of Work: Pen, ink? (Memory drawings)
Sources: *ArC 208*.

Kirst, John
Flourished: 1848 Centre Township, PA
Type of Work: Fabric (Weavings)
Sources: *ChAmC 75*.

Kirtland, James
Flourished: c1815 Pittsburgh, PA
Type of Work: Tin (Tinware)
Sources: *AmCoTW 156-7; ToCPS 7*.

Kisner, Benedict
Flourished: 1860 Baltimore, MD
Type of Work: Fabric (Weavings)
Sources: *ChAmC 75*
See: Kisner and Company; Kisner, John A.

Kisner, John A.
Flourished: 1856-1860 Baltimore, MD
Type of Work: Fabric (Weavings)
Sources: *ChAmC 75*
See: Kisner and Company.

Kisner and Company
Flourished: 1856-1860 Baltimore, MD
Type of Work: Fabric (Weavings)
Sources: *ChAmC 75*
See: Kisner, John A.; Kisner, Benedict.

Kitchen, Tella
b. 1902 Vinton County, OH
Flourished: 1963 Adelphi, OH
Type of Work: Oil (Landscape paintings)
Museums: 178
Sources: *AmFokArt 142-4*; ArtWo 141, 144*, 163; FoA 466; Full **.

Kitson, Nathan
Flourished: 1848 Richmond, IN
Type of Work: Fabric (Coverlets)
Sources: *ChAmC 76*.

Kittell, Nicholas Biddle
b. 1822 d. 1894
Type of Work: Oil (Portraits)
Museums: 184
Sources: *FoArA 40**.

Kittinger, John
Flourished: 1838-1840 Springfield, OH
Type of Work: Fabric (Weavings)
Sources: *ChAmC 76*.

Kittle, Nellie
Flourished: 1940 St. Lawrence, NY; Macomb, NY
Type of Work: Fabric (Quilts)
Museums: 246
Sources: *FouNY 63*.

Kivetoruk
See: Moses, James.

Klar, Francis Joseph
Flourished: 1838-1843 Reading, PA
Type of Work: Fabric (Weavings)
Sources: *AmSQu 277; ChAmC 76*.

Klehl, J.
Flourished: 1868 Hamilton County, IN
Type of Work: Fabric (Weavings)
Sources: *AmSQu 277; ChAmC 76*.

Klein, Andrew
Flourished: 1854-1857- Shelbyville, IN; Dearborn County, IN; Noblesville, IN
Ethnicity: German
Type of Work: Fabric (Weavings)
Remarks: Father is Michael; brothers are John, Francis and Fredoline
Sources: *ChAmC 76*.

Klein, Francis
b. c1829
Flourished: c1840-1854 Shelbyville, IN
Ethnicity: German
Type of Work: Fabric (Weavings)
Remarks: Father is Michael; brothers are Andrew, Fredoline and John
Sources: *ChAmC 76*.

Klein, Fredoline
b. c1831
Flourished: c1840-1854 Shelbyville, IN
Type of Work: Fabric (Weavings)
Remarks: Brothers are Abraham, Francis, and John; father is Michael
Sources: *ChAmC 76*.

Klein, John
b. c1834 d. 1901
Flourished: 1850-1868 Noblesville, IN; Shelbyville, IN; Hamilton County, IN
Ethnicity: German
Type of Work: Fabric (Coverlets)
Remarks: Brothers are Andrew, Francis, Fredoline; father is Michael
Sources: *AmSQu 260*, 276; ChAmC 76, 32-3*, 41*, 70**.

Klein, Mathias
[Clein]
Flourished: 1839-1850 Montgomery County, OH
Type of Work: Fabric (Coverlets)
Sources: *ChAmC 76*.

Klein, Michael
d. 1851
Flourished: c1840-1854 Shelbyville, IN
Ethnicity: German
Type of Work: Fabric (Weavings)
Remarks: Sons are Andrew, Francis, Fredoline, and John
Sources: *ChAmC 76.*

Kleinhofen, Henry
Flourished: 1859 Chicago, IL
Type of Work: Oil? (Landscape paintings)
Sources: *ArC 265.*

Klenk, Ferdinand
Flourished: 1875 Pennsylvania
Type of Work: Watercolor, ink (Frakturs)
Sources: *AmFoPa 188.*

Kline, A.
Flourished: late 19th cent
Type of Work: Oil (Paintings)
Sources: *AlAmD 4*.*

Kline, Charles S.
Flourished: c1890 Howell's Mill, GA
Type of Work: Stoneware (Churns)
Sources: *AmS 94*; MisPi 8*.*

Kline, Philip
Flourished: 1808, 1809- Carversville, PA
Type of Work: Clay (Pottery)
Sources: *AmPoP 165, 265; DicM 106*; PenDA 67*.*

Klinger, Absalom
b. 1817 Pennsylvania d. 1901
Flourished: 1843-1864 Millersburg, PA; Bethel Township, PA
Type of Work: Fabric (Coverlets)
Sources: *AmSQu 277; ChAmC 77*
See: Bordner, Daniel .

Klingman, C.L.
Flourished: 1800s Mifflinburg, PA
Type of Work: Tin (Tinware)
Sources: *ToCPS 21.*

Klinhinz, John
Flourished: 1848-1854 Ottawa County?, OH
Type of Work: Fabric (Coverlets)
Sources: *AmSQu 256*; ChAmC 77, 42*.*

Klinker, Christian
Flourished: c1770s-1780s Bucksville, PA
Ethnicity: German?
Type of Work: Clay (Pottery)
Museums: 227
Sources: *AmPoP 165; DicM 25*; FoArRP 22*, 29*.*

Klippenstein, S.
Flourished: 1974 Syracuse, NY
Type of Work: Wood (Roadrunner)
Sources: *WoScuNY.*

Klippert, Henry
Flourished: 1840
Type of Work: Fabric? (Coverlets?)
Sources: *ChAmC 77.*

Klumbach, Jacob
Flourished: 1860 New York, NY
Type of Work: Wood (Ship carvings, ship figures)
Sources: *AmFiTCa 195.*

Klumpp, Gustav
b. 1902 d. 1980
Flourished: 1966 Brooklyn, NY
Ethnicity: German
Type of Work: Oil (Paintings, particularly of nudes)
Sources: *AmFokArt 145-7*; FoA 48*, 466; FoPaAm 111, fig31; TwCA 216*.*

Knapp, F.J.
See: F.J. Knapp .

Knapp, F.K.
Flourished: 1863-1885 Akron, OH
Type of Work: Stoneware (Pottery)
Sources: *AmPoP 206; Decor 221.*

Knapp, Harriet
Flourished: 1854 Stamford, CT
Type of Work: Fabric (Quilts)
Museums: 266
Sources: *AmSQu 201*.*

Knapp, Harry
Flourished: Long Island, NY
Type of Work: Wood (Duck decoys)
Sources: *AmBiDe 97*; AmDecoy 70*.*

Knapp, Hazel
b. 1908
Flourished: Vermont
Type of Work: Oil, watercolor (Landscape paintings)
Sources: *PrimPa 175; ThTaT 178-81*.*

Knappenberger, G.
Flourished: 1876 Pennsylvania
Type of Work: Fabric (Quilts)
Museums: 171
Sources: *AmFoArt 135*; QuiAm 168*.*

Knight, Belinda D.
Flourished: 1815 New Hampshire
Type of Work: Watercolor, pinpricks (Still life drawings)
Sources: *NinCFo 198.*

Knight, Emily
Flourished: 1760-1770 Boston, MA
Type of Work: Fabric (Bedcovers)
Sources: *NewDis 26*.*

Knight, H.
Flourished: 1836 Connecticut; New York
Type of Work: Oil (Portraits)
Sources: *AmHo 14*; OneAmPr 95*, 145, 154.*

Knight, L.
Type of Work: Wood (Signs)
Sources: *MoBBTaS 9, 72*.*

Knight, Maurice A.
Flourished: 1911-1915 Akron, OH
Type of Work: Stoneware (Bowls, sewer tile sculpture)
Remarks: Worked for Chemical Stoneware
Sources: *AmS 102*; IlHaOS *.*

Knight, Richard
b. 1623
Flourished: 1689 Boston, MA
Type of Work: Wood (Ship carvings, ship figures)
Sources: *ShipNA 158.*

Knight, Stephanas
Flourished: 1772-1810 Enfield, CT
Type of Work: Wood (Signs)
Sources: *MoBBTaS 11.*

Knight, T.G.
Flourished: 1880 Pennsylvania
Type of Work: Oil (Genre paintings)
Sources: *AmPrP 153; Edith *; PrimPa 175.*

Knipers, W.
Flourished: 1860
Type of Work: Oil (Portraits)
Sources: *PrimPa 175.*

Knirim, A.D.
Flourished: 1868 Dixon, IL
Type of Work: Fabric (Weavings)
Sources: *ChAmC 77.*

Knoblock
See: Roherge and Knoblock .

Knoebel, Jacob
Flourished: c1840-1850 Belleville, IL
Type of Work: Wood (Furniture)
Sources: *ArC 174*.*

Knoedler, Cyriak
Flourished: 1860 New York, NY
Type of Work: Wood (Ship carvings, ship figures)
Sources: *AmFiTCa 195.*

Knost, Edward
Flourished: 1860 New York, NY
Type of Work: Wood (Ship carvings, ship figures)
Sources: *AmFiTCa 195.*

Knowles, Mrs. Henry L.
Flourished: 1844 Potsdam, NY
Type of Work: Clay, fabric, oil (Pottery, election banners)
Museums: 235
Sources: *FouNY 66.*

Knowles, Isaac W.
Flourished: 1853-1870 East Liverpool, OH
Type of Work: Yellow-ware, Rockingham (Pottery)
Sources: *AmPoP 75, 216*
See: Harvey, Isaac .

Knowles, Taylor, and Knowles
Flourished: 1854- East Liverpool, OH
Type of Work: Clay (Pottery)
Sources: *AmPoP 78, 216; DicM 79*, 90*, 125*, 136*, 141*, 145*, 152*, 162*, 174*, 176*-7*, 202*, 243-4*, 253-6*.*

Knox, W.C.
Flourished: c1870 Limestone County, TX
Type of Work: Stoneware (Jugs)
Sources: *AmS 234*.*

Knox Hill Pottery
See: Odom and Turnlee.

Koch
Flourished: c1866 Mound City, IL
Type of Work: Stoneware (Pottery)
Sources: *AmPoP 224; Decor 221.*

Koch, Ann Koenig
Flourished: c1859 Quincy, IL
Type of Work: Fabric (Quilts)
Sources: *ArC 140*.*

Koch, Samuel
[Kochmeister]
b. 1887
Flourished: New York, NY
Ethnicity: Polish
Type of Work: Oil (Genre paintings)
Sources: *PrimPa 175; ThTaT 204-7*.*

Koch, Valentine
See: Cook, Valentine.

Kochmeister, Samuel
See: Koch, Samuel.

Koenig, Joseph
Flourished: 1875 Wisconsin
Type of Work: Wood (Religious sculptures, carvings)
Sources: *AmFoS 186*.*

Koeth, Theo
Flourished: 1860
Type of Work: Oil (Genre paintings)
Sources: *PrimPa 175.*

Kohl, Peter
Flourished: 1860 New York, NY
Type of Work: Wood (Ship carvings, ship figures)
Sources: *AmFiTCa 195.*

Kohler, John W.
Flourished: 1868 Pensacola, FL
Type of Work: Clay (Pottery)
Sources: *EaAmFo 190*.*

Kohler, Rebecca Leiby
Flourished: 1832 Berks County, PA
Type of Work: Fabric (Quilts)
Museums: 225
Sources: *PenDuA 35*; QuiAm 89*.*

Kohler Pottery
See: Kohler, John W.

Kollner, August
b. 1813
Flourished: 1839-1849 Chicago, IL
Type of Work: (Drawings)
Sources: *ArC 265.*

Koontz, John
Flourished: c1807 East Liverpool, OH
Type of Work: Redware (Pottery)
Sources: *AmPoP 74, 214.*

Kost
Flourished: 1860 California
Type of Work: Oil (Still life paintings)
Sources: *OneAmPr 129*, 148, 154.*

Kostner, J.M.
Flourished: 1846 Lewisville, OH
Type of Work: Fabric (Weavings)
Sources: *ChAmC 77.*

Kountze, Mrs. De Lancey
Flourished: 1933 New York, NY
Type of Work: Fabric (Needlepoint pictures)
Sources: *AmNe 174-5*.*

Kozlowski, Karol
b. 1885 d. 1969 Congers, NY
Flourished: 1920-1968 Greenpoint, NY
Ethnicity: Polish
Type of Work: Oil (Scene paintings)
Remarks: Emigrated to U.S. in 1913
Sources: *FoAF 14; KaKo *.*

Krafe
See: William Krafe and E.F. Teubner.

Krager, C.L.
Flourished: 1870-1900 Daisy, TN
Type of Work: Stoneware (Pottery)
Sources: *AmPoP 237.*

Kral, Kadharina
Flourished: 1855 Pennsylvania
Type of Work: Fabric (Stitched linens)
Sources: *FoArRP 47.*

Kramlich, John
See: Gramlyg, John.

Krans, J.
Flourished: 1895 Brooklyn, NY
Type of Work: Wood (Tinman signs)
Museums: 096
Sources: *AmFoS 38*; TYeAmS 106*, 342.*

Krans, Olof
b. 1838 d. 1916 Altoona, IL
Flourished: 1896-1908 Bishop Hill, IL; Galva, IL
Ethnicity: Swedish
Type of Work: Oil (Community scene, historical paintings, portraits)
Museums: 028,044,189
Sources: *AmFokArt 148-151*; AmFoPaCe 203*; ArC 210*, 232*, 236*, 240-1*; FoA 466; HoKnAm 181;InAmD 25*; PicFoA 27, 120*; PrimPa 139-48*, 176; TwCA 34*.*

Kratzen, Joseph
Flourished: 1845-1850 Virginia
Type of Work: Watercolor, ink (Frakturs)
Sources: *SoFoA 87*, 219.*

Kraus, John
Flourished: c1800 Krausdale, PA
Type of Work: Redware (Pottery)
Sources: *AmPoP 170.*

Krause, Oscar
Flourished: 1891 Philadelphia, PA
Type of Work: Wood (Ship carvings, ship figures)
Sources: *AmFiTCa 195.*

Krause, Thomas
Flourished: 1814 North Carolina
Ethnicity: Moravian
Type of Work: Redware (Pottery)
Sources: *SoFoA 2*, 216.*

Krause, William O.
Flourished: 1886 Philadelphia, PA
Type of Work: Wood (Ship carvings, ship figures)
Sources: *AmFiTCa 195.*

Krauss, Johannes
b. 1770
Flourished: 1786 Pennsylvania
Type of Work: Watercolor, ink (Frakturs)
Sources: *AmFoPa 188.*

Krauss, Regina
Flourished: 1815 Pennsylvania
Type of Work: Watercolor, ink (Frakturs)
Sources: *AmFoPa 188.*

Krebs, Friedrich (Friederich; Frederick)
b. Dauphin County, PA d. 1815
Flourished: 1780-1815 Lancaster, PA; Berks County, PA
Type of Work: Watercolor, ink (Frakturs)
Museums: 176
Sources: *AmFoPa 186; BeyN 122; ColAWC 272, 276*; HoKnAm 149; NinCFo 187; PicFoA 146*.*

Krebs, Philip, Sr.
b. c1780 Pennsylvania
Flourished: 1810-1862 Fredericksburg, PA
Type of Work: Fabric (Weavings)
Remarks: Son is Philip, Jr.
Sources: *ChAmC 77.*

Krebs, Philip, Jr.
Flourished: c1850 Fredericksburg, PA
Type of Work: Fabric (Weavings)
Remarks: Father is Philip, Sr.
Sources: *ChAmC 77.*

Kreebel, Isaac
Flourished: 1857 Montgomery County, PA
Type of Work: Watercolor (Battle scene paintings)
Sources: *NinCFo 187.*

Kreider, Albert M.
Flourished: 1883-1925? Lititz, PA
Type of Work: Tin (Tinware)
Museums: 167
Remarks: Son is Maurice; son-in-law is Loercher, Everett
Sources: *ToCPS* 9, 10-1*, 24, 29, 43-4.51-2*, 74, 76-7*, fig.

Kreider, Maurice (Morris)
Flourished: 1925 Lititz, PA
Type of Work: Tin (Tinware)
Remarks: Father is Albert
Sources: *ToCPS* 7*, 9, 43-4, 52.

Kretzinger, Rose
Flourished: Kansas City, MO
Type of Work: Fabric (Quilts)
Sources: *QuiAm* 64.

Krider, Jacob
Flourished: 1825 Pennsylvania
Type of Work: Watercolor, ink (Horse and tiger illustrations)
Sources: *NinCFo* 187.

Kriebel, David
Flourished: 1803-1805 Pennsylvania
Type of Work: Watercolor, ink (Frakturs)
Sources: *AmFoPa* 188.

Kriebel, Hanna
Flourished: Pennsylvania
Type of Work: Watercolor, ink (Frakturs)
Sources: *AmFoPa* 188.

Kriebel, Job
Flourished: 1825 Pennsylvania
Type of Work: Watercolor, ink (Frakturs)
Sources: *AmFoPa* 188.

Kriebel, Maria
Flourished: 1843 Pennsylvania
Type of Work: Watercolor, ink (Frakturs)
Sources: *AmFoPa* 188.

Kriebel, Phebe
b. 1837 d. 1894
Flourished: Montgomery County, PA
Type of Work: Fabric (Embroidered landscapes)
Sources: *ArtWo* 103, 163, fig19.

Kriebel, Sara
Flourished: 1840s Pennsylvania
Type of Work: Watercolor, ink (Frakturs)
Sources: *AmFoPa* 188.

Krieble, Abraham
Flourished: 1782 Pennsylvania
Type of Work: Watercolor, ink (Frakturs)
Sources: *AmFoPa* 188.

Krieghoff, Philip E.
Flourished: 1876 Philadelphia, PA
Type of Work: Wood (Ship carvings, ship figures)
Sources: *AmFiTCa* 195.

Krimler, Henry
Flourished: c1767 Reading, PA
Type of Work: Redware (Pottery)
Sources: *AmPoP* 178.

Krimmel, John Lewis
Flourished: 1810-1813 Philadelphia, PA
Type of Work: Oil (Genre paintings)
Museums: 223
Sources: *AmFoS* 167*; *PlaFan* 196*.

Kriner, Robert
Flourished: 1887 Pennsylvania
Type of Work: Wood (Sculptures, carvings)
Sources: *AmFoS* 118*.

Kroebe, Michael
Flourished: 1850-1860 Hermann, MO
Type of Work: Wood (Lounges)
Sources: *ASeMo* 237*.

Kronauze, William
Flourished: 1860 Philadelphia, PA
Type of Work: Wood (Ship carvings, ship figures)
Sources: *AmFiTCa* 195.

Krone, Lawrence (Laurence)
Flourished: c1805-1810 Roanoke, VA; Wytheville, VA
Type of Work: Stone (Gravestones)
Remarks: Itinerant
Sources: *EaAmG* 95*-8*, 129; *SoFoA* 125*, 220.

Krumeich, B.J.
See: Krumeick, B.J.

Krumeick, B.J.
[Krumeich]
Flourished: 1845-1860 Newark, NJ
Type of Work: Stoneware, redware (Pottery)
Sources: *AmPoP* 48, 172, 267; *AmS* 238*; *Decor* 221; *DicM* 20*.

Kruschke, Herman
b. 1888
Flourished: 1932 or 1942? Ashland, WI
Type of Work: Wood (Cigar store Indians, figures)
Sources: *ArtWod* 153*; *CiStF* 65; *EaAmW* 48.

Kuch, Conrad
Flourished: 1767-1784 Reading, PA
Type of Work: Redware (Pottery)
Sources: *AmPoP* 178.

Kuder, Solomon
[Kuter]
b. c1806 Pennsylvania d. 1866
Flourished: 1835-1855 Trexlertown, PA
Type of Work: Fabric (Coverlets)
Remarks: Son is William
Sources: *ChAmC* 77
See: Backer, Hiram.

Kuder, William
Flourished: 1849-1850 Trexlertown, PA; Norristown, PA
Type of Work: Fabric (Weavings)
Remarks: Father is Solomon
Sources: *ChAmC* 77.

Kuehls, Theodore
Flourished: 1870 Philadelphia, PA
Type of Work: Wood (Ship carvings, ship figures)
Sources: *AmFiTCa* 195.

Kuhn, Justus Englehardt
d. 1717
Flourished: Annapolis, MD
Ethnicity: German
Type of Work: Oil (Portraits)
Museums: 153
Sources: *ArtWea* 160*.

Kumerle, D.
Flourished: mid 18th cent Pennsylvania
Type of Work: Metal (Ornamental works)
Museums: 224
Sources: *PenDA* 38*.

Kump, Andrew
b. 1811 d. 1868
Flourished: 1845-1853 Hanover, PA
Type of Work: Fabric (Coverlets)
Sources: *ChAmC* 17*, 77
See: Harch, J.

Kuns, Cadarina
Flourished: 1827 Pennsylvania
Type of Work: Fabric (Embroidered show towels)
Sources: *FoArRP* 58*.

Kunze, William
Flourished: 1840-1870 Warren, MO
Type of Work: Wood (Chairs)
Sources: *ASeMo* 326*.

Kurbaum and Schwartz
Flourished: c1850 Philadelphia, PA
Type of Work: Clay (Pottery)
Sources: *AmPoP* 104, 176; *DicM* 77*.

Kurpenski, C.
Flourished: 1930s Jackson, MI
Type of Work: Wood, paint (Carved animals)
Sources: *Rain* 50*-3*.

Kurtz, Sadie
b. 1888 d. 1973
Flourished: 1957-1973 Bayonne, NJ
Ethnicity: Austrian
Type of Work: Poster paint (Paintings)
Sources: *ArtWo* 163, pl.25; *FoAFb* 5-6; *TwCA* 211*.

Kurtz and Company
Flourished: 1873 New York, NY
Type of Work: Wood (Ship carvings, ship figures)
Sources: *ShipNA* 162.

Kurz, Max
Flourished: 1860 New York, NY
Type of Work: Wood (Ship carvings, ship figures)
Sources: *AmFiTCa 195*.

Kurz, Rudolf Friederich
Flourished: c1848 St. Louis, MO
Ethnicity: Swiss
Sources: *ArC 5, 218*.

Kuster, Friederick
Flourished: Pennsylvania
Type of Work: Watercolor, ink (Frakturs)
Sources: *HerSa*.

Kuter, Solomon
See: Kuder, Solomon.

Kutz, Anthony
Flourished: 1860 New York, NY
Type of Work: Wood (Ship carvings, ship figures)
Sources: *AmFiTCa 195*.

Kuzuguk, Bert
Flourished: 1970 Shismaref, AK
Type of Work: Whalebone, ivory (Whalebone, ivory art)
Sources: *FoAFm 2; TwCA 167**.

L

L'Enfant, Pierre Charles
Flourished: c1766 New York, NY
Type of Work: Metal (Weathervanes)
Sources: *WeaWhir 43.*

L. and B.G. Chase
Flourished: c1845-1850 Somerset, MA
Type of Work: Stoneware (Kegs)
Sources: *AmS 173*; DicM 83*.*

L.D. Berger Brothers Manufacturing
Flourished: 1895 Philadelphia, PA
Type of Work: Metal (Weathervanes)
Sources: *YankWe 210.*

L. Norton and Sons
Flourished: 1833-1840 Bennington, VT
Type of Work: Stoneware, redware (Pottery)
Sources: *AmPoP 187*
See: Norton, John, Captain; Norton, Luman.

L.S. Beerbauer and Company
See: Pruden, John; Beerbower, L.S.

L.W. Cushing and Sons
See: Cushing and White.

La Flair, John
Flourished: Red Mills, NY
Type of Work: Wood (Duck decoys)
Sources: *FouNY 64.*

La France, Mitchell
b. 1882
Flourished: St. Sophie, LA
Type of Work: Wood (Duck decoys)
Sources: *AmFokA 39*.*

La Tourette, Henry
[Latourette]
b. c1832 Indiana **d.** 1892 Colorado
Flourished: 1849-1871 Fountain County, IN
Type of Work: Fabric (Coverlets)
Remarks: Sister is Sarah La Tourette; father is John
Sources: *AmSQu 277; ChAmC 78.*

La Tourette, John
[LaTourette]
b. 1793 New Jersey **d.** 1849
Flourished: 1826, 1841-49 Fountain County, IN
Type of Work: Fabric (Coverlets)
Remarks: Son is Henry; daughter is Sarah
Sources: *AmSQu 277; ChAmC 78.*

La Tourette, Sarah (Van Sickle)
b. 1822 Germantown, OH **d.** 1914
Flourished: c1828-1858 Fountain County, IN; Vermilion County, IL
Type of Work: Fabric (Coverlets)
Museums: 116
Remarks: Brother is Henry; father is John
Sources: *AmSQu 277; ArC 171*; ArtWo 26, 27*, 163; ChAmC 13, 78, 113.*

Labeyril, Constant
Flourished: 1860 New York, NY
Type of Work: Wood (Ship carvings, ship figures)
Sources: *AmFiTCa 195.*

Labhart, J.M.
Flourished: c1846 Chicago, IL
Type of Work: Clay (Pottery)
Sources: *ArC 190.*

Labrie, Rose
b. 1916
Flourished: 1970s Portsmouth, NH; Boston, MA
Type of Work: Oil (Landscape paintings)
Sources: *AmFokArt 152-4*; FoA 50*, 466; FoPaAm 62-3*.*

Lafleur, Charles
Flourished: 1860 New York, NY
Type of Work: Wood (Ship carvings, ship figures)
Sources: *AmFiTCa 195.*

Lafon, Mary Virginia
Flourished: 1821 Versailles, KY
Type of Work: Fabric (Samplers)
Sources: *SoFoA 173*, 222.*

Laget, A.
Flourished: Middletown, OH
Type of Work: Fabric (Coverlets)
Sources: *ChAmC 78.*

Laighton, Deborah
Flourished: 1810 Portsmouth, NH
Type of Work: Fabric (Samplers)
Sources: *GalAmS 47*, 91.*

Laing, Albert
b. 1811 Rahway, NJ **d.** 1886
Flourished: c1870 Stratford, CT
Type of Work: Wood (Duck decoys)
Museums: 176
Sources: *AmBiDe 64-7*; AmDecoy xii, 9, 41*, 44*; AmSFo 26; ArtDe 155*; ColAWC 323-4*; Decoy16*, 41*, 62*, 75*; HoKnAm 40; WiFoD 55*; WoCar 140.*

Lake, Salmon
b. c1794 Connecticut
Flourished: 1832-1850 Fredonia, NY; Dunkirk, NY; Pomfret, NY
Type of Work: Fabric (Carpets, coverlets)
Sources: *AmSFo 95; ChAmC 78.*

Lake, William
Flourished: 1785 Philadelphia, PA
Type of Work: Wood (Ship carvings, ship figures)
Sources: *AmFiTCa 195; ShipNA 32, 163.*

Lakeman, Nathaniel
Flourished: 1780-1790 Massachusetts
Type of Work: Oil (Portraits)
Sources: *AmPrP 153; Edith *; PrimPa 176.*

Lamb, Anthony
Flourished: c1730 New York, NY
Type of Work: Brass (Compasses)
Sources: *AmCoB 228.*

Lamb, David
b. 1724 **d.** 1773
Flourished: Norwich, CT
Type of Work: Stone (Gravestones)
Remarks: Son is David, Jr.
Sources: *EaAmG 52-3*, 128.*

Lamb, David, Jr.
b. 1750 d. 1783
Flourished: Norwich, CT
Type of Work: Stone (Gravestones)
Remarks: Father is David
Sources: *EaAmG 52-3*, 128.*

Lamb, James
b. 1777 d. 1833
Flourished: New Britain, CT
Type of Work: Tin (Tinware)
Remarks: Apprenticed to Shubael Pattison; invented cooking stove
Sources: *TinC 172-3.*

Lamb, K.A.
Flourished: 1850 New England,
Type of Work: Oil (Paintings)
Sources: *PrimPa 176.*

Lamb, Lysis
Flourished: Connecticut
Type of Work: Tin (Tinware)
Remarks: Associated with Hubbard, John
Sources: *TinC 173.*

Lambert, Lydia
Flourished: mid 18th cent Salem, MA
Type of Work: Fabric (Embroidered aprons)
Sources: *AmNe 147.*

Lambert, Thomas
Flourished: 1845 New York, NY
Type of Work: Wood (Ship carvings, ship figures)
Sources: *AmFiTCa 195.*

Lambright, Mrs. Elizabeth
Flourished: 1920 Topeka, IN
Ethnicity: Amish
Type of Work: Fabric (Quilts)
Sources: *QuInA 55*.*

Lambright, Mrs. Menno
Flourished: 1936 Indiana
Ethnicity: Amish
Type of Work: Fabric (Quilts)
Sources: *QuInA 39*.*

Lambright, Mrs. Susan
Flourished: 1931 Emma, IN
Ethnicity: Amish
Type of Work: Fabric (Quilts)
Sources: *QuInA 35*.*

Lambright and Westhope
Flourished: c1885-1895 New Philadelphia, OH
Type of Work: Stoneware (Pottery)
Sources: *AmPoP 225; Decor 221.*

Lamerand, Ed
Flourished: Flat Rock, MI
Type of Work: Wood (Duck decoys)
Sources: *WaDec 128*.*

Lamielle, E.
Flourished: 1893 Louisville, OH
Type of Work: Clay (Sewer tile sculpture)
Sources: *IlHaOS *.*

Lamphere, Ralph
Flourished: pre 1851 Branford, CT
Type of Work: Wood (Duck decoys)
Museums: 260
Sources: *Decoy 74*.*

Lamson, Asa
Flourished: c1870-1900 Exeter, NH
Type of Work: Redware (Pottery)
Sources: *AmPoP 191.*

Lamson, Caleb
b. 1697 d. 1767
Flourished: c1716-1767 Charlestown, MA
Type of Work: Stone (Gravestones)
Remarks: Father is Joseph; brother is Nathaniel; son is John
Sources: *EaAmG viii, 126*, 128; GravNE 14, 46-8, 128.*

Lamson, David
Flourished: c1780 Charlestown, MA
Type of Work: Stone (Gravestones)
Sources: *EaAmG viii, 128.*

Lamson, John
b. 1732 d. 1776
Flourished: Charlestown, MA
Type of Work: Stone (Gravestones)
Remarks: Father is Caleb
Sources: *EaAmG viii, 128; GravNE 48, 129.*

Lamson, Joseph
b. 1656 Ipswich, MA d. 1722
Flourished: c1686-1712 Charlestown, MA
Type of Work: Stone (Gravestones, other stoneworks)
Remarks: Sons are Caleb and Nathaniel
Sources: *EaAmG viii, 11*, 15*, 128; GravNE 24, 40-4, 129.*

Lamson, Joseph
b. 1731 d. 1789
Flourished: Charlestown, MA
Type of Work: Stone (Gravestones)
Sources: *EaAmG viii, 128; GravNE 129.*

Lamson, Joseph
b. 1760 d. 1808
Flourished: Charlestown, MA
Type of Work: Stone (Gravestones)
Sources: *EaAmG viii, 128; GravNE 49, 129.*

Lamson, Nathaniel
b. 1693 Charlestown?, MA? d. 1755
Flourished: c1709-1767 Charlestown, MA
Type of Work: Stone (Gravestones)
Remarks: Father is Joseph; brother is Caleb
Sources: *EaAmG viii, 11*, 128; GravNE 46-8, 129.*

Lamson and Swazey
Flourished: c1875 Portland, ME
Type of Work: Stoneware (Pottery)
Sources: *AmPoP 201.*

Lancaster, Lydia
Flourished: 1830 Philadelphia, PA
Type of Work: Fabric (Samplers)
Sources: *AmNe 52, 60*.*

Landau, Sol
b. 1919 New York, NY
Flourished: 1981 New York, NY
Type of Work: Wood (Sculptures, carvings)
Sources: *AmFokArt 155-8*; FoA 142*, 466.*

Landes, Barbara
Flourished: 1827 Pennsylvania
Type of Work: Fabric (Samplers)
Sources: *FoArRP 55*.*

Landes, John
Flourished: c1756-1805 Pennsylvania
Ethnicity: Mennonite
Type of Work: Fabric (Coverlets)
Museums: 227
Sources: *AmSQu 221, 227; ChAmC 78; FoArRP 65-6.*

Landes, Rudolph
Flourished: 1810s Pennsylvania
Type of Work: Watercolor, ink (Frakturs)
Sources: *AmFoPa 188.*

Landis
See: Sosman and Landis Company.

Landis, Catherine L.
Flourished: 1840s Pennsylvania
Type of Work: Watercolor, ink (Frakturs)
Sources: *AmFoPa 188.*

Landis, John
Flourished: 1820s Pennsylvania
Type of Work: Watercolor, ink (Frakturs)
Sources: *AmFoPa 188; AmPrW 84*, 132*.*

Landis, John A.
Flourished: 1852 Pennsylvania
Type of Work: Watercolor, ink (Frakturs)
Sources: *AmFoPa 188.*

Landis, M.A.
Flourished: 1849 Leacock Township, PA
Type of Work: Fabric? (Coverlets?)
Sources: *ChAmC 124.*

Landrum, Amos
Flourished: c1840 South Carolina
Type of Work: Stoneware (Pottery)
Sources: *SoFoA 13*, 217.*

Landrum, L(ineas) M(ead)
Flourished: c1850 Columbia, SC
Type of Work: Stoneware (Pottery)
Sources: *SoFoA 13*, 217.*

Landry, Pierre Joseph
b. 1770 d. 1843
Flourished: c1833 Iberville Parish, LA
Ethnicity: French
Type of Work: Wood (Sculptures, carvings)
Museums: 127,136,201
Sources: *AmFoS 124*; EaAmW 67, 68*; FoArA 17*, 140-2*; SoFoA 112, 119*-120, 220.*

Lane
Flourished: 1885 Adirondack Mountains, NY
Type of Work: Oil (Genre paintings)
Sources: *FouNY 67.*

Lane, Charles
Flourished: c1800 Plymouth, MA
Type of Work: Stone (Gravestones)
Sources: *EaAmG 128.*

Lane, Elizabeth
Flourished: 1817
Type of Work: Fabric (Mourning pictures)
Sources: *MoBeA;WinGu 101*.*

Lane, Fitz Hugh
b. 1804 d. 1865
Flourished: Boston, MA
Type of Work: Oil (Ship, harbor scene, seascape paintings)
Sources: *AmFoPa 97, 106, 109, 125.*

Lane, Samuel "Sam"
b. 1698 d. 1776
Flourished: c1719 Hampton Falls, NH
Type of Work: Wood (Chests, boxes, press cupboards)
Museums: 313
Sources: *AmPaF 45; NeaT 18.*

Langan, Tom
b. Long Island, NY
Type of Work: Wood (Duck decoys, other carvings)
Museums: 171,188
Sources: *AmFokArt 159-161*.*

Langdon, Barnabas
Flourished: c1800-1810 Dedham, MA
Type of Work: Tin (Tinware)
Sources: *AmCoTW 45.*

Langdon, Elias
Flourished: 1833 Philadelphia, PA
Type of Work: Wood (Ship carvings, ship figures)
Sources: *AmFiTCa 195.*

Langenberg Pottery
Flourished: Franklin, WI
Type of Work: Clay (Pottery)
Sources: *EaAmFo 171*.*

Langlais, Bernard
Flourished: 1975 Cushing, ME
Type of Work: Wood (Sculptures, carvings)
Sources: *AlAmD 69*.*

Langston, Thomas
Flourished: 1877 Meriden, CT
Type of Work: Tin (Lanterns)
Sources: *TinC 173.*

Lannuier, John
Flourished: 1820 New York, NY
Type of Work: Wood (Ship carvings, ship figures)
Sources: *AmFiTCa 195.*

Lantz, Mrs. Ed
Flourished: 1910 Elkhart, IN
Ethnicity: Amish
Type of Work: Fabric (Quilts)
Museums: 171
Sources: *AmFoArt 140*; QuflnA 51*.*

Lantz, J.
Flourished: 1837 East Hempfield Township, PA; Northampton County, PA
Type of Work: Fabric (Coverlets)
Sources: *AmSQu 266*, 276; ChAmC 78.*

Lapp, Christian
Flourished: 1819 Pennsylvania
Type of Work: Watercolor, ink (Frakturs)
Sources: *AmFoPa 188.*

Lapp, Ferdinand
Flourished: 1890 Detroit, MI
Type of Work: Wood (Cigar store Indians, figures)
Sources: *ArtWod 143, 265.*

Lapp, Henry
b. 1822 d. 1913
Flourished: Pennsylvania
Type of Work: Watercolor, ink (Frakturs)
Sources: *AmFoPa 188.*

Lapp, Lydia
Flourished: c1938 Leola, PA
Type of Work: Fabric (Quilts)
Sources: *GalAmQ 4*.*

Larkin
Flourished: Lansingburgh, NY
Type of Work: Tin (Tinware)
Remarks: Worked for Filley
Sources: *TinC 173.*

Larson, Edward
b. 1931
Flourished: c1979 Joplin, MO; Illinois
Type of Work: Oil (Landscape paintings)
Sources: *FoA 46*, 466.*

Lashel
Flourished: 1850 Ohio
Type of Work: Fabric (Weavings)
Sources: *AmSQu 277.*

Lashell, L.M.
Flourished: Sullivan, OH
Type of Work: Fabric (Weavings)
Sources: *ChAmC 78.*

Laskoski, Pearl
Flourished: Des Moines, IA
Type of Work: Oil (Paintings)
Sources: *ThTaT 236*.*

Lathouse, Mrs. W.B.
Flourished: 1933 Warren, OH
Type of Work: Fabric (Quilts)
Sources: *ArtWo 130*; BirB 34*; NewDis 122-3*.*

Lathrop, Betsy B.
b. 1812
Flourished: New England,; New York
Type of Work: Watercolor (Paintings)
Museums: 001
Sources: *AmFoAr 30; AmPrP 154; ArtWo 69, 72*; PrimPa 176.*

Lathrop, Charles
Flourished: c1792-1796 Norwich, CT
Type of Work: Stoneware (Pottery)
Remarks: Son-in-law of Leffingwell, Christopher
Sources: *AmPoP 199, 267; Decor 221; DicM 97*.*

Lathrop, James S.
Flourished: Meriden, CT
Type of Work: Tin (Tinware)
Sources: *TinC 173.*

Lathrop, Loring
b. 1770 d. 1847
Flourished: Windsor, CT
Type of Work: Stone (Gravestones)
Sources: *EaAmG 128.*

Lathrop, Thatcher
b. 1734 d. 1806
Flourished: Windsor, CT
Type of Work: Stone (Gravestones)
Sources: *EaAmG 128.*

Latourette, Henry
See: La Tourette, Henry.

Latourette, John
See: La Tourette, John.

Latourette, Sarah
See: La Tourette, Sarah.

Laughlin
See: Simms and Laughlin.

Laughlin, Homer
See: Homer Laughlin China Company.

Laughlin, M.
Flourished: 1845 Logan County, OH
Type of Work: Fabric (Weavings)
Sources: *ChAmC 78.*

Laughlin Brothers
See: Homer Laughlin China Company.

Laughlin China Company
See: Homer Laughlin China Company.

Launsbury, John
Flourished: 1810 New York, NY
Type of Work: Wood (Ship carvings, ship figures)
Sources: AmFiTCa 195.

Law, Mrs. Edward
Flourished: Haverford, PA
Type of Work: Fabric (Needlepoint pillow tops)
Sources: AmNe 211*.

Lawrence, David
Flourished: Yellow Creek, OH
Type of Work: Fabric (Coverlets)
Sources: ChAmC 81.

Lawrence, George
Flourished: 1880s New York, NY
Type of Work: Wood (Circus and carousel figures)
Remarks: Worked for the Sebastian Wagon Company
Sources: AmFokAr 107; InAmD 156*.

Lawrence, L.G.
Flourished: 1845 Amherst, NH
Type of Work: Oil (Portraits)
Museums: 001
Sources: AmFoPo 138*.

Lawrence, Sherman B.
Flourished: Meriden, CT
Type of Work: Tin (Tinware)
Sources: TinC 173.

Lawrie, Alexander
[Lourie]
Flourished: 1850 Philadelphia, PA
Type of Work: Oil (Still life paintings)
Sources: AmFoPa 131*.

Lawson, David
b. c1790
Flourished: 1860 Pikes Township, OH
Ethnicity: Irish
Type of Work: Fabric (Weavings)
Sources: ChAmC 81.

Lawson, Oliver
Flourished: contemporary Crisfield, MD
Type of Work: Wood (Bird sculptures, carvings)
Sources: WoCar 164-5*.

Lawson, Thomas B.
Flourished: 1840 Massachusetts
Type of Work: Oil (Portraits)
Sources: AmPrP 154; PrimPa 176; SoAmP 160.

Lawton, C.
Flourished: 1824 North Brookfield, MA
Type of Work: Watercolor (Paintings)
Sources: EyoAm 26.

Lawyer, James
b. c1810 New Jersey
Flourished: c1838-1855 Washington County, IN
Type of Work: Fabric (Coverlets, table linens)
Sources: ChAmC 81.

Laycock, Eliza
Flourished: 1833 Dorchester, NJ
Type of Work: Fabric (Samplers)
Sources: GalAmS 76*-7.

Le Bar, Pamela
[LeBar]
Flourished: 1843 Northampton County, PA
Type of Work: Fabric (Weavings)
Sources: AmSQu 277; ChAmC 81.

Le Roux, Charles
Flourished: c1735 New York
Type of Work: Gold (Boxes)
Museums: 108
Sources: NeaT 81.

Leach, E.W.
Flourished: 1827 New Hampshire
Type of Work: Watercolor, ink, pen (Friendship letters)
Sources: Bes 19*.

Leach, H.
Flourished: Boston, MA
Type of Work: Wood (Ship carvings, ship figures)
Sources: AmFiTCa 195.

Leach, Henry
Flourished: 1867-1872 Boston, MA
Type of Work: Wood (Weathervanes)
Remarks: Made models for Cushing and White
Sources: AlAmD 10*; FoArA 152*; GalAmW 19*; YankWe 144*.

Leach, R.
Flourished: 1875
Type of Work: Oil (Still life paintings)
Sources: NinCFo 183.

Leake, William
Flourished: 1879 Bennington, VT; Elizabeth, NJ
Type of Work: Clay (Pottery)
Remarks: Partner in L.S. Beerbower and Company
Sources: AmPoP 49, 167.

Leaman, Godfrey
Flourished: c1780 Reading, PA
Type of Work: Redware (Pottery)
Sources: AmPoP 178.

Leatherman, Gebhard
Flourished: 1876 Philadelphia, PA
Type of Work: Wood (Ship carvings, ship figures)
Sources: AmFiTCa 195.

Leathers, John B.
Flourished: Mt. Eagle, PA
Type of Work: Stoneware (Pottery)
Sources: HerSa *.

Leavitt, Joseph Warren
Flourished: 1820s Chichester, NH
Type of Work: Watercolor (Interior house paintings, portraits)
Sources: AmDecor figv, 101; AmFokDe 95; AmFoPaN 101, 127*; PicFoA 114*; PrimPa 176.

Lebduska, Lawrence
b. 1894 Baltimore, MD d. 1966
Flourished: 1940-1966 New York, NY
Type of Work: Oil, pastel (Horses, fantasy drawings, scene paintings)
Sources: AmFokArt 162-3*; FoA 98*, 466; FoPaAm 107*, 108; PeiNa 250*; PrimPa 176; ThTaT 170-3*; TwCA 96*.

Lebkicker, Lewis
b. 1841 d. 1906
Flourished: New Berlin, PA
Type of Work: Tin (Tinware)
Sources: ToCPS 42.

Lebrecht, Frederick
Flourished: 1860 New York, NY
Type of Work: Wood (Ship carvings, ship figures)
Sources: AmFiTCa 195.

Leconey, James
Flourished: 1813 Philadelphia, PA
Type of Work: Wood (Ship carvings, ship figures)
Sources: AmFiTCa 195; ShipNA 163.

Lederman, Henry
b. c1819
Flourished: 1859-1860 Adams Township, IN
Ethnicity: French
Type of Work: Fabric (Weavings)
Sources: ChAmC 81.

Lee, Emma
See: Moss, Emma Lee.

Lee, Jared
Flourished: 1819 Southington, CT
Type of Work: Tin (Tinware)
Remarks: Associated with Filley, Oliver
Sources: AmCoTW 59, 63; TinC 173.

Lee, Joe
d. 1941
Flourished: c1925 Beaverhill, TN
Type of Work: Wood (Large figures)
Sources: AmFoS 321*; FoScu 32*.

Lee, John
b. c1788
Flourished: 1848 Gelena, IN
Ethnicity: English
Type of Work: Fabric (Coverlets)
Sources: ChAmC 81.

Leedskalnin, Edward
b. 1887 d. 1951
Flourished: Florida City, FL
Ethnicity: Latvian
Type of Work: Coral (Rock castle sculptures)
Sources: TwCA 56*.

Leehman, Joseph, Sr.
b. c1813 Pennsylvania
Flourished: c1870 Mount Joy, PA
Type of Work: Fabric (Coverlets)
Remarks: Son is Joseph, Jr.
Sources: ChAmC 81.

Leehman, Joseph, Jr.
Flourished: c1870 Mount Joy, PA
Type of Work: Fabric (Coverlets)
Remarks: Father is Joseph, Sr.
Sources: ChAmC 81.

Lees, A.
Flourished: 1880 Boston, MA
Type of Work: Wood (Ship carvings, ship figures)
Sources: AmFiTCa 195; ShipNA 160
See: Lees, J. Walter .

Lees, J.W.
See: Lees, J. Walter .

Lees, J. W(alter)
Flourished: 1867 Charlestown, MA
Type of Work: Wood (Ship carvings, ship figures)
Sources: AmFiTCa 195; ShipNA 160
See: Lees, A.

Lees and Preeble
Flourished: 1856 Chicago, IL
Type of Work: Wood (Ship carvings, ship figures)
Sources: AmFiTCa 195.

Lefever Pottery
Flourished: 1840-1900 Baxter, TN
Type of Work: Brownware, stoneware (Pottery)
Sources: AmPoP 235.

Lefferts, M.F.
Flourished: 1841
Type of Work: Watercolor (Scene paintings)
Sources: PrimPa 176.

Leffingwell, Christopher
Flourished: c1779-1792 Norwich, CT
Type of Work: Redware (Pottery)
Sources: AmPoP 199
See: Lathrop, Charles .

Leggett, Julia
Flourished: 1861 New York
Type of Work: Fabric (Quilts)
Sources: NewDis 80*.

Lehew and Company
Flourished: c1885 Strasburg, VA
Type of Work: Clay (Pottery)
Sources: AmPoP 242; DicM 84*, 143*.

Lehman, Amanda
Flourished: c1960 Topeka, IN
Ethnicity: Amish
Type of Work: Fabric (Quilts)
Museums: 171
Sources: AmFoArt 142*; QuIInA 64*.

Lehman, Johannes
Flourished: c1830 Tylersport, PA
Type of Work: Clay (Pottery)
Sources: AmPoP 186.

Lehman, Louis
[Lehman and Rudinger; Louis Lehman and Company]
Flourished: 1852-1861 Poughkeepsie, NY; New York, NY
Type of Work: Stoneware (Pottery)
Sources: AmPoP 201; Decor 221; DicM 84*, 86*; EaAmFo 285*; InAmD 89*.

Lehman and Rudinger
See: Lehman, Louis .

Lehn, G.
Flourished: Lancaster County, PA
Type of Work: Wood (Egg cups)
Museums: 129
Sources: FoArRP 102*.

Lehn, Henry
Flourished: 1843 Lancaster, PA
Type of Work: Watercolor, ink (Frakturs)
Museums: 176
Sources: AmFoPa 188; ColAWC 274, 277*.

Lehn, Joseph
b. 1798 d. 1892
Flourished: 1860-1880 Lititz, PA
Type of Work: Wood, metal, leather (Carved cups, decorated fire buckets)
Museums: 224
Sources: AmFokA 52*; AmFokDe x*, 42*; AmPaF 273; CoCoWA 45; InAmD 2*; PenDA 105*.

Lehn, Mrs. Mary
Flourished: 1845 Easton, PA
Type of Work: Fabric (Quilts)
Sources: QuiAm 279*.

Lehr, Daniel
Flourished: 1848 Wayne County, OH
Type of Work: Fabric (Coverlets)
Sources: ChAmC 81.

Lehr, George
b. 1795 Mountainville, PA d. 1871
Flourished: 1843- Wethersfield, PA; New Baltimore, OH; Wayne County, OH
Type of Work: Fabric (Weavings)
Sources: ChAmC 124.

Leibo, Jacob
Flourished: 1921
Type of Work: Metal (Weathervanes)
Remarks: Worked for C. G. Brunncknow and Company
Sources: WeaVan 14.

Leidig, Peter
Flourished: 1837-1841 Schaefferstown, PA
Type of Work: Fabric (Coverlets)
Sources: ChAmC 81
See: Renner, George .

Leidy, John
b. c1780?
Flourished: c1790's Franconia, PA; Soudertown?, PA
Type of Work: Clay (Pottery)
Museums: 189,227
Sources: AmPoP 44, 167, 179; FoArRP 25*; PenDuA 28*
See: Groff, Joseph .

Leighton, Ezekiel
b. 1657 d. 1723
Flourished: Rowley, MA
Type of Work: Stone (Gravestones)
Sources: EaAmG 128.

Leighton, Jonathan
b. 1715
Flourished: Rowley, MA
Type of Work: Stone (Gravestones)
Sources: EaAmG 128.

Leighton, Richard
b. 1686 d. 1749
Flourished: Rowley, MA
Type of Work: Stone (Gravestones)
Sources: EaAmG 128.

Leighty, Benjamin
See: Lichy, Benjamin .

Leisey, Peter
b. c1803 Pennsylvania
Flourished: 1859-1860 Denver, PA
Type of Work: Fabric (Weavings)
Sources: ChAmC 81.

Leisinger and Bell
Flourished: 1800-1813 Hagerstown, MD
Type of Work: Redware (Pottery)
Sources: AmPoP 168.

Leitz
Flourished: 1850 Milwaukee, WI
Type of Work: Fabric (Weavings)
Sources: AmSQu 2*; ChAmC 81.

Leitz, J.
Flourished: 1849 East Hempfield Township, PA
Type of Work: Fabric (Weavings)
Sources: ChAmC 81.

Leman, Henry
Flourished: mid 19th cent Lancaster, PA
Type of Work: Brass (Brassware)
Sources: AmCoB 185.

Leman, Johannes
Flourished: c1830 Tylersport, PA
Type of Work: Clay (Pottery)
Sources: DicM 73*.

Leman, John
Flourished: 1829- Albany, NY
Type of Work: Oil (Masonic paintings)
Sources: *Bes 40*.

Lembo, J. Lawrence
b. 1948
Flourished: contemporary New York, NY; New Orleans, LA; San Francisco, CA
Type of Work: Acrylic (Paintings)
Sources: *FoAFv 13*; FoAFw 15**.

Lengfelder, Balthasar
Flourished: c1860 Belleville, IL
Type of Work: Tin (Lamps, candlesticks)
Sources: *ArC 134*, 262**.

Lenox, E.S.
Flourished: Chicago, IL
Sources: *ArC 265*.

Lent, B
Flourished: c1827 Caldwell, NJ
Type of Work: Stoneware (Pottery)
Sources: *Decor 221*.

Lent, George
Flourished: 1825-1831 Lansingburgh, NY
Type of Work: Clay (Pottery)
Sources: *HoKnAm 54**.

Lentz, Cornelius
b. c1836 Pennsylvania
Flourished: 1860 Allentown, PA
Type of Work: Fabric (Coverlets)
Sources: *ChAmC 81*.

Leo, John William
[Leoe?]
Flourished: 1773 Staunton, VA
Type of Work: Watercolor, ink (Frakturs)
Sources: *SoFoA 79*, 218*.

Leoe, John William
See: Leo, John William.

Leonard, Barney
Flourished: c1780 Middleboro, MA
Type of Work: Stone (Gravestones)
Sources: *EaAmG 128*.

Leonard, Clark
See: Clark Leonard and Company.

Leonard, Rachel
Flourished: 1750 Plymouth, MA
Type of Work: Fabric (Embroidered handkerchiefs)
Museums: 176
Sources: *AmNe 77*.

Leonhard, August
Flourished: 1845-1855 Hermann, MO
Ethnicity: German
Type of Work: Tin, metal (Tinware, weathervanes)
Museums: 098
Sources: *ASeMo 425**.

Leopard, John
b. Rusk County, TX
Flourished: c1875
Type of Work: Stoneware (Pitchers, jugs)
Sources: *AmS 46*, 86*, 208*, 235*, 251*.

Leopard, Thaddeus
b. Winston County, MS
Flourished: c1880
Type of Work: Stoneware (Pottery)
Museums: 158
Sources: *AmS 25**.

Leopold, Valentine
Flourished: 1823-1833 Canton, OH
Type of Work: Fabric (Weavings)
Sources: *ChAmC 81*.

Lepine, Imelda
Flourished: Vermont
Ethnicity: Canadian
Type of Work: Fabric (Hooked rugs)
Sources: *FoAFp 5*, 19*.

Leroy, D.
Flourished: Walworth, NY
Type of Work: Stencils, frescos (Ornamental paintings)
Sources: *AmDecor 147**.

Lerving, Samuel
Flourished: 1800 New York, NY
Type of Work: Wood (Ship carvings, ship figures)
Sources: *AmFiTCa 195*.

Lerving, Samuel
Flourished: 1802 Philadelphia, PA; Germantown, PA
Type of Work: Wood (Ship carvings, ship figures)
Sources: *AmFiTCa 195*.

Lesh, Jane Barrow
b. 1888 d. 1920
Type of Work: Clay (Sewer tile sculpture)
Sources: *IlHaOS **.

Lessel, George
Flourished: 1879-1899 Cincinnati, OH
Type of Work: Stoneware (Pottery)
Remarks: Son of Peter
Sources: *AmPoP 210; Decor 221*.

Lessel, Peter
[Peter Lessel and Brothers]
Flourished: 1848-1879 Cincinnati, OH
Type of Work: Stoneware (Pottery)
Remarks: Father of George
Sources: *AmPoP 210; Decor 221*.

Lester, John W.
Flourished: 1859 Quincy, IL
Sources: *ArC 265*.

Lesueur, Charles
b. 1778
Flourished: c1826 New Harmony, IL
Ethnicity: French
Type of Work: Pen, ink (Drawings)
Museums: 010
Sources: *ArC 69*, 72-5**.

Letourneau, Charles
Flourished: 1852 Detroit, MI
Type of Work: Wood (Ship carvings, ship figures)
Sources: *AmFiTCa 195*.

Letts, Joshua
Flourished: c1778-1810 Cheesequake, NJ
Type of Work: Stoneware (Pottery)
Museums: 200
Sources: *AmPoP 180; AmS 182*; Decor 221; DicM 89**
See: Warne and Letts; Warne, Thomas.

Levan, Francis D.
Flourished: 1820-1850 Pennsylvania
Type of Work: Watercolor, ink (Frakturs)
Sources: *AmFoPa 188*.

Leve, Henry
Flourished: 1864 Fort Delaware, LA
Type of Work: Wood (Sculptures, carvings)
Sources: *WoCar 87**.

Leverett, Elizabeth
Flourished: c1704 Massachusetts
Type of Work: Fabric (Quilts)
Remarks: Mother is Leverett, Sarah Sedwick
Sources: *QuiAm 17**.

Leverett, Sarah Sedwick
Flourished: c1704 Massachusetts
Type of Work: Fabric (Quilts)
Remarks: Daughter is Elizabeth
Sources: *QuiAm 17**.

Levering, T.W.
Flourished: c1816 Philadelphia, PA
Type of Work: Brass (Bells)
Sources: *AmCoB 166**.

Levie, John E.
Flourished: 1835 New Orleans, LA; New York
Type of Work: Watercolor (Miniature paintings)
Museums: 176
Sources: *ColAWC 132*-3*.

Levill, A., Jr.
Flourished: 1885
Type of Work: Oil (Paintings)
Sources: *FoPaAm fig67*.

Levin, Abraham (Abram)
b. 1880 d. 1957 New York, NY
Flourished: c1940 New York, NY
Ethnicity: Lithuanian
Type of Work: Oil (Landscape and flower paintings)
Sources: *AmFokArt 164-7*; FoA 466; PrimPa 176; Trans 4, 6, 26*-7*, 54.*

Lewin, C.L.
Flourished: 1850 Pennsylvania
Type of Work: Oil (Portraits)
Sources: *AmPrP 154; PicFoA 97*; PrimPa 176.*

Lewin, Isaac
Flourished: 1871 New York, NY
Type of Work: Wood (Ship carvings, ship figures)
Sources: *AmFiTCa 195.*

Lewin, Isaac
[Lewis]
Flourished: 1895-1896 Chicago, IL
Type of Work: Wood (Cigar store Indians, figures)
Remarks: Worked for Brooks, Thomas V.
Sources: *ArtWod 185, 266; HoKnAm 164.*

Lewis, A.N.
Flourished: c1853 Woodbury, CT
Type of Work: Tin (Tinware)
Remarks: Owned a tinshop
Sources: *TinC 173.*

Lewis, Betsey
b. 1786 Dorchester, MA d. 1818
Flourished: c1801 Massachusetts
Type of Work: Pen, ink (Sketches)
Museums: 171
Sources: *AmFoArt 30-1*.*

Lewis, Elijah P.
Flourished: 1830 Maine
Type of Work: Oil (Portraits)
Sources: *AmPrP 154; PrimPa 176.*

Lewis, Erastus
Flourished: New Britain, CT
Type of Work: Tin (Tinware)
Remarks: Brothers are Isaac and Seth; relative is Smith, Samuel
Sources: *TinC 173.*

Lewis, Flora
b. 1903 Kansas
Flourished: 1909- Atcheson, KS
Type of Work: Pencil, brush, fabric (Needlework, crochet works)
Sources: *PeiNa 255*; PrimPa 176; ThTaT 208-12*.*

Lewis, Frank E.
Flourished: Ogdensburg, NY
Type of Work: Wood (Duck decoys)
Museums: 260
Sources: *Decoy 45*; FouNY 64.*

Lewis, Harvey
Flourished: 1831 Ohio
Type of Work: Fabric (Weavings)
Sources: *ChAmC 81.*

Lewis, Henry
Flourished: c1846-1849 St. Louis, MO
Type of Work: Oil (Panoramic paintings)
Museums: 113
Sources: *ArC 5*, 120*, 225-6*; PicFoA 20.*

Lewis, Henry
Flourished: c1825 Huntington, NH
Type of Work: Clay (Pottery)
Sources: *AmPoP 194, 267; DicM 62*.*

Lewis, Ira
Flourished: till 1830s Bristol, CT
Type of Work: Tin (Japanned tinware)
Sources: *TinC 173.*

Lewis, Isaac
Flourished: Berlin, CT
Type of Work: Tin (Tinware)
Remarks: Owned tin shop; brothers are Erastus and Seth
Sources: *TinC 173.*

Lewis, James Otto
b. 1799 d. 1858
Flourished: c1823-1833 Philadelphia, PA
Type of Work: Pencil (Sketches of Indians)
Sources: *ArC 114, 117, 121.*

Lewis, O.V.
Flourished: c1840 Greenwich, NY
Type of Work: Stoneware (Pottery)
Museums: 096
Sources: *Decor 135*.*

Lewis, Patrick
Flourished: c1826-34 Meriden, CT
Type of Work: Tin (Tinware)
Remarks: Partnership with Holt, Elias
Sources: *TinC 173.*

Lewis, Seth
Flourished: New Britain, CT
Type of Work: Tin (Tinware)
Remarks: Worked for Filley, Oliver; Erastus and Isaac are his brothers
Sources: *TinC 173.*

Lewis, Unity
Flourished: 1789 Philadelphia, PA
Type of Work: Fabric (Samplers)
Sources: *GalAmS 30*, 90.*

Lewis, W.A.
Flourished: c1860 Galesville, NY
Type of Work: Stoneware (Pottery)
Sources: *Decor 221.*

Lewis, William
[Lewis Pottery Co.]
Flourished: 1829 Louisville, KY
Type of Work: Yellow-ware (Pottery)
Remarks: Vodrey and Frost were managers
Sources: *AmPoP 88, 105, 239.*

Lewis and Cady
Flourished: c1860 Fairfax, VT
Type of Work: Stoneware (Pottery)
Sources: *Decor 221.*

Lewis and Gardner
Flourished: 1827-1854 Huntington, NY
Type of Work: Stoneware (Pottery)
Sources: *AmPoP 194, 267; Decor 221; DicM 85*; EaAmFo 114*, 194*, 227*.*

Lewis and Lewis
Flourished: c1860 Huntington, NY
Type of Work: Clay (Pottery)
Sources: *AmPoP 194, 267; DicM 85*.*

Lewis Johnson Pottery
Flourished: c1870-1900 Perkiomenville, PA
Type of Work: Clay (Pottery)
Sources: *AmPoP 174.*

Lewis Lehman and Company
See: Lehman, Lewis.

Lex, Henry
Flourished: 1833 Philadelphia, PA
Type of Work: Wood (Ship carvings, ship figures)
Sources: *AmFiTCa 195.*

Ley, Mary E.
b. 1944 Rio Grande Valley, TX
Flourished: 1983- Austin, TX
Type of Work: Acrylic, tempera, pen, ink (Paintings)
Sources: *FoAFa 13*.*

Leykauff, Michael
Flourished: c1850 Chester Township, OH
Ethnicity: German
Type of Work: Fabric (Coverlets)
Sources: *ChAmC 81.*

Lichy, Benjamin
[Leighty; Lighty]
b. 1811 Lancaster County, PA d. 1882 Lancaster County, PA
Flourished: 1832-1860 Bristol, OH; Jackson Township, OH; New Berlin, OH
Type of Work: Fabric (Weavings)
Sources: *AmSQu 277; ChAmC 81.*

Lieberman, Harry
b. 1877? d. 1983 Great Neck, NY
Flourished: 1956-1983 Great Neck, NY
Ethnicity: Polish
Type of Work: Oil (Religious scene paintings)
Sources: *AmFokArt 168-9; FoA 466; FoAFz 1*, 4-6*; FoPaAm 107*-8; PioPar 15, 43, 46*.*

Lighty, Benjamin
See: Lichy, Benjamin.

Ligon, C.P.
b. 1901 North Carolina
Flourished: 1967 Toccoa, GA
Type of Work: Wood (Sculptures, carvings)
Sources: *MisPi 70*-1.*

Lillagore, Theodore W.
Flourished: 1874 Philadelphia, PA
Type of Work: Wood (Ship carvings, ship figures)
Sources: *AmFiTCa 195.*

Lilly, Emily Jane
Flourished: Baltimore County, MD?
Type of Work: Fabric (Quilts)
Sources: *QuiAm 282*.*

Limbach, Christian
Flourished: 1795 Pennsylvania
Type of Work: Watercolor, ink (Frakturs)
Sources: *AmFoPa 188.*

Lincoln, Daniel H.
Flourished: c1845-1849 New Bedford, MA
Type of Work: Watercolor (Seascape paintings)
Museums: 123
Sources: *WhaPa 65*, 93*, 102*.*

Lincoln, Eunice
b. 1780 d. 1852
Flourished: 1794 Warren, RI
Type of Work: Fabric (Samplers)
Museums: 020,179
Sources: *LeViB 215, 230-2.*

Lincoln, James
Flourished: 1840 Massachusetts
Type of Work: Oil (Portraits)
Sources: *AmPrP 154; PrimPa 176.*

Lincoln, Joseph Whiting
b. 1859 d. 1938
Flourished: c1922 Accord, MA
Type of Work: Wood (Duck decoys)
Museums: 260
Sources: *AmBiDe 73, 85-7*; AmDecoy 22*, 32*; AmFokA 41*; AmSFo 24; ArtDe 118, 133*; Decoy 29*, 45*, 68*, 70*, 84*; EyoAm 4, 7*; WiFoD 116*, 96*.*

Lincoln, Martha
b. c1796
Flourished: 1806 Leominster, MA
Type of Work: Fabric (Samplers)
Sources: *GalAmS 42*.*

Linderman, Jacob
Flourished: 1841-1845 Union Township, PA
Type of Work: Fabric (Weavings)
Sources: *ChAmC 81.*

Lindmark, Winter
Flourished: 1857-1870 New York, NY
Type of Work: Wood (Ship carvings, ship figures, cigar store Indians, figures)
Sources: *AmFiTCa 195.*

Lindsay, William
b. Boston, MA
Flourished: 1859 Boston, MA
Type of Work: Wood (Ship carvings, ship figures)
Sources: *AmFiTCa 134, 195; ShipNA 159.*

Lindsey, Seymore S.
b. 1849 d. 1927
Flourished: Ohio
Type of Work: Paper (Silhouettes)
Sources: *YoWel 15.*

Lingard
See: Toy and Lingard.

Lingard, William
Flourished: 1856 Philadelphia, PA
Type of Work: Wood (Ship carvings, ship figures)
Sources: *ShipNA 163.*

Link, Christian
Flourished: c1870-1900 Stonetown, PA
Type of Work: Stoneware (Pottery)
Sources: *AmPoP 180, 267; Decor 221; DicM 30*.*

Link, John
Flourished: 1870-1898 Perkiomenville, PA; Frederick, PA
Type of Work: Redware (Pottery)
Sources: *AmPoP 167, 174.*

Linna, Irelan
Flourished: 1899- San Francisco, CA
Type of Work: Clay (Pottery)
Sources: *DicM 151*.*

Linss, Karl
Flourished: c1835 Missouri
Type of Work: Wood (Molds)
Sources: *EaAmW 100.*

Linstead, Mary
b. 1807
Flourished: 1818 Barrington, MA
Type of Work: Fabric (Samplers)
Sources: *GalAmS 52-3*.*

Linton, William
Flourished: c1842-1850 Baltimore, MD
Type of Work: Stoneware, redware (Pottery)
Sources: *AmPoP 164; Decor 221.*

Lippincott, Gideon
Flourished: c1870 Wading River, NJ; Delaware
Type of Work: Wood (Duck decoys)
Museums: 260
Sources: *ArtDe 163*; Decoy 171*.*

Lippitt, Julia
b. 1784 d. 1867
Flourished: 1797 Providence, RI
Type of Work: Fabric (Samplers)
Sources: *LeViB 131, 150.*

Liscombe, Mr.
[Luscombe]
Flourished: 1786 Salem, MA
Type of Work: Paint (Ornamental paintings)
Sources: *AmDecor 40.*

Litchfield, E.
Flourished: 1860 Roxbury, MA
Type of Work: Wood (Ship carvings, ship figures)
Sources: *AmFiTCa 195.*

Little, Ann
Flourished: 1820 Massachusetts
Type of Work: Oil (Landscape paintings)
Sources: *AmPrP 154; PrimPa 176.*

Little, B.
Flourished: Hudson River Valley, NY
Type of Work: Oil (Painted coaches)
Sources: *BeyN 116.*

Little, Charles
Flourished: 1835-1837 Dorchester, MA
Type of Work: Pen, ink (Whale stamp designs)
Museums: 123
Sources: *WhaPa 123*.*

Little, George F.
Flourished: 1847
Type of Work: Fabric (Candlewick spreads)
Museums: 227
Sources: *AmSQu 285*.*

Little, Joseph K.
Flourished: 1800s
Type of Work: Tin (Tinware)
Sources: *ToCPS 9-10.*

Little Lamb
b. c1804
Flourished: Canyon del Muerto, AZ
Ethnicity: American Indian
Type of Work: Rock (Paintings)
Remarks: Navajo tribe
Sources: *PicFoA 150*.*

Little, Mary L.
Flourished: 1835 Dennis Creek, NJ
Type of Work: Fabric (Samplers)
Sources: *GalAmS 79*.*

Little, Samuel
Flourished: 1841-1843 Cairo, IL
Type of Work: Glass (Glassware)
Sources: *ArC 176.*

Little, T.J.
b. 1907
Flourished: 1969- Bellingham, WA
Type of Work: Wood (Whirligigs)
Sources: *FoA 466; TwCA 174*.*

Little, Thomas
Flourished: 1830 New York, NY
Type of Work: Wood (Ship carvings, ship figures)
Sources: *AmFiTCa 195.*

Littlefield, Charles H.
Flourished: 1858 Portland, ME
Type of Work: Wood (Ship carvings, ship figures)
Remarks: Father is Nahorn; brothers are Francis and Nathan Jr.
Sources: *AmFiTCa 139, 196; ShipNA 157.*

Littlefield, Francis A.
Flourished: 1858 Portland, ME
Type of Work: Wood (Ship carvings, ship figures)
Remarks: Father is Nahorn; brothers are Charles H. and Nathan Jr.
Sources: *AmFiTCa 139, 196; ShipNA 157.*

Littlefield, Nahorn (Nahum)
Flourished: 1831 Portland, ME
Type of Work: Wood (Ship carvings, ship figures)
Museums: 221
Remarks: Sons are Charles H., Francis and Nathan, Jr.
Sources: *AmFiTCa 139, 196; ShipNA 87*-8, 157.*

Littlefield, Nathan, Jr.
Flourished: 1863 Portland, ME
Type of Work: Wood (Ship carvings, ship figures)
Remarks: Father is Nahorn; brothers are Charles H. and Francis
Sources: *AmFiTCa 139, 196; ShipNA 157.*

Littlefield Brothers
Flourished: 1858-1878 Portland, ME
Type of Work: Wood (Ship carvings, ship figures)
Remarks: Father is Nahorn; brothers are Nathan Jr., Charles, and Francis
Sources: *AmFiTCa 139, 196.*

Litwak, Israel
b. 1868
Flourished: Brooklyn, NY
Ethnicity: Russian
Type of Work: Oil, watercolor, pencil (Scene paintings)
Sources: *PrimPa 176; ThTaT 138-43*; TwCA 127*.*

Livingston, Ruth
Flourished: New York
Type of Work: Oil (Paintings)
Sources: *ThTaT 236*.*

Lo, William A.
Flourished: 1907 New England,
Type of Work: Oil (Sailboat paintings)
Sources: *FoAFm 3; FoPaAm 52*; TwCA 43*.*

Lochman, Christian L.
b. 1790 Pennsylvania d. 1864 Hamburg, PA
Flourished: 1838-1842 Hamburg, PA
Type of Work: Fabric (Weavings)
Remarks: Son is William
Sources: *ChAmC 81.*

Lochman, William
b. 1818 Pennsylvania d. 1900
Flourished: 1850 Hamburg, PA
Type of Work: Fabric (Weavings)
Remarks: Father is Christian L.
Sources: *ChAmC 81.*

Lock, Frank C.
Flourished: c1880-1900 Newtown, PA
Type of Work: Redware (Pottery)
Sources: *AmPoP 172.*

Lockard, Henry
Flourished: c1890 Maryland
Type of Work: Wood (Duck decoys)
Museums: 260
Sources: *AmBiDe 144-6*; Decoy 53*.*

Locke, John
b. 1752 d. 1837
Flourished: Deerfield, MA
Type of Work: Stone (Gravestones)
Sources: *EaAmG 128; GravNE 129.*

Locke, Ruth
b. c1790
Flourished: 1802 Lexington, MA
Type of Work: Fabric (Samplers)
Sources: *GalAmS 38*-9*, 90.*

Lockrow, William
Flourished: 1845 New York, NY
Type of Work: Wood (Ship carvings, ship figures)
Sources: *AmFiTCa 196.*

Lockwood, William
Flourished: 1834 New York, NY
Type of Work: Wood (Ship carvings, ship figures)
Sources: *AmFiTCa 196.*

Loebig, George
Flourished: 1880-1890 New Albany, IN
Type of Work: Metal (Weathervanes)
Sources: *AmFoS 53*.*

Loehr, Elizabeth
Flourished: 1852 Pennsylvania
Ethnicity: German
Type of Work: Fabric (Quilts)
Museums: 204
Sources: *AmSQu 187*.*

Loercher, Everett R.
Flourished: Lititz, PA
Type of Work: Tin (Tinware)
Remarks: Son-in-law of Kreider, Albert M; son is Ronald
Sources: *ToCPS 7*, 9, 43, 51-2*.*

Loercher, Ronald
Flourished: Lititz, PA
Type of Work: Tin (Tinware)
Remarks: Father is Everett; grandfather is Kreider, Albert M.
Sources: *ToCPS 7*, 9, 43.*

Loesch
Flourished: Michigan
Type of Work: Wood (Fish decoys)
Sources: *UnDec 20.*

Logan, A.
Flourished: 1874 New York
Type of Work: Oil (Paintings)
Sources: *OneAmPr 130*, 148, 155.*

Logan, James
Flourished: 1877 Meriden, CT
Type of Work: Tin (Tinware)
Sources: *TinC 174.*

Logan, Patrick
b. c752
Flourished: 1820 Franklin County, IN
Type of Work: Fabric (Coverlets)
Sources: *ChAmC 81.*

Loguen, Gerritt
Ethnicity: Black American
Type of Work: Paint (Paintings)
Sources: *AfAmA 96.*

Lohrman, William
Flourished: Peoria, IL
Type of Work: Wood (Duck decoys)
Sources: *AmBiDe 190.*

Lokke, S.R.
Flourished: 1880 Charlestown, MA
Type of Work: Wood (Ship carvings, ship figures)
Sources: *AmFiTCa 196.*

Lombard, James
b. 1865
Flourished: Bridgeton, MA
Type of Work: Wood (Weathervanes)
Museums: 203
Sources: *AmFokAr 13, fig32; AmFoS 136*; FoArtC 69; GalAmW 1*; WeaVan 23; YankWe 93, 95*.*

Lombard, Rachel H.
Flourished: 1816 Bath, ME
Type of Work: Wood (Furniture)
Sources: *BeyN 35*.*

Long
See: Luden and Long.

Long, C.
Flourished: 1845-1846 Jefferson County, OH
Type of Work: Fabric (Weavings)
Sources: *ChAmC 81.*

Long, David
d. 1904? Buffalo?, NY?
Flourished: 1846-1848 Chambersburg, PA
Type of Work: Fabric (Coverlets)
Sources: *ChAmC 81.*

Long, George
Flourished: contemporary New York
Type of Work: Wood (Circus and carousel figures)
Sources: *WoScuNY*.

Long, H.F.
Flourished: 1968 Pennsylvania
Type of Work: Oil (Scene paintings)
Sources: *MaAmFA**.

Long, J.H.
Flourished: c1890-1915 Crawford, GA
Type of Work: Stoneware (Pottery)
Sources: *AmS 140**.

Long, Jacob
Flourished: 1843 Knox County, OH
Type of Work: Fabric (Weavings)
Sources: *ChAmC 81*.

Long, James B.
See: Long's Pottery.

Long, James L.
Flourished: 1820-1840 Byron, GA
Type of Work: Clay (Pottery)
Sources: *AmPoP 236; MisPi 86*; SoFoA 31*, 217*
See: Long's Pottery.

Long, Jasper
See: Long's Pottery.

Long, John
Flourished: 1815 Haycock Township, PA
Type of Work: Fabric (Weavings)
Sources: *ChAmC 81*.

Long, John
Flourished: 1840-1855 Holmes County, OH
Type of Work: Fabric (Weavings)
Sources: *ChAmC 82*.

Long, John N.
See: Long's Pottery.

Long, John S.
See: Long's Pottery.

Long, M.A.
Flourished: 1835 New Britain Township, PA
Type of Work: Fabric? (Coverlets?)
Sources: *ChAmC 82*.

Long, Nicholas
Flourished: 1860 Cooper County, MO
Ethnicity: German
Type of Work: (Baskets)
Sources: *ASeMo 412*.

Long, Rufus
Flourished: 1860 Manchester, MA
Type of Work: Wood (Ship carvings, ship figures)
Sources: *AmFiTCa 196*.

Longenecker, Peter
b. c1821 Pennsylvania
Flourished: c1850 Woodberry, PA
Type of Work: Fabric (Coverlets)
Sources: *ChAmC 82*
See: Keagy, John.

Long's Pottery
[Long, James B., James L., Jasper, John N., John S
Flourished: mid 1800s Byron, GA
Type of Work: Clay (Pottery)
Sources: *AmPoP 85, 87, 91-2, 236; EaAmFo 133**
See: Long, James L.

Longworth, Maria
See: Storer, Mrs. Bellamy.

Lonhuda Pottery Company
Flourished: 1892- Steubenville, OH
Type of Work: Clay (Pottery)
Sources: *DicM 86*, 231**.

Looff, Charles I.D.
d. 1918
Flourished: 1875-1918 Brooklyn, NY
Type of Work: Wood (Carousel figures)
Sources: *AmSFor 24*; CaAn 9, 44-49*, 86-7**.

Look, Jim
Flourished: Martha's Vineyard, MA
Type of Work: Wood (Duck decoys)
Sources: *AmBiDe 73; AmSFo 24*.

Loomis
See: Purdy and Loomis.

Loomis, Amasa
d. 1840
Flourished: Coventry, CT
Type of Work: Stone (Gravestones)
Sources: *EaAmG 128*.

Loomis, John
b. 1745 d. 1791
Flourished: Coventry, CT
Type of Work: Stone (Gravestones)
Sources: *EaAmG 128*.

Loomis, Jonathan
b. 1722 d. 1785
Flourished: Coventry, CT
Type of Work: Stone (Gravestones)
Sources: *EaAmG 128*.

Loomis, Jonathan
Flourished: 1820s Whateley, MA
Type of Work: Wood (Decorated boxes)
Sources: *NeaT 152*.

Loomis, L.R.
Flourished: 1965-1980 Oklahoma
Type of Work: Wood (Circus and carousel figures)
Sources: *FoArO 93**.

Lopez, Antonia
b. 1834 d. 1923
Flourished: Park View, NM
Ethnicity: Hispanic
Type of Work: Fabric (Blankets)
Sources: *PopAs 237*.

Lopez, Ergencio
b. c1950
Flourished: 1981 Cordova, NM
Ethnicity: Hispanic
Type of Work: Wood (Sculptures)
Remarks: Related to Lopez, Jose Dolores
Sources: *FoAFu 8*-9*.

Lopez, Felix A.
b. 1942 Gilman, CO
Flourished: 1977- Espanola, NM; Gilman, CO
Ethnicity: Hispanic
Type of Work: Wood (Santeros, other religious carvings)
Sources: *AmFokArt 171*; FoA 136*, 466; HisCr 60*, 103**.

Lopez, George T.
b. 1900 Quemado, NM
Flourished: 1965 Cordova, NM
Ethnicity: Hispanic
Type of Work: Wood (Santeros, other religious carvings)
Museums: 263,272
Remarks: Father is Jose Dolores; wife is Lopez, Sylvanita; nephew is Martinez, Eluid Levi
Sources: *AmFokArt 173*; AmFoS 6, 316*; ConAmF 98-101*; FoAFab 6*-7*; HisCr 52*, 103*; TwCA204*; WoCar 204*.

Lopez, Jose Dolores
b. 1868 Cordova, NM d. 1937
Flourished: 1936 Cordova, NM
Ethnicity: Hispanic
Type of Work: Wood (Doors, santeros, other religious carvings)
Museums: 178,181,272
Remarks: Son is George T.; grandson is Martinez, E.L.; grand-daughter is Cordova, G.L.
Sources: *AmFokArt 172*; EaAmW 124; FoAFab 6-7; FoScu 70*; HisCr 29*, 36*, 40, 42-3, 45*-8*, 104*; PopAs 261*; TwCA 204**.

Lopez, Martina
Flourished: 1875-1890 Las Trampas, NM
Ethnicity: Hispanic
Type of Work: Fabric (Blankets)
Sources: *PopAs 237*.

Lopez, Sylvanita
Flourished: contemporary Cordova, NM
Ethnicity: Hispanic
Type of Work: Wood (Sculptures)
Remarks: Wife of Lopez, George T.
Sources: *FoAFab 7*.

Lopez Y Martinez, Eluid
See: Martinez, Eluid Levi.

Lord, Mary
Flourished: 1800 Litchfield, CT
Type of Work: Watercolor on silk (Decorative piece paintings)
Sources: *PrimPa 176*.

Lord, T.M.
Flourished: 1856 Blue Hill, ME
Type of Work: Wood (Ship carvings, ship figures)
Sources: *AmFiTCa 196; ShipNA 156*.

Lorentz, Peter
[Lorenz]
b. c1801
Flourished: 1836-1846 Wayne County, IN; Xenia, OH; Illinois
Ethnicity: French
Type of Work: Fabric (Coverlets)
Sources: *AmSQu 277; ChAmC 82*.

Lorenz, Frederick
Flourished: 1877 Meriden, CT
Type of Work: Tin (Tinware)
Sources: *TinC 174*.

Lorenz, Peter
See: Lorentz, Peter.

Loring, Hulda
b. 1786
Flourished: 1795 Massachusetts
Type of Work: Fabric (Samplers)
Sources: *PlaFan 53**.

Losea
See: Barry and Losea.

Lossing, Benjamin
Type of Work: (Drawings)
Sources: *HanWo 8-9**.

Lothrop, George E.
b. 1867 Dighton, MA d. 1939 Boston, MA
Flourished: Boston, MA
Type of Work: Oil (Imaginative scene, mythical paintings)
Sources: *AmFokArt 174-5*; PrimPa 176; ThTaT 216-9*; TwCA 83**.

Lothrop, Stillman
Flourished: 1790-1820 Salem, MA
Type of Work: Fabric (Needlework, embroidery)
Sources: *PlaFan 177-8*, 189**.

Louden, Emily Eastman
See: Eastman, Emily.

Louff, Charles
Flourished: 1880-1888 Riverside, RI
Type of Work: Wood (Carousel horses)
Sources: *AmFoS 232*; EaAmW 58-60*; FoA 466*.

Louis, C.
Flourished: 1818
Type of Work: Pencil (Landscape drawings)
Sources: *PrimPa 176*.

Louis Lehman and Company
See: Lehman, Louis.

Louis Miles Pottery
Flourished: 1859 Stoney Bluff, SC
Type of Work: Clay (Pottery)
Sources: *EaAmFo 166**.

Lourie, Alexander
See: Lawrie, Alexander.

Lovato, Jose
Flourished: Chama, CO
Ethnicity: Hispanic
Type of Work: Fabric (Blankets)
Museums: 103
Sources: *PopAs 238*.

Love Field Potteries
Flourished: 1925-1935 Dallas, TX
Type of Work: Clay (Pottery)
Remarks: Named after air field
Sources: *AmS 140*.

Lovejoy, Edward Bell
b. 1857 d. 1917
Flourished: San Francisco, CA
Type of Work: Wood (Ship carvings, ship figures)
Museums: 254
Remarks: Uncle is Gereau, William
Sources: *ShipNA 90*-3, 155*.

Loveland, Elijah
Flourished: Berlin, CT
Type of Work: Tin (Foot stoves)
Remarks: Worked with Loveland, George
Sources: *TinC 174*.

Loveland, George
See: Loveland, Elijah.

Lovett, Rodman
b. 1809 Pennsylvania d. 1895 Canton, OH
Flourished: 1832 Canton, OH
Type of Work: Fabric (Weavings)
Sources: *ChAmC 82*.

Lovett, William
Flourished: 1790 Massachusetts
Type of Work: Oil (Portraits)
Sources: *AmPrP 154; PrimPa 176*.

Low, Lucy
b. c1764
Flourished: 1776 Philadelphia, PA
Type of Work: Fabric (Samplers)
Sources: *GalAmS 26*, 90*.

Low, Max
b. 1899 d. 1970
Flourished: 1944-1965
Type of Work: Oil (Cityscape paintings)
Sources: *FoAFm 3; TwCA 182**.

Low, William
See: Low and Damon.

Low and Damon
[William Low and Benjamin Damon]
Flourished: 1816 Concord, NH
Type of Work: Oil (Ornamental paintings)
Sources: *Bes 41-2**.

Low Art Tile Company
Flourished: 1881 Chelsea, MA
Type of Work: Clay (Pottery)
Sources: *DicM 72**.

Lowery, Alexander
Flourished: 1844 Buffalo, NY
Type of Work: Wood (Ship carvings, ship figures)
Sources: *AmFiTCa 196; ShipNA 161*.

Lowery, Daniel
Flourished: Red Stone Hill, CT
Type of Work: Tin (Tinware)
Sources: *TinC 174*.

Lowmiller, William
b. 1809 Pennsylvania d. 1879
Flourished: 1836-1845 Muncey?, IN?; Level Corners, PA; Muncyborough, PA
Type of Work: Fabric (Coverlets)
Sources: *AmSQu 260*, 276; ChAmC 82*
See: Roberts, Charles.

Lowry, W.B.
[Lowry Brothers]
Flourished: Roseville, OH
Type of Work: Clay (Pottery)
Sources: *AmPoP 229*.

Lowry Brothers
See: Lowry, W.B.

Loy, M.
Flourished: c1874 Seagrove, NC
Type of Work: Stoneware (Pitchers)
Sources: *AmS 189**.

Lucas, David
b. 1948 Haymond, KY
Flourished: 1975- Haymond, KY
Type of Work: Oil (Paintings)
Sources: *GoMaD **.

Lucas, Martha Hobbs
Flourished: c1790-1800 Athens, AL
Type of Work: Fabric (Quilts)
Sources: *SoFoA 184*, 222*.

Lucas, Thomas
Flourished: c1760-1789 Boston, MA; Charlestown, MA
Type of Work: Wood (Ship carvings, ship figures)
Sources: *AmFiTCa 196; ShipNA 159-60*.

Luce, Benjamin
Flourished: 1876-1877 San Francisco, CA
Type of Work: Wood (Ship carvings, ship figures)
Sources: *ShipNA 93, 155*.

Luce, Shubael H.
Flourished: c1852-1853 Mattapoisett, MA
Type of Work: Pencil, watercolor (Ship portraits)
Museums: 123
Sources: *WhaPa 106*, 116**
See: Keith, Charles F.

Lucero, Juanita
Flourished: 1889
Type of Work: Oil (Paintings)
Remarks: Southwest artist
Sources: *FoPaAm 222*.*

Ludlow, Gabriel R.
Flourished: early 19th cent
Type of Work: Watercolor, ink (Landscape paintings)
Sources: *NinCFo 168, 194, fig116.*

Luckens
See: Hey and Luckens.

Ludon and Long
Flourished: 1856 Peoria, IL
Type of Work: Stoneware (Pottery)
Sources: *ArC 194.*

Lueckin, C.
Flourished: 1772 Pennsylvania
Type of Work: Watercolor, ink (Frakturs)
Sources: *AmFoPa 188.*

Luff, George W.
Flourished: 1860 New York, NY
Type of Work: Wood (Ship carvings, ship figures)
Sources: *AmFiTCa 196.*

Luff, John V.
[Luff and Monroe]
Flourished: 1834 New York, NY
Type of Work: Wood (Ship carvings, ship figures)
Sources: *AmFiTCa 196.*

Luff and Brother
Flourished: 1860 New York, NY
Type of Work: Wood (Ship carvings, ship figures)
Sources: *AmFiTCa 196.*

Luff and Monroe
[Luff, John V.]
Flourished: 1834 New York, NY
Type of Work: Wood (Ship carvings, ship figures)
Sources: *AmFiTCa 196.*

Lujan, Maria T.
b. 1895 Santa Fe, NM
Flourished: 1976 Espanola, NM
Ethnicity: Hispanic
Type of Work: Fabric (Colcha embroideries)
Sources: *HisCr 24*, 104*.*

Lukatch, Edward
Flourished: contemporary Jamaica Plain, MA
Type of Work: Wood (Sculptures, carvings)
Sources: *WoCar 204*.*

Luke, William
b. 1790 Portsmouth, VA
Flourished: 1800 Norfolk, VA; Portsmouth, VA
Type of Work: Wood (Ship carvings, ship figures)
Sources: *AmFiTCa figxvi, 96-7, 196; ShipNA 164.*

Lukolz, Philip
Flourished: 1788 Pennsylvania
Type of Work: Clay (Pottery)
Sources: *BeyN 114.*

Luman Norton and Son
See: Norton, Luman.

Luna, Maximo L.
b. 1896 Taos, NM d. 1964 Taos, NM
Flourished: 1940 Taos, NM
Ethnicity: Hispanic
Type of Work: Wood (Furniture)
Sources: *HisCr 32*, 105*.*

Lund, E.K.
b. c1910
Flourished: 1938- Maple City, MI
Type of Work: Wood, oil (Religious carvings in an environment)
Remarks: Created "Lund's Scenic Garden"
Sources: *Rain 115-8*.*

Lunde, Emily
b. 1914 Newfolden, MN
Flourished: 1950-1970 Grand Forks, ND
Type of Work: Oil (Childhood scene and genre paintings)
Sources: *AmFokArt 176-8*; FoA 466; FoPaAm 14, 215, fig62.*

Lundeen, F.V.
Flourished: 1932 Bishop Hill, IL
Type of Work: Paint (House portraits)
Sources: *ArC 234*.*

Lundmark, Winter
Flourished: 1857 New York, NY
Type of Work: Wood (Ship carvings, ship figures)
Sources: *ShipNA 162.*

Lundy
See: Clark and Lundy.

Lundy, W.
See: W. Lundy and Company.

Lunn, William
Flourished: 1832-1836 Utica, OH
Type of Work: Fabric (Coverlets)
Sources: *ChAmC 82.*

Luppold, John
Flourished: Warren County, MO
Type of Work: (Baskets)
Sources: *ASeMo 416*.*

Luppold, Matthias
Flourished: 1860-1890 Warren County, MO
Type of Work: Wood (Kitchen tables, pie safes)
Sources: *ASeMo 238*.*

Luscomb, William Henry
b. 1805 d. 1866
Flourished: 1840-1850s Ballston, NY
Type of Work: Oil (Ship paintings)
Sources: *AmFoPa 111.*

Lustig, Desider
b. 1900
Flourished: c1972 New York, NY
Ethnicity: Hungarian
Type of Work: Oil (Paintings)
Museums: 237
Sources: *FoAFp 9*.*

Lutz, E.
Flourished: 1847 East Hempfield Township, PA
Type of Work: Fabric (Weavings)
Sources: *ChAmC 82.*

Lutz, Jacob
b. c1806 Pennsylvania d. 1861
Flourished: 1831-1854 East Hempfield Township, PA?
Type of Work: Fabric (Weavings)
Sources: *AmSQu 277; ChAmC 82.*

Lycett, Edward
Flourished: c1900 Atlanta, GA
Type of Work: Clay (Pottery)
Sources: *DicM 39*.*

Lydon, William
Flourished: 1880-1899 Paducah, KY; Mayfield, KY
Type of Work: Stone (Gravestones, other stoneworks)
Remarks: Carved grave marker of Woolridge, Henry G., Colonel
Sources: *AmFoS 20*; SoFoA 125*, 220.*

Lyle, Fanny
Flourished: 19th cent
Type of Work: Watercolor, ink (Frakturs)
Sources: *Edith *.*

Lyman, Abel
b. 1749 d. 1828
Flourished: Middletown, CT
Type of Work: Stone (Gravestones)
Sources: *EaAmG 128.*

Lyman, Alanson
See: Alanson Lyman and Declus Clark.

Lyman, Mrs. Eunice
Flourished: 1770 Northfield, MA
Type of Work: Fabric (Embroidered pocket aprons)
Museums: 234
Sources: *AmNe 147-8**.

Lyman, H.
Flourished: 1820 Connecticut
Type of Work: Oil (Paintings)
Sources: *AmPrP 154; PrimPa 176*.

Lyman, Narcissa
Flourished: 1827 York, ME
Type of Work: Fabric (Samplers)
Museums: 213
Sources: *GalAmS 15*.

Lyman, Noah
b. 1714 **d.** 1756
Flourished: Durham, CT
Type of Work: Stone (Gravestones)
Sources: *EaAmG 128*.

Lyman and Clark
See: Alanson Lyman and Declus Clark.

Lyman, Fenton Company
Flourished: 1849-1852 Bennington, VT
Type of Work: Clay (Pottery)
Sources: *AmPoP 61, 188, 267; DicM 185**.

Lynch, Ann
Flourished: 1834
Type of Work: Fabric (Samplers)
Museums: 227
Sources: *MoBeA*.

Lynch, Kenneth
See: Kenneth Lynch and Sons.

Lynch, Laura
b. 1949 Chicago, IL
Flourished: New York, NY
Type of Work: Fabric (Appliqued pictures)
Sources: *AmFokArt 179-81**.

Lyon, Sarah
b. 1774 Newport, RI **d.** 1843
Flourished: 1786 Newport, RI
Type of Work: Fabric (Samplers)
Sources: *LeViB 85**.

Lyons Pottery
[Lyons Stoneware Company]
Flourished: c1855 Lyons, NY
Type of Work: Stoneware (Pottery)
Sources: *AmPoP 195; Decor 74**.

Lyons Stoneware Company
See: Lyons Pottery.

Lytle
Flourished: 20th century Medina County, OH
Type of Work: Wood (Boxes)
Sources: *AmFoS 286**.

M

M. Armbruster and Sons
Flourished: Columbus, OH
Type of Work: Oil (Circus banners)
Sources: *AmSFor 198*.

M. Barrett and Brother
Flourished: 1860 Baltimore, MD
Type of Work: Wood (Ship carvings, ship figures)
Sources: *AmFiTCa 187*.

M.C. Webster and Son
Flourished: c1850 Hartford, CT
Type of Work: Clay (Pottery)
Sources: *Decor 225; DicM 92**.

M.D. Jones and Company
Flourished: 1870-1902 Boston, MA
Type of Work: Metal (Weathervanes, ornamental metal works)
Sources: *YankWe 212*.

M.P. Paige Pottery
See: Paige Pottery.

M. Perrine and Company
See: Perrine, Maudden.

M. Tyler and Company
[Moses Tyler]
Flourished: 1826-1848 Albany, NY
Type of Work: Stoneware (Jugs)
Sources: *AmS 159*; Decor 225; EaAmFo 188**.

M.V. Mitchell and Sons
Flourished: c1903 Columbus, OH
Type of Work: Stone (Gravestones, other stone carvings)
Sources: *EaAmG 125**.

Mac, Mary
See: Franklin, Mary Mac.

Macca, Lorita
Flourished: c1930 Louisiana
Ethnicity: Acadian
Type of Work: Fabric (Bedspreads)
Museums: 136
Sources: *SoFoA 207*, 223*.

Mace, Richard
Flourished: 1856 Richmond, ME
Type of Work: Wood (Ship carvings, ship figures)
Sources: *AmFiTCa 196; ShipNA 88, 157*.

MacIntyre, A.
Type of Work: Fabric (Coverlets)
Sources: *ChAmC 82*.

MacKay
Flourished: 1790 Connecticut
Type of Work: Oil (Portraits)
Sources: *PrimPa 176*.

MacKenzie
Flourished: 19th century South Woodstock, VT
Type of Work: Stoneware (Pottery)
Sources: *Decor 221*.

MacKenzie, Carl
b. 1905 Pine Ridge, KY
Flourished: 1960s Slade, KY
Type of Work: Wood, paint (Animal, figure sculptures)
Sources: *FoAFr 14**.

Mackeon, Abraham B.
Flourished: 1841
Type of Work: Fabric (Weavings)
Sources: *AmSQu 277; ChAmC 82*.

Mackosikwe (Mrs. Michele Buckshot)
b. 1862
Ethnicity: American Indian
Type of Work: Straw (Baskets)
Remarks: Member of Algonquin tribe
Sources: *AmSFo 124*.

MacLeran, James
See: McLeran, James.

Macomb Pottery Company
Flourished: c1880-1900 Macomb, IL
Type of Work: Stoneware (Pottery)
Sources: *AmPoP 223; Decor 221*.

Macomber, Ann
b. 1788 Providence, RI **d.** 1862 Brooklyn?, CT?
Flourished: 1799 Providence, RI
Type of Work: Fabric (Samplers)
Museums: 034
Sources: *LeViB 136**.

Macpheadris, Archibald, Captain
Flourished: 1716 Portsmouth, NH
Remarks: Built a house with large Indian mural decorations
Sources: *FoPaAm 22**.

MacPherson, E.E.
Flourished: 1875-1900 Alabama
Type of Work: Stoneware (Pottery)
Museums: 002
Sources: *SoFoA 26*, 217*.

Macquoid, William A.
See: William A. Macquoid and Company

Macumber and Van Arsdale
Flourished: c1864 Ithaca, NY
Type of Work: Stoneware (Pottery)
Sources: *Decor 221*.

Macy
See: Heron and Macy.

Macy, Reuben
d. 1838 Baltimore, MD
Flourished: 1831-1838 New York, NY; Baltimore, MD
Type of Work: Wood (Ship carvings, ship figures)
Remarks: Brother is Robert
Sources: *AmFiTCa 121, 196; ShipNA 158, 162*.

Macy, Robert H.
Flourished: 1830 New York, NY; Baltimore, MD
Type of Work: Wood (Ship carvings, ship figures)
Remarks: Brother is Rueben
Sources: *AmFiTCa 121, 196; ShipNA 158, 162*.

Madden, J.M.
Flourished: c1870 Rondout, NY
Type of Work: Stoneware (Pottery)
Sources: *AmPoP 202; Decor 221; DicM 72**.

Maddhes, C.
Flourished: 1855 Davenport, IA
Type of Work: Fabric (Coverlets)
Sources: *ChAmC 84*.

Maddock, John
See: John Maddock and Sons.

Maddock and Son(s)
[Thomas Maddock]
Flourished: 1882-1900 Trenton, NJ
Type of Work: Clay (Pottery)
Sources: *AmPoP 181, 267; DicM 150*, 185*, 203**
See: Maddock Pottery Company.

Maddock Pottery Company
Flourished: 1893 Trenton, NJ
Type of Work: Clay (Pottery)
Sources: *DicM 91*, 177*, 241**
See: Maddock and Sons.

Maddov, Rance, Jr. "Bone"
Flourished: 1963- Alabama
Ethnicity: Black American
Type of Work: Oil (Portraits)
Sources: *FoA 32*; FoPaAm 181**.

Mader, Louis
b. c1842 d. 1892
Flourished: 1860-1880 Berks County, PA
Ethnicity: German
Type of Work: Oil (Scene paintings)
Sources: *AmFoPaS 103*; AmNa 17; FoA 71*; MaAmFA*.

Maental, Jacob
[Mantel; Maentle]
b. 1763 d. 1863 New Harmony, IN
Flourished: 1810- York, PA; New Harmony, IN
Ethnicity: German
Type of Work: Watercolor (Portraits)
Museums: 001, 097
Sources: *AlAmD 34-5*; AmDecor figx, 147; AmFoPa 48, 68-9*, 177; AmFoPaCe 116-23*; AmFoPaS 44*; AmFoPo 139-43*; AmPrW 42*; BeyN 115, 123, 59*, figvi, 108; EyoAm 21, 24*; FoA 7*, 466; FoArA 57*; FoPaAm 120, 125, fig37; HoKnAm 96*, 137*.

Maental, Jacob (Continued)
Sources: *MaAmFA *; NinCFo 168, 186, fig10, 14, 32; PrimPa 176*.

Maertz, Charles
Flourished: 1836 Quincy, IL
Ethnicity: German
Type of Work: Tin (Tinware)
Sources: *ArC 135*.

Magdelena
Flourished: 1815-1825 Pennsylvania
Type of Work: Watercolor, ink (Frakturs)
Sources: *AmFoPa 188*.

Mahaffey Brothers Tent and Awning Company
Flourished: Memphis, TN
Type of Work: Oil (Theater and sideshow scenes)
Sources: *AmSFor 198*.

Maher, E.
Flourished: 1871 Boston, MA
Type of Work: Wood (Ship carvings, ship figures)
Sources: *AmFiTCa 196*.

Mai, Thomas
Flourished: 1858 Pennsylvania
Type of Work: Paper (Valentines)
Museums: 147
Sources: *AmSFok 144**.

Main, William H.
Flourished: 1851 Philadelphia, PA
Type of Work: Wood (Ship carvings, ship figures)
Sources: *AmFiTCa 196*.

Maize, Adam
Flourished: 1810-1845 New Berlin, PA
Type of Work: Redware (Pottery)
Sources: *AmPoP 172*.

Major, William Warner
Flourished: 1847 Utah
Ethnicity: English
Type of Work: Oil (Portraits)
Sources: *FoPaAm 185*-6*.

Makinen, John Jacob, Sr.
b. c1890 d. 1942
Flourished: 1939 Kaleva, MI
Ethnicity: Finnish
Type of Work: Bottles (Bottle sculpture)
Remarks: Used 60,000 bottles in masonry walls of his house
Sources: *Rain 96*-8**.

Malcolm, Mrs.
Flourished: 1884 Indiana
Type of Work: Fabric (Quilts)
Museums: 282
Sources: *QuiAm 260**.

Maldonado, Alexander
b. 1901
Flourished: 1969- San Francisco, CA
Ethnicity: Mexican
Type of Work: Oil (Fantasy futuristic paintings)
Sources: *AlAmD 80*; PioPar 18, 37*, 47*.

Malinski, Irving
Flourished: Michigan
Type of Work: Wood (Duck decoys)
Sources: *WaDec xiii**.

Malone, Mildred
Flourished: 1817 Richmond, VA
Type of Work: Fabric (Samplers)
Museums: 287
Sources: *GalAmS 16*.

Mamn, Mathias
b. 1803 d. 1893 Hanover, PA
Flourished: 1834-1860 Hanover, PA
Ethnicity: German
Type of Work: Fabric (Weavings)
Sources: *ChAmC 84*.

Manard, John B.
Flourished: 1852 Detroit, MI
Type of Work: Wood (Ship carvings, ship figures)
Sources: *AmFiTCa 196*.

Mandel, A.
Flourished: Brooklyn, NY
Type of Work: Oil (Paintings)
Sources: *ThTaT 236**.

Mangin, John A.
Flourished: 1895 New Orleans, LA
Type of Work: Iron (Signs)
Sources: *AmFoS 29*; InAmD 68**.

Manley
See: Marks, Farmer, Manley, and Riley.

Manley, Jane Helena
Flourished: 1843 Kingston, NY
Type of Work: Crayon (Pastoral scene drawings)
Sources: *PrimPa 176*.

Mann, Ed
Flourished: contemporary Los Angeles, CA
Type of Work: Wood (Sculptures, toys, canes)
Sources: *FoAFs 1*, 5*-6*.

Mann, Electra
Flourished: 1870-1880 Ballston, NY
Type of Work: Watercolor (Paintings)
Museums: 256
Sources: *FouNY 67*.

Mann, John
Flourished: c1835 Rahway, NJ
Type of Work: Clay (Pottery)
Sources: *AmPoP 178, 268; DicM 73**.

Mann, Lydia Bishop
b. 1798 Wrentham, MA d. 1888 Westerly, RI
Flourished: 1816 Providence, RI
Type of Work: Embroidery (Mourning pictures)
Museums: 227
Sources: *LeViB 177*, 262*.

Mannebach, Lewis
Flourished: 1860 New York, NY
Type of Work: Wood (Ship carvings, ship figures)
Sources: *AmFiTCa 196*.

Manning
[Manning and Wantz]
Flourished: 1864 Mount Joy, PA
Type of Work: Fabric (Weavings)
Sources: *ChAmC 84*
See: Keener, John, and Wantz.

Manning, Frederick
b. 1758 **d.** 1806 or 1810
Flourished: 1792 Windham, CT
Type of Work: Stone (Gravestones)
Remarks: Father is Josiah; brother is Rockwell
Sources: *EaAmG 128; GravNE 107, 129.*

Manning, John
Flourished: 1820 New York, NY
Type of Work: Wood (Ship carvings, ship figures)
Sources: *AmFiTCa 196.*

Manning, Josiah
b. 1725 Hopkinton, MA **d.** 1806 Windham, CT
Flourished: c1764 Windham, CT; Lebanon, CT; Norwichtown, CT
Type of Work: Stone (Gravestones)
Remarks: Brother is Samuel; sons are Frederick and Rockwell
Sources: *EaAmG 128; GravNE 105-7, 129.*

Manning, Rockwell
b. 1760 **d.** 1806 Canterbury, CT
Flourished: c1778 Norwich, CT
Type of Work: Stone (Gravestones)
Remarks: Brother is Frederick; father is Josiah
Sources: *EaAmG 128; GravNE 107-8, 129.*

Manning, Samuel
Flourished: c1759 Norwichtown, CT
Type of Work: Stone (Gravestones)
Remarks: Brother is Josiah
Sources: *EaAmG 33*, 128; GravNE 106.*

Manning and Wantz
See: Manning.

Manross
See: Mitchell and Manross.

Mantel, Jacob
See: Maental, Jacob.

Mantell, James
Flourished: c1850 Pen Yan, NY
Type of Work: Stoneware (Pottery)
Sources: *Decor 221*
See: Mantell, Thomas.

Mantell, Thomas
Flourished: c1850 Pen Yan, NY
Type of Work: Stoneware (Pottery)
Sources: *Decor 221*
See: Mantell, James.

Manzanares, Luisa
b. 1864 **d.** 1949
Flourished: Los Brazos, NM
Ethnicity: Hispanic
Type of Work: Fabric (Blankets)
Sources: *PopAs 237.*

Maphis, John M.
Flourished: 1848 Shenandoah County, VA
Type of Work: Watercolor, ink (Frakturs)
Sources: *SoFoA 85*, 219.*

Mapp, F.T.
Flourished: 1900-1910 Randolph County, AL
Type of Work: Stoneware (Bowls)
Sources: *AmS 96*-7*.*

Mappes, H.
Flourished: 1859-1900 Cincinnati, OH
Type of Work: Yellow-ware, Rockingham (Pottery)
Sources: *AmPoP 212.*

Maran, Mrs. Mary Jane Green
Flourished: Baltimore, MD
Type of Work: Fabric (Quilts)
Museums: 263
Sources: *QuiAm 117*.*

Marble, John
b. 1764 **d.** 1844
Flourished: Bradford, MA
Type of Work: Stone (Gravestones)
Sources: *EaAmG 128; GravNE 129.*

Marble, Joseph
b. 1726 **d.** 1805
Flourished: Bradford, MA
Type of Work: Stone (Gravestones)
Sources: *EaAmG 128; GravNE 129.*

Marcellus, John
Flourished: 1830 New York, NY
Type of Work: Wood (Ship carvings, ship figures)
Sources: *AmFiTCa 196.*

March, J(ohn) H(enry)
d. 1847
Flourished: 1838-1847 Salona, PA
Type of Work: Fabric (Weavings)
Sources: *AmSQu 277; ChAmC 84.*

Marchant, Edward D.
Flourished: 1830 Massachusetts
Type of Work: Oil (Portraits)
Sources: *AmPrP 154; PrimPa 176.*

Marcher, James
Flourished: 1834 New York, NY
Type of Work: Wood (Ship carvings, ship figures)
Sources: *AmFiTCa 196.*

Marcile, Stanley
b. 1907 Swanton, **d.** Vermont
Flourished: Newport, VT
Type of Work: Pen, crayon, pencil (Building portraits)
Sources: *FoAFp 8*.*

Marcy, J.J.
Flourished: 1869 West Meriden, CT
Type of Work: Brass (Kettles)
Sources: *AmCoB 79.*

Marden, J.
Flourished: c1842 Baltimore, MD
Type of Work: Brass (Scales)
Sources: *AmCoB 231-2*.*

Marein, Mahala
Flourished: 1824 Harpswell, ME
Type of Work: Fabric (Samplers)
Sources: *GalAmS 63*, 91.*

Marford, Mirible "Miribe"
b. 1814 **d.** 1827
Flourished: Eatontown, NJ
Type of Work: Watercolor (Landscape paintings)
Museums: 176
Sources: *ColAWC 161, 166*; PrimPa 176.*

Margaretha
Flourished: late 18th cent Pennsylvania
Type of Work: Watercolor, ink (Frakturs)
Sources: *AmFoPa 188.*

Margaretten, Frederick M., Dr.
Flourished: Brooklyn, NY
Type of Work: Oil (Paintings)
Sources: *ThTaT 236*.*

Marion, Edward
Flourished: 1837 Steubenville, OH
Type of Work: Fabric (Weavings)
Sources: *ChAmC 84.*

Mark, George Washington
b. 1795 Charlestown, NH **d.** 1879
Flourished: 1817-1878 Greenfield, MA; Virginia
Type of Work: Oil (Landscape paintings)
Museums: 096
Sources: *AmPrP 154; Edith *; FoA 466; FoPaAm 57*; OneAmPr 82, 98*, 145, 154; PicFoA 103*; PrimPa 176.*

Mark, Matthew W.
Flourished: 1843 Fayette County, OH
Type of Work: Fabric (Weavings)
Sources: *ChAmC 84.*

Markell, Immon and Company
[Viall and Markell]
Flourished: c1869-1890 Akron, OH
Type of Work: Stoneware (Pottery)
Sources: *AmPoP 206; Decor 221; DicM 90*.*

Markert, Herman
Flourished: 1885 Troxellville, PA
Type of Work: Pen, ink (Drawings)
Sources: *HerSa *.*

Markley, James C.
Flourished: c1880-1882 Thurmont, MD
Type of Work: Redware (Pottery)
Sources: *AmPoP 181*.

Marks, A.H.
Flourished: 1869-1870 East Liverpool, OH
Type of Work: Yellow-ware (Pottery)
Sources: *AmPoP 217*.

Marks, Farmer, Manley and Riley
Flourished: 1863-1865 East Liverpool, OH
Type of Work: Yellow-ware (Pottery)
Sources: *AmPoP 217*.

Marlett, Eliza Ann
Flourished: c1838 Aurora, IL
Type of Work: Needlework (Samplers)
Museums: 019
Sources: *ArC 100**.

Marley, Mary Ann
b. 1820
Flourished: 1832
Type of Work: Fabric (Samplers)
Sources: *FoArtC 51**.

Marr, John
Flourished: 1843 Milton, IN
Type of Work: Fabric (Weavings)
Sources: *AmSQu 277; ChAmC 84*
See: Wissler, John.

Marrott, Ted
Flourished: Sturbridge, MA
Type of Work: Tin (Tinware)
Sources: *AmCoTW 60**.

Marsh, Ann
b. 1717 d. 1796
Flourished: 1727 Philadelphia, PA
Type of Work: Fabric (Samplers)
Sources: *LeViB 36**.

Marsh, J.
Flourished: 1840
Type of Work: Fabric (Weavings)
Sources: *AmSQu 277; ChAmC 84*.

Marsh, Mrs. John Bigelow
Flourished: 1938 New York, NY
Type of Work: Fabric (Family register samplers)
Sources: *AmNe 179*-180*.

Marsh, Joseph
Flourished: 1876 Philadelphia, PA
Type of Work: Wood (Ship carvings, ship figures)
Sources: *AmFiTCa 196*.

Marsh, William
Flourished: 1810-1860 Boston, MA
Type of Work: Oil (Ship paintings)
Sources: *AmFoPa 108*.

Marshall, Abner
Flourished: 1860-1866 Hockessen, DE
Type of Work: Yellow-ware, brownware (Pottery)
Sources: *AmPoP 169*.

Marshall, David George
b. 1936 Nassau County, NY
Flourished: Godeffrey, NY
Type of Work: Stone (Sculptures, carvings)
Sources: *AmFokArt 188-191**.

Marshall, Edward W.
Flourished: 1840 Steubenville, OH
Type of Work: Fabric (Coverlets)
Sources: *ChAmC 84*.

Marshall, Emily
Flourished: 1810-1840 White Plains, NY; New England,
Type of Work: Watercolor (Paintings)
Museums: 001
Sources: *AmPrP 154; ArtWo 71*; PrimPa 176*.

Marshall, Inez
b. 1907 d. 1984
Flourished: 1941-1984 Portis, KS
Type of Work: Stone (Carvings)
Sources: *FoAFd 9-10**.

Marshall, John
b. 1664 d. 1732
Flourished: Braintree, MA
Type of Work: Stone (Gravestones)
Sources: *EaAmG 128; GravNE 129*.

Marshall, William
Flourished: c1840 New York, NY
Type of Work: Earthenware (Pottery)
Sources: *AmPoP 197*.

Marshall Pottery
b. Marshall, TX
Type of Work: Stoneware (Pottery)
Sources: *AmS 53, 175, 178*, 253*, 261*.

Marsteller, A.
Flourished: 1854 Lower Saucon Township, PA
Type of Work: Fabric (Weavings)
Sources: *ChAmC 84*.

Marsteller, Thomas
b. c1812 Pennsylvania
Flourished: 1842-1860 Lower Saucon Township, PA
Type of Work: Fabric (Coverlets)
Sources: *AmSQu 277; ChAmC 84*.

Marston, James B.
Flourished: 1810 Boston, MA
Type of Work: Oil (Paintings)
Museums: 145
Sources: *AmPrP 154; FoPaAm 14*; PrimPa 176*.

Marston, W.W.
Flourished: 1871 New York, NY
Type of Work: Wood (Ship carvings, ship figures)
Sources: *AmFiTCa 196*.

Marta, Anna Maria
Flourished: 1822 California
Ethnicity: American Indian
Type of Work: Grass (Basket weavings)
Sources: *InAmD 30**.

Marteen, W.
Flourished: c1875 Pennsylvania
Type of Work: Clay (Pottcry)
Sources: *AmPoP 186; DicM 144**.

Marten, Richard
Flourished: c1736 Charleston, SC
Type of Work: Oil? (House, sign, ship paintings)
Sources: *AmDecor 7, 4*.

Martens, G.
Flourished: 1840
Type of Work: Oil (Portraits)
Sources: *AmPrP 154; PrimPa 176*.

Martin
Flourished: 1856 New York
Type of Work: Watercolor (Homestead paintings)
Sources: *FoPaAm 96-7**.

Martin, Adam E.
b. Stark County, OH
Flourished: 1852-1864 Ripley, IL
Type of Work: Stoneware (Pottery)
Sources: *ArC 193*.

Martin, Don "Duke"
b. 1920
Flourished: 1972
Ethnicity: Italian
Type of Work: Fabric (Symbolic and religious collages)
Sources: *TwCA 214**.

Martin, E.G.
Flourished: c1851 Camp Point, IL
Type of Work: Stoneware (Pottery)
Sources: *ArC 193*.

Martin, Eddie Owens "Saint EOM"
b. 1908
Flourished: Buena Vista, GA
Type of Work: Various materials (Environmental sculptures)
Sources: *FoAFk 2*; MisPi 12, 108**.

Martin, Emma E.
Flourished: mid 19th cent New England,
Type of Work: Pen, ink (Penmanship, calligraphy drawings)
Sources: *NinCFo 168, 202, fig135*.

Martin, J.
Flourished: c1800
Type of Work: Watercolor (Masonic aprons)
Sources: *Bes 51**.

Martin, James
Flourished: 1860s New Bedford, MA
Type of Work: Whalebone (Scrimshaw)
Museums: 186
Sources: *GravF 123.*

Martin, John
Flourished: 1801-1828 Harrisburg, PA
Type of Work: Tin (Tinware)
Sources: *AmCoTW 157-8; ToCPS 13.*

Martin, John
Flourished: 1850 Winchester, IL
Type of Work: Clay (Pottery)
Sources: *ArC 193.*

Martin, John F.
Flourished: 1843-1843 Wilmington, DE
Type of Work: Watercolor (Paintings)
Museums: 123
Sources: *WhaPa 8*, 34*, 53*, 64*, 73*-5*, 80*, 86, 89*, 91*, 157.*

Martin, John L.
b. Ohio
Flourished: 1836-1850 Exeter, IL
Type of Work: Stoneware (Pottery)
Sources: *ArC 190.*

Martin, Lucy
Flourished: c1816 Salem, MA
Type of Work: Paint (Mourning pictures)
Museums: 079
Sources: *MoBeA fig89.*

Martin, Moses
Flourished: c1844 Nauvoo, IL
Type of Work: Redware, brownware (Pottery)
Sources: *ArC 190.*

Martin, Nabby
b. 1775 East Windsor, CT d. 1864
Flourished: 1786 Providence, RI
Type of Work: Fabric (Samplers)
Museums: 205
Sources: *ArtWo 16-7, 13*; LeViB 113, 120*, 240-1*.*

Martin, Robert
Flourished: Jefferson County, OH
Ethnicity: Irish
Type of Work: Fabric (Weavings)
Sources: *ChAmC 84.*

Martin, William
Flourished: c1801-1828 Harrisburg, PA
Type of Work: Tin (Tinware)
Sources: *AmCoTW 156; ToCPS 13.*

Martinez, Angelina Delgado
b. Santa Fe, NM
Flourished: 1977 Santa Fe, NM
Ethnicity: Hispanic
Type of Work: Tin (Tinware)
Sources: *HisCr 76*, 105.*

Martinez, Apolonio
Flourished: contemporary New Mexico
Ethnicity: Hispanic
Type of Work: Wood (Santeros, other religious carvings)
Sources: *WoCar 204.*

Martinez, Cresencio
Flourished: San Idlefonso, NM
Ethnicity: American Indian
Type of Work: Clay, oil (Pottery, ceremonial scene paintings)
Sources: *PicFoA 47.*

Martinez, Eluid Levi
[Lopez y Martinez]
b. 1944 Cordova, NM
Flourished: 1971- Santa Fe, NM
Ethnicity: Hispanic
Type of Work: Wood (Santeros, other religious carvings)
Remarks: Grandson of Lopez, Jose Dolores; uncle is Lopez, George T.
Sources: *HisCr 54*, 106*; TwCA 203*, 205.*

Martinez de Pedro, Linda
b. 1946 Denver, CO
Flourished: 1977 Chimayo, NM
Ethnicity: Hispanic
Type of Work: Wood (Santeros, other religious carvings)
Sources: *HisCr 61*, 107*.*

Martz
Flourished: 1830
Type of Work: Watercolor, ink (Frakturs)
Sources: *Edith *.*

Marvin, Fay
Flourished: 1910-1920 Watertown, NY
Type of Work: Wood (Whirligigs)
Sources: *FouNY 67.*

Marx, John
Flourished: 1867 Pennsylvania
Type of Work: Stoneware (Pottery)
Museums: 096
Sources: *Decor 194*.*

Maryland Pottery Company
Flourished: 1880 Baltimore, MD
Type of Work: Clay (Pottery)
Sources: *DicM 32*, 251*.*

Maser, Jacob
[Mazer; Mazur; Mauser]
Flourished: 1825-1830s Mahantango Valley, PA
Type of Work: Wood, paint (Chests of drawers)
Museums: 097,171
Sources: *AmFoArt 55*; AmFokDe ix; AmPaF 265*; FoArRP 104*; HerSa *.*

Mason
See: Johnson and Mason.

Mason, Abigail (Payne)
Flourished: 1802-1808 Granby, MA
Type of Work: Watercolor, ink, fabric (Frakturs, embroidery)
Museums: 215
Sources: *ArtWo 69-70*.*

Mason, Benjamin Franklin
b. 1804 d. 1871
Flourished: 1825 Pomfret, VT
Type of Work: Oil (Portraits)
Sources: *AmPrP 154; PrimPa 176.*

Mason, David
Flourished: c1758 Roxbury, MA
Type of Work: Paint, varnish (Ornamental paintings)
Remarks: Apprentice of Greenwood, John
Sources: *AmDecor 8.*

Mason, J.
Flourished: 1800 New York
Type of Work: (Signs)
Museums: 151
Sources: *WoScuNY.*

Mason, Mrs. Jeremiah
Flourished: c1775-1828 Massachusetts
Type of Work: Fabric (Embroidered still life pictures)
Sources: *AmNe 89-90*.*

Mason, John W.
b. 1814 d. 1866
Flourished: 1838 Boston, MA
Ethnicity: Irish
Type of Work: Wood (Ship carvings, figures)
Museums: 221
Remarks: Apprentice to Beecher, Laban
Sources: *AmFiTCa figxxi, 99, 119, 124-7, 196; ArtWod 80*; ShipNA 67, 159.*

Mason, Jonathan, Jr.
Flourished: 1820-1830 Boston, MA
Type of Work: Oil (Portraits)
Sources: *AmPrP 154; PrimPa 176; SoAmP 287.*

Mason, Larkin
Flourished: c1808
Type of Work: Watercolor (Mourning paintings)
Museums: 056
Sources: *MoBeA.*

Mason, Marvin
b. 1940 Cheboygan, WI
Flourished: 1965- Cheboygan, WI
Type of Work: Wood, metal (Fish decoys)
Sources: *Rain 36*.*

Mason, William
Flourished: 19th cent
Type of Work: Watercolor (Paintings)
Sources: *Edith.*

Mason, William A.
Flourished: 1829 Fryeburg, ME
Type of Work: Wood (Dressing tables)
Museums: 096
Sources: *AmPaF 224-5**.

Mason, William Sanford
Flourished: 1840 Philadelphia, PA; Massachusetts
Type of Work: Oil (Portraits)
Sources: *AmPrP 154; PrimPa 176; SoAmP 208**.

Mason and Russell
Flourished: 1835-1870 Cortland, NY
Type of Work: Stoneware (Pottery)
Sources: *AmPoP 191; Decor 221; DicM 90**.

Mason Decoy Factory
[Mason Decoy Company]
Flourished: 1894-1926 Detroit, MI
Type of Work: Wood (Decoys)
Museums: 171,260
Sources: *AmBiDe 25-7, 45*, 195, 206*, 218-26*, figviii; AmDecoy xi*, 4-5*, 64-5*, 81*; AmFoArt 95*; AmFoS 292*, 304*; AmSFok 26*; ArtDe 98; CoCoWA 119-20*; Decoy 20*, 31*, 34*, 54*, 65*, 96-9*, 115-6*; FoA 224*, 466; HoKnAm 44*-5; MaAmFA *; WiFoD 71*, 76*, 89.*

Massey
See: Cogburne and Massey.

Massey, Marilyn
b. 1932 Omaha, NE
Flourished: Denver, CO
Type of Work: Acrylic (Paintings)
Sources: *FoAFe 14**.

Massey, William B.
Flourished: 1920s- St. Lawrence area, NY
Type of Work: Wood (Duck decoys)
Sources: *FouNY 12*, 23, 52*, 64, 68*.

Massillon Refractories Company
Flourished: Massillon, OH
Type of Work: Clay (Sewer tile sculpture)
Sources: *IlHaOS **.

Massillon Stoneware Company
See: Boerner, Shapley and Vogt.

Massilot, L.
Flourished: c1836 Ohio
Type of Work: Stoneware (Pottery)
Sources: *AmS 21**.

Mast, Barbara
Flourished: c1900 Middlebury, IN
Ethnicity: Amish
Type of Work: Fabric (Quilts)
Sources: *QufInA 50**.

Masters, E(lizabeth) B(ooth)
Flourished: 1818
Type of Work: Fabric, paint (Embroidered scenes)
Sources: *Edith **.

Masters, Margaret
Flourished: Belleville, OH
Type of Work: Fabric (Weavings)
Sources: *ChAmC 84*.

Mater, William Henry
b. c1794
Flourished: c1850-1851 Washington Township, OH; Fremont, OH
Type of Work: Fabric (Weavings)
Sources: *ChAmC 84*.

Mather, A.
Flourished: 1802 New England,
Type of Work: Fabric (Embroidered maps)
Sources: *AmNe 94**.

Mathes, Robert
Flourished: 1830 Milton, NH
Type of Work: Oil (Portraits)
Sources: *PrimPa 176*.

Mathis, Robert
Flourished: c1840 Edgefield district, SC
Type of Work: Stoneware (Pottery)
Museums: 099
Sources: *SoFoA 30*, 217*.

Matlick, William
Flourished: 1800 New Jersey
Type of Work: Watercolor (Genre paintings)
Sources: *PrimPa 176*.

Matt Morgan Art Pottery Company
Flourished: c1885 Cincinnati, OH
Type of Work: Clay (Pottery)
Sources: *DicM 91*, 95**.

Matteson, H.A.
Flourished: 1837 Bethany, NY
Type of Work: Fabric? (Coverlets?)
Sources: *ChAmC 84*.

Matteson, Thomas
Flourished: 1825 South Shaftsbury, VT
Type of Work: Wood (Blanket chests)
Sources: *AmPaF 220-1*; FlowAm 284, 234*.

Matthews, J.M.
Flourished: Columbus, GA
Type of Work: Clay (Pottery)
Sources: *AmPoP 237*.

Matthews, W.
Flourished: 19th cent
Type of Work: Oil (Portraits)
Sources: *Edith*.

Matthews, William J.
Flourished: c1900 Assawaman Island, VA; Nassawadox, VA
Type of Work: Wood (Duck decoys)
Museums: 260
Sources: *AmBiDe 157, 160*; AmDecoy 52-3*, 60*; Decoy 114**.

Mattice and Penfield
Flourished: c1857 Willoughby, OH
Type of Work: Clay (Pottery)
Sources: *AmPoP 223*.

Mattingly, Eliza Ann
Flourished: c1860 Grayson Springs, KY
Type of Work: Fabric (Quilts)
Sources: *KenQu 58-9, fig10, 47*.

Matzen, Herman
Flourished: Cleveland, OH
Type of Work: Wood (Cigar store Indians, figures)
Sources: *EaAmW 42*.

Maurer
See: Hoffman and Maurer.

Maurer, Johannes
b. 1784 d. 1856 Schuylkill Valley, PA
Flourished: Mahantango Valley, PA
Type of Work: Fabric (Weavings)
Sources: *ChAmC 84*.

Maurer, John
b. 1804
Flourished: 1835 Mahantango Valley, PA; Franklin County, IN; Ohio
Ethnicity: German
Type of Work: Fabric (Weavings)
Sources: *ChAmC 84*.

Maurer, Louis
b. 1832 d. 1932
Type of Work: (Midwestern landscape paintings)
Sources: *ArC 124*.

Maus, Philip
d. 1880
Flourished: 1845-1865 Nazareth Township, PA
Ethnicity: German
Type of Work: Fabric (Weavings)
Sources: *ChAmC 84; HerSa **.

Mauser, Jacob
See: Maser, Jacob.

Mawatee
Flourished: before 1836
Type of Work: Wood (Baskets)
Museums: 228
Sources: *AmSFo 124*.

Maxey, Levi
Flourished: c1800 Attleboro, MA
Type of Work: Stone (Gravestones)
Sources: *EaAmG 128*.

Maxwell, Ann
Flourished: 1861 Indiana
Type of Work: Fabric (Quilts)
Museums: 291
Sources: *QuiAm 269**.

Maxwell, J.
Flourished: Albany, NY
Type of Work: Brass (Balances)
Sources: *AmCoB 232**.

Maxwell, William
Flourished: Belmont County, OH
Type of Work: Fabric (Coverlets)
Sources: *ChAmC 84*.

May, Roy
b. 1930 Floyd County, KY
Flourished: contemporary Kentucky
Type of Work: Wood (Carvings)
Sources: *FoAroK* *.

May, Sibyl Huntington
b. 1734
Flourished: Haddam, CT
Type of Work: Oil (Paintings)
Sources: *ArtWo 22-3, 163, fig4*.

Mayall, Eliza McClellen
Flourished: 1840 Maine
Type of Work: Oil (Portraits)
Sources: *AmPrP 154; PrimPa 176*.

Maybury, Thomas
Flourished: c1747 Hereford Township, PA
Type of Work: Iron (Cast iron stove plates)
Museums: 035
Remarks: Owned Hereford Furnace
Sources: *AmFokAr 20, fig163; FoArRP 143**.

Mayer, Henry
Flourished: 1860 New York, NY
Type of Work: Wood (Ship carvings, ship figures)
Sources: *AmFiTCa 196*.

Mayer, James
Flourished: 1869 Trenton, NJ
Type of Work: White Granite (Pottery)
Sources: *AmPoP 183*.

Mayer, Joseph F.
Flourished: c1890- Biloxi, MS
Type of Work: Redware (Pottery)
Sources: *AmPoP 236*.

Mayer, Philip
Flourished: 1860 New York, NY
Type of Work: Wood (Ship carvings, ship figures)
Sources: *AmFiTCa 196*.

Mayer Pottery Company
Flourished: 1880 Beaver Falls, PA
Type of Work: White Granite (Pottery)
Sources: *AmPoP 71, 109, 208; DicM 163*, 173*, 175*-6*, 186*, 189*, 212*, 252*-6**.

Mayers, W.S.
Flourished: c1870-1880 Roseville, OH
Type of Work: Stoneware (Pottery)
Sources: *AmPoP 229; Decor 221; DicM 145**.

Mayes, H. Harrison
b. 1898 Tazewell, TN
Flourished: Kentucky
Type of Work: Wood, concrete, metal (Crosses, religious signs)
Sources: *FoAroK *; GoMaD **.

Mayhew, Bob
Flourished: contemporary
Type of Work: Oil (Portraits)
Sources: *BirB 114**.

Mayhew, Frederick W.
b. Chilmark, MA
Flourished: 1815-1836 Zanesville, OH
Type of Work: Oil, watercolor (Portraits)
Museums: 189
Sources: *AmNa 14, 25, 71*-2**.

Mayhew, M.H.
Flourished: Martha's Vineyard, MA
Type of Work: Wood (Duck decoys)
Sources: *AmBiDe 73; AmSFo 24*.

Mayhew, Nathaniel
Flourished: 1823 Massachusetts
Type of Work: Oil (Portraits)
Sources: *OneAmPr 68*, 143, 154*.

Maynard, A.E.
Flourished: 1880 Vermont
Type of Work: Oil (Farm scene paintings)
Sources: *PrimPa 176*.

Mayo, Charles S.
Flourished: 1849 Pulaski, OH
Type of Work: Fabric (Carpets, coverlets)
Sources: *ChAmC 84*.

Mayo, Robert
Flourished: c1775
Type of Work: Wood (Ship carvings, ship figures)
Remarks: Indentured servant
Sources: *AmFiTCa 196*.

Mazer, Jacob
See: Maser, Jacob.

Mazur, Frank
b. 1910
Flourished: 1973 Brooklyn, NY
Ethnicity: Ukrainian
Type of Work: Wood, oil (Sculptures, carvings, paintings)
Sources: *FoA 466; FoScu 29*; TwCA 186-7**.

Mazur, Jacob
See: Maser, Jacob.

Mc Fadden
See: Carlyle and Mc Fadden.

McAleese and Wyman
Flourished: 1860 Baltimore, MD
Type of Work: Wood (Ship carvings, ship figures)
Sources: *AmFiTCa 196*.

McAllister and Company
Flourished: c1839 Philadelphia, PA
Type of Work: Brass (Brassware)
Sources: *AmCoB 208**.

McAnney, John
Flourished: New Gretna, NJ
Type of Work: Wood (Duck and shorebird decoys)
Sources: *AmBiDe 52*, 132-3**.

McArthur, Grace
b. 1898 Michigan
Flourished: 1957- Rosebush, MI
Type of Work: Oil (Paintings)
Sources: *Rain 86-8**.

McAuliffe, J.
Flourished: 1830-1870
Type of Work: Velvet (Genre paintings)
Sources: *AmPrP 154; PrimPa 176*.

McBride, Adah
b. 1892
Flourished: 1914- Rockford, MI
Type of Work: Oil (Genre paintings)
Museums: 244
Sources: *Rain 47*-9**.

McCall, Philena
b. 1783 d. 1822
Flourished: Lebanon, CT
Type of Work: Fabric (Hooked rugs, bed rugs)
Sources: *AmSQu 19, 24*; ArtWo 5, 163*.

McCann, George
Flourished: Aurora, IL
Type of Work: Fabric (Weavings)
Sources: *ChAmC 82*.

McCarry, Ralph E.
["White Wolf of the Chippewas"]
b. c1900
Flourished: 1948 St. Ignace, MI
Type of Work: Wood, oil (Diarama, carvings)
Remarks: Made life sized totems and an Indian village
Sources: *Rain 110-3**.

McCarthy, Justin
b. 1891 Weatherly, PA d. 1977 Weatherly, PA
Flourished: 1920-1970s Weatherly, PA
Type of Work: Oil, acrylic, watercolor (Drawings, portraits, historic paintings)
Sources: *AlAmD 53*; AmFokArt 182-4*; BirB 151*; FoPaAm 143*; HoKnAm 186; JusMc *; TwCA 168**.

McCarthy Brothers
Flourished: c1870 Somerville, MA
Type of Work: Stoneware (Pottery)
Sources: *AmPoP 202*.

McChesney, Andrew
Flourished: 1840-1850 New Philadelphia, OH
Type of Work: Stoneware (Pottery)
Sources: *AmPoP 225; Decor 221*.

McClain, G.B.
Flourished: 1846 Boston, MA
Type of Work: Wood (Ship carvings, ship figures)
Sources: *AmFiTCa 196*.

McClellan, J.
Flourished: 1842 Orange, OH
Type of Work: Fabric (Weavings)
Sources: *ChAmC 82*.

McClellan Brothers
Flourished: 1871 Boston, MA
Type of Work: Wood (Ship carvings, ship figures)
Sources: *AmFiTCa 196*.

McColley
Flourished: 1850 New York, NY
Type of Work: Wood (Ship carvings, ship figures)
Sources: *AmFiTCa 196*.

McColley, Charles
Flourished: 1868 New York, NY
Type of Work: Wood (Ship carvings, ship figures)
Sources: *ShipNA 78, 162*.

McComb Stoneware Company
Flourished: c1875-1900 McComb, IL
Type of Work: Stoneware (Pottery)
Sources: *AmS 92**.

McConnell
Flourished: c1870-1880 Mercersburg, PA
Type of Work: Stoneware (Pottery)
Sources: *AmPoP 171; Decor 221*.

McConnell, G.
Flourished: 1870 Manchester, NH
Type of Work: Oil (Landscape paintings)
Sources: *PrimPa 176*.

McCord, Susan (Nokes)
b. 1828 or 1829 d. 1909 McCordville, IN
Flourished: 1840-1900 McCordsville, IN
Type of Work: Fabric (Quilts)
Museums: 096
Sources: *ArtWo 46, 49, 101, 164*; NewDis 110**.

McCoy
See: Williams and McCoy.

McCrea, Mrs. Mary Lawson Ruth
Flourished: 1866 Indiana
Type of Work: Fabric (Quilts)
Museums: 263
Sources: *QuiAm 119**.

McCulley, John
Flourished: 1779-1852 Trenton, NJ
Type of Work: Redware (Pottery)
Sources: *AmPoP 46, 181*.

McCulloch, Christina
Flourished: c1741 Philadelphia, PA
Type of Work: Fabric (Embroidered Bible covers)
Sources: *PlaFan 98**.

McCullough, William
Flourished: 1865-1895 East Liverpool, OH
Type of Work: Yellow-ware, Rockingham (Pottery)
Sources: *AmPoP 217*.

McCully and Company
Flourished: 1865 Boston, MA
Type of Work: Wood (Ship carvings, ship figures)
Sources: *AmFiTCa 196*.

McDade Pottery
b. McDade, TX
Flourished: 1920-1930
Type of Work: Stoneware (Doorstops)
Sources: *AmS 46*, 125*, 128*, 130**.

McDonald, Zeke
Flourished: St. Clair Flats, MI
Type of Work: Wood (Decoys)
Sources: *WaDec 6, 11*, 132*, 148**.

McDowell, Fred N.
Flourished: 1840 Charlestown, NH?; Rhode Island; Massachusetts
Type of Work: Watercolor (Landscape paintings)
Museums: 176
Sources: *ColAWC 166*-7, 169*.

McEntyre, Kent K.
Flourished: Sonoraville, GA
Type of Work: Various materials (Sculptures)
Sources: *MisPi 14*, 66-7**.

McFadden
See: Carlyle and McFadden.

McFarland, William
b. Kentucky
Flourished: c1799 Losantiville (Cincinnati), OH
Type of Work: Earthenware (Pottery)
Sources: *AmPoP 67, 209*.

McFarlane, R.
Flourished: 1840
Type of Work: Oil (Portraits)
Sources: *AmPrP 154; PrimPa 176; SoAmP 194**.

McGaw, Robert F.
[McGraw]
b. 1885 d. 1952
Flourished: 1929 Havre de Grace, MD
Type of Work: Wood (Duck decoys)
Museums: 260
Sources: *AmBiDe 144, 146-7*; Decoy 54*; WiFoD 134*, 131**.

McGeron
See: Rhodes, Strong and McGeron.

McGowan
See: Alpaugh and McGowan.

McGrath, George
Flourished: 1802 Philadelphia, PA
Type of Work: Wood (Ship carvings, ship figures)
Sources: *AmFiTCa 196*.

McGraw, Mrs. Curtis
Flourished: 1937 Princeton, NJ
Type of Work: Fabric (Embroidered pictures)
Sources: *AmNe 172**.

McGraw, Robert F.
See: McGaw, Robert F..

McGriff, Columbus
Flourished: 1975- Cairo, GA
Type of Work: Various materials (Sculptures)
Sources: *MisPi 68**.

McGuire, Dominick
Flourished: 1860 New York, NY
Type of Work: Wood (Ship carvings, ship figures)
Sources: *AmFiTCa 196*.

McGurk, Andrew
Flourished: Somerville, OH
Type of Work: Fabric? (Coverlets?)
Sources: *ChAmC 82*.

McIntire, James
Flourished: 1869 Malden, MA
Type of Work: Wood (Ship carvings, ship figures)
Sources: *AmFiTCa 196*.

McIntire, Joseph
b. 1747 d. 1825
Flourished: Salem, MA
Type of Work: Wood (Ship carvings, ship figures)
Sources: *ShipNA 26, 160*.

McIntire, Joseph, Jr.
d. 1862
Flourished: Salem, MA
Type of Work: Wood (Ship carvings, ship figures)
Sources: *ShipNA 26, 160*.

McIntire, Samuel
b. 1757 Salem, MA d. 1811 Boston, MA
Flourished: 1778-1802 Salem, MA
Type of Work: Wood (Ship carvings, figures)
Museums: 079,189,215,221
Remarks: Son is Samuel Field
Sources: *AmDecor 42-4*; AmEaAD 23*; AmFiTCa 32, 55, 72-5, 116, 196-7, figii, vii; AmFoS 5, 80*, 116*; AmFoSc 24*; AmPaF 96*; AmSFok 21*; BirB 118*; CiStF 27-8; EaAmW 34, 65-6*, 79-80, 88; FoArtC 32, 99*, 103-4*, 111, 224**.

McIntire, Samuel (Continued)
Sources: *InAmD 54, 190*; ShipNA 23-4*, 26, 29, 160; TYeAmS 29*, 289*-90, 343; WoScuNY*.

McIntire, Samuel Field
b. 1780 d. 1819
Flourished: Salem, MA
Type of Work: Wood (Ship carvings, ship figures)
Remarks: Father is Samuel
Sources: *ShipNA 29**.

McIntosh, Amanda
Flourished: 1875-1900 Ogdensburg, NY
Type of Work: Oil (Scene paintings)
Sources: *FouNY 66*.

McIntyre and Gleason
Flourished: 1865 Boston, MA
Type of Work: Wood (Ship carvings, ship figures)
Sources: *AmFiTCa 197*.

McKay
Flourished: 1788 Connecticut
Type of Work: Oil (Portraits)
Museums: 001
Sources: *AmFoAr 19; AmPrP 154, fig.15*.

McKeever, Ellen
Flourished: 1856 Merrimock, NH
Type of Work: Fabric (Hooked rugs, bed rugs)
Sources: *AmHo 40**.

McKeller, Candy
Flourished: contemporary Maine
Type of Work: Paint (Wall murals)
Museums: 237
Sources: *FoAFn 19**.

McKenna
Type of Work: Fabric (Coverlets)
Sources: *ChAmC 82*.

McKentee
Flourished: c1840 Nockamixon, PA
Type of Work: Redware (Pottery)
Sources: *AmPoP 173*.

McKenzie
See: Fowler and McKenzie.

McKenzie
See: Brown and McKenzie.

McKenzie, Carl
b. 1905 Wolfe County, KY
Flourished: 1930- Stanton, KY
Type of Work: Wood, paint (Animal, cane carvings)
Sources: *FoAF 10*, 18-9; GoMaD **.

McKenzie, Daniel, Jr.
b. 1821 New Bedford, MA d. 1862
Flourished: 1830s Boston, MA
Type of Work: Whalebone (Scrimshaw)
Museums: 186
Sources: *GravF 57-8**.

McKenzie, John
Flourished: Henry, IL
Type of Work: Wood (Duck decoys)
Remarks: Brother is Thomas
Sources: *AmBiDe 190*.

McKenzie, Thomas
Flourished: Henry, IL
Type of Work: Wood (Duck decoys)
Remarks: Brother is John
Sources: *AmBiDe 190*.

McKenzie Brothers
Flourished: c1840-1870 Vanport, PA
Type of Work: Stoneware (Pottery)
Sources: *AmPoP 232; Decor 221*.

McKillop, Edgar Alexander
b. 1878 Balfour, NC d. 1950 Balfour, NC
Flourished: c1926-1933 Balfour, NC
Type of Work: Wood (Sculptures, carvings)
Museums: 001,002,096
Sources: *AmFoS 6, 334*; FoAFz 2*; FoScu 16*; SoFoA xiv*, 108*, 120*, 216, 220; TwCA 71*; TYeAmS 99-100, 107*, 290*, 343*.

McKinney, James
Flourished: 1813 Brookville, IN
Type of Work: Fabric (Weavings)
Sources: *AmSQu 277; ChAmC 82*.

McKissack, Jeff
b. 1903 d. 1980
Flourished: Houston, TX
Type of Work: Various materials (Environmental sculptures)
Sources: *FoAFf 7**.

McLain
See: Fisher and McLain.

McLaughlin, James
Flourished: 1844 Steubenville, OH
Type of Work: Fabric (Weavings)
Sources: *ChAmC 82*.

McLaughlin
See: Stoddard and McLaughlin.

McLaughlin, Miss Mary Louise
Flourished: late 1800's Cincinnati, OH
Type of Work: Clay (Artware pottery)
Sources: *AmPoP 79; DicM 86*-7**.

McLean, A.C.
Flourished: 1830 Charlestown, MA
Type of Work: Oil (Portraits of children)
Sources: *AmPrP 154; PrimPa 176*.

McLean, Hugh
Flourished: 1845 New York, NY
Type of Work: Wood (Ship carvings, ship figures)
Sources: *AmFiTCa 197*.

McLeran, James
[MacLeran]
b. c1799
Flourished: 1848 Salem, OH
Ethnicity: Scottish
Type of Work: Fabric (Carpets, coverlets)
Sources: *ChAmC 82*.

McLuney, William
Flourished: c1809-1815 Charleston, WV
Type of Work: Stoneware (Pottery)
Sources: *AmPoP 209; Decor 221*.

McMahon, Thomas
Flourished: 1860 New York, NY
Type of Work: Wood (Ship carvings, ship figures)
Sources: *AmFiTCa 197*.

McMaster, William E.
Flourished: 1855 Chicago, IL
Type of Work: (Portraits)
Sources: *ArC 265*.

McMillan, J.W.
Flourished: 1867-1900 Miledgeville, GA
Type of Work: Stoneware (Pottery)
Sources: *AmPoP 240*.

McMillen, Samuel
b. c1822 Virginia
Flourished: 1837 Steubenville, OH
Type of Work: Fabric (Coverlets)
Sources: *ChAmC 84*.

McMinn, Charles Van Lineaus
b. 1847
Flourished: 1870-1891 Newberry, PA
Type of Work: Tin (Tinware)
Museums: 125
Sources: *ToCPS 42*-3*.

McMorrow, William
Flourished: c1870 Green Harbor, MA
Type of Work: Wood (Duck decoys)
Museums: 176
Sources: *ColAWC 324-5**.

McNabb, Marcena Coffman
Flourished: 1970 Oklahoma
Type of Work: Fabric (Quilts)
Sources: *FoArO 92**.

McNall, John
Type of Work: Fabric (Coverlets)
Sources: *ChAmC 84*.

McNaughton, Robert
Flourished: 1820 Schoharie, NY
Type of Work: Oil (Portraits)
Sources: *PrimPa 177*.

McNichol, D.E.
See: D.E. McNichol Pottery Company.

McNutt, Bryan
b. 1942 Phillips, TX
Flourished: Collegeville, TX
Type of Work: Wood (Sculptures, carvings)
Sources: *AmFokArt 185-7*; FoAFef 2*.

McQuate, Henry
Flourished: 1854-1859 Myerstown, PA
Type of Work: Redware (Pottery)
Sources: *AmPoP 172*.

McQuillen, James
Flourished: 1825 New York, NY
Type of Work: Wood (Ship carvings, ship figures)
Sources: *AmFiTCa 197.*

Mead, Dr.
Flourished: c1816-1819 New York, NY
Type of Work: White earthenware (Pottery)
Sources: *AmPoP 197.*

Mead, Abraham
[Meade, Deacon Abraham]
Flourished: c1773-1795 Greenwich, CT
Type of Work: Stoneware, redware (Pottery)
Museums: 263
Sources: *AmPoP 192; AmS 182*; Decor 177*, 179*, 221.*

Mead, William
Flourished: 1845 New York, NY
Type of Work: Wood (Ship carvings, ship figures)
Sources: *AmFiTCa 197.*

Meade, S.
Flourished: 1860 Medina County, OH
Type of Work: Stoneware (Pottery)
Sources: *AmPoP 235; Decor 221.*

Meaders, Aire (Mrs. Cheever)
Flourished: 1971 Mossy Creek, GA
Type of Work: Clay (Pottery)
Museums: 177
Remarks: Husband is Cheever; daughter is Lanier
Sources: *MisPi 100*.*

Meaders, Caspard
Flourished: 1886
Type of Work: Oil (Scenes for the America Opera Company)
Sources: *AmSFor 198.*

Meaders, Cheever
b. 1887 d. 1976
Flourished: Mossy Creek, GA
Type of Work: Clay (Face jugs, pottery)
Remarks: Wife is Aire; daughter is Lanier
Sources: *MisPi 99-100*.*

Meaders, Lanier
Flourished: 1970s Mossy Creek, GA
Type of Work: Clay (Face jugs, pottery)
Museums: 177
Remarks: Parents are Cheever and Aire
Sources: *MisPi 101*, 102*.*

Meaders Pottery
Flourished: 1830-1900 Cleveland, GA; Leo, GA
Type of Work: Stoneware (Churns)
Sources: *AmPoP 237, 239; AmS 93-5*, 208*, 260*; EaAmFo 90*, 247*.*

Meaher, J.W.
Flourished: 1865 Boston, MA
Type of Work: Wood (Ship carvings, ship figures)
Sources: *AmFiTCa 197.*

Mealy
Flourished: 1850 Milwaukee, WI
Type of Work: Fabric (Weavings)
Sources: *AmSQu 277; ChAmC 84.*

Mear
See: Salt and Mear.

Mear, Frederick
[Boston Earthenware Factory]
Flourished: c1840 Boston, MA
Type of Work: Clay (Pottery)
Sources: *AmPoP 64, 189, 269; DicM 48*.*

Meckel, J.S.
Flourished: Stark County, OH
Type of Work: Fabric (Coverlets)
Sources: *ChAmC 84.*

Medelli, Antonio
Flourished: 1848 St. Louis, MO
Type of Work: Oil (River scene paintings)
Remarks: Father-in-law of Pomarede, Leon D.
Sources: *ArC 226-7*.*

Medinger, Jacob
d. 1930?1932?
Flourished: c1885-1930 Pottstown, PA; Neiffer, PA
Type of Work: Clay (Pottery)
Sources: *AmPoP 32, 44, 172, 269; DicM 70*; DutCoF.*

Medinger, William
Flourished: c1850-1880 Neiffer, PA
Type of Work: Redware (Pottery)
Sources: *AmPoP 172.*

Meech, G.
Flourished: c1850 Lancaster, OH
Type of Work: Stone (Gravestones)
Sources: *EaAmG 129.*

Meed, I.M.
See: I.M. Meed and Company.

Meeks, Josiah
b. c1815 Virginia
Flourished: 1838-1850 Trumbull County, OH
Type of Work: Fabric (Coverlets)
Sources: *ChAmC 84.*

Meer, John
Flourished: c1820 Philadelphia, PA
Type of Work: Watercolor (Apron paintings)
Sources: *Bes 60-1*.*

Mehrle, W.
Flourished: 1854-1855 Chicago, IL
Type of Work: Paint (Sign and ornamental paintings)
Sources: *ArC 265.*

Mehweldt, Charles
Flourished: 1852- Bergholtz, NY
Type of Work: Redware (Pottery)
Sources: *AmPoP 59, 188.*

Meier, Henry
Flourished: St. Charles County, MO
Ethnicity: German
Type of Work: Wood (Furniture)
Sources: *ASeMo 378.*

Meiley, Charles S.
Flourished: 1830-1848 Mansfield, OH
Type of Work: Fabric (Weavings)
Sources: *AmSQu 277; ChAmC 86.*

Meily, Emanuel, Jr.
b. c1805 Pennsylvania d. 1869
Flourished: c1810-1860 Fredericksburg, PA
Type of Work: Fabric (Carpets, coverlets, diapers)
Sources: *ChAmC 86*
See: Bellman, Henry; Yingst, David; Mellinger, Samuel.

Meily, John Henry
b. 1817 Lebanon, PA d. 1883
Flourished: c1830-1850 Canton, OH; Lima, OH
Type of Work: Fabric (Carpets, coverlets)
Sources: *ChAmC 86.*

Meily, Samuel
b. c1806 Pennsylvania
Flourished: 1837-1857 West Lebanon, OH; Mansfield, OH
Type of Work: Fabric (Coverlets)
Sources: *ChAmC 86.*

Melcher, H.
Flourished: 1855-1861 Louisville, KY
Type of Work: Stoneware (Jars)
Sources: *AmS 86*.*

Melchers, Julius Caesar (Theodore)
b. 1829 d. 1908
Flourished: 1857?-1908 Detroit, MI
Ethnicity: German
Type of Work: Wood (Cigar store Indians, figures)
Museums: 071,203,294
Sources: *AmFoS 5, 154*, 253*, 262*; ArEn 31; ArtWod 44, 63, 80, 82, 137-50*, 198; CiStF ix, 14*, 21, 23-5, 27, 71; CoCoWA 114; EaAmW 42; Edith *; FoA 466; HoKnAm 13*, 164; InAmD 64; ShipNA 161.*

Melchers, Theodore
See: Melchers, Julius Caesar.

Meldrum, Alexander
Flourished: c1912 Fair Haven, MI
Type of Work: Wood (Decoys)
Sources: *WaDec 122*.*

Meldrum, John
Flourished: c1900 Pearl Beach, MI
Type of Work: Wood (Fish decoys)
Sources: *UnDec 20; WaDec 147*.*

Melish, John
Flourished: c1818 Philadelphia, PA
Ethnicity: Scottish
Type of Work: Pen, ink (Maps)
Sources: *ArC 62**.

Melleck, H.H.
Flourished: c1875 Roseville, OH
Type of Work: Stoneware (Pottery)
Sources: *AmPoP 229; Decor 221; DicM 62**.

Mellinger, Daniel
Flourished: 1848
Type of Work: Fabric (Weavings)
Sources: *ChAmC 86*.

Mellinger, John
See: John Mellinger and Sons.

Mellinger, Samuel
b. c1787 Pennsylvania
Flourished: 1834-1850 Lebanon, PA
Type of Work: Fabric (Weavings)
Sources: *ChAmC 86*
See: Meily, Emanuel, Jr.

Mellinger, W.S.
Flourished: 1838-1842
Type of Work: Fabric (Coverlets)
Sources: *ChAmC 88*.

Menard, Edmond "Bird Man"
b. 1942 Cabot, VT
Flourished: 1974- Marshfield, VT
Type of Work: Wood (Carved fans)
Remarks: Nutting, Chester was Bird Man's teacher
Sources: *FoAFp 4-5**.

Mench, E.
Flourished: 1840
Type of Work: Fabric (Weavings)
Sources: *AmSQu 277; ChAmC 88*.

Meneely, Andrew
See: Andrew Meneely and Sons.

Mengen, Theodore
Flourished: 1860 New York, NY
Type of Work: Wood (Ship carvings, ship figures)
Sources: *AmFiTCa 197*.

Menges, Adam
Flourished: 1860 New York, NY
Type of Work: Wood (Ship carvings, ship figures)
Sources: *AmFiTCa 197*.

Meninger, E.
Flourished: late 19th cent Clay, PA
Type of Work: Iron (Decorated tools)
Museums: 224
Sources: *BlkAr 54**.

Mensch, Irwin
Flourished: 1950- Barto, PA
Type of Work: Watercolor, ink (Frakturs)
Sources: *PenDuA 55**.

Menser, David
b. c1830 Pennsylvania
Flourished: 1850 Somerset Township, PA
Type of Work: Fabric (Weavings)
Sources: *ChAmC 88*
See: Casebeer, Aaron.

Mentelle, Ward, Sr.
Flourished: c1796 Lexington, KY; Gallipolis, OH
Ethnicity: French
Type of Work: Redware (Pottery)
Sources: *AmPoP 87, 239*.

Mercer, Henry C.
Flourished: 1890-1900 Doylestown, PA
Type of Work: Redware, sgraffito (Pottery)
Sources: *AmPoP 166; DicM 93**.

Mercer, William
Flourished: 1800 Pennsylvania
Type of Work: Oil (Scene paintings)
Sources: *PrimPa 177*.

Mercer Pottery Company
Flourished: c1868-1870 Trenton, NJ
Type of Work: Clay (Pottery)
Sources: *AmPoP 183, 269; DicM 20*, 96*, 120*, 125*, 140*, 178*-9*, 207**.

Merchant, Richard
Flourished: 1970-1980 Cape Vincent, NY
Type of Work: Metal (Welded horses)
Sources: *FouNY 50*-1*, 68*.

Merchant, S.
See: S. Merchant and Company.

Merck, C.
Flourished: 1855 Chicago, IL
Type of Work: Oil (Portraits)
Sources: *ArC 265*.

Merkle, Alexander
b. c1816
Flourished: 1837-1850 Steubenville, OH
Ethnicity: Scottish
Type of Work: Fabric (Weavings)
Remarks: Son is James
Sources: *ChAmC 88*.

Merkle, James
Flourished: c1850 Steubenville, OH
Type of Work: Fabric (Weavings)
Remarks: Father is Alexander
Sources: *ChAmC 88*.

Merrel, Peter
d. 1787
Flourished: Salem, NH
Type of Work: Stone (Gravestones)
Sources: *EaAmG 129*.

Merrett, Susan
See: Merritt, Susan.

Merriam, John
Flourished: 1791-1796 Philadelphia, PA
Type of Work: Wood (Ship carvings, ship figures)
Sources: *AmFiTCa 197; ShipNA 163*.

Merriam, Lawrence T.
Flourished: Meriden, CT
Type of Work: Tin (Tinware)
Remarks: Partners with Samuel Yale
Sources: *TinC 174*.

Merridan, Ann Page
Flourished: 1820
Type of Work: Watercolor (Literary scene paintings)
Sources: *PrimPa 177*.

Merrifield
Type of Work: Oil (Banner paintings)
Sources: *AmSFor 60*.

Merril, George Boardman
b. 1848 Laconia, NH
Flourished: c1860 Barre, VT
Type of Work: Marble (Book paperweights)
Sources: *NeaT 52-3**.

Merrill
See: Hill, Merrill and Company.

Merrill, Calvin
Flourished: 1847-1861 Akron, OH
Type of Work: Stoneware (Pottery)
Sources: *AmPoP 205; Decor 221*
See: Merrill, Edwin; Merrill, Henry; Akron Pottery Company.

Merrill, Earl
Flourished: c1880-1900 Mogadore, OH
Type of Work: Stoneware (Tobacco pipes)
Remarks: Worked with Merrill, Ford
Sources: *AmPoP 224; Decor 221*.

Merrill, Edwin
Flourished: 1847-1861 Akron, OH
Type of Work: Stoneware (Pottery)
Sources: *AmPoP 205; Decor 221*
See: Merrill, Calvin; Merrill, Henry; Akron Pottery Company.

Merrill, Edwin H.
Flourished: 1835-1847 Springfield, OH
Type of Work: Stoneware (Pottery)
Sources: *AmPoP 230; Decor 39, 221*.

Merrill, Ford
See: Merrill, Earl.

Merrill, Henry E.
Flourished: 1861-1888 Akron, OH
Type of Work: Stoneware (Pottery)
Sources: *AmPoP 205; Decor 221*
See: Akron Pottery Company; Merrill, Edwin; Merrill, Calvin.

Merrill, Henry W.
Flourished: East Hiram, ME
Type of Work: Metal (Ornamental works)
Sources: *FoArtC 70*.

Merrill, Joseph P.
Flourished: 1878 Portland, ME
Type of Work: Wood (Ship carvings, ship figures)
Remarks: Apprentice of Griffin, Edward Souther
Sources: *ShipNA 87-8, 157.*

Merrill, Sailor
Flourished: 1855 Salem, MA
Type of Work: Fabric (Embroidered ship pictures)
Museums: 079
Sources: *AmNe 90*.*

Merrill, Sarah
Flourished: 1810-1815
Type of Work: Watercolor (Mourning paintings)
Museums: 176
Sources: *ColAWC 210; PicFoA 130*; PrimPa 177.*

Merrill Powers and Company
Flourished: 1855-1858 Akron, OH
Type of Work: Stoneware (Pottery)
Sources: *AmPoP 205; Decor 221.*

Merrimac Ceramic Company
Flourished: 1897- Newburyport, MA
Type of Work: Clay (Pottery)
Sources: *DicM 157*, 248*.*

Merrimen, Ives
Flourished: 1819 Berlin, CT
Type of Work: Tin? (Tinware?)
Remarks: Associated with Hubbard
Sources: *TinC 174.*

Merritt, E.
Flourished: 1850
Type of Work: Watercolor (Paintings)
Sources: *PrimPa 177.*

Merritt, Susan
[Merrett]
b. 1826 d. 1879
Flourished: 1867-1878 South Weymouth, MA
Type of Work: Watercolor (Paintings)
Museums: 016
Sources: *AmFoPaN 103, 133*, 1-3*; ArtWo 103, 141, 164, fig18; FlowAm 281, 70*; PicFoA 123*; PrimPa 177.*

Merritt, William Dennis Billy
Flourished: 1900 Crawford County, GA
Type of Work: Clay (Pottery)
Museums: 177
Sources: *MisPi 92*.*

Merz, Jacob
Flourished: 1859-1865 Bennington, VT; Pennsylvania
Type of Work: Clay (Pottery)
Sources: *AmPoP 59, 188.*

Mesick, C.
Flourished: 1836
Type of Work: Fabric (Weavings)
Sources: *AmSQu 277.*

Mesker, J.B. and G.L.
See: J.B. and G.L. Mesker and Company

Messenger, Charles
Flourished: 1877 Meriden, CT
Type of Work: Tin (Tinware)
Sources: *TinC 174.*

Messner, Elizabeth
Type of Work: Watercolor, ink (Frakturs)
Museums: 176
Sources: *ColAWC 276, 278*.*

Metal Stamping and Spinning Company
Flourished: 1894 Grand Rapids, MI
Type of Work: Metal (Weathervanes)
Sources: *YankWe 212.*

Metcalf, Edward
Flourished: c1824 Connecticut
Type of Work: Tin (Tinder boxes, scoops)
Sources: *TinC 174*
See: Frances, Edward .

Metcalf, Savil
d. 1737
Flourished: Bellingham, MA
Type of Work: Stone (Gravestones)
Sources: *EaAmG 128; GravNE 129.*

Metz, L.
Flourished: 1841-1842 Montgomery County, PA
Type of Work: Fabric (Coverlets)
Sources: *AmSQu 277; ChAmC 88.*

Metzger, F.
Flourished: Pennsylvania
Type of Work: Fabric (Weavings)
Sources: *AmSQu 277; ChAmC 88.*

Metzler, Henry F.
Flourished: 1853-1857 New York, NY
Type of Work: Wood (Cigar store Indians, figures, eagles, various ornamental carvings)
Sources: *AmFiTCa 142, 197; ArtWod 268.*

Metzner, Adolph
Flourished: 1884-1900 Hamilton, OH
Type of Work: Stoneware (Pottery)
Sources: *AmPoP 221; Decor 221.*

Meyer, Catharine
Flourished: 1820 Springfield, PA
Type of Work: Fabric (Samplers)
Sources: *GalAmS 56*.*

Meyer, Elizabeth
Flourished: 1820s- Pennsylvania
Type of Work: Watercolor (Animal drawings, frakturs)
Sources: *AmFoPa 188*; AmPrP 154; PrimPa 177.*

Meyer, Joe
Flourished: Mitchells Bay, MI
Type of Work: Wood (Decoys)
Sources: *WaDec 127*.*

Meyer, Johann Philip
Flourished: 1794 Kutztown, PA
Type of Work: Fabric (Weavings)
Sources: *ChAmC 88.*

Meyer, Karen A.
b. 1961 Birmingham, MI
Flourished: 1981- Birmingham, MI
Type of Work: Clay (Pottery)
Sources: *ArtWo 58-9.*

Meyer, Lewis
b. 1795 d. 1882
Flourished: York, PA
Type of Work: Watercolor, pen (Genre drawings)
Sources: *PrimPa 177.*

Meyer, Martin J.
Flourished: 1835 Pennsylvania
Type of Work: Watercolor, ink (Frakturs)
Sources: *AmFoPa 188.*

Meyer Pottery
Flourished: 1900-1940 Bexar County, TX
Type of Work: Stoneware (Jugs)
Sources: *AmS 29*, 45*, 50*, 56, 58*, 76*, 85-6*, 89-92*, 94*, 100-2*, 104*, 106*, 112-3*, 115-8*, 121-4*, 126-7*, 130*, 132*, 134*, 162, 195*, 200*, 229*, 233*, 239*, 258-60*.*

Meyers
See: Fellows and Meyers .

Meyers, E.W.
Flourished: c1870 Mogadore, OH
Type of Work: Stoneware (Pottery)
Sources: *AmPoP 224.*

Meyers, William H.
Flourished: 1841-1847 California
Type of Work: Watercolor (Historical paintings)
Museums: 021,086
Sources: *FoPaAm 230-1*.*

Meyers and Hedian
Flourished: 1865 Baltimore, MD
Type of Work: Wood (Ship carvings, ship figures)
Sources: *AmFiTCa 197.*

Meysick, Mary Ann
Type of Work: Watercolor (Scene paintings)
Museums: 176
Sources: *ColAWC 167, 169.*

Michael, Enos
b. c1824 Dauphin County, PA d. 1890 Fremont, IN
Flourished: 1849-1860 Brockville, IN
Type of Work: Fabric (Coverlets)
Remarks: Father is Philip
Sources: *ChAmC 88*
See: Fridley, Abraham .

Michael, Philip
b. Dauphin County, PA d. Brockville, PA
Flourished: 1837-1846 Susquehanna Township, PA; Fremont, IN
Type of Work: Fabric (Coverlets)
Remarks: Son is Enos
Sources: *ChAmC 88.*

Michaels
Flourished: Albion, IL
Type of Work: Fabric (Weavings)
Sources: *ChAmC 88.*

Michelangelo of the Midway
See: Wolfinger, August.

Mickey, Julius
b. 1832 d. 1916
Flourished: North Carolina
Type of Work: Pencil (Church portraits, drawings)
Sources: *FoPaAm 163*.*

Middle Lane Pottery
Flourished: c1900 East Hampton, NY
Type of Work: Clay (Pottery)
Sources: *DicM 22*, 240*.*

MiddleKamp
Flourished: mid 19th cent Warrentown, MO
Type of Work: Wood (Chairs)
Sources: *ASeMo 379, 381*.*

Middleton, Ralph
b. New York
Flourished: New York, NY
Ethnicity: Black American
Type of Work: Oil, acrylic, pen, pencil (Paintings)
Sources: *AmFokArt 192-4*.*

Midkiff, Lula
See: Midkiff, Mary Louisa Givens.

Midkiff, Mary Louisa Givens "Lula"
Flourished: c1895 Hancock County, KY
Type of Work: Fabric (Quilts)
Sources: *KenQu 50, fig39.*

Miera y Pacheco, Bernardo, Captain
d. 1785
Flourished: 1754 Santa Fe, NM
Ethnicity: Spanish
Type of Work: Oil, wood (Chapel paintings, sculptures)
Museums: 178, 263, 272
Sources: *FoPaAm 228, 233*; PopAs 23, 91*-2*, 98-105*, 107*-9, 112*-5.*

Miesse, Gabriel
b. 1807 d. 1886
Flourished: Pennsylvania
Type of Work: Watercolor, ink (Frakturs)
Sources: *AmFoPa 188.*

Miguelito
Flourished: 1923 Gallup, NM
Ethnicity: American Indian
Type of Work: Sand (Paintings)
Remarks: Navajo tribe
Sources: *PicFoA 42-3*.*

Milan, Nettie
Flourished: 1876-83 Cincinnati, OH
Type of Work: Fabric (Quilts)
Museums: 046
Sources: *NewDis 115*.*

Miles, Diana
b. c1807
Flourished: 1820 Townshend, VT
Type of Work: Fabric (Samplers)
Sources: *GalAmS 59*.*

Miles, Pamela
b. 1939 Oak Park, IL
Flourished: c1980 Anchorage, KY
Type of Work: Oil, acrylic (Still life and landscape paintings)
Sources: *AmFokArt 195-7.*

Millard, Al(gernon) W. (John)
Flourished: early 20th cent Brooklyn, NY
Type of Work: Oil (Circus banners)
Sources: *AmSFor 57.*

Millard, John
See: Millard, Algernon W.

Millard, Thomas, Jr.
[Milliard]
b. 1803 Connecticut d. 1870
Flourished: 1827-1860 New York, NY; Brooklyn, NY
Type of Work: Wood (Cigar store Indians, figures, ship carvings, ship figures)
Remarks: Partner with Brooks, Thomas V.
Sources: *AmFiTCa 85-6, 197; ArtWod 5, 29, 119, 177-8, 183, 266; CiStF 29; ShipNA 162.*

Millard, Tom
Flourished: c1850 New York, NY
Type of Work: Wood (Signs)
Sources: *CiStF 29.*

Miller
See: Doran and Miller.

Miller, Abraham
Flourished: ?-1858 Philadelphia, PA
Type of Work: Redware, earthenware (Pottery)
Remarks: Son of Andrew
Sources: *AmPoP 45, 101, 174.*

Miller, Ambrose
[Muller]
b. 1812 d. c1891
Flourished: 1849-1868 Blair County, PA
Ethnicity: French
Type of Work: Fabric (Carpets, coverlets)
Sources: *ChAmC 88.*

Miller, Andrew
Flourished: 1785-? Philadelphia, PA
Type of Work: Redware (Pottery)
Remarks: Father of Abraham
Sources: *AmPoP 45, 174.*

Miller, Anna G.
Flourished: contemporary Louisville, KY
Type of Work: Oil (Religious paintings)
Sources: *GoMaD *.*

Miller, Anna Mari
Flourished: 1834 Pennsylvania
Type of Work: Fabric (Stitched linens)
Sources: *FoArRP 47.*

Miller, Anna Viola
b. 1900 Shipshewana, IN
Flourished: 1915-1937 Middlebury, IN; Honeyville, IN
Ethnicity: Amish
Type of Work: Fabric (Quilts)
Sources: *QuIInA 38*, 40*, 44*, 59*.*

Miller, Anne D.
Flourished: 1832 New York
Type of Work: Fabric (Candlewick pillow slips)
Sources: *ArtWo 8*.*

Miller, Anne Louisa
b. 1906 Glenbeaulah, WI
Flourished: 1940s Milwaukee, WI
Type of Work: Oil (Paintings)
Museums: 295
Sources: *FoAFl 7-8*.*

Miller, Athanasias
Flourished: 1882 Philadelphia, PA
Type of Work: Wood (Ship carvings, ship figures)
Sources: *AmFiTCa 197.*

Miller, August
Flourished: 1865-1900 Cincinnati, OH
Type of Work: Yellow-ware, Rockingham (Pottery)
Sources: *AmPoP 212.*

Miller, B.
See: Miller, M.

Miller, B.C.
Flourished: 1830
Type of Work: Stoneware (Pottery)
Museums: 097
Sources: *Decor 183*.*

Miller, Christian
Flourished: c1845-1850 New Britain, PA
Type of Work: Redware (Pottery)
Sources: *AmPoP 172.*

Miller, David
b. 1718 d. 1789
Flourished: Middlefield, CT
Type of Work: Stone (Gravestones)
Sources: *EaAmG 128.*

Miller, Mrs. David J.L.
See: Miller, Katie.

Miller, Edwin N.
Flourished: 1834 New York, NY
Type of Work: Wood (Ship carvings, ship figures)
Sources: *AmFiTCa 197.*

Miller, Eliza Armstead
Flourished: 18th cent Virginia
Type of Work: Fabric (Quilts)
Museums: 151
Sources: *QuiAm 121*.*

Miller, Ernest
Flourished: 1860 New York, NY
Type of Work: Wood (Ship carvings, ship figures)
Sources: *AmFiTCa 197.*

Miller, Fanny
Flourished: 1810
Type of Work: Fabric (Mourning samplers)
Sources: *MoBeA.*

Miller, Gabriel
b. c1823 Pennsylvania
Flourished: 1820-1850 Bethlehem, PA; Heidelberg Township, PA
Type of Work: Fabric (Coverlets)
Sources: *AmSQu 277; ChAmC 88.*

Miller, George A.
Flourished: 1830 New York, NY
Type of Work: Wood (Ship carvings, ship figures)
Sources: *AmFiTCa 197.*

Miller, Henry
Flourished: 1846-1851 McCuthenville, OH
Type of Work: Fabric (Weavings)
Sources: *ChAmC 88.*

Miller, Henry
Flourished: 1925 Topeka, IN
Ethnicity: Amish
Type of Work: Fabric (Quilts)
Sources: *QuflnA 86*.*

Miller, Howard
Flourished: 1920 Brooks County, GA
Ethnicity: Black American
Type of Work: Wood (Carved canes)
Sources: *MisPi 60-1*.*

Miller, J.
Flourished: 1840 New York
Type of Work: Oil (Sewing boxes)
Sources: *NeaT 135*.*

Miller, J.
Flourished: c1868
Type of Work: Gouache (Paintings)
Museums: 176
Sources: *ColAWC 240.*

Miller, J.
Flourished: c1869-1880 Wheeling, WV
Type of Work: Stoneware (Pottery)
Sources: *AmPoP 233; Decor 221.*

Miller, Jacob
Flourished: 1810 New York, NY
Type of Work: Wood (Ship carvings, ship figures)
Sources: *AmFiTCa 197.*

Miller, Jacob
Flourished: 1821 Pennsylvania
Type of Work: Watercolor, ink (Frakturs)
Sources: *AmFoPa 188.*

Miller, James
b. 1944
Flourished: contemporary Spanaway, WA
Type of Work: Oil (Paintings)
Museums: 306
Sources: *PioPar 15, 40*, 47, 64.*

Miller, John
Flourished: 1815 New York, NY
Type of Work: Wood (Ship carvings, ship figures)
Sources: *AmFiTCa 197.*

Miller, John F.
Flourished: 1845 New York, NY
Type of Work: Wood (Ship carvings, ship figures)
Sources: *AmFiTCa 197.*

Miller, John F., Jr.
Flourished: 1820 New York, NY
Type of Work: Wood (Ship carvings, ship figures)
Sources: *AmFiTCa 197.*

Miller, John G.
Flourished: 1831 Pennsylvania
Type of Work: Watercolor, ink (Frakturs)
Sources: *AmFoPa 188.*

Miller, Joseph
Flourished: c1720's Boston, MA
Type of Work: Tin (Tinware)
Sources: *AmCoTW 42; ToCPS 4.*

Miller, Katie (Mrs. David J.L.)
Flourished: c1900 Shipshewana, IN
Ethnicity: Amish
Type of Work: Fabric (Quilts)
Sources: *QuflnA 72*.*

Miller, Levi M.S.
Flourished: 1838-1860 Jackson Township, OH
Type of Work: Fabric (Weavings)
Sources: *AmSQu 277; ChAmC 88.*

Miller, Lewis
b. 1796 d. 1882
Flourished: York, PA
Type of Work: Ink, watercolor (Illustrated biographical essay of his community)
Museums: 096,110
Sources: *AmFoPaCe 121, 124-8*; AmFoS 154*; FoPaAm 97*, 132-3; HoKnAm 137; PicFoA 26.*

Miller, Louisa F.
Flourished: 1830 New Lebanon, NY
Type of Work: Velvet (Memorial paintings)
Sources: *PrimPa 177.*

Miller, Lydia Ann
Flourished: c1937 Emma, IN
Ethnicity: Amish
Type of Work: Fabric (Quilts)
Sources: *QuflnA 49*.*

Miller, Lynn
b. 1906 Glenbeulah, WI
Flourished: Augusta, WI
Type of Work: Oil (Portraits, memory, landscape, and fantasy paintings)
Museums: 295
Sources: *TwCA 120*.*

Miller, M.
Flourished: c1860-1870 Newport, PA
Type of Work: Stoneware (Pottery)
Museums: 097
Remarks: Worked with Miller, B.
Sources: *Decor 90*.*

Miller, Mary
b. c1770
Flourished: 1786 Pemberton, NJ
Type of Work: Fabric (Samplers)
Sources: *GalAmS 29*, 90.*

Miller, Mary
Flourished: 1910-1930 Indiana
Ethnicity: Amish
Type of Work: Fabric (Quilts)
Sources: *QuflnA 25*.*

Miller, Maxmilion
b. c1823
Flourished: c1860 Emmaus, PA
Ethnicity: German
Type of Work: Fabric (Coverlets)
Sources: *ChAmC 88.*

Miller, Minerva Butler
See: Butler, Minerva.

Miller, Mrs. Nathaniel
Flourished: 1930 Topeka, IN
Ethnicity: Amish
Type of Work: Fabric (Quilts)
Sources: *QuflnA 80*.*

Miller, Polly
Flourished: 1940 Emma, IN
Ethnicity: Amish
Type of Work: Fabric (Quilts)
Sources: *QuflnA 66*.*

Miller, Robert
b. c1832
Flourished: c1857-1862 Salem, IN
Ethnicity: English
Type of Work: Fabric (Weavings)
Sources: *AmSQu 277; ChAmC 89.*

Miller, Mrs. S.N.
Flourished: 1930 Hutchinson, KS
Ethnicity: Amish
Type of Work: Fabric (Quilts)
Sources: *QuInA 65**.

Miller, Sarah
Flourished: 1920-1935 Haven, KS
Ethnicity: Amish
Type of Work: Fabric (Quilts)
Museums: 171
Sources: *AmFoArt 141*; QuInA 61*, 67**.

Miller, Sarah Ann
Flourished: c1840 New Hanover, PA
Type of Work: Fabric (Samplers)
Sources: *GalAmS 84**.

Miller, Solomon
Flourished: c1870-1880 Waynesboro, PA
Type of Work: Clay (Pottery)
Remarks: Worked at Bell Pottery
Sources: *AmPoP 186*.

Miller, Mrs. Susie
Flourished: 1943 Topeka, IN
Ethnicity: Amish
Type of Work: Fabric (Quilts)
Sources: *QuInA 27**.

Miller, Theodore H.
b. c1823
Flourished: 1858-1870 Lafayette, IN
Ethnicity: German
Type of Work: Fabric (Weavings)
Sources: *ChAmC 89*
See: Neely, Henry.

Miller, Tobias
Flourished: 1867 La Grange County, IN
Type of Work: Fabric (Weavings)
Sources: *AmSQu 277; ChAmC 89*.

Miller, Mrs. William Snyder
Flourished: 1841
Type of Work: Fabric (Quilts)
Museums: 257
Sources: *QuiAm 111**.

Miller and Browne
Flourished: 1834 New York, NY
Type of Work: Wood (Ship carvings, ship figures)
Sources: *AmFiTCa 197*.

Miller and Tapp
See: Tapp and Miller.

Miller, Dubrul and Peters Manufacturing Company
Flourished: 1880 Cincinnati, OH
Type of Work: Metal, wood (Cigar store Indians, figures)
Sources: *ArtWod 73-4*; CiStF 41, 49*.

Miller Iron Company
Flourished: 1871-1883 Providence, RI
Type of Work: Metal (Weathervanes)
Sources: *YankWe 212*.

Milliard, Charles
Flourished: 1833 Philadelphia, PA
Type of Work: Wood (Ship carvings, ship figures)
Sources: *AmFiTCa 197; ShipNA 163*.

Milliard, James
Flourished: 1833-1856 Philadelphia, PA
Type of Work: Wood (Ship carvings, ship figures)
Sources: *ShipNA 163*.

Milliard, Thomas
Flourished: 1795 Philadelphia, PA
Type of Work: Wood (Ship carvings, ship figures)
Sources: *AmFiTCa 197; ShipNA 163*.

Milliard, Thomas, Jr.
See: Millard, Thomas, Jr.

Milliken, Robert
Flourished: 1830 New York, NY
Type of Work: Wood (Ship carvings, ship figures)
Remarks: Worked with Milliken, Thomas
Sources: *AmFiTCa 197*.

Milliken, Thomas
Flourished: 1820 New York, NY
Type of Work: Wood (Ship carvings, ship figures)
Sources: *AmFiTCa 197*.

Millington, Astbury and Poulson
Flourished: 1852-1870 Trenton, NJ
Type of Work: Clay (Pottery)
Sources: *AmPoP 49, 113, 181; DicM 182*, 185**.

Milosh, Christian
Flourished: 1860 New York, NY
Type of Work: Wood (Ship carvings, ship figures)
Sources: *AmFiTCa 197*.

Milosh, William
Flourished: 1860 New York, NY
Type of Work: Wood (Ship carvings, ship figures)
Sources: *AmFiTCa 197*.

Milroy
Flourished: 1851 Mifflin County, PA
Type of Work: Fabric? (Weavings?)
Sources: *AmSQu 277; ChAmC 89*.

Min, James A.
Flourished: 1834 Pennsylvania
Type of Work: Clay (Pottery)
Sources: *AlAmD 103**.

Minchell, Peter
b. 1889
Flourished: 1930-1940 Florida
Ethnicity: German
Type of Work: Watercolor (Landscape, scene, religious paintings)
Sources: *AmFokArt 198-9*; FoPaAm 176*, 180*.

Miner, Eliza(beth) Gratia Campbell
b. 1803 or 1805 d. 1891
Flourished: Canton, NY
Type of Work: Oil, fabric (Scene paintings, embroidered wool carpets)
Sources: *ArtWo 103, 107*, 165; FouNY 66*; PrimPa 177*.

Miner, William
Flourished: 1869-1883 Symnes Creek, OH
Type of Work: Stoneware (Pottery)
Sources: *AmPoP 231; Decor 221*.

Minifie, James
Flourished: 1840 New York, NY
Type of Work: Wood (Ship carvings, ship figures)
Sources: *AmFiTCa 197*.

Minkimer, Frederick
Flourished: 1877 Meriden, CT
Type of Work: Tin (Tinware)
Sources: *TinC 174*.

Minnesota Stoneware Company
Flourished: c1900 Red Wing, MN
Type of Work: Stoneware (Jugs)
Sources: *AmS 76**.

Minshall
See: Crabb and Minshall.

Minton, W.D.
Flourished: 1845 New York, NY
Type of Work: Wood (Ship carvings, ship figures)
Sources: *AmFiTCa 197*.

Miracle, Hazel
b. 1915 Sevier County, TN
Flourished: 1975 Meldrum, KY
Type of Work: Wood, apples, nuts (Dolls)
Remarks: Has son James who carves dolls and animals
Sources: *GoMaD*.

Misch, Otto
Flourished: Saginaw, MI
Type of Work: Wood (Decoys)
Sources: *WaDec 104-5*, 159**.

Misler Brothers
Flourished: c1880-1900 Ravenna, OH
Type of Work: Stoneware (Pottery)
Sources: *AmPoP 228*.

Mitchell, Almira
b. Bristol, CT
Flourished: Waterbury, CT
Type of Work: Tin (Japanned tinware)
Sources: *TinC 158*.

Mitchell, Catherine
Flourished: 1835-1845
Type of Work: Fabric (Quilts)
Museums: 144
Sources: *QuiAm 114**.

Mitchell, Elizabeth Roseberry
b. Pennsylvania **d.** Kentucky
Flourished: c1839 Lewis County, KY
Type of Work: Fabric (Quilts)
Museums: 124
Sources: *ArtWo* 46, 100-1*, 165; *KenQu* 52-3, fig42; *QuiAm* 227*.

Mitchell, H.R.
Flourished: Philadelphia, PA
Type of Work: Stoneware (Pottery)
Museums: 097
Sources: *Decor* 186*.

Mitchell, James
Flourished: 1850 Middlebury, VT
Type of Work: Stoneware (Pottery)
Sources: *AmPoP* 195.

Mitchell, M.V.
See: M.V. Mitchell and Sons.

Mitchell, Madison
Flourished: Havre de Grace, MD
Type of Work: Wood (Duck decoys)
Sources: *AmBiDe* 144, 146.

Mitchell, Phoebe
Flourished: 1800-1830 Port Washington, NY
Type of Work: Watercolor (Landscape paintings)
Museums: 176
Sources: *AmPrP* 154; *ColAWC* 168-9*; *PrimPa* 177.

Mitchell, Robert
Flourished: 1845 New York, NY
Type of Work: Wood (Ship carvings, ship figures)
Sources: *AmFiTCa* 197.

Mitchell, Thomas
Flourished: c1804
Type of Work: Tin (Tinware)
Remarks: Brother is William Alton
Sources: *TinC* 174
 See: Roberts, Candace.

Mitchell, Vernell
Flourished: 1971 Joliet, IL
Type of Work: Oil (Symbolic paintings)
Sources: *TwCA* 174*.

Mitchell, William
Flourished: c1818-1838 Nantucket, MA
Type of Work: Oil? (Decorated wall paintings)
Sources: *AmDecor* 9.

Mitchell, William Alton
 d. 1803
Flourished: c1777 Connecticut
Type of Work: Tin (Tinware)
Remarks: Ran tin shop; brother is Thomas
Sources: *TinC* 175.

Mitchell and Manross
Flourished: Bristol, CT
Type of Work: Tin (Tinware)
Sources: *TinC* 117, 120.

Mize, Mahulda
Flourished: c1860 Clay County, KY
Ethnicity: Black American
Type of Work: Fabric (Quilts)
Sources: *KenQu* 25*.

Mode, Amy
b. c1823
Flourished: 1834 Chester County, PA
Type of Work: Fabric (Samplers)
Sources: *GalAmS* 76*-7, 92.

Modern Decoy Company
Flourished: c1920 New Haven, CT
Type of Work: Wood (Duck decoys)
Museums: 260
Sources: *AmBiDe* 230; *Decoy* 66*.

Moffly, Samuel
Flourished: 1805 Pennsylvania
Type of Work: Watercolor, ink (Frakturs)
Sources: *AmFoPa* 188; *Edith* *.

Mohamed, Ethel Wright
b. 1906 Webster County, MS
Flourished: 1965- Belzoni, MS
Type of Work: Fabric (Needlework)
Sources: *ArtWo* 148*, 165*; *FoAFef* 1*, 4*; *LoCo* xviii-xxvii, 101*-131*.

Mohler, Anny
Flourished: c1830 Stark County, OH
Type of Work: Watercolor (Paintings)
Museums: 001
Sources: *ArtWo* 81-2*, 166*.

Mole, William
Flourished: 19th cent
Type of Work: Watercolor (Fantasy paintings)
Sources: *Edith* *.

Moll, Benjamin Franklin
Flourished: c1850-1865 Shoemakersville, PA
Type of Work: Redware (Pottery, especially decorative flower pots)
Remarks: Father is Henry; son is Franklin B.
Sources: *AmPoP* 179.

Moll, David
Flourished: 1841
Type of Work: Fabric? (Coverlets?)
Sources: *ChAmC* 89.

Moll, Franklin B.
Flourished: c1865-1885 Shoemakersville, PA
Type of Work: Redware (Pottery)
Remarks: Father is Moll, Benjamin Franklin; grandfather is Henry
Sources: *AmPoP* 179.

Moll, Henry
Flourished: c1840-1850 Shoemakersville, PA
Type of Work: Redware (Pottery)
Remarks: Son is Benjamin Franklin
Sources: *AmPoP* 179.

Molleno
Flourished: 1804-1845 New Mexico
Type of Work: Tempera, gesso (Paintings)
Museums: 068,181
Remarks: Called the "chili painter".
Sources: *FoPaAm* 220*; *HoKnAm* 72-3*; *PopAs* 119*, 349-65*.

Moment, Barbara
b. c1930 Easton, PA
Flourished: South Nyack, NY
Type of Work: Oil, acrylic (Paintings)
Sources: *AmFokArt* 200-202*.

Mon Hon
Flourished: 1861 San Francisco, CA
Ethnicity: Chinese
Type of Work: Wood (Ship carvings, ship figures)
Sources: *ShipNA* 91, 155.

Moncliff, A.B.
b. c1818
Flourished: c1850 Richland Township, OH; West Rushville, OH
Ethnicity: Scottish
Type of Work: Fabric (Coverlets)
Sources: *ChAmC* 89.

Mondeau, John
Flourished: c1830-1862 Haycock Township, PA
Type of Work: Redware (Pottery)
Sources: *AmPoP* 169.

Mondragon, Jose
Flourished: 1960s Cordova, NM
Type of Work: Wood (Santeros, other religious carvings)
Museums: 263,272
Sources: *AmFoS* 316*; *TwCA* 204*.

Money
Flourished: Ohio
Type of Work: Fabric (Weavings)
Sources: *AmSQu* 277.

Monmouth Pottery Company
Flourished: 1890-1900 Monmouth, IL
Type of Work: Stoneware (Pottery)
Sources: *AmPoP* 224; *AmS* 129*; *Decor* 221, 231*.

Monroe
See: Luff and Monroe.

Monroe, E.D.
See: Monroe, J.S.

Monroe, J.S.
Flourished: 1845-1880 Mogadore, OH
Type of Work: Stoneware (Pottery)
Remarks: Worked with Monroe, E.D.
Sources: *AmPoP* 224; *Decor* 221.

Monroe, John
Flourished: 1830 New York, NY
Type of Work: Wood (Ship carvings, ship figures)
Sources: *AmFiTCa 197.*

Monroeton Woolen Factory
Flourished: 1841-1845 Bradford County, PA
Type of Work: Fabric (Coverlets)
Sources: *ChAmC 89*
See: Ingham, David.

Montford
See: Burroughs and Mountford.

Montgomery, William
Flourished: 1830 New York, NY
Type of Work: Wood (Ship carvings, ship figures)
Sources: *AmFiTCa 197.*

Montgomery, William M.
Flourished: 1840 New York, NY
Type of Work: Wood (Ship carvings, ship figures)
Sources: *AmFiTCa 197.*

Montoya, Patricia
Flourished: 1890s El Valle, NM
Ethnicity: Hispanic
Type of Work: Fabric (Blankets)
Sources: *PopAs 237.*

Monza, Louis
b. 1897 d. 1984 Redondo Beach, CA
Flourished: New York, NY; Redondo Beach, CA
Ethnicity: Italian
Type of Work: Oil, wood, terra-cotta, metal (Paintings, monotypes, woodcuts, constructions)
Museums: 171
Sources: *FoAFb 14*; PioPar 41*, 47, 60.*

Mooers, Jacob B.
Flourished: 1840 Deerfield, NH
Type of Work: Oil (Portraits)
Sources: *PrimPa 177.*

Moon, Robert
b. c1801 d. 1887 Montgomery Township, OH
Flourished: 1843-1850 Columbus, OH
Ethnicity: English
Type of Work: Fabric (Weavings)
Sources: *ChAmC 89.*

Mooney, D.
Flourished: c1864 Ithaca, NY
Type of Work: Stoneware (Pottery)
Sources: *Decor 221.*

Mooney, J.C.
Flourished: c1810 Union, NJ
Type of Work: Stone (Gravestones)
Sources: *EaAmG 129.*

Mooney, Michael
Flourished: c1864 Ithaca, NY
Type of Work: Stoneware (Pottery)
Sources: *Decor 221.*

Mooney, Michael
Flourished: 1871 Baltimore, MD
Type of Work: Wood (Ship carvings, ship figures)
Sources: *AmFiTCa 197.*

Moor, W.T.
[Moore, W.T.]
Flourished: 1850-1870 Middlebury, OH
Type of Work: Clay (Pottery)
Sources: *EaAmFo 242*.*

Moore
Flourished: Michigan
Type of Work: Wood (Fish decoys)
Sources: *UnDec 20.*

Moore, A.E.
Flourished: 1830
Type of Work: Oil (Portraits)
Sources: *AmPrP 154; PrimPa 177; SoAmP 155*.*

Moore, Alvin S.
Flourished: c1850-1870 Tallmadge, OH
Type of Work: Stoneware (Pottery)
Sources: *AmPoP 231; Decor 221.*

Moore, Ann
Flourished: 1808-1812 Champlain, NY
Type of Work: Fabric (Rugs)
Museums: 151
Remarks: Sister is Sophie
Sources: *AmNe 97, 95**
See: Hicks, Harriet.

Moore, "Aunt Eliza"
Flourished: 1843 Trenton, NJ
Type of Work: Fabric (Quilts)
Museums: 063
Sources: *QuiAm 232*.*

Moore, Billy
Flourished: 1920 Oklahoma
Ethnicity: American Indian
Type of Work: Metal (Signs)
Sources: *FoArO 93*.*

Moore, Charles
Flourished: 1950-1972 Nashville, TN
Type of Work: Oil (House portraits)
Sources: *FoAFm 3; TwCA 149*.*

Moore, Cyrus
Flourished: late 19th cent Schuylkill County, PA
Type of Work: Tin (Tinware)
Sources: *ToCPS 4-5**
See: Philips, Solomon Alexander.

Moore, Emily S.
Flourished: 1855 Vermont
Type of Work: Charcoal, chalk (Landscape drawings)
Museums: 176
Sources: *ColAWC 191, 195*; PrimPa 177.*

Moore, Enoch
Flourished: mid 1800's South Amboy, NJ
Type of Work: Yellow-ware, brownware (Pottery)
Remarks: Partner with Greatbach, Daniel and Carr, James
Sources: *AmPoP 180.*

Moore, Harriet
Flourished: 1817 Concord, MA
Type of Work: Watercolor (Memorial paintings)
Museums: 203
Sources: *HoKnAm 12*.*

Moore, J.W.
Flourished: 1941 Uhrichsville, OH; Canton, OH
Type of Work: Clay (Sewer tile sculpture)
Sources: *IlHaOS *.*

Moore, Jacob Bailey
b. 1815 Candia, NH d. 1893
Flourished: c1842 Boston, MA; Candia, NH
Type of Work: Oil (Portraits)
Remarks: Member of the Prior-Hamblen school
Sources: *AmFoPa 76-81*; NinCFo 176; PrimPa 177.*

Moore, Mathew
Flourished: c1844 Nauvoo, IL
Type of Work: Redware, brownware (Pottery)
Sources: *ArC 190.*

Moore, Nelson Augustus
b. 1824 d. 1902
Type of Work: Oil (Paintings)
Museums: 054
Sources: *FoArA 104*.*

Moore, Richard
Flourished: c1824-1840 Carversville, PA
Type of Work: Redware, sgraffito (Pottery)
Sources: *AmPoP 165.*

Moore, Robert
Flourished: -1836 Newark, OH
Type of Work: Fabric (Weavings)
Sources: *ChAmC 89*
See: Stich, G.

Moore, Mrs. Roy
Flourished: 1971 Georgia
Type of Work: Fabric (Quilts)
Sources: *AmSQu 308*.*

Moore, Sophie
Flourished: 1808-1812 Champlain, NY
Type of Work: Fabric (Rugs)
Museums: 151
Remarks: Sister is Ann
Sources: *AmNe 97, 95**
See: Hicks, Harriet.

Moore, W.T.
See: Moor, W.T.

Moore, William, Jr.
Flourished: 19th century Barkhamsted, CT
Type of Work: Wood (Chairs)
Sources: *AmPaF 188.*

Moore and Kinzie
Flourished: c1840-1850 Quakertown, PA
Type of Work: Redware (Pottery)
Sources: *AmPoP 177.*

Moore and Walters
Flourished: c1831 Springfield, IL
Type of Work: Wood (Furniture)
Sources: *ArC 110*.*

Moorehead and Wilson
[Morehead Clay Works]
Flourished: c1866-1900 Spring Mills, PA
Type of Work: Redware (Flower pots, pottery)
Sources: *AmPoP 180.*

Moorhead, Scipio
Flourished: 1773? Boston, MA
Ethnicity: Black American
Type of Work: Oil? (Paintings)
Sources: *AfAmA 95, 97; AmNeg 22.*

Mootz
Flourished: c1825-1840 Putnam, OH
Type of Work: Stoneware (Pottery)
Sources: *AmPoP 228; Decor 222.*

Moran, Amanda Estill
b. 1810
Flourished: c1860 Garrard County, KY
Type of Work: Fabric (Quilts)
Sources: *KenQu fig14.*

Moran, Frank
b. 1877 d. 1967
Flourished: 1930-1940s Vermont
Type of Work: Wood (Sculptures, carvings)
Museums: 203
Sources: *AmFoS 120*; BirB 132*; TwCA 58*.*

Moravian Pottery
Flourished: 1765 Bethabara, NC
Type of Work: Clay (Pottery)
Remarks: Brother Gottfried Aust was chief potter
Sources: *EaAmFo 46-7, 206*.*

Moravian Pottery and Tile Work
Flourished: c1890 Doylestown, PA
Type of Work: Clay (Pottery)
Sources: *DicM 239*.*

More, Samuel
Flourished: 1736 Boston, MA
Type of Work: Wood (Ship carvings, ship figures)
Remarks: Father is Thomas
Sources: *AmFiTCa 46, 197; ShipNA 158.*

More, Thomas
Flourished: 1720 Kittery, ME
Type of Work: Wood (Ship carvings, ship figures)
Remarks: Son is Samuel
Sources: *AmFiTCa 46, 197; ShipNA 6, 157.*

Morehead Clay Works
See: Moorehead and Wilson.

Morehouse, P.M.
Flourished: 1837
Type of Work: Fabric (Coverlets)
Sources: *AmSQu 253*; ChAmC 89.*

Morey, Charlotte
Flourished: 1981 Potsdam, NY
Type of Work: Wood, grass (Baskets)
Sources: *FouNY 34*, 64.*

Morgan
See: Broome and Morgan.

Morgan, Charles W.
b. Ledyard, CT
Type of Work: Whalebone (Scrimshaw)
Museums: 186
Sources: *GravF 117*, 136-7*; Scrim 48*.*

Morgan, D.
Flourished: c1880 New York, NY
Type of Work: Clay (Pottery)
Sources: *AmPoP 197; DicM 37*.*

Morgan, David
Flourished: 1794-1804 New York, NY
Type of Work: Stoneware (Pottery)
Sources: *Decor 160*, 222.*

Morgan, Sister Gertrude
b. 1900 Lafayette, AL d. 1980
Flourished: 1960- New Orleans, LA
Ethnicity: Black American
Type of Work: Watercolor, acrylic, ink (Religious paintings)
Sources: *AmFokArt 203-5*; ArtWo 134*, 166*; ConAmF 25-30*; FoA 83*, 466; FoPaAm 13, 171, 174-5, fig54; Full *; HoKnAm 190; TwCA 188*.*

Morgan, James
[Morgan Pottery]
Flourished: 1775-1784 Cheesequake, NJ
Type of Work: Stoneware (Pottery)
Museums: 097
Sources: *AmS 164; Decor 50*, 194*, 222.*

Morgan, James, Jr.
[James Morgan and Co.]
Flourished: 1784-1805 Cheesequake, NJ; Old Bridge, NJ
Type of Work: Stoneware (Pottery)
Remarks: Partner with Van Winkle, Jacob and Nicholas, in Old Bridge, New Jersey Pottery
Sources: *Decor 76*, 86*, 169*, 194*, 222.*

Morgan, Mary
Flourished: c1821
Type of Work: Oil (Painted boxes)
Sources: *NeaT 124*.*

Morgan, Matt
See: Matt Morgan Art Pottery Company.

Morgan, Thomas
Flourished: c1800-1837 Baltimore, MD
Type of Work: Redware (Pottery)
Sources: *AmPoP 163; Decor 69*.*

Morgan, William H.
Flourished: 1833 Philadelphia, PA
Type of Work: Wood (Ship carvings, ship figures)
Sources: *AmFiTCa 197.*

Morgan, William S.
Flourished: 1871
Type of Work: Fabric (Coverlets)
Sources: *ChAmC 124.*

Morgan Pottery
See: Morgan, James.

Morley, William
Flourished: 1861 New York
Type of Work: Watercolor (Paintings)
Museums: 176
Sources: *ColAWC 240.*

Morley and Company
Flourished: 1879-1885 Wellsville, OH
Type of Work: White Granite (Pottery)
Sources: *AmPoP 232.*

Morley, Goodwin and Flentke
Flourished: 1857-1878 East Liverpool, OH
Type of Work: White Granite (Pottery)
Sources: *AmPoP 215.*

Moron, J.
Flourished: 1830 Massachusetts
Type of Work: Oil (Portraits)
Sources: *AmPrP 154; PrimPa 177; SoAmP 287.*

Morrell
See: Stratton and Morrell.

Morrell, Willett H.
Flourished: 1845 New York, NY
Type of Work: Wood (Ship carvings, ship figures)
Sources: *AmFiTCa 197; ShipNA 162.*

Morrell and Morriss
Flourished: 1834 New York, NY
Type of Work: Wood (Ship carvings, ship figures)
Sources: *AmFiTCa 197; ShipNA 162.*

Morrey
[Mowry]
Flourished: Ohio
Type of Work: Fabric (Weavings)
Sources: *ChAmC 89.*

Morrill, D.
Flourished: 1862 Connecticut
Type of Work: Oil (Genre paintings)
Museums: 297
Sources: *AmFoPaN 103, 135*; PicFoA 121*; PrimPa 177.*

Morrill, M.L.
Flourished: mid 19th cent Maine
Type of Work: Watercolor (Still life paintings)
Sources: *NinCFo 195.*

Morris, Debbe
Flourished: 1730-1770 Philadelphia, PA
Type of Work: Fabric (Embroidered Bible covers)
Museums: 110
Sources: *PlaFan 147*.*

Morris, George A.
[Bonin and Morris; Bonnin and Morris]
Flourished: c1769-1771 Philadelphia, PA
Type of Work: White earthenware (Pottery)
Sources: *AmPoP 45, 99, 174, 255; DicM 100**
See: Bonin, Gousse.

Morris, J.H.
Flourished: 1860 Bridgeport, CT
Type of Work: Wood (Ship carvings, ship figures)
Sources: *AmFiTCa 197.*

Morris, J.W.
Flourished: 1960 Saratoga, NY
Type of Work: Wood (Circus and carousel figures)
Sources: *WoScuNY.*

Morris, John
Flourished: 1791 Philadelphia, PA
Type of Work: Wood (Ship carvings, ship figures)
Sources: *AmFiTCa 197.*

Morris, Jones Fawson
b. Leominister, MA
Flourished: 1840 Sterling, MA
Type of Work: Oil (Portraits)
Sources: *AmPrP 154; PrimPa 177; SoAmP 78.*

Morris, Mattie Tooke
Flourished: c1890-1900 Trigg County, KY
Type of Work: Fabric (Quilts)
Remarks: Mother is Vanzant, Ellen Smith Tooke
Sources: *KenQu 40, fig6-7, 30-1, 42-3.*

Morris and Wilmore
Flourished: 1876-1900 Trenton, NJ
Type of Work: Clay (Pottery)
Sources: *AmPoP 183.*

Morrison, Catharine
Flourished: 1833
Type of Work: Fabric (Samplers)
Museums: 227
Sources: *MoBeA.*

Morrison, Ebenezer
Flourished: c1750-1813 Newburyport, MA
Type of Work: Redware (Pottery)
Sources: *AmPoP 196.*

Morrison, James
Flourished: c1793 Maryland
Type of Work: Oil (Ornamental paintings)
Sources: *AmDecor 113.*

Morrison, John C.
Flourished: 1851 Philadelphia, PA
Type of Work: Wood (Ship carvings, ship figures)
Sources: *AmFiTCa 197.*

Morrison and Carr
Flourished: c1870 New York, NY
Type of Work: Clay (Pottery)
Sources: *DicM 185*.*

Morriss
See: Morrell and Morriss.

Morse
See: Hays and Morse.

Morse, Alvin
[Moss]
Flourished: 1802 Bristol, CT
Type of Work: Tin (Tinware)
Remarks: Apprenticed to Hooker, Ira
Sources: *TinC 175.*

Morse, Asahel
Flourished: 1814- Bristol, CT
Type of Work: Tin (Tinware)
Sources: *TinC 175.*

Morse, Chauncey
Flourished: 1820 Bristol, CT
Type of Work: Tin (Tinware, footstoves etc.)
Sources: *TinC 175.*

Morse, E.
Flourished: 1814 Livermore, ME
Type of Work: Wood (Chests of drawers)
Museums: 096
Sources: *AmPaF 216-7*.*

Morse, J.G.
Flourished: 1850 Massachusetts
Type of Work: Pen, ink (Penmanship, calligraphy drawings)
Sources: *AmFoAr 34.*

Morse, Samuel Finley Breese
b. 1791 d. 1872
Flourished: 1811 Charlestown, MA; New York, NY
Type of Work: Watercolor (Drawings, group portraits)
Museums: 171, 263
Remarks: New England artist; invented the telegraph; taught Field, Erastus S.
Sources: *ArtWod 194; EraSaF 9-11, 18, 20, 29, 42; FloCo 49*; FoArA 60*; FoPaAm 13, 15*, 48-9; GraMo 34*-5.*

Morten, J.A.
Flourished: c1835 Fulton, OH
Type of Work: Stone (Gravestones)
Sources: *EaAmG 129.*

Morton, Charles
Flourished: c1834-1838 New Bedford, MA
Type of Work: Pen, watercolor (Scene drawings, portraits, mythical paintings)
Museums: 123
Sources: *WhaPa fig75*, 99*, 133*, 139*.*

Morton, Daniel O.
Flourished: 1849 Boston, MA
Type of Work: Wood (Ship carvings, ship figures)
Sources: *AmFiTCa 197.*

Morton, Emeline
Type of Work: Watercolor (Scene paintings)
Sources: *AmPrP 154; PrimPa 177.*

Morton, Emily
Flourished: 1826 Thorndyke, ME
Type of Work: Fabric (Stenciled bedcovers)
Museums: 001
Sources: *NewDis 96*.*

Morton, Joseph
Flourished: 1875 East Liverpool, OH
Type of Work: Clay (Pipes)
Sources: *AmPoP 219.*

Morton, Mary
Flourished: 1783 Pennsylvania
Type of Work: Fabric (Samplers)
Sources: *GalAmS 28*.*

Morton, Mary Ann
b. c1808
Flourished: 1820 Portland, ME
Type of Work: Fabric (Samplers)
Sources: *GalAmS 3*, 57*-8.*

Morton and Sheldon
Flourished: c1860 Jordan, NY
Type of Work: Stoneware (Pottery)
Sources: *Decor 222.*

Mory
See: Saterlee and Mory.

Moseley, Alice Latimer
b. 1910 Birmingham, AL
Flourished: 1970- Memphis, TN; Mississippi
Type of Work: Acrylic (Paintings)
Sources: *FoAF 18-9*; FoAFx 13*-4**.

Mosely, Susanna Richards
Flourished: 1850 Kentucky
Type of Work: Fabric (Quilts)
Museums: 282
Sources: *QuiAm 88**.

Moseman, Elizabeth E.
Flourished: c1849 Port Chester, NY
Type of Work: Fabric (Quilts)
Sources: *NewDis 34**.

Moser, Jacob
Flourished: 1836-1839 Pine Grove, PA
Type of Work: Fabric (Weavings)
Sources: *ChAmC 89; HerSa*.

Moser, Lucinda Vail
Flourished: 1825
Type of Work: Fabric (Wedding veils)
Museums: 151
Sources: *AmNe 70-1**.

Moses, Anna Mary Robertson
[Grandma Moses]
b. 1860 Greenwich, NY d. 1961 Hoosick Falls, NY
Flourished: 1935-1961 Eagle Bridge, NY
Type of Work: Oil (Landscape and memory paintings)
Museums: 096,151,229,260
Sources: *AmFokA 101*; AmFokArt 206-7*; ArtWo 132*, 147*, 166-7*; BeyN 96; FoA xiii*, 466; FoAFg 5*; FoPaAm 13, 105, 110*, 171; FouNY 67; GraMo *; HoKnAm 181; PeiNa 276*; PicFoA 159*-161, 164-6; PrimPa 177; ThTaT 128-37*; TwCA 104**.

Moses, John
See: John Moses and Sons.

Moses, Kivetoruk (James)
b. 1908
Flourished: 1965 Shismaref, AK
Ethnicity: Eskimo
Type of Work: Pencil, india ink (Folktale drawings)
Museums: 069,171
Sources: *FoA xiii*, 466; FoAFg 5*; TwCA 160**.

Moses, Thomas P.
Flourished: 1850 Portsmouth, NH
Type of Work: Oil (Ship paintings)
Sources: *AmPrP 154; PrimPa 177*.

Mosher, Anna
Flourished: Nicholville, NY
Type of Work: Mixed media (Farm scene models)
Sources: *FouNY 66*.

Moskowitz, Isidore
b. 1896
Flourished: 1966 Miami, FL
Ethnicity: Hungarian
Type of Work: Ink, watercolor (Paintings)
Sources: *FoAFx 1*, 12**.

Moss, Alvin
See: Morse, Alvin.

Moss, Emma Lee
b. 1916 Bethlehem, TN
Flourished: 1950s,1978- Austin, TX
Ethnicity: Black American
Type of Work: Oil (Paintings)
Sources: *FoAFn 13*-4**.

Moss, Frederick
Flourished: 1860 New York, NY
Type of Work: Wood (Ship carvings, ship figures)
Sources: *AmFiTCa 197*.

Moss, Margaret
b. c1814
Flourished: c1825 Philadelphia, PA
Type of Work: Fabric (Embroidered mourning pictures, samplers)
Sources: *AmNe 52, 60**.

Moss and Brother
Flourished: c1860 Philadelphia, PA
Type of Work: (Masonic regalia)
Sources: *Bes 38**.

Mosser, John
b. c1811
Flourished: c1850 Mifflin Township, OH
Ethnicity: German
Type of Work: Fabric (Coverlets)
Sources: *ChAmC 89*.

Mosser, Veronica
Flourished: c1810
Type of Work: Watercolor, ink (Frakturs)
Sources: *Edith **.

Mossy Creek Iron Works
Flourished: 19th cent Augusta County, VA
Type of Work: Iron (Sculptures)
Sources: *SoFoA 113*, 220*.

Mosteller, Johannes
Flourished: 1820 Pennsylvania
Type of Work: Watercolor, ink (Frakturs)
Sources: *AmFoPa 188*.

Mote, Marcus
Flourished: 1844
Type of Work: Oil (Landscape paintings)
Museums: 075
Sources: *FoPaAm 206**.

Mott, Dewitt C.
Flourished: 1845 New York, NY
Type of Work: Wood (Ship carvings, ship figures)
Sources: *AmFiTCa 198*
See: Mott and Passman.

Mott and Doran
Flourished: 1834 New York, NY
Type of Work: Wood (Ship carvings, ship figures)
Sources: *AmFiTCa 198*.

Mott and Pasman
[Dewitt C. Mott and Frances Pasman]
Flourished: 1845 New York, NY
Type of Work: Wood (Ship carvings, ship figures)
Sources: *AmFiTCa 198*.

Moulthrop, Major
b. 1805
Flourished: c1830 New Haven, CT
Type of Work: Oil? (Nature paintings)
Sources: *NeaT 120-2**.

Moulthrop, Reuben
b. 1763 East Haven, CT d. 1814 East Haven, CT
Flourished: 1788-1812 Connecticut; New York, NY; Massachusetts
Type of Work: Oil (Portraits)
Museums: 054,313
Sources: *AmNa 11, 13, 22; AmPrP 154; FoArtC 114; FoPaAm 30-1*, 33, 92, 125; OneAmPr 50*-1*, 82, 141, 155; PaiNE 17, 152-7*; PrimPa 177*.

Moulton, John
b. 1669 Hampton, NH d. 1740
Flourished: Hampton, NH
Type of Work: Wood (Boxes)
Sources: *NeaT 19*.

Moulton Brothers
Flourished: 1871 Boston, MA
Type of Work: Wood (Ship carvings, ship figures)
Sources: *AmFiTCa 198*.

Mount Pleasant Mills
Flourished: c1836 Mount Pleasant, PA
Type of Work: Fabric (Weavings)
Sources: *ChAmC 89*
See: Schnee, Joseph; Schnee, William; Angstad, Benjamin.

Mountford
See: Burroughs and Mountford.

Mountfort
See: Burroughs and Mountford.

Mounts, Aaron
See: Mountz, Aaron.

Mountz, Aaron
[Mounts]
b. 1873 Carlisle, PA d. 1949 Cumberland County, PA
Flourished: 1873-1918 Carlisle, PA
Type of Work: Wood (Animal carvings)
Museums: 001,176,189
Sources: *AmFoS 5, 209-11*; AmFoSc fig19; ColAWC 324; FoA 206*, 466; FoArA 138-9*; FoArRp 115*; FoArtC 103; InAmD 136-7*; MaAmFA *; PenDuA 41*; WiScAM*
See: Schimmel, Wilhelm.

Mowry
See: Morrey.

Moyall, James
Flourished: New Carlisle, OH
Type of Work: Fabric (Coverlets)
Sources: *ChAmC 89.*

Moyer, Martin
Flourished: 1835 Pennsylvania
Type of Work: Watercolor, ink (Frakturs)
Sources: *AmFoPa 188.*

Moyers Woolen Mill
Flourished: 1802 Schartelsville, PA
Type of Work: Fabric (Weavings)
Sources: *ChAmC 89.*

Muehlenhoff, Heinrich
Flourished: 1850 Duboistown, PA
Ethnicity: German
Type of Work: Fabric (Coverlets)
Sources: *ChAmC 89.*

Mueller, Rudolph
b. 1859 d. 1929
Flourished: Castroville, TX
Type of Work: Oil (Landscape paintings)
Sources: *SoFoA 60*-1*, 63, 218.*

Muench, Karl C.
Flourished: 1795-1825 Pennsylvania
Type of Work: Watercolor, ink (Frakturs)
Sources: *AmFoPa 189; HerSa.*

Muensenmayer, Jacob
Flourished: early 20th cent Franklin County, MO
Type of Work: Tin (Tinware)
Sources: *ASeMo 424*.*

Muhlbacher, Joe
b. 1876 d. 1955
Flourished: 1940 Cheyenne, OK
Type of Work: Cement (Sculptures)
Sources: *FoArO 92, 68*, 102.*

Muir, John
b. 1815 d. 1892 Jackson Township, IN
Flourished: 1843-1858 Greencastle, IN; Fillmore, IN
Ethnicity: Scottish
Type of Work: Fabric (Carpets, coverlets)
Remarks: Brothers are William, Thomas, and Robert
Sources: *AmSQu 277; ChAmC 89.*

Muir, Robert
b. c1808
Flourished: 1840-1858 Germantown, IN; Liberty Township, IN; Missouri
Ethnicity: Scottish
Type of Work: Fabric (Weavings)
Remarks: Brothers are Thomas, William, and John
Sources: *AmSQu 277.*

Muir, Thomas
b. c1810 d. Indianapolis, IN
Flourished: 1840-1858 Germantown, IN; Indianapolis, IN
Ethnicity: Scottish
Type of Work: Fabric (Weavings)
Remarks: Brothers are Robert, William, and John
Sources: *AmSQu 277; ChAmC 91.*

Muir, William
b. 1818 d. 1888
Flourished: 1840-1858 Germantown, IN; West Indianapolis, IN
Ethnicity: Scottish
Type of Work: Fabric (Weavings)
Remarks: Brothers are Robert, Thomas, and John
Sources: *AmSQu 277; ChAmC 91*
See: Shaw, Robert; Wilson, Jonathan.

Muje, H.D.
Flourished: c1770
Type of Work: Watercolor, ink (Frakturs)
Sources: *Edith *.*

Muk, George
Flourished: c1848 Bladensburg, MD
Type of Work: Redware (Pottery)
Sources: *AmPoP 165.*

Muler, Christian
Flourished: c1825 Chestnut Hill, PA
Type of Work: Watercolor (House portraits)
Sources: *MaAmFA *.*

Mulholland, William S.
b. 1870 Witherbee, NY d. 1936
Flourished: Vermont
Type of Work: Oil (Genre paintings)
Sources: *PrimPa 177; ThTaT 227-31*.*

Mulican, Joseph
b. 1704 d. 1768
Flourished: Bradford, MA
Type of Work: Stone (Gravestones)
Sources: *EaAmG 128.*

Mulican, Robert
b. 1668 d. 1741
Flourished: 1720's Bradford, MA
Type of Work: Stone (Gravestones)
Sources: *EaAmG 16-17*, 20-1*.128.*

Mulican, Robert, Jr.
b. 1688 d. 1756
Flourished: Bradford, MA
Type of Work: Stone (Gravestones)
Sources: *EaAmG 128; GravNE 15, 129.*

Mullard, Robert
Flourished: 1709-1722 Philadelphia, PA
Type of Work: Wood (Ship carvings, ship figures)
Sources: *ShipNA 5-6, 162.*

Mullen, James
Flourished: 1852-1858 Baltimore, MD
Type of Work: Wood (Ship carvings, ship figures)
Sources: *ArtWod 125; ShipNA 72, 158.*

Mullen, Richard
See: Alaska Silver and Ivory Company.

Muller, Alfred H.
[Muller Brothers]
Flourished: 1903-1912 Sandusky, OH; Philadelphia, PA
Type of Work: Wood (Carousel figures)
Sources: *AmSFor 18-19*, 22*; CaAn 9, 56-61*, 114-5*.*

Muller, Daniel Carl
[Muller Brothers]
Flourished: 1903-1917 Germantown, PA; Philadelphia, PA
Type of Work: Wood (Carousel horses)
Sources: *AmFoS 230*; AmSFor 18-9*, 22; CaAn 9, 56-61*, 114-5**
See: Tobaggan Company.

Muller Brothers
See: Muller, Alfred H.; Daniel Carl.

Mulligan, Michael
Flourished: 1871 Boston, MA
Type of Work: Wood (Ship carvings, ship figures)
Sources: *AmFiTCa 198.*

Mulliken, Edward H. "Ted"
Flourished: c1950 Old Saybrook, CT
Type of Work: Wood (Duck decoys)
Museums: 260
Sources: *Decoy 22*, 36, 71*.*

Mulliken, Ted
See: Mulliken, Edward H.

Mullins, W.H.
See: W.H. Mullins and Company.

Mullins, Walter S., General
b. 1899 d. 1979
Flourished: Mahopac Falls, NY
Type of Work: Various materials (Paintings, environmental sculptures)
Remarks: Said to be a General in the Coast Guard
Sources: *FoAFab 14*, 17*.*

Mullowney, Captain
Flourished: c1810-1817 Philadelphia, PA
Type of Work: Redware (Pottery)
Sources: *AmPoP 175.*

Mumbauer, Conrad
Flourished: 1760-1830 Haycock Township, PA
Type of Work: Redware (Pottery)
Sources: AmPoP 41, 44, 169
See: Singer, Simon.

Mumford, William
b. 1641 d. 1718
Flourished: 1666-1700 Boston, MA
Type of Work: Stone (Gravestones)
Sources: EaAmG 128; GravNE 21, 28-34, 129
See: Grice, Elias.

Munch, Carl E.
Flourished: 1808 Pennsylvania
Type of Work: Watercolor, ink (Frakturs)
Sources: AmPrW 35*.

Mundweiler, Samuel
See: Mundwiler, Samuel.

Mundwiler, Samuel
[Mundweiler]
Flourished: 1848-1851 Hopewell Township, OH
Type of Work: Fabric (Coverlets)
Museums: 016
Sources: AmSQu 277; ArtWea 241*; ChAmC 91.

Munger, George
Flourished: 1810 Massachusetts
Type of Work: Oil (Portraits)
Sources: AmPrP 154; PrimPa 177.

Munn
Flourished: 1815-1850 New Haven, CT
Type of Work: Oil (Portraits, scene paintings)
Sources: PrimPa 177.

Munro, Janet
b. 1949 Woburn, MA
Flourished: Anna Maria Island, FL
Type of Work: Oil (Interior and landscape paintings)
Museums: 263
Sources: AmFokArt 208-13*.

Munro, Rebekah S.
b. 1780 Providence, RI d. 1803 Providence, RI
Flourished: 1792 Providence, RI
Type of Work: Fabric (Samplers)
Sources: LeViB 146*.

Munro, Sally
b. 1786 d. 1851
Flourished: 1796 Providence, RI
Type of Work: Fabric (Samplers)
Museums: 093, 205
Sources: ArtWo 17*; LeViB 141*-2, 145.

Murphy, Charles
Flourished: Concord, MA
Type of Work: Wood (Duck decoys)
Sources: WoCar 169*.

Murphy, George
See: George Murphy Pottery Company.

Murphy, Richard
Flourished: 1827 Dorchester, NJ
Type of Work: Fabric (Coverlets, diapers)
Sources: ChAmC 91.

Murphy, W.
Flourished: Nauvoo, IL
Type of Work: Pen, ink (Sketches)
Sources: ArC 203*.

Murr, Lewis
b. c1812 Pennsylvania
Flourished: 1831 New Holland, PA
Type of Work: Fabric (Carpets, coverlets)
Sources: ChAmC 91.

Murray, Elenor
Flourished: 1820 Red Bank, NJ
Type of Work: Watercolor (Romantic scene paintings)
Sources: AmPrP 154; PrimPa 177.

Murray, Eliza
Flourished: 1810 New England,
Type of Work: Watercolor (Memorial paintings)
Sources: PrimPa 177.

Murray, William
Flourished: 1806-1819 Schenectady, NY
Type of Work: Watercolor, ink (Frakturs)
Sources: AmFokDe xi*; AmFoPa 189; FouNY 65*.

Musselman, Samuel B.
b. 1799 d. 1871
Flourished: 1837-1859 Hilltown, PA; Milford, PA; Bucks County, PA
Type of Work: Fabric (Coverlets)
Sources: AmSQu 251*, 276; ChAmC 48*, 91.

Muth, Marcia
b. 1919 Indiana
Flourished: 1975 Santa Fe, NM
Type of Work: Acrylic (Paintings)
Sources: FoAFu 9*; FoAFw 23*-4*.

Myer, I.
Flourished: 1836-1838 Millersville, PA
Type of Work: Fabric (Coverlets)
Sources: ChAmC 91.

Myer, P.
Flourished: 1838-1841
Type of Work: Fabric (Weavings)
Sources: AmSQu 277; ChAmC 92.

Myers, Charles D.
b. Ohio
Flourished: Wayne County, IN; Hamilton County, IN
Type of Work: Fabric (Coverlets)
Sources: ChAmC 92.

Myers, Daniel L.
Flourished: 1836-1852 Bethel Township, OH; East Hempfield Township, PA
Type of Work: Fabric (Carpets, coverlets)
Sources: AmSQu 277; ChAmC 92.

Myers, E.W.
Flourished: c1870 Mogadore, OH
Type of Work: Stoneware (Pottery)
Sources: AmPoP 224; Decor 222.

Myers, Elizabeth
b. 1828 d. 1917
Flourished: Streetsboro, OH
Type of Work: Fabric (Weavings)
Sources: ChAmC 92.

Myers, James
Flourished: Clark County, OH
Type of Work: Fabric (Coverlets)
Sources: ChAmC 92.

Myers, Mary
Flourished: 1732 Connecticut
Type of Work: Fabric (Embroidered wedding dresses)
Museums: 297
Sources: AmNe 65-6*.

Myers, Mary Rosalie Prestmen
Flourished: early 19th cent Baltimore, MD
Type of Work: Fabric (Quilts)
Museums: 032
Sources: QuiAm 77*.

Myers and Hall
Flourished: c1872-1875 Mogadore, OH
Type of Work: Stoneware (Pottery)
Sources: AmPoP 224; Decor 222; DicM 94*.

Myers, Baird, and Hall
Flourished: c1874-1880 Mogadore, OH
Type of Work: Stoneware (Pottery)
Sources: AmPoP 224; Decor 222.

Mygatt, Hiram
b. 1795 d. 1831 Berlin, CT
Flourished: c1823-1831 Berlin, CT
Type of Work: Tin (Japanned tinware)
Sources: AmCoTW 58, 82; AmDecor 113; AmFokDe 65; TinC 175
See: Guernsey, James.

Myric, Nancy
b. 1789-
Type of Work: Fabric (Samplers)
Sources: FoArtC 52.

Myrick, Fredrick
Flourished: 1820s-1828 Nantucket, MA
Type of Work: Whalebone (Scrimshaw)
Museums: 187
Remarks: Carved the "Susan" teeth
Sources: AmSFo 32*, 34-5; FoA 126*; GravF 20, 31, 131-4; Scrim 18*-9; ScriSW 83*.

N

N.A. White and Sons
Flourished: 1865-1875 Utica, NY
Type of Work: Stoneware (Jars)
Remarks: Father and grandfather are White, Noah
Sources: *AmPoP 204; AmS 84*, 154*; Decor 59*-60*, 86*, 93*, 120*; EaAmFo 178**.

N. Clark and Company
Flourished: Rochester, NY
Type of Work: Stoneware (Pitchers)
Museums: 243
Sources: *AmS 255**.

N.R. Stephens Chair Factory
Flourished: 1832 Cooperstown, NY
Type of Work: Wood (Chairs)
Sources: *AmPaF 195**.

Naber, George
Flourished: 1722 Kittery Point, ME
Type of Work: Wood (Ship carvings, ship figures)
Sources: *AmFiTCa 198; ShipNA 157*.

Naegelin, Charles
Flourished: 1839 Gasconade County, MO
Ethnicity: German
Type of Work: Stone (Gravestones, other stoneworks)
Sources: *ASeMo 431*.

Nagel, Philip
Flourished: 1834-1837 Dover Township, PA
Type of Work: Fabric (Weavings)
Sources: *ChAmC 89*.

Nagle, James F.
See: Naugle, James.

Naguy, Mary Jane
Flourished: 1855
Type of Work: Fabric (Quilts)
Sources: *AmSQu 204**.

Nantion, J.
Flourished: 1810 New York, NY
Type of Work: Wood (Ship carvings, ship figures)
Sources: *AmFiTCa 198*.

Nase, John
Flourished: c1830-1850 Tylersport, PA; Montgomery County, PA
Type of Work: Clay (Pottery)
Museums: 227
Remarks: Father is Neesz, Johannes
Sources: *AmFoSc 96; AmPoP 43, 184; FoArRP 26*; PenDA 61*, 63**.

Nash, E.
Flourished: c1820 Utica, NY
Type of Work: Clay (Pottery)
Sources: *AmPoP 59, 203; DicM 39**
See: Nash, G.; Nash, H.

Nash, F.M.
Flourished: 1850 Scott County, IL
Type of Work: Stoneware (Pottery)
Sources: *ArC 193*.

Nash, G.
Flourished: 1819-1829 Utica, NY
Type of Work: Stoneware (Pottery)
Sources: *AmPoP 59, 203; Decor 222; DicM 39**
See: Nash, E.; Nash, H.

Nash, H.
Flourished: 1819-1829 Utica, NY
Type of Work: Stoneware (Pottery)
Remarks: May be Nash, E.
Sources: *Decor 222*
See: Nash, G..

Nash, H. Mary
b. 1951 Washington, DC
Flourished: 1971-
Type of Work: Acrylic (Paintings)
Remarks: Paints in folk art style
Sources: *FoAFcd 15**.

Nash, Joseph
b. 1664 **d.** 1740
Flourished: Hadley, MA
Type of Work: Stone (Gravestones)
Sources: *EaAmG 128; GravNE 129*.

Nash, Matilda
Flourished: 1838 Switzerland County, IN
Type of Work: Fabric (Weavings)
Sources: *AmSQu 277; ChAmC 92*.

Nathan Clark Pottery
Flourished: 1805-1900 Athens, NY
Type of Work: Stoneware (Pottery)
Museums: 203
Sources: *AmPoP 59, 187, 195, 278; AmS 76*; Decor 67*, 84*, 128*, 136*, 165*, 181*, 186*, 189*, 209*, 217; DicM 96**
See: Clark and Fox.

Nathaniel, Inez
[Walker, Inez Nathaniel]
b. 1911 Sumter, SC
Flourished: 1971- Port Byron, NY; Geneva, NY
Ethnicity: Black American
Type of Work: Pencil, crayon (Drawings)
Remarks: Started painting in the Bedford Hills (NY) correctional facility
Sources: *AmFokArt 316-7*; ArtWo 136*, 166-7*; BlFoAr 104-9*; ConAmF 58-60*; FoA 31*, 470; FoAFt 6*-7; Full **.

National Fireproofing Company
Flourished: Pittsburgh, PA
Type of Work: Clay (Sewer tile sculpture)
Sources: *IlHaOS **.

National Iron Wire Company
Flourished: 1884 Detroit, MI
Type of Work: Metal (Weathervanes)
Sources: *YankWe 212*.

National Sewer Pipe Company
Flourished: Barberton, OH
Type of Work: Clay (Sewer tile sculpture)
Sources: *IlHaOS **.

Naughn, Martha Agry
Flourished: 1780's Hallowell, ME
Type of Work: Fabric (Quilts)
Sources: *PlaFan 210**.

Naugle, James
[Nagle, James F.]
d. 1924
Flourished: 1868-1923 New Berlin, PA
Type of Work: Tin (Tinware)
Sources: *ToCPS 20-1, 43*.

Navarre Stoneware Company
Flourished: c1880-1900 Navarre, OH
Type of Work: Stoneware (Pottery)
Sources: *AmPoP* 224; *Decor* 222.

Neal, Mr.
Flourished: 1840
Type of Work: Fabric (Table mats, pillow covers)
Sources: *AmSFok* 129*.

Neal, Joseph B.
Flourished: 1854 New London, CT
Type of Work: Wood (Ship carvings, ship figures)
Sources: *AmFiTCa* 198; *ShipNA* 155.

Ned
Flourished: 1840s Covington, GA
Ethnicity: Black American
Type of Work: Wood (Cabinets)
Sources: *AfAmA* 82.

Needhams, Mercy
Flourished: c1815
Type of Work: Wood (Spice boxes)
Sources: *NeaT* 158-9*.

Neely, Henry
Flourished: c1858 Lafayette, IN
Type of Work: Fabric (Weavings)
Sources: *ChAmC* 92
See: Miller, Theodore.

Neely, N.
Flourished: c1840 Chillicothe, OH
Type of Work: Stone (Gravestones)
Sources: *EaAmG* 129.

Neesz, Johannes
[Nessz]
b. 1775 d. 1867
Flourished: 1800- Tylersport, PA
Type of Work: Clay (Pottery)
Museums: 189,263
Remarks: Son is Nase, John
Sources: *AmPoP* 43, 184; *AmSFok* 130*; *FlowAm* 262*; *FoArRP* 27*; *InAmD* 4*; *PenDuA* 27.

Neff, Christian
Flourished: c1790-1810 Cumberland, MD
Type of Work: Redware (Pottery)
Sources: *AmPoP* 51, 166.

Neff, Elizabeth
Flourished: 1801 Pennsylvania
Type of Work: Watercolor, ink (Frakturs)
Sources: *AmFoPa* 189.

Neffensperger, J.D.
Flourished: 1840 Pennsylvania
Type of Work: Watercolor, ink (Scene drawings)
Sources: *AmPrP* 154; *PrimPa* 177.

Negus, Nathan
Flourished: 1817 Boston, MA
Type of Work: Paint (Masonic aprons, portraits)
Museums: 183
Sources: *Bes* 11, 40-1, 53*.

Negus, Nathan
Flourished: 1850 Massachusetts; Alabama
Type of Work: Oil (Portraits)
Sources: *AmPrP* 154; *PrimPa* 177.

Neiffer, Jacob
Flourished: c1830-1850 Neiffer, PA
Type of Work: Redware (Pottery)
Sources: *AmPoP* 172.

Neiman, James
Flourished: New Berlin, PA
Type of Work: Earthenware (Pottery)
Sources: *HerSa* *.

Neisser, Jacob
[Neizzer]
Flourished: 1827-1860 Carversville, PA
Type of Work: Redware (Pottery)
Sources: *AmPoP* 165.

Nelson, Mr.
Flourished: early 19th cent Pittsburgh, PA
Type of Work: Oil (Ornamental signs, portraits)
Sources: *AmFokDe* 129; *SoAmP* 251.

Nelson, Cal
Flourished: 1950-1980 Oklahoma
Type of Work: Various materials (Sculptures)
Sources: *FoArO* 93, 96-8*.

Nelson, Edward "Stubb"
b. 1905 d. 1969
Flourished: 1932 Ontonagon, MI
Remarks: "Stubbs Museum Bar" contains contributed items; Nelson not the maker
Sources: *Rain* 99*-100*.

Nelson, James L.
Flourished: until 1918 Crisfield, MD
Type of Work: Wood (Duck decoys)
Sources: *AmBiDe* 147.

Nelsonville Sewer Pipe Company
Type of Work: Clay (Sewer tile sculpture)
Sources: *IlHaOS*.

Nenniger, Louisa
Flourished: 1823 Baltimore, MD
Type of Work: Fabric (Samplers)
Museums: 056
Sources: *SoFoA* 179*, 222.

Nethery, Ned
Flourished: 1927 Guthrie, OK
Type of Work: Wood (Sculptures, carvings)
Sources: *FoArO* 86-7*, 77*, 102.

Netzley, Uriah
Flourished: Naperville, IL
Type of Work: Fabric (Weavings)
Sources: *ChAmC* 92.

Netzly, Jacob
Flourished: 1836-1850 Warwick Township, PA
Type of Work: Fabric (Coverlets)
Sources: *ChAmC* 92.

Neumann
Flourished: c1860 Bishop Hill, IL
Type of Work: Tin (Tinware)
Sources: *ArC* 237*.

Nevel, Frederick
b. 1838 d. 1923
Flourished: mid 19th cent Dundee, OH
Ethnicity: German
Type of Work: Fabric (Carpets, coverlets)
Sources: *ChAmC* 92.

New, James
b. 1692 d. 1781
Flourished: 1786 Wrentham, MA; Auburn, MA
Type of Work: Stone (Gravestones)
Remarks: Son is John; grandson is James
Sources: *EaAmG* 68*, 128; *GravNE* 88, 129.

New, James
b. 1751 Wrentham, MA d. 1835 Bellingham,
Flourished: 1761-1791 Wrentham, MA; Attleboro, MA; Grafton, MA
Type of Work: Stone (Gravestones)
Remarks: Father is John; grandfather is James
Sources: *EaAmG* 128; *GravNE* 87-8, 129.

New, John
b. 1722
Flourished: Wrentham, MA
Type of Work: Stone (Gravestones)
Remarks: Son is James; grandfather is James
Sources: *EaAmG* 128; *GravNE* 88.

New Castle Pottery Company
Flourished: 19th century New Castle, PA
Type of Work: Clay (Pottery)
Sources: *DicM* 171*.

New England Pottery Company
Flourished: 1854-1886 Boston, MA
Type of Work: Yellow-ware, Rockingham (Pottery)
Sources: *AmPoP* 64, 189, 272; *DicM* 162*, 185*, 211*, 231*-2*, 239*, 243*, 251*.

New Jersey Pottery Company
Flourished: c1869-1883 Trenton, NJ
Type of Work: White Granite (Pottery)
Sources: *AmPoP* 183.

New York City Pottery Company
Flourished: c1875 New York, NY
Type of Work: Clay (Pottery)
Sources: *DicM* 154*.

New York Stoneware Company
[Saterlee and Mory]
Flourished: 1861-1891 Fort Edward, NY
Type of Work: Stoneware (Pottery)
Museums: 189,203
Sources: *AmSFo 46-7*; Decor 222, 114*.*

New York Studios
Flourished: New York, NY
Type of Work: Oil (Circus banners)
Sources: *AmSFor 198.*

Newberry, Frances
Flourished: 1850 Gales Ferry, CT
Type of Work: Fabric (Quilts)
Museums: 139
Sources: *AmSQu 294*.*

Newcomb
Flourished: c1880 Bath, ME
Type of Work: Wood (Ship carvings, ship figures)
Sources: *ShipNA 79, 156.*

Newcomb Pottery Company
Flourished: c1895 New Orleans, LA
Type of Work: Clay (Pottery)
Sources: *DicM 25*, 248*.*

Newell, G.N.
Type of Work: Oil (Portraits)
Sources: *AmPrP 154; PrimPa 177; SoAmP 291.*

Newell, G.W.
See: Newell, G.N.

Newell, Hermon
b. 1774 **d.** 1833
Flourished: Longmeadow, MA
Type of Work: Stone (Gravestones)
Sources: *EaAmG 128; GravNE 129.*

Newell, Isaac
d. 1873
Flourished: Connecticut
Type of Work: Tin (Tinware)
Sources: *TinC 175.*

Newman, Benjamin
Flourished: 1810-1825 Gloucester, MA
Type of Work: Wood (Rocking chairs)
Museums: 079
Sources: *AmPaF 246*; AmSFok 102*.*

Newport Sewer Pipe Plant
Flourished: Newport, OH
Type of Work: Clay (Sewer tile sculpture)
Sources: *IlHaOS *.*

Newton, B.J(esus)
Flourished: 1972 California
Type of Work: Oil (Symbolic and mystic paintings)
Sources: *TwCA 215*.*

Newtown Pottery
Flourished: c1870-1900 Newtown, PA
Type of Work: Redware (Pottery)
Sources: *AmPoP 172.*

Ney, William
[Nye]
b. c1811 Pennsylvania **d.** 1892 Jackson Township, PA
Flourished: c1850-1860 Myerstown, PA
Type of Work: Fabric (Weavings)
Sources: *AmSQu 277; ChAmC 92.*

Nice, Bill
Flourished: Sarasota, FL
Type of Work: Oil (Circus banners)
Sources: *AmSFor 198.*

Nicely, M. Eva
Flourished: c1890
Type of Work: Fabric (Quilts)
Sources: *AmBiDe 75*.*

Nicely, Susan
See: Nicely, M. Eva.

Nichlan, Thalia
Flourished: 1931
Type of Work: Fabric (Embroidery on silk)
Sources: *BirB 71*; FoAFm 3; TwCA 84*.*

Nichols, Eleanor
Flourished: 1840 Bridgeport, CT
Type of Work: Watercolor (Landscape paintings)
Sources: *PrimPa 177.*

Nichols, Hannah
Flourished: 1760-1790 Marchfield, MA
Type of Work: Fabric (Samplers)
Sources: *PlaFan 56*.*

Nichols, Margaret
Flourished: 1813 Pennsylvania; Delaware
Type of Work: Fabric (Quilts)
Museums: 097
Sources: *PlaFan 211*; QuiAm 92*.*

Nichols, Maynard
Flourished: 1900 Stockholm, NY
Type of Work: Wood (Box violins)
Museums: 206
Sources: *FouNY 64.*

Nichols, Richard
b. c1785 Maryland **d.** 1860 Illinois
Flourished: c1816-1850 Metamora, IN; Illinois
Type of Work: Fabric (Weavings)
Sources: *ChAmC 92.*

Nichols and Alford
[Nichols and Boynton]
Flourished: 1854-1859 Burlington, VT
Type of Work: Stoneware (Pottery)
Sources: *AmPoP 63, 189-90, 272; Decor 222; DicM 97*.*

Nichols and Boynton
See: Nichols and Alford.

Nicholson, Susan Fauntleroy Quarles
b. c1820
Flourished: Baltimore, MD
Type of Work: Oil (Portraits)
Sources: *AmPrP 155; PrimPa 177; SoFoA x*, 50*, 216, 218.*

Nicholson, Washington A.
Flourished: 1871 Baltimore, MD
Type of Work: Wood (Ship carvings, ship figures)
Sources: *AmFiTCa 198.*

Nicklas, George
b. c1820 or c1827 **d.** 1860 Chambersburg?, PA?
Flourished: 1840-1860 Chambersburg, PA
Ethnicity: German
Type of Work: Fabric (Carpets)
Sources: *AmSQu 277; ChAmC 93*
See: Nicklas, Peter.

Nicklas, Peter
Flourished: 1862 Chambersburg, PA
Type of Work: Fabric (Weavings)
Sources: *ChAmC 93*
See: Nicklas, George.

Nickols, Alira
Flourished: 1876-1896 Dover, IL
Type of Work: Oil (Portraits, landscape paintings)
Sources: *AlAmD 56*; FoPaAm 211*.*

Nickols, John
Flourished: 1810 New York, NY
Type of Work: Wood (Ship carvings, ship figures)
Sources: *AmFiTCa 198.*

Nicomb
Flourished: c1880 Saline County, IL
Type of Work: Stoneware (Pottery)
Sources: *AmPoP 235; Decor 222.*

Niles, Jane
Flourished: 1791 Philadelphia, PA
Type of Work: Fabric (Samplers)
Sources: *AmNe 52.*

Niles, Melinda
Flourished: c1850
Type of Work: Watercolor (Still life paintings)
Sources: *Edith *.*

Nims, Mary Altha
Flourished: 1840 Bennington, VT
Type of Work: Watercolor (Romantic scene paintings)
Sources: *AmPrP 155; PrimPa 177.*

Nissen, Charles
Flourished: 1868
Type of Work: Oil (Ship portraits)
Museums: 001
Sources: *AmFoPaN 144, 152*.*

Nivelet
Flourished: 1820s Massachusetts
Type of Work: Pen, watercolor (Ship portraits)
Sources: AmPrW 77*, 131*.

Nixon, N.H.
Flourished: 1860-1880 Almance County, NC
Type of Work: Stoneware (Jars)
Museums: 236
Sources: AmS 146*.

Noble, Clarke
Flourished: c1900
Type of Work: Wood (Signs)
Museums: 205
Sources: EaAmW 54*.

Noble, George
Flourished: 1840 New York, NY
Type of Work: Wood (Ship carvings, ship figures)
Sources: AmFiTCa 198.

Nodine, Alexander
Flourished: 1850 Hartford, CT
Type of Work: Wood (Ship carvings, ship figures)
Sources: AmFiTCa 198.

Noel, M.P.
Flourished: 1878
Type of Work: Watercolor (Farm scene paintings)
Sources: EyoAm 30.

Noel, Mary Cathrine
Flourished: early 19th cent North Carolina
Type of Work: Velvet (Paintings)
Museums: 249
Sources: FoPaAm 165*.

Noll
Flourished: Selinsgrove, PA
Type of Work: Redware (Baptismal bowls)
Sources: HerSa.

Noll, John
See: Noll, William.

Noll, William
Flourished: 1872
Type of Work: Fabric (Weavings)
Sources: AmSQu 277.

Norberg, Virgil
b. 1930 Galenburg, IL
Flourished: 1978 Davenport, IA
Type of Work: Steel (Weathervanes)
Sources: AmFokArt 214-6*; FoAFm 4-5*; GalAmW 21*.

Norman, Charles
Flourished: New York
Type of Work: Oil (Paintings)
Sources: ThTaT 236*.

Norman, John
Flourished: 1775 Massachusetts
Type of Work: Oil (Portraits)
Sources: AmPrP 155; PrimPa 177.

Norris, William
b. 1861
Flourished: 1938-1939
Type of Work: Wood (Sculptures, carvings)
Museums: 001
Sources: AmFoS 118*; BirB 139*.

North, Abijah
Flourished: Berlin, CT; Bloomfield, CT
Type of Work: Tin (Tinware)
Remarks: Brothers are Seth and Silas
Sources: AmSFo 40-1*; TinC 175.

North, Alfred (Albert)
Flourished: 1800s Cooperstown, NY
Type of Work: Tin (Tinware)
Remarks: Brother is Linus; father is Stephen
Sources: AmCoTW 136, 138-9; AmSFo 42.

North, David
b. Berlin, CT
Flourished: 19th century Ludlow, VT; Palmyra, NY
Type of Work: Tin (Tinware)
Sources: TinC 176.

North, Elijah
Flourished: Berlin, CT; Falmouth, ME; Stevens Plains, ME
Type of Work: Tin (Tinware)
Sources: AmCoTW 93; AmSFo 40-1*; TinC 176.

North, Jedediah
b. 1789 **d.** 1867
Flourished: Southampton, CT
Type of Work: Tin (Tinware)
Remarks: Son is Stephen
Sources: AmCoTW 51, 66-8, 134, 136; AmSFo 40-1*; TinC 49-50*, 81, 176.

North, John
Flourished: Berlin, CT
Type of Work: Tin (Tinware)
Museums: 224
Sources: AmSFo 40-1*; BlkAr 55*; TinC 176.

North, Joseph
Flourished: Connecticut
Type of Work: Tin? (Tinware?)
Remarks: May have worked for Oliver Filley
Sources: AmSFo 40-1*; TinC 176.

North, Justinus Stroll
d. 1900 Brooklyn, NY
Flourished: 1871-1892 New York, NY
Type of Work: Wood (Cigar store Indians, figures)
Sources: ArtWod 246-7.

North, L.
Flourished: 1849 Illinois
Type of Work: (Drawings)
Sources: ArC 265.

North, Lemuel
b. 1786 **d.** 1845
Flourished: Berlin, CT
Type of Work: Tin (Tinware)
Sources: AmSFo 40-1*; TinC 176.

North, Linus
b. 1794 **d.** 1846
Flourished: c1800s Cooperstown, NY
Type of Work: Tin (Tinware)
Remarks: Brother is Alfred; father is Stephen
Sources: AmCoTW 136-8; AmSFo 40-2*; TinC 81, 176.

North, Lucinda
b. Farmington, CT
Flourished: 1803 Connecticut
Type of Work: Tin (Tinware)
Sources: AmCoTW 139; AmSFo 40-1*; TinC 158.

North, Mercy
Flourished: 1820-1840 Cooperstown, NY
Type of Work: Tin (Painted tinware)
Museums: 203
Remarks: Brother is Alfred; father is Stephen
Sources: AmCoTW 27*, 134, 138*-40, 169; AmSFo 40-2*; FoA 466.

North, Noah
b. 1809 **d.** 1880
Flourished: New York; Ohio; Kentucky
Type of Work: Oil (Portraits)
Museums: 001,027,150,260
Sources: AmFoPaCe 129-33*; AmFoPaS 70*; AmFoPo 18*, 143-5*; FoA 466; FoArA 113-9*.

North, Seth
Flourished: Lansingburgh, NY
Type of Work: Tin (Tinware)
Remarks: Brothers are Abijah and Silas
Sources: AmSFo 40-1*; TinC 130, 176.

North, Silas
Flourished: Connecticut
Type of Work: Tin (Tinware)
Remarks: Brother of Seth and Abijah
Sources: AmSFo 40-1*; TinC 176.

North, Simeon
Flourished: Wethersfield, CT
Type of Work: Tin (Tinware)
Remarks: Associated with Filley
Sources: AmSFo 40-1*; TinC 176.

North, Stephen
b. 1767
Flourished: c1790-1800s Fly Creek, NY; Cooperstown, NY; Connecticut
Type of Work: Tin (Tinware)
Remarks: Father to Mercy, Alfred and Linus; father is Jedediah
Sources: AmCoTW 134-8*, 141, 147; AmSFo 40-2*.

Northey, William, Jr.
Flourished: c1788 Salem, MA
Type of Work: Oil (Landscape paintings)
Sources: *AmDecor 40-1**.

Northford's Shop
Flourished: mid 19th cent Connecticut
Type of Work: Tin (Tinware)
Remarks: Large shop employing up to 30 people
Sources: *TinC 176*.

Northrop, Rodolphus E.
Flourished: 1840 New Haven, CT
Type of Work: Wood (Ship carvings, ship figures)
Sources: *AmFiTCa 198*.

Norton, Ann Eliza
Flourished: 1830 Sangerfield, NY
Type of Work: Fabric (Samplers)
Sources: *FouNY 65**.

Norton, E.
See: E. Norton and Company.

Norton, Edward
See: J. and E. Norton.

Norton, Ezra
Flourished: Bristol, CT
Type of Work: Tin (Tinware)
Sources: *TinC 176*.

Norton, J(ohn)
See: J. and E. Norton.

Norton, John, Captain
Flourished: 1793 Bennington, VT; Goshen, CT
Type of Work: Redware (Pottery)
Remarks: Son is Luman; grandson is Julius
Sources: *AmPoP 60, 187, 192; AmSFo 51*.

Norton, Julius
Flourished: 1833-1849 Bennington, VT; South Ashfield, VT
Type of Work: Stoneware, yellow-ware (Pottery)
Remarks: Grandfather is Capt. John; father is Luman; son is Luman P.
Sources: *AmPoP 60-1, 187, 272; AmS 26*, 59*, 76*, 191*; AmSFo 47, 51; Decor 222; DicM 73*, 76**
See: Fenton, Christopher Webber

Norton, Luman
Flourished: c1835 Bennington, VT
Type of Work: Clay (Pottery)
Remarks: Father is Capt. John; son is Julius
Sources: *AmPoP 187, 272; DicM 85**.

Norton, Luman P.
Flourished: c1875 Bennington, VT
Type of Work: Stoneware (Pottery)
Remarks: Father is Julius
Sources: *AmPoP 188, 272; AmSFo 47, 51; Decor 222; DicM 39*, 85**
See: Norton Pottery.

Norton, Samuel
Flourished: Berlin, CT
Type of Work: Tin (Tinware)
Remarks: Owned a tinshop
Sources: *TinC 176*.

Norton, Zachariah
Flourished: Berlin, CT
Type of Work: Tin (Tinware)
Remarks: Sold tinware to Hubbard
Sources: *TinC 176*.

Norton and Fenton
Flourished: c1845 Bennington, VT
Type of Work: Stoneware (Pottery)
Sources: *AmPoP 110, 187, 272; DicM 97**
See: Norton, Julius; Fenton, Christopher

Norton and Hancock
Flourished: 1858-1880 Worcester, MA
Type of Work: Stoneware (Pottery)
Sources: *AmPoP 205; Decor 222*.

Norton Pottery
[E. and L.P. Norton]
Flourished: 1861-1881 Bennington, VT
Type of Work: Clay (Pottery)
Museums: 023
Sources: *AmPoP 188, 273; AmSFok 132; BeyN 121; Decor 222; DicM 39*; EaAmFo 49, 61, 108*, 246*; FoArtC 43-4**.

Norwalk Pottery
Flourished: Norwalk, CT
Type of Work: Clay (Pottery)
Sources: *EaAmFo 214**.

Norwich, Beatty and Company
Flourished: 1793
Type of Work: Wood (Signs)
Sources: *MoBBTaS 11; TavS 11*.

Norwich Pottery Works
See: Risley, Sidney.

Nott, Zebedee
Flourished: c1817 Simsbury, CT
Type of Work: Tin (Tinware)
Remarks: Associated with Filley
Sources: *TinC 176*.

Nottingham, Luther
Flourished: c1916 Cape Charles, VA
Type of Work: Wood (Duck and shorebird decoys)
Sources: *AmBiDe 38-9*, 154-5*.

Novik, Jennie
Flourished: 1966 Flushing, NY
Type of Work: Oil (Cat paintings)
Sources: *FoAFm 3; TwCA 151**.

Nowlan, Margaret
Flourished: 1822 Maumee, OH
Type of Work: Fabric (Quilts)
Museums: 263
Sources: *QuiAm 124**.

Noyes, Abigail Parker
Flourished: 1812 Hartford, CT
Type of Work: Fabric (Embroidered landscapes)
Sources: *AmNe 88*.

Noyes, Enoch
b. 1743 d. 1808
Flourished: 1760s Old Newbury, MA
Type of Work: Wood (Combs)
Sources: *NeaT 99*.

Noyes, Morillo
Flourished: 1854 Burlington, VT
Type of Work: Tin (Tinware)
Sources: *AmCoTW 94*, 96, 169-72; ToCPS 12*.

Noyes, Paul
b. 1740 d. 1810
Flourished: Newburyport, MA
Type of Work: Stone (Gravestones)
Sources: *EaAmG 128; GravNE 129*.

Nuechterlein, John George
Flourished: 1869 Frankenmuth, MI
Type of Work: Watercolor, ink (Frakturs)
Museums: 085
Sources: *FoPaAm 195**.

Nunemacher Pottery
Flourished: 1850 Rich Valley, PA
Type of Work: Redware (Pottery)
Sources: *AmPoP 178*.

Nurre, Joseph
Flourished: 1839-1850 Dearborn County?, IN?; Cincinnati?, OH?
Type of Work: Fabric (Weavings)
Sources: *AmSQu 277; ChAmC 93*.

Nusser, Christian
Flourished: 1844 Findlay, OH
Type of Work: Fabric (Coverlets)
Sources: *ChAmC 124*.

Nutting, Benjamin F.
b. 1813 d. 1873
Flourished: 1826-1873 Boston, MA
Type of Work: Oil (Portraits)
Sources: *AmPrP 155; PrimPa 177; SoAmP 53**.

Nutting, Calvin, Sr.
Flourished: late 19th cent San Francisco, CA
Type of Work: Iron (Hitching posts)
Sources: *InAmD 73**.

Nutting, Chester
d. c1976
Flourished: Vermont
Type of Work: Wood (Carved fans)
Remarks: Menard, Edmond is his student
Sources: *FoAFp 4*.

Nuttman, I.W. Isaac
d. 1872
Flourished: 1835 Newark, NJ
Type of Work: Oil (Still life paintings)
Sources: *AmFoPa fig3; AmFoPaS 97*; AmNa 11.*

Nye, Alfred
Flourished: 1871 Boston, MA
Type of Work: Wood (Ship carvings, ship figures)
Sources: *AmFiTCa 198.*

Nye, Lucy
b. 1799
Flourished: 1810-1820 New England,
Type of Work: Fabric (Needlework, mourning drawings)
Sources: *BeyN 90*, 97-8, 123; PlaFan 156*.*

Nye, William
See: Ney, William.

Nyeste, James Joseph
b. 1943 Detroit, MI
Flourished: Green Valley, PA
Type of Work: Redware (Pottery)
Sources: *AmFokArt 217*.*

O

O. Henry Tent and Awning Company
Flourished: Chicago, IL
Type of Work: Oil (Circus banners, theater scenery)
Sources: *AmSFor 40.*

O'Brady, Gertrude
b. 1904 Chicago, IL
Type of Work: Oil (Paintings)
Sources: *PeiNa 285*.*

O'Brien, John Williams
Flourished: c1825 Plainfield, IL
Type of Work: Watercolor (Paintings)
Sources: *ArC 209*.*

O'Connell, R.
Flourished: c. 1850-1870 Albany, NY
Type of Work: Stoneware (Pottery)
Museums: 203
Sources: *Decor 109*, 222, 117*.*

O'Donnell, Mrs. D. Oliver
Flourished: contemporary New York, NY
Type of Work: Fabric (Embroidered pictures)
Remarks: Mother is Budd, Mrs. Kenneth
Sources: *AmNe 86, 202-3, 205*.*

O'Francis
Flourished: Michigan
Type of Work: Wood (Fish decoys)
Sources: *UnDec 20.*

O'Kelley, Mattie Lou
b. 1908?
Flourished: 1950-to present Maysville, GA
Type of Work: Acrylic, oil, watercolor (Farm scenes, memory paintings)
Museums: 099,156,171,178
Sources: *AmFoArt 33*; AmFokA 23*, 101*; AmFokArt 221-4*; ArtWo 141-2, 145-6*, 153, 168*; FoA49*, 466; FoAF 18-9; Full *; MisPi 50-1*.*

Oakes Manufacturing Company
Flourished: 1881 Boston, MA
Type of Work: Metal (Weathervanes)
Sources: *YankWe 212.*

Oakford, John
Flourished: 1850s Richmond, VA
Type of Work: Wood (Pipes)
Sources: *WoCar 84*.*

Obe
Flourished: 1850 New Hampshire
Type of Work: Oil (Genre paintings)
Sources: *PrimPa 177.*

Oberholser, Jacob
Flourished: 1851
Type of Work: Fabric? (Coverlets?)
Sources: *ChAmC 124.*

Oberholtzer, A.
Flourished: 1836-1838 Zieglersville, PA
Type of Work: Fabric (Coverlets)
Sources: *ChAmC 93.*

Oberly, Henry
b. c1805 Pennsylvania **d.** 1874
Flourished: c1840 Womelsdorf, PA
Type of Work: Fabric, pen, ink (Coverlets, eagle drawings)
Museums: 025
Sources: *AmSQu 246*, 276; ChAmC 23-4*, 70*, 88*, 90*, 93.*

Ochs, George N.
Flourished: 1876 Philadelphia, PA
Type of Work: Wood (Ship carvings, ship figures)
Sources: *AmFiTCa 198.*

Ochsle, John
Flourished: 1857-1877 Cincinnati, OH
Type of Work: Stoneware, brownware (Pottery)
Remarks: Son is Phillip T.
Sources: *AmPoP 211.*

Ochsle, Phillip T.
Flourished: 1877- Cincinnati, OH
Type of Work: Stoneware, brownware (Pottery)
Remarks: Son of John
Sources: *AmPoP 211.*

Odio, Saturnino Portuondo Pucho
b. 1928
Flourished: New York, NY
Ethnicity: Cuban
Type of Work: Wood (Sculptures, carvings)
Museums: 171
Sources: *AmFokArt 218-20*; FoA 466.*

Odom and Turnlee
[Odon]
Flourished: c1850-1860 Knox Hill, GA
Type of Work: Stoneware (Pottery)
Sources: *AmPoP 239; EaAmFo 174*.*

Odon and Turnlee
See: Odom and Turnlee .

Oertle, Joseph
Flourished: Peoria, IL
Type of Work: Fabric (Weavings)
Sources: *ChAmC 93.*

Ogden, James K.
Flourished: c1825-1829 Cincinnati, OH
Type of Work: Redware (Pottery)
Sources: *AmPoP 210.*

Ohio China Company
Flourished: 19th Century East Palestine, OH
Type of Work: Clay (Pottery)
Sources: *DicM 255*.*

Ohio Stoneware Company
Flourished: c1887 Akron, OH
Type of Work: Stoneware (Pottery)
Sources: *AmPoP 207; Decor 222.*

Ohio Valley China Company
Flourished: c1890-1895 Wheeling, WV
Type of Work: Clay (Pottery)
Sources: *AmPoP 233; DicM 98*.*

Ohnemus, Matthias
Flourished: 1838 Quincy, IL
Ethnicity: German
Type of Work: Leather (Saddles, harnesses)
Sources: *ArC 135.*

Ohno, Mitsugi
Flourished: contemporary Kansas
Ethnicity: Japanese
Type of Work: Glass (Glass works)
Museums: 263
Sources: *BirB 31**.

Ohr, George
Flourished: 1890-1900 East Biloxi, MS
Type of Work: Clay (Pottery)
Sources: *AmPoP 236; DicM 19**.

"Ol' Briscoe"
See: Briscoe, Thomas.

Oldridge
See: Aldridge.

Olevett, Charles
Flourished: 1850 Upper Alton, IL
Type of Work: Stoneware (Pottery)
Sources: *ArC 193*.

Oliver, C.K.
Flourished: 1856-1862 Tuscaloosa County, AL
Type of Work: Stoneware (Pottery)
Sources: *AmPoP 243; DicM 242**.

Oliver, D.(W.)
Flourished: 1870 Massachusetts
Type of Work: Oil (Farm scene paintings)
Sources: *AmPrP 155; PrimPa 177*.

Oliver, John A.
Flourished: c1839 Chicago, IL
Type of Work: Oil (Sign and ornamental paintings)
Sources: *ArC 159*.

Oliver China Company
Flourished: 1899 Sebring, OH
Type of Work: Clay (Pottery)
Sources: *DicM 130**.

Olson
Flourished: 1880 Solomon, MD
Type of Work: Wood (Ship carvings, ship figures)
Sources: *ShipNA 158*.

Olworth, C.W.
Flourished: mid 19th cent
Type of Work: Clay (Porcelain)
Sources: *NinCFo 202*.

Omensetter
See: Farrand and Omensetter.

Omensetter, Elhanan
Flourished: 1870 Philadelphia, PA
Type of Work: Wood (Ship carvings, ship figures)
Sources: *AmFiTCa 198*.

Ominsky, Linda
b. 1939
Flourished: 1967- Philadelphia, PA
Type of Work: Fabric (Appliqued pictures)
Sources: *FoAFa 14*-5**.

Onondago Pottery Company
Flourished: 1871-1884 Geddes, NY; Syracuse, NY
Type of Work: Stoneware (Pottery)
Sources: *AmPoP 109, 113, 203, 274; Decor 222, 244*; DicM 99*, 151*, 173*, 244**.

Onthank, N.B.
Flourished: 1850 New York; Massachusetts
Type of Work: Oil (Portraits)
Sources: *AmPrP 155; PrimPa 178; SoAmP 291*.

Oothout, Mary
Flourished: 1759 Long Island, NY
Type of Work: Fabric (Embroidered table clothes)
Sources: *PlaFan 117*; WinGu 46**.

Opie, Warren
Flourished: 1850-1865 Burlington, NJ
Type of Work: Fabric (Sailor's bags)
Sources: *BeyN 111*.

Oppel, C.
See: C. Oppel and Company.

Opper, E.
Flourished: 1880 New York
Type of Work: Oil (Genre paintings)
Sources: *AmPrP 155; PrimPa 178*.

Orcott, K.V.
Flourished: 1879 Gloucester, MA
Type of Work: Pencil (Portraits, sketches)
Sources: *PrimPa 178*.

Orcutt, Eleazer
Flourished: 1842-1860 Albany, NY; Troy, NY
Type of Work: Stoneware (Pottery)
Sources: *AmPoP 186; Decor 222*.

Orcutt, Stephen
Flourished: 1797-1810 Whateley, MA
Type of Work: Stoneware (Pottery)
Remarks: Partner with the Waits, Luke and Obediah
Sources: *AmPoP 204; Decor 222*.

Orcutt, Walter
[Orcutt, Belding and Company]
Flourished: 1848-1856 Ashfield, MA
Type of Work: Stoneware (Pottery)
Sources: *AmPoP 187, 274; Decor 222; DicM 99*, 140**.

Orcutt and Thompson
Flourished: c1860-1870 Poughkeepsie, NY
Type of Work: Stoneware (Pottery)
Sources: *AmPoP 202; Decor 222*.

Orcutt, Belding and Company
Flourished: c1850 Ashfield, MA
Type of Work: Clay (Pottery)
Sources: *AmPoP 187; DicM 99**
See: Orcutt, Walter.

Orcutt, Humiston, and Company
Flourished: c1830-1860 Troy, NY; Perth Amboy, NJ
Type of Work: Stoneware (Pottery)
Sources: *AmPoP 203, 274; Decor 220, 222; DicM 99**.

Ordway, Alfred
Flourished: 1840 Massachusetts
Type of Work: Oil (Portraits)
Sources: *AmPrP 155; PrimPa 178*.

Orme, Albert
Flourished: 1870s Southport, ME
Type of Work: Wood (Decoys)
Sources: *AmFokAr 18, fig128; FoA 466; WiFoD 89**.

Orms
Flourished: Malago, OH
Type of Work: Fabric (Weavings)
Sources: *AmSQu 277; ChAmC 93*.

Orr, George
Flourished: c1753 Philadelphia, PA
Type of Work: Copper (Copperware)
Sources: *AmCoB 34**.

Orr, Georgianna
b. 1946 Gridley, CA
Flourished: 1979 Gilchrist, OR
Type of Work: Oil (Religious paintings)
Sources: *FoAFu 12*-3*; PioPar 48*-9, 64*.

Orr, Richard
Flourished: Mystic, CT
Type of Work: Wood (Ship carvings, ship figures)
Museums: 186
Sources: *FigSh 114-5**.

Ortega, Ben
See: Ortega, Jose Benito.

Ortega, Benjamin
b. 1923 Santa Fe, NM
Flourished: Santa Fe, NM; Tesuque, NM
Ethnicity: Hispanic
Type of Work: Wood (Santeros, other religious carvings)
Sources: *FoA 138*, 466; HisCr 57*, 107**.

Ortega, David
b. 1917 Chimayo, NM
Flourished: 1977 Chimayo, NM
Ethnicity: Hispanic
Type of Work: Fabric (Blankets)
Sources: *HisCr 18*, 108**.

Ortega, Jose Benito
[Ben Ortega; Juan Benito]
b. 1858 or 1880 Rio Mora, NM d. 1941 Raton, NM
Flourished: 1870-1900 Tesuque, NM; Raton, NM
Ethnicity: Hispanic
Type of Work: Wood (Santeros, other religious carvings)
Museums: 068,171,263
Sources: *AmFoArt 72*; AmFokA fig47; FoA 137*, 466; FoScu 67*; HoKnAm fig45, 75; PopAs 412*-3*, 416*-425, 427-8.*

Ortega, Jose Ramon
b. 1828 d. 1904
Flourished: 1875-1900 Chimayo, NM
Ethnicity: Hispanic
Type of Work: Fabric (Blankets)
Sources: *HisCr 17*, 108.*

Ortega, Nicacio
b. 1875 Chimayo, NM d. 1964
Flourished: 1964 Chimayo, NM
Ethnicity: Hispanic
Type of Work: Fabric (Weavings)
Sources: *HisCr 18*, 108*.*

Ortega, Robert James
b. 1954 Chimayo, NM
Flourished: 1977 Chimayo, NM
Ethnicity: Hispanic
Type of Work: Fabric (Weavings)
Sources: *HisCr 18*, 108.*

Orth, Adam
Flourished: 1860 New York, NY
Type of Work: Wood (Ship carvings, ship figures)
Sources: *AmFiTCa 198.*

Osbon, Aaron C.
[Osburn; Osborne; Osborn]
b. c1840
Flourished: c1850s-1862 Jackson Township, IN
Type of Work: Fabric (Weavings)
Sources: *ChAmC 93*
See: Snyder, Jacob.

Osborn, Aaron C.
See: Osbon, Aaron C.

Osborn, B.F.
Flourished: 1870 Hampton, NH
Type of Work: Oil (Marine paintings)
Sources: *AmPrP 155; PrimPa 178.*

Osborn, Henry F.
See: Osborne, Henry F.

Osborn, James
Flourished: 1800
Type of Work: Watercolor (Portraits)
Museums: 176
Sources: *AmPrP 155; ColAWC 210; PrimPa 178.*

Osborn, Jonathan Hand
Flourished: c1795-1798 Scotch Plains, NJ; Warrenville, NJ
Type of Work: Stone (Gravestones)
Sources: *EaAmG 86-7*, 129.*

Osborne, Aaron C.
See: Osbon, Aaron C.

Osborne, Amos
Flourished: c1790-1836 Peabody, MA
Type of Work: Redware (Pottery)
Remarks: Father of Amos, Jr. and Phillip
Sources: *AmPoP 200.*

Osborne, Amos, Jr.
Flourished: c1836-1850 Peabody, MA
Type of Work: Redware (Pottery)
Sources: *AmPoP 200.*

Osborne, Elijah
Flourished: c1839-1845 Gonic, NH; Louden, NH
Type of Work: Redware (Pottery)
Sources: *AmPoP 192, 195.*

Osborne, Henry F.
[Osborn]
Flourished: 19th century Bellport, NY
Type of Work: Wood (Shorebird, duck decoys)
Sources: *AmBiDe 102*; AmDecoy 19*, 73*; ArtDe 153; WiFoD 15*.*

Osborne, James
Flourished: c1845-1875 Gonic, NH
Type of Work: Redware (Pottery)
Sources: *AmPoP 192.*

Osborne, James
Flourished: 1875-1885 Gonic, NH
Type of Work: Redware (Pottery)
Sources: *AmPoP 192.*

Osborne, John
See: Osborne, James.

Osborne, Johnathan
Flourished: c1780-1833 Peabody, MA
Type of Work: Redware (Pottery)
Remarks: Son of Joseph II
Sources: *AmPoP 200.*

Osborne, Joseph
Flourished: 1739 Salem, MA
Type of Work: Clay (Pottery)
Remarks: Father of Joseph II
Sources: *AmPoP 57, 200.*

Osborne, Joseph
Flourished: 1759-1800 Peabody, MA
Type of Work: Redware (Pottery)
Remarks: Son of Joseph
Sources: *AmPoP 200.*

Osborne, Phillip
See: Osborne, Amos, Jr.

Osborne, Richard
Flourished: c1833-1850 Peabody, MA
Type of Work: Redware (Pottery)
Remarks: Son of Joseph II
Sources: *AmPoP 200.*

Osborne, William
Flourished: 1639 Peabody, MA
Type of Work: Clay (Pottery)
Sources: *AmPoP 56-7, 200.*

Osborne, William
See: Osborne, James.

Osburn, Aaron C.
See: Osbon, Aaron C.

Osebold, Anthony, Jr.
Flourished: 1882 Detroit, MI
Type of Work: Wood (Cigar store Indians, figures)
Sources: *ArtWod 152, 264.*

Osgood, Captain
Flourished: 1849-1860 Salem, MA
Type of Work: Wood (Duck decoys)
Museums: 260
Sources: *ArtDe 150*; Decoy 87*; FlowAm 164*.*

Osgood, Charles
Flourished: 1840 Massachusetts
Type of Work: Oil (Portraits)
Sources: *AmPrP 155; PrimPa 178.*

Osgood, Samuel Stillman
Flourished: 1840 Massachusetts
Type of Work: Oil (Portraits)
Sources: *AmPrP 155; PrimPa 178.*

Osmon(d), (Anna) Maria
Flourished: 1860-1880 Chester County, PA; Kent County, DE
Type of Work: Iron (Tinned sheet iron dishes)
Sources: *AmCoTW 187*; BeyN 28*, 111.*

Ostheimer, A.
Flourished: 1871 Boston, MA
Type of Work: Wood (Ship carvings, ship figures)
Sources: *AmFiTCa 198.*

Ostner, Charles
Flourished: c1856-1859
Type of Work: Oil? (Scenes, paintings)
Sources: *CoCoWA 113*.*

Otis, Alferez Don Jose Antonio
Flourished: 1798 New Mexico
Remarks: Commissioned and paid for restoration of San Miguel Church
Sources: *PopAs 61*.*

Otis, Daniel
Flourished: 1818 Massachusetts
Type of Work: Ink, watercolor (Religious drawings)
Sources: *NinCFo 203.*

Otis, Fred
Flourished: Forestville, CT
Type of Work: Tin? (Clocks)
Sources: *TinC 177.*

Otis, Mercy (Warren)
Flourished: c1750's Barnstable, MA
Type of Work: Fabric (Needlepoint)
Museums: 230
Sources: *AmNe 25*-6.*

Ott, C.
Flourished: 1844 Franklin Township, OH
Type of Work: Fabric (Weavings)
Sources: *AmSQu 277; ChAmC 93.*

Ott and Brewer
[Otter and Brewer]
Flourished: c1867-1892 Trenton, NJ
Type of Work: Clay (Pottery)
Sources: *AmPoP 110, 113, 123, 183, 275*; DicM 90*, 98*, 155*-6*, 175*, 178*, 189*, 197*, 200*.*

Otter and Brewer
See: Ott and Brewer.

Ottman
See: Paxston, Ottman and Company Pottery.

Ottman Brothers and Company
Flourished: c1850-1875 Fort Edward, NY
Type of Work: Stoneware (Jugs)
Sources: *AmS 149.*

Ottman Haxstun and Company
See: Haxstun and Company.

Otto, Johann Henrich
Flourished: 1772-1788 Lancaster County, PA
Type of Work: Watercolor, ink (Frakturs)
Museums: 096,151,227
Sources: *AmFokDe xii, 144* ;AmFoPa 181-2*, 185-6, 189, 192; AmPaF 257*; BeyN 116, 124; FoArRP216-7*; FoPaAm 134*; HerSa *; InAmD 9*; MaAmFA *; NinCFo 188; OneAmPr 20*.*

Otto, Wilhelm
Flourished: 1834 Pennsylvania
Type of Work: Watercolor, ink (Frakturs)
Sources: *AmFoPa 189.*

Otton, J. Hare
Flourished: 1840 Philadelphia, PA
Type of Work: Wood (Ship carvings, ship figures)
Sources: *AmFiTCa 198.*

Outing Manufacturing Company
Flourished: c1920s Elkhart, IN
Type of Work: Wood (Duck decoys)
Sources: *AmBiDe 230.*

Ovenholt, Abraham
Flourished: Bucks County, PA
Type of Work: Wood (Dower chests)
Sources: *PenGer 37.*

Overholt, Henry O.
b. c1813 Pennsylvania
Flourished: 1842-1846 East Huntingdon Township, PA
Type of Work: Fabric (Weavings)
Sources: *AmSQu 277; ChAmC 93-4.*

Overton, Nathan
Flourished: 1821-1850 Randolph County, NC
Type of Work: Wood (Cupboards)
Museums: 001
Sources: *AmPaF 250*; SoFoA 146.*

Owen, J.B.
Flourished: c1930
Type of Work: Stoneware (Vases)
Sources: *AmS 260*.*

Owen, M.W.
Flourished: c1920 Moore County, NC
Type of Work: Stoneware (Bowls)
Sources: *AmS 96*, 98*.*

Owens, Frank
Flourished: c1831 South Burlington, VT
Type of Work: Wood (Duck decoys)
Museums: 260
Sources: *Decoy 46*.*

Owens, J.B.
[J.B. Owens Pottery Company]
Flourished: 1885-1900 Roseville, OH; Zanesville, OH
Type of Work: Brownware (Decorative flower pots, pottery)
Sources: *AmPoP 229, 234; DicM 62*, 100*.*

Ownby, Thomas
Flourished: c1864 Union County, SC
Type of Work: Stoneware (Jugs)
Sources: *AmS 146*.*

Owsley, Willie
b. 1897 Magoffin County, KY
Flourished: Knott County, KY
Type of Work: Various materials (House mosaics)
Remarks: Embedded momentos in cement outside walls of her house
Sources: *FoAroK.*

Oxford Furnace
Flourished: 1746 New Jersey
Type of Work: Iron (Ironware, firebacks)
Museums: 200
Sources: *EaAmI 29*.*

Oxley, Joseph
b. c1813 Ohio
Flourished: 1843 Cambridge, OH; Winterset, OH
Type of Work: Fabric (Coverlets)
Sources: *ChAmC 94.*

P

Pace
See: Balderson and Pace.

Pachtmann
See: Schneider and Pachtmann.

Packard, Samuel G.
Flourished: 1848 Fayette, ME
Type of Work: Oil (Portraits)
Sources: *NinCFo 168, 176, fig125.*

Packer, J.
Flourished: 1838-1841 Brownsville, PA
Type of Work: Fabric (Weavings)
Sources: *AmSQu 277; ChAmC 94*
See: Douglas, Charles.

Packer, T.A.
Flourished: c1875-1885 New Philadelphia, OH
Type of Work: Stoneware (Pottery)
Sources: *AmPoP 225; Decor 222.*

Padelford, R.W.
Flourished: 1859-1860 Elgin, IL
Type of Work: Paint? (Paintings?)
Sources: *ArC 266*
See: Wilkins, Benjamin.

Paducah Pottery
See: Bauer, A.J.

Page, H.
Type of Work: Wood (Signs)
Sources: *MoBBTaS 9, 62*.*

Page, S.P.
Flourished: 1855 Illinois
Type of Work: Pencil (Drawings)
Sources: *ArC 266.*

Page, William
Flourished: 1840 Massachusetts
Type of Work: Oil (Portraits)
Sources: *AmPrP 155; PrimPa 178.*

Paige Pottery
[M.P. Paige Pottery]
Flourished: South Danvers, MA; Peabody, MA
Type of Work: Clay (Pottery)
Sources: *AmPoP 200; FoArtC 43.*

Paine
Flourished: Parsonfield, ME
Type of Work: Oil? (Murals)
Remarks: Follower of Porter, Rufus
Sources: *AmDecor 128.*

Paine, Diana
b. 1817
Flourished: 1826 Stockbridge, MA; New York
Type of Work: Fabric (Samplers)
Sources: *GalAmS 66*.*

Paine, Josiah
b. c1840 **d.** c1910
Flourished: c1860 Cape Cod, MA
Type of Work: Papermache (Shorebird decoys)
Sources: *AmBiDe 82*.*

Paine, Nelson
Flourished: 1817 Meriden, CT
Type of Work: Tin (Tinware)
Sources: *TinC 177.*

Paine, W.
Flourished: 1845 New Bedford, MA
Type of Work: Oil (Portraits)
Sources: *PrimPa 178.*

Palladino, Angela
b. 1929
Flourished: New York, NY
Ethnicity: Italian
Type of Work: Acrylic, clay (Paintings, sculptures)
Sources: *AmFokArt 225-7*; BirB 151*; FoA 468; TwCA 179*.*

Palmer, Ch.B.R.
Flourished: 1826
Type of Work: Oil (Portraits)
Museums: 001
Sources: *AmFoAr 18*; AmFoPo 145-6*; AmPrP 155; PrimPa 178.*

Palmer, Jane
Flourished: 1780
Type of Work: Watercolor (Genre paintings)
Sources: *PrimPa 178.*

Palmer, Joel
b. 1812 **d.** 1884
Flourished: Belfast Township, PA
Type of Work: Wood (Decorated chests)
Sources: *PenGer 67, 181-2*.*

Palmer, Julia Ann
Flourished: 1820 Hallowell, ME
Type of Work: Watercolor (Genre paintings)
Sources: *PrimPa 178.*

Palmer, Susan Catherine
Flourished: 1900 Baltimore, MD
Type of Work: Fabric (Handkerchiefs)
Sources: *AmNe 164.*

Pansing, Fred
b. 1844 **d.** 1912
Flourished: c1885 Hoboken, NJ
Type of Work: Oil (Ship paintings)
Sources: *AmFoPa 116; FoA 63*, 468.*

Paper Hanging Manufactory
See: Freeman, Joseph L.

Papio, Stanley
b. 1915 **d.** 1982 Key Largo, FL
Flourished: Key Largo, FL
Type of Work: Metal (Sculptures)
Sources: *FoAFk 6-7*.*

Pappenberg, Henry
Flourished: 1860 New York, NY
Type of Work: Wood (Ship carvings, ship figures)
Sources: *AmFiTCa 198.*

Parell, Sarah
Flourished: 1826
Type of Work: Fabric (Quilts)
Sources: *InAmD 115*.*

Parete, Eliodoro
See: Patete, Eliodoro.

Parham, William, Jr.
d. 1666
Type of Work: Stone (Gravestones)
Sources: *GravNE 129.*

Paris, Delphina
Flourished: 1825-1835 Portland, ME
Type of Work: Watercolor (Theorems)
Sources: *FoPaAm fig10.*

Park, James
Flourished: Groton, MA
Ethnicity: Scottish
Type of Work: Stone (Gravestones)
Remarks: Father is William; brothers are John and Thomas
Sources: *GravNE 75.*

Park, John
b. 1731 or 1745 d. 1794 or 1806
Flourished: 1765-1794 Groton, MA
Ethnicity: Scottish
Type of Work: Stone (Gravestones)
Remarks: Father is William; brothers are Thomas and James
Sources: *EaAmG 128; GravNE 75, 120.*

Park, John
b. 1761 d. 1811
Flourished: Groton, MA
Type of Work: Stone (Gravestones)
Sources: *EaAmG 129; GravNE 129.*

Park, Linton
b. c1826 Marion, PA d. 1906
Flourished: 1860-1870 Indiana County, PA
Type of Work: Oil (Genre paintings)
Museums: 189
Sources: *AmFoPaN 102, 132*; AmNa 18, 25, 73*; AmPrP fig52, 155; OneAmPr 82, 124*, 155; PicFoA 27, 121*; PrimPa 178.*

Park, Thomas
b. 1745 d. 1806
Flourished: Groton, MA
Ethnicity: Scottish
Type of Work: Stone (Gravestones)
Remarks: Father is William; brothers are John and James
Sources: *EaAmG 129; GravNE 75, 129.*

Park, Thomas
Flourished: 1836 Boston, MA
Type of Work: Wood (Ship carvings, ship figures)
Sources: *AmFiTCa 198.*

Park, William
b. 1705 d. 1788
Flourished: c1756-1788 Groton, MA
Ethnicity: Scottish
Type of Work: Stone (Gravestones)
Remarks: Sons are James, Thomas, and John
Sources: *EaAmG 129; GravNE 71-5, 129.*

Park, William
b. 1763 d. 1795
Flourished: Groton, MA
Type of Work: Stone (Gravestones)
Sources: *EaAmG 129; GravNE 129.*

Park, William
b. 1779 or 1799 d. 1842 or 1854
Flourished: Harvard, MA
Type of Work: Stone (Gravestones)
Sources: *EaAmG 129; GravNE 129.*

Parke, Mary
Flourished: c1805 New England,
Type of Work: Watercolor (Paintings)
Museums: 001
Sources: *ArtWo 69, 72*, 168; PrimPa 178.*

Parker, Burr
b. 1915 North Star, MI
Flourished: 1964 Grand Ledge, MI
Type of Work: Wood (Carvings)
Sources: *Rain 58*-60*.*

Parker, Charles W., Colonel
Flourished: 1904-1920 Leavenworth, KS; San Diego, CA
Type of Work: Wood (Carousel figures)
Sources: *CaAn 10-3, 20-4*.*

Parker, Charlie
Flourished: 19th century New Jersey; Delaware
Type of Work: Wood (Duck decoys)
Sources: *ArtDe 163.*

Parker, Clarinda
b. c1811
Flourished: 1824 Massachusetts; New Hampshire
Type of Work: Fabric (Samplers)
Sources: *GalAmS 64*, 91-2.*

Parker, Clark
Flourished: 1836 Boston, MA
Type of Work: Wood (Ship carvings, ship figures)
Sources: *AmFiTCa 198.*

Parker, Ellis
Flourished: till early 1940 Beach Haven, NJ
Type of Work: Wood (Duck decoys)
Museums: 260
Sources: *AmBiDe 130; Decoy 66*.*

Parker, Grace
Flourished: 1742-1752? Cambridge, MA
Type of Work: Stoneware (Pottery)
Sources: *Decor 722.*

Parker, John
b. 18th century
Flourished: Charlestown, MA
Type of Work: Clay (Pottery)
Sources: *FoArtC 43.*

Parker, Life, Jr.
Flourished: 1840
Type of Work: Watercolor (Portraits)
Sources: *PrimPa 178.*

Parker, Lloyd
Flourished: Parkertown, NJ
Type of Work: Wood (Duck decoys)
Museums: 260
Sources: *AmBiDe 129*; AmDecoy xii; Decoy 94*; EyoAm 9.*

Parker, Nathaniel
b. 1802 North Weare, NH
Flourished: Antrim, NH
Type of Work: Stencils (Wall decorations, paintings)
Sources: *AmDecor 101, 154.*

Parker, S.
Flourished: 18th century Philadelphia, PA
Type of Work: Brass (Pulls)
Sources: *AmCoB 211*.*

Parker, Sally
Flourished: 1805
Type of Work: Watercolor, pinpricks (Scene and genre drawings)
Sources: *AmPrW 26*.*

Parker, Temperance
Flourished: 1745-1755 Boston, MA
Type of Work: Fabric (Samplers)
Sources: *PlaFan 57*.*

Parker and Gannett
Flourished: 1872-1883 Boston, MA
Type of Work: Metal (Weathervanes)
Sources: *AmCoB 137*; YankWe 213.*

Parker Carnival Supply Company
Flourished: c1890 Leavenworth, KS
Type of Work: Wood (Carousel horses)
Sources: *EaAmW 61*; InAmD 154*-5*.*

Parkinson, John
Flourished: 1777 Charleston, SC
Type of Work: Wood (Ship carvings, ship figures)
Sources: *ShipNA 163.*

Parkman, Abigail Lloyd
Flourished: 1758 Connecticut
Type of Work: Fabric (Needlework portraits)
Museums: 048
Sources: *AmNe 28, 49*.*

Parks, J.
Flourished: 1830 Mohawk Valley, NY
Type of Work: Oil (Portraits)
Sources: *PrimPa 178.*

Parmenter, N.H.
Flourished: 1890 Madrid, NY
Type of Work: Pen, ink (Penmanship, calligraphy drawings)
Museums: 246
Sources: *FouNY 65*.*

Parr, David
[David Parr & Company]
Flourished: 1819-1842 Baltimore, MD
Type of Work: Stoneware (Pottery)
Sources: *AmPoP 51, 163; Decor 222*
See: Parr, Margaret.

Parr, Elisha
Flourished: c1824-1837 Baltimore, MD
Type of Work: Redware, stoneware (Pottery)
Sources: AmPoP 163.

Parr, Jack
Flourished: 1900 Detroit, MI
Type of Work: Wood (Duck decoys)
Sources: AmFokA 42*.

Parr, James L.
[Maryland Pottery]
Flourished: 1842-1850 Baltimore, MD
Type of Work: Stoneware (Pottery)
Sources: AmPoP 163; Decor 222.

Parr, Margaret
Flourished: early 19th cent Baltimore, MD
Type of Work: Clay (Pottery)
Sources: AmPoP 51, 163
See: Parr, David.

Parry, Eliza
b. 1823
Flourished: 1838 Georgia
Type of Work: Fabric (Samplers)
Sources: MisPi 75*.

Parsell, Abraham
b. 1792
Flourished: 1820-1856 New York
Type of Work: Oil (Portraits)
Museums: 001
Sources: AmFoPo 146*.

Parsons
See: Whiting and Parsons.

Parsons, A.D.
Flourished: 1825
Type of Work: Watercolor, gouache, ink (Paintings)
Museums: 001
Remarks: Worked in England
Sources: AmFoPo 147*.

Parsons, Charles
b. 1821 d. 1910
Flourished: 1835 New York, NY
Ethnicity: English
Type of Work: Watercolor (Ship portraits)
Sources: AmFoPa 116; NinCFo 168, 195, fig132.

Parsons, Eli
Flourished: 1799-1804 Dedham, MA
Type of Work: Tin (Tinware)
Sources: AmCoTW 42-6, 62; AmFokDe 65.

Parsons, Polly
Flourished: Connecticut
Type of Work: Tin (Painted tinware)
Sources: TinC 158.

Pasanen, Robert I.
b. 1924 Hancock, MI
Flourished: 1964 White Pine, MI
Type of Work: Wood (Carvings)
Sources: Rain 74*-5*.

Paschal, Frances
Type of Work: Fabric (Samplers)
Sources: WinGu 18-9*.

Pashpatel, Leo
Flourished: c1950 Harsens Island, MI
Type of Work: Wood (Duck decoys)
Sources: WaDec 132*.

Pasman
See: Mott and Pasman.

Pasman, Frances
Flourished: 1845 New York, NY
Type of Work: Wood (Ship carvings, ship figures)
Sources: AmFiTCa 198.

Pass, James
Flourished: 1880-1883 Cape Girardeau, MO; Syracuse, NY
Type of Work: Whiteware, Rockingham (Pottery)
Sources: AmPoP 209.

Pass and Stow
Flourished: c1753 Philadelphia, PA
Type of Work: Brass (Bells)
Remarks: Made the Liberty Bell
Sources: AmCoB 172-3*.

Passmore, Thomas
Flourished: c1793 Philadelphia, PA
Type of Work: Tin (Tinware)
Sources: AmCoTW 153; ToCPS 4, 6-7.

Pastor, James
Flourished: 1834 New York, NY
Type of Work: Wood (Ship carvings, ship figures)
Sources: AmFiTCa 198.

Patete, Eliodoro
[Parete]
Flourished: 1863 Anawalt, WV
Ethnicity: Italian
Type of Work: Wood (Sculptures, carvings)
Museums: 189
Sources: AmFokAr 19, fig153, backcover; AmFoS 123*; ArtWea 38; ASeMo 84*; EaAmW figxii.

Patney, Peter
Flourished: 1855 Baltimore, MD
Type of Work: Wood (Ship carvings, ship figures)
Sources: AmFiTCa 198.

Patride, Marvin
b. 1912 Magoffin County, KY
Flourished: Kentucky
Type of Work: Wood (Carvings)
Sources: FoAroK.

Patten, P.C.
Flourished: Strinestown, PA
Type of Work: Fabric (Weavings)
Sources: ChAmC 94.

Patterson
Flourished: 1855 Baltimore, MD
Type of Work: Wood (Ship carvings, ship figures)
Sources: AmFiTCa 198.

Patterson, J.
See: J. Patterson and Company.

Patterson, Mary Ann "Polly" Tanner
Flourished: 1848 Ackworth, GA
Type of Work: Fabric (Quilts)
Sources: MisPi 76*.

Patterson, Thomas
b. c1781 Pennsylvania
Flourished: c1850 Conestoga Township, PA
Type of Work: Fabric (Weavings)
Sources: ChAmC 94
See: Yordy, Benjamin.

Patterson and Read
Flourished: 1840 Philadelphia, PA
Type of Work: Wood (Ship carvings, ship figures)
Sources: AmFiTCa 198.

Patterson Sisters
Flourished: c1775-1800 Binghamton, NY
Type of Work: Fabric (Quilts)
Sources: CoCoWA 38*.

Pattison
See: Peck, Pattison and Company.

Pattison, Edward
d. 1787
Flourished: 1738-1751 Berlin, CT
Ethnicity: Irish
Type of Work: Tin (Tinware)
Remarks: Brother is William; son is Edward, Jr.
Sources: AmCoTW 56-8; AmSFo 41; AmSFok 153; CoCoWA 57; EaAmI 136; FoArtC 65; TinC 3-7, 47, 59, 153, 177; ToCPS 4, 7, 41, 45.

Pattison, Edward, Jr.
d. 1809
Flourished: 1787-1809 Berlin, CT
Type of Work: Tin (Tinware)
Remarks: Brother is William; father is Edward
Sources: TinC 6, 177.

Pattison, Luther
Flourished: Berlin, CT
Type of Work: Tin (Tinware)
Remarks: Son of Samuel?
Sources: TinC 177.

Pattison, Samuel
Flourished: c1812 Berlin, CT
Type of Work: Tin (Tinware)
Remarks: Son of Shubael; son(?) is Luther
Sources: *TinC 177.*

Pattison, Shubael
b. 1764 d. 1828
Flourished: Berlin, CT
Type of Work: Tin (Tinware)
Remarks: Son of Edward, father of Samuel
Sources: *AmCoTW 58; TinC 177.*

Pattison, William
Flourished: 1740 Berlin, CT
Ethnicity: Irish
Type of Work: Tin (Tinware)
Remarks: Brother of Edward
Sources: *AmCoTW 57; AmFokDe 65; CoCoWA 57; FoArtC 73*.*

Patton, Ernest
b. 1935 Wolfe County, KY
Flourished: 1970 Kentucky
Type of Work: Wood (Religious, other carvings)
Sources: *FoAroK *; GoMaD *.*

Paul, J.W.S.
Flourished: 1840
Type of Work: Watercolor (Theorems)
Sources: *PrimPa 178.*

Paul, Jeremiah
Flourished: 1790 Philadelphia, PA
Type of Work: Oil (Portraits)
Sources: *AmPrP 155; PrimPa 178.*

Paul, John
Flourished: 1836 Boston, MA
Type of Work: Wood (Ship carvings, ship figures)
Sources: *AmFiTCa 198.*

Paul, John, Jr.
Flourished: 1815 Lykens Township, PA
Type of Work: Wood (Clocks)
Sources: *BeyN 108.*

Paul, Judith
b. 1777 Providence, RI d. 1851 Providence?, RI?
Flourished: 1797 Providence, RI
Type of Work: Fabric (Samplers)
Museums: 241
Sources: *LeViB 145*.*

Paul, Samuel
Flourished: c1798 Pennsylvania
Type of Work: Clay (Pottery, sgraffito plates)
Museums: 151
Sources: *AmPoP 186; FoArRP 30*.*

Paxston, Ottman, and Company Pottery
Flourished: 1867-1872 Fort Edward, NY
Type of Work: Clay (Pottery)
Sources: *FouNY 33*, 63.*

Paxton, Eliza
Flourished: 1814-1816 Philadelphia, PA
Type of Work: Watercolor (Still life paintings)
Sources: *PrimPa 178.*

Payne, A.C.
Flourished: 1872 Tennessee
Type of Work: Wood (Sculptures)
Sources: *SoFoA 113, 123*, 220.*

Payne, Abigail
See: Mason, Abigail.

Payne, Leslie J.
b. 1907 Fairport, VA d. 1981 Kilmarnock, VA
Flourished: contemporary Lillian, VA
Ethnicity: Black American
Type of Work: Various materials (Painted sheet figures)
Sources: *BirB 89*; BlFoAr 110*-5*, 174.*

Payson, Phillips
Flourished: late 18th cent
Type of Work: Watercolor, ink (Frakturs)
Sources: *Edith *.*

Peale, James
b. 1749 d. 1831
Flourished: 1771 Philadelphia, PA
Type of Work: Oil (Portraits)
Museums: 001
Sources: *AmFoPo 147-9*.*

Peale, Sophonisha
Flourished: 1850 Philadelphia, PA
Type of Work: Fabric (Quilts)
Museums: 227
Sources: *AmSQu 102*; ArtWo 49*.*

Pearl, Hannah
Flourished: 18th century Connecticut
Type of Work: Fabric (Hooked bed rugs)
Museums: 297
Sources: *AmSQu 24*.*

Pears, Tanneke
Flourished: c1766 New York
Type of Work: Needlework (Firescreens)
Sources: *WinGu 47*.*

Pearsen, J.
[Pearson, James]
Flourished: c1835-1840 Chippeway, OH; Chatham Center, OH
Type of Work: Fabric (Weavings, coverlets)
Sources: *AmSQu 277; ChAmC 86-7*, 94.*

Pearson, Hugh A.
Flourished: c1862 Cotton Rock, MO
Type of Work: Bone (Carved pipes)
Sources: *ScriSW 277*.*

Pearson, James
See: Pearsen, J.

Pease, Alanzo
See: Pease, H.A.

Pease, H.A(lanzo)
Flourished: 1842 Oberlin, OH
Type of Work: Oil (Portraits)
Sources: *FoPaAm 191*.*

Pease, John
Flourished: 17th cent Connecticut
Type of Work: Wood (Hope chests)
Sources: *AmPaF 19.*

Pebeahsy, Charles
[Pebeashy]
Flourished: 1979 Oklahoma
Type of Work: Beads (Figures)
Sources: *FoArO 91.*

Pebeashy, Charles
See: Pebeahsy, Charles.

Peck
Flourished: 1840 Nova, OH
Type of Work: Fabric (Weavings)
Sources: *ChAmC 94.*

Peck, Almyrah
b. 1806 Providence, RI d. 1861 Providence?, RI?
Flourished: 1818 Providence, RI
Type of Work: Embroidery (Mourning pictures)
Sources: *LeViB 180*.*

Peck, Ann J.
b. 1792 Providence?, RI? d. 1865 Providence?, RI?
Flourished: 1805 Providence, RI
Type of Work: Fabric (Samplers)
Sources: *LeViB 180.*

Peck, Asahel
Flourished: Meriden, CT
Type of Work: Tin (Tinware)
Remarks: Brother is Seth; son is David
Sources: *TinC 177.*

Peck, Charles
Flourished: c1858 Peoria, IL
Type of Work: Pen, ink (Drawings)
Sources: *ArC 230*.*

Peck, David
Flourished: Connecticut
Type of Work: Tin (Tinware)
Remarks: Father is Asahel; uncle is Seth
Sources: *TinC 177.*

Peck, Elisha
See: Peck, Pattison and Company.

Peck, Elisha
See: Foster, Holloway, Bacon and Company.

Peck, Jabez
See: Jabez Peck and Company.

Peck, Nathaniel
Flourished: 1830 Long Island, NY
Type of Work: Oil (Genre paintings)
Sources: *PrimPa 178.*

Peck, Oliver
See: Jabez Peck and Company.

Peck, Seth
Flourished: 1819 Windsor, CT
Type of Work: Tin (Tinware)
Remarks: Brother is Asahel; nephew is David
Sources: *AmCoTW 62-4; TinC 52-3, 57, 178*
See: Bunnell, Ralph.

Peck, Sheldon
b. 1797 Cornwall, VT d. 1868
Flourished: c1820-1845 Jordan, NY; Aurora, IL; Burlington, VT
Type of Work: Oil (Portraits)
Museums: 016,019,082,114,168,261
Sources: *AmFoPa 48, 68, 71; AmFoPaCe 134-8*; AmFoPaN 85, 95*; AmFoPaS 85*; AmPaF 249*; ArC 87*, 163-5*; BoLiC 79-82; FoA 24*, 468; FoArA 49, 83-94* FoPaAm 186*, 191-2, 194, 205; FouNY 65*; MaAmFA *; NinCFo fig74.*

Peck, Pattison and Company
[Elisha Peck and Shubael Pattison]
Flourished: c1809-1819 Connecticut
Type of Work: Tin (Tinware)
Sources: *TinC 178*
See: Pattison, Shubael.

Peckham, Deacon Robert
b. 1785 d. 1877
Flourished: Westminister, MA
Type of Work: Oil (Portraits)
Sources: *AlAmD 17*; AmPrP 155; NinCFo 176; PicFoA 82*; PrimPa 178; SoAmP 285.*

Peden, Joseph
Flourished: c1828 Clark County, IN
Type of Work: Fabric (Coverlets)
Sources: *ChAmC 94.*

Peele, Mary Mason
b. 1766
Flourished: 1778 Salem, MA
Type of Work: Fabric (Samplers)
Sources: *AmNe 46-7.*

Peirce, George W.
Flourished: 1871 Boston, MA
Type of Work: Wood (Ship carvings, ship figures)
Sources: *AmFiTCa 198.*

Pelkey, J.E.
Type of Work: Wood (Signs)
Sources: *MoBBTaS 9, 76*.*

Pelton, Emily
Flourished: 1805 Pennsylvania
Type of Work: Watercolor, gold leaf (Paintings)
Sources: *AmPrW 120*.*

Pen Yan Pottery
Flourished: c1840 Yater County, NY
Type of Work: Clay (Pottery)
Sources: *DicM 90*, 105*.*

Pendergast, W.W.
Flourished: c1850 Chicago, IL
Type of Work: Paint? (Paintings?)
Sources: *ArC 266.*

Penfield
See: Mattice and Penfield.

Penn, Thomas
Flourished: mid 18th cent Philadelphia, PA
Type of Work: Wood (Ship carvings, ship figures)
Remarks: Son of William Penn
Sources: *AmFiTCa 47.*

Pennell, George
Flourished: Long Island?, NY
Type of Work: Wood, cork (Duck decoys)
Sources: *AmBiDe 100.*

Pennell, Michael
See: Fennell, Michael.

Penniman, John
Flourished: 1810s
Type of Work: Wood (Furniture)
Museums: 176
Remarks: Painted a commode made by Thomas Seymour
Sources: *AmPaF 94*.*

Penniman, John Ritto
Flourished: 1800s Boston, MA
Type of Work: (Decorative paintings)
Sources: *Bes 40.*

Peoria Pottery Company
Flourished: 1864-1894 Peoria, IL
Type of Work: Stoneware, clay (Pottery)
Sources: *AmPoP 226, 275; AmS 90*, 92*; ArC 187; Decor 222; DicM 105*, 154*, 156*, 160*.*

Pepperrell, William
Flourished: 1722
Type of Work: Wood (Ship carvings, ship figures)
Sources: *AmFiTCa 40.*

Perates, J(ohn) W.
b. 1895 d. 1970 Portland, ME
Flourished: 1938- Portland, ME
Ethnicity: Greek
Type of Work: Wood (Icon sculptures, carvings)
Museums: 171
Sources: *AmFoArt 73*; AmFokArt 228-30*; AmFoS 200*; FoA 117*, 468; FoAFx 10*; FoAFcd 13*; Trans 6, 9, 13*, 55; TwCA 226*.*

Percel, E.
Flourished: c1850 New York, NY
Type of Work: Oil (Historical paintings)
Sources: *OneAmPr 119*, 147, 155.*

Perdew, Charles H.
b. 1874 d. 1963
Flourished: 1958 Henry, IL
Type of Work: Wood (Duck decoys)
Museums: 260
Sources: *AmBiDe 182-3*, 195; AmDecoy xii*, 81*; AmSFo 25; ArtDe fig187; Decoy 15*; HoKnAm 43*; WoCar 135, 141*, 146-7*.*

Perez, Mike
Flourished: contemporary New York, NY
Type of Work: Oil (Paintings)
Sources: *AmFokDe 103.*

Pering, Cornelius
Flourished: 1840 Bloomington, IN
Type of Work: Oil (Paintings)
Museums: 115
Sources: *FoArA 58*.*

Perkins, Clarence "Pa" "Cy"
b. 1906 Trumbull County, OH
Flourished: 1976 Pennsylvania
Type of Work: Oil (Paintings)
Remarks: Husband of Ruth; daughter is Robinson, Mary Lou
Sources: *AmFokArt 231*; FoA 51; FoAFx 5, 7*; FoPaAm 143*.*

Perkins, Elizabeth Taylor Brawner
Flourished: c1865 Somerset, KY
Type of Work: Fabric (Quilts)
Sources: *KenQu 57, fig45-6.*

Perkins, Horace Tidd
Flourished: 1866 Portland, ME
Type of Work: Oil (Harbor scene paintings)
Sources: *NinCFo 182.*

Perkins, Ma
See: Perkins, Ruth Hunter.

Perkins, Pa
See: Perkins, Clarence.

Perkins, Prudence
Flourished: 1810 Rhode Island
Type of Work: Watercolor (Mourning and landscape paintings)
Sources: *ArtWo 69-70*; FoPaAm fig11; NinCFo fig22.*

Perkins, Ruth Hunter "Ma"
b. 1911 Jamestown, PA
Flourished: 1960s Pennsylvania
Type of Work: Oil (Paintings)
Remarks: Wife of Clarence; daughter is Robinson, Mary Lou
Sources: *AmFokArt 231-2*; FoA 51*, 468; FoAFx 5-6*; FoPaAm 143*.*

Perkins, Samuel
Flourished: 1810 Boston, MA
Type of Work: Fabric (Printed floor cloths)
Sources: *FloCo 21.*

Perkins, Sarah
b. 1771 d. 1831
Flourished: 1790s Plainfield, CT
Type of Work: Pastel (Portraits)
Museums: 054
Sources: *ArtWo 21-2*, 168.*

Perrine, Maudden
[M. Perrine and Company]
Flourished: 1824-1900 Baltimore, MD
Type of Work: Stoneware (Pottery)
Sources: *AmPoP 51, 162-3; Decor 222.*

Perry, Eliza
Flourished: 1838 Georgia
Type of Work: Fabric (Samplers)
Sources: *SoFoA 171*, 222.*

Perry, Sanford S.
Flourished: 1831-1865 West Troy, NY
Type of Work: Stoneware (Pottery)
Sources: *AmPoP 205; Decor 222.*

Perry, Thomas, Jr.
Flourished: 1793 Albert County, GA
Type of Work: Pen, ink (Drawings, pages from a manuscript)
Museums: 090
Sources: *FoPaAm 156-7*; MisPi 42*.*

Perry, William
b. 1882 d. 1967
Flourished: Fair Port Harbor, OH
Ethnicity: Finnish
Type of Work: Oil (Seascape paintings)
Sources: *AmFokA 25*; FoPaAm 212*.*

Perry, William
b. 1895 New Bedford, MA
Flourished: 1920-60s New Bedford, MA
Type of Work: Whalebone (Scrimshaw, whaleships painting)
Museums: 186
Sources: *GravF 138*; Scrim 22*.*

Persac, Adrien
b. 1823 d. 1873 New Orleans, LA
Flourished: 1851- New Orleans, LA
Ethnicity: French
Type of Work: Tempera (Paintings)
Sources: *SoFoA 64, 66*, 218.*

Peter, H.P.
Flourished: 1839
Type of Work: Fabric (Coverlets)
Sources: *ChAmC 94.*

Peter, Reuben
b. c1821 Pennsylvania
Flourished: 1850 Heidelberg Township, PA; Allentown, PA
Type of Work: Fabric (Coverlets, blankets)
Sources: *ChAmC 94.*

Peter Lessel and Brothers
See: Lessel, Peter.

Peterman, Casper
b. c1780
Flourished: 1841-1850 Brandywine, PA
Ethnicity: German
Type of Work: Fabric (Coverlets)
Museums: 151
Sources: *ChAmC 95.*

Peterman, Daniel
b. 1809 d. 1857
Flourished: Shrewsbury Township, PA
Type of Work: Watercolor, ink (Frakturs)
Sources: *AmFoPa 189; FoAroK *; NinCFo 188.*

Peters
See: Miller, Dubrul; Peters Manufacturing Company.

Peters, C.
Flourished: 1835 Massachusetts
Type of Work: Watercolor (Memorial paintings)
Sources: *PrimPa 178.*

Peters, Christian
Flourished: 1777 Pennsylvania
Type of Work: Watercolor, ink (Frakturs)
Museums: 032
Sources: *AmFoPa 189; FoArRP 199*.*

Peters, J.
Flourished: 1840 Vermont
Type of Work: Oil (Genre paintings)
Sources: *AmPrP 155; PrimPa 178.*

Peters, Joseph
Flourished: 1846-1850 New Bedford, MA
Type of Work: Watercolor (Still life paintings)
Museums: 123
Sources: *WhaPa 30*, 142*, fig.*

Peters, Scott
Flourished: Michigan
Type of Work: Wood (Decoys)
Sources: *WaDec 144-5*.*

Petershime, Mrs. Samuel
Flourished: 1940 Topeka, IN
Ethnicity: Amish
Type of Work: Fabric (Quilts)
Sources: *QufInA 57*.*

Peterson, A.L.
Flourished: c1907 Scandia, MN
Type of Work: Wood (Figures)
Sources: *EaAmW 71.*

Peterson, George
Flourished: c1866 Detroit, MI
Type of Work: Wood (Decoys)
Sources: *WaDec 48-9, 54*, 61*.*

Peterson, Oscar B.
b. 1887
Flourished: c1905-1940 Cadillac, MI
Type of Work: Wood (Fish decoys, other carvings)
Sources: *FoA 227*, 468.*

Peterson, Petrina
Flourished: 1922 New York
Type of Work: Fabric (Commemorative samplers)
Sources: *AmNe 176-7.*

Petna, George
b. c1833 Ohio
Flourished: 1850 Lake Township, OH
Type of Work: Fabric (Weavings)
Sources: *ChAmC 95.*
See: Hefner, George.

Petrie
Flourished: Albany, NY
Type of Work: Fabric (Weavings)
Sources: *AmSQu 277; ChAmC 95.*

Petrie, John
Flourished: 1860 New York, NY
Type of Work: Wood (Ship carvings, ship figures)
Sources: *AmFiTCa 198.*

Petry, Henry
b. c1816 Pennsylvania
Flourished: 1827-1850 Canton, OH
Type of Work: Fabric (Coverlets)
Sources: *AmSQu 277; ChAmC 95.*

Petry, Peter
b. c1809 Washington County, MD
Flourished: 1835-1850 London, OH
Type of Work: Fabric (Weavings)
Sources: *ChAmC 95.*

Pettibone, Abraham
Flourished: Berlin, CT
Type of Work: Tin? (Painted cart wheels, sleighs, bed posts, etc.)
Sources: *TinC 178.*

Pettie, Henry
See: Henry Pettie and Company.

Pewtress, John B.
Flourished: 1835-1840 Perth Amboy, NJ
Type of Work: Stoneware (Pottery)
Sources: *AmS 96*, 98*; Decor 222.*

Peyrau, A.
Flourished: 1891 New York, NY
Type of Work: Clay (Pottery)
Sources: *DicM 10*.*

Pfaltzgraff Pottery
Flourished: 1840-1900 York, PA
Type of Work: Stoneware, clay (Pottery)
Sources: *AmPoP 185; Decor 222, 229*; DicM 105*.*

Pflagger, Henry
See: Phlegan, Henry.

Phares, Mary Anne
Flourished: 1838 Tennessee
Type of Work: Fabric (Trapunto coverlets)
Sources: *AmSQu 83*.*

Phelen, James
Flourished: 1845 New York, NY
Type of Work: Wood (Ship carvings, ship figures)
Sources: *AmFiTCa 198*.

Phelps, Elijah
b. 1761 d. 1842
Flourished: Lanesboro (Lanesborough), MA
Type of Work: Stone (Gravestones)
Sources: *EaAmG 129; GravNE 129*.

Phelps, H.G.
Flourished: Connecticut
Type of Work: Tin? (Tinware?)
Sources: *TinC 178*.

Phelps, Nathaniel
b. 1721 d. 1789
Flourished: 1777 Northampton, MA
Type of Work: Stone (Gravestones)
Sources: *EaAmG 56*-9, 129; GravNE 110, 129*.

Phenstein, W.A.
Flourished: Pennsylvania
Type of Work: Tin (Candlemolds)
Sources: *ToCPS 42*.

Philadelphia Toboggan Company
See: Toboggan Company.

Philips, Solomon Alexander
b. 1822 Lititz, PA d. 1909
Flourished: late 19th cent Schuylkill County, PA
Type of Work: Tin (Tinware)
Museums: 162
Sources: *ToCPS 4-5*, 42*
See: partner Moore, Cyrus.

Philles
Flourished: 1872-1877 Red Wing, MN
Type of Work: Stoneware (Pottery)
Sources: *AmPoP 228; Decor 222*.

Phillips, Ammi
b. 1788 Colebrook, CT d. 1865 Stockbridge, MA
Flourished: 1811-1865 Berkshire County, CT; Rhinebeck, NY; Massachusetts
Type of Work: Oil (Portraits)
Museums: 001,083,189,203,233,235,238
Sources: *AmFoPaCe 45, 77, 129-30, 139-44*; AmFoPaS 55*; AmFoPo 149-61*; AmNa 10, 12-3, 17, 25, 74*-6; AnP;AnPh;BoLiC 60-3*, 79; Edith *; EraSaF 9, 20-1; EyoAm 17*-8; FoA 25*, 468;FoArA 49; FouNY 64; GifAm 49*, 51*; GraMo 35*.

Phillips, Ammi (Continued)
Sources: *HoKnAm 92-3*; MaAmFA *; NinCFo 168, 176, figs28, 36, 37, 47, 48, 51, 52, 63, 118, 139; OneAmPr 82-3, 93*, 145, 155*.

Phillips, Ellen A.
Flourished: 19th cent
Type of Work: Watercolor (Portraits)
Sources: *Edith **.

Phillips, Felix
Flourished: 1876 Philadelphia, PA
Type of Work: Wood (Ship carvings, ship figures)
Sources: *AmFiTCa 198*.

Phillips, M.E.
Flourished: 1848 Ohio
Type of Work: Fabric? (Coverlets?)
Sources: *ChAmC 95*.

Phillips, Moro
Flourished: 1853-1897 Wilson's Landings, VA; Philadelphia, PA; Camden, NJ
Type of Work: Stoneware (Pottery)
Sources: *AmPoP 87, 165, 175, 243; Decor 222*.

Phillips, William S.
Flourished: 1860 Baltimore, MD
Type of Work: Wood (Ship carvings, ship figures)
Sources: *AmFiTCa 198*.

Phillips China Comapny
See: Smith-Phillips China Company.

Phindoodle, Captain
Flourished: late 19th cent
Type of Work: Oil (Seascape paintings)
Museums: 139
Sources: *PicFoA 18, 104*; PrimPa 178*.

Phinney, Gould
[Pinney]
Flourished: c1840 Elizabethtown, CT; Simsbury, CT
Type of Work: Tin (Tinware)
Remarks: Associated with Filley, Oliver
Sources: *TinC 178*.

Phippen, John
Flourished: 1780-1790
Type of Work: Watercolor (Ship paintings)
Sources: *AmFoPa 107*.

Phipps, Margarette R.
Flourished: 1830-1840 Pennsylvania
Type of Work: Watercolor (Paintings)
Sources: *FoPaAm 125, 135**.

Phlegan, Henry
[Pflagger]
b. c1810
Flourished: c1850 Lithopolis, OH
Ethnicity: German
Type of Work: Fabric (Coverlets)
Sources: *ChAmC 95*.

Phoenix Pottery
Flourished: 1867 Phoenixville, PA
Type of Work: Clay (Pottery)
Sources: *AmPoP 217; DicM 106**.

Phoenix Wire Works
Flourished: 1900 Detroit, MI
Type of Work: Metal (Weathervanes)
Sources: *YankWe 213*.

Phohl, Bessie
Flourished: c1880 Salem, NC
Type of Work: Fabric, paint (Dolls)
Sources: *SoFoA 115*, 220*
See: Phohl, Maggie.

Phohl, Maggie
Flourished: c1880 Salem, NC
Type of Work: Fabric, paint (Dolls)
Sources: *SoFoA 115*, 220*
See: Phohl, Bessie.

Pi, Aqwa
Flourished: 1925-1930 San Idlefonso, NM
Ethnicity: American Indian
Type of Work: Watercolor (Racing horse paintings)
Remarks: Tewa tribe
Sources: *PicFoA 47*, 148**.

Pickard, J.
Flourished: 1861 Detroit, MI
Type of Work: Wood (Ship carvings, ship figures)
Sources: *AmFiTCa 198*.

Pickett, Joseph
b. 1849 New Hope, PA d. 1918
Flourished: 1914-1918 New Hope, PA
Type of Work: Oil (Paintings)
Museums: 020,179,204,307
Sources: *AmFokArt 235-7*; AmFoPaCe 208-12*; AmPrP 147, fig45, 68; CoCoWA 104; FoA 468; FoArA 23; FoPaAm 140*, 142; GraMo 39, 41; HoKnAm 181; MaAmFA *; PeiNa 304*; PicFoA 101*, 158-9*, 162-3; PrimPa 178; ThTaT 110*; TwCA 50**.

Pickhil, Alexander
Flourished: New Orleans, LA
Ethnicity: Black American
Type of Work: Paint? (Paintings)
Sources: *AfAmA 96*.

Pickle, Helen
b. 1915 Texas
Flourished: 1972 Mississippi
Type of Work: Acrylic (Genre paintings)
Sources: *FoAFv 12**.

Pickney, Francis
b. 1726 d. 1777
Flourished: Massachusetts
Type of Work: Fabric (Samplers)
Remarks: Mother of a Governor of Massachusetts
Sources: *LeViB 37*.

Pie, Hugh
Flourished: 1803 New York
Ethnicity: American Indian
Type of Work: Wood (Poplar bowls)
Sources: *EaAmWo 124**.

Pierce, Augustus
Flourished: c1850-1860 Ripley, IL; Winchester, IL; White Hall, IL
Type of Work: Stoneware (Pottery)
Sources: *ArC 193.*

Pierce, Charles
Flourished: c1940 Galax, VA
Type of Work: Wood (Carved animals)
Sources: *SoFoA 113*, 220.*

Pierce, Elijah
b. 1892 Baldwyn, MS d. 1984 Columbus, OH
Flourished: 1920-1982 Columbus, OH
Ethnicity: Black American
Type of Work: Wood (Sculptures, carvings)
Sources: *AmFokArt 238-40*; AmFoS 198-9*; BirB 89*; BlFoAr 116*-121*, 174; ConAmF 85-8*; FoA 116*, 468 191 6, 38-42, 49, 55; FoAFe 2*-17*; FoAFt 4*-5*; FoScu 91*; TwCA 101*.*

Pierce, I.W.
Flourished: 1859
Type of Work: Pen, ink (Drawings)
Sources: *Edith *.*

Pierce, John
Flourished: c1753 Litchfield, CT
Type of Work: Redware (Pottery)
Sources: *AmPoP 195.*

Pierce, Merrily
Flourished: 1834
Type of Work: Fabric (Weavings)
Sources: *AmSQu 277; ChAmC 95.*

Piercey, Christian
Flourished: c1788-1794 Philadelphia, PA
Type of Work: Redware, cream-colored ware (Pottery)
Sources: *AmPoP 175.*

Pierre, F.J.
Flourished: 1856 Charlestown, MA
Type of Work: Wood (Ship carvings, ship figures)
Sources: *AmFiTCa 198.*

Pierson, Andrew
[Bangor Stoneware Works]
Flourished: c1890-1916 Bangor, ME
Type of Work: Stoneware (Pottery)
Sources: *Decor 222.*

Pierson, John
See: John Pierson and Company.

Pierson, Martha
Flourished: 1847
Type of Work: Fabric (Quilts)
Sources: *AmFokA 18*.*

Pierson and Horn
Flourished: 1875-1900 Gardiner, ME
Type of Work: Stoneware (Pottery)
Sources: *Decor 222.*

Pifer, William
Flourished: 1831 Baltimore, MD
Type of Work: Wood (Ship carvings, ship figures)
Sources: *AmFiTCa 198.*

Pile, John
Flourished: 1853 Pennsylvania
Type of Work: Watercolor, ink (Frakturs)
Sources: *AmFoPa 189.*

Pilkington, Adam
d. 1856
Flourished: Nauvoo, IL
Sources: *ArC 266.*

Pilliner, C.A.
Flourished: 1860 Cambridge, MA
Type of Work: Oil on tin (Landscape paintings)
Sources: *PrimPa 178.*

Pimat, P. Mignon
Flourished: 1810 Massachusetts
Type of Work: Oil (Portraits)
Sources: *AmPrP 155; PrimPa 178.*

Pinckard, Nathaniel
Flourished: c1820 Upper Alton, IL
Type of Work: Earthenware (Pottery)
Sources: *ArC 189.*

Pine, Robert Edge
Flourished: mid 18th cent Pennsylvania
Type of Work: Oil (Portraits)
Sources: *FoPaAm 116*.*

Pinney, Eunice Griswold Holcombe
b. 1770 Simsbury, CT d. 1849
Flourished: 1809-1826 Simsbury, CT; Windsor, CT
Type of Work: Watercolor, ink, pen (Paintings)
Museums: 171,176,189,203
Sources: *AmFoArt 20*; AmFoPaCe 145-8*, 171, 222; AmFoPaN 97-100*, 115-20; AmFoPaS 49*; AmPrP148, fig84-6; OneAmPr 43*, 61*, 123*, 127*; ArtWo 58-61*, 168-9, fig8; ColAWC 182*, 211*, 240-1*; EyoAm 28*, 30; FoA 79*, 468; NinCFo 198; PrimPa 22-30*, 178.*

Pinney, Gould
See: Phinney, Gould.

Pinniger, Abigail
b. 1715 Newport, RI d. 1779
Flourished: 1730 Newport, RI
Type of Work: Fabric (Samplers)
Museums: 173
Sources: *AmNe 43*, 46; LeViB 60, 64*.*

Pinsonault, L.
Flourished: 1871 Boston, MA
Type of Work: Wood (Ship carvings, ship figures)
Sources: *AmFiTCa 198.*

Pioneer Iron Works
Flourished: c1870 San Francisco, CA
Type of Work: Iron (Hitching posts)
Sources: *CoCoWA 12-3*.*

Pioneer Pottery Company
Flourished: c1890 Wellsville, OH
Type of Work: Clay (Pottery)
Sources: *AmPoP 232, 276*; DicM 85*, 144*, 154*, 243*.*

Piper, John C.
Flourished: 1860 Bath, ME
Type of Work: Wood (Ship carvings, ship figures)
Sources: *AmFiTCa 198.*

Pippin, Horace
b. 1888 Pennsylvania d. 1946
Flourished: 1929-1946 Goshen, NY; West Chester, PA
Ethnicity: Black American
Type of Work: Oil (Still life, narrative historical, biblical paintings)
Museums: 009,151,223,227,229,307
Sources: *AfAmA 120-1*, 132; AmFokArt 241-3*; AmFoPaCe 189, 213-9*; AmNeg 73*, 12*, fig10; FoA468; FoPaAm 140, 142; GraMo 14, 43-4; HoKnAm 190*; HoPip *; MaAmFA *; PeiNa 306*;PicFoA 158*, 163-4; ThTaT 186-91*; TwCA 112*.*

Pitkin, Elizabeth
Flourished: 1825 Saratoga, NY
Type of Work: Velvet (Still life paintings)
Museums: 006
Sources: *FouNY 65*.*

Pitkin, Richard
Flourished: 1800-1820 Manchester, CT
Type of Work: Stoneware (Pottery)
Remarks: Worked with Woodbridge, Dudley
Sources: *Decor 222.*

Pitkin Glass Works
Flourished: 1783-1830 East Manchester, CT
Type of Work: Glass (Flasks)
Sources: *AmSFo 84.*

Pitman, Benn
d. 1910
Flourished: 1873-1905 Cincinnati, OH
Type of Work: Wood (Furniture, walls)
Sources: *EaAmW 92.*

Pitman, Mary
b. 1758 Newport, RI d. 1841
Flourished: 1770 Newport, RI
Type of Work: Fabric (Samplers)
Museums: 032
Sources: *LeViB 80-1*, 82, 86.*

Pittman, J.W.
Flourished: 1870-1900 Lynville, KY
Type of Work: Brownware (Pottery)
Sources: *AmPoP 239.*

Plaisted, F.A.
Flourished: 1850-1874 Gardiner, ME
Type of Work: Stoneware (Pottery)
Sources: *Decor 223.*

Plaisted, T.J.
Flourished: New York
Type of Work: Oil (Theater and sideshow scenes)
Sources: *AmSFor 198.*

Plank, J.L.
Flourished: 1883 Pennsylvania
Type of Work: Watercolor, ink (Frakturs)
Sources: *AmFoPa 189.*

Plank, Samuel
b. 1821 d. 1900
Flourished: 1893 Kishacoquillas Valley, PA
Ethnicity: Amish
Type of Work: Wood (Saltboxes)
Museums: 1
Sources: *HerSa *; NeaT 145-6*.*

Platt, Augustus
Flourished: c1825-1850 Columbus, OH
Type of Work: Brass (Theodalites)
Sources: *AmCoB 224*.*

Platt, Mrs. Charles (Dorothy)
Flourished: 1938 Philadelphia, PA
Type of Work: Embroidery (Still life pictures)
Remarks: Designed for others as well as for herself
Sources: *AmNe 171-2*, 210, 212*, 218-9*.*

Platt, Lydia
Flourished: 1847
Type of Work: Fabric (Samplers)
Museums: 227
Sources: *MoBeA.*

Plattenberger
Flourished: 1860 Pennsylvania
Type of Work: Oil (Biblical scene paintings)
Sources: *AmPrP 155; PrimPa 178.*

Plichta, Fred
Flourished: 1938 Detroit, MI
Type of Work: Wood (Duck decoys)
Museums: 260
Sources: *Decoy 57*.*

Plourde, Ben
b. 1896 Norway, MI d. 1963
Flourished: 1960 Iron River, MI
Type of Work: Watercolor (Paintings)
Museums: 119
Sources: *Rain 43*-4*.*

Plum, Seth
Flourished: 1808-1835 Meriden, CT
Type of Work: Tin (Tinware)
Sources: *TinC 178.*

Plumb, Robert
Flourished: 1870-1900 Stratford, CT
Type of Work: Wood (Duck decoys)
Remarks: Painted ducks for Holmes, Benjamin
Sources: *ArtDe 156.*

Plumb, Seth
Flourished: Berlin, CT
Type of Work: Tin (Tinware)
Remarks: Associated with both Peck and Hubbard
Sources: *TinC 178.*

Plummer, Edward
Flourished: 1850 Connecticut
Type of Work: Oil, watercolor (Biblical, miniature paintings)
Sources: *AmPrP 155; PrimPa 178.*

Plummer, Edwin
b. 1820 d. 1880
Flourished: Haverhill, MA; Salem, MA
Type of Work: Watercolor, pencil (Miniature portraits)
Museums: 001
Sources: *AmFoPo 162*.*

Plummer, Harrison
Flourished: 1840 Haverhill, MA
Type of Work: Oil (Portraits)
Sources: *AmPrP 155; PrimPa 178.*

Plummer, R.
Flourished: 1860 Maine
Type of Work: Oil (Landscape paintings)
Sources: *PrimPa 178.*

Plummer, William
Flourished: 19th century
Type of Work: Oil (Ship and seascape paintings)
Sources: *AmFoPa 112.*

Plympton and Robertson Pottery Company
Flourished: c1860-1896 Boston, MA
Type of Work: White Granite (Pottery)
Sources: *AmPoP 189.*

Podhorsky, John
Flourished: c1950-1970 California
Type of Work: Mixed media (Drawings, paintings)
Sources: *FoAFm 3; PioPar 49*, 63; TwCA 116*.*

Poe, William
b. 1914
Flourished: 1964- Muskegon, MI
Type of Work: Oil (Paintings)
Sources: *Rain 45*-6*.*

Pohl, Joseph
Flourished: c1858-1870 Red Wing, MN
Type of Work: Stoneware (Pottery)
Sources: *AmPoP 70, 228; Decor 223.*

Poiteran Brothers, Inc.
Flourished: c1920s Pascagoula, MS
Type of Work: Wood (Duck decoys)
Sources: *AmBiDe 229.*

Polaha, Steven
Flourished: 1950-1960 Reading, PA
Type of Work: Wood (Sculptures, carvings)
Sources: *AlAmD 116*, 88*.*

Polk, Charles Peale
Flourished: 1783-1820 Philadelphia, PA; Baltimore, MD; Richmond, VA
Type of Work: Oil (Portraits)
Remarks: Nephew of Charles Wilson Peale
Sources: *AfAmA 98; FoPaAm 156; SoFoA 55.*

Pollard, A.W.
[A.W. Pollard and Company]
Flourished: 1847? Boston, MA
Type of Work: (Masonic regalia)
Remarks: Manufacturer
Sources: *Bes 38*.*

Pollard, Luke
Flourished: 1845 Harvard, MA
Type of Work: Oil (Portraits)
Sources: *AmPrP 155; PrimPa 178; SoAmP 7*.*

Pollock, Samuel
Flourished: 1859-1874 Cincinnati, OH
Type of Work: Yellow-ware, Rockingham (Pottery)
Sources: *AmPoP 211.*

Pollock, Sarah E.
Flourished: 1832 Roxbury, MA
Type of Work: Fabric (Embroidered handkerchiefs)
Sources: *AmNe 75*.*

Pomarede, Leon D.
b. 1807 d. 1892
Flourished: c1852 St. Louis, MO
Ethnicity: French
Sources: *ArC 222, 226-7.*

Pomeroy, Charles
Flourished: c1840s-1877 Meriden?, CT
Type of Work: Tin (Tinware)
Remarks: Employed up to 40 people
Sources: *TinC 178.*

Pomeroy, Lucinda
See: Pomroy, Lucinda.

Pomeroy, Noah
Flourished: 1817-1845 Meriden, CT
Type of Work: Tin (Tinware)
Sources: *TinC 179.*

Pompey, L.W.
Flourished: 1831
Type of Work: Fabric (Weavings)
Sources: *AmSQu 277; ChAmC 95.*

Pomroy, Lucinda
[Pomeroy]
Flourished: 1840 Somers, CT
Type of Work: Oil (Stenciled overmantel paintings)
Sources: *AmDecor 105-6*; AmFokDe xi, 96*.*

Pond, Burton
Flourished: Bristol, CT
Type of Work: Paint (Clock and dial paintings)
Sources: *TinC 179.*

Pond, Edward L.
Flourished: till 1849 Hartford, CT
Type of Work: Tin (Tinware)
Sources: *TinC 179.*

Poor, Jonathan D.
Flourished: c1831 Ithaca, NY
Type of Work: Oil (Paintings)
Museums: 260
Remarks: Nephew of Porter, Rufus
Sources: *AmDecor 66-7*, 127; AmFoPa 144.*

Pope
Type of Work: Wood (Ornamental duck carvings)
Museums: 260
Sources: *Decoy 9.*

Pope, Mrs.
See: Forrester, Laura Pope.

Pope, Sarah E.
b. 1762 Newport, RI d. 1845 Newport, RI
Flourished: 1773 Newport, RI
Type of Work: Fabric (Samplers)
Museums: 205
Sources: *LeViB 58-61, 81-2*, 87.*

Port, Elizabeth
Flourished: 1852 New Jersey
Type of Work: Fabric (Quilts)
Sources: *NewDis 70*.*

Porter
See: Dillon and Porter.

Porter, Abel
b. 1757 Berlin, CT d. 1850
Flourished: Waterbury, CT
Type of Work: Tin (Tinware)
Sources: *TinC 179.*

Porter, Benjamin
Flourished: c1790-1805 Wiscasset, ME
Type of Work: Redware (Pottery)
Sources: *AmPoP 205.*

Porter, C.C.
[Porter's Factory]
Flourished: 1863 Jefferson County, WV
Type of Work: Fabric (Coverlets)
Sources: *ChAmC 95.*

Porter, J.S.
Flourished: c1835 Chicago, IL
Type of Work: Oil (Miniature paintings)
Sources: *ToCPS 163.*

Porter, John
Flourished: 1819 Connecticut
Type of Work: Tin (Tinware)
Remarks: Associated with Filley
Sources: *TinC 179.*

Porter, John
Flourished: 1830 Boston, MA
Type of Work: Oil (Portraits)
Sources: *AmPrP 155; PrimPa 178.*

Porter, Moses
Flourished: Berlin, CT
Type of Work: Tin (Tinware)
Sources: *TinC 179.*

Porter, Rufus
b. 1792 West Boxford, MA d. 1884 West Haven, CT
Flourished: 1814-1845 Portland, ME; New Haven, CT; Hancock, NH
Type of Work: Watercolor, oil (Portraits, murals, miniatures, boxes, landscape paintings)
Museums: 001,088
Remarks: Founded "Scientific American" magazine; son is Stephen Twombly
Sources: *AmDecor figix, 147, 76, 116, 121-8*, 153; AmFokDe xi, 96*; AmFoPa 122, 141*-2; AmFoPaCe149-54*; AmFoPo 169-72*; AmPaF 40; AmPrP 122-5, 148, fig92-3; Bes 41-2, 52, 68; FoA33*, 468; GraMo 40-1, 47-8*, 79; HoKnAm 9; NeaT 27*; PicFoA 21; PrimPa 57-66*, 178.*

Porter, Solon
Flourished: 1955 Oklahoma
Type of Work: Oil (Paintings)
Museums: 232
Sources: *FoArO 82.*

Porter, Stephen Twombly
Type of Work: Oil (Paintings)
Remarks: Son of Rufus
Sources: *AmFoPa 141.*

Porter's Factory
See: Porter, C.C.

Portland Stoneware Company
Flourished: 1846-1880 Portland, ME
Type of Work: Stoneware, terra-cotta (Pottery)
Sources: *AmPoP 201.*

Portzline, Elizabeth
Flourished: 1834 Pennsylvania
Type of Work: Watercolor, ink (Frakturs)
Sources: *AmFoPa 189.*

Portzline, Francis
b. 1771
Flourished: 1801-1855 Chipman Township, PA; Union County, PA
Type of Work: Watercolor, ink (Frakturs)
Museums: 020,179,181,189,227
Sources: *AmFokDe xii, 144*; AmFoPa 189; BeyN 124; FoArRP 218-9*; FoPaAm 125*; HerSa *; NinCFo 168, 188, fig97; PicFoA 33, 147*.*

Potter, Lucy
b. 1778 Providence, RI d. 1864 Providence, RI
Flourished: c1791 Providence, RI
Type of Work: Fabric (Samplers)
Museums: 016
Sources: *LeViB 147*.*

Potter, W(oodbury) A(bner)
b. 1845 d. 1915
Flourished: c1880-1893 Bath, ME
Type of Work: Wood (Ship carvings, ship figures)
Sources: *AmFiTCa 140, 198; ShipNA 79, 156.*

Pottersville Community
Flourished: c1820-1840 Edgefield, SC
Type of Work: Stoneware (Jugs)
Sources: *AmS 142*, 207, 234*.*

Pottery in the Kloster of the United Brethren
Flourished: c1750-1800 Ephrata, PA
Type of Work: Redware (Pottery)
Sources: *AmPoP 167.*

Pottery of the Separatist Society of Zoar
Flourished: c1834-1850 Zoar, OH
Type of Work: Redware, brownware (Pottery)
Sources: *AmPoP 234.*

Pottman Brothers
Flourished: c1870 Fort Edward, NY
Type of Work: Stoneware (Pottery)
Sources: *Decor 223.*

Potts, Abram
Flourished: 1845 New York, NY
Type of Work: Wood (Ship carvings, ship figures)
Sources: *AmFiTCa 198.*

Potts, Christopher
See: Christopher Potts and Son.

Poulson
See: Millington, Astbury and Poulson.

Powder Valley Woolen Mill
Flourished: Milford Township, PA
Type of Work: Fabric (Weavings)
Sources: *ChAmC 95.*

Powell, H.M.T.
Flourished: c1855 California
Type of Work: Oil (Paintings)
Sources: *OneAmPr 83, 123*, 148, 155.*

Power, Nancy Willcockson
Flourished: c1840 Fancy Creek, IL
Type of Work: Fabric (Quilts)
Sources: *ArC 102**.

Power and Ferrell
Flourished: 1856 Chicago, IL
Type of Work: Wood (Ship carvings, ship figures)
Sources: *AmFiTCa 198*.

Powers
See: Hill, Powers and Company.

Powers, Asahel Lynde
b. 1813 Springfield, VT d. 1843 Olney, IL
Flourished: 1831-1840 Springfield, VT; New York; Ohio
Type of Work: Oil (Portraits)
Museums: 001,049,189,203,238,264
Sources: *AmFoPa 48, 75-6*; AmFoPaCe 155-9*; AmFoPaN 57, 78*; AmFoPo 172-5; AmPaF 242*; AshPo;FoA 468; FoArA 47-8*; FoPaAm 39*; FouNY 65*; MaAmFA *; NinCFo 168, 176, fig71, 73;PrimPa 178.*

Powers, Bridget
Flourished: c1777 New England,
Type of Work: Wood (Painted boxes)
Sources: *NeaT 22-3**.

Powers, Harriet
b. 1837 Georgia d. 1911
Flourished: 1886-1898 Athens, GA
Ethnicity: Black American
Type of Work: Fabric (Quilts)
Museums: 176,263
Sources: *AmSQu 211*; ArtWo 49, 54-5, 82, 94, 169*, fig6; BlFoAr 35*; MisPi 16-23*, 78-9*; PieQuendpapers*; QuiAm 306-7*; SoFoA 195-8, 222-3.*

Powers, Susan
b. 1954 Glen Cove, NY
Flourished: New York, NY
Type of Work: Oil (Still life paintings)
Sources: *AmFokArt 244-7**.

Poyner, Mrs. M.E.
Flourished: c1860 Paducah, KY
Type of Work: Fabric (Quilts)
Sources: *KenQu 38-9, fig27-8*.

Pozzini, Charlie L.
Flourished: 1956 Detroit, MI
Type of Work: Wood (Decoys)
Museums: 260
Sources: *Decoy 24*; WaDec 114**.

Pratt, Caroline H. Barrett
b. Stillwater, NY
Flourished: 1800-1850
Type of Work: Watercolor (Scene paintings)
Museums: 176
Sources: *ColAWC 169-70*, 213.*

Pratt, D.C.
Flourished: 1859-1860 Aurora, IL; St. Charles, IL
Sources: *ArC 266.*

Pratt, F.F.
Flourished: 1859-1860 Aurora, IL
Sources: *ArC 266.*

Pratt, Henry C.
Flourished: 1840 Maine
Type of Work: Oil (Portraits)
Sources: *AmPrP 155; PrimPa 178.*

Pratt, Leon B.
Flourished: 1878 Bucksport, ME
Type of Work: Wood (Ship carvings, ship figures)
Sources: *ShipNA 156.*

Pratt, Louisa Jane
Flourished: 1830
Type of Work: Watercolor (Paintings)
Remarks: Worked in the eastern United States
Sources: *ArtWo 64**.

Pratt, Matthew
Type of Work: Oil (Coach, sign paintings)
Sources: *AmFokDe 129**.

Pratt, Nathaniel
b. 1702 d. 1779
Flourished: Abington, MA
Type of Work: Stone (Gravestones)
Sources: *EaAmG 129.*

Pratt, Noah
d. 1731
Type of Work: Stone (Gravestones)
Sources: *GravNE 129.*

Pratt, Robert
b. 1758 d. 1830
Flourished: Hanover, MA
Type of Work: Stone (Gravestones)
Sources: *EaAmG 129.*

Pratt, William E.
See: William E. Pratt Manufacturing Company.

Pratt Company
See: Animal Trap Company.

Predmore, Cooper, Captain
Flourished: 1880 Barnegat, NJ; Delaware
Type of Work: Wood (Duck decoys)
Sources: *ArtDe 163; WiFoD 129, 125**.

Predmore, Jessie
b. 1896 Osco, IL
Flourished: California
Type of Work: Oil (Genre paintings)
Sources: *PrimPa 178; ThTaT 213-5**.

Preeble
See: Lees and Preeble.

Prescott, Martha Abbott
b. c1773
Flourished: Westford, MA
Type of Work: Fabric (Weavings)
Sources: *FoArtC 61**.

Pressley, Daniel
b. 1918 Wasamasaw, SC d. 1971 Brooklyn, NY
Flourished: 1962 Brooklyn, NY
Type of Work: Wood, oil (Sculptures, carvings, paintings)
Sources: *FoScu 92*; TwCA 134-5**.

Pressman, Meihel
Flourished: c1950
Ethnicity: Jewish
Type of Work: Watercolor (Paintings)
Museums: 121
Sources: *FoAFg 9**.

Price, Abial
Flourished: 1847-1852 Middletown Point, NJ
Type of Work: Stoneware (Pottery)
Sources: *Decor 223.*

Price, Albert
b. 1931 West Virginia
Flourished: 1965 East Hampton, NY
Type of Work: Wood (Sculptures, carvings)
Sources: *TwCA 107**.

Price, Ebenezer
b. 1728 d. 1788
Flourished: Elizabeth, NJ
Type of Work: Stone (Gravestones)
Sources: *EaAmG 129.*

Price, G.
Flourished: 1840-1849 South Amboy, NJ
Type of Work: Stoneware (Pottery)
Sources: *Decor 218*
See: Congress Pottery; Hancock, William H.; Cadmus, Abraham.

Price, Jane Wilder
Flourished: c1835 Maryland
Type of Work: Fabric (Samplers)
Sources: *SoFoA 178*, 222.*

Price, Janis
b. 1833 Nashport, OH
Flourished: Newark, OH
Type of Work: Oil, fabric (Paintings, fabric art)
Sources: *AmFokArt 248-51**.

Price, William
Flourished: 1830 Springfield, NY
Type of Work: Oil (Decorated walls and floors of houses)
Museums: 097
Sources: *AmDecor figxii, 149; FlowAm 211**.

Price, William
Flourished: 1805- Pittsburgh, PA
Type of Work: Delft-ware (Pottery)
Sources: *AmPoP 67-8, 227.*

Price, Xerxes
Flourished: c1802-1810 South Amboy (Sayreville), NJ
Type of Work: Clay (Pottery)
Sources: *AmPoP* 47, 179, 276; *Decor* 162*, 223; *DicM* 89*; *EaAmFo* 215*.

Pride, John
Flourished: 1635 Salem, MA
Ethnicity: English
Type of Work: Clay (Pottery)
Sources: *AmPoP* 57, 202; *EaAmFo* 14; *HoKnAm* 48.

Priest, William
Flourished: c1796 Baltimore, MD
Type of Work: Oil (Ornamental paintings)
Sources: *AmDecor* 99.

Priestman, James
Flourished: 1880 Boston, MA
Type of Work: Wood (Ship carvings, ship figures)
Sources: *AmFiTCa* 198.

Primrose, Jacob
Flourished: 1803 Sussex County, NJ; West Dryden, NY
Type of Work: Fabric (Coverlets)
Sources: *ChAmC* 95.

Primrose, Mordecai
Flourished: 1836 Buffalo, NY
Type of Work: Wood (Ship carvings, ship figures)
Sources: *AmFiTCa* 198.

Primrose, Robert
Flourished: 1830 New York, NY
Type of Work: Wood (Ship carvings, ship figures)
Sources: *AmFiTCa* 198.

Primus, Nelson
Ethnicity: Black American
Type of Work: (Paintings)
Sources: *AfAmA* 96.

Prince, Henry M.
Flourished: 1885 Camden, ME
Type of Work: Wood (Ship carvings, ship figures)
Sources: *AmFiTCa* 198; *ShipNA* 156.

Prince, Luke, Jr.
Flourished: 1840 Haverhill, MA
Type of Work: Oil (Portraits)
Sources: *AmPrP* 155; *PrimPa* 179.

Prindle, F.B.
Flourished: mid 19th cent Ohio
Type of Work: Oil (Peaceable kingdom paintings)
Sources: *NinCFo* 184.

Pringle, James Fulton
b. 1788 d. 1847
Type of Work: Oil (Paintings)
Sources: *FoArA* 145*.

Pringle, R.C.
See: R.C. Pringle and Company.

Pringle, Sylvester R.
Flourished: 1856 Claysburg, PA
Type of Work: Pen, ink, pencil (Calligraphy)
Sources: *HerSa* *.

Prior, Jane Otis
Flourished: c1822 Bath, ME
Type of Work: Enamel (Decorated sewing boxes)
Sources: *AmPaF* 182-3*; *ArtWo* 73, 169; *NeaT* 136*.

Prior, William Matthew
b. 1806 Bath, ME d. 1873 Boston, MA
Flourished: 1824-1873 Portland, ME; Boston, MA; Bath, ME
Type of Work: Oil (Portraits, landscape paintings)
Museums: 001,171,176,204,215
Remarks: Member of the Prior-Hamblen School
Sources: *AlAmD* 20*; *AmFoArt* 10, 16*; *AmFoPa* 4, 14-7*, 41-2, 48, 58, 76-82*, 122, 132, 134; *AmFoPo*176-182*; *AmNa* 15, 26, 77*-9*; *AmPrP* 155; *AmSFok* 160*; *BirB* 127*; *BoLiC* 68-71*; *Edith* *; *EyoAm* 18, 22*; *FoA* 3*, 468; *FoArtC* 111, 118*, 122.

Prior, William Matthew (Continued)
Sources: *FoPaAm* 23, 31-4*, 40-8, 61, 190-1, fig14-5; *GifAm* 53*; *HoKnAm* 96; *NinCFo* 168-9, 177, fig106, 121, 122, 128; *OneAmPr* 83, 117*, 121*, 147, 155; *PeiNa* 311*; *PicFoA* 12-3, 74*, 83*, 90*; *SoAmP* 31.

Prior-Hamblen School
See: Prior, W.M.; Hamblen, S.J.; Hartwell, G.G.; Alden, G.; Kennedy, W.W.

Prisbrey, Tressa (Grandma)
b. 1895 Minot, ND
Flourished: c1955-1976 Santa Susana, CA
Type of Work: Various materials (Environmental sculptures)
Remarks: Created "Bottle Village"
Sources: *ArtWo* 150-1*, 169-70*; *FoAFo* 8; *NaiVis* 10*, 76*-85*; *PioPar* 9.

Pritchard, James
Flourished: mid 19th cent
Type of Work: Pastel (House portraits)
Remarks: Worked in the southern United States
Sources: *FoPaAm* 177*.

Probst, Henry
[Probst and Seip]
b. c1805 Pennsylvania
Flourished: 1846-1857 Allentown, PA
Type of Work: Fabric (Coverlets)
Sources: *ChAmC* 95.

Probst and Seip
See: Probst, Henry.

Proby, Jacob
Flourished: 1774 South Carolina
Type of Work: Pewter (Spoons)
Sources: *AmCoB* 199.

Proby, Solomon
See: Proby, Jacob.

Proctor, D.R.
Flourished: 1860 Camden, ME
Type of Work: Wood (Ship carvings, ship figures)
Sources: *AmFiTCa* 198.

Proctor, David R.
Flourished: 1854-1866 Gloucester, MA; Belfast, ME
Type of Work: Wood (Ship carvings, cigarstore figures)
Museums: 079
Sources: *ArtWod* 156*, 265; *ShipNA* 156, 160.

Proctor, E.
b. 1760
Flourished: c1770
Type of Work: Wood (Buckets)
Sources: *EaAmWo* 170.

Prospect Hill Pottery Company
Flourished: 1880 Trenton, NJ
Type of Work: Clay (Pottery)
Sources: *DicM* 34*, 156*, 241*.

Prothro Pottery
Flourished: c1850 Rusk County, TX
Type of Work: Stoneware (Pitchers)
Sources: *AmS* 104.

Pruden, John
Flourished: 1816-1879 Elizabeth, NJ
Type of Work: Stoneware, redware (Pottery)
Sources: *AmPoP* 49, 166-7, 276; *Decor* 223; *DicM* 73*
See: John Jr.; Beerbauer, L. S.

Pruden, John M., Jr.
Flourished: 1835-1879 Elizabeth, NJ
Type of Work: Stoneware (Pottery)
Sources: *Decor* 223.

Pry, Lamont "Old Ironside"
b. 1921 Mauch Chunk, PA
Type of Work: Poster paint (Circus theme paintings)
Sources: *AmFokArt* 252-5*.

Pryce, Nathaniel
Flourished: 1661 New London, CT
Type of Work: Stone (Gravestones)
Sources: *GravNE* 129.

Pryor, Nannie Elizabeth (Sutherlin, Nannie Pryor)
Flourished: c1865 Grave County, KY
Type of Work: Fabric (Quilts)
Remarks: Sister of Sutherlin, Mary
Sources: *KenQu* fig20.

Pudor, H.
Flourished: 1860 Lawville, NY
Type of Work: Oil (Group portraits)
Sources: *PrimPa 179.*

Pugh, Dow (Loranzo)
Flourished: 1972 Monterey, TN
Type of Work: Oil, wood (Portraits, sculptures)
Museums: 172
Sources: *BirB 147*; ConAmF 107-12*; FoAFv 1*, 4-5*.*

Pugh, Loranzo
See: Pugh, Dow (Loranzo).

Pulaski, J. Irvin
Flourished: 1854 Oswego County, NY
Type of Work: Fabric (Coverlets)
Museums: 219
Sources: *FouNY 63.*

Punderson, Hannah
b. 1776 **d.** 1821
Type of Work: Watercolor (Mourning paintings)
Museums: 054
Remarks: Sister-in-law of Punderson, Prudence (Rossiter)
Sources: *ArtWo 7, 61*, 170.*

Punderson, Prudence (Rossiter)
b. 1758 **d.** 1784
Type of Work: Needlework (Portraits)
Museums: 054
Remarks: Mother is Prudence; sister-in-law is Hannah
Sources: *AmPaF 78*; AmSQu 57*; ArtWo 7, 30-1*, 61, 170.*

Punderson, Prudence Geer
b. 1735 **d.** 1822
Flourished: Preston, CT
Type of Work: Fabric (Coverlets)
Museums: 054
Remarks: Daughter is Prudence; daughter-in-law is Hannah
Sources: *AmSQu 57*; ArtWo 7*, 61, 151.*

Purcell, Eleanor
Flourished: c1755 Boston, MA
Type of Work: Fabric (Needlework)
Sources: *WinGu 134.*

Purchasem, Mark
Flourished: 1877 Meriden, CT
Type of Work: Tin (Tinware)
Sources: *TinC 179.*

Purdo, Nick
Flourished: 1950s Michigan
Type of Work: Wood (Decoys)
Sources: *WaDec 152*.*

Purdy, C.
Flourished: c1860s Atwater, OH
Type of Work: Stoneware (Pottery)
Museums: 208
Sources: *AmPoP 207; Decor 94*.*

Purdy, Charlie
Flourished: Salem, MA
Type of Work: Oil (Portraits, landscape paintings)
Sources: *AmPrP 155; PrimPa 179; SoAmP 161.*

Purdy, Fitzhugh
[Purdy and Loomis]
Flourished: 1800's Atwater, OH
Type of Work: Stoneware (Pottery)
Sources: *AmPoP 207; Decor 223.*

Purdy, Gordon B.
Flourished: 1860-1870 Atwater, OH
Type of Work: Stoneware (Pottery)
Remarks: Father is Solomon
Sources: *AmFokA 63-5, fig39; AmPoP 207; Decor 223.*

Purdy, Solomon
Flourished: c1820-1834 Atwater, OH; Putnam, OH
Type of Work: Stoneware, clay (Pottery)
Museums: 147
Remarks: Worked for Zoar Pottery; son is Gordon B.
Sources: *AmPoP 68, 207, 228; AmSFok 130*; Decor 223; DicM 124*.*

Purdy and Loomis
See: Purdy, Fitzhugh.

Purinton, Beulah
b. 1802
Flourished: 1812 Danvers, MA
Type of Work: Fabric (Samplers)
Sources: *PlaFan 84*.*

Purintum, Abigail
Flourished: 1788 Reading, MA
Type of Work: Fabric (Samplers)
Sources: *BeyN 109.*

Puritan Iron Works
Flourished: 1903-1931 Boston, MA
Type of Work: Iron (Weathervanes)
Sources: *YankWe 213.*

Purrington, Caleb B.
Flourished: 1848
Type of Work: Tempera (Panoramic paintings)
Sources: *AmFoPaN 103, 136-7*.*

Purrington, Henry J.
b. 1825 Mattapoisett, MA
Flourished: 1850-1900 Mattapoisett, MA; New Bedford, MA
Type of Work: Wood (Ship carvings, ship figures)
Museums: 186,194
Remarks: Also known as "Henry Carver" (Uncle Henry)
Sources: *AmFiTCa 38, 147-50, 198, figxxviii; AmFokAr 31; FigSh 60; ShipNA 160.*

Purrington and Tabor
Flourished: 1848
Sources: *AmFoPaN 103*
See: Purrington, Caleb B.

Pursell, Daniel
Flourished: 1840-1850 Portsmouth, OH
Type of Work: Fabric (Coverlets)
Sources: *AmSQu 160*, 176; ChAmC 96.*

Pursell, John
Flourished: 1865 Boston, MA
Type of Work: Wood (Ship carvings, ship figures)
Sources: *AmFiTCa 199.*

Purves, John W.
Flourished: 1864-1880 Washington
Type of Work: Wood (Glass cupboards)
Sources: *ASeMo 343*.*

Putnam, Betsy
Flourished: 1790-1810 Salem, MA
Type of Work: Fabric, watercolor (Family arms pictures)
Sources: *PlaFan 173*.*

Putnam, George
Flourished: 1821-1844 Hartford, CT
Type of Work: Wood, paper (Handboxes)
Museums: 056
Sources: *AmSFo 131*.*

Putnam, N.B.
Flourished: 1877 Meriden, CT
Type of Work: Tin (Tinware)
Sources: *TinC 179.*

Putnam, Ruthey
b. c1768
Flourished: 1778 Salem, MA
Type of Work: Fabric (Samplers)
Sources: *GalAmS 27*, 90.*

Putnam and Roff
Flourished: 1823-1824 Hartford, CT
Type of Work: (Hat boxes, other decorated boxes)
Sources: *InAmD 85*.*

Putney, Henry
Flourished: mid 19th cent
Type of Work: Watercolor (Paintings)
Sources: *AlAmD 23*.*

Puwelle, Arnold
Flourished: Pennsylvania
Type of Work: Watercolor, ink (Frakturs)
Sources: *AmFoPa 189.*

Pyatt, George
Flourished: 1846-1879 Zanesville, OH; Cincinnati, OH; Kaolin, MO
Type of Work: Yellow-ware, Rockingham (Pottery)
Remarks: Son is Pyatt, J.G.
Sources: *AmPoP 77-8, 210, 222, 234.*

Pyatt, J.G.
[Tremont Pottery]
Flourished: 1879-1900 Zanesville, OH
Type of Work: Yellow-ware, Rockingham (Pottery)
Remarks: Father is George
Sources: *AmPoP 234.*

Pyfer, William
Flourished: 1833 Philadelphia, PA
Type of Work: Wood (Ship carvings, ship figures)
Sources: *AmFiTCa 199.*

Pyle, John W.
Flourished: 1845 New York, NY
Type of Work: Wood (Ship carvings, ship figures)
Sources: *AmFiTCa 199.*

Q

Quade, Julius
Flourished: 1870 St. Charles, MO
Type of Work: Tin (Tinware)
Sources: *ASeMo 430.*

Queen City Terra-Cotta Company
Flourished: 1859-1870 Cincinnati, OH
Type of Work: Redware (Pottery)
Sources: *AmPoP 211.*

Queor, William B.
d. 1981
Flourished: North Lawrence, NY
Type of Work: Wood (Toys, fish, flower bowls)
Sources: *FouNY 23, 64*.*

Quest, Francis
Flourished: 1860 New York, NY
Type of Work: Wood (Ship carvings, ship figures)
Sources: *AmFiTCa 199.*

Quick, Sarah V.B.
Flourished: 1844
Type of Work: Fabric (Quilts)
Sources: *AmSQu 177*.*

Quidor, John
b. 1801 **d.** 1881
Flourished: c1839 Philadelphia, PA; Quincy, IL
Type of Work: Oil (Fire engines, hose carts, scene paintings)
Sources: *AmFokDe 130; ArC 162*; TwCA 14.*

Quigley, S.
Flourished: c1834 Cincinnati, OH
Type of Work: Stoneware, clay (Pottery)
Sources: *AmPoP 210, 276; Decor 223; DicM 125*.*

Quiles, Manuel
b. 1908
Flourished: New York, NY
Ethnicity: Puerto Rican
Type of Work: Wood (Whimsical figures)
Sources: *AmFokArt 256-8*.*

Quillen, Nate
b. 1839 **d.** 1908
Flourished: Point Mouille, MI
Type of Work: Wood (Decoys)
Sources: *WaDec 17-9*, 91, fig10.*

Quinby, Sarah A.
b. 1822
Type of Work: Fabric (Embroidered candlewick spreads)
Sources: *AmSQu 284*.*

Quincy, Caroline
Flourished: 1823
Type of Work: Fabric (Mourning pictures)
Sources: *Edith *.*

Quincy, Mary Perkins
Flourished: 1894 Litchfield, CT
Type of Work: Fabric (Coverlets)
Museums: 133
Sources: *AmNe 163-4*; AmSQu 305*.*

Quinn, C.F.
Flourished: 1871 Boston, MA
Type of Work: Wood (Ship carvings, ship figures)
Remarks: Worked with Quinn, J.C.
Sources: *AmFiTCa 199.*

Quinn, E.H.
Flourished: c1860 Brooklyn, NY
Type of Work: Stoneware (Pottery)
Sources: *Decor 223.*

Quinn, J.C.
See: Quinn, C.F.

Quinn, John
Flourished: 1877 Meriden, CT
Type of Work: Tin (Tinware)
Sources: *TinC 179.*

R

R. and B. Tisdale
See: Tisdale, Riley.

R.C. Pringle and Company
Flourished: 1893 Lewiston, ME
Type of Work: Wood (Ship carvings, ship figures)
Sources: *AmFiTCa 198.*

R. Clark and Company
Flourished: 1860-1890 Cannelton, IN
Type of Work: Stoneware (Pitchers)
Sources: *AmS 161*.*

R.H. Counce and Company
Flourished: 1856-1878 Thomaston, ME
Type of Work: Wood (Ship carvings, ship figures)
Sources: *AmFiTCa 190; ShipNA 157*
See: Counce, Harvey P.

R.R. Thomas and Company
Flourished: 1886 Philadelphia, PA
Type of Work: Wood (Ship carvings, ship figures)
Sources: *AmFiTCa 201.*

Rabinoffsky, Isaac Irwin
See: Rabinov, Irwin.

Rabinov, Irwin
[Rabinoffsky, Isaac Irwin]
b. 1898 New York, NY **d.** 1980 San Diego, CA
Ethnicity: Jewish
Type of Work: Enamel on metal (Enamel works)
Sources: *PioPar 50*, 62.*

Radfore, P.M.
Flourished: Illinois
Type of Work: (Paintings)
Sources: *ArC 266.*

Raeder, Hartman
Flourished: 1851 Baltimore, MD
Type of Work: Wood (Ship carvings, ship figures)
Sources: *AmFiTCa 199.*

Raeder, Sebastian
Flourished: 1851 Baltimore, MD
Type of Work: Wood (Ship carvings, ship figures)
Sources: *AmFiTCa 199.*

Rahmeier, Frederick
[Reymeyer]
d. 1850s
Flourished: 1833 St. Charles County, MO; Femme Osage Valley, MO
Type of Work: Wood (Chairs)
Sources: *ASeMo 316*.*

Raidel, Dorion
b. 1892 **d.** 1977
Flourished: late 1920's Charlotte, MI
Type of Work: Wood (Birdhouses, canes, plaques, whistles)
Remarks: Form known as "Bird Villa"; her father, Adam, also carved birdhouses
Sources: *Rain 93-5*.*

Raiser, Jacob
[Reiser]
Flourished: c1796 Philadelphia, PA
Type of Work: Tin (Tinware)
Sources: *AmCoTW 153; ToCPS 6.*

Rakestraw, Joseph
Flourished: 1787
Type of Work: Metal (Weathervanes)
Museums: 166
Remarks: Made the weathervane for Mount Vernon
Sources: *AmFoS 51*; GalAmW 12-13*, 18.*

Raleigh, Charles Sidney
b. 1830 **d.** 1925
Flourished: 1880-1890 New Bedford, MA; Bourne, MA
Ethnicity: English
Type of Work: Oil (Paintings)
Museums: 189
Sources: *AmFoPa 111*-2; AmNa 18, 26, 81; FoA 60*, 468; OneAmPr 132*, 135*, 148-9, 155.*

Ramirez, Martin
b. 1885 **d.** 1960 Auburn, CA
Flourished: c1945 Auburn, CA
Ethnicity: Mexican
Type of Work: Pencil, crayon, ink (Religious, fantasy and idealized drawings)
Museums: 165
Remarks: Artist's work done while a mute patient in DeWitt State Hospital, Sacramento
Sources: *AmFokArt 259-61*; FoAFa 4*-5*; FoPaAm 14, 238, fig69; Full *; PioPar 14-5*, 18, 44, 50*; Trans 6-7, 9, 17*-8*, 21, 55; TwCA 124-5*.*

Ramsey, Barnett
Flourished: c1850s Athens, IL
Type of Work: Clay (Pottery)
Sources: *ArC 193.*

Ramsey, Joseph
Flourished: 1851 Philadelphia, PA
Type of Work: Wood (Ship carvings, ship figures)
Sources: *AmFiTCa 199.*

Ramsey, Margaret
Flourished: 1789 Albany, NY
Type of Work: Fabric (Samplers)
Sources: *AmNe 48.*

Ramsey, William
Flourished: c1831-1833 White Hall, IL
Type of Work: Clay (Pottery)
Sources: *ArC 189.*

Rand, J.
Flourished: 1820
Type of Work: Oil (Portraits)
Sources: *PrimPa 179.*

Randall, A.M.
Flourished: 1777
Type of Work: Oil (Still life paintings)
Museums: 189
Sources: *AmNa 11.*

Randall, Amey
b. 1780 Providence, RI d. 1845 Providence?, RI?
Flourished: 1793 Providence, RI
Type of Work: Fabric (Samplers)
Museums: 241
Sources: *LeViB 128-9**.

Randall, James
Flourished: late 1600's Burlington, NJ
Type of Work: Clay (Pottery)
Remarks: Worked for Coxe, Daniel
Sources: *AmPoP 39*.

Randall, Jane Spillman
Flourished: 1979 Gouverneur, NY
Type of Work: Fabric (Quilts)
Sources: *FouNY 67*.

Randall, Sarah Ann
b. c1815
Flourished: 1828
Type of Work: Fabric (Samplers)
Sources: *SoFoA 174*, 222*.

Randel, Martin
Flourished: 1848 Chardon, OH
Type of Work: Fabric (Weavings)
Sources: *ChAmC 96*.

Randell, Martha
Flourished: 1848 Chardo, OH
Type of Work: Fabric (Weavings)
Sources: *AmSQu 277*.

Randolph, James T.
Flourished: 1840-1857 Baltimore, MD
Type of Work: Wood, marble (Ship carvings, ship figures, sculptures)
Remarks: Carver for Harold and Randolph
Sources: *AmFiTCa 120-1, 199; ArtWod 125; ShipNA 62, 72, 158*.

Randolph and Seward
Flourished: 1860 Baltimore, MD
Type of Work: Wood (Ship carvings, ship figures)
Sources: *AmFiTCa 199*.

Rank, John Peter (Johann)
Flourished: c1800 Columbia County, PA
Type of Work: Wood (Dower chests)
Museums: 097
Sources: *AmFokDe 11; PenGer 141-2**.

Rank, Peter
Flourished: c1800 Columbia County, PA; Lebanon County, PA
Type of Work: Wood (Dower chests)
Sources: *AmFokDe 11; PenGer 37, 57, 65-7, 141-2**.

Ranninger, Conrad
[Renninger]
Flourished: 1835-1845 Montgomery County, PA
Type of Work: Redware (Pottery)
Sources: *AmPoP 186; BeyN 77*, 113**.

Raper, Millie
Flourished: 1976
Ethnicity: Amish
Type of Work: Fabric (Quilts)
Sources: *QufInA 57**.

Rappe, Mary
Flourished: 1790 Ohio
Type of Work: Watercolor (Genre paintings)
Sources: *PrimPa 179*.

Raser, John H.
Flourished: 1850
Type of Work: Oil (Paintings)
Museums: 054
Sources: *FoArA 105**.

Rasmussen, Charles
Flourished: late 19th cent Pennsylvania
Ethnicity: German
Type of Work: Paint (Scene paintings)
Sources: *AmNa 17*.

Rasmussen, J(ohn)
d. 1895
Flourished: 1867-1880 Berks County, PA
Ethnicity: German
Type of Work: Oil on tin (Landscape paintings)
Sources: *AmFoPaS 103*; AmPrP 155; FoA 468; FoPaAm 132-3*, 142; PrimPa 179*.

Rasmussen, Nils
Flourished: 1859-1861 Chicago, IL
Sources: *ArC 266*
See: Kimball, H.C.

Rassweiler, H.
Flourished: 1843-1846 Allentown, PA
Type of Work: Fabric (Weavings)
Sources: *ChAmC 96*.

Rassweiler, Philip
b. c1822
Flourished: 1844-1867 Orwigsburg, PA; Millersburg, PA
Ethnicity: German
Type of Work: Fabric (Coverlets)
Sources: *AmSQu 277; ChAmC 96*.

Ratcliffe, M.T.
Flourished: 1930s Jacumba, CA
Type of Work: Rock, granite (Sculptures)
Sources: *TwCA 88**.

Rattray, Matthew
b. 1796 d. 1872
Flourished: 1822-1841? Richmond, IN
Ethnicity: Scottish
Type of Work: Fabric (Carpets, coverlets)
Sources: *ChAmC 17*, 96*.

Rauch, Elisaeet
Flourished: c1800-1850 Pennsylvania
Type of Work: Fabric (Hand towels)
Sources: *PlaFan 133**.

Rauch, M.
Flourished: 1850-1860 Ohio
Type of Work: Fabric (Weavings)
Sources: *ChAmC 96*.

Rauser, Gabriel
[Rausher]
b. c1803
Flourished: 1842-1858 Lehigh County, PA; Delaware County, OH
Ethnicity: German
Type of Work: Fabric (Coverlets)
Sources: *AmSQu 260*, 277; ChAmC 96*.

Rausher, Gabriel
See: Rauser, Gabriel.

Rawson, Eleanor
Flourished: 1820 Vermont
Type of Work: Watercolor (Genre paintings)
Sources: *PrimPa 179*.

Raymond, Edmund
Flourished: 1805-1807 Boston, MA
Type of Work: Wood (Ship carvings, ship figures)
Sources: *AmFiTCa 131, 199; EaAmW 73; ShipNA 42, 159*
See: Fowle, Isaac.

Raymond, J.
Flourished: 1825-1835 Essex County, MA
Type of Work: Wood (Rocking chairs)
Sources: *AmPaF 246**.

Raymond, James S., M.D.
Flourished: 1901 Potsdam, NY
Type of Work: Watercolor (Paintings)
Museums: 235
Sources: *FouNY 67**.

Raymond and Fowle
Flourished: 1807-1813 Boston, MA
Type of Work: Wood (Ship carvings, ship figures)
Sources: *ShipNA 159*
See: Raymond, Edmund; Fowle, Isaac.

Raynor, Ben
Flourished: Long Island, NY
Type of Work: Wood (Duck decoys)
Sources: *AmBiDe 95*.

Rea and Johnston
See: Johnston, John.

Read
See: Patterson and Read.

Read, Thomas
Flourished: c1850-1865 New Philadelphia, OH; Newport, OH
Type of Work: Stoneware (Pottery)
Sources: *AmPoP 225; Decor 223; DicM 132**.

Reade, Luke
See: Reed, Luke.

Reasoner, Mrs. A.E.
Flourished: 1885 New Jersey
Type of Work: Fabric (Quilts)
Museums: 204
Sources: *AmSQu 296**.

Reay, Charles
[Belleville Clay and Mining and Pottery Co.]
Flourished: 1848-1884 Belleville, IL
Type of Work: Stoneware (Pottery)
Sources: *ArC 190*.

Reber, John Slatington Carver
b. 1857 d. 1938
Flourished: 1880-1920 Pennsylvania
Type of Work: Wood (Sculptures, carvings)
Museums: 096
Sources: *AmFoS 178**, *338**.

Red Wing Pottery
[Red Wing Stoneware Company]
Flourished: 1872-1915 Red Wing, MN
Type of Work: Stoneware (Pottery)
Sources: *AmPoP 228*; *AmS 84**, *175**, *222**, *254*; *Decor 223*.

Red Wing Stoneware Company
See: Red Wing Pottery.

Redford Glass Works
Flourished: 1831-1851 Clinton County, NY
Type of Work: Glass (Glass works)
Museums: 049
Sources: *FouNY 63*.

Redick, John
Flourished: 1852-1869 Troy Township, OH; Tamaroa, IL
Type of Work: Fabric (Coverlets)
Sources: *ChAmC 96*.

Redman, Richard
Flourished: 1772 Philadelphia, PA
Type of Work: Tin (Tinware)
Remarks: Brother is Thomas
Sources: *ToCPS 4*.

Redman, Thomas
Flourished: 1772 Philadelphia, PA
Type of Work: Tin (Tinware)
Remarks: Brother is Richard
Sources: *ToCPS 4*.

Redwood Glass Works
Flourished: Jefferson County, NY
Type of Work: Glass (Glass works)
Sources: *FouNY 63*.

Reed, Abner
Flourished: c1800-1808 East Windsor, CT
Type of Work: Wood (Signs)
Sources: *FoPaAm 32*; *MoBBTaS 11*.

Reed, Dolly Hartwell
b. 1803
Type of Work: Fabric (Samplers)
Sources: *FoArtC 52*.

Reed, Ernest "Popeye"
b. 1924 Jackson, OH d. 1985
Flourished: 1938 Jackson, OH
Type of Work: Stone (Carvings)
Sources: *AmFokArt 262-4**; *FoAFm 12**.

Reed, Kate D.
Flourished: 19th century Frankfort, IN
Type of Work: Fabric (Quilts)
Museums: 016
Sources: *QuiAm 148**.

Reed, Kenneth
Flourished: South Warren, ME
Type of Work: Metal (Weathervanes)
Sources: *WeaWhir 111-2**.

Reed, Luke
[Reade]
Flourished: Berlin, CT
Type of Work: Tin (Tinware)
Remarks: Worked for Oliver Filley; sold to Hubbard, John
Sources: *TinC 179*.

Reed, P.
Flourished: 1840 Leominster, MA
Type of Work: Oil (Paintings)
Sources: *AmPrP 155*; *PrimPa 179*; *SoAmP 287*.

Reed, Eldress Polly
Flourished: 1847 Mount Lebanon, NY
Type of Work: Pen, ink (Religious drawings)
Sources: *CoCoWA 108**; *InAmD 14**.

Reed, Reuben Law
Type of Work: Oil (Portraits)
Museums: 001
Sources: *BirB 156**.

Reed, V.R.
Flourished: 1883 Benton, NY
Type of Work: Fabric (Weavings)
Sources: *AmSQu 277*; *ChAmC 96*.

Reed, William A.
Flourished: 1855-1856 Quincy, IL; Stark County, OH
Type of Work: Fabric (Coverlets)
Sources: *ArC 266*; *ChAmC 96*.

Reems Creek Pottery
Flourished: c1915 North Carolina
Type of Work: Stoneware (Pottery)
Museums: 132
Sources: *AmS 28-32**, *40-1*, *44*
See: Donkle, George.

Reese, Susannah S.
Flourished: 1800-1830 Lynchburg, VA
Type of Work: Fabric (Samplers)
Sources: *SoFoA 172**, *222*.

Reeve, Joseph H.
Flourished: 1817 Mount Holly, NJ
Type of Work: Fabric (Weavings)
Sources: *ChAmC 96*.

Reeves, B.
Flourished: c1850 Fulton, OH
Type of Work: Stone (Gravestones)
Sources: *EaAmG 129*.

Regensburg, Sophy
b. 1885 New York, NY d. 1974 New York, NY
Flourished: 1952- New York, NY
Type of Work: Oil (Still life paintings)
Sources: *HoKnAm 185*; *TwCA 144**.

Reghi, Ralph
b. 1914 Hillsboro, IL
Flourished: Detroit, MI
Type of Work: Wood (Decoys)
Sources: *WaDec 4-5**, *36-41**, *fig8*.

Reich, Elizabeth
Flourished: 1821 Pennsylvania
Type of Work: Watercolor, ink (Frakturs)
Sources: *AmFoPa 189*.

Reichard, Daniel
Flourished: c1813 Hagerstown, MD
Type of Work: Redware (Pottery)
Sources: *AmPoP 168*.

Reichert, H.
Flourished: Bucyrus, OH
Type of Work: Fabric (Coverlets)
Sources: *ChAmC 96*.

Reichter, Frederick
Flourished: Selinsgrove, PA
Type of Work: Tin (Tinware)
Sources: *ToCPS 43*.

Reid, A.D.
Flourished: 1834 New England,
Type of Work: Watercolor (Memorial paintings)
Sources: *FoPaAm 35**.

Reid, G.
Flourished: Winchester, VA
Type of Work: Copper (Tea kettles)
Sources: *AmCoB 66**.

Reid, Margaret
b. c1824
Flourished: 1837
Type of Work: Fabric (Samplers)
Sources: *AmNe 60*.

Reidinger and Caire
[Rudinger; Riedinger; Reidenger; Riedenger]
Flourished: 1856-1896 Poughkeepsie, NY
Type of Work: Clay (Pottery)
Sources: *AmPoP 201*; *AmSFo 45**; *Decor 223*; *DicM 113**; *EaAmFo 209**, *234**, *240**.

Reifsneider, Charles
Flourished: 1874 Philadelphia, PA
Type of Work: Wood (Ship carvings, ship figures)
Sources: *AmFiTCa 199*.

Reiner, Georg
Flourished: 1810 Milford Township, PA
Type of Work: Fabric (Weavings)
Sources: *ChAmC 96*.

Reinke, Samuel
Flourished: c1827 Bethlehem, PA
Type of Work: Wood (Mourning pictures)
Museums: 164
Sources: *MoBeA fig29*.

Reinwald, Sarah
Flourished: 1787 Pennsylvania
Type of Work: Watercolor, ink (Frakturs)
Sources: *AmFoPa 189*.

Reiser, Jacob
See: Raiser, Jacob.

Reiss, Al
b. 1917
Flourished: c1977 Fairhaven, MI
Type of Work: Wood (Carvings)
Remarks: Grandfather was Jack Reiss who worked for Melchers, Julius
Sources: *Rain 91*-2**.

Reiss, William
Flourished: c1851 Wilmington, DE
Type of Work: Stoneware, redware (Pottery)
Sources: *AmPoP 185; Decor 223*.

Reist, Johannes
Flourished: 1829
Type of Work: Watercolor, ink (Frakturs)
Museums: 176
Sources: *ColAWC 276, 279**.

Reiter, Nicholas
Flourished: 1850s Carthage, IN
Ethnicity: German
Type of Work: Fabric (Weavings)
Sources: *ChAmC 96*
See: Stinger, Samuel.

Reitz, Isaac Jones
b. 1863 d. 1949
Flourished: 1870-1922? Sunbury, PA
Type of Work: Tin (Tinware, tin dollhouses)
Sources: *ToCPS 43**.

Remey, Henry
See: Remmey, Henry, II.

Remington, Mary "Polly"
b. 1793 Warwick, RI d. 1820
Flourished: 1799-1815 East Greenwich, RI
Type of Work: Fabric (Embroidered mourning pictures, samplers, linens)
Museums: 097
Sources: *LeViB 218, 238-9*; PlaFan 77*, 158*; WinGu 53*, 126**.

Remington, "Polly"
See: Remington, Mary.

Remmey, Henry, I
Flourished: 1785 New York, NY
Type of Work: Stoneware (Pottery)
Remarks: Son is Henry II
Sources: *Decor 201*; HoKnAm pl10, 53*.

Remmey, Henry, II
[Remey]
Flourished: 1810-1835 Philadelphia, PA
Type of Work: Stoneware (Pottery)
Remarks: Father is Henry I; son is Henry III
Sources: *AmPoP 46, 51, 55, 175; ArEn 50, 54*; Decor 223*.

Remmey, Henry, III
Flourished: c1818-1859 Baltimore, MD; Philadelphia, PA
Type of Work: Stoneware (Pottery)
Remarks: Father is Henry II
Sources: *AmPoP 51, 163, 175; Decor 223*.

Remmey, Johannes, I
See: Remmey, John, I.

Remmey, John, I (Johannes)
Flourished: 1735-1762 New York, NY
Type of Work: Redware (Pottery)
Remarks: Son is John II
Sources: *AmPoP 46, 55, 175, 197, 276*.

Remmey, John, II
Flourished: 1762-1793 New York, NY
Type of Work: Stoneware (Pottery)
Remarks: Father is John I; son is John III
Sources: *AmPoP 55, 197*.

Remmey, John, III
Flourished: 1794-1820 New York, NY
Type of Work: Stoneware (Pottery)
Museums: 097
Remarks: Father is John II
Sources: *AmPoP 197*.

Remmey, Joseph Henry
Flourished: c1818-1826 South Amboy, NJ
Type of Work: Stoneware (Pottery)
Sources: *AmPoP 47, 180, 197; Decor 223*.

Remmey, R(ichard) C(linton)
Flourished: c1859-1880 Philadelphia, PA
Type of Work: Stoneware (Pottery)
Museums: 001, 227
Sources: *AmPoP 17fig22, 175, 276; AmS 105*; BeyN 125; Decor 153*, 171*, 187*, 223; DicM 109*, 111*, 251*; FoArRP 28*; PenDA 128**.

Remmey and Burnet
Flourished: c1840 Philadelphia, PA
Type of Work: Stoneware (Pottery)
Sources: *AmPoP 176; Decor 223*.

Remmick, Joseph
Flourished: 1875 Union, NH
Type of Work: Wood (Toys)
Sources: *FlowAm 175**.

Remney, Henry, I
See: Remmey, Henry, I.

Remney, Henry, II
See: Remmey, Henry, II.

Remney, Henry, III
See: Remmey, Henry, III.

Remney, John, I
See: Remmey, John, I.

Remney, John, II
See: Remmey, John, II.

Remney, John, III
See: Remmey, John, III.

Remney, Joseph Henry
See: Remmey, Joseph Henry.

Remney, Richard Clinton
See: Remmey, Richard Clinton.

Remy, James
Flourished: 1834-1840 Logan Township, IN
Type of Work: Fabric (Coverlets)
Sources: *ChAmC 98*.

Rendon, Enrique
b. 1923 Monero, NM
Flourished: 1976- Velarde, NM
Ethnicity: Hispanic
Type of Work: Wood (Santeros)
Sources: *FoAFc 12*-3**.

Renner, George
Flourished: 1838-1843 Schaefferstown, PA
Type of Work: Fabric (Weavings)
Sources: *ChAmC 98*
See: Leidig, Peter; Renner, P.

Renner, P.
Flourished: Lebanon County, PA
Type of Work: Fabric (Weavings)
Sources: *ChAmC 98*
See: Renner, George.

Renninger, Conrad
See: Ranninger, Conrad.

Renninger, Johannes, Jr. (John)
Flourished: 1843-1873 Gerysville, PA
Type of Work: Watercolor, ink (Frakturs)
Sources: *AmFoPa 189; AmPoP 168*.

Renninger, John
Flourished: c1815-1843 Gerysville, PA
Type of Work: Clay (Pottery)
Sources: *AmPoP 43, 168, 174, 179*.

Renninger, John, Jr.
See: Renninger, Johannes, Jr.

Renninger, Wendell
Flourished: c1800-1815 Gerysville, PA
Type of Work: Clay (Pottery)
Sources: *AmPoP 43, 168*.

Renouf, Edward M.
Flourished: 1834 New York, NY
Type of Work: Wood (Ship carvings, ship figures)
Sources: *AmFiTCa 199.*

Renouf and Brinckerhoff
See: Brinckerhoff, John P. .

Renshaw, Thomas
Flourished: 1814 Baltimore, MD
Type of Work: Wood (Furniture)
Sources: *AmPaF 136*.*
See: Barnhardt, John .

Reppert
See: Williams and Reppert .

Resser, William W. "Will"
b. 1860 d. 1941
Flourished: East Berlin, PA
Type of Work: Tin (Tinware)
Sources: *ToCPS 42, 45.*

Ressler, Rudolph
b. c1822 Pennsylvania
Flourished: 1850-1857 Leacock Township, PA
Type of Work: Fabric (Weavings)
Sources: *ChAmC 98*
See: Hersh, Henry .

Rexrode, James
Flourished: 1964 Sugar Grove, WV
Type of Work: Oil (Memory paintings)
Sources: *ConAmF 49-53*.*

Reyher, Max
b. 1862
Flourished: 1926- Belmar, NJ
Ethnicity: German
Type of Work: Oil (Mystical scene paintings)
Sources: *PrimPa 179; ThTaT 150-3*.*

Reymeyer, Frederick
See: Rahmeier, Frederick .

Reynell, John
Flourished: 18th century Philadelphia, PA
Type of Work: Wood (Ship carvings, ship figures)
Sources: *AmFiTCa 40, 47.*

Reynolds
Flourished: c1869 Owensboro, IN
Type of Work: Stoneware (Pottery)
Sources: *AmPoP 226; Decor 223.*

Reynolds, J.W.
Flourished: c1900 Chicago, IL
Type of Work: Wood (Duck decoys)
Sources: *AmBiDe 235*; AmDecoy 84*.*

Reynolds, Lydia Barlett
Flourished: 1788 Montgomery County, NY
Type of Work: Pen, ink, watercolor (Penmanship, calligraphy drawings)
Museums: 163
Sources: *FouNY 65.*

Reynolds, Mrs. P.
Flourished: 1820 New England,
Type of Work: Fabric (Quilts)
Museums: 022
Sources: *AmSQu 210*.*

Reynolds, W.J., Dr.
Flourished: early 20th cent Selma, AL
Type of Work: Wood (Whirligigs)
Sources: *SoFoA 94*, 219.*

Rezinor, John
b. New York
Flourished: 1850 Clinton Township, OH
Type of Work: Fabric (Weavings)
Sources: *ChAmC 98.*

Rheinhardt, Enoch W.
Flourished: c1930 Vale, NC
Type of Work: Stoneware (Jars, pitchers)
Museums: 157,236
Sources: *AmS 89*, 145*.*

"Rhenae"
Flourished: Los Angeles?, CA?
Ethnicity: Black American
Type of Work: (Paintings)
Sources: *FoAFc 2*.*

Rhoads, Jessie Dubose
b. 1900 Elba, AL d. 1972 Columbus, GA
Flourished: 1961 Phenix, AL
Type of Work: Oil (Paintings)
Sources: *TwCA 197*.*

Rhode, Henry
Flourished: 1840 New York, NY
Type of Work: Wood (Ship carvings, ship figures)
Sources: *AmFiTCa 199.*

Rhodes, Collin
Flourished: 1850 Edgefield, SC
Type of Work: Stoneware (Jars, bowls)
Sources: *AmS 43*, 86*, 90*, 96*, 101*, 170*, 173*, 209*, 257*; SoFoA 12*, 20*-1*, 217.*

Rhodes, D.
Flourished: 1970 Absecon, NJ
Type of Work: Wood (Duck decoys)
Sources: *WoCar 169*.*

Rhodes, Daniel
b. 1838 d. 1901
Flourished: Middleburg, PA
Type of Work: Tin (Tinware)
Sources: *ToCPS 42, 56-7*.*

Rhodes, T.
Flourished: 1865-1900 Lincolntown, NC
Type of Work: Stoneware (Pottery)
Sources: *AmPoP 239.*

Rhodes and Yates
Flourished: 1858-1865 Trenton, NJ
Type of Work: Cream-colored ware (Pottery)
Sources: *AmPoP 181.*

Rhodes, Strong and McGeron
Flourished: 1845-1854 Jersey City, NJ
Type of Work: Whiteware (Pottery)
Sources: *AmPoP 49, 170.*

Ricalton, William
Flourished: 1970 Watertown, NY
Type of Work: Wood (Sculptures, carvings)
Sources: *FouNY 67.*

Rice, Emery
Flourished: Hancock, NH
Type of Work: Oil (Ornamental paintings)
Sources: *AmDecor 101, 153.*

Rice, Ernest S.
Flourished: Camden, ME
Type of Work: Metal (Weathervanes)
Sources: *FoArtC 70.*

Rice, Prosper
Flourished: 1827-1850 Putnam, OH
Type of Work: Stoneware (Pottery)
Sources: *AmPoP 228; Decor 223; DicM 107*.*

Rice, R.
Flourished: c1890 Mobile Bay, AL
Type of Work: Wood (Duck decoys)
Museums: 260
Sources: *Decoy 13*.*

Rice, Sandra
b. 1949 Birmingham, AL
Type of Work: Clay (Pottery)
Sources: *AmFokArt 265-7*.*

Rice, William
b. 1773 d. 1847
Flourished: c1818-1850 Hartford, CT; Norway, ME
Type of Work: Oil, wood (Signs)
Sources: *AmFokDe xii; CoCoWA 6-7*; FlowAm 221*; FoA 468; InAmD 65*; MoBBTaS 9, 83*, 35*, 50*, 67*; PicFoA 14, 137*.*

Rich
Flourished: c1870 Roscoe, OH
Type of Work: Stoneware (Pottery)
Sources: *AmPoP 229; Decor 223.*

Rich, James
Flourished: c1859 Redford, OH
Type of Work: Wood (Dolls)
Sources: *EaAmW 102.*

Rich, John
b. 1786 d. 1871 Dunstable Township, PA
Flourished: 1854 Clinton County, PA
Ethnicity: English
Type of Work: Fabric (Weavings)
Sources: *AmSQu 277; ChAmC 98*
See: Chatham's Run Factory .

Rich, John
Flourished: 1877 Meriden, CT
Type of Work: Tin (Tinware)
Sources: *TinC 179.*

Rich, Sheldon
Flourished: c1804 Bristol, CT
Type of Work: Tin (Tinware, clocks)
Sources: *TinC 179.*

Richard, J.
Flourished: 1865
Type of Work: Oil (Genre paintings)
Sources: *PrimPa 179.*

Richards
See: Spafford and Richards.

Richards, Elizabeth
Flourished: Boston, MA
Type of Work: Fabric (Samplers)
Sources: *PlaFan 80*.*

Richards, Frank Pierson
b. 1852 d. 1929
Flourished: 1880-1888 Springfield, IL
Type of Work: Wood (Sculptures, carvings)
Museums: 114
Sources: *AmFoS 120*.*

Richards, John
b. 1831 d. 1889
Flourished: c1870
Type of Work: Pen, wash, pencil (Drawings)
Sources: *Edith *.*

Richardson
Flourished: 1835
Type of Work: Fabric (Weavings)
Sources: *AmSQu 277; ChAmC 98.*

Richardson
Flourished: c1865 Centreville, PA
Type of Work: Oil, wood (Signs)
Sources: *FoA 107*.*

Richardson, Edward, Jr.
b. 1824 d. 1858 Springfield, IL
Flourished: 1850-1858 Springfield, IL
Ethnicity: English
Type of Work: Oil (Portraits)
Museums: 114
Sources: *ArC 168*, 266.*

Richardson, Francis B.
Type of Work: Tin (Tinware)
Museums: 097
Sources: *AmCoTW 195*.*

Richardson, George
Flourished: 1824
Type of Work: Watercolor (Bay scene paintings)
Museums: 010
Sources: *FoArA 11*.*

Richardson, John
Flourished: 1800 Boston, MA
Type of Work: Wood (Ship carvings, ship figures)
Sources: *ShipNA 43, 159.*

Richardson, R.
Flourished: 1799 Boston, MA
Type of Work: Wood (Ship carvings, ship figures)
Sources: *AmFiTCa 80, 199.*

Richardson, Thomas
Flourished: 1781-1796 Boston, MA
Type of Work: Wood (Ship carvings, ship figures)
Sources: *ShipNA 43, 159.*

Richardson, William
Flourished: 1838 Massachuscetts
Type of Work: Ink, watercolor (Family tree drawings)
Sources: *EyoAm 26-7*; FoPaAm 41*; MaAmFA *.*

Richey and Hamilton
Flourished: c1875 Palatine, WV
Type of Work: Stoneware (Pottery)
Sources: *AmPoP 225; Decor 223; DicM 112*.*

Richmond, A.D.
Flourished: New Bedford, MA
Type of Work: Copper (Warming pans)
Museums: 096
Sources: *AmCoB 92-3**
See: A.D. Richmond and Company.

Richter, E.J.
Flourished: 1890-1900 Elmendorf, TX
Type of Work: Stoneware (Bowls)
Remarks: Worked at Star Pottery
Sources: *AmS 96, 132*, 146*.*

Ricket, Jacob
Flourished: 1782 Lancaster County, PA
Ethnicity: German
Type of Work: Wood (Dower chests)
Sources: *InAmD 7*.*

Ricketts
See: Wait and Ricketts.

Riddle, Hannah
Flourished: c.1870- Woolwich, ME
Type of Work: Fabric (Quilts, weavings)
Sources: *AmSQu 217*; ArtWo 49, 170, pl.5.*

Riddle, Morton
b. 1909 Owingsville, KY
Flourished: 1925? Whittier, CA
Type of Work: Wood (Carvings, clock frames, sculptures)
Sources: *PioPar 50-1*, 63-4.*

Rider, Lydia
b. 1755 Newport, RI
Flourished: 1767 Newport, RI
Type of Work: Fabric (Samplers)
Museums: 251
Sources: *LeViB 60-1, 69*.*

Rider, Peter
Flourished: New York
Type of Work: Pen, ink, watercolor (Drawings)
Sources: *FouNY 47*, 64.*

Ridgeway, Bindsall
Flourished: c1900 Barnegat, NJ
Type of Work: Wood (Duck decoys)
Museums: 260
Sources: *Decoy 90*, 95*.*

Ridgeway, Caroline
Flourished: 1812 Philadelphia, PA
Type of Work: Fabric (Religious embroidered pictures)
Sources: *AmNe 83.*

Ridley, Mary
Flourished: 1841 Connecticut
Type of Work: Tin (Tinware)
Sources: *TinC 158.*

Riedel, A.
Flourished: New York, NY
Type of Work: Paint (Decorated mugs)
Sources: *AmSFo 79.*

Riedinger and Caire
See: Reidinger and Caire.

Rieff, Christian
Flourished: c1767 Rockland Township, PA
Type of Work: Redware (Pottery)
Sources: *AmPoP 178.*

Riegel, Simon
b. c1807 Pennsylvania
Flourished: 1847-1872 Tremont City, OH
Type of Work: Fabric (Carpets, coverlets)
Sources: *ChAmC 98.*

Riemann, George
Flourished: 1860 New York, NY
Type of Work: Wood (Ship carvings, ship figures)
Sources: *AmFiTCa 199.*

Rife, Peter
Flourished: 1809 Pulaski County, VA
Type of Work: Wood (Clocks)
Sources: *SoFoA 165, 222*.*

Riffle, Martha Jane
Flourished: c1865 Lawrence County, KY
Type of Work: Fabric (Quilts)
Sources: *KenQu fig5.*

Rigby
See: Foster and Rigby.

Rigby, T.
See: T. Rigby and Company.

Rigel, Maria Magdalena
Flourished: 1838 Pennsylvania
Type of Work: Watercolor, ink (Frakturs)
Sources: *AmFoPa 189.*

Riggs, Wesley
Flourished: c1820-1830 Sandyville, OH
Type of Work: Stoneware (Pottery)
Sources: *AmPoP 230; Decor 223.*

Rightmeyer, J.E.
Type of Work: Pastel (Paintings)
Museums: 176
Sources: *ColAWC 240, 242*.*

Riland
See: Hedderly and Riland.

Riley
Flourished: Michigan
Type of Work: Wood, metal (Fish decoys)
Sources: *UnDec 20.*

Riley
See: Marks, Farmer, Manley, and Riley.

Rimby, W.B.
Flourished: c1841 Baltimore, MD
Type of Work: Iron (Trivets)
Sources: *EaAmI 48*; PenDA 124*.*

Ringer, Peter
b. c1829
Flourished: 1852-1858 Chester Township, OH
Type of Work: Fabric (Coverlets)
Sources: *ChAmC 98.*

Risely
See: Clark and Risely.

Rising, Lester
Flourished: Connecticut
Type of Work: Tin (Tinware)
Sources: *TinC 93, 180.*

Risley, Charles
Flourished: 1840 New York, NY
Type of Work: Wood (Ship carvings, ship figures)
Sources: *AmFiTCa 199.*

Risley, Charles E.
Flourished: 1860 New York, NY
Type of Work: Wood (Ship carvings, ship figures)
Sources: *AmFiTCa 199.*

Risley, George L.
Flourished: c1875-1881 Norwich, CT
Type of Work: Stoneware (Pottery)
Sources: *AmPoP 199.*

Risley, Russell
b. 1842 Kirby, VT d. 1927
Flourished: Kirby, VT
Type of Work: Wood, stone, oil (Sculptures, landscape paintings)
Sources: *FoAFp 1*, 4.*

Risley, Sidney
[Norwich Pottery Works]
Flourished: 1825-1875 Norwich, CT
Type of Work: Stoneware, clay (Pottery)
Sources: *AmPoP 199, 277; Decor 223; DicM 125*; EaAmFo 124*.*

Risser, L.D.
Flourished: Berks County, PA
Type of Work: Fabric (Weavings)
Sources: *ChAmC 98.*

Rittenhouse, Evans and Company
Flourished: c1880-1890 Trenton, NJ
Type of Work: Clay (Pottery)
Sources: *AmPoP 183.*

Ritter, Daniel
b. 1746 d. 1828
Flourished: East Hartford, CT
Type of Work: Stone (Gravestones)
Sources: *EaAmG 128.*

Ritter, Florent
Flourished: 1940-1970 Warren County, MO
Type of Work: Wood (Chairs)
Sources: *ASeMo 323*.*

Ritter, John
b. 1750
Flourished: East Hartford, CT
Type of Work: Stone (Gravestones)
Sources: *EaAmG 128.*

Ritter, Lydia
Flourished: c1826
Type of Work: Fabric, paint (Memorial paintings)
Sources: *Edith *.*

Ritter, Thomas
d. 1770
Flourished: East Hartford, CT
Type of Work: Stone (Gravestones)
Sources: *EaAmG 128.*

Roanoke, Bart
Flourished: c1846 Green Port, NY
Type of Work: Whalebone (Scrimshaw)
Sources: *ScriSW 21*.*

Roath, H.A.
Flourished: c1825 Connecticut
Type of Work: Oil (Ship portraits)
Sources: *OneAmPr 70*, 143, 155.*

Robb, Charles
b. 1855 d. 1904
Flourished: 1877-1903 New York, NY
Type of Work: Wood (Cigar store Indians, figures)
Sources: *ArtWod 268.*

Robb, Clarence
b. 1878 d. 1956
Flourished: 1902-1908 New York, NY
Type of Work: Wood (Cigar store Indians, figures)
Sources: *ArtWod 268.*

Robb, Samuel Anderson
b. 1851 d. 1928
Flourished: 1864-1928 New York, NY
Type of Work: Wood (Cigar store Indians, figures, ship carvings and figures, circus wagons)
Museums: 047, 097, 111, 171, 203, 238, 260, 263, 294
Sources: *AmFiTCa 155-6, 199; AmFoArt 64*; AmFoS 30*, 254*, 257*, 260*, 266*, 270*, 272*, 275*, 331*; ArtWod 34-5, 48*, 50, 78-82*, 93-4, 97-100, 110-12, 114*, 177, 181-3, 185, 191, 193, 238*, 244, 246-7, 268, fig1, 25; CiStF 24, 116; EaAmW 43, 46, 56*; FoA 152*, 468; .*

Robb, Samuel Anderson (Continued)
Sources: *FoAFm 3; HoKnAm 161, 163*-5*; InAmD 55, 155; ShipNA 162; TwCA 70*; TYeAmS 103*, 345; WoScuNY.*

Robbins, Lewis
Flourished: Bristol, CT
Type of Work: Tin (Tinware)
Sources: *TinC 180.*

Robbins, Marvin S.
b. 1813 d. 1872
Type of Work: Oil (House portraits)
Sources: *SoAmP 290.*

Robbins (Mrs.) and Son
Flourished: c1873 Calhoun, MO
Type of Work: Stoneware (Pottery)
Sources: *AmPoP 209; Decor 223.*

Roberts
See: Holmes and Roberts.

Roberts, Bishop
Flourished: 1735 Charleston, SC
Ethnicity: English
Type of Work: Oil (Paintings)
Sources: *AmDecor 17.*

Roberts, Candace
b. 1785 Bristol, CT d. 1806
Flourished: Bristol, CT
Type of Work: Tin (Tinware)
Sources: *TinC 24, 117, 127, 158*
See: Mitchell, Thomas.

Roberts, Charles
b. Pennsylvania
Flourished: c1850 Muncyborough, PA
Type of Work: Fabric (Weavings)
Sources: *ChAmC 98*
See: Lowmiller, William.

Roberts, David
Flourished: 1820s Utica, NY
Type of Work: Clay (Pottery)
Sources: *HoKnAm 55*.*

Roberts, George S.
Flourished: 1860 Portsmouth, NH
Type of Work: Wood (Ship carvings, ship figures)
Sources: *AmFiTCa 199.*

Roberts, Hosea
b. 1768 d. 1815
Flourished: Middletown, CT
Type of Work: Stone (Gravestones)
Sources: *EaAmG 128*.

Roberts, John M.
Flourished: c1831 Peoria, IL
Type of Work: Watercolor (Scene paintings)
Sources: *ArC 126**.

Roberts, Jonathan
Flourished: c1765 Killingly, CT
Type of Work: Stone (Gravestones)
Sources: *EaAmG 128*.

Roberts, Joseph
Flourished: 1753-1765 Putnam, CT
Type of Work: Stone (Gravestones)
Sources: *EaAmG 128; GravNE 130*.

Roberts, Joseph
Flourished: c1850 West Medway, ME
Type of Work: Stone (Gravestones)
Sources: *EaAmG 128*.

Roberts, Manuel S.
Flourished: Martha's Vineyard, MA
Type of Work: Wood (Duck decoys)
Sources: *AmBiDe 73*.

Roberts, Marvin S.
b. 1813 d. 1872
Flourished: Massachusetts
Type of Work: Oil (Portraits)
Sources: *AmPrP 155; PrimPa 179*.

Roberts, William
Flourished: 1848-1880s Binghamton, NY; Utica, NY
Type of Work: Stoneware (Pottery)
Museums: 080, 203
Sources: *AmSFo 51; Decor 57, 59-60*, 81*, 83*, 100*, 112*, 223; EaAmFo 116*
See: White, Noah, Jr.

Robertson, Anna Mary
See: Moses, Anna Mary Robertson (Grandma Moses).

Robertson, George J.
Flourished: 1860-1885 Rockford, IL
Type of Work: Oil (Portraits)
Sources: *ArC 158**.

Robertson, James
See: James Robertson and Sons.

Robertson, John
Flourished: c1760 South Carolina
Type of Work: Brass (Brassware)
Sources: *AmCoB 235*.

Robertson, John
Flourished: 1845
Type of Work: Oil, watercolor (Ship paintings)
Sources: *PrimPa 179*.

Robertson, Joseph
Flourished: 1791-1796 Boston, MA
Type of Work: Wood (Ship carvings, ship figures)
Sources: *ShipNA 43, 169*.

Robertson, William A.
Flourished: 1935-1960 Ipswich, MA
Ethnicity: Scottish
Type of Work: Wood (Ship carvings, ship figures)
Sources: *AmFiTCa 166, 199, figxxxii; ShipNA 145, 160*.

Robertson Art Tile Company
Flourished: 19th century Morrisville, PA
Type of Work: Clay (Pottery)
Sources: *DicM 25*, 58**.

Robertson Pottery Company
See: Plympton and Robertson Pottery Company.

Robinson
See: Whitman, Robinson and Company.

Robinson, Ann
b. 1813?
Flourished: 1814? Connecticut
Type of Work: Fabric (Quilts)
Sources: *FoArtC 134*; QuiAm 216**.

Robinson, Anson
Flourished: 1842
Type of Work: Fabric? (Coverlets?)
Sources: *ChAmC 98*.

Robinson, Faith
Flourished: c1770
Type of Work: Fabric (Samplers)
Museums: 139
Sources: *FoAFz 4**.

Robinson, Frank
Flourished: 1860
Type of Work: Watercolor, pencil (Ship drawings)
Sources: *AmPrP 155; PrimPa 179*.

Robinson, George
Flourished: 1681-1737 Boston, MA
Type of Work: Wood (Ship carvings, ship figures)
Sources: *ShipNA 2, 158*.

Robinson, James
Flourished: 1806 Newburgh, NY
Type of Work: Fabric (Coverlets, blankets)
Sources: *ChAmC 98*
See: Alexander, James.

Robinson, John L.
Flourished: 1830 New York, NY
Type of Work: Wood (Ship carvings, ship figures)
Sources: *AmFiTCa 199*.

Robinson, Josiah
b. 1837 Mattapoisett, MA
Flourished: 1850-1900
Type of Work: Whalebone (Scrimshaw)
Museums: 186
Sources: *GravF 29, 119*, 121-2*, 126-7**.

Robinson, Mary Lou Perkins
b. 1935
Flourished: 1979 Pennsylvania; Kinsman, OH
Type of Work: Acrylic (Farm scene, genre paintings)
Remarks: Mother is Perkins, Ruth; father is Perkins, Clarence
Sources: *AmFokArt 231, 233*; FoA 468; FoPaAm 144**.

Robinson Clay Products
Flourished: early 20th cent Akron, OH
Type of Work: Stoneware (Mugs)
Sources: *AmS 151**.

Roby, W(arren) G(ould)
Flourished: mid 19th cent Wayland, MA
Type of Work: Wood (Weathervanes)
Museums: 260
Sources: *AmFoS 141*; GalAmW 86*; WoCar 50*; YankWe 194**.

Rochas, Ramon
Flourished: 1960 El Paso, TX
Ethnicity: Hispanic
Type of Work: Wood (Santeros, other religious carvings)
Museums: 077
Sources: *HisCr 58*, 109*.

Rochester Iron Works
Type of Work: Metal (Weathervanes)
Sources: *ArtWe 27**.

Rochester Sewer Pipes
Flourished: c1889 Rochester, NY
Type of Work: Stoneware (Pitchers)
Sources: *AmS 220**.

Rochette, Roland
b. 1887
Flourished: Greensboro Bend, VT
Type of Work: Acrylic, various materials (Paintings)
Sources: *FoAFp 7**.

Rockwell, W.H.
See: W.H. Rockwell and Company.

Rodgers
See: Howard and Rodgers.

Rodia, Simon
b. 1879 d. 1965
Flourished: 1921-1954 Watts, CA
Ethnicity: Italian
Type of Work: Various materials (Environmental sculptures)
Remarks: Created "Watts Tower"
Sources: *AmFoS 8*; ConAmF 132-8*; HoKnAm 186*; NaiVis 6*, 20-31*; PioPar 9, 13, 18; TwCA 66*; TYeAmS 110-11**.

Rodriguez, Jose Miguel
Flourished: Taos?, NM; Arroyo Hondo?, NM
Type of Work: Wood (Santeros, other religious carvings)
Sources: *PopAs 434*.

Roebel, George
Flourished: 1860 New York, NY
Type of Work: Wood (Ship carvings, ship figures)
Sources: *AmFiTCa 199*.

Roeder, Conrad
d. 1877
Flourished: Alton, IL
Type of Work: Oil (Portraits)
Sources: *ArC 218-9**.

Roeder, John "The Blind Man"
b. 1877 d. 1964 Richmond, CA
Flourished: 1930-1948 Richmond, CA
Ethnicity: Luxembourg
Type of Work: Wood, oil, cement (Sculptures, carvings, scene paintings)
Remarks: Created life sized figures in a garden environment
Sources: *PioPar 13, 51-2*, 61; TwCA 111**.

Roes, Anna Eliza
Flourished: 1806 Philadelphia, PA
Ethnicity: Quaker
Type of Work: Fabric (Samplers)
Sources: *AmNe 52*, 54*.

Roesen, Severin
Flourished: 1842-1872 Williamsport, PA
Type of Work: Oil (Still life paintings)
Sources: *AmPrP 155; HerSa*.

Roff
See: Putnam and Roff.

Roff, Amos B.
Flourished: 1821-1844 Hartford, CT
Type of Work: Wood, paper (Handboxes)
Museums: 056
Sources: *AmSFo 131**.

Rogers, Bruce
Flourished: c1934 Fairfield, CT; Danbury, CT; New York, NY
Type of Work: Wood (Weathervanes, ship figures, figureheads)
Museums: 258
Sources: *AmFiTCa 166-7, 199, figxxxii; FigSh 82-3*; FoArtC 70*.

Rogers, Gene
Flourished: Martha's Vineyard, MA
Type of Work: Wood (Duck decoys)
Sources: *AmBiDe 73*.

Rogers, George H.
Flourished: c1862 Newton, MA
Type of Work: Whalebone (Scrimshaw)
Sources: *ScriSW 8-9**.

Rogers, Gertrude
b. 1896
Flourished: 1945- Sunfield, MI; Arcadia, FL
Type of Work: Oil (Paintings)
Sources: *ArtWo 141-2*, 153, 170-1*; Rain 79*-81**.

Rogers, James
Flourished: 1832 Buffalo, NY
Type of Work: Wood (Ship carvings, ship figures)
Sources: *AmFiTCa 199*.

Rogers, John
b. c1807
Flourished: c1848-1870 Washington Township, IN; Wayne County, IN
Ethnicity: Irish
Type of Work: Fabric (Weavings)
Sources: *ChAmC 98*.

Rogers, John
Flourished: 1860-1890 New York, NY
Type of Work: Terra-cotta (Pottery)
Sources: *AmPoP 65, 198, 277; DicM 113**.

Rogers, Juanita
Flourished: 1934-1985 Alabama
Ethnicity: Black American
Type of Work: Clay, tempera (Paintings, sculptures)
Sources: *FoAFc 17; FoAFp 12-3**.

Rogers, Nathaniel
Flourished: 1810 Massachusetts
Type of Work: Oil (Portraits)
Sources: *AmPrP 155; PrimPa 179*.

Rogers, Sarah
b. 1735 Newport, RI d. 1811
Flourished: 1746 Newport, RI
Type of Work: Fabric (Samplers)
Museums: 241
Sources: *LeViB 60, 67*, 71, 78, 98*.

Rogers, W.H.
Flourished: 1813 New York
Type of Work: Bone (Powderhorns)
Museums: 203
Remarks: Worked in North Country of New York State
Sources: *FouNY 62*.

Rogers, William
Flourished: 1720-1745 Yorktown, VA
Type of Work: Stoneware, clay (Pottery)
Remarks: Factory owner
Sources: *AmS 18*, 164, 219*; AmSFo 44; Decor 21, 35*; HoKnAm 53*.

Rogers, William
b. 1865 d. 1952
Flourished: Daven, GA
Ethnicity: Black American
Type of Work: Wood (Carved canes)
Sources: *BlFoAr 29*; MisPi 62-3**.

Rogers Pottery
Flourished: c1850-1900 Meansville, GA
Type of Work: Stoneware (Pottery)
Sources: *AmPoP 240*.

Rogerson, John
b. 1837 d. 1925
Flourished: 1883 New Brunswick, NJ; Boston, MA
Ethnicity: Canadian, Scottish
Type of Work: Wood (Ship carvings, ship figures)
Museums: 030,123
Sources: *ShipNA 94-5*, 98, 164*.

Roherge and Knoblock
Flourished: 1871 Providence, RI
Type of Work: Wood (Ship carvings, ship figures)
Sources: *AmFiTCa 199*.

Rohlfing, Frederick
Flourished: 1855 Gasconade County, MO
Type of Work: Wood (Glass cupboards)
Sources: *ASeMo 339**.

Rohrer, P.
Flourished: 18th century Lebanon, PA
Type of Work: Metal (Ornamental works)
Sources: *AmCoB 249*; PenDA 131**.

Rolader, William Washington "Uncle Don"
b. 1856 d. 1922
Flourished: Fulton County, GA
Type of Work: Clay (Pottery)
Sources: *MisPi 89**.

Rolling Mountain Thunder, Chief
[Frank Thunder, Thunder Spirit, Van Zant, Frank]
b. 1911
Flourished: Imlay, NV
Ethnicity: American Indian
Type of Work: Various materials (Sculptures)
Remarks: Creek tribe
Sources: *TwCA 194*-5**.

Rollings, Lucy
Flourished: 1804 New York
Type of Work: Watercolor, ink, pinprick (Memorial drawings)
Sources: *NinCFo 197*.

Rollins, George W.S.
Flourished: 1857 Salem, MA
Type of Work: Wood (Ship carvings, ship figures)
Sources: *AmFiTCa 199*.

Roman, D.F.
Flourished: 1870
Type of Work: Oil (Landscape paintings)
Sources: *PrimPa 179*.

Romer
Flourished: 1831 Pennsylvania
Type of Work: Watercolor, ink (Frakturs)
Sources: *AmFoPa 189*.

Romer, C.
Flourished: 1867 New Haven, CT
Type of Work: Wood (Ship carvings, ship figures)
Sources: *AmFiTCa* 199.

Romero, Emilio
b. 1910 Santa Fe, NM
Flourished: 1959- Santa Fe, NM
Ethnicity: Hispanic
Type of Work: Tin (Tinware)
Sources: *HisCr* 77*, 110*.

Romero, Orlando
b. 1945 Santa Fe, NM
Flourished: 1972 Santa Fe, NM
Ethnicity: Hispanic
Type of Work: Wood (Santeros, other religious carvings)
Sources: *HisCr* 56*, 110.

Romero, Senaida
b. 1909 Santa Fe, NM
Flourished: 1977 Santa Fe, NM
Ethnicity: Hispanic
Type of Work: Tin (Tinware)
Sources: *HisCr* 77*, 110*.

Romig Clay
Flourished: 1930s Gnadenhutten, OH
Type of Work: Clay (Sewer tile sculpture)
Sources: *IlHaOS* *.

Ronalds, Elizabeth F.
Flourished: c1848 Albion, IL
Type of Work: Oil (Still life paintings)
Sources: *ArC* 108*.

Ronaldson
See: Binney and Ronaldson.

Rookwood Pottery Company
Flourished: c1876- Cincinnati, OH
Type of Work: Clay (Pottery)
Sources: *AmPoP* 79, 212, 277; *DicM* 87*, 101*-2, 113*-4*, 147*, 163*, 185*, 255*, 259*
See: Taylor, W.W.; Storer, Mrs. Bellamy.

Roosebush, Joseph
Flourished: 1877 Meriden, CT
Type of Work: Paint (Carriage paintings)
Sources: *TinC* 180.

Roosetter, Charles H.
Flourished: 1833-1860 Philadelphia, PA; Charlestown, MA
Type of Work: Wood (Ship carvings, ship figures)
Sources: *AmFiTCa* 199.

Roosevelt, Mrs. Theodore, Jr.
Flourished: 1937 Long Island, NY
Type of Work: Fabric (Embroidered genre pictures)
Sources: *AmNe* 171-2*, 181, 178*.

Root
See: Hubbard and Root.

Root, Ed
b. 1868 d. 1959
Flourished: Wilson, KS
Type of Work: Cement (Environmental sculptures)
Museums: 283
Sources: *FoA* 468; *FoAFd* 9; *HoKnAm* 188; *TwCA* 40*.

Root, Elmira
Flourished: 1840 Ashley, OH
Type of Work: Watercolor, pinpricks (Portraits)
Sources: *PrimPa* 179.

Root, Lewis
Flourished: Bristol, CT; Georgia
Type of Work: Tin (Tinware)
Sources: *TinC* 180
See: Hubbard and Root.

Root, Lucy (Curtiss)
Flourished: 1764 Southington, CT
Type of Work: Fabric (Towels)
Sources: *ArtWea* 79*.

Root, Robert Marshall
b. 1863 d. 1937
Flourished: Shelbyville, IL
Type of Work: Oil (Landscape paintings)
Sources: *ArC* 126*.

Root, William
Flourished: Bristol, CT; Berlin, CT
Type of Work: Tin (Tinware)
Remarks: Worked for Filley, Oliver, Harvey, and Augustus
Sources: *TinC* 180.

Ropes, George
b. 1788 Salem, MA
Flourished: 1806-1850 Ashley, OH; Salem, MA
Type of Work: Oil (Seascape and landscape paintings)
Museums: 189, 221
Sources: *AmDecor* 44; *AmFoPa* 100, 108; *AmPaF* 168*; *AmPrP* 156; *FoArtC* 26*; *PicFoA* 18; *PrimPa* 179; *SoFoA* 70*, 218.

Rose, Mrs.
Flourished: c1850 Pennsylvania
Type of Work: Fabric (Embroidered pictures)
Sources: *AmNe* 125*.

Rose, Philip
b. c1791
Flourished: Boston, MA
Type of Work: Tin (Tinware)
Sources: *FoArtC* 83.

Rose, William Henry Harrison
b. 1839 d. 1913
Flourished: 1860 Kingston, RI
Type of Work: Fabric (Weavings)
Sources: *AmSQu* 277; *ChAmC* 100.

Rose Folding Decoys Company
Flourished: 1908 Chicago, IL
Type of Work: Wood (Duck decoys)
Museums: 260
Sources: *Decoy* 59*.

Rosebrook, Rod
b. 1900
Flourished: 1979 Redmond, OR
Type of Work: Metal (Sculptures)
Remarks: Collected tools for "old time museum"
Sources: *FoAFn* 4*-6.

Roseman, Bill
b. 1891 New York, NY
Flourished: 1957 New York, NY
Type of Work: Oil, acrylic (Paintings)
Sources: *AmFokArt* 268-70*.

Roseumen, Richard
Flourished: 1786 New York, NY
Type of Work: Tin (Tinware)
Sources: *AmCoTW* 109.

Roseville Pottery Company
Flourished: 19th century Zanesville, OH
Type of Work: Clay (Pottery)
Sources: *DicM* 172*.

Rosier, Joseph
Flourished: 1814 Jonathan Creek, OH
Type of Work: Stoneware (Pottery)
Sources: *AmPoP* 68, 222.

Ross, Abby F. Bell (Abby J. Ball)
Flourished: 1874 Irvington, NJ
Type of Work: Fabric (Quilts)
Sources: *AlAmD* 136*; *MaAmFA* *; *NewDis* 86*.

Ross, Calvin
Flourished: 19th century Siglerville, PA
Type of Work: Tin (Tinware)
Sources: *ToCPS* 42, 61*.

Ross, Jane
Flourished: 1835 Pennsylvania
Type of Work: Fabric (Samplers)
Sources: *HerSa* *.

Rosseel, Frank
Flourished: 1910 St. Lawrence, NY
Type of Work: Watercolor (Paintings)
Museums: 087
Sources: *FouNY* 67.

Rossiter, Prudence
See: Punderson, Prudence.

Rossvilles
Flourished: 1851 New York
Type of Work: Fabric? (Weavings?)
Sources: *AmSQu* 277; *ChAmC* 100.

Roth, John
Flourished: 1836 Quincy, IL
Ethnicity: German
Type of Work: Wood (Furniture)
Sources: *ArC* 135.

Roth, Louise Cook
Flourished: 1861-1865
Type of Work: Fabric (Needlepoint)
Sources: *BirB 127**.

Rothmann, Mary
b. 1850 New York, NY
Flourished: 1868-1879
Type of Work: Fabric (Embroidered pictures)
Sources: *AmNe 109, 111**.

Rothrock, Friedrich
Ethnicity: Moravian
Type of Work: Stoneware (Pottery)
Sources: *SoFoA 16*, 217*.

Rotschafer, F.A.
Flourished: 1870 Missouri
Type of Work: Watercolor (Theorems)
Sources: *ASeMo 487**.

Rottman, G.
Type of Work: Fabric (Coverlets)
Sources: *ChAmC 100*.

Rotzel, Mathias
Flourished: 1848 Columbiana County, OH
Type of Work: Fabric (Weavings)
Sources: *ChAmC 100*.

Roudebusch, William
Flourished: 1800's Pennsburg, PA
Type of Work: Clay (Pottery)
Sources: *AmPoP 174*.

Roudebuth, Henry
Flourished: 1810-1820 Montgomery County, PA
Type of Work: Clay (Pottery)
Sources: *AmPoP 185; DicM 58*, 62; EaAmFo 288*; PenDuA 28**.

Rounds, Mary M.
d. 1833
Flourished: Buckfield, PA
Type of Work: Fabric (Candlewick spreads)
Sources: *AmSQu 281**
See: Andrews, Fanny.

Rounsville, Helen Mary
Flourished: 1887 Fowlerville, MI
Type of Work: Fabric (Quilts)
Sources: *NewDis 115**.

Rouse, Richard
Flourished: 1856 Watertown, MA
Type of Work: Wood (Ship carvings, ship figures)
Sources: *AmFiTCa 199*.

Rouse, William
Flourished: c1681 Boston, MA
Type of Work: Silver (Boxes)
Museums: 313
Sources: *NeaT 91*.

Rouse and Turner
Flourished: 1875- Jersey City, NJ
Type of Work: Clay (Pottery)
Sources: *AmPoP 170, 278; DicM 154**.

Rouser, Gabriel
Flourished: 1843 Delaware County, OH
Type of Work: Fabric (Weavings)
Sources: *AmSQu 277*.

Rousmaniere, Elizabeth
See: Easton, Elizabeth.

Routson, Joseph
Flourished: late 19th cent Wooster, OH
Type of Work: Clay (Pottery)
Sources: *DicM 170**.

Routson, S.
Flourished: 1835-1886 Doylestown, OH; Wooster, OH
Type of Work: Brownware, stoneware (Pottery)
Sources: *AmPoP 213, 233; EaAmFo 219**.

Routt, Daniel
Flourished: 1838 Ohio
Type of Work: Fabric (Coverlets, blankets)
Sources: *ChAmC 100*.

Roux, Alexander
Flourished: 1865 New York, NY
Type of Work: Wood (Stools)
Museums: 151
Sources: *AmPaF 283**.

Rowe, L.K.
Flourished: 1860 Salem, MA
Type of Work: Oil (Portraits)
Sources: *AmPrP 156; PrimPa 179*.

Rowe, Nellie Mae
b. 1900 Fayette County, GA
Flourished: 1960s Vinings, GA
Ethnicity: Black American
Type of Work: Crayon, felt-tip pen (Drawings, quilts)
Museums: 099,171,178,190
Sources: *AmFokArt 271-3*; BlFoAr 122-7*, 174-5; MisPi 14, 52-3**.

Rowell, Samuel
Flourished: 1815 Amesbury, MA
Type of Work: Oil (Portraits)
Sources: *AmPrP 156; PrimPa 179*.

Rowland, Elizabeth
Flourished: Philadelphia, PA
Ethnicity: Quaker
Type of Work: Fabric (Samplers)
Sources: *AmNe 52-4**.

Rowley, Jacob
Flourished: 1815 Southville, CT
Type of Work: Tin (Tinware)
Sources: *TinC 180*.

Rowley, Philander
Flourished: Connecticut
Type of Work: Tin (Tinware)
Remarks: Associated with Filley
Sources: *TinC 180*.

Rowley, R.
Flourished: 1825 Amesbury, MA
Type of Work: Oil (Portraits)
Sources: *PrimPa 179*.

Rowley Pottery
Flourished: c1874 Akron, OH
Type of Work: Stoneware (Pottery)
Sources: *AmPoP 205, 207; Decor 223*.

Roybal, Maria Luisa Delgado
Flourished: 1977 Santa Fe, NM
Ethnicity: Hispanic
Type of Work: Tin (Tinware)
Sources: *HisCr 77*, 111*.

Roybal, Martin
b. 1860
Flourished: Jacona, NM
Ethnicity: Hispanic
Type of Work: Fabric (Jergas)
Sources: *PopAs 237*.

Royce, Jenny
Flourished: 1860
Type of Work: Oil (Paintings)
Museums: 312
Sources: *FoArA 98**.

Royer, A.
Flourished: c1865-1875 Akron, OH
Type of Work: Stoneware (Pottery)
Sources: *AmPoP 206; Decor 223*.

Royer, John
Flourished: 1836-1837 New Holland, PA
Type of Work: Fabric (Weavings)
Sources: *ChAmC 100*.

Ruckle, Thomas
Flourished: 1850 New York
Type of Work: Oil (Landscape paintings)
Sources: *PrimPa 179*.

Rude, Erastus
Flourished: 1811
Ethnicity: Shaker
Type of Work: Wood (Clock cases)
Sources: *HanWo 181*, 183*.

Rudiger
See: Reidinger and Caire.

Rudinger
See: Lehman and Rudinger.

Rudy, Durs
Flourished: 1804-1842 Pennsylvania
Type of Work: Watercolor, ink (Frakturs)
Sources: *AmFoPa 189*.

Ruef, Arnold
Flourished: 1850-1900 Tiffin, OH
Type of Work: Wood (Cigar store Indians, figures)
Museums: 096
Sources: *AmFoS 255*; CiStF v*, 67; FoA 153*, 468*
See: Ruef, Peter.

Ruef, Peter
Flourished: 1880 Tiffin, OH
Type of Work: Wood (Cigar store Indians, figures)
Museums: 096
Sources: *AmFoS 255*; FoA 153*, 468*
See: Ruef, Arnold.

Rugar, John
Flourished: c1765 New York
Type of Work: Paper (Wallpaper)
Sources: *AmDecor 81.*

Rugg, Lucy
Flourished: early 19th cent Lancaster, MA
Type of Work: Fabric (Samplers)
Sources: *GalAmS 49*.*

Rumbaugh, M.
Flourished: c1979 Lancaster County, PA
Type of Work: Wood (Boxes)
Sources: *FoA 282*.*

Rumney, George R.
Flourished: 1868 Boston, MA
Type of Work: Wood (Ship carvings, ship figures)
Sources: *AmFiTCa 199.*

Rumney, John
Flourished: 1868 Boston, MA
Type of Work: Wood (Ship carvings, ship figures)
Sources: *AmFiTCa 199.*

Rumney, William H.
[T.J. White and Company]
b. 1837 North Boston, MA d. 1927
Flourished: 1860-1870s East Boston, MA
Type of Work: Wood (Ship carvings, ship figures)
Sources: *AmFiTCa 137-8, 199; ArtWod 181; ShipNA 159.*

Rumrill, Edwin, Captain
Flourished: 1900 Maine
Type of Work: Fabric (Nautical carpets)
Sources: *FoPaAm 50*.*

Rupp, Salinda W.
Flourished: c1870 Lancaster County, PA
Type of Work: Fabric (Quilts)
Sources: *NewDis 48*.*

Rusby, John
Flourished: 1845 New York, NY
Type of Work: Wood (Ship carvings, ship figures)
Sources: *AmFiTCa 199.*

Rusch, Herman
b. 1885
Flourished: 1956 Wisconsin
Type of Work: Various materials (Environmental sculptures)
Sources: *NaiVis 70-5*.*

Rush, Benjamin
Flourished: 1783?-1793 Philadelphia, PA
Type of Work: Wood (Ship carvings, ship figures)
Sources: *AmFiTCa 199; ShipNA 163.*

Rush, Elizabeth
Flourished: 1734 Philadelphia, PA
Type of Work: Fabric (Samplers)
Sources: *PlaFan 49*; WinGu 33*.*

Rush, John
Flourished: 1814 Philadelphia, PA
Type of Work: Wood (Ship carvings, ship figures)
Remarks: Father is William
Sources: *AmFiTCa 63-3, 199; ShipNA 38, 163.*

Rush, William
b. 1756 Philadelphia, PA d. 1833
Flourished: 1800-1833 Philadelphia, PA
Type of Work: Wood (Signs, ship carvings, figures, sculptures)
Museums: 123,144,186,223,227,313
Remarks: Son is John
Sources: *AmEaAD 26*; AmFiTCa 32-40, 56-72*, 85-94, 102, 130, 145, 199, figvii, ix, xv, xvi; AmFoS 5, 27*, 79*, 82*, 167*; AmFoSc 14; ArtWod16-9*, 21, 80-3, 115-22*, 125, 172, 179, 268; BirB118; CiStF xiv*, 27, 29; CoCoWA 30-1*, 112*
See: Brown, John.

Rush, William (Continued)
Sources: *FoArtC 103; HoKnAm 155; InAmD 55, 193; ShipNa 11*20, 29, 31-3, 35-8, 42-3, 47, 50, 53, 71-2, 78, 121, 124, 126, 144, 163.*

Rushton, Joseph
Flourished: c1880 Rusk County, TX
Type of Work: Stoneware (Churns, pitchers)
Sources: *AmS 95*, 106*, 156*.*

Russel, William
Flourished: c1870 Elk Ridge Landing, MD
Type of Work: Redware (Pottery)
Sources: *AmPoP 167.*

Russell
See: Mason and Russell.

Russell, Amey
b. 1796 New Bedford?, MA? d. 1881 New Bedford?, MA?
Flourished: 1807 Providence, RI
Type of Work: Embroidery (Mourning pictures)
Museums: 212
Sources: *LeViB 159, 189-91*, 258.*

Russell, Benjamin
Flourished: 1848 New Bedford, MA
Type of Work: Tempera (Panoramic paintings)
Museums: 194,212
Sources: *AmFoPaN 103, 136-7*.*

Russell, D.W.
Flourished: c1870-1900 Bell City, KY
Type of Work: Stoneware, brownware (Pottery)
Sources: *AmPoP 235.*

Russell, John
Flourished: 1776 Windham, CT
Ethnicity: English
Type of Work: Wood (Figures)
Remarks: Prisoner of war during the American Revolution
Sources: *EaAmW 38, figiv.*

Russell, Joseph Shoemaker
b. 1795
Flourished: 1853 New Bedford, MA; Philadelphia, PA
Type of Work: Watercolor (Interior scene paintings)
Museums: 194
Sources: *FloCo 52*; FoArA 44*, 61*.*

Russell, Lydia Keene McNutt
Flourished: 1940s Vanceboro, ME
Type of Work: Fabric (Quilts)
Sources: *QuiAm 230*.*

Russell, Mary
b. 1778 Marblehead, MA
Flourished: 1791 Bristol, RI
Type of Work: Fabric (Samplers)
Sources: *LeViB 214, 224-5*.*

Russell, N.B.
Flourished: Baltimore, MD
Type of Work: Oil (Paintings)
Sources: *PrimPa 179.*

Russell Pottery
Flourished: Paris, TN
Type of Work: Stoneware (Pottery)
Sources: *AmPoP 240.*

Russell's Pottery
See: West Troy Pottery.

Rust, David
b. c1908
Flourished: Ashland, OR
Type of Work: Wood, paint (Swan carvings)
Sources: *PioPar 52-3, 62*, 64.*

Rutgers Factory
Flourished: 1801-1822 Paterson, NJ
Type of Work: Fabric (Candlewick spreads)
Sources: *AmSQu 279; NewDis 94-5*.*

Rutter, Thomas
Flourished: c1720 Pennsylvania
Type of Work: Iron (Stove plates, ironware)
Museums: 189
Sources: *FoArRP 142*.

Rutty
See: Goodrich, Ives and Rutty Co.

Ryder, David
Flourished: 1848 Middleboro, MA; Rochester, MA
Type of Work: Oil (Portraits)
Museums: 001
Sources: *AmFoPo 182*.

S

S. Bell and Sons Pottery
See: Bell, Solomon.

S. Hart Pottery
Flourished: 1840-1876 Fulton, NY
Type of Work: Clay, stoneware (Pottery, churns)
Sources: *AmS 185; FouNY 63.*

S.L. Stroll and Company
Flourished: c1864-1880 Mogadore, OH
Type of Work: Stoneware (Pottery)
Sources: *AmPoP 224; Decor 224.*

S. Merchant and Company
Flourished: 1868 Gloucester, MA
Type of Work: Wood (Ship carvings, ship figures)
Sources: *ShipNA 160.*

S. Sweetser and Sons
Flourished: 1747 Newburyport, MA
Type of Work: Oil, fabric (Painted carpets)
Sources: *AmFokDe 84.*

S.W. Gleason and Sons
Flourished: 1847-1854 Boston, MA
Type of Work: Wood (Ship carvings, ship figures)
Museums: 186
Sources: *AmEaAD 24*; AmFiTCa 192; FigSh 70*-1; ShipNA 60 *, 62 *, 67, 76, 159*
See: Gleason, William B.

S.W. Harley, The Invincible
See: Harley, Steve.

Saalmueler, Peter
Flourished: 1860 Missouri
Ethnicity: Saxe-Meiningen
Type of Work: Tin (Tinware)
Sources: *ASeMo 426.*

Sabin, Mark
b. 1936 New York, NY
Type of Work: Acrylic (Fantasy paintings)
Sources: *AmFokArt 274-6*.*

Sabin, Sarah "Sally" Smith (Wilson)
b. 1799 Bristol, RI **d.** 1847
Flourished: 1806 Providence, RI
Type of Work: Embroidery (Mourning pictures)
Remarks: Died in Spain
Sources: *LeViB 102-5, 174-5*, 212-3, 257.*

Sables, Thomas
See: T. Sables and Company.

Sabo, Ladis
b. 1870 **d.** 1953
Flourished: New York, NY
Ethnicity: Hungarian
Type of Work: Oil (Landscape paintings)
Sources: *PeiNa 334*; PrimPa 179.*

Sacket, Harriot
Flourished: 1795 Sheffield, MA
Type of Work: Fabric (Samplers)
Sources: *GalAmS 32*.*

Sackett, Alfred M.
Flourished: 1848-1863 Galena, IL
Type of Work: Redware (Pottery)
Sources: *ArC 193.*

Sackett, David A.
Flourished: 1850 Elizabeth, IL
Type of Work: Stoneware (Pottery)
Sources: *ArC 193, 188*
See: D.A. Sackett and Company.

Sackett, Ester
Flourished: 1840 New York
Type of Work: Watercolor (Still life paintings)
Sources: *AmPrP 156; PrimPa 179.*

Saddler, Lewis
See: Satler, Lewis.

Saeger, Martin
b. c1827
Flourished: c1860 Allentown, PA
Ethnicity: German
Type of Work: Fabric (Coverlets)
Sources: *ChAmC 100.*

Saenger, William
[Saenger's Pottery]
b. St. Hedwig, TX
Flourished: c1880
Type of Work: Stoneware (Jars, mugs)
Sources: *AmS 39*, 84*, 104*, 126*, 133*, 147*, 189*, 195*, 230-1*, 239*.*

Saengers Pottery
See: Saenger, William.

Sailor Jack
See: Cripe, Jack.

Sailor, S.H.
Flourished: 1840 Philadelphia, PA
Type of Work: Wood (Ship carvings, ship figures)
Sources: *AmFiTCa 199.*

Sailor, Samuel H.
Flourished: 1857-1885 Philadelphia, PA
Type of Work: Wood (Ship carvings, cigarstore figures)
Sources: *AmFiTCa 142, 199; ArtWod 122, 238, 268; ShipNA 78-9, 163.*

Sala, John
Flourished: 1850 Johnstown, PA
Type of Work: Wood (Chests of drawers)
Museums: 096
Sources: *AmPaF 271*.*

Salamander Works
Flourished: c1848 New York, NY
Type of Work: Clay (Pottery)
Sources: *AmPoP 67, 197, 278; DicM 185*.*

Salazar, Alejandro
Flourished: 1905 Harding County, NM
Ethnicity: Hispanic
Type of Work: Wood (Furniture)
Sources: *HisCr 26*.*

Salazar, David
b. 1901 Los Cerrillos, NM
Flourished: 1932 Ribera, NM
Ethnicity: Hispanic
Type of Work: Fabric (Weavings)
Museums: 178
Sources: *HisCr 20*, 111.*

Salazar, Leo G. (Leon)
b. 1933 Taos, NM
Flourished: 1966- Taos, NM
Ethnicity: Hispanic
Type of Work: Wood (Santeros, other religious carvings)
Museums: 272
Remarks: Nephew of Barela, Patrocino
Sources: *HisCr* 55*, 112*; *TwCA* 203*.

Salisbury, Henry
Flourished: 1849
Type of Work: Fabric (Weavings)
Sources: *AmSQu* 277; *ChAmC* 100.

Salisbury, J.
Flourished: 1838 Bethany, NY
Type of Work: Fabric (Coverlets)
Sources: *ChAmC* 100.

Salisbury, Mary
Flourished: 1842 Jefferson, NY
Type of Work: Fabric (Weavings)
Sources: *AmSQu* 277; *ChAmC* 100.

Salmon, Bradford
Flourished: Mayetta, NJ
Type of Work: Wood (Duck decoys)
Sources: *AmBiDe* 130.

Salt and Mear
Flourished: c1807 East Liverpool, OH
Type of Work: Redware (Pottery)
Sources: *AmPoP* 214.

Salter, Ann Elizabeth
Flourished: 1810 Massachusetts
Type of Work: Velvet (Memorial paintings)
Sources: *AmPrP* 156; *PrimPa* 179.

Salter, Ben S.
b. 1878 **d.** 1919
Flourished: Delray, GA
Type of Work: Clay (Pottery)
Museums: 177
Sources: *MisPi* 96*.

Salzberg, Helen
b. 1923 New York
Flourished: New York, NY
Type of Work: Acrylic, clay, paper (Collages)
Museums: 041,084
Sources: *AmFokArt* 277-9*.

Samet, William
b. Long Island, NY
Flourished: 1908
Type of Work: Paint (Paintings)
Sources: *ThTaT* 166-9*.

Sampier, Budgeon
Flourished: Pearl Beach, MI
Type of Work: Wood (Decoys)
Sources: *WaDec* 138*, 140*.

Sampson, C(harles) A.L., Captain
b. 1825 Boston, MA **d.** 1881 Bath, ME
Flourished: 1847-1877 Bath, ME; Boston, MA
Type of Work: Wood (Ship carvings, figures)
Museums: 142
Sources: *AmFiTCa* 35, 139, 200, figxxiv; *AmFokAr* 11, fig7; *AmSFok* 21*; *EaAmW* 22-3, 81; *FoA* 468; *InAmD* 55; *ShipNA* 75*, 79, 81*, 159; *TYeAmS* 77*, 90*, 307, 346.

Sampson, Deborah
Flourished: 1818 Warren, RI
Type of Work: Fabric (Embroidered pictures)
Museums: 151
Sources: *LeViB* 215, 233*.

Samson Cariss and Company
Flourished: 1860 Baltimore, MD
Type of Work: Wood (Ship carvings, ship figures)
Sources: *AmFiTCa* 189.

Samuel, W.M.G.
[W.S.M. Samuels]
b. 1815 Missouri **d.** 1902
Flourished: San Antonio, TX
Type of Work: Oil (Paintings)
Museums: 250
Sources: *FoPaAm* 224*, 238; *PrimPa* 179.

Samuel Bent and Sons
Flourished: 1875-1888 New York, NY
Type of Work: Metal (Weathervanes, ornamental metal works)
Sources: *ArtWe* 17; *YankWe* 210, 142.

Samuel Dyke and Company
Flourished: c1889-1891 Akron, OH
Type of Work: Stoneware (Pottery)
Sources: *AmPoP* 207; *Decor* 218.

Samuel J. Wetmore and Company
Flourished: c1805- Huntington, NY
Type of Work: Redware (Pottery)
Sources: *AmPoP* 194.

Samuel Yellin Company
d. 1940
Flourished: Philadelphia, PA
Ethnicity: Polish
Type of Work: Metal (Weathervanes, ornamental metal works)
Sources: *WeaVan* 24-5*
See: Yellin, Harvey.

Samuels, W.S.M.
See: Samuel, W.M.G.

San Antonio Pottery
Flourished: c1930 San Antonio, TX
Type of Work: Stoneware (Pitchers)
Sources: *AmS* 174*, 261*.

Sanbach, Herman
Flourished: 1851 Philadelphia, PA
Type of Work: Wood (Ship carvings, ship figures)
Sources: *AmFiTCa* 200.

Sanchez, Mario
b. 1908 Key West, FL
Flourished: Key West, FL
Ethnicity: Cuban
Type of Work: Wood (Sculptures, carvings of Key West scenes)
Sources: *ConAmF* 89-92*; *FoAF* 18-9; *FoAFk* 1*, 4-6*.

Sanders, Anna (Nancy)
b. 1791 **d.** 1860 Bristol?, RI?
Flourished: 1801 Warren, RI
Type of Work: Fabric (Samplers)
Museums: 311
Sources: *LeViB* 215, 229*.

Sanders, Daniel
Flourished: 1854 Oneco, IL
Type of Work: Clay (Pottery)
Sources: *ArC* 194.

Sanders, John
Flourished: 1817 Connecticut
Type of Work: Redware (Pottery)
Museums: 297
Sources: *DicM* 74*; *EaAmFo* 186*; *MaAmFA* *.

Sanders, Nancy
See: Sanders, Anna.

Sanderson, Francis
Flourished: Lancaster, PA
Type of Work: Copper (Stills)
Sources: *AmCoB* 104*, 114.

Sandford, Peter Peregrine
Flourished: 1770s-1789 White Plains, NY; Hackensack, NJ; Barbadoes Neck, NJ
Type of Work: Stoneware (Pottery)
Sources: *Decor* 135*, 223; *DicM* 107*.

Sandusky, William H.
b. 1813 **d.** 1849
Flourished: Austin, TX
Type of Work: Oil (Paintings)
Sources: *FoA* 468; *FoPaAm* 224*, 235.

Sanford, Isaac
Flourished: Connecticut
Type of Work: Oil (Signs, portraits, miniatures, chaise paintings)
Sources: *MoBBTaS* 13.

Sanford, M.M.
Flourished: 1850
Type of Work: Oil (Historical and battlescene paintings)
Museums: 203
Sources: *AmFoPaN* 160, 164*; *AmSFok* 169*; *PrimPa* 179.

Sanford, R.D.
Flourished: Stratford, CT
Type of Work: Wood (Duck decoys)
Sources: *AmBiDe 71.*

Sanford, Thomas
Flourished: c1850 Woodbury, CT
Type of Work: Pasteboard (Matchboxes)
Sources: *NeaT 123*.*

Sanford and Walsh
Flourished: c1789 Hartford, CT
Type of Work: Oil (Ornamental paintings)
Sources: *AmDecor 107.*

Santo, Patsy
b. 1893
Flourished: Bennington, VT
Ethnicity: Italian
Type of Work: Oil (Landscape paintings)
Museums: 020,179
Sources: *PrimPa 179; ThTaT 144-9*.*

Sapper
See: Getty and Sapper.

Sapper, William
Flourished: 1870 Philadelphia, PA
Type of Work: Wood (Ship carvings, ship figures)
Sources: *AmFiTCa 200.*

Sarah "Old Aunt Sarah"
Ethnicity: Black American
Type of Work: Fabric (Embroidery, weavings)
Sources: *AfAmA 90*.*

Sargent
See: Downes and Sargent.

Sargent, John B.
Flourished: 1854 Charlestown, MA
Type of Work: Wood (Ship carvings, ship figures)
Sources: *AmFiTCa 200.*

Sarle, Sister C.H.
Flourished: Old Chatham, NY
Ethnicity: Shaker
Type of Work: Oil (Hand painted postcards)
Sources: *HanWo 176*.*

Saterlee and Mory
[New York Stoneware Company]
Flourished: 1861-1891 Fort Edward, NY
Type of Work: Stoneware (Pottery)
Sources: *AmS 82*; Decor 223.*

Satler, J.
Flourished: 1845-1846 Leacock Township, PA
Type of Work: Fabric (Coverlets)
Sources: *ChAmC 100.*

Satler, J.M.
Flourished: 1846 Farmington, IL
Type of Work: Fabric? (Coverlets?)
Sources: *ChAmC 124.*

Satler, Lewis
[Saddler]
Flourished: 1842-1843 Leacock Township, PA
Type of Work: Fabric (Weavings)
Sources: *ChAmC 100.*

Satterlee, J.C.
Flourished: 1866 Corry, PA
Type of Work: Pen, ink (Penmanship, calligraphy drawings)
Sources: *FlowAm 104-5*.*

Satterlee and Mory
See: Saterlee and Mory.

Saunders, William
Flourished: c1819 Cincinnati, OH
Type of Work: Redware (Pottery)
Sources: *AmPoP 67, 210.*

Saurly, Nicholas
b. c1824
Flourished: c1860 Allentown, PA
Ethnicity: Dutch
Type of Work: Fabric (Coverlets)
Sources: *ChAmC 100.*

Savage, A.
Flourished: c1830 Lee, MA
Type of Work: Stone (Gravestones)
Sources: *EaAmG 129.*

Savage, A.J.
Flourished: 1845
Type of Work: Oil (Portraits)
Sources: *PrimPa 179.*

Savage, Charles K., Jr.
Flourished: contemporary Newburyport, MA
Type of Work: Wood (Sculptures, carvings)
Sources: *WoCar 203*.*

Savery, Lemuel
Flourished: c1775 Plymouth, MA
Type of Work: Stone (Gravestones)
Sources: *EaAmG 129.*

Savery, Rebecca Scattergood
Flourished: 1835-1840 Philadelphia, PA
Type of Work: Fabric (Quilts)
Museums: 171
Sources: *AmFoArt 128-9*.*

Saville, William
b. 1770 **d.** 1853
Flourished: 1801 Gloucester, MA; Hamilton, MA
Type of Work: Watercolor (Family tree, mourning paintings)
Sources: *AmFoPa 150, 160; Edith *.*

Savitsky, Jack
b. 1910 Silver Creek, PA
Flourished: 1959 Lansford, PA
Type of Work: Oil, crayon, pen, ink (Cityscape paintings)
Museums: 171
Sources: *AmFokArt 280-2*; FoA 468; FoAFt 2*; FoAFu 6*; FoPaAM 142-3, 150*; Full *; TwCA 176*.*

Savory, Thomas C.
Flourished: 1837-1865 Boston, MA
Type of Work: Paint (Ornamental and decorative paintings)
Sources: *AmFoPa 150, 160; Bes 38, 40.*

Savory and Company
Flourished: 19th cent Philadelphia, PA
Type of Work: Iron (Weathervanes, cast iron tea kettles)
Museums: 260
Sources: *EaAmI 39*, 46*, 48*; GalAmW 19; YankWe 213.*

Sawin, J.W.
Flourished: 1850 Springfield, MA
Type of Work: Oil (Landscape paintings)
Sources: *AmPrP 156; PrimPa 179.*

Sawin, Wealthy O.
Flourished: 1820 Massachusetts
Type of Work: Watercolor (Still life paintings)
Sources: *PrimPa 179.*

Sawyer, Mrs.
Flourished: 1880-1890 Maine
Type of Work: Fabric (Weavings)
Sources: *AmHo 32*.*

Sawyer, Belinda A.
Flourished: 1820
Type of Work: Watercolor (Still life paintings)
Museums: 001
Sources: *AmPrP 156; PicFoA 135*; PrimPa 179.*

Sawyer, H.
Flourished: 1860 Alton, IL
Type of Work: Earthenware (Pottery)
Sources: *ArC 194.*

Sawyer and Brothers
Flourished: c1858 Upper Alton, IL
Type of Work: Stoneware (Pottery)
Sources: *ArC 194.*

Sayels, J.M.
Flourished: 1851 Clinton County, IL; Knox County, IL
Type of Work: Fabric (Weavings)
Sources: *AmSQu 277; ChAmC 100.*

Sayler, C.
Flourished: 1836 New York
Type of Work: Fabric? (Coverlets?)
Sources: *ChAmC 100.*

Saylor, Jacob
Flourished: 1857 Tarlton, OH
Type of Work: Fabric (Weavings)
Sources: *ChAmC 100*.

Sayre, Caroline Eliza
b. 1824
Flourished: 1835 Newark, NJ
Type of Work: Fabric (Samplers)
Sources: *GalAmS 79**.

Scallon, L.
Flourished: 1865 Boston, MA
Type of Work: Wood (Ship carvings, ship figures)
Sources: *AmFiTCa 200*.

Scallon and Company
Flourished: 1871 Boston, MA
Type of Work: Wood (Ship carvings, ship figures)
Sources: *AmFiTCa 200*.

Schaaf, Henry
Flourished: 1860 St. Charles, MO
Type of Work: Tin (Lanterns)
Sources: *ASeMo 430**.

Schaefer
See: Sudbury and Schaefer.

Schaeffer, Henry
Flourished: 1860 New York, NY
Type of Work: Wood (Ship carvings, ship figures)
Sources: *AmFiTCa 200*.

Schaeffer, William
Flourished: 1886
Type of Work: Oil (Scenes for the America Opera Company)
Sources: *AmSFor 198*.

Schaeffner, Andrew
Flourished: 1870 Missouri
Ethnicity: German
Type of Work: Wood (Furniture)
Sources: *ASeMo 384*.

Schaettler
See: Wilson and Schaettler.

Schaffer, "Pop" "Poppsy"
b. 1880 d. 1964
Flourished: c1935 Mountainair, NM
Type of Work: Wood (Sculptures)
Museums: 171
Sources: *AmFoArt 73*; FoA 140**, 468.

Schaffer, Marea
Flourished: 1834 Pennsylvania
Type of Work: Fabric (Stitched linens)
Sources: *FoArRP 47*.

Schaffert, Charles
Flourished: 1860 New York, NY
Type of Work: Wood (Ship carvings, ship figures)
Sources: *AmFiTCa 200*.

Schaffner, Dexter L.
Flourished: contemporary Malden, MA
Type of Work: Wood (Sculptures, carvings)
Sources: *WoCar 197-8**.

Schantz, Joseph, Reverend
Flourished: Pennsylvania
Type of Work: Watercolor, ink (Frakturs)
Sources: *AmFoPa 189*.

Schatz, Bernard
Flourished: 1972 Virginia
Type of Work: Various materials (Masks, reliefs)
Sources: *FoAFc 6**.

Schauer, Jacob
Flourished: 1800's Pennsburg, PA
Type of Work: Clay (Pottery)
Sources: *AmPoP 174*.

Schauf, Wilhelm
Flourished: 1860-1880 Gasconade County, MO
Type of Work: Wood (Chairs)
Sources: *ASeMo 322**.

Scheckel, Conrad
Flourished: 1860 New York, NY
Type of Work: Wood (Ship carvings, ship figures)
Sources: *AmFiTCa 200*.

Scheelin, Conrad
Flourished: 1849
Type of Work: Fabric (Weavings)
Sources: *ChAmC 100*.

Scheffer, Richard
Flourished: Brownstown, PA
Type of Work: Tin (Tin roof ornaments)
Sources: *ToCPS 9**, 76.

Schell's Scenic Studio
Flourished: Columbus, OH
Type of Work: Oil (Circus banners)
Sources: *AmSFor 198*.

Schenck
Flourished: c1800 Springfield, NJ
Type of Work: Stone (Gravestones)
Sources: *EaAmG 129*.

Schenck, Cornelia Ann
Flourished: c1851 Flatbush, NY
Type of Work: Fabric (Quilts)
Sources: *QuiAm 98*, 108**.

Schenef, Friederich
Flourished: 1783 Pennsylvania
Type of Work: Watercolor, ink (Frakturs)
Sources: *AmFoPa 189*.

Schenefelder, Daniel P.
Flourished: 1869-1900 Reading, PA
Type of Work: Stoneware (Pottery)
Sources: *AmPoP 178, 279; Decor 223*.

Schenk, J.H.
Flourished: 1860 New York, NY
Type of Work: Oil (Cityscape paintings, building portraits)
Museums: 151
Sources: *AmFoPaN 104, 141**.

Schenkle
See: Frederick, Schenkle, Allen and Company.

Schenkle, William
[Shenkel]
Flourished: 1870-1875 Akron, OH
Type of Work: Stoneware (Pottery)
Sources: *AmPoP 206; AmS 253*; Decor 223*
See: Excelsior Pottery.

Scherg, Jacob
Flourished: 1811 Hempfield Township, PA
Type of Work: Watercolor, ink (Frakturs)
Sources: *AmFoPa 189; NinCFo 169, 188, fig15*.

Scherich, C.
Flourished: 1851 Pennsylvania
Type of Work: Watercolor, ink (Frakturs)
Sources: *AmFoPa 189*.

Schermerhorn
Flourished: late 19th cent Bay City, MI
Type of Work: Wood (Sculptures, carvings)
Sources: *AmFoS 336**.

Schetky, Caroline
See: Shetky, Caroline.

Scheuer, Joseph
Flourished: 1805
Type of Work: Watercolor, ink (Frakturs)
Sources: *Edith **.

Schifferl, Lou
Flourished: contemporary Green Bay, WI
Type of Work: Wood (Duck decoys)
Sources: *WoCar 157-8*, 168**.

Schimmel, Wilhelm
b. 1817 d. 1890 Carlisle, PA
Flourished: 1865-1885 Carlisle, PA
Ethnicity: German
Type of Work: Wood (Animals, toys, sculptures, carvings)
Museums: 096,171,176,227,260
Sources: *AmEaAD 29*; AmFoAr 42; AmFoArt 68*; AmFoS 5, 12, 204*, 206-9*, 278*, 337*; AmFoSc 17*;AmSFok 36*; BeyN 24-30*, 115, 126; BirB 48*;CoCoWA 16*, 122-3*; ColAWC 326-31*; EaAmW 104-5*; Edith * EyoAM 4, 8**
See: Mountz, Aaron.

Schimmel, Wilhelm (Continued)
Sources: *FoA 205*, 468; FoArA 22, 135-7*; FoArRP 115*; FoArtC 103; MaAmFA *; PenDuA 42*; WiScAm*.

Schipper, Jacob
Flourished: Quincy, IL
Type of Work: Fabric (Weavings)
Sources: *ChAmC 100.*

Schmeck, John
Flourished: 1842 Berks County, PA
Type of Work: Fabric (Weavings)
Sources: *ChAmC 100.*

Schmidt, Amalie August
Flourished: 1809 New York, NY
Type of Work: Fabric (Samplers)
Sources: *AmNe 61*, 63.*

Schmidt, Anna Marie
b. 1872 Louisville, KY
Flourished: 1890? Louisville, KY
Type of Work: Fabric (Quilts)
Sources: *KenQu fig57-8, 12.*

Schmidt, Benjamin J. "Ben"
b. 1884 d. 1968
Flourished: 1920s-1952 Center Line, MI
Type of Work: Wood (Decoys)
Museums: 260
Remarks: Brother is Frank
Sources: *BenS;Decoy 58*; WaDec xxii*, 4-5*, 80-7*, 129*, 152*, 161*, fig1, 14-5; .*

Schmidt, Clarence
b. 1897 Astoria, NY
Flourished: 1948-1971 Woodstock, VT
Type of Work: Various materials (Environmental sculptures)
Sources: *NaiVis 42*-51; TwCA 224-5*.*

Schmidt, Frank
Flourished: 1940s St. Clair Shores, MI
Type of Work: Wood, metal (Fish decoys)
Remarks: Brother is Ben
Sources: *UnDec 21*; WaDec xxiv*, 86-7*, 138*, 172*.*

Schmidt, Peter
b. 1795 d. 1838
Flourished: Shanesville, OH
Ethnicity: Swiss
Type of Work: Clay (Pottery)
Sources: *EaAmFo 214*.*

Schmidt, Peter
Flourished: 1860 New York, NY
Type of Work: Wood (Ship carvings, ship figures)
Sources: *AmFiTCa 200.*

Schmitt, Adam
Flourished: 1834- Quincy, IL
Ethnicity: German
Type of Work: Wood (Furniture)
Sources: *ArC 135.*

Schmitt, Ambrose
Flourished: 1860 New York, NY
Type of Work: Wood (Ship carvings, ship figures)
Sources: *AmFiTCa 200.*

Schmitz, Gail
b. 1936
Flourished: 1978? Lansing, MI
Type of Work: Beeswax, pencils, candles (Pysanky-Easter eggs)
Sources: *Rain 38*-9*.*

Schnee, Joseph F.
b. 1792 d. 1838 Freeburg, PA
Flourished: 1835-1841 Freeburg, PA; Lewisburg, PA; Lewistown, PA
Type of Work: Fabric (Carpets, coverlets)
Remarks: Son is William
Sources: *AmSQu 277; ChAmC 100-2*
See: Strunk's Mill .

Schnee, William
Flourished: 1838-1842 Freeburg, PA
Type of Work: Fabric (Weavings)
Remarks: Father is Joseph
Sources: *AmSQu 277; ChAmC 102.*

Schneider, Christian
Flourished: 1784 Pennsylvania
Type of Work: Watercolor, ink (Frakturs)
Sources: *AmFoPa 189.*

Schneider, Johann Adam
Flourished: 1830 Adams Township, OH
Type of Work: Fabric (Coverlets)
Sources: *ChAmC 102.*

Schneider, John E.
d. 1903
Flourished: 1848-1872 Hamburg, MO
Ethnicity: German
Type of Work: Fabric (Coverlets)
Sources: *ASeMo;ChAmC 102.*

Schneider and Pachtmann
Flourished: 1886 Philadelphia, PA
Type of Work: Wood (Ship carvings, ship figures)
Sources: *AmFiTCa 200.*

Schnell, Jacob
b. 1815 Pennsylvania d. 1902 Shrewsbury Township, PA
Flourished: 1840-1870 Shrewsbury, PA
Type of Work: Fabric (Weavings)
Sources: *ChAmC 102.*

Schnitzler, Paul
Flourished: 1868 New York
Type of Work: Pen, watercolor (Memorial drawings)
Sources: *AmPrW 139*, 116*.*

Schnure
Flourished: Hartleton, PA
Type of Work: Tin (Tinware)
Sources: *ToCPS 43.*

Schoch, Charles (G. Schoch)
Flourished: 1840-1862 Thompson Township, OH; Fulton County, IN
Type of Work: Fabric (Coverlets)
Sources: *ChAmC 102.*

Schoenfield, Emanual
Flourished: 20th century Brooklyn, NY
Type of Work: Wood? (Bookends)
Museums: 086
Sources: *WoScuNY.*

Schoenheider, Charles
b. 1854 d. 1944
Flourished: c1880-1930 Peoria, IL
Type of Work: Wood (Duck decoys)
Sources: *AmFoS 293*; EyoAm 9; FoA 220*, 468; TwCA 29*.*

Schofield, William
Flourished: 1825-1900 Honeybrook, PA; Lionville, PA
Type of Work: Redware (Pottery)
Sources: *AmPoP 169.*

Schofield, D.G. and Co.
See: D.G. Schofield and Company .

Scholl, John
b. 1827 d. 1916 Potter County, PA
Flourished: 1907-1916 Germania, PA
Ethnicity: German
Type of Work: Wood (Sculptures, carvings)
Museums: 150,171,203,307,309
Sources: *AmFoS 212-3*; CeIWo;FoA 468; MaAmFA *; TwCA 31*.*

Scholl, Michael
See: School, Michael .

Schone, Robert
Flourished: 1860 New York, NY
Type of Work: Wood (Ship carvings, ship figures)
Sources: *AmFiTCa 200.*

School, Michael
[Scholl, Michael]
Flourished: c1830 Tylersport, PA
Type of Work: Clay (Pottery)
Sources: *AmPoP 184, 278; DicM 164*, 210*.*

Schoolcraft, Henry R.
Flourished: 1815-1850 Keene, NH
Type of Work: Glass (Glass works)
Museums: 058,252
Sources: *AmSFok 126*.*

Schoolcraft, Henry Rowe
Flourished: Chicago, IL
Type of Work: Pen, ink (Landscape drawings)
Sources: *ArC 48, 221.*

Schoonmaker, James
Flourished: 1825 Paterson, NJ
Type of Work: Fabric (Carpets, coverlets)
Sources: *ChAmC 102.*

Schrack, Catharine
b. c1801
Flourished: 1815 Philadelphia, PA
Type of Work: Fabric (Samplers)
Sources: *GalAmS 20-1, 50-1*.*

Schrack, Joseph
Flourished: 1797 Heidelberg Township, PA
Type of Work: Fabric (Weavings)
Sources: *ChAmC 102.*

Schrader, H.
Flourished: 1849 Canal Winchester, OH; Jefferson County, OH
Type of Work: Fabric (Coverlets)
Sources: *ChAmC 102-3.*

Schramm, Butch
Flourished: c1945 New Baltimore, MI
Type of Work: Wood (Decoys)
Sources: *WaDec ix*.*

Schramm, Speck
Flourished: c1880-1890 Burlington, IA
Type of Work: Wood (Duck decoys)
Sources: *AmBiDe 190.*

Schrap, W.J.
Flourished: c1850 Springfield, OH
Type of Work: Stoneware (Jugs)
Museums: 303
Sources: *AmS 107*.*

Schreffler, Henry
b. 1814 d. 1881
Flourished: 1841-1856 Salona, PA
Type of Work: Fabric (Weavings)
Sources: *ChAmC 103.*

Schreffler, Isaac
b. c1826 Pennsylvania
Flourished: 1847-1858 Lamar Township, PA
Type of Work: Fabric (Coverlets)
Sources: *ChAmC 103.*

Schreffler, Samuel
b. c1804 Pennsylvania
Flourished: 1845-1853 Mifflinburg, PA; Salona, PA
Type of Work: Fabric (Coverlets)
Sources: *ChAmC 103.*

Schrieber, John
Flourished: c1870 Rondout, NY
Type of Work: Stoneware (Pottery)
Sources: *Decor 223.*

Schriver, Jacob
b. 1816 Pennsylvania d. 1896 Gettysburg, PA
Flourished: 1841-1860 Pennsylvania
Type of Work: Fabric (Weavings)
Remarks: Father is John
Sources: *ChAmC 103.*

Schriver, John
Flourished: c1841-1860 Pennsylvania
Type of Work: Fabric (Weavings)
Remarks: Son is Jacob
Sources: *ChAmC 103.*

Schrock, Mrs. Sam
Flourished: 1925-1930 Shipshewana, IN
Ethnicity: Amish
Type of Work: Fabric (Quilts)
Sources: *ArtWo fig23; QuInA 28*, 41*.*

Schrock, Susan
Flourished: 1930 Topeka, IN
Ethnicity: Amish
Type of Work: Fabric (Quilts)
Sources: *QuInA 76*.*

Schroeder, Carl
b. 1817 d. 1895
Flourished: Gasconade County, MO
Ethnicity: German
Type of Work: Stone (Gravestones, other stoneworks)
Remarks: Born in Schwarzburg
Sources: *ASeMo 432*.*

Schroeder, Tom
b. 1885 d. 1976
Flourished: c1949 Detroit, MI
Type of Work: Wood (Duck decoys)
Museums: 260
Sources: *AmBiDe 194; Decoy 50*, 59*, 61*; WaDec 72-9*, 129*, fig4-5.*

Schrontz
Flourished: Dearborn County, IN
Type of Work: Fabric (Coverlets)
Sources: *AmSQu 277; ChAmC 103.*

Schroth, Daniel, Reverend
Flourished: 1800s Helvetia, WV
Ethnicity: German
Type of Work: Paint (Murals)
Sources: *SoFoA 56*-7*, 218.*

Schrum
Flourished: 1845-1850 Plumstead, PA
Type of Work: Redware (Pottery)
Sources: *AmPoP 177.*

Schubert, John G.
b. 1838 d. 1909
Flourished: St. Charles, MO
Ethnicity: German
Type of Work: Wood (Sculptures, carvings)
Sources: *ASeMo 390.*

Schuller, Johann Valentin
d. 1812?
Flourished: 1795-1815 Pennsylvania
Type of Work: Watercolor, ink (Frakturs)
Sources: *AmFoPa 189; HerSa.*

Schultz, Barbara
Flourished: 1806 Pennsylvania
Type of Work: Watercolor, ink (Frakturs)
Sources: *AmFoPa 189.*

Schultz, J.N.
b. c1812
Flourished: c1847-1867 Mercersburg, PA; Peters Township, PA
Ethnicity: German
Type of Work: Yarn, fabric (Coverlets, carpets)
Museums: 189
Sources: *ChAmC 103; FoArRP 70*.*

Schultz, Johann Theobald
Flourished: c1790 Newmanstown, PA
Type of Work: Redware (Pottery)
Sources: *AmPoP 172.*

Schultz, Lidia
Flourished: 1826 Pennsylvania
Type of Work: Watercolor, ink (Frakturs)
Sources: *AmFoPa 189.*

Schultz, Martin
Flourished: 1860 Elgin, IL
Type of Work: Clay (Pottery)
Sources: *ArC 194.*

Schultz, Regina
Flourished: 1806-1848 Pennsylvania
Type of Work: Watercolor, ink (Frakturs)
Museums: 176
Sources: *AmFoPa 189; ColAWC 277.*

Schultz, Salamon
Flourished: 1836 Pennsylvania
Type of Work: Watercolor, ink (Frakturs)
Sources: *AmFoPa 189.*

Schultz, Sara
Flourished: 1827 Pennsylvania
Type of Work: Watercolor, ink (Frakturs)
Sources: *AmFoPa 189.*

Schultz, William L.
Flourished: 1968 Milwaukee, WI
Type of Work: Wood (Bird sculptures, carvings)
Sources: *WoCar 170*.*

Schultze, C.
Flourished: 19th century Pennsylvania
Type of Work: Watercolor, ink (Frakturs)
Sources: *AmFoPa 189.*

Schulz, Maria Boyd
Flourished: c1850 Charleston, SC
Type of Work: Fabric (Bedspreads)
Sources: *SoFoA 182*, 222.*

Schulze, Lizzie J.
Type of Work: Watercolor (Scene paintings)
Museums: 176
Sources: *ColAWC 240, 243*.*

Schum, Joseph
Flourished: Lancaster, PA
Type of Work: Fabric? (Coverlets?)
Sources: *ChAmC 103.*

Schum, Peter
Flourished: Lancaster, PA
Type of Work: Fabric (Coverlets)
Sources: *ChAmC 103.*

Schum, Philip
b. 1814 d. 1880
Flourished: 1844-1875 Lancaster, PA
Ethnicity: German
Type of Work: Fabric (Weavings)
Sources: *AmSQu 277; ChAmC 103.*

Schumacher, Daniel, Reverend
d. 1787
Flourished: 1754-1787 Berks County, PA; Lehigh, PA; Northhampton, PA
Type of Work: Watercolor, ink (Frakturs)
Sources: *AmFokDe 144; AmFoPa 185; FoArRP 212*; FoPaAm 113*-4; NinCFo 188.*

Schuman, E.
Flourished: last half 19th cent Lebanon County?, PA
Type of Work: Wood, paint (Signs)
Museums: 224
Sources: *ArEn 68.*

Schuyler, Angelica
Flourished: c1808 New York
Type of Work: Fabric, paint (Mourning pictures)
Museums: 006
Sources: *MoBeA fig52.*

Schwager, William
Flourished: 1860 New York, NY
Type of Work: Wood (Ship carvings, ship figures)
Sources: *AmFiTCa 200.*

Schwartz
See: Kurbaum and Schwartz.

Schwartz, Michael
b. c1810 Pennsylvania d. 1904
Flourished: 1842-1858 Manheim, PA
Type of Work: Fabric (Weavings)
Sources: *ChAmC 104.*

Schwartz, Peter
Flourished: 1791 Philadelphia, PA
Type of Work: Wood (Ship carvings, ship figures)
Sources: *AmFiTCa 200.*

Schwarzer, Franz
Flourished: 1860s Franklin County, MO
Type of Work: Wood (Altar sculptures, carvings)
Sources: *ASeMo 401.*

Schweikart, John
b. 1870 d. 1954
Flourished: Michigan
Ethnicity: German
Type of Work: Wood (Decoys)
Sources: *WaDec 3*, 6, 24-31*, 143*, fig2-3.*

Schweinfurt, John George
Flourished: mid 1800s New Market, VA
Type of Work: Earthenware (Sculptures)
Museums: 001
Sources: *SoFoA 130*-1, 220.*

Schwob, Antoinette
Flourished: c1950 New York, NY
Type of Work: Oil (Paintings)
Museums: 171, 178
Sources: *AmFokArt 283-6; FoAFab 10*; FoPaAm 112*.*

Schyfer, Martha
Flourished: 1839 Pennsylvania
Type of Work: Fabric (Hand towels, samplers)
Sources: *BeyN 123; WinGu 23*.*

Scofield, E.A.
Flourished: 1850 Darien, CT
Type of Work: Fabric (Quilts)
Sources: *QuiAm 274*.*

Scott, Alexander F.
Flourished: c1870-1909 Allston, MA
Type of Work: Stoneware (Pottery)
Sources: *Decor 217*
See: Bullard, Joseph O.

Scott, Ann
Flourished: 1820 Baltimore, MD
Type of Work: Fabric (Embroidered linen bureau covers)
Sources: *AmNe 75*, 78.*

Scott, Elizabeth
b. 1735 Newport, RI d. 1809
Flourished: 1741 Newport, RI
Type of Work: Fabric (Samplers)
Museums: 205
Sources: *LeViB 51, 58, 60.66*.*

Scott, George
[George Scott and Sons]
Flourished: 1846-1900 Cincinnati, OH
Type of Work: Stoneware (Pottery)
Sources: *AmPoP 77-8, 210; Decor 223.*

Scott, I.
Flourished: 1836 Wagram, NC
Type of Work: Oil (Room interior and overmantel paintings)
Museums: 001
Sources: *AmDecor figvii, 137; FoPaAm 168*.*

Scott, John
Flourished: 1860 Philadelphia, PA
Type of Work: Wood (Ship carvings, ship figures)
Sources: *AmFiTCa 200.*

Scott, Judy Ann
Flourished: c1880 Temple Hill, KY
Type of Work: Fabric (Quilts)
Sources: *KenQu fig4, 13.*

Scouten, O.B.
Flourished: 1880-1890 New York
Type of Work: Watercolor (Paintings)
Museums: 203
Sources: *FouNY 54, 66*.*

Scovill, Nancy Cooke
Flourished: 1821 Waterbury, CT
Type of Work: Fabric (Quilts)
Sources: *QuiAm 144*.*

Scriba, George Frederick William Augustus
Flourished: 1930 Scriba, NY
Type of Work: Wood, metal (Fish decoys)
Sources: *FouNY 52*, 68.*

Scripture, George
Flourished: Mason Village, NH
Type of Work: Tin (Stencils)
Sources: *TinC 144-6*.*

Scriven, Danny
Flourished: c1925 Michigan
Type of Work: Wood (Decoys)
Sources: *WaDec 135*.*

Scudder, Moses
Flourished: c1810-1825 Huntington, NY
Type of Work: Redware (Pottery)
Sources: *AmPoP 194.*

Scwartz, John, Sr.
b. c1811 Pennsylvania d. 1892 York, PA
Flourished: 1850-1888 York, PA
Type of Work: Fabric (Carpets, coverlets)
Remarks: Son is John, Jr.
Sources: *ChAmC 104.*

Scwartz, John, Jr.
b. c1856
Flourished: c1880-1888 York, PA
Type of Work: Fabric (Carpets, coverlets)
Remarks: Father is John, Sr.
Sources: *ChAmC 103.*

Seagle, Daniel
Flourished: 1825-1850 Lincoln County, NC
Type of Work: Stoneware (Jars)
Museums: 002,157
Sources: *AmS 206*; SoFoA 24*, 34*, 217.*

Seamen, W.
Flourished: 1850 New York
Type of Work: Oil (Cityscape paintings)
Museums: 203
Sources: *FoPaAm 101*.*

Searing, George E.
Flourished: 1840 New York, NY
Type of Work: Wood (Ship carvings, ship figures)
Sources: *AmFiTCa 200.*

Sears, Adeline Harris
Flourished: c1863 Providence, RI
Type of Work: Fabric (Quilts)
Sources: *QuiAm 169*.*

Sears, Gordon
Flourished: Michigan
Type of Work: Wood (Fish decoys)
Sources: *UnDec 20.*

Seaver, John
Flourished: 1815-1830 Taunton, MA
Type of Work: Stoneware (Pottery)
Sources: *Decor 224*
See: Seaver, William Jr.; Seaver, William

Seaver, William
Flourished: c1790-1815 Taunton, MA
Type of Work: Stoneware (Pottery)
Remarks: Son is William, Jr.
Sources: *Decor 224*
See: Seaver, John.

Seaver, William, Jr.
Flourished: 1815-1830 Taunton, MA
Type of Work: Stoneware (Pottery)
Remarks: Father is William
Sources: *Decor 224*
See: Seaver, John.

Seavey, Amos
Flourished: c1850 Chelsea, MA
Type of Work: Stoneware (Pottery)
Sources: *Decor 111.*

Seavey, Lafayette W.
Flourished: New York
Type of Work: Oil (Theater and sideshow scenes)
Sources: *AmSFor 198.*

Seavey, Thomas
d. 1886
Flourished: 1843-1886 Bangor, ME
Type of Work: Wood (Ship carvings, ship figures)
Museums: 221,270
Remarks: Son is William L.
Sources: *AmFiTCa 200; ShipNA 83, 156*
See: Thomas Seavey and Sons.

Seavey, William L.
b. 1834 d. 1912
Flourished: 1859-1911 Bangor, ME
Type of Work: Wood (Ship carvings, ship figures)
Remarks: Father is Thomas
Sources: *ShipNA 83, 156.*

Seavey and Sons
See: Thomas Seavey and Sons.

Seaward
Flourished: 1874 Portsmouth, NH
Type of Work: Wood (Ship carvings, ship figures)
Sources: *AmFiTCa 200.*

Sebastian, Jacob (John)
See: Sebastian Wagon Company.

Sebastian Wagon Company
[Sebastian, Jacob (John)]
Flourished: 1884-1902 New York, NY
Type of Work: Wood (Circus and carousel figures)
Remarks: Jacob founded the Sebastian Wagon Company
Sources: *AmFokAr 107, fig93, 94, 95; ArtWod 95, 114*; HoKnAm 164-5; InAmD 154**
See: Bright, Pete.

Sebring Pottery Company
Flourished: est.1887 Sebring, OH
Type of Work: Clay (Pottery)
Sources: *AmPoP 218, 279*; DicM 120*, 200*.*

Seckner, C.M.
Flourished: 1870 Lewis County, NY
Type of Work: Watercolor, ink (Drawings)
Sources: *FouNY 66*.*

Sedgwick, Susan
Flourished: c1811-
Type of Work: Oil (Portraits)
Museums: 145
Sources: *ArtWo 92*, 171.*

Seebeck, Walter
b. 1919 Bennett, IA
Flourished: c1980 Bennett, IA
Type of Work: Wood (Sculptures)
Sources: *FoAFm 1*, 6*.*

Seebold, Phillip
Flourished: 1820-1845 New Berlin, PA
Type of Work: Redware (Tobacco pipes)
Sources: *AmPoP 172.*

Seelig, Moritz J. (Morris; Maurice)
b. 1809
Flourished: Brooklyn, NY
Ethnicity: German
Type of Work: Wood, zinc (Cigar store Indians, figures, statuary)
Museums: 294
Sources: *AmFoS 260*; ArtWod fig2a, 8*, 33, 52*, 61*-4; EyoAm 9.*

Seewald, John (John Philip)
Flourished: 1828-1849 Belleville, IL; O'Fallon, IL; Philadelphia, PA
Ethnicity: German
Type of Work: Fabric (Weavings, linens, coverlets)
Sources: *ArC 171; ChAmC 104.*

Seibert, Henry
Flourished: 1813 Pennsylvania
Type of Work: Watercolor, ink (Frakturs)
Sources: *AmFoPa 189.*

Seibert, John, Sr.
b. 1796 Pennsylvania d. 1854
Flourished: 1844-1850 Lowhill Township, PA
Type of Work: Fabric (Weavings)
Remarks: Sons are John, Jr., Owen, and Peter
Sources: *AmSQu 277; ChAmC 104.*

Seibert, John, Jr.
b. Pennsylvania
Flourished: 1844-1850 Lowhill Township, PA
Type of Work: Fabric (Weavings)
Remarks: Father is John, Sr.
Sources: *ChAmC 104.*

Seibert, Owen
b. c1828 Pennsylvania
Flourished: c1850 Lowhill Township, PA
Type of Work: Fabric (Weavings)
Remarks: Father is John Sr.
Sources: *ChAmC 104.*

Seibert, Peter
b. 1821 Lowhill Township, PA
Flourished: c1850 Easton, PA
Type of Work: Fabric (Coverlets)
Remarks: Father is John Sr.
Sources: *ChAmC 104.*

Seidenspinner, John
b. c1831
Flourished: c1860 Allentown, PA
Ethnicity: German
Type of Work: Fabric (Coverlets)
Sources: *ChAmC 104*
See: Woodring; Fritzinger, Jerret.

Seifert, Andrew
b. c1820 York County, PA d. 1900
Flourished: 1847-1887 Mechanicsburg, PA
Type of Work: Fabric (Weavings)
Remarks: Brothers are Henry and Emanuel
Sources: *ChAmC 105*
See: Young, Charles.

Seifert, Emanuel
b. c1830 York County, PA
Flourished: 1850-1864 Mechanicsburg, PA
Type of Work: Fabric (Weavings)
Remarks: Brothers are Andrew and Henry
Sources: *ChAmC 105.*

Seifert, Henry
b. c1823 York County, PA d. 1905
Flourished: 1843-1852 Mechanicsburg, PA
Type of Work: Fabric (Coverlets)
Remarks: Brothers are Andrew and Emanuel
Sources: *ChAmC 105.*

Seifert, Paul A.
b. 1840 d. 1921
Flourished: 1879 Gothan, WI; Plain, WI
Ethnicity: German
Type of Work: Watercolor (Farm scene paintings)
Museums: 171
Sources: *AmFoArt 28*; AmFoPaCe 160-3*; FoA 41*, 468; PrimPa 149-56*, 179.*

Seifert and Company
Flourished: Mechanicsburg, PA
Type of Work: Fabric (Carpets, coverlets)
Sources: *ChAmC 105.*

Seigrist, Henry
b. 1788 Lancaster County, PA d. 1860
Flourished: c1826-1830 Wayne County, OH; Richland County, OH
Type of Work: Fabric (Weavings)
Sources: *ChAmC 105*.

Seiler, H.
Flourished: 1795-1815 Pennsylvania
Type of Work: Watercolor, ink (Frakturs)
Sources: *AmFoPa 183**.

Seip
Flourished: c1847 Allentown, PA
Type of Work: Fabric (Coverlets)
Sources: *ChAmC 105*.

Seixas, David G.
Flourished: 1790-1822 Philadelphia, PA
Type of Work: Cream-colored ware (Pottery)
Sources: *AmPoP 45, 101, 175*.

Selby, Cleland
Flourished: contemporary Essex Junction, VT
Type of Work: Fabric (Hooked rugs)
Sources: *FoAFp 19**.

Selby, Edward
Flourished: 1834-1836 Albany, NY; Hudson, NY
Type of Work: Stoneware (Pottery)
Sources: *Decor 224*
See: C. Dillon and Company.

Self, Bob
b. 1946
Flourished: 1976 New York, NY
Type of Work: Wood (Sculptures)
Sources: *FoA 183**.

Selleck and Smith
See: Smith, Asa E.

Seller, James
Flourished: 1837 Philadelphia, PA
Type of Work: Metal (Trivets)
Sources: *BeyN 16*, 18, 114*.

Sellers, George Escol
b. 1808 d. 1899
Flourished: Seller's Landing, IL
Remarks: Grandson of Charles Willson Peale
Sources: *ArC 266*.

Selman, William
Flourished: 1874 Philadelphia, PA
Type of Work: Wood (Ship carvings, ship figures)
Sources: *AmFiTCa 200*.

Seltzer, Christian
See: Selzer, Christian.

Seltzer, John
See: Selzer, John.

Selzer, Christian
[Seltzer]
b. 1749 d. 1831
Flourished: 1771-1796 Jonestown, PA
Type of Work: Wood (Dower chests)
Museums: 151
Remarks: Son is John
Sources: *AmFokDe ix*, 11*; AmPaF 273*; FoArRP 108*; InAmD 5*; PenDA 118*; PenGer 62, 142*, 192**.

Selzer, John
[Seltzer]
Flourished: Columbia County, PA
Type of Work: Wood (Dower chests)
Remarks: Father is Christian
Sources: *AmFokDe 11*.

Senior, C.F.
Flourished: 1780 Reading, PA
Type of Work: Oil (Genre paintings)
Sources: *AmNa 83*; PrimPa 179*.

Serff, Abraham
b. 1791 Pennsylvania d. 1876
Flourished: c1850 Codorus Township, PA
Type of Work: Fabric (Coverlets)
Museums: 110
Sources: *ChAmC 105*.

Serl, Jon
b. 1894 Oleans, NY
Flourished: 1945? San Juan Capistrano, CA; Lake Elsinore, CA
Type of Work: Paint (Fantasy paintings)
Sources: *FoAFb 6-7*; PioPar 8*-9, 19, 45*, 53, 63*.

Setzer, Jacob
b. 1819 Pennsylvania d. 1892
Flourished: 1850 Jackson Township, PA
Type of Work: Fabric (Weavings)
Sources: *ChAmC 106*.

Seultzer, Alexander
Flourished: 1839 Boonville, MO
Ethnicity: German
Type of Work: Stone (Gravestones, other stoneworks)
Sources: *ASeMo 430*.

Seuter, John
Flourished: Pennsylvania
Type of Work: Watercolor, ink (Frakturs)
Sources: *AmFoPa 189*.

Severence, Benjamin J.
Flourished: 1825 Northfield, MA; Shelburne, CT
Type of Work: Oil (Ornamental paintings)
Sources: *AmDecor 116; PrimPa 179*.

Sevres China Company
Flourished: 1900 East Liverpool, OH
Type of Work: Clay (Pottery)
Sources: *DicM 121*, 209*-210**.

Sewall, Harriet
Flourished: 1808-1810 New England,
Type of Work: Watercolor (Mourning paintings)
Museums: 176
Sources: *ColAWC 212*-3; FlowAm 87*; PrimPa 179*.

Seward
See: Randolph and Seward.

Seward, William
Flourished: 1858 Baltimore, MD
Type of Work: Wood (Ship carvings, ship figures)
Sources: *AmFiTCa 200; ShipNA 158*.

Seybert, Abraham
Flourished: 1812 Pennsylvania
Type of Work: Watercolor, ink (Frakturs)
Sources: *AmFoPa 189*.

Seybold, Carl F.
Flourished: 1843 Pennsylvania
Type of Work: Watercolor, ink (Frakturs)
Sources: *AmFoPa 189*.

Seymour
See: Webster and Seymour.

Seymour, George R.
Flourished: c1845-1860 West Troy, NY
Type of Work: Stoneware (Pottery)
Sources: *Decor 224*.

Seymour, Israel
[I. Seymour and Company]
Flourished: 1806-1865 Troy, NY; Albany, NY
Type of Work: Stoneware (Pottery)
Sources: *AmPoP 186, 203, 279; AmS 193*; Decor 105*, 224; DicM 68*; EaAmFo 3, 186**.

Seymour, John
Flourished: 1800 Boston, MA
Type of Work: Wood (Chairs)
Sources: *AmPaF 110**.

Seymour, Major
Flourished: 1825-1849 Hartford, CT
Type of Work: Redware (Flower pots)
Sources: *AmPoP 59, 193*.

Seymour, Nathaniel
Flourished: pre-1800 Hartford, CT
Type of Work: Redware (Pottery)
Sources: *AmPoP 59, 193*.

Seymour, Orson H.
[Seymour and Bosworth]
Flourished: 1867-1890 Hartford, CT
Type of Work: Stoneware (Pottery)
Sources: *Decor 224*
See: Webster, Mack C.; Webster and Seymour.

Seymour, Samuel
Flourished: 1819 Philadelphia, PA
Ethnicity: English
Type of Work: Oil (Genre, landscape paintings)
Museums: 307
Remarks: Painted scenes of a trip to Yellowstone
Sources: ArC 52, 114; PicFoA 112*; PrimPa 179.

Seymour, Walter J.
Flourished: 1852-1885 Troy, NY
Type of Work: Stoneware (Pottery)
Sources: Decor 224.

Seymour and Bosworth
Flourished: 1873-1883 Hartford, CT
Type of Work: Stoneware (Pottery)
Sources: AmPoP 193; Decor 224
See: Seymour, Orson H. .

Seymour and Steadman
See: Seymour and Stedman .

Seymour and Stedman
Flourished: c1825-1850 Ravenna, OH; New Haven, CT
Type of Work: Stoneware (Pottery)
Sources: AmPoP 228, 279; AmS 86*, 225*; Decor 224; DicM 122*.

Shade, J.
Flourished: c1835 Berks County, PA
Type of Work: Tin (Tinware)
Sources: AmCoTW 161; CoCoWA 56*.

Shade, P.
Flourished: c1793-1797 Berks County, PA
Type of Work: Tin (Tinware)
Sources: AmCoTW 151, 161.

Shade, Willoughby
b. 1820 Pennsylvania
Flourished: 1840-1866 Montgomery County, PA; Philadelphia, PA; Bucks County, PA
Type of Work: Tin (Tinware)
Sources: ToCPS 36*-8, 43, 48, 73, 76.

Shafer, J.
Flourished: 1847 Martinsburg, PA
Type of Work: Fabric (Coverlets)
Sources: ChAmC 106.

Shafer, Samuel C.
Flourished: 1810 Ohio
Type of Work: Oil, pen (Group portraits, drawings)
Sources: PrimPa 179.

Shaffner, Jacob
Flourished: c1890 Pennsylvania
Type of Work: Fabric (Quilts)
Sources: AmBiDe 55*.

Shalk, Jacob
d. 1864
Flourished: 1833-1864 Lebanon, PA; Ohio
Type of Work: Fabric (Weavings)
Sources: ChAmC 106.

Shalk, Jacob
Flourished: 1840-1850 Licking County, OH; Pennsylvania
Type of Work: Fabric (Weavings)
Sources: ChAmC 106.

Shalk, John
Flourished: 1835
Type of Work: Fabric? (Coverlets?)
Sources: ChAmC 106.

Shallenberger, Peter
Flourished: 1836-1839 Juniata County, PA
Type of Work: Fabric (Coverlets)
Sources: ChAmC 106.

Shamp, D.
Flourished: 1847 Wyoming County, NY; Petty, NY
Type of Work: Fabric (Coverlets)
Museums: 271
Sources: ChAmC 102*, 113*, 106.

Shank, H.
Flourished: 1847
Type of Work: Fabric (Coverlets)
Sources: ChAmC 106.

Shank, M.
Flourished: 1843 Fairfield County, OH
Type of Work: Fabric? (Coverlets?)
Sources: ChAmC 106.

Shank, W.
Flourished: 1831-1839 Montgomery County, OH
Type of Work: Fabric (Coverlets)
Sources: ChAmC 106.

Shank, William
b. Ohio
Flourished: 1854-1875 Paris, IL
Type of Work: Stoneware (Pottery)
Sources: ArC 194.

Shannon, George W.
Flourished: 1860 New York, NY
Type of Work: Wood (Ship carvings, ship figures)
Sources: AmFiTCa 200.

Shapiro, Pauline
b. 1920 New York, NY d. 1972 New York, NY
Flourished: New York, NY
Type of Work: Fabric (Embroidered and needlepoint imaginary pictures)
Sources: TwCA 157*.

Shapley
See: Boerner, Shapley and Vogt .

Sharp, Charles
Flourished: 1820 New York, NY
Type of Work: Wood (Ship carvings, ship figures)
Sources: AmFiTCa 200.

Sharpe, C(ornelius) N.
Flourished: 1815-1817 New York, NY
Type of Work: Wood (Ship carvings, ship figures)
Sources: AmFiTCa 92, 200; ShipNA 161
See: Dodge and Sharpe .

Sharpe and Ellis
Flourished: 1810 New York, NY
Type of Work: Wood (Ship carvings, ship figures)
Sources: AmFiTCa 200; ShipNA 161
See: Sharpe, C(ornelius) N.

Sharples, Elen T.
Flourished: 1819 Mahoning, PA
Type of Work: Fabric (Samplers)
Sources: GalAmS 54*.

Sharples, James
Type of Work: Crayon (Pastel portraits)
Museums: 151
Sources: FoArtC 113.

Sharpless, Samuel
Flourished: 1808-1830 St. Clairsville, OH
Type of Work: Redware (Pottery)
Sources: AmPoP 230.

Shaw, Martha Ann
Flourished: c1823 Crawford County, IL
Type of Work: Fabric (Needlework)
Sources: ArC 81.

Shaw, Robert
Flourished: c1850 West Indianapolis, IN
Ethnicity: Irish
Type of Work: Fabric (Weavings)
Sources: ChAmC 106
See: Wilson, Jonathan; Muir, William .

Shaw, Susan M.
Flourished: 19th cent
Type of Work: Velvet (Still life paintings)
Sources: Edith *.

Sheafer, Franklin D.
[Sheaffer]
Flourished: 1849
Type of Work: Fabric (Weavings)
Sources: AmSQu 277; ChAmC 106.

Sheaffer
See: Sheafer, Franklin D.

Sheaffer, Isaac
Flourished: 1836-1845 New Berlin, OH; Rabbit Hill, PA; Plain Township, OH
Type of Work: Fabric (Coverlets)
Sources: AmSQu 277; ChAmC 106.

Shearer, Henry
b. c1805
Flourished: c1850 Richland County, OH
Ethnicity: German
Type of Work: Fabric (Weavings)
Sources: *ChAmC 106*
See: Hipp, Sebastian.

Shearer, Jane
Flourished: 1806 Pennsylvania; New Jersey
Type of Work: Fabric (Samplers)
Sources: *GalAmS 42*-3**.

Shearer, Michael
Flourished: New Lebanon, OH
Type of Work: Fabric (Coverlets)
Sources: *ChAmC 106*.

Sheboygan Decoy Company
Flourished: 1880s Sheboygan, WI
Type of Work: Tin (Decoys)
Sources: *FoA 468*.

Sheets, Frank M.
Flourished: 1870 Allentown, PA
Type of Work: Oil (Portraits)
Sources: *PrimPa 180*.

Sheffield, Elizabeth
b. 1770s Newport?, RI?
Flourished: 1784 Newport, RI
Type of Work: Fabric (Samplers)
Sources: *LeViB 74**.

Sheffield, Isaac
b. 1798 Connecticut d. 1845
Flourished: 1830-1840 Stonington, CT; New London, CT
Type of Work: Oil (Portraits)
Museums: 139,171,189
Sources: *AmFoArt 15*; AmFoPa 48, 83-4*; AmFoPaN 57, 80*-1*; AmFoPaS 73*; AmNa 14; AmPrP 156;FoA 15*, 468; FoArA 49, 53-5*; FoArtC 113, 121*; FoPaAm 38*; NinCFo 169, 177, fig70;PrimPa 180; SoAmP 162*.

Sheffler, Isreal
b. c1826 Pennsylvania
Flourished: c1850 Salona, PA
Type of Work: Fabric (Coverlets)
Sources: *ChAmC 106*.

Shelby, George Cass
b. 1878 d. 1975
Flourished: 1922 Grand Rapids, MI
Type of Work: Oil, watercolor (Whimsical decorated letters, paintings, wall murals)
Sources: *Rain 72*-3**.

Sheldon
See: Morton and Sheldon.

Sheldon, Arabella Stebbens
See: Wells, Arabella Stebbens Sheldon.

Sheldon, F.L.
Flourished: 1845-1878 Mogadore, OH
Type of Work: Stoneware (Pottery)
Sources: *AmPoP 224; Decor 224*.

Sheldon, Lucy
Flourished: 1810 Litchfield, CT
Type of Work: Watercolor (Paintings)
Sources: *PrimPa 180*.

Shelite, L.G.
Flourished: 1980 Dacoma, OK
Type of Work: Oil (Paintings)
Sources: *FoArO 27, 84*, 102*.

Shelley, Mary
b. 1950 Doylestown, PA
Flourished: 1970s- West Danby, NY
Type of Work: Wood (Relief carvings)
Museums: 203
Sources: *AmFokArt 287-90*; FoA 118*, 468; FoAFab 15*; FoAFcd 2*.

Shenango China Company
Flourished: 19th century New Castle, PA
Type of Work: Clay (Pottery)
Sources: *DicM 172**.

Shenfelder, Daniel
Flourished: 1869 Reading, PA
Type of Work: Clay (Pottery)
Sources: *DicM 184**.

Shenkel, William
See: Schenkle, William; Excelsior Pottery

Shepard, Daniel
Flourished: c1832 Salem, MA
Type of Work: Oil (Ornamental paintings)
Sources: *AmDecor 114*.

Shepard, Elihu H.
b. St. Louis?, MO
Flourished: 1851 Kaolin, MO
Type of Work: Yellow-ware (Pottery)
Sources: *AmPoP 78, 222*.

Shepard, George
Flourished: 1860 Cooper County, MO
Ethnicity: German
Type of Work: (Baskets)
Sources: *ASeMo 412*.

Shepard, Joseph, Jr.
Flourished: 1858-1861 Geddes, NY
Type of Work: Stoneware (Pottery)
Sources: *Decor 224*.

Shepherd
See: Sims and Shepherd.

Shepherd, Miss
Flourished: 1841 Connecticut
Type of Work: Tin (Tinware)
Sources: *TinC 158*.

Shepherd, Jacob
Flourished: 1830 New York, NY
Type of Work: Wood (Ship carvings, ship figures)
Sources: *AmFiTCa 200*.

Shepherd, Robert
Flourished: early 18th cent Albany, NY
Type of Work: Silver (Spoons)
Sources: *MoBeA*.

Shepley and Smith
Flourished: c1865-1895 West Troy, NY
Type of Work: Stoneware (Pottery)
Sources: *AmPoP 205; Decor 224; DicM 122**.

Sheppard, R.H.
Flourished: 1842-1854 Baltimore, MD
Type of Work: Paint (Fire stations, fire station art)
Sources: *BirB 82-83**.

Sherman, Jacob
b. c1820
Flourished: 1838-1867 Attica, OH
Ethnicity: German
Type of Work: Fabric (Weavings)
Sources: *AmSQu 277; ChAmC 106*.

Sherman, Jesse T., Captain
Flourished: c1880-1890s New Bedford, MA
Type of Work: Pencil (Drawings)
Museums: 123
Sources: *WhaPa 136**.

Sherman, John
Flourished: 1837-1848 Mount Morris, NY; Kendall Mills, NY
Type of Work: Fabric (Weavings)
Sources: *AmSQu 277; ChAmC 106*.

Sherman, Lucy McFarland
Flourished: 1850 Peekskill, NY
Type of Work: Watercolor (Still life paintings)
Sources: *AmPrP fig76, 77, 156; PrimPa 180*.

Sherman, M.L.
Flourished: 1863 Corinth, MI
Type of Work: Stone (Sculptures)
Sources: *SoFoA 131*, 220*.

Sherrick, David
Flourished: c1840-1850 Canton, OH
Type of Work: Redware (Pottery)
Sources: *AmPoP 209*.

Sherril, Laura
Flourished: c1800 Richmond, MA
Type of Work: Fabric (Embroidered pictures)
Sources: *AmNe iii*, 83*.

Sherwood Brothers Company
Flourished: 1877-1900 New Brighton, PA
Type of Work: Stoneware (Pottery)
Sources: *AmPoP 225; Decor 218*
See: Elverson and Sherwood; Elverson, Thomas.

Shetky, Caroline
[Schetky]
Flourished: 1850 Philadelphia, PA; Boston, MA
Ethnicity: Scottish
Type of Work: Oil (Portraits, still life and landscape paintings)
Sources: *AmPrP 156; NeaT 115*-6; PrimPa 179.*

Shije, Velino
Flourished: San Idlefonso, NM
Ethnicity: American Indian
Type of Work: Oil (Indian ceremonial scene paintings)
Remarks: Pueblo tribe
Sources: *PicFoA 47.*

Shindel, J.P.
Flourished: 1855 Pennsylvania
Type of Work: Watercolor, ink (Frakturs)
Sources: *AmFoPa 189.*

Shindle, Catherine
b. 1790
Flourished: 1803 Lancaster, PA
Type of Work: Fabric (Samplers)
Sources: *GalAmS 40*.*

Shipshee, Louis
Flourished: Oklahoma
Type of Work: Oil (Portraits)
Sources: *FoArO 27.*

Shirvington, J.
Flourished: 1840 Charlottesville, VA
Type of Work: Watercolor (Miniature portraits)
Sources: *PrimPa 180.*

Shive, M.
Flourished: 1836 New Britain Township, PA
Type of Work: Fabric (Weavings)
Sources: *ChAmC 106.*

Shiveley
See: Horner and Shiveley.

Shively, Clio D.
Flourished: 1887 Berlin County, OH
Type of Work: Oil (Paintings)
Sources: *AlAmD 15*.*

Shoener, John
Flourished: 1841 Reading, PA
Type of Work: Wood (Ship carvings, ship figures)
Sources: *AmFiTCa 200.*

Shoenhut
Flourished: 1910 Philadelphia, PA
Type of Work: Wood (Sculptures, carvings)
Sources: *AmFoS 355*.*

Shorb, Adam A.
Flourished: 1824-1850 Canton, OH
Type of Work: Stoneware (Pottery)
Remarks: Father is J., Jr.
Sources: *AmPoP 209; Decor 224.*

Shorb, Adam L.
Flourished: 1840-1860 Canton, OH
Type of Work: Stoneware (Pottery)
Sources: *AmPoP 209; Decor 224.*

Shorb, J., Jr.
Flourished: 1817-1824 Canton, OH
Type of Work: Stoneware (Pottery)
Remarks: Son is Adam A.
Sources: *AmPoP 69, 209; Decor 224.*

Short, Lillie
b. 1900 Casey County, KY
Flourished: 1940s- Hustonville, KY
Type of Work: Rocks, shells (Creches, decorated objects)
Sources: *GoMaD.*

Shotwell
Flourished: 1845 Rahway, NJ
Type of Work: Fabric (Weavings)
Sources: *AmSQu 277; ChAmC 106.*

Shourdes, Harry M.
Flourished: Ocean County, NJ
Type of Work: Wood (Duck decoys)
Remarks: Father is Harry V(an Nuckson)
Sources: *AmBiDe 126; HoKnAm 38.*

Shourdes, Harry V(an Nuckson)
b. 1861(?) d. 1920
Flourished: c1900 Tuckerton, NJ
Type of Work: Wood (Duck decoys)
Museums: 096,260
Remarks: Son is Harry M.
Sources: *AmBiDe 17, 26, 40, 125-8*, 204*; AmDecoy vii*, xii, 75*; AmFoS 305*; AmSFo 24; ArtDe 127; Decoy 6, 48*, 79*, 85-7, 96*, 112-3*; HoKnAm 37-8; WoCar 134, 145.*

Shourds, Harry
See: Shourdes, Harry V(an Nuckson).

Shourds, Harry M.
See: Shourdes, Harry M.

Shouse, Nicholas
Flourished: early 19th cent Vincennes, IN
Type of Work: Fabric (Weavings)
Sources: *ChAmC 106.*

Shove, John J.
Flourished: 1840-1850
Type of Work: Pen, ink (Drawings)
Sources: *NinCFo 202.*

Shreffler, Henry
Flourished: 1851 Salona, PA
Type of Work: Fabric (Weavings)
Sources: *ChAmC 106.*

Shreffler, Samuel
b. c1804 Pennsylvania
Flourished: 1851 Salona, PA
Type of Work: Fabric (Coverlets)
Sources: *ChAmC 106.*

Shubert, Casper
[Shueburt]
b. 1825 d. 1901
Flourished: Hermann, MO
Type of Work: Wood (Furniture)
Sources: *ASeMo 389.*

Shulz, Randolph
Flourished: 1855 Baltimore, MD
Type of Work: Wood (Ship carvings, ship figures)
Sources: *AmFiTCa 200.*

Shurtleff, Isaac
b. 1780
Flourished: c1841 Augusta, ME
Type of Work: Wood, paint? (Decorated? boxes)
Remarks: Cabinetmaker
Sources: *NeaT 71*-2.*

Shute, Mrs. R(uth) W(hittier)
b. 1803 d. 1882
Flourished: 1830's Massachusetts; Peterboro, NH; Vermont
Type of Work: Watercolor, pencil (Portraits)
Museums: 171
Remarks: Husband is Shute, Samuel A.
Sources: *AmFoArt 14*; ArtWo 89, 171, fig13, 80, 90*; Edith *; EyoAm 21, 24*; FoA 14*, 470; MaAmFA *; NinCFo 169, 186, fig93; OneAmPr 100-1*, 136*.*

Shute, Samuel A., Dr.
b. 1803 d. 1836
Flourished: c1830s Peterboro, NH
Type of Work: Watercolor, pencil (Portraits)
Museums: 171
Remarks: Wife is Shute, Ruth Whittier
Sources: *AmFoArt 14*; Edith *; FoA 14*, 470; NinCFo 169, 186, fig93.*

Shutter, Christian
Flourished: 1852-1900 Fritztown, PA
Type of Work: Redware (Pottery)
Sources: *AmPoP 168.*

Sibbel, Susanna
Flourished: 1800-1810 Pennsylvania
Type of Work: Watercolor, ink (Frakturs)
Sources: *AmFoPaS 43*; FoA 87*, 470; FoPaAm 118-9*.*

Sickman, Theodore
Flourished: 1850 Alexander County, IL
Type of Work: Clay (Pottery)
Sources: *ArC 193.*

Siebert, Henry A.
Flourished: 1890-1895 Detroit, MI
Type of Work: Wood (Cigar store Indians, ship carvings, figures)
Remarks: Partner of Melcher, Julius
Sources: *ArtWod 265, 143.*

Siegfried, Samuel
Flourished: 1810 Pennsylvania
Type of Work: Watercolor, ink (Frakturs)
Sources: *AmFoPa 189.*

Sigler, Clarence Grant
b. 1897 d. 1959
Flourished: Akron, OH; Tampa, FL
Type of Work: Oil (Circus banners)
Remarks: Son is Jack
Sources: *AmSFor 61*
See: Sigler and Sons.

Sigler, Jack
b. 1925
Flourished: Tampa, FL
Type of Work: Oil (Circus banners)
Remarks: Father is Clarence Grant
Sources: *AmSFor 61.*

Sigler and Sons
[Sigler, Clarence Grant and Jack]
Flourished: 1950- Tampa, FL
Type of Work: Oil (Paintings)
Sources: *AmSFor 61.*

Sikes, Bessie
Flourished: c1930-1935 Tuscaloosa County, AL
Type of Work: Fabric (Quilts)
Sources: *SoFoA 195*, 222.*

Sikes, E.
Flourished: c1793 Plainfield, CT; Belchertown, MA
Type of Work: Stone (Gravestones)
Sources: *EaAmG 77*, 129; GravNE 109, 130.*

Silcox, Emily
b. c1832
Flourished: c1839
Type of Work: Fabric (Mourning samplers)
Sources: *AmNe 61.*

Silloway, Samuel
Flourished: c1825 Connecticut
Type of Work: Tin (Tinware)
Remarks: Worked for Filley
Sources: *TinC 180.*

Silsbe(e), Sarah
[Silsbee]
b. c1738
Flourished: 1748 Boston, MA
Type of Work: Fabric (Samplers)
Sources: *GalAmS 24*.*

Silvester
See: Choate and Silvester.

Silvia, Rafael
Flourished: 1840 New Mexico
Type of Work: Wood (Santeros, other religious carvings)
Sources: *PopAs 432.*

Simmons, Andrew
b. Vermont
Flourished: 1850 Andalusia, IL
Type of Work: Clay (Pottery)
Sources: *ArC 193*
See: Simmons, Jeremiah.

Simmons, Jermiah
b. Vermont
Flourished: 1850 Andalusia, IL
Type of Work: Clay (Pottery)
Sources: *ArC 193*
See: Simmons, Andrew.

Simmons, Peter
Flourished: 1700-1800s Mount Pleasant, SC
Ethnicity: Black American
Type of Work: Iron (Wrought ironworks)
Museums: 214
Remarks: Student is Simmons, Phillip (no relation)
Sources: *AfAmA 71*.*

Simmons, Phillip
Flourished: Charleston, SC
Ethnicity: Black American
Type of Work: Iron (Ironworks)
Remarks: Studied under Simmons, Peter (no relation)
Sources: *AfAmA 71.*

Simmons, Schtockschnitzler
b. 1870 d. 1910
Flourished: Bucks County, PA
Type of Work: Wood (Sculptures, carvings)
Sources: *BeyN 126.*

Simmons, W.A.
Flourished: 1878 Portland, ME
Type of Work: Wood (Ship carvings, ship figures)
Sources: *ShipNA 157.*

Simms, N.M.
Flourished: 1869-1870 East Liverpool, OH
Type of Work: Stoneware (Pottery)
Sources: *AmPoP 218; Decor 224.*

Simms and Ferguson
Flourished: 1872-1875 East Liverpool, OH
Type of Work: Yellow-ware (Pottery)
Sources: *AmPoP 218.*

Simms and Laughlin
Flourished: c1869-1872 East Liverpool, OH
Type of Work: Yellow-ware, Rockingham (Pottery)
Sources: *AmPoP 218.*

Simms and Starkey
Flourished: c1866-1869 East Liverpool, OH
Type of Work: Yellow-ware, Rockingham (Pottery)
Sources: *AmPoP 217.*

Simon, Jewel
Flourished: Atlanta, GA
Ethnicity: Black American
Type of Work: Watercolor (Genre scene paintings)
Sources: *AmNeg 47, 100*, fig14.*

Simon, Martin
Flourished: 1870 Philadelphia, PA
Type of Work: Wood (Ship carvings, ship figures)
Sources: *AmFiTCa 200.*

Simon, Pauline
b. 1894
Flourished: 1964- Chicago, IL
Ethnicity: Polish
Type of Work: Acrylic (Paintings)
Sources: *TwCA 207*.*

Simpson, George
b. 1795
Flourished: 1840-1860 Switzerland County, IN; Windsor, VT; New Haven, CT
Ethnicity: Scottish
Type of Work: Fabric (Coverlets)
Remarks: Son is Joseph
Sources: *AmSQu 277; ChAmC 106-7.*

Simpson, J.W.
Flourished: 1880
Type of Work: Oil (Landscape paintings)
Sources: *PrimPa 180.*

Simpson, Joseph
Flourished: c1860 Caledonia, IN
Type of Work: Fabric (Weavings)
Remarks: Father is George
Sources: *ChAmC 107.*

Simpson, William
b. 1812 Buffalo, NY d. 1872
Flourished: 1854 Boston, MA
Ethnicity: Black American
Type of Work: Oil (Portraits)
Sources: *AfAmA 102*; AmNeg 22-3, pl8.*

Sims, James
Flourished: 1825 Cincinnati, OH
Type of Work: Wood (Ship carvings, ship figures)
Sources: *AmFiTCa 200.*

Sims and Shepherd
Flourished: 1829 Pittsburgh, PA
Type of Work: Wood (Ship carvings, ship figures)
Sources: *AmFiTCa 153, 200.*

Sincerbox, Keeler
Flourished: 1981 Bath, NY
Type of Work: Wood (Sculptures)
Museums: 203
Sources: *FoAFf 14*.*

Sinclair, Mrs. William
Flourished: 1860 Hudson-on-Hudson, NY
Type of Work: Fabric (Beadwork purses)
Sources: *AmNe 142*, 144.*

Singer, John
Flourished: 1844-1853 Osnaburg Township, OH; Mapleton, OH
Type of Work: Fabric (Weavings)
Sources: *AmSQu 277; ChAmC 107.*

Singer, Simon
Flourished: c1862-1912 Haycock Township, PA
Type of Work: Redware (Pottery)
Remarks: Took over pottery of Mumbauer, Conrad
Sources: *AmPoP 41, 44, 169.*

Sisson, Hannah
b. 1802 Newport, RI
Flourished: 1812 Newport, RI
Type of Work: Fabric (Samplers)
Museums: 241
Sources: *LeViB 79*.*

Sisson, J.
Flourished: 1800-1830 Oswego area, NY
Type of Work: Wood (Chests)
Sources: *FouNY 35*, 62*.*

Sisson, Sussanna
b. 1800 Portsmouth, RI
Flourished: 1811 Newport, RI
Type of Work: Fabric (Samplers)
Museums: 241
Sources: *LeViB 78*.*

Sizer, Samuel
Flourished: 1806 Middletown, CT
Type of Work: Wood (Signs)
Sources: *MoBBTaS 12.*

Skaggs, Loren
b. 1891 Jamestown, KY
Flourished: 1945 Jamestown, KY
Type of Work: Wood (Carved canes, animals, figures)
Sources: *FoAroK *.*

Skarsten, Karee
Flourished: 1974 Buffalo, NY
Type of Work: Fabric (Quilts)
Sources: *NewDis 89*.*

Skeen, Jacob
Flourished: 1887 Louisville, KY
Ethnicity: Shaker
Type of Work: Pen, watercolor (Chronological and genealogical chart)
Sources: *AmFoArt 114-5*.*

Skeggs, T.W.
Flourished: 1870 Elmira, NY
Type of Work: Crayon (Genre drawings)
Sources: *PrimPa 180.*

Skillin, John
[Skilling]
b. 1746 d. 1800
Flourished: 1780 Boston, MA; New York?, NY?
Type of Work: Wood (Signs, ship carvings, figures)
Museums: 029
Remarks: Father is Simeon, Sr.; brothers are Simeon, Jr. and Samuel
Sources: *AmFiTCa 51-5, 67, 81, 102, 131, 200; AmFoS 25*, 79*; AmSFok 21; InAmD 54, 192-3*; ShipNA 18, 158, 161; TYeAmS 29, 310, 346.*

Skillin, Samuel
b. 1742? Boston, MA d. 1830 Boston, MA
Flourished: 1785-1816 Boston, MA; Philadelphia, PA
Type of Work: Wood (Ship carvings, ship figures)
Remarks: Son of Simeon; father of Simeon, III
Sources: *AmFiTCa 200; ArtWod 173; MaAmFA *; ShipNA 18-21, 25*, 158-9, 161; TYeAmS 310.*

Skillin, Simeon, Sr.
[Skilling]
b. 1716 d. 1778
Flourished: c1737-1778 Boston, MA
Type of Work: Wood (Sculptures, ship carvings, figures)
Museums: 029,221
Remarks: Sons are John, Samuel, Simeon, Jr.
Sources: *AmFiTCa 51, 200; AmFoS 23*, 25*, 79-80*; AmSFok 21; ArtWod 173; FoArtC 26*; ShipNA30*, 18, 158; TYeAmS 28*9, 310, 346.*

Skillin, Simeon, Jr.
[Skilling]
b. 1757 Boston, MA d. 1806
Flourished: c1792-1822 New York?, NY?; Boston, MA
Type of Work: Wood (Ship carvings, ship figures)
Museums: 202,203
Remarks: Father is Simeon, Sr.; brother is John
Sources: *AmFiTCa figi, 33, 47-55, 81, 92, 131, 200; AmFoS 79*; ArtWod 173-4; EaAmW 34, 72-5; FoArA 147*; HoKnAm 3*; InAmD 54, 70*, 192-3*; MaAmFA;ShipNA 18-20, 158, 161; TYeAmS 29, 310, 346.*

Skillin, Simeon, III
b. 1766 d. 1830
Flourished: 1792-1830 New York, NY
Type of Work: Wood (Ship carvings, ship figures)
Remarks: Son of Samuel
Sources: *AmFiTCa 200; ShipNA 18-9, 126, 161.*

Skillin and Dodge
[Simeon Skillin and Jeremiah Dodge]
Flourished: 1804-1810 New York, NY
Type of Work: Wood (Ship carvings, ship figures)
Sources: *AmFiTCa 200; ShipNA 47, 126, 161.*

Skilling, Simeon, Sr.
See: Skillin, Simeon, Sr.

Skilling, Simeon, Jr.
See: Skillin, Simeon, Jr.

Skilling, John
See: Skillin, John .

Skilling, Samuel
See: Skillin, Samuel .

Skinner, Edward
Flourished: 1890 Woolford, MD
Type of Work: Wood (Ship carvings, ship figures)
Sources: *ShipNA 158.*

Skinner, John
Flourished: c1890 Woolford, MD
Type of Work: Wood (Ship carvings, ship figures)
Sources: *ShipNA 158.*

Skinner, W. Hammond
Flourished: 1860-1900 Woolford, MD
Type of Work: Wood (Ship carvings, ship figures)
Sources: *ShipNA 158.*

Skyllas, Drossos P.
b. 1912 d. 1973 Chicago, IL
Flourished: late 1940s-1973 Chicago, IL
Ethnicity: Greek
Type of Work: Oil (Paintings)
Sources: *AmFokArt 291-5*.*

Slack, George R. H.
Flourished: 1829 Connecticut; Washington
Type of Work: Watercolor (Paintings)
Museums: 020,179
Sources: *PicFoA 139*.*

Slade, John
Flourished: Pennsylvania
Type of Work: Tin (Tinware)
Museums: 189
Sources: *FoArRP 158*.*

Slater, Alfred
Flourished: 1850 Deer Park Township, IL
Type of Work: Stoneware (Pottery)
Sources: *ArC 193.*

Slaybough, Charles
b. Pennsylvania
Flourished: 1845-1850 Bucyrus, OH
Type of Work: Fabric (Weavings)
Remarks: Brothers are Josiah and Charles; father is William
Sources: *ChAmC 107.*

Slaybough, Josiah
b. c1825 Pennsylvania
Flourished: 1845-1878 Bucyrus, OH; Van Rosen Township, IN; Washington Township, IN
Type of Work: Fabric (Weavings)
Remarks: Brothers are Charles and Samuel; father is William
Sources: *ChAmC 107.*

Slaybough, Samuel
b. c1819 Pennsylvania
Flourished: 1843-1855 Bucyrus, OH
Type of Work: Fabric (Coverlets)
Remarks: Brothers are Josiah and Charles
Sources: *ChAmC 107*
See: Fogle, Lewis .

Slaybough, William
Flourished: 1848-1855 Bucyrus, OH
Type of Work: Fabric (Weavings)
Remarks: Sons are Samuel, Josiah, and Charles
Sources: *ChAmC 107.*

Sleight
See: Brewster and Sleight.

Sloan, John R.
See: Sloan, Junius R.

Sloan, Junius R. (John)
b. 1827 d. 1900
Flourished: 1853-1864 Ohio; Pennsylvania; Princeton, IL
Type of Work: Oil (Portraits)
Remarks: Itinerant painter
Sources: *ArC 158*, 266.*

Sloane, Caroline M.
Flourished: 1853
Type of Work: Fabric (Embroidered handwoven blankets)
Sources: *AmSQu 69*.*

Sloane, L.S.
Flourished: 1930-1950 Oklahoma
Type of Work: Oil (Portraits)
Museums: 060
Sources: *FoArO 27.*

Slote, Alexander
Flourished: 1810 New York, NY
Type of Work: Wood (Ship carvings, ship figures)
Sources: *AmFiTCa 200.*

Slothower, P.
Flourished: 1837-1838 Pennsylvania
Type of Work: Fabric (Weavings)
Sources: *ChAmC 107.*

Slusser, Eli M.
b. c1823 Pennsylvania
Flourished: 1842-1850 Canton, OH
Type of Work: Fabric (Weavings)
Sources: *ChAmC 107.*

Slusser, Jacob M.
Flourished: 1840-1842 Bethlehem, OH
Type of Work: Fabric (Weavings)
Sources: *ChAmC 107.*

Slyman, Susan
b. Washington, DC
Flourished: c1982- Mount Kisco, NY
Type of Work: Acrylic (Genre scene paintings)
Sources: *AmFokArt 296-9*.*

Smagoinsky, Helen Fabri
b. 1933 Rochester, NY
Flourished: c1982- Brockport, NY
Type of Work: Oil (Scene and genre paintings)
Sources: *AmFokArt 300-2*.*

Smallwood, Zibiah
Flourished: 1800 Philadelphia, PA
Type of Work: Fabric (Quilts)
Museums: 227
Remarks: Wife of Hewson, John
Sources: *NewDis 24*.*

Smart, John
Flourished: 1797-1798 New York, NY
Type of Work: Leather (Saddles, box liners, boxes, canes)
Sources: *NeaT 35-7*.*

Smibert, John
b. 1688 d. 1751
Flourished: 1729 Boston, MA
Ethnicity: Scottish
Type of Work: Oil (Landscape paintings, group portraits)
Museums: 313
Sources: *AmFokDe 129; AmSFok 156; ArtWea 163*; FloCo 39*; FoA 470; FoPaAm 11-2, 19, 29, 81, 91*.*

Smiley, H.K.
Flourished: 1878- Zanesville, OH
Type of Work: Clay (Pottery)
Sources: *AmPoP 234.*

Smith
Flourished: Michigan
Type of Work: Wood (Fish decoys)
Sources: *UnDec 20.*

Smith
See: Shepley and Smith.

Smith
See: Taylor, Smith, and Taylor Company

Smith
See: Fiske and Smith.

Smith
See: Griffin, Smith and Hill.

Smith
See: Selleck and Smith.

Smith, Mrs.
Flourished: 1834 West Chester, PA
Type of Work: Needlework (Drawings)
Sources: *FlowAm 93.*

Smith, A.
Flourished: c1870 Springfield, OH
Type of Work: Stoneware (Pottery)
Sources: *AmPoP 230; Decor 224.*

Smith, A.E.
See: Smith, Asa E.

Smith, A.F.
Flourished: 1880-1900 New Brighton, PA
Type of Work: Yellow-ware (Pottery)
Sources: *AmPoP 225.*

Smith, A.V.
Flourished: c1846 Gratiot, OH
Type of Work: Stone (Gravestones)
Sources: *EaAmG 116-7*, 129.*

Smith, Alexander
Flourished: 1778 Philadelphia, PA
Type of Work: Whiteware (Pottery)
Sources: *AmCoB 177.*

Smith, Asa E.
[Selleck and Smith; Smith and Day]
Flourished: 1825-1898 Norwalk, CT
Type of Work: Stoneware (Pottery)
Sources: *AmPoP 56, 59, 198-9; Decor 224; EaAmFo 100*.*

Smith, Aurelius
Flourished: 1860 Indiana
Type of Work: Oil (Panoramic paintings)
Sources: *FoPaAm 210.*

Smith, Ben
b. 1870 d. 1942
Flourished: Monhegan Island, ME; Martha's Vineyard, MA
Type of Work: Wood (Duck decoys)
Museums: 176
Sources: *AmBiDe 73-5*; AmDecoy 18*; AmFokA 38*; AmSFo 24; ArtDe 175; FlowAm 171*.*

Smith, C(assius)
Flourished: c1890 Milford, CT
Type of Work: Wood (Duck decoys)
Sources: *AmBiDe 71.*

Smith, C.W.
Flourished: 1893 Lewiston, ME
Type of Work: Wood (Ship carvings, ship figures)
Sources: *AmFiTCa 200.*

Smith, Charlotte
Flourished: 1843 Long Island, NY
Type of Work: Fabric (Quilts)
Sources: *QuiAm 245*.*

Smith, Chris
Flourished: early 1900s Michigan
Type of Work: Wood (Decoys)
Sources: *WaDec xi*.*

Smith, Dana
Flourished: 1910 Franklin, NH
Type of Work: Oil (Paintings)
Sources: *TwCA 45*.*

Smith, Daniel S.
Flourished: 1841 Upper Hanover Township, PA
Type of Work: Fabric (Weavings)
Sources: *ChAmC 107.*

Smith, David H.
Flourished: c1844 Nauvoo, IL
Type of Work: Oil (Scene paintings)
Sources: *ArC 206*.*

Smith, E(rnest) A(rcher) "Frog"
b. 1896 Georgia
Flourished: contemporary Florida
Type of Work: Paint (Paintings)
Sources: *FoAFk 9**.

Smith, Edwin B.
Flourished: 1827 Clarke County, GA; Cincinnati and Troy, OH; New Orleans, LA
Type of Work: Oil (Portraits)
Sources: *FoPaAm 160, 164-5*; MisPi 34-5**.

Smith, Eldad
Flourished: c1819-1823 Bloomfield, CT
Type of Work: Tin (Toys)
Remarks: Associated with Filley, Oliver
Sources: *AmCoTW 59; TinC 180*.

Smith, F.E.D.
Flourished: 1876 New York, NY
Type of Work: Oil (Still life paintings)
Sources: *NinCFo 169, 183, fig146*.

Smith, Fred
b. Fairhaven, MA
Flourished: 1868-1874 New Bedford, MA
Type of Work: Whalebone, watercolor (Scrimshaw, genre pictures)
Museums: 123, 186
Sources: *GravF 19, 29, 31, 96-7*, 99, 102-3*, 108*, 112-3*, 116-8*, 120, 125*-6; ScriSW 229*; WhaPa125*, 131*, 157-8*.

Smith, Fred
b. 1886 Ogema, WI d. 1975 Phillips, WI
Flourished: 1950-1964 Phillips, WI
Type of Work: Cement (Environmental sculptures)
Sources: *FoA 470; FoAFl 4; FoAFw 1*, 4*-6*; HoKnAm 188*; NaiVis 52-9*; TwCA 128-9**.

Smith, "Frog"
See: Smith, E(rnest) A(rcher) "Frog".

Smith, George
Flourished: 1875 Milford, CT
Type of Work: Wood (Duck decoys)
Remarks: Brother is Minor
Sources: *AmBiDe 71*.

Smith, George
b. c1844 Pennsylvania
Flourished: c1860 Allentown, PA
Type of Work: Fabric (Coverlets)
Remarks: Father is George M.
Sources: *ChAmC 107*.

Smith, George M.
b. c1821
Flourished: c1860 Allentown, PA
Ethnicity: German
Type of Work: Fabric (Coverlets)
Remarks: Son is George
Sources: *ChAmC 107*.

Smith, Gil
Flourished: Long Island, NY
Type of Work: Wood (Duck decoys)
Sources: *ArtDe 165*.

Smith, H.C.
Flourished: c1850 Alexandria, DC
Type of Work: Stoneware (Pottery)
Sources: *AmS 90**.

Smith, H.S.
Flourished: c1890 Gamesville, MO
Type of Work: Stoneware (Pottery)
Sources: *AmPoP 220; Decor 224*.

Smith, Henry
Flourished: 1825 New York, NY
Type of Work: Wood (Ship carvings, ship figures)
Sources: *AmFiTCa 200*.

Smith, Henry E.
Flourished: 1865-1896 Hartleton, PA
Type of Work: Tin (Tinware)
Sources: *ToCPS 8, 11*, 24-6, 29, 32-5**.

Smith, Henry M.
Flourished: 1836-1850 New Bedford, MA
Type of Work: Wood (Ship carvings, ship figures)
Museums: 186
Sources: *AmFiTCa 147, 200; FigSh 60*.

Smith, Hezekiah
Flourished: 1782-1797 Gorham, ME
Type of Work: Stoneware (Pottery)
Sources: *AmPoP 192*.

Smith, Howland
Flourished: c1920 Maine
Type of Work: Wood (Duck decoys)
Sources: *FoA 215**.

Smith, I.R.
Flourished: c1829 Virginia
Type of Work: Watercolor (Mourning paintings)
Museums: 108
Sources: *MoBeA*.

Smith, Isaac
See: Isaac Smith and Thomas Lee.

Smith, J(oseph) C.
Flourished: c1862 Mogadore, OH
Type of Work: Stoneware (Pottery)
Sources: *AmPoP 224; AmS 186*; Decor 224*.

Smith, J. Kent
Flourished: 1960s Oklahoma
Type of Work: Stone, wood (Gravestones, sculptures, carvings)
Sources: *FoArO 89*, 93*.

Smith, J.W.
Flourished: before 1846 Washington, DC; Alexandria, VA
Type of Work: Stoneware (Pottery)
Museums: 289
Sources: *Decor 70**.

Smith, James
b. 1753
Flourished: Philadelphia, PA
Type of Work: Copper (Tableware)
Sources: *AmCoB 199*.

Smith, John
b. c1794 Pennsylvania
Flourished: 1839-1850 Schaefferstown, PA
Type of Work: Fabric (Coverlets, blankets)
Sources: *ChAmC 107*.

Smith, John
Flourished: 1840-1854 Cincinnati, OH; West Salem, OH
Type of Work: Fabric (Weavings)
Sources: *ChAmC 107*.

Smith, John E.
Flourished: pre 1850 Galena, IL
Type of Work: Silver (Silverware)
Sources: *ArC 180**.

Smith, John H.
Flourished: 1875 Thomaston, ME
Type of Work: Watercolor (Historical paintings)
Sources: *AmPrP fig71, 156; FoArA 25*; PrimPa 180*.

Smith, John Rowson
Type of Work: Oil (Scenic and panoramic paintings)
Sources: *PicFoA 20*.

Smith, Joseph
Flourished: c1763-1775 Wrightstown, PA
Type of Work: Clay (Pottery)
Sources: *AmPoP 185; DicM 67**.

Smith, Joseph
Flourished: 1835-1843 Millerstown, PA
Type of Work: Fabric (Coverlets)
Sources: *ChAmC 107*.

Smith, Joseph B.
b. 1798 d. 1876
Flourished: Brooklyn, NY
Type of Work: Oil (Ship and scene paintings)
Museums: 184
Sources: *AmFoPa 11, 116; PicFoA 114*; PrimPa 180*.

Smith, Joseph C.
Flourished: 1877 Meriden, CT
Type of Work: Tin (Tinware)
Sources: *TinC 181*.

Smith, Judith
Flourished: 1790
Type of Work: Fabric (Coverlets)
Museums: 287
Sources: *AmSFok 109*-10; AmSQu 61**.

Smith, LoAnn
b. 1772 d. 1799
Flourished: 1785 Providence, RI
Type of Work: Fabric (Samplers)
Museums: 173
Sources: *ArtWo 16-7*; LeViB 119**.

Smith, Margarette W.
Flourished: 1822 New Jersey
Type of Work: Watercolor (Memorial paintings)
Sources: *AmPrW 51*, 125**.

Smith, Martha Swale
b. 1872 d. 1950
Flourished: 1940- Glen Head, NY
Ethnicity: English
Type of Work: Fabric (Needlepoint tapestry)
Sources: *TwCA 102-3**.

Smith, Mary Ann (MaryAn)
Flourished: 1854 Pennsylvania
Type of Work: Watercolor (Portraits)
Sources: *AmFoPaS 92*; FoA 11**.

Smith, Mary Caroline Wooley
Flourished: 1840 Cincinnati, OH
Type of Work: Fabric (Quilts)
Museums: 046
Remarks: Granddaughter is Wilson, Mrs. Russel who finished quilt
Sources: *NewDis 53**.

Smith, Miles
b. c1920
Flourished: 1940? Marine City, MI
Type of Work: Wood, paint (Fish decoys)
Museums: 170
Sources: *Rain 34*-5**.

Smith, Minor
Flourished: 1875 Milford, CT
Type of Work: Wood (Duck decoys)
Remarks: Brother is George
Sources: *AmBiDe 71**.

Smith, Norman
Flourished: 1977 Ft. Lawley, AL
Type of Work: Stoneware (Banks)
Sources: *AmS 128*; SoFoA 37*, 218*.

Smith, P.H.
Flourished: c1850 Aurora, IL
Type of Work: Stoneware (Pottery)
Sources: *ArC 193*.

Smith, R.
Flourished: 1833 Philadelphia, PA
Type of Work: Wood (Ship carvings, ship figures)
Sources: *AmFiTCa 200*.

Smith, Rachel
Flourished: c1870
Type of Work: Fabric (Crib quilts)
Museums: 204
Sources: *AmSFo 100-1**.

Smith, Rebecca
Flourished: 1831 Lancaster?, PA
Type of Work: Fabric (Samplers)
Sources: *GalAmS 73*, 92*.

Smith, Roswell T.
Flourished: 1860 Nashua, NH
Type of Work: Oil (Portraits)
Sources: *AmPrP 156; PrimPa 180; SoAmP 91**.

Smith, Royal Brewster
b. 1801 d. 1849
Flourished: 1834-1838 Buxton, ME
Type of Work: Oil (Portraits)
Sources: *MaAmFA *; NinCFo 169, 177, fig58, 59*.

Smith, Sally
See: Sabin, Sarah Smith.

Smith, Samuel
Flourished: Connecticut
Type of Work: Tin (Tinware)
Sources: *NinCFo 169, 177, fig58, 59; TinC 181*
See: Lewis, Erastus; Smith, William.

Smith, Samuel
Flourished: c1924 Tuckerton, NJ
Type of Work: Wood (Decoys)
Sources: *AmBiDe 128*.

Smith, Sarah
See: Sabin, Sarah Smith.

Smith, Sarah Douglas
Flourished: 1840 Stonington, IL
Type of Work: Fabric (Weavings)
Museums: 016
Sources: *ArC 102*; ArtWea 238**.

Smith, Sophia Stevens
Flourished: 1818 North Branford, CT
Type of Work: Fabric (Samplers)
Sources: *AmNe 62-3*.

Smith, Sukey Jarvis
b. 1773 Bristol, RI d. 1809
Flourished: 1791 Bristol, RI
Type of Work: Fabric (Samplers)
Sources: *LeViB 206-7*, 224**.

Smith, Susan
b. 1783 Providence, RI d. 1853 Johnston?, RI?
Flourished: 1794 Providence, RI
Type of Work: Fabric (Samplers)
Museums: 097
Sources: *LeViB 115, 128*; PlaFan 42*, 59; WinGu 34**.

Smith, T.
Flourished: New Jersey
Type of Work: Wood (Duck decoys)
Sources: *ArtDe 133**.

Smith, Thomas, Captain
Flourished: c1690 Massachusetts
Type of Work: Oil (Portraits)
Museums: 311
Sources: *FoPaAm 19*, 30*.

Smith, Thomas
Flourished: c1800- Wrightstown, PA
Type of Work: Redware (Pottery)
Sources: *AmPoP 185*.

Smith, Thomas
b. Indiana
Flourished: 1860 Missouri; Washington
Type of Work: Tin (Tinware)
Sources: *ASeMo 426*.

Smith, Thomas C.
See: Thomas C. Smith and Sons.

Smith, Thomas H.
Flourished: 1834 New York, NY
Type of Work: Wood (Ship carvings, ship figures)
Sources: *AmFiTCa 201*.

Smith, Thomas H.
Flourished: 1860 New York, NY
Type of Work: Wood (Ship carvings, ship figures)
Sources: *AmFiTCa 201*.

Smith, Tryphena Goldsbury
b. 1801 d. 1836
Type of Work: Oil, watercolor, fresco (Ornamental paintings)
Sources: *PrimPa 180*.

Smith, Virginia Bland
Flourished: c1865-1870 Smiths Grove, KY
Type of Work: Fabric (Quilts)
Sources: *KenQu 44, fig32*.

Smith, W(ashington)
[Greenwich Pottery]
Flourished: 1834-1850 Long Island, NY
Type of Work: Stoneware (Pottery)
Sources: *AmPoP 198; Decor 106*, 224*.

Smith, W.A.
Flourished: 1880s Tacoma, FL
Type of Work: Wood (Toys)
Sources: *SoFoA 112, 118*, 220*.

Smith, Will
Flourished: 19th century Dillsburg, PA
Type of Work: Tin (Cookie cutters)
Sources: *ToCPS 61**.

Smith, William
Flourished: New Britain, CT
Type of Work: Tin (Tinware)
Remarks: Son of Samuel
Sources: *TinC 181*.

Smith, William
Flourished: 1854-1862 New York
Type of Work: Clay (Pottery, porcelain)
Remarks: Worked for Union Porcelain Works
Sources: AmSFok 141.

Smith, William
b. c1842 Kentucky
Flourished: Salem, IN
Type of Work: Fabric (Coverlets)
Sources: ChAmC 107.

Smith, William S.
Flourished: mid 19th cent Brooklyn, NY
Type of Work: Oil (Ship paintings)
Sources: AmFoPa 111, 116.

Smith, William W.
Flourished: 1840 New York, NY
Type of Work: Wood (Ship carvings, ship figures)
Sources: AmFiTCa 201.

Smith, Willoughby
Flourished: c1862-1905 Wrightstown, PA; Womelsdorf, PA
Type of Work: Stoneware (Pottery)
Sources: AmPoP 185; Decor 224; DicM 144*.

Smith and Crane
Flourished: 1834 New York, NY
Type of Work: Wood (Ship carvings, ship figures)
Sources: AmFiTCa 200.

Smith and Day
See: Smith, Asa E.

Smith, Fife and Company
Flourished: c1810-1830 Philadelphia, PA
Type of Work: Clay (Pottery)
Sources: AmPoP 104, 176, 279; DicM 123*.

Smith-Phillips China Company
Flourished: 19th century East Liverpool, OH
Type of Work: Clay (Pottery)
Sources: DicM 46*, 79*, 123*, 173*.

Smithfield, Ulrich
Flourished: 1850 Smithfield, IL
Type of Work: Stoneware (Pottery)
Sources: ArC 193.

Smithingham, George
Flourished: 1850 Upper Alton, IL
Type of Work: Stoneware (Pottery)
Sources: ArC 193.

Smithmeyer and Company
Flourished: 1859 Chicago, IL
Type of Work: Fresco (Paintings)
Sources: ArC 266.

Smolak, Stanley
b. c1900
Flourished: Cross Village, MI
Ethnicity: Polish
Type of Work: Stone, wood (Sculptures, environmental building)
Remarks: Created "Legs Inn" tavern
Sources: Rain 105*-6*.

Smyth, Joel
[Smyth and Harnell]
Flourished: c1840 Paris, OH
Type of Work: Stoneware (Pottery)
Sources: AmPoP 226; Decor 224.

Smyth, M.
Flourished: early 19th cent New York
Type of Work: Fabric (Mourning pictures)
Museums: 309
Sources: MoBeA.

Smyth and Harnell
See: Smyth, Joel.

Snaveley, John
Flourished: c1813 Hagerstown, MD
Type of Work: Redware (Pottery)
Sources: AmPoP 168.

Snell, Charles K.
[Snel, C.]
Flourished: mid 1800s Reading, PA
Type of Work: Tin (Tinware)
Remarks: Son is John L.
Sources: ToCPS 36, 40-3*.

Snell, John L.
Flourished: mid 1800s Reading, PA
Type of Work: Tin (Tinware)
Remarks: Son of Charles K.
Sources: ToCPS 41.

Snider, J.
Flourished: 1843 Pipe Crick, IN
Type of Work: Fabric (Weavings)
Sources: ChAmC 107
See: Deeds, William.

Snider, Samuel
[Snyder]
b. c1820 Pennsylvania
Flourished: 1843-1855 New Paris, IN
Type of Work: Fabric (Weavings)
Sources: AmSQu 277; ChAmC 107.

Snow, Jenny Emily
b. 1835?
Flourished: 1850 Hinsdale, MA
Type of Work: Oil (Paintings)
Museums: 001
Sources: AmPrP 156; ArtWo 94-5*, 171; PicFoA 109*; PrimPa 180.

Snow, Martin
Flourished: 1820s
Type of Work: Whalebone (Scrimshaw)
Museums: 186
Sources: GravF 68-9*.

Snow, W.A.
See: W.A. Snow Company.

Snyder, Daniel
Flourished: 1838-1844 Hanover Township, PA
Type of Work: Fabric (Weavings)
Sources: ChAmC 107.

Snyder, Henry
Flourished: c1875-1885 Millersburg, OH
Type of Work: Stoneware (Pottery)
Sources: AmPoP 223; Decor 224.

Snyder, Isaac
b. c1827 Pennsylvania
Flourished: 1850 Bethel Township, PA
Type of Work: Fabric (Coverlets)
Sources: ChAmC 107.

Snyder, Jacob
b. c1825 Pennsylvania **d.** c1892
Flourished: 1847-1857 Stark County, OH; Jackson Township, IN
Type of Work: Fabric (Weavings)
Sources: ChAmC 108
See: Osbon, Aaron C.

Snyder, John
Flourished: 1843 Milton, IN
Type of Work: Fabric (Weavings)
Sources: AmSQu 277; ChAmC 108
See: Wissler, John.

Snyder, John
Flourished: c1835-1873 Mohrsville, PA
Type of Work: Redware (Pottery)
Sources: AmPoP 171.

Snyder, John, Jr.
Flourished: c1873-1876 Mohrsville, PA
Type of Work: Redware (Pottery)
Sources: AmPoP 171.

Snyder, Mary
Flourished: 1837 Tappan, NY
Type of Work: Fabric (Weavings)
Sources: AmSQu 277; ChAmC 108.

Snyder, Philip
Flourished: 1830 Schoharie, NY
Type of Work: Oil (Scene paintings)
Sources: AmPrP 156; PrimPa 180.

Snyder, Samuel
See: Snider, Samuel.

Sobel, Lillie
Flourished: New York
Type of Work: Oil (Paintings)
Sources: ThTaT 236*.

Sohier, William
[Straten and Sohier]
Flourished: c1874 Boston, MA
Type of Work: Metal (Patented duck decoys)
Sources: AmBiDe 233*, 236*; AmDecoy 88*; FoA 225*, 470
See: Straten, Herman, Jr.

Solomon, John
Flourished: 1830 New York, NY
Type of Work: Wood (Ship carvings, ship figures)
Sources: *AmFiTCa 201*.

Somerby, F.T.
Flourished: 1832 Newburyport, MA
Type of Work: Oil (Trompe l'oeil)
Sources: *PrimPa 180*.

Somerby, Lorenzo
b. 1816 Newburyport, MA
Flourished: 1840 Boston, MA
Type of Work: Oil (Portraits)
Museums: 083
Sources: *AmPrP 156; PicFoA 15; PrimPa 180; SoAmP 109**.

Somerby, William S.
Flourished: 1840s
Type of Work: Ivory (Carved canes)
Museums: 186
Sources: *GravF 94-5**.

Somerset Pottery
Flourished: 1845-1909 Pottersville, MA; Somerset, MA
Type of Work: Stoneware (Pottery)
Sources: *Decor 217, 224; DicM 123**
See: Chace, L. and B.C.

Somerset Pottery Works
Flourished: c1875 Somerset, NJ
Type of Work: Stoneware (Pottery)
Sources: *AmPoP 179, 280; Decor 224*.

Somerset Trading Company
Flourished: Bridgewater, OH
Type of Work: Clay (Sewer tile sculpture)
Sources: *IlHaOS **.

Sonner, S(amuel) H.
Flourished: 1870-1883 Strasburg, VA
Type of Work: Stoneware (Jars)
Sources: *AmPoP 242; AmS 90**.

Soper, Alonzo
b. c1870 d. 1935
Flourished: Barnegat Bay, NJ
Type of Work: Wood (Duck decoys)
Remarks: Brother is Sam
Sources: *AmBiDe 121*.

Soper, Sam
b. 1875 d. 1942
Flourished: Barnegat Bay, NJ
Type of Work: Wood (Duck decoys)
Remarks: Brother is Alonzo
Sources: *AmBiDe 121-2*; CoCoWA 121*; EyoAm 9*.

Sosman and Landis Company
Flourished: Chicago, IL
Type of Work: Oil (Circus, theater scenes)
Sources: *AmSFor 198*.

Soule, Asaph
b. 1739 d. 1823
Flourished: Plympton, MA
Type of Work: Stone (Gravestones)
Sources: *EaAmG 49*, 129*.

Soule, Beza
b. 1750 d. 1835
Flourished: Middleboro, MA; Worcester, MA; Plympton, MA
Type of Work: Stone (Gravestones)
Remarks: Brother is Ebenezer, Jr.; father is Ebenezer, Sr.
Sources: *EaAmG 49*, 129; GravNE 85-6, 130*.

Soule, Coomer
b. 1747 d. 1777
Flourished: Barre, MA
Type of Work: Stone (Gravestones)
Sources: *EaAmG 49*, 129*.

Soule, Ebenezer, Sr.
b. 1710-1711 Plympton, MA d. 1792 Hinsdale, NH
Flourished: Plympton, MA
Type of Work: Stone (Gravestones)
Remarks: Sons are Beza and Ebenezer, Jr.
Sources: *EaAmG 49*, 129; GravNE 130, 85-6*.

Soule, Ebenezer, Jr.
b. 1737 d. 1817
Flourished: Plympton, MA; Brattleborough, VT; Hinsdale, NH
Type of Work: Stone (Gravestones)
Remarks: Brother is Beza; father is Ebenezer, Sr.
Sources: *EaAmG 49*, 129; GravNE 85*, 130*.

Soule, Ivory
b. 1760 d. 1848
Flourished: Hinsdale, NH
Type of Work: Stone (Gravestones)
Sources: *EaAmG 129*.

Souter, John
Flourished: c1790-1805 Hartford, CT
Type of Work: Redware (Pottery)
Sources: *AmPoP 183*.

Souther, E.E.
See: E.E. Souther Iron Company.

Southern Pines, N.C.
Flourished: 1890-1910 Seagrove, NC
Type of Work: Stoneware (Jugs)
Sources: *AmS 81**.

Southern Porcelain Company
Flourished: c1860 Kaolin, SC
Type of Work: Clay (Pottery)
Sources: *AmPoP 89, 238; DicM 123*, 240**.

Southward, George
Flourished: 1830 Massachusetts
Type of Work: Oil (Portraits)
Sources: *AmPrP 156; PrimPa 180*.

Southwick, John
Flourished: c1775-1826 Lyndeboro, NH
Type of Work: Redware (Pottery)
Remarks: Worked with Clark, William
Sources: *AmPoP 195*.

Southwick, Joseph A.
Flourished: c1759-1785 Peabody, MA
Type of Work: Redware (Pottery)
Remarks: Son is William; father is William
Sources: *AmPoP 200*.

Southwick, William
Flourished: 1735-1759 Salem, MA; Peabody, MA
Type of Work: Clay (Pottery)
Remarks: Son is Joseph A.; grandson is William
Sources: *AmPoP 56-7, 200*.

Southwick, William
Flourished: 1785-1828 Peabody, MA
Type of Work: Redware (Pottery)
Remarks: Father is Joseph A.
Sources: *AmPoP 200*.

Southwork, William
[Southworth]
b. 1826 Duxbury, MA d. 1909
Flourished: 1850-1909 Newcastle, ME; Portland, ME; Bath, ME
Type of Work: Wood (Ship carvings, ship figures)
Sources: *AmFiTCa 201; ShipNA 79, 81*, 88, 156-7*
See: Jones, Emory; Southworth and Jones.

Southworth, Ella
b. 1872
Flourished: Essex, CT
Type of Work: Oil, fresco (Landscape and still life paintings, church frescos)
Sources: *PrimPa 180; ThTaT 174-7**.

Southworth, William
See: Southwork, William.

Southworth and Jones
Flourished: 1856 Newcastle, ME
Type of Work: Wood (Ship carvings, ship figures)
Sources: *ShipNA 157*
See: Southwork, William.

Sowell, John A.
b. 1864 Grass Valley, CA
Flourished: c1935 California
Type of Work: Paint, wood, metal (Models of airplanes and tanks, drawings)
Sources: *PioPar 15, 53*-4, 60*.

Sowers, H.
Flourished: c1887 Roseville, OH
Type of Work: Stoneware (Pottery)
Sources: *AmPoP 229; Decor 224*.

Sowers, Rebecca
b. 1824 Lebanon, PA
Flourished: c1836 Lebanon, PA
Type of Work: Fabric (Samplers)
Sources: *GalAmS 80*-1.*

Spafford and Richards
Flourished: 1870-1895 Akron, OH
Type of Work: Stoneware (Pottery)
Sources: *AmPoP 206; Decor 224.*

Spalding, E.
Flourished: 1825-1850
Type of Work: Watercolor (Landscape paintings)
Sources: *PrimPa 180.*

Spalding, Eliza Hart
b. 1807 Berlin, CT **d.** 1851 Brownsville, OR
Flourished: 1844 Oregon
Type of Work: Watercolor (Religious paintings)
Museums: 218
Remarks: Created "The Protestant Ladder"
Sources: *PioPar 12, 17*, 59.*

Spalding, Frederick
Flourished: 1832 Buffalo, NY
Type of Work: Wood (Ship carvings, ship figures)
Sources: *AmFiTCa 201.*

Spalding, Rueben
Flourished: 1889 Rosita, CO
Type of Work: Wood (Sculptures, carvings)
Museums: 263
Remarks: Sculptures for patent applications
Sources: *AmFoS 290*-1.*

Spangenberger, Johannes Ernst
b. 1789 **d.** 1814
Flourished: Pennsylvania
Type of Work: Watercolor, ink (Frakturs)
Remarks: Easton Bible artist
Sources: *AmFoPa 189.*

Spangler, Samuel
Flourished: 1828-1831 Pennsylvania
Type of Work: Watercolor, ink (Frakturs)
Sources: *AmFoPa 189.*

Spark, Miss
See: Stark, Elizabeth.

Sparks, Fielden
b. 1897 Wolfe County, KY
Flourished: 1970s Kentucky
Type of Work: Wood, stone (Miniature houses)
Sources: *FoAroK *.*

Spaulding, C.F.
Flourished: 1866 St. Johnsbury, VT
Type of Work: Brass (Kettles)
Sources: *AmCoB 79.*

Spaulding, Frederick D.
Flourished: 1836 Buffalo, NY
Type of Work: Wood (Ship carvings, ship figures)
Sources: *AmFiTCa 201.*

Spaulding, James
Flourished: 1836 Buffalo, NY
Type of Work: Wood (Ship carvings, ship figures)
Sources: *AmFiTCa 201.*

Spaulding, Stephen
Flourished: c1790 Killingly, CT
Type of Work: Stone (Gravestones)
Sources: *EaAmG 128.*

Speakman, Joseph
Flourished: 1780-1789 Bucks County, PA
Type of Work: Tin (Tinware)
Sources: *ToCPS 24, 28, 32*.*

Spear, Chester
Flourished: Accord, MA
Type of Work: Wood (Duck decoys)
Sources: *ArtDe 176.*

Spear, P.
Flourished: 1851 California
Type of Work: Watercolor (Scroll paintings)
Sources: *FoPaAm pl.66.*

Spear, Thomas T.
Flourished: 1830 Massachusetts
Type of Work: Oil (Portraits)
Sources: *AmPrP 156; PrimPa 180.*

Specht, John G.
Flourished: 1852-1895 Fritztown, PA
Type of Work: Redware (Pottery)
Sources: *AmPoP 168.*

Speck, Johan Ludwig
Flourished: c1723 Pennsylvania
Type of Work: Fabric (Weavings)
Museums: 227
Sources: *AmSQu 277; ChAmC 108; FoArRP 65.*

Speck, John C.
Flourished: pre-1863 Martinsburg, WV
Type of Work: Fabric (Coverlets)
Sources: *ChAmC 108.*

Speeler
See: Taylor and Speeler.

Speeler, Henry
Flourished: c1850-1879 East Liverpool, OH; Trenton, NJ
Type of Work: Yellow-ware, Rockingham (Pottery)
Remarks: Former worker for Goodwin, John
Sources: *AmPoP 75, 181-2, 216*
See: Taylor and Speeler.

Spelce, Fannie Lou
b. 1908 Dyer, AR
Flourished: 1966- Austin, TX
Type of Work: Oil, watercolor (Landscape or genre paintings)
Sources: *AmFokArt 303-5; ArtWo 129, 132-4, 152, 171, fig22;FoAFr 5*-6*; QuiAm 28*; TwCA 185*.*

Spencer, Frederick B.
Flourished: 1840
Type of Work: Oil (Portraits)
Sources: *AmPrP 156; PrimPa 180.*

Spencer, Harry L.
Type of Work: Oil (Scene paintings)
Sources: *AmPrP 156; PrimPa 180.*

Spencer, Herman
Flourished: 20th century Tuscarawas County, OH
Type of Work: Clay (Sewer tile sculpture)
Sources: *IlHaOS **
See: partner, Baker, William A.

Spencer, James
b. 1828 **d.** 1861
Flourished: New York, NY
Type of Work: Iron (Tinned sheet iron toys)
Sources: *BeyN 125.*

Spencer, Lonnie
b. 1939 Menifee County, KY
Flourished: 1968 Frenchburg?, KY
Type of Work: Sandstone, paint (Sculptures)
Sources: *FoAroK *.*

Spencer, Platt Roger
b. 1800 East Fishkill, NY **d.** 1864 Geneva, OH
Flourished: Ephrata New York
Type of Work: Pen, ink (Penmanship, calligraphy drawings)
Sources: *PicFoA 30.*

Spencer, William
b. c1829 New York
Flourished: c1850 Wolcott, NY
Type of Work: Fabric (Weavings)
Sources: *ChAmC 108*
See: Conger, Daniel.

Sperling, Louis
Flourished: 1875 Jacksonville, PA
Type of Work: Fabric (Weavings)
Sources: *ChAmC 108.*

Sperry, John
Flourished: 1870s Homer, MN
Type of Work: Watercolor (Cityscape paintings)
Museums: 203
Sources: *FoPaAm 209*; PrimPa 180.*

Sperry's Decoy
Flourished: c1920s West Haven, CT
Type of Work: Wood (Duck decoys)
Sources: *AmBiDe 230.*

Speyer, Georg Frederick (Friedrich; Friederich)
Flourished: 1781-1800 Dauphin County?, PA; Berks County?, PA; Reading, PA
Type of Work: Watercolor, ink, wood (Frakturs, decorated chests)
Museums: 097,203
Sources: *AmFoPa 186, 189; BeyN 60*, 126; FoArRP 208*; NinCFo 188; PenGer 86*.*

Spiegel, Isaac, Sr.
Flourished: 1837-1858 Philadelphia, PA
Type of Work: Redware (Pottery)
Remarks: Sons are Isaac, Jr. and John
Sources: *AmPoP 46, 176.*

Spiegel, Isaac, Jr.
Flourished: 1858-1879 Philadelphia, PA
Type of Work: Redware (Pottery)
Remarks: Son of Isaac, Sr.; brother of John
Sources: *AmPoP 176.*

Spiegel, John
Flourished: c1879-1890 Philadelphia, PA
Type of Work: Clay (Pottery)
Remarks: Brother is Isaac Jr.; father is Isaac Sr.
Sources: *AmPoP 176.*

Spiller, Johan Valentin
Flourished: 1809 Pennsylvania
Type of Work: Watercolor, ink (Frakturs)
Sources: *AmFoPa 189.*

Spillman Engineering Corporation
Flourished: c1920 Brooklyn, NY
Type of Work: Wood (Carousel figures)
Sources: *CaAn 10.*

Spinner, David
b. 1758 **d.** 1811
Flourished: c1800-1811 Milford Township, PA; Willow Creek, PA
Type of Work: Clay (Pottery)
Museums: 227
Sources: *AmPoP 185, 278; BeyN 76*, 117; FlowAm 263*; FoArRP19*; InAmD 6*; PenDuA 28*.*

Spinney, Ivah W.
Flourished: Portsmouth, NH
Type of Work: Wood (Ship carvings, ship figures)
Sources: *ShipNA 161.*

Spirit, Thunder
See: Rolling Mountain Thunder, Chief.

Spitler, Johannes
b. 1774 Wythe County, VA
Flourished: 1800-1805 Page County, VA; Ohio
Type of Work: Wood (Furniture, chests)
Museums: 001
Sources: *PenGer 68, 104*; SoFoA 150*-1*, 221.*

Spofford, Salley
b. 1788
Flourished: 1799 Georgetown, MA
Type of Work: Fabric (Samplers)
Sources: *AmNe 43*, 47.*

Spokane Ornamental Iron and Wire Works
Flourished: 1890 Spokane, WA
Type of Work: Metal (Weathervanes)
Sources: *YankWe 213.*

Sprague, Chris
b. 1887
Flourished: 1952 Beach Haven, NJ; Long Beach Island, NJ
Type of Work: Wood (Duck decoys)
Museums: 260
Sources: *AmBiDe 9, 17, 28, 123, 130-1*; ArtDe 135*; Decoy 23*, 91*.*

Sprague, J.
Flourished: c1800
Type of Work: Pen, ink (Mourning pictures)
Sources: *MoBeA fig28.*

Sprague, Jed, Captain
Flourished: Beach Haven, NJ
Type of Work: Wood (Duck decoys)
Remarks: Grandfather of Chris Sprague
Sources: *AmBiDe 130.*

Spring, Rick
Flourished: contemporary Nantucket, MA
Type of Work: Whalebone (Scrimshaw, ship portraits)
Sources: *Scrim 32-3*, 106.*

Spurr, Eliza W.
b. 1794 Providence?, RI? **d.** 1819 Providence?, RI?
Flourished: 1810 Providence, RI
Type of Work: Fabric (Mythological embroidered pictures)
Sources: *LeViB 201*.*

Spurr, Polly
b. 1785 Providence, RI **d.** 1805 Providence, RI
Flourished: 1796 Providence, RI
Type of Work: Fabric (Samplers)
Museums: 173
Sources: *LeViB 117, 130*-1, 150, 161, 256.*

Spybuck, E.L.
Flourished: 1929 Oklahoma
Type of Work: Watercolor (Paintings)
Museums: 060
Sources: *FoArO 82.*

Squires, Ansel
Flourished: Berlin, CT
Type of Work: Tin (Tinware)
Sources: *TinC 181.*

Squires, Fred
Flourished: before 1825 Berlin, CT; Rhode Island
Type of Work: Tin (Tinware)
Sources: *TinC 181.*

St. Alary, E.
Flourished: 1855 Chicago, IL
Type of Work: Pastel (Portraits)
Sources: *ArC 266.*

St. Anne's Club
Flourished: St. Clair Flats, MI
Type of Work: Wood (Decoys)
Sources: *WaDec 13*, fig27.*

St. Louis Stoneware Company
Flourished: 1865-1900 St. Louis, MO
Type of Work: Stoneware (Pottery)
Sources: *AmPoP 230; Decor 223.*

Stabler, G.
Type of Work: Fabric? (Coverlets?)
Sources: *ChAmC 108.*

Stacy, George
b. Hazard, KY
Flourished: 1936-1940 Wabaco, KY
Type of Work: Mixed media (House designed in the form of a goose)
Sources: *FoAroK *.*

Staffel, Bertha
Flourished: 1885 San Antonio, TX
Ethnicity: German
Type of Work: Watercolor, ink (Frakturs)
Sources: *FoPaAm 237*.*

Stafford
See: Hull and Stafford.

Stafford, H.M.
Flourished: 1875 Vermont
Type of Work: Oil (Landscape paintings)
Sources: *PrimPa 180.*

Stager, Henry F.
b. c1820 Pennsylvania **d.** 1888
Flourished: 1843-1870 Mount Joy, PA
Type of Work: Fabric (Weavings)
Sources: *AmSQu 277; ChAmC 108.*

Stahl, Charles
Flourished: 1847-1898 Powder Valley, PA
Type of Work: Clay (Pottery)
Remarks: Son is Isaac
Sources: *AmPoP 44, 177.*

Stahl, Isaac
Flourished: 1896-1898 Powder Valley, PA
Type of Work: Redware (Pottery)
Remarks: Father is Charles
Sources: *AmPoP 177.*

Stahl, James
Flourished: c1893-1895 Chapel, PA
Type of Work: Redware (Pottery)
Sources: *AmPoP 166.*

Stahr, John F.W.
Flourished: 1835 Pennsylvania
Type of Work: Watercolor, ink (Frakturs)
Sources: *FoPaAm pl.35.*

Staley, Andrew
Flourished: 1870 Mechanicsburg, OH
Type of Work: Fabric (Weavings)
Sources: *ChAmC 108.*

Staley, Louie
Flourished: 1946 Tuscarawas County, OH
Type of Work: Clay (Sewer tile sculpture)
Sources: *IlHaOS *.*

Stamn, Mary
Flourished: 1845 Pennsylvania
Type of Work: Fabric (Embroidered hand towels)
Sources: *PlaFan 125*.*

Stancliff, J.W.
b. 1814
Flourished: 1860 Hartford, CT
Type of Work: Oil (Ship paintings)
Sources: *AmPrP 156; PrimPa 180.*

Stanclift, James, Sr.
b. 1634 d. 1712
Flourished: Portland, CT
Type of Work: Stone (Gravestones)
Remarks: Son is James, Jr.
Sources: *EaAmG viii, 128.*

Stanclift, James, Jr.
b. 1692 d. 1772
Flourished: Portland, CT
Type of Work: Stone (Gravestones)
Remarks: Father is James, Sr.
Sources: *EaAmG 128, vii.*

Stanclift, James, III
b. 1712 d. 1785
Flourished: Portland, CT
Type of Work: Stone (Gravestones)
Sources: *EaAmG 128.*

Stanclift, William
b. 1687 d. 1761
Flourished: Portland, CT
Type of Work: Stone (Gravestones)
Sources: *EaAmG 128.*

Standard Pottery Company
Flourished: 1886-1900 East Liverpool, OH
Type of Work: White Granite (Pottery)
Sources: *AmPoP 215.*

Standish, Alexander
Flourished: c1846-1870 Taunton, MA
Type of Work: Stoneware (Pottery)
Sources: *Decor 224*
See: Wright, Alexander.

Standish, Loara
Flourished: 1635 Plymouth, MA
Type of Work: Fabric (Samplers)
Museums: 230
Remarks: Miles Standish's daughter
Sources: *AmNe 43*, 46; LeViB 20, 23, 31*, 33; PlaFan 51.*

Stanley, James E.
b. 1856 d. 1927
Flourished: Cape Vincent, NY
Ethnicity: Australian
Type of Work: Wood (Duck decoys)
Museums: 180
Sources: *ArtDe 190*; FouNY 25*-6*, 63-4.*

Stanley, John Mix
b. 1814 d. 1872
Flourished: 1838-1839 Illinois
Type of Work: Oil (Portraits)
Sources: *ArC 117*.*

Stanley, William
Flourished: 1880
Type of Work: Pencil (House portraits)
Museums: 096
Sources: *FoPaAm 193*.*

Stanton, Nathaniel Palmer
Flourished: 1861 Stonington, CT
Type of Work: Fabric, paper (Embroidered pictures)
Museums: 270
Sources: *AmNe 127-9.*

Stanwood, A.
Flourished: 1850
Type of Work: Oil (Scene paintings)
Sources: *AmPrP 156; PrimPa 180.*

Staples, Hannah
Flourished: 1786 Connecticut
Type of Work: Fabric (Samplers)
Museums: 171
Sources: *AmFoArt 122*.*

Staples, Waity
Flourished: 1810 Illinois
Type of Work: Fabric (Weavings)
Sources: *AmSQu 277.*

Star Encaustic Tile Company
Flourished: 1882- Pittsburgh, PA
Type of Work: Clay (Pottery)
Sources: *DicM 121*.*

Star Porcelain Company
Flourished: 19th century Trenton, NJ
Type of Work: Clay (Pottery)
Sources: *DicM 258*.*

Star Pottery
Flourished: c1915 Bexar County, TX
Type of Work: Stoneware (Jugs)
Sources: *AmS 76*, 95*, 141*, 154*, 175*, 239**
See: Richter, E. J.

Starbuck, M.
Flourished: 1838 Nantucket, MA
Type of Work: Wood, paint (Figures)
Sources: *EyoAm 2*; MaAmFA *.*

Starckloff and Decker
Flourished: 1870 Philadelphia, PA
Type of Work: Wood (Ship carvings, ship figures)
Sources: *AmFiTCa 201.*

Stark, Elizabeth (Miss)
[Spark]
Flourished: early 19th cent New Hampshire
Type of Work: Fabric (Hooked rugs, bed rugs)
Museums: 063
Sources: *FoArtC 91*.*

Stark, Jeffrey
b. 1944
Flourished: 1968- New York, NY
Type of Work: Oil (Genre, scene paintings)
Sources: *TwCA 197*.*

Stark, Mary E.
b. 1826 d. 1909
Flourished: 1850s Mystic, CT
Type of Work: Whalebone (Scrimshaw)
Museums: 186
Sources: *GravF 88-9*.*

Stark, Tillie Gabaldon
b. 1910 Santa Fe, NM
Flourished: 1937- Santa Fe, NM
Ethnicity: Hispanic
Type of Work: Fabric (Colcha embroideries)
Sources: *HisCr 25*, 112*.*

Starkey
See: Simms and Starkey.

Starkey and Howard
Flourished: 1871-1875 Keene, NH
Type of Work: Stoneware (Pottery)
Sources: *Decor 224.*

Starkweather, J.M.
Flourished: 1855 Illinois
Type of Work: (Landscape paintings)
Sources: *ArC 266.*

Starr, Eliza
Flourished: 1802 Albany, NY
Type of Work: Watercolor (Mourning paintings)
Museums: 309
Sources: *MoBeA.*

Starr, F.
Type of Work: Fabric? (Coverlets?)
Sources: *ChAmC 108.*

States, Adam
Flourished: 1749-1767 Greenwich, CT; Huntington, NY
Type of Work: Stoneware (Pottery)
Sources: *AmPoP 56-7, 59, 194, 203; Decor 224.*

States, Ichabod
See: Swan and States.

States, Peter
Flourished: c1767 Stonington, CT
Type of Work: Stoneware (Pottery)
Sources: *Decor 224.*

States, William
Flourished: 1811-1823 Long Point, CT
Type of Work: Stoneware (Pottery)
Sources: *Decor 224.*

Statler
See: Cotten and Statler.

Statler, George
Flourished: 1798 Charleston, SC
Type of Work: Wood (Ship carvings, ship figures)
Sources: *AmFiTCa 201.*

Stauch, David, Sr.
d. 1839
Flourished: 1820-1839 York County, PA
Type of Work: Fabric (Coverlets, quilts)
Remarks: Son is David, Jr.
Sources: *ChAmC 109.*

Stauch, David, Jr.
b. 1807 d. 1879 North Codorus Township, PA
Flourished: 1833-1849 Weigelstown, PA
Type of Work: Fabric (Coverlets)
Remarks: Father is David, Sr.
Sources: *ChAmC 108.*

Staudt, Simon
Flourished: 1842-1848 Miami County, OH
Type of Work: Fabric (Weavings)
Sources: *AmSQu 277; ChAmC 109.*

Stauffer, Jacob
Flourished: 1879 Lancaster County, PA
Type of Work: Watercolor (Homestead paintings)
Sources: *FoPaAm fig38.*

Stauffer, Mary Ann
Flourished: 1830 East Hempfield, PA
Type of Work: Fabric (Samplers)
Sources: *GalAmS 72*, 92.*

Stauffer, R.
Flourished: 1855
Type of Work: Fabric? (Coverlets?)
Sources: *ChAmC 109.*

Steadman and Seymour
See: Seymour and Stedman.

Stearns
See: Farrar amd Stearns.

Stearns, E.
Flourished: 1931
Type of Work: Oil (Scene paintings)
Sources: *TwCA 92*.*

Stearns, Mary Ann H.
Flourished: 1827 Billerica, MA
Type of Work: Velvet (Still life paintings)
Sources: *PrimPa 180.*

Stearns, William
Flourished: 1825 Massachusetts; Maine
Type of Work: Velvet (Still life paintings)
Sources: *PrimPa 180.*

Stebbins, Caroline
Flourished: 1804 Old Deerfield, MA
Type of Work: Fabric (Embroidered architectural pictures)
Museums: 234
Sources: *AmNe 88, 91*.*

Stebbins, Ezra
b. 1760 d. 1819
Flourished: Longmeadow, MA
Type of Work: Stone (Gravestones)
Sources: *EaAmG 129; GravNE 130.*

Stebbins, Wyman H.
Flourished: 1833 Deerfield, MA
Type of Work: Wood (Cradles)
Museums: 234
Sources: *AmPaF 230-1*.*

Stedman
See: Seymour and Stedman.

Stedman, Absalom, and Seymour
Flourished: 1825-1835 Hartford, CT
Type of Work: Stoneware (Pottery)
Sources: *Decor 224.*

Stedman and Clark
Flourished: Meriden, CT
Type of Work: Tin (Tinware)
Sources: *TinC 93, 165, 181*
See: Clark, Patrick.

Steele, Horace
Flourished: Berlin, CT
Type of Work: Tin (Tinware)
Sources: *TinC 181.*

Steere, Arnold
b. 1792 d. 1832
Flourished: 1815-1832 Woonsocket, RI
Type of Work: Oil (Portraits)
Sources: *AmPrP 156; PrimPa 180; SoAmP 290.*

Stegagnini, L.
Flourished: 1833 Philadelphia, PA
Type of Work: Wood (Ship carvings, ship figures)
Sources: *AmFiTCa 201.*

Steier, W.
Flourished: 1844-1848 Hanover Township, PA
Type of Work: Fabric (Weavings)
Sources: *AmSQu 277; ChAmC 109.*

Steig, Laura
Flourished: Jersey City, NJ
Type of Work: Oil (Paintings)
Sources: *ThTaT 236*.*

Stein, Soloman
Flourished: Brooklyn, NY
Type of Work: Wood (Carousel figures)
Sources: *CaAn 10*
See: Stein and Goldstein; Goldstein, Henry.

Stein and Goldstein
[Stein, Soloman; Goldstein, Henry]
Flourished: 1912-1925 Brooklyn, NY
Type of Work: Wood (Carousel figures)
Museums: 263
Sources: *CaAn 28-9, 33*; FoA x*; TYeAmS 105*, 347.*

Steinbach, Henry
Flourished: 1860 Chicago, IL
Type of Work: Earthenware (Pottery)
Sources: *ArC 194.*

Steinberger, Samuel
Flourished: 1890-1900 New York, NY
Type of Work: Fabric (Quilts)
Sources: *NewDis 64*.*

Steiner, David
Flourished: Brecknock Township, PA
Type of Work: Fabric (Coverlets)
Sources: *ChAmC 109.*

Steiner, Thomas
Type of Work: Wood (Decoys)
Sources: *WaDec 125*.*

Steinhagen, Christofer Friderich Carl
Flourished: 1860 Anderson, TX
Type of Work: Wood (Sofas)
Sources: *SoFoA 156, 158*, 221.*

Steinhilber, Martin
b. 1833 d. 1920
Flourished: 1840-1852 Ross County, OH; Covington County, OH
Type of Work: Fabric (Coverlets)
Sources: *AmSQu 277; ChAmC 109.*

Steinhill Brothers
Flourished: Ross County, OH?
Type of Work: Fabric (Coverlets)
Sources: *ChAmC 109.*

Steinman, F.
Flourished: Lancaster, PA
Type of Work: Copper (Tea kettles)
Sources: *AmCoB 65*.*

Stenge, Bertha
Flourished: 1943-1948 Illinois
Type of Work: Fabric (Quilts)
Sources: *QuiAm 29*, 64.*

Stenger, Francis
Flourished: New Jersey
Type of Work: Glass (Flasks)
Sources: *AmSFo 84.*

Stephen, Jacob
Flourished: 1853 Springville, OH
Type of Work: Fabric (Weavings)
Sources: *ChAmC* 109.

Stephen, John
Flourished: 1880 New York, NY
Type of Work: Wood (Ship carvings, ship figures)
Sources: *AmFiTCa* 201.

Stephen, William
Flourished: 1830 New York, NY
Type of Work: Wood (Ship carvings, ship figures)
Sources: *AmFiTCa* 201.

Stephens
See: Brearley, Stephens and Tams.

Stephens, Ebenezer
Flourished: 1850 Portland, ME
Type of Work: Wood (Ship carvings, ship figures)
Sources: *AmFiTCa* 201.

Stephens, Henry
b. c1875?
Flourished: 1916 Crawford County, MI
Type of Work: Bottles (Bottle fence)
Remarks: Built a bottle fence 200 feet long and 4 feet high
Sources: *Rain* 103*.

Stephens, N.R.
See: N.R. Stephens Chair Factory.

Stephenson, Daniel
b. 1823 d. 1892
Flourished: 1845-1870 Fairfield, IA; Springfield, OH
Type of Work: Fabric (Coverlets)
Sources: *AmSQu* 277; *ChAmC* 109
See: Crossley, Robert.

Sterling, Mary E.
Flourished: 1860 Painesville, OH
Type of Work: Oil (Scene paintings)
Sources: *AmPrP* 156; *PrimPa* 180.

Sterling, Noah
Flourished: Crisfield, MD
Type of Work: Wood (Duck decoys)
Sources: *ArtDe* 183.

Sterling, Will
b. 1870 d. 1962
Flourished: Crisfield, MD
Type of Work: Wood (Duck decoys)
Sources: *AmBiDe* 147.

Sterling Brick Company
Flourished: Ohio
Type of Work: Clay (Sewer tile sculpture)
Sources: *IlHaOS* *.

Sterlingworth, Angelina
Flourished: 19th century
Type of Work: Velvet (Mourning pictures)
Sources: *MoBeA*.

Stern, S.
Flourished: late 1800s Philadelphia, PA
Type of Work: Tin (Tinware)
Sources: *ToCPS* 42-3.

Sternberg, William
Flourished: 1834, or 1838 Niagara, NY
Type of Work: Fabric (Coverlets)
Sources: *AmSQu* 277; *ChAmC* 110.

Sterns, E.
Flourished: 1931
Type of Work: Oil (Paintings)
Sources: *FoAFm* 3.

Stettinius, Samuel Enedy
b. 1768 d. 1815 Baltimore, MD
Flourished: Baltimore, MD; Hanover, PA
Ethnicity: German
Type of Work: Oil, watercolor (Portraits)
Museums: 176
Sources: *ColAWC* 133-5*; *FoA* 470.

Steurnagle, Andrew
Flourished: 1853 Inland, OH
Type of Work: Fabric (Coverlets)
Sources: *ChAmC* 110.

Steven, S.S.
Flourished: 1875
Type of Work: Watercolor (Paintings)
Museums: 176
Sources: *ColAWC* 169.

Stevens
See: Wenfold and Stevens.

Stevens, Alfred
Flourished: 1832 Stevens Plains, ME
Type of Work: Tin (Tinware)
Remarks: Father is Zachariah; brother is Samuel
Sources: *AmCoTW* 91; *FoArtC* 84.

Stevens, Augusta
Flourished: 1840
Type of Work: Watercolor (Paintings)
Museums: 242
Sources: *FoArA* 105*.

Stevens, C.W.
See: C.W. Stevens Factory.

Stevens, E.A.
Flourished: 1854 Portsmouth, NH
Type of Work: Wood (Ship carvings, ship figures)
Sources: *AmFiTCa* 201.

Stevens, George
Flourished: 1791 Boston, MA
Type of Work: Stone (Gravestones)
Sources: *GravNE* 130.

Stevens, Harvey A.
See: H.A. Stevens Factory.

Stevens, Henry
b. 1611 d. 1690
Flourished: Boston, MA
Type of Work: Stone (Gravestones)
Sources: *GravNE* 130.

Stevens, John, I
b. 1646 d. 1736
Flourished: c1690-1736 Newport, RI
Type of Work: Stone (Gravestones)
Remarks: Sons are John and William; grandson is John, Jr.
Sources: *EaAmG* 129; *GravNE* 90-4, 130; *HoKnAm* 19.

Stevens, John, II
b. 1702 d. 1778
Flourished: c1724-1769 Newport, RI
Type of Work: Stone (Gravestones, other stoneworks)
Remarks: Father is John; brother is William; son is John
Sources: *EaAmG* viii, 44*, 50*, 129; *GravNE* 93-4, 130; *HoKnAm* 19.

Stevens, John, Jr.
Flourished: c1770-1772 Newport, RI
Type of Work: Stone (Gravestones, other stoneworks)
Remarks: Father is John; grandfather is John
Sources: *EaAmG* 44*, 129, 150*; *GravNE* 95-7; *HoKnAm* 18*-9, 25.

Stevens, John
Flourished: c1875-79 Rochester, MN
Type of Work: Oil (Panoramic paintings)
Museums: 155
Sources: *FoPaAm* 197*; *PicFoA* 20, 112*; *PrimPa* 180.

Stevens, Joseph P.
Flourished: c1840 Martin's Ferry, OH
Type of Work: Stoneware (Pottery)
Sources: *AmPoP* 223; *Decor* 224
See: Harris, James; Danas, John.

Stevens, Samuel
Flourished: 1832- Stevens Plains, ME
Type of Work: Tin (Tinware)
Remarks: Father is Zachariah; brother is Alfred
Sources: *AmCoTW* 91-2; *FoArtC* 84.

Stevens, William
b. 1710 Newport, RI d. 1794 Alexandria, VA
Flourished: 1773 Newport, RI
Type of Work: Stone (Gravestones)
Remarks: Brother is John; father is John
Sources: *EaAmG* 129; *GravNE* 94-6.

Stevens, Zachariah Brackett
b. 1778 Stevens Plains, ME d. 1838
Flourished: 1798-1830s Stevens Plains, ME; Boston, MA
Type of Work: Tin, iron (Tinware, ironware)
Remarks: Sons are Alfred and Samuel
Sources: *AmCoTW* 90-3, 103-5; *AmFokDe* x, 66; *AmSFo* 38-9*, 41, 43; *EaAmI* 136; *FoArtC* 82*.

Stevens Decoy Factory
See: H.A. Stevens Factory.

Stevens Pottery
[Henry Stevens, J.H. Stevens, W.C. Stevens]
Flourished: 1861-1900 Baldwin County, GA
Type of Work: Stoneware (Pottery)
Sources: AmPoP 241.

Stevenson, George
Flourished: c1763 Pennsylvania
Type of Work: Iron (Stove plates)
Sources: CoCoWA 32*-3*.

Steward, David
Flourished: 1845 New York, NY
Type of Work: Wood (Ship carvings, ship figures)
Sources: AmFiTCa 201.

Steward, Joseph, Reverend
b. 1753 Upton, MA **d.** 1822
Flourished: c1793-1822 Hanover, NH; Hartford, CT; Hampton, CT
Type of Work: Oil (Portraits)
Museums: 054,062
Remarks: Taught Brewster, John, Jr.
Sources: AmDecor 99-100*; AmFoPaCe 18; AmNa 11, 22; EraSaF 9; FoA 470; PaiNE 10, 17, 158-163*.

Stewart
Flourished: Michigan
Type of Work: Wood (Fish decoys)
Sources: UnDec 20.

Stewart, Abner
Flourished: c1800 Elizabeth, NJ
Type of Work: Stone (Gravestones)
Sources: EaAmG 129.

Stewart, Alexander
Flourished: 1769 Philadelphia, PA
Ethnicity: English
Type of Work: Oil (Landscape paintings)
Sources: AmDecor 17.

Stewart, James, Jr.
Flourished: 1870 Philadelphia, PA
Type of Work: Wood (Ship carvings, ship figures)
Sources: AmFiTCa 201.

Stewart, Jonas
Flourished: c1785 Claremont, NH; Dorset, VT
Type of Work: Stone (Gravestones)
Sources: EaAmG 129; GravNE 130.

Stewart, L.
Flourished: c1812 Hartford, CT
Type of Work: Clay (Pottery)
Sources: DicM 51*
See: Benton, G.

Stewart, Virginia
Flourished: c1899 Gracey, KY
Type of Work: Fabric (Quilts)
Museums: 125
Sources: KenQu 10, fig4.

Stewart, William
Flourished: 1830 New York, NY
Type of Work: Wood (Ship carvings, ship figures)
Sources: AmFiTCa 201.

Stewart, William
Flourished: 1886 Philadelphia, PA
Type of Work: Wood (Ship carvings, ship figures)
Sources: AmFiTCa 201.

Stewart, William M.
Flourished: Putnam County, IL
Type of Work: Wood (Spinningwheels)
Sources: ArC 110*.

Stewart and Randolf
See: Harold and Randolf.

Stich, G.
Flourished: 1838-1848 Newark, OH
Type of Work: Fabric (Coverlets)
Sources: AmSQu 277; ChAmC 110.

Stickler, Mary Royer
b. 1814 **d.** 1890
Flourished: 1834 Pennsylvania
Type of Work: Fabric (Quilts)
Sources: QuiAm 135*.

Stickney, Mehetable
Flourished: 1825
Type of Work: (Memorial drawings)
Sources: AmPrP 156; PrimPa 180.

Stiebig, John
Flourished: 1830s- Wayne County, IN
Type of Work: Fabric (Weavings)
Sources: AmSQu 277.

Stiegel, Henry Wilhelm, Baron
b. 1729 **d.** 1785
Flourished: 1763 Manheim, PA
Ethnicity: German
Type of Work: Glass, iron (Stove plates)
Museums: 035
Remarks: Owned Elizabeth Furnace
Sources: AmSFo 82, 85*; AmSFok 122*; FoArRP 142-3*; InAmD 97*; PenDuA 28-32*.

Stierwalt, Moses
Flourished: 1840-1850 Washington Township, OH
Type of Work: Fabric (Weavings)
Sources: ChAmC 110.

Stiff, J.
Flourished: 1834-1858 Milford, PA; Montague, NJ; Stillwater, NJ
Type of Work: Fabric (Coverlets)
Sources: AmSQu 277; ArtWea 247*; ChAmC 67*, 110.

Stiles, Jeremiah
b. 1771 **d.** 1826
Flourished: Keene, NH; Massachusetts
Type of Work: Oil (Portraits)
Sources: AmPrP 156; PrimPa 180.

Stiles, Samuel
Flourished: 1820 Massachusetts
Type of Work: Oil (Portraits)
Sources: AmPrP 156; PrimPa 180.

Stiles, Susan Piece
Flourished: 1860-1875 Lexington, MA
Type of Work: Fabric (Samplers)
Sources: FouNY 65.

Stillwell, Ida
Flourished: 1786 Gravesend, NY
Type of Work: Fabric (Coverlets)
Sources: ArtWea 132*.

Stimmel, S.
Flourished: 1851-1853
Type of Work: Fabric (Coverlets)
Sources: ChAmC 110.

Stimp
Flourished: Northfield Farms, MA
Type of Work: Oil (Ornamental paintings)
Remarks: Itinerant
Sources: AmDecor 105-6*, 147.

Stinger, Samuel
b. c1801 Pennsylvania **d.** 1879
Flourished: 1832-1857 Carthage, IN; Montgomery County, OH
Type of Work: Fabric (Weavings)
Sources: AmSQu 277; ChAmC 110.
See: Reiter, Nicholas.

Stingfield, Clarence
b. 1903 Erin, TN
Flourished: 1930- Nashville, TN
Type of Work: Wood (Sculptures, carvings)
Sources: FoScu 28*; TwCA 141*.

Stinson, Henry
Flourished: 1829-1833 Nantucket, MA
Type of Work: Inked stamps (Whale stamps)
Museums: 123
Sources: WhaPa 140*.

Stivers, John, Captain
Flourished: 1860s; Massachusetts
Type of Work: Shell, ivory (Decorated boxes)
Museums: 186
Sources: GravF figiv, 108-9.

Stivour, Sarah
Flourished: Salem, MA
Type of Work: Fabric (Samplers)
Sources: PlaFan 65.

Stizelberger, Jacob, Sr.
Flourished: 1853-1935 Belleville, IL
Ethnicity: German
Type of Work: Redware, stoneware (Pottery)
Remarks: Son is William
Sources: *ArC 194.*

Stizelberger, William
Flourished: 1853-1935 Belleville, IL
Type of Work: Redware, stoneware (Pottery)
Remarks: Father is Jacob Sr.
Sources: *ArC 194.*

Stober, John
Flourished: 1852 Pennsylvania
Type of Work: Watercolor, ink (Frakturs)
Sources: *AmFoPa 189.*

Stock, Joseph Whiting (M.)
b. 1815 Springfield, MA **d.** 1855 Springfield, MA
Flourished: 1830-1855 Chicopee, MA; Springfield, MA; New Haven, CT
Type of Work: Oil (Portraits)
Museums: 001,189,203,265
Remarks: Studied under White, Francis in 1832; partially paralyzed
Sources: *AmFoPa 48, 87-8; AmFoPaS 88*; AmFoPo 184-7*; AmNa 13-4, 17, 26, 84*-6*; AmPrP 148, pl11, 12; AmSFok 160*; Edith *; EraSaF 10; FoA 10, 470; FoArtC 112*, 122; FoPaAm pl.18; HoKnAm 96; NinCFo 169, 178, fig114.*

Stock, Joseph Whiting (M) (Continued)
Sources: *OneAmPr 2*, 83, 92, 145, 155; PicFoA 16, 18, 83*, 91*-2*, 95*; SoAmP 89*.*

Stockes, L. (Ralph)
Flourished: 1920 Tuscarawas County, OH
Type of Work: Clay (Sewer tile sculpture)
Sources: *IlHaOS *.*

Stockton, Hannah
Flourished: 1830 Stockton, NJ
Type of Work: Fabric (Quilts)
Museums: 203
Sources: *FlowAm 277*; QuiAm 213.*

Stockton, Sam
Type of Work: Oil (Panoramic paintings)
Sources: *PicFoA 20.*

Stockton Art Pottery
Flourished: 19th Century Stockton, CA
Type of Work: Clay (Pottery)
Sources: *DicM 177*.*

Stockwell, Amey Ann
Flourished: c1825-1850
Type of Work: Embroidery (Mourning samplers)
Museums: 227
Sources: *MoBeA fig43.*

Stockwell, Henry
Flourished: 1830 Perth Amboy, NJ
Type of Work: Clay (Pottery)
Sources: *DicM 89*.*

Stoddard, N.
Flourished: 1859 Boston, MA
Type of Work: Wood (Ship carvings, ship figures)
Sources: *ShipNA 159.*

Stoddard and McLaughlin
Flourished: 1852-1863 Richmond, ME; Boston, MA
Type of Work: Wood (Ship carvings, ship figures)
Sources: *AmFiTCa 201; ShipNA 77, 157, 161.*

Stoddart, N.
Flourished: 1861 Boston, MA
Type of Work: Wood (Ship carvings, ship figures)
Sources: *AmFiTCa 201.*

Stoddart and McLaughlin
See: Stoddard and McLaughlin.

Stoeckert City Pottery Company
Flourished: 1870 New Ulm, MN
Type of Work: Clay (Pottery)
Sources: *EaAmFo 200*.*

Stoehr, Daniel
Flourished: 1821
Type of Work: Copper (Stills)
Museums: 110
Sources: *AmCoB 110-1*, 113.*

Stofer, L.D.
b. Summit, OH
Flourished: 1847-1860 Ripley, IL
Type of Work: Stoneware (Pottery)
Sources: *ArC 190.*

Stofflet, Heinrich
Flourished: c1815 Berks County, PA
Type of Work: Clay (Pottery)
Remarks: Son is Jacob
Sources: *AmPoP 178; DicM 63*.*

Stofflet, Jacob
Flourished: 1830-1845 Rockland Township, PA
Type of Work: Redware (Pottery)
Remarks: Son of Heinrich
Sources: *AmPoP 178.*

Stofflet, Jacob
Flourished: 1874- Perkiomenville, PA
Type of Work: Redware (Pottery)
Sources: *AmPoP 174.*

Stohl, F.
Flourished: 1833-1834 Lampeter Township, PA
Type of Work: Fabric (Weavings)
Sources: *ChAmC 110.*

Stoltzfus, Mrs.
Flourished: 1915 Elverson, PA
Ethnicity: Amish
Type of Work: Fabric (Quilts)
Sources: *AmSQu 118*.*

Stone, George
Flourished: 1851 Philadelphia, PA
Type of Work: Wood (Ship carvings, ship figures)
Sources: *AmFiTCa 201.*

Stone, Hannah
Flourished: c1812 Massachusetts
Type of Work: Watercolor (Mourning paintings)
Sources: *MoBeA.*

Stone, N.
Flourished: 1830 Prattsville, NY
Type of Work: Oil (Paintings)
Sources: *PrimPa 180.*

Stone, Robert
Flourished: c1780-1811 Peabody, MA
Type of Work: Redware (Pottery)
Sources: *AmPoP 201.*

Stone, Sarah
Flourished: 1678 Salem, MA
Type of Work: Fabric (Samplers)
Sources: *GalAmS 22*, 89.*

Stoner, Albert
Flourished: c1880 McConnellsburg, PA
Type of Work: Tin (Tinware)
Museums: 228
Sources: *ToCPS 22-3*.*

Stoner, Henry
Flourished: 1841
Type of Work: Fabric? (Coverlets?)
Sources: *ChAmC 110.*

Stoneware and Tile Company
Flourished: 1880-1900 Louisville, OH
Type of Work: Stoneware (Pottery, sewer tile sculpture)
Sources: *AmPoP 222; Decor 224; IlHaOS.*

Storer, Mrs. Bellamy (Maria Longworth)
[Rookwood Pottery]
Flourished: 1880-1890 Cincinnati, OH
Type of Work: Clay (Pottery, glazes)
Sources: *AmPoP 79, 212.*

Storey
Type of Work: Wood (Ship carvings, ship figures)
Sources: *AmFiTCa 201.*

Storie, Harold
Flourished: 1950 Gouverneur, NY
Type of Work: Wood (Steam boat models)
Museums: 092
Sources: *FouNY 67.*

Stork, E(dward) L(eslie)
Flourished: 1910-1920 Orange, GA
Type of Work: Clay (Pottery)
Sources: *MisPi 94*, 96*, 98.*

Stoud, William
Flourished: 1830-1838 Cadiz, OH
Type of Work: Fabric (Weavings)
Sources: *ChAmC 110.*

Stoughton, Jonathan
Flourished: Windsor, CT
Type of Work: Tin (Tinware)
Sources: *AmCoTW 53.*

Stout, Francis Marion
b. Kentucky
Flourished: 1848-1878 Ripley, IL
Type of Work: Stoneware (Pottery)
Sources: *ArC 193.*

Stout, Isaac
Flourished: c1790-1810 Fritztown, PA
Type of Work: Clay (Pottery)
Sources: *AmPoP 168; EaAmFo 12.*

Stout, John N.
Flourished: 1800's Ripley, IL
Type of Work: Brownware, stoneware (Pottery)
Sources: *AmPoP 69, 229.*

Stout, Samuel
Flourished: 1818-1845 Washington, NJ
Type of Work: Stoneware (Pottery)
Sources: *Decor 218*
See: Eaton, Jacob.

Stouter, D.G.
Flourished: c1840 Pennsylvania
Type of Work: Oil (Genre paintings)
Sources: *OneAmPr 96*, 145, 155.*

Stovall, Queena
b. 1888 Lynchburg, VA d. 1980
Flourished: 1949-1980 Lynchburg, VA
Type of Work: Oil (Memory paintings)
Museums: 294
Sources: *ArtWo 139-41*, 153, 171-2; FoAFw 16-7*, 33*.*

Stow
See: Pass and Stow.

Stow, John
Flourished: 1749-1774 Philadelphia, PA
Type of Work: Metal (Ornamental works)
Sources: *AmCoB 163; AmFokAr 81, fig85.*

Stow, O.W.
Flourished: Windsor, CT
Type of Work: Tin (Tinware)
Sources: *AmCoTW 64.*

Stow, Samuel E.
Flourished: 1860 Guilford, CT
Type of Work: Wood (Ship carvings, ship figures)
Sources: *AmFiTCa 201.*

Stow, Solomon
Flourished: 1836-1840 Southington, CT
Type of Work: Wood (Shelf clocks)
Museums: 011
Sources: *AmPaF 174*.*

Stower, Manuel
Flourished: 1825
Type of Work: Pen, wash (Drawings)
Museums: 176
Sources: *ColAWC 277, 280*.*

Stracke, Barnhardt
Flourished: 1856 Hocking County, OH
Type of Work: Fabric (Weavings)
Sources: *AmSQu 277; ChAmC 110.*

Strang, Charles
Flourished: Long Island, NY
Type of Work: Wood (Duck decoys)
Sources: *ArtDe 165.*

Strater, Herman, Jr.
[Strater and Sohier]
Flourished: c1874-1890 Boston, MA
Type of Work: Metal (Patented duck, shorebird decoys)
Sources: *AmBiDe 233*, 236*; AmDecoy 88*; FoA 225*, 470*
See: Sohier, William.

Strater and Sohier
See: Strater, Herman, Jr.; Sohier, William.

Stratton, Joseph
Flourished: 1845-1852 Buffalo, NY; New York, NY
Type of Work: Wood (Ship carvings, ship figures)
Sources: *AmFiTCa 201; ShipNA 162.*

Stratton and Morrell
Flourished: 1845 New York, NY
Type of Work: Wood (Ship carvings, ship figures)
Sources: *AmFiTCa 201; ShipNA 152.*

Strauser, Elias
b. c1826 Pennsylvania
Flourished: c1850 Plain Township, OH
Type of Work: Fabric (Weavings)
Sources: *ChAmC 110.*

Strauss, Simon
d. 1897
Flourished: 1866-1897 New York, NY
Ethnicity: German
Type of Work: Wood (Cigar store Indians, figures)
Sources: *ArtWod 239-41, 267.*

Straw, Michael
Flourished: c1837 Greensburg, PA
Type of Work: Stoneware (Pottery)
Sources: *AmPoP 221; Decor 224.*

Strawn, John
Flourished: 1797 Bucks County, PA
Type of Work: Clay (Pottery)
Sources: *BeyN 79*, 113*.*

Street, Austin
Flourished: 1858-1864 Philadelphia, PA
Type of Work: Oil (Portraits)
Sources: *AmNe 74*.*

Street, Robert
b. 1796
Flourished: 1830-1840 Philadelphia, PA
Type of Work: Oil (Portraits)
Remarks: Itinerant
Sources: *AmPrP 156; PrimPa 180; SoAmP 286.*

Strenge, Christian
Flourished: 1794-1814 Pennsylvania
Type of Work: Watercolor, ink (Frakturs)
Sources: *AmFoPa 189; NinCFo 188.*

Strickland, Simon
Flourished: Berlin, CT
Type of Work: Tin (Tinware)
Sources: *TinC 181.*

Strickler, Jacob
b. 1770 Shendanoah County, VA
Flourished: 1787-1815 Shenandoah County, VA
Ethnicity: Mennonite
Type of Work: Watercolor, ink (Frakturs)
Sources: *AmFoPa 189; BeyN 58*; SoFoA 40*, 80*, 90, 218.*

Strickler, John
Flourished: c1840-1845 Logan, OH
Type of Work: Stone (Gravestones)
Sources: *EaAmG 114*-5, 126*, 129.*

Striebig, John K.
b. 1809 d. 1868 York County, PA
Flourished: 1834-1847 York Township, PA; Maryland
Type of Work: Fabric (Weavings)
Sources: *ChAmC 110.*

Strobel, Lorenz
b. c1812 d. 1900
Flourished: 1846-1850 Coventry County, OH
Ethnicity: German
Type of Work: Fabric (Weavings)
Sources: *AmSQu 277; ChAmC 110.*

Strokes, Willie
b. 1954
Flourished: 1976- Philadelphia, PA
Type of Work: Pen, crayon (Drawings)
Sources: *FoAFk 13*.*

Stroll, S.L.
See: S.L. Stroll and Company.

Strong
See: Rhodes, Strong and McGeron.

Strong, Anne
Flourished: 1859 Portland, CT
Type of Work: Fabric (Embroidered pictures)
Sources: *AmNe 109.*

Strubing, Walter
Flourished: Marine City, MI
Type of Work: Wood (Decoys)
Sources: *WaDec 6*, 106*, 107*.*

Strunks Mill
Flourished: 1841 Lewistown, PA
Type of Work: Fabric (Weavings)
Sources: *ChAmC 110*
See: Schnee, Joseph F.

Stuart
See: Farrand and Stuart.

Stuart, Alexander W.
Flourished: 1825 New York, NY
Type of Work: Wood (Ship carvings, ship figures)
Sources: *AmFiTCa 201.*

Stuart, Nobil
b. 1882 Michigan d. 1976
Flourished: Medina, OH
Type of Work: Wood (Sculptures, carvings)
Sources: *AlAmD 82*; AmFokA 14*, 97*.*

Stubbs, William P.
b. 1842
Flourished: 1858 Bucksport, ME; Boston, MA
Type of Work: Pastel (Portraits, landscape, ship paintings)
Sources: *AmFoPa 98, 112-3*, 213; FoPaAm 60*.*

Stubenville Pottery Company
Flourished: c1879-1900 Steubenville, OH
Type of Work: White Granite (Decorative ware)
Sources: *AmPoP 231.*

Stucker, F.
Flourished: 1885
Type of Work: Oil (Genre paintings)
Sources: *PicFoA 100*.*

Stuckey, Martin or Upton
Flourished: 1860-1870 Loogootee, IN
Type of Work: Stoneware (Jugs)
Museums: 118
Sources: *AmS 187*.*

Stuckey, Upton
See: Stuckey, Martin or Upton.

Stueler, Charles
Flourished: 1891 Philadelphia, PA
Type of Work: Wood (Ship carvings, ship figures)
Sources: *AmFiTCa 201.*

Stumpf, Valentine
Flourished: 1860 New York, NY
Type of Work: Wood (Ship carvings, ship figures)
Sources: *AmFiTCa 201.*

Sturgis, Samuel
Flourished: 1840-1893 Lititz, PA
Type of Work: Redware (Tobacco pipes)
Sources: *AmPoP 171.*

Sturtevant, Louisa
Flourished: Newport, RI
Type of Work: Fabric (Embroidered linen altar cloths)
Museums: 245
Sources: *AmNe 168*.*

Stutchfield, Joseph T.
Flourished: 1871 Baltimore, MD
Type of Work: Wood (Ship carvings, ship figures)
Sources: *AmFiTCa 201.*

Sublett, Harriet
Flourished: c1800-1850
Type of Work: Fabric (Needlepoint)
Sources: *CoCoWA 42*.*

Sudbury, Joseph M.
Flourished: 1871 Baltimore, MD
Type of Work: Wood (Ship carvings, ship figures)
Remarks: Partner in Sudbury and Schaefer
Sources: *AmFiTCa 201.*

Sudbury and Schaefer
Flourished: 1860 Baltimore, MD
Type of Work: Wood (Ship carvings, ship figures)
Sources: *AmFiTCa 201*
See: Sudbury, Joseph M.

Suddouth, Jimmy Lee
[Jim L. Suddth]
b. 1910
Flourished: 1970- Fayette, AL
Ethnicity: Black American
Type of Work: Clay fixed to plywood (Sculptures)
Sources: *FoAF 18-9*; FoAFo 1*, 12*-3*; FoPaAm 171, 174, 177*, 181.*

Suddth, Jim L.
See: Suddouth, Jimmy Lee.

Sudenberg, Otto N.
Flourished: 1887-1895 Norwich, CT
Type of Work: Stoneware (Pottery)
Sources: *AmPoP 199.*

Sullins, David
Flourished: 1870 Calvey Township, MO
Type of Work: Wood (Furniture)
Sources: *ASeMo 384.*

Sullivan, Charles
b. 1794 d. 1867
Flourished: Ohio
Type of Work: Oil (Landscape paintings)
Museums: 210
Sources: *PicFoA 65*.*

Sullivan, Patrick J.
b. 1894 d. 1967
Flourished: Wheeling, WV
Type of Work: Oil (Symbolic scene paintings)
Sources: *FoPaAm 142, 144*; HoKnAm 188; PeiNa 363*; PrimPa 180; ThTaT 53*; TwCA 98*.*

Sullivan, Samuel
Flourished: 1808- Zanesville, OH
Type of Work: Redware (Pottery)
Sources: *AmPoP 68, 233.*

Sullivan, Sarah Crisco
Ethnicity: American Indian
Type of Work: Wood (Decorated baskets)
Remarks: Nipmuc tribe
Sources: *AmSFo 123.*

Sullivan, William
Flourished: c1776 New York, NY
Type of Work: Wood (Figures)
Museums: 067
Sources: *EaAmW 69-70*.*

Sully
Type of Work: Paint (Decorated fire engines, hose carts)
Sources: *AmFokDe 130.*

Sully, Thomas
Flourished: 1822 Philadelphia, PA
Type of Work: Oil (Portraits)
Sources: *BeyN 107*.*

Sulser, Henry
Flourished: 1853 Greenfield, OH
Type of Work: Fabric (Coverlets)
Sources: *ChAmC 110.*

Summit China Company
Flourished: c1890 Akron, OH
Type of Work: White Granite, earthenware (Pottery)
Sources: *AmPoP 207; DicM 240.*

Summit Sewer Pipe Company
b. Akron, OH
Flourished: 1925-1930
Type of Work: Stoneware (Planters)
Sources: *AmS 54*.*

Sunderland Knotts and Company
Flourished: c1870-1900 Palatine, WV
Type of Work: Stoneware (Pottery)
Sources: *AmPoP 226; Decor 221.*

Sunshine
See: Euler and Sunshine.

Sutherland, Charlotte
Flourished: 1809 Washington, DC
Type of Work: Fabric (Samplers)
Sources: *GalAmS 47*.*

Sutherland, H.
Type of Work: Fabric? (Coverlets?)
Sources: *ChAmC 124.*

Sutherland, J.
b. c1808 Pennsylvania
Flourished: 1840 Brighton Township, PA; Beaver, PA
Type of Work: Fabric? (Coverlets?)
Sources: *ChAmC 110.*

Sutherlin, Mary
Flourished: c1865 Grave County, KY
Type of Work: Fabric (Quilts)
Remarks: Sister is Pryor, Nannie Elizabeth
Sources: *KenQu fig20.*

Sutherlin, Nannie Pryor
See: Pryor, Nannie Elizabeth.

Sutterly, Clement
Flourished: 1859-1860 Chicago, IL
Sources: *ArC 267.*

Suttles, G.W.
Flourished: 1890-1900 Wilson County, TX
Type of Work: Stoneware (Birdhouses)
Sources: *AmS 124*, 160*, 238*.*

Suttles, I.
Flourished: 1872-1882 La Vernia, TX
Type of Work: Stoneware (Jars, bowls, pots)
Sources: *AmS 84*, 96*, 139*, 231*.*

Sutton
Flourished: Camden, SC
Ethnicity: Black American
Type of Work: Wood (Furniture)
Sources: *AfAmA 85*-6*.*

Sutton, E.
Flourished: c1840 Jacksontown, OH
Type of Work: Stone (Gravestones)
Sources: *EaAmG 129.*

Sutton, W.
Flourished: 1840-1850
Type of Work: Oil (Portraits)
Sources: *PicFoA 69*; PrimPa 180.*

Swain, Harriet
Flourished: 1830 Nantucket, MA
Type of Work: Watercolor (Portraits)
Sources: *PrimPa 180.*

Swain, William
Flourished: 1825 Massachusetts
Type of Work: Oil (Portraits)
Sources: *AmPrP 156; PrimPa 180.*

Swallow, William
Flourished: contemporary Allentown, PA
Type of Work: Clay (Pottery)
Sources: *PenDuA 28*.*

Swam, George
Flourished: 1883 Richmond, VA
Type of Work: Wood (Ship carvings, ship figures)
Sources: *AmFiTCa 201.*

Swan, Cyrus
b. 1824 Pennsylvania
Flourished: c1848-1850 Salt Creek Township, OH
Type of Work: Fabric (Weavings)
Sources: *ChAmC 110.*

Swan, Jonathan R.
Flourished: 1847 Providence, RI
Type of Work: Wood (Ship carvings, ship figures)
Sources: *AmFiTCa 201.*

Swan, Joshua
See: Swan and States.

Swan and States
[Joshua Swan and Ichabod States]
Flourished: 1823-1835 Stonington, CT; Long Point, CT
Type of Work: Stoneware (Pottery)
Sources: *AmS 194*; Decor 224.*

Swan Hill Pottery
Flourished: 1849 South Amboy, NJ
Type of Work: Clay (Pottery)
Sources: *AmPoP 180; DicM 161**
See: Fish, C.

Swank, Hiram
See: Hiram Swank and Sons.

Swank, J.
Flourished: 1846 Knox County, OH
Type of Work: Fabric (Weavings)
Sources: *ChAmC 110.*

Swasey, Alexander G.
b. 1784 **d.** 1864
Flourished: 1856 Newport, RI
Type of Work: Wood (Ship carvings, ship figures)
Sources: *AmFiTCa 201; EaAmW 69.*

Swasey, E.
See: E. Swasey and Company.

Swazey
See: Lamson and Swazey.

Sweatland, Joel
Flourished: 1844 Buffalo, NY
Type of Work: Wood (Ship carvings, ship figures)
Sources: *AmFiTCa 201.*

Sweeny, T.W.
Flourished: 1853 Armstrongs Mills, OH
Type of Work: Fabric (Weavings)
Sources: *ChAmC 110.*

Sweet, Sarah Foster
b. 1806 Providence, RI **d.** 1831 Providence, RI
Flourished: 1814 Providence, RI
Type of Work: Fabric (Samplers)
Sources: *LeViB 116, 132*-3*.*

Sweetland, Isaac
Flourished: c1800 Hartford, CT
Type of Work: Stone (Gravestones)
Sources: *EaAmG 128.*

Sweetser, S.
See: S. Sweetser and Sons.

Sweitzer
See: Herreter and Sweitzer.

Swift
Type of Work: Oil (Paintings)
Remarks: Follower of Porter, Rufus
Sources: *AmFoPa 141.*

Swift, Ann Waterman
Flourished: 1810 Poughkeepsie, NY
Type of Work: Watercolor (Romantic scene paintings)
Sources: *AmPrP 156; PrimPa 181.*

Swift, R.G.N.
Flourished: c1868-1870
Type of Work: Pen, ink (Drawings)
Museums: 123
Sources: *WhaPa 135*, 143*.*

Swift, S.W.
Flourished: c1850 Galena, IL
Type of Work: Fresco (Paintings)
Sources: *ArC 267.*

Swift Studios
Type of Work: Oil (Theater and sideshow scenes)
Sources: *AmSFor 198.*

Swope
See: Key and Swope.

Swope, George A.
Flourished: c1830-1865 Lancaster, PA; Bird-in-Hand, PA
Type of Work: Redware (Pottery)
Sources: *AmPoP 170.*

Swope, Jacob
Flourished: c1820 Lancaster, PA
Type of Work: Redware (Pottery)
Remarks: Father of Zuriel
Sources: *AmPoP 164.*

Swope, Zuriel
Flourished: c1860 Lancaster, PA
Type of Work: Redware (Pottery)
Remarks: Son of Jacob
Sources: *AmPoP 164; ToCPS 48.*

Symme, Polly Thompson
b. 1790
Type of Work: Fabric (Samplers)
Sources: *FoArtC 52.*

Symonds, Nathaniel, Sr.
Flourished: c1740-1790 Salem, MA
Type of Work: Redware (Pottery)
Remarks: Son is Nathaniel, Jr.; grandson is Nathaniel
Sources: *AmPoP 202.*

Symonds, Nathaniel, Jr.
Flourished: 1790-1803 Salem, MA
Type of Work: Redware (Pottery)
Remarks: Father is Nathaniel, Sr.; son is Nathaniel
Sources: *AmPoP 202.*

Symonds, Nathaniel
Flourished: 1803-1850 Salem, MA
Type of Work: Redware (Pottery)
Remarks: Son of Nathaniel, Jr.
Sources: *AmPoP 202.*

Synan, Patrick
Flourished: 1893-1912 Somerset, MA
Type of Work: Stoneware (Pottery)
Sources: *Decor 224*
 See: Synan, William.

Synan, William
Flourished: 1893-1912 Somerset, MA
Type of Work: Stoneware (Pottery)
Sources: *Decor 224*
 See: Synan, Patrick.

Synder, Jacob
Flourished: 1849 Strake County, OH
Type of Work: Fabric (Weavings)
Sources: *AmSQu 277.*

Syng, Phillip
Flourished: Annapolis, MD
Type of Work: Brass (Bells)
Sources: *AmCoB 163, 211-2*, 214.*

Syracuse Stoneware Company
Flourished: 1849 Syracuse, NY
Type of Work: Stoneware (Pottery)
Museums: 203
Sources: *Decor 213*.*

T

T.G. Boone and Sons
See: Boone, J.G.

T.J. White and Company
Flourished: 1859-1868 Boston, MA
Type of Work: Wood (Ship carvings, ship figures)
Sources: *ShipNA 159*
See: White and Company; Rumney, William H.

T. Rigby and Company
Flourished: 1860-1872 East Liverpool, OH
Type of Work: Yellow-ware, Rockingham (Pottery)
Sources: *AmPoP 216.*

T. Sables and Company
Flourished: 1838-1844 Medford, MA
Type of Work: Stoneware (Pottery)
Remarks: Thomas and John Sables
Sources: *Decor 223.*

Tabor
See: Purrington and Tabor.

Taccard, Patrick
Flourished: Liberty, NY
Type of Work: Oil (Paintings)
Sources: *ThTaT 236*.*

Taft, James Scholly
Flourished: 1871-1880 Keene, NH
Type of Work: Stoneware (Pottery)
Sources: *Decor 224*
See: J.S. Taft and Co.

Tainter, Benjamin
b. 1753 **d.** 1844
Flourished: Newton, MA
Type of Work: Stone (Gravestones)
Sources: *EaAmG 129; GravNE 130.*

Tait, Arther Fitzwilliam
b. 1819 **d.** 1905
Type of Work: Oil (Midwestern landscape paintings)
Sources: *ArC 124.*

Taite, Augustus
Flourished: 1840 Albany, NY
Type of Work: Oil (Portraits)
Sources: *PrimPa 181.*

Talbot, Jane Lewis
b. 1811 **d.** 1849
Flourished: c1830 Missouri
Type of Work: Fabric (Needlework)
Sources: *WinGu 131*.*

Talbot, Mary
b. 1787 Providence, RI **d.** 1863 Providence, RI
Flourished: 1796-1800 Providence, RI
Type of Work: Embroidery (Mourning pictures)
Sources: *LeViB 141-2, 166-7*.*

Talbott, Emeline
Flourished: 1844 Montgomery County, MD
Type of Work: Fabric (Quilts)
Sources: *AmSQu 117*.*

Talcott, William
Flourished: 1820-1836 Massachusetts
Type of Work: Oil (Portraits)
Sources: *AmPrP 156; PrimPa 181.*

Talpey, J.M.
Flourished: 1825
Type of Work: Fabric (Weavings)
Sources: *AmHo 17*.*

Tams
See: Brearley, Stephens and Tams.

Taney, Jacob
See: Tawney, Jacob.

Tanner, M.J.
Flourished: 1856
Type of Work: Oil (Landscape paintings)
Sources: *FoPaAm 98*.*

Tanner, Mary Ann
See: Patterson, Mary Ann Tanner.

Tapia, Luis
b. 1950 Santa Fe, NM
Flourished: 1977 New Mexico
Ethnicity: Hispanic
Type of Work: Wood (Furniture, santeros, religious carvings)
Museums: 178
Sources: *HisCr 33*, 59*-60*, 113.*

Tapia, Star
b. 1952 Santa Fe, NM
Flourished: 1977 Santa Fe, NM
Ethnicity: Hispanic
Type of Work: Straw (Inlaid candle holders, crosses)
Sources: *HisCr 79*, 113.*

Tapp, Edward
Flourished: 1815 New York, NY
Type of Work: Wood (Ship carvings, ship figures)
Sources: *AmFiTCa 201.*

Tapp and Miller
Flourished: 1810-1815 New York, NY
Type of Work: Wood (Ship carvings, ship figures)
Sources: *AmFiTCa 197, 201.*

Tarbell, William
Flourished: c1790-1816 Beverley, MA
Type of Work: Redware (Pottery)
Remarks: Son is William, Jr.
Sources: *AmPoP 188.*

Tarbell, William, Jr.
Flourished: c1816-1819 Beverley, MA
Type of Work: Redware (Pottery)
Remarks: Father is William
Sources: *AmPoP 188.*

Tarr
See: Fisher and Tarr.

Tatham, Thomas
Flourished: Middletown, NY
Type of Work: Fabric (Carpets, coverlets)
Sources: *ChAmC 111.*

Tatro, Curtis
b. 1890
Flourished: 1977 Greensboro, VT
Ethnicity: Canadian
Type of Work: Pen, crayon, pencil (Paintings)
Sources: FoAFp 15*.

Taubert, T.
Flourished: Green Bay, WI
Type of Work: Wood (Duck decoys)
Sources: ArtDe 77*.

Tawney, Jacob
[Taney]
Flourished: c1794 Nockamixon, PA
Type of Work: Redware (Pottery)
Sources: AmPoP 134, 173.

Taylor
See: Harker, Taylor and Company.

Taylor
See: Knowles, Taylor, and Knowles.

Taylor, A.M.
Flourished: 1825 New York
Type of Work: Watercolor (Landscape paintings)
Sources: AmPrP 156; PrimPa 181.

Taylor, Alexander
Flourished: 1829 Ohio
Type of Work: Watercolor, ink (Frakturs)
Sources: AmFoPa 189.

Taylor, Alice
b. 1789 Providence, RI d. 1883 New Albany?, IN?
Flourished: 1805 Providence, RI
Type of Work: Embroidery (Mourning pictures)
Sources: LeViB 192-3*.

Taylor, Bayard
b. 1825 d. 1878
Flourished: 1852 Galena, IL
Type of Work: Oil (Harbor scene paintings)
Sources: ArC 192*.

Taylor, Charles Ryall
Flourished: 1860
Type of Work: Oil (Scene paintings)
Sources: AmPrP 156; PrimPa 181.

Taylor, Eliza Andrews
b. 1797 Providence, RI d. 1876 Scituate?, RI?
Flourished: 1811 Providence, RI
Type of Work: Embroidery (Mourning pictures)
Museums: 241
Sources: LeViB 184*.

Taylor, Eliza Ann
Flourished: c1850 Delaware
Ethnicity: Shaker
Type of Work: Pen, ink, watercolor (Drawings)
Museums: 303
Sources: ArtWo 94, 172, fig15; PicFoA 144*; PrimPa 181.

Taylor, Eliza Winslow
b. 1797 Providence, RI d. 1864 Providence?, RI?
Flourished: 1822 Providence, RI
Type of Work: Embroidery (Literary and mythical pictures)
Museums: 173
Sources: LeViB 161, 203*, 258.

Taylor, Elizabeth
Flourished: 1745? Norwich?, CT
Type of Work: Fabric (Crewel bedspreads)
Museums: 133
Sources: AmNe 33.

Taylor, Elizabeth
Flourished: 1785? Chester County, PA
Type of Work: Fabric (Crewel pictures)
Sources: PlaFan 143*.

Taylor, Enoch
Flourished: 1833 Philadelphia, PA
Type of Work: Wood (Ship carvings, ship figures)
Sources: AmFiTCa 201.

Taylor, George
Flourished: 1856 Manchester, MA
Type of Work: Wood (Ship carvings, ship figures)
Sources: AmFiTCa 201.

Taylor, H.M.
Flourished: 1850 Delaware
Type of Work: Pencil (Drawings)
Sources: PrimPa 181.

Taylor, Hannah
b. 1763 Newport?, RI?
Flourished: 1774 Newport, RI
Type of Work: Fabric (Samplers)
Museums: 013
Sources: LeViB 58-9, 72*.

Taylor, John
Flourished: c1793-1815 New York, NY; Richmond, VA
Type of Work: Wood (Ship carvings, ship figures)
Sources: ShipNA 161.

Taylor, John
Flourished: 1806 New York, NY
Type of Work: Wood (Ship carvings, ship figures)
Sources: AmFiTCa 201.

Taylor, Lillian Gary (Mrs. Robert Coleman Taylor)
Flourished: 1914-1934 New York, NY
Type of Work: Fabric (Embroidered history pictures, samplers)
Remarks: Mother is Gary, Mrs. James A.
Sources: AmNe 110, 113, 143-4, 149, 160, 162, 169*-70, 173*, 175-6, 209*, 211, 214-5*, 218.

Taylor, Mary Wilcox
Flourished: 19th century Detroit, MI
Type of Work: Fabric (Quilts)
Museums: 263
Sources: QuiAm 120*.

Taylor, S.F.
Flourished: late 19th cent Milford, CT
Type of Work: Iron (Sculptures)
Sources: AlAmD 100.

Taylor, Sally
b. 1792 Providence?, RI? d. 1883
Flourished: 1799 Providence, RI
Type of Work: Fabric (Family register samplers)
Sources: LeViB 184.

Taylor, Sarah
b. 1744 South Kingston?, RI?
Flourished: 1756 Newport, RI
Type of Work: Fabric (Samplers)
Remarks: This sampler was made in Hampton, NH.
Sources: GalAmS 25*, 90; LeViB 60, 68*.

Taylor, W.W.
Flourished: c1889 Cincinnati, OH
Type of Work: Matte glaze on clay (Pottery)
Remarks: Partner in Rookwood Pottery with Storer, Mrs. Bellamy
Sources: AmPoP 79.

Taylor, William
Flourished: c1850-1872 Jersey City, NJ; East Liverpool, OH; Trenton, NJ
Type of Work: Clay (Pottery)
Sources: AmPoP 49, 75, 118
See: Taylor and Speeler.

Taylor, William W.
Flourished: 1835-1837 Dartmouth, MA
Type of Work: Pen, watercolor (Whaling scene paintings)
Museums: 123
Sources: WhaPa 14*, 158.

Taylor and Speeler
Flourished: 1852 Trenton, NJ
Type of Work: Clay (Pottery)
Sources: AmPoP 49, 181
See: Speeler, Henry; Taylor, William.

Taylor, Smith, and Taylor Company
Flourished: 1900- East Liverpool, OH
Type of Work: Clay (Pottery)
Sources: DicM 128*, 152*, 186*.

Teames, Judak
Flourished: 1827
Type of Work: Clay (Pottery)
Sources: *EaAmFo 207**.

Teibel, Georg (Johann)
Flourished: 1763-1779 Pennsylvania
Type of Work: Watercolor, ink (Frakturs)
Sources: *AmFoPa 189*.

Teibel, Johann
See: Teibel, Georg.

Telan, W.A.
Flourished: 1866 New Orleans, LA
Type of Work: Wood (Ship carvings, ship figures)
Sources: *AmFiTCa 201*.

Telfair, Jessie
Flourished: 1975 Parrot, GA
Ethnicity: Black American
Type of Work: Fabric (Quilts)
Sources: *MisPi 81**.

Telfer, James W.
Flourished: 1870 San Francisco, CA
Type of Work: Wood (Ship carvings, ship figures)
Sources: *ShipNA 155*.

Tempest
See: Brewer and Tempest.

Tempest, Michael
[Hamilton Street Pottery]
Flourished: 1860-1865 Cincinnati, OH
Type of Work: Yellow-ware (Bisque porcelain, pottery, fruit jars)
Sources: *AmPoP 78, 211*.

Tempest, Nimrod
[Hamilton Street Pottery]
Flourished: 1860-1865 Cincinnati, OH
Type of Work: Yellow-ware (Bisque porcelain, pottery, fruit jars)
Sources: *AmPoP 78, 211*.

Tempest, Brockman and Company
Flourished: 1862- Cincinnati, OH
Type of Work: Yellow-ware (Pottery)
Sources: *AmPoP 78, 211*.

Ten Eyck, Margaret Bleeker
Flourished: c1805 Albany, NY
Type of Work: Fabric (Needlework)
Sources: *WinGu 92**.

Tenebaum, Morris
b. 1897 d. 1977
Flourished: 1933-1976 Norman, OK
Type of Work: Various materials (Sewn buttons, quilts, canes)
Sources: *FoArO 13, 90-2*, 66-7*, 96*, 101*.

Tenney, M.B.
Flourished: 1840
Type of Work: Oil (Portraits)
Sources: *AmPrP 156; PrimPa 181; SoAmP 287*.

Tenny, Ulysses Dow
b. 1826 d. 1904
Flourished: Lebanon, NH
Type of Work: Oil (Paintings)
Museums: 130
Sources: *FoArA 160**.

Terhune, Nicholas
Flourished: 1830 New York, NY
Type of Work: Wood (Ship carvings, ship figures)
Sources: *AmFiTCa 201*.

Tern, C.H.
Flourished: 1825 Stoddard, NH
Type of Work: Oil (Landscape paintings)
Sources: *PrimPa 181*.

Terrillion, Veronica
b. 1908 Indian River, NY
Flourished: 1952-1985 Indian River, NY
Type of Work: Cement (Sculptures)
Sources: *FoAFc 10-11*; FouNY 67*.

Terry, Elizabeth
Flourished: 1836 Marietta, PA
Type of Work: Fabric (Mourning paintings)
Museums: 001
Sources: *MoBeA*.

Terry, Sarah F.
Flourished: Massachusetts
Type of Work: Velvet (Still life paintings)
Sources: *AmPrP 156; Edith *; PrimPa 181*.

Test Woolen Mills
Flourished: 1850s Hagerstown, IN
Type of Work: Fabric (Weavings)
Sources: *ChAmC 111*
See: Favorite, Elias; Hoover, John; Jordan, Thomas.

Teubner, E.F.
See: William Krafe and E.F. Teubner.

Teubner, William
Flourished: 1855 Baltimore, MD
Ethnicity: German
Type of Work: Wood (Cigar store Indians, ship carvings, figures)
Remarks: Son is William, Jr.
Sources: *ArtWod 133*-4, 263*.

Teubner, William, Jr.
b. 1857 d. 1926
Flourished: Baltimore, MD
Type of Work: Wood (Sculptures, carvings)
Remarks: Father is William
Sources: *ArtWod 133*-4*.

Texarkana Pottery
Flourished: c1880
Type of Work: Stoneware (Piggy jugs)
Sources: *AmS 80**.

Thatcher, Lucretia Mumford
Flourished: c1800 New London, CT
Type of Work: Fabric (Embroidered bedspreads)
Remarks: Bedspread was designed by her husband, Anthony
Sources: *AmNe 39*, 41*.

Thaxter, Rachel
b. 1784
Flourished: 1796 Hingham, MA
Type of Work: Fabric (Needlework pictures)
Sources: *PlaFan 178**.

Thayer, Hannah F.
b. 1807
Flourished: 1818 Randolph, MA
Type of Work: Fabric (Samplers)
Sources: *GalAmS 54*, 91*.

Thayer, Nathan
b. 1781 Milford, NH d. 1830
Flourished: c1825 Hollis, NH
Type of Work: Oil (Ornamental paintings)
Remarks: Painted in many small towns in southern NH.
Sources: *AmDecor 153*.

Thayer, Pliny
Flourished: 1850 Lansingburgh, NY
Type of Work: Clay (Pottery)
Sources: *EaAmFo 140**.

Theall, Isaac
Flourished: 1830 New York, NY
Type of Work: Wood (Ship carvings, ship figures)
Sources: *AmFiTCa 201*.

Theiss, Steven
Flourished: 1869-1890 Bennington, VT; Philadelphia, PA
Type of Work: Clay (Pottery)
Remarks: Designer for J.E. Jeffords and Company
Sources: *AmPoP 46, 177*.

Theus, Jeremiah
b. c1719 d. 1774 Charleston, SC
Flourished: 1739- Charleston, SC
Ethnicity: Swiss
Type of Work: Oil (Portraits)
Museums: 096
Sources: *FoA 470; FoPaAm 149, 151*; OneAmPr 39*, 84, 140, 155*.

Thew, John Gerrett
Flourished: contemporary Norfolk, CT
Type of Work: Metal (Weathervanes)
Sources: *WeaVan 26*.

Thiekson, Joseph
Flourished: 1722 New Jersey
Type of Work: Clay (Pottery)
Sources: *EaAmFo 39*.

Thielke, Henry D.
Flourished: 1855-1878 Chicago, IL
Type of Work: (Portraits)
Sources: *ArC 267*.

Thierwaechter, John
Flourished: c1875 Silvertown, PA
Type of Work: Redware (Pottery)
Sources: *AmPoP 179*.

Thiessen, Louise Berg
b. 1876 Sacramento, CA d. 1960
Flourished: 1930 Omaha, NE
Type of Work: Felt (Mosaics)
Museums: 263
Sources: *TwCA 113**.

Thomas, C. Susan
Flourished: 1847
Type of Work: Fabric (Quilts)
Museums: 016
Sources: *QuiAm 287**.

Thomas, Carl C.
Flourished: 1871 Worcester, MA
Type of Work: Wood (Ship carvings, ship figures)
Sources: *AmFiTCa 201*.

Thomas, Edward K.
Flourished: mid 19th cent
Type of Work: Oil (Landscape paintings)
Museums: 156
Sources: *FoPaAm 209**.

Thomas, Eli
b. c1900 Oscoda, MI
Flourished: Mount Pleasant, MI
Ethnicity: American Indian
Type of Work: Wood (Baskets)
Remarks: Chippewa tribe; friend of Bennett, Alice
Sources: *Rain 24**.

Thomas, I.
Flourished: c1850 Maysville, KY
Type of Work: Stoneware (Jars, jugs)
Sources: *AmS 183*, 252*.

Thomas, J.R.
[Thomas Brothers]
Flourished: 1852-1900 Cuyahoga Falls, OH
Type of Work: Stoneware (Pottery)
Sources: *AmPoP 212-3; Decor 224*.

Thomas, James "Son Ford"
b. 1926 Yazoo County, MS
Flourished: Leland, MS; Eden, MS
Ethnicity: Black American
Type of Work: Molded clay (Sculptures)
Sources: *BlFoAr 128-31*; LoCo xvii, xxi, xxiii-xxvi, 133-156*.

Thomas, Pat
b. 1918 d. 1984
Flourished: 1972 Milwaukee, WI
Type of Work: Paint (Memory paintings)
Sources: *FoAFc 17*.

Thomas, R.R.
See: R.R. Thomas and Company.

Thomas, Robert D.
Flourished: 1860 New York, NY
Type of Work: Wood (Ship carvings, ship figures)
Sources: *AmFiTCa 202*.

Thomas, "Son Ford"
See: Thomas, James.

Thomas(?), W.S.
Flourished: 1840 Carbon Cliff, IL; Tazewell County, IL; Jersey County, IL
Type of Work: Clay (Pottery)
Sources: *ArC 190*.

Thomas and Webster
Flourished: 1869-1873 Beaver Falls, PA; East Liverpool, OH
Type of Work: Clay (Pottery)
Sources: *AmPoP 208*.

Thomas Brothers
See: Thomas, J.R.

Thomas C. Smith and Sons
Flourished: c1870-1900 New York, NY
Type of Work: Clay (Porcelain and art ware)
Sources: *AmPoP 198, 279*.

Thomas China Company
Flourished: 19th Century Lisbon, OH
Type of Work: Clay (Bone china)
Sources: *DicM 256**.

Thomas Croxall and Brothers
[Croxall and Cartwright]
Flourished: 1844-1898 East Liverpool, OH
Type of Work: Yellow-ware, Rockingham (Pottery)
Sources: *AmPoP 214-5*.

Thomas D. Chollar
[Chollar and Bennett]
Flourished: 1832-1849 Cortland, NY
Type of Work: Stoneware (Pottery)
Museums: 033
Sources: *Decor 208*, 217*
See: Chollar and Darby.

Thomas Maddock's Sons Company
See: Maddock and Son(s).

Thomas Seavey and Sons
[Seavey and Sons]
Flourished: Bangor, ME
Type of Work: Wood (Ship carvings, ship figures)
Sources: *AmFiTCa 142, 200*
See: Seavey, Thomas; Seavey, William.

Thomas Vickers and Sons
[Caln Pottery]
See: Vickers, Thomas; Vickers, John.

Thompson
See: Camp and Thompson.

Thompson
See: Coxon and Thompson.

Thompson
See: Goodrich and Thompson.

Thompson
See: Orcutt and Thompson.

Thompson, Mr.
Flourished: 1814-1819 New Jersey
Type of Work: Watercolor (Drawings)
Museums: 001
Sources: *AmFoPo 189-90**.

Thompson, C.C.
See: C.C. Thompson Pottery Company.

Thompson, Cephas Giovanni
b. 1775 Maine d. 1856
Flourished: 1835 Bath, ME
Type of Work: Oil (Portraits)
Museums: 001
Sources: *AmFoPo 187-9*; AmPrP 156; PrimPa 181; SoAmP 213**.

Thompson, Elizabeth A.
b. c1811
Flourished: 1822 New York
Type of Work: Embroidery (Mourning samplers)
Sources: *GalAmS 61*; MoBeA fig45*.

Thompson, George
Flourished: 1838 Corydon, IN
Type of Work: Fabric (Weavings)
Sources: *ChAmC 111*.

Thompson, Greenland
Flourished: c1840-1890 Morgantown, WV
Type of Work: Stoneware (Pottery)
Sources: *AmPoP 67, 223*.

Thompson, Israel
Flourished: c1831-1837 Cincinnati, OH
Type of Work: Clay (Pottery)
Sources: *AmPoP 210*.

Thompson, James A.
Flourished: Stevens Plains, ME
Type of Work: Tin (Tinware)
Sources: *FoArtC 84*.

Thompson, John
Flourished: 1825 New York, NY
Type of Work: Wood (Ship carvings, ship figures)
Sources: *AmFiTCa 202*.

Thompson, John W.
Flourished: 1800-1840 Morgantown, WV
Type of Work: Redware (Pottery)
Sources: *AmPoP 67, 223*.

Thompson, M.
Flourished: 19th century Pennsylvania
Type of Work: Watercolor, ink (Frakturs)
Sources: *AmFoPa 189*.

Thompson, M.
Flourished: 1833 Philadelphia, PA
Type of Work: Wood (Ship carvings, ship figures)
Sources: *AmFiTCa 202.*

Thompson, Major
Flourished: Bristol, CT
Type of Work: Tin (Tinware)
Sources: *TinC 181.*

Thompson, Ritchie
Flourished: 1834 Brownsville, IN
Type of Work: Fabric (Weavings)
Sources: *AmSQu 277; ChAmC 111.*

Thompson, William
Flourished: 1840 Harvard, MA
Type of Work: Oil (Portraits)
Sources: *AmPrP 156; PrimPa 181; SoAmP 3-4*.*

Thompson and Herbert
Flourished: 1868-1870 East Liverpool, OH
Type of Work: Yellow-ware, Rockingham (Pottery)
Sources: *AmPoP 218.*

Thompson Pottery
Flourished: 1785-1890 Morgantown, WV
Type of Work: Stoneware (Pottery)
Museums: 263
Sources: *Decor 46-7*.*

Thompson Pottery
See: C.C. Thompson Pottery Company.

Thomson, Isaac
b. 1749 d. 1819
Type of Work: Stone (Gravestones)
Sources: *GravNE 130.*

Thomson, Jerome
Flourished: 1835 Massachusetts
Type of Work: Oil (Portraits)
Sources: *AmPrP 156; PrimPa 181.*

Thomson, Sarah
Flourished: 1800 Massachusetts
Type of Work: Oil (Portraits)
Sources: *AmPrP 157; PrimPa 181.*

Thomson, William
Flourished: c1806 Georgetown, DC
Type of Work: Tin (Tinware)
Sources: *AmCoTW 158.*

Thorn, Catherine
Flourished: 1724-1728 Ipswich, MA
Type of Work: Fabric (Hooked bed rugs)
Museums: 302
Sources: *AmHo 9*; ArtWo 172.*

Thresher, George
Flourished: 1806-1812 New York, NY
Type of Work: Oil (Marine paintings)
Sources: *AmFoPa 100, 109.*

Throckmorton, Jeannette Dean, Dr.
Flourished: 1953 Des Moines, IA
Type of Work: Fabric (Quilts)
Museums: 016
Sources: *QuiAm 64-5*.*

Throop, Deborah
See: Goldsmith, Deborah.

Thropp
See: Fell and Thropp Company.

Thunder, Frank
See: Rolling Mountain Thunder, Chief.

Thurman, Mary Elizabeth Woods
Flourished: c1885 Somerset, KY
Type of Work: Fabric (Quilts)
Sources: *KenQu fig2.*

Thurston, Elizabeth
Flourished: 1820 Canaan, CT
Type of Work: Watercolor (Memorial paintings)
Sources: *AmPrP 157; PrimPa 181.*

Tibbets, Susan
Flourished: 1847 Nebraska
Type of Work: Fabric (Candlewick spreads)
Sources: *NewDis 92*.*

Tilles, J.A.
Flourished: 1829 Pennsylvania
Type of Work: Watercolor (Paintings)
Museums: 001
Sources: *AmFoPaN 190, 194*.*

Tillinghast, Joseph
Flourished: 1800s New Bedford, MA
Type of Work: Wood, paper (Handboxes)
Museums: 260
Sources: *AmSFo 129.*

Tillinghast, Mary
b. 1764 Newport, RI
Flourished: 1772 Newport, RI
Type of Work: Fabric (Samplers)
Museums: 205
Sources: *LeViB 70*.*

Tillman, Frances
Flourished: 1812 Savannah, GA
Type of Work: Fabric (Weavings)
Sources: *MisPi 75*.*

Tilyard, Philip
Flourished: 1810 Massachusetts
Type of Work: Oil (Portraits)
Sources: *AmPrP 157; PrimPa 181.*

Timberlake, Alcinda C.
Flourished: 1817 Charlestown, WV
Type of Work: Fabric (Samplers)
Museums: 263
Sources: *SoFoA 176*, 222.*

Tingley, Samuel
b. 1689 d. 1765
Flourished: South Attleboro, MA; Providence, RI
Type of Work: Stone (Gravestones)
Remarks: Son is Samuel; grandson is Samuel
Sources: *EaAmG 129, viii; GravNE 98-9, 130.*

Tingley, Samuel, Jr.
b. 1714 d. 1784
Flourished: South Attleboro, MA; Providence, RI
Type of Work: Stone (Gravestones)
Remarks: Father is Samuel; son is Samuel
Sources: *EaAmG 129, viii; GravNE 98-9, 130.*

Tingley, Samuel
b. 1752 d. 1846
Flourished: c1793 South Attleboro, MA; Providence, RI
Type of Work: Stone (Gravestones)
Remarks: Father is Samuel; grandfather is Samuel
Sources: *EaAmG 129, viii; GravNE 98-9, 130.*

Tinkham, Seth
b. 1703 d. 1751
Flourished: Middleboro, MA
Type of Work: Stone (Gravestones)
Sources: *EaAmG 129.*

Tipton, Vena
b. 1895-
Flourished: 1960 Tulsa, OK
Type of Work: Fabric (Scenery pictures)
Sources: *FoArO 91*, 72*, 101.*

Tisdale, Elkanah
Flourished: c1805 Norwich, CT
Type of Work: Fabric, leather (Masonic aprons)
Sources: *Bes 48*.*

Tisdale, Riley
[R. and B. Tisdale]
Flourished: Connecticut
Type of Work: Tin (Tinware)
Sources: *TinC 182.*

Titcomb, James
Flourished: 1722 Kittery, ME
Type of Work: Wood (Ship carvings, ship figures)
Sources: *AmFiTCa 202; ShipNA 157.*

Tittery, Joshua
Flourished: c1863 Philadelphia, PA
Type of Work: Clay (Pottery)
Sources: *AmPoP 174.*

Titus, Francis
Flourished: 1860 New York, NY
Type of Work: Wood (Ship carvings, ship figures)
Sources: *AmFiTCa 202.*

Titus, Jim
Flourished: 1925 Astoria, OR
Type of Work: Wood (Duck decoys)
Sources: *WoCar 149**.

Titus, Jonathan
Flourished: c1785-1805 Huntington, NY
Type of Work: Stoneware (Pottery)
Sources: *AmPoP 194; Decor 224*.

Tobin, John
b. c1827
Flourished: 1853 Newark, OH
Ethnicity: Irish
Type of Work: Fabric (Coverlets)
Sources: *ChAmC 111*.

Toboggan Company
[Philadelphia Toboggan Company]
Flourished: 1900-1934 Philadelphia, PA
Type of Work: Wood (Carousel figures)
Sources: *AmFoS 230*; AmSFor 18-20*, 69; CaAn 9, 11, 50-5*, 116*
See: Auchy, Henry; Albright, Chester; Muller, Daniel Carl; Zalar, John.

Toby, Charles B.
Flourished: 1819
Type of Work: Whalebone, ivory (Carvings, watch stands)
Museums: 142
Sources: *AmFoS 113**.

Todd
See: Gray and Todd.

Todd, James
Flourished: 1860-1880 East Machias, ME; Rockland, ME
Ethnicity: English
Type of Work: Wood (Ship carvings, ship figures)
Sources: *AmFiTCa 202; ShipNA 88, 100-1, 157*.

Todd, Mary A.
b. c1800
Flourished: 1837 Westfield, MA
Type of Work: Fabric (Embroidered candlewick spreads, samplers)
Sources: *AmSQu 281*; GalAmS 41*, 90-1*.

Toledo, Father Juan Jose
Flourished: 18th century Nambe, NM
Type of Work: Wood (Santeros, other religious carvings)
Sources: *PopAs 429*.

Toler, William
Flourished: 1850 Missouri
Type of Work: Wood (Furniture)
Sources: *ASeMo 391*.

Tolliver, Mose
b. 1915 Montgomery, AL
Flourished: 1970-1985 Alabama
Ethnicity: Black American
Type of Work: Housepaint (Fantasy and memory paintings)
Sources: *AmFokArt 306-8*; BlFoAr 132-7*; FoA 470; FoAF 18-9*; FoAFq 12-3*; FoPaAm 171, 174, 180*; Full *; Trans 6, 9, 34*-5*, 55*.

Tolman, John (Jack)
Flourished: 1815 Boston, MA; Salem, MA
Type of Work: Oil (Portraits)
Remarks: Itinerant
Sources: *AmPrP 157 PrimPa 181; SoAmP 290*.

Tolson, Donny
b. 1958 Campton, KY
Flourished: 1979- Campton, KY
Type of Work: Wood (Carvings)
Remarks: Son of Edgar
Sources: *FoAfr 1*, 12-3*; GoMaD **.

Tolson, Edgar
b. 1904 Wolfe County, KY d. 1984 Manchester, KY
Flourished: 1957-1983 Campton, KY
Type of Work: Stone, wood (Sculptures, carvings)
Remarks: Son is Donny
Sources: *AmFokA 87*; AmFokArt 309-312*; AmFoS 194-6*, 329*, 354*; BirB 104*; Edgar *; FoA xv*, 470; FoAFe 2, 17*; FoAFu 4-5*; FoAroK *; FoScu 34*, 40-1*; GoMaD *; HoKnAm 188;Trans 8, 13, 29-31*, 55; TwCA 8*, 114**.

Tomlinson, Lewis K.
Flourished: c1850-1889 Dryville, PA
Type of Work: Redware (Pottery)
Remarks: Identification mark: LKT
Sources: *AmPoP 166, 281*.

Tommerup, Matthias
Flourished: 1771 Bethlehem, PA
Ethnicity: Danish
Type of Work: Brass (Bells)
Sources: *AmCoB 168**.

Tomson, George
b. 1770 d. 1845
Flourished: Middleboro, MA
Type of Work: Stone (Gravestones)
Sources: *EaAmG 129*.

Tomson, Isaac
b. 1749 d. 1819
Flourished: Middleboro, MA
Type of Work: Stone (Gravestones)
Sources: *EaAmG 129*.

Toole, John
b. 1815 d. 1860
Flourished: 1832 Harper's Ferry, VA; Charlottesville, NC
Ethnicity: Irish
Type of Work: Oil (Miniature portraits)
Museums: 189
Remarks: Itinerant, worked in the south
Sources: *FoPaAm 161, 163, 169, 174*; SoFoA 64, 69*, 78, 218*.

Toomer, Lucinda
Flourished: 1975 Dawson, GA
Ethnicity: Black American
Type of Work: Fabric (Quilts)
Sources: *MisPi 82**.

Toomey, Helfreich
Flourished: 1830-1860 Plumstead, PA
Type of Work: Redware (Pottery)
Sources: *AmPoP 177*.

Toppan, Sarah
b. 1748
Flourished: 1756 Newbury, MA
Type of Work: Fabric (Samplers)
Sources: *GalAmS 24*, 90*.

Torbert and Baker
Flourished: c1880 Brazil, IN
Type of Work: Stoneware (Jars)
Sources: *AmS 84**.

Totten, Mary (Betsy)
b. 1781
Flourished: 1810 Staten Island, NY
Type of Work: Fabric (Quilts)
Sources: *ArtWea 132*; QuiAm 32*, 67**.

Toupe, Robert
Flourished: c1876 Maysville, KY
Type of Work: Fabric (Quilts)
Sources: *KenQu fig10*.

Tourneur, Renault
b. 1851
Flourished: New York, NY
Type of Work: Oil (Fantasy paintings)
Sources: *PrimPa 181; ThTaT 182-5**.

Tourpet and Becker
Flourished: 1859-1900 Brazil, IN
Type of Work: Stoneware (Pottery)
Sources: *AmPoP 208; Decor 224*.

Towers, J.
Flourished: 1850 New York
Type of Work: Watercolor (Portraits)
Sources: *PrimPa 181*.

Townsend, Albert
Flourished: late 19th cent Wilton, NH
Type of Work: Wood, metal (Weathervanes)
Sources: *GalAmW 64**.

Townsend, Charles
b. 1836 d. 1894
Flourished: New York; Neponset, IL
Sources: *ArC 267*.

Townsend, Edmund
Flourished: Newport, RI
Type of Work: Wood (Chests)
Sources: *EaAmW 88*.

Townsend, George
Flourished: 1850s New Bedford, MA
Type of Work: Whalebone (Scrimshaw)
Museums: 186
Sources: *GravF 125*-6*.

Townsend, Ted
b. 1889 d. 1970
Flourished: Hennessey, OK
Type of Work: Various materials (Sculptures)
Sources: *FoArO 74*, 99*, 104*.

Towson and Hines
Flourished: 1851 Philadelphia, PA
Type of Work: Wood (Ship carvings, ship figures)
Sources: *AmFiTCa 202*.

Toy, Nicholas, Jr.
Flourished: 1851 Philadelphia, PA
Type of Work: Wood (Ship carvings, ship figures)
Sources: *AmFiTCa 202*.

Toy and Lingard
Flourished: 1860 Philadelphia, PA
Type of Work: Wood (Ship carvings, ship figures)
Sources: *AmFiTCa 202*.

Trabich, Bertha
d. 1941
Flourished: New York, NY
Type of Work: Gouache (Landscape and flower paintings)
Sources: *PrimPa 181; ThTaT 236**.

Trabue, Fannie Sales
Flourished: c1860 Todd County, KY
Type of Work: Fabric (Quilts)
Sources: *KenQu fig11*.

Tracy, Andrew
Flourished: 1786-1798 Norwich, CT
Type of Work: Stoneware (Pottery)
Remarks: Brother is Huntington
Sources: *AmPoP 199; Decor 224*.

Tracy, G.P.
Flourished: 1859 Illinois
Type of Work: Paint (Landscape paintings)
Sources: *ArC 267*.

Tracy, Huntington
See: Tracy, Andrew.

Tracy, John B.
Flourished: c1875-1890 New Philadelphia, OH
Type of Work: Stoneware (Pottery)
Remarks: Father is Nelson
Sources: *AmPoP 225; Decor 224*.

Tracy, Nelson
Flourished: c1865-1875 New Philadelphia, OH
Type of Work: Stoneware (Pottery)
Remarks: Son is John B.
Sources: *AmPoP 225; Decor 224*.

Tracy, Simon P.
d. 1863
Flourished: 1859-1861 Chicago, IL
Type of Work: Paint (Landscape paintings)
Sources: *ArC 267*.

Train, Daniel N.
Flourished: 1799-1812 New York, NY
Type of Work: Wood (Ship carvings, ship figures)
Remarks: Studied under Rush, William
Sources: *AmFiTCa 70, 80, 92, 202; AmFoS 83; ArtWod 119, 172, 266; ShipNA 35, 47, 126, 129, 138, 161; WoScuNY*
See: Train and Collins.

Train and Collins
[D.N. Train and Collins]
Flourished: 1806 New York, NY
Type of Work: Wood (Ship carvings, ship figures)
Sources: *AmFiTCa 202; ShipNA 161*
See: Train, Daniel N.

Trapp and Chandler
Flourished: c1848-1850 Edgefield, SC
Type of Work: Stoneware (Pottery)
Sources: *SoFoA 10, 217*.

Trappe, Samuel J.
Flourished: 1856
Type of Work: Fabric (Weavings)
Sources: *AmSQu 277; ChAmC 111*.

Trask, Joseph
Flourished: c1790-1813 Peabody, MA
Type of Work: Redware (Pottery)
Sources: *AmPoP 201*.

Trautz, August
Flourished: 1860 New York, NY
Type of Work: Wood (Ship carvings, ship figures)
Sources: *AmFiTCa 202*.

Traylor, Bill
b. 1854 Benton, AL d. 1947 Montgomery, AL
Flourished: 1939-1942 Montgomery, AL
Ethnicity: Black American
Type of Work: Pencil, pen, crayon, watercolor, gouache (Drawings)
Sources: *AmFokArt 313-5*; BilT *; BlFoAr 138-45**.

Treadwell, H.S.
Flourished: 1880 Boston, MA
Type of Work: Wood (Ship carvings, ship figures)
Sources: *AmFiTCa 202*.

Treadwell, Jona
Flourished: 1840 Readfield, ME
Type of Work: Oil (Portraits)
Sources: *AmPrP 157; PrimPa 181*.

Treadwell and Godbold
Flourished: 1885 Boston, MA
Type of Work: Wood (Ship carvings, ship figures)
Sources: *AmFiTCa 202*.

Treat, S(amuel) L.
Flourished: 1868 Millbridge, ME; Rockland, ME
Type of Work: Wood (Ship carvings, ship figures)
Sources: *AmFiTCa 147, 202; ShipNA 88, 157*.

Trenholm, Portia Ash Burden
b. 1813 d. 1892
Flourished: Charleston, SC; Johns Island, SC
Type of Work: Oil (Landscape, fruit, and flower paintings)
Museums: 001
Sources: *ArtWo 109*, 172; FoArA 22**.

Trentmann, John
b. 1860 d. 1880
Flourished: Missouri; Washington
Type of Work: Wood (Desks, bookcases)
Sources: *ASeMo 359**.

Trenton China Company
Flourished: 1860-1891 Trenton, NJ
Type of Work: Clay (Pottery)
Sources: *AmPoP 182; DicM 132**.

Trenton Pottery Company
Flourished: 1865 Trenton, NJ
Type of Work: Clay (Pottery)
Sources: *AmPoP 181, 183; DicM 106*, 130*, 132*, 243**.

Trenton Tile Company
Flourished: 1855 Trenton, NJ
Type of Work: Clay (Pottery)
Sources: *DicM 132**.

Trepner, William
Flourished: 1855 Baltimore, MD
Type of Work: Wood (Ship carvings, ship figures)
Sources: *AmFiTCa 202*.

Trevits, Johann Conrad
[Trewitz]
Flourished: 1790-1820 Pennsylvania
Type of Work: Watercolor, ink (Frakturs)
Sources: *AmFoPa 189; Edith *; MaAmFa **.

Trewitz, Conrad
See: Trevits, Johann Conrad.

Tribbel, John
Flourished: c1845 Plymouth, MA
Type of Work: Stone (Gravestones)
Sources: *EaAmG 129*.

Trombley, Andy
b. 1919 d. 1975
Flourished: c1950 St. Clair Shores, MI; St. Clair Flats, MI
Type of Work: Wood, metal (Fish decoys)
Sources: *UnDec* 16*, 18*.

Trotter, Alexander
Flourished: 1790-1822 Philadelphia, PA; Pittsburgh, PA
Type of Work: Creme-colored ware (Pottery)
Sources: *AmPoP* 45, 100, 105, 175.

Trotter and Company
Flourished: c1813-1815 Pittsburgh, PA; Philadelphia, PA
Type of Work: Earthenware (Pottery)
Sources: *AmPoP* 227.

Trout, Hannah
Flourished: 1841 Pennsylvania
Type of Work: Fabric (Samplers)
Sources: *MaAmFA* *.

Trowbridge, Emily
Flourished: 1800 Connecticut
Type of Work: Fabric (Embroidered pictures)
Museums: 234
Sources: *AmNe* 86*-7.

Troxel, Samuel
Flourished: 1823-1846 Montgomery County, PA
Type of Work: Earthenware (Pottery)
Sources: *AmPoP* 184; *AmSFok* 130; *BeyN* 117*; *DicM* 119*, 126*; *InAmD* 3*; *PenDuA* 28*; *PlaFan* 39*.

Troxel Pottery
See: Troxel, Samuel.

Troxell, John
Flourished: c1850-1866 Exeter Township, PA
Type of Work: Clay (Pottery)
Remarks: Son is William
Sources: *AmPoP* 167.

Troxell, William
Flourished: 1886-1899 Exeter Township, PA
Type of Work: Redware (Pottery)
Remarks: Son of John
Sources: *AmPoP* 167.

Troy Factory
See: Seymour, Israel.

Troyer, Amanda S.
Flourished: c1920 Middlebury, IN
Ethnicity: Amish
Type of Work: Fabric (Quilts)
Sources: *QuiInA* 22*, 49*.

Troyer, Mary Ann D.
Flourished: 1905 Goshen, IN
Ethnicity: Amish
Type of Work: Fabric (Quilts)
Sources: *QuiInA* 20*.

Troyer, William
Flourished: 19th century Lancaster, PA
Type of Work: Tin (Cheesemolds, tinware)
Sources: *ToCPS* 48.

Truax, Rhoades
d. 1930
Flourished: Absecon, NJ
Type of Work: Wood (Duck decoys)
Sources: *AmBiDe* 134.

Truay, Ike, Captain
Flourished: c1890 Atlantic County, NJ
Type of Work: Wood (Duck decoys)
Sources: *AmBiDe* 130.

True, Joseph
b. 1785? Chichester, NH d. 1873? Peoria, IL
Flourished: 1809-1873 Salem, MA
Type of Work: Wood (Carved eagle sculptures, ship carvings, figures)
Sources: *AmFiTCa* 76, 202; *BirB* 42*; *ShipNA* 46-7, 160.

Trujillo, Celestino
Flourished: 19th century Monterey, CA
Type of Work: Gold (Dove pins)
Sources: *InAmD* 29*.

Trujillo, John R.
b. 1914- Chimayo, NM
Flourished: 1977 Chimayo, NM
Type of Work: Fabric (Weavings)
Museums: 117, 189, 267
Sources: *HisCr* 21*, 114*.

Truman, James
Flourished: c1796 Philadelphia, PA
Type of Work: Tin (Tinware)
Sources: *AmCoTW* 153; *ToCPS* 6.

Tryday, G.H.
Flourished: 1840 Philadelphia, PA
Type of Work: Wood (Ship carvings, ship figures)
Sources: *AmFiTCa* 202.

Tryon, Elijah
b. 1844 New York, NY
Flourished: 1872-1899 New York, NY
Type of Work: Wood (Cigar store Indians, ship carvings, figures)
Sources: *ArtWod* 246, 267.

Tryon, George
Flourished: c1796 Philadelphia, PA
Type of Work: Tin (Tinware)
Sources: *AmCoTW* 153; *ToCPS* 6.

Tschappler, L.W.
d. 1960
Flourished: Gasconade County, MO; Morrison Community, MO
Type of Work: Wood (Bird and animal sculptures, carvings)
Sources: *ASeMo* 404*.

Tsireh, Awa
Flourished: 1920-1930 San Idlefonso, NM
Ethnicity: American Indian
Type of Work: Watercolor (Indian ceremonial scene paintings)
Sources: *PicFoA* 47.

Tucker, Alice
Flourished: 1807 New Bedford, MA
Type of Work: Watercolor (Flower paintings)
Sources: *PrimPa* 181.

Tucker, Joseph
b. 1745 d. 1800
Flourished: Bolton, CT
Type of Work: Stone (Gravestones)
Sources: *EaAmG* 128.

Tucker, Joshua
Flourished: 1825 Greenville, SC
Type of Work: Watercolor (Townscape paintings)
Museums: 219
Sources: *SoFoA* 76*-7*, 218.

Tucker, Mary B.
Flourished: 1840 Concord, MA; Sudbury, MA
Type of Work: Watercolor (Portraits)
Sources: *AmPrP* 157; *Edith* *; *MaAmFA* *; *PrimPa* 181.

Tucker, Mehitable
b. 1802 Providence, RI d. 1832 Providence?, RI?
Flourished: 1817 Providence, RI
Type of Work: Embroidery (Mourning pictures)
Sources: *LeViB* 178*-9, 258.

Tucker, Phoebe Parker
Flourished: 1802
Ethnicity: Quaker
Type of Work: Fabric (Quilts)
Sources: *QuiAm* 185*.

Tucker, William Ellis
See: Tucker and Hemphill; Tucker and Hulme.

Tucker and Hemphill
[William Ellis Tucker; Judge Hemphill]
Flourished: 1826-1837
Type of Work: Clay (Porcelain)
Sources: *AmPoP* 45, 175-6, 282, fig82, 85.

Tucker and Hulme
[W.E. Tucker]
Flourished: 1825 Philadelphia, PA
Type of Work: Clay (Pottery)
Sources: *AmPoP* 176; *DicM* 133*, 143*.

Tuel, Sarah
b. 1769 Newport?, RI?
Flourished: 1785 Newport, RI
Type of Work: Fabric (Samplers)
Museums: 173
Sources: *LeViB* 73*.

Tuels, Anna
Flourished: 1785 Maine
Type of Work: Fabric (Quilts)
Museums: 297
Remarks: Quilt was probably made by her mother
Sources: *PieQu 27*; QuiAm 216**.

Tuller, M.
Flourished: 1841 Connecticut
Type of Work: Tin (Painted tinware)
Remarks: Employed by Filley
Sources: *TinC 182*.

Tupper, C.
Flourished: c1870 Portage County, OH
Type of Work: Stoneware (Pottery)
Sources: *AmPoP 235; Decor 225; DicM 32**.

Turley Brothers
Flourished: 1870-1900 Burlington, IA
Type of Work: Stoneware (Pottery)
Sources: *AmPoP 208; Decor 225*.

Turnbaugh, Joseph
b. c1829 PA,
Flourished: c1849-1851 Luzerne County, PA; Sugarloaf, PA
Type of Work: Fabric (Coverlets)
Remarks: Father is Samuel
Sources: *ChAmC 25*, 111*.

Turnbaugh, Samuel
Flourished: 1849-1851 Sugarloaf, PA
Type of Work: Fabric (Coverlets)
Remarks: Son is Joseph
Sources: *ChAmC 111*
See: Dornbach, Samuel.

Turnbull, Eliza J.
d. 1807
Flourished: 1819 New York
Type of Work: Fabric (Samplers)
Sources: *GalAmS 55**.

Turner
See: Rouse and Turner.

Turner, Edward
Flourished: Berlin, CT
Type of Work: Tin (Tinware)
Remarks: Sold for Hubbard, John
Sources: *TinC 182*.

Turner, Harriet French
b. 1886 Virginia d. 1967
Flourished: Blue Ridge Mountains, VA
Type of Work: Oil (Paintings)
Museums: 001
Sources: *ArtWo 149*, 173*.

Turner, Polly
b. 1775 Providence, RI? d. 1800 Providence?, RI?
Flourished: 1786 Providence, RI
Type of Work: Fabric (Samplers)
Museums: 056
Sources: *LeViB 115, 140*, 152, 215, 228, 249*.

Turner, William
b. c1802
Flourished: c1850 Dayton, OH
Ethnicity: English
Type of Work: Fabric (Coverlets)
Sources: *ChAmC 111*.

Turner, William
Flourished: c1860 West Troy, NY
Type of Work: Brownware, Rockingham (Pottery)
Sources: *AmPoP 205*.

Turnlee
See: Odom and Turnlee.

Tuska, Seth
b. 1957 New York, NY
Flourished: contemporary Kentucky
Type of Work: Pencil, crayon, felt tip pen (Paintings, drawings)
Sources: *FoAroK **.

Tuthill, Abraham G.D.
b. 1777 d. 1843
Flourished: New York; Vermont
Type of Work: Oil (Portraits)
Sources: *PrimPa 181*.

Tuthill, Silas
Flourished: c1845-1855 Liberty, IL
Type of Work: Wood (Chairs)
Sources: *ArC 174**.

Tuttle, Miss Ann
Flourished: Hancock, NH
Type of Work: Fabric (Weavings)
Sources: *ArtWea 145*.

Tuttle, Henrietta
b. c1810
Flourished: 1823
Type of Work: Fabric (Samplers)
Sources: *AmNe 60*.

Tweadwell
See: Brown and Tweadwell.

Tweed, Susannah
Flourished: 1850 Wyoming, IL
Type of Work: Fabric (Quilts)
Sources: *ArC 286**.

Twing, George B.
Flourished: 1893 China, ME
Type of Work: Wood (Ship carvings, ship figures)
Sources: *AmFiTCa 202*.

Twiss, Lizzie
Flourished: c1880 Washington
Type of Work: Watercolor, pencil (Genre paintings, drawings)
Museums: 299
Sources: *PioPar 12, 55*.

Tyler, Elman
b. Oswego County, NY d. 1906
Flourished: 1848 Jefferson County, NY
Type of Work: Fabric (Coverlets)
Museums: 246
Remarks: Father is Harry
Sources: *ChAmC 111; FouNY 63**.

Tyler, Harry
b. 1801 Connecticut d. 1858
Flourished: 1834-1859 Butterville, NY; Jefferson County, NY
Type of Work: Fabric (Rugs, carpets, coverlets)
Museums: 016, 102
Remarks: Son is Elman
Sources: *AmSQu 277; ArtWea 240, 245*; ChAmC 7*, 39*, 46-7*, 72*, 111; FouNY 32*, 63; InAmD 187*.

Tyler, Lloyd
b. 1898 d. 1970
Flourished: Crisfield, MD
Type of Work: Wood (Duck decoys)
Museums: 260
Sources: *ArtDe 183; Decoy 48**.

Tyler, M(oses)
See: M. Tyler and Company.

Tyler and Dillon
See: M. Tyler and Company.

Tyron, George
See: Tryon, George.

Tyron, Wright and Company
Flourished: 1868-1875 Tallmadge, OH
Type of Work: Stoneware (Pottery)
Sources: *AmPoP 231; Decor 225*.

U

Uebele, Martin
Flourished: c1830-1850 Bucks County, PA; Montgomery County, PA; Reamstown, PA
Type of Work: Tin (Coffee pots, tinware)
Museums: 227
Sources: *AmCoTW 161; EaAmI 143*; ToCPS 36, 39-40*, 43, 48, 73, 76.*

Uhl, Peter
Flourished: 1838-1841 Trumbull County, OH
Type of Work: Fabric (Coverlets)
Sources: *ChAmC 112.*

Uhle, Herman
Flourished: 1886 Philadelphia, PA
Type of Work: Wood (Ship carvings, ship figures)
Sources: *AmFiTCa 202.*

Ulrich
See: Grommes and Ulrich.

Ulrich and Whitfield
Flourished: 1836-1860 Upper Alton, IL
Ethnicity: German
Type of Work: Redware, stoneware (Pottery)
Sources: *ArC 190.*

Umbarger, Michael, Jr.
b. c1811 Pennsylvania
Flourished: 1839-1851 Dauphin County, PA
Type of Work: Fabric (Weavings)
Remarks: His father was also a weaver.
Sources: *AmSQu 277; ChAmC 112.*

Umble, John
Flourished: 1802 Pennsylvania
Type of Work: Watercolor, ink (Drawings)
Sources: *NinCFo 188.*

Umbrick, Gabriel
Flourished: 1855 Baltimore, MD
Type of Work: Wood (Ship carvings, ship figures)
Sources: *AmFiTCa 202.*

Uncle Henry
See: Purrington, Henry J.

Uncle Jack
See: Dey, Jack.

Underwood, J.A. and L.W.
See: J.A. and L.W. Underwood.

Unger, Charles J.
d. 1881 Detroit, MI
Flourished: Detroit, MI
Ethnicity: German
Type of Work: Wood (Decoys)
Sources: *WaDec 20-3*.*

Unger, Fredrick
b. 1851 Detroit, MI **d.** 1925
Flourished: 1870-1916 Detroit, MI
Type of Work: Wood (Decoys)
Sources: *WaDec 20-3*.*

Unger, I.
Flourished: 1844 Lancaster County, PA
Type of Work: Fabric (Coverlets)
Sources: *ChAmC 112.*

Union Malleable Iron Company
Flourished: 1880 Moline, IL
Type of Work: Metal (Weathervanes)
Sources: *YankWe 213.*

Union Porcelain Works
Flourished: 1854-1880 New York, NY
Type of Work: Clay (Pottery, porcelain)
Sources: *AmPoP 65, 112, 156, 198, 279; AmSFok 141; DicM 78*, 160*, 162*, 173*, 253**
See: Block, William; Smith, William.

Union Potteries Company
Flourished: 19th Century East Liverpool, OH
Type of Work: Clay (Pottery)
Sources: *AmPoP 215; DicM 181*, 255*.*

Union Pottery
[Haidle and Company]
Flourished: 1871-1875 Newark, NJ
Type of Work: Stoneware (Pottery)
Sources: *AmPoP 183; Decor 225*
See: Zipf, Jacob.

United States Porcelain Company
Flourished: mid 19th cent Bennington, VT
Type of Work: Clay (Porcelain)
Museums: 023
Sources: *AmSFok 141*.*

United States Pottery
Flourished: 1846- Bennington, VT; East Liverpool, OH
Type of Work: Clay (Pottery)
Sources: *AmPoP 61-2, 96, 110-1, 157, 188, 282; DicM 29*, 110*, 129*, 182*, 186*, 256*; InAmD 88*.*

United States Stoneware Company
Flourished: 1885-1900 Akron, OH
Type of Work: Stoneware (Pottery)
Sources: *AmPoP 206; Decor 225.*

United States Tent and Awning Company
Flourished: 1906 Chicago, IL
Type of Work: Oil (Circus banners, theater scenery)
Sources: *AmSFor 44.*

Unser, C.
Flourished: c1870 Jeffersonville, IN
Type of Work: Stoneware (Jars)
Sources: *AmS 90*.*

Updike, John
Flourished: Mullica, NJ
Type of Work: Wood (Duck decoys)
Sources: *AmBiDe 130-1.*

Upham, J.C.
Flourished: Thousand Islands, NY
Type of Work: Pastel (Boat paintings)
Museums: 120
Sources: *FouNY 67.*

Upson, Asahel
b. Marion, CT
Flourished: c1790-1850 Marion, CT
Type of Work: Tin (Tinware)
Remarks: Father is Upson, James; brother is Salmon
Sources: *AmCoTW 61; AmSFo 41; TinC 7-8, 12*, 158, 182.*

Upson, James
d. 1803 Marion, CT
Flourished: 1790-1803 Marion, CT
Type of Work: Tin (Tinware)
Remarks: Partner with Cowles, Josiah, father-in-law; sons are Asahel and (James) Salmon
Sources: *AmCoTW 61; AmSFo 37*; TinC 7-9*, 124*, 147, 182.*

Upson, (James) Salmon
b. 1791 Marion, CT
Flourished: 1816-1850 Marion, CT
Type of Work: Tin (Tinware)
Remarks: Brother of Asahel, husband of Sarah
Sources: *AmCoTW 81; TinC 8, 10-11, 182.*

Upson, Sarah Greenleaf
b. Marion, CT
Flourished: 1840's Marion, CT
Type of Work: Tin (Painted tinware)
Remarks: Second wife of Upson, James Salmon
Sources: *AmCoTW 81, 84; AmSFo 41; TinC 10-12*, 158.*

Upson, Chapman, and Wright Manufacturers
See: Chapman, Upson and Wright Manufacturers.

Upton, ?
Flourished: c1775 East Greenwich, NY
Type of Work: Redware (Pottery)
Sources: *AmPoP 191.*

Utley, Thomas L.
Flourished: 1838
Type of Work: Oil (Portraits)
Sources: *AmFokA 23*.*

Uzziah Kendall and Sons
See: Kendall, Uriah.

V

Vagen, Bette
b. 1919 Barre, VT
Flourished: 1960 Hyanis, MA
Type of Work: Acrylic, oil (Paintings)
Sources: *FoAFw 24*-5**.

Valdes, Georgio
b. 1879 Florida **d.** 1939
Flourished: Key West, FL
Ethnicity: Cuban
Type of Work: Oil (Paintings)
Sources: *PeiNa 373**; *ThTaT 117-27**.

Valdez, Horacio E.
b. 1929 Dixon, NM
Flourished: 1974- Dixon, NM
Ethnicity: Hispanic
Type of Work: Wood (Santeros, other religious carvings)
Museums: 272
Sources: *HisCr 59**, 114.

Van Alstyne, Mary
Flourished: 1825 Massachusetts
Type of Work: Velvet (Paintings)
Sources: *PrimPa 168*.

Van Antwerp, Glen
b. 1949
Flourished: contemporary Lansing, MI
Type of Work: Wood (Carved fans)
Remarks: Son of Stan
Sources: *Rain 25*-7**.

Van Antwerp, Stan
b. 1922
Flourished: Hudsonville, MI
Type of Work: Wood (Carved fans)
Remarks: Father of Glen
Sources: *Rain 28*-9**.

Van Arsdale
See: Macumber and Van Arsdale.

Van Beek, Hermann
Flourished: mid 19th cent Warren, MO; Montgomery, MO
Type of Work: Wood (Chairs)
Sources: *ASeMo 316**.

Van Briggle Pottery Company
Flourished: 1900- Colorado Springs, CO
Type of Work: Clay (Pottery)
Sources: *DicM 173**, *248**, *252**.

Van Buskirk, Jacob
b. c1803 Pennsylvania
Flourished: c1850-1853 Woodview, OH
Type of Work: Fabric (Coverlets)
Sources: *ChAmC 112*.

Van Cortland
Flourished: 1775-1780 Exeter, NH
Type of Work: Oil (Overmantel paintings)
Sources: *FlowAm 194*.

Van Dalind, G.
Flourished: 1939 Pennsylvania
Type of Work: Oil (House portraits)
Sources: *FoAFm 3*; *TwCA 38**.

Van den Bossche, Theodore
Flourished: 1930s Detroit, MI; Mount Clemens, MI
Type of Work: Wood, metal (Fish decoys)
Sources: *UnDec 19**; *WaDec 116**.

Van der Pool, James
Flourished: 1787
Type of Work: Oil (Portraits)
Museums: 204
Sources: *PicFoA 49*, *58**.

Van Doort, M.
Flourished: 1825 Massachusetts
Type of Work: Oil (Portraits)
Sources: *AmPrP 157*; *PrimPa 181*.

Van Doren, Abram William
b. 1808 Millstone, NJ **d.** 1884 Supply Creek, NE
Flourished: 1838-1863 Avon, MI
Type of Work: Fabric (Coverlets)
Museums: 016
Remarks: Brothers are Garret, Isaac, and Peter
Sources: *AmSQu 277*; *ArtWea 240**; *ChAmC 112*.

Van Doren, Garret William
b. c1811 New Jersey
Flourished: 1838 Millstone, NJ; Farmerville, NJ
Type of Work: Fabric (Coverlets)
Remarks: Brothers are Abram, Isaac, and Peter
Sources: *ChAmC 112*, *68**, *85**.

Van Doren, Isaac William
b. 1798 Millstone, NJ **d.** 1869
Flourished: 1835-1853 Millstone, NJ
Type of Work: Fabric (Coverlets)
Remarks: Brothers are Abram, Garret, and Peter
Sources: *ChAmC 112*.

Van Doren, Peter Sutphen
b. 1806 **d.** 1899
Flourished: 1838-1846 Millstone, NJ
Type of Work: Fabric (Coverlets)
Remarks: Brothers are Isaac, Garret, and Abram
Sources: *ChAmC 113*.

Van Dorn Iron Works
Flourished: Cleveland, OH
Type of Work: Metal (Weathervanes)
Sources: *YankWe 213*.

Van Fleck, Peter
Flourished: Gallipolis, OH
Type of Work: Fabric (Coverlets)
Sources: *ChAmC 113*.

Van Gendorff
Flourished: New Hampshire
Type of Work: Watercolor (Landscape paintings)
Museums: 176
Sources: *ColAWC 171-2**.

Van Gordon, William H.
[Vangordon]
b. c1824 Pennsylvania
Flourished: 1849-1853 Covington, OH
Type of Work: Fabric (Weavings)
Sources: *AmSQu 25**, 276; *ChAmC 113*.

Van Hoecke, Allan
b. 1892 d. 1970 VanCouver, WA
Flourished: c1950 Chehalis, WA
Ethnicity: Belgian
Type of Work: Wood (Towers, carvings)
Museums: 042,043
Sources: *PioPar 13, 54*-6, 62.*

Van Horn, Fielding
Flourished: 1831 Baltimore, MD
Type of Work: Wood (Ship carvings, ship figures)
Sources: *AmFiTCa 202.*

Van Horn and Boyden
Flourished: c1855 Ashfield, MA
Type of Work: Clay (Pottery)
Sources: *AmPoP 187; DicM 135*.*

Van Meter, Joel
Flourished: 1826 Cumberland County, NJ
Type of Work: Fabric (Coverlets)
Sources: *ChAmC 113.*

Van Minian, John
b. 1791
Flourished: 1823-1842 Pennsylvania
Ethnicity: German
Type of Work: Watercolor, ink (Frakturs)
Sources: *AmFoPa 189; AmFoPaN 192, 198*.*

Van Ness, James
Flourished: 1849-1852 Palmyra, NY
Type of Work: Fabric (Coverlets)
Museums: 271
Sources: *AmSFo 92*; AmSQu 274*, 276; ArtWea 251*; ChAmC 26*, 113.*

Van Ness, Sarah Oldcott Hawley
Flourished: 1830-1835 Fulton County, NY
Type of Work: Watercolor (Paintings)
Museums: 203
Sources: *FouNY 66.*

Van Nortwic, C.
[Van Nortwick]
Flourished: 1837-1849 Ashbury, NJ
Type of Work: Fabric (Coverlets)
Sources: *AmSQu 277; ChAmC 113.*

Van Schaik and Dunn
See: Van Schoik and Dunn.

Van Schoik and Dunn
[Van Schaik]
Flourished: 1852-1859 Middlepoint, NJ
Type of Work: Stoneware (Pottery)
Sources: *AmPoP 171; Decor 225*
See: Dunn, Ezra .

Van Sickle, Sarah LaTourette
See: La Tourette, Sarah .

Van Sicklen, Cornelia
Flourished: Flatlands, NY
Type of Work: Fabric (Quilts)
Sources: *ArtWea 133*.*

Van Vleck, Jay A.
[vanVleck]
b. c1827 New York
Flourished: c1845-1850 Gallipolis, OH
Type of Work: Fabric (Coverlets)
Sources: *ChAmC 113, 109*; TwCA 277.*

Van Vleet, Abraham
Flourished: 1820s-1830 Connersville, IN; Warren County, OH; Fayette County, IN
Type of Work: Fabric (Coverlets)
Sources: *ChAmC 113*
See: Bundy, Hiram .

Van Voorhis, Mary
Flourished: 1850 Pennsylvania
Type of Work: Fabric (Quilts)
Museums: 250
Sources: *FlowAm 268*; QuiAm 200*.*

Van Wagner, Jas. D.L.
Flourished: 1886 Massachusetts
Type of Work: Watercolor (Paintings)
Museums: 096
Sources: *FoPaAm 51*.*

Van Wie, Carrie
b. 1880 d. 1947 San Francisco, CA
Flourished: 1900-1915 California
Type of Work: Watercolor, gouache (Architectural paintings)
Museums: 207
Sources: *PioPar 12, 56*, 60.*

Van Winckle
See: Van Winkle Pottery .

Van Winckle, Jacob
Flourished: c1800-1830 Cheesequake, NJ
Type of Work: Stoneware (Pottery)
Remarks: Partners with Van Winckle, Nicholas and Morgan, James, Jr.
Sources: *Decor 168*, 222, 225.*

Van Winckle, Nicholas
Flourished: c1820-1840 Herbertsville, NJ
Type of Work: Stoneware (Pottery)
Remarks: Partners with Van Winckle, Jacob and Morgan Jr., James
Sources: *Decor 106*, 168*, 225.*

Van Winkle Pottery
[Winckle]
Flourished: 1800 Old Bridge, NJ
Type of Work: Stoneware (Pottery)
Sources: *AmPoP 47, 173.*

Van Wymen and Brother
Flourished: 1871 Brooklyn, NY
Type of Work: Wood (Ship carvings, ship figures)
Sources: *AmFiTCa 202; ShipNA 161.*

Van Wynen, Bernard
Flourished: 1853-1858 Baltimore, MD
Type of Work: Wood (Ship carvings, ship figures)
Sources: *ShipNA 72.*

Van Zant, Frank
See: Rolling Mountain Thunder, Chief .

Van Zile, John
b. 1899 Indiana
Flourished: 1975 Union City, MI
Type of Work: Wood, paint, fabric (Sculptures, wind toys in an environment)
Sources: *FoAFcd 6-7*; Rain 66*-9*.*

Vance, Alexander
Flourished: c1800-1810 Greensboro, PA
Type of Work: Redware (Pottery)
Sources: *AmPoP 220*
See: Vance, James .

Vance, James
Flourished: 1800- Greensboro, PA; Cincinnati, OH
Type of Work: Redware (Pottery)
Sources: *AmPoP 67-8, 210, 220*
See: Vance, Alexander .

Vance Faience Company
Flourished: 1880 Tiltonville, OH
Type of Work: Clay (Pottery)
Museums: 176
Sources: *AmPoP 63, 231; DicM 173**
See: Faience Manufacturing Company .

Vandemark, John
Flourished: c1840-1850 Frazeesburg Road, OH
Type of Work: Stoneware (Pottery)
Sources: *AmPoP 220; Decor 225.*

Vanderbree, Kenneth
Flourished: 1955-1960 Connecticut
Type of Work: Wood (Ship carvings, figures)
Sources: *AmFoS 97*.*

Vanderhoof, William H.
Flourished: 1845 New York, NY
Type of Work: Wood (Ship carvings, ship figures)
Sources: *AmFiTCa 202.*

Vanderlyn, John
b. 1775 d. 1852
Type of Work: Oil (Paintings)
Remarks: Grandson of Pieter
Sources: *HoKnAm 87.*

Vanderlyn, Pieter
b. 1687 d. 1778
Flourished: c1720-1732 Albany, NY; Kingston, NY
Ethnicity: Dutch
Type of Work: Oil (Portraits)
Museums: 006
Remarks: Probably the Ganswoort Limner; grandfather of John
Sources: *AmFoPaCe 41-6*; AmNa 10, 13, 23, 59; FoA 470; GifAm 21*; HoKnAm 87-9*; OneAmPr 35*, 84, 140, 155.*

Vanderpoel, Emily Noyes
Flourished: 1898 Litchfield, CT
Type of Work: Fabric (Embroidered needlework)
Museums: 133
Sources: *AmNe 163-4*.*

Vangordon, William H.
See: Van Gordon, William H.

Vannorden, John G.
Flourished: 1825 New York, NY
Type of Work: Wood (Ship carvings, ship figures)
Sources: AmFiTCa 202.

vanVleck, Jay A.
See: Van Vleck, Jay A.

Vanzant, Ellen Smith Tooke
b. 1860 Kentucky
Flourished: c1890-1900 Trigg County, KY
Type of Work: Fabric (Quilts)
Remarks: Daughter is Morris, Mattie Tooke
Sources: KenQu 40-3, fig6, 29-31.

Vanzile, Ginge
Flourished: 1875 New York, NY
Type of Work: Wood (Ship carvings, ship figures)
Sources: AmFiTCa 202.

Vardeman, Paul E., Judge
Flourished: contemporary Kansas City, MO
Type of Work: Whalebone (Scrimshaw)
Sources: Scrim 34.

Varick
Flourished: 1835-1838
Type of Work: Fabric (Weavings)
Sources: AmSQu 277; ChAmC 113.

Vater, Ehre
Flourished: c1810 Rowan County, NC
Type of Work: Watercolor, ink (Frakturs)
Museums: 001
Sources: SoFoA 84*, 219.

Vaughan, N.J.
Flourished: 1825
Type of Work: Watercolor (Still life paintings)
Sources: PrimPa 181.

Vaughn, M.A.
Flourished: 1830 New York
Type of Work: Watercolor (Landscape paintings)
Sources: AmPrW 79*, 131*.

Vaughn, Martha Agry
Flourished: 1800-1820
Type of Work: Fabric (Quilts)
Sources: WinGu 109*.

Vaupel, Cornelius
Flourished: 1877-1886 Brooklyn, NY
Type of Work: Stoneware (Pottery)
Sources: Decor 225.

Veeder, Ferguson G.
Flourished: 1840 Rotterdam, NY
Type of Work: Oil (Paintings)
Museums: 257
Sources: FouNY 57*, 66.

Velasquez, Juan Ramon
d. 1902
Flourished: 1850-1900 Canajilon, NM
Type of Work: Oil, wood (Altar screens, paintings)
Sources: HoKnAm 75; PopAs 408.

Velghe, Joseph (Father John)
b. 1857 d. 1939
Flourished: 1899-1904 Homaunau, HI
Ethnicity: Belgian
Type of Work: Oil (Murals)
Sources: TwCA 23*.

Venter, Augustus
Flourished: Meriden, CT
Type of Work: Tin (Ornamental tinware)
Sources: TinC 182.

Vergara-Wilson, Maria
b. 1943? Albuquerque, NM
Flourished: 1977 La Madera, NM
Type of Work: Fabric (Weavings)
Museums: 178
Sources: HisCr 22*, 114*.

Verill, J(oseph) E.
Flourished: 1839-1878 Rockland, ME; Rockport, ME; Thomaston, ME
Type of Work: Wood (Ship carvings, ship figures)
Sources: AmFiTCa 139, 202; EaAmW 80, 82; ShipNA 72, 157.

Verity, Nelson
b. 1861 d. 1954
Flourished: Seaford, NY; Amityville, NY; Babylon, NY
Type of Work: Wood (Shorebird decoys)
Sources: AmBiDe 58*, 95, 100-1; AmDecoy 74*.

Verity, Obadiah
b. c1870 d. 1940
Flourished: 1880-Bellport, NY; Massapeque, NY
Type of Work: Wood (Decoys)
Museums: 171
Sources: AmBiDe 101; AmSFo 25; ArtDe 154; HoKnAm 40-1*; WoScuNY.

Verleger, C. Fred(ric)k
Flourished: 1851 Baltimore, MD
Type of Work: Wood (Ship carvings, ship figures)
Sources: AmFiTCa 202.

Vermillion, John
Flourished: 1860 Montgomery County, MO
Type of Work: Wood (Pie safes)
Sources: ASeMo 352
See: Hogue, Samuel.

Vermont Glass Factory
Flourished: 1812-1817 Salisbury, VT
Type of Work: Glass (Glass works)
Museums: 023
Sources: AmSFok 126.

Verplank, Samuel
Flourished: 1843 Fishkill, NY
Type of Work: Fabric (Weavings)
Sources: AmSQu 277; ChAmC 113.

Very, Lydia
Flourished: Salem, MA
Type of Work: Fabric (Embroidered ship pictures)
Museums: 079
Sources: AmNe 90.

Viall and Markell
See: Markell, Immon and Company.

Viana, Helen
See: Dunn, Helen.

Vickers, A.J.
Flourished: c1805 Lionville, PA
Type of Work: Clay (Pottery)
Sources: DicM 69.

Vickers, John
See: Vickers, Thomas.

Vickers, John
See: John Vickers and Son.

Vickers, Monroe
Flourished: c1880-1900 Baxter, TN
Type of Work: Stoneware (Pottery)
Sources: AmPoP 235.

Vickers, Paxton
Flourished: 1850-1878 Lionville, PA
Type of Work: Redware (Pottery)
Sources: AmPoP 171.

Vickers, Thomas
See: Thomas Vickers and Sons.

Vickers, Thomas
Flourished: c1740-1822 Lionville, PA; Caln, PA
Type of Work: Redware, sgraffito (Pottery)
Sources: AmPoP 40, 43-4, 165, 170-1, 185; BeyN 81*; DicM 128*, 134*
See: John Vickers and Son.

Vickery, Eliza
b. 1783 Taunton, MA d. 1846 Taunton, MA
Flourished: 1796 Warren?, RI?
Type of Work: Fabric (Samplers)
Museums: 211
Sources: LeViB 214-5, 230-1*.

Vidal
Flourished: 1852 Philadelphia?, PA?
Ethnicity: Black American
Sources: AfAmA 96.

Vieille, Ludwig
Flourished: 1860 New York, NY
Type of Work: Wood (Ship carvings, ship figures)
Sources: AmFiTCa 202.

Vierling, G.H.
Flourished: 1879 Mississippi City, MS
Type of Work: Wood (Cupboards)
Sources: *AmPaF 280-1**.

Vigil, Francisco
Flourished: c1870-1880s La Valle, NM
Ethnicity: Hispanic
Type of Work: Wood (Santeros, other religious carvings)
Museums: 272
Sources: *HisCr 91*; PopAs 434, 436*.

Villalpando, Monico
Flourished: 1910 Ojo Caliente, NM
Ethnicity: Hispanic
Type of Work: Wood (Santeros, other religious carvings)
Sources: *PopAs 436*.

Ville, Charlie D., Captain
Flourished: 1880
Type of Work: Wood (Duck decoys)
Sources: *WiFoD 10**.

Villeneuve
Flourished: 1950 Michigan
Type of Work: Oil (Scene paintings)
Sources: *FoAFm 3; TwCA 146**.

Vinal, Jacob
b. 1670 d. 1736
Flourished: Scituate, MA
Type of Work: Stone (Gravestones)
Remarks: Jacob Jr. is son; John is a relative
Sources: *EaAmG 129*.

Vinal, Jacob, Jr.
b. 1700 d. 1788
Flourished: Scituate, MA
Type of Work: Stone (Gravestones)
Remarks: Jacob is father; John is a relative
Sources: *EaAmG 129; GravNE 86-7, 130*.

Vinal, John
Flourished: 1898 Scituate, MA
Type of Work: Stone (Gravestones)
Sources: *GravNE 86-7*
See: Vinal, Jacob; Vinal, Jacob Jr.

Vincent, William
Flourished: 1635 Salem, MA
Ethnicity: English
Type of Work: Clay (Pottery)
Sources: *EaAmFo 14*.

Viney
See: Burgess, Webster and Viney.

Vinson, William
Flourished: 1641 Salem, MA
Type of Work: Clay (Pottery)
Sources: *AmPoP 57, 202; HoKnAm 48*.

Vinton, Mary
Flourished: 1840 East Braintree, MA
Type of Work: Fabric (Hooked rugs, bed rugs)
Sources: *AmHo 33**.

Virgil, Juan Miguel
Flourished: San Luis, CO
Ethnicity: Hispanic
Type of Work: Fabric (Blankets)
Museums: 103
Sources: *PopAs 238*.

Vivolo, John
b. 1887
Flourished: 1960
Ethnicity: Italian
Type of Work: Wood (Sculptures)
Sources: *FoAFgh 1*, 6**.

Vodrey
See: Woodward and Vodrey.

Vodrey, Jabez
Flourished: 1839-1847 Troy, IN; Louisville, KY; East Liverpool, OH
Ethnicity: English
Type of Work: Yellow-ware, brownware (Pottery)
Sources: *AmPoP 231, 239*
See: Vodrey Brothers.

Vodrey and Frost
Flourished: 1827 Pittsburgh, PA; Louisville, KY
Ethnicity: English
Type of Work: Yellow-ware, Rockingham (Pottery)
Sources: *AmPoP 74, 76, 88, 105, 227, 239*
See: Lewis, William.

Vodrey Brothers
Flourished: 1857-1885 East Liverpool, OH
Type of Work: Clay (Pottery)
Remarks: Sons of Jabez
Sources: *AmPoP 75, 215; DicM 11*, 63*, 114*, 153*, 163*, 171*, 180*, 184*, 200*, 253*, 256**.

Voegtlin, William
Flourished: New York
Type of Work: Oil (Theater, circus, and sideshow scenes)
Sources: *AmSFor 198*.

Vogdes, Ann H.
Flourished: 1823 Willistown, PA
Type of Work: Fabric (Samplers)
Sources: *GalAmS 62*, 91*.

Vogel, August
b. 1801
Flourished: 1836-1854 Cranfordsville, IN
Ethnicity: German
Type of Work: Fabric (Weavings)
Sources: *AmSQu 277; ChAmC 113-5*
See: Eckert, Gottlieb.

Vogell, Charles
Flourished: 1851 Baltimore, MD
Type of Work: Wood (Ship carvings, ship figures)
Sources: *AmFiTCa 202*.

Vogiesong, Susanna
Flourished: c1831 York, PA
Type of Work: Embroidery (Mourning pictures)
Museums: 224
Sources: *MoBeA fig30*.

Vogler, Elias
Flourished: 1845
Type of Work: Watercolor (Landscape paintings)
Remarks: Worked in the south
Sources: *FoPaAm 163**.

Vogler, Milton
b. 1825
Flourished: 1855-1856 Adams County, OH
Type of Work: Fabric (Weavings)
Sources: *ChAmC 115*.

Vogt
See: Boerner, Shapley and Vogt.

Vogt, Fritz G.
Flourished: c1850-1900 Stone Arabia, NY
Type of Work: Pencil, watercolor (House and farm scene drawings)
Sources: *AmFoPaS 105*; FoA 42*, 470; FoPaAm 92*; NinCFo 169, 200, fig149*.

Voldan, J.R.
Ethnicity: Czechoslovakian
Type of Work: Paint (Decorated mugs)
Sources: *AmSFo 79*.

Volk, Leonard W.
Flourished: 1860 Chicago, IL
Type of Work: Marble (Busts)
Sources: *ArC 261**.

Volkmar Keramic Company
Flourished: c1880 Greenpoint, NY
Type of Work: Clay (Pottery)
Sources: *DicM 25**.

Volozan, Denis A.
Flourished: 1806-1819 Philadelphia, PA
Type of Work: Oil (Historical and landscape paintings)
Sources: *Bes 112*.

Voltheiser, Joseph
Flourished: 1860 New York, NY
Type of Work: Wood (Ship carvings, ship figures)
Sources: *AmFiTCa 202*.

Von Bruenchenhein, Eugene
b. 1910 Marinette, WI d. 1983
Flourished: -1982 Milwaukee, WI
Type of Work: Oil, chicken bones (Fantasy paintings, sculptures)
Sources: *FoAFg 1*, 12*-4*.

von Hedeken, Ludwig Gottfried
Flourished: 1787 Salem, NC
Type of Work: Watercolor (Landscape paintings)
Sources: *FoPaAm 163**.

Voohees, Betsy Reynolds
Flourished: 1824-1825 Amsterdam, NY
Type of Work: Fabric, watercolor, ink (Hooked rugs, maps)
Museums: 163
Sources: *FouNY 36*, backcover, 63, 65.*

Voos, Robert
Flourished: 1860 New York, NY
Type of Work: Wood (Ship carvings, ship figures)
Sources: *AmFiTCa 202.*

Vought, Samuel L.
Flourished: 1825 New York, NY
Type of Work: Wood (Ship carvings, ship figures)
Sources: *AmFiTCa 202.*

W

W.A. Snow Company, Inc.
Flourished: 1850 Boston, MA
Type of Work: Metal (Weathervanes)
Sources: *AmFokAr 51, 12, fig26; ArtWe 17, 22*; YankWe 46*, 214.*

W.B. Allison and Company
[Allison and Hart]
Flourished: c1865-1880 Middlebury, OH; Akron, OH
Type of Work: Stoneware (Pottery)
Sources: *AmPoP 206; Decor 216.*

W.G. Higgins
Flourished: c1920s Kansas City, MO
Type of Work: Wood (Duck decoys)
Sources: *AmBiDe 229.*

W.H. Farrar and Company
See: William H. Farrar.

W.H. Mullins and Company
Flourished: 1896-1913 Salem, OH
Type of Work: Metal (Weathervanes)
Sources: *YankWe 212.*

W.H. Rockwell and Company
Flourished: 1860-1890 Akron, OH
Type of Work: Stoneware (Pottery)
Sources: *AmPoP 206; Decor 223.*

W. Hart Pottery
Flourished: 1858-1869 St. Lawrence, NY; Ogdensburg, NY
Type of Work: Clay (Pottery)
Sources: *FouNY 63*
See: J.J. Hart; C. Hart and Company Potteries.

W. Lundy and Company
Flourished: 1820-1840 Troy, NY
Type of Work: Stoneware (Pottery)
Sources: *Decor 96*.*

W.M.A. Clark's Superior Friction Matches
Flourished: c1835 Connecticut
Type of Work: Pasteboard (Matchboxes)
Sources: *NeaT 122-3*.*

W.P. Harris Factory (Pottery)
See: Harris, W.P.

Waddell, R.
Flourished: 1833 Philadelphia, PA
Type of Work: Wood (Ship carvings, ship figures)
Sources: *AmFiTCa 202.*

Wade, Frances
Flourished: 1798 Savannah, GA
Type of Work: Fabric (Embroidered maps)
Sources: *AmNe 94.*

Wadhams, Jesse
Flourished: c1753 Litchfield, CT
Type of Work: Redware (Pottery)
Sources: *AmPoP 195.*

Wadsworth, Charles
Flourished: 1845 Brooklyn, NY
Type of Work: Wood (Ship carvings, ship figures)
Sources: *AmFiTCa 202.*

Waelde, J.C.
See: J.C. Waelde Pottery.

Wagan, Robert
Flourished: 1800s Mount Lebanon, NY
Ethnicity: Shaker
Type of Work: Wood (Shaker chairs)
Sources: *HanWo 138*
See: Andersen, Elder William; Collins, Sister Sarah.

Wagenhurst, Charles
Flourished: Kutztown, PA
Type of Work: Tin (Tinware)
Sources: *ToCPS 13, 20-1.*

Wagguno
Flourished: 1858
Type of Work: Oil (Still life paintings)
Museums: 189
Sources: *AmNa 87*.*

Waghorne, John
Flourished: c1740 Boston, MA
Type of Work: Wood, paint (Furniture)
Sources: *AmDecor 14.*

Wagner
Flourished: Michigan
Type of Work: Wood, metal (Fish decoys)
Sources: *UnDec 20.*

Wagner, Christina
Flourished: 1840s-1872 San Antonio, TX
Ethnicity: German
Type of Work: Fabric (Needlework pictures)
Sources: *AmNe 121, 124*.*

Wagner, George A.
Flourished: 1875-1896 Pfeiffer's Corner, PA
Type of Work: Redware, yellow-ware (Pottery)
Sources: *AmPoP 173.*

Wagner, John
Flourished: 1844-1846 Lebanon County, PA
Type of Work: Fabric (Weavings)
Sources: *ChAmC 115.*

Wagner, Paul L.
Flourished: 1930
Type of Work: Concrete, mixed media (Chapel and memorial sculptures)
Sources: *TwCA 78*.*

Wagoner, Maria
Flourished: c1830
Type of Work: Watercolor (Scene paintings)
Sources: *Edith *.*

Wagoner Brothers
Flourished: c1860-1870 Vanport, PA
Type of Work: Stoneware, clay (Pottery)
Sources: *AmPoP 232, 283; Decor 225; DicM 140*.*

Wait, Luke
Flourished: c1810-1830 Whateley, MA
Type of Work: Stoneware (Pottery)
Remarks: Partners with Orcutt, Stephen and Wait, Obediah
Sources: *Decor 225.*

Wait, Obediah
See: Wait, Luke.

Wait and Ricketts
Flourished: c1870 Springfield, OH
Type of Work: Stoneware (Pottery)
Sources: *AmPoP 230; Decor 225; DicM 140*.*

Waite, Sarah
b. 1826 Newport, RI **d.** 1861
Flourished: 1835 Newport, RI
Type of Work: Fabric (Samplers)
Museums: 205
Sources: *LeViB 87*.*

Wakeman, Esther Dimar
Type of Work: Fabric (Needlework pictures)
Sources: *AmNe 126.*

Wakeman, Thomas
b. 1812 **d.** 1878
Flourished: 1840-1860 Illinois
Ethnicity: English
Type of Work: (Building portraits)
Sources: *ArC 267.*

Walber, T.B.
Type of Work: Watercolor (Paintings)
Sources: *EyoAm 30.*

Walborn, Catarina
Flourished: 1825 Lebanon, PA; Berks County, PA
Type of Work: Fabric (Embroidered linens)
Sources: *BeyN 110.*

Walbridge and Company
Flourished: 1895 Buffalo, NY
Type of Work: Metal (Weathervanes)
Sources: *YankWe 213.*

Walden, John, Sr.
b. 1732 **d.** 1807
Flourished: 1794 Windham, CT
Type of Work: Stone (Gravestones)
Sources: *EaAmG 126*, 128; GravNE 108.*

Walden, John, Jr.
d. 1807
Flourished: Windham, CT
Type of Work: Stone (Gravestones)
Sources: *GravNE 108, 130.*

Waldron, Jane D.
b. 1828
Flourished: 1848 Castile, NY
Ethnicity: English
Type of Work: Fabric (Quilts)
Sources: *AmSQu 137*.*

Wale, T.
Flourished: 1820 White River Junction, VT
Type of Work: Oil (Portraits)
Sources: *PrimPa 181.*

Wales, Nathaniel F.
Flourished: 1803-1815 Oswego, NY; Litchfield, CT
Type of Work: Oil (Portraits, signs)
Sources: *AmFoPaN 22, 44*; EyoAm 20*-1; HoKnAm 92; PaiNE 170-3*.*

Walford, Mr.
Flourished: 1848 Washington, MO
Type of Work: Earthenware (Pottery)
Sources: *AmPoP 69-70, 232.*

Walhaus, Henry
Flourished: Belleville, IL; Quincy, IL
Type of Work: Fabric (Weavings)
Sources: *ChAmC 115.*

Walk, Jacob M.
Flourished: Stark County, OH
Type of Work: Fabric (Coverlets)
Sources: *ChAmC 115.*

Walker
See: Humistown and Walker.

Walker, Charles
b. 1875 **d.** 1954
Flourished: c1900 Princeton, IL
Type of Work: Wood (Duck decoys)
Sources: *AmBiDe 183-5*; AmDecoy 10*; WoCar 146-7*.*

Walker, Elizabeth L.
Flourished: 1840 Massachusetts
Type of Work: Watercolor (Romantic scene paintings)
Sources: *AmPrP 157; PrimPa 181.*

Walker, George
Flourished: 1860-1880 West Troy, NY
Type of Work: Brownware, Rockingham (Pottery)
Sources: *AmPoP 205.*

Walker, Inez Nathaniel
See: Nathaniel, Inez Walker.

Walker, James L.
Flourished: c1792 Baltimore, MD
Type of Work: Oil (Landscape paintings)
Sources: *AmDecor 23.*

Walker, Jane McKinney
Flourished: mid 19th cent Tennessee
Type of Work: Fabric (Quilts)
Sources: *QuiAm 180*.*

Walker, John Brown
b. 1815 Washington County, PA **d.** 1905 Mason, MI
Flourished: Geauga City, OH; Burton, OH; Lansing, MI
Type of Work: Paper (Cut-outs)
Remarks: Paper cut pictures are call scherenschnitte
Sources: *YoWel.*

Walker, M.
Flourished: 1835
Type of Work: Watercolor (Genre paintings)
Sources: *PrimPa 181.*

Walker, N.U.
Flourished: 1852-1890 East Liverpool, OH
Type of Work: Rockingham (Pottery)
Sources: *AmPoP 216.*

Walker, Peter
Flourished: 1886 Philadelphia, PA
Type of Work: Wood (Ship carvings, ship figures)
Sources: *AmFiTCa 202.*

Walker, Rebecca
Flourished: 1820 Francestown, NH
Type of Work: Watercolor (Paintings)
Museums: 176
Sources: *ColAWC 240.*

Walker, Wilton
Flourished: c1900 Tulls Creek, NC
Type of Work: Wood (Duck decoys)
Museums: 260
Sources: *Decoy 53.*

Wallace, G.E.
Flourished: 1900 Barnegat, NJ
Type of Work: Wood (Duck decoys)
Sources: *AmDecoy 76*.*

Wallace, Richard
Flourished: 1796-1803 Baltimore, MD
Type of Work: Redware (Pottery)
Sources: *AmPoP 163.*

Wallace and Gregory Brothers
Flourished: 1890-1920 Paducah, KY
Type of Work: Stoneware (Jugs)
Sources: *AmS 143.*

Wallach, Carl
Flourished: Michigan
Type of Work: Wood (Decoys)
Sources: *WaDec 9*.*

Wallack, W.S.
Flourished: 1876 Nebraska
Type of Work: Oil (Historical paintings)
Sources: *OneAmPr 131*, 148, 156.*

Waller, John
b. 1830
Flourished: 1910 Warren County, MO
Type of Work: (Baskets)
Sources: *ASeMo 46*.*

Wallin, Hugo
b. 1891
Flourished: 1962 Los Angeles, CA
Ethnicity: Swedish
Type of Work: Oil (Landscape paintings)
Sources: *PioPar 56-7*, 63.*

Wallis, Frederick I. (J.)
Flourished: 1859-1860 Chicago, IL
Sources: *ArC 267.*

Walls, Jack
Flourished: Sunbury, PA
Type of Work: Tin (Tinware)
Sources: *ToCPS 43.*

Walsh
See: Sanford and Walsh.

Walter, Jacob
b. 1800
Flourished: 1836 Franklin County, IN
Type of Work: Fabric (Weavings)
Sources: *ChAmC 54, 115*
See: Eckert, Gottlieb; Vogel, August; G.W. Kimble Woolen Factory.

Walter Orcutt and Company
See: Orcutt, Walter.

Walters
See: Moore and Walters.

Walters, J.
Flourished: c1840 Chillicothe, OH
Type of Work: Stone (Gravestones)
Sources: *EaAmG 129.*

Walters, Susane
Flourished: 1852 New York
Type of Work: Oil (Portraits of children)
Sources: *OneAmPr 120*, 147, 156.*

Walton, Henry
d. 1865
Flourished: 1835-1850 Ithaca, NY; Elmira, PA; Michigan
Type of Work: Watercolor, oil (Townscapes, miniature portraits, paintings)
Sources: *AmFoPa 126; AmFoPo 190-1*; EaAmFo 99*, 136*; EyoAm 21; FoA 470; FoAFx 16*.*

Wands, I.H.
Flourished: c1852-1870 Olean (Oleans), NY
Type of Work: Clay (Pottery)
Sources: *AmPoP 200; Decor 225; DicM 66*, 94*; EaAmFo 126*.*

Wantz
Flourished: 1864 Mount Joy, PA
Type of Work: Fabric (Carpets, coverlets)
Sources: *ChAmC 115*
See: Keener, John; Manning.

Warburton
Flourished: 1729 New York, NY
Type of Work: Wood (Ship carvings, ship figures)
Sources: *ShipNA 161.*

Ward, A.B.M.
Flourished: 1870 Paterson, NJ
Type of Work: Oil (Paintings)
Sources: *FoPaAM 102*; MaAmFA *.*

Ward, Edwin P.
b. 1900 Lone Oak, KY
Flourished: 1950 Kentucky
Type of Work: Wood, metal, paint (Whirligigs)
Sources: *FoAroK *.*

Ward, H.
Flourished: 1840 Youngstown, OH
Type of Work: Watercolor (Scene paintings)
Sources: *AmFoAr 28; AmPrP 157; FoPaAm 102*; PrimPa 181.*

Ward, Lemuel T.
b. 1896
Flourished: c1930-1966 Crisfield, MD
Type of Work: Paint (Painted duck decoys, decorative duck carvings)
Museums: 171,260
Remarks: Brother Steve is carver of the decoys
Sources: *AmBiDe 147-8*; AmDecoy xii, 2-3*; AmFoArt 93*; AmSFo 25; BirB fig13; Decoy 40, 58*, 68*; EyoAm 4, 7*; FoA 218*, 470; HoKnAm 42*; WoCar 144-5*, 165.*

Ward, M. Paul
Flourished: contemporary Chelmsford, MA
Type of Work: Wood (Sculptures, carvings)
Sources: *WoCar 200*.*

Ward, Steve
Flourished: 1930s-1960s Crisfield, MD
Type of Work: Wood (Duck decoys)
Remarks: Brother Lemuel is painter of the decoys
Sources: *AmBiDe 147-8*; AmDecoy xii, 2-3*; AmSFo 25; ArtDe 183*; EyoAm 4, 7*; FoA 218*, 470;HoKnAm 42*; WoCar 144-5*, 165*.*

Ward, Velox
b. 1901
Flourished: 1960- Longview, TX
Type of Work: Oil (Genre, symbolic paintings)
Sources: *FoA 470; FoAF 14-5; FoPaAm 238-9*; TwCA 154*.*

Ware, Dewey
b. 1895
Flourished: 1965-1980 Saline, OK
Type of Work: Wood (Sculptures, carvings)
Sources: *FoArO 13, 88*, 79*, 101.*

Ware, Julia
b. c1789 Wrentham, MA d. 1860 Wrentham?, MA?
Flourished: 1805 Providence, RI
Type of Work: Embroidery (Mourning pictures)
Sources: *LeViB 158, 172-3*, 192.*

Warick, J.
[Warwick]
Flourished: 1849
Type of Work: Fabric (Weavings)
Sources: *AmSQu 277; ChAmC 115.*

Warin, George
Flourished: Michigan
Type of Work: Wood (Decoys)
Sources: *WaDec 10*, 93*, 95-6, 111*, fig16.*

Waring, David
Flourished: 1835 Bucks County, PA
Type of Work: Clay (Pottery)
Sources: *EaAmFo 208*.*

Warne, Thomas
Flourished: c1800-1805 Cheesequake, NJ; South Amboy, NJ
Type of Work: Stoneware (Pottery)
Sources: *Decor 225; DicM 140**
See: Warne and Letts Pottery; Letts, Joshua.

Warne and Letts Pottery
[Thomas Warne; Joshua Letts]
Flourished: 1800-1812 South Amboy, NJ; Cheesequake, NJ
Type of Work: Stoneware (Pottery)
Museums: 227
Sources: *AmPoP 47, 180, 284; AmS 155*, 160*; Decor 143*, 161*, 163*, 199*, 225; DicM 69*, 128*, 141*; EaAmFo 113*, 129*.*

Warner, Ann Maria
Flourished: 1822
Type of Work: Fabric (Quilts)
Museums: 203
Sources: *QuiAm 277*.*

Warner, Ann Walgrave
b. 1758 d. 1826
Flourished: 1800 New York
Type of Work: Fabric (Weavings)
Museums: 151
Sources: *AmNe 135*, 137; AmSQu 12*, 14*-5*.*

Warner, Catherine Townsend
b. 1785 Warwick, RI d. 1828
Flourished: c1809 Warwick, RI
Type of Work: Watercolor (Memorial paintings)
Museums: 001
Sources: *AmFoAr 28; AmPrP 157; LeViB 218, 234-5*, 238; PrimPa 181.*

Warner, H.(W.)
Flourished: 1860 Marina City, IL
Type of Work: Clay (Pottery)
Sources: *ArC 194.*

Warner, J.H.
Flourished: 1840 Fitchburg, MA
Type of Work: Oil (Decorated interiors, mural scenes for houses)
Sources: *AmDecor 109-11*, 153; FlowAm 206*; PrimPa 181.*

Warner, Pecolia
b. 1901 Bentonia, MS
Flourished: c1970 Yazoo City, MS
Ethnicity: Black American, American Indian
Type of Work: Fabric (Quilts)
Sources: *LoCo xviii, xix, xxiv-xxv, xxvii, 175*-191; SoFoA 191*, 194*, 222.*

Warner, Phebe
Flourished: c1800 New York, NY
Type of Work: Fabric (Coverlets)
Museums: 151
Sources: *QuiAm 208*.*

Warner, Sarah Furman
Flourished: 1800-1815 New York, NY; Greenfield Hills, CT
Type of Work: Fabric (Coverlets)
Museums: 096
Sources: *AmSQu 9*; ArtWo 45*, 173; BeyN 110; QuiAm 209*.*

Warner, William E.
[Columbia Pottery]
Flourished: 1830-1870 West Troy, NY; Amboy, NJ
Type of Work: Stoneware (Pottery)
Museums: 203
Sources: *Decor 95*, 127*, 225; DicM 144*; EaAmFo 12, 117*, 125*.*

Warns and Letts
See: Warne and Letts Pottery.

Warren, M., Jr.
Flourished: 1830 White Plains, NY
Type of Work: Watercolor, pencil (Portraits)
Sources: *AmFoPo 192-3*; AmPrP 157; PrimPa 181.*

Warren, Marvin
b. 1895 Oxley, AR
Flourished: 1960 Marshall, AR
Type of Work: Wood (Sculptures, toys)
Sources: *FoAFy 1*, 4*-5, 15.*

Warren, S.K.
Flourished: 1859-1860 Dundee, IL
Sources: *ArC 267.*

Warren, Sarah
Flourished: c1748 Barnstable, MA
Type of Work: Fabric (Embroidered pictures)
Sources: *WinGu 36*.*

Warwack, Isaac
Flourished: 1860 Alton, IL
Type of Work: Stoneware (Pottery)
Sources: *ArC 194.*

Warwell
Flourished: c1776 Charleston, SC
Ethnicity: English
Type of Work: Oil (Landscape paintings)
Sources: *AmDecor 17.*

Warwick, J.
See: Warick, J.

Warwick China Company
Flourished: 1887-1900 Wheeling, WV
Type of Work: White Granite (Pottery)
Sources: *AmPoP 233; DicM 141*.*

Wasey, Jane
Type of Work: (Weathervanes)
Sources: *WeaWhir 181-2*.*

Washburn, B.
b. 1762 **d.** 1852
Flourished: Kingston, MA
Type of Work: Stone (Gravestones)
Sources: *EaAmG 129.*

Washburn, H.L.
See: H.L. Washburn and Company.

Washburn, S.H.
Flourished: 1875 Vergennes, VT
Type of Work: Oil (Landscape paintings)
Museums: 260
Sources: *FoPaAm 60*.*

Washburn, W.L.
Flourished: 1860 Springfield, MA
Type of Work: Wood (Ship carvings, ship figures)
Sources: *AmFiTCa 202.*

Washburne, E.G.
See: E.G. Washburne and Company.

Washington, James
b. 1911 Mississippi
Flourished: 1957 Seattle, WA
Ethnicity: Black American
Type of Work: Wood, granite, oil (Sculptures, paintings)
Sources: *AmNeg 47, 100*, fig15.*

Washington, Martha
Flourished: c1785 Mount Vernon, VA; Pinwheel, VA
Type of Work: Fabric (Quilts, needlepoint seat cushions)
Museums: 166
Sources: *AmNe 25-6*; ArtWo 20-1*; PieQu 27-8*.*

Washington Stoneware Company
Flourished: c1897 Washington, MO
Type of Work: Stoneware (Pottery)
Sources: *AmPoP 233; Decor 225.*

Wasilewski, John
b. 1890 **d.** 1975 Detroit, MI
Flourished: 1965-1975 Detroit, MI
Ethnicity: Polish
Type of Work: Wood, plastic, paint, paper (Carvings)
Sources: *Rain 54-7*.*

Wass, Harry
Flourished: 1910 Maine
Type of Work: Wood (Decoys)
Sources: *FoA 215*.*

Waterman, Charles
Flourished: Meriden, CT
Type of Work: Tin (Tinware)
Remarks: Employed 5 people
Sources: *TinC 182.*

Waterman, Eliza
b. 1777 Providence, RI **d.** 1870 Providence?, RI?
Flourished: 1788 Providence, RI
Type of Work: Fabric (Samplers)
Sources: *LeViB 114, 124-5*.*

Waterman, Sarah (Sally)
b. 1775 Providence, RI **d.** 1852
Flourished: 1785 Providence, RI
Type of Work: Fabric (Samplers)
Sources: *LeViB 114, 118*, 124.*

Waters, Almira
Flourished: c1830 Portland, ME
Type of Work: Watercolor (Still life paintings)
Museums: 176
Sources: *AmPrP 157; ColAWC 240; PrimPa 181.*

Waters, D.E.
Flourished: 1840
Type of Work: Watercolor (Paintings)
Sources: *AmPrP 157; PrimPa 181.*

Waters, E.A.
Flourished: 1843
Type of Work: Watercolor (Allegorical drawings)
Museums: 001
Sources: *PicFoA 129*; PrimPa 181.*

Waters, Samuel
Flourished: 1820s Sutton, MA
Type of Work: Oil? (Carriage paintings)
Sources: *AmDecor 9.*

Waters, Susan C.
b. 1823 Binghamton, NY **d.** 1900 Bordentown, NJ
Flourished: 1841-1900 Friendsville, PA; New York; Bordentown, NJ
Type of Work: Oil (Portraits)
Museums: 189
Sources: *AmFoPaS 82*; AmNa 15, 27, 88*; ArtWo xii, pl.12, 89, 173; FoA 6*, 470.*

Watkins, R.
Flourished: Long Island, NY
Type of Work: Metal (Weathervanes)
Sources: *WeaWhir 186.*

Watrous, Seymour
Flourished: 19th century Hartford, CT
Type of Work: Wood (Chairs)
Sources: *AmPaF 188.*

Watson, Ann
Flourished: 1808
Type of Work: Fabric (Samplers)
Sources: *AmNe 62.*

Watson, Dave "Umbrella"
d. 1938
Flourished: Chincoteague, VA
Type of Work: Wood (Duck decoys)
Sources: *AmBiDe 162-4**.

Watson, J.R.
Flourished: c1833-1840 Perth Amboy, NJ
Type of Work: Stoneware (Pottery)
Sources: *AmPoP 174; Decor 225*.

Watson, John
Flourished: early 18th cent Hudson River Valley, NY; New Jersey
Ethnicity: Scottish
Type of Work: Oil (Portraits)
Museums: 203
Sources: *FoPaAm 76*, 78*.

Watson, Richard
Flourished: 1798 Philadelphia, PA
Type of Work: Wood (Ship carvings, ship figures)
Sources: *ShipNA 163*.

Watson, "Umbrella"
See: Watson, Dave.

Watson Woolen Mill
Flourished: 1815 Chelsea, VT
Type of Work: Fabric (Coverlets)
Sources: *ChAmC 115*.

Watts, Charles
Flourished: c1840 Farmingdale, IL
Type of Work: Wood (Furniture)
Sources: *ArC 151**.

Waugh, Henry C.
Flourished: Illinois
Type of Work: Pencil (Landscape drawings)
Remarks: Itinerant
Sources: *ArC 288**.

Waugh, Henry W.
Flourished: 1853-1860 Indianapolis, IN; Illinois
Type of Work: (Panorama and landscape paintings)
Sources: *ArC 267*.

Way, Rebecca
Flourished: 1818 Downingtown, PA
Type of Work: Fabric (Stitched poems)
Sources: *PlaFan 64**.

Wayn(e), Sarah
Flourished: 1787 Philadelphia, PA
Type of Work: Fabric (Needlelace samplers)
Sources: *PlaFan 131**.

Weand, Charles
See: Wiand, Charles.

Weand, David
See: Wiand, David.

Weand, Michael
See: Wiend, Michael.

Weand, William
b. c1826 Pennsylvania
Flourished: 1860 Allentown, PA
Type of Work: Fabric (Coverlets)
Sources: *ChAmC 115*.

Wearehs
Flourished: 1852-1858 Loudonville, OH
Type of Work: Fabric (Coverlets)
Sources: *ChAmC 115*.

Weaver, Abraham
Flourished: 1824-1844 Nockamixon, PA
Type of Work: Clay (Pottery)
Sources: *DicM 12**.

Weaver, Carolina
Flourished: 19th century Pennsylvania
Type of Work: Watercolor, ink (Frakturs)
Sources: *AmFoPa 189*.

Weaver, Elias
Flourished: c1825-1831 Albion, IL
Ethnicity: German
Type of Work: Clay (Pottery)
Sources: *ArC 189*.

Weaver, F.L.
Flourished: c1875 San Francisco, CA
Type of Work: Wood (Ship carvings, ship figures)
Sources: *ShipNA 155*.

Weaver, Frederick
d. 1885 Aaronsburg, PA
Flourished: 1851 Aaronsburg, PA
Type of Work: Fabric (Weavings)
Sources: *ChAmC 115*.

Weaver, Henry
Flourished: 1800s Penn Township, PA
Type of Work: Tin, clay (Tinware, pottery)
Sources: *ToCPS 15*.

Weaver, J.G.
Flourished: c1837 Pennsylvania
Type of Work: Fabric (Coverlets, weavings)
Museums: 189
Sources: *ChAmC 115; FoArRP 72**.

Weaver, James L.
Flourished: c1877 Roseville, OH
Type of Work: Stoneware (Pottery)
Sources: *AmPoP 229; Decor 225*.

Weaver, John W.
b. c1824 Pennsylvania
Flourished: 1850-1857 Rowsburg, OH
Type of Work: Fabric (Coverlets)
Remarks: Brother is Samuel
Sources: *AmSQu 277; ChAmC 115*.

Weaver, Mary Ann
Flourished: 1857
Type of Work: Fabric (Pillow cases)
Sources: *HoKnAm 141**.

Weaver, Samuel
b. c1830 Pennsylvania
Flourished: c1850-1862 Rowsburg, OH
Type of Work: Fabric (Coverlets)
Remarks: Brother is John
Sources: *ChAmC 115*.

Weaver, Thomas
d. 1843
Flourished: 1837-1843 Upper Milford Township, PA
Type of Work: Fabric (Coverlets)
Sources: *ChAmC 115*.

Webb, E.
Type of Work: Oil on glass (Historical paintings)
Sources: *AmPrP 157; PrimPa 181*.

Webb, H.T.
Flourished: 1840 Connecticut
Type of Work: Oil (Portraits)
Sources: *PrimPa 181*.

Webber, John
Flourished: c1849 Lancaster County, PA
Type of Work: Wood (Boxes)
Sources: *NeaT fig5**.

Weber, Isaac
Flourished: 1822 Pennsylvania
Type of Work: Watercolor, ink (Frakturs)
Sources: *AmFoPa 189*.

Weber, J.A.
Flourished: c1875 Barnesville, PA
Type of Work: Redware (Pottery)
Sources: *AmPoP 164, 284; DicM 70**.

Weber, R.
Flourished: Emmaus, PA
Type of Work: Fabric (Weavings)
Sources: *ChAmC 115*.

Weber, T.
Flourished: 1837-1843 Emmaus, PA
Type of Work: Fabric (Coverlets)
Sources: *ChAmC 115*.

Webster
See: Thomas and Webster.

Webster
See: Burgess, Webster and Viney.

Webster, Abel
b. 1726 d. 1801
Flourished: c1765 Hollis, NH
Type of Work: Stone (Gravestones)
Sources: *EaAmG 40*, 129*.

Webster, C.
See: C. Webster and Son.

Webster, Derek
Flourished: 1980 Chicago, IL
Ethnicity: Honduran
Type of Work: Wood, enamel (Sculptures)
Sources: *FoAFa 15**.

Webster, Elijah
Flourished: 1859-1864 East Liverpool, OH
Type of Work: Stoneware (Pottery)
Sources: *AmPoP 217; Decor 225.*

Webster, M.C.
See: M.C. Webster and Son.

Webster, Mack
Flourished: 1810-1867 Hartford, CT
Type of Work: Stoneware (Pottery)
Sources: *Decor 97*, 225*
See: Goodwin, Horace; Seymour, Orson H.

Webster, Stephen
b. 1718 d. 1798
Flourished: Hollis, NH
Type of Work: Stone (Gravestones)
Sources: *EaAmG 129.*

Webster and Seymour
Flourished: 1857-1873 Hartford, CT
Type of Work: Clay (Pottery)
Sources: *AmPoP 193, 284; Decor 225; DicM 141**
See: Seymour, Orson H.

Weckerly, Eliza
Flourished: 1817 Philadelphia, PA
Type of Work: Fabric (Samplers)
Sources: *GalAmS 52*, 91.*

Weddell, Liza Jane
Flourished: 1819 Floyd, VA
Type of Work: Fabric (Coverlets)
Sources: *ChAmC 115; InAmD 112*.*

Weeden
See: Heron and Weeden.

Weeden, John
Flourished: 1836 Buffalo, NY
Type of Work: Wood (Ship carvings, ship figures)
Sources: *AmFiTCa 202.*

Weeden, Mary
b. 1790 Providence, RI d. 1835
Flourished: 1800 Providence, RI
Type of Work: Embroidery (Mourning pictures)
Museums: 173
Sources: *LeViB 158, 164, 168-9*, 174.*

Weedon, J(ohn)
Flourished: 1852-1857 New York, NY
Type of Work: Wood (Ship carvings, ship figures)
Sources: *AmFiTCa 202; ShipNA 162.*

Weedon, John
Flourished: 1836 New York, NY
Type of Work: Wood (Ship carvings, ship figures)
Sources: *ShipNA 162.*

Weeks, F.W.
See: F.W. Weeks.

Weeks, Cook and Weeks
Flourished: 1882-1900 Akron, OH
Type of Work: Stoneware (Pottery)
Sources: *AmPoP 207; DicM 142*.*

Wehmhoemer, Johann Friedrich
Flourished: 1850-1860 Missouri
Type of Work: Wood (Corner cupboards)
Sources: *ASeMo 345*.*

Weidel, George
[Widle]
b. c1815 Pennsylvania
Flourished: 1848-1855 Bedford Township, PA
Type of Work: Fabric (Coverlets)
Sources: *ChAmC 115.*

Weidinger, Joe
Flourished: 20th century Easton, PA
Type of Work: Wood (Sculptures, carvings)
Sources: *AmFoS 338*.*

Weidle
Flourished: c1880-1900 Jackson Township, PA
Type of Work: Redware (Pottery)
Sources: *AmPoP 169.*

Weidner, Heinrich
Flourished: 1832 Pennsylvania
Type of Work: Watercolor, ink (Frakturs)
Sources: *AmFoPa 189.*

Weil, George P.
Flourished: 1860 Allentown, PA
Type of Work: Fabric (Coverlets)
Sources: *ChAmC 115*
See: Gabriel, Henry.

Weiner, Isidor "Pop"
See: Wiener, Isador "Pop".

Weinland, Henry
b. 1862 d. 1950
Flourished: Hermann, MO
Remarks: Brother is Nicholas
Sources: *ASeMo 411*.*

Weinland, Nicholas
b. c1862 d. 1950
Flourished: Hermann, MO
Remarks: Brother is Henry
Sources: *ASeMo 411*.*

Weir
Flourished: 1892-1900 Akron, OH; Monmouth, IL
Type of Work: Stoneware (Jars)
Sources: *AmS 90-2*.*

Weise, Henry
Flourished: c1870 Hagerstown, MD; Shepardstown, WV
Type of Work: Stoneware (Pottery)
Sources: *AmPoP 168, 179; Decor 225.*

Weise, James
Flourished: c1870 Martinsburg, WV
Type of Work: Redware, stoneware (Pottery)
Sources: *AmPoP 171.*

Weisel, W.C.
Flourished: 1854
Type of Work: Watercolor (Scene paintings)
Museums: 176
Sources: *ColAWC 244*.*

Weiss, Anna
Flourished: 1793 Pennsylvania
Type of Work: Watercolor, ink (Frakturs)
Sources: *AmFoPa 189.*

Weiss, George
Flourished: 1876 Philadelphia, PA
Type of Work: Wood (Ship carvings, ship figures)
Sources: *AmFiTCa 202.*

Weiss, Henrich
Flourished: 1791-1796 Pennsylvania
Type of Work: Watercolor, ink (Frakturs)
Sources: *AmFoPa 189.*

Weiss, Noah
b. 1842 d. 1907
Flourished: 1862 Steinsberg, PA; Lehigh County, PA
Type of Work: Oil, wood (Painted barns, carved toys, sculpture)
Sources: *FlowAm 219*; FoArRP 87.*

Weiss, William
Flourished: 1807-1808 Lancaster, PA
Type of Work: Metal (Rifles)
Sources: *BirB 27*.*

Weitel, J.
Flourished: 1834
Type of Work: Copper (Stills)
Sources: *AmCoB 105*.*

Welch, John
b. 1711 d. 1789
Flourished: 1750-1775 Boston, MA
Type of Work: Wood (Ship carvings, ship figures)
Sources: *AmFoS 128*; EaAmW 88-9*; ShipNA 158.*

Welch, Thomas
b. 1655 d. 1703
Flourished: Charlestown, MA
Type of Work: Stone (Gravestones)
Sources: *EaAmG 129; GravNE 22, 44, 130.*

Welfare, Daniel (Christian)
[Wohlfahrt]
b. 1796 d. 1841
Flourished: Salem, NC
Ethnicity: Moravian
Type of Work: Oil (Portraits)
Sources: *FoPaAm 160, 162*.*

Welk, George
b. c1795 Pennsylvania
Flourished: Springfield Township, OH
Type of Work: Fabric (Coverlets)
Sources: *ChAmC 117.*

Welker, Adam
Flourished: c1860-1885 Massillon, OH
Type of Work: Stoneware (Pottery)
Sources: *AmPoP 223; Decor 225.*

Weller, Benneville
Flourished: 1849 Montgomery County, PA
Type of Work: Tin (Tinware)
Sources: *ToCPS 24, 29, 32-5.*

Weller, Laura Elliott
Flourished: Rockwood, PA
Type of Work: Oil (Paintings)
Sources: *ThTaT 236*.*

Weller, S.A.
Flourished: c1890 Zanesville, OH
Type of Work: Clay (Pottery)
Sources: *DicM 11*, 36*, 40*, 86*.*

Weller, Samuel
Flourished: 1873-1900 Fultonham, OH
Type of Work: Stoneware (Pottery)
Sources: *AmPoP 220; Decor 225.*

Welles, Lydia
Flourished: 1800 Boston, MA
Type of Work: Fabric (Mythological embroidered pictures)
Remarks: Great-granddaughter is Budd, Alice M.
Sources: *AmNe 85-7*.*

Wellford, R.
Flourished: 1811 Philadelphia, PA
Type of Work: Wood (Chimney pieces)
Museums: 227
Sources: *MoBeA fig46.*

Wellman, Betsy
Flourished: 1840
Type of Work: Watercolor (Equestrian portraits)
Sources: *AmPrP 157; PrimPa 182.*

Wells, Arabella Stebbins Sheldon
Flourished: 1845 Deerfield, MA
Type of Work: Fabric (Rugs)
Museums: 234
Sources: *AmNe 95-6*.*

Wells, Ashbel
Flourished: c1785-1800 Hartford, CT
Type of Work: Stoneware (Pottery)
Sources: *Decor 225.*

Wells, Henry
Flourished: 1746-1748 Philadelphia, PA
Type of Work: Wood (Ship carvings, ship figures)
Sources: *ShipNA 163.*

Wells, Henry
Flourished: 1800 Norfolk, VA
Type of Work: Wood (Ship carvings, ship figures)
Sources: *AmFiTCa 202; ShipNA 164.*

Wells, J.F.
Flourished: 1889 Wisconsin
Type of Work: Wood (Farm scene sculptures, carvings)
Sources: *AmFoS 287*.*

Wells, Sister Jennie
Flourished: Old Chatham, NY
Ethnicity: Shaker
Type of Work: Fabric (Rugs)
Sources: *HanWo 102*.*

Wells, Joseph
Flourished: 1826-1835 Wellsville, OH
Type of Work: Stoneware (Pottery)
Sources: *AmPoP 232; Decor 225.*

Wells, S.
Flourished: c1835-1856 Wellsville, OH
Type of Work: Stoneware (Pottery)
Sources: *AmPoP 232; Decor 225.*

Wells, Crafts, and Wells
Flourished: 1849-1851 Whateley, MA
Type of Work: Stoneware (Pottery)
Sources: *Decor 225.*

Wellsville China Company
Flourished: 1879- Wellsville, OH
Type of Work: Clay (Pottery)
Sources: *DicM 172*, 174*, 255-6*, 258*.*

Welsh, John
Flourished: 1770 Boston, MA
Type of Work: Wood (Ship carvings, ship figures)
Sources: *AmFiTCa 202.*

Welshhans, J.
Flourished: York, PA
Type of Work: Brass (Tomahawks)
Sources: *AmCoB 218*.*

Welton, Hobart Victory
See: Wilton, Hobart Victory.

Welty, John B.
Flourished: 1833-1851 Boonsboro, MD
Type of Work: Fabric (Coverlets)
Museums: 016,263
Sources: *AmSFo 96*; AmSQu 277; ChAmC 117; SoFoA 203*, 223.*

Wendell, Elizabeth
Flourished: 1733 Boston, MA
Type of Work: Various materials (Quill work sconces)
Sources: *PlaFan 70*.*

Wenfold and Stevens
Flourished: Litchfield, CT
Type of Work: Tin (Tinware)
Sources: *TinC 138.*

Wensel, Charles
b. c1828
Flourished: c1860 Allentown, PA
Ethnicity: German
Type of Work: Fabric (Coverlets)
Sources: *ChAmC 117.*

Wentworth
See: Armstrong and Wentworth.

Wentworth, Ellen
Flourished: 1825 New Hampshire
Type of Work: Pen, watercolor (Memorial drawings)
Sources: *AmPrW 124*, 46*.*

Wentworth, Josiah W.
Flourished: 1783-1784 Norwich, CT
Type of Work: Oil? (Coach, sign paintings)
Sources: *MoBBTaS 13.*

Wentworth, P(erley) M.
Flourished: 1930s-1950s San Francisco, CA
Type of Work: Pencil, crayon, gouache (Scene drawings)
Sources: *FoA 470; FoAFm 3; FoPaAm 238; PioPar 15, 18*, 57, 60; TwCA 106-7*.*

Wentworth, T(homas) H.
d. 1849
Flourished: 1820 Connecticut; Oswego, NY
Type of Work: Watercolor (Portraits)
Sources: *AmPrP 157; PicFoA 17; PrimPa 182.*

Werner, Casper
Flourished: 1876 Philadelphia, PA
Type of Work: Wood (Ship carvings, ship figures)
Sources: *AmFiTCa 202.*

Werner, Ignatz
Flourished: 1870 Missouri
Type of Work: Wood (Furniture)
Sources: *ASeMo 384.*

Wernerus, Father Mathias
b. 1873 d. 1931
Flourished: 1926-1931 Dickeyville, WI
Ethnicity: German
Type of Work: Various materials (Environmental sculptures)
Remarks: Built Holy Ghost Park
Sources: *FoAFl 12-3*; TwCA 40*.*

Werrbach, L.
Flourished: 1850-1900 Milwaukee, WI
Type of Work: Stoneware (Jugs)
Sources: *AmS 82*.*

Wescott, P.B.
Flourished: 1835 Greenfield, MA
Type of Work: Watercolor (Memorial paintings)
Sources: *PrimPa 182.*

Wesenberg, Carl
Flourished: 1972- Ann Arbor, MI
Type of Work: Wood (Sculptures, carvings)
Remarks: A cabinet maker by trade who carves in 19th cent style
Sources: *AmFoS 359*, 373*.*

West, Benjamin
b. 1738 Springfield, PA d. 1820
Flourished: 1750 Philadelphia, PA
Type of Work: Oil (Landscape paintings)
Museums: 001,227
Sources: *ArtWod 14; EdwH 22-3, 31, 48*, 50-1; FoPaAm 31*, 115-6*, 165; GifAm 19; GraMo 34; HoKnAm 95; OneAmPr 41*, 85, 140, 156; PicFoA 9-10, 62*-3*; TwCA 14.*

West, Benjamin
Flourished: c1844 Rochester, IL
Type of Work: Pen, ink (Sketches)
Sources: *ArC 205*.*

West, Benjamin Franklin
b. 1818 d. 1854
Flourished: Salem, MA
Type of Work: Oil (Ship and marine paintings)
Sources: *AmFoPa 111.*

West, E.
Flourished: 1862 Cleveland, OH
Type of Work: Watercolor (Locomotive portraits)
Sources: *FoPaAm 192*.*

West, Francis
Flourished: 1833 Philadelphia, PA
Type of Work: Wood (Ship carvings, ship figures)
Sources: *AmFiTCa 202.*

West, Horace B.
Flourished: 1848-1849 Illinois
Type of Work: (Portraits, decorative paintings)
Sources: *ArC 267.*

West, James
Flourished: 1837-1848 Ohio
Ethnicity: English
Type of Work: Fabric (Coverlets)
Sources: *ChAmC 117.*

West, Washington J.
Flourished: 1848 Belleville, IL
Type of Work: (Portraits, ornamental paintings)
Sources: *ArC 267.*

West, William
Flourished: 1826 Mount Holly, NJ
Type of Work: Fabric (Coverlets, bedspreads)
Sources: *ChAmC 117.*

West Buffalo Factory Union Company
See: Clapham J.

West End Pottery Company
Flourished: 1893 East Liverpool, OH
Type of Work: Clay (Pottery)
Sources: *DicM 142*, 232*.*

West Troy Pottery
[Russell's Pottery]
Flourished: 1870s-1880 West Troy, NY
Type of Work: Stoneware (Pottery)
Sources: *AmS 226*; Decor 116*, 121*, 214*, 225.*

West Virginia China Company
Flourished: Wheeling, WV
Type of Work: Whiteware (China)
Sources: *AmPoP 233.*

West Virginia Pottery Company
Flourished: 1880-1900 Bridgeport, WV
Type of Work: Stoneware (Pottery)
Sources: *AmPoP 208; Decor 225.*

Western, A.S.
Flourished: 1820 Boston, MA
Type of Work: Oil (Landscape paintings)
Sources: *AmPrP 157; PrimPa 182.*

Western Grille Manufacturing Company
Flourished: Chicago, IL
Type of Work: Metal (Weathervanes)
Sources: *YankWe 214.*

Western Stoneware Company
Flourished: 1870-1930 Monmouth, IL
Type of Work: Stoneware (Pottery)
Sources: *AmPoP 224; AmS 177*; Decor 225.*

Westervelt, A.B. and W.T.
See: A.B. and W.T. Westervelt Company

Westhope
See: Lambright and Westhope.

Weston, H.
Flourished: 1850 Virginia
Type of Work: Oil (Landscape paintings)
Sources: *PrimPa 182.*

Weston, Loren
Flourished: 1818-1822 Connecticut
Type of Work: Tin (Tinware)
Sources: *TinC 73, 75*, 183.*

Weston, Mary Pillsbury
Flourished: 1850 Bradford, NH
Type of Work: Watercolor (Scene paintings)
Sources: *PrimPa 182.*

Weston, Thomas
Flourished: 1833 Philadelphia, PA
Type of Work: Wood (Ship carvings, ship figures)
Sources: *AmFiTCa 202.*

Weston, William Henry
Flourished: 1860 Duxbury, MA
Type of Work: Wood (Duck decoys)
Sources: *ArtDe 152*.*

Westwood, William H.
Flourished: Meriden, CT
Type of Work: Tin (Ornamental tinware)
Sources: *TinC 183.*

Wetherby, Isaac Augustus
[Wetherbee]
b. 1819 Providence, RI d. 1904 Iowa City, IA
Flourished: 1862 Norway, ME; Boston, MA; Tama County, IA
Type of Work: Oil (Portraits)
Museums: 203
Sources: *AmPrP 157; BoLiC 79-80; FoA 470; FoPaAm 187*, 190-1*; PicFoA 12-5, 90*, 92*; PrimPa182; SoAmP 285.*

Wetherby, Jeremiah W.
b. 1780
Type of Work: Oil (Paintings)
Sources: *SoAmP 285.*

Wever, H.S.
Flourished: 1844
Type of Work: Fabric (Coverlets)
Sources: *ChAmC 117.*

Weymouth Furnace
Flourished: c1800-1862 Gloucester County, NJ
Type of Work: Iron (Ironware)
Museums: 199
Sources: *EaAmI 28*.*

Weyrich, Charles
Flourished: 1870 Boonville, MO
Type of Work: Clay (Pottery)
Sources: *ASeMo 465*.*

Weyzundt
Flourished: 19th century Pennsylvania
Type of Work: Watercolor, ink (Frakturs)
Sources: *AmFoPa 189.*

Whealton, Dan, Captain
Flourished: Chincoteague, VA
Type of Work: Wood (Duck decoys)
Sources: *AmBiDe 165.*

Wheatley, Thomas
Flourished: 1880-1900 Cincinnati, OH
Type of Work: Clay (Artware pottery)
Sources: *AmPoP 212.*

Wheaton, Hiram
Flourished: 1873
Type of Work: Stoneware (Bottles)
Sources: *Decor 197*.*

Wheeler, Candace
Flourished: 1880s New York, NY
Type of Work: Fabric (Embroidered pictures)
Sources: *AmNe 161-2, 164*.*

Wheeler, Cathrine
Flourished: 1825 New England,
Type of Work: Fabric (Samplers)
Museums: 001
Sources: *ArtWo 19**.

Wheeler, Charles E. (Shang)
b. 1872 Stratford, CT d. 1949
Flourished: c1925-1930 Westport, CT; Stratford, CT
Type of Work: Wood, cork (Duck decoys)
Museums: 001,027,171,260
Sources: *AmBiDe 68-71*; AmDecoy viii*, xii, 8-9*, 14*, 34-5*, 56-7*; AmFoArt 92*; AmFoS 294; AmSFo 23*, 26; ArtDe 155, 178*; Decoy 6, 11-2*, 21-2*, 55*, 62*, 65*, 74*, 95*, 122-3*; FoA216*, 470; HoKnAm 40*; MaAmFA *; WiFoD 40*, 105*, 108-9*; WoCar 140-5*; WoScuNY.*

Wheeler, Chauncey
Flourished: 1920s-1930s Alexandria Bay, NY
Type of Work: Wood (Duck decoys)
Sources: *AmBiDe 106-7*; FouNY 23.*

Wheeler, Eveline Foleman
b. c1813
Flourished: 1824 Morristown, NJ
Type of Work: Fabric (Samplers)
Sources: *GalAmS 64*, 92.*

Wheeler, Henrietta Virginia
Flourished: 1828 Maryland
Type of Work: Fabric (Embroidered pictures)
Sources: *SoFoA 169*, 222.*

Wheeler, Hulda
Flourished: 1818-1821 Connecticut
Type of Work: Paint (Clock faces)
Sources: *TinC 158.*

Wheeler, Jonathan Dodge
Flourished: 1834 Brockton, MA
Type of Work: Oil (Paintings)
Museums: 300
Sources: *PicFoA 15.*

Wheeler, Obadiah
b. 1673
Flourished: c1745 Lebanon, CT
Type of Work: Stone (Gravestones)
Sources: *EaAmG 24*-5, 128.*

Wheeler, Rebekah
b. 1649
Flourished: 1664 Concord, MA
Type of Work: Fabric (Historic needlework pictures)
Museums: 053
Sources: *AmNe 24*-5.*

Wheeler, Sam
b. 1742 Philadelphia, PA d. 1810 Philadelphia, PA
Flourished: 1785 Philadelphia, PA
Type of Work: Iron (Gates)
Sources: *EaAmI 75-7*.*

Wheeler, Shang
See: Wheeler, Charles E. .

Wheeling Pottery Company
Flourished: 1879 Wheeling, WV
Type of Work: Clay (Pottery)
Sources: *AmPoP 233; DicM 83*, 130*, 155*, 160*, 170*, 179*, 181*, 230*, 238*, 244*, 251*-3*, 260*.*

Whetstone, Lydia S.
Flourished: 1925-1934 Shipshewana, IN
Ethnicity: Amish
Type of Work: Fabric (Quilts)
Sources: *QuiInA 36*, 39*.*

Whim, John A.
See: John A. Whim; A.J. Harris and Company .

Whipple, Clarissa
Flourished: c1830
Type of Work: Velvet (Mourning pictures)
Sources: *MoBeA.*

Whisler, John
See: Wissler, John .

Whitaker, E.M.
Flourished: 1857 Illinois
Type of Work: (Drawings)
Sources: *ArC 267.*

Whitcomb, J.H.
Flourished: 1830
Type of Work: Watercolor (Paintings)
Museums: 176
Sources: *ColAWC 244, 247*.*

Whitcomb, Susan
Flourished: 1840s Brandon, VT
Type of Work: Watercolor (Scene paintings)
Museums: 001
Sources: *AmFoAr 32; AmFoPaN 142-3*, 147*; AmPrP fig89, 157; ArtWo 64-5*; FoArA 24*; PrimPa182.*

White
Type of Work: Fabric (Coverlets)
Sources: *ChAmC 117.*

White
See: Cushing and White .

White, Abel
Flourished: 1820-1826 Lumberton, NJ
Type of Work: Fabric (Weavings)
Sources: *ChAmC 117*
See: Holland, James .

White, Alexander
Flourished: c1839 Chicago, IL
Type of Work: Oil (Sign and ornamental paintings)
Sources: *ArC 159*.*

White, Alvin A.
Type of Work: Whalebone (Scrimshaw)
Sources: *ScriSW 50-3*.*

White, Mrs. Cecil
Flourished: 1930 Hartford, CT
Type of Work: Fabric (Quilts)
Sources: *ArtWo 129, 173, 121*; FoAFm 3; TwCA 84*.*

White, Ebenezer Baker
b. 1806 Massachusetts
Flourished: 1840 Providence, RI
Type of Work: Oil (Portraits)
Sources: *AmPrP 157; PrimPa 182; SoAmP 113*.*

White, Edwin
b. New London, CT
Type of Work: Whalebone? (Scrimshaw?)
Museums: 186
Sources: *GravF 109-10*.*

White, Francis
Type of Work: Oil (Paintings)
Remarks: Taught Stock, Joseph Whiting
Sources: *AmFoPa 87; EraSaF 10.*

White, George
b. 1903 Cedar Creek, TX d. 1970
Flourished: 1961 Dallas, TX
Ethnicity: Black American, Mexican, American Indian
Type of Work: Wood, oil, mixed media (Romantic western paintings, sculptures, carvings)
Museums: 190,263
Sources: *AmFokArt 318-9*; BlFoAr 146-51*.*

White, Henry J.
Flourished: 1955
Type of Work: Metal (Weathervanes)
Sources: *YankWe 207*.*

White, Iva Martin
b. 1882 Washington, DC d. 1955 Washington, DC
Flourished: 1940-1950 Washington, DC
Type of Work: Fabric (Quilts)
Sources: *ArtWo 128.*

White, John
Flourished: 1850 Cheshire, CT
Type of Work: Oil (Landscape paintings)
Sources: *AmPrP 157; PrimPa 182.*

White, N.A.
See: N.A. White and Son .

White, N(oah) A., Jr.
See: N.A. White and Son .

White, Noah
Flourished: 1828-1859 Binghamton, NY; Utica, NY
Type of Work: Stoneware (Pottery)
Museums: 203
Sources: *AmPoP 59, 204; AmSFo 51; Decor 59*, 225*
See: Roberts, William; N.A. White and Son .

White, Richard H.
Flourished: 1860 Norwich, CT
Type of Work: Wood (Ship carvings, ship figures)
Museums: 186
Sources: *AmFiTCa 202; FigSh 60.*

White, T.J.
See: White and Company.

White, Thomas J.
b. 1825 d. 1902
Flourished: c1863 New York, NY; New Bedford, MA
Type of Work: Wood, pen, watercolor (Figures, signs, seascapes)
Museums: 123
Sources: *AmFokAr 74; ArtWod 82, 93, 181-3, 197-8, 206, 209, 211, 215; CiStF 29, 31; WhaPa 59*, 88*.*

White, William
d. 1673
Flourished: Boston, MA
Type of Work: Stone (Gravestones)
Sources: *GravNE 21, 130.*

White, William
Flourished: 1853-1860 Jugtown, IL
Type of Work: Stoneware (Pottery)
Sources: *ArC 194.*

White, William Fred
Flourished: c1837 Ashburnham, MA
Type of Work: Wood (Signs)
Sources: *MoBBTaS 77*.*

White, Winfield
Flourished: c1850 Seabright, NJ; Delaware
Type of Work: Wood (Duck decoys)
Museums: 260
Sources: *ArtDe 163; Decoy 39*.*

White and Company
[T.J. White]
Flourished: 1861 Boston, MA
Type of Work: Wood (Ship carvings, ship figures)
Sources: *AmFiTCa 202.*

White and Wood
Flourished: c1850-1877 Binghamton, NY
Type of Work: Stoneware (Pottery)
Museums: 033
Sources: *AmPoP 189; Decor 87*, 225; DicM 142*.*

Whitefield, Edwin
d. 1892
Flourished: 1836-1892
Ethnicity: English
Type of Work: (Paintings)
Sources: *NeaT 119-120, fig19*.*

Whitehall Metal Studio
Flourished: mid 20th cent Montague, MI
Type of Work: Metal (Weathervanes)
Sources: *WeaWhir 186; YankWe 104*.*

Whitehead, L(iberty) N.
Flourished: 1839
Type of Work: Fabric (Weavings)
Museums: 297
Sources: *AmSQu 288*.*

Whitehill, Mrs. Charlotte Jane
Flourished: 1930s Colorado
Type of Work: Fabric (Quilts)
Museums: 068
Sources: *AmSQu 159*, 162*, 182*, 190*; QuiAm 64.*

Whiteman, Henry
Flourished: New York, NY
Type of Work: Brass (Buttons)
Sources: *AmCoB 223.*

Whiteman, T.W.
Flourished: c1860-1870 Perth Amboy, NJ
Type of Work: Stoneware (Pottery)
Museums: 097
Sources: *AmPoP 48, 174, 285; AmSFo 48*; Decor 225.*

Whitener, Thomas
Flourished: 1910
Type of Work: (Baskets)
Sources: *MisPi 72*.*

Whitfield
See: Ulrich and Whitfield.

Whiting, Calvin
Flourished: c1804-1811 Dedham, MA
Type of Work: Tin (Tinware)
Sources: *AmCoTW 43-6, 62, 77.*

Whiting, Riley
Flourished: 1808-1835 Winchester, CT
Type of Work: Wood (Clocks)
Museums: 096, 263
Sources: *AmPaF 238*; BirB 8*.*

Whitman, Eliza
b. c1786
Flourished: 1796 Massachusetts
Type of Work: Fabric (Samplers)
Sources: *GalAmS 34*, 90.*

Whitman, J.M.
Flourished: c1860-1870 Havana, NY
Type of Work: Stoneware (Pottery)
Museums: 203
Sources: *Decor 225, 138*.*

Whitman, Robinson and Company
Flourished: c1862-1886 Akron, OH
Type of Work: Stoneware (Pottery)
Sources: *AmPoP 206; Decor 226.*

Whitmer, J.
Flourished: 1838 Manor Township, PA
Type of Work: Fabric (Weavings)
Sources: *AmSQu 277.*

Whitmore, Susan
b. 1789 Providence, RI d. 1867 Providence, RI
Flourished: 1799 Providence, RI
Type of Work: Fabric (Samplers)
Sources: *LeViB 115, 140, 152*-3.*

Whitney, L.
Flourished: 19th century
Type of Work: Oil (Village scene paintings)
Museums: 204
Sources: *AmPrP 157; PicFoA 104*; PrimPa 182.*

Whitney Glass Works
Flourished: 1860-1870 Glassboro, NJ
Type of Work: Glass (Glass works)
Museums: 058
Sources: *AmSFok 125*.*

Whittaker, James
Flourished: Albany, NY
Ethnicity: Shaker
Type of Work: Fabric (Weavings)
Sources: *HanWo 4.*

Whittaker, John, Captain
Flourished: 1860 Jamaica Bay, NY
Type of Work: Wood (Duck decoys)
Sources: *WiFoD 40*, 68*, 150*.*

Whittemore, Daniel
Flourished: c1780-1850 Peabody, MA
Type of Work: Redware (Pottery)
Remarks: Father is Joseph
Sources: *AmPoP 200.*

Whittemore, Joseph
b. 1667 d. 1745
Flourished: Charlestown, MA
Type of Work: Stone (Gravestones)
Sources: *EaAmG 129; GravNE 44, 130.*

Whittemore, Joseph
Flourished: c1750 Peabody, MA
Type of Work: Redware (Pottery)
Remarks: Son is Daniel
Sources: *AmPoP 200.*

Whittemore, R.O.
Flourished: c1860-1880 Havana, NY
Type of Work: Stoneware (Pottery)
Sources: *Decor 226.*

Whittington, Hector "Heck"
Flourished: 1924- Oglesby, IL
Type of Work: Wood (Duck decoys)
Sources: *AmBiDe 193-94; WoCar 160, 163*.*

Whittle, B.
Flourished: 1837 New York, NY
Type of Work: Oil (Building portraits)
Museums: 203
Sources: *FoPaAm 103*.*

Whitwell, Rebecca
b. 1773 Newport, RI
Flourished: 1785 Newport, RI
Type of Work: Fabric (Samplers)
Sources: *GalAmS 28*, 90; LeViB 74*.*

Wiand, Charles
[Weand]
b. 1818 Pennsylvania
Flourished: c1843 Allentown, PA; Trexlertown, PA
Type of Work: Fabric (Weavings)
Museums: 189
Sources: *AmSQu 277; ChAmC 117; FoArRP 69**
See: Gramlyg, John.

Wiand, David
[Weand]
Flourished: 1837-1841 Zieglersville, PA
Type of Work: Fabric (Weavings)
Sources: *AmSQu 277; ChAmC 117.*

Wiand, Joel
b. c1820 Pennsylvania
Flourished: c1860 Allentown, PA
Type of Work: Fabric (Carpets, coverlets)
Sources: *ChAmC 117*
See: Wiand, John.

Wiand, John
b. c1844 Pennsylvania
Flourished: c1860 Allentown, PA
Type of Work: Fabric (Coverlets)
Sources: *ChAmC 117*
See: Wiand, Joel.

Wiand, Jonathan D.
[Wieand; Wend]
b. c1828 Pennsylvania **d.** 1884
Flourished: c1850-1868 Allentown, PA
Type of Work: Fabric (Carpets, coverlets)
Sources: *ChAmC 117.*

Wibb, Ward
Flourished: 1969 Oregon
Type of Work: Wood (Sculptures)
Sources: *FoAFn 6.*

Wicks, Robert F. "Bobby"; "Texas"
b. 1902 Brooklyn, NY
Flourished: 1916-1972
Type of Work: Oil (Circus banners)
Sources: *AmSFor 52.*

Widle, George
See: Weidel, George.

Widow, M. Queen
Flourished: 1791 New York, NY
Type of Work: Wood, paper (Handboxes)
Sources: *AmSFo 126.*

Wieand, Jonathan D.
See: Wiand, Jonathan D.

Wiemer and Brother
Flourished: 1868-1872 Snydertown, PA
Type of Work: Stoneware (Pottery)
Sources: *HerSa *.*

Wiend, Jonathan D.
See: Wiand, Jonathan D.

Wiend, Michael
[Weand]
Flourished: 1838 Pottstown, PA
Type of Work: Fabric (Weavings)
Sources: *ChAmC 117.*

Wiener, Isador "Pop"
b. 1886 **d.** 1970 New York, NY
Flourished: 1950-1970 New York, NY
Ethnicity: Russian
Type of Work: Wood, oil (Sculptures, carvings, scene-genre paintings)
Sources: *HoKnAm 185-6; TwCA 122-3*.*

Wiess, J.
Flourished: 1797 Mount Vernon, VA
Type of Work: Oil (Landscape paintings)
Sources: *OneAmPr 56*, 142, 156.*

Wiggin, Alfred J.
Flourished: 1847-1853 Cape Ann, MA
Type of Work: Oil (Portraits)
Sources: *AmPrP 157; PrimPa 182; SoAmP 290.*

Wiggins, C.
Flourished: 1840
Type of Work: Fabric (Coverlets)
Sources: *ChAmC 124.*

Wight, John
b. 1702 **d.** 1777
Flourished: c1765 Londonderry, NH
Type of Work: Stone (Gravestones)
Sources: *EaAmG 40*, 129.*

Wightman, Mary
b. 1785 Warwick?, RI? **d.** 1865 Warwick?, RI?
Flourished: c1810 Warwick, RI
Type of Work: Embroidery (Mourning pictures)
Sources: *LeViB 218, 236-7*; MoBeA fig13.*

Wightman, Thomas
Flourished: 1816 Boston, MA
Type of Work: Wood (Ship carvings, ship figures)
Sources: *AmFiTCa 203.*

Wilbur, A. E.
Flourished: c1930 Dallas, TX
Type of Work: Stoneware (Free modeling of whimseys, including snakes)
Sources: *AmS 152*.*

Wilbur, C.
Flourished: 1845-1850 Putnam, OH
Type of Work: Stoneware (Jars)
Sources: *AmS 86*.*

Wilburn, Tom
b. 1925 Ramage, WV
Flourished: contemporary
Type of Work: Wood (Sculptures)
Sources: *FoAFm 15*.*

Wilcox, Allyn
Flourished: c1811 Berlin, CT
Type of Work: Tin (Tinware)
Sources: *TinC 183.*

Wilcox, Benjamin
Flourished: c1812- Berlin, CT
Type of Work: Tin (Tinware)
Remarks: Associated with Hubbard; owned a shop
Sources: *AmCoTW 98; TinC 183.*

Wilcox, Daniel
Flourished: 1808 Connecticut
Type of Work: Tin (Tinware)
Remarks: Associated with Filley
Sources: *TinC 183.*

Wilcox, Francis C.
Flourished: mid 19th cent Middletown, CT; Hartford, CT
Type of Work: Tin (Tinware)
Remarks: Apprentice to Phillips, William
Sources: *TinC 183.*

Wilcox, Hepzibah
Flourished: 1818 Berlin, CT
Type of Work: Tin (Japanned tinware)
Sources: *TinC 158-9.*

Wilcox, Lewis S.
Flourished: 1877 Meriden, CT
Type of Work: Tin (Tinware)
Sources: *TinC 183.*

Wilcox, Richard
Flourished: Berlin, CT
Type of Work: Tin (Tinware)
Remarks: Associated with Hubbard
Sources: *TinC 183.*

Wilcox Pottery
Flourished: 1840 West Bloomfield, NY
Type of Work: Redware (Pottery)
Sources: *HoKnAm pl.8.*

Wild, John Casper
b. 1806 **d.** 1846
Flourished: 1835-1841 St. Louis, MO; Davenport, IA
Ethnicity: Swiss
Type of Work: Gouache (Landscape paintings)
Remarks: Worked in the midwest
Sources: *ArC 4*, 192*, 213-5*; FoPaAm 209*.*

Wilder, F(ranklin) H.
Flourished: c1865 Fitchburg, MA; Leominster, MA; Hingham, MA
Type of Work: Oil, pen, ink, pencil, watercolor (Fracturs)
Museums: 171
Sources: *AmFoArt 38-9*; FoA 88*, 470; PrimPa 182; SoAmP 287.*

Wilder, James
b. 1741 **d.** 1794
Flourished: Lancaster, MA
Type of Work: Stone (Gravestones)
Sources: *EaAmG 129; GravNE 78-9, 130.*

Wilder, Matilda
Flourished: 1820 Massachusetts
Type of Work: Oil (Paintings)
Sources: *AmFoAr 32; AmPrP 157; PrimPa 182.*

Wilder, Thomas
Flourished: 1842 New England,
Type of Work: Oil (Portraits)
Sources: *NinCFo 178.*

Wildfowler Decoy Company
Flourished: 1939 Old Saybrook, CT
Type of Work: Wood (Duck decoys)
Museums: 260
Sources: *Decoy 28*.*

Wildin, John
b. c1803
Flourished: 1840-1850 York Township, PA
Ethnicity: German
Type of Work: Fabric (Weavings)
Sources: *ChAmC 117.*

Wiley, Martin
Flourished: c1850-1875 Ono, PA
Type of Work: Redware (Pottery)
Sources: *AmPoP 173.*

Wilke, Mr.
Flourished: c1860 Nantucket, MA
Type of Work: Wood (Duck decoys)
Museums: 260
Sources: *Decoy 47*.*

Wilkerson, Lizzie
b. 1902 Georgia d. 1984
Flourished: 1979 Atlanta, GA
Ethnicity: Black American
Type of Work: Paint (Religious paintings)
Sources: *FoAFb 4-5*.*

Wilkie, John
Flourished: 1840
Type of Work: Oil (Portraits)
Museums: 006
Sources: *AmPrP 157; CoCoWA 104-5*; Edith *; MaAmFA *; PrimPa 182.*

Wilkie, William
Flourished: 1801 Albany, NY
Type of Work: Watercolor (Portraits)
Museums: 006
Sources: *AmFoPaN 101, 125*; FoArA 60*.*

Wilkin, Godfrey
Flourished: 1801 Hardy County, VA
Type of Work: Wood (Decorated chests)
Museums: 096
Sources: *PenGer 69; SoFoA 164*, 221.*

Wilkins, Benjamin
Flourished: c1860 Elgin, IL
Type of Work: Paint? (Paintings?)
Sources: *ArC 267*
See: Padelford, R. W. .

Wilkins, James
b. 1808 d. 1888
Flourished: c1836 Peoria, IL
Type of Work: Oil (Portraits)
Museums: 226
Sources: *ArC 166-7*.*

Wilkins, Sarah
Flourished: 1830 Massachusetts
Type of Work: Watercolor (Memorial paintings)
Sources: *AmPrP 157; PrimPa 182.*

Wilkinson, Anthony
d. 1765
Flourished: c1728 Philadelphia, PA
Type of Work: Wood (Ship carvings, ship figures)
Sources: *AmFiTCa 47, 203; FigSh 92; ShipNA 162.*

Wilkinson, Bryant
Flourished: 1749 Philadelphia, PA
Type of Work: Wood (Ship carvings, ship figures)
Sources: *ShipNA 163.*

Wilkinson, Knox
b. 1955 Rome, GA
Flourished: 1982- Atlanta, GA
Type of Work: Magic marker (Paintings)
Sources: *FoAFa 1*, 10-11*.*

Wilkison, Emily
Flourished: 1836 Bethany, NY
Type of Work: Fabric (Weavings)
Sources: *AmSQu 277; ChAmC 117.*

Will, William
Flourished: 1764-1796 Philadelphia, PA
Type of Work: Pewter (Mugs)
Sources: *BeyN 84*, 108; PenDA 25-6.*

Will, William
b. c1798
Flourished: c1850 Knox Township, OH; Columbiana County, OH
Ethnicity: German
Type of Work: Fabric (Coverlets)
Sources: *ChAmC 117.*

Willard, Aaron
b. 1757 d. 1844
Flourished: Boston, MA
Type of Work: Wood (Clocks)
Museums: 032,176
Sources: *AmPaF 172**
See: Willard, Simon; Willard, Zabadiel .

Willard, Alfred
Flourished: 1831-1836 Boston, MA
Type of Work: Wood (Comb boxes)
Sources: *NeaT 101*.*

Willard, Archibald M.
b. 1836 Bedford, OH d. 1918
Flourished: Wellington, OH
Type of Work: Oil (Portraits)
Remarks: Painted the "Spirit of 1776"
Sources: *SoAmP 29*, 290-1.*

Willard, Eliza
Flourished: 1760 Salem, MA
Type of Work: Fabric (Needlepoint pocketbooks)
Sources: *AmNe 25*, 27.*

Willard, Simon
b. 1802
Flourished: 1839 Boston, MA
Type of Work: Wood (Clocks)
Museums: 097
Sources: *AmPaF 129*; InAmD 130*
See: Willard, Aaron; Willard, Zabadiel .

Willard, Solomon
[Williard]
b. 1783 or 1773 Petersham, MA d. 1861
Flourished: 1813-1817 Boston, MA; Richmond, VA
Type of Work: Wood (Ship carvings, ship figures)
Museums: 142
Sources: *AmFiTCa 32, 84-5, 87, 203, figxvi, figxvii; ShipNA 43-4*, 159.*

Willard, Zabadiel
Flourished: 1850 Boston, MA
Type of Work: Wood (Clocks)
Sources: *AmPaF 175*
See: Willard, Aaron; Willard, Simon .

Willard and Sons
Flourished: c1880-1895 Ballardville, MA
Type of Work: Stoneware (Pottery)
Sources: *Decor 226.*

Willcox, Marcy
Flourished: Connecticut
Type of Work: Tin (Japanned tinware)
Sources: *TinC 159.*

Willeto, Charles
Flourished: c1965
Type of Work: Wood (Sculptures)
Sources: *FoAFm 3.*

Willett, George H.
Flourished: 1880-1883 Lake George, NY
Type of Work: Wood (Cigar box churches)
Museums: 128
Sources: *FouNY 51*, 68; WhoScuNY.*

Willetts Manufacturing Company
Flourished: c1860-1900 Trenton, NJ
Type of Work: Clay (Pottery)
Sources: *AmPoP 182; DicM 156*, 179*, 227*.*

Willey, Philo Levi "The Chief"
b. 1886 Canaan, CT d. 1980
Flourished: 1970 New Orleans, LA
Type of Work: Acrylic, oil, watercolor, pencil (Fantasy and memory paintings)
Museums: 178,203
Sources: *AmFokArt 320-2*; FoA 44*, 470; FoPaAm 14, 175-6, fig56; Full *.*

William, Abram
Flourished: 1838- Avon Township, MI
Type of Work: Fabric (Weavings)
Sources: *AmSQu 277.*

William, George
b. 1911
Flourished: Jefferson County, MS
Ethnicity: Black American
Type of Work: Wood (Gate posts, figures)
Sources: *BlFoAr 152-5*.*

William A. Macquoid and Company, Pottery Works
Flourished: 1863-1870 New York, NY
Type of Work: Stoneware (Pottery)
Museums: 203
Sources: *Decor 99*, 128*, 130*, 145*, 221; EaAmFo 13, 98-9*, 102*, 142*.*

William and Carl Wingender Pottery
See: Wingender Brothers Pottery.

William Brunt Pottery Company
Flourished: 1850-1895 East Liverpool, OH
Type of Work: Clay (Pottery)
Sources: *AmPoP 215, 217; DicM 9*, 29*, 189*, 249*.*

William Burroughs
Flourished: c1821 Charlestown, MA
Type of Work: Stoneware (Pottery)
Sources: *Decor 167**
See: Barnabus Edmonds and Company.

William Demuth and Company
b. 1835-1911
Flourished: New York, NY
Type of Work: Metal, wood (Cigar store Indians, figures)
Museums: 096
Sources: *AmFoS 38*, 260*; ArEn 31; BirB 85*; CiStF 2*, 11, 17, 19, 29, 45, 49, 75*; FoArtC 158; HoKnAm 161; InAmD 64; WoCar 33.*

William E. Pratt Manufacturing Company
Flourished: c1926-1938? Joliet, IL
Type of Work: Wood (Duck decoys)
Museums: 001
Remarks: Bought Mason Decoy Factory equipment
Sources: *AmBiDe 196*, 227-28; AmFoS 303*.*

William Fische Pot Factory
Flourished: c1869-1870 Allentown, PA
Type of Work: Clay (Pottery)
Sources: *AmPoP 162.*

William H. Farrar
[W.H. Farrar and Company]
Flourished: c1841-1871 Geddes, NY
Type of Work: Stoneware (Pottery)
Museums: 217
Sources: *Decor 68*, 219.*

William Krafe and E.F. Teubner
Flourished: 1860 Philadelphia, PA
Type of Work: Wood (Ship carvings, ship figures)
Sources: *AmFiTCa 195.*

William R. Johnson Company Inc.
Flourished: Seattle, WA
Type of Work: Wood (Duck decoys)
Museums: 260
Sources: *Decoy 91*.*

William Rogers Pottery
See: Rogers, William.

William Shenkel and Company
See: Schenkle, William; Excelsior Pottery.

William Young and Sons
Flourished: c1852 Trenton, NJ
Type of Work: Brownware, Rockingham (Pottery)
Sources: *AmPoP 49, 113, 182.*

Williams
Flourished: c1850 Back Bay, VA
Type of Work: Wood (Duck decoys)
Museums: 260
Sources: *Decoy 98-9*.*

Williams, A.
Flourished: 1850
Type of Work: Oil (Ship paintings)
Sources: *PrimPa 182.*

Williams, Abigail
Flourished: Connecticut
Type of Work: Tin (Japanned tinware)
Sources: *AmCoTW 82; TinC 140, 159.*

Williams, Amy
Flourished: 1779 Connecticut
Type of Work: Fabric (Woven and hooked bed rugs, coverlets)
Museums: 048
Sources: *AmSQu 27*.*

Williams, Arthur
Flourished: 1920 New Bedford, MA
Type of Work: Whalebone, ivory (Carved whale teeth)
Sources: *BirB 49*.*

Williams, Charles P.
Flourished: 1875
Type of Work: Oil (Farm scene paintings)
Sources: *PrimPa 182.*

Williams, Cynthia
Flourished: 1803 Providence, RI
Type of Work: Embroidery (Still life pictures)
Sources: *LeViB 163, 165*.*

Williams, E.
Flourished: 1838 New Orleans, LA
Type of Work: Wood (Ship carvings, ship figures)
Sources: *AmFiTCa 203.*

Williams, Frances
b. 1797 Brooklyn, CT **d.** 1816
Flourished: 1812 Providence, RI
Type of Work: Embroidery (Mourning pictures)
Sources: *LeViB 185*.*

Williams, H.R.
b. c1809 Pennsylvania
Flourished: c1850 Mill Hall, PA
Type of Work: Fabric (Weavings)
Sources: *ChAmC 117.*

Williams, Henry T.
Flourished: Dover Township, PA
Type of Work: Fabric? (Coverlets?)
Sources: *ChAmC 117.*

Williams, Jeff
b. 1958 Salemburg, NC
Flourished: Salemburg, NC
Ethnicity: Black American
Type of Work: Wood (Sculptures)
Sources: *FoAFh 12*-3*.*

Williams, John
b. 1857 **d.** 1937
Flourished: c1890 Cedar Island, VA
Type of Work: Wood (Duck decoys)
Sources: *AmBiDe 165, 168-72*; AmDecoy 25*, 44*.*

Williams, John
Flourished: Kittery, ME
Type of Work: Wood (Ship carvings, ship figures)
Sources: *AmFiTCa 203.*

Williams, John T. (T.J.)
Flourished: 1834-1836 Mechanicsburg, PA
Type of Work: Fabric (Weavings)
Sources: *ChAmC 117.*
See: Young, Charles.

Williams, Lydia Eldridge
b. 1793 Yarmouth, MA
Flourished: c1812-1854 Ashfield, MA
Type of Work: Oil (Ornamental paintings)
Sources: *AmDecor 97; AmFokDe 96.*

Williams, Mary
Flourished: 1744 New England,
Type of Work: Fabric (Samplers)
Museums: 191
Sources: *ArtWo 13*.*

Williams, Mary Lou
See: Dick, Mrs. Mary Lou Williams.

Williams, May
Flourished: 1817 Falmouth, KY
Type of Work: Fabric (Coverlets)
Sources: *ChAmC 118; InAmD 112*.*

Williams, Micah
b. 1782 **d.** 1837
Flourished: 1790-1832 New Brunswick, NJ; Mataway, NJ; Freehold, NJ
Type of Work: Pastel, oil (Portraits)
Museums: 161,176,198,227
Sources: *AmFoPa 48, 89-90*; AmFoPaN 56, 74-5*; AmFoPo 193-5*; AmPrP 157; AmSFok 161*; ColAWC 133, 136*; Edith *; EyoAm 18; MaAmFA *; NinCFo 169, 199, fig33, 34; PrimPa 182.*

Williams, R.
Flourished: 1770-1790 Sheepshead Bay, NY
Type of Work: Wood (Duck decoys)
Sources: *ArtDe 150; HoKnAm 37*.*

Williams, S.
Flourished: c1982 Knotts Island, NC
Type of Work: Wood (Swan decoys)
Sources: *SoFoA 163*, 221.*

Williams, Smith
Flourished: Berlin, CT
Type of Work: Tin (Tinware)
Sources: *TinC 183.*

Williams, T.
Flourished: 1790 Long Island, NY
Type of Work: Wood (Duck decoys)
Sources: *AmFoS 295*; FoScu 48*.*

Williams, William
b. 1710 **d.** 1790
Flourished: 1772 New York
Type of Work: Oil (Portraits)
Sources: *AmPaF 84*; FoA 470; FoPaAm 79*.*

Williams, William
Flourished: 1920 New Bedford, MA
Type of Work: Whalebone, ivory (Carvings)
Sources: *AmFoS 25, 114*.*

Williams, William T.
b. c1816 Pennsylvania
Flourished: 1844-1850 Paradise Township, PA; Dover Township, PA
Type of Work: Fabric (Weavings)
Sources: *ChAmC 118.*

Williams and McCoy
Flourished: 1886-1900 Roseville, OH
Type of Work: Stoneware (Pottery)
Sources: *AmPoP 229; Decor 226.*

Williams and Reppert
Flourished: Greensboro, PA
Type of Work: Stoneware (Pottery)
Sources: *AmPoP 68, 221, 285.*

Williamson, Clara McDonald
b. 1875 Iredell, TX **d.** 1976
Flourished: 1943-1976 Dallas, TX
Type of Work: Oil (Memory and genre paintings)
Museums: 020,061,179
Sources: *ArtWo 132-3*, 173-4*; FoAF 15; FoPaAm 236*, 238; MaAmFA *; PicFoA 158*, 166; PrimPa165*, 182; TwCA 158-9*.*

Williard, Solomon
See: Willard, Solomon.

Willis, Edward
Flourished: 1851 Philadelphia, PA
Type of Work: Wood (Ship carvings, ship figures)
Sources: *AmFiTCa 203.*

Willis, Eveline F.
Flourished: 1828-1880 Washington, DC; Castleton, VT
Type of Work: Watercolor (Paintings)
Museums: 176
Sources: *ColAWC 170-2*; PrimPa 182.*

Willis, Luster
b. 1913 Terry, MS
Flourished: 1930s- Crystal Springs, MS
Ethnicity: Black American
Type of Work: Wood, oil, watercolor (Carved canes, secular and religious paintings)
Museums: 039,040
Sources: *AmFokArt 323-4*; BlFoAr 156-61*; LoCo xviii-xix, xxii-xxiv, xxvi-xxvii, 193*-212*.*

Willis, Sarah
Flourished: 1803 New Bedford, MA
Type of Work: Fabric (Embroidered maps)
Sources: *AmNe 93-4*.*

Willitt, John
Flourished: 1880
See: Willett, George H.

Willoughby, Edward C.
Flourished: c1860 Chicago, IL
Type of Work: (Landscape paintings)
Sources: *ArC 267.*

Willson, Mr.
Flourished: 1822 New Hampshire
Type of Work: Watercolor (Portraits)
Museums: 203
Sources: *AmFoPaN 57, 77*; FoPaAm 58*.*

Willson, Mary Ann
[Wilson]
Flourished: 1810-1825 Greenville, NY
Type of Work: Oil, watercolor (Paintings)
Museums: 173,176,189,203
Sources: *AmFoPaCe 171-4*, 221; AmPrW 52-5*, 125*; ArtWo 85-6*, 174*, 110*; ColAWC 245*, 247-9*;FoA 470; FoArA fig, 106-12*; FoPaAm 89*; HoKnAm 10*; PrimPa 50-6*, 182.*

Willson, Sulie Hartsuck
Flourished: late 19th cent Washington
Type of Work: Oil (Paintings)
Museums: 298
Sources: *PioPar 12, 59.*

Wilmore
See: Morris and Wilmore.

Wilson
Flourished: 1852 Philadelphia, PA
Ethnicity: Black American
Sources: *AfAmA 96.*

Wilson, Mr.
Flourished: 1816 Cooperstown, NH
Type of Work: (Portraits)
Museums: 203
Sources: *FloCo 47*.*

Wilson, A.
See: Wilson, William.

Wilson, A.B.
Ethnicity: Black American
Type of Work: (Paintings)
Sources: *AfAmA 96.*

Wilson, Albert H.
See: Wilson, Alfred.

Wilson, Alexander
Flourished: 1809
Type of Work: Oil (Nature paintings)
Remarks: Ornithologist who worked in the midwest and Niagra Falls
Sources: *ArC 49, 55.*

Wilson, Alfred (Albert H.)
b. 1828?
Flourished: 1822-1851 Newburyport, MA
Type of Work: Wood (Ship carvings, ship figures)
Museums: 142
Remarks: Brother is James W.; also had a sister Jane W. Wilson.
Sources: *AmFiTCa 141, figxx, 203; ShipNA 69, 160.*

Wilson, Amelia Emelina
Flourished: late 19th cent
Type of Work: Fabric (Quilts)
Museums: 046
Sources: *NewDis 36*.*

Wilson, Ann Jefferis
Flourished: c1800-1820 Philadelphia, PA
Type of Work: Fabric (Needlework)
Sources: *WinGu 76*.*

Wilson, Augustus
Flourished: early 20th cent Portland, ME
Type of Work: Wood (Animal sculptures, carvings)
Sources: *FoScu 80*.*

Wilson, Charles T., Professor
Flourished: 1900 Havre de Grace, MD
Type of Work: Wood (Duck decoys)
Museums: 260
Sources: *Decoy 30*; WiFoD 138*.*

Wilson, Elder Delmar
b. 1873 d. 1961
Flourished: Sabbathday Lake, ME
Ethnicity: Shaker
Type of Work: Wood (Shaker boxes)
Sources: *FoA 470; HanWo 143.*

Wilson, E.
Flourished: New Hampshire
Type of Work: Oil (Portraits)
Sources: *AmPrP 157; PrimPa 182; SoAmP 286.*

Wilson, Fanny
Flourished: 1795 Pennsylvania
Type of Work: Fabric (Family register samplers)
Sources: *GalAmS 32*.*

Wilson, G.
Flourished: c1850 Chillicothe, OH
Type of Work: Stone (Gravestones)
Sources: *EaAmG 129.*

Wilson, George W.
Flourished: 1850-1860
Type of Work: Charcoal (Drawings)
Sources: *PrimPa 182.*

Wilson, H.
See: H. Wilson and Company.

Wilson, Henry
Flourished: 1850 New Winchester, IN; Hendricks County, IN
Type of Work: Fabric (Weavings)
Sources: *AmSQu 277; ChAmC 118.*

Wilson, Henry
Flourished: 1855 Chicago, IL
Type of Work: Oil (Animal paintings)
Remarks: Exhibited with Wilson, Oliver
Sources: *ArC 267.*

Wilson, Hugh
b. 1803 d. 1884 Coatesville, IN
Flourished: 1824-1860 Shelbyville, KY; Hendricks County, IN; Coatesville, IN
Type of Work: Fabric (Weavings)
Sources: *ArtWea 139; ChAmC 118.*

Wilson, Ida
Type of Work: (Baskets)
Sources: *AfAmA 58-9*.*

Wilson, Isabella Maria
Flourished: c1826
Type of Work: Velvet (Still life paintings)
Sources: *CoCoWA 101*; Edith *.*

Wilson, James
Flourished: c1767 Providence, RI
Type of Work: Redware (Pottery)
Sources: *AmPoP 202; CoCoWA 101*.*

Wilson, James S.
Flourished: 1860 Mt. Sterling, IL
Type of Work: Clay (Pottery)
Sources: *ArC 194.*

Wilson, James W.
b. 1825 d. 1893
Flourished: 1851-Newburyport, MA
Type of Work: Wood (Ship carvings, ship figures)
Remarks: Brother is Alfred
Sources: *AmFiTCa 141, 203, figxx; ShipNA 69, 160.*

Wilson, Jane W.
See: Wilson, Alfred.

Wilson, Jeremy
Flourished: c1830-1840 Huntingdon, PA
Type of Work: Oil (Portraits)
Sources: *HerSa.*

Wilson, Job
Flourished: c1780-1791 Peabody, MA
Type of Work: Redware (Pottery)
Remarks: Son is Robert
Sources: *AmPoP 201.*

Wilson, John
Flourished: 1806 Orange County, NY
Type of Work: Fabric (Weavings)
Sources: *ChAmC 31, 118*
See: Alexander, James.

Wilson, John M.
[John M. Wilson Pottery]
Flourished: c1860 Guadalupe County, TX
Type of Work: Stoneware (Jugs)
Sources: *AmS 76*, 84*, 233*.*

Wilson, Jonathan
Flourished: c1850 West Indianapolis, IN
Ethnicity: Irish
Type of Work: Fabric (Weavings)
Sources: *ChAmC 118*
See: Muir, William; Shaw, Robert.

Wilson, Joseph
Flourished: 1798-1810 Newburyport, MA
Type of Work: Wood (Ship carvings, ship figures)
Museums: 263
Sources: *AmFiTCa 114, 124, 203, fig.xx; AmFoS 166*; EaAmW 74; ShipNA 160*
See: Joseph Wilson and Son.

Wilson, M.
Flourished: 1830-1840 Kalamazoo, MI
Type of Work: Oil (Portraits)
Sources: *FoPaAm 203*.*

Wilson, Maria
See: Vergara-Wilson, Maria.

Wilson, Mary R.
Flourished: 1820 Massachusetts
Type of Work: Watercolor (Paintings)
Sources: *AmFoAr 32; AmPrP 157; PrimPa 182.*

Wilson, Oliver
Flourished: 1855 Chicago, IL
Type of Work: Oil (Animal portraits)
Remarks: Exhibited with Wilson, Henry
Sources: *ArC 267.*

Wilson, Professor
See: Wilson, Charles T..

Wilson, Robert
Flourished: c1791-1803 Peabody, MA
Type of Work: Redware (Pottery)
Remarks: Father is Job
Sources: *AmPoP 201.*

Wilson, Robert B.
b. c1792
Flourished: c1842-1850 New Philadelphia, OH
Ethnicity: Scottish
Type of Work: Fabric (Carpets, coverlets)
Sources: *ChAmC 118.*

Wilson, Mrs. Russell
Flourished: 1950 Cincinnati, OH
Type of Work: Fabric (Quilts)
Museums: 046
Remarks: Grandmother is Smith, Mary Caroline W., who started quilt
Sources: *NewDis 53*.*

Wilson, Sally
See: Sabin, Sarah Smith.

Wilson, Sarah
See: Sabin, Sarah Smith.

Wilson, Steve
Flourished: contemporary
Type of Work: Whalebone (Scrimshaw)
Sources: *Scrim 23*.*

Wilson, Thomas
Flourished: 1845 Eagle Mills, NY
Type of Work: Oil (Cityscape paintings)
Museums: 001
Sources: *FoArA 45*.*

Wilson, William (A. Wilson)
Flourished: 1818 Madison County, NY
Ethnicity: Scottish
Type of Work: Fabric (Coverlets)
Sources: *ChAmC 118.*

Wilson and Schaettler
Flourished: 1853-1854 New York, NY
Type of Work: Wood (Ship carvings, ship figures)
Sources: *ShipNA 162.*

Wilton, Hobart Victory
[Welton]
Flourished: 1850 Waterbury, CT
Type of Work: Wood, stone, iron (Carved gates)
Sources: *AmFokAr 20, fig166; FlowAm 217*; InAmD 79*.*

Wiltz, Emilie
Flourished: 1830 New Orleans, LA
Type of Work: Fabric (Samplers)
Museums: 136
Sources: *AmNe 59.*

Wimar, Karl
[Weimar]
b. 1828 d. 1862
Flourished: St. Louis, MO; Springfield, IL
Ethnicity: German
Type of Work: Oil (Panoramic paintings)
Sources: ArC 222-3*.

Wimmer, Mrs. Marie
Flourished: 1924-1925 Belgium, WI
Type of Work: Wood (Sculptures)
Sources: FoAFp 2.

Windsor, Nathaniel
See: Winsor, Nathaniel.

Windsor, Samuel L.
See: Winsor, Samuel L..

"Windy"
Flourished: Ohio
Type of Work: Clay (Sewer tile sculpture)
Sources: IlHaOS *.

Wineland, N.W.
Flourished: 1880 Canterbury, OH
Type of Work: Pen, watercolor (Paintings)
Museums: 176
Sources: ColAWC 248, 250*; PrimPa 182.

Winfel, R.
Flourished: c1876 Perry, MO
Type of Work: Stoneware (Pottery)
Sources: AmPoP 227; Decor 226.

Wing, Samantha R. Barto
Flourished: 19th century Vermont
Type of Work: Fabric (Quilts)
Museums: 260
Sources: QuiAm 268*.

Wing, Zelinda
b. c1816
Flourished: 1826 Butternuts, NY
Type of Work: Fabric (Samplers)
Sources: GalAmS 66*.

Wingate, Mehitabel
Flourished: 1810 New England,
Type of Work: Watercolor (Memorial paintings)
Museums: 096
Sources: FoPaAm 35*.

Wingender, Carl
See: Wingender Brothers Pottery.

Wingender, Charles, Sr.
Flourished: 1890-1904 Haddonfield, NJ
Type of Work: Stoneware (Pottery)
Remarks: Son is Charles, Jr.
Sources: AmPoP 168, 285; Decor 226
See: Charles Wingender and Brother.

Wingender, Charles, Jr.
Flourished: 1890-1904 Haddonfield, NJ
Type of Work: Stoneware (Pottery)
Remarks: Father is Charles, Sr.
Sources: Decor 226.

Wingender, Jakob
Flourished: c1885 Haddonfield, NJ
Ethnicity: German
Type of Work: Stoneware (Pottery)
Sources: AmS 56, 148*, 244.

Wingender, William
See: Wingender Brothers Pottery.

Wingender Brothers Pottery
[Carl and William Wingender]
Flourished: 1805-1825,1850 Haddonfield, NJ
Type of Work: Clay (Pottery)
Sources: AmSFo 51*; EaAmFo 127*.

Wingert, George S.
Flourished: 1832-1838 Landisburg, PA
Type of Work: Fabric (Weavings)
Sources: AmSQu 277; ChAmC 118.

Wingert, Henry
b. c1826 Pennsylvania
Flourished: 1841-1848 Landisburg, PA
Type of Work: Fabric (Weavings)
Sources: AmSQu 277; ChAmC 118.

Winkelmeyer, Henry
d. 1871
Flourished: 1860-1870 Boonville, MO
Type of Work: Wood (Benches, cupboards)
Sources: ASeMo 314*.

Winkler, Matilda Amalia
Flourished: c1828 Salem, NC
Type of Work: Ink (Mourning pictures)
Sources: MoBeA fig31.

Winn, John A.
Flourished: Boston, MA
Type of Work: Metal (Weathervanes)
Remarks: Agent for Jewell and Cushing
Sources: YankWe 214.

Winnemore, Philip
Flourished: 1846 Philadelphia, PA
Type of Work: Wood (Ship carvings, ship figures)
Sources: AmFiTCa 203.

Winningham, Susan Elizabeth
Flourished: 1880 Allens, TN
Type of Work: Fabric (Striped woven blankets)
Sources: ArtWea 88*.

Winslow, Ebenezer
d. 1824
Flourished: Berkley, MA
Type of Work: Stone (Gravestones)
Sources: EaAmG 129; GravNE 130.

Winslow, Ebenezer
b. 1772 d. 1841
Flourished: Uxbridge, MA
Type of Work: Stone (Gravestones)
Sources: EaAmG 129; GravNE 130.

Winslow, George Marcus
Flourished: 1855 Duxbury, MA
Type of Work: Wood (Duck decoys)
Sources: ArtDe 136*.

Winslow, J.T.
Flourished: c1857 Portland, ME
Type of Work: Stoneware (Pottery)
Sources: AmPoP 201.

Winslow, John T.
Flourished: 1846- Portland, ME
Type of Work: Stoneware (Pottery)
Sources: Decor 226.

Winsor, Fanny (Francis)
b. 1791 Providence, RI d. 1883 Providence, RI
Flourished: 1802 Providence, RI
Type of Work: Embroidery (Still life pictures)
Sources: LeViB 164*.

Winsor, John
Flourished: Duxbury, MA
Type of Work: Wood (Duck decoys)
Sources: AmBiDe 88*.

Winsor, Nancy
b. 1778 Providence, RI d. 1850 Providence, RI
Flourished: 1786 Providence, RI
Type of Work: Fabric (Samplers)
Museums: 241
Sources: EaAmI 57-8; LeViB 99-100, 113, 117, 148-9*.

Winsor, Nathaniel
[Windsor]
Flourished: 1820 Bath, ME; Duxbury, MA
Type of Work: Wood (Ship carvings, ship figures)
Sources: AmFiTCa 142, 203; ShipNA 156, 160.

Winsor, Samuel L.
[Windsor]
Flourished: 1832-1848 Boston, MA
Type of Work: Wood (Ship carvings, ship figures)
Sources: AmFiTCa 31, 203, figv; ShipNA 159.

Winsor, Susan Jenckes
b. 1789 Providence, RI d. 1879 Providence, RI
Flourished: 1803 Providence, RI
Type of Work: Embroidery (Memorial pictures)
Sources: LeViB 148.

Winsor and Brother
Flourished: 1848 Boston, MA
Type of Work: Wood (Ship carvings, ship figures)
Sources: AmFiTCa 203.

Winstanley, William
Flourished: 1800 Philadelphia, PA
Type of Work: Oil (Portraits)
Sources: *AmPrP 157; PrimPa 182.*

Winter, Henry
Flourished: contemporary Long Island, NY
Type of Work: Wood (Sculptures, carvings)
Sources: *WoCar 25*; WoScuNY.*

Winter, John
Flourished: c1760-1771 Charles County, MD
Type of Work: Paint (Floor paintings)
Sources: *AmDecor 7; FloCo 19.*

Winter, William(?)
Flourished: 1855 Chicago, IL
Type of Work: (Miniature paintings)
Sources: *ArC 267.*

Winterbotham, Mrs. John Humphrey
Flourished: 1830 Chicago, IL
Type of Work: Fabric (Samplers)
Sources: *AmNe 63.*

Winthrop, John
Flourished: 1645-1646 Saugus, MA
Type of Work: Iron (Ironware)
Sources: *AmCoTW 13.*

Wippich, Louis C.
b. 1896 Gilman, MN d. 1973 Sauk Rapids, MN
Flourished: 1949 Sauk Rapids, MN
Type of Work: Stone, clay (Environmental sculpture)
Sources: *NaiVis 86-93*.*

Wirick, John
b. c1808 Pennsylvania
Flourished: 1848-1861 Midway, OH; Johnson Township, OH
Type of Work: Fabric (Weavings)
Remarks: Son is William
Sources: *AmSQu 277; ChAmC 118.*

Wirick, William
Flourished: c1849-1850 Johnson Township, OH
Type of Work: Fabric (Weavings)
Remarks: Father is John
Sources: *ChAmC 118.*

Wirig, Nicholas
Flourished: 1860-1896 Rock Island, IL
Type of Work: Oil (Paintings)
Museums: 001
Sources: *FoPaAm 207*.*

Wisdom, Sarah B.
Flourished: 1812-1818 Richmond, VA
Type of Work: Fabric (Bedcovers)
Museums: 001
Sources: *SoFoA 200*, 223.*

Wise, E.
Flourished: 1842 Derry Township, PA
Type of Work: Fabric (Coverlets)
Sources: *ChAmC 118.*

Wise, H.
Flourished: 1838-1839 Leacock Township, PA
Type of Work: Fabric (Weavings)
Sources: *ChAmC 120.*

Wissler, Cornelia Everhart
Flourished: 1857-1907
Type of Work: Fabric (Quilts)
Museums: 063
Sources: *QuiAm 232*.*

Wissler, John
[Whisler]
b. 1816 Lancaster County, PA d. 1896
Flourished: 1833-1846 Milton, IN
Type of Work: Fabric (Weavings)
Sources: *AmSQu 277; ChAmC 120*
See: Snyder, John; Marr, John.

Wistar, Casper
b. 1676 d. 1752
Flourished: 1739- Salem County, NJ; Philadelphia, PA
Ethnicity: German
Type of Work: Glass, brass (Bottles, buttons)
Museums: 058
Sources: *AmCoB 223; AmSFo 82; AmSFok 120-2*; CoCoWA 76*; InAmD 96, 169.*

Wistar, Sarah
b. c1738
Flourished: 1752 Philadelphia, PA
Type of Work: Fabric (Embroidered pictures, samplers)
Sources: *PlaFan 80*; WinGu 90*, 103.*

Witherle, Joshua
Flourished: c1775-1800 Boston, MA
Type of Work: Copper (Warming pans)
Sources: *AmCoB 88, 89*.*

Witherstone, Phillip
Flourished: 1773 Charleston, SC
Type of Work: Wood (Ship carvings, ship figures)
Sources: *ShipNA 163.*

Witmann, John H.
Flourished: 1850 Hermann, MO
Ethnicity: German
Type of Work: (Baskets)
Sources: *ASeMo 411.*

Witmer, Galen (Gale)
b. 1859 Pennsylvania d. 1936
Flourished: 1860-1880s(?) Hartleton, PA; Mifflinburg, PA
Type of Work: Tin (Tinware)
Remarks: Son of Philip
Sources: *ToCPS 21-2, 43.*

Witmer, Henry
b. Pennsylvania
Flourished: Pennsylvania
Type of Work: Tin (Tinware)
Sources: *ToCPS 22.*

Witmer, Jacob
b. c1814 Pennsylvania d. 1887 Lancaster, PA
Flourished: 1837-1851 Lancaster County, PA
Type of Work: Fabric (Weavings)
Sources: *AmSQu 277; ChAmC 120.*

Witmer, Peter
b. Pennsylvania
Flourished: Pennsylvania
Type of Work: Tin (Tinware)
Sources: *ToCPS 22.*

Witmer, Philip
b. Pennsylvania
Flourished: Pennsylvania
Type of Work: Tin (Tinware)
Remarks: Father of Galen
Sources: *ToCPS 22, 43.*

Witmer and Brothers
See: Cope, Thomas.

Witt
Flourished: 1847 New York
Type of Work: Fabric (Weavings)
Sources: *AmSQu 277; ChAmC 120.*

Wittfield, Henry
Flourished: 1860 Philadelphia, PA
Type of Work: Wood (Ship carvings, ship figures)
Sources: *AmFiTCa 203.*

Wohe, W. (Wolfe)
Flourished: 1860 Pittsfield, MI
Type of Work: Fabric (Weavings)
Sources: *AmSQu 277; ChAmC 120.*

Wohlfahrt, Daniel
See: Welfare, Daniel.

Wolf, Adam
b. c1816 Pennsylvania
Flourished: 1835-1852 Blooming Grove, OH
Type of Work: Fabric (Weavings)
Sources: *AmSQu 277; ChAmC 120.*

Wolf, H.
Flourished: 1852-1858 Ohio
Type of Work: Fabric (Weavings)
Sources: *ChAmC 120.*

Wolf, William
Flourished: 1836 Hanover, OH
Type of Work: Fabric (Weavings)
Sources: *ChAmC 120.*

Wolfe, John C.
Flourished: c1860 Chicago, IL
Type of Work: (Landscape paintings)
Sources: *ArC 267.*

Wolfe, William
Flourished: 1848-1881 Blountsville, TN; Big Spring Gap, VA
Type of Work: Redware, brownware, stoneware (Pottery)
Sources: *AmPoP 87, 236.*

Wolfert, Frank
b. 1906
Flourished: 1980 Wisconsin
Ethnicity: Dutch
Type of Work: Wood (Sculptures)
Sources: *FoAFl 8-9*.*

Wolfinger, August
[Michelangelo of the Midway]
b. 1879 d. 1950
Flourished: Brooklyn, NY
Ethnicity: German
Type of Work: Oil (Circus banners)
Sources: *AmSFor 60-1*.*

Wood
Flourished: c1870 Dayton, OH
Type of Work: Clay (Pottery)
Sources: *AmPoP 213; DicM 144*.*

Wood
See: White and Wood.

Wood, Hanna
Flourished: 1870 New Hampshire
Type of Work: Watercolor (Portraits)
Sources: *AmPrP 157; PrimPa 182.*

Wood, J.C.
d. 1860 East Ashtabula, OH
Flourished: 1836 East Village, OH
Type of Work: Fabric (Weavings)
Sources: *ChAmC 120.*

Wood, John
Flourished: 1870 New York
Type of Work: Wood (Carved shrines)
Sources: *FouNY 64*.*

Wood, Mrs. Jonathan
Flourished: 1850-1890 Ohio
Type of Work: Fabric (Quilts)
Sources: *QuiAm 172*.*

Wood, Joseph
Flourished: c1750
Type of Work: Brass (Candlesticks)
Sources: *AmCoB 237*, 240.*

Wood, Orison
b. 1811 d. 1842
Flourished: c1830 Webster Corner, ME
Type of Work: Oil (Ornamental paintings)
Remarks: Follower of Porter, Rufus
Sources: *AmDecor 126-7*, 153; AmFoPa 141; AmFoPaN 114, 151*.*

Woodbridge, Dudley
See: Pitkin, Richard; Woodbridge, Dudley.

Woodcocke
Flourished: c1850 Middle Woodbury Township, PA
Type of Work: Fabric (Coverlets)
Sources: *ChAmC 120.*

Wooden, J.A.
[Woodin]
Flourished: 1830 Palmyra, NY
Type of Work: Watercolor (Portraits)
Sources: *AmPrP 157; PrimPa 182.*

Woodhouse, Eulalie E.
Flourished: 1891-1928 Newark, NJ
Type of Work: Fabric (Quilts)
Museums: 175
Sources: *NewDis 33*.*

Woodman, Samuel
Flourished: 1800-1820 Poultney, VT
Type of Work: Redware, stoneware (Pottery)
Sources: *AmPoP 202.*

Woodnutt, Martha
Flourished: 1814 Westtown, PA
Type of Work: Fabric (Samplers)
Sources: *GalAmS 50*, 91.*

Woodnutt, Rachel Goodwin
b. 1787 d. 1828
Flourished: Salem, NJ
Type of Work: Fabric (Needlework quilts)
Sources: *WinGu 111*.*

Woodring
[Woodring and Seidenspinner]
Flourished: c1860-1870 Allentown, PA; Emmaus, PA
Type of Work: Fabric (Coverlets)
Sources: *ChAmC 120*
See: Seidenspinner, John.

Woodruff, D.C.
Flourished: 1850 Elizabeth, IL
Type of Work: Clay (Pottery)
Sources: *ArC 193.*

Woodruff, Madison
Flourished: c1849-1889? Cortland, NY
Type of Work: Stoneware, clay (Pottery)
Museums: 059,203
Sources: *AmPoP 191, 285; Decor 71*, 101*, 175*, 226; DicM 94*.*

Woods, David
d. 1975
Flourished: Kansas
Type of Work: Various materials (Environmental sculptures)
Museums: 283
Sources: *FoAFd 9.*

Woods, Martin
Flourished: c1795 Whateley, MA
Type of Work: Stone (Gravestones)
Sources: *EaAmG 129.*

Woodside, John A.
Flourished: Philadelphia, PA
Type of Work: Paint (Decorated fire engines, hose carts)
Sources: *AmFokDe 130; HisCr 65, 67*.*

Woodward, Cordelia Caroline Sentenne
Flourished: 1893 Johnsburgh, NY
Type of Work: Oil (Farm house paintings)
Sources: *FouNY 67*.*

Woodward and Vodrey
Flourished: 1849 East Liverpool, OH
Type of Work: Yellow-ware (Pottery)
Sources: *AmPoP 215.*

Woodward, Blakely and Company
Flourished: 1849- East Liverpool, OH
Type of Work: Yellow-ware, Rockingham (Pottery)
Sources: *AmPoP 76, 78, 215.*

Woolrich Woolen Mills
Flourished: c1862 Woolrich, PA
Type of Work: Fabric (Weavings)
Sources: *ChAmC 122.*

Woolridge, Henry C.
b. 1822 Williamson County, KY d. 1899 Mayfield, KY
Remarks: Sponsored 12 life sized sculptures of his family, friends
Sources: *AmFoS 20*; FoAroK;SoFoA 220*
See: Lydon, Wm. C.

Woolson, Ezra
b. 1842
Flourished: Boston, MA
Type of Work: Oil (Paintings)
Sources: *AmPrP 157; FoArtC 119*; PrimPa 182.*

Woolum, Wayne
b. 1947 Swan Lake, KY
Flourished: contemporary Barbourville, KY
Type of Work: Matchsticks, matchboxes, cigar boxes, leather (Frames, lamps, wallets, purses)
Sources: *GoMaD *.*

Woolworth, Charlotte A.
Flourished: 1865 New Haven, CT
Type of Work: Pastel (Dog portraits)
Museums: 307
Sources: *AmPrP 157; PicFoA 69*; PrimPa 182.*

Woolworth, F.
[Ballard Pottery]
Flourished: 1872-1895 Burlington, VT
Type of Work: Stoneware (Pottery)
Sources: *AmPoP 190; Decor 226.*

Wooster, A.N.
Flourished: 1860 New York, NY
Type of Work: Wood (Ship carvings, ship figures)
Sources: *ShipNA 162.*

Wooster, A.V.
Flourished: 1860 Buffalo, NY
Type of Work: Wood (Ship carvings, ship figures)
Sources: *AmFiTCa 203.*

Worcester
See: Bulger and Worcester.

Worcester, Caroline
Flourished: 1823 Massachusetts
Type of Work: Watercolor (Mourning paintings)
Sources: *MoBeA.*

Worcester, Jonathan
b. 1707 Bradford?, MA? d. 1754
Flourished: c1745-1748 Harvard, MA; Groton, MA; Lancaster, MA
Type of Work: Stone (Gravestones)
Remarks: Son is Moses
Sources: *EaAmG 25*, 129; GravNE 77-8, 130.*

Worcester, Moses
b. 1739
Flourished: Harvard, MA; Groton, MA
Type of Work: Stone (Gravestones)
Remarks: Father is Jonathan
Sources: *EaAmG 129; GravNE 78, 130.*

Worchester, Samuel
Flourished: 1872-1875 East Liverpool, OH
Type of Work: Yellow-ware (Pottery)
Sources: *AmPoP 218.*

Wores, H.
Flourished: c1825-1846 Dover, OH
Type of Work: Stoneware (Pottery)
Sources: *AmPoP 213; Decor 226; DicM 63*.*

Works, Laban H.
Flourished: c1845 New Philadelphia, OH; Newport, OH
Type of Work: Stoneware (Pottery)
Sources: *AmPoP 225; Decor 226; DicM 85*.*

Worley, W.C.
Flourished: Lewistown, IL
Type of Work: Fabric (Weavings)
Sources: *ChAmC 122.*

Worstall, Edwin
See: Bluebird Pottery.

Worth, D.J.
Flourished: c1863
Type of Work: Whalebone (Scrimshaw)
Sources: *ScriSW 104*.*

Worthen, C.F.
Flourished: c1870 Peabody, MA
Type of Work: Stoneware (Pottery)
Sources: *Decor 226.*

Wray, H.
Flourished: Poughkeepsie, NY
Type of Work: Brass (Door locks)
Sources: *AmCoB 248*.*

Wrenn Brothers
Flourished: c1894 Seagrove, NC
Type of Work: Stoneware (Jugs)
Sources: *AmS 77*.*

Wright
See: Tyron, Wright and Company.

Wright, Alexander
Flourished: 1846-1860 Tauton, MA; Barnstable, MA
Type of Work: Stoneware (Pottery)
Sources: *Decor 226*
See: Standish, Alexander.

Wright, Almira Kidder
Flourished: early 19th cent Vermont
Type of Work: Watercolor (Paintings)
Sources: *AmPrP 157; PrimPa 182.*

Wright, Alpheus
Flourished: c1820 Rockingham, VT
Type of Work: Stone (Gravestones)
Sources: *EaAmG 129.*

Wright, Cruger
Flourished: Elizabethtown, NJ
Type of Work: Tin (Tinware)
Sources: *TinC 93, 184.*

Wright, Dan
Flourished: Bloomfield, CT
Type of Work: Tin (Tinware)
Sources: *AmCoTW 59; TinC 184.*

Wright, Dean C.
Flourished: c1841-1844 Warren, RI
Type of Work: Pen, watercolor (Drawings)
Museums: 123
Sources: *WhaPa 76*, 88*.*

Wright, Edward Harland
Flourished: 1850 Norwich, CT
Type of Work: Oil (Portraits)
Sources: *PrimPa 182.*

Wright, Franklin
Flourished: 1850-1854 Ashfield, MA
Type of Work: Stoneware (Pitchers)
Remarks: Worked for Hastings and Belding Pottery
Sources: *AmS 111.*

Wright, George Fredrick
Flourished: Connecticut
Type of Work: Oil (Portraits)
Museums: 044
Sources: *ArC 90*, 130.*

Wright, Isaac
See: Isaac Wright and Company.

Wright, J(ames) H(enry)
b. 1813 d. 1883
Type of Work: Oil (Ship paintings)
Museums: 176
Sources: *AmFoPa 120*; FlowAm 58*.*

Wright, Kate Vaughan
b. 1875 Floyd, VA d. 1970 Floyd, VA
Flourished: 1940-1960 Floyd, VA
Type of Work: Fabric (Quilts)
Sources: *ArtWo 18.*

Wright, L.G.
Flourished: Chesapeake Bay, VA
Type of Work: Oil (Portraits)
Sources: *BirB 141-2, 150.*

Wright, Mother Lucy
Ethnicity: Shaker
Type of Work: (Spirit drawings)
Sources: *HanWo 176.*

Wright, Lydia
Flourished: 1725-1775 Sandwich, MA
Type of Work: Fabric (Embroidered pictures)
Sources: *WinGu 29*.*

Wright, Malcolm
Flourished: c1796 Philadelphia, PA
Type of Work: Tin (Tinware)
Sources: *AmCoTW 153; ToCPS 6.*

Wright, Mary
Flourished: 1758 Middletown, CT
Type of Work: Fabric (Needlework pocketbooks)
Sources: *WinGu 58*, 123-5*.*

Wright, Morrison
Flourished: 1848 Louisville, KY
Type of Work: Wood (Ship carvings, ship figures)
Sources: *AmFiTCa 203.*

Wright, Moses
Flourished: c1800 Rockingham, VT
Type of Work: Stone (Gravestones)
Sources: *EaAmG 129.*

Wright, Patience
b. 1725 d. 1786
Flourished: c1784 Philadelphia, PA; Bordentown, NJ
Ethnicity: Quaker
Type of Work: Wax, paper (Portraits)
Sources: *AmFoSc 38; FoArtC 171.*

Wright, Ruth
Flourished: 1815 Exeter, PA
Type of Work: Fabric (Global samplers)
Sources: *EaAmI 61*; WinGu 21*.*

Wright, Solomon, Jr.
Flourished: c1830 Rockingham, VT
Type of Work: Stone (Gravestones)
Sources: *EaAmG 129.*

Wright, Thomas Jefferson
b. 1798 d. 1846
Flourished: Houston, TX
Type of Work: Oil (Portraits)
Museums: 277
Sources: *FoA 470; FoPaAm 227*, 229*, 235, 238.*

Wright Manufacturers
See: Chapman, Upson, and Wright Manufacturers.

Wrightman, John
Flourished: c1815 Berlin, CT
Type of Work: Tin (Tinware)
Remarks: Worked for Filley
Sources: *TinC 184.*

Wuertz, Adam
Flourished: 1820 York County, PA
Type of Work: Watercolor, ink (Frakturs)
Sources: *NinCFo 189.*

Wunterlich, John
Flourished: 1857-1858 Norton Township, OH
Type of Work: Fabric (Coverlets)
Sources: *ChAmC 122.*

Wyant, David
Flourished: 1850-1875 Seneca County, OH
Type of Work: Clay (Pottery)
Sources: *EaAmFo 166*.*

Wyatt, David Clarence "Snap"
b. 1905 North Carolina
Flourished: 1950 Brooklyn, NY
Type of Work: Oil (Circus banners)
Sources: *AmSFor 52*, 57*, 61*; TwCA 229*.*

Wybrant
Flourished: 1850 Gloucester, MA
Type of Work: Watercolor (Portraits)
Sources: *PrimPa 182.*

Wychoff, Ellen
Flourished: 1810 New York, NY
Type of Work: Fabric (Mourning samplers)
Museums: 184
Sources: *AmNe 81-2*.*

Wylie, John
Flourished: 1870-1874 Pittsburgh, PA
Type of Work: White Granite (Pottery)
Sources: *AmPoP 228.*

Wylie Brothers
Flourished: c1848-1854 East Liverpool, OH; Pittsburgh, PA
Type of Work: Yellow-ware, Rockingham (Pottery)
Sources: *AmPoP 215.*

Wyllie, Alexander
Type of Work: Metal (Weathervanes)
Museums: 260
Sources: *YankWe 118*.*

Wyllis, Elizabeth
Flourished: early 18th cent Connecticut
Type of Work: Fabric (Crewel bedspreads)
Sources: *AmNe 32-3*.*

Wyman
See: McAleese and Wyman.

Wyman, Samuel D.
b. 1828
Flourished: Bath, ME; Waldoboro, ME
Type of Work: Wood (Ship carvings, ship figures)
Sources: *ShipNA 156-7.*

Wynkoop, Emma T.
Flourished: 1870 Pennsylvania
Type of Work: Oil (Landscape paintings)
Sources: *AmPrP 158; PrimPa 182.*

X-Y-Z

Yager, Rick
Type of Work: Whalebone (Scrimshaw)
Remarks: Drew the comic strip "Buck Rogers in the 25th Century"
Sources: *Scrim 25-7*, 106.*

Yale, E.A.
Flourished: Connecticut
Type of Work: Tin (Tinware)
Remarks: Associated with Hubbard
Sources: *TinC 184.*

Yale, Edwin R.
Flourished: Connecticut
Type of Work: Tin (Tinware)
Remarks: Son of William
Sources: *TinC 184.*

Yale, Hiram
Flourished: Meriden, CT
Type of Work: Tin (Tinware)
Remarks: Brother of Samuel
Sources: *TinC 184.*

Yale, Samuel
Flourished: c1799 Meriden, CT
Type of Work: Tin (Tinware)
Remarks: Brothers are Hiram and Edwin R.
Sources: *TinC 184.*

Yale, William
See: Yale, Samuel.

Yardy, Christian
[Yordy]
b. c1811 Pennsylvania
Flourished: 1835-1852 West Lampeter Township, PA; Conestoga Township, PA
Type of Work: Fabric (Weavings)
Sources: *AmSQu 277; ChAmC 122.*

Yates
See: Rhodes and Yates.

Yates, H.H.
Flourished: c1840 Chicago, IL
Type of Work: Stoneware (Pottery)
Sources: *ArC 190, 186*.*

Yeager, John Philip
b. 1823 d. 1899
Flourished: Baltimore, MD
Ethnicity: German
Type of Work: Wood (Cigar store Indians, figures)
Museums: 144,203
Sources: *AmFoS 164*, 251*; ArtWod 126-32*, 80-1.*

Yearous, Adam
b. c1827
Flourished: 1847-1867 Jackson Township, OH
Ethnicity: German
Type of Work: Fabric (Weavings)
Sources: *ChAmC 122.*

Yearous, F.
Flourished: 1840-1858 Ashland County, OH
Type of Work: Fabric (Coverlets)
Sources: *AmSQu 277; ChAmC 122.*

Yellin, Harvey
Flourished: Philadelphia, PA
Type of Work: Metal (Weathervanes, ornamental metal works)
Remarks: Succeeded his father Samuel
Sources: *WeaVan 25*
See: Samuel Yellin Company.

Yergin, William K.
b. c1813 Pennsylvania
Flourished: c1850-1852 Sugar Creek Township, OH
Type of Work: Fabric (Weavings)
Sources: *ChAmC 122.*

Yingst, David
b. c1818 Pennsylvania d. 1889
Flourished: c1842-1889 Lebanon, PA
Type of Work: Fabric (Weavings)
Sources: *ChAmC 122*
See: Meily Jr., Emmanuel.

Yoakum, Joseph E.
b. 1886 Window Rock, AZ d. 1972 Chicago, IL
Flourished: 1962-1970 Chicago, IL
Ethnicity: Black American?, American Indian?
Type of Work: Crayon, pen, watercolor, pastel (Landscape and fantasy drawings)
Remarks: Navajo tribe
Sources: *AmFokArt 325-8*; BlFoAr 162-7*; FoA 470; FoAFr 7-8*; Full *; HoKnAm 186*; Trans6-7, 21*-2*, 55; TwCA 176*.*

Yoder, Amanda Sunthimer
Flourished: 1915-1930 Middlebury, IN; Honeyville, IN
Ethnicity: Amish
Type of Work: Fabric (Quilts)
Sources: *QuflnA 29*, 47*, 81*.*

Yoder, Amelia
Flourished: 1930 Honeyville, IN
Ethnicity: Amish
Type of Work: Fabric (Quilts)
Sources: *QuflnA 51*.*

Yoder, Mrs. Daniel T.
Flourished: 1915 Topeka, IN
Ethnicity: Amish
Type of Work: Fabric (Quilts)
Sources: *QuflnA 64*.*

Yoder, Fanny
Flourished: 1875 Indiana
Ethnicity: Amish
Type of Work: Fabric (Quilts)
Sources: *QuflnA 60*.*

Yoder, Lydia
Flourished: c1875 Indiana
Ethnicity: Amish
Type of Work: Fabric (Quilts)
Sources: *QuflnA 60*.*

Yoder, Mrs. Menno
Flourished: 1935-1943 Emma, IN
Ethnicity: Amish
Type of Work: Fabric (Quilts)
Sources: *QuflnA 23*, 46*.*

Yoder, Mrs. Mose V.
d. 1980
Flourished: 1975 Honeyville, IN
Ethnicity: Amish
Type of Work: Fabric (Quilts)
Sources: *QuInA 42**.

Yoder, Mrs. Yrias V. (Mrs. Urias V.) (Anna)
Flourished: 1900-1930 Honeyville, IN; Topeka, IN
Ethnicity: Amish
Type of Work: Fabric (Quilts)
Sources: *QuInA 46*, 48*, 69*, 85**.

Yordy, Benjamin
b. c1820 Pennsylvania
Flourished: c1850-1858 Conestoga Township, PA
Type of Work: Fabric (Weavings)
Sources: *ChAmC 122*
See: Patterson, Thomas.

Yordy, Christian
See: Yardy, Christian.

York, H.F.
Flourished: 1880- Lake Butler, FL
Type of Work: Redware (Pottery)
Sources: *AmPoP 239*.

Yost, Sallie
Flourished: 1884-1893 Missouri
Type of Work: Fabric (Quilts)
Sources: *QuiAm 177**.

Young
Flourished: c1840s Cincinnati, OH
Type of Work: Fabric (Weavings)
Sources: *ChAmC 122*.

Young, Abraham
Flourished: 1840 Waltersville, MD
Type of Work: Fabric (Coverlets)
Sources: *ChAmC 122*.

Young, Brigham
Flourished: Mendon, NY
Type of Work: Wood (Furniture)
Sources: *ArC 195, 198**.

Young, Celestia
Flourished: 1856 Plymouth, MI
Type of Work: Oil (Paintings)
Museums: 096
Sources: *AmFoS 337*; ArtWo 101*, 174*.

Young, Charles
Flourished: 1838-1844 Mechanicsburg, PA
Type of Work: Fabric (Weavings)
Sources: *ChAmC 122*
See: Williams, John T.; Seifert, Andrew.

Young, H(enry)
b. 1792 d. 1861
Flourished: 1820-1838 Union County, PA
Type of Work: Watercolor, ink (Frakturs)
Sources: *AmFoPa 189, 214; BeyN 124; FoPaAm 135*; HerSa *; NinCFo 169, 189, fig75*.

Young, J(ames) Harvey
b. 1830 Massachusetts d. 1918
Flourished: Medford, MA; Boston, MA
Type of Work: Oil (Portraits)
Museums: 088
Sources: *AmFoPa 91*; AmPrP 157; PrimPa 182; SoAmP 85**.

Young, John
b. 1891
Flourished: East Lansing, MI
Type of Work: Paint, wood, metal (Whirligigs, wind machines, paintings, drawings)
Sources: *Rain 70*-1**.

Young, John W.
b. c1804 New York
Flourished: 1832-1853 Fort Jefferson, OH; Center Township, IN; New York
Type of Work: Fabric (Quilts, weavings, coverlets)
Sources: *ChAmC 122-23; QuiAm 165**.

Young, Matthew
b. 1813 d. 1890
Flourished: 1851-1881 Canton, IN; Greensburg, IN
Type of Work: Fabric (Weavings)
Sources: *AmSQu 277; ChAmC 122*
See: Craig, James.

Young, Nathaniel
Flourished: 1840s Bergen County, NJ; Hudson County, NJ
Type of Work: Fabric (Coverlets)
Sources: *ArtWea 242; ChAmC 123*.

Young, Peter
b. c1826
Flourished: c1860 Allentown, PA
Ethnicity: German
Type of Work: Fabric (Coverlets)
Sources: *ChAmC 123*.

Young, Reverend
Flourished: 1825-1840 Centre County, PA
Type of Work: Oil (Portraits)
Remarks: Believed to be the son of Young, H(enry)
Sources: *AmFokDe xii*; AmFoPa 189, 214; NinCFo 169, 189, fig76; PicFoA 146*; PrimPa 182*.

Young, S.
Flourished: c1840 Chillicothe, OH
Type of Work: Stone (Gravestones)
Sources: *EaAmG 129*.

Young, Samuel
Flourished: c1850 Martin's Ferry, OH
Type of Work: Stoneware (Pottery)
Sources: *AmPoP 223; Decor 226*.

Young, William
b. 1711 d. 1795
Flourished: 1740-1795 Worcester, MA
Ethnicity: Irish
Type of Work: Stone (Gravestones)
Sources: *EaAmG 34-5*, 129; GravNE 80-5, 130; HoKnAm 25**.

Young, William
Flourished: 1803 Philadelphia, PA
Type of Work: Wood (Ship carvings, ship figures)
Sources: *AmFiTCa 203*.

Youngs, Benjamin S.
b. 1774 d. 1855
Flourished: 1840 Watervliet, NY
Ethnicity: Shaker
Type of Work: Wood (Clocks)
Sources: *HanWo 182-3; InAmD 22**.

Youngs, Icabod
Flourished: 1834 Brooklyn, NY
Type of Work: Wood (Ship carvings, ship figures)
Sources: *AmFiTCa 203*.

Youngs, Isaac N(ewton)
b. 1793 d. 1865
Flourished: 1840 New Lebanon, NY
Ethnicity: Shaker
Type of Work: Wood (Clocks)
Sources: *HanWo 182-3**.

Zabbart, M.
Flourished: 1835 Highland, IL
Type of Work: Redware? (Pottery)
Sources: *ArC 190*.

Zachmann, John
Flourished: Michigan
Type of Work: Wood (Decoys)
Sources: *WaDec 12*, 118**.

Zahn, Albert
d. c1950
Flourished: 1950s Bailey's Harbor, WI
Ethnicity: German
Type of Work: Wood (Sculptures, religious carvings)
Museums: 044
Sources: *AmFoS 190**.

Zalar, John
Flourished: 1903 Philadelphia, PA
Type of Work: Wood (Circus and carousel figures)
Remarks: Head carver for the Tobaggan Company
Sources: *AmSFor 18*; CaAn 52-3**.

Zanesville Stoneware Company
Flourished: 1887-1900 Zanesville, OH
Type of Work: Stoneware (Pottery)
Sources: *AmPoP 234*.

Zarn, George
Flourished: 1843 Schaefferstown, PA
Type of Work: Fabric (Weavings)
Sources: *ChAmC 123*.

Zaumzeil, Ernestine Eberhardt
Flourished: c1865 Chandlerville, IL
Type of Work: Fabric (Quilts)
Sources: *ArtWo 46, backcover, notes on backcover*.

Zeitz, Frederick
Flourished: 1875 Philadelphia, PA
Type of Work: Tin (Tinware)
Sources: *BeyN 36*, 106*, 111*
See: Zeitz, Louis.

Zeitz, Louis
Flourished: 1825 Philadelphia, PA
Type of Work: Tin (Tinware)
Sources: *BeyN 36*, 106*, 111*
See: Zeitz, Frederick.

Zeldis, Malcah
b. 1932 New York, NY
Flourished: c1960s- New York, NY
Ethnicity: Jewish
Type of Work: Oil, acrylic (Paintings)
Museums: 169,170,171,178
Remarks: Paintings are social and political commentary
Sources: *AmFokArt 329-32; ArtWo 126*, 143-4*, 174; BirB 142*; FoA 47*, 470; FoAFcd 4*-5, 7*; FoPaAm 110-1, 130*; Full *; Rain 76-8*; TwCA 207*.*

Zell, William D.
Flourished: Lancaster, PA
Type of Work: Copper (Stencils)
Sources: *AmCoB 118*.*

Zeller, George
b. 1818 d. 1889
Flourished: Pennsylvania
Type of Work: Watercolor, ink (Frakturs)
Sources: *FoA 470.*

Zelna, A.
Flourished: c1840 Plumstead Township, PA
Type of Work: Fabric (Coverlets)
Museums: 189
Sources: *FoArRP 72*.*

Zelner, Aaron
b. 1812 Pennsylvania d. 1893
Flourished: 1840-1845 Bucks County, PA
Type of Work: Fabric (Weavings)
Sources: *ChAmC 123.*

Zent, August
Flourished: after 1940 Michigan
Type of Work: Wood (Fish decoys)
Sources: *UnDec 20.*

Ziegler, H.
[Zeigler]
Flourished: 1840
Type of Work: Watercolor (Portraits)
Sources: *AmPrP 158; PrimPa 182.*

Zinck, John
Flourished: 1834 Pennsylvania
Type of Work: Watercolor, ink (Frakturs)
Sources: *AmFoPa 189.*

Zinck, John
b. c1827 d. 1880
Flourished: 1851 York, PA
Ethnicity: German
Type of Work: Fabric (Coverlets)
Sources: *ChAmC 123.*

Zingale, Larry
b. Florida, NY
Flourished: 1977 New York, NY
Type of Work: Oil (Paintings)
Museums: 178
Sources: *AlAmD 48*; AmFokArt 333-6.*

Zipf, Jacob
[Union Pottery]
Flourished: 1877-1906 Newark, NJ
Type of Work: Stoneware (Pottery)
Sources: *Decor 226.*

Zoar Industries
Flourished: 1871 Zoar, OH
Type of Work: Fabric (Weavings)
Sources: *ChAmC 123.*

Zoar Pottery
Flourished: 1818-1845 Zoar, OH
Type of Work: Clay (Pottery)
Sources: *AmSFok 130*; DicM 125*; EaAmFo 31, 204*, 220*.*

Zoarite Community Pottery
Flourished: 1836 Zoar, OH
Type of Work: Clay (Pottery)
Sources: *EaAmFo 31, 204*, 220*.*

Zoller, George
Flourished: Pennsylvania
Type of Work: Watercolor, ink (Frakturs)
Sources: *FoPaAm fig44.*

Zom
See: Eval and Zom.

Zook, J.W.
Flourished: 1880 Oak Grove, IL
Type of Work: Watercolor (Horse portraits, frakturs)
Museums: 096
Sources: *FoA 470; FoPaAm 195*.*

Zornfall, Martin
Flourished: 1812 Pennsylvania
Type of Work: Watercolor, ink (Frakturs)
Sources: *AmFoPa 189.*

Zufall, Moses
b. c1830
Flourished: c1850 Somerset Township, PA
Type of Work: Fabric (Weavings)
Sources: *ChAmC 123*
See: Casebeer, Aaron.

Zug, Johan
Flourished: 1788 Pennsylvania
Type of Work: Watercolor, ink (Frakturs)
Sources: *AmFoPa 189.*

Zuricher, John
Flourished: c1785 New York, NY; Southhampton, NY
Type of Work: Stone (Gravestones)
Sources: *EaAmG 64-5*, 129.*

INDEXES

Art Locator Index

(See the "Special Indexes to Contents" section of the Introduction for an explanation of this index and its limitations.)

Abby Aldrich Rockefeller Folk Art Center
Aldridge
Arnold, John James Trumbull
Badger, Joseph
Bahin, Louis Joseph
Barnes, Lucius
Bartlett, Jonathan Adams
Bartoll, William Thompson
Bascom, Ruth Henshaw
Bedell, Prudence
Blunt, John Samuel
Bradley, I. (John)
Brown, Hannah
Cady, Emma Jane
Corbin
Corwin, Salmon W.
Crafft, R.B.
Dalee, Justus
Dare, Charles W.F.
Davis, E(ben) P(earson)
Davis, J(ane) A.
Davis, Joseph H.
Doolittle, Amos
Dowler, Charles Parker
Edmonson, William
Field, Erastus Salisbury
Finch, Ruby Derd
French, B.
Gillespie, J.H.
Goldsmith, Deborah (Throop)
Goodell, Ira Chaffee
Hall, George Henry
Hamblen, Sturtevant J.
Hamilton, Charles J.
Hamilton, James
Harley, Steve
Hart, Anna S.
Hathaway, Rufus, Dr.
Herring, James
Hicks, Edward
Hidley, Joseph H.
Hillyer, William, Jr.
Hoffman, C.W. (Charles L.)
Jester, Doug (S.D.M.)
Jordan, Samuel
Joy, Caroline
Lathrop, Betsy B.
Lawrence, L.G.
Maental, Jacob
Marshall, Emily
McKay
McKillop, Edgar Alexander
Mohler, Anny
Morton, Emily
Mountz, Aaron
Nissen, Charles
Norris, William
North, Noah
Overton, Nathan
Palmer, Ch.B.R.
Parke, Mary
Parsell, Abraham
Parsons, A.D.
Peale, James
Phillips, Ammi
Plank, Samuel
Plummer, Edwin
Porter, Rufus
Powers, Asahel Lynde
Prior, William Matthew
Reed, Reuben Law
Remmey, R(ichard) C(linton)
Ryder, David
Sawyer, Belinda A.
Schweinfurt, John George
Scott, I.
Snow, Jenny Emily
Spitler, Johannes
Stock, Joseph Whiting (M.)
Terry, Elizabeth
Thompson, Cephas Giovanni
Thompson, Mr.
Tilles, J.A.
Trenholm, Portia Ash Burden
Turner, Harriet French
Vater, Ehre
Warner, Catherine Townsend
Waters, E.A.
West, Benjamin
Wheeler, Cathrine
Wheeler, Charles E. (Shang)
Whitcomb, Susan
William E. Pratt Manufacturing Company
Wilson, Thomas
Wirig, Nicholas
Wisdom, Sarah B.

Ackland Art Museum
MacPherson, E.E.
McKillop, Edgar Alexander
Seagle, Daniel

Addison Gallery of American Art
Billings, Pheobe

Adirondack Museum
Dobson

Akwesasne Museum
Hopps, David Vernon

Albany Institute of History and Art
Ames, Ezra
Buckingham, David Austin
Cushman, Paul
Dillon and Porter
Jacobsen, Antonio
Pitkin, Elizabeth
Schuyler, Angelica
Vanderlyn, Pieter
Wilkie, John
Wilkie, William

Albright-Knox Art Gallery
Earl, Ralph

Allen County Museum
Crites, Cyrus
Esten, Edwin
Keller, Adam

Allen Memorial Museum of Art
Pippin, Horace

American Antiquarian Society
Drowne, Deacon Shem
Jennys, Richard
Johnston, John
Lesueur, Charles
Richardson, George

American Clock and Watch Museum, Inc.
Stow, Solomon

American Federation of Arts
Boghosian, Nounoufar

American Museum of Britain
 Taylor, Hannah

Anadarko Philomothe Museum
 Baker, Tom

Anglo-American Art Museum
 Hunter, Clementine

Art Institute of Chicago
 Allen, Abram
 Cosley, Dennis
 Craig, William, Sr.
 Damitz, Ernst
 Denholm, John
 Gilmore, Joseph
 Gragg, Samuel
 Hamilton, Rebexy Gray
 Haring, David D.
 Hart, J.
 Hedden, Martha
 Johnson, Hannah
 Merritt, Susan
 Mundwiler, Samuel
 Peck, Sheldon
 Potter, Lucy
 Reed, Kate D.
 Smith, Sarah Douglas
 Thomas, C. Susan
 Throckmorton, Jeannette Dean, Dr.
 Tyler, Harry
 Van Doren, Abram William
 Welty, John B.

Ashy Museum
 Bascom, Ruth Henshaw

Atlanta University
 Flanagan, Thomas Jefferson, Reverend

Aurora Historical Museum
 Marlett, Eliza Ann
 Peck, Sheldon

Baltimore Museum of Art
 Barela, Patrocinio
 Davis, Joseph H.
 Doriani, William
 Duchamp, Helen
 Hamblett, Theora
 Hicks, Edward
 Hirshfield, Morris
 Kane, John
 Lincoln, Eunice
 Pickett, Joseph
 Portzline, Francis
 Santo, Patsy
 Slack, George R. H.
 Williamson, Clara McDonald

Bancroft Library
 Meyers, William H.

Bedford Historical Society, Museum of the
 Reynolds, Mrs. P.

Bennington Museum
 Birmingham Glass Works
 Norton Pottery
 United States Porcelain Company
 Vermont Glass Factory

Bergen County Historical Society
 Haring, David D.

Berks County Historical Society
 Dehart, John, Jr.
 Endy, Benjamin
 Gilbert, Daniel
 Hechler, Samuel
 Oberly, Henry

Big World Memorial Library
 Chandler, Joseph Goodhue

Bird Craft Museum
 North, Noah
 Wheeler, Charles E. (Shang)

Bishop Hill State Historic Site
 Krans, Olof

Bostonian Society
 Fowle, Isaac
 Skillin, John
 Skillin, Simeon, Sr.

Bourne Museum
 Rogerson, John

Brookline Society
 Chandler, Winthrop

Brooklyn Museum
 Canfield, Betsey
 Esteves, Antonio
 Greer, R.
 Hall, E.B.
 Hall, George Henry
 Heyne, Johann Christopher
 Hicks, Edward
 Kirk, Elisha
 Myers, Mary Rosalie Prestmen
 Peters, Christian
 Pitman, Mary
 Willard, Aaron

Broome County Historical Society
 Thomas D. Chollar
 White and Wood

Brown University
 Daggett, Clarissa
 Hobart, Abigail Adams
 Macomber, Ann

Bucks County Historical Society
 G. and F. Harley
 Headman, Andrew
 Hicks, Edward
 Maybury, Thomas
 Stiegel, Henry Wilhelm, Baron

Calaveras County Historical Society
 Johnston, Effie

Cape Vincent Historical Rooms
 Chapman, Hicks David

Carnegie Institute
 Hastings and Gleason
 Kane, John

Center for the Study of Southern Culture
 Willis, Luster

Center of Southern Folklore
 Willis, Luster

Central Synogogue
 Salzberg, Helen

Centralia/Timberland Library
 Van Hoecke, Allan

Chehalis/Timberland Library
 Van Hoecke, Allan

Chicago Historical Society
 Berry, James
 Brooks, Samuel Marsden
 Ernest, Mrs. Austin
 Frymire, Jacob (J.)
 Krans, Olof
 Wright, George Fredrick
 Zahn, Albert

Children's Museum of Nashville
 Edmonson, William

Cincinnati Art Museum
 Dabney, Mrs. Charlotte
 Hewson, John
 Milan, Nettie
 Smith, Mary Caroline Wooley
 Wilson, Amelia Emelina
 Wilson, Mrs. Russell

Circus World Museum
 Robb, Samuel Anderson

Cleveland Museum of Art
 Allis, John
 Crowell, A.E(lmer)
 Parkman, Abigail Lloyd
 Williams, Amy

Clinton County Historical Museum
 Banker, Martha Calista Larkin
 Powers, Asahel Lynde
 Redford Glass Works

Colby College Museum of Art
 Evans, J.
 Huff, Celesta

Columbia County Historical Society
 Johnson, James E.

Columbus Museum of Arts and Crafts, Inc.
 Flanagan, Thomas Jefferson, Reverend

Concord Antiquarian Society
 Bascom, Ruth Henshaw
 Wheeler, Rebekah

Connecticut Historical Society
 Brewster, John, Jr.
 Brunton, Richard

Buddington, J.
Coggeshall, Esther
Foot(e), Elizabeth
Foot, Lewis
Hoadley, David
Isaac Wright and Company
Jennys, Richard
Johnston, John
Johnston, William
Moore, Nelson Augustus
Moulthrop, Reuben
Perkins, Sarah
Punderson, Hannah
Punderson, Prudence (Rossiter)
Punderson, Prudence Geer
Raser, John H.
Steward, Joseph, Reverend

Connecticut Valley Historical Museum
Ellsworth, James Sanford

Cooper-Hewitt Museum
Butler, Martha
Congdon, Catharine
Davis, Hannah
Follet, Mary
Mason, Larkin
Nenniger, Louisa
Putnam, George
Roff, Amos B.
Turner, Polly

Cooper Union Society
Clough, Ebenezer

Corning Museum of Glass
Amelung, John Frederick
Birmingham Glass Works
Schoolcraft, Henry R.
Whitney Glass Works
Wistar, Casper

Cortland County Historical Museum
Hamblen, Sturtevant J.
Howland, Lucinda
Woodruff, Madison

Creek Council House Museum
Coon, Phillip
Sloane, L.S.
Spybuck, E.L.

Dallas Museum of Arts
Williamson, Clara McDonald

Dartmouth College
Chandler, Joseph Goodhue
Steward, Joseph, Reverend

Daughters of the American Revolution Museum
Moore, "Aunt Eliza"
Stark, Elizabeth (Miss)
Wissler, Cornelia Everhart

Daughters of the Republic of Texas Library
Gentilz, Theodore

Dauphin County Historical Society
Crabb and Minshall

Deerfield Academy
King, Samuel

Delaware Historical Society
Sullivan, William

Denver Art Museum
Aragon, Jose Rafael (Miguel)
Cline, Elizabeth Ann
Fresquis, Pedro Antonio
Gamble, J.
Graham, Samuel
Herrera, Jose Inez (Ines)
Molleno
Ortega, Jose Benito
Whitehill, Mrs. Charlotte Jane

Department of the Interior Museum, United States
Cordero, Helen
Day, Frank Leveva
Moses, Kivetoruk (James)

Detroit Institue of Arts
Frantz, Sara L'Estrange Stanley "Sali"

Detroit Public Library
Melchers, Julius Caesar (Theodore)

Drumwright Community Historical Association
Eyman, Earl

Dwight Eisenhower's Birth Place Museum
Eisenhower, Mrs. Ida Elizabeth Stover

Dyer-York Library and Museum
Brewster, John, Jr.

Earlham College
Mote, Marcus

Edwards County Historical Museum
Flower, Mary Elizabeth
Hubbard, Tryphena Martague

El Paso Museum of Art
Rochas, Ramon

Essex County Historical Society and Adirondack Center Museum
Durand, Helen

Essex Institute
Avery, Mary
Blyth, Benjamin
Bowditch, Eunice
Brown, Joseph
Cheever, Miss Mary
Cleaveland, Mrs. Mary
Corne, Michele Felice
Danvers Pottery
Holingsworth, Mary
Martin, Lucy
McIntire, Samuel
Merrill, Sailor
Newman, Benjamin
Proctor, David R.
Very, Lydia

Everhart Museum of Natural History, Science, and Art
G. Adley and Company
Roberts, William

Fall River Historical Society
Borden, Delana

Flint Institute of Art
Peck, Sheldon

Fogg Art Museum
Blunt, John Samuel
Elwell, William S.
Feke, Robert
Fogg, Mercy (Mary)
Hewins, Philip
Phillips, Ammi
Somerby, Lorenzo

Fordham University
Salzberg, Helen

Frankenmuth Historical Society
Nuechterlein, John George

Franklin D. Roosevelt Library and Museum
Frischwasser, Ben
Meyers, William H.
Schoenfield, Emanual

Frederic Remington Art Museum
Rosseel, Frank

Fruitlands Museum
Alden, G.
Dana, Lucinda
Evans, J.
Hartwell, George G.
Kindall, George
Porter, Rufus
Young, J(ames) Harvey

Georgia Department of Archives and History
Perry, Thomas, Jr.

Georgia Historical Society
Cerveau, Joseph Louis Firman (Fermin)

Gouveneur Museum
Storie, Harold

Hagley Museum
Munro, Sally

Hancock Shaker Village, Inc.
Cohoon, Hannah
Hazard, Mary

Harwinton Historical Society
Alfred, Cynthia

Henry Ford Museum and Greenfield Village
Alten, Fred K.
Bartoll, William Thompson
Bellamy, John Hales
Bennett, Caroline

Henry Ford Museum and Greenfield Village (Cont.)
Blackstone, Eleanor
Blauch, Christian
Blin, Peter
Blunt, John Samuel
Bradford, Esther S.
Bridges, Charles
Canfield, Abijah
Cockefair Mills
Cohen, F.E.
Crongeyer, Theodore
Cushing and White
DeWees, George M.
Dry, Daniel
Firth, E.F.
Fulivier, James
Funk, E.H.
Goodale, Daniel, Jr.
Goodall, Premella
Gordon, Thomas Clarkson
Grimm, Peter
Hall, E.B.
Headman, Andrew
Headman, John
Heerlein, W.
Hewson, John
Hoy, David
Jakobsen, Kathy (Katherine)
Joe
Johnson and Baldwin
Jones, Emily Edson
Kilpatrick, R.L., Captain
Krans, J.
Lewis, O.V.
Mark, George Washington
Marx, John
Mason, William A.
McCord, Susan (Nokes)
McKillop, Edgar Alexander
Miller, Lewis
Morse, E.
Moses, Anna Mary Robertson
Otto, Johann Henrich
Reber, John Slatington Carver
Richmond, A.D.
Ruef, Arnold
Ruef, Peter
Sala, John
Schimmel, Wilhelm
Shourds, Harry V(an Nuckson)
Stanley, William
Theus, Jeremiah
Van Wagner, Jas. D.L.
Warner, Sarah Furman
Whiting, Riley
Wilkin, Godfrey
William Demuth and Company
Wingate, Mehitabel
Young, Celestia
Zook, J.W.

Henry Francis du Pont Winterthur Museum
Boughner, Daniel
Cross, J.E.

Cushman, Paul
Dennis, Thomas
Duyckinck, Gerret
Endriss, George
Fenton, Jonathan
Gragg, Samuel
Haig, Thomas, Sr.
Hamilton and Jones Pottery
Henry Cushing and Company
Hewson, John
Hord, Jacob
Hoyt, Mary Ann
J. and E. Norton
James, D.C.
Johnson, Mary Myers
Jones, Wealthy P.S.
Kemmelmeyer, Frederick
Ketterer, J(ohn) B.
King, Daniel
Maental, Jacob
Maser, Jacob
Miller, B.C.
Miller, M.
Mitchell, H.R.
Morgan, James
Nichols, Margaret
Price, William
Rank, John Peter (Johann)
Remington, Mary "Polly"
Remmey, John, III
Richardson, Francis B.
Robb, Samuel Anderson
Smith, Susan
Speyer, Georg Frederick (Friedrich; Friederich)
Whiteman, T.W.
Willard, Simon

Hermann Museum
Leonhard, August

High Museum of Art
Cartledge, William Ned
Ferguson, Mrs.
Garrett, Carlton Elonzo
Mathis, Robert
O'Kelley, Mattie Lou
Rowe, Nellie Mae

Historic Deerfield, Inc.
Chandler, Joseph Goodhue
Foot(e), Abigail

Historic New Orleans Collection
Brown, William Henry

Historical Association of South Jefferson
Collie, S.
Tyler, Harry

Historical Society
Duran, Damian
Esquibel, Felix
Gallegos
Garcia, Pablo
Lovato, Jose
Virgil, Juan Miguel

Historical Society of Cocalico Valley
Burkholder, J.P.

Historical Society of Early American Decoration
Cook, Ransom

Historical Society of Montgomery County
Hoffman, C.W. (Charles L.)

Historical Society of Old Newbury
Brewster, John, Jr.

Historical Society of Pennsylvania
Le Roux, Charles
Smith, I. R.

Historical Society of Saratoga Springs Museum
De Lee, Francis H.

Historical Society of York County
Fisher
Fisher, John
Frey, Christian
Hewson, John
Hicks, Elizabeth
King, Daniel
Miller, Lewis
Morris, Debbe
Serff, Abraham
Stoehr, Daniel

Hudson River Museum
Carswell, Mrs. N.W.
Robb, Samuel Anderson

Idaho State Historical Museum
Brown, Mary

Illinois State Historical Library
Flower, George
Lewis, Henry

Illinois State Museum
Baker, John B.
Degge, Mary Frances
Ellis, Lucebra
Etter, Elizabeth Davidson
Gauss, George
Gilcrest, Helen
Peck, Sheldon
Richards, Frank Pierson
Richardson, Edward, Jr.

Indiana University
Pering, Cornelius

Indiana University Art Museum
La Tourette, Sarah (Van Sickle)

Indiana University Museum of Anthropology
Trujillo, John R.

Indianapolis Museum of Art
Atcheson, D.L.
Stuckey, Martin or Upton

Iron County Historical and Museum Society
Plourde, Ben

Jefferson County Historical Society
Huntington, Dyer
Upham, J.C.

Jewish Museum
Pressman, Meihel

Johnstown Museum
Cooper, Richard P., Reverend

Kendall Whaling Museum
Baker, Warren W.
Bertoncini, John
Bolles, John, Captain
Burdett, Edward
Chase, Elijah
Chase, Joseph T., Captain
Clark, George S.
Coleman, William, Captain
Eldredge, William Wells
Gifford, M.T.
Goram, J.
Gould, George A.
Halstead, Israel T.
Hersey, Joseph
Jacobs, A. Douglas
Jones, Reuben, Captain
Joseph, Charles
Keith, Charles F.
Lincoln, Daniel H.
Little, Charles
Luce, Shubael H.
Martin, John F.
Morton, Charles
Peters, Joseph
Rogerson, John
Rush, William
Sherman, Jesse T., Captain
Smith, Fred
Stinson, Henry
Swift, R.G.N.
Taylor, William W.
White, Thomas J.
Wright, Dean C.

Kentucky Historical Society
Anderson, Sarah Runyan
Mitchell, Elizabeth Roseberry

Kentucky Museum
Calvert, Margaret Younglove
Fink, Willie Sharpe
McMinn, Charles Van Lineaus
Stewart, Virginia

Kiah Museum, A Museum for the Masses
Davis, Ulysses

Ladies' Hermitage Association
Landry, Pierre Joseph

Lake George Historical Association Museum
Willett, George H.

Landis Valley Museum, Pennsylvania Farm
Keener, Henry
Lehn, G.

Lebanon Public Library
Tenny, Ulysses Dow

Leicester Museum
Bascom, Ruth Henshaw

Library of Congress
Donkle, George
Reems Creek Pottery

Litchfield Historical Society and Museum
Bacon, Mary
Catlin, Betsy
Earl, Ralph
Hopkins, Lucy M.
Quincy, Mary Perkins
Taylor, Elizabeth
Vanderpoel, Emily Noyes

Long Beach Museum of Art
Cavalla, Marcel
Gabriel, Romano

Long Island Historical Society
Dodge, Charles J.

Louisiana State Museum
Landry, Pierre Joseph
Macca, Lorita
Wiltz, Emilie

Louisiana State University
Hunter, Clementine
Hureau, Madame E.

Lyndon Baines Johnson Library and Museum
Cartledge, William Ned

Lyman-Allyn Museum
Butler, J.B.
Gooding, William T.
Jennys, Richard
Newberry, Frances
Phindoodle, Captain
Robinson, Faith
Sheffield, Isaac

Maine State Library
Jackson, Charles Thomas

Marblehead Historical Society
Bartoll, William Thompson
Frost, J(ohn) O(rne) J(ohnson)

Mariner's Museum
Bard, James
Bellamy, John Hales
Geggie, William W.
Harris, Elihu
Huge, Jurgan Frederick (Friedrick; Fredrick)
Jones, Emery
Sampson, C(harles) A.L., Captain
Toby, Charles B.

Willard, Solomon
Wilson, Alfred (Albert H.)

Martha Canfield Memorial Library
Heyde, Charles Louis

Maryland Historical Society
Buckingham, Susannah
Johnson, Joshua
Mitchell, Catherine
Rush, William
Yeager, John Philip

Massachusetts Historical Society
Marston, James B.
Sedgwick, Susan

Massachusetts Medical Library
Greenleaf, Benjamin

Massillon Museum
Hurxthal, Isabel Hall
Mai, Thomas
Purdy, Solomon

Mattatuck Museum of the Mattatuck Society
Beecher, Laban S.
Carswell, Mrs. N.W.

Mead Art Museum
Chandler, Joseph Goodhue

Memorial Art Gallery of the University of Rochester
Bohacket, Albert
Edmonson, William
North, Noah
Scholl, John

Metropolitan Museum of Art
Aetna Furnace
Barnard, Lucy
Blackstone, Eleanor
Breed, Mary
Buttre, William
Caswell, Zeruah Higley Guernsey
Chester, Sarah Noyes
Coggeshall, Patty
Crosman, Robert
Davidson, Betsy W.
Durand, John
Easton, Elizabeth (Rousmaniere)
Hathaway, Rufus, Dr.
Herr, Anna
Hicks, Harriet
Hubener, Georg(e)
Joseph Meeks and Sons
Kemmelmeyer, Frederick
Mason, J.
Miller, Eliza Armstead
Moore, Ann
Moore, Sophie
Moser, Lucinda Vail
Moses, Anna Mary Robertson
Otto, Johann Henrich
Paul, Samuel
Peterman, Casper
Pippin, Horace
Roux, Alexander

Metropolitan Museum of Art (Cont.)
Sampson, Deborah
Schenk, J.H.
Selzer, Christian
Sharples, James
Warner, Ann Walgrave
Warner, Phebe

Michigan Historical Museum
Cunningham, Earl

Milwaukee Art Museum
Kuhn, Justus Englehardt

Milwaukee County Historical Society
Joe

Minnesota Historical Society
Andrews, S. Holmes
Stevens, John

Minneapolis Institute of Art
Chambers, Thomas
O'Kelley, Mattie Lou
Thomas, Edward K.

Mint Museum of History
Rheinhardt, Enoch W.
Seagle, Daniel

Mississippi State Historical Museum
Leopard, Thaddeus

Missouri Historical Society
Barbier, D.

MIT Museum
Carpenter, Frederick

Monmouth County Historical Association
Williams, Micah

Monroe Historical Society
Florys, William
Philips, Solomon Alexander

Montgomery County Historical Society
Houghenon, Dorothy
Hutton, Christopher
Jackson, Samuel
Reynolds, Lydia Barlett
Voohees, Betsy Reynolds

Moravian Museum of Bethlehem
Kichline, Christine S.
Reinke, Samuel

Moore College of Art
Ramirez, Martin

Mount Vernon Ladies Association of the Union
Rakestraw, Joseph
Washington, Martha

Mueller House Museum
Kreider, Albert M.

Munson-Williams-Proctor Institute
Peck, Sheldon

Musee d'Art Naif de l'Ile de France
Zeldis, Malcah

Museum, Michigan State University
Freeland, Anna C.
Johnson, Ray
Kay, Edward A.
Smith, Miles
Zeldis, Malcah

Museum of American Folk Art
Adkins, J.R.
Alten, Fred K.
Ames, Asa (Alexander)
Aulisio, Joseph P.
Borkowski, Mary K.
Bowman, William
Butler, David
Campbell, Daniel
Carmel, Charles
Davis, J(ane) A.
Dey, John William "Uncle Jack"
Dieter, Charlie
Eaton, Moses, Sr.
Edmonson, William
Esteves, Antonio
Fenton, Christopher Webber
Field, Erastus Salisbury
Glover, John
Hamblen, Sturtevant J.
Hamm, Lillian
Hunt, Peter "Pa"
Jakobsen, Kathy (Katherine)
Jones, Frank
Jones, Shields Landon
Kane, Andy
Knappenberger, G.
Langan, Tom
Lantz, Mrs. Ed
Lehman, Amanda
Lewis, Betsey
Maser, Jacob
Mason Decoy Factory
Miller, Sarah
Monza, Louis
Morse, Samuel Finley Breese
Moses, Kivetoruk (James)
O'Kelley, Mattie Lou
Odio, Saturnino Portuondo Pucho
Ortega, Jose Benito
Perates, J(ohn) W.
Pinney, Eunice Griswold Holcombe
Prior, William Matthew
Robb, Samuel Anderson
Rowe, Nellie Mae
Savery, Rebecca Scattergood
Savitsky, Jack
Schaffer, "Pop" "Poppsy"
Schimmel, Wilhelm
Scholl, John
Schwob, Antoinette
Seifert, Paul A.
Sheffield, Isaac
Shute, Mrs. R(uth) W(hittier)
Shute, Samuel A., Dr.
Staples, Hannah
Verity, Obadiah

Ward, Lemuel T.
Wheeler, Charles E. (Shang)
Wilder, F(ranklin) H.
Zeldis, Malcah

Museum of Appalachia
Black, Minnie
Pugh, Dow (Loranzo)

Museum of Art, Rhode Island School of Design
Allen, Abby (Abigail Crawford)
Bicknell, Charlotte
Burr, Cynthia
Daggett, Clarissa
Downer, Ruth
Ide, Mary
Pinniger, Abigail
Smith, LoAnn
Spurr, Polly
Taylor, Eliza Winslow
Tuel, Sarah
Weeden, Mary
Willson, Mary Ann

Museum of Art Brut
Gordon, Theodore

Museum of Early Southern Decorative Arts
Bell, Solomon
Boush, Elizabeth
Johnson, Joshua
Woodhouse, Eulalie E.

Museum of Fine Arts
Anthony, Anne
Arnold, Thomas
Bacheller, Celestine
Baker, J.W.
Barrett, Salley
Bascom, Ruth Henshaw
Bishop, Abby
Brewster, John, Jr.
Brown, George R.
Bunting, J.D.
Burke-Rand, Ravinia
Burr, E(lisha)
Chandler, Joseph Goodhue
Chapin, Alpheus
Chapin, Mary S.
Cobb, Anna C.
Coleman
Crispell, John H.
Crowley, J.M.
Cushing, Mrs. Thomas
Darby, Henry F.
Davis, Betsy (Betsey?)
Davis, E(ben) P(earson)
Davis, Joseph H.
Dennis, Thomas
Dousa, Henry
Eastman, Emily (Baker) (Eastman Louden)
Echstein, John
Ellis, Levi
Ellis, Rachel E.
Ellsworth, James Sanford

Evans, J.
Evans, John T.
Evans, William B.
Fairbanks, Sarah
Fairman, Edward
Field, Erastus Salisbury
Fifield, Mary Thurston
Fleet, Mary
Gleason, Mrs. L.
Gragg, Samuel
Greenwood, John
Guiffer, D.
Hamilton, Sophie
Harvey, M.T.
Heath, Mrs. John
Hemenway, Asa
Holmes, Benjamin
Jacob, K.S.
Jacobi, J.C.
Jennys, Richard
Johnson, Philip
Krebs, Friedrich (Friederich; Frederick)
Laing, Albert
Lehn, Henry
Leonard, Rachel
Levie, John E.
Marford, Mirible "Miribe"
McDowell, Fred N.
McMorrow, William
Merrill, Sarah
Messner, Elizabeth
Meysick, Mary Ann
Miller, J.
Mitchell, Phoebe
Moore, Emily S.
Morley, William
Mountz, Aaron
Osborn, James
Penniman, John
Pinney, Eunice Griswold Holcombe
Powers, Harriet
Pratt, Caroline H. Barrett
Prior, William Matthew
Reist, Johannes
Rightmeyer, J.E.
Schimmel, Wilhelm
Schultz, Regina
Schulze, Lizzie J.
Sewall, Harriet
Smith, Ben
Stettinius, Samuel Enedy
Steven, S.S.
Stower, Manuel
Van Gendorff
Vance Faience Company
Walker, Rebecca
Waters, Almira
Weisel, W.C.
Whitcomb, J.H.
Willard, Aaron
Williams, Micah
Willis, Eveline F.
Willson, Mary Ann
Wineland, N.W.
Wright, J(ames) H(enry)

Museum of Georgia Folk Culture at Georgia State University
Dorsey, Tarp (Joseph Tarplin)
Gordy, D.X.
Gordy, William Thomas Belah
Meaders, Aire (Mrs. Cheever)
Meaders, Lanier
Merritt, William Dennis Billy
Salter, Ben S.

Museum of International Folk Art
Aragon, Luis
Archuleta, Felipe Benito
Bender, David
Dey, John William "Uncle Jack"
Garrett, Carlton Elonzo
Kitchen, Tella
Lopez, Jose Dolores
Miera y Pacheco, Bernardo, Captain
O'Kelley, Mattie Lou
Rowe, Nellie Mae
Salazar, David
Schwob, Antoinette
Tapia, Luis
Vergara-Wilson, Maria
Willey, Philo Levi "The Chief"
Zeldis, Malcah
Zingale, Larry

Museum of Modern Art
Barela, Patrocinio
Davis, Joseph H.
Doriani, William
Duchamp, Helen
Hamblett, Theora
Hicks, Edward
Hirshfield, Morris
Kane, John
Lincoln, Eunice
Pickett, Joseph
Portzline, Francis
Santo, Patsy
Slack, George R. H.
Williamson, Clara McDonald

Museum of Natural History
Stanley, James E.

Museum of New Mexico
Aragon, Jose Rafael (Miguel)
Barela, Patrocinio
Fresquis, Pedro Antonio
Kellner, Anthony
Lopez, Jose Dolores
Molleno
Portzline, Francis

Museum of Northern Arizona
Bazan, Joaquin

Museum of Our National Heritage
Negus, Nathan

Museum of the City of New York
Anderson, Jacob S.
Bard, James
Crowell, A.E(lmer)
Dodge, Charles J.
Durand, John
Gatto, (Victor) Joseph
Hayden, J.
Hustace, Maria
Jones, A.W.
Kittell, Nicholas Biddle
Smith, Joseph B.
Wychoff, Ellen

Museum of Wood Carving
Barta, Joseph Thomas

Mystic Seaport Museum, Inc.
Abbott, Henry R.
Albro, T.L.
Anderson, James
Bayley, Charles
Bradford, Benjamin W.
Burdett, Edward
Dodge, Ephraim J.
Earle, James, Captain
Foster, Washington
Greene, Samuel
Harris, Albert
Hatch, Edbury
Hewit, Charles
Howland, John
Huggins, Samuel, Jr.
Martin, James
McKenzie, Daniel, Jr.
Morgan, Charles W.
Orr, Richard
Perry, William
Purrington, Henry J.
Robinson, Josiah
Rush, William
S.W. Gleason and Sons
Smith, Fred
Smith, Henry M.
Snow, Martin
Somerby, William S.
Stark, Mary E.
Stivers, John, Captain
Townsend, George
White, Edwin
White, Richard H.

Nantucket Historical Association
Myrick, Fredrick

Nassau County Museum
Herschell-Spillman Company
Langan, Tom

National Gallery of Art
Alexander, Francis
Angstad, E.
Badger, Joseph
Bard, James
Beckett, Francis A.
Bellamy, John Hales
Boghosian, Nounoufar
Bond, Charles V.
Bradley, I. (John)
Brechall, Martin
Brown, W.H.
Bundy, Horace
Chambers, Thomas

National Gallery of Art (Cont.)
Chandler, Joseph Goodhue
Chandler, Winthrop
Cook, Eunice W.
Cosley, Dennis
Davis, Joseph H.
Drissell, John
Earl, Ralph E.W.
Eubele, M.
Evans, J.
Forman, Irene B.
Gilbert, David
Hamblen, Sturtevant J.
Headman, Andrew
Hicks, Edward
Hoffman, C.W. (Charles L.)
Hubbell and Cheseboro
Hubener, Georg(e)
Janey, Jacob
Johnson, Joshua
Ketterer, J(ohn) B.
Krans, Olof
Leidy, John
Mayhew, Frederick W.
McIntire, Samuel
Mountz, Aaron
Neesz, Johannes
New York Stoneware Company
Park, Linton
Patete, Eliodoro
Phillips, Ammi
Pinney, Eunice Griswold Holcombe
Portzline, Francis
Powers, Asahel Lynde
Raleigh, Charles Sidney
Randall, A.M.
Ropes, George
Rutter, Thomas
Schultz, J.N.
Sheffield, Isaac
Slade, John
Stock, Joseph Whiting (M.)
Toole, John
Trujillo, John R.
Wagguno
Waters, Susan C.
Weaver, J.G.
Wiand, Charles
Willson, Mary Ann
Zelna, A.

National Museum of American Art
Hampton, John (James)
Rowe, Nellie Mae
White, George

National Museum of History and Technology
Williams, Mary

Natural History Museum of Los Angeles County
Gove, Jane

Naval Asylum
Gerrish, Woodbury

New Bedford Whaling Museum
Blunt, John Samuel
Hatch, Edbury
King, Samuel
Purrington, Henry J.
Russell, Benjamin
Russell, Joseph Shoemaker

New England Historic Genealogical Society
Hathaway, Rufus, Dr.

New England Medical Center Hospital
Johnston, John

New Jersey Historical Society
Williams, Micah

New Jersey State Library Collection
Barsto Furnace
Weymouth Furnace

New Jersey State Museum
Letts, Joshua
Oxford Furnace

New Orleans Museum of Art
Butler, David
De Laclotte, Jean Hyacinthe
Landry, Pierre Joseph

New York Public Library
Ames, Ezra
Hyde de Neuville, Baroness
Skillin, Simeon, Jr.

New York State Historical Association
Albany Stoneware Factory
Andrews, Ambrose
Bartoll, William Thompson
Bennett, F.R.
Bosworth, Stanley
Brooks, T(homas) V.
Brown, J.
C(harles) Hart and Company Pottery
Campbell, Justin
Clark, Frances
Corwin, Salmon W.
Cothead, Phoebe
Covill, H.E.
Crolius, Clarkson, I
Darling, Robert
Davis, E(ben) P(earson)
Davis, Joseph H.
Dodge, Charles J.
Durand, John
Ellis, A.
Evans, J.
Fasanella, Ralph
Fort Edward Pottery Company
Freeman, Mr.
Fulper Brothers Pottery
Grider, Rufus A.
Hallowell, William, Dr.
Harrington, Thomas
Hidley, Joseph H.
J. and E. Norton
J.A. and L.W. Underwood
Jacobsen, Antonio
Job
Josephs, Joseph "Elephant Joe"
Kirkpatrick, Cornwall E.
Lombard, James
Melchers, Julius Caesar (Theodore)
Moore, Harriet
Moran, Frank
Nathan Clark Pottery
New York Stoneware Company
North, Mercy
O'Connell, R.
Phillips, Ammi
Pinney, Eunice Griswold Holcombe
Powers, Asahel Lynde
Robb, Samuel Anderson
Roberts, William
Rogers, W.H.
Sanford, M.M.
Scholl, John
Scouten, O.B.
Seamen, W.
Shelley, Mary
Sincerbox, Keeler
Skillin, Simeon, Jr.
Sperry, John
Speyer, Georg Frederick (Friedrich; Friederich)
Stock, Joseph Whiting (M.)
Stockton, Hannah
Syracuse Stoneware Company
Van Ness, Sarah Oldcott Hawley
Warner, Ann Maria
Warner, William E.
Watson, John
Wetherby, Isaac Augustus
White, Noah
Whitman, J.M.
Whittle, B.
Willey, Philo Levi "The Chief"
William A. Macquoid and Company, Pottery Works
Willson, Mary Ann
Willson, Mr.
Wilson, Mr.
Woodruff, Madison
Yeager, John Philip

Newark Museum
Allen, Abram
Dean, Emeline
Eddy, Abby (Abigail)
Fry, George
Hamilton, Elizabeth Robeson
Loehr, Elizabeth
Pickett, Joseph
Prior, William Matthew
Reasoner, Mrs. A.E.
Smith, Rachel
Van der Pool, James
Whitney, L.

Newport Historical Society
Baley, Sarah
Burrill, Hannah
Dean, Frances E.
Feke, Sarah

Goddard, Mary
Hoockey, Hannah
Martin, Nabby
Munro, Sally
Noble, Clarke
Pope, Sarah E.
Scott, Elizabeth
Tillinghast, Mary
Waite, Sarah

Norwood Historical Association and Museum
Nichols, Maynard

Oakland Museum
Anderson, Lloyd, Captain
Van Wie, Carrie

Ohio Historical Society, Inc.
Bluebird Pottery
Brown and Crooks
Chapman, T.A.
Cook, Phebe
Purdy, C.

Ohio State Archeological and Historical Society
Bosworth, Sala

Ohio State Museum
Sullivan, Charles

Old Colony Historical Society
Hathaway, Rufus, Dr.
Vickery, Eliza

Old Dartmouth Historical Society
Russell, Amey
Russell, Benjamin

Old Gaol Museum
Bulman, Mary
Lyman, Narcissa

Old Slave Mart Museum
Simmons, Peter

Old Sturbridge Village
Bascom, Ruth Henshaw
Bosworth, Stanley
Brewster, John, Jr.
Charlestown Massachusetts Pottery
Dana, Sara H.
Davis, Joseph H.
Holmes, Anna Maria
Mason, Abigail (Payne)
McIntire, Samuel
Prior, William Matthew

Oneida Historical Society
Buell, William

Onondaga County Historical Association
J.M. Burney and Sons
William H. Farrar

Oregon Historical Society
Doud, Delia Ann
Spalding, Eliza Hart

Oswego County Historical Society
Brown, David E.
Cleveland Glass Works
Pulaski, J. Irvin
Tucker, Joshua

P.T. Barnum Museum
Brinley, William R.

Peabody Museum of Salem
Bellamy, John Hales
Burdett, Edward
Corne, Michele Felice
Crowningshield, Hannah
Frothingham, James
Hastings, E.W(arren) (Warren E.)
Littlefield, Nahorn (Nahum)
Mason, John W.
McIntire, Samuel
Ropes, George
Seavey, Thomas
Skillin, Simeon, Sr.

Pejepscot Historical Society
Hall, Betsy

Pennsylvania Academy of Fine Arts
Jennys, Richard
Krimmel, John Lewis
Pippin, Horace
Rush, William

Pennsylvania Farm Museum of Landis Valley
Burkholder, J.P.
Hatch, Sara
Kumerle, D.
Lehn, Joseph
Meninger, E.
North, John
Schuman, E.
Vogiesong, Susanna

Pennsylvania Historical and Museum Commission
Hill, Lovice
Kohler, Rebecca Leiby

Peoria Historical Society
Wilkins, James

Philadelphia Museum of Art
Arsworth, Cynthia
Bergey, Benjamin
Bolkcom, Betsey
Dodson, Mrs. Priscilla
Eno, William
Fox, Anne Mary B.
Fretz, J.
Geistweite, George, Reverend
Headman, Charles
Henning, Herman D.A.
Herr, Elizabeth R.
Hewson, John
Hubener, Georg(e)
Ketterer, J(ohn) B.
Kings, Martha Y.
Klinker, Christian
Landes, John
Leidy, John
Little, George F.
Lynch, Ann
Mann, Lydia Bishop
Morrison, Catharine
Nase, John
Otto, Johann Henrich
Peale, Sophonisha
Pippin, Horace
Platt, Lydia
Portzline, Francis
Remmey, R(ichard) C(linton)
Rush, William
Schimmel, Wilhelm
Smallwood, Zibiah
Speck, Johan Ludwig
Spinner, David
Stockwell, Amey Ann
Uebele, Martin
Warne and Letts Pottery
Wellford, R.
West, Benjamin
Williams, Micah

Philbrook Art Center
Mawatee
Stoner, Albert

Phillips Collection
Hicks, Edward
Kane, John
Moses, Anna Mary Robertson
Pippin, Horace

Pilgrim Hall
Otis, Mercy (Warren)
Standish, Loara

Pilgrim John Howland Society
Gorham, Bethiah

Plains Indians and Pioneer Historical Museum
Porter, Solon

Plattsburgh Public Library
Phillips, Ammi

Pocumtuck Valley Memorial Association
Chandler, Joseph Goodhue
Denison, Nancy Noyes
Field, Erastus Salisbury
Jessup, Jared
Lyman, Mrs. Eunice
Stebbins, Caroline
Stebbins, Wyman H.
Trowbridge, Emily
Wells, Arabella Stebbins Sheldon

Potsdam Public Museum
Dewey, Ormand Sales
Ellis, Freeman
Gibson, Mary L.
Knowles, Mrs. Henry L.
Phillips, Ammi
Raymond, James S., M.D.

Potters Museum
 Nixon, N.H.
 Rheinhardt, Enoch W.

Pratt Museum of Natural History
 Lustig, Desider
 McKeller, Candy

Princeton University
 Ames, Ezra
 Phillips, Ammi
 Powers, Asahel Lynde
 Robb, Samuel Anderson

Reading Public Museum Art Gallery
 Buehler, John George

Red Barn Museum
 Barker, Harriett Petrie

Rhode Island Historical Society
 Baker, Nancy
 Balch, Mary
 Barton, Ann Maria
 Clark, Ann Eliza
 Cozzens, Eliza
 Davis, Patty (Martha)
 Deans, Sarah Ann Curry
 Holden, Katharine
 Jones, Harriet Dunn
 King, Samuel
 Paul, Judith
 Randall, Amey
 Rogers, Sarah
 Sisson, Hannah
 Sisson, Sussanna
 Taylor, Eliza Andrews
 Winsor, Nancy

Robert Hull Fleming Museum
 Stevens, Augusta

Rochester Museum of Art and Science Center
 Cornwall
 N. Clark and Company

Rockford Historical Society Museum
 McBride, Adah

St. George School
 Sturtevant, Louisa

St. Lawrence County Historical Association
 Hicks, Edward
 Kittle, Nellie
 Parmenter, N.H.
 Tyler, Elman

St. Louis Art Museum
 Egan, John J.

St. Michael's Church
 Beekman, Miss Florence

Salem Academy and College
 Noel, Mary Cathrine

San Antonio Museum Association
 Freeland, Henry C.
 Samuel, W.M.G.
 Van Voorhis, Mary

San Diego Historical Society
 Rider, Lydia

San Diego Museum of Art
 Schoolcraft, Henry R.

San Francisco Art Institute
 Bond, Peter Mason "PEMABO"

San Francisco Maritime Museum
 Anderson, Jacob S.
 Lovejoy, Edward Bell

San Francisco Museum of Modern Art
 Johnson, Sargent

Saratoga County Museum
 Mann, Electra

Schenectady County Historical Society
 Howe, Louise
 Miller, Mrs. William Snyder
 Veeder, Ferguson G.

Seaman's Church Institute of New York and New Jersey
 Rogers, Bruce

Shaker Museum
 Collins, Sister Sarah

Shelburne Museum, Inc.
 Armstrong Company
 Bacon, George H.
 Ballard, A.K.
 Barber, Joel
 Barnes, Samuel T.
 Birdsall, Jess, Captain
 Blair, John
 Bliss, Roswell E.
 Bowman, William
 Brooks, T(homas) V.
 Brown, Charles
 Browne, George
 Burke, Edgar, Dr.
 Burr, Russ
 Chambers, Tom
 Chandler, Winthrop
 Cobb, E(lkenah), Captain
 Cobb, Elijah
 Cobb, N(athan), Jr.
 Collins, Samuel, Jr.
 Collins, Samuel, Sr.
 Comstock, Mary
 Corwin, Wilbur R., Captain
 Coudon, Joseph
 Cranford, Ralph M.
 Crowell, A.E(lmer)
 Cushing and White
 Denny, Sara
 Disbrow, Charles
 Doane, Mr.
 Dodge, Charles J.
 Dodge, Jasper N.
 Dudley, Lee
 Dye, Ben, Captain
 Ely, Sarah Weir
 Field, Erastus Salisbury
 Grant, Henry
 Grant, Percy
 H.A. Stevens Factory
 Harvey, George
 Hawkins, Ben
 Headley, Somers G.
 Heywood, Manie
 Holly, Ben, Captain
 Holmes, Benjamin
 Hudson, Ira
 Hunt, Ben
 J. and E. Norton
 J.N. Dodge Factory
 J.W. Fiske (Ironworks)
 Jester, Doug (S.D.M.)
 Jewitt, Clarissa
 Johnson, Lloyd
 Kears, Mark
 Ketchum, C.K., Sr.
 Lamphere, Ralph
 Lewis, Frank E.
 Lincoln, Joseph Whiting
 Lippincott, Gideon
 Lockard, Henry
 Mason Decoy Factory
 Matthews, William J.
 McGaw, Robert F.
 Modern Decoy Company
 Moses, Anna Mary Robertson
 Mulliken, Edward H. "Ted"
 North, Noah
 Osgood, Captain
 Owens, Frank
 Parker, Ellis
 Parker, Lloyd
 Perdew, Charles H.
 Plichta, Fred
 Poor, Jonathan D.
 Pope
 Pozzini, Charlie L.
 Rice, R.
 Ridgeway, Bindsall
 Robb, Samuel Anderson
 Roby, W(arren) G(ould)
 Rose Folding Decoys Company
 Savory and Company
 Schimmel, Wilhelm
 Schmidt, Benjamin J. "Ben"
 Schroeder, Tom
 Shourdes, Harry V(an Nuckson)
 Sprague, Chris
 Tillinghast, Joseph
 Tyler, Lloyd
 Walker, Wilton
 Ward, Lemuel T.
 Washburn, S.H.
 Wheeler, Charles E. (Shang)
 White, Winfield
 Wildfowler Decoy Company
 Wilke, Mr.
 William R. Johnson Company Inc.
 Williams
 Wilson, Charles T., Professor
 Wing, Samantha R. Barto
 Wyllie, Alexander

Art Locator Index — **Wadsworth Atheneum Museum**

Sheldon Art Museum, Archaeological and Historical Society
Peck, Sheldon

Sheldon Memorial Art Gallery
Baker, Samuel Colwell

Smithsonian Institute
Bard, James
Bazan, Ignacio Ricardo
Beall-Hammond, Jemima Ann
Boyley, Daniel
Bradburg, Harriett
Brannan, Daniel
Christian, Nancy
Converse, Hannah
Cushing and White
Dieter, Charlie
Edmonson, William
Esputa, Susan Adel
Gay, Pocahontas Virginia
Goins, Luther
Gordon, Theodore
Gorham, Jemima
Hampton, John (James)
Harrison, Mary
Hewson, John
Ivy, Virginia Mason
Jakobsen, Kathy (Katherine)
Jones, Shields Landon
Lopez, George T.
Maran, Mrs. Mary Jane Green
McCrea, Mrs. Mary Lawson Ruth
Mead, Abraham
Miera y Pacheco, Bernardo, Captain
Mondragon, Jose
Morse, Samuel Finley Breese
Munro, Janet
Neesz, Johannes
Nowlan, Margaret
Ohno, Mitsugi
Ortega, Jose Benito
Powers, Harriet
Robb, Samuel Anderson
Spalding, Rueben
Stein and Goldstein
Taylor, Mary Wilcox
Thiessen, Louise Berg
Thompson Pottery
Timberlake, Alcinda C.
Welty, John B.
White, George
Whiting, Riley
Wilson, Joseph

Springfield Art and Historical Society
Powers, Asahel Lynde

Springfield Museum of Fine Arts
Corbit, Mary Pennell
Earl, Ralph
Field, Erastus Salisbury
Fuller, Augustus
Stock, Joseph Whiting (M.)

Stamford Historical Society, Inc.
Foot, Lucy
Hoyt, Esther
Knapp, Harriet

State Historical Society
Trujillo, John R.

State Museum of Oklahoma
Goff, G.
Hagen, Horace Henry
Harkins, Mrs. A.

Staten Island Historical Society
Birdsall, Jess, Captain

Stonington Historical Society
Seavey, Thomas
Stanton, Nathaniel Palmer

Strong Museum
Shamp, D.
Van Ness, James

Taylor Museum of the Colorado Springs Fine Arts Center
Aragon, Jose
Archuleta, Manuel
Barela, Patrocinio
Fresquis, Pedro Antonio
Hurd, Jacob
Lopez, George T.
Lopez, Jose Dolores
Miera y Pacheco, Bernardo, Captain
Mondragon, Jose
Salazar, Leo G. (Leon)
Valdez, Horacio E.
Vigil, Francisco

Telfair Academy of Arts and Sciences, Inc.
Cooke, George

Tennessee Department of Conservation, Archeology Div.
Grindstaff, William

Tennessee Fine Arts Center at Cheekwood
Edmonson, William

Tennessee State Museum
Buchanan, Mrs. John
Chester, Rebecca
Decker, Charles F.

Texas State Library
Wright, Thomas Jefferson

Thomas Gilcrease Institute of American History and Art
Becker, Joseph
Cosley, Dennis

Thomas Jefferson Memorial Foundation
Jefferson, Thomas

United States Naval Academy Museum
Dodge and Son

University Art Museum
Bradley, I. (John)

University of Kansas Museum of Art
Hewson, John
Malcolm, Mrs.
Mosely, Susanna Richards

University of Kentucky Art Museum
Root, Ed
Woods, David

University of Michigan Museum of Art
Blunt, John Samuel

University of Tennessee
Edmonson, William

University of Texas
Herff, Charles Adelbert

Valentine Museum
Brown, Angeline
Holmes, Flora Virginia
Malone, Mildred
Smith, Judith

Vatican Collection
Fresquis, Pedro Antonio

Vermont Museum
Andrews, Ambrose
Boush, Elizabeth
Smith, J.W.

Vesterheim Norwegian-American Museum
Christenson, Lars

Vigo County Historical Society
Maxwell, Ann

Vinland Museum
Childers, Russell

Virginia Historical Society
Drinker, John

Virginia Museum of Fine Arts
Brooks, T(homas) V.
Melchers, Julius Caesar (Theodore)
Robb, Samuel Anderson
Seelig, Moritz J. (Morris; Maurice)
Stovall, Queena

Viterbo College Museum
Miller, Anne Louisa
Miller, Lynn

Wachovie Historical Society
Aust, Brother Gottfried

Wadsworth Atheneum Museum
Abraham, Carl
Belcher, Sally Wilson
Dumbay, Harriet
Fitch, Simon, Captain
Johnson, Mary Myers
Morrill, D.
Myers, Mary
Pearl, Hannah
Sanders, John
Tuels, Anna

Wadsworth Atheneum Museum (Cont.)
 Whitehead, L(iberty) N.

Washington State Capital Museum
 Willson, Sulie Hartsuck

Washington State Historical Society
 Ginther, R(oland) D(ebs)
 Twiss, Lizzie

Wayside Museum
 Wheeler, Jonathan Dodge

Webb-Deane-Stevens Museum
 Griswold, Lucy

Wenham Historical Association and Museum, Inc.
 Thorn, Catherine

Western Reserve Historical Society
 Boler, Daniel
 Schrap, W.J.
 Taylor, Eliza Ann

Whaling Museum Society, Inc.
 Glover, Elizabeth

White County Historical Society
 Foster, Mary Ann Kelly

The White House
 Miller, James

Whitney Museum of American Art
 Gatto, (Victor) Joseph
 Pickett, Joseph
 Pippin, Horace
 Scholl, John
 Seymour, Samuel
 Woolworth, Charlotte A.

Willamette Valley Rehabilitation Center
 Childers, Russell

William Penn Memorial Museum
 Scholl, John
 Smyth, M.
 Starr, Eliza

Witte Memorial
 Bacheller, Lucinda
 Craghead, Elizabeth
 Foot, Fanny

Worcester Art Museum
 Earl, Ralph
 Gullager, Christian
 Hicks, Edward
 Sanders, Anna (Nancy)
 Smith, Thomas, Captain

Wright Memorial Library
 Royce, Jenny

Yale University Art Gallery
 Brace, Deborah Loomis
 Earl, Ralph
 Gudgell, Henry
 Johnston, Henrietta (Mrs.)
 King, Samuel
 Lane, Samuel "Sam"
 Moulthrop, Reuben
 Rouse, William
 Rush, William
 Smibert, John

Zanesville Art Center
 Hall, E.B.

Ethnicity Index

(See the "Special Indexes to Contents" section of the Introduction for an explanation of this index and its limitations.)

Acadian
Macca, Lorita

American Indian
Bennett, Alice
Bennett, Russell
Day, Frank Leveva
Descillie, Mamie
Irving, Clarabelle
Kabotie, Fred
Little Lamb
Mackosikwe (Mrs. Michele Buckshot)
Marta, Anna Maria
Martinez, Cresencio
Miguelito
Moore, Billy
Pi, Aqwa
Pie, Hugh
Rolling Mountain Thunder, Chief
Shije, Velino
Sullivan, Sarah Crisco
Thomas, Eli
Tsireh, Awa

American Indian and Irish
Blizzard, Georgia

Amish
Bontager, Mrs. Clara
Bontrager, Mrs. Eli
Bontrager, Mrs. Lydia
Bontrager, Mrs. Rudy
Bontrager, Polly
Burkholder, Lydia
Christner, Mrs. John
Coon, Clara
Eash, Lydia
Frye, Mary
Greenawalt, Katie
Herschberger, Mrs. Manuel
Hochstetter, Katie
Hochstetter, Mrs. Manas (Mary)
Hostetler, Nina D.
Lambright, Mrs. Elizabeth
Lambright, Mrs. Menno
Lambright, Mrs. Susan
Lantz, Mrs. Ed
Lehman, Amanda

Mast, Barbara
Miller, Anna Viola
Miller, Henry
Miller, Katie (Mrs. David J.L.)
Miller, Lydia Ann
Miller, Mary
Miller, Mrs. Nathaniel
Miller, Mrs. S.N.
Miller, Mrs. Susie
Miller, Polly
Miller, Sarah
Petershime, Mrs. Samuel
Plank, Samuel
Raper, Millie
Schrock, Mrs. Sam
Schrock, Susan
Stoltzfus, Mrs.
Troyer, Amanda S.
Troyer, Mary Ann D.
Whetstone, Lydia S.
Yoder, Amanda Sunthimer
Yoder, Amelia
Yoder, Fanny
Yoder, Lydia
Yoder, Mrs. Daniel T.
Yoder, Mrs. Menno
Yoder, Mrs. Mose V.
Yoder, Mrs. Yrias V. (Mrs. Urias V.) (Anna)

Armenian
Bochero, Peter "Charlie"
Boghosian, Nounoufar

Australian
Bond, Peter Mason "PEMABO"
Grimes, Leslie
Stanley, James E.

Austrian
Deker, Francis Jacob
Frye, William
Kurtz, Sadie

Belgian
Van Hoecke, Allan
Velghe, Joseph (Father John)

Black American
Almon, Leroy
Ashby, Steve
Augustus, Sampson
Baddler
Bollinger, Leslie
Brice, Bruce
Brown, William Henry
Burr, John P.
Burris, J.C. "Jack"
Butler, David
Chaplin, J.G.
Clark, Irene
Clark, Leon "Peck"
Coaxum, Bea
Coe, Clark
Craft, William
Crane, Harry
Crawford, Cleo
Crite, Allan Rohan
Dave
Davis, Alfred "Shoe"
Davis, Ulysses
Davis, Virgil
Dawson, William
Day, Thomas
Dicus, Ellen
Dorsey, William H.
Douglass, Robert M., Jr.
Doyle, Sam "Uncle Sam"
Edmonson, William
Emmaline
Evans, Minnie
Farmer, Josephus, Reverend
Fields, Leonard
Finn, Marvin
Flanagan, Thomas Jefferson, Reverend
Foreman, Mary Lou
Foreman, Regina
Gibbs, Ezekial
Golding, William O.
Gudgell, Henry
Hampton, John (James)
Harley
Hemp, Robert
Hobbs, G.W., Reverend
Hunter, Clementine

Black American (Cont.)
 Job
 Joe
 Johnson, Joshua
 Loguen, Gerritt
 Maddov, Rance, Jr. "Bone"
 Middleton, Ralph
 Miller, Howard
 Mize, Mahulda
 Moorhead, Scipio
 Morgan, Sister Gertrude
 Moss, Emma Lee
 Nathaniel, Inez
 Ned
 Payne, Leslie J.
 Pickhil, Alexander
 Pierce, Elijah
 Pippin, Horace
 Powers, Harriet
 Primus, Nelson
 "Rhenae"
 Rogers, Juanita
 Rogers, William
 Rowe, Nellie Mae
 Sarah "Old Aunt Sarah"
 Simmons, Peter
 Simmons, Phillip
 Simon, Jewel
 Simpson, William
 Suddouth, Jimmy Lee
 Sutton
 Telfair, Jessie
 Thomas, James "Son Ford"
 Tolliver, Mose
 Toomer, Lucinda
 Traylor, Bill
 Vidal
 Washington, James
 Wilkerson, Lizzie
 William, George
 Williams, Jeff
 Willis, Luster
 Wilson
 Wilson, A.B.

Black American, American Indian
 Aaron, Jesse
 Jones, Frank
 Warner, Pecolia

Black American, Mexican, American Indian
 White, George

Black American?, American Indian?
 Yoakum, Joseph E.

Brazilian
 Esteves, Antonio

Canadian
 Cote, Adelard
 Kelson, James R.
 Lepine, Imelda
 Tatro, Curtis

Canadian, Scottish
 Rogerson, John

Chinese
 Mon Hon

Cuban
 Odio, Saturnino Portuondo Pucho
 Sanchez, Mario
 Valdes, Georgio

Czechoslovakian
 Voldan, J.R.

Danish
 Block, Andrew
 Gullager, Christian
 Jacobsen, Antonio
 Tommerup, Matthias

Dutch
 Kirk, Elisha
 Saurly, Nicholas
 Vanderlyn, Pieter
 Wolfert, Frank

English
 Ainslee, Henry Francis, Colonel
 Bennett, Daniel
 Bennett, Edwin
 Bennett, James S.
 Bennett, William
 Berresford, Benjamin
 Birch, Thomas
 Booth, Thomas
 Boulton, William
 Briscoe, Thomas "Ol' Briscoe"
 Brunton, Richard
 Buell, William
 Burch, John
 Burnett, Henry
 Buttersworth, James E.
 Chambers, Thomas
 Collins, Thomas
 Cutbush, Edward
 Dennis, Thomas
 Dowler, Charles Parker
 Drinker, Philip
 Dwight, John
 Fairbrothers, William
 Filcher, Thomas J.
 Goodwin, John
 Graham, Samuel
 Greatbach, Daniel
 Hall, Basil, Captain
 Harrison, John
 Hazlitt, John
 Hewson, John
 Hudson, William, Jr.
 Ingham, David
 Jackson, Thomas
 Johnston, Henrietta (Mrs.)
 Kieff, John
 Lee, John
 Major, William Warner
 Miller, Robert
 Moon, Robert
 Parsons, Charles
 Pride, John
 Raleigh, Charles Sidney
 Rich, John
 Richardson, Edward, Jr.
 Roberts, Bishop
 Russell, John
 Seymour, Samuel
 Smith, Martha Swale
 Stewart, Alexander
 Todd, James
 Turner, William
 Vincent, William
 Vodrey and Frost
 Vodrey, Jabez
 Wakeman, Thomas
 Waldron, Jane D.
 Warwell
 West, James
 Whitefield, Edwin

Eskimo
 Moses, Kivetoruk (James)

Finnish
 Jarvie, Unto
 Makinen, John Jacob, Sr.
 Perry, William

French
 Adolf, Charles
 Adolf, George
 Adolf, Henry
 Audin, Anthony
 Boulanger, John F.
 Campbell, Daniel
 Castelnau, Francis
 Cohen, Alfred
 Couloy, Isadore
 De Laclotte, Jean Hyacinthe
 Dehate, Abraham
 Durand, John
 Hureau, Madame E.
 Landry, Pierre Joseph
 Lederman, Henry
 Lesueur, Charles
 Lorentz, Peter
 Mentelle, Ward, Sr.
 Miller, Ambrose
 Persac, Adrien
 Pomarede, Leon D.

French Huguenot
 Duche, Anthony

German
 Alten, Fred K.
 Amelung, John Frederick
 Ardner, Jacob
 Ardner, Michael
 Aust, Brother Gottfried
 Bell, Peter
 Bick, John
 Boettger, Carl
 Bower, George
 Brechall, Martin
 Breeswine, Peter N.
 Brinkman, Henry
 Buehler, John George
 Crongeyer, Theodore
 Damitz, Ernst
 Dash, John Baltus

Ethnicity Index **Hispanic**

Decker, Charles F.
Deitsch, Andrew
Dengler, John
Dentzel, Gustav A.
Eckert, Gottlieb
Eckler, Henry
Enders, Henry
Fabian, Gisela
Finger, Henry
Fischer, Charles
Fleck, Joseph
Fliehr, Charles B.
Fogle, Lewis
Folk, John
Frey, Christian
Friedel, Robert
Friedrich, Johann
Gabriel, Henry
Gauss, George
German, Henry
Gerthner, Xavier
Greef, Adolph
Gross, Magdalena
Gross, William
Haag, Jacob
Haidt, John Valentine
Haman, Barbara Becker
Hartman, John
Hartman, Peter
Hesse, F.E.
Hesse, L.
Heye, Frederick
Hipp, Sebastian
Hoerr, Adam
Hoffman, C.W. (Charles L.)
Hoffman, Christopher
Hoke, Martin
Huber, Damus
Huber, John
Huge, Jurgan Frederick (Friedrich; Fredrick)
Jansen, Frederick William
Kean, Carl Lewis
Kean, Frederick A.
Keszler, Henry
Ketterer, J(ohn) B.
Kinderlen, Conrad
Klein, Andrew
Klein, Francis
Klein, John
Klein, Michael
Klumpp, Gustav
Kuhn, Justus Englehardt
Leonhard, August
Leykauff, Michael
Loehr, Elizabeth
Long, Nicholas
Mader, Louis
Maental, Jacob
Maertz, Charles
Mamn, Mathias
Maurer, John
Maus, Philip
Meier, Henry
Melchers, Julius Caesar (Theodore)
Miller, Maxmilion

Miller, Theodore H.
Minchell, Peter
Mosser, John
Muehlenhoff, Heinrich
Naegelin, Charles
Nevel, Frederick
Nicklas, George
Ohnemus, Matthias
Peterman, Casper
Phlegan, Henry
Rasmussen, Charles
Rasmussen, J(ohn)
Rassweiler, Philip
Rauser, Gabriel
Reiter, Nicholas
Reyher, Max
Ricket, Jacob
Roth, John
Saeger, Martin
Schaeffner, Andrew
Schimmel, Wilhelm
Schmitt, Adam
Schneider, John E.
Scholl, John
Schroeder, Carl
Schroth, Daniel, Reverend
Schubert, John G.
Schultz, J.N.
Schum, Philip
Schweikart, John
Seelig, Moritz J. (Morris; Maurice)
Seewald, John (John Philip)
Seidenspinner, John
Seifert, Paul A.
Seultzer, Alexander
Shearer, Henry
Shepard, George
Sherman, Jacob
Smith, George M.
Staffel, Bertha
Stettinius, Samuel Enedy
Stiegel, Henry Wilhelm, Baron
Stizelberger, Jacob, Sr.
Strauss, Simon
Strobel, Lorenz
Teubner, William
Ulrich and Whitfield
Unger, Charles J.
Van Minian, John
Vogel, August
Wagner, Christina
Weaver, Elias
Wensel, Charles
Wernerus, Father Mathias
Wildin, John
Will, William
Wimar, Karl
Wingender, Jakob
Wistar, Casper
Witmann, John H.
Wolfinger, August
Yeager, John Philip
Yearous, Adam
Young, Peter
Zahn, Albert
Zinck, John

German?
Klinker, Christian

Greek
Aulont, George
Gavrelos, John J.
Perates, J(ohn) W.
Skyllas, Drossos P.

Hispanic
Apodaca, Manuelita
Aragon, Luis
Archuleta, Antonio
Archuleta, Felipe Benito
Archuleta, Manuel
Armijo, Frederico
Barela, Patrocinio
Cordova, Alfredo
Cordova, Gloria Lopez
Cordova, Grabielita
Cordova, Harry
Cordova, Herminio
Delgado, Francisco
Fernandez, Gilbert
Garcia
Garcia, Pablo
Gonzales, Elidio
Herrera, Antonio
Herrera, Jose Inez (Ines)
Herrera, Miguel
Jaramillo, Juanita
Lopez, Antonia
Lopez, Ergencio
Lopez, Felix A.
Lopez, George T.
Lopez, Jose Dolores
Lopez, Martina
Lopez, Sylvanita
Lovato, Jose
Lujan, Maria T.
Luna, Maximo L.
Manzanares, Luisa
Martinez de Pedro, Linda
Martinez, Angelina Delgado
Martinez, Apolonio
Martinez, Eluid Levi
Montoya, Patricia
Ortega, Benjamin
Ortega, David
Ortega, Jose Benito
Ortega, Jose Ramon
Ortega, Nicacio
Ortega, Robert James
Rendon, Enrique
Rochas, Ramon
Romero, Emilio
Romero, Orlando
Romero, Senaida
Roybal, Maria Luisa Delgado
Roybal, Martin
Salazar, Alejandro
Salazar, David
Salazar, Leo G. (Leon)
Stark, Tillie Gabaldon
Tapia, Luis
Tapia, Star
Valdez, Horacio E.

Hispanic (Cont.)
- Vigil, Francisco
- Villalpando, Monico
- Virgil, Juan Miguel

Honduran
- Webster, Derek

Hungarian
- Gyory, Esther
- Lustig, Desider
- Moskowitz, Isidore
- Sabo, Ladis

Irish
- Baird, James
- Bereman, John
- Burnside, John
- Campbell, James
- Gibbs, John
- Ginn, Robert
- Graham, John
- Lawson, David
- Martin, Robert
- Mason, John W.
- Pattison, Edward
- Pattison, William
- Rogers, John
- Shaw, Robert
- Tobin, John
- Toole, John
- Wilson, Jonathan
- Young, William

Italian
- Cavalla, Marcel
- Corne, Michele Felice
- De Mejo, Oscar
- Fracarossi, Joseph
- Gabriel, Romano
- Martin, Don "Duke"
- Monza, Louis
- Palladino, Angela
- Patete, Eliodoro
- Rodia, Simon
- Santo, Patsy
- Vivolo, John

Japanese
- Ohno, Mitsugi

Jewish
- Pressman, Meihel
- Rabinov, Irwin
- Zeldis, Malcah

Latvian
- Leedskalnin, Edward

Lithuanian
- Levin, Abraham (Abram)

Luxembourg
- Roeder, John "The Blind Man"

Mennonite
- Landes, John
- Strickler, Jacob

Mexican
- Fresquis, Pedro Antonio
- Garcia, Fray Andres
- Gonzales, Jose de Garcia
- Maldonado, Alexander
- Ramirez, Martin

Moravian
- Christ, Rudolph
- Krause, Thomas
- Rothrock, Friedrich
- Welfare, Daniel (Christian)

Polish
- Hirshfield, Morris
- Koch, Samuel
- Kozlowski, Karol
- Lieberman, Harry
- Samuel Yellin Company
- Simon, Pauline
- Smolak, Stanley
- Wasilewski, John

Prussian
- Hasenritter, C(arl) W(illiam)

Puerto Rican
- Quiles, Manuel

Quaker
- Brinton, Eleanor
- Hicks, Edward
- Jackson, Mary
- James, Sarah H.
- Jones, Eliza
- Roes, Anna Eliza
- Rowland, Elizabeth
- Tucker, Phoebe Parker
- Wright, Patience

Russian
- Kikoin, Aaron
- Litwak, Israel
- Wiener, Isador "Pop"

Saxe-Meiningen
- Saalmueler, Peter

Scottish
- Alexander, James
- Alexander, Robert
- Balantyne, John
- Balantyne, Samuel
- Bisset, William
- Campbell, John
- Cowan, Robert
- Craig, James
- Cranston, Thomas
- Cunningham, James
- Davidson, Archibald
- Gamble, J.A.
- Geggie, William W.
- Gilchrist, Hugh
- Gilchrist, William
- Gilmore, Thomas
- Gilmore, William
- Glen, Hugh
- Hinshillwood, Robert
- Kane, John
- McLeran, James
- Melish, John
- Merkle, Alexander
- Moncliff, A.B.
- Muir, John
- Muir, Robert
- Muir, Thomas
- Muir, William
- Park, James
- Park, John
- Park, Thomas
- Park, William
- Rattray, Matthew
- Robertson, William A.
- Shetky, Caroline
- Simpson, George
- Smibert, John
- Watson, John
- Wilson, Robert B.
- Wilson, William (A. Wilson)

Shaker
- Andersen, Elder William
- Avery, Gilbert
- Becker, Joseph
- Boler, Daniel
- Burlingame, Elder Philip
- Cohoon, Hannah
- Collins, Sister Sarah
- Green, Elder Henry
- Hazard, Mary
- Holy Mother Wisdom
- Jewett, Amos
- Rude, Erastus
- Sarle, Sister C.H.
- Skeen, Jacob
- Taylor, Eliza Ann
- Wagan, Robert
- Wells, Sister Jennie
- Whittaker, James
- Wilson, Elder Delmar
- Wright, Mother Lucy
- Youngs, Benjamin S.
- Youngs, Isaac N(ewton)

Spanish
- Aragon, Jose
- Aragon, Jose Rafael (Miguel)
- Miera y Pacheco, Bernardo, Captain

Swedish
- Almini, Peter M.
- Krans, Olof
- Wallin, Hugo

Swiss
- Eggen, Jacob
- Kurz, Rudolf Friederich
- Schmidt, Peter
- Theus, Jeremiah
- Wild, John Casper

Ukrainian
- Mazur, Frank

West Indian
- Beckett, Francis A.

Yugoslavian
- Erceg, Rose "Ruza"
- Jeremenko, Theodore

Geographic Index

(See the "Special Indexes to Contents" section of the Introduction for an explanation of this index and its limitations.)

ALABAMA
 MacPherson, E.E.
 Maddov, Rance, Jr. "Bone"
 Negus, Nathan
 Rogers, Juanita
 Tolliver, Mose
Athens
 Lucas, Martha Hobbs
Bedford
 Cribbs, Peter
Birmingham
 Gibson, Sybil
Fayette
 Suddouth, Jimmy Lee
Ft. Lawley
 Smith, Norman
Greene County
 Bulluck, Panthed Coleman
Huntsville
 Frye, William
Mobile Bay
 Rice, R.
Montgomery
 Traylor, Bill
Phenix
 Rhoads, Jessie Dubose
Randolph County
 Boggs Pottery
 Mapp, F.T.
Selma
 Reynolds, W.J., Dr.
Tuscaloosa
 Cribbs, Daniel
Tuscaloosa County
 Oliver, C.K.
 Sikes, Bessie

ALASKA
 Alaska Silver and Ivory Company
Shismaref
 Kuzuguk, Bert
 Moses, Kivetoruk (James)

ARIZONA
Canyon del Muerto
 Little Lamb
Tucson
 Falk, Barbara (Busketter)
 Grimes, Leslie
Yuma
 Kasling, "Driftwood Charlie"

ARKANSAS
Clinton
 Joe, Pappy
Marshall
 Warren, Marvin
North Little Rock
 Casebier, Jerry

CALIFORNIA
 August Blanck Pottery
 Bennett, F.R.
 Choris, Louis
 Day, Frank Leveva
 Dickson, W.
 Fortner, Myrtle M.
 Kost
 Marta, Anna Maria
 Meyers, William H.
 Newton, B.J(esus)
 Podhorsky, John
 Powell, H.M.T.
 Predmore, Jessie
 Sowell, John A.
 Spear, P.
 Van Wie, Carrie
Auburn
 Ramirez, Martin
Eureka
 Gabriel, Romano
Fresno
 Grimes, Leslie
Jacumba
 Ratcliffe, M.T.
Lake Elsinore
 Serl, Jon
Los Angeles
 Acheo Brothers
 Ara
 Aschert Brothers
 Blair, Streeter
 Cavalla, Marcel
 Ehn, John
 Flagg, Edwin H.
 Grimes, Leslie
 Joy, Josephine
 Mann, Ed
 Wallin, Hugo
Los Angeles?
 "Rhenae"
Mendocino
 Albertson, Erick
Mill Valley
 Fletcher, Eric
 Fletcher, Marianne
Monterey
 Trujillo, Celestino
Oroville
 Carter, Bob Eugene
Pasadena
 Boghosian, Nounoufar
Point Arena
 Johnson, Melvin
Redondo Beach
 Monza, Louis
Richmond
 Roeder, John "The Blind Man"
Sacramento
 Becker, Joseph
San Andreas
 Johnston, Effie
San Antonio
 Brannan, Daniel
San Diego
 Hoff, John
 Parker, Charles W., Colonel
San Francisco
 Bertoncini, John
 Bond, Peter Mason "PEMABO"
 Burris, J.C. "Jack"
 Butler, Nellie
 Carroll, Thomas
 Coyle, Carlos Cortes
 Earl, Tarleton B.
 Farrell, John
 Forbes, Jack
 Galloway, Lyle
 Gereau, William
 Gordon, Theodore
 Haehnlen, Louis A.
 Hiler, Pere
 Horgos, William "Bill"
 Hubbard, Paul

CALIFORNIA (Cont.)
 San Francisco (Cont.)
 Lembo, J. Lawrence
 Linna, Irelan
 Lovejoy, Edward Bell
 Luce, Benjamin
 Maldonado, Alexander
 Mon Hon
 Nutting, Calvin, Sr.
 Pioneer Iron Works
 Telfer, James W.
 Weaver, F.L.
 Wentworth, P(erley) M.
 San Juan Capistrano
 Serl, Jon
 Santa Barbara
 Darling, Sanford
 Hendricks, J.P.
 Santa Susana
 Prisbrey, Tressa (Grandma)
 Stockton
 Beckett, Francis A.
 Stockton Art Pottery
 Watts
 Rodia, Simon
 Westport
 Colclough, Jim "Suh Jim"
 Whittier
 Riddle, Morton
 Woodside
 Kennecott Copper Workshop
 Yermo
 Black, Calvin
 Black, Ruby

COLORADO
 Gallegos
 Whitehill, Mrs. Charlotte Jane
 Chama
 Lovato, Jose
 Colorado Springs
 Van Briggle Pottery Company
 Conejos
 Garcia, Pablo
 Denver
 Cline, Elizabeth Ann
 Massey, Marilyn
 Gilman
 Lopez, Felix A.
 La Isla
 Garcia
 Los Pinos
 Duran, Damian
 Rosita
 Spalding, Rueben
 San Luis
 Virgil, Juan Miguel
 San Pablo
 Esquibel, Felix
 Weston
 Fernandez, Gilbert

CONNECTICUT
 Avery, Mary
 Barber, Betsy
 Barber, James
 Barber, T.G.
 Barrett, Jonathan
 Bartholomew, Samuel
 Beach, Chauncey
 Beckwith, Israel
 Beeman, S.
 Belcher, Sally Wilson
 Belden, Aziel
 Belden, Joshua
 Belden, Sylvester
 Bennett, Elizabeth K.
 Benton, Jared
 Bishop, Uri
 Bond, Caleb
 Booth, Salmon
 Brasher, Rex
 Brewster, John, Jr.
 Briggs, Amos
 Bronson, Silas
 Brown, Nathan
 Brown, Sally
 Brown, Samuel
 Buckley, Justus
 Buckley, Luther
 Buckley, Moses
 Buckley, Orrin
 Buckley, William, Jr.
 Budington, Jonathan
 Burr, A.
 Burr, C.
 Burr, Charles H.
 Burr, Emerson
 Burr, Jason
 Burr, M.
 Burrows, Esther
 Butler, Thomas C.
 Butler, William
 Cadwell, A.
 Cadwell, I.
 Cadwell, L.
 Camp, Emily
 Candee, G.E.
 Case, E.H.
 Case, H.H.
 Case, Robert
 Case, T.
 Clark, Abna
 Clark, Elisha
 Clark, Nathaniel
 Cornish, H.
 Cossett, M.
 Cowles, Thomas
 Denison, Harriet
 Dick, Mrs. Mary Low Williams
 Dickerman, Edwin S.
 Dodge, Eliza Rathbone
 Doolittle, Amos
 Doyle, B.
 Dunbar, H.
 Dyer, Henry
 Eno, Chester
 Eno, Ira
 Eno, Reuben
 Filley, I.A.
 Foley, Nicholas
 Folger, George
 Foote, Lewis
 Frazer, Thomas
 Frisbie
 Gibson, Page
 Gilchrist, Hugh
 Goodman, Hezekiah
 Goodrich, Asahel (Asohet)
 Goodrich, Seth
 Graham, B.
 Grinniss, Charles
 Griswold, Lucy
 Guernsey, James
 Hall, Hannah
 Hall, Joseph P.
 Hartshorn, John
 Hathaway, C.H.
 Jennys, Richard
 Johnson, Ann
 Johnson, Mary Myers
 Jones (of Conn.)
 King, Josiah Brown
 Kingsbury, Mary
 Knight, H.
 Lamb, Lysis
 Lyman, H.
 MacKay
 McKay
 Metcalf, Edward
 Mitchell, William Alton
 Morrill, D.
 Moulthrop, Reuben
 Myers, Mary
 Newell, Isaac
 North, Joseph
 North, Lucinda
 North, Silas
 North, Stephen
 Northford's Shop
 Parkman, Abigail Lloyd
 Parsons, Polly
 Pearl, Hannah
 Pease, John
 Peck, David
 Peck, Pattison and Company
 Phelps, H.G.
 Plummer, Edward
 Porter, John
 Ridley, Mary
 Rising, Lester
 Roath, H.A.
 Robinson, Ann
 Rowley, Philander
 Sanders, John
 Sanford, Isaac
 Shepherd, Miss
 Silloway, Samuel
 Slack, George R. H.
 Smith, Samuel
 Staples, Hannah
 Tisdale, Riley
 Trowbridge, Emily
 Tuller, M.
 Vanderbree, Kenneth
 W.M.A. Clark's Superior Friction Matches
 Webb, H.T.

Geographic Index — Enfield, CT

Wentworth, T(homas) H.
Weston, Loren
Wheeler, Hulda
Wilcox, Daniel
Willcox, Marcy
Williams, Abigail
Williams, Amy
Wright, George Fredrick
Wyllis, Elizabeth
Yale, E.A.
Yale, Edwin R.

Barkhamsted
Moore, William, Jr.

Berkshire County
Phillips, Ammi

Berlin
Barnes, Blakeslee
Barrows, Asahel
Beckwith, Benjamin
Belden, Horace
Bennett, Mrs.
Bronson, Asahel
Bronson, Samuel
Brown, Moses
Buckman, John
Butler, Thomas
Butler, Timothy
Clarke, Warren
Coab, Joseph
Cole, John
Cowles, Elisha
Crofoot, Joseph
Curtis, Emory
Curtis, Thomas S.
Davenport, Maria
Deming, Levi
Deming, Roger
Dickinson, Russel
Dobson, Isaac
Dunham, John
Dunham, Solomon
Eddy, Jesse
Ellis, John
Evans, Robert
Flagg, Abijah
Foster, Holloway, Bacon, and Company
Gilbert, David
Goodrich, Asaph
Goodrich, John J.
Goodrich, Samuel
Goodrich, Walter
Goodwin, William F.
Gridley, R.
Howard, Freeman
Hubbard Girls
Hubbard, John
Kelsey, Samuel
Lewis, Isaac
Loveland, Elijah
Merrimen, Ives
Mygatt, Hiram
North, Abijah
North, Elijah
North, John
North, Lemuel
Norton, Samuel
Norton, Zachariah
Pattison, Edward
Pattison, Edward, Jr.
Pattison, Luther
Pattison, Samuel
Pattison, Shubael
Pattison, William
Pettibone, Abraham
Plumb, Seth
Porter, Moses
Reed, Luke
Root, William
Squires, Ansel
Squires, Fred
Steele, Horace
Strickland, Simon
Turner, Edward
Wilcox, Allyn
Wilcox, Benjamin
Wilcox, Hepzibah
Wilcox, Richard
Williams, Smith
Wrightman, John

Bloomfield
Bronson, Oliver
Clark, Samuel
Filley, Harvey
Filley, Jay Humphrey
Filley, Oliver
Filley, Oliver (Dwight)
Francis, Edward
Hubbard, John
Humphrey, Hiram
North, Abijah
Smith, Eldad
Wright, Dan

Bolton
Tucker, Joseph

Bozrah
Hough, Catharine Westcot

Branford
Lamphere, Ralph

Bridgeport
David C. Sanford Company
Huge, Jurgan Frederick (Friedrick; Fredrick)
Morris, J.H.
Nichols, Eleanor

Bridgewater
Burt, Mary Jane Alden

Bristol
Bailey, Abner
Barnes, Edward
Bartholomew, Jacob, Jr.
Brewster, Elisha C.
Byington, Martin
Darrow, Elijah
Foot, Lewis
Hooker, Asahel
Hooker, Bryan, Captain
Hooker, Ira
Johnson, Zachariah
Lewis, Ira
Mitchell and Manross
Morse, Alvin
Morse, Asahel
Morse, Chauncey
Norton, Ezra
Pond, Burton
Rich, Sheldon
Robbins, Lewis
Roberts, Candace
Root, Lewis
Root, William
Thompson, Major

Canaan
Thurston, Elizabeth

Chatham
Barton, Philura
Cook, S.
Crosby, William

Cheshire
Clark, Mrs. Frank T.
White, John

Chusetown
Canfield, Abijah

Clark's Falls
Chapman, Ernst

Clinton
Hull and Stafford

Colchester
Foot(e), Abigail
Foot(e), Elizabeth
Foot(e), Mary
Foot, Lucy

Coventry
Loomis, Amasa
Loomis, John
Loomis, Jonathan

Cromwell
Johnson, Thomas, Jr.

Danbury
Rogers, Bruce

Darien
Cole, Dexter K.
Scofield, E.A.

Deerfield
Fuller, Augustus
Hawks, John

Durham
Lyman, Noah

East Granby
Brunton, Richard

East Hartford
Bartlett, Gershom
Buckland, Peter
Buckland, William, Jr.
Chandler, Daniel
Chandler, Daniel, Jr.
Ritter, Daniel
Ritter, John
Ritter, Thomas

East Manchester
Pitkin Glass Works

East Windsor
Burnap, Daniel
Reed, Abner

Elizabethtown
Phinney, Gould

Enfield
Allen, Luther

323

CONNECTICUT (Cont.)
 Enfield (Cont.)
 Burlingame, Elder Philip
 Knight, Stephanas
 Essex
 Collins, Samuel, Jr.
 Collins, Samuel, Sr.
 Southworth, Ella
 Fairfield
 Bond, Milton
 Ennin, Joseph G.
 Rogers, Bruce
 Fairhaven
 Brown, George H.
 Farmington
 Andrews, Asa
 Curtis, Anne
 Foot, Lewis
 Hill, Asa
 Hill, Ithuel
 Farmington?
 Bidwell, Titus
 Forestville
 Bulkeley, George
 Otis, Fred
 Franklin
 Hartshorn, Samuel
 Gales Ferry
 Newberry, Frances
 Goshen
 Fitch, Simon, Captain
 Norton, John, Captain
 Greenfield Hills
 Warner, Sarah Furman
 Greenwich
 Mead, Abraham
 States, Adam
 Guilford
 Gillam, Charles
 Stow, Samuel E.
 Haddam
 May, Sibyl Huntington
 Hadley
 Allis, Ichabod
 Allis, John
 Belding, Samuel, Jr.
 Hampton
 Hodgkins, Nathaniel
 Steward, Joseph, Reverend
 Hartford
 Andrews, Fanny
 Andross, Chester
 Barrow, John Sutcliff
 Benton, G.
 Blyderburg, S.
 Bosworth, Stanley
 Brewster and Sleight
 Bull, John C.
 Butler, Catherine
 C. Webster & Son
 Cross, Peter
 Ellsworth, James Sanford
 Field, Erastus Salisbury
 Fisher, J.C.
 Golding, John
 Goodale and Stedman
 Goodale, Daniel, Jr.
 Goodwin and Webster
 Goodwin, Horace
 Goodwin, Seth
 Goodwin, Thomas (O'Hara)
 Goodwin, Webster
 Grimes, John
 Hanford, Isaac
 Harrington, Thomas
 Hewins, Philip
 Isaac Wright and Company
 James, Webster
 Janes, Alfred
 Jewett, Frederick Stiles
 M.C. Webster and Son
 Nodine, Alexander
 Noyes, Abigail Parker
 Pond, Edward L.
 Putnam and Roff
 Putnam, George
 Rice, William
 Roff, Amos B.
 Sanford and Walsh
 Seymour and Bosworth
 Seymour, Major
 Seymour, Nathaniel
 Seymour, Orson H.
 Souter, John
 Stancliff, J.W.
 Stedman, Absalom, and Seymour
 Steward, Joseph, Reverend
 Stewart, L.
 Sweetland, Isaac
 Watrous, Seymour
 Webster and Seymour
 Webster, Mack
 Wells, Ashbel
 White, Mrs. Cecil
 Wilcox, Francis C.
 Hartford County
 Bissell, Thomas
 Harwinton
 Alfred, Cynthia
 Alfred, Louisa
 Alfred, Nabby
 Camp, Lucy
 Hill, Phinehas
 Hatfield
 Allis, Ichabod
 Allis, John
 Hawks, John
 Kensington
 Cowles, Seth
 Kent
 Barnum, Julia Fuller
 Killingly
 Adams, Joseph
 Roberts, Jonathan
 Spaulding, Stephen
 Killingworth
 Coe, Clark
 Hull, John L.
 Lebanon
 Collins, Benjamin
 Collins, Julius
 Collins, Zerubbabel
 Fitch, Isaac
 Fitch, Simon, Captain
 Huntington, John
 Kimball, Chester
 Manning, Josiah
 McCall, Philena
 Wheeler, Obadiah
 Litchfield
 Bacon, Mary Ann
 Brooks, Hervey
 Canfield, Caroline
 Catlin, Betsy
 Earl, Ralph
 Hopkins, Lucy M.
 Johnson, Hamlin
 Lord, Mary
 Pierce, John
 Quincy, Mary Perkins
 Sheldon, Lucy
 Vanderpoel, Emily Noyes
 Wadhams, Jesse
 Wales, Nathaniel F.
 Wenfold and Stevens
 Long Point
 States, William
 Swan and States
 Lyme
 Griswold, Matthew, Jr.
 Griswold, Matthew, Sr.
 Hewit, Charles
 Manchester
 Brown, William Elliot
 Pitkin, Richard
 Marion
 Cowles, Josiah
 Upson, (James) Salmon
 Upson, Asahel
 Upson, James
 Upson, Sarah Greenleaf
 Meriden
 Ahrens, Otto
 Andrews, Burr
 Andrews, H.
 Barth, Louis
 Beckley, John
 Bierman, Fred
 Blake, S. and J.
 Blakeslee Stiles and Company
 Brady, Hiram
 Burke, Michael
 Carter, Thomas
 Chalker, Walter H.
 Clark, Charles
 Clark, Patrick
 Clarke, S.S.
 Corrigan, William
 Cowles, Elisha
 Curtis, Daniel
 Curtiss, H.W.
 Elderkin, E.B.
 Erbest, John
 Flanagan, John
 Gale, F.A.
 Gminder, Gottlieb
 Goodrich, Ives and Rutty Co.
 Henrie, John

Hillard, E.
Holmes, Allen E.
Holmes, Eleazer
Holt, Elias
Howell, Elias L.
Hubbard, Enoch
Ives, Julius
Johnson, Alfred
Kentz, Joseph
Kilsey, Edward A.
Langston, Thomas
Lathrop, James S.
Lawrence, Sherman B.
Lewis, Patrick
Logan, James
Lorenz, Frederick
Merriam, Lawrence T.
Messenger, Charles
Minkimer, Frederick
Paine, Nelson
Peck, Asahel
Plum, Seth
Pomeroy, Noah
Purchasem, Mark
Putnam, N.B.
Quinn, John
Rich, John
Roosebush, Joseph
Smith, Joseph C.
Stedman and Clark
Venter, Augustus
Waterman, Charles
Westwood, William H.
Wilcox, Lewis S.
Yale, Hiram
Yale, Samuel

Meriden?
Pomeroy, Charles

Middle Haddam
Isham, John

Middlebury
Farrar and Stearns

Middlefield
Miller, David

Middletown
Alsop, Mary Wright
Andrews, Ambrose
Barnes, Lucius
Barrow, John Sutcliff
Brainard, Isaac
Brewer, Daniel
Cotton, Shubael Banks
Gill, Ebenezer
Hamlin, John
Johnson, Joseph
Johnson, Thomas
Johnson, Thomas
Lyman, Abel
Roberts, Hosea
Sizer, Samuel
Wilcox, Francis C.
Wright, Mary

Milford
Gillette, Susan Buckingham
Smith, C(assius)
Smith, George

Smith, Minor
Taylor, S.F.

Montville
Barker, Peter
Bradford, Esther S.

Mystic
Campbell and Colby
Campbell, James
Colby, John
Denison, Nancy Noyes
Fish, Eliza R.
Foster, Washington
Harris, Albert
Orr, Richard
Stark, Mary E.

Naugatuck?
Hoadley, David

New Britain
Isaac Smith and Thomas Lee
Lamb, James
Lewis, Erastus
Lewis, Seth
Smith, William

New Haven
Baldwin, Michael
Brown, George H.
Clinton, George H.
Day, Elizabeth
Delanoy, Abraham
Durand, John
Ehrler, Charles
Fenton and Carpenter
Fenton, Jacob
Gold, Thomas
Hall, Sylvester
Johnston, William
Modern Decoy Company
Moulthrop, Major
Munn
Northrop, Rodolphus E.
Porter, Rufus
Romer, C.
Seymour and Stedman
Simpson, George
Stock, Joseph Whiting (M.)
Woolworth, Charlotte A.

New Haven?
Clark, Emily

New London
Bears, O.I. (Orlando Hand)
Bolles, John, Captain
Bruer, Stephen T.
Buell, Benjamin
Canfield, Betsey
Clark, Elizabeth Potter
Gooding, William T.
Goodwin, William
Greene, Samuel
Hempstead, Joshua
Johnston, William
Neal, Joseph B.
Pryce, Nathaniel
Sheffield, Isaac
Thatcher, Lucretia Mumford

Norfolk
Browne, George

Thew, John Gerrett

North Branford
Keen, Palmyra M.
Smith, Sophia Stevens

Norwalk
Norwalk Pottery
Smith, Asa E.

Norwich
Armstrong and Wentworth
Burroughs, Sarah A.
Chamberlain, C.B.
Christopher Potts and Sons
Cleveland, William
Collier, Richard
Emmons, Alexander Hamilton
Greer, R.
Gridley, George
Hartshorn, John
Hosmer, Joseph, Captain
Huntington, Caleb
James, Webster
Lamb, David
Lamb, David, Jr.
Lathrop, Charles
Leffingwell, Christopher
Manning, Rockwell
Risley, George L.
Risley, Sidney
Sudenberg, Otto N.
Tisdale, Elkanah
Tracy, Andrew
Wentworth, Josiah W.
White, Richard H.
Wright, Edward Harland

Norwich?
Taylor, Elizabeth

Norwichtown
Manning, Josiah
Manning, Samuel

Old Lyme
Jessup, Jared

Old Saybrook
Mulliken, Edward H. "Ted"
Wildfowler Decoy Company

Plainfield
Perkins, Sarah
Sikes, E.

Plainville
Hill, George
Hooker, Asahel

Plymouth
Fenn

Pomfret
Kimball, Lebbeus
Kimball, Richard

Portland
Stanclift, James, III
Stanclift, James, Jr.
Stanclift, James, Sr.
Stanclift, William
Strong, Anne

Preston
Punderson, Prudence Geer

Putnam
Roberts, Joseph

CONNECTICUT (Cont.)

Red Stone Hill
 Bishop, Nathaniel
 Ives, Ira
 Lowery, Daniel
Robertsville
 Holmes and Roberts
Rockville
 Butler, W. and L.
Salisbury
 Keyes, Caroline
Saybrook
 Dolph, Charles
 Gillam, Charles
Shelburne
 Severence, Benjamin J.
Simsbury
 Barber, Titus
 Eno, William
 Ensign, Moses
 Nott, Zebedee
 Phinney, Gould
 Pinney, Eunice Griswold
 Holcombe
Somers
 Pomroy, Lucinda
Southbury
 Jaeger, Michael
Southhampton
 North, Jedediah
Southington
 Lee, Jared
 Root, Lucy (Curtiss)
 Stow, Solomon
Southville
 Rowley, Jacob
Stamford
 Hoyt, Esther
 Knapp, Harriet
Stepney
 Cook, Mr.
Stonington
 Adam States and Sons
 Sheffield, Isaac
 Stanton, Nathaniel Palmer
 States, Peter
 Swan and States
Stratford
 Baldwin
 Bliss, Roswell E.
 Burr, Julia
 Disbrow, Charles
 Holmes, Benjamin
 Laing, Albert
 Plumb, Robert
 Sanford, R.D.
 Wheeler, Charles E. (Shang)
Thompson Village
 Carter, Elias
 Dresser, Harvey
Thompsonville
 Alexander, Robert
Wallingford
 Beckley, John
 Hall, Sylvester
 Hodgetts, Sam

Waterbury
 Carswell, Mrs. N.W.
 Greco, John
 Hayden, Hiram
 Mitchell, Almira
 Porter, Abel
 Scovill, Nancy Cooke
 Wilton, Hobart Victory
West Cornwall
 Francis, J.P.
West Hartford
 Goodwin, Harvey
West Haven
 Sperry's Decoy
West Meriden
 Marcy, J.J.
West Simsbury
 Dyer, Candace
Westport
 Hall, Margaret L. (Mrs. George)
 Wheeler, Charles E. (Shang)
Wethersfield
 Blin, Peter
 Broadbent, Samuel, Dr.
 Buckley, Oliver
 Chester, Sarah Noyes
 North, Simeon
Wilton
 Barber, Joel
 Kenneth Lynch and Sons
Winchester
 Whiting, Riley
Windham
 Huntington, Julie Swift
 Manning, Frederick
 Manning, Josiah
 Russell, John
 Walden, John, Jr.
 Walden, John, Sr.
Windham County
 Alexander, Francis
 Alexander, Frank
 Fairfield, Hannah
Windsor
 Brown, Joseph, Jr.
 Buell, William
 Day, Nathan
 Drake, Ebenezer
 Drake, Nathaniel, Jr.
 Drake, Silas
 Filley, Oliver
 Griswold, George
 Horsfield, Israel
 Lathrop, Loring
 Lathrop, Thatcher
 Peck, Seth
 Pinney, Eunice Griswold
 Holcombe
 Stoughton, Jonathan
 Stow, O.W.
Woodbury
 Bacon, Mary
 Hirsch, Cliff
 Lewis, A.N.
 Sanford, Thomas

Woodstock
 Chandler, Winthrop
 Corbin, Hannah
 Haywood, Thomas
 Holmes, John

DELAWARE
 Blair, John
 Brown, Elinor
 Eicholtz, Jacob
 English, Dan
 Grant, Henry
 Janvier, George Washington
 Lippincott, Gideon
 Nichols, Margaret
 Parker, Charlie
 Predmore, Cooper, Captain
 Taylor, Eliza Ann
 Taylor, H.M.
 White, Winfield
Delaware Bay Area
 English, John
Hockessen
 Marshall, Abner
Kent County
 Osmon(d), (Anna) Maria
New Castle
 Hare Pottery
Newcastle County
 England, Ann E.
Odessa
 Corbit, Mary Pennell
Wilmington
 Culin, Elizabeth B.
 Frishmuth, Sarah
 Headley, Somers G.
 Jeffries, Deborah Hunt
 Kennedy, Mary
 Martin, John F.
 Reiss, William

DISTRICT OF COLUMBIA
Alexandria
 Smith, H.C.
Georgetown
 Thomson, William
Washington
 Arnold, John James Trumbull
 Clark, Irene
 Concklin
 Eastman, Seth
 Esputa, Susan Adel
 Gottier, Edward
 Hamilton, Charles J.
 Hamilton, James
 Hampton, John (James)
 Smith, J.W.
 Sutherland, Charlotte
 White, Iva Martin
 Willis, Eveline F.

FLORIDA
 Minchell, Peter
 Smith, E(rnest) A(rcher) "Frog"
Anna Maria Island
 Munro, Janet

Arcadia
 Rogers, Gertrude
Florida City
 Leedskalnin, Edward
Gainesville
 Aaron, Jesse
Key Largo
 Papio, Stanley
Key West
 Sanchez, Mario
 Valdes, Georgio
Lake Butler
 York, H.F.
Leesburg
 Coyle, Carlos Cortes
Miami
 Cooke, Captain
 Gatto, (Victor) Joseph
 Gibson, Sybil
 Moskowitz, Isidore
Pensacola
 Kohler, John W.
Sarasota
 Nice, Bill
Seffner
 Adkins, J.R.
St. Augustine
 Cunningham, Earl
Tacoma
 Smith, W.A.
Tampa
 Cripe, Jack "Sailor Jack"
 Sigler and Sons
 Sigler, Clarence Grant
 Sigler, Jack

GEORGIA
 Almon, Leroy
 Becham, Washington
 Fabian, Caroline Broughton
 Foote, Lewis
 Gray, Grace
 King, Martha Ellen
 Moore, Mrs. Roy
 Parry, Eliza
 Perry, Eliza
 Root, Lewis
Ackworth
 Patterson, Mary Ann "Polly" Tanner
Albert County
 Perry, Thomas, Jr.
Alvaton
 Gordy, William Thomas Belah
Athens
 Powers, Harriet
Atlanta
 Bailey, Eldren
 Cartledge, William Ned
 Flanagan, Thomas Jefferson, Reverend
 Lycett, Edward
 Simon, Jewel
 Wilkerson, Lizzie
 Wilkinson, Knox

Baldwin County
 Stevens Pottery
Bogart
 Brewer, J.D.
Bolton
 Bird, C.H.
Brooks County
 Miller, Howard
Buena Vista
 Martin, Eddie Owens "Saint EOM"
Byron
 Long's Pottery
 Long, James L.
Cairo
 McGriff, Columbus
Carroll County
 Barr, Eliza
Cartersville
 Gordy Pottery
 Gordy, William J.
Clarke County
 Smith, Edwin B.
Cleveland
 Meaders Pottery
Columbus
 Cooke, George
 Matthews, J.M.
Covington
 Ned
Coweeta County
 Bailey, Mary
Crawford
 Long, J.H.
Crawford County
 Avera, John C.
 Merritt, William Dennis Billy
Daven
 Rogers, William
Dawson
 Toomer, Lucinda
Delray
 Salter, Ben S.
Dent
 Beecham Pottery
Emerson
 Jefferson, Mannie Holland
Fulton County
 Rolader, William Washington "Uncle Don"
Howell's Mill
 Kline, Charles S.
Jasper
 Gibson, Sybil
Knox Hill
 Odom and Turnlee
Leo
 Meaders Pottery
Macon
 Craft, William
Maysville
 O'Kelley, Mattie Lou
Meansville
 Rogers Pottery

Meigs
 Forrester, Laura Pope (Mrs. Pope)
Miledgeville
 McMillan, J.W.
Mossy Creek
 Dorsey, W.F. "Daddy Bill"
 Hewell, Will
 Meaders, Aire (Mrs. Cheever)
 Meaders, Cheever
 Meaders, Lanier
Mossy Creek District
 Dorsey, Tarp (Joseph Tarplin)
Orange
 Stork, E(dward) L(eslie)
Parrot
 Telfair, Jessie
Pennville
 Finster, Howard, Reverend
Pleasant Hill
 Ferguson, Mrs.
Salem
 Holland, John Frederick
Savannah
 Carter, David
 Cerveau, Joseph Louis Firman (Fermin)
 Davis, Ulysses
 Duche, Andrew
 Golding, William O.
 Tillman, Frances
 Wade, Frances
Sonoraville
 McEntyre, Kent K.
Summerville
 Finster, Howard, Reverend
Toccoa
 Ligon, C.P.
Vinings
 Rowe, Nellie Mae
Washington County
 Cogburne and Massey
Westville
 Gordy, D.X.
Wilkes County
 Harper, Cassandra Stone

HAWAII
 Anderson, Eleanor S.
Homaunau
 Velghe, Joseph (Father John)

IDAHO
 Brown, Mary
 Castle, James

ILLINOIS
 Ainslee, Henry Francis, Colonel
 Allen, Marie W.
 Barton, Major
 Collot, George Henri Victor
 Daniel, Holy
 Deady, Stephen
 Dennis, S.A.
 Dennis, William
 Egan, John J.

Illinois — *Folk Artists Biographical Index • 1st Ed.*

ILLINOIS (Cont.)
 Hall, Basil, Captain
 Hubban, E.A.
 Larson, Edward
 Lorentz, Peter
 Nichols, Richard
 North, L.
 Page, S.P.
 Radfore, P.M.
 Stanley, John Mix
 Staples, Waity
 Starkweather, J.M.
 Stenge, Bertha
 Tracy, G.P.
 Wakeman, Thomas
 Waugh, Henry C.
 Waugh, Henry W.
 West, Horace B.
 Whitaker, E.M.
Albion
 Bower, George
 Chism, Mrs. Charles
 Flower, George
 Michaels
 Ronalds, Elizabeth F.
 Weaver, Elias
Alexander County
 Sickman, Theodore
Alton
 Berresford, Benjamin
 Blair, J.B.
 Roeder, Conrad
 Sawyer, H.
 Warwack, Isaac
Amboy Township
 Andruss, Mrs. W.B.
Andalusia
 Simmons, Andrew
 Simmons, Jermiah
Anna
 Anna Pottery
 Kirkpatrick, Cornwall E.
 Kirkpatrick, Wallace (V.)
Anna (Lowell)
 Kirkpatrick
Athens
 John Pierson and Company
 Ramsey, Barnett
Augusta
 Cherrill, Adolphus
Aurora
 Ackerman and Brothers
 Cross, J. George
 Marlett, Eliza Ann
 McCann, George
 Peck, Sheldon
 Pratt, D.C.
 Pratt, F.F.
 Smith, P.H.
Avon
 Holton, Chancy
Barnbridge Township
 Croxton, Walter
Batavia
 Dawson, R.W.
Belleville
 Bynum, B.
 Gauss, George
 Gruenig
 Knoebel, Jacob
 Lengfelder, Balthasar
 Reay, Charles
 Seewald, John (John Philip)
 Stizelberger, Jacob, Sr.
 Stizelberger, William
 Walhaus, Henry
 West, Washington J.
Bishop Hill
 Krans, Olof
 Lundeen, F.V.
 Neumann
Bloomington
 Hunt, Elisha
Bluff Springs
 Berry
Bureau
 Elliston, Robert A.
Cahokia
 Harrison, Robert
Cairo
 Little, Samuel
Camp Point
 Martin, E.G.
Carbon Cliff
 Thomas(?), W.S.
Carmi
 Foster, Mary Ann Kelly
Carthage
 Cherrill, Adolphus
Casey
 Frazie, J.
Champaign County
 Herrmann, Charles A.
Chandlerville
 Zaumzeil, Ernestine Eberhardt
Chicago
 Almini, Peter M.
 American Terra-Cotta Company
 Attwood, J.M.
 Baker, Eliza Jane
 Barbee, W.T.
 Bates, A.S.
 Beckert, L.
 Blankensee, John
 Bond, Charles V.
 Bronesky, S.S.
 Brooks, James A.
 Brooks, Samuel Marsden
 Brooks, T(homas) V.
 Caberey
 Castelnau, Francis
 Chambers, Joseph T.
 Clapperton, William R.
 Clark, G.W.
 Clark, Harry A.
 Cleveland and Company
 Clifford, Edward M.
 Cole, A.C.
 Cote, Claude
 Cridland, Charles E.
 Darger, Henry
 Davis, George
 Dawson, William
 Dee, William M.
 Dibblee, Henry
 Dillinham, John E.
 Felski, Albina
 Frune, George W.
 Glassen, John
 Godie, Lee
 Goodman, J. Reginald
 Gould Brothers and Diblee
 Grommes and Ulrich
 Hawks, George W.
 Holmes, L.W.
 Howland, E.D.
 Ingalls, Walter
 Isherwood, Henry
 Jackson, Henry
 Jackson, J.
 Jevne, Otto
 Kimball, H.C. and Compamy
 Kinzie, John
 Kinzie, Juliette M.
 Kleinhofen, Henry
 Kollner, August
 Labhart, J.M.
 Lees and Preeble
 Lenox, E.S.
 Lewin, Isaac
 McMaster, William E.
 Mehrle, W.
 Merck, C.
 O. Henry Tent and Awning
 Company
 Oliver, John A.
 Pendergast, W.W.
 Porter, J.S.
 Power and Ferrell
 Rasmussen, Nils
 Reynolds, J.W.
 Rose Folding Decoys Company
 Schoolcraft, Henry Rowe
 Simon, Pauline
 Skyllas, Drossos P.
 Smithmeyer and Company
 Sosman and Landis Company
 St. Alary, E.
 Steinbach, Henry
 Sutterly, Clement
 Thielke, Henry D.
 Tracy, Simon P.
 United States Tent and Awning
 Company
 Volk, Leonard W.
 Wallis, Frederick I. (J.)
 Webster, Derek
 Western Grille Manufacturing
 Company
 White, Alexander
 Willoughby, Edward C.
 Wilson, Henry
 Wilson, Oliver
 Winter, William(?)
 Winterbotham, Mrs. John
 Humphrey
 Wolfe, John C.

Yates, H.H.
Yoakum, Joseph E.
Chillicothe
Cameron, Glen, Judge
Clark County
Fasig, A.
Fasig, Christian
Clinton County
Sayels, J.M.
Cooperstown
Donnahower, Michael
Cotton Hill
Brunk, David
Ebey, George
Crawford County
Shaw, Martha Ann
Decatur
Cornell, James
Deer Park Township
Slater, Alfred
Dixon
Brooks, Noah
Knirim, A.D.
Dover
Nickols, Alira
Dundee
Goodwin, Russell F.
Warren, S.K.
Dunleith County
A. Jennings Pottery
East Dundee
Haertel, Harold
Effingham
Hartmann, Charles G.
Elgin
Elgin Windmill Power Company
Padelford, R.W.
Schultz, Martin
Wilkins, Benjamin
Elizabeth
King, Samuel B.
Sackett, David A.
Woodruff, D.C.
Exeter
Martin, John L.
Fairfield
Jessup, James
Fancy Creek
Power, Nancy Willcockson
Farmingdale
Watts, Charles
Farmington
Satler, J.M.
Franklin
Ellis, Lucebra
Galena
Barber, John W(arner)
Barth, Otto
Bender, A.S., Major
D.A. Sackett and Company
Sackett, Alfred M.
Smith, John E.
Swift, S.W.
Taylor, Bayard
Galesburg
Blood, M.I.

Cassini, Frank
Galva
Krans, Olof
Geneva
Hawkins, D.W.
Goodfield
Hohulin, Gottlich
Greene County
Ebey, John Neff
Greenville
Blatter, Jacob
Grundy County
Goose Lake Stoneware
 Manufacturings Company
Havana
Glick, Herman
Hazel Hill
Flower, Mary Elizabeth
Hennepin
Ford, J.S.
Henry
McKenzie, John
McKenzie, Thomas
Perdew, Charles H.
Highland
Eggen, Jacob
Zabbart, M.
Hill's Grove
Gilcrest, Helen
Hillsboro
Blackman, George
Illinois City
Gorham, Joshua
Jacksonville
Cherrill, Adolphus
Jackson, Anne Wakely
Jersey County
Heitzie, Christian
Thomas(?), W.S.
Joliet
Mitchell, Vernell
William E. Pratt Manufacturing
 Company
Jugtown
White, William
Knox County
Sayels, J.M.
Lacon
Cook, G.W.E.
Lanark
Hamilton, John
Lanark?
Hamelton, John
Lewistown
Worley, W.C.
Liberty
Tuthill, Silas
Loami
Darneille, Benjamin
Logan County
Bock, Mrs. William N.
Lowell
Anna Pottery
Macomb
Eagle Pottery
Macomb Pottery Company

Macon
Blackstone, Eleanor
Madison County
George Morley and Brothers
Manchester
Ebey, George
Ebey, John Neff
Marina City
Warner, H.(W.)
Marissa
Finger, Henry
Maroupin County
Etter, Elizabeth Davidson
Martinsville
Fasig, William
McComb
McComb Stoneware Company
Menard County
Baker, John B.
Bone, Elihu
Mendota City
Fernberg, Samuel
Moline
Fullerton, Hugh
Union Malleable Iron Company
Monmouth
Monmouth Pottery Company
Weir
Western Stoneware Company
Mound City
Kirkpatrick, Alexander
Kirkpatrick, Cornwall E.
Kirkpatrick, Murray
Kirkpatrick, Wallace (V.)
Koch
Mt. Sterling
Wilson, James S.
Naperville
Netzley, Uriah
Nauvoo
Carlin, John
Chenne, Joseph
Couloy, Isadore
DeBault, Charles
Dibble, Philo
Field, J.A.
Filcher, Thomas J.
Fleury, Elsie
Fuller, Elijah K.
Grocott, J.
Kirschbaum, Joseph, Sr.
Martin, Moses
Moore, Mathew
Murphy, W.
Pilkington, Adam
Smith, David H.
Neponset
Townsend, Charles
New Harmony
Lesueur, Charles
O'Fallon
Seewald, John (John Philip)
Oak Grove
Zook, J.W.
Oglesby
Whittington, Hector "Heck"

ILLINOIS (Cont.)
Oneco
 Sanders, Daniel
Paris
 Ernest, Mrs. Austin
 Shank, William
Pekin
 Englehart, Nick
Peoria
 American Pottery Company
 Bush, John A.
 Clark, Decius W.
 Convay, John B.
 Davis, James
 Fenton and Clark
 Fenton, Christopher Webber
 Graves, Bert
 Greatbach, Daniel
 Jager, Joseph
 King, Samuel B.
 Lohrman, William
 Ludon and Long
 Oertle, Joseph
 Peck, Charles
 Peoria Pottery Company
 Roberts, John M.
 Schoenheider, Charles
 Wilkins, James
Petersburg
 Degge, Mary Frances
Plainfield
 O'Brien, John Williams
Princeton
 Bryant, Julian Edwards
 Clark, Mason
 Sloan, Junius R. (John)
 Walker, Charles
Putnam
 Dawson, Tube
Putnam County
 Stewart, William M.
Quincy
 Beck, Augustus
 Becker, A.H.
 Dan's Duck Factory
 Funk, J.S.
 Herberling
 Jansen, Frederick William
 Koch, Ann Koenig
 Lester, John W.
 Maertz, Charles
 Ohnemus, Matthias
 Quidor, John
 Reed, William A.
 Roth, John
 Schipper, Jacob
 Schmitt, Adam
 Walhaus, Henry
Ripley
 Glenn and Hughes
 Glenn, William
 Haukins, W.W.
 Hubbs, W.W.
 Irwin, Harvey
 Keith, Charles W.
 Martin, Adam E.

Pierce, Augustus
Stofer, L.D.
Stout, Francis Marion
Stout, John N.
Rochester
 West, Benjamin
Rock Island
 Brahm, B.
 Wirig, Nicholas
Rockford
 Robertson, George J.
Saline County
 Nicomb
Sangamon County
 Ebey, John Neff
Santa Fe
 Crock, Charles
Scott County
 Davidson, Seth
 Nash, F.M.
Seller's Landing
 Sellers, George Escol
Shelbyville
 Hartmann, Charles G.
 Root, Robert Marshall
Smithfield
 Smithfield, Ulrich
Springfield
 Abston, U.C.
 Cabanis, Ethan T.
 Conant, S.
 Doyle, William G.
 Hillman, Richard S.
 Ives and Curran
 Moore and Walters
 Richards, Frank Pierson
 Richardson, Edward, Jr.
 Wimar, Karl
St. Charles
 Pratt, D.C.
Staunton
 Cowell, Benjamin
Stephenson County
 Haag, Jacob
Stonington
 Smith, Sarah Douglas
Sumner
 Davenport, Patrick Henry
Tamaroa
 Redick, John
Tazewell County
 Thomas(?), W.S.
Upper Alton
 Harrison, C.R.
 Harrison, Fielding T.
 Harrison, Robert
 Heath, William
 Olevett, Charles
 Pinckard, Nathaniel
 Sawyer and Brothers
 Smithingham, George
 Ulrich and Whitfield
Vandalia
 Berry, James
Vermilion County
 La Tourette, Sarah (Van Sickle)

Vermilionville
 Kirkpatrick, Andrew
 Kirkpatrick, Murray
Wanborough
 Cooper, Thomas
Warren County
 Damitz, Ernst
Wheeling
 Arnold, Lorenz
White Hall
 Baker, Michael
 Heath, William
 Pierce, Augustus
 Ramsey, William
Winchester
 Ebey, George
 Harrison, Robert
 Martin, John
 Pierce, Augustus
Wyoming
 Tweed, Susannah

INDIANA
 Balantyne
 Burkholder, Lydia
 Crafft, R.B.
 Davenport, Patrick Henry
 Fennell, Michael
 Gordon, Thomas Clarkson
 Lambright, Mrs. Menno
 Malcolm, Mrs.
 Maxwell, Ann
 McCrea, Mrs. Mary Lawson Ruth
 Miller, Mary
 Smith, Aurelius
 Yoder, Fanny
 Yoder, Lydia
Adams Township
 Lederman, Henry
Alamo?
 Cumbie
Andersonville
 Craig, James
Annapolis
 Atcheson, D.L.
 Atcheson, H.S.(R.)
Auburn
 Getty, J.A.
Bloomington
 Pering, Cornelius
Brazil
 Cordrey, Isaac
 Torbert and Baker
 Tourpet and Becker
Brockville
 Michael, Enos
Brookville
 Bolton, Thomas
 Burkholder, Isaac
 McKinney, James
Brownsville
 Thompson, Ritchie
Caledonia
 Simpson, Joseph
Cannelton
 Cannelton Sewer Pipe Company

Geographic Index — New Harmony, IN

R. Clark and Company
Canton
Craig, James
Young, Matthew
Carthage
Reiter, Nicholas
Stinger, Samuel
Center Township
Young, John W.
Centerville
Corbin
Clark County
Peden, Joseph
Coatesville
Wilson, Hugh
Connersville
Bundy, Hiram
Van Vleet, Abraham
Corydon
Thompson, George
Cranfordsville
Vogel, August
Dalton Township
Favorite, Elias
Dearborn County
Huber, Damus
Huber, John
Klein, Andrew
Schrontz
Dearborn County?
Nurre, Joseph
Decatur County
Gilmore, Gabriel
Dunlapville
Gilmore, Joseph
Eel Township
Balantyne, John
Elkhart
Lantz, Mrs. Ed
Outing Manufacturing Company
Emma
Greenawalt, Katie
Hostetler, Nina D.
Lambright, Mrs. Susan
Miller, Lydia Ann
Miller, Polly
Yoder, Mrs. Menno
Evansville
Beck, A.M.
Becting Brothers
Crown Pottery Company
J.B. and G.L. Mesker and Company
Fairfield
Dare, Robert
Fayette County
Van Vleet, Abraham
Fillmore
Muir, John
Floyd County
Craig, James
Fountain County
La Tourette, Henry
La Tourette, John
La Tourette, Sarah (Van Sickle)

Frankfort
Reed, Kate D.
Franklin
Bisset, William
Franklin County
Craig, William, Sr.
Eckert, Gottlieb
G.W. Kimble Woolen Factory
Gilchrist, Hugh
Gilmore, Thomas
Logan, Patrick
Maurer, John
Walter, Jacob
Fremont
Michael, Philip
Fulton County
Schoch, Charles (G. Schoch)
Gelena
Lee, John
Germantown
Muir, Robert
Muir, Thomas
Muir, William
Goshen
Troyer, Mary Ann D.
Greencastle
Muir, John
Greensburg
Craig, James
Craig, William, Jr.
Craig, William, Sr.
Young, Matthew
Hagerstown
Hoover, John
Jordan, Thomas
Test Woolen Mills
Hamilton County
Forrer, Martin
Klehl, J.
Klein, John
Myers, Charles D.
Harmony
Brown, S.H.
Harmony Township
Cockefair Mills
Hendricks County
Wilson, Henry
Wilson, Hugh
Henry County
Adolf, Charles
Adolf, George
Fairbrothers, William
Graham, Samuel
Honeyville
Bontrager, Mrs. Lydia
Christner, Mrs. John
Hochstetter, Mrs. Manas (Mary)
Miller, Anna Viola
Yoder, Amanda Sunthimer
Yoder, Amelia
Yoder, Mrs. Mose V.
Yoder, Mrs. Yrias V. (Mrs. Urias V.) (Anna)
Huntington
Becting Brothers

Indianapolis
Muir, Thomas
Waugh, Henry W.
Jackson Township
Osbon, Aaron C.
Snyder, Jacob
Jeffersonville
Unser, C.
La Grange County
Miller, Tobias
La Porte County
Burkerd, E.
Burkerd, Peter
Lafayette
Balantyne, Abraham
Balantyne, Samuel
Barbee, W.T.
Hoagland, James S.
J.S. Hogeland and Son
Jackson, Thomas
Miller, Theodore H.
Neely, Henry
Liberty Township
Muir, Robert
Logan Township
Remy, James
Loogootee
Stuckey, Martin or Upton
Madison County
Hicks, William
McCordsville
McCord, Susan (Nokes)
Metamora
Nichols, Richard
Miami County
Deeds, William
Middlebury
Bontrager, Mrs. Lydia
Eash, Lydia
Mast, Barbara
Miller, Anna Viola
Troyer, Amanda S.
Yoder, Amanda Sunthimer
Milford
Craig, William, Sr.
Milton
Marr, John
Snyder, John
Wissler, John
Morgan County
Graves, David Isaac
Mount Carmel
Gilchrist, William
Muncey?
Lowmiller, William
Muncie
Heffner
Nappanee
Hochstetter, Katie
New Albany
Loebig, George
New Castle
Dousa, Henry
Graham, Samuel
New Harmony
Maental, Jacob

INDIANA (Cont.)
 New Paris
 Snider, Samuel
 New Winchester
 Wilson, Henry
 Noblesville
 Adolf, Henry
 Klein, Andrew
 Klein, John
 Ovid
 Hicks, Samuel
 Owensboro
 Reynolds
 Pipe Crick
 Snider, J.
 Richmond
 Bott, Hammersley and Company
 Dunlap, William S.
 Kitson, Nathan
 Rattray, Matthew
 Ripley County
 Herman, John
 Salem
 Miller, Robert
 Smith, William
 Shelby Township
 Cranston, Thomas
 Shelbyville
 Klein, Andrew
 Klein, Francis
 Klein, Fredoline
 Klein, John
 Klein, Michael
 Shipshewana
 Bontrager, Mrs. Eli
 Bontrager, Mrs. Rudy
 Miller, Katie (Mrs. David J.L.)
 Schrock, Mrs. Sam
 Whetstone, Lydia S.
 Shoals
 Deval and Catterson
 South Bend
 Fisher, Daniel
 Fisher, Levi
 Steuben County
 Fridley, Abraham
 Switzerland County
 Baird, James
 Cowam, Donald
 Cranston, Thomas
 Frances
 Nash, Matilda
 Simpson, George
 Terre Haute
 Kean, Frederick A.
 Topeka
 Herschberger, Mrs. Manuel
 Lambright, Mrs. Elizabeth
 Lehman, Amanda
 Miller, Henry
 Miller, Mrs. Nathaniel
 Miller, Mrs. Susie
 Petershime, Mrs. Samuel
 Schrock, Susan
 Yoder, Mrs. Daniel T.
 Yoder, Mrs. Yrias V. (Mrs. Urias V.) (Anna)
 Troy
 Bennett, Edwin
 Clews, James
 Hinchco, Benjamin
 Vodrey, Jabez
 Union County
 Dare, Robert
 Gilmore, Gabriel
 Gilmore, Thomas
 Gilmore, William
 Valparaiso
 Garis, John
 Van Rosen Township
 Slaybough, Josiah
 Vincennes
 Shouse, Nicholas
 Wabash Township
 Kerns, William
 Washington County
 Lawyer, James
 Washington Township
 Rogers, John
 Slaybough, Josiah
 Wayne County
 Adolf, Charles
 Adolf, George
 Lorentz, Peter
 Myers, Charles D.
 Rogers, John
 Stiebig, John
 West Indianapolis
 Muir, William
 Shaw, Robert
 Wilson, Jonathan
 White County
 Balantyne, Samuel
 Yoder Corner
 Bontrager, Polly

IOWA
 Bennett
 Seebeck, Walter
 Burlington
 Greenless, Kenneth
 Schramm, Speck
 Turley Brothers
 Davenport
 Maddhes, C.
 Norberg, Virgil
 Wild, John Casper
 Des Moines
 Laskoski, Pearl
 Throckmorton, Jeannette Dean, Dr.
 Fairfield
 Stephenson, Daniel
 Gutenberg
 Friedlein, Paul
 Johnson County
 Bender, David
 Mahaska County
 Adolf, Henry
 Oskaloosa
 Gilmore, William
 Shenandoah
 Baker, Samuel Colwell
 Tama County
 Wetherby, Isaac Augustus

KANSAS
 Coon, Clara
 Ohno, Mitsugi
 Woods, David
 Atcheson
 Lewis, Flora
 Cadmus
 Blair, Streeter
 Douglas County
 Adolf, Henry
 Haven
 Bontager, Mrs. Clara
 Frye, Mary
 Miller, Sarah
 Hutchinson
 Miller, Mrs. S.N.
 Leavenworth
 Parker Carnival Supply Company
 Parker, Charles W., Colonel
 Lucas
 Deeble, Florence
 Dinsmoor, S.P.
 Osage County
 Adolf, Charles
 Portis
 Marshall, Inez
 Wilson
 Root, Ed

KENTUCKY
 Anderson, Sarah Runyan
 Bartlett, I.
 Byrley, Frank J.
 Campbell, Larry
 Clayton, Theodore
 Crafft, R.B.
 Davenport, Patrick Henry
 Dudley, Samantha Charlotte
 Feltner, Jim
 Fodor, Richard L.
 Hobdy, Ann F.
 Hodge, Mack
 Hurst, John W.
 Hurst, T.W.
 Irvine, Eldon
 Karsner, Clark
 Kinney, Charles
 Kinney, Noah
 May, Roy
 Mayes, H. Harrison
 Mosely, Susanna Richards
 North, Noah
 Patride, Marvin
 Patton, Ernest
 Sparks, Fielden
 Tuska, Seth
 Ward, Edwin P.
 Anchorage
 Miles, Pamela
 Auburn
 Jarvie, Unto

Barbourville
 Woolum, Wayne
Bell City
 Howard and Son
 Russell, D.W.
Bourbon County
 Curry, Sam
Bowling Green
 Calvert, Margaret Younglove
 Haney, Clyde
Campbell County
 Geiger, Margaret
Campton
 Dunn, Mary
 Tolson, Donny
 Tolson, Edgar
Clark County
 Dupue
 Hart, E.J.
Clay County
 Mize, Mahulda
Corbin
 Creech, Homer E.
Cumberland County
 Cumberland, Mary Alexander
Delta
 Decker, Evan
Drakes Creek
 Allcock, Cirendilla
Dwarf
 Cornett, Chester
East Bernstadt
 Black, Minnie
Ezel
 Goodpastor, Denzil
Falmouth
 Williams, May
Fayette County
 Curry, Sam
Frenchburg?
 Spencer, Lonnie
Garrard County
 Moran, Amanda Estill
Glasgow
 Gamble, Sam
Gracey
 Stewart, Virginia
Grane? County
 Cona
Grave County
 Pryor, Nannie Elizabeth
 (Sutherlin, Nannie Pryor)
 Sutherlin, Mary
Grayson Springs
 Mattingly, Eliza Ann
Hancock County
 Midkiff, Mary Louisa Givens
 "Lula"
Haymond
 Lucas, David
Henderson
 Allison, Mary H.
 Hollinger, Lizzie
Henderson Settlement
 Ellis, Clarence

Henry County
 Bruce, Sophronia Ann
 Hieatt, Martha Tribble
Hickman
 Adams Decoy Company
Hillsboro
 Garr, Sarah Crain
Hustonville
 Short, Lillie
Jamestown
 Hay, T.
 Skaggs, Loren
Knott County
 Owsley, Willie
Lakeland
 Hughes, Charles Edward, Jr.
Lawrence County
 Riffle, Martha Jane
Lewis County
 Mitchell, Elizabeth Roseberry
Lexington
 Carty, John, Sr.
 Deyarmon, Abraham
 Jones, Arthur
 Mentelle, Ward, Sr.
Louisville
 Banvard, John
 Davis, Alfred "Shoe"
 Doane, George
 Fields, Leonard
 Finn, Marvin
 Frye, William
 Gibbs, James
 Herbert(?)
 Kean, Carl Lewis
 Kean, Frederick A.
 Lewis, William
 Melcher, H.
 Miller, Anna G.
 Schmidt, Anna Marie
 Skeen, Jacob
 Vodrey and Frost
 Vodrey, Jabez
 Wright, Morrison
Lynville
 Pittman, J.W.
Mayfield
 Lydon, William
Maysville
 Thomas, I.
 Toupe, Robert
McLean County
 Bidwell, Elizabeth Sullivan
Meldrum
 Miracle, Hazel
Mercer County
 Fink, Willie Sharpe
New Yersey
 Anderson, Sarah Runyan
Oldham County
 Dorsey, Henry
Paducah
 Bauer, A.J.
 Boucher, Doris
 Flemings, Isabella
 Lydon, William

 Poyner, Mrs. M.E.
 Wallace and Gregory Brothers
Queensboro
 Beckham, Julia Wickliffe
Richmond
 Bybee Pottery
Russell County
 Grider, Nancy Miller
Russellville
 Ivy, Virginia Mason
Scott County
 Curry, Sam
 Kean, Carl Lewis
Shelbyville
 Wilson, Hugh
Slade
 MacKenzie, Carl
Smiths Grove
 Smith, Virginia Bland
Somerset
 Perkins, Elizabeth Taylor
 Brawner
 Thurman, Mary Elizabeth Woods
Squib
 Cress, Edward
Stanton
 McKenzie, Carl
Temple Hill
 Scott, Judy Ann
Todd County
 Trabue, Fannie Sales
Trigg County
 Morris, Mattie Tooke
 Vanzant, Ellen Smith Tooke
Versailles
 Lafon, Mary Virginia
Wabaco
 Stacy, George
Warrenton
 Horner, Gustavus Richard Brown
Woodford County
 Cohen, Alfred
 Frymire, Jacob (J.)

LOUISIANA
 Floote, Mrs. A.A.
 Macca, Lorita
Fort Delaware
 Leve, Henry
Iberville Parish
 Landry, Pierre Joseph
Natchitoches Parish
 Hunter, Clementine
New Orleans
 Brice, Bruce
 Brook, Miss M.
 De Laclotte, Jean Hyacinthe
 Degrasse, Aug.
 Evans, James Guy
 Foy, P.
 Gastal, J.
 Hureau, Madame E.
 Hutson, Charles Woodward
 Lembo, J. Lawrence
 Levie, John E.
 Mangin, John A.

LOUISIANA (Cont.)
 New Orleans (Cont.)
 Morgan, Sister Gertrude
 Newcomb Pottery Company
 Persac, Adrien
 Pickhil, Alexander
 Smith, Edwin B.
 Telan, W.A.
 Willey, Philo Levi "The Chief"
 Williams, E.
 Wiltz, Emilie
 Patterson
 Butler, David
 St. Sophie
 La France, Mitchell

MAINE
 Bennett, E.V.
 Butler, Esteria
 Capen, Azel
 Cook, Mehitable J.
 Davis, Joseph H.
 Gilbert, E.J.
 Goodwin, Harmon
 Granger, Charles H.
 Hardy, Jeremiah P.
 Heeling, John
 Hildreth, Herbert L.
 Kent, A.D.
 King, Charles Bird
 Lewis, Elijah P.
 Mayall, Eliza McClellen
 McKeller, Candy
 Morrill, M.L.
 Plummer, R.
 Pratt, Henry C.
 Rumrill, Edwin, Captain
 Sawyer, Mrs.
 Smith, Howland
 Stearns, William
 Tuels, Anna
 Wass, Harry
 Alfred
 Bussell, Joshua H.
 Green, Elder Henry
 Augusta
 Evans, Daniel
 Finch, E.E.
 Shurtleff, Isaac
 Bangor
 Bowman, William
 Hoyt, Thomas
 Pierson, Andrew
 Seavey, Thomas
 Seavey, William L.
 Thomas Seavey and Sons
 Bath
 Dullen, C.
 G.B. McLain and Company
 Hatch, Edbury
 Hillings, John
 Ingalls, C(yrus) A.
 Jones, Wealthy P.S.
 Lombard, Rachel H.
 Newcomb
 Piper, John C.
 Potter, W(oodbury) A(bner)
 Prior, Jane Otis
 Prior, William Matthew
 Sampson, C(harles) A.L., Captain
 Southwork, William
 Thompson, Cephas Giovanni
 Winsor, Nathaniel
 Wyman, Samuel D.
 Belfast
 Abbot, J.C.
 Gilbert and Worcester
 Gilbert, Fitz W.
 Proctor, David R.
 Berwick
 Cutts, Elizabeth
 Kennedy, William W.
 Biddeford
 Cote, Adelard
 Blue Hill
 Fisher, Jonathan, Reverend
 Lord, T.M.
 Brunswick
 Jones, Emery
 Bucksport
 Colby, Emery and Company
 Emery, L.
 Pratt, Leon B.
 Stubbs, William P.
 Buxton
 Brewster, John, Jr.
 Smith, Royal Brewster
 Calais
 Drew
 Camden
 Cushing, Jere C.
 Cushing, Jeremiah C.
 Prince, Henry M.
 Proctor, D.R.
 Rice, Ernest S.
 China
 Twing, George B.
 Cross Island
 Berry, Hans
 Cushing
 Langlais, Bernard
 Damariscotta
 Jones, Emery
 Dixfield Common
 Barnard, Lucy
 East Hiram
 Merrill, Henry W.
 East Machias
 Chaloner, Holman Waldron
 Todd, James
 Ellsworth
 Cole, Joseph Greenleaf
 Crane, James
 Falmouth
 North, Elijah
 Fayette
 Packard, Samuel G.
 Freeport
 Griffin, G.J.
 Jones, Emery
 Fryeburg
 Mason, William A.
 Gardiner
 Alanson Lyman & Declus Clark
 Pierson and Horn
 Plaisted, F.A.
 Gorham
 Smith, Hezekiah
 Hallowell
 Currier, Alexander
 Drew, Alvin
 Evans, Daniel
 Hobbs, John, Jr.
 Naughn, Martha Agry
 Palmer, Julia Ann
 Harpswell
 Marein, Mahala
 Kennebunk
 Badger
 Hodges, Susana
 Kittery
 Coutis, T.W.
 Deering, William, Jr.
 More, Thomas
 Titcomb, James
 Williams, John
 Kittery Point
 Bellamy, John Hales
 Naber, George
 Lewiston
 R.C. Pringle and Company
 Smith, C.W.
 Livermore
 Morse, E.
 Millbridge
 Treat, S(amuel) L.
 Monhegan Island
 Davis, Ben, Captain
 Humphrey, Harrison
 Smith, Ben
 Newcastle
 Hatch, Edbury
 Southwork, William
 Southworth and Jones
 North Litchfield
 Dunn, C.F.
 Norway
 Huff, Celesta
 Rice, William
 Wetherby, Isaac Augustus
 Otisville
 Appleton, George W.
 Parsonfield
 Paine
 Phippsburg
 Greenleaf, Benjamin
 Portland
 Chapman, A.
 Chapman, Nathan
 Clough, Calhoun and Company
 Codman, Charles
 Corey, Walter
 Crafts, Caleb
 Crafts, Martin
 Darton, W.D.
 Dyer, Sophia
 E. Swasey and Company
 Griffin, Edward Souther

Griffin, John
Hamblen, Sturtevant J.
Hatch, Edbury
Higgins, Stephen
Jenney, N.D.
Johnson, Theodore
Lamson and Swazey
Littlefield Brothers
Littlefield, Charles H.
Littlefield, Francis A.
Littlefield, Nahorn (Nahum)
Littlefield, Nathan, Jr.
Merrill, Joseph P.
Morton, Mary Ann
Paris, Delphina
Perates, J(ohn) W.
Perkins, Horace Tidd
Porter, Rufus
Portland Stoneware Company
Prior, William Matthew
Simmons, W.A.
Southwork, William
Stephens, Ebenezer
Waters, Almira
Wilson, Augustus
Winslow, J.T.
Winslow, John T.
Readfield
Treadwell, Jona
Richmond
Farren and Edlefson
Mace, Richard
Stoddard and McLaughlin
Rockland
Todd, James
Treat, S(amuel) L.
Verill, J(oseph) E.
Rockport
Verill, J(oseph) E.
Rumford Point
Howard, B.
Sabbathday Lake
Wilson, Elder Delmar
Saco
Cote, Adelard
Saco-Biddeford
Bernier
Salmon Falls
Bradbury, Gideon
Solon
Bacheller, Lucinda
South Berwick
Andrews, Jane Margaret
South Rumford
Bartlett, Jonathan Adams
South Warren
Reed, Kenneth
Southport
Orme, Albert
Stevens Plains
Briscoe, Thomas "Ol' Briscoe"
Buckley, Mary Ann
Buckley, Oliver
Deshon, Thomas
Goodrich, Walter
North, Elijah

Stevens, Alfred
Stevens, Samuel
Stevens, Zachariah Brackett
Thompson, James A.
Thomaston
Counce, Harvey P.
R.H. Counce and Company
Smith, John H.
Verill, J(oseph) E.
Thorndyke
Morton, Emily
Vanceboro
Russell, Lydia Keene McNutt
Waldoboro
Wyman, Samuel D.
Warren
Crane, Mr.
Webster Corner
Wood, Orison
West Medway
Roberts, Joseph
Winthrop
Gilbert, A.V.
Wiscasset
Gove, Jane
Porter, Benjamin
Woolwich
Riddle, Hannah
Yarmouth
Gooding, Charles Gustavus
York
Bulman, Mary
Johnston, John
Lyman, Narcissa

MARYLAND
Gernand, J.B.
Goins, Luther
Goldsborough, Moria T.
Hecht, Abslam
Hesselius, Gustavus
Lockard, Henry
Morrison, James
Price, Jane Wilder
Striebig, John K.
Wheeler, Henrietta Virginia
Aiken
Coudon, Joseph
Annapolis
Crouch, Henry
Hesselius, John
Kemmelmeyer, Frederick
Kuhn, Justus Englehardt
Syng, Phillip
Bacon Hill
Grosh Pottery
Baltimore
Amos, William
Appleton, Thomas
Armstrong, James L.
Arsworth, Cynthia
Atkinson, W.A.
Auer, Nicolas (Ayer)
Barkley, Hugh
Barnhardt, John
Barrett and Debeet

Basye, Joyce
Bennett, Edwin
Bennett, James S.
Bennett, Mrs.
Bias, Joseph
Boyd, Ann
Brieschaft, Joseph
Brown, Catherine
Brown, James
Brown, John
Brown, John
Brown, Jon
Bruce, John M.
Bryne and Company
Bryne, Joseph
Callaham, Richard
Callanan, Richard
Campbell, James
Capalano, Anthony
Chanceaulier, Martin
Churchill, Lemuel
Clark, Levin P.
Clements, Seth
Crabb and Minshall
Curlett, Thomas
D.F. Haynes and Company
Dixon, Thomas Fletcher
Eckhart, L.
F. Haynes and Company
Farrington, Anna Putney
Finlay, Hugh
Finlay, John
Fisher, Robert
Frey, Christian
Fryer, James
G.V. Keen and Company
Garmons, William
Gary, Mrs. James A. (L.W.) (Daisy)
Gaspari, P(ierre) G.
Glaser, Elizabeth
Greble, Benjamin
Guy, Francis
Harold and Randolph
Harrison, Henry
Haynes, Bennett and Company
Hays and Morse
Hays, Robert
Hedian, T.
Henning, Herman D.A.
Herrmann, P(eter)
Herzog, James J.
Hobbs, G.W., Reverend
Hoffman, Alexander
Hubbard, Samuel
Hubbart, Samuel
James, Isaac
Johnson and Mason
Johnson, Joshua
Jones, James E.
Jones, N.S.
Kelly, James
Kemmelmeyer, Frederick
Kennard, William J., Jr.
Kennedy, William W.
Kisner and Company

MARYLAND (Cont.)
Baltimore (Cont.)
Kisner, Benedict
Kisner, John A.
Linton, William
M. Barrett and Brother
Macy, Reuben
Macy, Robert H.
Maran, Mrs. Mary Jane Green
Marden, J.
Maryland Pottery Company
McAleese and Wyman
Meyers and Hedian
Mooney, Michael
Morgan, Thomas
Mullen, James
Myers, Mary Rosalie Prestmen
Nenniger, Louisa
Nicholson, Susan Fauntleroy Quarles
Nicholson, Washington A.
Palmer, Susan Catherine
Parr, David
Parr, Elisha
Parr, James L.
Parr, Margaret
Patney, Peter
Patterson
Perrine, Maudden
Phillips, William S.
Pifer, William
Polk, Charles Peale
Priest, William
Raeder, Hartman
Raeder, Sebastian
Randolph and Seward
Randolph, James T.
Remmey, Henry, III
Renshaw, Thomas
Rimby, W.B.
Russell, N.B.
Samson Cariss and Company
Scott, Ann
Seward, William
Sheppard, R.H.
Shulz, Randolph
Stettinius, Samuel Enedy
Stutchfield, Joseph T.
Sudbury and Schaefer
Sudbury, Joseph M.
Teubner, William
Teubner, William, Jr.
Trepner, William
Umbrick, Gabriel
Van Horn, Fielding
Van Wynen, Bernard
Verleger, C. Fred(ric)k
Vogell, Charles
Walker, James L.
Wallace, Richard
Yeager, John Philip
Baltimore (Old Town)
Kelly, John
Baltimore County
Lilly, Emily Jane
Beaver Dams
Garber, Jonathan
Betterton
Joyner, Charles
Bladensburg
Muk, George
Boonsboro
Bothman
Welty, John B.
Bowie
Basye, Joyce
Charles County
Winter, John
Chesapeake Bay
Howlett, Dick
Crisfield
Dize, Elwood
Lawson, Oliver
Nelson, James L.
Sterling, Noah
Sterling, Will
Tyler, Lloyd
Ward, Lemuel T.
Ward, Steve
Cumberland
Easter, Jacob
Neff, Christian
Dorchester
Dabney, Mrs. Charlotte
Elk Ridge Landing
Hughes, Daniel
Russel, William
Elkton
Blair, John
Emmitsburg
Creamer, Susan
Fells Point
Floyd, Caleb
Floyd, Thomas and Caleb
Harold and Randolph
Frederick
Beall-Hammond, Jemima Ann
Johnson, Fanny
Frederick County
Amelung, John Frederick
Frederick County?
Greenwalt, Maria B.
Graceham
Gernand, Jacob B.
Hagerstown
Adams, Henry
Bell, Peter
Garrett, Thomas
Leisinger and Bell
Reichard, Daniel
Snaveley, John
Weise, Henry
Havre de Grace
Barnes, Samuel T.
Carver, James
Dye, Ben, Captain
Holly, Ben, Captain
McGaw, Robert F.
Mitchell, Madison
Wilson, Charles T., Professor
Johnsville
Hammond, Denton
Hammond, John
Leitersburg
Good, Jacob
Middletown
Corick, Joshua
Corwick, Andrew
Montgomery County
Talbott, Emeline
Perryville
Armstrong Stove and Foundry Company
Solomon
Olson
St. Mary's
Baker, Thomas
Thurmont
Baecher, Anthony W.
Baecher, J.W.
Markley, James C.
Waltersville
Young, Abraham
Westminster
Gernand, W.H.
Woolford
Skinner, Edward
Skinner, John
Skinner, W. Hammond

MASSACHUSETTS
Adams, Abigail
Alden, G.
Ammidown, C.L.
Anderson, Maria
Atwood, Jeremiah
Aubry, Jean
Barstow, Salome
Bartlett, Lucy
Beauregard, C.G.
Bridport, Hugh
Brooks, Newton (N.)
Brown, J.
Brown, Jane
Burr, Leonard
Camiletti, Edmund
Cheever, Miss Mary
Clark, Alvan
Cleaveland, Mrs. Mary
Coyle, James
Davidson, George, Captain
Davis, J(ane) A.
Davis, Joseph H.
Dean, Polly C.
Dixon, J.F.
Dobson
Downer, Ruth
Doyle, William M.S.
Drexel, Anthony
Ellsworth, James Sanford
Fogg, Mercy (Mary)
Fowle, William H.
French, C.
Furnass, John Mason
Gasner, George
Gilchrist, Hugh

Geographic Index

Goodell, Ira Chaffee
Greenleaf, Benjamin
Griswold, Lucy
Hamilton, Amos
Harding, Jeremiah L.
Hartwell, Alonzo
Hawes, Sarah E.
Hayse, Martha S.
Herr, Henry
Herring, J.
Holingsworth, Mary
Ingraham, Mary L.
Johnston, Thomas
Lakeman, Nathaniel
Lawson, Thomas B.
Leverett, Elizabeth
Leverett, Sarah Sedwick
Lewis, Betsey
Lincoln, James
Little, Ann
Loring, Hulda
Lovett, William
Marchant, Edward D.
Mason, Mrs. Jeremiah
Mason, William Sanford
Mayhew, Nathaniel
McDowell, Fred N.
Moron, J.
Morse, J.G.
Moulthrop, Reuben
Munger, George
Negus, Nathan
Nivelet
Norman, John
Oliver, D.(W.)
Onthank, N.B.
Ordway, Alfred
Osgood, Charles
Osgood, Samuel Stillman
Otis, Daniel
Page, William
Parker, Clarinda
Peters, C.
Phillips, Ammi
Pickney, Francis
Pimat, P. Mignon
Richardson, William
Roberts, Marvin S.
Rogers, Nathaniel
Salter, Ann Elizabeth
Sawin, Wealthy O.
Shute, Mrs. R(uth) W(hittier)
Smith, Thomas, Captain
Southward, George
Spear, Thomas T.
Stearns, William
Stiles, Jeremiah
Stiles, Samuel
Stivers, John, Captain
Stone, Hannah
Swain, William
Talcott, William
Terry, Sarah F.
Thomson, Jerome
Thomson, Sarah
Tilyard, Philip

Van Alstyne, Mary
Van Doort, M.
Van Wagner, Jas. D.L.
Walker, Elizabeth L.
Whitman, Eliza
Wilder, Matilda
Wilkins, Sarah
Wilson, Mary R.
Worcester, Caroline

Abington
Pratt, Nathaniel
Accord
Lincoln, Joseph Whiting
Spear, Chester
Allston
Bullard, Joseph O.
Scott, Alexander F.
Amesbury
Badger, Stephen
Chase, Phineas
Ellison, Orrin B.
Rowell, Samuel
Rowley, R.
Annisquam
Davis, Gilbert, Captain
Arlington
Cohen, Gideon
Ashburnham
White, William Fred
Ashfield
Elmer, Edwin Romanzo
Orcutt, Belding and Company
Orcutt, Walter
Van Horn and Boyden
Williams, Lydia Eldridge
Wright, Franklin
Attleboro
Doggett, Lydia
Maxey, Levi
New, James
Auburn
Hartwell, George G.
New, James
Ballardville
Willard and Sons
Barnstable
Bourne, Mercy
Fuller, Nathaniel
Hamlin, Isaac
Otis, Mercy (Warren)
Warren, Sarah
Wright, Alexander
Barre
Soule, Coomer
Barrington
Linstead, Mary
Bedford
Harrop, James A., Jr.
Belchertown
Sikes, E.
Bellingham
Metcalf, Savil
Berkley
Winslow, Ebenezer
Bernardston
Jessup, Jared

Beverley
Herrick, Robert A.
Tarbell, William
Tarbell, William, Jr.
Billerica
Stearns, Mary Ann H.
Boston
A.J. Harris and Company
Abbott, Henry R.
Alexander, Francis
Allen, Calvin
Allen, Priscilla A.
Alley, Nathaniel
Ames Plow Company
Anderson, James
Andrews, Bernard
Badger, Joseph
Badger, S.F.M.
Badger, Thomas
Bean, W.P.
Beatly, Spencer
Beecher, Laban S.
Beiber, C.G.
Blunt, John Samuel
Bond, Charles V.
Boston Fancy Wood Carving Company
Boston Pottery Company
Bourguianon and Britt
Bowles, Joshua
Boyd, James
Bradford, Joseph
Breed, Mary
Briggs, Cornelius
Briggs, L.A.
Broad Gauge Iron Works
Brown, William H.
Bubier and Company
Budd, Edward
Bull, Miss Elizabeth
Bundy, Horace
Burnham, Mary Dodge
Butler, Martha
Byles, Abgail
C.A. Jackson and Company
Cabot, Mrs. Samuel
Carpenter, Frederick
Chambers, Thomas
Chandler, Joseph Goodhue
Chapin, Alpheus
Chapman and Hastings
Charlton, Frederic
Chelmsford Foundry Company
Child, Thomas
Clough, Ebenezer
Codman, William P.
Codner, Abraham
Codner, John
Codner, William
Coffin, Henry
Coles, John, Jr.
Condy, Mrs.
Conian, P.T.
Corne, Michele Felice
Crehore, S.
Crite, Allan Rohan

Boston, MA

Geographic Index

337

MASSACHUSETTS (Cont.)
Boston (Cont.)

- Cushing, Levi L.
- Dannenburg, C.F.
- Daroche, Frank
- Davis, James
- Dawes, Thomas, Captain
- Delano, Joseph
- Dellaway, Thomas
- Dimond, C.C.
- Doherty, Joseph J.
- Doolittle, Amos
- Dorchester Pottery Works
- Dotterer, Charles
- Doughty, John H.
- Doyle, John M.
- Drowne, Deacon Shem
- Drowne, Thomas
- DuPee, Isaac
- Eaton, W.P.
- Eliaers, Augustus
- Elliot, John
- Emmes, Henry
- Emmes, Joshua
- Emmes, Nathaniel
- Emmons, Mary
- Esterbrucks, Richard
- Evans, J.
- Evans, John
- Evans, John T.
- Feke, Robert
- Fenton, Jonathan
- Ferguson, Frederica
- Fifield, Mary Thurston
- Fischer, Albert
- Fleet, Mary
- Foley, Theodore H.
- Forg, P.
- Fowle, Isaac
- Fowle, John D.
- Frothingham, James
- Fuller, George
- Gaud, John
- Gerrick, Sarah
- Geyer, Henry Christian
- Geyer, John Just.
- Gilchrist, James
- Glad, George H.
- Gleason and Company
- Gleason and Henderson
- Gleason, Benjamin A.
- Gleason, Henry (Herbert)
- Gleason, W.G.
- Gleason, William B.
- Gore, John
- Gould and Hazlett
- Gragg, Samuel
- Grant, William
- Grant, William
- Greenwood, Ethan Allan
- Grice, Elias
- Grueby Faience Company
- Gullager, Christian
- Halsall, William Formsby
- Hamblen, Sturtevant J.
- Hamblin, L.J.
- Hammatt, Fanny Rand
- Hancock, Nathaniel
- Harris and Company
- Hastings and Gleason
- Hastings, Daniel
- Higgin, Peter
- Hoit, Albert Gallatin
- Holliman, John
- Holman, Jonas W.
- Homer, John
- Homer, William
- Hord, Jacob
- Hubard, William James
- Hubbard
- Hudson, William, Jr.
- Hughes, Robert Ball
- Hunneman, William C.
- Ives, Chauncey B.
- James, Boyd
- Jennys, Richard
- John A. Whim
- Johnston, John
- Johnston, Thomas
- Jones, Henry A.
- Jordan, Samuel
- Joseph Breck and Sons
- Keid, Andrew
- Killcup, George, Jr.
- Killeran, Rebecca
- King, William
- Knight, Emily
- Knight, Richard
- Labrie, Rose
- Lane, Fitz Hugh
- Leach, H.
- Leach, Henry
- Lees, A.
- Lindsay, William
- Lothrop, George E.
- Lucas, Thomas
- M.D. Jones and Company
- Maher, E.
- Marsh, William
- Marston, James B.
- Mason, John W.
- Mason, Jonathan, Jr.
- McClain, G.B.
- McClellan Brothers
- McCully and Company
- McIntyre and Gleason
- McKenzie, Daniel, Jr.
- Meaher, J.W.
- Mear, Frederick
- Miller, Joseph
- Moore, Jacob Bailey
- Moorhead, Scipio
- More, Samuel
- Morton, Daniel O.
- Moulton Brothers
- Mulligan, Michael
- Mumford, William
- Negus, Nathan
- New England Pottery Company
- Nutting, Benjamin F.
- Nye, Alfred
- Oakes Manufacturing Company
- Ostheimer, A.
- Park, Thomas
- Parker and Gannett
- Parker, Clark
- Parker, Temperance
- Paul, John
- Peirce, George W.
- Penniman, John Ritto
- Perkins, Samuel
- Pinsonault, L.
- Plympton and Robertson Pottery Company
- Pollard, A.W.
- Porter, John
- Priestman, James
- Prior, William Matthew
- Purcell, Eleanor
- Puritan Iron Works
- Pursell, John
- Quinn, C.F.
- Raymond and Fowle
- Raymond, Edmund
- Richards, Elizabeth
- Richardson, John
- Richardson, R.
- Richardson, Thomas
- Robertson, Joseph
- Robinson, George
- Rogerson, John
- Rose, Philip
- Rouse, William
- Rumney, George R.
- Rumney, John
- S.W. Gleason and Sons
- Sampson, C(harles) A.L., Captain
- Savory, Thomas C.
- Scallon and Company
- Scallon, L.
- Seymour, John
- Shetky, Caroline
- Silsbe(e), Sarah
- Simpson, William
- Skillin, John
- Skillin, Samuel
- Skillin, Simeon, Jr.
- Skillin, Simeon, Sr.
- Smibert, John
- Sohier, William
- Somerby, Lorenzo
- Stevens, George
- Stevens, Henry
- Stevens, Zachariah Brackett
- Stoddard and McLaughlin
- Stoddard, N.
- Stoddart, N.
- Strater, Herman, Jr.
- Stubbs, William P.
- T.J. White and Company
- Tolman, John (Jack)
- Treadwell and Godbold
- Treadwell, H.S.
- W.A. Snow Company, Inc.
- Waghorne, John
- Welch, John
- Welles, Lydia
- Welsh, John

Wendell, Elizabeth
Western, A.S.
Wetherby, Isaac Augustus
White and Company
White, William
Wightman, Thomas
Willard, Aaron
Willard, Alfred
Willard, Simon
Willard, Solomon
Willard, Zabadiel
Winn, John A.
Winsor and Brother
Winsor, Samuel L.
Witherle, Joshua
Woolson, Ezra
Young, J(ames) Harvey
Boston area
Balch, Sarah Eaton
Bourne
Raleigh, Charles Sidney
Bradford
Gage, Nancy
Ingersoll, John Gage
Marble, John
Marble, Joseph
Mulican, Joseph
Mulican, Robert
Mulican, Robert, Jr.
Braintree
Clark, Peter
Marshall, John
Brewster
Clifford, Robert
Bridgeton
Lombard, James
Bridgewater
Hartwell, George G.
Hayward, Nathan
Howard, J.
Brockton
Kingman, Mary Dunham
Wheeler, Jonathan Dodge
Brookline
Draper, Augusta
Heath, Mrs. John
Heath, Susan
Byfield
Davis, E(ben) P(earson)
Cambridge
Chelmsford Foundry Company
Dodson, Mrs. Priscilla
Douglas, Marya
Henderson, Joseph
Hewes Pottery
Parker, Grace
Pilliner, C.A.
Cape Ann
Wiggin, Alfred J.
Cape Cod
Gould, M.H.
Paine, Josiah
Charlestown
Barnabus Edmonds and Company
Beecher, Laban S.

Bellamy, John Hales
Bickner, Sam
Carpenter, Frederick
Charlestown Massachusetts Pottery
Clark Leonard and Company
Downes and Sargent
Downes, Peter B.
Downs, P.T.
Drinker, Philip
Fifield, Daniel
Gerrish, Woodbury
Goodwin, John
Gould and Hazlett
Harrington, Ellen T.
Holden, Oliver
Jeffers, James T.
Lamson, Caleb
Lamson, David
Lamson, John
Lamson, Joseph
Lamson, Joseph
Lamson, Joseph
Lamson, Nathaniel
Lees, J. W(alter)
Lokke, S.R.
Lucas, Thomas
McLean, A.C.
Morse, Samuel Finley Breese
Parker, John
Pierre, F.J.
Roosetter, Charles H.
Sargent, John B.
Welch, Thomas
Whittemore, Joseph
William Burroughs
Chelmsford
Chelmsford Foundry Company
Ward, M. Paul
Chelsea
Chelsea Keramic Art Works
James Robertson and Sons
Kendall, Loammi
Low Art Tile Company
Seavey, Amos
Cheshire
Cole, Maria
Chicopee
Stock, Joseph Whiting (M.)
Concord
Fisk, Lorenza
Hosmer, Lydia
Moore, Harriet
Murphy, Charles
Tucker, Mary B.
Wheeler, Rebekah
Danvers
Bushby, Asa
Dwinell, Hezekiah
E.G. Washburne and Company
Purinton, Beulah
Danvers?
Danvers Pottery
Dartmouth
Gifford, Stephen B.
Taylor, William W.

Dedham
Balch, Sarah Eaton
Dedham Pottery
Hewins, Amasa
Langdon, Barnabas
Parsons, Eli
Whiting, Calvin
Deerfield
Ashley, Solomon
Fuller, George
Locke, John
Stebbins, Wyman H.
Wells, Arabella Stebbins Sheldon
Dorchester
Barnard, Ebenezer
Buell, William
Dorchester Pottery Works
Foster, Hopestill
Foster, James
Foster, James, III
Foster, James, Jr.
Little, Charles
Duxbury
Burr, E(lisha)
Glover, John
Hathaway, Rufus, Dr.
Hunt, Ben
Weston, William Henry
Winslow, George Marcus
Winsor, John
Winsor, Nathaniel
East Boston
Doherty, Joseph J.
Hunt, D.W. Lewis
Rumney, William H.
East Braintree
Vinton, Mary
East Dorset
Fenton, Richard L.
East Harwich
Crowell, A.E(lmer)
East Springfield
Ely, John
Essex
Burnham, Aaron L.
Choate, John C.
Essex County
Holliman, John
Raymond, J.
Fitchburg
Warner, J.H.
Wilder, F(ranklin) H.
Franklin
Cleaveland, Nathan
Franklin County
Bascom, Ruth Henshaw
Georgetown
Spofford, Salley
Gloucester
Elwell, Samuel, III
Gullager, Christian
Newman, Benjamin
Orcott, K.V.
Proctor, David R.
S. Merchant and Company
Saville, William

MASSACHUSETTS (Cont.)
Gloucester (Cont.)
Wybrant
Grafton
New, James
Granby
Mason, Abigail (Payne)
Green Harbor
McMorrow, William
Greenfield
Belcher, M.D.
Mark, George Washington
Wescott, P.B.
Groton
Boutwell
Giles, Polly
Park, James
Park, John
Park, John
Park, Thomas
Park, William
Park, William
Worcester, Jonathan
Worcester, Moses
Hadley
Howe, Louise
Nash, Joseph
Halifax
Briggs, Martha
Hamilton
Saville, William
Hancock
Cohoon, Hannah
Hanover
Pratt, Robert
Harvard
Kindall, George
Park, William
Pollard, Luke
Thompson, William
Worcester, Jonathan
Worcester, Moses
Hatfield
Belding, Samuel, Jr.
Haverhill
G.B. McLain and Company
Hartshorn, John
Ingersoll, John
Kimball, Mary Grove
Plummer, Edwin
Plummer, Harrison
Prince, Luke, Jr.
Hingham
Burr, E(lisha)
Burr, Russ
Emory, Ella
Hazlitt, John
Hersey, Edmond
Hersey, Samuel
Hingham Wooden Ware
Thaxter, Rachel
Wilder, F(ranklin) H.
Hinsdale
Snow, Jenny Emily
Holliston
Johnson, Persis

Hyanis
Vagen, Bette
Ipswich
Dennis, Thomas
Robertson, William A.
Thorn, Catherine
Jamaica Plain
Lukatch, Edward
Kingston
Bailey, I. Clarence, Captain
Drew, Clement
Holmes, Benjamin
Holmes, Lothrop T., Captain
Washburn, B.
Lampster
Honeywell, Martha Ann
Lancaster
Rugg, Lucy
Wilder, James
Worcester, Jonathan
Lanesboro
Bentley, E.W.
Lanesboro (Lanesborough)
Phelps, Elijah
Lee
Bradley, Mary
Savage, A.
Leominster
Lincoln, Martha
Reed, P.
Wilder, F(ranklin) H.
Lexington
Locke, Ruth
Stiles, Susan Piece
Lexington area
Fisk, Lorenza
Longmeadow
Bliss, Aaron
Colton, Lucretia
Newell, Hermon
Stebbins, Ezra
Lowell
Anderson, Peter
Cortwright, J.D.
Cranston, Thomas
Lunenburg
Bennett, Caroline
Lynn
Goodrich, Walter
Malden
Cobb, Cyrus
Cobb, Darius
McIntire, James
Schaffner, Dexter L.
Manchester
Long, Rufus
Taylor, George
Marblehead
Bartoll, William Thompson
Frost, J(ohn) O(rne) J(ohnson)
Marchfield
Nichols, Hannah
Martha's Vineyard
Adams, Frank
Chadwick, H(enry) Keyes
Deegan, Bill

Hancock, Herbert
Hancock, Russell
Joy, Charles
Look, Jim
Mayhew, M.H.
Roberts, Manuel S.
Rogers, Gene
Smith, Ben
Mattapoisett
Keith, Charles F.
Luce, Shubael H.
Purrington, Henry J.
Medfield
Hinsdale, Samuel
Medford
Burgess, Everard
Frink, O.E.S.
T. Sables and Company
Young, J(ames) Harvey
Meridan
Brown, W.H.
Methuen
Johnson, Philip
Middleboro
Alden, Noah
Cushman, Noah
Cushman, William
Leonard, Barney
Ryder, David
Soule, Beza
Tinkham, Seth
Tomson, George
Tomson, Isaac
Milton
Adams, B.
Geyer, Henry Christian
Nantucket
Appletown, William L.
Atkins, A.D.W.
Ceeley, Lincoln J.
Chase, Elijah
Clark, George S.
Coleman, William, Captain
Folger, David
Gardnier, Sally
Goram, J.
Gould, George A.
Harris, Al
Howland, John
Huggins, Samuel, Jr.
Mitchell, William
Myrick, Fredrick
Spring, Rick
Starbuck, M.
Stinson, Henry
Swain, Harriet
Wilke, Mr.
Needham
Buyer, Alfred
New Bedford
A.D. Richmond and Company
Akin, John F.
Baker, P.
Baker, Warren W.
Bayley, Charles
Blunt, John Samuel

Bradford, William
Chappell, William
Chase, Joseph T., Captain
Choate and Silvester
Coleman, Alvin
Coleman, Hezekiah
Cooke, Captain
Delano, Temperance
Dodge, Ephraim J.
Eldredge, William Wells
Finch, Ruby Derd
Freeman, Joseph L
Gifford, M.T.
Gilbert, J.
Joseph, Charles
Kennedy, William W.
Lincoln, Daniel H.
Martin, James
Morton, Charles
Paine, W.
Perry, William
Peters, Joseph
Purrington, Henry J.
Raleigh, Charles Sidney
Richmond, A.D.
Russell, Benjamin
Russell, Joseph Shoemaker
Sherman, Jesse T., Captain
Smith, Fred
Smith, Henry M.
Tillinghast, Joseph
Townsend, George
Tucker, Alice
White, Thomas J.
Williams, Arthur
Williams, William
Willis, Sarah

New Bedford?
Gilbert, I.

Newbury
Baily, Joseph
Hartshorn, Jonathan
Toppan, Sarah

Newburyport
Boyley, Daniel
Burnham, Mary Dodge
Cole, Charles Octavius
Cole, Lyman Emerson
Dannenburg, C.F.
Davenport, William, Captain
Dennett, Olive
Doggett, Lydia
Gullager, Christian
Jones, Reuben, Captain
Merrimac Ceramic Company
Morrison, Ebenezer
Noyes, Paul
S. Sweetser and Sons
Savage, Charles K., Jr.
Somerby, F.T.
Wilson, Alfred (Albert H.)
Wilson, James W.
Wilson, Joseph

Newton
Hastings, Daniel
Rogers, George H.

Tainter, Benjamin

North Andover
Avery, Mary

North Brookfield
Lawton, C.

Northampton
Harding, Chester
Phelps, Nathaniel

Northfield
Lyman, Mrs. Eunice
Severence, Benjamin J.

Northfield Farms
Stimp

Old Deerfield
Stebbins, Caroline

Old Newbury
Noyes, Enoch

Osterville
Cahoon, Ralph

Peabody
Conklin, Ananias
Goldthwaite, William
Holmes, Obediah
Kendall, Miles
Kettle, Johnathan
Osborne, Amos
Osborne, Amos, Jr.
Osborne, Johnathan
Osborne, Joseph, II
Osborne, Richard
Osborne, William
Paige Pottery
Southwick, Joseph A.
Southwick, William
Southwick, William
Stone, Robert
Trask, Joseph
Whittemore, Daniel
Whittemore, Joseph
Wilson, Job
Wilson, Robert
Worthen, C.F.

Pittsfield
Daugherty, S.
Ely, John

Plymouth
Lane, Charles
Leonard, Rachel
Savery, Lemuel
Standish, Loara
Tribbel, John

Plympton
Fuller, Nathaniel
Soule, Asaph
Soule, Beza
Soule, Ebenezer, Jr.
Soule, Ebenezer, Sr.

Pottersville
Somerset Pottery

Princeton
Dana, Lucinda

Provincetown
Hersey, Joseph
Hunt, Peter "Pa"

Randolph
Thayer, Hannah F.

Reading
Purintum, Abigail

Rehoboth
Allen, George
Allen, George, Jr.

Revere
Edes, Jonathan W.

Richmond
Sherril, Laura

Rochester
Ryder, David

Rowley
Hartshorn, John
Leighton, Ezekiel
Leighton, Jonathan
Leighton, Richard

Roxbury
Crafts, Thomas
Dudley, Samantha Charlotte
Evans, J.
Finnerard, M.T.
Gendrot Gahery and Company
Gore, John
Gore, Samuel
Litchfield, E.
Mason, David
Pollock, Sarah E.

Salem
Augustus, Sampson
Beadle, Leaman
Blyth, Benjamin
Bowditch, Eunice
Brown, Joseph
Buckley, Patrick
Carey, Joseph
Cheever, Sarah F.
Conklin, Ananias
Corne, Michele Felice
Cowan, Robert
Crowningshield, Hannah
Decker, Robert M.
Derby, Madame
Door, Edward
Emery, Charles
Ferran, Joseph
Fowle, Robert
Frothingham, James
Gray, William
Hancock, Nathaniel
Harvey, Thomas
Hastings, E.W(arren) (Warren E.)
Hobbs, John E.
Holliman, John
Holmes, Obediah
Jennison, Mary
King, William
Lambert, Lydia
Liscombe, Mr.
Lothrop, Stillman
Martin, Lucy
McIntire, Joseph
McIntire, Joseph, Jr.
McIntire, Samuel
McIntire, Samuel Field
Merrill, Sailor
Northey, William, Jr.

MASSACHUSETTS (Cont.)
 Salem (Cont.)
 Osborne, Joseph
 Osgood, Captain
 Peele, Mary Mason
 Plummer, Edwin
 Pride, John
 Purdy, Charlie
 Putnam, Betsy
 Putnam, Ruthey
 Rollins, George W.S.
 Ropes, George
 Rowe, L.K.
 Shepard, Daniel
 Southwick, William
 Stivour, Sarah
 Stone, Sarah
 Symonds, Nathaniel
 Symonds, Nathaniel, Jr.
 Symonds, Nathaniel, Sr.
 Tolman, John (Jack)
 True, Joseph
 Very, Lydia
 Vincent, William
 Vinson, William
 West, Benjamin Franklin
 Willard, Eliza
 Salisbury
 Deering, William, Jr.
 Sandwich
 Amidon, Douglas
 Wright, Lydia
 Saugus
 Winthrop, John
 Scituate
 Daman, Desire Ells
 Daman, Ruth Tilden
 Vinal, Jacob
 Vinal, Jacob, Jr.
 Vinal, John
 Sheffield
 Keep, George
 Sacket, Harriot
 Shelburn
 Gibbs, H.R.
 Shirley
 Dwight, John
 Somerset
 Chace, L.
 Hathaway, Charles E.
 L. and B.G. Chase
 Somerset Pottery
 Synan, Patrick
 Synan, William
 Somerville
 McCarthy Brothers
 South Ashfield
 Hastings and Belding
 South Attleboro
 Tingley, Samuel
 Tingley, Samuel
 Tingley, Samuel, Jr.
 South Danvers
 Paige Pottery
 South Hadley
 Collins, C.
 South Weymouth
 Merritt, Susan
 Springfield
 Adams, Willis Seaver
 Cooley, William H.
 Elwell, William S.
 Fordham, H.
 Sawin, J.W.
 Stock, Joseph Whiting (M.)
 Washburn, W.L.
 Springfield?
 Cooly
 Sterling
 Brown, G.
 Burpee, Sophia (Constant)
 Colburn, Paul
 Morris, Jones Fawson
 Stockbridge
 Paine, Diana
 Sturbridge
 Marrott, Ted
 Sudbury
 Tucker, Mary B.
 Suffolk
 King, Daniel
 Sunderland
 Field, Erastus Salisbury
 Hubbard, Tryphena Martague
 Sutton
 Waters, Samuel
 Taunton
 Crosman, Robert
 Hathaway, Rufus, Dr.
 Ingell, Jonathan W.
 Seaver, John
 Seaver, William
 Seaver, William, Jr.
 Standish, Alexander
 Tauton
 F.T. Wright and Son
 Wright, Alexander
 Townsend
 Belknap, Zedakiah
 Uxbridge
 Winslow, Ebenezer
 Waltham
 A.L. Jewell and Company
 Clark, John
 Cushing and White
 Edes, Jonathan W.
 Watertown
 Bent, Everett
 Fewkes, J.
 Rouse, Richard
 Wayland
 Roby, W(arren) G(ould)
 West Bridgewater
 Jonathan Howard and Company
 West Medway
 Barber, Joseph
 West Stockbridge
 Clark, Anson
 West Tisbury
 Adams, Frank
 Westfield
 Todd, Mary A.
 Westford
 Prescott, Martha Abbott
 Westminister
 Peckham, Deacon Robert
 Weston
 Abraham Hews and Son
 Hews, Abraham
 Westport
 Finch, Ruby Derd
 Weymouth
 Hazlitt, John
 Whateley
 Belding, David
 Crafts, Caleb
 Crafts, Edward A.
 Crafts, Martin
 Crafts, Thomas
 Crafts, Thomas
 Loomis, Jonathan
 Orcutt, Stephen
 Wait, Luke
 Wells, Crafts, and Wells
 Woods, Martin
 Worcester
 C. Foster and Company
 Chandler, Winthrop
 Curtis, Charles
 Guthrie, Elwood
 Norton and Hancock
 Soule, Beza
 Thomas, Carl C.
 Young, William
 Worcester County
 Earl, Ralph
 Wrentham
 Farrington, Daniel
 Fisher, Jeremiah
 Fisher, Samuel
 Fisher, Samuel, Jr.
 New, James
 New, James
 New, John
 Wyoma
 Bacheller, Celestine

MICHIGAN
 Alexander, Stanley
 Allabach, Philip
 Baumgartner, Doc
 C.C. Smith Co.
 Chambers, Thomas
 Chambers, Tom
 Dreschel, Alfred
 Finch, John
 Flieman
 Foote, Jim
 Gier, David
 Hoag
 Johnson, Ray
 Jorgenson
 Kelly
 Loesch
 Malinski, Irving
 Moore
 O'Francis
 Peters, Scott

Purdo, Nick
Riley
Schweikart, John
Scriven, Danny
Sears, Gordon
Smith
Smith, Chris
Stewart
Villeneuve
Wagner
Wallach, Carl
Walton, Henry
Warin, George
Zachmann, John
Zent, August
Ann Arbor
Ackley, R.D.
Wesenberg, Carl
Au Gres
Christie, Bernard
Avon
Van Doren, Abram William
Avon Township
William, Abram
Battle Creek
Hart, Anna S.
Bay City
Schermerhorn
Birmingham
Horshack, Jay
Meyer, Karen A.
Cadillac
Peterson, Oscar B.
Center Line
Schmidt, Benjamin J. "Ben"
Charlotte
Raidel, Dorion
Coldwater
Caspori
Corinth
Sherman, M.L.
Crawford County
Stephens, Henry
Cross Village
Smolak, Stanley
Detroit
Barlow, Myron
Barnum, E.T.
Bond, Charles V.
Brittin, Sanford
Brown, Caspar
Cluczs, H.
Cohen, F.E.
Cortrite, Nettie (Antoinette)
Crongeyer, Theodore
Dodge, Jasper N.
Gies, Joseph
Guhie, Charles
J.E. Bolles and Company
J.N. Dodge Factory
Kelson, James R.
Kinzie, John
Lapp, Ferdinand
Letourneau, Charles
Manard, John B.
Mason Decoy Factory
Melchers, Julius Caesar (Theodore)
National Iron Wire Company
Osebold, Anthony, Jr.
Parr, Jack
Peterson, George
Phoenix Wire Works
Pickard, J.
Plichta, Fred
Pozzini, Charlie L.
Reghi, Ralph
Schroeder, Tom
Siebert, Henry A.
Taylor, Mary Wilcox
Unger, Charles J.
Unger, Fredrick
Van den Bossche, Theodore
Wasilewski, John
East Lansing
Young, John
Fair Haven
Meldrum, Alexander
Fairhaven
Reiss, Al
Flat Rock
Lamerand, Ed
Fowlerville
Rounsville, Helen Mary
Frankenmuth
Nuechterlein, John George
Goulette's Point
Goulette, Abe
Grand Ledge
Parker, Burr
Grand Rapids
Metal Stamping and Spinning Company
Shelby, George Cass
Grass Lake
Cady, Emma Jane
Harsens Island
Cummings, Frank
Pashpatel, Leo
Holland
Blocksma, Dewey Douglas
Hudsonville
Van Antwerp, Stan
Iron River
Plourde, Ben
Ishpeming
Jakobsen, Kathy (Katherine)
Jackson
Kurpenski, C.
Kalamazoo
Henderson, Frank K.
Wilson, M.
Kaleva
Makinen, John Jacob, Sr.
Lansing
Cook, R.K.
Cook, Ransom
Hewes, Clarence "Charlie"
Schmitz, Gail
Van Antwerp, Glen
Walker, John Brown
Lincoln Park
Ackerman, H(enry) H(arrison)
Maple City
Lund, E.K.
Marine City
DeCoe, G.
Joe
Smith, Miles
Strubing, Walter
Mitchells Bay
Meyer, Joe
Monroe
Kellie, Ed
Montague
Whitehall Metal Studio
Mount Clemens
Dehate, Abraham
Jenner, Augie
Jenner, Hans, Jr.
Jenner, Hans, Sr.
Kay, Edward A.
Van den Bossche, Theodore
Mount Clemens?
Buchman
Mount Pleasant
Bennett, Alice
Bennett, Russell
Thomas, Eli
Muskegon
Poe, William
New Baltimore
Goulette, Abe
Schramm, Butch
Ontonagon
Nelson, Edward "Stubb"
Ossineke
Domke, Paul
Pearl Beach
Meldrum, John
Sampier, Budgeon
Pittsfield
Wohe, W. (Wolfe)
Plymouth
Young, Celestia
Point Mouille
Quillen, Nate
Rockford
McBride, Adah
Rosebush
McArthur, Grace
Saginaw
Frantz, Sara L'Estrange Stanley "Sali"
Misch, Otto
Scottsville
Harley, Steve
St. Clair Flats
Finkel, Bill (William)
McDonald, Zeke
St. Anne's Club
Trombley, Andy
St. Clair Shores
Schmidt, Frank
Trombley, Andy
St. Ignace
McCarry, Ralph E.

MICHIGAN (Cont.)
Sunfield
 Rogers, Gertrude
Three Oaks
 Freeland, Anna C.
Tomrun
 Crooks, Floyd
Union City
 Van Zile, John
White Pine
 Pasanen, Robert I.
Wyandotte
 Alten, Fred K.

MINNESOTA
Benson
 Christenson, Lars
Homer
 Sperry, John
Marine
 Hassler, Sven
New Ulm
 Stoeckert City Pottery Company
Red Wing
 Boynton
 Hallam, David
 Minnesota Stoneware Company
 Philles
 Pohl, Joseph
 Red Wing Pottery
Rochester
 Stevens, John
Sauk Rapids
 Wippich, Louis C.
Scandia
 Peterson, A.L.
Wauseca
 Herter Sporting Goods Company

MISSISSIPPI
 Bahin, Louis Joseph
 Moseley, Alice Latimer
 Pickle, Helen
Belzoni
 Mohamed, Ethel Wright
Biloxi
 Mayer, Joseph F.
Boonville
 Bendele, Louis
Crystal Springs
 Willis, Luster
East Biloxi
 Ohr, George
Eden
 Thomas, James "Son Ford"
Jefferson County
 William, George
Jones County
 Ferguson, Sarah
Leland
 Thomas, James "Son Ford"
Mississippi City
 Vierling, G.H.
Oxford
 Hamblett, Theora

Pascagoula
 Animal Trap Company
 Grubbs Manufacturing Company
 Hudson Decoy Plant
 Poiteran Brothers, Inc.
Sharon
 Clark, Leon "Peck"
Vicksburg
 Bobb, Victor "Hickory Stick Vic"
 Brown, William Henry
Yazoo City
 Warner, Pecolia

MISSOURI
 Bohlken, Johann H.
 Fasig, William
 Gentner, George Henry
 Gilmore, Joseph
 Gross, William
 Hausgen, Frederick
 Kemper, Simon
 Linss, Karl
 Muir, Robert
 Rotschafer, F.A.
 Saalmueler, Peter
 Schaeffner, Andrew
 Smith, Thomas
 Talbot, Jane Lewis
 Toler, William
 Trentmann, John
 Wehmhoemer, Johann Friedrich
 Werner, Ignatz
 Yost, Sallie
Augusta
 Beverburg, Lorenz
Augusta Community
 Hilker, Frederick
Boeuf Township
 Hiatt, James
Boles Township
 Ald, Henry
Booneville
 Jaegglin, E.A.
Boonville
 Bedwell, Elias J.
 Boonville Marble Works
 Jegglin Pottery
 Seultzer, Alexander
 Weyrich, Charles
 Winkelmeyer, Henry
Calhoun
 Robbins (Mrs.) and Son
California
 Boonville Pottery
Calvey Township
 Sullins, David
Cape Girardeau
 Pass, James
Chartette Township
 Johnson, John
Chillicothe
 Bisset, William
Cooper County
 Long, Nicholas
 Shepard, George

Cotton Rock
 Pearson, Hugh A.
Drake
 Friedrich, Johann
Dutzow, Warren County
 Dieckhaus, Franz
Femme Osage Valley
 Rahmeier, Frederick
Franklin County
 Brinker, George Henry
 Elvins, George D.
 Muensenmayer, Jacob
 Schwarzer, Franz
Fulton
 Howard, Jesse
Gamesville
 Smith, H.S.
Gasconade County
 Brinker, George Henry
 Eppler, George
 Fricke, John Frederick
 Gaebler, Carl Frederick (William)
 Kemper, Edward
 Naegelin, Charles
 Rohlfing, Frederick
 Schauf, Wilhelm
 Schroeder, Carl
 Tschappler, L.W.
Greenfield
 Dicus, Ellen
Hamburg
 Schneider, John E.
Hermann
 Bezold, George Adam
 Fischer, Charles
 German, Henry
 Hasenritter, C(arl) W(illiam)
 Hasenritter, Robert Hermann
 Heckmann, John H.
 Hoffman, Christopher
 Kimmel
 Kroebe, Michael
 Leonhard, August
 Shubert, Casper
 Weinland, Henry
 Weinland, Nicholas
 Witmann, John H.
Jefferson County
 J.M. Hays Wood Products Company
Joplin
 Larson, Edward
Kansas City
 Baker-Lockwood
 Kretzinger, Rose
 Vardeman, Paul E., Judge
 W.G. Higgins
Kaolin
 Pyatt, George
 Shepard, Elihu H.
Lakenan
 Huggins and Company
Livingston County
 Gudgell, Henry
Monteau County
 August Blanck Pottery

Montgomery
 Van Beek, Hermann
Montgomery County
 Hogue, Samuel
 Vermillion, John
Morrison Community
 Tschappler, L.W.
Osage County
 Amend, Charles
 Artz, William
Pacific
 Keszler, Henry
Perry
 Winfel, R.
Pittsburg
 Hoffman, Christopher
St. Charles
 Boschert, Bernard
 Buschman, Frederick
 Commiller, Lewis
 Eveling, Frederick
 Heye, Frederick
 Quade, Julius
 Schaaf, Henry
 Schubert, John G.
St. Charles County
 Meier, Henry
 Rahmeier, Frederick
St. Louis
 Barth, Bartholomew
 Boyle, Ferdinand T.L.
 Burridge
 Daugherty Brothers Tent and
 Awning Company
 E.E. Souther Iron Company
 Filley, Giles
 Filley, Oliver (Dwight)
 Gallier, Edward
 Greef, Adolph
 Grimm, Curt
 Harding, Chester
 Hoffman, Gustav
 J.B. and G.L. Mesker and
 Company
 Kurz, Rudolf Friederich
 Lewis, Henry
 Medelli, Antonio
 Pomarede, Leon D.
 St. Louis Stoneware Company
 Wild, John Casper
 Wimar, Karl
Warren
 Kunze, William
 Van Beek, Hermann
Warren County
 Bruere, Theodore
 Kinderlen, Conrad
 Luppold, John
 Luppold, Matthias
 Ritter, Florent
 Waller, John
Warrentown
 MiddleKamp
Washington
 Glassir and Company
 Walford, Mr.

Washington Stoneware Company

MONTANA
 Day, Frank Leveva

NEBRASKA
 Hubbard, Maria Cadman
 Tibbets, Susan
 Wallack, W.S.
Garfield County
 Cover, Sallie
Omaha
 Badami, Andrea
 Enkeboll Art Company
 Thiessen, Louise Berg

NEVADA
Imlay
 Rolling Mountain Thunder, Chief

NEW HAMPSHIRE
 Atkinson, Sarah Weber
 Baldwin, Frank
 Brewer
 Brooks, Newton (N.)
 Bundy, Horace
 Cole, Major
 Davies, Albert Webster
 Davis, Joseph H.
 Drake, Samuel Gardiner
 Fletcher
 Hoyt, Thomas R., Jr.
 Ingalls, Walter
 Knight, Belinda D.
 Leach, E.W.
 Obe
 Parker, Clarinda
 Stark, Elizabeth (Miss)
 Van Gendorff
 Wentworth, Ellen
 Willson, Mr.
 Wilson, E.
 Wood, Hanna
Amherst
 Burpee, Sophia (Constant)
 Lawrence, L.G.
Antrim
 Parker, Nathaniel
Barrington
 Clarke, Laura Etta
Boscawen
 Burpee, Jeremiah
Bradford
 Weston, Mary Pillsbury
Candia
 Moore, Jacob Bailey
Charlestown
 Bradburg, Harriett
 McDowell, Fred N.
Chichester
 Leavitt, Joseph Warren
Claremont
 Stewart, Jonas
Concord
 Burgum, John
 Low and Damon

Cooperstown
 Wilson, Mr.
Danbury
 Jewett, George
Dartmouth
 Guiffer, D.
Deerfield
 Goodrich, Henry O.
 Mooers, Jacob B.
Dover
 Fenton, C.L.
 Folson, Abraham
 Gookin, William S.
Dublin
 Eaton, Moses, Jr.
 Eaton, Moses, Sr.
East Jaffrey
 Davis, Hannah
Exeter
 Dodge, Asa
 Dodge, Jabesh
 Dodge, Rufus
 Dodge, Samuel
 Ellis, A.
 Lamson, Asa
 Van Cortland
Fisherville
 Holmes and Evans
Fitswilliam?
 Bascom, Ruth Henshaw
Francestown
 Fairbanks, Sarah
 Walker, Rebecca
Franklin
 Smith, Dana
Gonic
 Osborne, Elijah
 Osborne, James
 Osborne, James
Hampton
 Moulton, John
 Osborn, B.F.
Hampton Falls
 Lane, Samuel "Sam"
Hancock
 Eaton, Moses, Jr.
 Eaton, Moses, Sr.
 Porter, Rufus
 Rice, Emery
 Tuttle, Miss Ann
Hanover
 Steward, Joseph, Reverend
Hill
 Harrisman, Mehitable
Hinsdale
 Soule, Ebenezer, Jr.
 Soule, Ivory
Hollis
 Thayer, Nathan
 Webster, Abel
 Webster, Stephen
Huntington
 Lewis, Henry
Keene
 Charles, the Painter
 J.S. Taft and Company

NEW HAMPSHIRE (Cont.)
Keene (Cont.)
Schoolcraft, Henry R.
Starkey and Howard
Stiles, Jeremiah
Taft, James Scholly
Kensington
Dow, John
Landoff
Gilbert, Archie
Lebanon
Chandler, William
Tenny, Ulysses Dow
Londonderry
Wight, John
Louden
Eastman, Emily (Baker) (Eastman Louden)
Osborne, Elijah
Lyndeboro
Clark, Benjamin
Clark, Peter
Clark, Peter, III
Clark, William
Hutchinson, Ebenezer
Southwick, John
Manchester
Ingles, Thomas
McConnell, G.
Mason Village
Scripture, George
Merrimock
McKeever, Ellen
Middletown
Avery, John
Milton
Mathes, Robert
Moultonboro
Bennett, James S.
Nashua
Crafts, Martin
Smith, Roswell T.
Newbury
Eaton, Mary
Northwood
Edgerly, D.S.
Peterboro
Shute, Mrs. R(uth) W(hittier)
Shute, Samuel A., Dr.
Portsmouth
Bellamy, John Hales
Blunt, John Samuel
Brown, M(andivilette) E(lihu) D(earing)
Deering, William
Deering, William, Jr.
Dockum, S.M.
Evans, J.
Ferguson, Adaline M.
Gerrish, Woodbury
Henderson, Joseph
Hood, E.R.
Johnston, William
King, William
Labrie, Rose
Laighton, Deborah

Macpheadris, Archibald, Captain
Moses, Thomas P.
Roberts, George S.
Seaward
Spinney, Ivah W.
Stevens, E.A.
Rochester
Demeriett, Elizabeth J.
Salem
Merrel, Peter
Seabrook
Boyd, George
Stoddard
Badger, Stephen
Tern, C.H.
Union
Remmick, Joseph
Walpole
Fenton, Jonathan
Howard, Rebecca F.
Warner
Badger, Nancy
Waterboro
Avery, John
Weare
Gove, Mary Breed
Wilton
Hadley, Sara
Townsend, Albert

NEW JERSEY
Aetna Furnace
Anson, James
Bauman, Leila T.
Bower, Mary
Buell, S.J.
Coward, Eleanor L.
De Groot, Ann
Ely, Miss
English, Dan
Gamble, Sarah E.
Hallowell, William, Dr.
Hellick, Ann
Hering
Hillyer, William, Jr.
Matlick, William
Oxford Furnace
Parker, Charlie
Port, Elizabeth
Reasoner, Mrs. A.E.
Shearer, Jane
Smith, Margarette W.
Smith, T.
Stenger, Francis
Thiekson, Joseph
Thompson, Mr.
Watson, John
Absecon
Rhodes, D.
Truax, Rhoades
Amboy
Warner, William E.
Ashbury
Van Nortwic, C.
Atlantic County
Truay, Ike, Captain

Barbadoes Neck
Sandford, Peter Peregrine
Barnegat
Barkelow, Lou
Birdsall, Jess, Captain
Grant, Henry
Grant, Stanley
Kilpatrick, Henry
Predmore, Cooper, Captain
Ridgeway, Bindsall
Wallace, G.E.
Barnegat Bay
Gaskill, Tom
Soper, Alonzo
Soper, Sam
Bay Head
Hance, Ben
Johnson, Lloyd
Johnson, Taylor
Bayonne
Kurtz, Sadie
Beach Haven
Parker, Ellis
Sprague, Chris
Sprague, Jed, Captain
Belmar
Reyher, Max
Bergen County
Christie, I.
Young, Nathaniel
Bethehem Township
Craig, Robert
Bordentown
Black, Charles
Waters, Susan C.
Wright, Patience
Bridgeton
Hamlyn, George
Hamlyn, George, II
Burlington
Coxe, Daniel
Opie, Warren
Randall, James
Burlington County
Barsto Furnace
Hooton, Martha C.
Burlington County?
Antrim, Mary
Caldwell
Lent, B
Camden
Burrough, Mark
Phillips, Moro
Cheesequake
Bowne, Catherine
Furman, Noah
Letts, Joshua
Morgan, James
Morgan, James, Jr.
Van Winckle, Jacob
Warne and Letts Pottery
Warne, Thomas
Convent
Castles, Mrs. John W. (Elizabeth Eshleman)

Geographic Index

Cumberland County
 Van Meter, Joel
Dennis Creek
 Little, Mary L.
Dorchester
 Laycock, Eliza
 Murphy, Richard
Ducks Island
 Dawson, John
East Orange
 Dean, Emeline
Eatontown
 Marford, Mirible "Miribe"
Elizabeth
 Acken, J.
 Beerbower, L.S.
 Jeffries, David
 Leake, William
 Price, Ebenezer
 Pruden, John
 Pruden, John M., Jr.
 Stewart, Abner
Elizabethtown
 Wright, Cruger
Englewood
 Cooper, Teunis
Farmerville
 Van Doren, Garret William
Flemington
 Fulper Brothers Pottery
Forked River
 Barkelow, Lou
 Cornelius, John
Freehold
 Job
 Williams, Micah
Glassboro
 Whitney Glass Works
Gloucester
 American Porcelain Manufacturing Company
Gloucester County
 Weymouth Furnace
Hackensack
 Sandford, Peter Peregrine
Haddonfield
 Charles Wingender and Brother
 Wingender Brothers Pottery
 Wingender, Charles, Jr.
 Wingender, Charles, Sr.
 Wingender, Jakob
Herbertsville
 Van Winckle, Nicholas
Hoboken
 Ingalls, C(yrus) A.
 Jacobsen, Antonio
 Pansing, Fred
Hudson County
 Young, Nathaniel
Irvington
 Ross, Abby F. Bell (Abby J. Ball)
Jersey City
 American Pottery (Manufacturing) Company
 D. and J. Henderson
 Farrar, H.W.

 Jersey City Pottery Company
 Rhodes, Strong and McGeron
 Rouse and Turner
 Steig, Laura
 Taylor, William
Long Beach Island
 Sprague, Chris
Lumberton
 Holland, James
 White, Abel
Madison
 Fenimore, Janice
Manahawkin
 Conklin, Hurley
 Horner, Roland (Nathan Rowley)
Mataway
 Williams, Micah
Mayetta
 Salmon, Bradford
Middlepoint
 Dunn, Ezra
 Van Schoik and Dunn
Middletown Point
 Price, Abial
Millstone
 Andrews, M.
 Van Doren, Garret William
 Van Doren, Isaac William
 Van Doren, Peter Sutphen
Monmouth County
 Conover, Henry
Montague
 Stiff, J.
Moorestown
 Heuling, Martha
Morristown
 Wheeler, Eveline Foleman
Mount Holly
 Earnest, Joseph
 Hartman, Sarah Ann
 Reeve, Joseph H.
 West, William
Mullica
 Updike, John
New Brunswick
 A.J. Butler and Company
 Green, Adam
 Horner and Shiveley
 Rogerson, John
 Williams, Micah
New Gretna
 Cramer, Chalkly
 McAnney, John
Newark
 Campbell, James
 Fischer, Charles Henry
 Hild, Michael
 Jeliff, John
 Krumeick, B.J.
 Nuttman, I.W. Isaac
 Sayre, Caroline Eliza
 Union Pottery
 Woodhouse, Eulalie E.
 Zipf, Jacob
Northfield
 English, Mark

Norwood
 Haring, David D.
 Haring, James A.
Ocean County
 Shourdes, Harry M.
Old Bridge
 Bissett, Asher
 Morgan, James, Jr.
 Van Winkle Pottery
Osbornsville
 Grant, Percy
Parkertown
 King, Joe
 Parker, Lloyd
Paterson
 Rutgers Factory
 Schoonmaker, James
 Ward, A.B.M.
Pemberton
 Miller, Mary
Perth Amboy
 A. Hall and Sons
 Columbian Pottery
 Orcutt, Humiston, and Company
 Pewtress, John B.
 Stockwell, Henry
 Watson, J.R.
 Whiteman, T.W.
Pleasant Point
 Hankins, Ezra
Pleasantville
 Hammell, Guarner
Princeton
 McGraw, Mrs. Curtis
Rahway
 Mann, John
 Shotwell
Red Bank
 Frazier, Mrs.
 Murray, Elenor
Rumson
 Harvey, George
Salem
 Woodnutt, Rachel Goodwin
Salem County
 Carll, E.S.
 Wistar, Casper
Scotch Plains
 Osborn, Jonathan Hand
Seabright
 White, Winfield
Somers Point
 Doane, Mr.
 Kears, Mark
Somerset
 Somerset Pottery Works
South Amboy
 Allen, William
 Cadmus, Abraham
 Carr, James
 Congress Pottery
 Fish, C.
 Furman, Noah
 Greatbach, Daniel
 Hancock, John
 Hancock, John

NEW JERSEY (Cont.)
South Amboy (Cont.)
- Hancock, William
- Humistown and Walker
- Moore, Enoch
- Price, G.
- Remmey, Joseph Henry
- Swan Hill Pottery
- Warne and Letts Pottery
- Warne, Thomas

South Amboy (Sayreville)
- Price, Xerxes

Springfield
- Schenck

Stillwater
- Stiff, J.

Stockholm
- Keegan, Marie

Stockton
- Stockton, Hannah

Sussex County
- Primrose, Jacob

Trenton
- Alpaugh and McGowan
- American Art China Works
- American Crockery Company
- Anchor Pottery Company
- Bellmark Pottery Company
- Bloor, William
- Brearley, Stephens and Tams
- Broome, Isaac
- Burgess and Campbell
- Burroughs and Mountford
- Ceramic Art Company
- City Pottery Co.
- Columbian Art Pottery
- Cook Pottery Company
- Coxon and Company
- Coxon and Thompson
- Cresent Pottery Company
- Davis, Isaac
- Dawson, John
- Dawson, Joseph
- Delaware Pottery Company
- Eagle Pottery Company
- East Trenton Pottery Company
- Empire Pottery Company
- Enterprise Pottery Company
- Fell and Thropp Company
- Greenwood Pottery Company
- Hanlen, Bernard
- Hattersley, Charles
- International Pottery Company
- John Maddock and Sons
- John Moses and Sons
- Keytone Pottery Company
- Maddock and Son(s)
- Maddock Pottery Company
- Mayer, James
- McCulley, John
- Mercer Pottery Company
- Millington, Astbury and Poulson
- Moore, "Aunt Eliza"
- Morris and Wilmore
- New Jersey Pottery Company
- Ott and Brewer
- Prospect Hill Pottery Company
- Rhodes and Yates
- Rittenhouse, Evans and Company
- Speeler, Henry
- Star Porcelain Company
- Taylor and Speeler
- Taylor, William
- Trenton China Company
- Trenton Pottery Company
- Trenton Tile Company
- Willetts Manufacturing Company
- William Young and Sons

Tuckerton
- Frazer, Nate
- Shourdes, Harry V(an Nuckson)
- Smith, Samuel

Union
- Mooney, J.C.

Wading River
- Lippincott, Gideon

Warrenville
- Osborn, Jonathan Hand

Washington
- Eaton, Jacob
- Stout, Samuel

West Hoboken
- Buttersworth, James E.

Woodbury
- Clark, Mary Ann

NEW MEXICO
- Aragon, Rafael
- Archuleta, Manuel
- Atencio, Patricio
- Cervantes
- Cervantez, Pedro
- Day, Frank Leveva
- Delgado, Fray Carlos Joseph
- Descillie, Mamie
- Kabotie, Fred
- Martinez, Apolonio
- Molleno
- Otis, Alferez Don Jose Antonio
- Silvia, Rafael
- Tapia, Luis

Agua Fria
- Gallegos, Celso

Albuquerque
- Aragon, Luis
- Armijo, Frederico
- Benavides, Rafael, Father
- Garcia, Fray Andres
- Irving, Clarabelle

Arroyo Hondo
- Herrera, Miguel

Arroyo Hondo?
- Rodriguez, Jose Miguel

Belen
- Bazan, Joaquin

Canajilon
- Velasquez, Juan Ramon

Chamisal
- Aragon, Jose

Chamita
- Fresquis, Pedro Antonio

Chimayo
- Martinez de Pedro, Linda
- Ortega, David
- Ortega, Jose Ramon
- Ortega, Nicacio
- Ortega, Robert James
- Trujillo, John R.

Cochiti Pueblo
- Cordero, Helen

Cordova
- Aragon, Jose Rafael (Miguel)
- Cordova, Gloria Lopez
- Cordova, Herminio
- Lopez, Ergencio
- Lopez, George T.
- Lopez, Jose Dolores
- Lopez, Sylvanita
- Mondragon, Jose

Dixon
- Valdez, Horacio E.

El Rito
- Herrera, Jose Inez (Ines)

El Valle
- Montoya, Patricia

Espanola
- Lopez, Felix A.
- Lujan, Maria T.

Gallup
- Miguelito

Harding County
- Salazar, Alejandro

Jacona
- Roybal, Martin

La Madera
- Vergara-Wilson, Maria

La Valle
- Vigil, Francisco

Las Trampas
- Gonzales, Jose de Garcia
- Lopez, Martina

Las Truchas
- Fresquis, Pedro Antonio

Los Brazos
- Manzanares, Luisa

Mountainair
- Schaffer, "Pop" "Poppsy"

Nambe
- Fresquis, Pedro Antonio
- Toledo, Father Juan Jose

Ojo Caliente
- Villalpando, Monico

Park View
- Lopez, Antonia

Raton
- Ortega, Jose Benito

Ribera
- Salazar, David

San Idlefonso
- Martinez, Cresencio
- Pi, Aqwa
- Shije, Velino
- Tsireh, Awa

San Juan Pueblo
- Chain

San Luis
- Herrera, Antonio

Santa Cruz
 Garcia, Fray Andres
Santa Cruz de la Canada
 Benabides, Jose Manuel
Santa Fe
 Bazan, Ignacio Ricardo
 Delgado, Francisco
 Garcia, Fray Andres
 Kellner, Anthony
 Martinez, Angelina Delgado
 Martinez, Eluid Levi
 Miera y Pacheco, Bernardo, Captain
 Muth, Marcia
 Ortega, Benjamin
 Romero, Emilio
 Romero, Orlando
 Romero, Senaida
 Roybal, Maria Luisa Delgado
 Stark, Tillie Gabaldon
 Tapia, Star
Taos
 Archuleta, Antonio
 Barela, Patrocinio
 Brett, Lady Dorothy
 Gonzales, Elidio
 Jaramillo, Juanita
 Luna, Maximo L.
 Salazar, Leo G. (Leon)
Taos?
 Rodriguez, Jose Miguel
Tesuque
 Archuleta, Felipe Benito
 Ortega, Benjamin
 Ortega, Jose Benito
Tome
 Bazan, Joaquin
Truchas
 Cordova, Alfredo
 Cordova, Grabielita
 Cordova, Harry
Velarde
 Rendon, Enrique
Watrous
 Apodaca, Manuelita

NEW YORK
 Abbe, John
 Acheson, Eurphemia J.
 Aldich, Mrs. Richard
 Alexander, John
 Andaries, Elizabeth
 Andrew Meneely and Sons
 Arnold, A.
 Banker, Elizabeth
 Bardick, Lewis
 Bauch, Stan, Dr.
 Beaver, Chief
 Beekman, Miss Florence
 Bennet, Cordelia Lathan
 Bennett, S.A.
 Bohacket, Albert
 Bonnell, William
 Brewster, John, Jr.
 Brink, R.J.
 Broadbent, Samuel, Dr.
 Brown, J.
 Brown, John
 Browne, William
 Buckley, Mary Ann
 Buddington, J.
 Budington, Jonathan
 Buttersworth, James E.
 Buxton, Hannah P.
 Cary, Mary
 Clarke, Harriet B.
 Cole, Abraham
 Conger, J.
 Cornwall
 Cothead, Phoebe
 Covey, Harriet
 Cox, Henry F.
 Crowley, J.M.
 Crygier, Ealli
 Dare, Charles W.F.
 Davis, Ed
 Downes, P.S.
 Durfee, George H.
 Duyckinck, I. Evert
 E.G. Washburne and Company
 Ellsworth, James Sanford
 Evans, James I.
 Foot, D.
 Frink, L.W.
 Gerthner, Xavier
 Getty, J.A.
 Gilchrist, Catherine Williams
 Goodwin, F.W.
 Gouverneur, Maria Monroe
 Graziani, Reverend Dr.
 Hamilton, Sophie
 Harvey, Sarah E.
 Havins, N.
 Hayden, J.
 Hayes, George A.
 Hedden, Martha
 Heyman, F.B.
 Holloway, Isabella
 Hopeman
 Hoyt, Henry E.
 Hubbard
 Huntington, Dyer
 Irish, Tom
 Jordan, Samuel
 Joseph Meeks and Sons
 Kimball, Mary G.
 Knight, H.
 Lathrop, Betsy B.
 Le Roux, Charles
 Leggett, Julia
 Levie, John E.
 Livingston, Ruth
 Logan, A.
 Long, George
 Martin
 Mason, J.
 Miller, Anne D.
 Miller, J.
 Morley, William
 Norman, Charles
 North, Noah
 Onthank, N.B.
 Opper, E.
 Paine, Diana
 Parsell, Abraham
 Pears, Tanneke
 Peterson, Petrina
 Pie, Hugh
 Plaisted, T.J.
 Powers, Asahel Lynde
 Rider, Peter
 Rogers, W.H.
 Rollings, Lucy
 Rossvilles
 Ruckle, Thomas
 Rugar, John
 Sackett, Ester
 Sayler, C.
 Schnitzler, Paul
 Schuyler, Angelica
 Scouten, O.B.
 Seamen, W.
 Seavey, Lafayette W.
 Smith, William
 Smyth, M.
 Sobel, Lillie
 Spencer, Platt Roger
 Taylor, A.M.
 Thompson, Elizabeth A.
 Towers, J.
 Townsend, Charles
 Turnbull, Eliza J.
 Tuthill, Abraham G.D.
 Vaughn, M.A.
 Voegtlin, William
 Walters, Susane
 Warner, Ann Walgrave
 Waters, Susan C.
 Williams, William
 Witt
 Wood, John
 Young, John W.
Adams
 Greene, E. De Chois
Adirondack Mountains
 Dobson
 Lane
Albany
 Albany Stoneware Factory
 Ames, Ezra
 Brickner, John
 C. Dillon and Company
 Capron, William
 Chambers, Thomas
 Collins, William
 Cushman, Paul
 Dillon and Porter
 Eights, James
 Giadding, T.
 Gre(en?), G.
 Henry, Jacob
 Leman, John
 M. Tyler and Company
 Maxwell, J.
 O'Connell, R.
 Orcutt, Eleazer
 Petrie
 Ramsey, Margaret

NEW YORK (Cont.)
 Albany (Cont.)
 Selby, Edward
 Seymour, Israel
 Shepherd, Robert
 Starr, Eliza
 Taite, Augustus
 Ten Eyck, Margaret Bleeker
 Vanderlyn, Pieter
 Whittaker, James
 Wilkie, William
 Alexandria Bay
 Wheeler, Chauncey
 Alexandria Bay Area
 Conklin, Roy
 Coombs, Frank
 Amityville
 Carmen, T.
 Gardner, Lester
 Verity, Nelson
 Amonia
 Adams, Charlotte
 Amsterdam
 Voohees, Betsy Reynolds
 Ardsley
 Fasanella, Ralph
 Athens
 Clark and Company Pottery
 Clark and Fox
 Clark, Nathan, Jr.
 Fox, E.S.
 Nathan Clark Pottery
 Auburn
 Auburn State Prison
 Bisset, William
 Goodwin, E.W.
 Kennedy, Terence J.
 Babylon
 Cranford, Ralph M.
 Kellum, Frank
 Verity, Nelson
 Baldwinsville
 Darrow, John
 Ballston
 Luscomb, William Henry
 Mann, Electra
 Balmville
 Gibbs, John
 Bath
 Sincerbox, Keeler
 Bellport
 Corwin, Wilbur A.
 Corwin, Wilbur R., Captain
 Hawkins, Ben
 Osborne, Henry F.
 Verity, Obadiah
 Benton
 Reed, V.R.
 Bergen's Island
 Bergen, Johanna
 Bergholtz
 Mehweldt, Charles
 Berkshires
 Griffing, Martin
 Bethany
 E. Aram Factory

 French, P.
 Gilbert, C.A.
 Humphreys, S.
 Matteson, H.A.
 Salisbury, J.
 Wilkison, Emily
Binghamton
 Brown, W.H.
 Patterson Sisters
 Roberts, William
 White and Wood
 White, Noah
Brandy Hill
 Butler, Aaron
 Butler, Ann
 Butler, Marilla
 Butler, Minerva (Miller)
Brockport
 Smagoinsky, Helen Fabri
Bronx
 Frischwasser, Ben
 Johnson, R.
Bronxville
 Green, Virginia
Brooklyn
 Barlow, Miss Lydia
 Block, William
 Boone, Benjamin
 Boone, J.G.
 Boone, Thomas E.
 Brown, Charles
 Bruce, Joseph
 Bulsterbaum, John
 C. Bykeepers and Sons
 Carmel, Charles
 Davis, Vestie
 Dodge, Charles J.
 E.J. Hayden and Company
 Esteves, Antonio
 Goldstein, Harry
 Guy, Francis
 Hirshfield, Morris
 Illions, Marcus Charles
 Klumpp, Gustav
 Krans, J.
 Litwak, Israel
 Looff, Charles I.D.
 Mandel, A.
 Margaretten, Frederick M., Dr.
 Mazur, Frank
 Millard, Al(gernon) W. (John)
 Millard, Thomas, Jr.
 Pressley, Daniel
 Quinn, E.H.
 Schoenfield, Emanual
 Seelig, Moritz J. (Morris; Maurice)
 Smith, Joseph B.
 Smith, William S.
 Spillman Engineering Corporation
 Stein and Goldstein
 Stein, Soloman
 Van Wymen and Brother
 Vaupel, Cornelius
 Wadsworth, Charles

 Wolfinger, August
 Wyatt, David Clarence "Snap"
 Youngs, Icabod
Buffalo
 Ames, Asa (Alexander)
 Braun, C.W.
 Buffalo Pottery Company
 Davidson, William
 Drew, W.H.
 Gardner, Andrew
 Gardner, John
 Goodall, Premella
 Josephs, Joseph "Elephant Joe"
 Lowery, Alexander
 Primrose, Mordecai
 Rogers, James
 Skarsten, Karee
 Spalding, Frederick
 Spaulding, Frederick D.
 Spaulding, James
 Stratton, Joseph
 Sweatland, Joel
 Walbridge and Company
 Weeden, John
 Wooster, A.V.
Burlington
 Fenton, Jacob
Butternuts
 Wing, Zelinda
Butterville
 Tyler, Harry
Cambridge
 Conant, Maria T.
 Dalee, Justus
Canaan
 Avery, Gilbert
 Hatch, Elisha
Canajoharie
 Grider, Rufus A.
Canton
 Kip, Henry D.
 Miner, Eliza(beth) Gratia Campbell
Cape Vincent
 Chapman, Hicks David
 Merchant, Richard
 Stanley, James E.
Castile
 Waldron, Jane D.
Catskills
 Elliot, Nathan
Cattaraugus
 Cox, W.A.
Cazenovia
 French, B.
Champlain
 Hicks, Harriet
 Moore, Ann
 Moore, Sophie
Chittenango
 Chittenango Pottery Company
Clinton
 Fletcher, Aaron Dean
 French, B.
Clinton County
 Banker, Martha Calista Larkin

Freleigh, Margaret Ann
Redford Glass Works
Columbia County
Johnson, Mr.
Cooperstown
Dunn, Justus
Freeman, Mr.
N.R. Stephens Chair Factory
North, Alfred (Albert)
North, Linus
North, Mercy
North, Stephen
Copiague
Ketcham, Al, Captain
Ketchum, C.K., Sr.
Corlears Hook
Commeraw's Pottery
Corona
American Art Ceramic Company
Bologna, Frank
Cortland
Blair, Sylvester
Hansenclever, Peter
J. Sage and Company
Mason and Russell
Thomas D. Chollar
Woodruff, Madison
Cortland County
Impson, Jacob
Dansville
Artman, Abraham
Dunkirk
Lake, Salmon
Dutchess County
Field, Rebecca
Eagle Bridge
Moses, Anna Mary Robertson
Eagle Mills
Wilson, Thomas
East Chatham
Cady, Emma Jane
East Greenville
Butler, Abel
Butler, Ann
Butler, Marilla
Butler, Minerva (Miller)
East Greenwich
Upton, ?
East Hampton
Dominy, Nathaniel, V
Gallatin, Almy Goelet Gerry
Huntting, Marcy
Middle Lane Pottery
Price, Albert
Elizabethtown
Durand, Helen
Elmira
Farrington, E.W.
Skeggs, T.W.
Essex
Fletcher, Aaron Dean
Fishkill
Verplank, Samuel
Flatbush
Schenck, Cornelia Ann

Flatlands
Van Sicklen, Cornelia
Flatlands Bay
Bergen, Johanna
Flushing
Novik, Jennie
Fly Creek
North, Stephen
Fort Edward
Fort Edward Pottery Company
Haxstun and Company
J.A. and L.W. Underwood
New York Stoneware Company
Ottman Brothers and Company
Paxston, Ottman, and Company
 Pottery
Pottman Brothers
Saterlee and Mory
Franklin
Ellis, Rachel E.
Fredonia
Lake, Salmon
Fulton
S. Hart Pottery
Fulton County
Van Ness, Sarah Oldcott Hawley
Galesville
Lewis, W.A.
Gardiners Island
Griffin, Mark
Geddes
Geddes Stoneware Pottery
 Company
Hubbell and Cheseboro
Onondago Pottery Company
Shepard, Joseph, Jr.
William H. Farrar
Geneva
Nathaniel, Inez
Glen Head
Smith, Martha Swale
Godeffrey
Marshall, David George
Goshen
Pippin, Horace
Gouverneur
Randall, Jane Spillman
Storie, Harold
Gravesend
Stillwell, Ida
Great Neck
Lieberman, Harry
Green Port
Roanoke, Bart
Greene County
Eaton, J.N.
Greenpoint
Cartlidge, Charles
Faience Manufacturing Company
Kozlowski, Karol
Volkmar Keramic Company
Greenville
Willson, Mary Ann
Greenwich
Lewis, O.V.

Groton
Conger, Jonathan
Detterick, George
Groveland
Allen, B. Hausman
Hausman, Allen B.
Gt. Barrington
Andrews, Ambrose
Hamilton
Goldsmith, Deborah (Throop)
Hammond
Elethorp, Robert
Havana
Whitman, J.M.
Whittemore, R.O.
Haverstraw
Crawford, Cleo
Henniker
Conner, Morris
Heuvelton
Ashworth, Helen
Hickman County
Armstrong, Ann Johnson
Hogansburg
Hopps, David Vernon
Homer
Bennett and Chollar
Chollar and Darby
Hudson
Selby, Edward
Hudson River Area
Baldwin, Henry
Hudson River Valley
Little, B.
Watson, John
Hudson-on-Hudson
Sinclair, Mrs. William
Huntington
Brown Brothers
Caire, Frederick J.
Keeler, Benjamin
Lewis and Gardner
Lewis and Lewis
Samuel J. Wetmore and
 Company
Scudder, Moses
States, Adam
Titus, Jonathan
Indian River
Terrillion, Veronica
Ithaca
Darrow, J.M.
Davidson, Archibald
G. Adley and Company
Macumber and Van Arsdale
Mooney, D.
Mooney, Michael
Poor, Jonathan D.
Walton, Henry
Jamaica Bay
Carter, John W.
Whittaker, John, Captain
Jefferson
Salisbury, Mary
Jefferson County
Calister, James C.

Jefferson County, NY *Folk Artists Biographical Index • 1st Ed.*

NEW YORK (Cont.)
 Jefferson County (Cont.)
 Collie, S.
 Denny, Samuel
 Redwood Glass Works
 Tyler, Elman
 Tyler, Harry
 Johnsburgh
 Woodward, Cordelia Caroline Sentenne
 Jordan
 J.M. Burney and Sons
 Morton and Sheldon
 Peck, Sheldon
 Katonah
 Farrington, Anna Putney
 Kendall Mills
 Sherman, John
 Kingston
 Manley, Jane Helena
 Vanderlyn, Pieter
 Lake George
 Willett, George H.
 Lansingburgh
 Clark, Samuel
 Crane, Harry
 Deming, Horace
 Deming, Luther
 Filley, Augustus
 Filley, Harvey
 Filley, Marcus Lucius
 Goodrich, Asahel (Asohet)
 Hall, Joseph P.
 Larkin
 Lent, George
 North, Seth
 Thayer, Pliny
 Lawrence
 Bowman, William
 Lawville
 Pudor, H.
 Lew-Beach
 Briggs, John H.
 Lewis County
 Seckner, C.M.
 Liberty
 Taccard, Patrick
 Lisbon
 Bickstead, A.E.
 Lisle
 Howland, Lucinda
 Little Britian
 Alexander, James
 Lockport
 Getty, A.
 Getty, James
 Getty, John
 Keys, Mary
 Lodi
 Cass, David
 Cass, Josiah
 Cass, Nathan
 Long Island
 Baldwin, John Lee
 Bigelow, P.W.
 Bowman, William
 Cooper, Ann Eliza
 Dangler, Samuel
 Dilly, John
 Gelston, Thomas
 Havens, George
 Jacobs, A. Douglas
 Kellum, Frank
 Knapp, Harry
 Oothout, Mary
 Peck, Nathaniel
 Raynor, Ben
 Roosevelt, Mrs. Theodore, Jr.
 Smith, Charlotte
 Smith, Gil
 Smith, W(ashington)
 Strang, Charles
 Watkins, R.
 Williams, T.
 Winter, Henry
 Long Island?
 Pennell, George
 Lyons
 Clark and Company Pottery
 Fisher, J(acob)
 Harrington, Thomas
 Harrington, Thompson
 Lyons Pottery
 Macomb
 Kittle, Nellie
 Madison County
 Wilson, William (A. Wilson)
 Madrid
 Besner, Fred M.
 Parmenter, N.H.
 Mahopac Falls
 Mullins, Walter S., General
 Malden Bridge
 Goodell, J.C.
 Manhatten Wells
 Crolius, Clarkson, I
 Massapeque
 Verity, Obadiah
 Mendon
 Young, Brigham
 Middlefield
 Glen, Hugh
 Middlesex
 Adams, Olive M.
 Middletown
 Tatham, Thomas
 Mohawk Valley
 Parks, J.
 Montgomery County
 Houghenon, Dorothy
 Jackson, Samuel
 Reynolds, Lydia Barlett
 Montgomery County?
 Cole, Rufus
 Morristown
 Barker, Harriett Petrie
 Mount Kisco
 Slyman, Susan
 Mount Lebanon
 Andersen, Elder William
 Collins, Sister Sarah
 Reed, Eldress Polly
 Wagan, Robert
 Mount Morris
 Sherman, John
 New Albany
 Bleecher, Margaret
 New Baltimore
 Bedell, Prudence
 New Hartford
 Butterfield, J.
 Butterfield, Samuel
 Cunningham, James
 New Hudson
 Jennings, J.S.
 New Lebanon
 Beers, Martha Stuart
 Cady, Emma Jane
 Jewett, Amos
 Miller, Louisa F.
 Youngs, Isaac N(ewton)
 New Lisbon
 Holcomb, Allen
 New Rochelle
 Chute, Bill
 New York
 A.B. and W.T. Westervelt Company
 Abig, Adolphus
 Akin, Phebe
 Alback, John
 Allison, Walter
 Alt, Godfried
 Alt, William
 Amthor, John
 Anderson, Alonzo
 Anderson, Jacob S.
 Anderson, James
 Anderson, Jane
 Anderson, John W.
 Antres, Charles
 Arend, Michael
 Ashe, Thomas
 Atlantic Garden
 Auld, Wilberforce
 Aulont, George
 Austin, Peter H.
 Bailly, Alexis J.
 Banta, John W.
 Banvard, David
 Bard, James
 Bard, John
 Barker, Elizabeth Ann
 Barna, William
 Barnes, William
 Barry and Losea
 Barry, Thomas
 Baum, Mark
 Baumback, Theodore
 Bayer, Michael
 Beadle, Edward
 Beiderlinden, Nicol
 Bennett, John
 Bennett, Thomas
 Bensing, Dirick
 Benson, Henry
 Best Duck Decoy Company, Inc.
 Betsch, M.

Bickel, George
Bijotat, Simon
Bird, Charles
Bogun, Maceptaw, Reverend
Boize, Charles
Bokee, John
Bolden, Robert H.
Boos, John
Booth, Thomas
Boulton, William
Bowers, Ezekial
Bowers, Joseph
Boyle, Ferdinand T.L.
Bradley, I. (John)
Branchard, Emile Pierre
Bright, Pete
Brinckerhoff, John P.
Brooks and White
Brooks, James A.
Brooks, James A.
Brooks, T(homas) V.
Brotherton and North
Brown, Charles
Brown, Charles
Browne, John H.
Browne, John S.
Bruce, Joseph
Buck, George H.
Burch, John
Burkfeldt, August
Burman, Augustus
Burtis, Jacob H.
Buttling, Avery
Buttre, William
Byerley and Ely
Byerley, Edwin
Campbell and Greig
Campbell, Thomas
Canade, Vincent
Carr, James
Cellarinus, Ferdinand
Chambers, Thomas
Chapin, Alpheus
Chatterson and Higgins
Chatterson, Joseph
Claesen, Dirick
Clark and Risely
Clark, John W.
Classic Woodcarving Company
Collins and Brown
Collins, Nicholas E.
Collins, Thomas
Collyer, Thomas
Conger, John
Conger, John
Cook, William
Cordery, William
Cornell, John V.
Cornwell, Stephen
Court, Lewis
Crane, Jacob B.
Crane, Margaret Smyser
Creiger, Augustus
Crocker, Ephraim
Crolius, Clarkson, I
Crolius, Clarkson, II
Crolius, George
Crolius, John
Crolius, Peter
Crolius, William
Croll, John
Cromwell and Harold
Cromwell, John L. (S.)
Cromwell, Stephen
Cross, John
Croylas, William
Curtis, H.B.
Dash, John Baltus
Davis, Charles
Davis, Vestie
de Freest, Mrs. Daniel L.
Decker, Louis
Deene, John
Delmont, David
Dengler, J.
Denman, David
Derlom, Francis
Desaville, William W.
Dippel, Ferdinand
Dodge and Anderson
Dodge and Sharpe
Dodge and Son
Dodge, Charles J.
Dodge, Jeremiah
Dodson, W.K.
Dolan, James
Donegan, James
Doran and Miller
Doran, John B.
Dorendorf, D.
Doriani, William
Drawbridge, William S.
Drummond, M.J.
Dunlavey, Martha
Dunn, Helen (Helen Viana)
Durand, John
Durrell, Jonathan
Duyckinck, Gerardus I.
Duyckinck, Gerret
Dwight, Stephen
Earl, Ralph
Easson, James
East Morrisania China Works
Eberle, Mark
Ellenbass, Theodore
Ellis, John
Ellis, John, Jr.
Ely, Abraham
Esteves, Antonio
Eureka Steam Machine Carving Company
Eutatse, John
Fabian, Gisela
Farnham, Henry
Farnham, John D.
Farrand and Stuart
Farrand, Stephen
Fasanella, Ralph
Fash, William B.
Fellini, William
Field, Erastus Salisbury
Finch, Nathaniel
Fischer, Charles
Flandrow, Joseph B.
Fleming, James Adam
Follett, T.
Forman, Irene B.
Fothergill, Emily
Fracarossi, Joseph
Fraser, John
French, William B.
Frothingham, James
Frouchtben, Bernard
Fuentes, Lucas
Fuller, George
Gager, Oliver A.
Gantz, Frederick
Garing, Christian
Gatto, (Victor) Joseph
Geidt, Anthony E.
Geiger, Jacob
Goldin, Elizabeth Ann
Goodell, Ira Chaffee
Graham, John
Green and Board
Guiterman, Gustave
Gyory, Esther
Haberland, Benno
Haden Company
Hahnle, Egidius
Halliday, Thomas
Harbeson, Georgiana Brown
Hardcastle, Henry
Harding, John T.
Harding, Richard H.
Hasslock, Charles
Hatfield, Joseph
Hausel, Martin
Hausel, William
Haviland Company
Heath, Samuel
Hein, John
Heiss, Balthus
Heron and Macy
Heron and Weeden
Heron, James
Herr, John
Herring, James
Hicks, Walter
Hirshfield, Morris
Hoffman and Maurer
Hoffman, John
Hoffman, Leonard
Hoffmaster, Charles A.
Honey, John
Horton, Daniel
Howard, Bill
Hudson River Pottery
Hurley, George
Hustace, Maria
Isroff, Lola K.
J(ohn) W. Banta and Company
J.L. Mott Iron Works
J.S. Anderson and Son
J.W. Fiske (Ironworks)
Jackson, Joseph
Jackson, Joseph H.B.
Jacob Anderson and Company

NEW YORK (Cont.)
 New York (Cont.)
 Jacobsen, Antonio
 Jakobsen, Kathy (Katherine)
 Jeremenko, Theodore
 Jeremiah Dodge and Son
 Jewsson, George
 Johnson, Charles M.
 Johnson, John
 Jones, A.W.
 Jones, Anthony W.
 Kaiffer, Frederick W.
 Kane, Andy
 Kaufman, Jacob
 Keena, John
 Kellogg, Mrs. Francis Leonard
 Kemmon, Joseph
 Kemp, Frederick
 Kempton, Samuel
 Kennedy, Samuel
 Kertell, George
 Kessel and Hartung
 Kessler, Charles
 Kikoin, Aaron
 Killalea, Thomas
 Klumbach, Jacob
 Knoedler, Cyriak
 Knost, Edward
 Koch, Samuel
 Kohl, Peter
 Kountze, Mrs. De Lancey
 Kurtz and Company
 Kurz, Max
 Kutz, Anthony
 L'Enfant, Pierre Charles
 Labeyril, Constant
 Lafleur, Charles
 Lamb, Anthony
 Lambert, Thomas
 Landau, Sol
 Lannuier, John
 Launsbury, John
 Lawrence, George
 Lebduska, Lawrence
 Lebrecht, Frederick
 Lehman, Louis
 Lembo, J. Lawrence
 Lerving, Samuel
 Levin, Abraham (Abram)
 Lewin, Isaac
 Lindmark, Winter
 Little, Thomas
 Lockrow, William
 Lockwood, William
 Luff and Brother
 Luff and Monroe
 Luff, George W.
 Luff, John V.
 Lundmark, Winter
 Lustig, Desider
 Lynch, Laura
 Macy, Reuben
 Macy, Robert H.
 Mannebach, Lewis
 Manning, John
 Marcellus, John

Marcher, James
Marsh, Mrs. John Bigelow
Marshall, William
Marston, W.W.
Mayer, Henry
Mayer, Philip
McColley
McColley, Charles
McGuire, Dominick
McLean, Hugh
McMahon, Thomas
McQuillen, James
Mead, Dr.
Mead, William
Mengen, Theodore
Menges, Adam
Metzler, Henry F.
Middleton, Ralph
Millard, Thomas, Jr.
Millard, Tom
Miller and Browne
Miller, Edwin N.
Miller, Ernest
Miller, George A.
Miller, Jacob
Miller, John
Miller, John F.
Miller, John F., Jr.
Milliken, Robert
Milliken, Thomas
Milosh, Christian
Milosh, William
Minifie, James
Minton, W.D.
Mitchell, Robert
Monroe, John
Montgomery, William
Montgomery, William M.
Monza, Louis
Morgan, D.
Morgan, David
Morrell and Morriss
Morrell, Willett H.
Morrison and Carr
Morse, Samuel Finley Breese
Moss, Frederick
Mott and Doran
Mott and Pasman
Mott, Dewitt C.
Moulthrop, Reuben
Nantion, J.
New York City Pottery Company
New York Studios
Nickols, John
Noble, George
North, Justinus Stroll
O'Donnell, Mrs. D. Oliver
Odio, Saturnino Portuondo
 Pucho
Orth, Adam
Palladino, Angela
Pappenberg, Henry
Parsons, Charles
Pasman, Frances
Pastor, James
Percel, E.

Perez, Mike
Petrie, John
Peyrau, A.
Phelen, James
Potts, Abram
Powers, Susan
Primrose, Robert
Pyle, John W.
Quest, Francis
Quiles, Manuel
Regensburg, Sophy
Remmey, Henry, I
Remmey, John, I (Johannes)
Remmey, John, II
Remmey, John, III
Renouf, Edward M.
Rhode, Henry
Riedel, A.
Riemann, George
Risley, Charles
Risley, Charles E.
Robb, Charles
Robb, Clarence
Robb, Samuel Anderson
Robinson, John L.
Roebel, George
Rogers, Bruce
Rogers, John
Roseman, Bill
Roseumen, Richard
Roux, Alexander
Rusby, John
Sabo, Ladis
Salamander Works
Salzberg, Helen
Samuel Bent and Sons
Schaeffer, Henry
Schaffert, Charles
Scheckel, Conrad
Schenk, J.H.
Schmidt, Amalie August
Schmidt, Peter
Schmitt, Ambrose
Schone, Robert
Schwager, William
Schwob, Antoinette
Searing, George E.
Sebastian Wagon Company
Self, Bob
Shannon, George W.
Shapiro, Pauline
Sharp, Charles
Sharpe and Ellis
Sharpe, C(ornelius) N.
Shepherd, Jacob
Skillin and Dodge
Skillin, Simeon, III
Slote, Alexander
Smart, John
Smith and Crane
Smith, F.E.D.
Smith, Henry
Smith, Thomas H.
Smith, Thomas H.
Smith, William W.
Solomon, John

Spencer, James
Stark, Jeffrey
Steinberger, Samuel
Stephen, John
Stephen, William
Steward, David
Stewart, William
Stratton and Morrell
Stratton, Joseph
Strauss, Simon
Stuart, Alexander W.
Stumpf, Valentine
Sullivan, William
Tapp and Miller
Tapp, Edward
Taylor, John
Taylor, John
Taylor, Lillian Gary (Mrs. Robert Coleman Taylor)
Terhune, Nicholas
Theall, Isaac
Thomas C. Smith and Sons
Thomas, Robert D.
Thompson, John
Thresher, George
Titus, Francis
Tourneur, Renault
Trabich, Bertha
Train and Collins
Train, Daniel N.
Trautz, August
Tryon, Elijah
Union Porcelain Works
Vanderhoof, William H.
Vannorden, John G.
Vanzile, Ginge
Vieille, Ludwig
Voltheiser, Joseph
Voos, Robert
Vought, Samuel L.
Warburton
Warner, Phebe
Warner, Sarah Furman
Weedon, J(ohn)
Weedon, John
Wheeler, Candace
White, Thomas J.
Whiteman, Henry
Whittle, B.
Widow, M. Queen
Wiener, Isador "Pop"
William A. Macquoid and Company, Pottery Works
William Demuth and Company
Wilson and Schaettler
Wooster, A.N.
Wychoff, Ellen
Zeldis, Malcah
Zingale, Larry
Zuricher, John

New York?
French, Daniel Chester
Hosmer, Elizabeth Janes
Skillin, John
Skillin, Simeon, Jr.

Newburgh
Aikens, James
Davis, M.O.
Gibbs, John
Robinson, James

Newport Habor
Budd, Alice M. (Mrs. Kenneth)

Niagara
Sternberg, William

Nicholville
Mosher, Anna

North Bay
J.C. Waelde Pottery

North Lawrence
Queor, William B.

North Tonawanda
Armitage, James
Armitage-Herschell Company
Herschell, Allen
Herschell-Spillman Company

Ogdensburg
C(harles) Hart and Company Pottery
J.J. Hart Pottery
Kanoff, W.H.
Lewis, Frank E.
McIntosh, Amanda
W. Hart Pottery

Old Chatham
Sarle, Sister C.H.
Wells, Sister Jennie

Olean (Oleans)
Wands, I.H.

Oneida County
Cunningham, James
Hutton, Christopher

Orange County
Alexander, James
Ball, H.H.
Crothers, Samuel
Wilson, John

Orleans County
Johnson, D.P.

Oswego
Brown, David E.
Green, John H.
Hart, James
Kilpatrick, R.L., Captain
Wales, Nathaniel F.
Wentworth, T(homas) H.

Oswego area
Sisson, J.

Oswego County
Cleveland Glass Works
Pulaski, J. Irvin

Oswego Falls
Hart, James

Ottisville
Corwin, Salmon W.

Palmyra
Hadsell, Ira
North, David
Van Ness, James
Wooden, J.A.

Peekskill
Sherman, Lucy McFarland

Pekin
Bagley, S.

Pekin?
Habecker, David

Pen Yan
Mantell, James
Mantell, Thomas

Petty
Shamp, D.

Pittsfield
De Forest, J.H.

Pleasant Valley
Franklin, Mary M.

Poestenkill
Hidley, Joseph H.

Pomfret
Lake, Salmon

Port Byron
Nathaniel, Inez

Port Chester
Moseman, Elizabeth E.

Port Washington
Mitchell, Phoebe

Potsdam
Ellis, Freeman
Knowles, Mrs. Henry L.
Morey, Charlotte
Raymond, James S., M.D.

Poughkeepsie
Caire Pottery
Caire, Jacob
Caire, John P.
Evans, J.M.
Gideon Crisbaum and Company
Lehman, Louis
Orcutt and Thompson
Reidinger and Caire
Swift, Ann Waterman
Wray, H.

Prattsville
Stone, N.

Pulaski
Irvin, James
Irwin, L.

Red Mills
La Flair, John

Rhinebeck
Phillips, Ammi

Rochester
Burger, John
Clark and Company Pottery
Harrington
Hirzel, William
Hubbard Girls
Hubbard, John
N. Clark and Company
Rochester Sewer Pipes

Rome
Judd, Norman L.

Rondout
Madden, J.M.
Schrieber, John

Rotterdam
Veeder, Ferguson G.

Sag Harbor
Glover, Elizabeth

NEW YORK (Cont.)

Sangerfield
- Norton, Ann Eliza

Saratoga
- Deuel, Elizabeth
- Morris, J.W.
- Pitkin, Elizabeth

Saratoga Springs
- De Lee, Francis H.

Schenectady
- Murray, William

Schoharie
- McNaughton, Robert
- Snyder, Philip

Scriba
- Scriba, George Frederick William Augustus

Seaford
- Verity, Nelson

Sheepshead Bay
- Williams, R.

Shelburne
- C(harles) Hart and Company Pottery
- Hart, James

Skaneateles
- Beauchamp, William Millet

South Haven
- Carmen, Caleb

South Nyack
- Moment, Barbara

Southhampton
- Zuricher, John

Southport
- Conger, Jonathan

Spencertown
- Johnson, James E.

Springfield
- Price, William

St. Lawrence
- J.J. Hart Pottery
- Kittle, Nellie
- Rosseel, Frank
- W. Hart Pottery

St. Lawrence area
- Massey, William B.

St. Lawrence County
- Barker, Harriett Petrie
- Dewey, Ormand Sales
- Gibson, Mary L.

Staten Island
- Bradley, I. (John)
- Johnson, John
- Totten, Mary (Betsy)

Stockholm
- Nichols, Maynard

Stone Arabia
- Vogt, Fritz G.

Syracuse
- Campbell, John
- Geddes Stoneware Pottery Company
- Klippenstein, S.
- Onondago Pottery Company
- Pass, James
- Syracuse Stoneware Company

Tappan
- Snyder, Mary

Thousand Islands
- Upham, J.C.

Troy
- C. Boynton and Company
- Chapman, J(osiah)
- Clark and Lundy
- Crafts, Caleb
- Filley, Marcus Lucius
- Goodrich, Mahala
- Hidley, Joseph H.
- J. Clark and Company
- Keys, Jane
- Orcutt, Eleazer
- Orcutt, Humiston, and Company
- Seymour, Israel
- Seymour, Walter J.
- W. Lundy and Company

Ulster County
- Bevier, Ellen Bange

Utica
- Brayton Kellogg and Doolittle
- Bronson, J.
- Bronson, R.
- Brown, M(andivilette) E(lihu) D(earing)
- Campbell, Justin
- Central New York Pottery Company
- Dunn, Justus
- Fayette, Shavalia
- Field, L.F.
- Gay, Amos
- N.A. White and Sons
- Nash, E.
- Nash, G.
- Nash, H.
- Roberts, David
- Roberts, William
- White, Noah

Waddington
- Johnson, Isaac

Walton
- Hoy, David

Walworth
- Leroy, D.

Warwick
- Coe, Elias V.

Washington
- Fort Edward Pottery Company

Watertown
- Marvin, Fay
- Ricalton, William

Waterville
- French, B.

Watervliet
- Buckingham, David Austin
- Youngs, Benjamin S.

Weedsport
- C.W. Stevens Factory
- H.A. Stevens Factory

West Bloomfield
- Wilcox Pottery

West Charlton
- Brown, Jon

West Danby
- Shelley, Mary

West Dryden
- Primrose, Jacob

West Hartwick
- Harrington, Lyman

West Point
- Eastman, Seth

West Troy
- Edward Selby and Son
- Perry, Sanford S.
- Seymour, George R.
- Shepley and Smith
- Turner, William
- Walker, George
- Warner, William E.
- West Troy Pottery

White Plains
- Marshall, Emily
- Sandford, Peter Peregrine
- Warren, M., Jr.

Williamsburg
- Cromwell, John L. (S.)

Wolcott
- Conger, Daniel
- Huntington, Edwin
- Spencer, William

Woodville
- Harris, Ken

Wyoming County
- Shamp, D.

Yater County
- Pen Yan Pottery

NORTH CAROLINA

- Donkle, George
- Dudley, Lee
- Dudley, Lem
- Hopper, Annie
- Krause, Thomas
- Mickey, Julius
- Noel, Mary Cathrine
- Reems Creek Pottery

Airlie Gardens
- Evans, Minnie

Almance County
- Nixon, N.H.

Ashville
- Bianchi, John

Back Bay
- Grandy, A.

Balfour
- McKillop, Edgar Alexander

Bethabara
- Aust, Brother Gottfried
- Moravian Pottery

Charlottesville
- Toole, John

Halifax County
- Higgs, Harriet W.

Hickory
- Hilton Pottery Company
- Huffman, Barry G.

Kernersville
- Evans, W.D.

Killpevil
 Heywood, Manie
Knotts Island
 Williams, S.
Lincoln
 Hartsoe, Sylvanus
Lincoln County
 Craig, Burlon
 Seagle, Daniel
Lincolntown
 Rhodes, T.
Marshville Township
 Bailey, James Bright
Milton
 Day, Thomas
Montgomery County
 Auman, Fletcher
Moore County
 Owen, M.W.
Ocracoke
 Burke, Edgar, Dr.
Randolph County
 Brower, J.F.
 Craven, John A.
 Craven, Thomas W.
 Overton, Nathan
Rowan County
 Vater, Ehre
Salem
 Aust, Brother Gottfried
 Christ, Rudolph
 Fries
 Hawkes, Elizabeth Jane
 Hawkes, Mary Lou
 Phohl, Bessie
 Phohl, Maggie
 von Hedeken, Ludwig Gottfried
 Welfare, Daniel (Christian)
 Winkler, Matilda Amalia
Salemburg
 Williams, Jeff
Saluda
 Green, Virginia
Seagrove
 Cole Pottery
 Fox, H.
 Fox, N.
 Jugtown Pottery
 Loy, M.
 Southern Pines, N.C.
 Wrenn Brothers
Steeds
 Craven, Peter
Tulls Creek
 Walker, Wilton
Vale
 Rheinhardt, Enoch W.
Wagram
 Scott, I.
Waynesville
 Greer, Exell
Wilkes County
 Cowles, Calvin
Wilmington
 Evans, Minnie

NORTH DAKOTA
Grand Forks
 Lunde, Emily

OHIO
 Bandel, Frederick
 Black, Willaim
 Bosworth, Sala
 Brown and Crooks
 Cezeron
 Cook, John
 Cramlet, C.
 Edgington, James McCallister
 Esten, Edwin
 Fairbrothers, William
 Good, Jacob
 Graves, David Isaac
 Humphrey, Maria Hyde
 Lashel
 Lewis, Harvey
 Lindsey, Seymore S.
 Massilot, L.
 Maurer, John
 Money
 Morrey
 North, Noah
 Phillips, M.E.
 Powers, Asahel Lynde
 Prindle, F.B.
 Rappe, Mary
 Rauch, M.
 Routt, Daniel
 Shafer, Samuel C.
 Shalk, Jacob
 Sloan, Junius R. (John)
 Spitler, Johannes
 Sterling Brick Company
 Sullivan, Charles
 Taylor, Alexander
 West, James
 "Windy"
 Wolf, H.
 Wood, Mrs. Jonathan
Adams County
 Vogler, Milton
Adams Township
 Schneider, Johann Adam
Adelphi
 Heilbronn, J(ohn) J.
 Kitchen, Tella
Akron
 A.L. Dyke and Company
 Akron Porcelain Company
 Akron Pottery Company
 American Sewer Pipe Company
 Beecher and Lantz
 Bodenbuhl, Peter
 Boss Brothers
 Camp and Thompson
 Cook and Richardson
 F.W. Weeks
 Hill and Adams
 Hill, Foster and Co.
 Hill, Merrill and Company
 Hill, Powers and Company
 Isroff, Lola K.
 Johnson and Baldwin
 Kane, John
 Knapp, F.K.
 Knight, Maurice A.
 Markell, Immon and Company
 Merrill Powers and Company
 Merrill, Calvin
 Merrill, Edwin
 Merrill, Henry E.
 Ohio Stoneware Company
 Robinson Clay Products
 Rowley Pottery
 Royer, A.
 Samuel Dyke and Company
 Schenkle, William
 Sigler, Clarence Grant
 Spafford and Richards
 Summit China Company
 United States Stoneware Company
 W.B. Allison and Company
 W.H. Rockwell and Company
 Weeks, Cook and Weeks
 Weir
 Whitman, Robinson and Company
Amherst
 Filker, John
Armstrongs Mills
 Sweeny, T.W.
Ashland
 Brown, Isaac
 Brown, W.W.
Ashland County
 Yearous, F.
Ashley
 Root, Elmira
 Ropes, George
Ashtabula
 Baldwin, V.
Attica
 Sherman, Jacob
Atwater
 Atwater, Caleb
 Atwater, Joshua
 Burns, W.F.
 I.M. Meed and Company
 Purdy, C.
 Purdy, Fitzhugh
 Purdy, Gordon B.
 Purdy, Solomon
Barberton
 National Sewer Pipe Company
Bascom
 Brinkman, Henry
Basil
 Heilbronn, George
 Heilbronn, J(ohn) J.
Batavia
 Hay Weaving Shop
Belleville
 Masters, Margaret
Belmont County
 Maxwell, William
Berlin County
 Shively, Clio D.

357

OHIO (Cont.)
Bethel Township
 Myers, Daniel L.
Bethlehem
 Slusser, Jacob M.
Blooming Grove
 Wolf, Adam
Bolivar
 Blocher, S. (B.)
 Flocher, S.
Bridgewater
 Somerset Trading Company
Bristol
 Lichy, Benjamin
Brunswick
 June, Benjamin
Bucyrus
 Fogle, Lewis
 Reichert, H.
 Slaybough, Charles
 Slaybough, Josiah
 Slaybough, Samuel
 Slaybough, William
Burton
 Walker, John Brown
Butler County
 Herman, John
Cadiz
 Crozier, John
 Stoud, William
Cambridge
 Cambridge Art Pottery Company
 Oxley, Joseph
Canal Dover
 Burkhardt, P.H.
Canal Winchester
 Schrader, H.
Canfield
 Alexander, Robert
Canterbury
 Wineland, N.W.
Canton
 Berger Manufacturing Company
 Binkley, George
 Danner, Philip
 "El Diadlo"
 Grace, Daniel
 Hoover, M.
 Keifer, Louis
 Leopold, Valentine
 Lovett, Rodman
 Meily, John Henry
 Moore, J.W.
 Petry, Henry
 Sherrick, David
 Shorb, Adam A.
 Shorb, Adam L.
 Shorb, J., Jr.
 Slusser, Eli M.
Carrollton
 Anshutz, Philip
Chagrin Falls
 Church, Henry, Jr.
Chambersburg
 Hicks, Samuel

Chardo
 Randell, Martha
Chardon
 Randel, Martin
Chatfield Corners
 French, Eben
Chatham Center
 Pearsen, J.
Chester Township
 Leykauff, Michael
 Ringer, Peter
Chesterville
 Colman, Peter
Chillicothe
 Burns, James
 Heiser, William L.
 Neely, N.
 Walters, J.
 Wilson, G.
 Young, S.
Chippeway
 Pearsen, J.
Cincinnati
 Avon Pottery
 Baily, Joseph
 Ball, Nelson
 Behn, Andrew
 Behn, George Peter
 Brewer and Tempest
 Brockman Pottery Company
 Bromley, William
 Burnside, John
 Caldwell, James
 Cincinnati Art Pottery Company
 Clark, Isaac
 Cole, Anthony
 Cooper, James
 Cooper, William
 Coultry, P.L.
 Craig, John
 Cridland, Charles E.
 Dallas, Frederich
 Doane, James
 Duncan, M.L.
 Eichenlaub, Valentine
 Eyre, John
 Findlay, Robert
 Fisher, John
 Francisco, James F.
 Frazer, Hiram
 Fry, William H.
 Greatbach, Hamlet
 Hayes Brothers
 Humble, John
 Iler, William
 Ingersoll, W.S.
 Jeffries, W.P.
 Jones, William
 Kendall, Uriah
 Lessel, George
 Lessel, Peter
 Mappes, H.
 Matt Morgan Art Pottery Company
 McLaughlin, Miss Mary Louise
 Milan, Nettie

 Miller, August
 Miller, Dubrul and Peters Manufacturing Company
 Ochsle, John
 Ochsle, Phillip T.
 Ogden, James K.
 Pitman, Benn
 Pollock, Samuel
 Pyatt, George
 Queen City Terra-Cotta Company
 Quigley, S.
 Rookwood Pottery Company
 Saunders, William
 Scott, George
 Sims, James
 Smith, John
 Smith, Mary Caroline Wooley
 Storer, Mrs. Bellamy (Maria Longworth)
 Taylor, W.W.
 Tempest, Brockman and Company
 Tempest, Michael
 Tempest, Nimrod
 Thompson, Israel
 Vance, James
 Wheatley, Thomas
 Wilson, Mrs. Russell
 Young
Cincinnati and Troy
 Smith, Edwin B.
Cincinnati?
 Nurre, Joseph
Circleville
 Hemon, James
Clark County
 Myers, James
Cleveland
 Cleveland Glass Works
 Giddings, C.M.
 Hamas, Elias
 Higgins, A.D.
 Matzen, Herman
 Van Dorn Iron Works
 West, E.
Clinton Township
 Rezinor, John
Columbiana County
 Rotzel, Mathias
 Will, William
Columbus
 Abbe, Frederick
 Almon, Leroy
 Baker, David
 Baker, John
 Barth, Andrew
 Buchanan, Thomas
 Coleman, Sarah Whinery
 Howard, A.
 Jenkins, A.
 M. Armbruster and Sons
 M.V. Mitchell and Sons
 Moon, Robert
 Pierce, Elijah
 Platt, Augustus

Schell's Scenic Studio
Cornersburg
Bury, Daniel
Jones, L.
Coventry County
Strobel, Lorenz
Covington
Kepner, Absalom B.
Van Gordon, William H.
Covington County
Steinhilber, Martin
Crooksville
Barley and Winters
Bluebird Pottery
Burley, Lazalier
Crooksville China Company
Cuyahoga Falls
Camp Cook and Company
Harris, Thomas
Thomas, J.R.
Dalton
Curtis Houghton and Company
Dalton Pottery Company
Houghton, Edward
Houghton, Edwin
Houghton, Eugene
Dayton
Bert L. Daily Scenic Studio
Borkowski, Mary K.
Broome and Morgan
Getz
Turner, William
Wood
Delaware County
Rauser, Gabriel
Rouser, Gabriel
Dover
Wores, H.
Doylestown
Routson, S.
Dundee
Nevel, Frederick
Dunlevy
Beard, William
Eagle Springs
Iliff, Richard
East Liverpool
Adams Brothers
Agner and Gaston
Agner, Fouts and Company
Baggott, S.
Blythe, David Gilmour
Booth Brothers
Bulger and Worcester
Burford Brothers Pottery Company
Burgess, Webster and Viney
Burton, William
C.C. Thompson Pottery Co.
Cartwright and Brothers
Colclough, William
D.E. McNichol Pottery Company
Dresden Pottery
East End Pottery Company
East Liverpool Pottery Co.
Foster and Rigby
Frederick, Schenkle, Allen and Company
George Murphy Pottery Company
Globe Pottery Company
Goodwin Brothers
Goodwin Pottery Company
Harker Pottery Comapny
Harker, Benjamin
Harker, Taylor and Company
Harvey, Isaac A.
Henderson, John
Homer Laughlin China Company
Jackson, Samuel
John W. Croxall and Sons
Knowles, Isaac W.
Knowles, Taylor, and Knowles
Koontz, John
Marks, A.H.
Marks, Farmer, Manley and Riley
McCullough, William
Morley, Goodwin and Flentke
Morton, Joseph
Salt and Mear
Sevres China Company
Simms and Ferguson
Simms and Laughlin
Simms and Starkey
Simms, N.M.
Smith-Phillips China Company
Speeler, Henry
Standard Pottery Company
T. Rigby and Company
Taylor, Smith, and Taylor Company
Taylor, William
Thomas and Webster
Thomas Croxall and Brothers
Thompson and Herbert
Union Potteries Company
United States Pottery
Vodrey Brothers
Vodrey, Jabez
Walker, N.U.
Webster, Elijah
West End Pottery Company
William Brunt Pottery Company
Woodward and Vodrey
Woodward, Blakely and Company
Worchester, Samuel
Wylie Brothers
East Palestine
Ohio China Company
East Village
Wood, J.C.
English Township
Fleck, Joseph
Erie County
Armstrong, J.H.
Fair Port Harbor
Perry, William
Fairfield County
Shank, M.
Farmington
Conoly, David
Fayette County
Mark, Matthew W.
Findlay
Fleck, William
Nusser, Christian
Fort Jefferson
Young, John W.
Franklin
Franklin Pottery Company
Franklin Township
Hinshillwood, Robert
Ott, C.
Frazeesburg Road
Vandemark, John
Fremont
Mater, William Henry
Fulton
Morten, J.A.
Reeves, B.
Fulton County
Burkerd, Peter
Fultonham
Weller, Samuel
Gallipolis
Mentelle, Ward, Sr.
Van Fleck, Peter
Van Vleck, Jay A.
Geauga City
Walker, John Brown
Gnadenhutten
Baker, W(ilbur) A.
Romig Clay
Grandville
Dyker, Henry
Granville
Hughes
Gratiot
Smith, A.V.
Greenfield
Sulser, Henry
Greentown
Hefner, George
Greenville
Beichler, Ed
Hamilton
Bingham, David
Metzner, Adolph
Hanover
Wolf, William
Hayesville
Heifner, J. Philip
Hebron
Hught, E.
Hillsboro
Allen, Abram
Fisher and McLain
Iliff, Richard
Hocking County
Stracke, Barnhardt
Holmes County
Bysel, Phillip
Long, John
Hopewell Township
Brinkman, Henry
Mundwiler, Samuel

OHIO (Cont.)
 Huron County
 Baird, G.
 Inland
 Steurnagle, Andrew
 Jackson
 Reed, Ernest "Popeye"
 Jackson County
 Kell, D.
 Jackson Township
 Lichy, Benjamin
 Miller, Levi M.S.
 Yearous, Adam
 Jacksontown
 Sutton, E.
 Jefferson County
 Long, C.
 Martin, Robert
 Schrader, H.
 Johnson Township
 Wirick, John
 Wirick, William
 Jonathan Creek
 Emsinger, A.
 Rosier, Joseph
 Kendall
 Binkley, George
 Kinsman
 Robinson, Mary Lou Perkins
 Knox County
 Clearfield Textile Mill
 Long, Jacob
 Swank, J.
 Knox Township
 Will, William
 La Fayette
 Hartman, John
 Hartman, Peter
 Lake Township
 Petna, George
 Lancaster
 Alton Foundry
 Heilbronn, George
 Heilbronn, J(ohn) J.
 Meech, G.
 Lewisville
 Kostner, J.M.
 Lexington
 Baughman, John
 Licking County
 Shalk, Jacob
 Lima
 Meily, John Henry
 Lisbon
 Chore, L.
 Thomas China Company
 Lithopolis
 Jungkurth, J.W.
 Phlegan, Henry
 Liverpool
 Brunt, Bloor, and Martin
 Goodwin, John
 Lodi
 Davidson, J.M.
 Logan
 Bichel, W.
 Hesse, D.
 Strickler, John
 Logan County
 Laughlin, M.
 Logan Village
 Hesse, F.E.
 London
 Petry, Peter
 Losantiville (Cincinnati)
 McFarland, William
 Loudonville
 Grimm, Peter
 Wearehs
 Louisville
 Lamielle, E.
 Stoneware and Tile Company
 Madison Township
 Ayrhart, Peter
 Malago
 Orms
 Mansfield
 Meiley, Charles S.
 Meily, Samuel
 Mapleton
 Singer, John
 Marietta
 Backus, Thaddeus
 Marion County
 Forster, William
 Martin's Ferry
 Callahan, William
 Danas, John
 Harris, James
 Stevens, Joseph P.
 Young, Samuel
 Massillon
 Boerner, Shapley and Vogt
 Forrer, Martin
 Massillon Refractories Company
 Welker, Adam
 Maumee
 Nowlan, Margaret
 McCuthenville
 Fox, John
 Miller, Henry
 Mechanicsburg
 Staley, Andrew
 Medina
 Baldwin, H.
 Stuart, Nobil
 Medina County
 Bean, Mrs.
 Lytle
 Meade, S.
 Miami County
 Armbruster, J.
 Franz, Michael
 Staudt, Simon
 Middlebury
 Chapman, Upson, and Wright
 Manufacturers
 Moor, W.T.
 W.B. Allison and Company
 Middletown
 Laget, A.
 Midford Center
 Canfield
 Midway
 Wirick, John
 Mifflin Township
 Hipp, Sebastian
 Mosser, John
 Millersburg
 Snyder, Henry
 Milton Township
 Hartman, John
 Mogadore
 Fenton, J.H.
 Fossbender, N.
 Merrill, Earl
 Meyers, E.W.
 Monroe, J.S.
 Myers and Hall
 Myers, Baird, and Hall
 Myers, E.W.
 S.L. Stroll and Company
 Sheldon, F.L.
 Smith, J(oseph) C.
 Monroe
 Jotter, Jacob
 Monroeville
 Bennett, R.
 Montgomery County
 Baden, C.
 Klein, Mathias
 Shank, W.
 Stinger, Samuel
 Morris Township
 Graham, John
 Morristown
 Birch, S.A.
 King, Joseph
 Mt. Gilead
 Cook, Phebe
 Mt. Sterling
 Burley, John
 Mt. Vernon
 Ardner, Jacob
 Ardner, Michael
 Graham, John
 Navarre
 Navarre Stoneware Company
 New Baltimore
 Lehr, George
 New Berlin
 Berthalemy, Jacob
 Lichy, Benjamin
 Sheaffer, Isaac
 New Carlisle
 Moyall, James
 New Chambersburg
 Eckler, Henry
 New Lebanon
 Boler, Daniel
 Shearer, Michael
 New Lisbon
 Horsefall, Henry
 New Philadelphia
 Campbell, James
 Figley, Joseph
 Lambright and Westhope

McChesney, Andrew
Packer, T.A.
Read, Thomas
Tracy, John B.
Tracy, Nelson
Wilson, Robert B.
Works, Laban H.
New Portage
Bury, Daniel
New Springfield
Bower, L.
Newark
Bichel, W.
Clark, Jacob N.
Engel, G.
Flowers, Peter
Jeffries, Theodore
Moore, Robert
Price, Janis
Stich, G.
Tobin, John
Newcomerstown
Fox, Harmon
Newport
Figley, Joseph
Newport Sewer Pipe Plant
Read, Thomas
Works, Laban H.
Newtown Township
Hall, E.B.
Harris, W.P.
North Georgetown
Bartler, Joseph
North Lima
Bayard, Jacob
Norton Township
Wunterlich, John
Nova
Peck
Oakhill
Aetna Fire Brick Company
Oberlin
Cohen, F.E.
Pease, H.A(lanzo)
Olney
Heifner, J. Philip
Orange
McClellan, J.
Orrville
Cochran, Robert
Eichert, Peter
Fleckinger, Jacob
Hall, Amos
Osnaburg Township
Singer, John
Ottawa County?
Klinhinz, John
Ovid
Davidson, J.M.
Painesville
Baker, William
Sterling, Mary E.
Paris
Smyth, Joel
Perry Township
Heifner, J. Philip

Pikes Township
Lawson, David
Piketon
Fouth, Jacob
Piqua
Gerbry, M.Y.
Ginn, Robert
Plain Township
Hefner, George
Sheaffer, Isaac
Strauser, Elias
Poplar
Heshe, Henry
Portage County
Tupper, C.
Portsmouth
Pursell, Daniel
Pulaski
Mayo, Charles S.
Putnam
Bell, Joseph
Bodine, J.
Havens, Samuel
Mootz
Purdy, Solomon
Rice, Prosper
Wilbur, C.
Ravenna
Misler Brothers
Seymour and Stedman
Reading Township
Flowers, Peter
Redford
Rich, James
Richland County
Clark, Jacob N.
Etner, Reuben
Seigrist, Henry
Shearer, Henry
Richland Township
Moncliff, A.B.
Richwood
Chapman, T.A.
Rome
Bick, John
Roscoe
Rich
Roseville
Balderson and Pace
Bullock, W.
Burton, John
Lowry, W.B.
Mayers, W.S.
Melleck, H.H.
Owens, J.B.
Sowers, H.
Weaver, James L.
Williams and McCoy
Ross County
Steinhilber, Martin
Steinhill Brothers
Rowsburg
Weaver, John W.
Weaver, Samuel
Salem
Harmon, Christian

Hinshillwood, Robert
Hughes, Thomas
McLeran, James
W.H. Mullins and Company
Salt Creek Township
Swan, Cyrus
Sandusky
Muller, Alfred H.
Sandyville
Riggs, Wesley
Sebring
Oliver China Company
Sebring Pottery Company
Seneca County
Hopkins, John
Wyant, David
Shanesville
Bysel, Phillip
Schmidt, Peter
Shreve
Brumman, David W.
Sidney
Enders, Henry
Granold, J. George
Smithfield
Carter, Achsah
Somerset
Heighshoe, S.E.
Hesse, L.
Somerville
McGurk, Andrew
Springfield
Black, G.
Crossley, Robert
Ettinger, John
Fiske and Smith
Kittinger, John
Merrill, Edwin H.
Schrap, W.J.
Smith, A.
Stephenson, Daniel
Wait and Ricketts
Springfield Township
Welk, George
Springville
Stephen, Jacob
St. Clairsville
Burns, James
Hornbreaker, Henry
Sharpless, Samuel
Stark County
Jenison, J.
King, Daniel
Meckel, J.S.
Mohler, Anny
Reed, William A.
Snyder, Jacob
Walk, Jacob M.
Steubenville
Beerbower, William
Cross, Peter
Fisher and Tarr
Fisher, J.C.
Fisher, Thomas
Ginn, Robert
Holden, Jesse

OHIO (Cont.)
 Steubenville (Cont.)
 Kennedy, David
 Lonhuda Pottery Company
 Marion, Edward
 Marshall, Edward W.
 McLaughlin, James
 McMillen, Samuel
 Merkle, Alexander
 Merkle, James
 Stubenville Pottery Company
 Strake County
 Synder, Jacob
 Strasburg
 Garner, Jacob
 Streetsboro
 Myers, Elizabeth
 Sucer Creek
 Henning, A.
 Sugar Creek Township
 Yergin, William K.
 Sullivan
 Lashell, L.M.
 Summit County
 F.J. Knapp
 Symnes Creek
 Miner, William
 Tallmadge
 Fenton, T.H.
 Moore, Alvin S.
 Tyron, Wright and Company
 Tarlton
 Saylor, Jacob
 Thompson Township
 Schoch, Charles (G. Schoch)
 Thornville
 Colman, Peter
 Tiffin
 Ruef, Arnold
 Ruef, Peter
 Tiltonville
 Vance Faience Company
 Toledo
 Funk, E.H.
 Toronto
 American China Company
 Tremont City
 Riegel, Simon
 Troy Township
 Redick, John
 Trumbull County
 Meeks, Josiah
 Uhl, Peter
 Tuscarawas County
 Biddle, Robert W.
 Bosio, Louie
 Dick, Jacob
 Fouts, Edward
 Hall, E.B.
 Hamilton, Clem
 Spencer, Herman
 Staley, Louie
 Stockes, L. (Ralph)
 Tuscarawas County?
 Crockett, Otto
 Uhrichsville
 Baker, W(ilbur) A.
 Evans Pipe Company
 Moore, J.W.
 Upper Sandusky
 Duddleson, C.
 Urbana
 Ambrose, Frederick
 Utica
 Lunn, William
 Vernon Township
 Cole, J.C.
 Warren
 Lathouse, Mrs. W.B.
 Warren County
 Dunscombe, Hannah
 Van Vleet, Abraham
 Washington Township
 Mater, William Henry
 Stierwalt, Moses
 Wayne County
 Alexander, Thomas M.
 Breidenthal, P.
 Fasig, William
 Lehr, Daniel
 Lehr, George
 Seigrist, Henry
 Wellington
 Willard, Archibald M.
 Wellsville
 Baum, J.H.
 J. Patterson and Company
 Jones, George
 Morley and Company
 Pioneer Pottery Company
 Wells, Joseph
 Wells, S.
 Wellsville China Company
 West Brookfield
 Hoke, George
 West Hope
 Ford, Saddie
 West Lebanon
 Meily, Samuel
 West Rushville
 Moncliff, A.B.
 West Salem
 Smith, John
 Willoughby
 Mattice and Penfield
 Wilmington
 Allen, Abram
 Hart, J.
 Winterset
 Oxley, Joseph
 Woodstock
 Cushman, Warren S.
 Woodview
 Van Buskirk, Jacob
 Wooster
 Hartman, John
 Hartman, Peter
 Routson, Joseph
 Routson, S.
 Xenia
 Cosley, Dennis
 Cosley, G(eorge)
 Lorentz, Peter
 Yellow Creek
 Lawrence, David
 Youngstown
 Bury, Daniel
 Golonko, Joe
 Ward, H.
 Zanesville
 American Encaustic Tiling Company
 Bodine, R.H.
 C. Goetz, Smith, and Jones, Slago Pottery
 Dubors, Oliver
 Hanelsack, Daniel
 Howson, Bernard
 Howson, John
 Key and Swope
 Mayhew, Frederick W.
 Owens, J.B.
 Pyatt, George
 Pyatt, J.G.
 Roseville Pottery Company
 Smiley, H.K.
 Sullivan, Samuel
 Weller, S.A.
 Zanesville Stoneware Company
 Zoar
 C. Oppel and Company
 Gottfried Kappel and Company
 Pottery of the Separatist Society of Zoar
 Zoar Industries
 Zoar Pottery
 Zoarite Community Pottery

OKLAHOMA
 Austin, Roy
 Baker, Tom
 Balzer, John
 Burk, Eldon
 Carroll, Tessie
 Chwalinski, Joe Moore
 Cochran, Hazel
 Coon, Phillip
 Cortez, Maxine
 Coville, A.M.
 Davis, Gwyn
 Duncan, O.P.
 Echols, Alice
 Eyman, Earl
 Getty, Marshall
 Goff, G.
 Guthrie, Woody
 Hagen, Horace Henry
 Harkins, Mrs. A.
 Harvey, Bill
 Hedges, Joe
 Loomis, L.R.
 McNabb, Marcena Coffman
 Moore, Billy
 Nelson, Cal
 Pebeahsy, Charles
 Porter, Solon
 Shipshee, Louis

Sloane, L.S.
Smith, J. Kent
Spybuck, E.L.
Cheyenne
Muhlbacher, Joe
Dacoma
Shelite, L.G.
El Reno
Harrold, John "Spotter Jack"
Eufaula
Hall, Irene
Grand Lake
Galloway, Ed
Guthrie
Nethery, Ned
Hennessey
Townsend, Ted
Norman
Tenebaum, Morris
Saline
Ware, Dewey
Tulsa
Tipton, Vena

OREGON
Bennett, F.R.
Spalding, Eliza Hart
Wibb, Ward
Ashland
Rust, David
Astoria
Titus, Jim
Gilchrist
Orr, Georgianna
Lebanon
Childers, Russell
Portland
Doud, Delia Ann
Erceg, Rose "Ruza"
Redmond
Rosebrook, Rod

PENNSYLVANIA
Ache, H.M.
Anders, Abraham
Anders, Andrew
Anders, Judith
Andreas, Jacob
Angstad, E.
Bachman, Christian
Bard, Johannes
Barnhott, Margaret
Bart, Daniel
Bart, Susanna
Bauer, Andeas B.
Bauman, August
Becker, J.M.
Beidler, C.Y.
Bergey, Joseph K.
Bicksler, Jacob S.
Blank, Elizabeth
Bollinger, Leslie
Border, Ann Amelia Mathilda
Borton, Mary Ann
Brackbill, Eliza Ann
Braidt, Frohica

Breininger, Barbara
Breininger, Lester
Brubacher, Abraham
Brubacher, Hans Jacob
Brubacher, Johannes
Brusgaeger, J. George
Bunting, J.D.
Burton, Rebecca
Byberin, Barbara
Caldwell, Booth
Campbell, Daniel
Cassell, Christian
Cassell, Huppert
Cassell, Joel D.
Cezeron
Clayman, Susan
Cleland, Jennie
Clemens, Johannes
Cooper, Peter
Cordier, David
Cross, J.E.
Davis, Ellsworth
Denholm, John
Denlinger, David
Detweiler, John H.
Detweiller, Martin M.
Dille, Susann
Dirdorff, Abraham
Ditmars, Peter
Dreese, Thomas
Dressler, S.O.
Dulheuer, Henrich
Dutye, Henre
Egelmann, Carl Friederich
Eisenhauer, Jacob
Ellinger, David
Faber, Wilhelmus Antonius
Fair, Hannah
Fellows and Meyers
Fieter, Michael
Flory, John
Forrer, Johann
Francis, John F.
Fretz, J.
Fries, Isaac
Fritz, Jacob
Fromfield, William
Fulivier, James
Gahman, John
Gamble, Sarah E.
Gerhardt, George
Gerlach, C.
Gilberth, J.H.
Gill
Gise, Henry
Gleason, Mrs. L.
Godshalk, Enos
Godshall, M.
Green, J.D.
Griffith, Thomas
Grimes, William
Gross, Isaac
Gross, Jacob
Gross, Magdalena
Guisewite, Reverend
Hafline, Mary

Hall, James
Hartman, Christian B.
Hartzel, John, Jr.
Hechler, Samuel
Heebner, David
Heebner, John
Heebner, Maria
Hellick, Ann
Herr, Anna
Herr, Anna
Herr, David
Hesselius, Gustavus
Hessin, Christina
Heydrich, Balzer
Heyman, F.B.
Hill, Henry
Hillegas, Jacob
Hoffman, Johannes
Hofmann, Anna
Hollinshead, Mary Ann
Hooton, Martha C.
Horn, Daniel Stephen
Hosterman, Anna
Huebner, Abraham
Huebner, Henrich
Huebner, Susanna
Jackson, John Hamilton
Jackson, Samuel
Jaeckel, Christoph
Jamison, J.S.
Jones, Eliza
Kassel, Georg
Kauffman, Daniel
Kauffman, Samuel
Keeper, Heinrich
Kehm, Anthony
Kemp, D.
Kichline, Euphemia
Kiehn, David
Killian, Abraham
Kimball, Mary Ann
King, Mary
Kinsey, Abraham K.
Klenk, Ferdinand
Knappenberger, G.
Knight, T.G.
Kral, Kadharina
Krauss, Johannes
Krauss, Regina
Krider, Jacob
Kriebel, David
Kriebel, Hanna
Kriebel, Job
Kriebel, Maria
Kriebel, Sara
Krieble, Abraham
Kriner, Robert
Kumerle, D.
Kuns, Cadarina
Kuster, Friederick
Landes, Barbara
Landes, John
Landes, Rudolph
Landis, Catherine L.
Landis, John
Landis, John A.

Pennsylvania

PENNSYLVANIA (Cont.)
Lapp, Christian
Lapp, Henry
Levan, Francis D.
Lewin, C.L.
Limbach, Christian
Loehr, Elizabeth
Long, H.F.
Lueckin, C.
Lukolz, Philip
Magdelena
Mai, Thomas
Margaretha
Marteen, W.
Marx, John
Mercer, William
Merz, Jacob
Metzger, F.
Meyer, Elizabeth
Meyer, Martin J.
Miesse, Gabriel
Miller, Anna Mari
Miller, Jacob
Miller, John G.
Min, James A.
Moffly, Samuel
Morton, Mary
Mosteller, Johannes
Moyer, Martin
Muench, Karl C.
Munch, Carl E.
Neff, Elizabeth
Neffensperger, J.D.
Nichols, Margaret
Otto, Wilhelm
Paul, Samuel
Pelton, Emily
Perkins, Clarence "Pa" "Cy"
Perkins, Ruth Hunter "Ma"
Peters, Christian
Phenstein, W.A.
Phipps, Margarette R.
Pile, John
Pine, Robert Edge
Plank, J.L.
Plattenberger
Portzline, Elizabeth
Puwelle, Arnold
Rasmussen, Charles
Rauch, Elisaeet
Reber, John Slatington Carver
Reich, Elizabeth
Reinwald, Sarah
Rigel, Maria Magdalena
Robinson, Mary Lou Perkins
Romer
Rose, Mrs.
Ross, Jane
Rudy, Durs
Rutter, Thomas
Schaffer, Marea
Schantz, Joseph, Reverend
Schenef, Friederich
Scherich, C.
Schneider, Christian
Schriver, Jacob
Schriver, John
Schuller, Johann Valentin
Schultz, Barbara
Schultz, Lidia
Schultz, Regina
Schultz, Salamon
Schultz, Sara
Schultze, C.
Schyfer, Martha
Seibert, Henry
Seiler, H.
Seuter, John
Seybert, Abraham
Seybold, Carl F.
Shaffner, Jacob
Shalk, Jacob
Shearer, Jane
Shindel, J.P.
Sibbel, Susanna
Siegfried, Samuel
Slade, John
Sloan, Junius R. (John)
Slothower, P.
Smith, Mary Ann (MaryAn)
Spangenberger, Johannes Ernst
Spangler, Samuel
Speck, Johan Ludwig
Spiller, Johan Valentin
Stahr, John F.W.
Stamn, Mary
Stevenson, George
Stickler, Mary Royer
Stober, John
Stouter, D.G.
Strenge, Christian
Teibel, Georg (Johann)
Thompson, M.
Tilles, J.A.
Trevits, Johann Conrad
Trout, Hannah
Umble, John
Van Dalind, G.
Van Minian, John
Van Voorhis, Mary
Weaver, Carolina
Weaver, J.G.
Weber, Isaac
Weidner, Heinrich
Weiss, Anna
Weiss, Henrich
Weyzundt
Wilson, Fanny
Witmer, Henry
Witmer, Peter
Witmer, Philip
Wynkoop, Emma T.
Zeller, George
Zinck, John
Zoller, George
Zornfall, Martin
Zug, Johan

Aaronsburg
Ettinger, Emanuel
Ettinger, William (Henry)
Weaver, Frederick

Adams County
Ditzler, Jacob
Griest Fulling Mill
Keller, Adam

Albany Township
Greenwald, John W.

Allentown
Albert, Henry
Bach, George W.
Christmas, W.F.
Dannert, Henry
Fritzinger, Jerret (Jared)
Gabriel, Henry
Gramlyg, John
Hausman, B(enjamin)
Horn, Samuel
Hosfield, F
Inger, J. Fritz
Lentz, Cornelius
Peter, Reuben
Probst, Henry
Rassweiler, H.
Saeger, Martin
Saurly, Nicholas
Seidenspinner, John
Seip
Sheets, Frank M.
Smith, George
Smith, George M.
Swallow, William
Weand, William
Weil, George P.
Wensel, Charles
Wiand, Charles
Wiand, Joel
Wiand, John
Wiand, Jonathan D.
William Fische Pot Factory
Woodring
Young, Peter

Anderson's Landing
Anderson, William A.

Anthony Township
Gramlyg, John

Antrim Township
Bohn, Adam

Barnesville
Weber, J.A.

Barto
Mensch, Irwin

Beaver
Sutherland, J.

Beaver Falls
Beaver Falls Art Tile Company
Economite Potters
Graff, J.
Harvey, Isaac A.
Mayer Pottery Company
Thomas and Webster

Bedford County
Gordon, L.

Bedford County?
Geller, Adam

Bedford Township
Weidel, George

Geographic Index | Danville, PA

Bedminster
 Drach, Rudolf
Bedminster Township
 Ketterer, J(ohn) B.
Belfast Township
 Palmer, Joel
Belleville
 Haffly, Joseph
Berks County
 Bixler, Absalom
 Brechall, Martin
 Crecelius, Ludwig
 Eisenhause, Peter
 Eubele, M.
 Hiester, Catherine
 Hoffman, C.W. (Charles L.)
 Joder, Jacob
 Ketterer, J(ohn) B.
 Kiehl, Benjamin
 Kohler, Rebecca Leiby
 Krebs, Friedrich (Friederich; Frederick)
 Mader, Louis
 Rasmussen, J(ohn)
 Risser, L.D.
 Schmeck, John
 Schumacher, Daniel, Reverend
 Shade, J.
 Shade, P.
 Stofflet, Heinrich
 Walborn, Catarina
Berks County?
 Goebell, Henry
 Speyer, Georg Frederick (Friedrich; Friederich)
Berlin
 Eval and Zom
Bermudian Creek
 Good Intent Woolen Factory
Bernville
 Hume, Joseph
Bethel
 Dubbs, Isaac
Bethel Township
 Klinger, Absalom
 Snyder, Isaac
Bethlehem
 Haidt, John Valentine
 Miller, Gabriel
 Reinke, Samuel
 Tommerup, Matthias
Bird-in-Hand
 Swope, George A.
Birmingham (Pittsburgh)
 Auber, P.
 Bennett, James S.
 Bennett, William
 Foel and Ault
Black Creek
 Goodman, John S.
Black Creek Township
 Goodman, Peter
Blair County
 Miller, Ambrose
Blandon
 Fretzinger

Bradford County
 Ingham, David
 Monroeton Woolen Factory
Brandywine
 Peterman, Casper
Brecknock Township
 Steiner, David
Bridgewater
 Hamilton, W.L.
Brighton Township
 Sutherland, J.
Bristol Township
 Boudro(u), Alexandr(e)
Brownstown
 Scheffer, Richard
Brownsville
 Douglas, Charles
 Packer, J.
Buckfield
 Rounds, Mary M.
Bucks County
 Drissell, John
 Eyer, Johann Adam
 Headman, Andrew
 Headman, Charles
 Hicks, Edward
 Hudders, J.S.
 Kaufman, John
 Musselman, Samuel B.
 Ovenholt, Abraham
 Shade, Willoughby
 Simmons, Schtockschnitzler
 Speakman, Joseph
 Strawn, John
 Uebele, Martin
 Waring, David
 Zelner, Aaron
Bucks County?
 Bush, W.
Bucksville
 Klinker, Christian
Caln
 Vickers, Thomas
Cambria County
 Fisher, John
Canonsburg
 Balantyne, Samuel
Carbon County
 Dieter, Charlie
Carlisle
 Boyle, M.
 Mountz, Aaron
 Schimmel, Wilhelm
Carroll Township
 Baker, Daniel, Jr.
Carversville
 Kline, Philip
 Moore, Richard
 Neisser, Jacob
Cassville
 Greenland, N(orval) W.
 Hyssong, C.B.
Centre County
 Ettinger, Emanuel
 Geistweite, George, Reverend
 Young, Reverend

Centre Township
 Kirst, John
Centreville
 Richardson
Chambersburg
 Arnold, Daniel
 Ashberry
 Bell, Charley
 Bell, John
 Bell, John W.
 Denig, Ludwig
 Heyser, W.
 Long, David
 Nicklas, George
 Nicklas, Peter
Chapel
 Frederick, John
 Stahl, James
Chester
 Chester Pottery Company
Chester County
 Brown, Margaret
 Garrett, Mary Hibberd
 Griscom, Rachel Denn
 Hoopes, Lydia
 Howard, Thomas
 Howard, William
 Mode, Amy
 Osmon(d), (Anna) Maria
 Taylor, Elizabeth
Chestnut Hill
 Muler, Christian
Chestnut Hill Township
 Dotter, Cornelius
Chipman Township
 Portzline, Francis
Clay
 Meninger, E.
Claysburg
 Pringle, Sylvester R.
Climax
 Bish, W.H.
Clinton County
 Chatham's Run Factory
 Rich, John
Cloisters
 Henrill, Hermann
Codorus Township
 Serff, Abraham
Columbia County
 Rank, John Peter (Johann)
 Rank, Peter
 Selzer, John
Conestoga Township
 Patterson, Thomas
 Yardy, Christian
 Yordy, Benjamin
Corry
 Satterlee, J.C.
Creekside
 Cooper, Richard P., Reverend
Cumberland County
 Frederick, Henry K.
Danville?
 Goodman, Peter

PENNSYLVANIA (Cont.)
 Dauphin County
 Umbarger, Michael, Jr.
 Dauphin County?
 Speyer, Georg Frederick
 (Friedrich; Friederich)
 Delaware Township
 Goodman, Peter
 Denver
 Bixler, Absalom
 Leisey, Peter
 Derry Station
 Derry China Company
 Derry Township
 Wise, E.
 Dillsburg
 Smith, Will
 Dover
 Hoke, Martin
 Dover Township
 Nagel, Philip
 Williams, Henry T.
 Williams, William T.
 Downingtown
 Downing, Mary
 Hoopes, Milton
 Way, Rebecca
 Doylestown
 Hoffman, William
 Mercer, Henry C.
 Moravian Pottery and Tile Work
 Dryville
 Dry, Daniel
 Dry, John
 Dry, Lewis
 Tomlinson, Lewis K.
 Duboistown
 Muehlenhoff, Heinrich
 Eagle Point
 Haas, Peter
 East Berlin
 Resser, William W. "Will"
 East Hempfield
 Stauffer, Mary Ann
 East Hempfield Township
 Andrews, Jacob
 Lantz, J.
 Leitz, J.
 Lutz, E.
 Lutz, Jacob
 Myers, Daniel L.
 East Huntingdon Township
 Overholt, Henry O.
 East Lampeter Township
 Cassel, Joseph H.
 Easton
 Black, Daniel (David)
 Black, James
 Cleever, John
 Drinkhouse, John N.
 Engle, Sarah Ann
 Lehn, Mrs. Mary
 Seibert, Peter
 Weidinger, Joe
 Easton?
 Drinkhouse, William H.

Economy
 Economite Potters
Edgemont
 Gamble, J.A.
Elizabethtown
 Hippert, Samuel
Elmira
 Walton, Henry
Elverson
 Stoltzfus, Mrs.
Emmaus
 Fehr and Keck
 Fehr, Abraham
 Fehr, C.
 Haag, Jacob
 Keck
 Miller, Maxmilion
 Weber, R.
 Weber, T.
 Woodring
Ephrata
 Baer, Martin
 Bixler, David
 Burkholder, J.P.
 Henrill, Hermann
 Pottery in the Kloster of the
 United Brethren
Exeter
 Wright, Ruth
Exeter Township
 Guldin, Mahlon
 Troxell, John
 Troxell, William
Fairfield
 Frey, Christian
Fallston
 Enterprise Pottery Company
 Fallston Pottery Company
Fayetteville
 Bishop, P.
 Franklin Woolen Factory
Ford City
 Ford City Company
Forks Township
 Cleever, John
Franconia
 Groff, Joseph
 Leidy, John
Franklin County
 Baer, Gabriel
Franklin Township
 Biesecker, Jacob, Jr.
Frederick
 Cope, Enos
 Link, John
Fredericksburg
 Krebs, Philip, Jr.
 Krebs, Philip, Sr.
 Meily, Emanuel, Jr.
Freeburg
 Schnee, Joseph F.
 Schnee, William
Freystown
 Frey, George
 Glaes, Abraham

Friedensburg
 Endy, Benjamin
 Hausman, Jacob, Jr.
Friendsville
 Waters, Susan C.
Fritztown
 Shutter, Christian
 Specht, John G.
 Stout, Isaac
Germania
 Scholl, John
Germantown
 Britton, William
 Carretta, Frank
 Fry, John
 Hortter, Amanda Malvina
 Lerving, Samuel
 Muller, Daniel Carl
Gerysville
 Renninger, Johannes, Jr. (John)
 Renninger, John
 Renninger, Wendell
Green Township
 Henderson, George, Jr.
Green Valley
 Nyeste, James Joseph
Greencastle
 Adam
 Ambrouse
 Bohn, Adam
 Bohn, Jacob W.
Greensboro
 A. and W. Boughner
 Boughner, Alexander
 Boughner, Daniel
 Eagle Pottery
 Hamilton and Jones Pottery
 Hamilton, James
 James, D.C.
 Vance, Alexander
 Vance, James
 Williams and Reppert
Greensburg
 Fletcher, Alex
 Straw, Michael
Greenwich Township
 Greenwald, John W.
Haines Township
 Ettinger, Emanuel
 Ettinger, William (Henry)
 Fisher, Jacob
 Folk, John
Hamburg
 Gerbrich, Conrad
 Humsicker, Christian
 Lochman, Christian L.
 Lochman, William
Hanover
 Cook, Valentine
 Gitt, Wilhelm
 Hoover, Andrew
 Kump, Andrew
 Mamn, Mathias
 Stettinius, Samuel Enedy
Hanover Township
 Snyder, Daniel

Steier, W.
Hanover?
　Harch, J.
Harrisburg
　Baner, Barbara A.
　Beatty, Gavin I.
　Boas, Jacob
　Carson, William
　Cowden and Wilcox
　Dehart, John, Jr.
　Finney, Elizabeth
　Kelly, Ann E.
　Martin, John
　Martin, William
Hartleton
　Schnure
　Smith, Henry E.
　Witmer, Galen (Gale)
Haverford
　Law, Mrs. Edward
Haycock Township
　Long, John
　Mondeau, John
　Mumbauer, Conrad
　Singer, Simon
Heidelberg Township
　Hain, Peter L.
　Miller, Gabriel
　Peter, Reuben
　Schrack, Joseph
Hempfield Township
　Scherg, Jacob
Hereford
　Greiseiner Pottery
Hereford Township
　Christman, G.
　Maybury, Thomas
Hershey
　Esteline, Martha
Hillsboro
　Gossett, Amariah
Hilltown
　Musselman, Samuel B.
Honeybrook
　Schofield, William
Howard
　Barrett
Hummelstown
　Frailey, Michael
Huntingdon
　Glazier, Henry
　Wilson, Jeremy
Huntington
　Hiram Swank and Sons
Indiana County
　Park, Linton
Jackson Township
　Hamelton, John
　Setzer, Jacob
　Weidle
Jacksonville
　Sperling, Louis
Johnstown
　Blauch, Christian
　Hiram Swank and Sons
　J. Swank and Company

　Sala, John
Jonestown
　Gingerich, Zach
　Selzer, Christian
Juniata County
　Eichman, Michael
　Shallenberger, Peter
Kensington
　Bulyn, Mary
　Hewson, Martha N.
Kishacoquillas Valley
　Plank, Samuel
Krausdale
　Kraus, John
Kutztown
　Butz, Mary
　Meyer, Johann Philip
　Wagenhurst, Charles
Lamar Township
　Grape
　Schreffler, Isaac
Lampeter Township
　Stohl, F.
Lancaster
　Attlee, William
　Bratton, Phebe
　Brotherton, E.
　Dambock, Adam
　Davis, S(amuel)
　Eicholtz, George
　Eicholtz, Jacob
　Eicholtz, Leonard
　Eisemann, Philip
　Gans, H.
　Gast, Henry
　Getz, John
　Keener, Jacob
　Krebs, Friedrich (Friederich;
　　Frederick)
　Lehn, Henry
　Leman, Henry
　Sanderson, Francis
　Schum, Joseph
　Schum, Peter
　Schum, Philip
　Shindle, Catherine
　Steinman, F.
　Swope, George A.
　Swope, Jacob
　Swope, Zuriel
　Troyer, William
　Weiss, William
　Zell, William D.
Lancaster County
　Cloister, Ephrata
　Crider, Susy A.
　Halduman, Jacob
　Heyne, Johann Christopher
　Holcomb, Sarah
　Kiehl, Benjamin
　Kinstler, W.
　Lehn, G.
　Otto, Johann Henrich
　Ricket, Jacob
　Rumbaugh, M.
　Rupp, Salinda W.

　Stauffer, Jacob
　Unger, I.
　Webber, John
　Witmer, Jacob
Lancaster?
　Smith, Rebecca
Landisburg
　Wingert, George S.
　Wingert, Henry
Langhorne
　Johnson, Joseph
Lansford
　Savitsky, Jack
Laurelton
　Bingman, Samuel Harrison
　Bingman, Yost
Leacock Township
　Hersh, Henry
　Landis, M.A.
　Ressler, Rudolph
　Satler, J.
　Satler, Lewis
　Wise, H.
Lebanon
　Bellman, Henry
　Eagle Foundry
　Mellinger, Samuel
　Rohrer, P.
　Shalk, Jacob
　Sowers, Rebecca
　Walborn, Catarina
　Yingst, David
Lebanon County
　Rank, Peter
　Renner, P.
　Wagner, John
Lebanon County?
　Schuman, E.
Ledgedale
　Bells, T.
Leechburg
　Bochero, Peter "Charlie"
Leesport
　Buehler, John George
Lehigh
　Schumacher, Daniel, Reverend
Lehigh County
　Fatsinger, Adam
　Rauser, Gabriel
　Weiss, Noah
Lehigh Valley?
　Greenwalt, Maria B.
Leola
　Lapp, Lydia
Level Corners
　Lowmiller, William
Lewisburg
　Angstad, Benjamin
　Angstadt, Nathaniel
　Schnee, Joseph F.
Lewisburg (Lewistown)
　Dipple, A.G. Curtain
Lewistown
　Dipple, Anna Margretta
　Schnee, Joseph F.
　Strunks Mill

PENNSYLVANIA (Cont.)

Lincoln University
- Cope, Thomas

Lionville
- John Vickers and Son
- Schofield, William
- Vickers, A.J.
- Vickers, Paxton
- Vickers, Thomas

Lititz
- Animal Trap Company
- Deavler, Joseph
- Eichler, Maria
- Foltz, Harry
- Kreider, Albert M.
- Kreider, Maurice (Morris)
- Lehn, Joseph
- Loercher, Everett R.
- Loercher, Ronald
- Sturgis, Samuel

Little Marsh Creek
- Herreter and Sweitzer
- Kepners Woolen Mill

Lobachsville
- Greenwald, John W.
- Hausman, Jacob, Jr.
- Hausman, Jacob, Sr.
- Hausman, Tilgham (Tilghman)

Logantown
- Gerstung, John

Lookstown
- Blaney, Justus

Lower Saucon Township
- Fehr, Thomas
- Marsteller, A.
- Marsteller, Thomas

Lowhill Township
- Seibert, John, Jr.
- Seibert, John, Sr.
- Seibert, Owen

Luzerne County
- Turnbaugh, Joseph

Lykens Township
- Paul, John, Jr.

Machenoy
- Hamelton, John

Mahantango Valley
- Maser, Jacob
- Maurer, Johannes
- Maurer, John

Mahoning
- Sharples, Elen T.

Manchester Township
- Eyster, Elizabeth

Manheim
- Brosey, John, Jr.
- Brosey, John, Sr.
- Brosey, William
- Gibble, John
- Schwartz, Michael
- Stiegel, Henry Wilhelm, Baron

Manor Township
- Andrews, Jacob
- Whitmer, J.

Marietta
- Caseel, Hester
- Terry, Elizabeth

Martinsburg
- Shafer, J.

Maytown
- Geb, L.R. (John)
- Gebhart, John R.

McConnellsburg
- Stoner, Albert

Mechanicsburg
- Seifert and Company
- Seifert, Andrew
- Seifert, Emanuel
- Seifert, Henry
- Williams, John T. (T.J.)
- Young, Charles

Mercersburg
- McConnell
- Schultz, J.N.

Middle Woodbury Township
- Globe Factory
- Woodcocke

Middleburg
- Rhodes, Daniel

Mifflin County
- Gamble, J.A.
- Milroy

Mifflinburg
- Klingman, C.L.
- Schreffler, Samuel
- Witmer, Galen (Gale)

Milford
- Hicks, Edward
- Musselman, Samuel B.
- Stiff, J.

Milford Township
- Powder Valley Woolen Mill
- Reiner, Georg
- Spinner, David

Mill Hall
- Flanigan, George
- Williams, H.R.

Millersburg
- Bordner, Daniel
- Klinger, Absalom
- Rassweiler, Philip

Millerstown
- Boettger, Carl
- Fliehr, Charles B.
- Gabriel, Henry
- Hicks, Samuel
- John Mellinger and Sons
- Smith, Joseph

Millersville
- Myer, I.

Mohrsville
- Egoff, Daniel
- Snyder, John
- Snyder, John, Jr.

Montgomery County
- Bergey, Benjamin
- Dock, Christopher
- Glaes, William
- Heebner, Susanna
- Heebneren, Susanha
- Hoffman, C.W. (Charles L.)
- Hubener, Georg(e)
- Kreebel, Isaac
- Kriebel, Phebe
- Metz, L.
- Nase, John
- Ranninger, Conrad
- Roudebuth, Henry
- Shade, Willoughby
- Troxel, Samuel
- Uebele, Martin
- Weller, Benneville

Montgomery County?
- Bush, W.

Morrison's Cove
- Keagy, Abraham, I
- Keagy, Abraham, II
- Keagy, John
- Keagy, Samuel

Morrisville
- Robertson Art Tile Company

Mount Bethel Township
- Hilliard, Philip H.

Mount Joy
- Brown, David
- Frey, Abraham
- Frey, Samuel B.
- Friedel, Robert
- Glassey, Joseph
- Glassley, John
- Hipp, Sebastian
- Hippert, Samuel
- Keener, John
- Leehman, Joseph, Jr.
- Leehman, Joseph, Sr.
- Manning
- Stager, Henry F.
- Wantz

Mount Pleasant
- Mount Pleasant Mills

Mt. Eagle
- Leathers, John B.

Mt. Etna
- Fair, Henry
- Fisher, Michael B.

Muncyborough
- Lowmiller, William
- Roberts, Charles

Myerstown
- Deitsch, Andrew
- McQuate, Henry
- Ney, William

Nazareth
- Beitel, Josiah

Nazareth Township
- Maus, Philip

Neffsville
- Bowman, Henry B.

Neiffer
- Medinger, Jacob
- Medinger, William
- Neiffer, Jacob

Nescopeck
- Goodman, Daniel

New Berlin
- Lebkicker, Lewis
- Maize, Adam
- Naugle, James

Geographic Index Philadelphia, PA

 Neiman, James
 Seebold, Phillip
New Brighton
 D.G. Schofield and Company
 Elverson and Sherwood
 Elverson, Thomas
 Jackson, Thomas
 Sherwood Brothers Company
 Smith, A.F.
New Britain
 Miller, Christian
New Britain Township
 Gotwals, M.
 Haldeman, John M.
 Long, M.A.
 Shive, M.
New Castle
 New Castle Pottery Company
 Shenango China Company
New Galilee
 Beaver Clay Manufacturing Company
New Hamburg
 Beil, David
New Hanover
 Miller, Sarah Ann
New Holland
 Brubaker, Isaac
 Hull, Lewis
 Murr, Lewis
 Royer, John
New Hope
 Pickett, Joseph
Newberry
 McMinn, Charles Van Lineaus
Newcomerstown
 Bagnall, George
Newfoundland
 Huguenin, George
Newmanstown
 Schultz, Johann Theobald
Newport
 Miller, M.
Newry
 Dengler, John
Newtown
 Lock, Frank C.
 Newtown Pottery
Nockamixon
 Haring, David
 Herstine, Cornelius
 Herstine, Daniel
 Herstine, Daniel
 Herstine, David
 Kintner, Jacob
 McKentee
 Tawney, Jacob
 Weaver, Abraham
Nockamixon Township
 Janey, Jacob
Norristown
 Hallowell, William, Dr.
 Keller Pottery Company
 Kuder, William
North Lebanon
 Huth, Abraham

Northampton County
 Drach, Rudolf
 Hilliard, Philip H.
 Lantz, J.
 Le Bar, Pamela
Northhampton
 Schumacher, Daniel, Reverend
Northumberland County?
 Hamilton, John
Noxatawney Township
 Haas, Peter
Old Economy
 Hoerr, Adam
Oley Township
 Hausman, Tilgham (Tilghman)
Ono
 Hook, Solomon
 Wiley, Martin
Orwigsburg
 Haeseler, H.
 Rassweiler, Philip
Paradise Township
 Williams, William T.
Passmore
 Glaes, John G.
Penn Township
 Weaver, Henry
Pennsburg
 Roudebusch, William
 Schauer, Jacob
Perkiomenville
 Lewis Johnson Pottery
 Link, John
 Stofflet, Jacob
Peters Township
 Schultz, J.N.
Pfeiffer's Corner
 Wagner, George A.
Philadelphia
 Albright, Chester
 Allen, George
 Apple, Henry
 Apple, W.
 Appleton, Chris
 Ashmore, A.P.
 Ashmore, Abraham V.
 Aube, Peter R.
 Auchy, Henry
 Bachman, Anceneta
 Backman, Henry G.
 Badger, Hiram
 Bagaly and Ford
 Baird, James
 Baker, Joseph
 Baldauf, Joseph
 Barnes, Henry
 Barrett, Edward P.(T.)
 Beaujoy, Dennis
 Beech, Ralph Bagnall
 Bering, Thomas G.
 Bias
 Biddle, Beulah
 Bids
 Bigger, Peacock
 Binney and Ronaldson
 Birch, Thomas

 Black, James
 Black, Robert
 Blair, John
 Bolen, Maria
 Bolland, Martin
 Bolton, William
 Bonin, Gousse
 Boudro(u), Alexandr(e)
 Boulanger, John F.
 Boulter, Charles
 Bradley, Thomas
 Bready, Eliza Ely
 Briggs, Amos
 Brinton, Eleanor
 Brown, James
 Brown, John
 Brown, M(andivilette) E(lihu) D(earing)
 Bunn and Brother
 Burd, Eliza Howard
 Burr, John P.
 Buschor, Charles
 Cambell, Anna D.
 Cameron, Mary Elizabeth
 Cannon, Hugh
 Carver, Jacob
 Cather, David
 Cernigliaro, Salvatore
 Ceutsch, J.H.
 Chaplin, J.G.
 Charlton and Williams
 Charlton, F.
 Chatterson, Joseph
 Collins, Abraham
 Collis, S.C.
 Conner, William M.
 Conrad, Ann
 Cornelius and Baker
 Cornelius, Robert
 Creus, William
 Curtis, Daniel
 Curtis, John
 Cutbush, Edward
 Cutbush, Samuel
 Dean, Thomas
 Decker, Fritz
 Deker, Francis Jacob
 Dentzel, Gustav A.
 Dentzel, William
 Dodge, Nathan
 Dorsey, William H.
 Douglass, Robert M., Jr.
 Drinker, Elizabeth
 Duche, Andrew
 Duche, Anthony
 Earle, James
 Eicholtz, Jacob
 Eidenbries, John
 Endriss, George
 Ernst, Carl
 Evans, John T.
 Farrand and Omensetter
 Ferg, Henry
 Filley, Harvey
 Finchour, Joseph
 Fleeson, Plunket

Geographic Index

PENNSYLVANIA (Cont.)
 Philadelphia (Cont.)
 Flower, Ann
 Fox, Francis
 Francis, Edward
 French, Asa
 Freytag, Daniel
 Fry, George
 G. and F. Harley
 Galloway and Graff
 Gally, Thomas J.
 Gardiner, John
 Getty and Sapper
 Getty, Robert
 Gilbert, Mordecai
 Gillingham, James
 Ginn, Robert
 Gorbut, Robert
 Gossett, Henry
 Gracey, William
 Graham, Francis
 Graham, Thomas
 Gray and Todd
 Greeley, John
 Green, Branch
 Green, Charles E.
 Green, George W.
 Greer, James
 Griffith, William
 Grist, Thomas
 Haig, James
 Haig, Thomas, Sr.
 Haley, John C.
 Hamilton, Charles J.
 Hamilton, James
 Hamilton, James
 Hansbury, John
 Harding, Samuel
 Harned, Henry
 Hauser, Joseph
 Hedderly and Riland
 Heiligmann and Brother
 Heiss, William
 Hemphill, Joseph
 Henis, William
 Henry, David H.
 Henry, Samuel C.
 Hetzell, George J.
 Hewson, John
 Hey and Luckens
 Hindes, John M.
 Holly, William
 Holzer, Julius
 Horton, James
 Hotz, Martin
 How, Joseph
 Humphreys, Jane
 Hunt, William
 Irwin, Joseph
 J. Bentley Sons
 J.E. Jeffords and Company
 James, Rachel
 Jardalla, Joseph
 Jones, Samuel D.
 Keebler, Julius
 Keller, Conrad
 Kelley, Asahel A.
 Kelley, Peter
 Kemp, A.
 Kett, John F.
 King, Daniel
 Krause, Oscar
 Krause, William O.
 Krieghoff, Philip E.
 Krimmel, John Lewis
 Kronauze, William
 Kuehls, Theodore
 Kurbaum and Schwartz
 L.D. Berger Brothers
 Manufacturing
 Lake, William
 Lancaster, Lydia
 Langdon, Elias
 Lawrie, Alexander
 Leatherman, Gebhard
 Leconey, James
 Lerving, Samuel
 Levering, T.W.
 Lewis, James Otto
 Lewis, Unity
 Lex, Henry
 Lillagore, Theodore W.
 Lingard, William
 Low, Lucy
 Main, William H.
 Marsh, Ann
 Marsh, Joseph
 Mason, William Sanford
 McAllister and Company
 McCulloch, Christina
 McGrath, George
 Meer, John
 Melish, John
 Merriam, John
 Miller, Abraham
 Miller, Andrew
 Miller, Athanasias
 Milliard, Charles
 Milliard, James
 Milliard, Thomas
 Mitchell, H.R.
 Morgan, William H.
 Morris, Debbe
 Morris, George A.
 Morris, John
 Morrison, John C.
 Moss and Brother
 Moss, Margaret
 Mullard, Robert
 Muller, Alfred H.
 Muller, Daniel Carl
 Mullowney, Captain
 Niles, Jane
 Ochs, George N.
 Omensetter, Elhanan
 Ominsky, Linda
 Orr, George
 Otton, J. Hare
 Parker, S.
 Pass and Stow
 Passmore, Thomas
 Patterson and Read
 Paul, Jeremiah
 Paxton, Eliza
 Peale, James
 Peale, Sophonisha
 Penn, Thomas
 Phillips, Felix
 Phillips, Moro
 Piercey, Christian
 Platt, Mrs. Charles (Dorothy)
 Polk, Charles Peale
 Pyfer, William
 Quidor, John
 R.R. Thomas and Company
 Raiser, Jacob
 Ramsey, Joseph
 Redman, Richard
 Redman, Thomas
 Reifsnider, Charles
 Remmey and Burnet
 Remmey, Henry, II
 Remmey, Henry, III
 Remmey, R(ichard) C(linton)
 Reynell, John
 Ridgeway, Caroline
 Roes, Anna Eliza
 Roosetter, Charles H.
 Rowland, Elizabeth
 Rush, Benjamin
 Rush, Elizabeth
 Rush, John
 Rush, William
 Russell, Joseph Shoemaker
 Sailor, S.H.
 Sailor, Samuel H.
 Samuel Yellin Company
 Sanbach, Herman
 Sapper, William
 Savery, Rebecca Scattergood
 Savory and Company
 Schneider and Pachtmann
 Schrack, Catharine
 Schwartz, Peter
 Scott, John
 Seewald, John (John Philip)
 Seixas, David G.
 Seller, James
 Selman, William
 Seymour, Samuel
 Shade, Willoughby
 Shetky, Caroline
 Shoenhut
 Simon, Martin
 Skillin, Samuel
 Smallwood, Zibiah
 Smith, Alexander
 Smith, Fife and Company
 Smith, James
 Smith, R.
 Spiegel, Isaac, Jr.
 Spiegel, Isaac, Sr.
 Spiegel, John
 Starckloff and Decker
 Stegagnini, L.
 Stern, S.
 Stewart, Alexander
 Stewart, James, Jr.

Stewart, William
Stone, George
Stow, John
Street, Austin
Street, Robert
Strokes, Willie
Stueler, Charles
Sully, Thomas
Taylor, Enoch
Theiss, Steven
Thompson, M.
Tittery, Joshua
Toboggan Company
Towson and Hines
Toy and Lingard
Toy, Nicholas, Jr.
Trotter and Company
Trotter, Alexander
Truman, James
Tryday, G.H.
Tryon, George
Tucker and Hulme
Uhle, Herman
Volozan, Denis A.
Waddell, R.
Walker, Peter
Watson, Richard
Wayn(e), Sarah
Weckerly, Eliza
Weiss, George
Wellford, R.
Wells, Henry
Werner, Casper
West, Benjamin
West, Francis
Weston, Thomas
Wheeler, Sam
Wilkinson, Anthony
Wilkinson, Bryant
Will, William
William Krafe and E.F. Teubner
Willis, Edward
Wilson
Wilson, Ann Jefferis
Winnemore, Philip
Winstanley, William
Wistar, Casper
Wistar, Sarah
Wittfield, Henry
Woodside, John A.
Wright, Malcolm
Wright, Patience
Yellin, Harvey
Young, William
Zalar, John
Zeitz, Frederick
Zeitz, Louis
Philadelphia?
Vidal
Phoenixville
Chester Pottery Company
Griffin, Smith and Hill
Phoenix Pottery
Pine Grove
Moser, Jacob

Pittsburgh
Baldwin, Frank
Barr, James
Bauders, F.
Bennett Brothers
Bennett, Edwin
Birmingham Glass Works
Blayney, William Alvin
Bracken and James
Burchfield, A.N.
Byrne and Kiefer Company
Contis, Peter A.
Donaldson, Hugh
Euler and Sunshine
Freeman, Thomas
Gephart, S.S.
Griffith Brothers
Harding, Chester
Henry Pettie and Company
Hocusweiler, Jacob
Horn, John
Howard and Rodgers
John Frell and Company
Kane, John
Kepner, William
Kier, S.M.
Kirtland, James
National Fireproofing Company
Nelson, Mr.
Price, William
Sims and Shepherd
Star Encaustic Tile Company
Trotter and Company
Trotter, Alexander
Vodrey and Frost
Wylie Brothers
Wylie, John
Pittston
Jones, Evan R.(B)
Plumstead
Bartleman
Schrum
Toomey, Helfreich
Plumstead Township
Zelna, A.
Pottsgrove Township
Gilbert, Daniel
Pottstown
Gilbert, David
Kepner, Isaac
Medinger, Jacob
Wiend, Michael
Powder Valley
Stahl, Charles
Stahl, Isaac
Price's Landing
Hewett, Isaac
Providence
Bowman, Henry B.
Quaker Hill
Kichline, Christine S.
Quakertown
Moore and Kinzie
Rabbit Hill
Sheaffer, Isaac

Reading
Allen, James
Babb, Conrad
Balsh, Conrad
Beidler, Mary Ann Yost
Degenhardt, Henry
Fox, Haag and Company
Fry, John
Hoyt, Mary Ann
Jackson, Mary
Klar, Francis Joseph
Krimler, Henry
Kuch, Conrad
Leaman, Godfrey
Polaha, Steven
Schenefelder, Daniel P.
Senior, C.F.
Shenfelder, Daniel
Shoener, John
Snell, Charles K.
Snell, John L.
Speyer, Georg Frederick
 (Friedrich; Friederich)
Reamstown
Uebele, Martin
Reinhold
Brunner, Hattie Klapp
Rich Valley
Nunemacher Pottery
Robeson Township
Kachel, John
Rock Hill
Diehl, George
Headman, Andrew
Headman, Charles
Headman, John
Headman, Peter
Rockland
Hausman, Jacob, Jr.
Rockland Township
Rieff, Christian
Stofflet, Jacob
Rockwood
Weller, Laura Elliott
Ronk
Ganse Pottery
Ruffs Creek
Garber, C.
Rush
Fisher, Eleanor
Salem Township
Fennell, Michael
Salisbury Township
Fehr, Abraham
Haag, Jacob
Salona
March, J(ohn) H(enry)
Schreffler, Henry
Schreffler, Samuel
Sheffler, Isreal
Shreffler, Henry
Shreffler, Samuel
Schaefferstown
Leidig, Peter
Renner, George
Smith, John

PENNSYLVANIA (Cont.)
 Schaefferstown (Cont.)
 Zarn, George
 Schartelsville
 Moyers Woolen Mill
 Schuylkill County
 Boyer, John
 Moore, Cyrus
 Philips, Solomon Alexander
 Schuyville
 Andrews, Ambrose
 Scranton
 Aulisio, Joseph P.
 Selinsgrove
 Noll
 Reichter, Frederick
 Seneca County
 John Mellinger and Sons
 Sharpsburg
 Heerlein, W.
 Shartlesville
 Henne, Daniel P.
 Henne, J.S.
 Henne, Joseph K.
 Shippensburg
 Frymire, Jacob (J.)
 Hinkel, C(hristian) K.
 Shoemakersville
 Moll, Benjamin Franklin
 Moll, Franklin B.
 Moll, Henry
 Shrewsbury
 Ettinger, William
 Schnell, Jacob
 Shrewsbury Township
 Peterman, Daniel
 Siglerville
 Ross, Calvin
 Silvertown
 Thierwaechter, John
 Skippack
 Cassel, Joseph H.
 Snydertown
 Wiemer and Brother
 Somerset County
 Casebeer, Abraham
 Somerset County?
 Geller, Adam
 Hoffman
 Somerset Township
 Casebeer, Aaron
 Menser, David
 Zufall, Moses
 Soudertown?
 Leidy, John
 South Middleton Township
 Frederick, Henry T.
 Spring Mills
 Moorehead and Wilson
 Springfield
 Meyer, Catharine
 Springfield Township
 Bechtel, John
 Steinsberg
 Weiss, Noah
 Stonetown
 Link, Christian
 Stouchsburg
 Dinyes, Mary Ann
 Strasburg
 Cassel, Joseph H.
 Strinestown
 Daron, Jacob
 Patten, P.C.
 Stroudsburg
 Aulisio, Joseph P.
 Florys, William
 Sugarloaf
 Dornbach, Samuel
 Turnbaugh, Joseph
 Turnbaugh, Samuel
 Sunbury
 Huntington, J.C.
 Reitz, Isaac Jones
 Walls, Jack
 Susquehanna Township
 Michael, Philip
 Trappe
 Gilbert, Samuel
 Trexlertown
 Hausman, Ephrain
 Hausman, G.
 Hausman, Jacob, Sr.
 Hausman, Solomon
 Kuder, Solomon
 Kuder, William
 Wiand, Charles
 Troxellville
 Markert, Herman
 Tulpehocken Township
 Brichdel, Christian
 Brown, David
 Frantz, Henry
 Frantz, Isaac
 Tylersport
 Fillman, Michael
 Hildebrand, Frederick
 Lehman, Johannes
 Leman, Johannes
 Nase, John
 Neesz, Johannes
 School, Michael
 Tyrone Township
 Galley, Jacob
 Union County
 Clapham, J.
 Portzline, Francis
 Young, H(enry)
 Union Township
 Bewford, Elias
 Linderman, Jacob
 Uniontown
 Blythe, David Gilmour
 Upper Bern Township
 Fischer, Samuel
 Herme, Daniel
 Upper Hanover Township
 Smith, Daniel S.
 Upper Macungie Township
 Backer, Hiram
 Hausman, Joel
 Upper Milford Township
 Weaver, Thomas
 Vanport
 Fowler and McKenzie
 McKenzie Brothers
 Wagoner Brothers
 Vera Cruz
 Harting, Peter
 Vincent
 Hubener, Georg(e)
 Virginsville
 Egoff, Daniel
 Warren County
 Baurichter, Fritz
 Warwick Township
 Deavler, Joseph
 Grube, Emanuel
 John Mellinger and Sons
 Kapp, Christof
 Netzly, Jacob
 Washington County
 Boalt, James
 Garber, C.
 Washington Township
 Dorward, John
 Dorward, Joshua
 Waynesboro
 Bell, Charley
 Bell, John
 Bell, John W.
 Bell, Upton
 Miller, Solomon
 Waynesbury
 Hamilton, Rebexy Gray
 Weatherly
 McCarthy, Justin
 Weigelstown
 Stauch, David, Jr.
 Weissport
 Fliehr, Charles B.
 West Bridgewater
 Hamilton Brothers
 West Chester
 Pippin, Horace
 Smith, Mrs.
 West Fallowfield
 Hennis, John
 West Lampeter Township
 Yardy, Christian
 West Manchester Township
 Breeswine, Peter N.
 Westtown
 Cox, Susanna
 Haines, Rebecca M.
 James, Ruth
 James, Sarah H.
 Woodnutt, Martha
 Wethersfield
 Lehr, George
 White Deer
 Gross, Catherine
 Williamsport
 Barrett, Edward P.(T.)
 Endriss, George
 Roesen, Severin

Geographic Index

Willistown
 Vogdes, Ann H.
Willow Creek
 Spinner, David
Windsor Township
 Forry, Rudolph
Womelsdorf
 Brehm, Henry
 Keener, Henry
 Oberly, Henry
 Smith, Willoughby
Woodberry
 Keagy, Abraham, II
 Keagy, I.
 Keagy, John
 Longenecker, Peter
Woolrich
 Woolrich Woolen Mills
Wrightstown
 Beck, Jesse
 Feege and Feege
 Smith, Joseph
 Smith, Thomas
 Smith, Willoughby
York
 Bailey, William
 Breeswine, Peter N.
 Fisher
 Fisher, John
 Imsweller, Henry
 Maental, Jacob
 Meyer, Lewis
 Miller, Lewis
 Pfaltzgraff Pottery
 Scwartz, John, Jr.
 Scwartz, John, Sr.
 Vogiesong, Susanna
 Welshhans, J.
 Zinck, John
York County
 Arnold, John James Trumbull
 Breneman, Martin B.
 Hausman, B(enjamin)
 Hoke, Martin
 Stauch, David, Sr.
 Wuertz, Adam
York Township
 Striebig, John K.
 Wildin, John
Yorktown
 Kirk, Elisha
Zieglersville
 Oberholtzer, A.
 Wiand, David

RHODE ISLAND
 Allin, William
 Clark, Alvan
 Collis, Miss
 Cushman, Mary
 Davis, J(ane) A.
 Foot, F.H.
 France, Joseph
 McDowell, Fred N.
 Perkins, Prudence
 Squires, Fred

Bristol
 Bradford, Benjamin W.
 Clark, Ann Eliza
 Coggeshall, Patty
 Coggeshall, Polly
 Follet, Mary
 Gorham, Jemima
 Ingraham, Peggy
 Russell, Mary
 Smith, Sukey Jarvis
East Greenwich
 Remington, Mary "Polly"
Kingston
 Rose, William Henry Harrison
Little Compton
 Church, Hannah
Middletown
 Bull, John, Captain
Newport
 Albro, T.L.
 Anthony, Anne
 Balch, Mary
 Brown, Mrs. Nicholas E.
 Bull, John, Captain
 Burrill, Hannah
 Carr, Mary
 Coggeshall, Eliza
 Coggeshall, Esther
 Congdon, Catharine
 Corne, Michele Felice
 Davis, Patty (Martha)
 Dean, Frances E.
 Easton, Elizabeth (Rousmaniere)
 Easton, Mary
 Emmes, Henry
 Feke, Sarah
 Gibbs, Sarah
 Goddard, Mary
 Godfrey, Mary Greene
 Holden, Katharine
 Hoockey, Hannah
 King, Samuel
 Lyon, Sarah
 Pinniger, Abigail
 Pitman, Mary
 Pope, Sarah E.
 Rider, Lydia
 Rogers, Sarah
 Scott, Elizabeth
 Sheffield, Elizabeth
 Sisson, Hannah
 Sisson, Sussanna
 Stevens, John, I
 Stevens, John, II
 Stevens, John, Jr.
 Stevens, William
 Sturtevant, Louisa
 Swasey, Alexander G.
 Taylor, Hannah
 Taylor, Sarah
 Tillinghast, Mary
 Townsend, Edmund
 Tuel, Sarah
 Waite, Sarah
 Whitwell, Rebecca

Newport?
 Baley, Sarah
Providence
 Alexander, Francis
 Allen, Abby (Abigail Crawford)
 Angell, John Anthony
 Angell, Richard
 Barton, Ann Maria
 Bicknell, Charlotte
 Billings, William
 Bishop, Abby
 Bishop, Sally Foster
 Borden, Delana
 Brown, Olive W.
 Burr, Cynthia
 C.G. Brunncknow Company
 Cady, Almira
 Carter, Rebecca
 Cozzens, Eliza
 Daggett, Clarissa
 Davis, Betsy (Betsey?)
 Dean, Abigail "Abby"
 Deans, Sarah Ann Curry
 Dexter, Abby (Abigail G.)
 Dexter, Nabby (Abigail)
 Dowler, Charles Parker
 Eddy, Abby (Abigail)
 Gladding, Benjamin
 Gladding, Lydia
 Gladding, Susan Cary
 Gorham, Bethiah
 Hall, Abija
 Hall, Betsy
 Hall, Nancy (Anna)
 Hamlin, Samuel E.
 Hartshorn, Stephen
 Henry Cushing and Company
 Hill, Cad
 Hill, Harriet
 Hill, Lovice
 Hobart, Abigail Adams
 Hobart, Salome
 Hoppin, Davis W.
 Ide, Mary
 Jones, Harriet Dunn
 Lippitt, Julia
 Macomber, Ann
 Mann, Lydia Bishop
 Martin, Nabby
 Miller Iron Company
 Munro, Rebekah S.
 Munro, Sally
 Paul, Judith
 Peck, Almyrah
 Peck, Ann J.
 Potter, Lucy
 Randall, Amey
 Roherge and Knoblock
 Russell, Amey
 Sabin, Sarah "Sally" Smith
 (Wilson)
 Sears, Adeline Harris
 Smith, LoAnn
 Smith, Susan
 Spurr, Eliza W.
 Spurr, Polly

RHODE ISLAND (Cont.)
 Providence (Cont.)
 Swan, Jonathan R.
 Sweet, Sarah Foster
 Talbot, Mary
 Taylor, Alice
 Taylor, Eliza Andrews
 Taylor, Eliza Winslow
 Taylor, Sally
 Tingley, Samuel
 Tingley, Samuel
 Tingley, Samuel, Jr.
 Tucker, Mehitable
 Turner, Polly
 Ware, Julia
 Waterman, Eliza
 Waterman, Sarah (Sally)
 Weeden, Mary
 White, Ebenezer Baker
 Whitmore, Susan
 Williams, Cynthia
 Williams, Frances
 Wilson, James
 Winsor, Fanny (Francis)
 Winsor, Nancy
 Winsor, Susan Jenckes
 Provincetown
 Enos, John
 Riverside
 Louff, Charles
 Rumford
 Allen, George
 Warren
 Baker, Nancy
 Hunt, Content
 Lincoln, Eunice
 Sampson, Deborah
 Sanders, Anna (Nancy)
 Wright, Dean C.
 Warren?
 Vickery, Eliza
 Warwick
 Warner, Catherine Townsend
 Wightman, Mary
 Westerly
 Bullard, A.
 Woonsocket
 Steere, Arnold

SOUTH CAROLINA
 Bridges, Charles
 Caldwell, Sarah S.
 Dering, William
 Harley
 Landrum, Amos
 Proby, Jacob
 Robertson, John
 Aiken
 Byrley, Frank J.
 Aikens County
 Baddler
 Anderson
 Catlett, Lucy Tucker
 Bath
 Davies, Thomas J.
 Camden
 Champion, Richard
 Sutton
 Charleston
 Audin, Anthony
 Bartlam, John
 Brown, William Henry
 Burnett, Henry
 Cotten and Statler
 Davidson, Betsy W.
 Duche, Andrew
 Elfe, Thomas
 Gardner, William
 Gernerick, Emelia Smith
 Hainsdorf, Henry
 Hamilton, Charles J.
 Harris, George
 Hext, Elizabeth
 Johnston, Henrietta (Mrs.)
 Marten, Richard
 Parkinson, John
 Roberts, Bishop
 Schulz, Maria Boyd
 Simmons, Phillip
 Statler, George
 Theus, Jeremiah
 Trenholm, Portia Ash Burden
 Warwell
 Witherstone, Phillip
 Charleston?
 Day, Thomas
 Columbia
 Landrum, L(ineas) M(ead)
 Edgefield
 Chandler, Thomas
 Dave
 Pottersville Community
 Rhodes, Collin
 Trapp and Chandler
 Edgefield district
 Mathis, Robert
 Frogmore
 Doyle, Sam "Uncle Sam"
 Greenville
 Tucker, Joshua
 Johns Island
 Trenholm, Portia Ash Burden
 Kaolin
 Farrar, H.W.
 Southern Porcelain Company
 Lancaster
 Hinson, John
 Mount Pleasant
 Coaxum, Bea
 Simmons, Peter
 Stoney Bluff
 Louis Miles Pottery
 Trenton
 Hann, W.F.
 Union County
 Cook, Jermima Ann (Jermina)
 Ownby, Thomas
 York County
 Adkins, J.R.

TENNESSEE
 Crafft, R.B.
 Payne, A.C.
 Phares, Mary Anne
 Walker, Jane McKinney
 Allens
 Winningham, Susan Elizabeth
 Baxter
 Hedicaugh, William
 Lefever Pottery
 Vickers, Monroe
 Beaverhill
 Lee, Joe
 Blountsville
 Wolfe, William
 Buffalo
 Hailey, Molly (Mrs. George)
 Daisy
 Krager, C.L.
 Green County
 Harmon, P.
 Jonesboro
 Chester, Rebecca
 Knox County
 Grindstaff, William
 Memphis
 Mahaffey Brothers Tent and
 Awning Company
 Moseley, Alice Latimer
 Monterey
 Pugh, Dow (Loranzo)
 Nashville
 Buchanan, Mrs. John
 Earl, Ralph E.W.
 Edmonson, William
 Foster, Rebecah
 Harding, Jane
 Harley Pottery
 Moore, Charles
 Stingfield, Clarence
 Paris
 Russell Pottery
 Putnam County
 Eli La Fever Pottery
 Red Mound
 I.W. Craven and Company
 Rogersville
 Hasson, Sallie E.
 Sullivan County
 Cain, Abraham
 Cain, Martin
 Trousdale County
 Carmen, Elizabeth (Mrs. Caleb)
 Washington County
 Decker, Charles F.
 Woodbury
 Blair, Fred

TEXAS
 Berg's Mill
 Freeland, Henry C.
 Gentilz, Theodore
 Herp, Charles Adelbert
 Hoppe, Louis
 Amarillo
 Blocksma, Dewey Douglas

Geographic Index

Anderson
 Steinhagen, Christofer Friderich Carl
Austin
 Arning, Eddie
 Ley, Mary E.
 Moss, Emma Lee
 Sandusky, William H.
 Spelce, Fannie Lou
Beaumont
 Gavrelos, John J.
Bexar County
 Meyer Pottery
 Star Pottery
Castroville
 Mueller, Rudolph
Collegeville
 McNutt, Bryan
Dallas
 Ideal Pottery
 Love Field Potteries
 White, George
 Wilbur, A. E.
 Williamson, Clara McDonald
Denison
 Eisenhower, Mrs. Ida Elizabeth Stover
El Paso
 Rochas, Ramon
Elmendorf
 Richter, E.J.
Guadalupe
 H. Wilson and Company
Guadalupe County
 Wilson, John M.
Henderson
 Henderson Pottery
Houston
 Armstrong Company
 Gibbs, Ezekial
 McKissack, Jeff
 Wright, Thomas Jefferson
Huntsville
 Jones, Frank
Jefferson
 Clark, Floyd
 Clark, Mildred Foster
 Frank, Mrs. Gustav
La Vernia
 Suttles, I.
Limestone County
 Knox, W.C.
Longview
 Ward, Velox
Rusk County
 Hunt, John
 Prothro Pottery
 Rushton, Joseph
San Antonio
 Hardin, Esther McGrew
 Samuel, W.M.G.
 San Antonio Pottery
 Staffel, Bertha
 Wagner, Christina
Tyler
 Byrd Pottery

Wilson County
 Suttles, G.W.

UTAH
 Christensen, Carl Christian Anton
 Major, William Warner
Ordenville
 Bolander, Joseph
St. George
 Eardley Brothers Pottery
 John Eardley's Pottery

VERMONT
 Brewer
 Bundy, Horace
 Chapin, Alpheus
 Converse, Hannah
 Cook, Eunice W.
 Dundy, H.
 Fletcher
 Giles, J.B.
 Griffing, Martin
 Hough, E.K.
 Hutchinson, Ebenezer
 Knapp, Hazel
 Lepine, Imelda
 Maynard, A.E.
 Moore, Emily S.
 Moran, Frank
 Mulholland, William S.
 Nutting, Chester
 Peters, J.
 Rawson, Eleanor
 Shute, Mrs. R(uth) W(hittier)
 Stafford, H.M.
 Tuthill, Abraham G.D.
 Wing, Samantha R. Barto
 Wright, Almira Kidder
Arlington
 Benedict, Mary Canfield (Baker)
Barre
 Aiken, Gayleen
 Merril, George Boardman
Bennington
 Adams, Enos
 Booth, Roger
 Collins, Zerubbabel
 E. Norton and Company
 Farrar, H.W.
 Fenton, Christopher Webber
 Gager, Oliver A.
 Greatbach, Daniel
 Harrison, John
 Houghton, Edward
 J. and E. Norton
 L. Norton and Sons
 Leake, William
 Lyman, Fenton Company
 Merz, Jacob
 Nims, Mary Altha
 Norton and Fenton
 Norton Pottery
 Norton, John, Captain
 Norton, Julius
 Norton, Luman

 Norton, Luman P.
 Santo, Patsy
 Theiss, Steven
 United States Porcelain Company
 United States Pottery
Brandon
 Whitcomb, Susan
Brattleboro
 Harris and Company
Brattleborough
 Soule, Ebenezer, Jr.
Burlington
 Bacon, George H.
 Ballard, A.K.
 Farrar, Ebenezer L.
 Fenton, L(eander) W.
 Nichols and Alford
 Noyes, Morillo
 Peck, Sheldon
 Woolworth, F.
Castleton
 Caswell, Zeruah Higley Guernsey
 Willis, Eveline F.
Chelsea
 Watson Woolen Mill
Dorset
 Baldwin, Asa
 Fenton, Jonathan
 Fenton, L(eander) W.
 Stewart, Jonas
East Poultney
 Clark, Enos
Essex Junction
 Selby, Cleland
Fairfax
 Farrar and Stearns
 Farrar, Isaac Brown
 Farrar, S.H.
 Lewis and Cady
Greensboro
 Tatro, Curtis
Greensboro Bend
 Rochette, Roland
Halifax
 Edson, Almira
Hardwick
 Bailey, Charles
Kirby
 Risley, Russell
Ludlow
 North, David
Marshfield
 Menard, Edmond "Bird Man"
Middlebury
 Farrar, Caleb
 Hemenway, Asa
 Jewitt, Clarissa
 Mitchell, James
Newport
 Marcile, Stanley
Old Brock Farm
 Brock, Harriet E.
Plymouth
 Gates, Erastus
Pomfret
 Mason, Benjamin Franklin

VERMONT (Cont.)
Poultney
 Woodman, Samuel
Rockingham
 Adams, Joseph
 Adams, Sampson
 Wright, Alpheus
 Wright, Moses
 Wright, Solomon, Jr.
Salisbury
 Vermont Glass Factory
Shaftsbury
 Collins, Zerubbabel
 Dwight, Samuel
 Dyer, Benjamin
Shelburne
 Comstock, Mary
South Ashfield
 Norton, Julius
South Burlington
 Owens, Frank
South Royalton
 Hull, Lee
South Shaftsbury
 Matteson, Thomas
South Woodstock
 MacKenzie
Springfield
 Powers, Asahel Lynde
St. Albans
 Boynton and Farrar
St. Johnsbury
 Brown, Edmond
 Fenton and Hancock
 Fenton, L(eander) W.
 Fenton, Richard Webber
 Hutchinson, William
 Spaulding, C.F.
Townshend
 Ball, Silas
 Miles, Diana
Vergennes
 Washburn, S.H.
White River Junction
 Wale, T.
Windsor
 Simpson, George
Woodstock
 Schmidt, Clarence

VIRGINIA
 Aldridge
 Barnes, R.
 Brady, Walter
 Cerere, Pete
 Durand, John
 Hammen, Elias
 Hemp, Robert
 Kratzen, Joseph
 Mark, George Washington
 Miller, Eliza Armstead
 Schatz, Bernard
 Smith, I.R.
 Weston, H.
Alexandria
 Frymire, Jacob (J.)

 Harrison, Mary
 Kemmelmeyer, Frederick
 Smith, J.W.
Appalachia
 Carter, A.G.
Assawaman Island
 Matthews, William J.
Augusta County
 Mossy Creek Iron Works
Axton
 Hundley, Joe Henry
Back Bay
 Williams
Belpre
 Hollister, W.R.
Big Spring Gap
 Wolfe, William
Blacksburg
 Dober, Virginia
Blue Ridge Mountains
 Turner, Harriet French
Cape Charles
 Nottingham, Luther
Cedar Island
 Williams, John
Charlottesville
 Baker, Dorothy
 Shirvington, J.
Chesapeake Bay
 Wright, L.G.
Chesterfield County
 Bowles, Amanda A.
Chincoteague
 Hancock, Miles
 Hudson, Ira
 Jester, Doug (S.D.M.)
 Watson, Dave "Umbrella"
 Whealton, Dan, Captain
Church's Island
 Burgess, Ed
Cobb's Island
 Cobb, Arthur A(lbert)
 Cobb, E(lkenah), Captain
 Cobb, Elijah
 Cobb, N(athan), Jr.
 Haff, John
Delaplane
 Ashby, Steve
Dyster
 Crumb, Charles H., Captain
Fauquier County
 Ashby, Steve
Flint Hill
 Duvall, Flo
Floyd
 Weddell, Liza Jane
 Wright, Kate Vaughan
Fluvanna County
 Gay, Pocahontas Virginia
Franklin City
 Ellis, Levi
Galax
 Pierce, Charles
Gloucester
 Dering, William

Hardy County
 Wilkin, Godfrey
Harper's Ferry
 Toole, John
Keezletown
 Bernhardt, Peter
Knotts Island
 Dudley, Lee
Lebanon
 Fields, Charlie "Creek Charlie"
Lexington
 Kahle, Mathew S., Captain
Lillian
 Payne, Leslie J.
Lynchburg
 Reese, Susannah S.
 Stovall, Queena
Monticello
 Jefferson, Thomas
Moorefield
 Harness, Martha
Mount Vernon
 Washington, Martha
 Wiess, J.
Nassawadox
 Matthews, William J.
New Bedford
 Halstead, Israel T.
New Market
 Henkel, Ambrose
 Schweinfurt, John George
Newport
 Geggie, William W.
Norfolk
 Benson, Frank
 Boush, Elizabeth
 Luke, William
 Wells, Henry
Page County
 Spitler, Johannes
Pinwheel
 Washington, Martha
Portsmouth
 Luke, William
Pulaski County
 Rife, Peter
Richmond
 Batson, Mary Jane
 Dey, John William "Uncle Jack"
 Gleason, Charles
 Holmes, Flora Virginia
 Malone, Mildred
 Oakford, John
 Polk, Charles Peale
 Swam, George
 Taylor, John
 Willard, Solomon
 Wisdom, Sarah B.
Roanoke
 Krone, Lawrence (Laurence)
Rockbridge County
 Christian, Nancy
Rockingham County
 Funk, Abraham
Shenandoah County
 Becker, Barbara

Geographic Index

Bowers, Reuben
Haman, Barbara Becker
Maphis, John M.
Strickler, Jacob
Shenandoah Valley
Drinker, John
Staunton
Bell, Joseph "Joe"
Leo, John William
Stephens City
Ambrose, Edward
Strasburg
Begerly, Levi
Bell, Richard Franklin
Bell, Samuel
Bell, Solomon
Crisman, W.H.
Eberley, Jacob J(eremiah)
Fleet, Theodore
Funkhouser, L.D.
Grim, T.
Lehew and Company
Sonner, S(amuel) H.
Waverly
Carpenter, Miles B.
Williamsburg
Dering, William
Kidd, Joseph
Kieff, John
Wilson's Landings
Phillips, Moro
Winchester
Baecher, Anthony W.
Bell, Peter
Reid, G.
Wytheville
Krone, Lawrence (Laurence)
Yorktown
Adelman, Joseph E.
Flax, Walter
Rogers, William

WASHINGTON

Achey, Mary E.
Emigh, Mary
Ginther, R(oland) D(ebs)
Gross, William
Hausgen, Frederick
Purves, John W.
Slack, George R. H.
Smith, Thomas
Trentmann, John
Twiss, Lizzie
Willson, Sulie Hartsuck
Bellingham
Little, T.J.
Chehalis
Van Hoecke, Allan
Olympia
Kimball, Elizabeth O.
Seattle
Coyle, Carlos Cortes
Fryer, Flora
Washington, James
William R. Johnson Company Inc.

Spanaway
Miller, James
Spokane
Spokane Ornamental Iron and Wire Works

WEST VIRGINIA

Burns, Martin
Cook, Harvey
Coulter, George
Gatewood, Jane Warwick
Anawalt
Patete, Eliodoro
Bridgeport
Campbell, Daniel
Harper, William
West Virginia Pottery Company
Charleston
McLuney, William
Charlestown
Timberlake, Alcinda C.
East River
Brown and McKenzie
Freeman's Landings
Carlyle and McFadden
Helvetia
Schroth, Daniel, Reverend
Jefferson County
Porter, C.C.
Lewisburg
Foglesong, Christopher
Martinsburg
Bauer, William
Duble, Jonathan
Speck, John C.
Weise, James
Morgantown
Foulke
Thompson Pottery
Thompson, Greenland
Thompson, John W.
New Cumberland
Chelsea China Company
Palatine
Richey and Hamilton
Sunderland Knotts and Company
Parkersburg
Donahue Pottery
Pine Hill
Jones, Shields Landon
Shepardstown
Weise, Henry
Sugar Grove
Rexrode, James
Wellsburg
Bakewell, H.N.
Brown, R.
Wheeling
Miller, J.
Ohio Valley China Company
Sullivan, Patrick J.
Warwick China Company
West Virginia China Company
Wheeling Pottery Company

WISCONSIN

Beecher, Laban S.
Koenig, Joseph
Rusch, Herman
Wells, J.F.
Wolfert, Frank
Ashland
Kruschke, Herman
Augusta
Miller, Lynn
Bailey's Harbor
Zahn, Albert
Belgium
Wimmer, Mrs. Marie
Cheboygan
Mason, Marvin
Dickeyville
Wernerus, Father Mathias
Franklin
Langenberg Pottery
Gothan
Seifert, Paul A.
Green Bay
Schifferl, Lou
Taubert, T.
Ladysmith
Evans, Walter
Maiden Rock
Inabet, Mike
Menasha
Batchelder Pottery
Milwaukee
Archer, Dr.
Blair, J.B.
C. Herman Company Pottery
Farmer, Josephus, Reverend
Joe
Leitz
Mealy
Miller, Anne Louisa
Schultz, William L.
Thomas, Pat
Von Bruenchenhein, Eugene
Werrbach, L.
Phillips
Smith, Fred
Plain
Seifert, Paul A.
Racine
Baumann, S.
Sheboygan
Sheboygan Decoy Company
Spooner
Barta, Joseph Thomas
Sullivan
Bereman, John
Valton
Hupendon, Ernest

NEW ENGLAND

Allen, Caleb
Allen, Edward
Allen, Elizabeth
Banton, S.
Beam, Caroline

NEW ENGLAND (Cont.)

Blackburn, Joseph
Covill, H.E.
Cunning, Susan
Dana, Sara H.
Darling, Robert
Douglas, Lucy
Elliot, R.P.
Firth, E.F.
Fowler, Elizabeth Starr
Gillespie, J.H.
Golcher, James
Golder, C.H.
Greenwood, John
Griffin, G.J.
Hankes, Master
Holmes, Anna Maria
Hook, Susan
Jennys, William
Johnston, L.
Jones, Gershom
Joy, Caroline
Lamb, K.A.
Lathrop, Betsy B.
Lo, William A.
Marshall, Emily
Martin, Emma E.
Mather, A.
Murray, Eliza
Nye, Lucy
Parke, Mary
Powers, Bridget
Reid, A.D.
Reynolds, Mrs. P.
Sewall, Harriet
Wheeler, Cathrine
Wilder, Thomas
Williams, Mary
Wingate, Mehitabel

Media Index

(See the "Special Indexes to Contents" section of the Introduction for an explanation of this index and its limitations.)

Acrylic
 Architectural paintings
 Jeremenko, Theodore
 Fantasy paintings
 Sabin, Mark
 Farm scene, genre paintings
 Robinson, Mary Lou Perkins
 Genre paintings
 Pickle, Helen
 Genre scene paintings
 Slyman, Susan
 Paintings
 Abraham, Carl
 Butler, Nellie
 Clark, Floyd
 Clark, Mildred Foster
 Fabian, Gisela
 Falk, Barbara (Busketter)
 Hardee, Rodney
 Lembo, J. Lawrence
 Massey, Marilyn
 Moseley, Alice Latimer
 Muth, Marcia
 Nash, H. Mary
 Simon, Pauline
 Street genre paintings
 Brice, Bruce

Acrylic, clay
 Paintings, sculptures
 Palladino, Angela

Acrylic, clay, paper
 Collages
 Salzberg, Helen

Acrylic, oil
 Genre, memory paintings
 Carter, Bob Eugene
 Paintings
 Jakobsen, Kathy (Katherine)
 Vagen, Bette

Acrylic, oil, watercolor
 Farm scenes, memory paintings
 O'Kelley, Mattie Lou

Acrylic, oil, watercolor, pencil
 Fantasy and memory paintings
 Willey, Philo Levi "The Chief"

Acrylic, tempera, pen, ink
 Paintings
 Ley, Mary E.

Acrylic, various materials
 Paintings
 Rochette, Roland

Airplane enamel
 Paintings
 Dey, John William "Uncle Jack"

Beads
 Beadwork map of New York
 Hopps, David Vernon
 Figures
 Pebeahsy, Charles

Beeswax, pencils, candles
 Pysanky-Easter eggs
 Schmitz, Gail

Blocks
 Block prints for decorations
 Eliot, John, Reverend

Bone
 Carved pipes
 Pearson, Hugh A.
 Powderhorns
 Hutton, Christopher
 Rogers, W.H.

Bottles
 Bottle fence
 Stephens, Henry
 Bottle sculpture
 Makinen, John Jacob, Sr.

Brass
 Andirons
 Davis, James
 Balances
 Maxwell, J.
 Bells
 Andrew Meneely and Sons
 Levering, T.W.
 Pass and Stow
 Syng, Phillip
 Tommerup, Matthias
 Brassware
 Adams, James W.
 Burnap, Daniel
 Fellows and Meyers
 Leman, Henry
 McAllister and Company
 Robertson, John
 Buttons
 Whiteman, Henry
 Candlesticks
 Cornelius and Baker
 Wood, Joseph
 Compasses
 Lamb, Anthony
 Door locks
 Green and Board
 Wray, H.
 Kettles
 Hayden, Hiram
 Heyser, W.
 Marcy, J.J.
 Spaulding, C.F.
 Lock plates
 Golcher, James
 Pulls
 Parker, S.
 Scales
 Marden, J.
 Tea kettles
 Harbeson, Benjamin
 Theodalites
 Platt, Augustus
 Tomahawks
 Welshhans, J.

Brownware
 Decorative flower pots, pottery
 Owens, J.B.
 Face jugs
 Davies, Thomas J.

379

Brownware

Brownware (Cont.)
 Pottery
 D. and J. Henderson
 Pittman, J.W.

Brownware, Rockingham
 Pottery
 Adams, Enos
 Allen, William
 Turner, William
 Walker, George
 William Young and Sons

Brownware, stoneware
 Pottery
 Adams Brothers
 Balderson and Pace
 Houghton, Edward
 Lefever Pottery
 Routson, S.
 Stout, John N.

Brownware, yellow-ware
 Pottery
 American Pottery Company

Cardboard
 Boxes
 Henry Cushing and Company

Cement
 Environmental sculptures
 Dinsmoor, S.P.
 Greco, John
 Root, Ed
 Smith, Fred
 Sculptures
 Bailey, Eldren
 Domke, Paul
 Ehn, John
 Muhlbacher, Joe
 Terrillion, Veronica

Ceramic
 Bottles, pottery
 Greatbach, Daniel

Chalk
 Paintings
 Arnold, Thomas
 Harvey, M.T.
 Whaling scene paintings
 Coleman

Charcoal
 Drawings
 Adams, Olive M.
 Beam, Caroline
 Folsom, Mrs.
 Wilson, George W.
 Still life paintings
 Cobb, Anna C.

Charcoal, chalk
 Farm scene drawings
 Baldwin, Henry
 Landscape drawings
 Moore, Emily S.

Charcoal, oil
 Portraits
 Aldridge

Charcoal, pencil
 Drawings
 Dewey, Ormand Sales

Clay
 Artware pottery
 Ingles, Thomas
 McLaughlin, Miss Mary Louise
 Wheatley, Thomas
 Bone china
 Alpaugh and McGowan
 Thomas China Company
 Face jugs
 Baddler
 Face jugs, pottery
 Meaders, Cheever
 Meaders, Lanier
 Parian sculptures
 Harrison, John
 Pipes
 Morton, Joseph
 Porcelain
 American Porcelain Manufacturing Company
 Block, William
 Cartlidge, Charles
 Olworth, C.W.
 Tucker and Hemphill
 United States Porcelain Company
 Porcelain and art ware
 Thomas C. Smith and Sons
 Pottery
 A. Hall and Sons
 A. Jennings Pottery
 American Art Ceramic Company
 American Art China Works
 American China Company
 American Crockery Company
 American Encaustic Tiling Company
 American Pottery (Manufacturing) Company
 American Terra-Cotta Company
 Anchor Pottery Company
 Armstrong and Wentworth
 Atkinson, W.A.
 August Blanck Pottery
 Aust, Brother Gottfried
 Avera, John C.
 Avon Pottery
 Baecher, Anthony W.
 Baily, Joseph
 Baird, G.
 Baker, Michael
 Ball, Nelson
 Barley and Winters
 Becham, Washington
 Beck, A.M.
 Beecham Pottery
 Beerbower, L.S.
 Begerly, Levi
 Bell, Charley
 Bell, John W.
 Bell, Peter
 Bell, Richard Franklin
 Bell, Samuel
 Bell, Solomon
 Bell, Upton
 Bellmark Pottery Company
 Bennett and Chollar
 Bennett, Edwin
 Bennett, John
 Benton, G.
 Bird, C.H.
 Bixler, Absalom
 Blair, Sylvester
 Blaney, Justus
 Bloor, William
 Bodine, R.H.
 Boonville Pottery
 Bott, Hammersley and Company
 Boulter, Charles
 Boyer, John
 Boyley, Daniel
 Breininger, Barbara
 Breininger, Lester
 Brewster and Sleight
 Brockman Pottery Company
 Broome, Isaac
 Brunt, Bloor, and Martin
 Buehler, John George
 Buffalo Pottery Company
 Burford Brothers Pottery Company
 Burgess and Campbell
 Burpee, Jeremiah
 Burroughs and Mountford
 C. Bykeepers and Sons
 C. Goetz, Smith, and Jones, Slago Pottery
 C. Herman Company Pottery
 Cadmus, Abraham
 Caire, Jacob
 Cambridge Art Pottery Company
 Cartwright and Brothers
 Ceramic Art Company
 Chapman, Upson, and Wright Manufacturers
 Charles Wingender and Brother
 Chelsea Keramic Art Works
 Chester Pottery Company
 Chittenango Pottery Company
 Chollar and Darby
 Christ, Rudolph
 Cincinnati Art Pottery Company
 Clark, Nathan, Jr.
 Clark, Peter
 Clews, James
 Columbian Art Pottery
 Conklin, Ananias
 Convay, John B.
 Cook Pottery Company

Cope, Thomas
Cordero, Helen
Couloy, Isadore
Coxon and Company
Crafts, Thomas
Craven, Peter
Cresent Pottery Company
Crolius, Clarkson, I
Crolius, George
Crolius, Peter
Crooksville China Company
Cross, Peter
Crown Pottery Company
Croxton, Walter
Croylas, William
Curtis, John
D.F. Haynes and Company
Dallas, Frederich
Dalton Pottery Company
Danvers Pottery
Dave
Davidson, Seth
Davis, Isaac
Dedham Pottery
Delaware Pottery Company
Derry China Company
Dipple, A.G. Curtain
Dipple, Anna Margretta
Dorsey, Tarp (Joseph Tarplin)
Dorsey, W.F. "Daddy Bill"
Drach, Rudolf
Drinker, Philip
Dry, Daniel
Dry, John
Dry, Lewis
Dubors, Oliver
Duche, Andrew
Duche, Anthony
Eardley Brothers Pottery
East End Pottery Company
East Liverpool Pottery Co.
East Morrisania China Works
East Trenton Pottery Company
Eisemann, Philip
Empire Pottery Company
Faience Manufacturing Company
Farrar, H.W.
Fell and Thropp Company
Fenton and Carpenter
Fenton and Clark
Field, L.F.
Filcher, Thomas J.
Fillman, Michael
Fisher, J.C.
Fleet, Theodore
Ford City Company
Franklin Pottery Company
Fritz, Jacob
Funkhouser, L.D.
Gager, Oliver A.
Galloway and Graff
Gans, H.
George Murphy Pottery Company
Gerlach, C.
Globe Pottery Company

Goodale and Stedman
Goodwin, Seth
Goodwin, Thomas (O'Hara)
Gordy, D.X.
Gordy, William J.
Gordy, William Thomas Belah
Gorham, Joshua
Gre(en?), G.
Griffin, Smith and Hill
Grim, T.
Grueby Faience Company
Haig, James
Hanelsack, Daniel
Hare Pottery
Haring, David
Harker Pottery Comapny
Harker, Benjamin
Harker, Taylor and Company
Harkins, Mrs. A.
Harrington, Thompson
Haukins, W.W.
Haviland Company
Headman, Charles
Hemphill, Joseph
Henne, J.S.
Hewell, Will
Hewes Pottery
Holland, John Frederick
Holmes, Obediah
Homer Laughlin China Company
Hoopes, Milton
Howard, Bill
Hubener, Georg(e)
Hudson River Pottery
Hughes, Daniel
Iler, William
International Pottery Company
Irwin, Harvey
J.C. Waelde Pottery
J.J. Hart Pottery
J.S. Taft and Company
Jackson, Samuel
Janey, Jacob
Jegglin Pottery
Joder, Jacob
John Eardley's Pottery
John Maddock and Sons
John Moses and Sons
John Pierson and Company
Kelley, Peter
Key and Swope
Keytone Pottery Company
Kirkpatrick, Murray
Kline, Philip
Klinker, Christian
Knowles, Taylor, and Knowles
Kohler, John W.
Kurbaum and Schwartz
Labhart, J.M.
Langenberg Pottery
Leake, William
Lehew and Company
Lehman, Johannes
Leidy, John
Leman, Johannes
Lent, George

Lewis and Lewis
Lewis Johnson Pottery
Lewis, Henry
Linna, Irelan
Long's Pottery
Long, James L.
Lonhuda Pottery Company
Louis Miles Pottery
Love Field Potteries
Low Art Tile Company
Lowry, W.B.
Lukolz, Philip
Lycett, Edward
Lyman, Fenton Company
M.C. Webster and Son
Maddock and Son(s)
Maddock Pottery Company
Mann, John
Marteen, W.
Martin, John
Maryland Pottery Company
Matt Morgan Art Pottery Company
Matthews, J.M.
Mattice and Penfield
Meaders, Aire (Mrs. Cheever)
Mear, Frederick
Medinger, Jacob
Mercer Pottery Company
Merrimac Ceramic Company
Merritt, William Dennis Billy
Merz, Jacob
Meyer, Karen A.
Middle Lane Pottery
Miller, Solomon
Millington, Astbury and Poulson
Min, James A.
Moor, W.T.
Moravian Pottery
Moravian Pottery and Tile Work
Morgan, D.
Morris and Wilmore
Morrison and Carr
Nase, John
Nash, E.
Neesz, Johannes
New Castle Pottery Company
New York City Pottery Company
Newcomb Pottery Company
Norton Pottery
Norton, Luman
Norwalk Pottery
Ohio China Company
Ohio Valley China Company
Ohr, George
Oliver China Company
Orcutt, Belding and Company
Osborne, Joseph
Osborne, William
Ott and Brewer
Paige Pottery
Parker, John
Parr, Margaret
Paxston, Ottman, and Company Pottery
Pen Yan Pottery

Clay (Cont.)
 Pottery (Cont.)
 Peyrau, A.
 Phoenix Pottery
 Pioneer Pottery Company
 Price, Xerxes
 Pride, John
 Prospect Hill Pottery Company
 Ramsey, Barnett
 Ramsey, William
 Randall, James
 Reidinger and Caire
 Renninger, John
 Renninger, Wendell
 Rice, Sandra
 Rittenhouse, Evans and Company
 Roberts, David
 Robertson Art Tile Company
 Rolader, William Washington "Uncle Don"
 Rookwood Pottery Company
 Roseville Pottery Company
 Roudebusch, William
 Roudebuth, Henry
 Rouse and Turner
 Routson, Joseph
 Salamander Works
 Salter, Ben S.
 Sanders, Daniel
 Schauer, Jacob
 Schmidt, Peter
 School, Michael
 Schultz, Martin
 Sebring Pottery Company
 Sevres China Company
 Shenango China Company
 Shenfelder, Daniel
 Sickman, Theodore
 Simmons, Andrew
 Simmons, Jermiah
 Smiley, H.K.
 Smith, Fife and Company
 Smith, Joseph
 Smith-Phillips China Company
 Southern Porcelain Company
 Southwick, William
 Spiegel, John
 Spinner, David
 Stahl, Charles
 Star Encaustic Tile Company
 Star Porcelain Company
 Stewart, L.
 Stockton Art Pottery
 Stockwell, Henry
 Stoeckert City Pottery Company
 Stofflet, Heinrich
 Stork, E(dward) L(eslie)
 Stout, Isaac
 Strawn, John
 Swallow, William
 Swan Hill Pottery
 Taylor and Speeler
 Taylor, Smith, and Taylor Company
 Taylor, William
 Teames, Judak
 Thayer, Pliny
 Theiss, Steven
 Thiekson, Joseph
 Thomas and Webster
 Thomas(?), W.S.
 Thompson, Israel
 Tittery, Joshua
 Trenton China Company
 Trenton Pottery Company
 Trenton Tile Company
 Troxell, John
 Tucker and Hulme
 Union Potteries Company
 United States Pottery
 Van Briggle Pottery Company
 Van Horn and Boyden
 Vance Faience Company
 Vickers, A.J.
 Vincent, William
 Vinson, William
 Vodrey Brothers
 Volkmar Keramic Company
 W. Hart Pottery
 Wands, I.H.
 Waring, David
 Warner, H.(W.)
 Weaver, Abraham
 Weaver, Elias
 Webster and Seymour
 Weller, S.A.
 Wellsville China Company
 West End Pottery Company
 Weyrich, Charles
 Wheeling Pottery Company
 Willetts Manufacturing Company
 William Brunt Pottery Company
 William Fische Pot Factory
 Wilson, James S.
 Wingender Brothers Pottery
 Wood
 Woodruff, D.C.
 Wyant, David
 Zoar Pottery
 Zoarite Community Pottery
 Pottery, fanciful jugs, pipes
 Kirkpatrick, Cornwall E.
 Pottery, glazes
 Storer, Mrs. Bellamy (Maria Longworth)
 Pottery, porcelain
 Smith, William
 Union Porcelain Works
 Pottery, sgraffito plates
 Bergey, Benjamin
 Paul, Samuel
 Sculptures
 Blizzard, Georgia
 French, Daniel Chester
 Fretz, J.
 Sewer tile sculpture
 Aetna Fire Brick Company
 Akron Porcelain Company
 American Sewer Pipe Company
 Baker, W(ilbur) A.
 Beaver Clay Manufacturing Company
 Biddle, Robert W.
 Bish, W.H.
 Bosio, Louie
 Cannelton Sewer Pipe Company
 Cramlet, C.
 Crockett, Otto
 Dee, William M.
 Dorsey, Miss Edith
 "El Diadlo"
 Evans Pipe Company
 Exley, F.
 Fouts, Edward
 Funk, Abraham
 Gudy, Ernest
 Hirzel, William
 Hutchinson, John A.
 Lamielle, E.
 Lesh, Jane Barrow
 Massillon Refractories Company
 Moore, J.W.
 National Fireproofing Company
 National Sewer Pipe Company
 Nelsonville Sewer Pipe Company
 Newport Sewer Pipe Plant
 Romig Clay
 Somerset Trading Company
 Spencer, Herman
 Staley, Louie
 Sterling Brick Company
 Stockes, L. (Ralph)
 "Windy"
 Statues
 Hornaday, William T.
 Teapots, pottery
 Binney and Ronaldson
 Tile
 Beaver Falls Art Tile Company
 Tobacco pipes
 Creus, William
 Frantz, Isaac

Clay, acrylic, poster paint
 Puppets, carvings
 Kinney, Charles

Clay, fabric, oil
 Pottery, election banners
 Knowles, Mrs. Henry L.

Clay fixed to plywood
 Sculptures
 Suddouth, Jimmy Lee

Clay, oil
 Pottery, ceremonial scene paintings
 Martinez, Cresencio

Clay, stoneware
 Pottery, churns
 S. Hart Pottery

Clay, tempera
 Paintings, sculptures
 Rogers, Juanita

Colored pencil
Drawings
Hughes, Charles Edward, Jr.
Jones, Frank

Concrete, mixed media
Chapel and memorial sculptures
Wagner, Paul L.

Copper
Boxes
Alley, Nathaniel
Copperware
A.D. Richmond and Company
Attlee, William
Fuller, John
Getz, John
Heiss, William
Holmes and Evans
Orr, George
Fish kettles
G. and F. Harley
Kettles
Howard and Rodgers
Ladles
Allen, Caleb
Jones, Gershom
Mugs
Apple, W.
Saucepans
Crabb and Minshall
J. Bentley Sons
Stencils
Collis, S.C.
Zell, William D.
Stills
Sanderson, Francis
Stoehr, Daniel
Weitel, J.
Stills, kettles
Bruce, John M.
Tableware
Smith, James
Tea kettles
Reid, G.
Steinman, F.
Warming pans
Collier, Richard
Hunneman, William C.
Richmond, A.D.
Witherle, Joshua
Weathervanes
Cushing and White
Harris and Company

Copper, tin
Copperware, tinware
Bailey, William
Brotherton, E.

Coral
Rock castle sculptures
Leedskalnin, Edward

Crayon
Drawings
Allen, Marie W.
Clark, Harry A.
Genre drawings
Skeggs, T.W.
Pastel portraits
Sharples, James
Pastoral scene drawings
Manley, Jane Helena

Crayon, felt-tip pen
Drawings, quilts
Rowe, Nellie Mae

Crayon, pastel
Drawings
Arning, Eddie

Crayon, pen, watercolor, pastel
Landscape and fantasy drawings
Yoakum, Joseph E.

Cream-colored ware
Pottery
Coxon and Thompson
Goodwin Brothers
Rhodes and Yates
Seixas, David G.

Creme-colored ware
Pottery
Trotter, Alexander

Delft-ware
Pottery
Price, William

Dirt, stone, wood
Sculptures
Kasling, "Driftwood Charlie"

Driftwood, putty
Biblical sculptures
Hopper, Annie

Earthenware
Pottery
Cain, Abraham
Cain, Martin
Caldwell, James
Cornell, James
George Morley and Brothers
Glassen, John
Grocott, J.
Heitzie, Christian
Marshall, William
McFarland, William
Neiman, James
Pinckard, Nathaniel
Sawyer, H.
Steinbach, Henry
Trotter and Company
Troxel, Samuel
Walford, Mr.

Sculptures
Schweinfurt, John George

Embroidery
Genre pictorials
Cady, Almira
Hatchments
Flower, Ann
Literary and mythical pictures
Deans, Sarah Ann Curry
Taylor, Eliza Winslow
Memorial pictures
Winsor, Susan Jenckes
Mourning pictures
Arnold, Elizabeth
Barton, Ann Maria
Bicknell, Charlotte
Bolkcom, Betsey
Borden, Delana
Dean, Abigail "Abby"
Eddy, Abby (Abìgail)
Hall, Betsy
Hill, Lovice
Hobart, Salome
Mann, Lydia Bishop
Peck, Almyrah
Russell, Amey
Sabin, Sarah "Sally" Smith (Wilson)
Talbot, Mary
Taylor, Alice
Taylor, Eliza Andrews
Tucker, Mehitable
Vogiesong, Susanna
Ware, Julia
Weeden, Mary
Wightman, Mary
Williams, Frances
Mourning samplers
Stockwell, Amey Ann
Thompson, Elizabeth A.
Needlework
Drinker, Elizabeth
Sewing cases
Biddle, Beulah
Still life pictures
Cheever, Miss Mary
Platt, Mrs. Charles (Dorothy)
Williams, Cynthia
Winsor, Fanny (Francis)

Embroidery, paint
Mourning pictures, portraits
Ide, Mary

Enamel
Decorated sewing boxes
Prior, Jane Otis
House and barn paintings
Johnson, Ray

Enamel on metal
Enamel works
Rabinov, Irwin

Fabric
- Appliqued linens
 - Hurxthal, Isabel Hall
- Appliqued pictures
 - Hardin, Esther McGrew
 - Lynch, Laura
 - Ominsky, Linda
- Appliques
 - Gilcrest, Helen
- Beadwork purses
 - Sinclair, Mrs. William
- Bed rugs
 - Baldwin, Hannah
 - Brace, Deborah Loomis
 - Clayman, Susan
 - Comstock, Mary
 - Foot(e), Abigail
 - Foot(e), Elizabeth
 - Foot(e), Mary
 - Johnson, Hannah
- Bedcovers
 - Canfield, Betsey
 - Hewson, John
 - Huntington, Julie Swift
 - Knight, Emily
 - Wisdom, Sarah B.
- Bedspreads
 - Macca, Lorita
 - Schulz, Maria Boyd
- Blankets
 - Duran, Damian
 - Esquibel, Felix
 - Garcia
 - Garcia, Pablo
 - Lopez, Antonia
 - Lopez, Martina
 - Lovato, Jose
 - Manzanares, Luisa
 - Montoya, Patricia
 - Ortega, David
 - Ortega, Jose Ramon
 - Virgil, Juan Miguel
- Blankets, jergas
 - Gallegos
- Candlewick pillow slips
 - Miller, Anne D.
- Candlewick spreads
 - Beall-Hammond, Jemima Ann
 - Jones, Emily Edson
 - Little, George F.
 - Rounds, Mary M.
 - Rutgers Factory
 - Tibbets, Susan
- Carpets
 - Nicklas, George
- Carpets, coverlets
 - Auburn State Prison
 - Boettger, Carl
 - Burnside, John
 - Butterfield, Samuel
 - Cass, Josiah
 - Cole, Anthony
 - Conger, Jonathan
 - Craig, John
 - Davidson, Archibald
 - Dehart, John, Jr.
 - Dunlap, William S.
 - Endy, Benjamin
 - Eyre, John
 - Findlay, Robert
 - Fliehr, Charles B.
 - Gauss, George
 - Grimm, Peter
 - Hersh, Henry
 - Keener, John
 - Lake, Salmon
 - Mayo, Charles S.
 - McLeran, James
 - Meily, John Henry
 - Miller, Ambrose
 - Muir, John
 - Murr, Lewis
 - Myers, Daniel L.
 - Nevel, Frederick
 - Rattray, Matthew
 - Riegel, Simon
 - Schnee, Joseph F.
 - Schoonmaker, James
 - Scwartz, John, Jr.
 - Scwartz, John, Sr.
 - Seifert and Company
 - Tatham, Thomas
 - Wantz
 - Wiand, Joel
 - Wiand, Jonathan D.
 - Wilson, Robert B.
- Carpets, coverlets, diapers
 - Meily, Emanuel, Jr.
- Carpets, coverlets, weavings
 - Kennedy, David
- Colcha embroideries
 - Lujan, Maria T.
 - Stark, Tillie Gabaldon
- Commemorative samplers
 - Brown, Mrs. Nicholas E.
 - Peterson, Petrina
- Costumed wooden dolls in an environment
 - Black, Ruby
- Coverlets
 - Alexander, James
 - Alexander, John
 - Alexander, Robert
 - Allen, Abram
 - Allen, B. Hausman
 - Annis, Clark
 - Anshutz, Philip
 - Ayrhart, Peter
 - Bacheller, Lucinda
 - Bachman, Anceneta
 - Backer, Hiram
 - Baer, Gabriel
 - Baldwin, H.
 - Bartler, Joseph
 - Bauer, William
 - Baughman, John
 - Bayard, Jacob
 - Bean, Mrs.
 - Beard, M.
 - Beard, William
 - Beatty, Gavin I.
 - Bechtel, John
 - Beil, David
 - Berthalemy, Jacob
 - Bewford, Elias
 - Birch, S.A.
 - Blocher, S. (B.)
 - Bock, Mrs. William N.
 - Bohn, Adam
 - Bohn, Jacob W.
 - Bower, L.
 - Bowman, Henry B.
 - Brailer, Augustin
 - Breeswine, Peter N.
 - Breidenthal, P.
 - Breneman, Martin B.
 - Brinkman, Henry
 - Bronson, J.
 - Bronson, R.
 - Brosey, John, Sr.
 - Brosey, William
 - Brumman, David W.
 - Burkerd, E.
 - Bush, W.
 - Cable, Henry K.
 - Campbell, Daniel
 - Chapman, Ernst
 - Christie, I.
 - Christmas, W.F.
 - Clapham, J.
 - Clearfield Textile Mill
 - Coble, Henry K.
 - Cockefair Mills
 - Cook, Valentine
 - Craig, James
 - Cunningham, James
 - Curry, Sam
 - Dare, Robert
 - Davidson, J.
 - Davidson, J.M.
 - Davis, J.
 - Dornbach, Samuel
 - Douglas, Charles
 - Duddleson, C.
 - Dudley, Samantha Charlotte
 - Emigh, Mary
 - Engel, G.
 - Etner, Reuben
 - Etter, Elizabeth Davidson
 - Ettinger, William
 - Fasig, A.
 - Fasig, William
 - Fehr and Keck
 - Fehr, Abraham
 - Fehr, C.
 - Fehr, Thomas
 - Fennell, Michael
 - Fischer, Samuel
 - Fisher, Daniel
 - Fisher, Jacob
 - Fisher, Levi
 - Flowers, Peter
 - Forrer, Martin
 - Foster, Mary Ann Kelly
 - Fouth, Jacob
 - Fox, John
 - Frailey, Michael
 - Frederick, Henry K.

Frederick, Henry T.
Frey, Abraham
Frey, Christian
Frey, Samuel B.
Fridley, Abraham
Friedel, Robert
Galley, Jacob
Gamber, M.G.
Gamble, J.
Gamble, Sam
Garber, Jonathan
Garner, Jacob
Garrett, Thomas
Gepfert, A
Gerbry, M.Y.
Gerthner, Xavier
Gilmore, Gabriel
Gilmore, Joseph
Gilmore, Thomas
Gilmore, William
Glassey, Joseph
Glassley, John
Good, Jacob
Goodall, Premella
Graham, Samuel
Habecker, David
Hadsell, Ira
Haeseler, H.
Hallack, Jane E.
Hamelton, John
Haring, David D.
Harlmz, David D.
Harper, William
Harrisman, Mehitable
Hart, E.J.
Hart, J.
Harting, Peter
Hartmann, Charles G.
Hausman, B(enjamin)
Hausman, Joel
Hechler, Samuel
Hedden, Martha
Heffner
Hefner, George
Heilbronn, J(ohn) J.
Heiser, William L.
Hemon, James
Herman, John
Heshe, Henry
Hesse, D.
Hicks, William
Hilliard, Philip H.
Hinkel, C(hristian) K.
Hoagland, James S.
Hoerr, Adam
Hoke, George
Hoke, Martin
Horsefall, Henry
Hoyt, Esther
Huntting, Marcy
Impson, Jacob
Imsweller, Henry
Jenison, J.
Johnson, D.P.
Jordan, Thomas
Jotter, Jacob

Jukes, Benjamin
June, Benjamin
Kaufman, John
Keagy, I.
Kean, Carl Lewis
Keck
Keener, Jacob
Keffer, William
Kepner, Absalom B.
Kerns, William
Kitson, Nathan
Klein, John
Klein, Mathias
Klinger, Absalom
Klinhinz, John
Kuder, Solomon
Kump, Andrew
La Tourette, Henry
La Tourette, John
La Tourette, Sarah (Van Sickle)
Laget, A.
Landes, John
Lantz, J.
Lawrence, David
Lee, John
Leehman, Joseph, Jr.
Leehman, Joseph, Sr.
Lehr, Daniel
Leidig, Peter
Lentz, Cornelius
Leykauff, Michael
Logan, Patrick
Long, David
Longenecker, Peter
Lorentz, Peter
Lowmiller, William
Lunn, William
MacIntyre, A.
Maddhes, C.
Marshall, Edward W.
Marsteller, Thomas
Maxwell, William
McKenna
McMillen, Samuel
McNall, John
Meckel, J.S.
Meeks, Josiah
Meily, Samuel
Mellinger, W.S.
Metz, L.
Michael, Enos
Michael, Philip
Miller, Gabriel
Miller, Maxmilion
Moncliff, A.B.
Monroeton Woolen Factory
Morehouse, P.M.
Morgan, William S.
Mosser, John
Moyall, James
Muehlenhoff, Heinrich
Mundwiler, Samuel
Musselman, Samuel B.
Myer, I.
Myers, Charles D.
Myers, James

Netzly, Jacob
Nusser, Christian
Oberholtzer, A.
Oxley, Joseph
Peden, Joseph
Peter, H.P.
Peterman, Casper
Petry, Henry
Phlegan, Henry
Porter, C.C.
Primrose, Jacob
Probst, Henry
Pulaski, J. Irvin
Punderson, Prudence Geer
Pursell, Daniel
Quincy, Mary Perkins
Rassweiler, Philip
Rauser, Gabriel
Redick, John
Reed, William A.
Reichert, H.
Remy, James
Ringer, Peter
Rottman, G.
Saeger, Martin
Salisbury, J.
Satler, J.
Saurly, Nicholas
Schneider, Johann Adam
Schneider, John E.
Schoch, Charles (G. Schoch)
Schrader, H.
Schreffler, Isaac
Schreffler, Samuel
Schrontz
Schum, Peter
Seibert, Peter
Seidenspinner, John
Seifert, Henry
Seip
Serff, Abraham
Shafer, J.
Shallenberger, Peter
Shamp, D.
Shank, H.
Shank, W.
Sheaffer, Isaac
Shearer, Michael
Sheffler, Isreal
Shreffler, Samuel
Simpson, George
Slaybough, Samuel
Smith, George
Smith, George M.
Smith, Joseph
Smith, Judith
Smith, William
Snyder, Isaac
Speck, John C.
Stauch, David, Jr.
Steiner, David
Steinhilber, Martin
Steinhill Brothers
Stephenson, Daniel
Sternberg, William
Steurnagle, Andrew

Fabric (Cont.)
 Coverlets (Cont.)
 Stich, G.
 Stiff, J.
 Stillwell, Ida
 Stimmel, S.
 Sulser, Henry
 Tobin, John
 Turnbaugh, Joseph
 Turnbaugh, Samuel
 Turner, William
 Tyler, Elman
 Uhl, Peter
 Unger, I.
 Van Buskirk, Jacob
 Van Doren, Abram William
 Van Doren, Garret William
 Van Doren, Isaac William
 Van Doren, Peter Sutphen
 Van Fleck, Peter
 Van Meter, Joel
 Van Ness, James
 Van Nortwic, C.
 Van Vleck, Jay A.
 Van Vleet, Abraham
 Walk, Jacob M.
 Warner, Phebe
 Warner, Sarah Furman
 Watson Woolen Mill
 Weand, William
 Wearehs
 Weaver, John W.
 Weaver, Samuel
 Weaver, Thomas
 Weber, T.
 Weddell, Liza Jane
 Weidel, George
 Weil, George P.
 Welk, George
 Welty, John B.
 Wensel, Charles
 West, James
 Wever, H.S.
 White
 Wiand, John
 Wiggins, C.
 Will, William
 Williams, May
 Wilson, William (A. Wilson)
 Wise, E.
 Woodcocke
 Woodring
 Wunterlich, John
 Yearous, F.
 Young, Abraham
 Young, Nathaniel
 Young, Peter
 Zelna, A.
 Zinck, John
 Coverlets, bedspreads
 West, William
 Coverlets, blankets
 Peter, Reuben
 Robinson, James
 Routt, Daniel
 Smith, John
 Coverlets, carpets
 John Mellinger and Sons
 Coverlets, carpets, blankets
 Crothers, Samuel
 Coverlets, diapers
 Murphy, Richard
 Coverlets, diapers, carpets
 Henderson, George, Jr.
 Coverlets, quilts
 Stauch, David, Sr.
 Coverlets, table linens
 Lawyer, James
 Coverlets, weavings
 Campbell, John
 Keener, Henry
 Weaver, J.G.
 Crewel and embroidered purses
 Eaton, Mary
 Crewel bed assemblies
 Bulman, Mary
 Crewel bedspreads
 Breed, Mary
 Taylor, Elizabeth
 Wyllis, Elizabeth
 Crewel needlepoint works
 Burnham, Mary Dodge
 Crewel pictures
 Taylor, Elizabeth
 Crewel samplers
 Dick, Mrs. Mary Low Williams
 Crib quilts
 Gilchrist, Catherine Williams
 Smith, Rachel
 Decorative apron trims
 Ferguson, Frederica
 Dolls
 Edgerly, D.S.
 Dolls, weavings
 Emmaline
 Embroidered and needlepoint imaginary pictures
 Shapiro, Pauline
 Embroidered aprons
 Lambert, Lydia
 Embroidered architectural, still life pictures
 Barker, Elizabeth Ann
 Embroidered architectural pictures
 Stebbins, Caroline
 Embroidered baby dresses
 Holloway, Isabella
 Embroidered bay scene pictures, samplers
 Budd, Alice M. (Mrs. Kenneth)
 Embroidered bedspreads
 Christian, Nancy
 Thatcher, Lucretia Mumford
 Embroidered Bible covers
 Craghead, Elizabeth
 McCulloch, Christina
 Morris, Debbe
 Embroidered bookmarks
 Custis, Nelly
 Embroidered candlewick spreads
 Quinby, Sarah A.
 Embroidered candlewick spreads, samplers
 Todd, Mary A.
 Embroidered chairseats, samplers
 Banker, Elizabeth
 Embroidered check black wool blankets
 Johnson, Catherine
 Embroidered genre pictures
 Roosevelt, Mrs. Theodore, Jr.
 Embroidered hand towels
 Stamn, Mary
 Embroidered handkerchiefs
 Leonard, Rachel
 Pollock, Sarah E.
 Embroidered handwoven blankets
 Sloane, Caroline M.
 Embroidered hatchments
 Brown, Jane
 Embroidered history pictures, samplers
 Taylor, Lillian Gary (Mrs. Robert Coleman Taylor)
 Embroidered landscapes
 Kriebel, Phebe
 Noyes, Abigail Parker
 Embroidered linen altar cloths
 Sturtevant, Louisa
 Embroidered linen bureau covers
 Scott, Ann
 Embroidered linens
 Byberin, Barbara
 Walborn, Catarina
 Embroidered maps
 Goldin, Elizabeth Ann
 Jones, Eliza
 Mather, A.
 Wade, Frances
 Willis, Sarah
 Embroidered Masonic aprons
 Andrews, Bernard
 Embroidered mourning pictures, samplers
 Moss, Margaret
 Embroidered mourning pictures, samplers, linens
 Remington, Mary "Polly"
 Embroidered needlework
 Vanderpoel, Emily Noyes
 Embroidered pictures
 Acheson, Eurphemia J.
 Aldich, Mrs. Richard
 Bacon, Mary
 Belcher, Sally Wilson
 Bower, Mary
 Burrows, Esther
 Clark, Mrs. Frank T.
 Conrad, Ann
 Harbeson, Georgiana Brown
 King, Mary
 McGraw, Mrs. Curtis
 O'Donnell, Mrs. D. Oliver
 Rose, Mrs.
 Rothmann, Mary
 Sampson, Deborah
 Sherril, Laura

Strong, Anne
Trowbridge, Emily
Warren, Sarah
Wheeler, Candace
Wheeler, Henrietta Virginia
Wright, Lydia
Embroidered pictures, samplers
 Wistar, Sarah
Embroidered pictures, screens
 Gary, Mrs. James A. (L.W.) (Daisy)
Embroidered pocket aprons
 Lyman, Mrs. Eunice
Embroidered pocketbooks
 Brown, Elinor
 Hicks, Elizabeth
Embroidered prayerbook covers
 Cabot, Mrs. Samuel
Embroidered religious pictures
 Barlow, Miss Lydia
 Crafts, Mary S.
Embroidered religious samplers
 Colton, Lucretia
Embroidered sewing baskets
 Denison, Nancy Noyes
Embroidered ship pictures
 Merrill, Sailor
 Very, Lydia
Embroidered show towels
 Brackbill, Eliza Ann
 Kuns, Cadarina
Embroidered still life pictures
 Mason, Mrs. Jeremiah
Embroidered table clothes
 Oothout, Mary
Embroidered towels
 Herr, Anna
Embroidered veils
 Beekman, Miss Florence
Embroidered wedding dresses
 Bull, Miss Elizabeth
 Myers, Mary
Embroidered wool bed covers
 Dumbay, Harriet
Embroidery
 Fleet, Mary
Embroidery and applique on capes
 Hureau, Madame E.
Embroidery on silk
 Nichlan, Thalia
Embroidery, weavings
 Sarah "Old Aunt Sarah"
Family register samplers
 Cambell, Anna D.
 Denison, Marcia
 Giles, Polly
 Hall, Sally
 Johnson, Persis
 Marsh, Mrs. John Bigelow
 Taylor, Sally
 Wilson, Fanny
Global samplers
 Wright, Ruth
Hand towels
 Rauch, Elisaeet

Hand towels, samplers
 Schyfer, Martha
Handkerchiefs
 Palmer, Susan Catherine
Hatchments
 Hall, Hannah
Historic needlework pictures
 Wheeler, Rebekah
Hooked bed rugs
 Greer, R.
 Pearl, Hannah
 Thorn, Catherine
Hooked rugs
 Lepine, Imelda
 Selby, Cleland
Hooked rugs, bed rugs
 Avery, Mary
 Barnard, Lucy
 Billings, Pheobe
 Blackstone, Eleanor
 Clarke, Laura Etta
 Denny, Sara
 Filker, John
 Franklin, Mary Mac
 Gove, Jane
 McCall, Philena
 McKeever, Ellen
 Stark, Elizabeth (Miss)
 Vinton, Mary
Jergas
 Roybal, Martin
Lace cutwork samplers
 Keen, Sarah
Linen baby caps
 Jeffries, Deborah Hunt
Mourning paintings
 Terry, Elizabeth
Mourning pictures
 Avery, Mary
 Hamilton, Elizabeth Robeson
 Hatch, Sara
 Hodges, Susana
 Lane, Elizabeth
 Quincy, Caroline
 Smyth, M.
Mourning pictures, samplers
 Bennett, Elizabeth K.
Mourning samplers
 Douglas, Marya
 Kimball, Mary G.
 Miller, Fanny
 Silcox, Emily
 Wychoff, Ellen
Mythological embroidered pictures
 Boush, Elizabeth
 Spurr, Eliza W.
 Welles, Lydia
Nautical carpets
 Rumrill, Edwin, Captain
Needlelace samplers
 Wayn(e), Sarah
Needlepoint
 Burt, Mary Jane Alden
 Otis, Mercy (Warren)
 Roth, Louise Cook
 Sublett, Harriet

Needlepoint pictures
 Gallatin, Almy Goelet Gerry
 Kountze, Mrs. De Lancey
Needlepoint pillow tops
 Law, Mrs. Edward
Needlepoint pocketbooks
 Willard, Eliza
Needlepoint sofa panels
 Kellogg, Mrs. Francis Leonard
Needlepoint squares
 Duvall, Flo
Needlepoint stool tops
 de Freest, Mrs. Daniel L.
Needlepoint tapestry
 Smith, Martha Swale
Needlework
 Cary, Mary
 Hartley, Florence
 Mohamed, Ethel Wright
 Purcell, Eleanor
 Shaw, Martha Ann
 Talbot, Jane Lewis
 Ten Eyck, Margaret Bleeker
 Wilson, Ann Jefferis
Needlework, embroidery
 Lothrop, Stillman
Needlework, mourning drawings
 Nye, Lucy
Needlework pictures
 Dana, Lucinda
 Dodge, Eliza Rathbone
 Downing, Mary
 Frazier, Mrs.
 Thaxter, Rachel
 Wagner, Christina
 Wakeman, Esther Dimar
Needlework pocketbooks
 Wright, Mary
Needlework portraits
 Parkman, Abigail Lloyd
Needlework quilts
 Woodnutt, Rachel Goodwin
Needlework slipper cases
 Day, Elizabeth
Patchwork show towels
 Kichline, Euphemia
Pillow cases
 Weaver, Mary Ann
Pin-cushions, embroidered pocketbooks
 Alsop, Mary Wright
Printed floor cloths
 Perkins, Samuel
Printed handkerchiefs
 Gray and Todd
Quilts
 Addison, E.A.
 Allcock, Cirendilla
 Anderson, Eleanor S.
 Anderson, Sarah Runyan
 Armstrong, Ann Johnson
 Arsworth, Cynthia
 Bacheller, Celestine
 Bailey, Mary
 Baker, Dorothy
 Barker, Harriett Petrie

Fabric (Cont.)
 Quilts (Cont.)
 Barr, Eliza
 Batson, Mary Jane
 Beckham, Julia Wickliffe
 Benedict, Mary Canfield (Baker)
 Bergen, Johanna
 Bidwell, Elizabeth Sullivan
 Bontager, Mrs. Clara
 Bontrager, Mrs. Eli
 Bontrager, Mrs. Lydia
 Bontrager, Mrs. Rudy
 Bontrager, Polly
 Boucher, Doris
 Bradburg, Harriett
 Bready, Eliza Ely
 Brock, Harriet E.
 Bruce, Sophronia Ann
 Buckingham, Susannah
 Buell, S.J.
 Bulluck, Panthed Coleman
 Burkholder, Lydia
 Calvert, Margaret Younglove
 Carswell, Mrs. N.W.
 Catlett, Lucy Tucker
 Chance, A.I.
 Childs, Hannah
 Christner, Mrs. John
 Cleland, Jennie
 Cline, Elizabeth Ann
 Cona
 Cook, Eunice W.
 Cook, Phebe
 Coon, Clara
 Counts, Charles
 Cree, Matilda
 Cumberland, Mary Alexander
 Dabney, Mrs. Charlotte
 Darrow, Mrs. Newton
 De Groot, Ann
 Dean, Emeline
 Degge, Mary Frances
 Dennett, Olive
 Dicus, Ellen
 Dodson, Mrs. Priscilla
 Duchamp, Helen
 Dunn, Mary
 Eash, Lydia
 Eisenhower, Mrs. Ida Elizabeth Stover
 Ely, Sarah Weir
 Ernest, Mrs. Austin
 Esputa, Susan Adel
 Farrington, Anna Putney
 Ferguson, Mrs.
 Fink, Willie Sharpe
 Fitzgerald, Mrs. Joshua
 Flemings, Isabella
 Ford, Saddie
 Forman, Irene B.
 Fortner, Myrtle M.
 Foster, Rebecah
 Frank, Mrs. Gustav
 Frye, Mary
 Garr, Sarah Crain
 Gatewood, Jane Warwick
 Gay, Pocahontas Virginia
 Geiger, Margaret
 Getty, Marshall
 Gibson, Mary L.
 Gillette, Susan Buckingham
 Glover, Elizabeth
 Godwin, Abigail
 Gouverneur, Maria Monroe
 Gray, Grace
 Greenawalt, Katie
 Grider, Nancy Miller
 Gross, Catherine
 Gurney, P. Thompson
 Hailey, Molly (Mrs. George)
 Hamilton, Rebexy Gray
 Hardman, Mrs. Edwin
 Hasson, Sallie E.
 Heath, Mrs. John
 Herschberger, Mrs. Manuel
 Hieatt, Martha Tribble
 Hochstetter, Katie
 Hochstetter, Mrs. Manas (Mary)
 Holcomb, Sarah
 Hollinger, Lizzie
 Hostetler, Nina D.
 Howe, Louise
 Hoyt, Mary Ann
 Hubbard, Maria Cadman
 Hubbard, Tryphena Martague
 Ivy, Virginia Mason
 Jefferson, Mannie Holland
 Johnson, Fanny
 Kenedy, Sarah
 Kichline, Christine S.
 Kingman, Mary Dunham
 Kittle, Nellie
 Knapp, Harriet
 Knappenberger, G.
 Koch, Ann Koenig
 Kohler, Rebecca Leiby
 Kretzinger, Rose
 Lambright, Mrs. Elizabeth
 Lambright, Mrs. Menno
 Lambright, Mrs. Susan
 Lantz, Mrs. Ed
 Lapp, Lydia
 Lathouse, Mrs. W.B.
 Leggett, Julia
 Lehman, Amanda
 Lehn, Mrs. Mary
 Leverett, Elizabeth
 Leverett, Sarah Sedwick
 Lilly, Emily Jane
 Loehr, Elizabeth
 Lucas, Martha Hobbs
 Malcolm, Mrs.
 Maran, Mrs. Mary Jane Green
 Mast, Barbara
 Mattingly, Eliza Ann
 Maxwell, Ann
 McCord, Susan (Nokes)
 McCrea, Mrs. Mary Lawson Ruth
 McNabb, Marcena Coffman
 Midkiff, Mary Louisa Givens "Lula"
 Milan, Nettie
 Miller, Anna Viola
 Miller, Eliza Armstead
 Miller, Henry
 Miller, Katie (Mrs. David J.L.)
 Miller, Lydia Ann
 Miller, Mary
 Miller, Mrs. Nathaniel
 Miller, Mrs. S.N.
 Miller, Mrs. Susie
 Miller, Mrs. William Snyder
 Miller, Polly
 Miller, Sarah
 Mitchell, Catherine
 Mitchell, Elizabeth Roseberry
 Mize, Mahulda
 Moore, "Aunt Eliza"
 Moore, Mrs. Roy
 Moran, Amanda Estill
 Morris, Mattie Tooke
 Mosely, Susanna Richards
 Moseman, Elizabeth E.
 Myers, Mary Rosalie Prestmen
 Naguy, Mary Jane
 Naughn, Martha Agry
 Newberry, Frances
 Nicely, M. Eva
 Nichols, Margaret
 Nowlan, Margaret
 Parell, Sarah
 Patterson Sisters
 Patterson, Mary Ann "Polly" Tanner
 Peale, Sophonisha
 Perkins, Elizabeth Taylor Brawner
 Petershime, Mrs. Samuel
 Pierson, Martha
 Port, Elizabeth
 Power, Nancy Willcockson
 Powers, Harriet
 Poyner, Mrs. M.E.
 Pryor, Nannie Elizabeth (Sutherlin, Nannie Pryor)
 Quick, Sarah V.B.
 Randall, Jane Spillman
 Raper, Millie
 Reasoner, Mrs. A.E.
 Reed, Kate D.
 Reynolds, Mrs. P.
 Riffle, Martha Jane
 Robinson, Ann
 Ross, Abby F. Bell (Abby J. Ball)
 Rounsville, Helen Mary
 Rupp, Salinda W.
 Russell, Lydia Keene McNutt
 Savery, Rebecca Scattergood
 Schenck, Cornelia Ann
 Schmidt, Anna Marie
 Schrock, Mrs. Sam
 Schrock, Susan
 Scofield, E.A.
 Scott, Judy Ann
 Scovill, Nancy Cooke
 Sears, Adeline Harris
 Shaffner, Jacob
 Sikes, Bessie

Skarsten, Karee
Smallwood, Zibiah
Smith, Charlotte
Smith, Mary Caroline Wooley
Smith, Virginia Bland
Steinberger, Samuel
Stenge, Bertha
Stewart, Virginia
Stickler, Mary Royer
Stockton, Hannah
Stoltzfus, Mrs.
Sutherlin, Mary
Talbott, Emeline
Taylor, Mary Wilcox
Telfair, Jessie
Thomas, C. Susan
Throckmorton, Jeannette Dean, Dr.
Thurman, Mary Elizabeth Woods
Toomer, Lucinda
Totten, Mary (Betsy)
Toupe, Robert
Trabue, Fannie Sales
Troyer, Amanda S.
Troyer, Mary Ann D.
Tucker, Phoebe Parker
Tuels, Anna
Tweed, Susannah
Van Sicklen, Cornelia
Van Voorhis, Mary
Vanzant, Ellen Smith Tooke
Vaughn, Martha Agry
Waldron, Jane D.
Walker, Jane McKinney
Warner, Ann Maria
Warner, Pecolia
Whetstone, Lydia S.
White, Iva Martin
White, Mrs. Cecil
Whitehill, Mrs. Charlotte Jane
Wilson, Amelia Emelina
Wilson, Mrs. Russell
Wing, Samantha R. Barto
Wissler, Cornelia Everhart
Wood, Mrs. Jonathan
Woodhouse, Eulalie E.
Wright, Kate Vaughan
Yoder, Amanda Sunthimer
Yoder, Amelia
Yoder, Fanny
Yoder, Lydia
Yoder, Mrs. Daniel T.
Yoder, Mrs. Menno
Yoder, Mrs. Mose V.
Yoder, Mrs. Yrias V. (Mrs. Urias V.) (Anna)
Yost, Sallie
Zaumzeil, Ernestine Eberhardt
Quilts, crewel embroidered bedspreads
 Fifield, Mary Thurston
Quilts, needlepoint seat cushions
 Washington, Martha
Quilts, needleworks
 Herbert(?)

Quilts, weavings
 Riddle, Hannah
Quilts, weavings, coverlets
 Young, John W.
Religious embroidered pictures
 Fish, Eliza R.
 Ridgeway, Caroline
Rugs
 Collins, Sister Sarah
 Hawks, Mary
 Hicks, Harriet
 Moore, Ann
 Moore, Sophie
 Wells, Arabella Stebbins Sheldon
 Wells, Sister Jennie
Rugs, carpets, coverlets
 Tyler, Harry
Sailor's bags
 Opie, Warren
Samplers
 Adams, Abigail
 Allen, Abby (Abigail Crawford)
 Allison, Mary H.
 Andaries, Elizabeth
 Anderson, Maria
 Andrews, Jane Margaret
 Anthony, Anne
 Antrim, Mary
 Atkinson, Sarah Weber
 Baker, Nancy
 Balch, Clarissa
 Balch, Mary
 Baley, Sarah
 Baner, Barbara A.
 Barnhott, Margaret
 Barton, Philura
 Beidler, Mary Ann Yost
 Belcher, Mary
 Bennet, Cordelia Lathan
 Berry, Hans
 Bevier, Ellen Bange
 Bishop, Abby
 Blank, Elizabeth
 Bolen, Maria
 Border, Ann Amelia Mathilda
 Borton, Mary Ann
 Bowditch, Eunice
 Bowles, Amanda A.
 Boyd, Ann
 Bratton, Phebe
 Briggs, Martha
 Brinton, Eleanor
 Brown, Angeline
 Bulyn, Mary
 Burr, Cynthia
 Burrill, Hannah
 Burton, Rebecca
 Butler, Martha
 Butz, Mary
 Byles, Abgail
 Caldwell, Sarah S.
 Cameron, Mary Elizabeth
 Carr, Mary
 Carter, Achsah
 Carter, Rebecca
 Caseel, Hester

Castles, Mrs. John W. (Elizabeth Eshleman)
Church, Hannah
Clark, Emily
Clark, Mary Ann
Coggeshall, Eliza
Coggeshall, Esther
Coggeshall, Patty
Coggeshall, Polly
Congdon, Catharine
Cooper, Ann Eliza
Cox, Susanna
Cozzens, Eliza
Crider, Susy A.
Crygier, Ealli
Culin, Elizabeth B.
Cunning, Susan
Cutts, Elizabeth
Daggett, Clarissa
Daman, Desire Ells
Daman, Ruth Tilden
Davidson, Betsy W.
Davis, Betsy (Betsey?)
Davis, Patty (Martha)
Dean, Frances E.
Demeriett, Elizabeth J.
Dexter, Abby (Abigail G.)
Dexter, Nabby (Abigail)
Dinyes, Mary Ann
Doggett, Lydia
Dunlavey, Martha
Dyer, Sophia
Easton, Elizabeth (Rousmaniere)
Easton, Mary
Emmons, Mary
England, Ann E.
Engle, Sarah Ann
Fabian, Caroline Broughton
Feke, Sarah
Ferguson, Adaline M.
Field, Rebecca
Finney, Elizabeth
Fisher, Eleanor
Fleetwood, Miles
Fogg, Mercy (Mary)
Follet, Mary
Foot, Fanny
Fothergill, Emily
Fowler, Elizabeth Starr
Fox, Anne Mary B.
Franklin, Mary M.
Frishmuth, Sarah
Garrett, Mary Hibberd
Gawthorn, Ann
Gibbs, Sarah
Gladding, Lydia
Gladding, Susan Cary
Goddard, Mary
Godfrey, Mary Greene
Gorham, Bethiah
Gorham, Jemima
Gove, Mary Breed
Green, Virginia
Greenwalt, Maria B.
Griscom, Rachel Denn
Hafline, Mary

Fabric (Cont.)
 Samplers (Cont.)
 Haines, Rebecca M.
 Hall, Abija
 Hall, Margaret L. (Mrs. George)
 Hall, Nancy (Anna)
 Hamilton, Mary
 Hammatt, Fanny Rand
 Harding, Jane
 Harrison, Mary
 Hartman, Sarah Ann
 Hawkes, Elizabeth Jane
 Hawkes, Mary Lou
 Heebneren, Susanha
 Hellick, Ann
 Herr, Elizabeth R.
 Hessin, Christina
 Heuling, Martha
 Hewson, Martha N.
 Hext, Elizabeth
 Hiester, Catherine
 Higgs, Harriet W.
 Hill, Harriet
 Hobart, Abigail Adams
 Hobdy, Ann F.
 Hofmann, Anna
 Holden, Katharine
 Holingsworth, Mary
 Hollinshead, Mary Ann
 Holmes, Flora Virginia
 Holmes, Mrs. Christian R. (Bettie)
 Hoockey, Hannah
 Hoopes, Lydia
 Hooton, Martha C.
 Hopkins, Lucy M.
 Hortter, Amanda Malvina
 Hosmer, Elizabeth Janes
 Hough, Catharine Westcot
 Humphreys, Jane
 Hunt, Content
 Ingraham, Peggy
 Irving, Clarabelle
 Jackson, Mary
 James, Rachel
 James, Ruth
 James, Sarah H.
 Jennison, Mary
 Jones, Harriet Dunn
 Keen, Palmyra M.
 Kelly, Ann E.
 Kennedy, Mary
 Killeran, Rebecca
 Kimball, Mary Grove
 Kings, Martha Y.
 Lafon, Mary Virginia
 Laighton, Deborah
 Lancaster, Lydia
 Landes, Barbara
 Laycock, Eliza
 Lewis, Unity
 Lincoln, Eunice
 Lincoln, Martha
 Linstead, Mary
 Lippitt, Julia
 Little, Mary L.
 Locke, Ruth
 Loring, Hulda
 Low, Lucy
 Lyman, Narcissa
 Lynch, Ann
 Lyon, Sarah
 Macomber, Ann
 Malone, Mildred
 Marein, Mahala
 Marley, Mary Ann
 Marsh, Ann
 Martin, Nabby
 Meyer, Catharine
 Miles, Diana
 Miller, Mary
 Miller, Sarah Ann
 Mode, Amy
 Morrison, Catharine
 Morton, Mary
 Morton, Mary Ann
 Munro, Rebekah S.
 Munro, Sally
 Myric, Nancy
 Nenniger, Louisa
 Nichols, Hannah
 Niles, Jane
 Norton, Ann Eliza
 Paine, Diana
 Parker, Clarinda
 Parker, Temperance
 Parry, Eliza
 Paschal, Frances
 Paul, Judith
 Peck, Ann J.
 Peele, Mary Mason
 Perry, Eliza
 Pickney, Francis
 Pinniger, Abigail
 Pitman, Mary
 Platt, Lydia
 Pope, Sarah E.
 Potter, Lucy
 Price, Jane Wilder
 Purinton, Beulah
 Purintum, Abigail
 Putnam, Ruthey
 Ramsey, Margaret
 Randall, Amey
 Randall, Sarah Ann
 Reed, Dolly Hartwell
 Reese, Susannah S.
 Reid, Margaret
 Richards, Elizabeth
 Rider, Lydia
 Robinson, Faith
 Roes, Anna Eliza
 Rogers, Sarah
 Ross, Jane
 Rowland, Elizabeth
 Rugg, Lucy
 Rush, Elizabeth
 Russell, Mary
 Sacket, Harriot
 Sanders, Anna (Nancy)
 Sayre, Caroline Eliza
 Schmidt, Amalie August
 Schrack, Catharine
 Scott, Elizabeth
 Sharples, Elen T.
 Shearer, Jane
 Sheffield, Elizabeth
 Shindle, Catherine
 Silsbe(e), Sarah
 Sisson, Hannah
 Sisson, Sussanna
 Smith, LoAnn
 Smith, Rebecca
 Smith, Sophia Stevens
 Smith, Sukey Jarvis
 Smith, Susan
 Sowers, Rebecca
 Spofford, Salley
 Spurr, Polly
 Standish, Loara
 Staples, Hannah
 Stauffer, Mary Ann
 Stiles, Susan Piece
 Stivour, Sarah
 Stone, Sarah
 Sutherland, Charlotte
 Sweet, Sarah Foster
 Symme, Polly Thompson
 Taylor, Hannah
 Taylor, Sarah
 Thayer, Hannah F.
 Tillinghast, Mary
 Timberlake, Alcinda C.
 Toppan, Sarah
 Trout, Hannah
 Tuel, Sarah
 Turnbull, Eliza J.
 Turner, Polly
 Tuttle, Henrietta
 Vickery, Eliza
 Vogdes, Ann H.
 Waite, Sarah
 Waterman, Eliza
 Waterman, Sarah (Sally)
 Watson, Ann
 Weckerly, Eliza
 Wheeler, Cathrine
 Wheeler, Eveline Foleman
 Whitman, Eliza
 Whitmore, Susan
 Whitwell, Rebecca
 Williams, Mary
 Wiltz, Emilie
 Wing, Zelinda
 Winsor, Nancy
 Winterbotham, Mrs. John Humphrey
 Woodnutt, Martha
 Scenery pictures
 Tipton, Vena
 Sculptures
 Echols, Alice
 Shawls
 Goodrich, Mahala
 Show towels
 Gross, Magdalena
 Hosterman, Anna

Stenciled bedcovers
 Morton, Emily
Stitched linens
 Dille, Susann
 Kral, Kadharina
 Miller, Anna Mari
 Schaffer, Marea
Stitched poems
 Way, Rebecca
Striped woven blankets
 Winningham, Susan Elizabeth
Symbolic and religious collages
 Martin, Don "Duke"
Table mats, pillow covers
 Neal, Mr.
Tablecloths
 Ellis, Lucebra
Towels
 Root, Lucy (Curtiss)
Trapunto coverlets
 Foot, Lucy
 Phares, Mary Anne
Unidentified Type of Work
 Cochran, Hazel
Weavings
 Adam
 Adolf, Charles
 Adolf, George
 Adolf, Henry
 Aikens, James
 Akin, Phebe
 Alexander, F.M.
 Alexander, Thomas M.
 Allabach, Philip
 Ambrouse
 Anderson, Sarah Runyan
 Andrews, Fanny
 Andrews, Jacob
 Angstad, Benjamin
 Angstadt, Nathaniel
 Apodaca, Manuelita
 Ardner, Jacob
 Ardner, Michael
 Armstrong, J.H.
 Arnold, Daniel
 Artman, Abraham
 Backus, Thaddeus
 Baden, C.
 Baird, James
 Baker, Daniel, Jr.
 Baker, David
 Baker, Eliza Jane
 Baker, John
 Balantyne
 Balantyne, Abraham
 Balantyne, John
 Balantyne, Samuel
 Ball, H.H.
 Barrett
 Barth, Andrew
 Bartlet, Jerusha
 Bazan, Ignacio Ricardo
 Bazan, Joaquin
 Beck, Augustus
 Beerbower, William
 Beil, B.
 Bellman, Henry
 Bender, David
 Bennett, R.
 Bennett, S.A.
 Berry
 Bichel, W.
 Bick, John
 Biesecker, Jacob, Jr.
 Bingham, David
 Bishop, P.
 Bisset, William
 Bivenouer, M.
 Black, G.
 Black, Willaim
 Boalt, James
 Boeshor, Heinrich
 Bolton, Thomas
 Bone, Elihu
 Bordner, Daniel
 Brehm, Henry
 Brick, Zena
 Brosey, John, Jr.
 Brosey, W.
 Brown, David
 Brown, Isaac
 Brown, John
 Brown, W.W.
 Brubaker, A.
 Brubaker, Isaac
 Buchanan, Mrs. John
 Buchwalder, A.
 Bundy, Hiram
 Burkerd, Peter
 Burkhardt, P.H.
 Burkholder, Isaac
 Burns, James
 Burns, Martin
 Burrough, Mark
 Bury, Daniel
 Butterfield, J.
 Bysel, Phillip
 Calister, James C.
 Campbell, James
 Carmen, Elizabeth (Mrs. Caleb)
 Casebeer, Aaron
 Casebeer, Abraham
 Cass, David
 Cass, Nathan
 Cassel, Joseph H.
 Caswell, Zeruah Higley Guernsey
 Chappelear, Mary
 Chatham's Run Factory
 Chenne, Joseph
 Chester, Sarah Noyes
 Chew, Ada
 Christman, G.
 Clark, Jacob N.
 Cleever, John
 Cole, J.C.
 Coleman, Sarah Whinery
 Collings, S.
 Colman, Peter
 Conger, Daniel
 Conger, J.
 Conner, C.S.
 Conoly, David
 Cook, Harvey
 Cook, John
 Cooper, Teunis
 Corbin, Hannah
 Cordova, Alfredo
 Cordova, Grabielita
 Cordova, Harry
 Corick, Joshua
 Corwick, Andrew
 Cosley, Dennis
 Cosley, G(eorge)
 Cothead, Phoebe
 Coulter, George
 Covey, Harriet
 Cowam, Donald
 Craig, James
 Craig, Robert
 Craig, William, Jr.
 Craig, William, Sr.
 Cranston, Thomas
 Crossley, Robert
 Crozier, John
 Cumbie
 Danhouse, F.
 Danner, Philip
 Dannert, Henry
 Daron, Jacob
 Darrow, J.M.
 Deavler, Joseph
 Deeds, William
 Deitsch, Andrew
 Dengler, John
 Denholm, John
 Detterick, George
 Deuel, Elizabeth
 Deyarmon, Abraham
 Diller, P.
 Dorward, John
 Dorward, Joshua
 Earnest, Joseph
 Eckert, Gottlieb
 Eckler, Henry
 Eichman, Michael
 Enders, Henry
 Ettinger, Emanuel
 Ettinger, William (Henry)
 Fairbrothers, William
 Fasig, Christian
 Fatsinger, Adam
 Favorite, Elias
 Fernandez, Gilbert
 Fernberg, Samuel
 Flanigan, George
 Fleck, Joseph
 Fleck, William
 Flocher, S.
 Fogle, Lewis
 Folk, John
 Foltz, Harry
 Forry, Rudolph
 Forster, William
 France, Joseph
 Frances
 Franklin Woolen Factory
 Franz, Michael
 Frazie, J.

Fabric

Fabric (Cont.)
 Weavings (Cont.)
 French, B.
 Fritzinger, Jerret (Jared)
 G.W. Kimble Woolen Factory
 Gabriel, Henry
 Gamble, J.A.
 Garber, C.
 Garis, John
 Geb, L.R. (John)
 Gebhart, John R.
 Geller, Adam
 Gernand, J.B.
 Gernand, Jacob B.
 Gernand, W.H.
 Getty, A.
 Getty, J.A.
 Getty, James
 Getty, John
 Gibbs, John
 Gilbert, Samuel
 Gilchrist, Hugh
 Gilchrist, William
 Ginn, Robert
 Glen, Hugh
 Globe Factory
 Goebell, Henry
 Good Intent Woolen Factory
 Goodman, Daniel
 Goodman, John S.
 Goodman, Peter
 Goodwin, Harmon
 Gordon, L.
 Gottfried Kappel and Company
 Graham, John
 Gramlyg, John
 Granold, J. George
 Grape
 Graves, David Isaac
 Greenwald, John W.
 Griest Fulling Mill
 Grube, Emanuel
 Haag, Jacob
 Hain, Peter L.
 Haldeman, John M.
 Hamas, Elias
 Hamilton, John
 Hammond, Denton
 Hammond, John
 Harch, J.
 Haring, James A.
 Hart
 Hartman, John
 Hartman, Peter
 Hausman, Allen B.
 Hausman, Ephrain
 Hausman, G.
 Hausman, Jacob, Jr.
 Hausman, Jacob, Sr.
 Hausman, Solomon
 Hausman, Tilgham (Tilghman)
 Hecht, Abslam
 Heifner, J. Philip
 Heilbronn, George
 Herreter and Sweitzer
 Herrmann, Charles A.
 Hesse, F.E.
 Hesse, L.
 Hicks, Samuel
 Hinshillwood, Robert
 Hipp, Sebastian
 Hippert, Samuel
 Hoffman
 Hohulin, Gottlich
 Holland, James
 Hoover, Andrew
 Hoover, John
 Hoover, M.
 Hopeman
 Hornbreaker, Henry
 Hosfield, F
 Housman
 Howland, Lucinda
 Huber, John
 Hudders, J.S.
 Hull, Lewis
 Hull, Mathias
 Humphreys, S.
 Huntington, Edwin
 Inger, J. Fritz
 Ingham, David
 Irvin, James
 Irwin, L.
 J.S. Hogeland and Son
 Jackson, Thomas
 Jessup, James
 Jones, L.
 Kachel, John
 Kaley, John
 Kapp, Christof
 Keagy, Abraham, I
 Keagy, Abraham, II
 Keagy, John
 Keagy, Samuel
 Kean, Frederick A.
 Keifer, Louis
 Kell, D.
 Kepner, Isaac
 Kepners Woolen Mill
 Kiehl, Benjamin
 King, Daniel
 King, Joseph
 King, Martha Ellen
 Kirst, John
 Kisner and Company
 Kisner, Benedict
 Kisner, John A.
 Kittinger, John
 Klar, Francis Joseph
 Klehl, J.
 Klein, Andrew
 Klein, Francis
 Klein, Fredoline
 Klein, Michael
 Knirim, A.D.
 Kostner, J.M.
 Krebs, Philip, Jr.
 Krebs, Philip, Sr.
 Kuder, William
 Lashel
 Lashell, L.M.
 Laughlin, M.
 Lawson, David
 Le Bar, Pamela
 Lederman, Henry
 Lehr, George
 Leisey, Peter
 Leitz
 Leitz, J.
 Leopold, Valentine
 Lewis, Harvey
 Lichy, Benjamin
 Linderman, Jacob
 Lochman, Christian L.
 Lochman, William
 Long, C.
 Long, Jacob
 Long, John
 Long, John
 Lovett, Rodman
 Lutz, E.
 Lutz, Jacob
 Mackeon, Abraham B.
 Mamn, Mathias
 Manning
 March, J(ohn) H(enry)
 Marion, Edward
 Mark, Matthew W.
 Marr, John
 Marsh, J.
 Marsteller, A.
 Martin, Robert
 Masters, Margaret
 Mater, William Henry
 Maurer, Johannes
 Maurer, John
 Maus, Philip
 McCann, George
 McClellan, J.
 McKinney, James
 McLaughlin, James
 Mealy
 Meiley, Charles S.
 Mellinger, Daniel
 Mellinger, Samuel
 Mench, E.
 Menser, David
 Merkle, Alexander
 Merkle, James
 Mesick, C.
 Metzger, F.
 Meyer, Johann Philip
 Michaels
 Miller, Henry
 Miller, Levi M.S.
 Miller, Robert
 Miller, Theodore H.
 Miller, Tobias
 Money
 Moon, Robert
 Moore, Robert
 Morrey
 Moser, Jacob
 Mount Pleasant Mills
 Moyers Woolen Mill
 Muir, Robert
 Muir, Thomas
 Muir, William

Myer, P.
Myers, Elizabeth
Nagel, Philip
Nash, Matilda
Neely, Henry
Netzley, Uriah
Ney, William
Nichols, Richard
Nicklas, Peter
Noll, William
Nurre, Joseph
Oertle, Joseph
Orms
Ortega, Nicacio
Ortega, Robert James
Osbon, Aaron C.
Ott, C.
Overholt, Henry O.
Packer, J.
Patten, P.C.
Patterson, Thomas
Peck
Petna, George
Petrie
Petry, Peter
Pierce, Merrily
Pompey, L.W.
Powder Valley Woolen Mill
Prescott, Martha Abbott
Randel, Martin
Randell, Martha
Rassweiler, H.
Rauch, M.
Reed, V.R.
Reeve, Joseph H.
Reiner, Georg
Reiter, Nicholas
Renner, George
Renner, P.
Ressler, Rudolph
Rezinor, John
Rich, John
Richardson
Risser, L.D.
Roberts, Charles
Rogers, John
Rose, William Henry Harrison
Rotzel, Mathias
Rouser, Gabriel
Royer, John
Salazar, David
Salisbury, Henry
Salisbury, Mary
Satler, Lewis
Sawyer, Mrs.
Sayels, J.M.
Saylor, Jacob
Scheelin, Conrad
Schipper, Jacob
Schmeck, John
Schnee, William
Schnell, Jacob
Schrack, Joseph
Schreffler, Henry
Schriver, Jacob
Schriver, John

Schum, Philip
Schwartz, Michael
Seibert, John, Jr.
Seibert, John, Sr.
Seibert, Owen
Seifert, Andrew
Seifert, Emanuel
Seigrist, Henry
Setzer, Jacob
Shalk, Jacob
Shalk, Jacob
Shaw, Robert
Sheafer, Franklin D.
Shearer, Henry
Sherman, Jacob
Sherman, John
Shive, M.
Shotwell
Shouse, Nicholas
Shreffler, Henry
Simpson, Joseph
Singer, John
Slaybough, Charles
Slaybough, Josiah
Slaybough, William
Slothower, P.
Slusser, Eli M.
Slusser, Jacob M.
Smith, Daniel S.
Smith, John
Smith, Sarah Douglas
Snider, J.
Snider, Samuel
Snyder, Daniel
Snyder, Jacob
Snyder, John
Snyder, Mary
Speck, Johan Ludwig
Spencer, William
Sperling, Louis
Stager, Henry F.
Staley, Andrew
Staples, Waity
Staudt, Simon
Steier, W.
Stephen, Jacob
Stiebig, John
Stierwalt, Moses
Stinger, Samuel
Stohl, F.
Stoud, William
Stracke, Barnhardt
Strauser, Elias
Striebig, John K.
Strobel, Lorenz
Strunks Mill
Swan, Cyrus
Swank, J.
Sweeny, T.W.
Synder, Jacob
Talpey, J.M.
Test Woolen Mills
Thompson, George
Thompson, Ritchie
Tillman, Frances
Trappe, Samuel J.

Trujillo, John R.
Tuttle, Miss Ann
Umbarger, Michael, Jr.
Van Gordon, William H.
Varick
Vergara-Wilson, Maria
Verplank, Samuel
Vogel, August
Vogler, Milton
Wagner, John
Walhaus, Henry
Walter, Jacob
Warick, J.
Warner, Ann Walgrave
Weaver, Frederick
Weber, R.
White, Abel
Whitehead, L(iberty) N.
Whitmer, J.
Whittaker, James
Wiand, Charles
Wiand, David
Wiend, Michael
Wildin, John
Wilkison, Emily
William, Abram
Williams, H.R.
Williams, John T. (T.J.)
Williams, William T.
Wilson, Henry
Wilson, Hugh
Wilson, John
Wilson, Jonathan
Wingert, George S.
Wingert, Henry
Wirick, John
Wirick, William
Wise, H.
Wissler, John
Witmer, Jacob
Witt
Wohe, W. (Wolfe)
Wolf, Adam
Wolf, H.
Wolf, William
Wood, J.C.
Woolrich Woolen Mills
Worley, W.C.
Yardy, Christian
Yearous, Adam
Yergin, William K.
Yingst, David
Yordy, Benjamin
Young
Young, Charles
Young, Matthew
Zarn, George
Zelner, Aaron
Zoar Industries
Zufall, Moses
Weavings, coverlets
 Hay Weaving Shop
 Pearsen, J.
Weavings, linens, coverlets
 Seewald, John (John Philip)

Fabric (Cont.)
 Weavings, quilts
 Bradford, Esther S.
 Cook, Jermima Ann (Jermina)
 Wedding gowns, quilts
 Johnson, Mary Myers
 Wedding veils
 Canfield, Caroline
 Harness, Martha
 Hustace, Maria
 Moser, Lucinda Vail
 Woven and hooked bed rugs, coverlets
 Williams, Amy

Fabric, leather
 Masonic aprons
 Tisdale, Elkanah

Fabric, oil
 Mourning pictures
 Butler, Catherine
 Weavings, murals
 Jaramillo, Juanita

Fabric, paint
 Dolls
 Phohl, Bessie
 Phohl, Maggie
 Embroidered scenes
 Masters, E(lizabeth) B(ooth)
 Memorial paintings
 Ritter, Lydia
 Mourning pictures
 Coolidge, E.B.
 Eichler, Maria
 Gamble, Sarah E.
 Schuyler, Angelica

Fabric, paper
 Embroidered pictures
 Stanton, Nathaniel Palmer

Fabric, pen, ink
 Coverlets, eagle drawings
 Oberly, Henry

Fabric, pencil, embroidery
 Still life pictures
 Bishop, Sally Foster

Fabric, various materials
 Genre scene sculptures
 Cleaveland, Mrs. Mary

Fabric, watercolor
 Family arms pictures
 Putnam, Betsy
 Mourning pictures
 Creamer, Susan

Fabric, watercolor, ink
 Hooked rugs, maps
 Voohees, Betsy Reynolds

Fabric?
 Coverlets?
 Armbruster, J.
 Arnold, Lorenz
 Bagley, S.
 Baliot, Abraham
 Boardman, E.
 Brink, R.J.
 Buschong, W.F.
 Chattin, Benjamin
 Chore, L.
 Davis, E.
 Duble, Jonathan
 E. Aram Factory
 Ely, Edwin
 Ettinger, John
 Fetter, E.
 Fordenbach, E.
 French, P.
 Geret, Jacob
 Gilbert, C.A.
 Gish, S.M.
 Gotwals, M.
 Haag, Jonathan
 Hackman, L.
 Hartz, Daniel
 Hay, Ann
 Henning, A.
 Holler, J.
 Klippert, Henry
 Landis, M.A.
 Long, M.A.
 Matteson, H.A.
 McGurk, Andrew
 Moll, David
 Oberholser, Jacob
 Phillips, M.E.
 Robinson, Anson
 Satler, J.M.
 Sayler, C.
 Schum, Joseph
 Shalk, John
 Shank, M.
 Stabler, G.
 Starr, F.
 Stauffer, R.
 Stoner, Henry
 Sutherland, H.
 Sutherland, J.
 Williams, Henry T.
 Weavings?
 Andrews, M.
 Brand, D.
 C. Oppel and Company
 Hall
 Huber, Damus
 Jackson, John Hamilton
 Milroy
 Rossvilles

Felt
 Mosaics
 Thiessen, Louise Berg

Flint stoneware
 Pottery
 Horner and Shiveley

Fresco
 Landscapes
 Gilbert, A.V.
 Ornamental paintings
 Almini, Peter M.
 Cohen, Alfred
 Jevne, Otto
 Paintings
 Ackerman and Brothers
 Beckert, L.
 Gilbert, E.J.
 Smithmeyer and Company
 Swift, S.W.

Glass
 Flasks
 Ellenville Glass Works
 Pitkin Glass Works
 Stenger, Francis
 Glass works
 Amelung, John Frederick
 Birmingham Glass Works
 Cleveland Glass Works
 Ohno, Mitsugi
 Redford Glass Works
 Redwood Glass Works
 Schoolcraft, Henry R.
 Vermont Glass Factory
 Whitney Glass Works
 Glassware
 Little, Samuel
 Neon signs
 Karsner, Clark

Glass, brass
 Bottles, buttons
 Wistar, Casper

Glass, iron
 Stove plates
 Stiegel, Henry Wilhelm, Baron

Gold
 Boxes
 Hurd, Jacob
 Le Roux, Charles
 Dove pins
 Trujillo, Celestino

Gouache
 Landscape and flower paintings
 Trabich, Bertha
 Landscape paintings
 Wild, John Casper
 Paintings
 Miller, J.

Gouache on reverse glass
 Paintings
 Canfield, Abijah

Media Index | Metal

Grass
 Basket weavings
 Marta, Anna Maria
 Baskets
 Coaxum, Bea
 Foreman, Mary Lou
 Foreman, Regina

Hair
 Wreaths
 Harper, Cassandra Stone

Hardpaste
 Porcelain
 Champion, Richard

Housepaint
 Fantasy and memory paintings
 Tolliver, Mose
 Painted panels, furniture
 Darling, Sanford

Husks
 Corn husk toy
 Cleveland, Mrs.

Ink
 Mourning pictures
 Converse, Hannah
 Winkler, Matilda Amalia

Ink, linen
 Decorated handkerchiefs
 Kingsley, Mary

Ink, needlework
 Memorial drawings
 Holmes, Anna Maria

Ink, watercolor
 Family tree drawings
 Richardson, William
 Illustrated biographical essay of his community
 Miller, Lewis
 Map drawings
 Kindall, George
 Paintings
 Moskowitz, Isidore
 Portraits
 Fair, Hannah
 Religious drawings
 Otis, Daniel
 Spirit drawings
 Holy Mother Wisdom

Inked stamps
 Whale stamps
 Stinson, Henry

Iron
 Bar iron banner signs, weathervanes
 Howard, Thomas
 Howard, William
 Cast iron kettles
 Eagle Foundry
 Cast iron stove plates
 Maybury, Thomas
 Cast ironware
 Herberling
 Decorated tools
 Meninger, E.
 Fireback ironware
 Aetna Furnace
 Forks
 Eisenhause, Peter
 Gates
 Wheeler, Sam
 Hitching posts
 Nutting, Calvin, Sr.
 Pioneer Iron Works
 Inkstands
 Ives, Julius
 Iron forges
 Hansenclever, Peter
 Iron wing duck decoys
 Armstrong Stove and Foundry Company
 Ironware
 Weymouth Furnace
 Winthrop, John
 Ironware, firebacks
 Oxford Furnace
 Ironworks
 Simmons, Phillip
 Mill weights
 Elgin Windmill Power Company
 Sculptures
 Mossy Creek Iron Works
 Taylor, S.F.
 Signs
 Mangin, John A.
 Stove plates
 Barsto Furnace
 Stevenson, George
 Stove plates, ironware
 Rutter, Thomas
 Tinned sheet iron dishes
 Osmon(d), (Anna) Maria
 Tinned sheet iron toys
 Spencer, James
 Trivets
 Rimby, W.B.
 Waffle irons
 Cook, S.
 Weathervanes
 Fisher
 Gould and Hazlett
 Puritan Iron Works
 Weathervanes, cast iron tea kettles
 Savory and Company
 Wrought ironworks
 Simmons, Peter

Iron, brass
 Door latches, andirons
 King, Daniel

Ivory
 Carved canes
 Somerby, William S.
 Fantasy snuff boxes
 Johnson, Melvin
 Jewelry
 Alaska Silver and Ivory Company
 Ship models
 Anderson, Lloyd, Captain

Ivory, silver
 Belt buckles
 Fletcher, Eric

Ivory, wood
 Carved animals, boxes
 Covart, W.A.

Ivory?
 Carved canes
 Earle, James, Captain

Leather
 Boxes
 Boyd, James
 James, Boyd
 Saddles, box liners, boxes, canes
 Smart, John
 Saddles, harnesses
 Ohnemus, Matthias

Loom-art
 Scene paintings
 Dunn, Helen (Helen Viana)

Magic marker
 Paintings
 Wilkinson, Knox

Marble
 Book paperweights
 Merril, George Boardman
 Busts
 Volk, Leonard W.

Matchsticks, matchboxes, cigar boxes, leather
 Frames, lamps, wallets, purses
 Woolum, Wayne

Matte glaze on clay
 Pottery
 Taylor, W.W.

Metal
 Grills
 Esten, Edwin
 Ornamental works
 Baker, P.
 Baumann, S.
 Butler, David
 Crites, Cyrus
 Humphrey, Harrison
 Kumerle, D.
 Merrill, Henry W.

Metal (Cont.)
 Ornamental works (Cont.)
 Rohrer, P.
 Stow, John
 Patented duck decoys
 Sohier, William
 Patented duck, shorebird decoys
 Strater, Herman, Jr.
 Rifles
 Weiss, William
 Sculptures
 Clayton, Theodore
 Papio, Stanley
 Rosebrook, Rod
 Signs
 Dayton, B.
 Moore, Billy
 Sleighbells
 Barton, William
 Trivets
 Seller, James
 Weathervanes
 Ames Plow Company
 Baldwin, V.
 Berger Manufacturing Company
 Broad Gauge Iron Works
 C. Foster and Company
 C.G. Brunncknow Company
 Clark, John
 Crowell, Andrew (Andres)
 Drowne, Thomas
 E.E. Souther Iron Company
 E.G. Washburne and Company
 Gould Brothers and Diblee
 H.L. Washburn and Company
 Hallberg, Charles
 Harvey, Bill
 Hayes Brothers
 Henis, William
 Howard, J.
 J.B. and G.L. Mesker and Company
 J.E. Bolles and Company
 J.L. Mott Iron Works
 J.W. Fiske (Ironworks)
 John A. Whim
 Jonathan Howard and Company
 Joseph Breck and Sons
 Kennecott Copper Workshop
 Kenneth Lynch and Sons
 Kessler, Charles
 L'Enfant, Pierre Charles
 L.D. Berger Brothers Manufacturing
 Leibo, Jacob
 Loebig, George
 Metal Stamping and Spinning Company
 Miller Iron Company
 National Iron Wire Company
 Oakes Manufacturing Company
 Parker and Gannett
 Phoenix Wire Works
 Rakestraw, Joseph
 Reed, Kenneth
 Rice, Ernest S.
 Rochester Iron Works
 Spokane Ornamental Iron and Wire Works
 Thew, John Gerrett
 Union Malleable Iron Company
 Van Dorn Iron Works
 W.A. Snow Company, Inc.
 W.H. Mullins and Company
 Walbridge and Company
 Watkins, R.
 Western Grille Manufacturing Company
 White, Henry J.
 Whitehall Metal Studio
 Winn, John A.
 Wyllie, Alexander
 Weathervanes, brassware
 Hamlin, Samuel E.
 Weathervanes, ornamental metal works
 A.B. and W.T. Westervelt Company
 A.J. Harris and Company
 Barbee, W.T.
 Barnum, E.T.
 Bubier and Company
 Chelmsford Foundry Company
 M.D. Jones and Company
 Samuel Bent and Sons
 Samuel Yellin Company
 Yellin, Harvey
 Weathervanes, signs, ornamental metal works
 A.L. Jewell and Company
 Weathervanes, tinware
 Drowne, Deacon Shem
 Welded horses
 Merchant, Richard

Metal, oil
 Painted iron sculptures
 Alton Foundry

Metal, wood
 Cigar store Indians, figures
 Miller, Dubrul and Peters Manufacturing Company
 William Demuth and Company
 Saws
 Campbell, Larry

Metal?
 Weathervanes
 Dorendorf, D.

Mixed media
 Drawings
 Godie, Lee
 Drawings, paintings
 Podhorsky, John
 Farm scene models
 Mosher, Anna
 House designed in the form of a goose
 Stacy, George
 Sculpture, relief paintings
 Jones, Arthur

Molded clay
 Sculptures
 Thomas, James "Son Ford"

Mud, fabric
 Dolls, toys
 Descillie, Mamie

Needlepoint
 Chimney pieces
 Condy, Mrs.

Needlework
 Chimney pieces
 Bourne, Mercy
 Drawings
 Smith, Mrs.
 Firescreens
 Pears, Tanneke
 Genealogical samplers
 Fisk, Lorenza
 Headcloths
 Gerrick, Sarah
 Mourning pictures
 Bleecher, Margaret
 Portraits
 Punderson, Prudence (Rossiter)
 Samplers
 Allen, Priscilla A.
 Braidt, Frohica
 Corbit, Mary Pennell
 Marlett, Eliza Ann

Needlework, string
 Embroidered pictures
 Borkowski, Mary K.

Oil
 Altar paintings
 Fresquis, Pedro Antonio
 Altar paintings, santeros
 Gonzales, Jose de Garcia
 Animal paintings
 Wilson, Henry
 Animal portraits
 Wilson, Oliver
 Banner paintings
 E.J. Hayden and Company
 Merrifield
 Barn paintings
 Burk, Eldon
 Battle scene paintings
 Brown, David E.
 De Laclotte, Jean Hyacinthe
 Biblical scene paintings
 Plattenberger
 Boxes, overmantels, firebuckets, signs
 Eaton, Moses, Jr.
 Building portraits
 Follett, T.
 Heerlein, W.
 Whittle, B.

Media Index — Oil

Carriage paintings
 Burke, Michael
Cat paintings
 Elliot, R.P.
 Novik, Jennie
Childhood scene and genre paintings
 Lunde, Emily
Children's portraits
 Brewer
Circus banners
 Baker-Lockwood
 Bruce, Joseph
 Bulsterbaum, John
 Hill, Cad
 Johnson, Fred G.
 M. Armbruster and Sons
 Millard, Al(gernon) W. (John)
 New York Studios
 Nice, Bill
 Schell's Scenic Studio
 Sigler, Clarence Grant
 Sigler, Jack
 Wicks, Robert F. "Bobby"; "Texas"
 Wolfinger, August
 Wyatt, David Clarence "Snap"
Circus banners, frescos, signs
 Josephs, Joseph "Elephant Joe"
Circus banners, theater scenery
 O. Henry Tent and Awning Company
 United States Tent and Awning Company
Circus, theater scenes
 Sosman and Landis Company
Cityscape paintings
 Fracarossi, Joseph
 Griffin, G.J.
 Hunt, Peter "Pa"
 Kellner, Anthony
 Low, Max
 Seamen, W.
 Wilson, Thomas
Cityscape paintings, building portraits
 Schenk, J.H.
Coach, sign paintings
 Pratt, Matthew
Community scene, historical paintings, portraits
 Krans, Olof
Decorated interiors, mural scenes for houses
 Warner, J.H.
Decorated walls and floors of houses
 Price, William
Dog portraits
 Elmer, W.
Domestic scene paintings
 Dow, John
Fantasy futuristic paintings
 Maldonado, Alexander
Fantasy, landscape, genre scene paintings
 Gatto, (Victor) Joseph
Fantasy paintings
 Tourneur, Renault
Farm house paintings
 Woodward, Cordelia Caroline Sentenne
Farm scene paintings
 Ashworth, Helen
 Hildreth, Herbert L.
 Johnston, L.
 Maynard, A.E.
 Oliver, D.(W.)
 Williams, Charles P.
Fire engines, fire station art
 Betsch, M.
 Curlett, Thomas
Fire engines, hose carts, scene paintings
 Quidor, John
Fishing boat paintings
 Kent, A.D.
Genre, history, literary, landscape paintings
 Adkins, J.R.
Genre, landscape paintings
 Seymour, Samuel
Genre, memory paintings
 Hunter, Clementine
Genre paintings
 Aulont, George
 Burridge
 Covill, H.E.
 Gentilz, Theodore
 Hayes, George A.
 Hays, George
 Key, Charles B.
 Knight, T.G.
 Koch, Samuel
 Koeth, Theo
 Krimmel, John Lewis
 Lane
 McBride, Adah
 Morrill, D.
 Mulholland, William S.
 Obe
 Opper, E.
 Park, Linton
 Peck, Nathaniel
 Peters, J.
 Predmore, Jessie
 Richard, J.
 Senior, C.F.
 Stouter, D.G.
 Stucker, F.
Genre, religious paintings
 Hamblett, Theora
Genre, scene paintings
 Stark, Jeffrey
Genre street scene paintings
 Crite, Allan Rohan
Genre, symbolic paintings
 Ward, Velox
Genre, town scene paintings
 Gleason, Charles
Group portraits
 Pudor, H.
Hand painted postcards
 Sarle, Sister C.H.
Harbor paintings
 Dixon, J.F.
Harbor scene, overmantel paintings
 Edes, Jonathan W.
Harbor scene paintings
 Perkins, Horace Tidd
 Taylor, Bayard
Historical and battlescene paintings
 Sanford, M.M.
Historical and landscape paintings
 Volozan, Denis A.
Historical and still life paintings
 Boyle, M.
Historical, genre, landscape paintings
 Davies, Albert Webster
Historical paintings
 Barnes, R.
 Frost, J(ohn) O(rne) J(ohnson)
 Heeling, John
 Hillings, John
 Percel, E.
 Wallack, W.S.
House painted in patriotic colors
 Fields, Charlie "Creek Charlie"
House portraits
 Moore, Charles
 Robbins, Marvin S.
 Van Dalind, G.
House portraits, farm scene paintings
 Dousa, Henry
Imaginative scene, mythical paintings
 Lothrop, George E.
Indian ceremonial scene paintings
 Shije, Velino
Indian festival paintings
 Kabotie, Fred
Indian portraits
 Cooke, George
Interior and landscape paintings
 Munro, Janet
Interior scene paintings
 Emory, Ella
 Freeland, Anna C.
Landscape and flower paintings
 Levin, Abraham (Abram)
Landscape and historical paintings
 Bolander, Joseph
Landscape and memory paintings
 Moses, Anna Mary Robertson
Landscape, fruit, and flower paintings
 Trenholm, Portia Ash Burden
Landscape paintings
 Andrews, S. Holmes
 Bacon, Mary Ann
 Barbier, D.
 Barnum, Julia Fuller
 Bartlett, W.H.
 Basye, Joyce
 Bauman, Leila T.
 Beaver, Chief

Oil (Cont.)
 Landscape paintings (Cont.)
 Bennett, F.R.
 Blent, John
 Branchard, Emile Pierre
 Bryant, Julian Edwards
 Buck, William H.
 Carter, A.G.
 Eights, James
 Fibich, R.
 Gier, David
 Guy, Francis
 Harley, Steve
 Hidley, Joseph H.
 Hood, E.R.
 Kingsley, Addison
 Kitchen, Tella
 Labrie, Rose
 Larson, Edward
 Little, Ann
 Mark, George Washington
 McConnell, G.
 Mote, Marcus
 Mueller, Rudolph
 Northey, William, Jr.
 Plummer, R.
 Roman, D.F.
 Root, Robert Marshall
 Ruckle, Thomas
 Sabo, Ladis
 Santo, Patsy
 Sawin, J.W.
 Simpson, J.W.
 Stafford, H.M.
 Stewart, Alexander
 Sullivan, Charles
 Tanner, M.J.
 Tern, C.H.
 Thomas, Edward K.
 Walker, James L.
 Wallin, Hugo
 Warwell
 Washburn, S.H.
 West, Benjamin
 Western, A.S.
 Weston, H.
 White, John
 Wiess, J.
 Wynkoop, Emma T.
 Landscape paintings, group portraits
 Smibert, John
 Landscape paintings, portraits
 Blunt, John Samuel
 Landscape, scene paintings
 Baum, Mark
 Landscape, scene, religious paintings
 Baker, Samuel Colwell
 Landscape, still life, religious paintings
 Davis, Alfred "Shoe"
 Landscapes, genre paintings
 Crawford, Cleo
 Marine and historical paintings
 Evans, James Guy
 Marine paintings
 Osborn, B.F.
 Thresher, George
 Masonic and portrait paintings
 Hoppin, Davis W.
 Masonic paintings
 Leman, John
 Masonic, sign and ornamental paintings
 Codman, Charles
 Memory and genre paintings
 Williamson, Clara McDonald
 Memory paintings
 Boghosian, Nounoufar
 Dober, Virginia
 Rexrode, James
 Stovall, Queena
 Midwestern landscape paintings
 Tait, Arther Fitzwilliam
 Miniature paintings
 Badger, Thomas
 Clark, Alvan
 Goodwin, E.W.
 Porter, J.S.
 Miniature portraits
 Butler, Esteria
 Toole, John
 Morality paintings
 Fields, Leonard
 Murals
 Chain
 Velghe, Joseph (Father John)
 Murals, frescos pictures
 Boutwell
 Murals, paintings
 Hewes, Clarence "Charlie"
 Mystical scene paintings
 Reyher, Max
 Nature paintings
 Wilson, Alexander
 Ornamental and landscape paintings
 Badger, Stephen
 Ornamental paintings
 Avery, John
 Hall, Sylvester
 Low and Damon
 Morrison, James
 Priest, William
 Rice, Emery
 Sanford and Walsh
 Severence, Benjamin J.
 Shepard, Daniel
 Stimp
 Thayer, Nathan
 Williams, Lydia Eldridge
 Wood, Orison
 Ornamental signs, portraits
 Nelson, Mr.
 Overmantel paintings
 Jessup, Jared
 Van Cortland
 Painted boxes
 Morgan, Mary
 Painted coaches
 Little, B.

Paintings
 Aiken, Gayleen
 Ara
 Ashberry
 Badami, Andrea
 Bardick, Lewis
 Bartlett, I.
 Bauch, Stan, Dr.
 Bdogna, Frank
 Becker, Joseph
 Beckett, Francis A.
 Bennett, E.V.
 Besner, Fred M.
 Blair, Streeter
 Block, Andrew
 Bologna, Frank
 Bond, Peter Mason "PEMABO"
 Bowers, E.
 Bradbury, Gideon
 Brahm, B.
 Bronesky, S.S.
 Brown, Mary
 Brown, W.H.
 Burr, John P.
 Buttersworth, James E.
 Candee, G.E.
 Cavalla, Marcel
 Cervantez, Pedro
 Child, Thomas
 Chism, Mrs. Charles
 Choris, Louis
 Clark, Frances
 Clark, Minerva
 Cohen, F.E.
 Cohen, Gideon
 Collins, William
 Cooper, Peter
 Cortrite, Nettie (Antoinette)
 Corwin, Salmon W.
 Cover, Sallie
 Coyle, Carlos Cortes
 Crehore, S.
 Cummings, J.C.
 Curtis, H.B.
 Davis, Gwyn
 Day, Frank Leveva
 Delgado, Fray Carlos Joseph
 Dickson, W.
 Dobson
 Doolittle
 Doriani, William
 Doud, Delia Ann
 Draper, Augusta
 Duyckinck, I. Evert
 Dwyer, William J.
 Ellison, Orrin B.
 Ely, Miss
 Emerson, I.L.
 Ennin, Joseph G.
 Enos, John
 Evans, J.M.
 Ewen, John, Jr.
 Felski, Albina
 Fischer, Charles Henry
 Flanagan, Thomas Jefferson, Reverend

Fletcher, Aaron Dean
Fletcher, Alex
Foley, Nicholas
Francis, J.P.
Frouchtben, Bernard
Fryer, Flora
Gage, Nancy
Gephart, S.S.
Gerry, Samuel Lancaster
Giddings, C.M.
Gladding, Benjamin
Golder, C.H.
Goodwin, William
Gookin, William S.
Graziani, Reverend Dr.
Hadley, Sara
Haney, Clyde
Harrington, Addie A.
Harris, Harriet A.
Harrold, John "Spotter Jack"
Hart, Anna S.
Harvey, Sarah E.
Hathaway, C.H.
Hemp, Robert
Heyde, Charles Louis
Hicks, Edward
Hiler, Pere
Hirshfield, Morris
Hood, Washington
Hope, James
Hudson, Samuel Adams
Huffman, Barry G.
Hull, Lee
Hutson, Charles Woodward
Ingersoll, John Gage
Ingraham, Mary L.
Irish, Tom
Jennings, J.S.
Jewett, Frederick Stiles
Joy, Josephine
Kane, John
Kelly, W.H.
Kemp, D.
Kennedy, Terence J.
Keys, Jane
Kimball, Elizabeth O.
Kip, Henry D.
Kline, A.
Lamb, K.A.
Laskoski, Pearl
Levill, A., Jr.
Livingston, Ruth
Logan, A.
Lucas, David
Lucero, Juanita
Lustig, Desider
Lyman, H.
Mandel, A.
Margaretten, Frederick M., Dr.
Marston, James B.
May, Sibyl Huntington
McArthur, Grace
Miller, Anne Louisa
Miller, James
Moore, Nelson Augustus
Moss, Emma Lee

Norman, Charles
O'Brady, Gertrude
Perez, Mike
Pering, Cornelius
Perkins, Clarence "Pa" "Cy"
Perkins, Ruth Hunter "Ma"
Pickett, Joseph
Poe, William
Poor, Jonathan D.
Porter, Solon
Porter, Stephen Twombly
Powell, H.M.T.
Pringle, James Fulton
Raleigh, Charles Sidney
Raser, John H.
Reed, P.
Rhoads, Jessie Dubose
Roberts, Bishop
Rogers, Gertrude
Royce, Jenny
Russell, N.B.
Samuel, W.M.G.
Sandusky, William H.
Schwob, Antoinette
Shelite, L.G.
Shively, Clio D.
Sigler and Sons
Skyllas, Drossos P.
Smith, Dana
Snow, Jenny Emily
Sobel, Lillie
Steig, Laura
Sterns, E.
Stone, N.
Swift
Taccard, Patrick
Tenny, Ulysses Dow
Turner, Harriet French
Valdes, Georgio
Vanderlyn, John
Veeder, Ferguson G.
Ward, A.B.M.
Weller, Laura Elliott
Wetherby, Jeremiah W.
Wheeler, Jonathan Dodge
White, Francis
Wilder, Matilda
Willson, Sulie Hartsuck
Wirig, Nicholas
Woolson, Ezra
Young, Celestia
Zingale, Larry
Paintings, panoramas
 Blair, J.B.
Paintings, particularly of nudes
 Klumpp, Gustav
Panoramic paintings
 Banvard, John
 Christensen, Carl Christian Anton
 Gordon, Thomas Clarkson
 Lewis, Henry
 Smith, Aurelius
 Stevens, John
 Stockton, Sam
 Wimar, Karl

Pastoral scene paintings
 Call, H.
Peaceable kingdom paintings
 Prindle, F.B.
Political paintings
 Fasanella, Ralph
Portraits
 Adams, Willis Seaver
 Alden, G.
 Alden, Noah
 Allen, Edward
 Appleton, George W.
 Arnold, John James Trumbull
 Atwood, Jeremiah
 Aubry, Jean
 Aulisio, Joseph P.
 Badger
 Bancroft, G.F.
 Barnes, Lucius
 Bartlett, Jonathan Adams
 Bears, O.I. (Orlando Hand)
 Beauregard, C.G.
 Belknap, Zedakiah
 Berry, James
 Blackburn, Joseph
 Blake, E.W.
 Bonnell, William
 Bosworth, Sala
 Bounell, W.
 Boyle, Ferdinand T.L.
 Brewster, John, Jr.
 Bridges, Charles
 Bridport, Hugh
 Brooks, Newton (N.)
 Brooks, Samuel Marsden
 Brunton, Richard
 Buddington, J.
 Bunting, J.D.
 Burgum, John
 Burr, Leonard
 Bushby, Asa
 Campbell, Pryse
 Capen, Azel
 Cezeron
 Chandler, Joseph Goodhue
 Chandler, Winthrop
 Charles, the Painter
 Cobb, Cyrus
 Cobb, Darius
 Codman, William P.
 Coe, Elias V.
 Coffin, William A.
 Cole, Charles Octavius
 Cole, Joseph Greenleaf
 Cole, Lyman Emerson
 Cole, Major
 Coles, John, Jr.
 Conant, Maria T.
 Cook, Mehitable J.
 Coyle, James
 Crafft, R.B.
 Crawford, Alphia
 Curtis, Charles
 Darby, Henry F.
 Darling, Robert
 Davidson, George, Captain

Oil (Cont.)
 Portraits (Cont.)
 Dering, William
 Dobson
 Drexel, Anthony
 Drinker, John
 Drummond, Rose Emma
 Dundy, H.
 Durand, John
 Duyckinck, Gerardus I.
 Duyckinck, Gerret
 Earl, Ralph E.W.
 Eaton, J.N.
 Ellis, A.
 Elmer, Edwin Romanzo
 Elwell, William S.
 Fairfield, Hannah
 Fees, C.
 Feke, Robert
 Fenton, C.L.
 Finch, E.E.
 Fischer, Albert
 Fitch, Simon, Captain
 Fletcher
 Folsom, Clara M.
 Folson, Abraham
 Fordham, H.
 Fowler, O.K.
 French, C.
 Frothingham, James
 Frymire, Jacob (J.)
 Fuller, Augustus
 Furnass, John Mason
 Gardnier, Sally
 Gasner, George
 Gibson, Charles S.
 Gilbert, I.
 Gilbert, J.
 Gladding, T.
 Goodell, Ira Chaffee
 Goodell, J.C.
 Goodman, H.K.
 Goodwin, F.W.
 Granger, Charles H.
 Greenleaf, Benjamin
 Greenwood, Ethan Allan
 Greenwood, John
 Grinniss, Charles
 Grout, J.H.
 Hagen, Horace Henry
 Hall, George Henry
 Hamblen, Sturtevant J.
 Hamblin, L.J.
 Hamilton, Amos
 Hancock, Nathaniel
 Hanson
 Harding, Chester
 Harding, Jeremiah L.
 Hardy, Jeremiah P.
 Hartwell, Alonzo
 Hartwell, George G.
 Hering
 Herring, J.
 Herring, James
 Hesselius, Gustavus
 Hesselius, John
 Hewins, Amasa
 Hewins, Philip
 Hillyer, William, Jr.
 Hoit, Albert Gallatin
 Holman, Jonas W.
 Howard, Mary Ann Eliza
 Hoyt, Thomas
 Hubbard
 Hudson, William, Jr.
 Huff, Celesta
 Hughes, Robert Ball
 Jenkins, H.
 Jenney, N.D.
 Jennys, Richard
 Jennys, William
 Joe
 Johnson, Hamlin
 Johnson, James E.
 Johnson, Joshua
 Johnson, Mr.
 Johnston, John
 Johnston, William
 Jordan, Samuel
 King, Charles Bird
 Kittell, Nicholas Biddle
 Knight, H.
 Knipers, W.
 Kuhn, Justus Englehardt
 Lakeman, Nathaniel
 Lawrence, L.G.
 Lawson, Thomas B.
 Lewin, C.L.
 Lewis, Elijah P.
 Lincoln, James
 Lovett, William
 MacKay
 Maddov, Rance, Jr. "Bone"
 Major, William Warner
 Marchant, Edward D.
 Martens, G.
 Mason, Benjamin Franklin
 Mason, Jonathan, Jr.
 Mason, William Sanford
 Mathes, Robert
 Matthews, W.
 Mayall, Eliza McClellen
 Mayhew, Bob
 Mayhew, Nathaniel
 McFarlane, R.
 McKay
 McNaughton, Robert
 Merck, C.
 Mooers, Jacob B.
 Moore, A.E.
 Moore, Jacob Bailey
 Moron, J.
 Morris, Jones Fawson
 Moulthrop, Reuben
 Munger, George
 Negus, Nathan
 Newell, G.N.
 Nicholson, Susan Fauntleroy Quarles
 Norman, John
 North, Noah
 Nutting, Benjamin F.
 Onthank, N.B.
 Ordway, Alfred
 Osgood, Charles
 Osgood, Samuel Stillman
 Packard, Samuel G.
 Page, William
 Paine, W.
 Palmer, Ch.B.R.
 Parks, J.
 Parsell, Abraham
 Paul, Jeremiah
 Peale, James
 Pease, H.A(lanzo)
 Peck, Sheldon
 Peckham, Deacon Robert
 Phillips, Ammi
 Pimat, P. Mignon
 Pine, Robert Edge
 Plummer, Harrison
 Polk, Charles Peale
 Pollard, Luke
 Porter, John
 Powers, Asahel Lynde
 Pratt, Henry C.
 Prince, Luke, Jr.
 Rand, J.
 Reed, Reuben Law
 Richardson, Edward, Jr.
 Roberts, Marvin S.
 Robertson, George J.
 Roeder, Conrad
 Rogers, Nathaniel
 Rowe, L.K.
 Rowell, Samuel
 Rowley, R.
 Ryder, David
 Savage, A.J.
 Sedgwick, Susan
 Sheets, Frank M.
 Sheffield, Isaac
 Shipshee, Louis
 Simpson, William
 Sloan, Junius R. (John)
 Sloane, L.S.
 Smith, Edwin B.
 Smith, Roswell T.
 Smith, Royal Brewster
 Smith, Thomas, Captain
 Somerby, Lorenzo
 Southward, George
 Spear, Thomas T.
 Spencer, Frederick B.
 Stanley, John Mix
 Steere, Arnold
 Steward, Joseph, Reverend
 Stiles, Jeremiah
 Stiles, Samuel
 Stock, Joseph Whiting (M.)
 Street, Austin
 Street, Robert
 Sully, Thomas
 Sutton, W.
 Swain, William
 Taite, Augustus
 Talcott, William
 Tenney, M.B.

Theus, Jeremiah
Thompson, Cephas Giovanni
Thompson, William
Thomson, Jerome
Thomson, Sarah
Tilyard, Philip
Tolman, John (Jack)
Treadwell, Jona
Tuthill, Abraham G.D.
Utley, Thomas L.
Van der Pool, James
Van Doort, M.
Vanderlyn, Pieter
Wale, T.
Waters, Susan C.
Watson, John
Webb, H.T.
Welfare, Daniel (Christian)
Wetherby, Isaac Augustus
White, Ebenezer Baker
Wiggin, Alfred J.
Wilder, Thomas
Wilkie, John
Wilkins, James
Willard, Archibald M.
Williams, William
Wilson, E.
Wilson, Jeremy
Wilson, M.
Winstanley, William
Wright, Edward Harland
Wright, George Fredrick
Wright, L.G.
Wright, Thomas Jefferson
Young, J(ames) Harvey
Young, Reverend
Portraits, genre and cityscape paintings
 Davis, Vestie
Portraits, genre and landscape paintings
 Bahin, Louis Joseph
Portraits, landscape and still life paintings
 Canade, Vincent
 Fisher, Jonathan, Reverend
Portraits, landscape, decorative paintings
 Gullager, Christian
Portraits, landscape, mural and fresco paintings
 Corne, Michele Felice
Portraits, landscape paintings
 Bogun, Maceptaw, Reverend
 Bond, Charles V.
 Broadbent, Samuel, Dr.
 Budington, Jonathan
 Chambers, Thomas
 Frye, William
 Hathaway, Rufus, Dr.
 Nickols, Alira
 Prior, William Matthew
 Purdy, Charlie
Portraits, memory, landscape, and fantasy paintings
 Miller, Lynn

Portraits, miniatures
 Bradley, I. (John)
Portraits of children
 McLean, A.C.
 Walters, Susane
Portraits of fish, animals and people
 Alexander, Frank
Portraits, paintings
 Bundy, Horace
 Chandler, Lucretia Ann Waite
 Earl, Ralph
 Field, Erastus Salisbury
 Frink, O.E.S.
 Hazlitt, John
 Hobbs, G.W., Reverend
 Johnson, Charles M.
Portraits, paintings, signs
 Badger, Joseph
Portraits, scene paintings
 Munn
Portraits, signs
 Wales, Nathaniel F.
Portraits, signs, ornamental paintings
 Delanoy, Abraham
Portraits, still life and scene paintings
 Ingalls, Walter
Portraits, still life and landscape paintings
 Shetky, Caroline
Portraits, symbolic scene paintings
 Kennedy, William W.
Railroad paintings
 Chute, Bill
Religious paintings
 Baldwin, Frank
 Blayney, William Alvin
 Cervantes
 Kikoin, Aaron
 Miller, Anna G.
 Orr, Georgianna
Religious portraits, paintings
 Haidt, John Valentine
Religious scene paintings
 Lieberman, Harry
River scene paintings
 Medelli, Antonio
Room interior and overmantel paintings
 Eaton, Moses, Sr.
 Scott, I.
Sailboat paintings
 Lo, William A.
Scene and genre paintings
 Smagoinsky, Helen Fabri
Scene paintings
 Achey, Mary E.
 Bannon, S.S.
 Boudro(u), Alexandr(e)
 Carey, Joseph
 Isroff, Lola K.
 Keegan, Marie
 Kozlowski, Karol
 Long, H.F.
 Mader, Louis

 McIntosh, Amanda
 Mercer, William
 Smith, David H.
 Snyder, Philip
 Spencer, Harry L.
 Stanwood, A.
 Stearns, E.
 Sterling, Mary E.
 Taylor, Charles Ryall
 Villeneuve
Scenes for the America Opera Company
 Emens, Homer
 Graham, Charles
 Meaders, Caspard
 Schaeffer, William
Scenic and panoramic paintings
 Smith, John Rowson
Seascape and landscape paintings
 Ropes, George
Seascape paintings
 Cunningham, Earl
 Perry, William
 Phindoodle, Captain
Sewing boxes
 Miller, J.
Ship and harbor paintings
 Gooding, William T.
Ship and marine paintings
 West, Benjamin Franklin
Ship and scene paintings
 Smith, Joseph B.
Ship and seascape paintings
 Plummer, William
Ship, harbor scene, seascape paintings
 Lane, Fitz Hugh
Ship paintings
 Bradford, William
 Cooke, Captain
 Dannenburg, C.F.
 Halsall, William Formsby
 Jacobsen, Antonio
 Luscomb, William Henry
 Marsh, William
 Moses, Thomas P.
 Pansing, Fred
 Smith, William S.
 Stancliff, J.W.
 Williams, A.
 Wright, J(ames) H(enry)
Ship portraits
 Badger, S.F.M.
 Cluczs, H.
 Cornell, John V.
 Evans, James I.
 Johnson, R.
 Nissen, Charles
 Roath, H.A.
Ship, seascape, lighthouse paintings
 Drew, Clement
Sign and ornamental paintings
 Attwood, J.M.
 Cleveland and Company
 Cole, A.C.
 Oliver, John A.

Oil (Cont.)
 Sign and ornamental paintings (Cont.)
 White, Alexander
 Signs
 Freeland, Henry C.
 Signs, bible paintings
 Howard, Jesse
 Signs, portraits, miniatures, chaise paintings
 Sanford, Isaac
 Stenciled overmantel paintings
 Pomroy, Lucinda
 Still life, landscape paintings
 Fellini, William
 Still life, narrative historical, biblical paintings
 Pippin, Horace
 Still life paintings
 Chipman
 Francis, John F.
 Kost
 Lawrie, Alexander
 Leach, R.
 Nuttman, I.W. Isaac
 Powers, Susan
 Randall, A.M.
 Regensburg, Sophy
 Roesen, Severin
 Ronalds, Elizabeth F.
 Smith, F.E.D.
 Wagguno
 Symbolic and mystic paintings
 Newton, B.J(esus)
 Symbolic paintings
 Mitchell, Vernell
 Symbolic scene paintings
 Sullivan, Patrick J.
 Theater and sideshow scenes
 Daugherty Brothers Tent and Awning Company
 Enkeboll Art Company
 Flagg, Edwin H.
 Hoyt, Henry E.
 Mahaffey Brothers Tent and Awning Company
 Plaisted, T.J.
 Seavey, Lafayette W.
 Swift Studios
 Theater, circus, and sideshow scenes
 Voegtlin, William
 Townscape paintings
 Britton, William
 Trompe l'oeil
 Somerby, F.T.
 Village scene paintings
 Arnold, A.
 Whitney, L.

Oil, acrylic
 Historic scene paintings
 De Mejo, Oscar
 Paintings
 Esteves, Antonio
 Forbes, Jack
 Gyory, Esther
 Moment, Barbara
 Roseman, Bill
 Zeldis, Malcah
 Scene paintings
 Kane, Andy
 Still life and landscape paintings
 Miles, Pamela

Oil, acrylic, pen, pencil
 Paintings
 Middleton, Ralph

Oil, acrylic, watercolor
 Drawings, portraits, historic paintings
 McCarthy, Justin

Oil, chicken bones
 Fantasy paintings, sculptures
 Von Bruenchenhein, Eugene

Oil, collage, acrylic
 Religious and landscape paintings
 Cooper, Richard P., Reverend

Oil, crayon, pen, ink
 Cityscape paintings
 Savitsky, Jack

Oil, daguerreotypes
 Portraits
 Cabanis, Ethan T.

Oil, fabric
 Painted carpets
 Gore, John
 Killcup, George, Jr.
 S. Sweetser and Sons
 Paintings, fabric art
 Price, Janis
 Scene paintings, embroidered wool carpets
 Miner, Eliza(beth) Gratia Campbell

Oil, fresco
 Landscape and still life paintings, church frescos
 Southworth, Ella
 Landscape paintings, portraits
 Bartoll, William Thompson

Oil, housepaint
 Religious and mystic paintings
 Bochero, Peter "Charlie"

Oil, masonite
 Still life paintings
 Alberts, Sylvia

Oil, oilcloth
 Ship portraits, seascape paintings
 Crane, James

Oil on glass
 Historical paintings
 Webb, E.
 Scenes, paintings
 Bond, Milton

Oil on shell
 Portraits
 Fuller, George

Oil on tin
 Landscape paintings
 Pilliner, C.A.
 Rasmussen, J(ohn)

Oil, pastel
 Horses, fantasy drawings, scene paintings
 Lebduska, Lawrence
 Paintings
 Gibbs, Ezekial

Oil, pen
 Group portraits, drawings
 Shafer, Samuel C.

Oil, pen, ink, crayon, collages
 Biblical, fantasy drawings
 Evans, Minnie

Oil, pen, ink, pencil, watercolor
 Fracturs
 Wilder, F(ranklin) H.

Oil, stone
 Interior paintings, gravestones
 Holliman, John
 Paintings, gravestones, other stoneworks
 Johnston, Thomas

Oil, tin, copper
 Portraits, tinware, copperware
 Eicholtz, Jacob

Oil, watercolor
 Biblical, miniature paintings
 Plummer, Edward
 Landscape or genre paintings
 Spelce, Fannie Lou
 Landscape paintings
 Knapp, Hazel
 Miniatures, portraits
 Ellsworth, James Sanford
 Miniatures, portraits, paintings
 Emmons, Alexander Hamilton
 Paintings
 Hoffman, C.W. (Charles L.)
 Horner, Gustavus Richard Brown
 Willson, Mary Ann
 Portraits
 Brown, J.
 Goldsmith, Deborah (Throop)
 Mayhew, Frederick W.
 Stettinius, Samuel Enedy

Portraits, paintings
 Andrews, Ambrose
Ship paintings
 Bard, James
 Bard, John
 Robertson, John
Ship portraits, scene paintings
 Huge, Jurgan Frederick
 (Friedrick; Fredrick)
Whimsical decorated letters,
 paintings, wall murals
 Shelby, George Cass

Oil, watercolor, fresco

Ornamental paintings
 Smith, Tryphena Goldsbury

Oil, watercolor, pastel

Portraits
 Alexander, Francis

Oil, watercolor, pencil

Portraits
 Davis, Joseph H.
Scene paintings
 Litwak, Israel

Oil, watercolor, pencil, pastel

Portraits, paintings
 Harrington, Ellen T.

Oil, watercolor, velvet

Theorems, frakturs
 Ellinger, David

Oil, watercolor, wood

Cityscape paintings, portraits,
 cigarstore figures
 Hamilton, Charles J.

Oil, wood

Altar screens, paintings
 Velasquez, Juan Ramon
Chapel paintings, sculptures
 Miera y Pacheco, Bernardo,
 Captain
Painted barns, carved toys,
 sculpture
 Weiss, Noah
Portraits, cigar store Indians, figures
 Ames, Ezra
Portraits, sculptures
 Pugh, Dow (Loranzo)
Portraits, woodcuts
 Foster, John
Signs
 Andross, Chester
 Angell, Richard
 Bouve, S.R.
 Carter, J.
 Rice, William
 Richardson

Oil, wood, paint

Portraits, furniture, boxes
 Crowningshield, Hannah

Oil, wood, plexiglass

Biblical scene paintings,
 environmental, other sculptures
 Finster, Howard, Reverend

Oil, wood, terra-cotta, metal

Paintings, monotypes, woodcuts,
 constructions
 Monza, Louis

Oil?

Carriage paintings
 Waters, Samuel
Chimney board paintings
 Kidd, Joseph
Coach, sign paintings
 Wentworth, Josiah W.
Decorated wall paintings
 Mitchell, William
Frescos, ornamental, sign paintings
 Becker, A.H.
Group portraits
 Echstein, John
House, sign, ship paintings
 Marten, Richard
Indian paintings
 Drake, Samuel Gardiner
Landscape paintings
 Bender, A.S., Major
 Kleinhofen, Henry
Murals
 Paine
Nature paintings
 Moulthrop, Major
Ornamental paintings
 Cowan, Robert
 Crafts, Thomas
 Gore, Samuel
 Gray, William
Paintings
 Coppola, Alphonse
 Moorhead, Scipio
Portraits
 Clifford, Edward M.
 Davenport, Patrick Henry
Portraits, daguerreotypes
 Cooly
Portraits, miniatures
 Douglass, Robert M., Jr.
Scenes, paintings
 Ostner, Charles

Paint

Boxes
 Evans, Daniel
 Kelly, Mary F.
Carriage paintings
 Coab, Joseph
 Roosebush, Joseph
Circus banners
 Cripe, Jack "Sailor Jack"
Clock and dial paintings
 Pond, Burton
Clock faces
 Wheeler, Hulda
Decorated fire engines, hose carts
 Sully
 Woodside, John A.
Decorated mugs
 Grimm, Curt
 Riedel, A.
 Voldan, J.R.
Fantasy paintings
 Serl, Jon
Fire stations, fire station art
 Sheppard, R.H.
Floor paintings
 Winter, John
House portraits
 Lundeen, F.V.
Indian paintings
 Hall, James
Landscape paintings
 Barth, Otto
 Cridland, Charles E.
 Inman, Henry
 Kieff, John
 Kimball, H.C. and Compamy
 Tracy, G.P.
 Tracy, Simon P.
Masonic aprons, portraits
 Negus, Nathan
Memory paintings
 Thomas, Pat
Mourning pictures
 Martin, Lucy
Murals
 Hupendon, Ernest
 Schroth, Daniel, Reverend
Naval engagement, ship paintings
 Birch, Thomas
Ornamental and decorative
 paintings
 Savory, Thomas C.
Ornamental paintings
 Audin, Anthony
 Augustus, Sampson
 Booth, Thomas
 Carter, Elias
 Dresser, Harvey
 Gates, Erastus
 Johnston, John
 Liscombe, Mr.
Ornamentals
 Derby, Madame
Painted duck decoys, decorative
 duck carvings
 Ward, Lemuel T.
Painted tin toys
 Goodwin, William F.
Paintings
 Allen, Luther
 Brooks, Noah
 Egan, John J.
 Gibson, Sybil
 Loguen, Gerritt
 Samet, William

Paint (Cont.)
 Paintings (Cont.)
 Smith, E(rnest) A(rcher) "Frog"
 Portraits
 Abston, U.C.
 Bynum, B.
 Crowley, J.M.
 Hunt, Elisha
 Portraits, scene paintings
 Clark, Irene
 Religious paintings
 Wilkerson, Lizzie
 Scene paintings
 Davis, George
 Isherwood, Henry
 Rasmussen, Charles
 Sign and miniature paintings
 James, Webster
 Sign and ornamental paintings
 Mehrle, W.
 Wall murals
 McKeller, Candy

Paint, stencils
 Clock faces, panels
 Alfred, Cynthia
 Alfred, Louisa

Paint, varnish
 Ornamental paintings
 Mason, David

Paint, wood
 Coach, sign paintings
 Bull, John C.
 Signs
 Blyderburg, S.
 Burkholder, J.P.
 Janes, Alfred
 Kinstler, W.

Paint, wood, metal
 Models of airplanes and tanks, drawings
 Sowell, John A.
 Whirligigs, wind machines, paintings, drawings
 Young, John

Paint?
 Paintings
 Pickhil, Alexander
 Paintings?
 Padelford, R.W.
 Pendergast, W.W.
 Wilkins, Benjamin

Paper
 Cut-outs
 Walker, John Brown
 Hat boxes
 Higgin, Peter
 Paper works
 Crane, Margaret Smyser
 Silhouettes
 Ellis, Freeman
 Griffing, Martin
 Hankes, Master
 Honeywell, Martha Ann
 Hubard, William James
 Lindsey, Seymore S.
 Valentines
 Mai, Thomas
 Wallpaper
 Fleeson, Plunket
 Rugar, John
 Wallpaper designs
 Barkley, Hugh

Paper, watercolor
 Silhouettes, collages
 Brown, William Henry

Papermache
 Animals
 Hammond, H.W.
 Shorebird decoys
 Paine, Josiah

Pasteboard
 Matchboxes
 Sanford, Thomas
 W.M.A. Clark's Superior Friction Matches

Pastel
 Boat paintings
 Upham, J.C.
 Building portraits
 Floote, Mrs. A.A.
 Dog portraits
 Woolworth, Charlotte A.
 Drawings
 Hough, E.K.
 Howard, B.
 House portraits
 Pritchard, James
 Landscape paintings
 Guiffer, D.
 Paintings
 Rightmeyer, J.E.
 Portraits
 Berry, Jonnie E.
 Blood, M.I.
 Bullard, A.
 Conover, Henry
 Doyle, B.
 Doyle, William M.S.
 Johnston, Henrietta (Mrs.)
 Perkins, Sarah
 St. Alary, E.
 Portraits, landscape, ship paintings
 Stubbs, William P.
 Scene paintings
 Burke-Rand, Ravinia
 Still life paintings
 Bowers, J.

Pastel, crayon, pencil
 Portraits
 Bascom, Ruth Henshaw

Pastel, oil
 Paintings
 Blyth, Benjamin
 Portraits
 Williams, Micah

Pen, crayon
 Drawings
 Strokes, Willie
 Illustrated manuscripts
 Eldredge, William Wells
 Landscape drawings
 Fairman, Edward

Pen, crayon, pencil
 Building portraits
 Marcile, Stanley
 Paintings
 Tatro, Curtis

Pen, ink
 Calligraphy drawings
 Bause, K.F.
 Cronk, T.J.
 Cross, J. George
 Cummings, C.W.
 Doodles
 Joseph, Charles
 Drawings
 Babbitt, George F.
 Baldwin, S.R.
 Barber, John W(arner)
 Bouton, S.S.
 Brown, O.F.
 Brown, William
 Cox, W.A.
 Davenport, A.F.
 Dennis, S.A.
 Dennis, William
 Dyer, Candace
 Fagley, S.
 Guthrie, Woody
 Hallowell, William, Dr.
 Hansee, Willard S.
 Jewell, D.B.
 Lesueur, Charles
 Markert, Herman
 Peck, Charles
 Pierce, I.W.
 Shove, John J.
 Swift, R.G.N.
 Drawings, pages from a manuscript
 Perry, Thomas, Jr.
 Landscape drawings
 Dieter, Charlie
 Schoolcraft, Henry Rowe
 Maps
 Melish, John
 Mourning pictures
 Sprague, J.
 Penmanship, calligraphy drawings
 Brown, William Elliot
 Butler, J.B.
 Durand, Helen
 Frink, L.W.
 Goldsmith, Oliver B.

Media Index **Poster paint**

Harris, Elihu
Heyman, F.B.
Jewitt, Clarissa
Kanoff, W.H.
Martin, Emma E.
Morse, J.G.
Parmenter, N.H.
Satterlee, J.C.
Spencer, Platt Roger
Portraits
 Giles, J.B.
Religious drawings
 Reed, Eldress Polly
Sketches
 Castelnau, Francis
 Collot, George Henri Victor
 Hall, Basil, Captain
 Jackson, Anne Wakely
 Jackson, J.
 Lewis, Betsey
 Murphy, W.
 West, Benjamin
Spirit drawings
 Boler, Daniel
Whale stamp designs
 Little, Charles

Pen, ink, colored pencil
Drawings
 Johnston, Effie

Pen, ink, crayon
Drawings, paintings
 Gordon, Theodore

Pen, ink, pencil
Calligraphy
 Pringle, Sylvester R.

Pen, ink, watercolor
Calligraphy paintings
 Hamm, Lillian
Drawings
 Furnier, V.H.
 Haffly, Joseph
 Halduman, Jacob
 Rider, Peter
 Taylor, Eliza Ann
Penmanship, calligraphy drawings
 Foot, F.H.
 Reynolds, Lydia Barlett

Pen, ink, wood
Silhouettes, drawings, furniture
 King, William

Pen, ink?
Memory drawings
 Kirschbaum, Joseph, Sr.

Pen, pencil, ink, watercolors
Drawings, calligraphy
 Hersey, Joseph

Pen, wash
Drawings
 Gilman, J.F.
 Stower, Manuel

Pen, wash, pencil
Drawings
 Richards, John

Pen, watercolor
Chronological and genealogical chart
 Skeen, Jacob
Drawings
 Ammidown, C.L.
 Wright, Dean C.
Landscape paintings
 Carll, E.S.
Memorial drawings
 Schnitzler, Paul
 Wentworth, Ellen
Paintings
 Brown, George R.
 Wineland, N.W.
Portraits
 Herr, Henry
Scene drawings, portraits, mythical paintings
 Morton, Charles
Ship portraits
 Chase, Elijah
 Chase, Joseph T., Captain
 Nivelet
Whaling scene paintings
 Baker, Warren W.
 Bertoncini, John
 Clark, George S.
 Jones, Reuben, Captain
 Taylor, William W.

Pen, watercolor, oil
Paintings
 Clark, Mason

Pencil
Church portraits, drawings
 Mickey, Julius
Drawings
 Cook, G.W.E.
 Dillinham, John E.
 Halkett, A.
 Page, S.P.
 Sherman, Jesse T., Captain
 Taylor, H.M.
Genre drawings
 Gifford, M.T.
Genre drawings in a letter
 Clark, Ann Eliza
House portraits
 Bolles, John, Captain
 Stanley, William
Landscape and mythical drawings
 Halstead, Israel T.
Landscape drawings
 Howard, Rebecca F.
 Louis, C.
 Waugh, Henry C.
Portraits, sketches
 Orcott, K.V.
Sketches of Indians
 Lewis, James Otto

Pencil, brush, fabric
Needlework, crochet works
 Lewis, Flora

Pencil, crayon
Drawings
 Nathaniel, Inez

Pencil, crayon, felt tip pen
Paintings, drawings
 Tuska, Seth

Pencil, crayon, gouache
Scene drawings
 Wentworth, P(erley) M.

Pencil, crayon, ink
Religious, fantasy and idealized drawings
 Ramirez, Martin

Pencil, india ink
Folktale drawings
 Moses, Kivetoruk (James)

Pencil, pen, crayon, watercolor, gouache
Drawings
 Traylor, Bill

Pencil, pen, watercolor
Flag guide drawings
 Coleman, William, Captain

Pencil, watercolor
House and farm scene drawings
 Vogt, Fritz G.
Landscape drawings
 Beauchamp, William Millet
Ship portraits
 Akin, John F.
 Keith, Charles F.
 Luce, Shubael H.

Pewter
Mugs
 Will, William
Pewterware
 Billings, William
 Heyne, Johann Christopher
 Kirk, Elisha
Spoons
 Hedderly and Riland
 Proby, Jacob

Poster paint
Circus theme paintings
 Pry, Lamont "Old Ironside"

Poster paint (Cont.)
 Drawings of Christ
 Jackson, Henry
 Paintings
 Kurtz, Sadie

Queensware
 Pottery
 Fuller, Elijah K.

Redware
 Baptismal bowls
 Noll
 Flower pots
 Seymour, Major
 Flower pots, pottery
 Moorehead and Wilson
 Indian-head tobacco pipes
 Gibble, John
 Log cabin banks, pottery
 Bagaly and Ford
 Pottery
 A. and W. Boughner
 Adams, Henry
 Albert, Henry
 Ambrose, Frederick
 Bach, George W.
 Baecher, J.W.
 Bailey, Charles
 Baker, Thomas
 Bartleman
 Beck, Jesse
 Behn, George Peter
 Bell, John
 Bells, T.
 Bensing, Dirick
 Benson, Henry
 Bothman
 Boughner, Alexander
 Bracken and James
 Brichdel, Christian
 Brooks, Hervey
 Brown, John
 Brown, R.
 Campbell, Thomas
 Carty, John, Sr.
 Chace, L.
 Chase, Phineas
 Clark, Benjamin
 Clark, Isaac
 Clark, Peter, III
 Clark, William
 Cope, Enos
 Cross, Peter
 D.A. Sackett and Company
 Diehl, George
 Ditzler, Jacob
 Dodge, Asa
 Dodge, Jabesh
 Dodge, Rufus
 Dodge, Samuel
 Dubbs, Isaac
 Durrell, Jonathan
 Easter, Jacob
 Eberley, Jacob J(eremiah)
 Egoff, Daniel
 Eutatse, John
 Fair, Henry
 Feege and Feege
 Fisher, J.C.
 Fisher, Michael B.
 Floyd, Caleb
 Floyd, Thomas and Caleb
 Foulke
 Francisco, James F.
 Frantz, Henry
 Frederick, John
 Freeman, Thomas
 Frey, George
 Fry, John
 Ganse Pottery
 Gerbrich, Conrad
 Gilbert, Mordecai
 Gingerich, Zach
 Glaes, Abraham
 Glaes, John G.
 Glaes, William
 Goldthwaite, William
 Greiseiner Pottery
 Griffith Brothers
 Grosh Pottery
 Guldin, Mahlon
 Haas, Peter
 Harrison, Robert
 Headman, John
 Headman, Peter
 Heath, William
 Henne, Joseph K.
 Herme, Daniel
 Herrick, Robert A.
 Herstine, Cornelius
 Herstine, Daniel
 Herstine, Daniel
 Herstine, David
 Hews, Abraham
 Hildebrand, Frederick
 Hocusweiler, Jacob
 Hook, Solomon
 Horn, Samuel
 Huggins and Company
 Hume, Joseph
 Humsicker, Christian
 Hutchinson, Ebenezer
 Hutchinson, William
 Jackson, Thomas
 James Robertson and Sons
 John Vickers and Son
 Johnson and Mason
 Johnson, Joseph
 Jones, James E.
 Keeler, Benjamin
 Keller Pottery Company
 Kelly, James
 Kelly, John
 Kendall, Miles
 Kettle, Johnathan
 Kintner, Jacob
 Koontz, John
 Kraus, John
 Krause, Thomas
 Krimler, Henry
 Kuch, Conrad
 Lamson, Asa
 Leaman, Godfrey
 Leffingwell, Christopher
 Leisinger and Bell
 Link, John
 Lock, Frank C.
 Maize, Adam
 Markley, James C.
 Mayer, Joseph F.
 McCulley, John
 McKentee
 McQuate, Henry
 Medinger, William
 Mehweldt, Charles
 Mentelle, Ward, Sr.
 Miller, Andrew
 Miller, Christian
 Moll, Franklin B.
 Moll, Henry
 Mondeau, John
 Moore and Kinzie
 Morgan, Thomas
 Morrison, Ebenezer
 Muk, George
 Mullowney, Captain
 Mumbauer, Conrad
 Neff, Christian
 Neiffer, Jacob
 Neisser, Jacob
 Newtown Pottery
 Norton, John, Captain
 Nunemacher Pottery
 Nyeste, James Joseph
 Ogden, James K.
 Osborne, Amos
 Osborne, Amos, Jr.
 Osborne, Elijah
 Osborne, James
 Osborne, James
 Osborne, Johnathan
 Osborne, Joseph, II
 Osborne, Richard
 Pierce, John
 Porter, Benjamin
 Pottery in the Kloster of the
 United Brethren
 Queen City Terra-Cotta
 Company
 Ranninger, Conrad
 Reichard, Daniel
 Remmey, John, I (Johannes)
 Rieff, Christian
 Russel, William
 Sackett, Alfred M.
 Salt and Mear
 Samuel J. Wetmore and
 Company
 Sanders, John
 Saunders, William
 Schofield, William
 Schrum
 Schultz, Johann Theobald
 Scudder, Moses
 Seymour, Nathaniel
 Sharpless, Samuel
 Sherrick, David

Shutter, Christian
Singer, Simon
Smith, Thomas
Snaveley, John
Snyder, John
Snyder, John, Jr.
Souter, John
Southwick, John
Southwick, Joseph A.
Southwick, William
Specht, John G.
Spiegel, Isaac, Jr.
Spiegel, Isaac, Sr.
Stahl, Isaac
Stahl, James
Stofflet, Jacob
Stofflet, Jacob
Stone, Robert
Sullivan, Samuel
Swope, George A.
Swope, Jacob
Swope, Zuriel
Symonds, Nathaniel
Symonds, Nathaniel, Jr.
Symonds, Nathaniel, Sr.
Tarbell, William
Tarbell, William, Jr.
Tawney, Jacob
Thierwaechter, John
Thompson, John W.
Tomlinson, Lewis K.
Toomey, Helfreich
Trask, Joseph
Troxell, William
Upton, ?
Vance, Alexander
Vance, James
Vickers, Paxton
Wadhams, Jesse
Wallace, Richard
Weber, J.A.
Weidle
Whittemore, Daniel
Whittemore, Joseph
Wilcox Pottery
Wiley, Martin
Wilson, James
Wilson, Job
Wilson, Robert
York, H.F.
Pottery, especially decorative flower pots
 Moll, Benjamin Franklin
Pottery, especially toys and modeled pieces
 Henne, Daniel P.
Pottery, sgraffito plates
 Headman, Andrew
Tobacco pipes
 Eval and Zom
 Gast, Henry
 Seebold, Phillip
 Sturgis, Samuel
Vases
 Fox, Haag and Company

Redware, brownware
Pottery
 Bauer, A.J.
 Hattersley, Charles
 Martin, Moses
 Moore, Mathew
 Pottery of the Separatist Society of Zoar

Redware, brownware, stoneware
Pottery
 Wolfe, William

Redware, cream-colored ware
Pottery
 Piercey, Christian

Redware, earthenware
Pottery
 Miller, Abraham

Redware, Rockingham, white clay
Porcelain, pottery
 Beech, Ralph Bagnall

Redware, sgraffito
Pottery
 Coxe, Daniel
 Mercer, Henry C.
 Moore, Richard
 Vickers, Thomas

Redware, stoneware
Pottery
 Abraham Hews and Son
 Barr, James
 Brown, Catherine
 Brunk, David
 Caire, John P.
 Callahan, William
 Clark and Fox
 Ebey, John Neff
 Farrar, Caleb
 Groff, Joseph
 Jones, N.S.
 King, Samuel B.
 Parr, Elisha
 Stizelberger, Jacob, Sr.
 Stizelberger, William
 Ulrich and Whitfield
 Weise, James
 Woodman, Samuel

Redware, yellow-ware
Pottery
 Wagner, George A.

Redware?
Pottery
 Auer, Nicolas (Ayer)
 Brown, James
 Claesen, Dirick
 Eggen, Jacob
 Zabbart, M.

Rock
Paintings
 Little Lamb

Rock, granite
Sculptures
 Ratcliffe, M.T.

Rockingham
Pig banks, clay pipes
 Colclough, William
Pottery
 Carr, James
 J.E. Jeffords and Company
 Walker, N.U.

Rockingham, brownware
Pottery
 Harvey, Isaac A.
 Hinchco, Benjamin

Rockingham, Flint Enamel, brownware
Pottery
 Farrar, S.H.

Rockingham, yellow-ware
Pottery
 D.E. McNichol Pottery Company

Rocks, shells
Creches, decorated objects
 Short, Lillie

Sand
Paintings
 Miguelito

Sandstone
Sandstone works
 Coon, Phillip

Sandstone, paint
Sculptures
 Spencer, Lonnie

Sawdust, clay
Constructions
 Fodor, Richard L.

Scrap material
Weathervanes
 Hirsch, Cliff

Scrimshaw
Boxes
 Fletcher, Marianne

Seeds
Wreaths
 Banker, Martha Calista Larkin

Shell, ivory
Decorated boxes
 Stivers, John, Captain

Silver
Boxes
Rouse, William
Jewelry
Kinzie, John
Silverware
Smith, John E.
Spoons
Shepherd, Robert

Soot on paper
Drawings
Castle, James

Steel
Weathervanes
Norberg, Virgil

Stencils
Ornamental paintings
De Forest, J.H.
Wall decorations, paintings
Parker, Nathaniel

Stencils, frescos
Ornamental paintings
Leroy, D.

Stone
Carvings
Marshall, Inez
Reed, Ernest "Popeye"
Gravestones
Acken, J.
Adams, B.
Adams, Joseph
Adams, Joseph
Adams, Sampson
Allen, George
Allen, George, Jr.
Angell, John Anthony
Baldwin, Asa
Baldwin, Michael
Barber, Joseph
Barker, Peter
Barnard, Ebenezer
Bartlett, Gershom
Bentley, E.W.
Bickner, Sam
Bliss, Aaron
Booth, Roger
Brainard, Isaac
Brewer, Daniel
Buckland, Peter
Buckland, William, Jr.
Buell, Benjamin
Bull, John, Captain
Chandler, Daniel
Chandler, Daniel, Jr.
Chandler, William
Clark, Enos
Codner, Abraham
Codner, John
Colburn, Paul
Collins, Benjamin
Collins, Julius
Collins, Zerubbabel
Cowles, Elisha
Cowles, Seth
Crosby, William
Cushman, Noah
Cushman, Warren S.
Cushman, William
Daugherty, S.
Dawes, Thomas, Captain
Dolph, Charles
Drake, Ebenezer
Drake, Nathaniel, Jr.
Drake, Silas
Dullen, C.
Dwight, John
Dwight, Samuel
Dyer, Benjamin
Ely, John
Ely, John
Emery, L.
Emmes, Henry
Emmes, Joshua
Emmes, Nathaniel
Farrington, Daniel
Felton, Ebenezer
Fisher, Jeremiah
Fisher, Samuel
Fisher, Samuel, Jr.
Foglesong, Christopher
Foster, Hopestill
Foster, James
Foster, James, III
Foster, James, Jr.
Fowle, Robert
Fuller, Nathaniel
Gaud, John
Geyer, Henry Christian
Geyer, John Just.
Gilchrist, James
Gill, Ebenezer
Gold, Thomas
Goodwin, John
Grant, William
Grice, Elias
Griswold, George
Griswold, Matthew, Jr.
Griswold, Matthew, Sr.
Hamlin, Isaac
Hamlin, John
Hartshorn, John
Hartshorn, John
Hartshorn, Jonathan
Hartshorn, Samuel
Hartshorn, Stephen
Hastings, Daniel
Hayward, Nathan
Hempstead, Joshua
Hill, Asa
Hill, Ithuel
Hill, Phinehas
Hinsdale, Samuel
Hodgkins, Nathaniel
Hollister, W.R.
Holmes, John
Homer, John
Homer, William
Howard, A.
Hughes
Hught, E.
Humble, John
Huntington, Caleb
Huntington, John
Ingersoll, W.S.
Isham, John
Jeffries, David
Jeffries, W.P.
Johnson, Joseph
Johnson, Thomas
Johnson, Thomas
Johnson, Thomas, Jr.
Jungkurth, J.W.
Keep, George
Keid, Andrew
Kimball, Chester
Kimball, Lebbeus
Kimball, Richard
Krone, Lawrence (Laurence)
Lamb, David
Lamb, David, Jr.
Lamson, Caleb
Lamson, David
Lamson, John
Lamson, Joseph
Lamson, Joseph
Lamson, Nathaniel
Lane, Charles
Lathrop, Loring
Lathrop, Thatcher
Leighton, Ezekiel
Leighton, Jonathan
Leighton, Richard
Leonard, Barney
Locke, John
Loomis, Amasa
Loomis, John
Loomis, Jonathan
Lyman, Abel
Lyman, Noah
Manning, Frederick
Manning, Josiah
Manning, Rockwell
Manning, Samuel
Marble, John
Marble, Joseph
Marshall, John
Maxey, Levi
Meech, G.
Merrel, Peter
Metcalf, Savil
Miller, David
Mooney, J.C.
Morten, J.A.
Mulican, Joseph
Mulican, Robert
Mulican, Robert, Jr.
Mumford, William
Nash, Joseph
Neely, N.
New, James
New, James
New, John

Newell, Hermon
Noyes, Paul
Osborn, Jonathan Hand
Parham, William, Jr.
Park, James
Park, John
Park, John
Park, Thomas
Park, William
Park, William
Park, William
Phelps, Elijah
Phelps, Nathaniel
Pratt, Nathaniel
Pratt, Noah
Pratt, Robert
Price, Ebenezer
Pryce, Nathaniel
Reeves, B.
Ritter, Daniel
Ritter, John
Ritter, Thomas
Roberts, Hosea
Roberts, Jonathan
Roberts, Joseph
Roberts, Joseph
Savage, A.
Savery, Lemuel
Schenck
Sikes, E.
Smith, A.V.
Soule, Asaph
Soule, Beza
Soule, Coomer
Soule, Ebenezer, Jr.
Soule, Ebenezer, Sr.
Soule, Ivory
Spaulding, Stephen
Stanclift, James, III
Stanclift, James, Jr.
Stanclift, James, Sr.
Stanclift, William
Stebbins, Ezra
Stevens, George
Stevens, Henry
Stevens, John, I
Stevens, William
Stewart, Abner
Stewart, Jonas
Strickler, John
Sutton, E.
Sweetland, Isaac
Tainter, Benjamin
Thomson, Isaac
Tingley, Samuel
Tingley, Samuel
Tingley, Samuel, Jr.
Tinkham, Seth
Tomson, George
Tomson, Isaac
Tribbel, John
Tucker, Joseph
Vinal, Jacob
Vinal, Jacob, Jr.
Vinal, John
Walden, John, Jr.
Walden, John, Sr.
Walters, J.
Washburn, B.
Webster, Abel
Webster, Stephen
Welch, Thomas
Wheeler, Obadiah
White, William
Whittemore, Joseph
Wight, John
Wilder, James
Wilson, G.
Winslow, Ebenezer
Winslow, Ebenezer
Woods, Martin
Worcester, Jonathan
Worcester, Moses
Wright, Alpheus
Wright, Moses
Wright, Solomon, Jr.
Young, S.
Young, William
Zuricher, John
Gravestones, other sculptures
 Bedwell, Elias J.
Gravestones, other stone carvings
 M.V. Mitchell and Sons
Gravestones, other stoneworks
 Ashley, Solomon
 Boonville Marble Works
 Codner, William
 Edmonson, William
 Lamson, Joseph
 Lydon, William
 Naegelin, Charles
 Schroeder, Carl
 Seultzer, Alexander
 Stevens, John, II
 Stevens, John, Jr.
Masks
 Dibble, Philo
Monuments
 Friedlein, Paul
Sculptures
 Sherman, M.L.
Sculptures, carvings
 Marshall, David George

Stone, clay

Environmental sculpture
 Wippich, Louis C.

Stone, wood

Gravestones, sculptures, carvings
 Smith, J. Kent
Sculptures, carvings
 Tolson, Edgar
Sculptures, environmental building
 Smolak, Stanley

Stoneware

Banks
 Smith, Norman
Birdhouses
 Suttles, G.W.
Bottles
 Wheaton, Hiram
Bowls
 Harmon, P.
 Harrington
 Henderson Pottery
 Herrmann, P(eter)
 Mapp, F.T.
 Owen, M.W.
 Richter, E.J.
Bowls, sewer tile sculpture
 Knight, Maurice A.
Churns
 Brannan, Daniel
 Clark and Lundy
 Doane, George
 Ideal Pottery
 Kline, Charles S.
 Meaders Pottery
Churns, pitchers
 Rushton, Joseph
Doorstops
 McDade Pottery
Doorstops, pottery
 Grand Ledge Sewer Pipe Factory
Elaborate jugs
 Hall, E.B.
Free modeling of whimseys, including snakes
 Wilbur, A. E.
Hunting horns, churns
 Grindstaff, William
Jars
 Auman, Fletcher
 Boggs Pottery
 Brown and Crooks
 E. Swasey and Company
 Fox, H.
 Fox, N.
 Goodwin, Webster
 Hunt, John
 Melcher, H.
 N.A. White and Sons
 Nixon, N.H.
 Seagle, Daniel
 Sonner, S(amuel) H.
 Torbert and Baker
 Unser, C.
 Weir
 Wilbur, C.
Jars, bowls
 Rhodes, Collin
Jars, bowls, pots
 Suttles, I.
Jars, jugs
 Thomas, I.
Jars, mugs
 Saenger, William
Jars, pitchers
 Rheinhardt, Enoch W.
Jugs
 Braun, C.W.
 Cogburne and Massey
 F.T. Wright and Son
 F.W. Weeks
 H. Wilson and Company

Stoneware (Cont.)
 Jugs (Cont.)
 Hann, W.F.
 Hartsoe, Sylvanus
 J. and E. Norton
 Jaegglin, E.A.
 Jones, Evan R.(B)
 Jugtown Pottery
 Knox, W.C.
 M. Tyler and Company
 Meyer Pottery
 Minnesota Stoneware Company
 Ottman Brothers and Company
 Ownby, Thomas
 Pottersville Community
 Schrap, W.J.
 Southern Pines, N.C.
 Star Pottery
 Stuckey, Martin or Upton
 Wallace and Gregory Brothers
 Werrbach, L.
 Wilson, John M.
 Wrenn Brothers
 Jugs, flasks
 Cornwall
 Jugs, pitchers
 Chandler, Thomas
 Kegs
 L. and B.G. Chase
 Mugs
 Robinson Clay Products
 Piggy jugs
 Texarkana Pottery
 Pitchers
 Byrd Pottery
 Hilton Pottery Company
 J. Swank and Company
 Loy, M.
 N. Clark and Company
 Prothro Pottery
 R. Clark and Company
 Rochester Sewer Pipes
 San Antonio Pottery
 Wright, Franklin
 Pitchers, jugs
 Leopard, John
 Planters
 Summit Sewer Pipe Company
 Pottery
 A.A. Austin and Company
 A.J. Butler and Company
 A.L. Dyke and Company
 Abbe, Frederick
 Adam States and Sons
 Akron Pottery Company
 Alanson Lyman & Declus Clark
 Albany Stoneware Factory
 Amos, William
 Anderson, William A.
 Anna Pottery
 Atcheson, D.L.
 Atcheson, H.S.(R.)
 Atlantic Garden
 Atwater, Caleb
 Atwater, Joshua
 Auber, P.
 Bagnall, George
 Bakewell, H.N.
 Ballard, A.K.
 Barnabus Edmonds and Company
 Batchelder Pottery
 Bauders, F.
 Becting Brothers
 Beecher and Lantz
 Belding, David
 Bell, Joseph
 Berg's Mill
 Berresford, Benjamin
 Binkley, George
 Bissett, Asher
 Bluebird Pottery
 Bodenbuhl, Peter
 Bodine, J.
 Boerner, Shapley and Vogt
 Boone, Benjamin
 Boone, J.G.
 Boone, Thomas E.
 Booth Brothers
 Boss Brothers
 Boston Pottery Company
 Bosworth, Stanley
 Bower, George
 Bowne, Catherine
 Boynton
 Boynton and Farrar
 Brewer, J.D.
 Brickner, John
 Briggs, John H.
 Bromley, William
 Broome and Morgan
 Brower, J.F.
 Brown and McKenzie
 Brown Brothers
 Brown, S.H.
 Bruer, Stephen T.
 Buchanan, Thomas
 Bullard, Joseph O.
 Bullock, W.
 Burchfield, A.N.
 Burger, John
 Burgess, Webster and Viney
 Burley, John
 Burley, Lazalier
 Burns, W.F.
 Burton, John
 Bybee Pottery
 C(harles) Hart and Company Pottery
 C. Boynton and Company
 C. Dillon and Company
 C. Webster & Son
 Caire Pottery
 Caire, Frederick J.
 Camp Cook and Company
 Campbell, Justin
 Canfield
 Capron, William
 Carlin, John
 Carlyle and McFadden
 Carpenter, Frederick
 Central New York Pottery Company
 Chamberlain, C.B.
 Chapman, J(osiah)
 Charlestown Massachusetts Pottery
 Christopher Potts and Sons
 Clark and Company Pottery
 Cleveland, William
 Clough, Calhoun and Company
 Cochran, Robert
 Cole Pottery
 Columbian Pottery
 Commeraw's Pottery
 Congress Pottery
 Cook and Richardson
 Cooper, Thomas
 Cordrey, Isaac
 Cowden and Wilcox
 Cowles, Calvin
 Crafts, Caleb
 Crafts, Edward A.
 Crafts, Martin
 Crafts, Thomas
 Craig, Burlon
 Craven, John A.
 Craven, Thomas W.
 Cribbs, Daniel
 Cribbs, Peter
 Crisman, W.H.
 Crock, Charles
 Crolius, Clarkson, II
 Curtis Houghton and Company
 D.G. Schofield and Company
 Danas, John
 Darrow, John
 Decker, Charles F.
 Deval and Catterson
 Dick, Jacob
 Dillon and Porter
 Donahue Pottery
 Donaldson, Hugh
 Donkle, George
 Donnahower, Michael
 Dorchester Pottery Works
 Dunn, Ezra
 Dunscombe, Hannah
 E. Norton and Company
 Eagle Pottery
 Eagle Pottery
 Eaton, Jacob
 Edward Selby and Son
 Eichenlaub, Valentine
 Eichert, Peter
 Elverson and Sherwood
 Emsinger, A.
 Enterprise Pottery Company
 Euler and Sunshine
 Evans Pottery
 F.J. Knapp
 Fallston Pottery Company
 Farrar and Stearns
 Farrar, Ebenezer L.
 Farrar, Isaac Brown
 Farrington, E.W.
 Fayette, Shavalia

Fenton and Hancock
Fenton, J.H.
Fenton, Jacob
Fenton, Jonathan
Fenton, Richard L.
Fenton, Richard Webber
Fenton, T.H.
Figley, Joseph
Fish, C.
Fisher and McLain
Fisher and Tarr
Fisher, J(acob)
Fisher, John
Fisher, Thomas
Fiske and Smith
Fleckinger, Jacob
Foel and Ault
Fort Edward Pottery Company
Fossbender, N.
Fowler and McKenzie
Fox, E.S.
Fox, Harmon
French, Eben
Fullerton, Hugh
Furman, Noah
G. Adley and Company
Gay, Amos
Geddes Stoneware Pottery
 Company
Gerstung, John
Getz
Gideon Crisbaum and Company
Glassir and Company
Glazier, Henry
Glenn and Hughes
Glenn, William
Goodale, Daniel, Jr.
Goodwin, Harvey
Goodwin, Horace
Goose Lake Stoneware
 Manufacturings Company
Gordy Pottery
Gossett, Amariah
Grace, Daniel
Greble, Benjamin
Green, Adam
Green, Branch
Greenland, N(orval) W.
Grommes and Ulrich
Gruenig
Haig, Thomas, Sr.
Hall, Amos
Hallam, David
Hamilton and Jones Pottery
Hamilton Brothers
Hamilton, Clem
Hamilton, James
Hamilton, W.L.
Hamlyn, George
Hamlyn, George, II
Hancock, John
Hancock, William
Hanford, Isaac
Hanlen, Bernard
Harmon, Christian
Harrington, Thomas

Harris, James
Harris, Thomas
Harris, W.P.
Harrison, C.R.
Harrison, Fielding T.
Hart, James
Hastings and Belding
Hathaway, Charles E.
Havens, Samuel
Havins, N.
Haxstun and Company
Heighshoe, S.E.
Henry Pettie and Company
Henry, Jacob
Hewett, Isaac
Higgins, A.D.
Hill, Foster and Co.
Hill, Merrill and Company
Hill, Powers and Company
Hiram Swank and Sons
Holden, Jesse
Hopkins, John
Hosmer, Joseph, Captain
Houghton, Edwin
Houghton, Eugene
Hubbell and Cheseboro
Hubbs, W.W.
Hughes, Thomas
Humistown and Walker
Hyssong, C.B.
I.M. Meed and Company
I.W. Craven and Company
Iliff, Richard
Ingell, Jonathan W.
J. Clark and Company
J. Sage and Company
J.A. and L.W. Underwood
J.M. Burney and Sons
Jager, Joseph
Jenkins, A.
John Frell and Company
Johnson and Baldwin
Johnson, John
Judd, Norman L.
Keith, Charles W.
Kendall, Loammi
Kendall, Uriah
Kier, S.M.
Kirkpatrick
Kirkpatrick, Alexander
Kirkpatrick, Andrew
Knapp, F.K.
Koch
Krager, C.L.
Lambright and Westhope
Lamson and Swazey
Landrum, Amos
Landrum, L(ineas) M(ead)
Lathrop, Charles
Leathers, John B.
Lehman, Louis
Lent, B
Leopard, Thaddeus
Lessel, George
Lessel, Peter
Letts, Joshua

Lewis and Cady
Lewis and Gardner
Lewis, O.V.
Lewis, W.A.
Link, Christian
Long, J.H.
Ludon and Long
Lyons Pottery
MacKenzie
Macomb Pottery Company
MacPherson, E.E.
Macumber and Van Arsdale
Madden, J.M.
Mantell, James
Mantell, Thomas
Markell, Immon and Company
Marshall Pottery
Martin, Adam E.
Martin, E.G.
Martin, John L.
Marx, John
Mason and Russell
Massilot, L.
Mathis, Robert
Mayers, W.S.
McCarthy Brothers
McChesney, Andrew
McComb Stoneware Company
McConnell
McKenzie Brothers
McLuney, William
McMillan, J.W.
Meade, S.
Melleck, H.H.
Merrill Powers and Company
Merrill, Calvin
Merrill, Edwin
Merrill, Edwin H.
Merrill, Henry E.
Metzner, Adolph
Meyers, E.W.
Miller, B.C.
Miller, J.
Miller, M.
Miner, William
Misler Brothers
Mitchell, H.R.
Mitchell, James
Monmouth Pottery Company
Monroe, J.S.
Mooney, D.
Mooney, Michael
Moore, Alvin S.
Mootz
Morgan, David
Morgan, James
Morgan, James, Jr.
Morton and Sheldon
Myers and Hall
Myers, Baird, and Hall
Myers, E.W.
Nash, F.M.
Nash, G.
Nash, H.
Nathan Clark Pottery
Navarre Stoneware Company

Stoneware (Cont.)
 Pottery (Cont.)
 New York Stoneware Company
 Nichols and Alford
 Nicomb
 Norton and Fenton
 Norton and Hancock
 Norton, Luman P.
 O'Connell, R.
 Odom and Turnlee
 Ohio Stoneware Company
 Olevett, Charles
 Oliver, C.K.
 Onondago Pottery Company
 Orcutt and Thompson
 Orcutt, Eleazer
 Orcutt, Humiston, and Company
 Orcutt, Stephen
 Orcutt, Walter
 Packer, T.A.
 Parker, Grace
 Parr, David
 Parr, James L.
 Perrine, Maudden
 Perry, Sanford S.
 Pewtress, John B.
 Philles
 Phillips, Moro
 Pierce, Augustus
 Pierson and Horn
 Pierson, Andrew
 Pitkin, Richard
 Plaisted, F.A.
 Pohl, Joseph
 Pottman Brothers
 Price, Abial
 Price, G.
 Pruden, John M., Jr.
 Purdy, C.
 Purdy, Fitzhugh
 Purdy, Gordon B.
 Quinn, E.H.
 Read, Thomas
 Reay, Charles
 Red Wing Pottery
 Reems Creek Pottery
 Remmey and Burnet
 Remmey, Henry, I
 Remmey, Henry, II
 Remmey, Henry, III
 Remmey, John, II
 Remmey, John, III
 Remmey, Joseph Henry
 Remmey, R(ichard) C(linton)
 Reynolds
 Rhodes, T.
 Rice, Prosper
 Rich
 Richey and Hamilton
 Riggs, Wesley
 Risley, George L.
 Robbins (Mrs.) and Son
 Roberts, William
 Rogers Pottery
 Rosier, Joseph
 Rothrock, Friedrich
 Rowley Pottery
 Royer, A.
 Russell Pottery
 S.L. Stroll and Company
 Sackett, David A.
 Samuel Dyke and Company
 Sandford, Peter Peregrine
 Saterlee and Mory
 Sawyer and Brothers
 Schenefelder, Daniel P.
 Schenkle, William
 Schrieber, John
 Scott, Alexander F.
 Scott, George
 Seaver, John
 Seaver, William
 Seaver, William, Jr.
 Seavey, Amos
 Selby, Edward
 Seymour and Bosworth
 Seymour and Stedman
 Seymour, George R.
 Seymour, Israel
 Seymour, Orson H.
 Seymour, Walter J.
 Shank, William
 Sheldon, F.L.
 Shepard, Joseph, Jr.
 Shepley and Smith
 Sherwood Brothers Company
 Shorb, Adam A.
 Shorb, Adam L.
 Shorb, J., Jr.
 Simms, N.M.
 Slater, Alfred
 Smith, A.
 Smith, Asa E.
 Smith, H.C.
 Smith, H.S.
 Smith, Hezekiah
 Smith, J(oseph) C.
 Smith, J.W.
 Smith, P.H.
 Smith, W(ashington)
 Smith, Willoughby
 Smithfield, Ulrich
 Smithingham, George
 Smyth, Joel
 Snyder, Henry
 Somerset Pottery
 Somerset Pottery Works
 Sowers, H.
 Spafford and Richards
 St. Louis Stoneware Company
 Standish, Alexander
 Starkey and Howard
 States, Adam
 States, Peter
 States, William
 Stedman, Absalom, and Seymour
 Stevens Pottery
 Stevens, Joseph P.
 Stofer, L.D.
 Stout, Francis Marion
 Stout, Samuel
 Straw, Michael
 Sudenberg, Otto N.
 Sunderland Knotts and Company
 Swan and States
 Synan, Patrick
 Synan, William
 Syracuse Stoneware Company
 T. Sables and Company
 Taft, James Scholly
 Thomas D. Chollar
 Thomas, J.R.
 Thompson Pottery
 Thompson, Greenland
 Titus, Jonathan
 Tourpet and Becker
 Tracy, Andrew
 Tracy, John B.
 Tracy, Nelson
 Trapp and Chandler
 Tupper, C.
 Turley Brothers
 Tyron, Wright and Company
 Union Pottery
 United States Stoneware Company
 Van Schoik and Dunn
 Van Winckle, Jacob
 Van Winckle, Nicholas
 Van Winkle Pottery
 Vandemark, John
 Vaupel, Cornelius
 Vickers, Monroe
 W. Lundy and Company
 W.B. Allison and Company
 W.H. Rockwell and Company
 Wait and Ricketts
 Wait, Luke
 Warne and Letts Pottery
 Warne, Thomas
 Warner, William E.
 Warwack, Isaac
 Washington Stoneware Company
 Watson, J.R.
 Weaver, James L.
 Webster, Elijah
 Webster, Mack
 Weeks, Cook and Weeks
 Weise, Henry
 Welker, Adam
 Weller, Samuel
 Wells, Ashbel
 Wells, Crafts, and Wells
 Wells, Joseph
 Wells, S.
 West Troy Pottery
 West Virginia Pottery Company
 Western Stoneware Company
 White and Wood
 White, Noah
 White, William
 Whiteman, T.W.
 Whitman, J.M.
 Whitman, Robinson and Company
 Whittemore, R.O.
 Wiemer and Brother
 Willard and Sons

William A. Macquoid and
 Company, Pottery Works
William Burroughs
William H. Farrar
Williams and McCoy
Williams and Reppert
Winfel, R.
Wingender, Charles, Jr.
Wingender, Charles, Sr.
Wingender, Jakob
Winslow, J.T.
Winslow, John T.
Woolworth, F.
Wores, H.
Works, Laban H.
Worthen, C.F.
Wright, Alexander
Yates, H.H.
Young, Samuel
Zanesville Stoneware Company
Zipf, Jacob
Pottery, fanciful jugs
 Kirkpatrick, Wallace (V.)
Pottery, sewer tile sculpture
 Camp and Thompson
 Stoneware and Tile Company
Sculptures
 Boughner, Daniel
 James, D.C.
Tobacco pipes
 Merrill, Earl
Vases
 Eli La Fever Pottery
 Owen, J.B.

Stoneware, brownware

Pottery
 Fenton, L(eander) W.
 Goodwin and Webster
 Harley Pottery
 Hedicaugh, William
 Howard and Son
 Ochsle, John
 Ochsle, Phillip T.
 Russell, D.W.

Stoneware, clay

Jugs, pottery
 Cushman, Paul
Pottery
 Crolius, William
 Peoria Pottery Company
 Pfaltzgraff Pottery
 Purdy, Solomon
 Quigley, S.
 Risley, Sidney
 Rogers, William
 Wagoner Brothers
 Woodruff, Madison
Punchbowls, pottery
 Crolius, John

Stoneware, redware

Pottery
 Brayton Kellogg and Doolittle
 Ebey, George
 Economite Potters
 Fulper Brothers Pottery
 Krumeick, B.J.
 L. Norton and Sons
 Linton, William
 Mead, Abraham
 Pruden, John
 Reiss, William

Stoneware, Rockingham

Pottery
 Fenton, Christopher Webber

Stoneware, sewer-pipe

Pottery
 Hill and Adams

Stoneware, terra-cotta

Pottery
 Portland Stoneware Company

Stoneware, yellow-ware

Pottery
 Hancock, John
 Norton, Julius

Straw

Baskets
 Folger, R.
 Mackosikwe (Mrs. Michele Buckshot)
Inlaid candle holders, crosses
 Tapia, Star

Tempera

Cityscape paintings
 Cerveau, Joseph Louis Firman (Fermin)
 Contis, Peter A.
Paintings
 Persac, Adrien
Panoramic paintings
 Purrington, Caleb B.
 Russell, Benjamin
Portraits
 Cortwright, J.D.

Tempera, gesso

Paintings
 Molleno

Tempera on tin

Paintings
 Brett, Lady Dorothy

Terra-cotta

Pottery
 Rogers, John

Terra-cotta, redware

Pottery
 Jones, George

Tin

Candlemolds
 Phenstein, W.A.
Cheesemolds, tinware
 Troyer, William
Coffee pots
 Eubele, M.
 Gilberth, J.H.
Coffee pots, tinware
 Ketterer, J(ohn) B.
 Uebele, Martin
Cookie cutters
 Fretzinger
 Gill
 Smith, Will
Decoys
 Sheboygan Decoy Company
Foot stoves
 Loveland, Elijah
Japanned tinware
 Barber, Betsy
 Burch, John
 Dobson, Isaac
 Gridley, R.
 Guernsey, James
 Howell, Elias L.
 Hubbard Girls
 Lewis, Ira
 Mitchell, Almira
 Mygatt, Hiram
 Wilcox, Hepzibah
 Willcox, Marcy
 Williams, Abigail
Lamps
 Cornelius, Robert
 Green, Charles E.
 Grist, Thomas
Lamps, candlesticks
 Lengfelder, Balthasar
Lanterns
 G.V. Keen and Company
 Langston, Thomas
 Schaaf, Henry
Ornamental tinware
 Hillard, E.
 Venter, Augustus
 Westwood, William H.
Painted tinware
 Bennett, Mrs.
 Blake, S. and J.
 Brewster, Elisha C.
 Brown, Sally
 Brown, Samuel
 Curtis, Anne
 Francis, Edward
 North, Mercy
 Parsons, Polly
 Tuller, M.
 Upson, Sarah Greenleaf
Spice boxes
 Dreese, Thomas
Stencils
 Scripture, George
Tin roof ornaments
 Scheffer, Richard

Tin (Cont.)
 Tinder boxes
 Ives, Ira
 Tinder boxes, scoops
 Metcalf, Edward
 Tinware
 Ahrens, Otto
 Ald, Henry
 Alfred, Nabby
 American Tea Tray Works
 Andrews, Asa
 Andrews, Burr
 Andrews, H.
 Angstad, E.
 Babb, Conrad
 Bacon, Nathaniel
 Bailey, Abner
 Baker, Joseph
 Balsh, Conrad
 Barber, James
 Barber, Titus
 Barnes, Blakeslee
 Barnes, Edward
 Barrett, Edward P.(T.)
 Barth, Louis
 Bartholomew, Jacob, Jr.
 Bartholomew, Samuel
 Beckley, John
 Beeman, S.
 Belden, Aziel
 Belden, Joshua
 Belden, Sylvester
 Benton, Jared
 Bidwell, Titus
 Bierman, Fred
 Bigger, Peacock
 Bingman, Samuel Harrison
 Bingman, Yost
 Bishop, Nathaniel
 Bishop, Uri
 Black, Daniel (David)
 Black, James
 Blakeslee Stiles and Company
 Boas, Jacob
 Booth, Salmon
 Boschert, Bernard
 Bradford, Joseph
 Bradley, Thomas
 Brady, Hiram
 Briggs, Amos
 Briscoe, Thomas "Ol' Briscoe"
 Bronson, Asahel
 Bronson, Oliver
 Bronson, Samuel
 Bronson, Silas
 Brown, Joseph, Jr.
 Brown, Moses
 Buckley, Justus
 Buckley, Mary Ann
 Buckley, Moses
 Buckley, Oliver
 Buckley, Orrin
 Buckley, William, Jr.
 Buckman, John
 Bulkeley, George
 Burr, Jason
 Buschman, Frederick
 Butler, Aaron
 Butler, Abel
 Butler, Ann
 Butler, Marilla
 Butler, Minerva (Miller)
 Butler, Thomas
 Butler, Thomas C.
 Butler, W. and L.
 Butler, William
 Byrne and Kiefer Company
 Camp, Emily
 Camp, Lucy
 Carson, William
 Carter, Thomas
 Case, T.
 Chalker, Walter H.
 Clark, Charles
 Clark, Elisha
 Clark, Nathaniel
 Clark, Patrick
 Clark, Samuel
 Clarke, S.S.
 Clarke, Warren
 Cloister, Ephrata
 Commiller, Lewis
 Corrigan, William
 Cotton, Shubael Banks
 Cowles, Josiah
 Crane, Harry
 Cross, J.E.
 Curtis, Daniel
 Curtiss, H.W.
 Dash, John Baltus
 Davis, S(amuel)
 Day, Nathan
 Degenhardt, Henry
 Delgado, Francisco
 Deming, Horace
 Deming, Luther
 Deshon, Thomas
 Dickinson, Russel
 Drinkhouse, John N.
 Drinkhouse, William H.
 Dunham, John
 Dunham, Solomon
 Dyer, Henry
 Eddy, Jesse
 Eicholtz, George
 Eicholtz, Leonard
 Elderkin, E.B.
 Elliot, John
 Elliot, Nathan
 Endriss, George
 Eno, Reuben
 Erbest, John
 Esterbrucks, Richard
 Eveling, Frederick
 Filley, Augustus
 Filley, Giles
 Filley, Harvey
 Filley, Jay Humphrey
 Filley, Marcus Lucius
 Filley, Oliver
 Filley, Oliver (Dwight)
 Finchour, Joseph
 Fischer, Charles
 Flanagan, John
 Florys, William
 Foot, Lewis
 Foote, Lewis
 Frazer, Thomas
 French, Asa
 Frisbie
 Fry, John
 Gale, F.A.
 Gilbert, Daniel
 Gilbert, David
 Gminder, Gottlieb
 Goodrich, Asahel (Asohet)
 Goodrich, Ives and Rutty Co.
 Goodrich, John J.
 Goodrich, Samuel
 Goodrich, Seth
 Goodrich, Walter
 Graham, Francis
 Graham, John
 Griffith, Thomas
 Gross, William
 Hall, Joseph P.
 Harrington, Lyman
 Haywood, Thomas
 Hennis, John
 Henrie, John
 Heye, Frederick
 Hill, George
 Hoffman, William
 Holmes, Allen E.
 Holmes, Eleazer
 Hooker, Asahel
 Hooker, Bryan, Captain
 Hooker, Ira
 Horn, John
 Horsfield, Israel
 Hubbard and Root
 Hubbard, Enoch
 Hubbard, John
 Hull and Stafford
 Humphrey, Hiram
 Isaac Smith and Thomas Lee
 Jabez Peck and Company
 Johnson, Alfred
 Johnson, Zachariah
 Keller, Conrad
 Kelsey, Samuel
 Kempton, Samuel
 Kentz, Joseph
 Kepner, William
 Killens, B.
 Kilsey, Edward A.
 Kingsbury, Mary
 Kirtland, James
 Klingman, C.L.
 Kreider, Albert M.
 Kreider, Maurice (Morris)
 Lamb, James
 Lamb, Lysis
 Langdon, Barnabas
 Larkin
 Lathrop, James S.
 Lawrence, Sherman B.
 Lebkicker, Lewis

Lee, Jared
Lewis, A.N.
Lewis, Erastus
Lewis, Isaac
Lewis, Patrick
Lewis, Seth
Little, Joseph K.
Loercher, Everett R.
Loercher, Ronald
Logan, James
Lorenz, Frederick
Lowery, Daniel
Maertz, Charles
Marrott, Ted
Martin, John
Martin, William
Martinez, Angelina Delgado
McMinn, Charles Van Lineaus
Merriam, Lawrence T.
Messenger, Charles
Miller, Joseph
Minkimer, Frederick
Mitchell and Manross
Mitchell, Thomas
Mitchell, William Alton
Moore, Cyrus
Morse, Alvin
Morse, Asahel
Muensenmayer, Jacob
Naugle, James
Neumann
Newell, Isaac
North, Abijah
North, Alfred (Albert)
North, David
North, Elijah
North, Jedediah
North, John
North, Lemuel
North, Linus
North, Lucinda
North, Seth
North, Silas
North, Simeon
North, Stephen
Northford's Shop
Norton, Ezra
Norton, Samuel
Norton, Zachariah
Nott, Zebedee
Noyes, Morillo
Paine, Nelson
Parsons, Eli
Passmore, Thomas
Pattison, Edward
Pattison, Edward, Jr.
Pattison, Luther
Pattison, Samuel
Pattison, Shubael
Pattison, William
Peck, Asahel
Peck, David
Peck, Pattison and Company
Peck, Seth
Philips, Solomon Alexander
Phinney, Gould

Plum, Seth
Plumb, Seth
Pomeroy, Charles
Pomeroy, Noah
Pond, Edward L.
Porter, Abel
Porter, John
Porter, Moses
Purchasem, Mark
Putnam, N.B.
Quade, Julius
Quinn, John
Raiser, Jacob
Redman, Richard
Redman, Thomas
Reed, Luke
Reichter, Frederick
Resser, William W. "Will"
Rhodes, Daniel
Rich, John
Richardson, Francis B.
Ridley, Mary
Rising, Lester
Robbins, Lewis
Roberts, Candace
Romero, Emilio
Romero, Senaida
Root, Lewis
Root, William
Rose, Philip
Roseumen, Richard
Ross, Calvin
Rowley, Jacob
Rowley, Philander
Roybal, Maria Luisa Delgado
Saalmueler, Peter
Schnure
Shade, J.
Shade, P.
Shade, Willoughby
Shepherd, Miss
Silloway, Samuel
Slade, John
Smith, Henry E.
Smith, Joseph C.
Smith, Samuel
Smith, Thomas
Smith, William
Snell, Charles K.
Snell, John L.
Speakman, Joseph
Squires, Ansel
Squires, Fred
Stedman and Clark
Steele, Horace
Stern, S.
Stevens, Alfred
Stevens, Samuel
Stoner, Albert
Stoughton, Jonathan
Stow, O.W.
Strickland, Simon
Thompson, James A.
Thompson, Major
Thomson, William
Tisdale, Riley

Truman, James
Tryon, George
Turner, Edward
Upson, (James) Salmon
Upson, Asahel
Upson, James
Wagenhurst, Charles
Walls, Jack
Waterman, Charles
Weller, Benneville
Wenfold and Stevens
Weston, Loren
Whiting, Calvin
Wilcox, Allyn
Wilcox, Benjamin
Wilcox, Daniel
Wilcox, Francis C.
Wilcox, Lewis S.
Wilcox, Richard
Williams, Smith
Witmer, Galen (Gale)
Witmer, Henry
Witmer, Peter
Witmer, Philip
Wright, Cruger
Wright, Dan
Wright, Malcolm
Wrightman, John
Yale, E.A.
Yale, Edwin R.
Yale, Hiram
Yale, Samuel
Zeitz, Frederick
Zeitz, Louis
Tinware, clocks
 Rich, Sheldon
Tinware, footstoves
 Goodrich, Asaph
Tinware, footstoves etc.
 Morse, Chauncey
Tinware, tin dollhouses
 Reitz, Isaac Jones
Toys
 Smith, Eldad

Tin, clay

Tinware, pottery
 Weaver, Henry

Tin, copper

Tinware, copperware
 Holmes, L.W.

Tin, glass

Tin mirrors
 Byington, Martin

Tin, iron

Tinware, ironware
 Stevens, Zachariah Brackett

Tin, metal

Tinware, weathervanes
 Leonhard, August

Tin painted

Clock faces
 Darrow, Elijah
 Fenn
Coffee pots
 Fulivier, James

Tin?

Clocks
 Otis, Fred
Painted cart wheels, sleighs, bed posts, etc.
 Pettibone, Abraham
Tinware?
 Allen, Pelotiah
 Barber, T.G.
 Barrett, Jonathan
 Barrows, Asahel
 Beach, Chauncey
 Beckwith, Israel
 Belden, Horace
 Bond, Caleb
 Brown, Nathan
 Buckley, Luther
 Burr, A.
 Burr, C.
 Burr, Charles H.
 Burr, Emerson
 Burr, M.
 Butler, Timothy
 Cadwell, A.
 Cadwell, I.
 Cadwell, L.
 Case, E.H.
 Case, H.H.
 Case, Robert
 Clark, Abna
 Cole, John
 Colton, S.
 Cornish, H.
 Cossett, M.
 Cowles, Elisha
 Cowles, Thomas
 Crofoot, Joseph
 Curtis, Emory
 Curtis, Thomas S.
 Deming, Levi
 Deming, Roger
 Dickerman, Edwin S.
 Dunbar, H.
 Ellis, John
 Ellsworth, James
 Eno, Chester
 Eno, Ira
 Eno, William
 Ensign, Moses
 Evans, Robert
 Farmington, Silas
 Filley, I.A.
 Flagg, Abijah
 Foster, Holloway, Bacon, and Company
 Frazier, Stephen
 Gibson, Page
 Goodman, Hezekiah
 Graham, B.
 Holt, Elias
 Merrimen, Ives
 North, Joseph
 Phelps, H.G.

Unidentified Media

Advertising drops for theaters, motion pictures, etc.
 Bert L. Daily Scenic Studio
Baskets
 Appletown, William L.
 Atkins, A.D.W.
 Brandt, Mrs. Henry
 Elvins, George D.
 Johnson, John
 Kinderlen, Conrad
 Long, Nicholas
 Luppold, John
 Shepard, George
 Waller, John
 Whitener, Thomas
 Wilson, Ida
 Witmann, John H.
Building portraits
 Wakeman, Thomas
Carriage paintings
 Howard, Freeman
Decorative paintings
 Penniman, John Ritto
Decorative wall paintings
 Dixon, Thomas Fletcher
Drawings
 Coville, A.M.
 Fleury, Elsie
 Kollner, August
 Lossing, Benjamin
 North, L.
 Whitaker, E.M.
Drawings of furniture
 Bezold, George Adam
Drums
 Kilbourne, William
Hat boxes, other decorated boxes
 Keller, Adam
 Putnam and Roff
Landscape paintings
 Starkweather, J.M.
 Willoughby, Edward C.
 Wolfe, John C.
Letter openers
 Dangler, Samuel
Masonic paintings
 Bush, John A.
Masonic regalia
 Caberey
 Drew, W.H.
 Drummond, M.J.
 Henderson, Frank K.
 Moss and Brother
 Pollard, A.W.
Memorial drawings
 Stickney, Mehetable
Midwestern landscape paintings
 Maurer, Louis
Miniature paintings
 Winter, William(?)

Mourning pictures
 Griswold, Lucy
Ornamental and landscape paintings
 Clapperton, William R.
Ornamental paintings
 Goodrich, Henry O.
 Hodgetts, Sam
Paintings
 Chaplin, J.G.
 Dorsey, William H.
 Primus, Nelson
 Radfore, P.M.
 "Rhenae"
 Whitefield, Edwin
 Wilson, A.B.
Panorama and landscape paintings
 Waugh, Henry W.
Portraits
 Brown, Samuel
 Clark, G.W.
 Davis, James
 DeBault, Charles
 McMaster, William E.
 Thielke, Henry D.
 Wilson, Mr.
Portraits, decorative paintings
 West, Horace B.
Portraits, ornamental paintings
 West, Washington J.
Powderhorns
 Ball, John
Scene paintings
 Adelman, Joseph E.
Sign and decorative paintings
 Hillman, Richard S.
Signs
 Mason, J.
Sketches
 Kinzie, Juliette M.
Spirit drawings
 Wright, Mother Lucy
Still life paintings
 Hubban, E.A.
Theatrical and banner art
 Bianchi, John
Weathervanes
 Wasey, Jane

Various materials

Architectural constructions
 Cusie, Ray
Battleship fleet sculptures
 Flax, Walter
Circus figures
 Brinley, William R.
Environmental sculptures
 Deeble, Florence
 Dorsey, Henry
 Hall, Irene
 Hay, T.
 Hoff, John
 Martin, Eddie Owens "Saint EOM"
 McKissack, Jeff
 Prisbrey, Tressa (Grandma)

Rodia, Simon
Rusch, Herman
Schmidt, Clarence
Wernerus, Father Mathias
Woods, David
House mosiacs
 Owsley, Willie
Masks, reliefs
 Schatz, Bernard
Painted sheet figures
 Payne, Leslie J.
Paintings, environmental sculptures
 Mullins, Walter S., General
Petrified statues, lace-like walls, concrete arches
 Forrester, Laura Pope (Mrs. Pope)
Portraits, still life paintings, sculptures
 Church, Henry, Jr.
Quill work sconces
 Wendell, Elizabeth
Sculptures
 Cortez, Maxine
 Davis, Ellsworth
 Goff, G.
 Hampton, John (James)
 McEntyre, Kent K.
 McGriff, Columbus
 Nelson, Cal
 Rolling Mountain Thunder, Chief
 Townsend, Ted
Sewn buttons, quilts, canes
 Tenebaum, Morris
Yarn winders
 Dominy, Nathaniel, V

Various materials, oil

Decorated objects, nautical theme paintings
 Cahoon, Ralph

Velvet

Genre paintings
 McAuliffe, J.
Memorial paintings
 Bartlett, Lucy
 Kimball, Mary Ann
 Miller, Louisa F.
 Salter, Ann Elizabeth
Mourning paintings
 Hosmer, Lydia
Mourning pictures
 Sterlingworth, Angelina
 Whipple, Clarissa
Paintings
 Adams, Charlotte
 Allo, P.A.
 Barstow, Salome
 Beers, Martha Stuart
 Bradley, Mary
 Bullard, C.
 Buxton, Hannah P.
 Capron, Elizabeth W.
 Cheever, Sarah F.
 Clark, Elizabeth Potter
 Clarke, Harriet B.
 Cole, Maria
 Coward, Eleanor L.
 Cushing, Mrs. Thomas
 Davis, M.O.
 Dean, Polly C.
 Forbes, Hannah Lucinda
 Gage, Martha
 Haviland, Matilda A.
 Noel, Mary Cathrine
 Van Alstyne, Mary
Still life paintings
 Freleigh, Margaret Ann
 Hale, Eliza Camp Miller
 Pitkin, Elizabeth
 Shaw, Susan M.
 Stearns, Mary Ann H.
 Stearns, William
 Terry, Sarah F.
 Wilson, Isabella Maria
Theorems
 Hook, Susan

Watercolor

Allegorical drawings
 Douglas, Lucy
 Waters, E.A.
Animal drawings, frakturs
 Meyer, Elizabeth
Apron paintings
 Meer, John
Apron paintings, portraits, landscape paintings
 Brown, M(andivilette) E(lihu) D(earing)
Army base life paintings
 Kilpatrick, R.L., Captain
Battle scene paintings
 Kreebel, Isaac
Bay scene paintings
 Richardson, George
Boat portraits
 Downes, P.S.
Cityscape paintings
 Bussell, Joshua H.
 Sperry, John
Drawings
 Thompson, Mr.
Drawings, group portraits
 Morse, Samuel Finley Breese
Equestrian portraits
 Wellman, Betsy
Family tree, mourning paintings
 Saville, William
Fantasy paintings
 Mole, William
Fantasy paintings of children
 Darger, Henry
Farm scene paintings
 Noel, M.P.
 Seifert, Paul A.
Flower paintings
 Delano, Temperance
 Tucker, Alice
Genre paintings
 Dalzell, M.J.
 Flower, George
 Herff, Charles Adelbert
 Keyes, Caroline
 Matlick, William
 Palmer, Jane
 Palmer, Julia Ann
 Rappe, Mary
 Rawson, Eleanor
 Walker, M.
Genre scene paintings
 Simon, Jewel
Historical paintings
 Baker, J.W.
 Cole, A.
 Meyers, William H.
 Smith, John H.
Homestead paintings
 Martin
 Stauffer, Jacob
Horse portraits, frakturs
 Zook, J.W.
House pictures
 Damitz, Ernst
House portraits
 Muler, Christian
Indian ceremonial scene paintings
 Tsireh, Awa
Interior house paintings, portraits
 Leavitt, Joseph Warren
Interior scene paintings
 Russell, Joseph Shoemaker
Landscape and memory paintings
 Erceg, Rose "Ruza"
Landscape paintings
 Belcher, M.D.
 Browne, William
 Burroughs, Sarah A.
 Clark, F.C.
 Daniel, Holy
 Dunn, C.F.
 Hamilton, Sophie
 Marford, Mirible "Miribe"
 McDowell, Fred N.
 Mitchell, Phoebe
 Nichols, Eleanor
 Spalding, E.
 Taylor, A.M.
 Van Gendorff
 Vaughn, M.A.
 Vogler, Elias
 von Hedeken, Ludwig Gottfried
Landscape, scene, religious paintings
 Minchell, Peter
Literary scene paintings
 Merridan, Ann Page
Locomotive portraits
 West, E.
Marriage and birth certificate drawings
 Firth, E.F.
Masonic aprons
 Martin, J.
Memorial drawings, valentines
 Gurney, Thomas

Watercolor

Watercolor (Cont.)
 Memorial paintings
 Burr, Julia
 Collins, C.
 Cushman, Mary
 Ellis, Rachel E.
 Goldsborough, Moria T.
 Hawes, Sarah E.
 Moore, Harriet
 Murray, Eliza
 Peters, C.
 Reid, A.D.
 Smith, Margarette W.
 Thurston, Elizabeth
 Warner, Catherine Townsend
 Wescott, P.B.
 Wilkins, Sarah
 Wingate, Mehitabel
 Minatures, paintings
 Finch, Ruby Derd
 Miniature paintings
 King, Josiah Brown
 Levie, John E.
 Miniature portraits
 Carpenter, Miss
 Davenport, Maria
 Shirvington, J.
 Miniatures, landscapes, historical paintings
 Kemmelmeyer, Frederick
 Mourning and landscape paintings
 Perkins, Prudence
 Mourning paintings
 Barrett, Salley
 Beitel, Josiah
 Mason, Larkin
 Merrill, Sarah
 Punderson, Hannah
 Sewall, Harriet
 Smith, I.R.
 Starr, Eliza
 Stone, Hannah
 Worcester, Caroline
 Paintings
 Ainslee, Henry Francis, Colonel
 Bromfield, Catherine
 Brook, Miss M.
 Chapin, Mary S.
 Cherrill, Adolphus
 Chester, Rebecca
 Clarke, David
 Collie, S.
 Collis, Miss
 Dalee, Justus
 Dana, Sara H.
 De Lee, Francis H.
 Doolittle, Amos
 Downer, Ruth
 Durfee, George H.
 Eastman, Seth
 Evans, William B.
 Fairbanks, Sarah
 Fredenburg, George
 Gibbs, H.R.
 Grider, Rufus A.
 Harley
 Hayse, Martha S.
 Heath, Susan
 Hemenway, Asa
 Herp, Charles Adelbert
 Houghenon, Dorothy
 Howland, Charity
 Hoyt, Thomas R., Jr.
 Humphrey, Maria Hyde
 Huntington, Dyer
 Huntington, J.C.
 Ingersoll, John
 Jackson, Charles Thomas
 Jacob, K.S.
 Johnson, Ann
 Johnson, S.D.
 Johnston, Thomas
 Joy, Caroline
 Keys, Mary
 Lathrop, Betsy B.
 Lawton, C.
 Mann, Electra
 Marshall, Emily
 Martin, John F.
 Mason, William
 Merritt, E.
 Merritt, Susan
 Mohler, Anny
 Morley, William
 O'Brien, John Williams
 Parke, Mary
 Phipps, Margarette R.
 Plourde, Ben
 Pratt, Louisa Jane
 Pressman, Meihel
 Putney, Henry
 Raymond, James S., M.D.
 Rosseel, Frank
 Scouten, O.B.
 Sheldon, Lucy
 Slack, George R. H.
 Spybuck, E.L.
 Steven, S.S.
 Stevens, Augusta
 Tilles, J.A.
 Van Ness, Sarah Oldcott Hawley
 Van Wagner, Jas. D.L.
 Walber, T.B.
 Walker, Rebecca
 Waters, D.E.
 Whitcomb, J.H.
 Willis, Eveline F.
 Wilson, Mary R.
 Wright, Almira Kidder
 Political and social paintings
 Ginther, R(oland) D(ebs)
 Portraits
 Abbe, John
 Banton, S.
 Bruere, Theodore
 Chapin, Alpheus
 Davis, Gilbert, Captain
 Davis, J(ane) A.
 Dawkins, Henry
 Dupue
 Eastman, Emily (Baker) (Eastman Louden)
 Esteline, Martha
 Evans, J.
 Freeman, Mr.
 Gore, Joshua
 Hatch, Elisha
 Jones (of Conn.)
 Maental, Jacob
 Osborn, James
 Parker, Life, Jr.
 Phillips, Ellen A.
 Smith, Mary Ann (MaryAn)
 Swain, Harriet
 Towers, J.
 Tucker, Mary B.
 Wentworth, T(homas) H.
 Wilkie, William
 Willson, Mr.
 Wood, Hanna
 Wooden, J.A.
 Wybrant
 Ziegler, H.
 Portraits, genre paintings
 Glaser, Elizabeth
 Portraits, landscape paintings
 Evans, John T.
 Racing horse paintings
 Pi, Aqwa
 Religious paintings
 Spalding, Eliza Hart
 Romantic scene paintings
 Murray, Elenor
 Nims, Mary Altha
 Swift, Ann Waterman
 Walker, Elizabeth L.
 Scene paintings
 Bliss, H.
 Burd, Eliza Howard
 Harrison, Benjamin J.
 Jacobi, J.C.
 Lefferts, M.F.
 Meysick, Mary Ann
 Morton, Emeline
 Pratt, Caroline H. Barrett
 Roberts, John M.
 Schulze, Lizzie J.
 Wagoner, Maria
 Ward, H.
 Weisel, W.C.
 Weston, Mary Pillsbury
 Whitcomb, Susan
 Scroll paintings
 Spear, P.
 Seascape paintings
 Goram, J.
 Gould, George A.
 Lincoln, Daniel H.
 Ship and townscape paintings
 Anderson, Peter
 Ship paintings
 Bowen, Ashley
 Briggs, L.A.
 Phippen, John
 Ship portraits
 Camiletti, Edmund
 Parsons, Charles

Media Index

Spirit drawings
 Hazard, Mary
Still life paintings
 Babcock, Amory L.
 Badger, Nancy
 Cady, Emma Jane
 Forney, Henry
 Gilpin, A.W.S.
 Holden, H.
 Morrill, M.L.
 Niles, Melinda
 Paxton, Eliza
 Peters, Joseph
 Sackett, Ester
 Sawin, Wealthy O.
 Sawyer, Belinda A.
 Sherman, Lucy McFarland
 Vaughan, N.J.
 Waters, Almira
Street scene paintings
 Goodman, J. Reginald
 Hyde de Neuville, Baroness
Theorems
 Bennett, Caroline
 Ferguson, Sarah
 Gernerick, Emelia Smith
 Paris, Delphina
 Paul, J.W.S.
 Rotschafer, F.A.
Townscape paintings
 Henrill, Hermann
 Tucker, Joshua

Watercolor, acrylic, ink
Religious paintings
 Morgan, Sister Gertrude

Watercolor, chalk, magic marker
Paintings of toys
 Folger, George

Watercolor, crayon
Boat portraits
 Golding, William O.
Scene paintings
 Crispell, John H.

Watercolor, fabric
Embroidery pictures
 Denison, Harriet

Watercolor, gold leaf
Paintings
 Pelton, Emily

Watercolor, gouache
Architectural paintings
 Van Wie, Carrie
Fantasy and whimsical paintings
 Frantz, Sara L'Estrange Stanley "Sali"

Watercolor, gouache, ink
Paintings
 Parsons, A.D.

Watercolor, ink
Drawings
 Allen, Elizabeth
 Seckner, C.M.
 Umble, John
Frakturs
 Ache, H.M.
 Anders, Abraham
 Anders, Andrew
 Anders, Judith
 Andreas, Jacob
 Anson, James
 Bachman, Christian
 Baer, Martin
 Bandel, Frederick
 Bard, Johannes
 Bart, Daniel
 Bart, Susanna
 Bauer, Andeas B.
 Bauman, August
 Becker, Barbara
 Becker, J.M.
 Beidler, C.Y.
 Bergey, Joseph K.
 Bernhardt, Peter
 Bicksler, Jacob S.
 Bisco, Adaline
 Bixler, David
 Bowers, Reuben
 Brechall, Martin
 Brubacher, Abraham
 Brubacher, Hans Jacob
 Brubacher, Johannes
 Brusgaeger, J. George
 Cassell, Christian
 Cassell, Huppert
 Cassell, Joel D.
 Clemens, Johannes
 Conner, Morris
 Cordier, David
 Crecelius, Ludwig
 Dambock, Adam
 Denig, Ludwig
 Denlinger, David
 Detweiler, John H.
 Detweiller, Martin M.
 Dirdorff, Abraham
 Ditmars, Peter
 Dock, Christopher
 Dotter, Cornelius
 Dressler, S.O.
 Dulheuer, Henrich
 Dutye, Henre
 Edson, Almira
 Egelmann, Carl Friederich
 Eisenhauer, Jacob
 Eyer, Johann Adam
 Eyster, Elizabeth
 Faber, Wilhelmus Antonius
 Fieter, Michael
 Forrer, Johann
 Fries, Isaac
 Fromfield, William
 Gahman, John
 Gerhardt, George
 Gifford, Stephen B.
 Gise, Henry
 Gitt, Wilhelm
 Godshalk, Enos
 Godshall, M.
 Grimes, William
 Gross, Isaac
 Gross, Jacob
 Guisewite, Reverend
 Haman, Barbara Becker
 Hammen, Elias
 Hartman, Christian B.
 Hartzel, John, Jr.
 Heebner, David
 Heebner, John
 Heebner, Maria
 Heebner, Susanna
 Henkel, Ambrose
 Herr, Anna
 Herr, David
 Heydrich, Balzer
 Hill, Henry
 Hillegas, Jacob
 Hoffman, Johannes
 Hoppe, Louis
 Horn, Daniel Stephen
 Huebner, Abraham
 Huebner, Henrich
 Huebner, Susanna
 Huth, Abraham
 Jackson, Samuel
 Jaeckel, Christoph
 Jamison, J.S.
 Kassel, Georg
 Kauffman, Daniel
 Kauffman, Samuel
 Kauffman, Zoe
 Keeper, Heinrich
 Kehm, Anthony
 Kiehn, David
 Kinsey, Abraham K.
 Klenk, Ferdinand
 Kratzen, Joseph
 Krauss, Johannes
 Krauss, Regina
 Krebs, Friedrich (Friederich; Frederick)
 Kriebel, David
 Kriebel, Hanna
 Kriebel, Job
 Kriebel, Maria
 Kriebel, Sara
 Krieble, Abraham
 Kuster, Friederick
 Landes, Rudolph
 Landis, Catherine L.
 Landis, John
 Landis, John A.
 Lapp, Christian
 Lapp, Henry
 Lehn, Henry
 Leo, John William
 Levan, Francis D.
 Limbach, Christian
 Lueckin, C.
 Lyle, Fanny
 Magdelena

Watercolor, ink

Watercolor, ink (Cont.)
 Frakturs (Cont.)
 Maphis, John M.
 Margaretha
 Martz
 Mensch, Irwin
 Messner, Elizabeth
 Meyer, Martin J.
 Miesse, Gabriel
 Miller, Jacob
 Miller, John G.
 Moffly, Samuel
 Mosser, Veronica
 Mosteller, Johannes
 Moyer, Martin
 Muench, Karl C.
 Muje, H.D.
 Munch, Carl E.
 Murray, William
 Neff, Elizabeth
 Nuechterlein, John George
 Otto, Johann Henrich
 Otto, Wilhelm
 Payson, Phillips
 Peterman, Daniel
 Peters, Christian
 Pile, John
 Plank, J.L.
 Portzline, Elizabeth
 Portzline, Francis
 Puwelle, Arnold
 Reich, Elizabeth
 Reinwald, Sarah
 Reist, Johannes
 Renninger, Johannes, Jr. (John)
 Rigel, Maria Magdalena
 Romer
 Rudy, Durs
 Schantz, Joseph, Reverend
 Schenef, Friederich
 Scherg, Jacob
 Scherich, C.
 Scheuer, Joseph
 Schneider, Christian
 Schuller, Johann Valentin
 Schultz, Barbara
 Schultz, Lidia
 Schultz, Regina
 Schultz, Salamon
 Schultz, Sara
 Schultze, C.
 Schumacher, Daniel, Reverend
 Seibert, Henry
 Seiler, H.
 Seuter, John
 Seybert, Abraham
 Seybold, Carl F.
 Shindel, J.P.
 Sibbel, Susanna
 Siegfried, Samuel
 Spangenberger, Johannes Ernst
 Spangler, Samuel
 Spiller, Johan Valentin
 Staffel, Bertha
 Stahr, John F.W.
 Stober, John
 Strenge, Christian
 Strickler, Jacob
 Taylor, Alexander
 Teibel, Georg (Johann)
 Thompson, M.
 Trevits, Johann Conrad
 Van Minian, John
 Vater, Ehre
 Weaver, Carolina
 Weber, Isaac
 Weidner, Heinrich
 Weiss, Anna
 Weiss, Henrich
 Weyzundt
 Wuertz, Adam
 Young, H(enry)
 Zeller, George
 Zinck, John
 Zoller, George
 Zornfall, Martin
 Zug, Johan
 Frakturs, religious paintings
 Geistweite, George, Reverend
 Historical drawings
 Janvier, George Washington
 Horse and tiger illustrations
 Krider, Jacob
 Illustrated bookplates
 Killian, Abraham
 Landscape paintings
 Ludlow, Gabriel R.
 Memorial drawings
 Brown, Olive W.
 Mourning pictures
 Brown, Hannah
 Brown, Jon
 Brown, Margaret
 Portraits
 Carr, Henry A.
 Religious drawings
 Cohoon, Hannah
 Scene drawings
 Neffensperger, J.D.

Watercolor, ink, fabric
 Frakturs, embroidery
 Mason, Abigail (Payne)

Watercolor, ink, pen
 Drawings
 Buckingham, David Austin
 Friendship letters
 Leach, E.W.
 Paintings
 Pinney, Eunice Griswold
 Holcombe

Watercolor, ink, pinprick
 Memorial drawings
 Rollings, Lucy

Watercolor, ink, wood
 Frakturs, decorated chests
 Speyer, Georg Frederick
 (Friedrich; Friederich)

Watercolor, ink?
 Frakturs
 Baker, John B.

Watercolor, oil
 Genre, memory scene paintings
 Brunner, Hattie Klapp
 Paintings
 Burpee, Sophia (Constant)
 Portraits
 Davis, E(ben) P(earson)
 Portraits, murals, miniatures, boxes, landscape paintings
 Porter, Rufus
 Townscapes, miniature portraits, paintings
 Walton, Henry

Watercolor on silk
 Decorative piece paintings
 Lord, Mary
 Mourning pictures
 Catlin, Betsy

Watercolor, paper
 Cut-outs
 Fries

Watercolor, pen
 Genre drawings
 Meyer, Lewis
 Scene paintings
 Gleason, Mrs. L.

Watercolor, pencil
 Drawings
 Bedell, Prudence
 Genre paintings, drawings
 Twiss, Lizzie
 Miniature portraits
 Gillespie, J.H.
 Plummer, Edwin
 Portraits
 Shute, Mrs. R(uth) W(hittier)
 Shute, Samuel A., Dr.
 Warren, M., Jr.
 Ship drawings
 Robinson, Frank

Watercolor, pinpricks
 Portraits
 Root, Elmira
 Scene and genre drawings
 Parker, Sally
 Still life drawings
 Knight, Belinda D.

Wax, paper
 Portraits
 Wright, Patience

Whalebone
 Scrimshaw
 Abbott, Henry R.
 Albro, T.L.

Bower, W.M.
Bradford, Benjamin W.
Burdett, Edward
Butts, F.A.
Delano, Milton
Dodge, Ephraim J.
Folger, David
Foster, Washington
Galloway, Lyle
Greene, Samuel
Harris, Albert
Hewit, Charles
Hord, Jacob
Horgos, William "Bill"
Howland, John
Huggins, Samuel, Jr.
Jacobs, A. Douglas
Martin, James
McKenzie, Daniel, Jr.
Morgan, Charles W.
Myrick, Fredrick
Roanoke, Bart
Robinson, Josiah
Rogers, George H.
Snow, Martin
Stark, Mary E.
Townsend, George
Vardeman, Paul E., Judge
White, Alvin A.
Wilson, Steve
Worth, D.J.
Yager, Rick
Scrimshaw, ship portraits
Spring, Rick
Scrimshaw, whaleships painting
Perry, William

Whalebone, ivory
Carved canes
Bayley, Charles
Carved whale teeth
Hayden, J.
Williams, Arthur
Carvings
Williams, William
Carvings, watch stands
Toby, Charles B.
Whalebone, ivory art
Kuzuguk, Bert

Whalebone, paint
Scrimshaw, whaling scene paintings
Ashley, Clifford W.

Whalebone, watercolor
Scrimshaw, genre pictures
Smith, Fred

Whalebone?
Scrimshaw?
White, Edwin

Whalebones, wood
Scrimshaw sculptures
Chappell, William

Whaletooth
Scrimshaw
Healy, Nathaniel

White earthenware
Porcelain
Bartlam, John
Pottery
Bonin, Gousse
Chelsea China Company
Freytag, Daniel
Jersey City Pottery Company
Mead, Dr.
Morris, George A.

White Granite
Decorative ware
Stubenville Pottery Company
Porcelain
Dresden Pottery
Porcelain, pottery
Greenwood Pottery Company
Pottery
Baum, J.H.
Brearley, Stephens and Tams
Eagle Pottery Company
F. Haynes and Company
Mayer Pottery Company
Mayer, James
Morley and Company
Morley, Goodwin and Flentke
New Jersey Pottery Company
Plympton and Robertson Pottery Company
Standard Pottery Company
Warwick China Company
Wylie, John

White Granite, cream-colored ware
Pottery
City Pottery Co.

White Granite, earthenware
Pottery
Summit China Company

Whiteware
China
West Virginia China Company
Pottery
Allen, George
Goodwin Pottery Company
Haynes, Bennett and Company
Rhodes, Strong and McGeron
Smith, Alexander

Whiteware, Rockingham
Pottery
Pass, James

Wood
Altar sculptures, carvings
Schwarzer, Franz
Animal carvings
Mountz, Aaron
Animal sculptures, carvings
Wilson, Augustus
Animals, toys, sculptures, carvings
Schimmel, Wilhelm
Baskets
Clark, Leon "Peck"
Mawatee
Thomas, Eli
Beds
Blatter, Jacob
Benches, cupboards
Kemper, Simon
Winkelmeyer, Henry
Bird and animal sculptures, carvings
Tschappler, L.W.
Bird decoys
Carter, John W.
Bird sculptures, carvings
Foraner, Robert
Jaeger, Michael
Lawson, Oliver
Schultz, William L.
Birdhouses, canes, plaques, whistles
Raidel, Dorion
Blanket chests
Matteson, Thomas
Bookcases
Hausgen, Frederick
Box churns
Funk, E.H.
Box violins
Nichols, Maynard
Boxes
Ball, Silas
Cleaveland, Nathan
Dunn, Justus
Fitch, Isaac
Hersey, Samuel
Lytle
Moulton, John
Rumbaugh, M.
Webber, John
Boxes, coffins
Jewett, George
Buckets
Proctor, E.
Bureau chests
Kimmel
Cabinets
Craft, William
Day, Thomas
Hiatt, James
Ned
Cabinets, chairs
Isaac Wright and Company
Cakeboards
Conger, John
Cape Vincent terminal models
Chapman, Hicks David
Carousel figures
Albright, Chester
Armitage, James
Auchy, Henry
Brown, Edmond
Goldstein, Harry

Wood (Cont.)
 Carousel figures (Cont.)
 Herschell, Allen
 Looff, Charles I.D.
 Muller, Alfred H.
 Parker, Charles W., Colonel
 Spillman Engineering Corporation
 Stein and Goldstein
 Stein, Soloman
 Toboggan Company
 Carousel horses
 Louff, Charles
 Muller, Daniel Carl
 Parker Carnival Supply Company
 Carousel, other figures
 Dentzel, William
 Illions, Marcus Charles
 Carved animals
 Pierce, Charles
 Carved boxes
 Bissell, Thomas
 Buell, William
 Carved boxes, furniture
 Crosman, Robert
 Carved canes
 Bobb, Victor "Hickory Stick Vic"
 Caldwell, Booth
 Frischwasser, Ben
 Goodpastor, Denzil
 Gudgell, Henry
 Miller, Howard
 Rogers, William
 Carved canes, animals, figures
 Skaggs, Loren
 Carved eagle sculptures, ship carvings, figures
 True, Joseph
 Carved fans
 Menard, Edmond "Bird Man"
 Nutting, Chester
 Van Antwerp, Glen
 Van Antwerp, Stan
 Carved fiddle
 Hundley, Joe Henry
 Carved shrines
 Wood, John
 Carvings
 Byrley, Frank J.
 Childers, Russell
 Cress, Edward
 Garrett, Carlton Elonzo
 Hurst, John W.
 Jarvie, Unto
 Kinney, Noah
 May, Roy
 Parker, Burr
 Pasanen, Robert I.
 Patride, Marvin
 Reiss, Al
 Tolson, Donny
 Carvings, clock frames, scultpures
 Riddle, Morton
 Carvings, figures
 Job

 Chainsaw sculptures
 Joe, Pappy
 Chairs
 Avery, Gilbert
 Ford, J.S.
 Gillingham, James
 Gragg, Samuel
 Holcomb, Allen
 Holmes and Roberts
 Hull, John L.
 Johnson, Isaac
 Kunze, William
 MiddleKamp
 Moore, William, Jr.
 N.R. Stephens Chair Factory
 Rahmeier, Frederick
 Ritter, Florent
 Schauf, Wilhelm
 Seymour, John
 Tuthill, Silas
 Van Beek, Hermann
 Watrous, Seymour
 Chairs, tables
 Gaebler, Carl Frederick (William)
 Chandelier
 Goins, Luther
 Chests
 Sisson, J.
 Townsend, Edmund
 Chests, boxes, press cupboards
 Lane, Samuel "Sam"
 Chests of drawers
 Morse, E.
 Sala, John
 Chimney pieces
 Wellford, R.
 Cigar box churches
 Willett, George H.
 Cigar store Indians
 Dibblee, Henry
 Cigar store Indians, circus, other figures
 Carretta, Frank
 Cigar store Indians, figures
 Boulton, William
 Brooks, James A.
 Brown, James
 Cigar store Indians, figures, sculptures, carvings
 Brown, Joseph
 Cigar store Indians, figures
 Callanan, Richard
 Collins, Nicholas E.
 Cote, Claude
 Crongeyer, Theodore
 Decker, Fritz
 Deker, Francis Jacob
 Dengler, J.
 Dowler, Charles Parker
 Fisher, John
 Gaspari, P(ierre) G.
 Guhle, Charles
 Hadden, Elias W.
 Hamilton, James
 Inabet, Mike
 Jeremiah Dodge and Son

 Kaiffer, Frederick W.
 Kruschke, Herman
 Lapp, Ferdinand
 Lewin, Isaac
 Matzen, Herman
 Melchers, Julius Caesar (Theodore)
 Cigar store Indians, figures, eagles, various ornamental carvings
 Metzler, Henry F.
 Cigar store Indians, figures, ship carvings, ship figures
 Millard, Thomas, Jr.
 Cigar store Indians, figures
 North, Justinus Stroll
 Osebold, Anthony, Jr.
 Robb, Charles
 Robb, Clarence
 Cigar store Indians, figures, ship carvings and figures, circus wagons
 Robb, Samuel Anderson
 Cigar store Indians, figures
 Ruef, Arnold
 Ruef, Peter
 Strauss, Simon
 Yeager, John Philip
 Cigar store Indians, ship figures
 Anderson, John W.
 Cigar store Indians, ship carvings, ship figures
 Brown, Charles
 Cigar store Indians, ship figures, other figures
 Cromwell, John L. (S.)
 Cigar store Indians, ship carvings, ship figures
 Dodge, Charles J.
 Cigar store Indians, ship carvings, figures
 Siebert, Henry A.
 Teubner, William
 Tryon, Elijah
 Circus and carousel figures
 Armitage-Herschell Company
 Breit, Peter
 Bright, Pete
 Carmel, Charles
 Cernigliaro, Salvatore
 Dare, Charles W.F.
 Dentzel, Gustav A.
 Herschell-Spillman Company
 Lawrence, George
 Long, George
 Loomis, L.R.
 Morris, J.W.
 Sebastian Wagon Company
 Zalar, John
 Clock cases
 Rude, Erastus
 Clocks
 Green, J.D.
 Jewett, Amos
 Paul, John, Jr.
 Rife, Peter
 Whiting, Riley

Willard, Aaron
Willard, Simon
Willard, Zabadiel
Youngs, Benjamin S.
Youngs, Isaac N(ewton)
Comb boxes
 Freeman, Joseph L
 Willard, Alfred
Combs
 Noyes, Enoch
Corner cupboards
 Wehmhoemer, Johann Friedrich
Cradles
 Stebbins, Wyman H.
Cribs
 Hilker, Frederick
Crosses, chairs, 20 foot boat
 Cornett, Chester
Cupboards
 Overton, Nathan
 Vierling, G.H.
Daybeds
 Keszler, Henry
Decorated baskets
 Sullivan, Sarah Crisco
Decorated boxes
 Loomis, Jonathan
Decorated chests
 Blauch, Christian
 Flory, John
 Palmer, Joel
 Wilkin, Godfrey
Decorated salt boxes
 Drissell, John
Decorative duck decoys
 Clifford, Robert
 Haertel, Harold
Decoys
 Archer, Dr.
 Bach, Ferdinand
 Barkelow, Lou
 Baumgartner, Doc
 C.C. Smith Co.
 Chambers, Thomas
 Christie, Bernard
 Cornelius, John
 Crooks, Floyd
 Cummings, Frank
 DeCoe, G.
 Dreschel, Alfred
 Finch, John
 Foote, Jim
 Glick, Herman
 Kellie, Ed
 Kelson, James R.
 Mason Decoy Factory
 McDonald, Zeke
 Meldrum, Alexander
 Meyer, Joe
 Misch, Otto
 Orme, Albert
 Peters, Scott
 Peterson, George
 Pozzini, Charlie L.
 Purdo, Nick
 Quillen, Nate
 Reghi, Ralph
 Sampier, Budgeon
 Schmidt, Benjamin J. "Ben"
 Schramm, Butch
 Schweikart, John
 Scriven, Danny
 Smith, Chris
 Smith, Samuel
 St. Anne's Club
 Steiner, Thomas
 Strubing, Walter
 Unger, Charles J.
 Unger, Fredrick
 Verity, Obadiah
 Wallach, Carl
 Warin, George
 Wass, Harry
 Zachmann, John
Desks, bookcases
 Trentmann, John
Dolls
 Rich, James
Doors, santeros, other religious carvings
 Lopez, Jose Dolores
Dower chests
 Ovenholt, Abraham
 Rank, John Peter (Johann)
 Rank, Peter
 Ricket, Jacob
 Selzer, Christian
 Selzer, John
Dressing tables
 Mason, William A.
Duck and owl decoys
 Herter Sporting Goods Company
Duck and shorebird decoys
 McAnney, John
 Nottingham, Luther
Duck decoys
 Acheo Brothers
 Ackerman, H(enry) H(arrison)
 Adams Decoy Company
 Adams, Frank
 Alexander, Stanley
 Animal Trap Company
 Armstrong Company
 Aschert Brothers
 Bacon, George H.
 Bailey, I. Clarence, Captain
 Baldwin
 Baldwin, William
 Barber, Joel
 Barnes, Samuel T.
 Best Duck Decoy Company, Inc.
 Bigelow, P.W.
 Birdsall, Jess, Captain
 Black, Charles
 Blair, John
 Bliss, Roswell E.
 Boyd, George
 Brady, Walter
 Browne, George
 Burgess, Ed
 Burr, E(lisha)
 C.W. Stevens Factory
 Cameron, Glen, Judge
 Carmen, Caleb
 Carmen, T.
 Carver, James
 Cassini, Frank
 Chadwick, H(enry) Keyes
 Chambers, Tom
 Classic Woodcarving Company
 Cobb, Arthur A(lbert)
 Cobb, E(lkenah), Captain
 Cobb, Elijah
 Cobb, N(athan), Jr.
 Collins, Samuel, Jr.
 Collins, Samuel, Sr.
 Conklin, Hurley
 Conklin, Roy
 Coombs, Frank
 Corwin, Wilbur A.
 Coudon, Joseph
 Cramer, Chalkly
 Crumb, Charles H., Captain
 Culver, R.I.
 Dan's Duck Factory
 Darton, W.D.
 David C. Sanford Company
 Davis, Ben, Captain
 Dawson, John
 Dawson, Joseph
 Dawson, Tube
 Deegan, Bill
 Denny, Samuel
 Disbrow, Charles
 Dize, Elwood
 Doane, Mr.
 Dodge, Jasper N.
 Dudley, Lee
 Dudley, Lem
 Dye, Ben, Captain
 Ellis, Levi
 Elliston, Robert A.
 Englehart, Nick
 English, Dan
 English, John
 English, Mark
 Evans, Walter
 Frazer, Nate
 Gardner, Lester
 Gaskill, Tom
 Gelston, Thomas
 Grandy, A.
 Grant, Henry
 Grant, Percy
 Grant, Stanley
 Graves, Bert
 Greenless, Kenneth
 Griffin, Mark
 Grubbs Manufacturing Company
 H.A. Stevens Factory
 Haff, John
 Hammell, Guarner
 Hance, Ben
 Hancock, Herbert
 Hancock, Miles
 Hancock, Russell
 Hankins, Ezra
 Harris, Al

Wood (Cont.)
 Duck decoys (Cont.)
 Harris, Ken
 Harvey, George
 Havens, George
 Hawkins, Ben
 Headley, Somers G.
 Hendricks, J.P.
 Heywood, Manie
 Holly, Ben, Captain
 Holmes, Lothrop T., Captain
 Horner, Roland (Nathan Rowley)
 Horshack, Jay
 Howlett, Dick
 Hudson Decoy Plant
 Hunt, Ben
 J.M. Hays Wood Products Company
 J.N. Dodge Factory
 Jester, Doug (S.D.M.)
 Johnson, Lloyd
 Johnson, Taylor
 Joy, Charles
 Joyner, Charles
 Kears, Mark
 Kellum, Frank
 Ketcham, Al, Captain
 Ketchum, C.K., Sr.
 Kilpatrick, Henry
 King, Joe
 Knapp, Harry
 La Flair, John
 La France, Mitchell
 Laing, Albert
 Lamerand, Ed
 Lamphere, Ralph
 Lewis, Frank E.
 Lincoln, Joseph Whiting
 Lippincott, Gideon
 Lockard, Henry
 Lohrman, William
 Look, Jim
 Malinski, Irving
 Massey, William B.
 Matthews, William J.
 Mayhew, M.H.
 McGaw, Robert F.
 McKenzie, John
 McKenzie, Thomas
 McMorrow, William
 Mitchell, Madison
 Modern Decoy Company
 Mulliken, Edward H. "Ted"
 Murphy, Charles
 Nelson, James L.
 Osgood, Captain
 Outing Manufacturing Company
 Owens, Frank
 Parker, Charlie
 Parker, Ellis
 Parker, Lloyd
 Parr, Jack
 Pashpatel, Leo
 Perdew, Charles H.
 Plichta, Fred
 Plumb, Robert
 Poiteran Brothers, Inc.
 Predmore, Cooper, Captain
 Raynor, Ben
 Reynolds, J.W.
 Rhodes, D.
 Rice, R.
 Ridgeway, Bindsall
 Roberts, Manuel S.
 Rogers, Gene
 Rose Folding Decoys Company
 Salmon, Bradford
 Sanford, R.D.
 Schifferl, Lou
 Schoenheider, Charles
 Schramm, Speck
 Schroeder, Tom
 Shourdes, Harry M.
 Shourdes, Harry V(an Nuckson)
 Smith, Ben
 Smith, C(assius)
 Smith, George
 Smith, Gil
 Smith, Howland
 Smith, Minor
 Smith, T.
 Soper, Alonzo
 Soper, Sam
 Spear, Chester
 Sperry's Decoy
 Sprague, Chris
 Sprague, Jed, Captain
 Stanley, James E.
 Sterling, Noah
 Sterling, Will
 Strang, Charles
 Taubert, T.
 Titus, Jim
 Truax, Rhoades
 Truay, Ike, Captain
 Tyler, Lloyd
 Updike, John
 Ville, Charlie D., Captain
 W.G. Higgins
 Walker, Charles
 Walker, Wilton
 Wallace, G.E.
 Ward, Steve
 Watson, Dave "Umbrella"
 Weston, William Henry
 Whealton, Dan, Captain
 Wheeler, Chauncey
 White, Winfield
 Whittaker, John, Captain
 Whittington, Hector "Heck"
 Wildfowler Decoy Company
 Wilke, Mr.
 William E. Pratt Manufacturing Company
 William R. Johnson Company Inc.
 Williams
 Williams, John
 Williams, R.
 Williams, T.
 Wilson, Charles T., Professor
 Winslow, George Marcus
 Winsor, John
 Duck decoys, miniature duck carvings
 Baldwin, John Lee
 Duck decoys, other carvings
 Langan, Tom
 Duck decoys, sculptures, carvings
 Hudson, Ira
 Duck decoys, weathervanes, miniature duck carvings
 Bowman, William
 Egg cups
 Lehn, G.
 Environmental sculpture
 Gabriel, Romano
 Farm scene sculptures, carvings
 Wells, J.F.
 Figures
 Barlow, Myron
 Gies, Joseph
 Henning, Herman D.A.
 Huguenin, George
 Peterson, A.L.
 Russell, John
 Sullivan, William
 Fish decoys
 Buchman
 Gould, M.H.
 Hoag
 Jenner, Augie
 Jenner, Hans, Jr.
 Jenner, Hans, Sr.
 Jorgenson
 Kelly
 Loesch
 Meldrum, John
 Moore
 O'Francis
 Sears, Gordon
 Smith
 Stewart
 Zent, August
 Fish decoys, other carvings
 Peterson, Oscar B.
 Frames
 Duncan, M.L.
 Furniture
 Amend, Charles
 Archuleta, Antonio
 Archuleta, Manuel
 Artz, William
 Balch, Sarah Eaton
 Barnhardt, John
 Bates, A.S.
 Bendele, Louis
 Beverburg, Lorenz
 Blackman, George
 Blin, Peter
 Bohlken, Johann H.
 Brinker, George Henry
 Buttre, William
 Carter, David
 Casebier, Jerry
 Conant, S.
 Corey, Walter
 Cowell, Benjamin

Crowningshield, Maria
Darneille, Benjamin
Dennis, Thomas
Dieckhaus, Franz
Doyle, William G.
Elfe, Thomas
Eppler, George
Finlay, Hugh
Finlay, John
Fisher, Robert
Friedrich, Johann
Fry, William H.
Funk, J.S.
Gonzales, Elidio
Greef, Adolph
Green, Elder Henry
Hasenritter, C(arl) W(illiam)
Hoffman, Christopher
Holton, Chancy
Ives and Curran
Jansen, Frederick William
Jones, Wealthy P.S.
Kemper, Edward
Knoebel, Jacob
Lombard, Rachel H.
Luna, Maximo L.
Meier, Henry
Moore and Walters
Penniman, John
Renshaw, Thomas
Roth, John
Salazar, Alejandro
Schaeffner, Andrew
Schmitt, Adam
Shubert, Casper
Sullins, David
Sutton
Toler, William
Watts, Charles
Werner, Ignatz
Young, Brigham

Furniture, chests
 Spitler, Johannes

Furniture, santeros, religious carvings
 Tapia, Luis

Furniture, walls
 Pitman, Benn

Gate posts, figures
 William, George

Genre carvings
 Cross, John

Glass cupboards
 Fricke, John Frederick
 Gentner, George Henry
 Hasenritter, Robert Hermann
 Purves, John W.
 Rohlfing, Frederick

Hat boxes
 Fleming, James Adam

Hat boxes, other decorated boxes
 Davis, Hannah

Hobby horses, ship carvings, ship figures
 Gerrish, Woodbury

Hope chests
 Allis, Ichabod
 Allis, John
 Hawks, John
 Pease, John

Hope or Hadley chests
 Belding, Samuel, Jr.

Icon sculptures, carvings
 Perates, J(ohn) W.

Kitchen tables, pie safes
 Luppold, Matthias

Large figures
 Lee, Joe

Lounges
 Kroebe, Michael

Maple sugaring scenes
 Elethorp, Robert

Miniature duck carvings, duck decoys
 Burr, Russ

Miniature figures
 Edgington, James McCallister

Models of churches, boxes, carvings
 Hodge, Mack

Molds
 Cox, Henry F.
 Linss, Karl

Mourning pictures
 Reinke, Samuel

Ornamental carvings
 Flower, Mary Elizabeth

Ornamental duck carvings
 Pope

Painted boxes
 Powers, Bridget

Painted chests
 Gillam, Charles

Painted picture frames
 Clark, Anson

Pie safes
 Hogue, Samuel
 Vermillion, John

Pipes
 Hassler, Sven
 Kidder, O.G.
 Oakford, John

Poplar bowls
 Pie, Hugh

Pull toys
 Green, John H.

Puppets
 Burris, J.C. "Jack"
 Diefendorter, John
 Irving, George

Relief carvings
 Almon, Leroy
 Shelley, Mary

Religious and historic carvings
 Farmer, Josephus, Reverend

Religious carvings
 Bereman, John

Religious, other carvings
 Christenson, Lars
 Patton, Ernest

Religious sculptures, carvings
 Koenig, Joseph

Roadrunner
 Klippenstein, S.

Rocking chairs
 Newman, Benjamin
 Raymond, J.

Saltboxes
 Plank, Samuel

Santeros
 Aragon, Rafael
 Rendon, Enrique

Santeros, other religious carvings
 Aragon, Jose
 Aragon, Jose Rafael (Miguel)
 Aragon, Luis
 Atencio, Patricio
 Barela, Patrocinio
 Benabides, Jose Manuel
 Benavides, Rafael, Father
 Gallegos, Celso
 Garcia, Fray Andres
 Herrera, Antonio
 Herrera, Miguel
 Lopez, Felix A.
 Lopez, George T.
 Martinez de Pedro, Linda
 Martinez, Apolonio
 Martinez, Eluid Levi
 Mondragon, Jose
 Ortega, Benjamin
 Ortega, Jose Benito
 Rochas, Ramon
 Rodriguez, Jose Miguel
 Romero, Orlando
 Salazar, Leo G. (Leon)
 Silvia, Rafael
 Toledo, Father Juan Jose
 Valdez, Horacio E.
 Vigil, Francisco
 Villalpando, Monico

Sculptures
 Aaron, Jesse
 Ackley, R.D.
 Anderson, James
 Bailey, James Bright
 Bohacket, Albert
 Cerere, Pete
 Chapman, T.A.
 Cote, Adelard
 Decker, Evan
 Finn, Marvin
 Greer, Exell
 Johnson, Philip
 Kahle, Mathew S., Captain
 Lopez, Ergencio
 Lopez, Sylvanita
 Payne, A.C.
 Schaffer, "Pop" "Poppsy"
 Seebeck, Walter
 Self, Bob
 Sincerbox, Keeler
 Vivolo, John
 Wibb, Ward
 Wilburn, Tom
 Willeto, Charles
 Williams, Jeff
 Wimmer, Mrs. Marie

Wood (Cont.)
 Sculptures (Cont.)
 Wolfert, Frank
 Sculptures, carvings
 Albertson, Erick
 Ambrose, Edward
 Ames, Asa (Alexander)
 Amidon, Douglas
 Anderson, Jacob S.
 Archuleta, Felipe Benito
 Armijo, Frederico
 Ashby, Steve
 Baker, Tom
 Balzer, John
 Barber, A.H.
 Barta, Joseph Thomas
 Barton, Major
 Baurichter, Fritz
 Buyer, Alfred
 Carpenter, Miles B.
 Carroll, Tessie
 Caspori
 Chwalinski, Joe Moore
 Colclough, Jim "Suh Jim"
 Corbin
 Cordova, Gloria Lopez
 Cordova, Herminio
 Crow, S.N.
 Davis, Ed
 Davis, Ulysses
 Davis, Virgil
 Deady, Stephen
 DeWees, George M.
 Doyle, Sam "Uncle Sam"
 Duncan, O.P.
 Dyker, Henry
 Eyman, Earl
 Galloway, Ed
 Gilbert, Archie
 Golonko, Joe
 Guthrie, Elwood
 Harrop, James A., Jr.
 Hedges, Joe
 Jeffries, Theodore
 Jeliff, John
 Johnson, Sargent
 Jones, A.W.
 Kriner, Robert
 Landau, Sol
 Landry, Pierre Joseph
 Langlais, Bernard
 Leve, Henry
 Ligon, C.P.
 Lukatch, Edward
 McKillop, Edgar Alexander
 McNutt, Bryan
 Moran, Frank
 Nethery, Ned
 Norris, William
 Odio, Saturnino Portuondo Pucho
 Patete, Eliodoro
 Pierce, Elijah
 Polaha, Steven
 Price, Albert
 Reber, John Slatington Carver
 Ricalton, William
 Richards, Frank Pierson
 Savage, Charles K., Jr.
 Schaffner, Dexter L.
 Schermerhorn
 Scholl, John
 Schubert, John G.
 Shoenhut
 Simmons, Schtockschnitzler
 Spalding, Rueben
 Stingfield, Clarence
 Stuart, Nobil
 Teubner, William, Jr.
 Ward, M. Paul
 Ware, Dewey
 Weidinger, Joe
 Wesenberg, Carl
 Winter, Henry
 Sculptures, carvings of Key West scenes
 Sanchez, Mario
 Sculptures, carvings, show wagons, biblical stories
 Hoy, David
 Sculptures, cigar store Indians, ship figures
 Brooks, T(homas) V.
 Sculptures, duck decoys, carvings
 Holmes, Benjamin
 Sculptures, religious carvings
 Zahn, Albert
 Sculptures, ship carvings, figures
 Skillin, Simeon, Sr.
 Sculptures, toys
 Warren, Marvin
 Sculptures, toys, canes
 Mann, Ed
 Secretaries
 Joseph Meeks and Sons
 Shaker boxes
 Wilson, Elder Delmar
 Shaker chairs
 Andersen, Elder William
 Burlingame, Elder Philip
 Wagan, Robert
 Shelf clocks
 Stow, Solomon
 Ship carvings
 Benson, Frank
 Ship carvings, cigarstore figures
 Proctor, David R.
 Sailor, Samuel H.
 Ship carvings, figures
 Counce, Harvey P.
 Cushing, Levi L.
 Dellaway, Thomas
 Dodge and Anderson
 Fowle, Isaac
 Garmons, William
 Geggie, William W.
 Harris, Daniel, Captain
 Hastings and Gleason
 Mason, John W.
 McIntire, Samuel
 Sampson, C(harles) A.L., Captain
 Vanderbree, Kenneth
 Ship carvings, ship figures
 Abbot, J.C.
 Abig, Adolphus
 Alback, John
 Allen, Calvin
 Allen, James
 Allin, William
 Allison, Walter
 Alt, Godfried
 Alt, William
 Amthor, John
 Anderson, Alonzo
 Anderson, James
 Anderson, Jane
 Antres, Charles
 Apple, Henry
 Appleton, Chris
 Appleton, Thomas
 Arend, Michael
 Armstrong, James L.
 Ashe, Thomas
 Ashmore, A.P.
 Ashmore, Abraham V.
 Aube, Peter R.
 Auld, Wilberforce
 Austin, Peter H.
 Backman, Henry G.
 Badger, Hiram
 Bailly, Alexis J.
 Baird, James
 Baker, William
 Baldauf, Joseph
 Banta, John W.
 Banvard, David
 Barna, William
 Barnes, William
 Barrett and Debeet
 Barry and Losea
 Barry, Thomas
 Barth, Bartholomew
 Baumback, Theodore
 Bayer, Michael
 Beadle, Edward
 Beadle, Leaman
 Bean, W.P.
 Beatly, Spencer
 Beatty, Spencer
 Beaujoy, Dennis
 Beecher, Laban S.
 Beiber, C.G.
 Beiderlinden, Nicol
 Bellamy, John Hales
 Bennett, Thomas
 Bent, Everett
 Bering, Thomas G.
 Bias
 Bias, Joseph
 Bickel, George
 Bids
 Bird, Charles
 Black, James
 Black, Robert
 Blankensee, John
 Blythe, David
 Boize, Charles
 Bokee, John

Bolden, Robert H.
Bolland, Martin
Bolton, William
Boos, John
Boston Fancy Wood Carving
 Company
Boulanger, John F.
Bourguianon and Britt
Bowers, Ezekial
Bowers, Joseph
Bowles, Joshua
Brieschaft, Joseph
Briggs, Cornelius
Brinckerhoff, John P.
Brittin, Sanford
Brooks and White
Brooks, James A.
Brotherton and North
Brown and Tweadwell
Brown, Caspar
Brown, Charles
Brown, George H.
Brown, John
Brown, Jon
Brown, W.H.
Brown, William H.
Browne, John H.
Browne, John S.
Bryne and Company
Bryne, Joseph
Buck, George H.
Buckley, Patrick
Budd, Edward
Bunn and Brother
Burgess, Everard
Burkfeldt, August
Burman, Augustus
Burnett, Henry
Burnham, Aaron L.
Burtis, Jacob H.
Buschor, Charles
Buttling, Avery
Byerley and Ely
Byerley, Edwin
C.A. Jackson and Company
Callaham, Richard
Campbell and Colby
Campbell and Greig
Ship carvings, ship figures, cigar
 store Indians, figures
Campbell, James
Ship carvings, ship figures
 Cannon, Hugh
 Capalano, Anthony
 Carroll, Thomas
 Carver, Jacob
 Cather, David
 Cellarinus, Ferdinand
 Ceutsch, J.H.
 Chaloner, Holman Waldron
 Chanceaulier, Martin
 Chapman and Hastings
 Chapman, A.
 Chapman, Nathan
 Charlton and Williams
 Charlton, F.

Charlton, Frederic
Chatterson and Higgins
Chatterson, Joseph
Chatterson, Joseph
Choate and Silvester
Choate, John C.
Churchill, Lemuel
Clark and Risely
Clark Leonard and Company
Clark, John W.
Clark, Levin P.
Clements, Seth
Clinton, George H.
Coffin, Henry
Colby, Emery and Company
Colby, John
Cole, Dexter K.
Coleman, Alvin
Coleman, Hezekiah
Collins and Brown
Collins, Abraham
Collins, Thomas
Collyer, Thomas
Concklin
Conger, John
Conian, P.T.
Conner, William M.
Cook, William
Cooley, William H.
Cooper, James
Cooper, William
Cordery, William
Cornwell, Stephen
Cotten and Statler
Court, Lewis
Coutis, T.W.
Crane, Jacob B.
Creiger, Augustus
Crocker, Ephraim
Croll, John
Cromwell and Harold
Cromwell, Stephen
Crouch, Henry
Currier, Alexander
Cushing, Jere C.
Cushing, Jeremiah C.
Cutbush, Edward
Cutbush, Samuel
Daroche, Frank
Davenport, William, Captain
Davidson, William
Davis, Charles
Dean, Thomas
Decker, Louis
Decker, Robert M.
Deene, John
Deering, William
Deering, William, Jr.
Degrasse, Aug.
Delano, Joseph
Delmont, David
Denman, David
Derlom, Francis
Desaville, William W.
Dimond, C.C.
Dippel, Ferdinand

Dockum, S.M.
Dockum, Samuel M.
Dodge and Sharpe
Dodge and Son
Dodge, Jeremiah
Dodge, Nathan
Dodson, W.K.
Doherty, Joseph J.
Doherty, Joseph J.
Dolan, James
Donegan, James
Door, Edward
Doran and Miller
Doran, John B.
Dotterer, Charles
Doughty, John H.
Downes and Sargent
Downes, Peter B.
Downs, P.T.
Doyle, John M.
Drawbridge, William S.
Drew
Drew, Alvin
DuPee, Isaac
Dwinell, Hezekiah
Earl, Tarleton B.
Earle, James
Easson, James
Eberle, Mark
Eckhart, L.
Ehrler, Charles
Eidenbries, John
Eliaers, Augustus
Ellenbass, Theodore
Ellis, John
Ellis, John, Jr.
Elwell, Samuel, III
Ely, Abraham
Emery, Charles
Ernst, Carl
Eureka Steam Machine Carving
 Company
Evans, John
Farnham, Henry
Farnham, John D.
Farrand and Omensetter
Farrand and Stuart
Farrand, Stephen
Farrell, John
Farren and Edlefson
Fash, William B.
Ferg, Henry
Ferran, Joseph
Fewkes, J.
Fifield, Daniel
Finch, Nathaniel
Finnerard, M.T.
Fischer, Charles
Flandrow, Joseph B.
Foley, Theodore H.
Forg, P.
Fowle, John D.
Fowle, William H.
Fox, Francis
Foy, P.
Fraser, John

Wood (Cont.)
 Ship carvings, ship figures (Cont.)
- Frazer, Hiram
- French, William B.
- Fryer, James
- Fuentes, Lucas
- G.B. McLain and Company
- Gallier, Edward
- Gally, Thomas J.
- Gantz, Frederick
- Gardiner, John
- Gardner, Andrew
- Gardner, John
- Gardner, William
- Garing, Christian
- Gastal, J.
- Geidt, Anthony E.
- Geiger, Jacob
- Gendrot Gahery and Company
- Gereau, William
- Getty and Sapper
- Getty, Robert
- Gibbs, James
- Gilbert and Worcester
- Gilbert, Fitz W.
- Glad, George H.
- Gleason and Company
- Gleason and Henderson
- Gleason, Benjamin A.
- Gleason, Henry (Herbert)
- Gleason, W.G.
- Gleason, William B.
- Golding, John
- Gooding, Charles Gustavus
- Gorbut, Robert
- Gossett, Henry
- Gottier, Edward
- Gracey, William
- Graham, Thomas
- Grant, William
- Greeley, John
- Green, George W.
- Greer, James
- Gridley, George
- Griffin, Edward Souther
- Griffin, John
- Griffith, William
- Guiterman, Gustave
- Haberland, Benno
- Haden Company
- Haehnlen, Louis A.
- Hahnle, Egidius
- Hainsdorf, Henry
- Haley, John C.
- Halliday, Thomas
- Hansbury, John
- Hardcastle, Henry
- Harding, John T.
- Harding, Richard H.
- Harding, Samuel
- Harned, Henry
- Harold and Randolph
- Harris, George
- Harrison, Henry
- Harvey, Thomas
- Hasslock, Charles
- Hastings, E.W(arren) (Warren E.)
- Hatch, Edbury
- Hatfield, Joseph
- Hausel, Martin
- Hausel, William
- Hauser, Joseph
- Hawks, George W.
- Hays and Morse
- Hays, Robert
- Heath, Samuel
- Hedian, T.
- Heiligmann and Brother
- Hein, John
- Heiss, Balthus
- Henderson, Joseph
- Henry, David H.
- Henry, Samuel C.
- Heron and Macy
- Heron and Weeden
- Heron, James
- Herr, John
- Herzog, James J.
- Hetzell, George J.
- Hey and Luckens
- Hicks, Walter
- Higgins, Stephen
- Hild, Michael
- Hindes, John M.
- Hobbs, John E.
- Hobbs, John, Jr.
- Hoffman and Maurer
- Hoffman, Alexander
- Hoffman, Gustav
- Hoffman, John
- Hoffman, Leonard
- Hoffmaster, Charles A.
- Holden, Oliver
- Holly, William
- Holzer, Julius
- Honey, John
- Horton, Daniel
- Horton, James
- Hotz, Martin
- How, Joseph
- Howland, E.D.
- Hubbard, Paul
- Hubbard, Samuel
- Hubbart, Samuel
- Hunt, D.W. Lewis
- Hunt, William
- Hurley, George
- Ingalls, C(yrus) A.
- Irwin, Joseph
- Ives, Chauncey B.
- J(ohn) W. Banta and Company
- J.S. Anderson and Son
- Jackson, Joseph
- Jackson, Joseph H.B.
- Jacob Anderson and Company
- James, Isaac
- Jardalla, Joseph
- Jeffers, James T.
- Jewsson, George
- Joe
- Johnson, John
- Johnson, Theodore
- Jones, Anthony W.
- Jones, Emery
- Jones, Henry A.
- Jones, Samuel D.
- Jones, William
- Kaufman, Jacob
- Keebler, Julius
- Keena, John
- Kelley, Asahel A.
- Kemmon, Joseph
- Kemp, A.
- Kemp, Frederick
- Kennard, William J., Jr.
- Kennedy, Samuel
- Kertell, George
- Kessel and Hartung
- Kett, John F.
- Killalea, Thomas
- Klumbach, Jacob
- Knight, Richard
- Knoedler, Cyriak
- Knost, Edward
- Kohl, Peter
- Krause, Oscar
- Krause, William O.
- Krieghoff, Philip E.
- Kronauze, William
- Kuehls, Theodore
- Kurtz and Company
- Kurz, Max
- Kutz, Anthony
- Labeyril, Constant
- Lafleur, Charles
- Lake, William
- Lambert, Thomas
- Langdon, Elias
- Lannuier, John
- Launsbury, John
- Leach, H.
- Leatherman, Gebhard
- Lebrecht, Frederick
- Leconey, James
- Lees and Preeble
- Lees, A.
- Lees, J. W(alter)
- Lerving, Samuel
- Lerving, Samuel
- Letourneau, Charles
- Lewin, Isaac
- Lex, Henry
- Lillagore, Theodore W.

 Ship carvings, ship figures, cigar store Indians, figures
- Lindmark, Winter

 Ship carvings, ship figures
- Lindsay, William
- Lingard, William
- Litchfield, E.
- Little, Thomas
- Littlefield Brothers
- Littlefield, Charles H.
- Littlefield, Francis A.
- Littlefield, Nahorn (Nahum)
- Littlefield, Nathan, Jr.
- Lockrow, William
- Lockwood, William

Lokke, S.R.
Long, Rufus
Lord, T.M.
Lovejoy, Edward Bell
Lowery, Alexander
Lucas, Thomas
Luce, Benjamin
Luff and Brother
Luff and Monroe
Luff, George W.
Luff, John V.
Luke, William
Lundmark, Winter
M. Barrett and Brother
Mace, Richard
Macy, Reuben
Macy, Robert H.
Maher, E.
Main, William H.
Manard, John B.
Mannebach, Lewis
Manning, John
Marcellus, John
Marcher, James
Marsh, Joseph
Marston, W.W.
Mayer, Henry
Mayer, Philip
Mayo, Robert
McAleese and Wyman
McClain, G.B.
McClellan Brothers
McColley
McColley, Charles
McCully and Company
McGrath, George
McGuire, Dominick
McIntire, James
McIntire, Joseph
McIntire, Joseph, Jr.
McIntire, Samuel Field
McIntyre and Gleason
McLean, Hugh
McMahon, Thomas
McQuillen, James
Mead, William
Meaher, J.W.
Mengen, Theodore
Menges, Adam
Merriam, John
Merrill, Joseph P.
Meyers and Hedian
Miller and Browne
Miller, Athanasias
Miller, Edwin N.
Miller, Ernest
Miller, George A.
Miller, Jacob
Miller, John
Miller, John F.
Miller, John F., Jr.
Milliard, Charles
Milliard, James
Milliard, Thomas
Milliken, Robert
Milliken, Thomas

Milosh, Christian
Milosh, William
Minifie, James
Minton, W.D.
Mitchell, Robert
Mon Hon
Monroe, John
Montgomery, William
Montgomery, William M.
Mooney, Michael
More, Samuel
More, Thomas
Morgan, William H.
Morrell and Morriss
Morrell, Willett H.
Morris, J.H.
Morris, John
Morrison, John C.
Morton, Daniel O.
Moss, Frederick
Mott and Doran
Mott and Pasman
Mott, Dewitt C.
Moulton Brothers
Mullard, Robert
Mullen, James
Mulligan, Michael
Naber, George
Nantion, J.
Neal, Joseph B.
Newcomb
Nicholson, Washington A.
Nickols, John
Noble, George
Nodine, Alexander
Northrop, Rodolphus E.
Nye, Alfred
Ochs, George N.
Olson
Omensetter, Elhanan
Orr, Richard
Orth, Adam
Ostheimer, A.
Otton, J. Hare
Pappenberg, Henry
Park, Thomas
Parker, Clark
Parkinson, John
Pasman, Frances
Pastor, James
Patney, Peter
Patterson
Patterson and Read
Paul, John
Peirce, George W.
Penn, Thomas
Pepperrell, William
Petrie, John
Phelen, James
Phillips, Felix
Phillips, William S.
Pickard, J.
Pierre, F.J.
Pifer, William
Pinsonault, L.
Piper, John C.

Potter, W(oodbury) A(bner)
Potts, Abram
Power and Ferrell
Pratt, Leon B.
Priestman, James
Primrose, Mordecai
Primrose, Robert
Prince, Henry M.
Proctor, D.R.
Purrington, Henry J.
Pursell, John
Pyfer, William
Pyle, John W.
Quest, Francis
Quinn, C.F.
R.C. Pringle and Company
R.H. Counce and Company
R.R. Thomas and Company
Raeder, Hartman
Raeder, Sebastian
Ramsey, Joseph
Randolph and Seward
Raymond and Fowle
Raymond, Edmund
Reifsneider, Charles
Renouf, Edward M.
Reynell, John
Rhode, Henry
Richardson, John
Richardson, R.
Richardson, Thomas
Riemann, George
Risley, Charles
Risley, Charles E.
Roberts, George S.
Robertson, Joseph
Robertson, William A.
Robinson, George
Robinson, John L.
Roebel, George
Rogers, James
Rogerson, John
Roherge and Knoblock
Rollins, George W.S.
Romer, C.
Roosetter, Charles H.
Rouse, Richard
Rumney, George R.
Rumney, John
Rumney, William H.
Rusby, John
Rush, Benjamin
Rush, John
S. Merchant and Company
S.W. Gleason and Sons
Sailor, S.H.
Samson Cariss and Company
Sanbach, Herman
Sapper, William
Sargent, John B.
Scallon and Company
Scallon, L.
Schaeffer, Henry
Schaffert, Charles
Scheckel, Conrad
Schmidt, Peter

Wood (Cont.)
 Ship carvings, ship figures (Cont.)
 Schmitt, Ambrose
 Schneider and Pachtmann
 Schone, Robert
 Schwager, William
 Schwartz, Peter
 Scott, John
 Searing, George E.
 Seavey, Thomas
 Seavey, William L.
 Seaward
 Selman, William
 Seward, William
 Shannon, George W.
 Sharp, Charles
 Sharpe and Ellis
 Sharpe, C(ornelius) N.
 Shepherd, Jacob
 Shoener, John
 Shulz, Randolph
 Simmons, W.A.
 Simon, Martin
 Sims and Shepherd
 Sims, James
 Skillin and Dodge
 Skillin, Samuel
 Skillin, Simeon, III
 Skillin, Simeon, Jr.
 Skinner, Edward
 Skinner, John
 Skinner, W. Hammond
 Slote, Alexander
 Smith and Crane
 Smith, C.W.
 Smith, Henry
 Smith, Henry M.
 Smith, R.
 Smith, Thomas H.
 Smith, Thomas H.
 Smith, William W.
 Solomon, John
 Southwork, William
 Southworth and Jones
 Spalding, Frederick
 Spaulding, Frederick D.
 Spaulding, James
 Spinney, Ivah W.
 Starckloff and Decker
 Statler, George
 Stegagnini, L.
 Stephen, John
 Stephen, William
 Stephens, Ebenezer
 Stevens, E.A.
 Steward, David
 Stewart, James, Jr.
 Stewart, William
 Stewart, William
 Stoddard and McLaughlin
 Stoddard, N.
 Stoddart, N.
 Stone, George
 Storey
 Stow, Samuel E.
 Stratton and Morrell
 Stratton, Joseph
 Stuart, Alexander W.
 Stueler, Charles
 Stumpf, Valentine
 Stutchfield, Joseph T.
 Sudbury and Schaefer
 Sudbury, Joseph M.
 Swam, George
 Swan, Jonathan R.
 Swasey, Alexander G.
 Sweatland, Joel
 T.J. White and Company
 Tapp and Miller
 Tapp, Edward
 Taylor, Enoch
 Taylor, George
 Taylor, John
 Taylor, John
 Telan, W.A.
 Telfer, James W.
 Terhune, Nicholas
 Theall, Isaac
 Thomas Seavey and Sons
 Thomas, Carl C.
 Thomas, Robert D.
 Thompson, John
 Thompson, M.
 Titcomb, James
 Titus, Francis
 Todd, James
 Towson and Hines
 Toy and Lingard
 Toy, Nicholas, Jr.
 Train and Collins
 Train, Daniel N.
 Trautz, August
 Treadwell and Godbold
 Treadwell, H.S.
 Treat, S(amuel) L.
 Trepner, William
 Tryday, G.H.
 Twing, George B.
 Uhle, Herman
 Umbrick, Gabriel
 Van Horn, Fielding
 Van Wymen and Brother
 Van Wynen, Bernard
 Vanderhoof, William H.
 Vannorden, John G.
 Vanzile, Ginge
 Verill, J(oseph) E.
 Verleger, C. Fred(ric)k
 Vieille, Ludwig
 Vogell, Charles
 Voltheiser, Joseph
 Voos, Robert
 Vought, Samuel L.
 Waddell, R.
 Wadsworth, Charles
 Walker, Peter
 Warburton
 Washburn, W.L.
 Watson, Richard
 Weaver, F.L.
 Weeden, John
 Weedon, J(ohn)
 Weedon, John
 Weiss, George
 Welch, John
 Wells, Henry
 Wells, Henry
 Welsh, John
 Werner, Casper
 West, Francis
 Weston, Thomas
 White and Company
 White, Richard H.
 Wightman, Thomas
 Wilkinson, Anthony
 Wilkinson, Bryant
 Willard, Solomon
 William Krafe and E.F. Teubner
 Williams, E.
 Williams, John
 Willis, Edward
 Wilson and Schaettler
 Wilson, Alfred (Albert H.)
 Wilson, James W.
 Wilson, Joseph
 Winnemore, Philip
 Winsor and Brother
 Winsor, Nathaniel
 Winsor, Samuel L.
 Witherstone, Phillip
 Wittfield, Henry
 Wooster, A.N.
 Wooster, A.V.
 Wright, Morrison
 Wyman, Samuel D.
 Young, William
 Youngs, Icabod
 Shorebird decoys
 Dilly, John
 Glover, John
 Verity, Nelson
 Shorebird, duck decoys
 Osborne, Henry F.
 Signs
 Barrow, John Sutcliff
 Grimes, John
 Hoadley, David
 Knight, L.
 Knight, Stephanas
 Millard, Tom
 Noble, Clarke
 Norwich, Beatty and Company
 Page, H.
 Pelkey, J.E.
 Reed, Abner
 Sizer, Samuel
 White, William Fred
 Signs, paintings
 Crossman, G.
 Signs, ship carvings, figures,
 sculptures
 Rush, William
 Signs, ship carvings, figures
 Skillin, John
 Social and political genre carvings
 Cartledge, William Ned

Sofas
 Steinhagen, Christofer Friderich Carl
Spice boxes
 Needhams, Mercy
Spinningwheels
 Stewart, William M.
Steam boat models
 Storie, Harold
Stenciled chairs
 Eaton, W.P.
 Johnson, Jarred
Stools
 Roux, Alexander
Swan decoys
 Williams, S.
Three-footed tables
 Foot, D.
Tinman signs
 Krans, J.
Totem poles
 Kay, Edward A.
Towers, carvings
 Van Hoecke, Allan
Toys
 Remmick, Joseph
 Smith, W.A.
Toys, fish, flower bowls
 Queor, William B.
Wallpaper designs
 Clough, Ebenezer
Wardrobes
 Heckmann, John H.
Weathervanes
 Cook, Mr.
 Crane, Mr.
 Gray, Mr.
 Greene, E. De Chois
 Leach, Henry
 Lombard, James
 Roby, W(arren) G(ould)
Weathervanes, duck decoys, shore bird decoys, other carvings
 Crowell, A.E(lmer)
Weathervanes, sculptures, carvings
 Ceeley, Lincoln J.
Weathervanes, ship figures, figureheads
 Rogers, Bruce
Weathervanes, whirligigs
 Bell, Joseph "Joe"
Western mural sculptures, carvings
 Grimes, Leslie
Whimsical figures
 Quiles, Manuel
Whirligigs
 Austin, Roy
 Fenimore, Janice
 Hinson, John
 Little, T.J.
 Marvin, Fay
 Reynolds, W.J., Dr.
Whirligigs, yard art
 Irvine, Eldon
Windsor chairs
 Fry, George

Windsor furniture
 Brown, G.
Windsor rockers
 Jackson, Samuel
Wood sculptures
 Blythe, David Gilmour
Wood sculptures, carvings
 Bernier
 Bickstead, A.E.
 Bixler, Absalom
 Blair, Fred
Woodenware
 Hersey, Edmond
Woodenware, buckets
 Hingham Wooden Ware

Wood, apples, nuts
Dolls
 Miracle, Hazel

Wood, cement
Mummy cases, carvings
 Cook, R.K.
 Cook, Ransom

Wood, concrete, metal
Crosses, religious signs
 Mayes, H. Harrison

Wood, cork
Duck decoys
 Burke, Edgar, Dr.
 Corwin, Wilbur R., Captain
 Cranford, Ralph M.
 Pennell, George
 Wheeler, Charles E. (Shang)

Wood, dye
Baskets
 Bennett, Alice
 Bennett, Russell

Wood, enamel
Sculptures
 Webster, Derek

Wood, gourds
Sculpture
 Black, Minnie

Wood, granite, oil
Sculptures, paintings
 Washington, James

Wood, grass
Baskets
 Morey, Charlotte

Wood, iron
Decorated tool box
 Hersh, H.S.

Wood, marble
Ship carvings, ship figures, sculptures
 Randolph, James T.

Wood, metal
Animal sculptures, carvings
 Alten, Fred K.
Fish decoys
 Dehate, Abraham
 Finkel, Bill (William)
 Flieman
 Goulette, Abe
 Mason, Marvin
 Riley
 Schmidt, Frank
 Scriba, George Frederick William Augustus
 Trombley, Andy
 Van den Bossche, Theodore
 Wagner
Sculptures, carvings
 Coe, Clark
Weathervanes
 Townsend, Albert
Wind indicators, compasses
 Jefferson, Thomas

Wood, metal, leather
Carved cups, decorated fire buckets
 Lehn, Joseph

Wood, metal, paint
Whirligigs
 Ward, Edwin P.

Wood, oil
Diarama, carvings
 McCarry, Ralph E.
Figures, signs, portraits
 King, Samuel
Historical portraits, paintings, ship carvings, ship figures
 Dwight, Stephen
Religious carvings in an environment
 Lund, E.K.
Sculpture, landscape paintings
 Beichler, Ed
Sculptures, carvings, paintings
 Gavrelos, John J.
 Mazur, Frank
 Pressley, Daniel
Sculptures, carvings, portraits
 German, Henry
Sculptures, carvings, scene-genre paintings
 Wiener, Isador "Pop"
Sculptures, carvings, totem poles, paintings
 Dawson, William

Wood, oil, cement
Sculptures, carvings, scene paintings
 Roeder, John "The Blind Man"

Wood, oil, mixed media
Romantic western paintings, sculptures, carvings
- White, George

Wood, oil, watercolor
Carved canes, secular and religious paintings
- Willis, Luster

Wood, paint
Animal, cane carvings
- McKenzie, Carl

Animal, figure sculptures
- MacKenzie, Carl

Carved animals
- Kurpenski, C.

Carvings, paintings
- Hurst, T.W.

Chairs
- Beckwith, Benjamin
- Bollinger, Leslie

Chests of drawers
- Evans, W.D.
- Maser, Jacob

Clocks
- Cole, Abraham
- Cole, Rufus

Costumed wooden dolls in an environment
- Black, Calvin

Figures
- Starbuck, M.

Fish decoys
- Smith, Miles

Furniture
- Waghorne, John

Religious paintings, sculptures
- Ellis, Clarence

Signs
- Schuman, E.

Swan carvings
- Rust, David

Wood, paint, fabric
Sculptures, wind toys in an environment
- Van Zile, John

Wood, paint?
Decorated? boxes
- Shurtleff, Isaac

Wood, paper
Bandboxes
- Barnes, Henry
- Bijotat, Simon

Handboxes
- Putnam, George
- Roff, Amos B.
- Tillinghast, Joseph
- Widow, M. Queen

Wood, paper, plastic beads, coins
Boxes, hearts, beaded crosses
- Feltner, Jim

Wood, pen, watercolor
Figures, signs, seascapes
- White, Thomas J.

Wood, pencil
Clocks, set of praying hands
- Creech, Homer E.

Wood, plastic, paint, paper
Carvings
- Wasilewski, John

Wood, stone
Carvings
- Cole, Richard

Miniature houses
- Sparks, Fielden

Wood, stone, iron
Carved gates
- Wilton, Hobart Victory

Wood, stone, oil
Sculptures, landscape paintings
- Risley, Russell

Wood, tin, paint, canvas
Sculptures, constructions
- Gilkerson, Robert

Wood, various materials
Sculpture constructions
- Blocksma, Dewey Douglas

Sculptures
- Herrera, Jose Inez (Ines)

Wood, watercolor
Sculptures, figural carvings, paintings
- Jones, Shields Landon

Wood, zinc
Cigar store Indians, figures, statuary
- Seelig, Moritz J. (Morris; Maurice)

Wood?
Bookends
- Schoenfield, Emanual

Boxes?
- Coist, P.F.

Weathervanes, sculptures, carvings
- Brasher, Rex

Wool
Needlepoint
- Cotton, Dorothy

Yarn, fabric
Coverlets, carpets
- Schultz, J.N.

Yellow-ware
Bisque porcelain, pottery, fruit jars
- Tempest, Michael
- Tempest, Nimrod

Pottery
- Agner and Gaston
- Agner, Fouts and Company
- Behn, Andrew
- Bulger and Worcester
- Doane, James
- Foster and Rigby
- Graff, J.
- Greatbach, Hamlet
- Howson, John
- J. Patterson and Company
- Lewis, William
- Marks, A.H.
- Marks, Farmer, Manley and Riley
- Shepard, Elihu H.
- Simms and Ferguson
- Smith, A.F.
- Tempest, Brockman and Company
- Woodward and Vodrey
- Worchester, Samuel

Yellow-ware, brownware
Pottery
- Bennett Brothers
- Bennett, Daniel
- Bennett, James S.
- Bennett, William
- Marshall, Abner
- Moore, Enoch
- Vodrey, Jabez

Yellow-ware, Rockingham
Bird whistles, toys, pottery
- Henderson, John

Pottery
- Brewer and Tempest
- Burton, William
- C.C. Thompson Pottery Co.
- Elverson, Thomas
- Frederick, Schenkle, Allen and Company
- Goodwin, John
- Howson, Bernard
- John W. Croxall and Sons
- Knowles, Isaac W.
- Mappes, H.
- McCullough, William
- Miller, August
- New England Pottery Company
- Pollock, Samuel
- Pyatt, George
- Pyatt, J.G.
- Simms and Laughlin
- Simms and Starkey
- Speeler, Henry
- T. Rigby and Company
- Thomas Croxall and Brothers
- Thompson and Herbert
- Vodrey and Frost
- Woodward, Blakely and Company

Wylie Brothers

Yellow-ware, Rockingham, artware
Pottery
　Coultry, P.L.

Yellow-ware, white-ware, Rockingham
Pottery
　Clark, Decius W.

Type of Work Index

*(See the "Special Indexes to Contents" section of the Introduction
for an explanation of this index and its limitations.)*

Advertising drops for theaters, motion pictures, etc.
Unidentified Media
 Bert L. Daily Scenic Studio

Allegorical drawings
Watercolor
 Douglas, Lucy
 Waters, E.A.

Altar paintings
Oil
 Fresquis, Pedro Antonio

Altar paintings, santeros
Oil
 Gonzales, Jose de Garcia

Altar screens, paintings
Oil, wood
 Velasquez, Juan Ramon

Altar sculptures, carvings
Wood
 Schwarzer, Franz

Andirons
Brass
 Davis, James

Animal, cane carvings
Wood, paint
 McKenzie, Carl

Animal carvings
Wood
 Mountz, Aaron

Animal drawings, frakturs
Watercolor
 Meyer, Elizabeth

Animal, figure sculptures
Wood, paint
 MacKenzie, Carl

Animal paintings
Oil
 Wilson, Henry

Animal portraits
Oil
 Wilson, Oliver

Animal sculptures, carvings
Wood
 Wilson, Augustus
Wood, metal
 Alten, Fred K.

Animals
Papermache
 Hammond, H.W.

Animals, toys, sculptures, carvings
Wood
 Schimmel, Wilhelm

Appliqued linens
Fabric
 Hurxthal, Isabel Hall

Appliqued pictures
Fabric
 Hardin, Esther McGrew
 Lynch, Laura
 Ominsky, Linda

Appliques
Fabric
 Gilcrest, Helen

Apron paintings
Watercolor
 Meer, John

Apron paintings, portraits, landscape paintings
Watercolor
 Brown, M(andivilette) E(lihu) D(earing)

Architectural constructions
Various materials
 Cusie, Ray

Architectural paintings
Acrylic
 Jeremenko, Theodore
Watercolor, gouache
 Van Wie, Carrie

Army base life paintings
Watercolor
 Kilpatrick, R.L., Captain

Artware pottery
Clay
 Ingles, Thomas
 McLaughlin, Miss Mary Louise
 Wheatley, Thomas

Balances
Brass
 Maxwell, J.

Bandboxes
Wood, paper
 Barnes, Henry
 Bijotat, Simon

Banks
Stoneware
 Smith, Norman

Banner paintings
Oil
 E.J. Hayden and Company
 Merrifield

Baptismal bowls
Redware
 Noll

Bar iron banner signs, weathervanes
Iron
 Howard, Thomas
 Howard, William

435

Barn paintings
 Oil
 Burk, Eldon

Basket weavings
 Grass
 Marta, Anna Maria

Baskets
 Grass
 Coaxum, Bea
 Foreman, Mary Lou
 Foreman, Regina
 Straw
 Folger, R.
 Mackosikwe (Mrs. Michele Buckshot)
 Unidentified Media
 Appletown, William L.
 Atkins, A.D.W.
 Brandt, Mrs. Henry
 Elvins, George D.
 Johnson, John
 Kinderlen, Conrad
 Long, Nicholas
 Luppold, John
 Shepard, George
 Waller, John
 Whitener, Thomas
 Wilson, Ida
 Witmann, John H.
 Wood
 Clark, Leon "Peck"
 Mawatee
 Thomas, Eli
 Wood, dye
 Bennett, Alice
 Bennett, Russell
 Wood, grass
 Morey, Charlotte

Battle scene paintings
 Oil
 Brown, David E.
 De Laclotte, Jean Hyacinthe
 Watercolor
 Kreebel, Isaac

Battleship fleet sculptures
 Various materials
 Flax, Walter

Bay scene paintings
 Watercolor
 Richardson, George

Beadwork map of New York
 Beads
 Hopps, David Vernon

Beadwork purses
 Fabric
 Sinclair, Mrs. William

Bed rugs
 Fabric
 Baldwin, Hannah
 Brace, Deborah Loomis
 Clayman, Susan
 Comstock, Mary
 Foot(e), Abigail
 Foot(e), Elizabeth
 Foot(e), Mary
 Johnson, Hannah

Bedcovers
 Fabric
 Canfield, Betsey
 Hewson, John
 Huntington, Julie Swift
 Knight, Emily
 Wisdom, Sarah B.

Beds
 Wood
 Blatter, Jacob

Bedspreads
 Fabric
 Macca, Lorita
 Schulz, Maria Boyd

Bells
 Brass
 Andrew Meneely and Sons
 Levering, T.W.
 Pass and Stow
 Syng, Phillip
 Tommerup, Matthias

Belt buckles
 Ivory, silver
 Fletcher, Eric

Benches, cupboards
 Wood
 Kemper, Simon
 Winkelmeyer, Henry

Biblical, fantasy drawings
 Oil, pen, ink, crayon, collages
 Evans, Minnie

Biblical, miniature paintings
 Oil, watercolor
 Plummer, Edward

Biblical scene paintings
 Oil
 Plattenberger

Biblical scene paintings, environmental, other sculptures, carvings
 Oil, wood, plexiglass
 Finster, Howard, Reverend

Biblical sculptures
 Driftwood, putty
 Hopper, Annie

Bird and animal sculptures, carvings
 Wood
 Tschappler, L.W.

Bird decoys
 Wood
 Carter, John W.

Bird sculptures, carvings
 Wood
 Foraner, Robert
 Jaeger, Michael
 Lawson, Oliver
 Schultz, William L.

Bird whistles, toys, pottery
 Yellow-ware, Rockingham
 Henderson, John

Birdhouses
 Stoneware
 Suttles, G.W.

Birdhouses, canes, plaques, whistles
 Wood
 Raidel, Dorion

Bisque porcelain, pottery, fruit jars
 Yellow-ware
 Tempest, Michael
 Tempest, Nimrod

Blanket chests
 Wood
 Matteson, Thomas

Blankets
 Fabric
 Duran, Damian
 Esquibel, Felix
 Garcia
 Garcia, Pablo
 Lopez, Antonia
 Lopez, Martina
 Lovato, Jose
 Manzanares, Luisa
 Montoya, Patricia
 Ortega, David
 Ortega, Jose Ramon
 Virgil, Juan Miguel

Blankets, jergas
 Fabric
 Gallegos

Block prints for decorations
 Blocks
 Eliot, John, Reverend

Type of Work Index — **Candlewick pillow slips**

Boat paintings
Pastel
Upham, J.C.

Boat portraits
Watercolor
Downes, P.S.
Watercolor, crayon
Golding, William O.

Bone china
Clay
Alpaugh and McGowan
Thomas China Company

Book paperweights
Marble
Merril, George Boardman

Bookcases
Wood
Hausgen, Frederick

Bookends
Wood?
Schoenfield, Emanual

Bottle fence
Bottles
Stephens, Henry

Bottle sculpture
Bottles
Makinen, John Jacob, Sr.

Bottles
Stoneware
Wheaton, Hiram

Bottles, buttons
Glass, brass
Wistar, Casper

Bottles, pottery
Ceramic
Greatbach, Daniel

Bowls
Stoneware
Harmon, P.
Harrington
Henderson Pottery
Herrmann, P(eter)
Mapp, F.T.
Owen, M.W.
Richter, E.J.

Bowls, sewer tile sculpture
Stoneware
Knight, Maurice A.

Box churns
Wood
Funk, E.H.

Box violins
Wood
Nichols, Maynard

Boxes
Cardboard
Henry Cushing and Company
Copper
Alley, Nathaniel
Gold
Hurd, Jacob
Le Roux, Charles
Leather
Boyd, James
James, Boyd
Paint
Evans, Daniel
Kelly, Mary F.
Scrimshaw
Fletcher, Marianne
Silver
Rouse, William
Wood
Ball, Silas
Cleaveland, Nathan
Dunn, Justus
Fitch, Isaac
Hersey, Samuel
Lytle
Moulton, John
Rumbaugh, M.
Webber, John

Boxes, coffins
Wood
Jewett, George

Boxes, hearts, beaded crosses
Wood, paper, plastic beads, coins
Feltner, Jim

Boxes, overmantels, firebuckets, signs
Oil
Eaton, Moses, Jr.

Boxes?
Wood?
Coist, P.F.

Brassware
Brass
Adams, James W.
Burnap, Daniel
Fellows and Meyers
Leman, Henry
McAllister and Company
Robertson, John

Buckets
Wood
Proctor, E.

Building portraits
Oil
Follett, T.
Heerlein, W.
Whittle, B.
Pastel
Floote, Mrs. A.A.
Pen, crayon, pencil
Marcile, Stanley
Unidentified Media
Wakeman, Thomas

Bureau chests
Wood
Kimmel

Busts
Marble
Volk, Leonard W.

Buttons
Brass
Whiteman, Henry

Cabinets
Wood
Craft, William
Day, Thomas
Hiatt, James
Ned

Cabinets, chairs
Wood
Isaac Wright and Company

Cakeboards
Wood
Conger, John

Calligraphy
Pen, ink, pencil
Pringle, Sylvester R.

Calligraphy drawings
Pen, ink
Bause, K.F.
Cronk, T.J.
Cross, J. George
Cummings, C.W.

Calligraphy paintings
Pen, ink, watercolor
Hamm, Lillian

Candlemolds
Tin
Phenstein, W.A.

Candlesticks
Brass
Cornelius and Baker
Wood, Joseph

Candlewick pillow slips
Fabric
Miller, Anne D.

Candlewick spreads
- Fabric
 - Beall-Hammond, Jemima Ann
 - Jones, Emily Edson
 - Little, George F.
 - Rounds, Mary M.
 - Rutgers Factory
 - Tibbets, Susan

Cape Vincent terminal models
- Wood
 - Chapman, Hicks David

Carousel figures
- Wood
 - Albright, Chester
 - Armitage, James
 - Auchy, Henry
 - Brown, Edmond
 - Goldstein, Harry
 - Herschell, Allen
 - Looff, Charles I.D.
 - Muller, Alfred H.
 - Parker, Charles W., Colonel
 - Spillman Engineering Corporation
 - Stein and Goldstein
 - Stein, Soloman
 - Toboggan Company

Carousel horses
- Wood
 - Louff, Charles
 - Muller, Daniel Carl
 - Parker Carnival Supply Company

Carousel, other figures
- Wood
 - Dentzel, William
 - Illions, Marcus Charles

Carpets
- Fabric
 - Nicklas, George

Carpets, coverlets
- Fabric
 - Auburn State Prison
 - Boettger, Carl
 - Burnside, John
 - Butterfield, Samuel
 - Cass, Josiah
 - Cole, Anthony
 - Conger, Jonathan
 - Craig, John
 - Davidson, Archibald
 - Dehart, John, Jr.
 - Dunlap, William S.
 - Endy, Benjamin
 - Eyre, John
 - Findlay, Robert
 - Fliehr, Charles B.
 - Gauss, George
 - Grimm, Peter
 - Hersh, Henry
 - Keener, John
 - Lake, Salmon
 - Mayo, Charles S.
 - McLeran, James
 - Meily, John Henry
 - Miller, Ambrose
 - Muir, John
 - Murr, Lewis
 - Myers, Daniel L.
 - Nevel, Frederick
 - Rattray, Matthew
 - Riegel, Simon
 - Schnee, Joseph F.
 - Schoonmaker, James
 - Scwartz, John, Jr.
 - Scwartz, John, Sr.
 - Seifert and Company
 - Tatham, Thomas
 - Wantz
 - Wiand, Joel
 - Wiand, Jonathan D.
 - Wilson, Robert B.

Carpets, coverlets, diapers
- Fabric
 - Meily, Emanuel, Jr.

Carpets, coverlets, weavings
- Fabric
 - Kennedy, David

Carriage paintings
- Oil
 - Burke, Michael
- Oil?
 - Waters, Samuel
- Paint
 - Coab, Joseph
 - Roosebush, Joseph
- Unidentified Media
 - Howard, Freeman

Carved animals
- Wood
 - Pierce, Charles
- Wood, paint
 - Kurpenski, C.

Carved animals, boxes
- Ivory, wood
 - Covart, W.A.

Carved boxes
- Wood
 - Bissell, Thomas
 - Buell, William

Carved boxes, furniture
- Wood
 - Crosman, Robert

Carved canes
- Ivory
 - Somerby, William S.
- Ivory?
 - Earle, James, Captain
- Whalebone, ivory
 - Bayley, Charles
- Wood
 - Bobb, Victor "Hickory Stick Vic"
 - Caldwell, Booth
 - Frischwasser, Ben
 - Goodpastor, Denzil
 - Gudgell, Henry
 - Miller, Howard
 - Rogers, William

Carved canes, animals, figures
- Wood
 - Skaggs, Loren

Carved canes, secular and religious paintings
- Wood, oil, watercolor
 - Willis, Luster

Carved cups, decorated fire buckets
- Wood, metal, leather
 - Lehn, Joseph

Carved eagle sculptures, ship carvings, figures
- Wood
 - True, Joseph

Carved fans
- Wood
 - Menard, Edmond "Bird Man"
 - Nutting, Chester
 - Van Antwerp, Glen
 - Van Antwerp, Stan

Carved fiddle
- Wood
 - Hundley, Joe Henry

Carved gates
- Wood, stone, iron
 - Wilton, Hobart Victory

Carved pipes
- Bone
 - Pearson, Hugh A.

Carved shrines
- Wood
 - Wood, John

Carved whale teeth
- Whalebone, ivory
 - Hayden, J.
 - Williams, Arthur

Carvings
- Stone
 - Marshall, Inez
 - Reed, Ernest "Popeye"
- Whalebone, ivory
 - Williams, William

Wood
- Byrley, Frank J.
- Childers, Russell
- Cress, Edward
- Garrett, Carlton Elonzo
- Hurst, John W.
- Jarvie, Unto
- Kinney, Noah
- May, Roy
- Parker, Burr
- Pasanen, Robert I.
- Patride, Marvin
- Reiss, Al
- Tolson, Donny

Wood, plastic, paint, paper
- Wasilewski, John

Wood, stone
- Cole, Richard

Carvings, clock frames, scultpures
Wood
- Riddle, Morton

Carvings, figures
Wood
- Job

Carvings, paintings
Wood, paint
- Hurst, T.W.

Carvings, watch stands
Whalebone, ivory
- Toby, Charles B.

Cast iron kettles
Iron
- Eagle Foundry

Cast iron stove plates
Iron
- Maybury, Thomas

Cast ironware
Iron
- Herberling

Cat paintings
Oil
- Elliot, R.P.
- Novik, Jennie

Chainsaw sculptures
Wood
- Joe, Pappy

Chairs
Wood
- Avery, Gilbert
- Ford, J.S.
- Gillingham, James
- Gragg, Samuel
- Holcomb, Allen
- Holmes and Roberts
- Hull, John L.
- Johnson, Isaac
- Kunze, William
- MiddleKamp
- Moore, William, Jr.
- N.R. Stephens Chair Factory
- Rahmeier, Frederick
- Ritter, Florent
- Schauf, Wilhelm
- Seymour, John
- Tuthill, Silas
- Van Beek, Hermann
- Watrous, Seymour

Wood, paint
- Beckwith, Benjamin
- Bollinger, Leslie

Chairs, tables
Wood
- Gaebler, Carl Frederick (William)

Chandelier
Wood
- Goins, Luther

Chapel and memorial sculptures
Concrete, mixed media
- Wagner, Paul L.

Chapel paintings, sculptures
Oil, wood
- Miera y Pacheco, Bernardo, Captain

Cheesemolds, tinware
Tin
- Troyer, William

Chests
Wood
- Sisson, J.
- Townsend, Edmund

Chests, boxes, press cupboards
Wood
- Lane, Samuel "Sam"

Chests of drawers
Wood
- Morse, E.
- Sala, John

Wood, paint
- Evans, W.D.
- Maser, Jacob

Childhood scene and genre paintings
Oil
- Lunde, Emily

Children's portraits
Oil
- Brewer

Chimney board paintings
Oil?
- Kidd, Joseph

Chimney pieces
Needlepoint
- Condy, Mrs.

Needlework
- Bourne, Mercy

Wood
- Wellford, R.

China
Whiteware
- West Virginia China Company

Chronological and genealogical chart
Pen, watercolor
- Skeen, Jacob

Church portraits, drawings
Pencil
- Mickey, Julius

Churns
Stoneware
- Brannan, Daniel
- Clark and Lundy
- Doane, George
- Ideal Pottery
- Kline, Charles S.
- Meaders Pottery

Churns, pitchers
Stoneware
- Rushton, Joseph

Cigar box churches
Wood
- Willett, George H.

Cigar store Indians
Wood
- Dibblee, Henry

Cigar store Indians, circus, other figures
Wood
- Carretta, Frank

Cigar store Indians, figures
Metal, wood
- Miller, Dubrul and Peters Manufacturing Compa
- William Demuth and Company

Wood
- Boulton, William
- Brooks, James A.
- Brown, James
- Callanan, Richard
- Collins, Nicholas E.
- Cote, Claude
- Crongeyer, Theodore
- Decker, Fritz
- Deker, Francis Jacob
- Dengler, J.
- Dowler, Charles Parker
- Fisher, John
- Gaspari, P(ierre) G.

Cigar store Indians, figures (Cont.)
 Wood (Cont.)
 Guhle, Charles
 Hadden, Elias W.
 Hamilton, James
 Inabet, Mike
 Jeremiah Dodge and Son
 Kaiffer, Frederick W.
 Kruschke, Herman
 Lapp, Ferdinand
 Lewin, Isaac
 Matzen, Herman
 Melchers, Julius Caesar (Theodore)
 North, Justinus Stroll
 Osebold, Anthony, Jr.
 Robb, Charles
 Robb, Clarence
 Ruef, Arnold
 Ruef, Peter
 Strauss, Simon
 Yeager, John Philip

Cigar store Indians, figures, eagles, various ornamental carvings
 Wood
 Metzler, Henry F.

Cigar store Indians, figures, sculptures, carvings
 Wood
 Brown, Joseph

Cigar store Indians, figures, ship carvings, ship figures
 Wood
 Millard, Thomas, Jr.

Cigar store Indians, figures, ship carvings and figures, circus wagons
 Wood
 Robb, Samuel Anderson

Cigar store Indians, figures, statuary
 Wood, zinc
 Seelig, Moritz J. (Morris; Maurice)

Cigar store Indians, ship carvings, figures
 Wood
 Siebert, Henry A.
 Teubner, William
 Tryon, Elijah

Cigar store Indians, ship carvings, ship figures
 Wood
 Brown, Charles
 Dodge, Charles J.

Cigar store Indians, ship figures
 Wood
 Anderson, John W.

Cigar store Indians, ship figures, other figures
 Wood
 Cromwell, John L. (S.)

Circus and carousel figures
 Wood
 Armitage-Herschell Company
 Breit, Peter
 Bright, Pete
 Carmel, Charles
 Cernigliaro, Salvatore
 Dare, Charles W.F.
 Dentzel, Gustav A.
 Herschell-Spillman Company
 Lawrence, George
 Long, George
 Loomis, L.R.
 Morris, J.W.
 Sebastian Wagon Company
 Zalar, John

Circus banners
 Oil
 Baker-Lockwood
 Bruce, Joseph
 Bulsterbaum, John
 Hill, Cad
 Johnson, Fred G.
 M. Armbruster and Sons
 Millard, Al(gernon) W. (John)
 New York Studios
 Nice, Bill
 Schell's Scenic Studio
 Sigler, Clarence Grant
 Sigler, Jack
 Wicks, Robert F. "Bobby"; "Texas"
 Wolfinger, August
 Wyatt, David Clarence "Snap"
 Paint
 Cripe, Jack "Sailor Jack"

Circus banners, frescos, signs
 Oil
 Josephs, Joseph "Elephant Joe"

Circus banners, theater scenery
 Oil
 O. Henry Tent and Awning Company
 United States Tent and Awning Company

Circus figures
 Various materials
 Brinley, William R.

Circus, theater scenes
 Oil
 Sosman and Landis Company

Circus theme paintings
 Poster paint
 Pry, Lamont "Old Ironside"

Cityscape paintings
 Oil
 Fracarossi, Joseph
 Griffin, G.J.
 Hunt, Peter "Pa"
 Kellner, Anthony
 Low, Max
 Seamen, W.
 Wilson, Thomas
 Oil, crayon, pen, ink
 Savitsky, Jack
 Tempera
 Cerveau, Joseph Louis Firman (Fermin)
 Contis, Peter A.
 Watercolor
 Bussell, Joshua H.
 Sperry, John

Cityscape paintings, building portraits
 Oil
 Schenk, J.H.

Cityscape paintings, portraits, cigarstore figures
 Oil, watercolor, wood
 Hamilton, Charles J.

Clock and dial paintings
 Paint
 Pond, Burton

Clock cases
 Wood
 Rude, Erastus

Clock faces
 Paint
 Wheeler, Hulda
 Tin painted
 Darrow, Elijah
 Fenn

Clock faces, panels
 Paint, stencils
 Alfred, Cynthia
 Alfred, Louisa

Clocks
 Tin?
 Otis, Fred
 Wood
 Green, J.D.
 Jewett, Amos
 Paul, John, Jr.
 Rife, Peter
 Whiting, Riley
 Willard, Aaron
 Willard, Simon
 Willard, Zabadiel
 Youngs, Benjamin S.
 Youngs, Isaac N(ewton)
 Wood, paint
 Cole, Abraham
 Cole, Rufus

Clocks, set of praying hands
Wood, pencil
 Creech, Homer E.

Coach, sign paintings
Oil
 Pratt, Matthew
Oil?
 Wentworth, Josiah W.
Paint, wood
 Bull, John C.

Coffee pots
Tin
 Eubele, M.
 Gilberth, J.H.
Tin painted
 Fulivier, James

Coffee pots, tinware
Tin
 Ketterer, J(ohn) B.
 Uebele, Martin

Colcha embroideries
Fabric
 Lujan, Maria T.
 Stark, Tillie Gabaldon

Collages
Acrylic, clay, paper
 Salzberg, Helen

Comb boxes
Wood
 Freeman, Joseph L
 Willard, Alfred

Combs
Wood
 Noyes, Enoch

Commemorative samplers
Fabric
 Brown, Mrs. Nicholas E.
 Peterson, Petrina

Community scene, historical paintings, portraits
Oil
 Krans, Olof

Compasses
Brass
 Lamb, Anthony

Constructions
Sawdust, clay
 Fodor, Richard L.

Cookie cutters
Tin
 Fretzinger
 Gill
 Smith, Will

Copperware
Copper
 A.D. Richmond and Company
 Attlee, William
 Fuller, John
 Getz, John
 Heiss, William
 Holmes and Evans
 Orr, George

Copperware, tinware
Copper, tin
 Bailey, William
 Brotherton, E.

Corn husk toy
Husks
 Cleveland, Mrs.

Corner cupboards
Wood
 Wehmhoemer, Johann Friedrich

Costumed wooden dolls in an environment
Fabric
 Black, Ruby
Wood, paint
 Black, Calvin

Coverlets
Fabric
 Alexander, James
 Alexander, John
 Alexander, Robert
 Allen, Abram
 Allen, B. Hausman
 Annis, Clark
 Anshutz, Philip
 Ayrhart, Peter
 Bacheller, Lucinda
 Bachman, Anceneta
 Backer, Hiram
 Baer, Gabriel
 Baldwin, H.
 Bartler, Joseph
 Bauer, William
 Baughman, John
 Bayard, Jacob
 Bean, Mrs.
 Beard, M.
 Beard, William
 Beatty, Gavin I.
 Bechtel, John
 Beil, David
 Berthalemy, Jacob
 Bewford, Elias
 Birch, S.A.
 Blocher, S. (B.)
 Bock, Mrs. William N.
 Bohn, Adam
 Bohn, Jacob W.
 Bower, L.
 Bowman, Henry B.
 Brailer, Augustin
 Breeswine, Peter N.
 Breidenthal, P.
 Breneman, Martin B.
 Brinkman, Henry
 Bronson, J.
 Bronson, R.
 Brosey, John, Sr.
 Brosey, William
 Brumman, David W.
 Burkerd, E.
 Bush, W.
 Cable, Henry K.
 Campbell, Daniel
 Chapman, Ernst
 Christie, I.
 Christmas, W.F.
 Clapham, J.
 Clearfield Textile Mill
 Coble, Henry K.
 Cockefair Mills
 Cook, Valentine
 Craig, James
 Cunningham, James
 Curry, Sam
 Dare, Robert
 Davidson, J.
 Davidson, J.M.
 Davis, J.
 Dornbach, Samuel
 Douglas, Charles
 Duddleson, C.
 Dudley, Samantha Charlotte
 Emigh, Mary
 Engel, G.
 Etner, Reuben
 Etter, Elizabeth Davidson
 Ettinger, William
 Fasig, A.
 Fasig, William
 Fehr and Keck
 Fehr, Abraham
 Fehr, C.
 Fehr, Thomas
 Fennell, Michael
 Fischer, Samuel
 Fisher, Daniel
 Fisher, Jacob
 Fisher, Levi
 Flowers, Peter
 Forrer, Martin
 Foster, Mary Ann Kelly
 Fouth, Jacob
 Fox, John
 Frailey, Michael
 Frederick, Henry K.
 Frederick, Henry T.
 Frey, Abraham
 Frey, Christian
 Frey, Samuel B.
 Fridley, Abraham
 Friedel, Robert
 Galley, Jacob
 Gamber, M.G.
 Gamble, J.
 Gamble, Sam
 Garber, Jonathan

Coverlets (Cont.)
 Fabric (Cont.)
 Garner, Jacob
 Garrett, Thomas
 Gepfert, A
 Gerbry, M.Y.
 Gerthner, Xavier
 Gilmore, Gabriel
 Gilmore, Joseph
 Gilmore, Thomas
 Gilmore, William
 Glassey, Joseph
 Glassley, John
 Good, Jacob
 Goodall, Premella
 Graham, Samuel
 Habecker, David
 Hadsell, Ira
 Haeseler, H.
 Hallack, Jane E.
 Hamelton, John
 Haring, David D.
 Harlmz, David D.
 Harper, William
 Harrisman, Mehitable
 Hart, E.J.
 Hart, J.
 Harting, Peter
 Hartmann, Charles G.
 Hausman, B(enjamin)
 Hausman, Joel
 Hechler, Samuel
 Hedden, Martha
 Heffner
 Hefner, George
 Heilbronn, J(ohn) J.
 Heiser, William L.
 Hemon, James
 Herman, John
 Heshe, Henry
 Hesse, D.
 Hicks, William
 Hilliard, Philip H.
 Hinkel, C(hristian) K.
 Hoagland, James S.
 Hoerr, Adam
 Hoke, George
 Hoke, Martin
 Horsefall, Henry
 Hoyt, Esther
 Huntting, Marcy
 Impson, Jacob
 Imsweller, Henry
 Jenison, J.
 Johnson, D.P.
 Jordan, Thomas
 Jotter, Jacob
 Jukes, Benjamin
 June, Benjamin
 Kaufman, John
 Keagy, I.
 Kean, Carl Lewis
 Keck
 Keener, Jacob
 Keffer, William
 Kepner, Absalom B.
 Kerns, William
 Kitson, Nathan
 Klein, John
 Klein, Mathias
 Klinger, Absalom
 Klinhinz, John
 Kuder, Solomon
 Kump, Andrew
 La Tourette, Henry
 La Tourette, John
 La Tourette, Sarah (Van Sickle)
 Laget, A.
 Landes, John
 Lantz, J.
 Lawrence, David
 Lee, John
 Leehman, Joseph, Jr.
 Leehman, Joseph, Sr.
 Lehr, Daniel
 Leidig, Peter
 Lentz, Cornelius
 Leykauff, Michael
 Logan, Patrick
 Long, David
 Longenecker, Peter
 Lorentz, Peter
 Lowmiller, William
 Lunn, William
 MacIntyre, A.
 Maddhes, C.
 Marshall, Edward W.
 Marsteller, Thomas
 Maxwell, William
 McKenna
 McMillen, Samuel
 McNall, John
 Meckel, J.S.
 Meeks, Josiah
 Meily, Samuel
 Mellinger, W.S.
 Metz, L.
 Michael, Enos
 Michael, Philip
 Miller, Gabriel
 Miller, Maxmilion
 Moncliff, A.B.
 Monroeton Woolen Factory
 Morehouse, P.M.
 Morgan, William S.
 Mosser, John
 Moyall, James
 Muehlenhoff, Heinrich
 Mundwiler, Samuel
 Musselman, Samuel B.
 Myer, I.
 Myers, Charles D.
 Myers, James
 Netzly, Jacob
 Nusser, Christian
 Oberholtzer, A.
 Oxley, Joseph
 Peden, Joseph
 Peter, H.P.
 Peterman, Casper
 Petry, Henry
 Phlegan, Henry
 Porter, C.C.
 Primrose, Jacob
 Probst, Henry
 Pulaski, J. Irvin
 Punderson, Prudence Geer
 Pursell, Daniel
 Quincy, Mary Perkins
 Rassweiler, Philip
 Rauser, Gabriel
 Redick, John
 Reed, William A.
 Reichert, H.
 Remy, James
 Ringer, Peter
 Rottman, G.
 Saeger, Martin
 Salisbury, J.
 Satler, J.
 Saurly, Nicholas
 Schneider, Johann Adam
 Schneider, John E.
 Schoch, Charles (G. Schoch)
 Schrader, H.
 Schreffler, Isaac
 Schreffler, Samuel
 Schrontz
 Schum, Peter
 Seibert, Peter
 Seidenspinner, John
 Seifert, Henry
 Seip
 Serff, Abraham
 Shafer, J.
 Shallenberger, Peter
 Shamp, D.
 Shank, H.
 Shank, W.
 Sheaffer, Isaac
 Shearer, Michael
 Sheffler, Isreal
 Shreffler, Samuel
 Simpson, George
 Slaybough, Samuel
 Smith, George
 Smith, George M.
 Smith, Joseph
 Smith, Judith
 Smith, William
 Snyder, Isaac
 Speck, John C.
 Stauch, David, Jr.
 Steiner, David
 Steinhilber, Martin
 Steinhill Brothers
 Stephenson, Daniel
 Sternberg, William
 Steurnagle, Andrew
 Stich, G.
 Stiff, J.
 Stillwell, Ida
 Stimmel, S.
 Sulser, Henry
 Tobin, John
 Turnbaugh, Joseph
 Turnbaugh, Samuel
 Turner, William

Type of Work Index

Tyler, Elman
Uhl, Peter
Unger, I.
Van Buskirk, Jacob
Van Doren, Abram William
Van Doren, Garret William
Van Doren, Isaac William
Van Doren, Peter Sutphen
Van Fleck, Peter
Van Meter, Joel
Van Ness, James
Van Nortwic, C.
Van Vleck, Jay A.
Van Vleet, Abraham
Walk, Jacob M.
Warner, Phebe
Warner, Sarah Furman
Watson Woolen Mill
Weand, William
Wearehs
Weaver, John W.
Weaver, Samuel
Weaver, Thomas
Weber, T.
Weddell, Liza Jane
Weidel, George
Weil, George P.
Welk, George
Welty, John B.
Wensel, Charles
West, James
Wever, H.S.
White
Wiand, John
Wiggins, C.
Will, William
Williams, May
Wilson, William (A. Wilson)
Wise, E.
Woodcocke
Woodring
Wunterlich, John
Yearous, F.
Young, Abraham
Young, Nathaniel
Young, Peter
Zelna, A.
Zinck, John

Coverlets, bedspreads
Fabric
 West, William

Coverlets, blankets
Fabric
 Peter, Reuben
 Robinson, James
 Routt, Daniel
 Smith, John

Coverlets, carpets
Fabric
 John Mellinger and Sons
Yarn, fabric
 Schultz, J.N.

Coverlets, carpets, blankets
Fabric
 Crothers, Samuel

Coverlets, diapers
Fabric
 Murphy, Richard

Coverlets, diapers, carpets
Fabric
 Henderson, George, Jr.

Coverlets, eagle drawings
Fabric, pen, ink
 Oberly, Henry

Coverlets, quilts
Fabric
 Stauch, David, Sr.

Coverlets, table linens
Fabric
 Lawyer, James

Coverlets, weavings
Fabric
 Campbell, John
 Keener, Henry
 Weaver, J.G.

Coverlets?
Fabric?
 Armbruster, J.
 Arnold, Lorenz
 Bagley, S.
 Baliot, Abraham
 Boardman, E.
 Brink, R.J.
 Buschong, W.F.
 Chattin, Benjamin
 Chore, L.
 Davis, E.
 Duble, Jonathan
 E. Aram Factory
 Ely, Edwin
 Ettinger, John
 Fetter, E.
 Fordenbach, E.
 French, P.
 Geret, Jacob
 Gilbert, C.A.
 Gish, S.M.
 Gotwals, M.
 Haag, Jonathan
 Hackman, L.
 Hartz, Daniel
 Hay, Ann
 Henning, A.
 Holler, J.
 Klippert, Henry
 Landis, M.A.
 Long, M.A.
 Matteson, H.A.
 McGurk, Andrew
 Moll, David
 Oberholser, Jacob
 Phillips, M.E.
 Robinson, Anson
 Satler, J.M.
 Sayler, C.
 Schum, Joseph
 Shalk, John
 Shank, M.
 Stabler, G.
 Starr, F.
 Stauffer, R.
 Stoner, Henry
 Sutherland, H.
 Sutherland, J.
 Williams, Henry T.

Cradles
Wood
 Stebbins, Wyman H.

Creches, decorated objects
Rocks, shells
 Short, Lillie

Crewel and embroidered purses
Fabric
 Eaton, Mary

Crewel bed assemblies
Fabric
 Bulman, Mary

Crewel bedspreads
Fabric
 Breed, Mary
 Taylor, Elizabeth
 Wyllis, Elizabeth

Crewel needlepoint works
Fabric
 Burnham, Mary Dodge

Crewel pictures
Fabric
 Taylor, Elizabeth

Crewel samplers
Fabric
 Dick, Mrs. Mary Low Williams

Crib quilts
Fabric
 Gilchrist, Catherine Williams
 Smith, Rachel

Cribs
Wood
 Hilker, Frederick

Crosses
Wood
 Cornett, Chester

Crosses, religious signs
Wood, concrete, metal
Mayes, H. Harrison

Cupboards
Wood
Overton, Nathan
Vierling, G.H.

Cut-outs
Paper
Walker, John Brown
Watercolor, paper
Fries

Daybeds
Wood
Keszler, Henry

Decorated baskets
Wood
Sullivan, Sarah Crisco

Decorated boxes
Shell, ivory
Stivers, John, Captain
Wood
Loomis, Jonathan

Decorated chests
Wood
Blauch, Christian
Flory, John
Palmer, Joel
Wilkin, Godfrey

Decorated fire engines, hose carts
Paint
Sully
Woodside, John A.

Decorated handkerchiefs
Ink, linen
Kingsley, Mary

Decorated interiors, mural scenes for houses
Oil
Warner, J.H.

Decorated mugs
Paint
Grimm, Curt
Riedel, A.
Voldan, J.R.

Decorated objects, nautical theme paintings
Various materials, oil
Cahoon, Ralph

Decorated salt boxes
Wood
Drissell, John

Decorated sewing boxes
Enamel
Prior, Jane Otis

Decorated tool box
Wood, iron
Hersh, H.S.

Decorated tools
Iron
Meninger, E.

Decorated wall paintings
Oil?
Mitchell, William

Decorated walls and floors of houses
Oil
Price, William

Decorated? boxes
Wood, paint?
Shurtleff, Isaac

Decorative apron trims
Fabric
Ferguson, Frederica

Decorative duck decoys
Wood
Clifford, Robert
Haertel, Harold

Decorative flower pots, pottery
Brownware
Owens, J.B.

Decorative paintings
Unidentified Media
Penniman, John Ritto

Decorative piece paintings
Watercolor on silk
Lord, Mary

Decorative wall paintings
Unidentified Media
Dixon, Thomas Fletcher

Decorative ware
White Granite
Stubenville Pottery Company

Decoys
Tin
Sheboygan Decoy Company
Wood
Archer, Dr.
Bach, Ferdinand
Barkelow, Lou
Baumgartner, Doc
C.C. Smith Co.
Chambers, Thomas
Christie, Bernard
Cornelius, John
Crooks, Floyd
Cummings, Frank
DeCoe, G.
Dreschel, Alfred
Finch, John
Foote, Jim
Glick, Herman
Kellie, Ed
Kelson, James R.
Mason Decoy Factory
McDonald, Zeke
Meldrum, Alexander
Meyer, Joe
Misch, Otto
Orme, Albert
Peters, Scott
Peterson, George
Pozzini, Charlie L.
Purdo, Nick
Quillen, Nate
Reghi, Ralph
Sampier, Budgeon
Schmidt, Benjamin J. "Ben"
Schramm, Butch
Schweikart, John
Scriven, Danny
Smith, Chris
Smith, Samuel
St. Anne's Club
Steiner, Thomas
Strubing, Walter
Unger, Charles J.
Unger, Fredrick
Verity, Obadiah
Wallach, Carl
Warin, George
Wass, Harry
Zachmann, John

Desks, bookcases
Wood
Trentmann, John

Diarama, carvings
Wood, oil
McCarry, Ralph E.

Dog portraits
Oil
Elmer, W.
Pastel
Woolworth, Charlotte A.

Dolls
Fabric
Edgerly, D.S.
Fabric, paint
Phohl, Bessie
Phohl, Maggie
Wood
Rich, James
Wood, apples, nuts
Miracle, Hazel

Dolls, toys
Mud, fabric
 Descillie, Mamie

Dolls, weavings
Fabric
 Emmaline

Domestic scene paintings
Oil
 Dow, John

Doodles
Pen, ink
 Joseph, Charles

Door latches, andirons
Iron, brass
 King, Daniel

Door locks
Brass
 Green and Board
 Wray, H.

Doors, santeros, other religious carvings
Wood
 Lopez, Jose Dolores

Doorstops
Stoneware
 McDade Pottery

Doorstops, pottery
Stoneware
 Grand Ledge Sewer Pipe Factory

Dove pins
Gold
 Trujillo, Celestino

Dower chests
Wood
 Ovenholt, Abraham
 Rank, John Peter (Johann)
 Rank, Peter
 Ricket, Jacob
 Selzer, Christian
 Selzer, John

Drawings
Charcoal
 Adams, Olive M.
 Beam, Caroline
 Folsom, Mrs.
 Wilson, George W.
Charcoal, pencil
 Dewey, Ormand Sales
Colored pencil
 Hughes, Charles Edward, Jr.
 Jones, Frank
Crayon
 Allen, Marie W.
 Clark, Harry A.

Crayon, pastel
 Arning, Eddie
Mixed media
 Godie, Lee
Needlework
 Smith, Mrs.
Pastel
 Hough, E.K.
 Howard, B.
Pen, crayon
 Strokes, Willie
Pen, ink
 Babbitt, George F.
 Baldwin, S.R.
 Barber, John W(arner)
 Bouton, S.S.
 Brown, O.F.
 Brown, William
 Cox, W.A.
 Davenport, A.F.
 Dennis, S.A.
 Dennis, William
 Dyer, Candace
 Fagley, S.
 Guthrie, Woody
 Hallowell, William, Dr.
 Hansee, Willard S.
 Jewell, D.B.
 Lesueur, Charles
 Markert, Herman
 Peck, Charles
 Pierce, I.W.
 Shove, John J.
 Swift, R.G.N.
Pen, ink, colored pencil
 Johnston, Effie
Pen, ink, watercolor
 Furnier, V.H.
 Haffly, Joseph
 Halduman, Jacob
 Rider, Peter
 Taylor, Eliza Ann
Pen, wash
 Gilman, J.F.
 Stower, Manuel
Pen, wash, pencil
 Richards, John
Pen, watercolor
 Ammidown, C.L.
 Wright, Dean C.
Pencil
 Cook, G.W.E.
 Dillinham, John E.
 Halkett, A.
 Page, S.P.
 Sherman, Jesse T., Captain
 Taylor, H.M.
Pencil, crayon
 Nathaniel, Inez
Pencil, pen, crayon, watercolor, gouache
 Traylor, Bill
Soot on paper
 Castle, James
Unidentified Media
 Coville, A.M.

 Fleury, Elsie
 Kollner, August
 Lossing, Benjamin
 North, L.
 Whitaker, E.M.
Watercolor
 Thompson, Mr.
Watercolor, ink
 Allen, Elizabeth
 Seckner, C.M.
 Umble, John
Watercolor, ink, pen
 Buckingham, David Austin
Watercolor, pencil
 Bedell, Prudence

Drawings, calligraphy
Pen, pencil, ink, watercolors
 Hersey, Joseph

Drawings, group portraits
Watercolor
 Morse, Samuel Finley Breese

Drawings of Christ
Poster paint
 Jackson, Henry

Drawings of furniture
Unidentified Media
 Bezold, George Adam

Drawings, pages from a manuscript
Pen, ink
 Perry, Thomas, Jr.

Drawings, paintings
Mixed media
 Podhorsky, John
Pen, ink, crayon
 Gordon, Theodore

Drawings, portraits, historic paintings
Oil, acrylic, watercolor
 McCarthy, Justin

Drawings, quilts
Crayon, felt-tip pen
 Rowe, Nellie Mae

Dressing tables
Wood
 Mason, William A.

Drums
Unidentified Media
 Kilbourne, William

Duck and owl decoys
Wood
 Herter Sporting Goods Company

Duck and shorebird decoys
Wood
 McAnney, John

Duck and shorebird decoys

Duck and shorebird decoys (Cont.)
 Wood (Cont.)
 Nottingham, Luther

Duck decoys
 Wood
 Acheo Brothers
 Ackerman, H(enry) H(arrison)
 Adams Decoy Company
 Adams, Frank
 Alexander, Stanley
 Animal Trap Company
 Armstrong Company
 Aschert Brothers
 Bacon, George H.
 Bailey, I. Clarence, Captain
 Baldwin
 Baldwin, William
 Barber, Joel
 Barnes, Samuel T.
 Best Duck Decoy Company, Inc.
 Bigelow, P.W.
 Birdsall, Jess, Captain
 Black, Charles
 Blair, John
 Bliss, Roswell E.
 Boyd, George
 Brady, Walter
 Browne, George
 Burgess, Ed
 Burr, E(lisha)
 C.W. Stevens Factory
 Cameron, Glen, Judge
 Carmen, Caleb
 Carmen, T.
 Carver, James
 Cassini, Frank
 Chadwick, H(enry) Keyes
 Chambers, Tom
 Classic Woodcarving Company
 Cobb, Arthur A(lbert)
 Cobb, E(lkenah), Captain
 Cobb, Elijah
 Cobb, N(athan), Jr.
 Collins, Samuel, Jr.
 Collins, Samuel, Sr.
 Conklin, Hurley
 Conklin, Roy
 Coombs, Frank
 Corwin, Wilbur A.
 Coudon, Joseph
 Cramer, Chalkly
 Crumb, Charles H., Captain
 Culver, R.I.
 Dan's Duck Factory
 Darton, W.D.
 David C. Sanford Company
 Davis, Ben, Captain
 Dawson, John
 Dawson, Joseph
 Dawson, Tube
 Deegan, Bill
 Denny, Samuel
 Disbrow, Charles
 Dize, Elwood
 Doane, Mr.
 Dodge, Jasper N.
 Dudley, Lee
 Dudley, Lem
 Dye, Ben, Captain
 Ellis, Levi
 Elliston, Robert A.
 Englehart, Nick
 English, Dan
 English, John
 English, Mark
 Evans, Walter
 Frazer, Nate
 Gardner, Lester
 Gaskill, Tom
 Gelston, Thomas
 Grandy, A.
 Grant, Henry
 Grant, Percy
 Grant, Stanley
 Graves, Bert
 Greenless, Kenneth
 Griffin, Mark
 Grubbs Manufacturing Company
 H.A. Stevens Factory
 Haff, John
 Hammell, Guarner
 Hance, Ben
 Hancock, Herbert
 Hancock, Miles
 Hancock, Russell
 Hankins, Ezra
 Harris, Al
 Harris, Ken
 Harvey, George
 Havens, George
 Hawkins, Ben
 Headley, Somers G.
 Hendricks, J.P.
 Heywood, Manie
 Holly, Ben, Captain
 Holmes, Lothrop T., Captain
 Horner, Roland (Nathan Rowley)
 Horshack, Jay
 Howlett, Dick
 Hudson Decoy Plant
 Hunt, Ben
 J.M. Hays Wood Products
 Company
 J.N. Dodge Factory
 Jester, Doug (S.D.M.)
 Johnson, Lloyd
 Johnson, Taylor
 Joy, Charles
 Joyner, Charles
 Kears, Mark
 Kellum, Frank
 Ketcham, Al, Captain
 Ketchum, C.K., Sr.
 Kilpatrick, Henry
 King, Joe
 Knapp, Harry
 La Flair, John
 La France, Mitchell
 Laing, Albert
 Lamerand, Ed
 Lamphere, Ralph
 Lewis, Frank E.
 Lincoln, Joseph Whiting
 Lippincott, Gideon
 Lockard, Henry
 Lohrman, William
 Look, Jim
 Malinski, Irving
 Massey, William B.
 Matthews, William J.
 Mayhew, M.H.
 McGaw, Robert F.
 McKenzie, John
 McKenzie, Thomas
 McMorrow, William
 Mitchell, Madison
 Modern Decoy Company
 Mulliken, Edward H. "Ted"
 Murphy, Charles
 Nelson, James L.
 Osgood, Captain
 Outing Manufacturing Company
 Owens, Frank
 Parker, Charlie
 Parker, Ellis
 Parker, Lloyd
 Parr, Jack
 Pashpatel, Leo
 Perdew, Charles H.
 Plichta, Fred
 Plumb, Robert
 Poiteran Brothers, Inc.
 Predmore, Cooper, Captain
 Raynor, Ben
 Reynolds, J.W.
 Rhodes, D.
 Rice, R.
 Ridgeway, Bindsall
 Roberts, Manuel S.
 Rogers, Gene
 Rose Folding Decoys Company
 Salmon, Bradford
 Sanford, R.D.
 Schifferl, Lou
 Schoenheider, Charles
 Schramm, Speck
 Schroeder, Tom
 Shourdes, Harry M.
 Shourdes, Harry V(an Nuckson)
 Smith, Ben
 Smith, C(assius)
 Smith, George
 Smith, Gil
 Smith, Howland
 Smith, Minor
 Smith, T.
 Soper, Alonzo
 Soper, Sam
 Spear, Chester
 Sperry's Decoy
 Sprague, Chris
 Sprague, Jed, Captain
 Stanley, James E.
 Sterling, Noah
 Sterling, Will
 Strang, Charles
 Taubert, T.

Type of Work Index — **Embroidered needlework**

Titus, Jim
Truax, Rhoades
Truay, Ike, Captain
Tyler, Lloyd
Updike, John
Ville, Charlie D., Captain
W.G. Higgins
Walker, Charles
Walker, Wilton
Wallace, G.E.
Ward, Steve
Watson, Dave "Umbrella"
Weston, William Henry
Whealton, Dan, Captain
Wheeler, Chauncey
White, Winfield
Whittaker, John, Captain
Whittington, Hector "Heck"
Wildfowler Decoy Company
Wilke, Mr.
William E. Pratt Manufacturing Company
William R. Johnson Company Inc.
Williams
Williams, John
Williams, R.
Williams, T.
Wilson, Charles T., Professor
Winslow, George Marcus
Winsor, John
Wood, cork
 Burke, Edgar, Dr.
 Corwin, Wilbur R., Captain
 Cranford, Ralph M.
 Pennell, George
 Wheeler, Charles E. (Shang)

Duck decoys, miniature duck carvings
Wood
 Baldwin, John Lee

Duck decoys, other carvings
Wood
 Langan, Tom

Duck decoys, sculptures, carvings
Wood
 Hudson, Ira

Duck decoys, weathervanes, miniature duck carvings
Wood
 Bowman, William

Egg cups
Wood
 Lehn, G.

Elaborate jugs
Stoneware
 Hall, E.B.

Embroidered and needlepoint imaginary pictures
Fabric
 Shapiro, Pauline

Embroidered aprons
Fabric
 Lambert, Lydia

Embroidered architectural pictures
Fabric
 Stebbins, Caroline

Embroidered architectural, still life pictures
Fabric
 Barker, Elizabeth Ann

Embroidered baby dresses
Fabric
 Holloway, Isabella

Embroidered bay scene pictures, samplers
Fabric
 Budd, Alice M. (Mrs. Kenneth)

Embroidered bedspreads
Fabric
 Christian, Nancy
 Thatcher, Lucretia Mumford

Embroidered Bible covers
Fabric
 Craghead, Elizabeth
 McCulloch, Christina
 Morris, Debbe

Embroidered bookmarks
Fabric
 Custis, Nelly

Embroidered candlewick spreads
Fabric
 Quinby, Sarah A.

Embroidered candlewick spreads, samplers
Fabric
 Todd, Mary A.

Embroidered chairseats, samplers
Fabric
 Banker, Elizabeth

Embroidered check black wool blankets
Fabric
 Johnson, Catherine

Embroidered genre pictures
Fabric
 Roosevelt, Mrs. Theodore, Jr.

Embroidered hand towels
Fabric
 Stamn, Mary

Embroidered handkerchiefs
Fabric
 Leonard, Rachel
 Pollock, Sarah E.

Embroidered handwoven blankets
Fabric
 Sloane, Caroline M.

Embroidered hatchments
Fabric
 Brown, Jane

Embroidered history pictures, samplers
Fabric
 Taylor, Lillian Gary (Mrs. Robert Coleman Tay

Embroidered landscapes
Fabric
 Kriebel, Phebe
 Noyes, Abigail Parker

Embroidered linen altar cloths
Fabric
 Sturtevant, Louisa

Embroidered linen bureau covers
Fabric
 Scott, Ann

Embroidered linens
Fabric
 Byberin, Barbara
 Walborn, Catarina

Embroidered maps
Fabric
 Goldin, Elizabeth Ann
 Jones, Eliza
 Mather, A.
 Wade, Frances
 Willis, Sarah

Embroidered Masonic aprons
Fabric
 Andrews, Bernard

Embroidered mourning pictures, samplers
Fabric
 Moss, Margaret

Embroidered mourning pictures, samplers, linens
Fabric
 Remington, Mary "Polly"

Embroidered needlework
Fabric
 Vanderpoel, Emily Noyes

Embroidered pictures
 Fabric
 Acheson, Eurphemia J.
 Aldich, Mrs. Richard
 Bacon, Mary
 Belcher, Sally Wilson
 Bower, Mary
 Burrows, Esther
 Clark, Mrs. Frank T.
 Conrad, Ann
 Harbeson, Georgiana Brown
 King, Mary
 McGraw, Mrs. Curtis
 O'Donnell, Mrs. D. Oliver
 Rose, Mrs.
 Rothmann, Mary
 Sampson, Deborah
 Sherril, Laura
 Strong, Anne
 Trowbridge, Emily
 Warren, Sarah
 Wheeler, Candace
 Wheeler, Henrietta Virginia
 Wright, Lydia
 Fabric, paper
 Stanton, Nathaniel Palmer
 Needlework, string
 Borkowski, Mary K.

Embroidered pictures, samplers
 Fabric
 Wistar, Sarah

Embroidered pictures, screens
 Fabric
 Gary, Mrs. James A. (L.W.) (Daisy)

Embroidered pocket aprons
 Fabric
 Lyman, Mrs. Eunice

Embroidered pocketbooks
 Fabric
 Brown, Elinor
 Hicks, Elizabeth

Embroidered prayerbook covers
 Fabric
 Cabot, Mrs. Samuel

Embroidered religious pictures
 Fabric
 Barlow, Miss Lydia
 Crafts, Mary S.

Embroidered religious samplers
 Fabric
 Colton, Lucretia

Embroidered scenes
 Fabric, paint
 Masters, E(lizabeth) B(ooth)

Embroidered sewing baskets
 Fabric
 Denison, Nancy Noyes

Embroidered ship pictures
 Fabric
 Merrill, Sailor
 Very, Lydia

Embroidered show towels
 Fabric
 Brackbill, Eliza Ann
 Kuns, Cadarina

Embroidered still life pictures
 Fabric
 Mason, Mrs. Jeremiah

Embroidered table clothes
 Fabric
 Oothout, Mary

Embroidered towels
 Fabric
 Herr, Anna

Embroidered veils
 Fabric
 Beekman, Miss Florence

Embroidered wedding dresses
 Fabric
 Bull, Miss Elizabeth
 Myers, Mary

Embroidered wool bed covers
 Fabric
 Dumbay, Harriet

Embroidery
 Fabric
 Fleet, Mary

Embroidery and applique on capes
 Fabric
 Hureau, Madame E.

Embroidery on silk
 Fabric
 Nichlan, Thalia

Embroidery pictures
 Watercolor, fabric
 Denison, Harriet

Embroidery, weavings
 Fabric
 Sarah "Old Aunt Sarah"

Enamel works
 Enamel on metal
 Rabinov, Irwin

Environmental sculpture
 Stone, clay
 Wippich, Louis C.
 Wood
 Gabriel, Romano

Environmental sculptures
 Cement
 Dinsmoor, S.P.
 Greco, John
 Root, Ed
 Smith, Fred
 Various materials
 Deeble, Florence
 Dorsey, Henry
 Hall, Irene
 Hay, T.
 Hoff, John
 Martin, Eddie Owens "Saint EOM"
 McKissack, Jeff
 Prisbrey, Tressa (Grandma)
 Rodia, Simon
 Rusch, Herman
 Schmidt, Clarence
 Wernerus, Father Mathias
 Woods, David

Equestrian portraits
 Watercolor
 Wellman, Betsy

Face jugs
 Brownware
 Davies, Thomas J.
 Clay
 Baddler

Face jugs, pottery
 Clay
 Meaders, Cheever
 Meaders, Lanier

Family arms pictures
 Fabric, watercolor
 Putnam, Betsy

Family register samplers
 Fabric
 Cambell, Anna D.
 Denison, Marcia
 Giles, Polly
 Hall, Sally
 Johnson, Persis
 Marsh, Mrs. John Bigelow
 Taylor, Sally
 Wilson, Fanny

Family tree drawings
 Ink, watercolor
 Richardson, William

Family tree, mourning paintings
 Watercolor
 Saville, William

Fantasy and memory paintings
Acrylic, oil, watercolor, pencil
 Willey, Philo Levi "The Chief"
Housepaint
 Tolliver, Mose

Fantasy and whimsical paintings
Watercolor, gouache
 Frantz, Sara L'Estrange Stanley "Sali"

Fantasy futuristic paintings
Oil
 Maldonado, Alexander

Fantasy, landscape, genre scene paintings
Oil
 Gatto, (Victor) Joseph

Fantasy paintings
Acrylic
 Sabin, Mark
Oil
 Tourneur, Renault
Paint
 Serl, Jon
Watercolor
 Mole, William

Fantasy paintings of children
Watercolor
 Darger, Henry

Fantasy paintings, sculptures
Oil, chicken bones
 Von Bruenchenhein, Eugene

Fantasy snuff boxes
Ivory
 Johnson, Melvin

Farm house paintings
Oil
 Woodward, Cordelia Caroline Sentenne

Farm scene drawings
Charcoal, chalk
 Baldwin, Henry

Farm scene, genre paintings
Acrylic
 Robinson, Mary Lou Perkins

Farm scene models
Mixed media
 Mosher, Anna

Farm scene paintings
Oil
 Ashworth, Helen
 Hildreth, Herbert L.
 Johnston, L.
 Maynard, A.E.
 Oliver, D.(W.)
 Williams, Charles P.
Watercolor
 Noel, M.P.
 Seifert, Paul A.

Farm scene sculptures, carvings
Wood
 Wells, J.F.

Farm scenes, memory paintings
Acrylic, oil, watercolor
 O'Kelley, Mattie Lou

Figures
Beads
 Pebeahsy, Charles
Wood
 Barlow, Myron
 Gies, Joseph
 Henning, Herman D.A.
 Huguenin, George
 Peterson, A.L.
 Russell, John
 Sullivan, William
Wood, paint
 Starbuck, M.

Figures, signs, portraits
Wood, oil
 King, Samuel

Figures, signs, seascapes
Wood, pen, watercolor
 White, Thomas J.

Fire engines, fire station art
Oil
 Betsch, M.
 Curlett, Thomas

Fire engines, hose carts, scene paintings
Oil
 Quidor, John

Fire stations, fire station art
Paint
 Sheppard, R.H.

Fireback ironware
Iron
 Aetna Furnace

Firescreens
Needlework
 Pears, Tanneke

Fish decoys
Wood
 Buchman
 Gould, M.H.
 Hoag
 Jenner, Augie
 Jenner, Hans, Jr.
 Jenner, Hans, Sr.
 Jorgenson
 Kelly
 Loesch
 Meldrum, John
 Moore
 O'Francis
 Sears, Gordon
 Smith
 Stewart
 Zent, August
Wood, metal
 Dehate, Abraham
 Finkel, Bill (William)
 Flieman
 Goulette, Abe
 Mason, Marvin
 Riley
 Schmidt, Frank
 Scriba, George Frederick William Augustus
 Trombley, Andy
 Van den Bossche, Theodore
 Wagner
Wood, paint
 Smith, Miles

Fish decoys, other carvings
Wood
 Peterson, Oscar B.

Fish kettles
Copper
 G. and F. Harley

Fishing boat paintings
Oil
 Kent, A.D.

Flag guide drawings
Pencil, pen, watercolor
 Coleman, William, Captain

Flasks
Glass
 Ellenville Glass Works
 Pitkin Glass Works
 Stenger, Francis

Floor paintings
Paint
 Winter, John

Flower paintings
Watercolor
 Delano, Temperance
 Tucker, Alice

Flower pots
Redware
 Seymour, Major

Flower pots, pottery
Redware
 Moorehead and Wilson

Folktale drawings
 Pencil, india ink
 Moses, Kivetoruk (James)

Foot stoves
 Tin
 Loveland, Elijah

Forks
 Iron
 Eisenhause, Peter

Fracturs
 Oil, pen, ink, pencil, watercolor
 Wilder, F(ranklin) H.

Frakturs
 Watercolor, ink
 Ache, H.M.
 Anders, Abraham
 Anders, Andrew
 Anders, Judith
 Andreas, Jacob
 Anson, James
 Bachman, Christian
 Baer, Martin
 Bandel, Frederick
 Bard, Johannes
 Bart, Daniel
 Bart, Susanna
 Bauer, Andeas B.
 Bauman, August
 Becker, Barbara
 Becker, J.M.
 Beidler, C.Y.
 Bergey, Joseph K.
 Bernhardt, Peter
 Bicksler, Jacob S.
 Bisco, Adaline
 Bixler, David
 Bowers, Reuben
 Brechall, Martin
 Brubacher, Abraham
 Brubacher, Hans Jacob
 Brubacher, Johannes
 Brusgaeger, J. George
 Cassell, Christian
 Cassell, Huppert
 Cassell, Joel D.
 Clemens, Johannes
 Conner, Morris
 Cordier, David
 Crecelius, Ludwig
 Dambock, Adam
 Denig, Ludwig
 Denlinger, David
 Detweiler, John H.
 Detweiller, Martin M.
 Dirdorff, Abraham
 Ditmars, Peter
 Dock, Christopher
 Dotter, Cornelius
 Dressler, S.O.
 Dulheuer, Henrich
 Dutye, Henre
 Edson, Almira
 Egelmann, Carl Friederich
 Eisenhauer, Jacob
 Eyer, Johann Adam
 Eyster, Elizabeth
 Faber, Wilhelmus Antonius
 Fieter, Michael
 Forrer, Johann
 Fries, Isaac
 Fromfield, William
 Gahman, John
 Gerhardt, George
 Gifford, Stephen B.
 Gise, Henry
 Gitt, Wilhelm
 Godshalk, Enos
 Godshall, M.
 Grimes, William
 Gross, Isaac
 Gross, Jacob
 Guisewite, Reverend
 Haman, Barbara Becker
 Hammen, Elias
 Hartman, Christian B.
 Hartzel, John, Jr.
 Heebner, David
 Heebner, John
 Heebner, Maria
 Heebner, Susanna
 Henkel, Ambrose
 Herr, Anna
 Herr, David
 Heydrich, Balzer
 Hill, Henry
 Hillegas, Jacob
 Hoffman, Johannes
 Hoppe, Louis
 Horn, Daniel Stephen
 Huebner, Abraham
 Huebner, Henrich
 Huebner, Susanna
 Huth, Abraham
 Jackson, Samuel
 Jaeckel, Christoph
 Jamison, J.S.
 Kassel, Georg
 Kauffman, Daniel
 Kauffman, Samuel
 Kauffman, Zoe
 Keeper, Heinrich
 Kehm, Anthony
 Kiehn, David
 Kinsey, Abraham K.
 Klenk, Ferdinand
 Kratzen, Joseph
 Krauss, Johannes
 Krauss, Regina
 Krebs, Friedrich (Friederich; Frederick)
 Kriebel, David
 Kriebel, Hanna
 Kriebel, Job
 Kriebel, Maria
 Kriebel, Sara
 Krieble, Abraham
 Kuster, Friederich
 Landes, Rudolph
 Landis, Catherine L.
 Landis, John
 Landis, John A.
 Lapp, Christian
 Lapp, Henry
 Lehn, Henry
 Leo, John William
 Levan, Francis D.
 Limbach, Christian
 Lueckin, C.
 Lyle, Fanny
 Magdelena
 Maphis, John M.
 Margaretha
 Martz
 Mensch, Irwin
 Messner, Elizabeth
 Meyer, Martin J.
 Miesse, Gabriel
 Miller, Jacob
 Miller, John G.
 Moffly, Samuel
 Mosser, Veronica
 Mosteller, Johannes
 Moyer, Martin
 Muench, Karl C.
 Muje, H.D.
 Munch, Carl E.
 Murray, William
 Neff, Elizabeth
 Nuechterlein, John George
 Otto, Johann Henrich
 Otto, Wilhelm
 Payson, Phillips
 Peterman, Daniel
 Peters, Christian
 Pile, John
 Plank, J.L.
 Portzline, Elizabeth
 Portzline, Francis
 Puwelle, Arnold
 Reich, Elizabeth
 Reinwald, Sarah
 Reist, Johannes
 Renninger, Johannes, Jr. (John)
 Rigel, Maria Magdalena
 Romer
 Rudy, Durs
 Schantz, Joseph, Reverend
 Schenef, Friederich
 Scherg, Jacob
 Scherich, C.
 Scheuer, Joseph
 Schneider, Christian
 Schuller, Johann Valentin
 Schultz, Barbara
 Schultz, Lidia
 Schultz, Regina
 Schultz, Salamon
 Schultz, Sara
 Schultze, C.
 Schumacher, Daniel, Reverend
 Seibert, Henry
 Seiler, H.
 Seuter, John
 Seybert, Abraham

Type of Work Index — **Genre paintings**

Seybold, Carl F.
Shindel, J.P.
Sibbel, Susanna
Siegfried, Samuel
Spangenberger, Johannes Ernst
Spangler, Samuel
Spiller, Johan Valentin
Staffel, Bertha
Stahr, John F.W.
Stober, John
Strenge, Christian
Strickler, Jacob
Taylor, Alexander
Teibel, Georg (Johann)
Thompson, M.
Trevits, Johann Conrad
Van Minian, John
Vater, Ehre
Weaver, Carolina
Weber, Isaac
Weidner, Heinrich
Weiss, Anna
Weiss, Henrich
Weyzundt
Wuertz, Adam
Young, H(enry)
Zeller, George
Zinck, John
Zoller, George
Zornfall, Martin
Zug, Johan
 Watercolor, ink?
 Baker, John B.

Frakturs, decorated chests
 Watercolor, ink, wood
 Speyer, Georg Frederick (Friedrich; Friederic)

Frakturs, embroidery
 Watercolor, ink, fabric
 Mason, Abigail (Payne)

Frakturs, religious paintings
 Watercolor, ink
 Geistweite, George, Reverend

Frames
 Wood
 Duncan, M.L.

Frames, lamps, wallets, purses
 Matchsticks, matchboxes, cigar boxes, leather
 Woolum, Wayne

Free modeling of whimseys, including snakes
 Stoneware
 Wilbur, A. E.

Frescos, ornamental, sign paintings
 Oil?
 Becker, A.H.

Friendship letters
 Watercolor, ink, pen
 Leach, E.W.

Furniture
 Wood
 Amend, Charles
 Archuleta, Antonio
 Archuleta, Manuel
 Artz, William
 Balch, Sarah Eaton
 Barnhardt, John
 Bates, A.S.
 Bendele, Louis
 Beverburg, Lorenz
 Blackman, George
 Blin, Peter
 Bohlken, Johann H.
 Brinker, George Henry
 Buttre, William
 Carter, David
 Casebier, Jerry
 Conant, S.
 Corey, Walter
 Cowell, Benjamin
 Crowningshield, Maria
 Darneille, Benjamin
 Dennis, Thomas
 Dieckhaus, Franz
 Doyle, William G.
 Elfe, Thomas
 Eppler, George
 Finlay, Hugh
 Finlay, John
 Fisher, Robert
 Friedrich, Johann
 Fry, William H.
 Funk, J.S.
 Gonzales, Elidio
 Greef, Adolph
 Green, Elder Henry
 Hasenritter, C(arl) W(illiam)
 Hoffman, Christopher
 Holton, Chancy
 Ives and Curran
 Jansen, Frederick William
 Jones, Wealthy P.S.
 Kemper, Edward
 Knoebel, Jacob
 Lombard, Rachel H.
 Luna, Maximo L.
 Meier, Henry
 Moore and Walters
 Penniman, John
 Renshaw, Thomas
 Roth, John
 Salazar, Alejandro
 Schaeffner, Andrew
 Schmitt, Adam
 Shubert, Casper
 Sullins, David
 Sutton
 Toler, William
 Watts, Charles
 Werner, Ignatz
 Young, Brigham
 Wood, paint
 Waghorne, John

Furniture, chests
 Wood
 Spitler, Johannes

Furniture, santeros, religious carvings
 Wood
 Tapia, Luis

Furniture, walls
 Wood
 Pitman, Benn

Gate posts, figures
 Wood
 William, George

Gates
 Iron
 Wheeler, Sam

Genealogical samplers
 Needlework
 Fisk, Lorenza

Genre carvings
 Wood
 Cross, John

Genre drawings
 Crayon
 Skeggs, T.W.
 Pencil
 Gifford, M.T.
 Watercolor, pen
 Meyer, Lewis

Genre drawings in a letter
 Pencil
 Clark, Ann Eliza

Genre, history, literary, landscape paintings
 Oil
 Adkins, J.R.

Genre, landscape paintings
 Oil
 Seymour, Samuel

Genre, memory paintings
 Acrylic, oil
 Carter, Bob Eugene
 Oil
 Hunter, Clementine

Genre, memory scene paintings
 Watercolor, oil
 Brunner, Hattie Klapp

Genre paintings
 Acrylic
 Pickle, Helen

Genre paintings (Cont.)
　Oil
　　Aulont, George
　　Burridge
　　Covill, H.E.
　　Gentilz, Theodore
　　Hayes, George A.
　　Hays, George
　　Key, Charles B.
　　Knight, T.G.
　　Koch, Samuel
　　Koeth, Theo
　　Krimmel, John Lewis
　　Lane
　　McBride, Adah
　　Morrill, D.
　　Mulholland, William S.
　　Obe
　　Opper, E.
　　Park, Linton
　　Peck, Nathaniel
　　Peters, J.
　　Predmore, Jessie
　　Richard, J.
　　Senior, C.F.
　　Stouter, D.G.
　　Stucker, F.
　Velvet
　　McAuliffe, J.
　Watercolor
　　Dalzell, M.J.
　　Flower, George
　　Herff, Charles Adelbert
　　Keyes, Caroline
　　Matlick, William
　　Palmer, Jane
　　Palmer, Julia Ann
　　Rappe, Mary
　　Rawson, Eleanor
　　Walker, M.

Genre paintings, drawings
　Watercolor, pencil
　　Twiss, Lizzie

Genre pictorials
　Embroidery
　　Cady, Almira

Genre, religious paintings
　Oil
　　Hamblett, Theora

Genre scene paintings
　Acrylic
　　Slyman, Susan

Genre, scene paintings
　Oil
　　Stark, Jeffrey

Genre scene paintings
　Watercolor
　　Simon, Jewel

Genre scene sculptures
　Fabric, various materials
　　Cleaveland, Mrs. Mary

Genre street scene paintings
　Oil
　　Crite, Allan Rohan

Genre, symbolic paintings
　Oil
　　Ward, Velox

Genre, town scene paintings
　Oil
　　Gleason, Charles

Glass cupboards
　Wood
　　Fricke, John Frederick
　　Gentner, George Henry
　　Hasenritter, Robert Hermann
　　Purves, John W.
　　Rohlfing, Frederick

Glass works
　Glass
　　Amelung, John Frederick
　　Birmingham Glass Works
　　Cleveland Glass Works
　　Ohno, Mitsugi
　　Redford Glass Works
　　Redwood Glass Works
　　Schoolcraft, Henry R.
　　Vermont Glass Factory
　　Whitney Glass Works

Glassware
　Glass
　　Little, Samuel

Global samplers
　Fabric
　　Wright, Ruth

Gravestones
　Stone
　　Acken, J.
　　Adams, B.
　　Adams, Joseph
　　Adams, Joseph
　　Adams, Sampson
　　Allen, George
　　Allen, George, Jr.
　　Angell, John Anthony
　　Baldwin, Asa
　　Baldwin, Michael
　　Barber, Joseph
　　Barker, Peter
　　Barnard, Ebenezer
　　Bartlett, Gershom
　　Bentley, E.W.
　　Bickner, Sam
　　Bliss, Aaron
　　Booth, Roger
　　Brainard, Isaac
　　Brewer, Daniel
　　Buckland, Peter
　　Buckland, William, Jr.
　　Buell, Benjamin
　　Bull, John, Captain
　　Chandler, Daniel
　　Chandler, Daniel, Jr.
　　Chandler, William
　　Clark, Enos
　　Codner, Abraham
　　Codner, John
　　Colburn, Paul
　　Collins, Benjamin
　　Collins, Julius
　　Collins, Zerubbabel
　　Cowles, Elisha
　　Cowles, Seth
　　Crosby, William
　　Cushman, Noah
　　Cushman, Warren S.
　　Cushman, William
　　Daugherty, S.
　　Dawes, Thomas, Captain
　　Dolph, Charles
　　Drake, Ebenezer
　　Drake, Nathaniel, Jr.
　　Drake, Silas
　　Dullen, C.
　　Dwight, John
　　Dwight, Samuel
　　Dyer, Benjamin
　　Ely, John
　　Ely, John
　　Emery, L.
　　Emmes, Henry
　　Emmes, Joshua
　　Emmes, Nathaniel
　　Farrington, Daniel
　　Felton, Ebenezer
　　Fisher, Jeremiah
　　Fisher, Samuel
　　Fisher, Samuel, Jr.
　　Foglesong, Christopher
　　Foster, Hopestill
　　Foster, James
　　Foster, James, III
　　Foster, James, Jr.
　　Fowle, Robert
　　Fuller, Nathaniel
　　Gaud, John
　　Geyer, Henry Christian
　　Geyer, John Just.
　　Gilchrist, James
　　Gill, Ebenezer
　　Gold, Thomas
　　Goodwin, John
　　Grant, William
　　Grice, Elias
　　Griswold, George
　　Griswold, Matthew, Jr.
　　Griswold, Matthew, Sr.
　　Hamlin, Isaac
　　Hamlin, John
　　Hartshorn, John
　　Hartshorn, John
　　Hartshorn, Jonathan

Hartshorn, Samuel
Hartshorn, Stephen
Hastings, Daniel
Hayward, Nathan
Hempstead, Joshua
Hill, Asa
Hill, Ithuel
Hill, Phinehas
Hinsdale, Samuel
Hodgkins, Nathaniel
Hollister, W.R.
Holmes, John
Homer, John
Homer, William
Howard, A.
Hughes
Hught, E.
Humble, John
Huntington, Caleb
Huntington, John
Ingersoll, W.S.
Isham, John
Jeffries, David
Jeffries, W.P.
Johnson, Joseph
Johnson, Thomas
Johnson, Thomas
Johnson, Thomas, Jr.
Jungkurth, J.W.
Keep, George
Keid, Andrew
Kimball, Chester
Kimball, Lebbeus
Kimball, Richard
Krone, Lawrence (Laurence)
Lamb, David
Lamb, David, Jr.
Lamson, Caleb
Lamson, David
Lamson, John
Lamson, Joseph
Lamson, Joseph
Lamson, Nathaniel
Lane, Charles
Lathrop, Loring
Lathrop, Thatcher
Leighton, Ezekiel
Leighton, Jonathan
Leighton, Richard
Leonard, Barney
Locke, John
Loomis, Amasa
Loomis, John
Loomis, Jonathan
Lyman, Abel
Lyman, Noah
Manning, Frederick
Manning, Josiah
Manning, Rockwell
Manning, Samuel
Marble, John
Marble, Joseph
Marshall, John
Maxey, Levi
Meech, G.
Merrel, Peter

Metcalf, Savil
Miller, David
Mooney, J.C.
Morten, J.A.
Mulican, Joseph
Mulican, Robert
Mulican, Robert, Jr.
Mumford, William
Nash, Joseph
Neely, N.
New, James
New, James
New, John
Newell, Hermon
Noyes, Paul
Osborn, Jonathan Hand
Parham, William, Jr.
Park, James
Park, John
Park, John
Park, Thomas
Park, William
Park, William
Park, William
Phelps, Elijah
Phelps, Nathaniel
Pratt, Nathaniel
Pratt, Noah
Pratt, Robert
Price, Ebenezer
Pryce, Nathaniel
Reeves, B.
Ritter, Daniel
Ritter, John
Ritter, Thomas
Roberts, Hosea
Roberts, Jonathan
Roberts, Joseph
Roberts, Joseph
Savage, A.
Savery, Lemuel
Schenck
Sikes, E.
Smith, A.V.
Soule, Asaph
Soule, Beza
Soule, Coomer
Soule, Ebenezer, Jr.
Soule, Ebenezer, Sr.
Soule, Ivory
Spaulding, Stephen
Stanclift, James, III
Stanclift, James, Jr.
Stanclift, James, Sr.
Stanclift, William
Stebbins, Ezra
Stevens, George
Stevens, Henry
Stevens, John, I
Stevens, William
Stewart, Abner
Stewart, Jonas
Strickler, John
Sutton, E.
Sweetland, Isaac
Tainter, Benjamin

Thomson, Isaac
Tingley, Samuel
Tingley, Samuel
Tingley, Samuel, Jr.
Tinkham, Seth
Tomson, George
Tomson, Isaac
Tribbel, John
Tucker, Joseph
Vinal, Jacob
Vinal, Jacob, Jr.
Vinal, John
Walden, John, Jr.
Walden, John, Sr.
Walters, J.
Washburn, B.
Webster, Abel
Webster, Stephen
Welch, Thomas
Wheeler, Obadiah
White, William
Whittemore, Joseph
Wight, John
Wilder, James
Wilson, G.
Winslow, Ebenezer
Winslow, Ebenezer
Woods, Martin
Worcester, Jonathan
Worcester, Moses
Wright, Alpheus
Wright, Moses
Wright, Solomon, Jr.
Young, S.
Young, William
Zuricher, John

Gravestones, other sculptures

Stone
 Bedwell, Elias J.

Gravestones, other stone carvings

Stone
 M.V. Mitchell and Sons

Gravestones, other stoneworks

Stone
 Ashley, Solomon
 Boonville Marble Works
 Codner, William
 Edmonson, William
 Lamson, Joseph
 Lydon, William
 Naegelin, Charles
 Schroeder, Carl
 Seultzer, Alexander
 Stevens, John, II
 Stevens, John, Jr.

Gravestones, sculptures, carvings

Stone, wood
 Smith, J. Kent

Grills

Metal
 Esten, Edwin

Group portraits
 Oil
 Pudor, H.
 Oil?
 Echstein, John

Group portraits, drawings
 Oil, pen
 Shafer, Samuel C.

Hand painted postcards
 Oil
 Sarle, Sister C.H.

Hand towels
 Fabric
 Rauch, Elisaeet

Hand towels, samplers
 Fabric
 Schyfer, Martha

Handboxes
 Wood, paper
 Putnam, George
 Roff, Amos B.
 Tillinghast, Joseph
 Widow, M. Queen

Handkerchiefs
 Fabric
 Palmer, Susan Catherine

Harbor paintings
 Oil
 Dixon, J.F.

Harbor scene, overmantel paintings
 Oil
 Edes, Jonathan W.

Harbor scene paintings
 Oil
 Perkins, Horace Tidd
 Taylor, Bayard

Hat boxes
 Paper
 Higgin, Peter
 Wood
 Fleming, James Adam

Hat boxes, other decorated boxes
 Unidentified Media
 Keller, Adam
 Putnam and Roff
 Wood
 Davis, Hannah

Hatchments
 Embroidery
 Flower, Ann
 Fabric
 Hall, Hannah

Headcloths
 Needlework
 Gerrick, Sarah

Historic needlework pictures
 Fabric
 Wheeler, Rebekah

Historic scene paintings
 Oil, acrylic
 De Mejo, Oscar

Historical and battlescene paintings
 Oil
 Sanford, M.M.

Historical and landscape paintings
 Oil
 Volozan, Denis A.

Historical and still life paintings
 Oil
 Boyle, M.

Historical drawings
 Watercolor, ink
 Janvier, George Washington

Historical, genre, landscape paintings
 Oil
 Davies, Albert Webster

Historical paintings
 Oil
 Barnes, R.
 Frost, J(ohn) O(rne) J(ohnson)
 Heeling, John
 Hillings, John
 Percel, E.
 Wallack, W.S.
 Oil on glass
 Webb, E.
 Watercolor
 Baker, J.W.
 Cole, A.
 Meyers, William H.
 Smith, John H.

Historical portraits, paintings, ship carvings, ship figures
 Wood, oil
 Dwight, Stephen

Hitching posts
 Iron
 Nutting, Calvin, Sr.
 Pioneer Iron Works

Hobby horses, ship carvings, ship figures
 Wood
 Gerrish, Woodbury

Homestead paintings
 Watercolor
 Martin
 Stauffer, Jacob

Hooked bed rugs
 Fabric
 Greer, R.
 Pearl, Hannah
 Thorn, Catherine

Hooked rugs
 Fabric
 Lepine, Imelda
 Selby, Cleland

Hooked rugs, bed rugs
 Fabric
 Avery, Mary
 Barnard, Lucy
 Billings, Pheobe
 Blackstone, Eleanor
 Clarke, Laura Etta
 Denny, Sara
 Filker, John
 Franklin, Mary Mac
 Gove, Jane
 McCall, Philena
 McKeever, Ellen
 Stark, Elizabeth (Miss)
 Vinton, Mary

Hooked rugs, maps
 Fabric, watercolor, ink
 Voohees, Betsy Reynolds

Hope chests
 Wood
 Allis, Ichabod
 Allis, John
 Hawks, John
 Pease, John

Hope or Hadley chests
 Wood
 Belding, Samuel, Jr.

Horse and tiger illustrations
 Watercolor, ink
 Krider, Jacob

Horse portraits, frakturs
 Watercolor
 Zook, J.W.

Horses, fantasy drawings, scene paintings
 Oil, pastel
 Lebduska, Lawrence

House and barn paintings
 Enamel
 Johnson, Ray

House and farm scene drawings
Pencil, watercolor
　Vogt, Fritz G.

House designed in the form of a goose
Mixed media
　Stacy, George

House mosiacs
Various materials
　Owsley, Willie

House painted in patriotic colors
Oil
　Fields, Charlie "Creek Charlie"

House pictures
Watercolor
　Damitz, Ernst

House portraits
Oil
　Moore, Charles
　Robbins, Marvin S.
　Van Dalind, G.
Paint
　Lundeen, F.V.
Pastel
　Pritchard, James
Pencil
　Bolles, John, Captain
　Stanley, William
Watercolor
　Muler, Christian

House portraits, farm scene paintings
Oil
　Dousa, Henry

House, sign, ship paintings
Oil?
　Marten, Richard

Hunting horns, churns
Stoneware
　Grindstaff, William

Icon sculptures, carvings
Wood
　Perates, J(ohn) W.

Illustrated biographical essay of his community
Ink, watercolor
　Miller, Lewis

Illustrated bookplates
Watercolor, ink
　Killian, Abraham

Illustrated manuscripts
Pen, crayon
　Eldredge, William Wells

Imaginative scene, mythical paintings
Oil
　Lothrop, George E.

Indian ceremonial scene paintings
Oil
　Shije, Velino
Watercolor
　Tsireh, Awa

Indian festival paintings
Oil
　Kabotie, Fred

Indian paintings
Oil?
　Drake, Samuel Gardiner
Paint
　Hall, James

Indian portraits
Oil
　Cooke, George

Indian-head tobacco pipes
Redware
　Gibble, John

Inkstands
Iron
　Ives, Julius

Inlaid candle holders, crosses
Straw
　Tapia, Star

Interior and landscape paintings
Oil
　Munro, Janet

Interior house paintings, portraits
Watercolor
　Leavitt, Joseph Warren

Interior paintings, gravestones
Oil, stone
　Holliman, John

Interior scene paintings
Oil
　Emory, Ella
　Freeland, Anna C.
Watercolor
　Russell, Joseph Shoemaker

Iron forges
Iron
　Hansenclever, Peter

Iron wing duck decoys
Iron
　Armstrong Stove and Foundry Company

Ironware
Iron
　Weymouth Furnace
　Winthrop, John

Ironware, firebacks
Iron
　Oxford Furnace

Ironworks
Iron
　Simmons, Phillip

Japanned tinware
Tin
　Barber, Betsy
　Burch, John
　Dobson, Isaac
　Gridley, R.
　Guernsey, James
　Howell, Elias L.
　Hubbard Girls
　Lewis, Ira
　Mitchell, Almira
　Mygatt, Hiram
　Wilcox, Hepzibah
　Willcox, Marcy
　Williams, Abigail

Jars
Stoneware
　Auman, Fletcher
　Boggs Pottery
　Brown and Crooks
　E. Swasey and Company
　Fox, H.
　Fox, N.
　Goodwin, Webster
　Hunt, John
　Melcher, H.
　N.A. White and Sons
　Nixon, N.H.
　Seagle, Daniel
　Sonner, S(amuel) H.
　Torbert and Baker
　Unser, C.
　Weir
　Wilbur, C.

Jars, bowls
Stoneware
　Rhodes, Collin

Jars, bowls, pots
Stoneware
　Suttles, I.

Jars, jugs
Stoneware
　Thomas, I.

Jars, mugs
Stoneware
　Saenger, William

Jars, pitchers
 Stoneware
 Rheinhardt, Enoch W.

Jergas
 Fabric
 Roybal, Martin

Jewelry
 Ivory
 Alaska Silver and Ivory Company
 Silver
 Kinzie, John

Jugs
 Stoneware
 Braun, C.W.
 Cogburne and Massey
 F.T. Wright and Son
 F.W. Weeks
 H. Wilson and Company
 Hann, W.F.
 Hartsoe, Sylvanus
 J. and E. Norton
 Jaegglin, E.A.
 Jones, Evan R.(B)
 Jugtown Pottery
 Knox, W.C.
 M. Tyler and Company
 Meyer Pottery
 Minnesota Stoneware Company
 Ottman Brothers and Company
 Ownby, Thomas
 Pottersville Community
 Schrap, W.J.
 Southern Pines, N.C.
 Star Pottery
 Stuckey, Martin or Upton
 Wallace and Gregory Brothers
 Werrbach, L.
 Wilson, John M.
 Wrenn Brothers

Jugs, flasks
 Stoneware
 Cornwall

Jugs, pitchers
 Stoneware
 Chandler, Thomas

Jugs, pottery
 Stoneware, clay
 Cushman, Paul

Kegs
 Stoneware
 L. and B.G. Chase

Kettles
 Brass
 Hayden, Hiram
 Heyser, W.
 Marcy, J.J.
 Spaulding, C.F.
 Copper
 Howard and Rodgers

Kitchen tables, pie safes
 Wood
 Luppold, Matthias

Lace cutwork samplers
 Fabric
 Keen, Sarah

Ladles
 Copper
 Allen, Caleb
 Jones, Gershom

Lamps
 Tin
 Cornelius, Robert
 Green, Charles E.
 Grist, Thomas

Lamps, candlesticks
 Tin
 Lengfelder, Balthasar

Landscape and fantasy drawings
 Crayon, pen, watercolor, pastel
 Yoakum, Joseph E.

Landscape and flower paintings
 Gouache
 Trabich, Bertha
 Oil
 Levin, Abraham (Abram)

Landscape and historical paintings
 Oil
 Bolander, Joseph

Landscape and memory paintings
 Oil
 Moses, Anna Mary Robertson
 Watercolor
 Erceg, Rose "Ruza"

Landscape and mythical drawings
 Pencil
 Halstead, Israel T.

Landscape and still life paintings, church frescos
 Oil, fresco
 Southworth, Ella

Landscape drawings
 Charcoal, chalk
 Moore, Emily S.
 Pen, crayon
 Fairman, Edward
 Pen, ink
 Dieter, Charlie
 Schoolcraft, Henry Rowe
 Pencil
 Howard, Rebecca F.
 Louis, C.
 Waugh, Henry C.
 Pencil, watercolor
 Beauchamp, William Millet

Landscape, fruit, and flower paintings
 Oil
 Trenholm, Portia Ash Burden

Landscape or genre paintings
 Oil, watercolor
 Spelce, Fannie Lou

Landscape paintings
 Gouache
 Wild, John Casper
 Oil
 Andrews, S. Holmes
 Bacon, Mary Ann
 Barbier, D.
 Barnum, Julia Fuller
 Bartlett, W.H.
 Basye, Joyce
 Bauman, Leila T.
 Beaver, Chief
 Bennett, F.R.
 Blent, John
 Branchard, Emile Pierre
 Bryant, Julian Edwards
 Buck, William H.
 Carter, A.G.
 Eights, James
 Fibich, R.
 Gier, David
 Guy, Francis
 Harley, Steve
 Hidley, Joseph H.
 Hood, E.R.
 Kingsley, Addison
 Kitchen, Tella
 Labrie, Rose
 Larson, Edward
 Little, Ann
 Mark, George Washington
 McConnell, G.
 Mote, Marcus
 Mueller, Rudolph
 Northey, William, Jr.
 Plummer, R.
 Roman, D.F.
 Root, Robert Marshall
 Ruckle, Thomas
 Sabo, Ladis
 Santo, Patsy
 Sawin, J.W.
 Simpson, J.W.
 Stafford, H.M.
 Stewart, Alexander
 Sullivan, Charles
 Tanner, M.J.
 Tern, C.H.
 Thomas, Edward K.
 Walker, James L.
 Wallin, Hugo
 Warwell
 Washburn, S.H.

Type of Work Index — Masonic, sign and ornamental paintings

West, Benjamin
Western, A.S.
Weston, H.
White, John
Wiess, J.
Wynkoop, Emma T.
Oil on tin
 Pilliner, C.A.
 Rasmussen, J(ohn)
Oil, watercolor
 Knapp, Hazel
Oil?
 Bender, A.S., Major
 Kleinhofen, Henry
Paint
 Barth, Otto
 Cridland, Charles E.
 Inman, Henry
 Kieff, John
 Kimball, H.C. and Compamy
 Tracy, G.P.
 Tracy, Simon P.
Pastel
 Guiffer, D.
Pen, watercolor
 Carll, E.S.
Unidentified Media
 Starkweather, J.M.
 Willoughby, Edward C.
 Wolfe, John C.
Watercolor
 Belcher, M.D.
 Browne, William
 Burroughs, Sarah A.
 Clark, F.C.
 Daniel, Holy
 Dunn, C.F.
 Hamilton, Sophie
 Marford, Mirible "Miribe"
 McDowell, Fred N.
 Mitchell, Phoebe
 Nichols, Eleanor
 Spalding, E.
 Taylor, A.M.
 Van Gendorff
 Vaughn, M.A.
 Vogler, Elias
 von Hedeken, Ludwig Gottfried
Watercolor, ink
 Ludlow, Gabriel R.

Landscape paintings, group portraits
Oil
 Smibert, John

Landscape paintings, portraits
Oil
 Blunt, John Samuel
Oil, fresco
 Bartoll, William Thompson

Landscape, scene paintings
Oil
 Baum, Mark

Landscape, scene, religious paintings
Oil
 Baker, Samuel Colwell
Watercolor
 Minchell, Peter

Landscape, still life, religious paintings
Oil
 Davis, Alfred "Shoe"

Landscapes
Fresco
 Gilbert, A.V.

Landscapes, genre paintings
Oil
 Crawford, Cleo

Lanterns
Tin
 G.V. Keen and Company
 Langston, Thomas
 Schaaf, Henry

Large figures
Wood
 Lee, Joe

Letter openers
Unidentified Media
 Dangler, Samuel

Linen baby caps
Fabric
 Jeffries, Deborah Hunt

Literary and mythical pictures
Embroidery
 Deans, Sarah Ann Curry
 Taylor, Eliza Winslow

Literary scene paintings
Watercolor
 Merridan, Ann Page

Lock plates
Brass
 Golcher, James

Locomotive portraits
Watercolor
 West, E.

Log cabin banks, pottery
Redware
 Bagaly and Ford

Lounges
Wood
 Kroebe, Michael

Map drawings
Ink, watercolor
 Kindall, George

Maple sugaring scenes
Wood
 Elethorp, Robert

Maps
Pen, ink
 Melish, John

Marine and historical paintings
Oil
 Evans, James Guy

Marine paintings
Oil
 Osborn, B.F.
 Thresher, George

Marriage and birth certificate drawings
Watercolor
 Firth, E.F.

Masks
Stone
 Dibble, Philo

Masks, reliefs
Various materials
 Schatz, Bernard

Masonic and portrait paintings
Oil
 Hoppin, Davis W.

Masonic aprons
Fabric, leather
 Tisdale, Elkanah
Watercolor
 Martin, J.

Masonic aprons, portraits
Paint
 Negus, Nathan

Masonic paintings
Oil
 Leman, John
Unidentified Media
 Bush, John A.

Masonic regalia
Unidentified Media
 Caberey
 Drew, W.H.
 Drummond, M.J.
 Henderson, Frank K.
 Moss and Brother
 Pollard, A.W.

Masonic, sign and ornamental paintings
Oil
 Codman, Charles

Matchboxes
Pasteboard
Sanford, Thomas
W.M.A. Clark's Superior Friction Matches

Memorial drawings
Ink, needlework
Holmes, Anna Maria
Pen, watercolor
Schnitzler, Paul
Wentworth, Ellen
Unidentified Media
Stickney, Mehetable
Watercolor, ink
Brown, Olive W.
Watercolor, ink, pinprick
Rollings, Lucy

Memorial drawings, valentines
Watercolor
Gurney, Thomas

Memorial paintings
Fabric, paint
Ritter, Lydia
Velvet
Bartlett, Lucy
Kimball, Mary Ann
Miller, Louisa F.
Salter, Ann Elizabeth
Watercolor
Burr, Julia
Collins, C.
Cushman, Mary
Ellis, Rachel E.
Goldsborough, Moria T.
Hawes, Sarah E.
Moore, Harriet
Murray, Eliza
Peters, C.
Reid, A.D.
Smith, Margarette W.
Thurston, Elizabeth
Warner, Catherine Townsend
Wescott, P.B.
Wilkins, Sarah
Wingate, Mehitabel

Memorial pictures
Embroidery
Winsor, Susan Jenckes

Memory and genre paintings
Oil
Williamson, Clara McDonald

Memory drawings
Pen, ink?
Kirschbaum, Joseph, Sr.

Memory paintings
Oil
Boghosian, Nounoufar
Dober, Virginia
Rexrode, James
Stovall, Queena
Paint
Thomas, Pat

Midwestern landscape paintings
Oil
Tait, Arther Fitzwilliam
Unidentified Media
Maurer, Louis

Mill weights
Iron
Elgin Windmill Power Company

Minatures, paintings
Watercolor
Finch, Ruby Derd

Miniature duck carvings, duck decoys
Wood
Burr, Russ

Miniature figures
Wood
Edgington, James McCallister

Miniature houses
Wood, stone
Sparks, Fielden

Miniature paintings
Oil
Badger, Thomas
Clark, Alvan
Goodwin, E.W.
Porter, J.S.
Unidentified Media
Winter, William(?)
Watercolor
King, Josiah Brown
Levie, John E.

Miniature portraits
Oil
Butler, Esteria
Toole, John
Watercolor
Carpenter, Miss
Davenport, Maria
Shirvington, J.
Watercolor, pencil
'Gillespie, J.H.
Plummer, Edwin

Miniatures, landscapes, historical paintings
Watercolor
Kemmelmeyer, Frederick

Miniatures, portraits
Oil, watercolor
Ellsworth, James Sanford

Miniatures, portraits, paintings
Oil, watercolor
Emmons, Alexander Hamilton

Models of airplanes and tanks, drawings
Paint, wood, metal
Sowell, John A.

Models of churches, boxes, carvings
Wood
Hodge, Mack

Molds
Wood
Cox, Henry F.
Linss, Karl

Monuments
Stone
Friedlein, Paul

Morality paintings
Oil
Fields, Leonard

Mosaics
Felt
Thiessen, Louise Berg

Mourning and landscape paintings
Watercolor
Perkins, Prudence

Mourning paintings
Fabric
Terry, Elizabeth
Velvet
Hosmer, Lydia
Watercolor
Barrett, Salley
Beitel, Josiah
Mason, Larkin
Merrill, Sarah
Punderson, Hannah
Sewall, Harriet
Smith, I.R.
Starr, Eliza
Stone, Hannah
Worcester, Caroline

Mourning pictures
Embroidery
Arnold, Elizabeth
Barton, Ann Maria
Bicknell, Charlotte
Bolkcom, Betsey
Borden, Delana
Dean, Abigail "Abby"
Eddy, Abby (Abigail)
Hall, Betsy
Hill, Lovice
Hobart, Salome
Mann, Lydia Bishop
Peck, Almyrah

Russell, Amey
Sabin, Sarah "Sally" Smith (Wilson)
Talbot, Mary
Taylor, Alice
Taylor, Eliza Andrews
Tucker, Mehitable
Vogiesong, Susanna
Ware, Julia
Weeden, Mary
Wightman, Mary
Williams, Frances
Fabric
 Avery, Mary
 Hamilton, Elizabeth Robeson
 Hatch, Sara
 Hodges, Susana
 Lane, Elizabeth
 Quincy, Caroline
 Smyth, M.
Fabric, oil
 Butler, Catherine
Fabric, paint
 Coolidge, E.B.
 Eichler, Maria
 Gamble, Sarah E.
 Schuyler, Angelica
Fabric, watercolor
 Creamer, Susan
Ink
 Converse, Hannah
 Winkler, Matilda Amalia
Needlework
 Bleecher, Margaret
Paint
 Martin, Lucy
Pen, ink
 Sprague, J.
Unidentified Media
 Griswold, Lucy
Velvet
 Sterlingworth, Angelina
 Whipple, Clarissa
Watercolor, ink
 Brown, Hannah
 Brown, Jon
 Brown, Margaret
Watercolor on silk
 Catlin, Betsy
Wood
 Reinke, Samuel

Mourning pictures, portraits

Embroidery, paint
 Ide, Mary

Mourning pictures, samplers

Fabric
 Bennett, Elizabeth K.

Mourning samplers

Embroidery
 Stockwell, Amey Ann
 Thompson, Elizabeth A.
Fabric
 Douglas, Marya

Kimball, Mary G.
Miller, Fanny
Silcox, Emily
Wychoff, Ellen

Mugs

Copper
 Apple, W.
Pewter
 Will, William
Stoneware
 Robinson Clay Products

Mummy cases, carvings

Wood, cement
 Cook, R.K.
 Cook, Ransom

Murals

Oil
 Chain
 Velghe, Joseph (Father John)
Oil?
 Paine
Paint
 Hupendon, Ernest
 Schroth, Daniel, Reverend

Murals, frescos pictures

Oil
 Boutwell

Murals, paintings

Oil
 Hewes, Clarence "Charlie"

Mystical scene paintings

Oil
 Reyher, Max

Mythological embroidered pictures

Fabric
 Boush, Elizabeth
 Spurr, Eliza W.
 Welles, Lydia

Nature paintings

Oil
 Wilson, Alexander
Oil?
 Moulthrop, Major

Nautical carpets

Fabric
 Rumrill, Edwin, Captain

Naval engagement, ship paintings

Paint
 Birch, Thomas

Needlelace samplers

Fabric
 Wayn(e), Sarah

Needlepoint

Fabric
 Burt, Mary Jane Alden
 Otis, Mercy (Warren)
 Roth, Louise Cook
 Sublett, Harriet
Wool
 Cotton, Dorothy

Needlepoint pictures

Fabric
 Gallatin, Almy Goelet Gerry
 Kountze, Mrs. De Lancey

Needlepoint pillow tops

Fabric
 Law, Mrs. Edward

Needlepoint pocketbooks

Fabric
 Willard, Eliza

Needlepoint sofa panels

Fabric
 Kellogg, Mrs. Francis Leonard

Needlepoint squares

Fabric
 Duvall, Flo

Needlepoint stool tops

Fabric
 de Freest, Mrs. Daniel L.

Needlepoint tapestry

Fabric
 Smith, Martha Swale

Needlework

Embroidery
 Drinker, Elizabeth
Fabric
 Cary, Mary
 Hartley, Florence
 Mohamed, Ethel Wright
 Purcell, Eleanor
 Shaw, Martha Ann
 Talbot, Jane Lewis
 Ten Eyck, Margaret Bleeker
 Wilson, Ann Jefferis

Needlework, crochet works

Pencil, brush, fabric
 Lewis, Flora

Needlework, embroidery

Fabric
 Lothrop, Stillman

Needlework, mourning drawings

Fabric
 Nye, Lucy

Needlework pictures
 Fabric
 Dana, Lucinda
 Dodge, Eliza Rathbone
 Downing, Mary
 Frazier, Mrs.
 Thaxter, Rachel
 Wagner, Christina
 Wakeman, Esther Dimar

Needlework pocketbooks
 Fabric
 Wright, Mary

Needlework portraits
 Fabric
 Parkman, Abigail Lloyd

Needlework quilts
 Fabric
 Woodnutt, Rachel Goodwin

Needlework slipper cases
 Fabric
 Day, Elizabeth

Neon signs
 Glass
 Karsner, Clark

Ornamental and decorative paintings
 Paint
 Savory, Thomas C.

Ornamental and landscape paintings
 Oil
 Badger, Stephen
 Unidentified Media
 Clapperton, William R.

Ornamental carvings
 Wood
 Flower, Mary Elizabeth

Ornamental duck carvings
 Wood
 Pope

Ornamental paintings
 Fresco
 Almini, Peter M.
 Cohen, Alfred
 Jevne, Otto
 Oil
 Avery, John
 Hall, Sylvester
 Low and Damon
 Morrison, James
 Priest, William
 Rice, Emery
 Sanford and Walsh
 Severence, Benjamin J.
 Shepard, Daniel
 Stimp
 Thayer, Nathan

 Williams, Lydia Eldridge
 Wood, Orison
 Oil, watercolor, fresco
 Smith, Tryphena Goldsbury
 Oil?
 Cowan, Robert
 Crafts, Thomas
 Gore, Samuel
 Gray, William
 Paint
 Audin, Anthony
 Augustus, Sampson
 Booth, Thomas
 Carter, Elias
 Dresser, Harvey
 Gates, Erastus
 Johnston, John
 Liscombe, Mr.
 Paint, varnish
 Mason, David
 Stencils
 De Forest, J.H.
 Stencils, frescos
 Leroy, D.
 Unidentified Media
 Goodrich, Henry O.
 Hodgetts, Sam

Ornamental signs, portraits
 Oil
 Nelson, Mr.

Ornamental tinware
 Tin
 Hillard, E.
 Venter, Augustus
 Westwood, William H.

Ornamental works
 Metal
 Baker, P.
 Baumann, S.
 Butler, David
 Crites, Cyrus
 Humphrey, Harrison
 Kumerle, D.
 Merrill, Henry W.
 Rohrer, P.
 Stow, John

Ornamentals
 Paint
 Derby, Madame

Overmantel paintings
 Oil
 Jessup, Jared
 Van Cortland

Painted barns, carved toys, sculpture
 Oil, wood
 Weiss, Noah

Painted boxes
 Oil
 Morgan, Mary

 Wood
 Powers, Bridget

Painted carpets
 Oil, fabric
 Gore, John
 Killcup, George, Jr.
 S. Sweetser and Sons

Painted cart wheels, sleighs, bed posts, etc.
 Tin?
 Pettibone, Abraham

Painted chests
 Wood
 Gillam, Charles

Painted coaches
 Oil
 Little, B.

Painted duck decoys, decorative duck carvings
 Paint
 Ward, Lemuel T.

Painted iron sculptures
 Metal, oil
 Alton Foundry

Painted panels, furniture
 Housepaint
 Darling, Sanford

Painted picture frames
 Wood
 Clark, Anson

Painted sheet figures
 Various materials
 Payne, Leslie J.

Painted tin toys
 Paint
 Goodwin, William F.

Painted tinware
 Tin
 Bennett, Mrs.
 Blake, S. and J.
 Brewster, Elisha C.
 Brown, Sally
 Brown, Samuel
 Curtis, Anne
 Francis, Edward
 North, Mercy
 Parsons, Polly
 Tuller, M.
 Upson, Sarah Greenleaf

Paintings
 Acrylic
 Abraham, Carl
 Butler, Nellie

Type of Work Index **Paintings**

- Clark, Floyd
- Clark, Mildred Foster
- Fabian, Gisela
- Falk, Barbara (Busketter)
- Hardee, Rodney
- Lembo, J. Lawrence
- Massey, Marilyn
- Moseley, Alice Latimer
- Muth, Marcia
- Nash, H. Mary
- Simon, Pauline

Acrylic, oil
- Jakobsen, Kathy (Katherine)
- Vagen, Bette

Acrylic, tempera, pen, ink
- Ley, Mary E.

Acrylic, various materials
- Rochette, Roland

Airplane enamel
- Dey, John William "Uncle Jack"

Chalk
- Arnold, Thomas
- Harvey, M.T.

Fresco
- Ackerman and Brothers
- Beckert, L.
- Gilbert, E.J.
- Smithmeyer and Company
- Swift, S.W.

Gouache
- Miller, J.

Gouache on reverse glass
- Canfield, Abijah

Ink, watercolor
- Moskowitz, Isidore

Magic marker
- Wilkinson, Knox

Oil
- Aiken, Gayleen
- Ara
- Ashberry
- Badami, Andrea
- Bardick, Lewis
- Bartlett, I.
- Bauch, Stan, Dr.
- Bdogna, Frank
- Becker, Joseph
- Beckett, Francis A.
- Bennett, E.V.
- Besner, Fred M.
- Blair, Streeter
- Block, Andrew
- Bologna, Frank
- Bond, Peter Mason "PEMABO"
- Bowers, E.
- Bradbury, Gideon
- Brahm, B.
- Bronesky, S.S.
- Brown, Mary
- Brown, W.H.
- Burr, John P.
- Buttersworth, James E.
- Candee, G.E.
- Cavalla, Marcel
- Cervantez, Pedro
- Child, Thomas
- Chism, Mrs. Charles
- Choris, Louis
- Clark, Frances
- Clark, Minerva
- Cohen, F.E.
- Cohen, Gideon
- Collins, William
- Cooper, Peter
- Cortrite, Nettie (Antoinette)
- Corwin, Salmon W.
- Cover, Sallie
- Coyle, Carlos Cortes
- Crehore, S.
- Cummings, J.C.
- Curtis, H.B.
- Davis, Gwyn
- Day, Frank Leveva
- Delgado, Fray Carlos Joseph
- Dickson, W.
- Dobson
- Doolittle
- Doriani, William
- Doud, Delia Ann
- Draper, Augusta
- Duyckinck, I. Evert
- Dwyer, William J.
- Ellison, Orrin B.
- Ely, Miss
- Emerson, I.L.
- Ennin, Joseph G.
- Enos, John
- Evans, J.M.
- Ewen, John, Jr.
- Felski, Albina
- Fischer, Charles Henry
- Flanagan, Thomas Jefferson, Reverend
- Fletcher, Aaron Dean
- Fletcher, Alex
- Foley, Nicholas
- Francis, J.P.
- Frouchtben, Bernard
- Fryer, Flora
- Gage, Nancy
- Gephart, S.S.
- Gerry, Samuel Lancaster
- Giddings, C.M.
- Gladding, Benjamin
- Golder, C.H.
- Goodwin, William
- Gookin, William S.
- Graziani, Reverend Dr.
- Hadley, Sara
- Haney, Clyde
- Harrington, Addie A.
- Harris, Harriet A.
- Harrold, John "Spotter Jack"
- Hart, Anna S.
- Harvey, Sarah E.
- Hathaway, C.H.
- Hemp, Robert
- Heyde, Charles Louis
- Hicks, Edward
- Hiler, Pere
- Hirshfield, Morris
- Hood, Washington
- Hope, James
- Hudson, Samuel Adams
- Huffman, Barry G.
- Hull, Lee
- Hutson, Charles Woodward
- Ingersoll, John Gage
- Ingraham, Mary L.
- Irish, Tom
- Jennings, J.S.
- Jewett, Frederick Stiles
- Joy, Josephine
- Kane, John
- Kelly, W.H.
- Kemp, D.
- Kennedy, Terence J.
- Keys, Jane
- Kimball, Elizabeth O.
- Kip, Henry D.
- Kline, A.
- Lamb, K.A.
- Laskoski, Pearl
- Levill, A., Jr.
- Livingston, Ruth
- Logan, A.
- Lucas, David
- Lucero, Juanita
- Lustig, Desider
- Lyman, H.
- Mandel, A.
- Margaretten, Frederick M., Dr.
- Marston, James B.
- May, Sibyl Huntington
- McArthur, Grace
- Miller, Anne Louisa
- Miller, James
- Moore, Nelson Augustus
- Moss, Emma Lee
- Norman, Charles
- O'Brady, Gertrude
- Perez, Mike
- Pering, Cornelius
- Perkins, Clarence "Pa" "Cy"
- Perkins, Ruth Hunter "Ma"
- Pickett, Joseph
- Poe, William
- Poor, Jonathan D.
- Porter, Solon
- Porter, Stephen Twombly
- Powell, H.M.T.
- Pringle, James Fulton
- Raleigh, Charles Sidney
- Raser, John H.
- Reed, P.
- Rhoads, Jessie Dubose
- Roberts, Bishop
- Rogers, Gertrude
- Royce, Jenny
- Russell, N.B.
- Samuel, W.M.G.
- Sandusky, William H.
- Schwob, Antoinette
- Shelite, L.G.
- Shively, Clio D.
- Sigler and Sons
- Skyllas, Drossos P.
- Smith, Dana

461

Paintings

Paintings (Cont.)
 Oil (Cont.)
 Snow, Jenny Emily
 Sobel, Lillie
 Steig, Laura
 Sterns, E.
 Stone, N.
 Swift
 Taccard, Patrick
 Tenny, Ulysses Dow
 Turner, Harriet French
 Valdes, Georgio
 Vanderlyn, John
 Veeder, Ferguson G.
 Ward, A.B.M.
 Weller, Laura Elliott
 Wetherby, Jeremiah W.
 Wheeler, Jonathan Dodge
 White, Francis
 Wilder, Matilda
 Willson, Sulie Hartsuck
 Wirig, Nicholas
 Woolson, Ezra
 Young, Celestia
 Zingale, Larry
 Oil, acrylic
 Esteves, Antonio
 Forbes, Jack
 Gyory, Esther
 Moment, Barbara
 Roseman, Bill
 Zeldis, Malcah
 Oil, acrylic, pen, pencil
 Middleton, Ralph
 Oil, pastel
 Gibbs, Ezekial
 Oil, watercolor
 Hoffman, C.W. (Charles L.)
 Horner, Gustavus Richard Brown
 Willson, Mary Ann
 Oil?
 Coppola, Alphonse
 Moorhead, Scipio
 Paint
 Allen, Luther
 Brooks, Noah
 Egan, John J.
 Gibson, Sybil
 Loguen, Gerritt
 Samet, William
 Smith, E(rnest) A(rcher) "Frog"
 Paint?
 Pickhil, Alexander
 Pastel
 Rightmeyer, J.E.
 Pastel, oil
 Blyth, Benjamin
 Pen, crayon, pencil
 Tatro, Curtis
 Pen, watercolor
 Brown, George R.
 Wineland, N.W.
 Pen, watercolor, oil
 Clark, Mason
 Poster paint
 Kurtz, Sadie
 Rock
 Little Lamb
 Sand
 Miguelito
 Tempera
 Persac, Adrien
 Tempera, gesso
 Molleno
 Tempera on tin
 Brett, Lady Dorothy
 Unidentified Media
 Chaplin, J.G.
 Dorsey, William H.
 Primus, Nelson
 Radfore, P.M.
 "Rhenae"
 Whitefield, Edwin
 Wilson, A.B.
 Velvet
 Adams, Charlotte
 Allo, P.A.
 Barstow, Salome
 Beers, Martha Stuart
 Bradley, Mary
 Bullard, C.
 Buxton, Hannah P.
 Capron, Elizabeth W.
 Cheever, Sarah F.
 Clark, Elizabeth Potter
 Clarke, Harriet B.
 Cole, Maria
 Coward, Eleanor L.
 Cushing, Mrs. Thomas
 Davis, M.O.
 Dean, Polly C.
 Forbes, Hannah Lucinda
 Gage, Martha
 Haviland, Matilda A.
 Noel, Mary Cathrine
 Van Alstyne, Mary
 Watercolor
 Ainslee, Henry Francis, Colonel
 Bromfield, Catherine
 Brook, Miss M.
 Chapin, Mary S.
 Cherrill, Adolphus
 Chester, Rebecca
 Clarke, David
 Collie, S.
 Collis, Miss
 Dalee, Justus
 Dana, Sara H.
 De Lee, Francis H.
 Doolittle, Amos
 Downer, Ruth
 Durfee, George H.
 Eastman, Seth
 Evans, William B.
 Fairbanks, Sarah
 Fredenburg, George
 Gibbs, H.R.
 Grider, Rufus A.
 Harley
 Hayse, Martha S.
 Heath, Susan
 Hemenway, Asa
 Herp, Charles Adelbert
 Houghenon, Dorothy
 Howland, Charity
 Hoyt, Thomas R., Jr.
 Humphrey, Maria Hyde
 Huntington, Dyer
 Huntington, J.C.
 Ingersoll, John
 Jackson, Charles Thomas
 Jacob, K.S.
 Johnson, Ann
 Johnson, S.D.
 Johnston, Thomas
 Joy, Caroline
 Keys, Mary
 Lathrop, Betsy B.
 Lawton, C.
 Mann, Electra
 Marshall, Emily
 Martin, John F.
 Mason, William
 Merritt, E.
 Merritt, Susan
 Mohler, Anny
 Morley, William
 O'Brien, John Williams
 Parke, Mary
 Phipps, Margarette R.
 Plourde, Ben
 Pratt, Louisa Jane
 Pressman, Meihel
 Putney, Henry
 Raymond, James S., M.D.
 Rosseel, Frank
 Scouten, O.B.
 Sheldon, Lucy
 Slack, George R. H.
 Spybuck, E.L.
 Steven, S.S.
 Stevens, Augusta
 Tilles, J.A.
 Van Ness, Sarah Oldcott Hawley
 Van Wagner, Jas. D.L.
 Walber, T.B.
 Walker, Rebecca
 Waters, D.E.
 Whitcomb, J.H.
 Willis, Eveline F.
 Wilson, Mary R.
 Wright, Almira Kidder
 Watercolor, gold leaf
 Pelton, Emily
 Watercolor, gouache, ink
 Parsons, A.D.
 Watercolor, ink, pen
 Pinney, Eunice Griswold
 Holcombe
 Watercolor, oil
 Burpee, Sophia (Constant)

Paintings, drawings
 Pencil, crayon, felt tip pen
 Tuska, Seth

Paintings, environmental sculptures
Various materials
 Mullins, Walter S., General

Paintings, fabric art
Oil, fabric
 Price, Janis

Paintings, gravestones, other stoneworks
Oil, stone
 Johnston, Thomas

Paintings, monotypes, woodcuts, constructions
Oil, wood, terra-cotta, metal
 Monza, Louis

Paintings of toys
Watercolor, chalk, magic marker
 Folger, George

Paintings, panoramas
Oil
 Blair, J.B.

Paintings, particularly of nudes
Oil
 Klumpp, Gustav

Paintings, sculptures
Acrylic, clay
 Palladino, Angela
Clay, tempera
 Rogers, Juanita

Paintings?
Paint?
 Padelford, R.W.
 Pendergast, W.W.
 Wilkins, Benjamin

Panorama and landscape paintings
Unidentified Media
 Waugh, Henry W.

Panoramic paintings
Oil
 Banvard, John
 Christensen, Carl Christian Anton
 Gordon, Thomas Clarkson
 Lewis, Henry
 Smith, Aurelius
 Stevens, John
 Stockton, Sam
 Wimar, Karl
Tempera
 Purrington, Caleb B.
 Russell, Benjamin

Paper works
Paper
 Crane, Margaret Smyser

Parian sculptures
Clay
 Harrison, John

Pastel portraits
Crayon
 Sharples, James

Pastoral scene drawings
Crayon
 Manley, Jane Helena

Pastoral scene paintings
Oil
 Call, H.

Patchwork show towels
Fabric
 Kichline, Euphemia

Patented duck decoys
Metal
 Sohier, William

Patented duck, shorebird decoys
Metal
 Strater, Herman, Jr.

Peaceable kingdom paintings
Oil
 Prindle, F.B.

Penmanship, calligraphy drawings
Pen, ink
 Brown, William Elliot
 Butler, J.B.
 Durand, Helen
 Frink, L.W.
 Goldsmith, Oliver B.
 Harris, Elihu
 Heyman, F.B.
 Jewitt, Clarissa
 Kanoff, W.H.
 Martin, Emma E.
 Morse, J.G.
 Parmenter, N.H.
 Satterlee, J.C.
 Spencer, Platt Roger
Pen, ink, watercolor
 Foot, F.H.
 Reynolds, Lydia Barlett

Petrified statues, lace-like walls, concrete arches
Various materials
 Forrester, Laura Pope (Mrs. Pope)

Pewterware
Pewter
 Billings, William
 Heyne, Johann Christopher
 Kirk, Elisha

Pie safes
Wood
 Hogue, Samuel
 Vermillion, John

Pig banks, clay pipes
Rockingham
 Colclough, William

Piggy jugs
Stoneware
 Texarkana Pottery

Pillow cases
Fabric
 Weaver, Mary Ann

Pin-cushions, embroidered pocketbooks
Fabric
 Alsop, Mary Wright

Pipes
Clay
 Morton, Joseph
Wood
 Hassler, Sven
 Kidder, O.G.
 Oakford, John

Pitchers
Stoneware
 Byrd Pottery
 Hilton Pottery Company
 J. Swank and Company
 Loy, M.
 N. Clark and Company
 Prothro Pottery
 R. Clark and Company
 Rochester Sewer Pipes
 San Antonio Pottery
 Wright, Franklin

Pitchers, jugs
Stoneware
 Leopard, John

Planters
Stoneware
 Summit Sewer Pipe Company

Political and social paintings
Watercolor
 Ginther, R(oland) D(ebs)

Political paintings
Oil
 Fasanella, Ralph

Poplar bowls
Wood
 Pie, Hugh

Porcelain
 Clay
 American Porcelain
 Manufacturing Company
 Block, William
 Cartlidge, Charles
 Olworth, C.W.
 Tucker and Hemphill
 United States Porcelain Company
 Hardpaste
 Champion, Richard
 White earthenware
 Bartlam, John
 White Granite
 Dresden Pottery

Porcelain and art ware
 Clay
 Thomas C. Smith and Sons

Porcelain, pottery
 Redware, Rockingham, white clay
 Beech, Ralph Bagnall
 White Granite
 Greenwood Pottery Company

Portraits
 Charcoal, oil
 Aldridge
 Ink, watercolor
 Fair, Hannah
 Needlework
 Punderson, Prudence (Rossiter)
 Oil
 Adams, Willis Seaver
 Alden, G.
 Alden, Noah
 Allen, Edward
 Appleton, George W.
 Arnold, John James Trumbull
 Atwood, Jeremiah
 Aubry, Jean
 Aulisio, Joseph P.
 Badger
 Bancroft, G.F.
 Barnes, Lucius
 Bartlett, Jonathan Adams
 Bears, O.I. (Orlando Hand)
 Beauregard, C.G.
 Belknap, Zedakiah
 Berry, James
 Blackburn, Joseph
 Blake, E.W.
 Bonnell, William
 Bosworth, Sala
 Bounell, W.
 Boyle, Ferdinand T.L.
 Brewster, John, Jr.
 Bridges, Charles
 Bridport, Hugh
 Brooks, Newton (N.)
 Brooks, Samuel Marsden
 Brunton, Richard
 Buddington, J.
 Bunting, J.D.
 Burgum, John

Burr, Leonard
Bushby, Asa
Campbell, Pryse
Capen, Azel
Cezeron
Chandler, Joseph Goodhue
Chandler, Winthrop
Charles, the Painter
Cobb, Cyrus
Cobb, Darius
Codman, William P.
Coe, Elias V.
Coffin, William A.
Cole, Charles Octavius
Cole, Joseph Greenleaf
Cole, Lyman Emerson
Cole, Major
Coles, John, Jr.
Conant, Maria T.
Cook, Mehitable J.
Coyle, James
Crafft, R.B.
Crawford, Alphia
Curtis, Charles
Darby, Henry F.
Darling, Robert
Davidson, George, Captain
Dering, William
Dobson
Drexel, Anthony
Drinker, John
Drummond, Rose Emma
Dundy, H.
Durand, John
Duyckinck, Gerardus I.
Duyckinck, Gerret
Earl, Ralph E.W.
Eaton, J.N.
Ellis, A.
Elmer, Edwin Romanzo
Elwell, William S.
Fairfield, Hannah
Fees, C.
Feke, Robert
Fenton, C.L.
Finch, E.E.
Fischer, Albert
Fitch, Simon, Captain
Fletcher
Folsom, Clara M.
Folson, Abraham
Fordham, H.
Fowler, O.K.
French, C.
Frothingham, James
Frymire, Jacob (J.)
Fuller, Augustus
Furnass, John Mason
Gardnier, Sally
Gasner, George
Gibson, Charles S.
Gilbert, I.
Gilbert, J.
Gladding, T.
Goodell, Ira Chaffee
Goodell, J.C.

Goodman, H.K.
Goodwin, F.W.
Granger, Charles H.
Greenleaf, Benjamin
Greenwood, Ethan Allan
Greenwood, John
Grinniss, Charles
Grout, J.H.
Hagen, Horace Henry
Hall, George Henry
Hamblen, Sturtevant J.
Hamblin, L.J.
Hamilton, Amos
Hancock, Nathaniel
Hanson
Harding, Chester
Harding, Jeremiah L.
Hardy, Jeremiah P.
Hartwell, Alonzo
Hartwell, George G.
Hering
Herring, J.
Herring, James
Hesselius, Gustavus
Hesselius, John
Hewins, Amasa
Hewins, Philip
Hillyer, William, Jr.
Hoit, Albert Gallatin
Holman, Jonas W.
Howard, Mary Ann Eliza
Hoyt, Thomas
Hubbard
Hudson, William, Jr.
Huff, Celesta
Hughes, Robert Ball
Jenkins, H.
Jenney, N.D.
Jennys, Richard
Jennys, William
Joe
Johnson, Hamlin
Johnson, James E.
Johnson, Joshua
Johnson, Mr.
Johnston, John
Johnston, William
Jordan, Samuel
King, Charles Bird
Kittell, Nicholas Biddle
Knight, H.
Knipers, W.
Kuhn, Justus Englehardt
Lakeman, Nathaniel
Lawrence, L.G.
Lawson, Thomas B.
Lewin, C.L.
Lewis, Elijah P.
Lincoln, James
Lovett, William
MacKay
Maddov, Rance, Jr. "Bone"
Major, William Warner
Marchant, Edward D.
Martens, G.
Mason, Benjamin Franklin

Type of Work Index — Portraits

Mason, Jonathan, Jr.
Mason, William Sanford
Mathes, Robert
Matthews, W.
Mayall, Eliza McClellen
Mayhew, Bob
Mayhew, Nathaniel
McFarlane, R.
McKay
McNaughton, Robert
Merck, C.
Mooers, Jacob B.
Moore, A.E.
Moore, Jacob Bailey
Moron, J.
Morris, Jones Fawson
Moulthrop, Reuben
Munger, George
Negus, Nathan
Newell, G.N.
Nicholson, Susan Fauntleroy Quarles
Norman, John
North, Noah
Nutting, Benjamin F.
Onthank, N.B.
Ordway, Alfred
Osgood, Charles
Osgood, Samuel Stillman
Packard, Samuel G.
Page, William
Paine, W.
Palmer, Ch.B.R.
Parks, J.
Parsell, Abraham
Paul, Jeremiah
Peale, James
Pease, H.A(lanzo)
Peck, Sheldon
Peckham, Deacon Robert
Phillips, Ammi
Pimat, P. Mignon
Pine, Robert Edge
Plummer, Harrison
Polk, Charles Peale
Pollard, Luke
Porter, John
Powers, Asahel Lynde
Pratt, Henry C.
Prince, Luke, Jr.
Rand, J.
Reed, Reuben Law
Richardson, Edward, Jr.
Roberts, Marvin S.
Robertson, George J.
Roeder, Conrad
Rogers, Nathaniel
Rowe, L.K.
Rowell, Samuel
Rowley, R.
Ryder, David
Savage, A.J.
Sedgwick, Susan
Sheets, Frank M.
Sheffield, Isaac
Shipshee, Louis

Simpson, William
Sloan, Junius R. (John)
Sloane, L.S.
Smith, Edwin B.
Smith, Roswell T.
Smith, Royal Brewster
Smith, Thomas, Captain
Somerby, Lorenzo
Southward, George
Spear, Thomas T.
Spencer, Frederick B.
Stanley, John Mix
Steere, Arnold
Steward, Joseph, Reverend
Stiles, Jeremiah
Stiles, Samuel
Stock, Joseph Whiting (M.)
Street, Austin
Street, Robert
Sully, Thomas
Sutton, W.
Swain, William
Taite, Augustus
Talcott, William
Tenney, M.B.
Theus, Jeremiah
Thompson, Cephas Giovanni
Thompson, William
Thomson, Jerome
Thomson, Sarah
Tilyard, Philip
Tolman, John (Jack)
Treadwell, Jona
Tuthill, Abraham G.D.
Utley, Thomas L.
Van der Pool, James
Van Doort, M.
Vanderlyn, Pieter
Wale, T.
Waters, Susan C.
Watson, John
Webb, H.T.
Welfare, Daniel (Christian)
Wetherby, Isaac Augustus
White, Ebenezer Baker
Wiggin, Alfred J.
Wilder, Thomas
Wilkie, John
Wilkins, James
Willard, Archibald M.
Williams, William
Wilson, E.
Wilson, Jeremy
Wilson, M.
Winstanley, William
Wright, Edward Harland
Wright, George Fredrick
Wright, L.G.
Wright, Thomas Jefferson
Young, J(ames) Harvey
Young, Reverend
Oil, daguerreotypes
 Cabanis, Ethan T.
Oil on shell
 Fuller, George

Oil, watercolor
 Brown, J.
 Goldsmith, Deborah (Throop)
 Mayhew, Frederick W.
 Stettinius, Samuel Enedy
Oil, watercolor, pastel
 Alexander, Francis
Oil, watercolor, pencil
 Davis, Joseph H.
Oil?
 Clifford, Edward M.
 Davenport, Patrick Henry
Paint
 Abston, U.C.
 Bynum, B.
 Crowley, J.M.
 Hunt, Elisha
Pastel
 Berry, Jonnie E.
 Blood, M.I.
 Bullard, A.
 Conover, Henry
 Doyle, B.
 Doyle, William M.S.
 Johnston, Henrietta (Mrs.)
 Perkins, Sarah
 St. Alary, E.
Pastel, crayon, pencil
 Bascom, Ruth Henshaw
Pastel, oil
 Williams, Micah
Pen, ink
 Giles, J.B.
Pen, watercolor
 Herr, Henry
Tempera
 Cortwright, J.D.
Unidentified Media
 Brown, Samuel
 Clark, G.W.
 Davis, James
 DeBault, Charles
 McMaster, William E.
 Thielke, Henry D.
 Wilson, Mr.
Watercolor
 Abbe, John
 Banton, S.
 Bruere, Theodore
 Chapin, Alpheus
 Davis, Gilbert, Captain
 Davis, J(ane) A.
 Dawkins, Henry
 Dupue
 Eastman, Emily (Baker) (Eastman Louden)
 Esteline, Martha
 Evans, J.
 Freeman, Mr.
 Gore, Joshua
 Hatch, Elisha
 Jones (of Conn.)
 Maental, Jacob
 Osborn, James
 Parker, Life, Jr.
 Phillips, Ellen A.

Portraits

Portraits (Cont.)
 Watercolor (Cont.)
 Smith, Mary Ann (MaryAn)
 Swain, Harriet
 Towers, J.
 Tucker, Mary B.
 Wentworth, T(homas) H.
 Wilkie, William
 Willson, Mr.
 Wood, Hanna
 Wooden, J.A.
 Wybrant
 Ziegler, H.
 Watercolor, ink
 Carr, Henry A.
 Watercolor, oil
 Davis, E(ben) P(earson)
 Watercolor, pencil
 Shute, Mrs. R(uth) W(hittier)
 Shute, Samuel A., Dr.
 Warren, M., Jr.
 Watercolor, pinpricks
 Root, Elmira
 Wax, paper
 Wright, Patience

Portraits, cigar store Indians, figures
 Oil, wood
 Ames, Ezra

Portraits, daguerreotypes
 Oil?
 Cooly

Portraits, decorative paintings
 Unidentified Media
 West, Horace B.

Portraits, furniture, boxes
 Oil, wood, paint
 Crowningshield, Hannah

Portraits, genre and cityscape paintings
 Oil
 Davis, Vestie

Portraits, genre and landscape paintings
 Oil
 Bahin, Louis Joseph

Portraits, genre paintings
 Watercolor
 Glaser, Elizabeth

Portraits, landscape and still life paintings
 Oil
 Canade, Vincent
 Fisher, Jonathan, Reverend

Portraits, landscape, decorative paintings
 Oil
 Gullager, Christian

Portraits, landscape, mural and fresco paintings
 Oil
 Corne, Michele Felice

Portraits, landscape paintings
 Oil
 Bogun, Maceptaw, Reverend
 Bond, Charles V.
 Broadbent, Samuel, Dr.
 Budington, Jonathan
 Chambers, Thomas
 Frye, William
 Hathaway, Rufus, Dr.
 Nickols, Alira
 Prior, William Matthew
 Purdy, Charlie
 Watercolor
 Evans, John T.

Portraits, landscape, ship paintings
 Pastel
 Stubbs, William P.

Portraits, memory, landscape, and fantasy paintings
 Oil
 Miller, Lynn

Portraits, miniatures
 Oil
 Bradley, I. (John)
 Oil?
 Douglass, Robert M., Jr.

Portraits, murals, miniatures, boxes, landscape paintings
 Watercolor, oil
 Porter, Rufus

Portraits of children
 Oil
 McLean, A.C.
 Walters, Susane

Portraits of fish, animals and people
 Oil
 Alexander, Frank

Portraits, ornamental paintings
 Unidentified Media
 West, Washington J.

Portraits, paintings
 Oil
 Bundy, Horace
 Chandler, Lucretia Ann Waite
 Earl, Ralph
 Field, Erastus Salisbury
 Frink, O.E.S.
 Hazlitt, John
 Hobbs, G.W., Reverend
 Johnson, Charles M.
 Oil, watercolor
 Andrews, Ambrose
 Oil, watercolor, pencil, pastel
 Harrington, Ellen T.

Portraits, paintings, signs
 Oil
 Badger, Joseph

Portraits, scene paintings
 Oil
 Munn
 Paint
 Clark, Irene

Portraits, sculptures
 Oil, wood
 Pugh, Dow (Loranzo)

Portraits, signs
 Oil
 Wales, Nathaniel F.

Portraits, signs, ornamental paintings
 Oil
 Delanoy, Abraham

Portraits, sketches
 Pencil
 Orcott, K.V.

Portraits, still life and landscape paintings
 Oil
 Shetky, Caroline

Portraits, still life and scene paintings
 Oil
 Ingalls, Walter

Portraits, still life paintings, sculptures
 Various materials
 Church, Henry, Jr.

Portraits, symbolic scene paintings
 Oil
 Kennedy, William W.

Portraits, tinware, copperware
 Oil, tin, copper
 Eicholtz, Jacob

Portraits, woodcuts
 Oil, wood
 Foster, John

Pottery
 Brownware
 D. and J. Henderson
 Pittman, J.W.
 Brownware, Rockingham
 Adams, Enos

Type of Work Index — Pottery

Allen, William
Turner, William
Walker, George
William Young and Sons
Brownware, stoneware
 Adams Brothers
 Balderson and Pace
 Houghton, Edward
 Lefever Pottery
 Routson, S.
 Stout, John N.
Brownware, yellow-ware
 American Pottery Company
Clay
 A. Hall and Sons
 A. Jennings Pottery
 American Art Ceramic Company
 American Art China Works
 American China Company
 American Crockery Company
 American Encaustic Tiling Company
 American Pottery (Manufacturing) Company
 American Terra-Cotta Company
 Anchor Pottery Company
 Armstrong and Wentworth
 Atkinson, W.A.
 August Blanck Pottery
 Aust, Brother Gottfried
 Avera, John C.
 Avon Pottery
 Baecher, Anthony W.
 Baily, Joseph
 Baird, G.
 Baker, Michael
 Ball, Nelson
 Barley and Winters
 Becham, Washington
 Beck, A.M.
 Beecham Pottery
 Beerbower, L.S.
 Begerly, Levi
 Bell, Charley
 Bell, John W.
 Bell, Peter
 Bell, Richard Franklin
 Bell, Samuel
 Bell, Solomon
 Bell, Upton
 Bellmark Pottery Company
 Bennett and Chollar
 Bennett, Edwin
 Bennett, John
 Benton, G.
 Bird, C.H.
 Bixler, Absalom
 Blair, Sylvester
 Blaney, Justus
 Bloor, William
 Bodine, R.H.
 Boonville Pottery
 Bott, Hammersley and Company
 Boulter, Charles
 Boyer, John
 Boyley, Daniel

Breininger, Barbara
Breininger, Lester
Brewster and Sleight
Brockman Pottery Company
Broome, Isaac
Brunt, Bloor, and Martin
Buehler, John George
Buffalo Pottery Company
Burford Brothers Pottery Company
Burgess and Campbell
Burpee, Jeremiah
Burroughs and Mountford
C. Bykeepers and Sons
C. Goetz, Smith, and Jones, Slago Pottery
C. Herman Company Pottery
Cadmus, Abraham
Caire, Jacob
Cambridge Art Pottery Company
Cartwright and Brothers
Ceramic Art Company
Chapman, Upson, and Wright Manufacturers
Charles Wingender and Brother
Chelsea Keramic Art Works
Chester Pottery Company
Chittenango Pottery Company
Chollar and Darby
Christ, Rudolph
Cincinnati Art Pottery Company
Clark, Nathan, Jr.
Clark, Peter
Clews, James
Columbian Art Pottery
Conklin, Ananias
Convay, John B.
Cook Pottery Company
Cope, Thomas
Cordero, Helen
Couloy, Isadore
Coxon and Company
Crafts, Thomas
Craven, Peter
Cresent Pottery Company
Crolius, Clarkson, I
Crolius, George
Crolius, Peter
Crooksville China Company
Cross, Peter
Crown Pottery Company
Croxton, Walter
Croylas, William
Curtis, John
D.F. Haynes and Company
Dallas, Frederich
Dalton Pottery Company
Danvers Pottery
Dave
Davidson, Seth
Davis, Isaac
Dedham Pottery
Delaware Pottery Company
Derry China Company
Dipple, A.G. Curtain
Dipple, Anna Margretta

Dorsey, Tarp (Joseph Tarplin)
Dorsey, W.F. "Daddy Bill"
Drach, Rudolf
Drinker, Philip
Dry, Daniel
Dry, John
Dry, Lewis
Dubors, Oliver
Duche, Andrew
Duche, Anthony
Eardley Brothers Pottery
East End Pottery Company
East Liverpool Pottery Co.
East Morrisania China Works
East Trenton Pottery Company
Eisemann, Philip
Empire Pottery Company
Faience Manufacturing Company
Farrar, H.W.
Fell and Thropp Company
Fenton and Carpenter
Fenton and Clark
Field, L.F.
Filcher, Thomas J.
Fillman, Michael
Fisher, J.C.
Fleet, Theodore
Ford City Company
Franklin Pottery Company
Fritz, Jacob
Funkhouser, L.D.
Gager, Oliver A.
Galloway and Graff
Gans, H.
George Murphy Pottery Company
Gerlach, C.
Globe Pottery Company
Goodale and Stedman
Goodwin, Seth
Goodwin, Thomas (O'Hara)
Gordy, D.X.
Gordy, William J.
Gordy, William Thomas Belah
Gorham, Joshua
Gre(en?), G.
Griffin, Smith and Hill
Grim, T.
Grueby Faience Company
Haig, James
Hanelsack, Daniel
Hare Pottery
Haring, David
Harker Pottery Comapny
Harker, Benjamin
Harker, Taylor and Company
Harkins, Mrs. A.
Harrington, Thompson
Haukins, W.W.
Haviland Company
Headman, Charles
Hemphill, Joseph
Henne, J.S.
Hewell, Will
Hewes Pottery
Holland, John Frederick

467

Pottery (Cont.)
 Clay (Cont.)
 Holmes, Obediah
 Homer Laughlin China Company
 Hoopes, Milton
 Howard, Bill
 Hubener, Georg(e)
 Hudson River Pottery
 Hughes, Daniel
 Iler, William
 International Pottery Company
 Irwin, Harvey
 J.C. Waelde Pottery
 J.J. Hart Pottery
 J.S. Taft and Company
 Jackson, Samuel
 Janey, Jacob
 Jegglin Pottery
 Joder, Jacob
 John Eardley's Pottery
 John Maddock and Sons
 John Moses and Sons
 John Pierson and Company
 Kelley, Peter
 Key and Swope
 Keytone Pottery Company
 Kirkpatrick, Murray
 Kline, Philip
 Klinker, Christian
 Knowles, Taylor, and Knowles
 Kohler, John W.
 Kurbaum and Schwartz
 Labhart, J.M.
 Langenberg Pottery
 Leake, William
 Lehew and Company
 Lehman, Johannes
 Leidy, John
 Leman, Johannes
 Lent, George
 Lewis and Lewis
 Lewis Johnson Pottery
 Lewis, Henry
 Linna, Irelan
 Long's Pottery
 Long, James L.
 Lonhuda Pottery Company
 Louis Miles Pottery
 Love Field Potteries
 Low Art Tile Company
 Lowry, W.B.
 Lukolz, Philip
 Lycett, Edward
 Lyman, Fenton Company
 M.C. Webster and Son
 Maddock and Son(s)
 Maddock Pottery Company
 Mann, John
 Marteen, W.
 Martin, John
 Maryland Pottery Company
 Matt Morgan Art Pottery
 Company
 Matthews, J.M.
 Mattice and Penfield
 Meaders, Aire (Mrs. Cheever)
 Mear, Frederick
 Medinger, Jacob
 Mercer Pottery Company
 Merrimac Ceramic Company
 Merritt, William Dennis Billy
 Merz, Jacob
 Meyer, Karen A.
 Middle Lane Pottery
 Miller, Solomon
 Millington, Astbury and Poulson
 Min, James A.
 Moor, W.T.
 Moravian Pottery
 Moravian Pottery and Tile Work
 Morgan, D.
 Morris and Wilmore
 Morrison and Carr
 Nase, John
 Nash, E.
 Neesz, Johannes
 New Castle Pottery Company
 New York City Pottery Company
 Newcomb Pottery Company
 Norton Pottery
 Norton, Luman
 Norwalk Pottery
 Ohio China Company
 Ohio Valley China Company
 Ohr, George
 Oliver China Company
 Orcutt, Belding and Company
 Osborne, Joseph
 Osborne, William
 Ott and Brewer
 Paige Pottery
 Parker, John
 Parr, Margaret
 Paxston, Ottman, and Company
 Pottery
 Pen Yan Pottery
 Peyrau, A.
 Phoenix Pottery
 Pioneer Pottery Company
 Price, Xerxes
 Pride, John
 Prospect Hill Pottery Company
 Ramsey, Barnett
 Ramsey, William
 Randall, James
 Reidinger and Caire
 Renninger, John
 Renninger, Wendell
 Rice, Sandra
 Rittenhouse, Evans and Company
 Roberts, David
 Robertson Art Tile Company
 Rolader, William Washington
 "Uncle Don"
 Rookwood Pottery Company
 Roseville Pottery Company
 Roudebusch, William
 Roudebuth, Henry
 Rouse and Turner
 Routson, Joseph
 Salamander Works
 Salter, Ben S.
 Sanders, Daniel
 Schauer, Jacob
 Schmidt, Peter
 School, Michael
 Schultz, Martin
 Sebring Pottery Company
 Sevres China Company
 Shenango China Company
 Shenfelder, Daniel
 Sickman, Theodore
 Simmons, Andrew
 Simmons, Jermiah
 Smiley, H.K.
 Smith, Fife and Company
 Smith, Joseph
 Smith-Phillips China Company
 Southern Porcelain Company
 Southwick, William
 Spiegel, John
 Spinner, David
 Stahl, Charles
 Star Encaustic Tile Company
 Star Porcelain Company
 Stewart, L.
 Stockton Art Pottery
 Stockwell, Henry
 Stoeckert City Pottery Company
 Stofflet, Heinrich
 Stork, E(dward) L(eslie)
 Stout, Isaac
 Strawn, John
 Swallow, William
 Swan Hill Pottery
 Taylor and Speeler
 Taylor, Smith, and Taylor
 Company
 Taylor, William
 Teames, Judak
 Thayer, Pliny
 Theiss, Steven
 Thiekson, Joseph
 Thomas and Webster
 Thomas(?), W.S.
 Thompson, Israel
 Tittery, Joshua
 Trenton China Company
 Trenton Pottery Company
 Trenton Tile Company
 Troxell, John
 Tucker and Hulme
 Union Potteries Company
 United States Pottery
 Van Briggle Pottery Company
 Van Horn and Boyden
 Vance Faience Company
 Vickers, A.J.
 Vincent, William
 Vinson, William
 Vodrey Brothers
 Volkmar Keramic Company
 W. Hart Pottery
 Wands, I.H.
 Waring, David
 Warner, H.(W.)
 Weaver, Abraham
 Weaver, Elias

Type of Work Index — Pottery

Webster and Seymour
Weller, S.A.
Wellsville China Company
West End Pottery Company
Weyrich, Charles
Wheeling Pottery Company
Willetts Manufacturing Company
William Brunt Pottery Company
William Fische Pot Factory
Wilson, James S.
Wingender Brothers Pottery
Wood
Woodruff, D.C.
Wyant, David
Zoar Pottery
Zoarite Community Pottery

Cream-colored ware
 Coxon and Thompson
 Goodwin Brothers
 Rhodes and Yates
 Seixas, David G.

Creme-colored ware
 Trotter, Alexander

Delft-ware
 Price, William

Earthenware
 Cain, Abraham
 Cain, Martin
 Caldwell, James
 Cornell, James
 George Morley and Brothers
 Glassen, John
 Grocott, J.
 Heitzie, Christian
 Marshall, William
 McFarland, William
 Neiman, James
 Pinckard, Nathaniel
 Sawyer, H.
 Steinbach, Henry
 Trotter and Company
 Troxel, Samuel
 Walford, Mr.

Flint stoneware
 Horner and Shiveley

Matte glaze on clay
 Taylor, W.W.

Queensware
 Fuller, Elijah K.

Redware
 A. and W. Boughner
 Adams, Henry
 Albert, Henry
 Ambrose, Frederick
 Bach, George W.
 Baecher, J.W.
 Bailey, Charles
 Baker, Thomas
 Bartleman
 Beck, Jesse
 Behn, George Peter
 Bell, John
 Bells, T.
 Bensing, Dirick
 Benson, Henry
 Bothman
 Boughner, Alexander
 Bracken and James
 Brichdel, Christian
 Brooks, Hervey
 Brown, John
 Brown, R.
 Campbell, Thomas
 Carty, John, Sr.
 Chace, L.
 Chase, Phineas
 Clark, Benjamin
 Clark, Isaac
 Clark, Peter, III
 Clark, William
 Cope, Enos
 Cross, Peter
 D.A. Sackett and Company
 Diehl, George
 Ditzler, Jacob
 Dodge, Asa
 Dodge, Jabesh
 Dodge, Rufus
 Dodge, Samuel
 Dubbs, Isaac
 Durrell, Jonathan
 Easter, Jacob
 Eberley, Jacob J(eremiah)
 Egoff, Daniel
 Eutatse, John
 Fair, Henry
 Feege and Feege
 Fisher, J.C.
 Fisher, Michael B.
 Floyd, Caleb
 Floyd, Thomas and Caleb
 Foulke
 Francisco, James F.
 Frantz, Henry
 Frederick, John
 Freeman, Thomas
 Frey, George
 Fry, John
 Ganse Pottery
 Gerbrich, Conrad
 Gilbert, Mordecai
 Gingerich, Zach
 Glaes, Abraham
 Glaes, John G.
 Glaes, William
 Goldthwaite, William
 Greiseiner Pottery
 Griffith Brothers
 Grosh Pottery
 Guldin, Mahlon
 Haas, Peter
 Harrison, Robert
 Headman, John
 Headman, Peter
 Heath, William
 Henne, Joseph K.
 Herme, Daniel
 Herrick, Robert A.
 Herstine, Cornelius
 Herstine, Daniel
 Herstine, Daniel
 Herstine, David
 Hews, Abraham
 Hildebrand, Frederick
 Hocusweiler, Jacob
 Hook, Solomon
 Horn, Samuel
 Huggins and Company
 Hume, Joseph
 Humsicker, Christian
 Hutchinson, Ebenezer
 Hutchinson, William
 Jackson, Thomas
 James Robertson and Sons
 John Vickers and Son
 Johnson and Mason
 Johnson, Joseph
 Jones, James E.
 Keeler, Benjamin
 Keller Pottery Company
 Kelly, James
 Kelly, John
 Kendall, Miles
 Kettle, Johnathan
 Kintner, Jacob
 Koontz, John
 Kraus, John
 Krause, Thomas
 Krimler, Henry
 Kuch, Conrad
 Lamson, Asa
 Leaman, Godfrey
 Leffingwell, Christopher
 Leisinger and Bell
 Link, John
 Lock, Frank C.
 Maize, Adam
 Markley, James C.
 Mayer, Joseph F.
 McCulley, John
 McKentee
 McQuate, Henry
 Medinger, William
 Mehweldt, Charles
 Mentelle, Ward, Sr.
 Miller, Andrew
 Miller, Christian
 Moll, Franklin B.
 Moll, Henry
 Mondeau, John
 Moore and Kinzie
 Morgan, Thomas
 Morrison, Ebenezer
 Muk, George
 Mullowney, Captain
 Mumbauer, Conrad
 Neff, Christian
 Neiffer, Jacob
 Neisser, Jacob
 Newtown Pottery
 Norton, John, Captain
 Nunemacher Pottery
 Nyeste, James Joseph
 Ogden, James K.
 Osborne, Amos
 Osborne, Amos, Jr.
 Osborne, Elijah
 Osborne, James

Pottery

Pottery (Cont.)
 Redware (Cont.)
 Osborne, James
 Osborne, Johnathan
 Osborne, Joseph, II
 Osborne, Richard
 Pierce, John
 Porter, Benjamin
 Pottery in the Kloster of the United Brethren
 Queen City Terra-Cotta Company
 Ranninger, Conrad
 Reichard, Daniel
 Remmey, John, I (Johannes)
 Rieff, Christian
 Russel, William
 Sackett, Alfred M.
 Salt and Mear
 Samuel J. Wetmore and Company
 Sanders, John
 Saunders, William
 Schofield, William
 Schrum
 Schultz, Johann Theobald
 Scudder, Moses
 Seymour, Nathaniel
 Sharpless, Samuel
 Sherrick, David
 Shutter, Christian
 Singer, Simon
 Smith, Thomas
 Snaveley, John
 Snyder, John
 Snyder, John, Jr.
 Souter, John
 Southwick, John
 Southwick, Joseph A.
 Southwick, William
 Specht, John G.
 Spiegel, Isaac, Jr.
 Spiegel, Isaac, Sr.
 Stahl, Isaac
 Stahl, James
 Stofflet, Jacob
 Stofflet, Jacob
 Stone, Robert
 Sullivan, Samuel
 Swope, George A.
 Swope, Jacob
 Swope, Zuriel
 Symonds, Nathaniel
 Symonds, Nathaniel, Jr.
 Symonds, Nathaniel, Sr.
 Tarbell, William
 Tarbell, William, Jr.
 Tawney, Jacob
 Thierwaechter, John
 Thompson, John W.
 Tomlinson, Lewis K.
 Toomey, Helfreich
 Trask, Joseph
 Troxell, William
 Upton, ?
 Vance, Alexander
 Vance, James
 Vickers, Paxton
 Wadhams, Jesse
 Wallace, Richard
 Weber, J.A.
 Weidle
 Whittemore, Daniel
 Whittemore, Joseph
 Wilcox Pottery
 Wiley, Martin
 Wilson, James
 Wilson, Job
 Wilson, Robert
 York, H.F.
 Redware, brownware
 Bauer, A.J.
 Hattersley, Charles
 Martin, Moses
 Moore, Mathew
 Pottery of the Separatist Society of Zoar
 Redware, brownware, stoneware
 Wolfe, William
 Redware, cream-colored ware
 Piercey, Christian
 Redware, earthenware
 Miller, Abraham
 Redware, sgraffito
 Coxe, Daniel
 Mercer, Henry C.
 Moore, Richard
 Vickers, Thomas
 Redware, stoneware
 Abraham Hews and Son
 Barr, James
 Brown, Catherine
 Brunk, David
 Caire, John P.
 Callahan, William
 Clark and Fox
 Ebey, John Neff
 Farrar, Caleb
 Groff, Joseph
 Jones, N.S.
 King, Samuel B.
 Parr, Elisha
 Stizelberger, Jacob, Sr.
 Stizelberger, William
 Ulrich and Whitfield
 Weise, James
 Woodman, Samuel
 Redware, yellow-ware
 Wagner, George A.
 Redware?
 Auer, Nicolas (Ayer)
 Brown, James
 Claesen, Dirick
 Eggen, Jacob
 Zabbart, M.
 Rockingham
 Carr, James
 J.E. Jeffords and Company
 Walker, N.U.
 Rockingham, brownware
 Harvey, Isaac A.
 Hinchco, Benjamin
 Rockingham, Flint Enamel, brownware
 Farrar, S.H.
 Rockingham, yellow-ware
 D.E. McNichol Pottery Company
 Stoneware
 A.A. Austin and Company
 A.J. Butler and Company
 A.L. Dyke and Company
 Abbe, Frederick
 Adam States and Sons
 Akron Pottery Company
 Alanson Lyman & Declus Clark
 Albany Stoneware Factory
 Amos, William
 Anderson, William A.
 Anna Pottery
 Atcheson, D.L.
 Atcheson, H.S.(R.)
 Atlantic Garden
 Atwater, Caleb
 Atwater, Joshua
 Auber, P.
 Bagnall, George
 Bakewell, H.N.
 Ballard, A.K.
 Barnabus Edmonds and Company
 Batchelder Pottery
 Bauders, F.
 Becting Brothers
 Beecher and Lantz
 Belding, David
 Bell, Joseph
 Berg's Mill
 Berresford, Benjamin
 Binkley, George
 Bissett, Asher
 Bluebird Pottery
 Bodenbuhl, Peter
 Bodine, J.
 Boerner, Shapley and Vogt
 Boone, Benjamin
 Boone, J.G.
 Boone, Thomas E.
 Booth Brothers
 Boss Brothers
 Boston Pottery Company
 Bosworth, Stanley
 Bower, George
 Bowne, Catherine
 Boynton
 Boynton and Farrar
 Brewer, J.D.
 Brickner, John
 Briggs, John H.
 Bromley, William
 Broome and Morgan
 Brower, J.F.
 Brown and McKenzie
 Brown Brothers
 Brown, S.H.
 Bruer, Stephen T.
 Buchanan, Thomas
 Bullard, Joseph O.
 Bullock, W.

Pottery

Burchfield, A.N.
Burger, John
Burgess, Webster and Viney
Burley, John
Burley, Lazalier
Burns, W.F.
Burton, John
Bybee Pottery
C(harles) Hart and Company Pottery
C. Boynton and Company
C. Dillon and Company
C. Webster & Son
Caire Pottery
Caire, Frederick J.
Camp Cook and Company
Campbell, Justin
Canfield
Capron, William
Carlin, John
Carlyle and McFadden
Carpenter, Frederick
Central New York Pottery Company
Chamberlain, C.B.
Chapman, J(osiah)
Charlestown Massachusetts Pottery
Christopher Potts and Sons
Clark and Company Pottery
Cleveland, William
Clough, Calhoun and Company
Cochran, Robert
Cole Pottery
Columbian Pottery
Commeraw's Pottery
Congress Pottery
Cook and Richardson
Cooper, Thomas
Cordrey, Isaac
Cowden and Wilcox
Cowles, Calvin
Crafts, Caleb
Crafts, Edward A.
Crafts, Martin
Crafts, Thomas
Craig, Burlon
Craven, John A.
Craven, Thomas W.
Cribbs, Daniel
Cribbs, Peter
Crisman, W.H.
Crock, Charles
Crolius, Clarkson, II
Curtis Houghton and Company
D.G. Schofield and Company
Danas, John
Darrow, John
Decker, Charles F.
Deval and Catterson
Dick, Jacob
Dillon and Porter
Donahue Pottery
Donaldson, Hugh
Donkle, George
Donnahower, Michael

Dorchester Pottery Works
Dunn, Ezra
Dunscombe, Hannah
E. Norton and Company
Eagle Pottery
Eagle Pottery
Eaton, Jacob
Edward Selby and Son
Eichenlaub, Valentine
Eichert, Peter
Elverson and Sherwood
Emsinger, A.
Enterprise Pottery Company
Euler and Sunshine
Evans Pottery
F.J. Knapp
Fallston Pottery Company
Farrar and Stearns
Farrar, Ebenezer L.
Farrar, Isaac Brown
Farrington, E.W.
Fayette, Shavalia
Fenton and Hancock
Fenton, J.H.
Fenton, Jacob
Fenton, Jonathan
Fenton, Richard L.
Fenton, Richard Webber
Fenton, T.H.
Figley, Joseph
Fish, C.
Fisher and McLain
Fisher and Tarr
Fisher, J(acob)
Fisher, John
Fisher, Thomas
Fiske and Smith
Fleckinger, Jacob
Foel and Ault
Fort Edward Pottery Company
Fossbender, N.
Fowler and McKenzie
Fox, E.S.
Fox, Harmon
French, Eben
Fullerton, Hugh
Furman, Noah
G. Adley and Company
Gay, Amos
Geddes Stoneware Pottery Company
Gerstung, John
Getz
Gideon Crisbaum and Company
Glassir and Company
Glazier, Henry
Glenn and Hughes
Glenn, William
Goodale, Daniel, Jr.
Goodwin, Harvey
Goodwin, Horace
Goose Lake Stoneware Manufacturings Company
Gordy Pottery
Gossett, Amariah
Grace, Daniel

Greble, Benjamin
Green, Adam
Green, Branch
Greenland, N(orval) W.
Grommes and Ulrich
Gruenig
Haig, Thomas, Sr.
Hall, Amos
Hallam, David
Hamilton and Jones Pottery
Hamilton Brothers
Hamilton, Clem
Hamilton, James
Hamilton, W.L.
Hamlyn, George
Hamlyn, George, II
Hancock, John
Hancock, William
Hanford, Isaac
Hanlen, Bernard
Harmon, Christian
Harrington, Thomas
Harris, James
Harris, Thomas
Harris, W.P.
Harrison, C.R.
Harrison, Fielding T.
Hart, James
Hastings and Belding
Hathaway, Charles E.
Havens, Samuel
Havins, N.
Haxstun and Company
Heighshoe, S.E.
Henry Pettie and Company
Henry, Jacob
Hewett, Isaac
Higgins, A.D.
Hill, Foster and Co.
Hill, Merrill and Company
Hill, Powers and Company
Hiram Swank and Sons
Holden, Jesse
Hopkins, John
Hosmer, Joseph, Captain
Houghton, Edwin
Houghton, Eugene
Hubbell and Cheseboro
Hubbs, W.W.
Hughes, Thomas
Humistown and Walker
Hyssong, C.B.
I.M. Meed and Company
I.W. Craven and Company
Iliff, Richard
Ingell, Jonathan W.
J. Clark and Company
J. Sage and Company
J.A. and L.W. Underwood
J.M. Burney and Sons
Jager, Joseph
Jenkins, A.
John Frell and Company
Johnson and Baldwin
Johnson, John
Judd, Norman L.

471

Pottery (Cont.)
 Stoneware (Cont.)
 Keith, Charles W.
 Kendall, Loammi
 Kendall, Uriah
 Kier, S.M.
 Kirkpatrick
 Kirkpatrick, Alexander
 Kirkpatrick, Andrew
 Knapp, F.K.
 Koch
 Krager, C.L.
 Lambright and Westhope
 Lamson and Swazey
 Landrum, Amos
 Landrum, L(ineas) M(ead)
 Lathrop, Charles
 Leathers, John B.
 Lehman, Louis
 Lent, B
 Leopard, Thaddeus
 Lessel, George
 Lessel, Peter
 Letts, Joshua
 Lewis and Cady
 Lewis and Gardner
 Lewis, O.V.
 Lewis, W.A.
 Link, Christian
 Long, J.H.
 Ludon and Long
 Lyons Pottery
 MacKenzie
 Macomb Pottery Company
 MacPherson, E.E.
 Macumber and Van Arsdale
 Madden, J.M.
 Mantell, James
 Mantell, Thomas
 Markell, Immon and Company
 Marshall Pottery
 Martin, Adam E.
 Martin, E.G.
 Martin, John L.
 Marx, John
 Mason and Russell
 Massilot, L.
 Mathis, Robert
 Mayers, W.S.
 McCarthy Brothers
 McChesney, Andrew
 McComb Stoneware Company
 McConnell
 McKenzie Brothers
 McLuney, William
 McMillan, J.W.
 Meade, S.
 Melleck, H.H.
 Merrill Powers and Company
 Merrill, Calvin
 Merrill, Edwin
 Merrill, Edwin H.
 Merrill, Henry E.
 Metzner, Adolph
 Meyers, E.W.
 Miller, B.C.
 Miller, J.
 Miller, M.
 Miner, William
 Misler Brothers
 Mitchell, H.R.
 Mitchell, James
 Monmouth Pottery Company
 Monroe, J.S.
 Mooney, D.
 Mooney, Michael
 Moore, Alvin S.
 Mootz
 Morgan, David
 Morgan, James
 Morgan, James, Jr.
 Morton and Sheldon
 Myers and Hall
 Myers, Baird, and Hall
 Myers, E.W.
 Nash, F.M.
 Nash, G.
 Nash, H.
 Nathan Clark Pottery
 Navarre Stoneware Company
 New York Stoneware Company
 Nichols and Alford
 Nicomb
 Norton and Fenton
 Norton and Hancock
 Norton, Luman P.
 O'Connell, R.
 Odom and Turnlee
 Ohio Stoneware Company
 Olevett, Charles
 Oliver, C.K.
 Onondago Pottery Company
 Orcutt and Thompson
 Orcutt, Eleazer
 Orcutt, Humiston, and Company
 Orcutt, Stephen
 Orcutt, Walter
 Packer, T.A.
 Parker, Grace
 Parr, David
 Parr, James L.
 Perrine, Maudden
 Perry, Sanford S.
 Pewtress, John B.
 Philles
 Phillips, Moro
 Pierce, Augustus
 Pierson and Horn
 Pierson, Andrew
 Pitkin, Richard
 Plaisted, F.A.
 Pohl, Joseph
 Pottman Brothers
 Price, Abial
 Price, G.
 Pruden, John M., Jr.
 Purdy, C.
 Purdy, Fitzhugh
 Purdy, Gordon B.
 Quinn, E.H.
 Read, Thomas
 Reay, Charles
 Red Wing Pottery
 Reems Creek Pottery
 Remmey and Burnet
 Remmey, Henry, I
 Remmey, Henry, II
 Remmey, Henry, III
 Remmey, John, II
 Remmey, John, III
 Remmey, Joseph Henry
 Remmey, R(ichard) C(linton)
 Reynolds
 Rhodes, T.
 Rice, Prosper
 Rich
 Richey and Hamilton
 Riggs, Wesley
 Risley, George L.
 Robbins (Mrs.) and Son
 Roberts, William
 Rogers Pottery
 Rosier, Joseph
 Rothrock, Friedrich
 Rowley Pottery
 Royer, A.
 Russell Pottery
 S.L. Stroll and Company
 Sackett, David A.
 Samuel Dyke and Company
 Sandford, Peter Peregrine
 Saterlee and Mory
 Sawyer and Brothers
 Schenefelder, Daniel P.
 Schenkle, William
 Schrieber, John
 Scott, Alexander F.
 Scott, George
 Seaver, John
 Seaver, William
 Seaver, William, Jr.
 Seavey, Amos
 Selby, Edward
 Seymour and Bosworth
 Seymour and Stedman
 Seymour, George R.
 Seymour, Israel
 Seymour, Orson H.
 Seymour, Walter J.
 Shank, William
 Sheldon, F.L.
 Shepard, Joseph, Jr.
 Shepley and Smith
 Sherwood Brothers Company
 Shorb, Adam A.
 Shorb, Adam L.
 Shorb, J., Jr.
 Simms, N.M.
 Slater, Alfred
 Smith, A.
 Smith, Asa E.
 Smith, H.C.
 Smith, H.S.
 Smith, Hezekiah
 Smith, J(oseph) C.
 Smith, J.W.
 Smith, P.H.
 Smith, W(ashington)

Smith, Willoughby
Smithfield, Ulrich
Smithingham, George
Smyth, Joel
Snyder, Henry
Somerset Pottery
Somerset Pottery Works
Sowers, H.
Spafford and Richards
St. Louis Stoneware Company
Standish, Alexander
Starkey and Howard
States, Adam
States, Peter
States, William
Stedman, Absalom, and Seymour
Stevens Pottery
Stevens, Joseph P.
Stofer, L.D.
Stout, Francis Marion
Stout, Samuel
Straw, Michael
Sudenberg, Otto N.
Sunderland Knotts and Company
Swan and States
Synan, Patrick
Synan, William
Syracuse Stoneware Company
T. Sables and Company
Taft, James Scholly
Thomas D. Chollar
Thomas, J.R.
Thompson Pottery
Thompson, Greenland
Titus, Jonathan
Tourpet and Becker
Tracy, Andrew
Tracy, John B.
Tracy, Nelson
Trapp and Chandler
Tupper, C.
Turley Brothers
Tyron, Wright and Company
Union Pottery
United States Stoneware Company
Van Schoik and Dunn
Van Winckle, Jacob
Van Winckle, Nicholas
Van Winkle Pottery
Vandemark, John
Vaupel, Cornelius
Vickers, Monroe
W. Lundy and Company
W.B. Allison and Company
W.H. Rockwell and Company
Wait and Ricketts
Wait, Luke
Warne and Letts Pottery
Warne, Thomas
Warner, William E.
Warwack, Isaac
Washington Stoneware Company
Watson, J.R.
Weaver, James L.
Webster, Elijah

Webster, Mack
Weeks, Cook and Weeks
Weise, Henry
Welker, Adam
Weller, Samuel
Wells, Ashbel
Wells, Crafts, and Wells
Wells, Joseph
Wells, S.
West Troy Pottery
West Virginia Pottery Company
Western Stoneware Company
White and Wood
White, Noah
White, William
Whiteman, T.W.
Whitman, J.M.
Whitman, Robinson and Company
Whittemore, R.O.
Wiemer and Brother
Willard and Sons
William A. Macquoid and Company, Pottery Work
William Burroughs
William H. Farrar
Williams and McCoy
Williams and Reppert
Winfel, R.
Wingender, Charles, Jr.
Wingender, Charles, Sr.
Wingender, Jakob
Winslow, J.T.
Winslow, John T.
Woolworth, F.
Wores, H.
Works, Laban H.
Worthen, C.F.
Wright, Alexander
Yates, H.H.
Young, Samuel
Zanesville Stoneware Company
Zipf, Jacob
Stoneware, brownware
 Fenton, L(eander) W.
 Goodwin and Webster
 Harley Pottery
 Hedicaugh, William
 Howard and Son
 Ochsle, John
 Ochsle, Phillip T.
 Russell, D.W.
Stoneware, clay
 Crolius, William
 Peoria Pottery Company
 Pfaltzgraff Pottery
 Purdy, Solomon
 Quigley, S.
 Risley, Sidney
 Rogers, William
 Wagoner Brothers
 Woodruff, Madison
Stoneware, redware
 Brayton Kellogg and Doolittle
 Ebey, George
 Economite Potters

 Fulper Brothers Pottery
 Krumeick, B.J.
 L. Norton and Sons
 Linton, William
 Mead, Abraham
 Pruden, John
 Reiss, William
Stoneware, Rockingham
 Fenton, Christopher Webber
Stoneware, sewer-pipe
 Hill and Adams
Stoneware, terra-cotta
 Portland Stoneware Company
Stoneware, yellow-ware
 Hancock, John
 Norton, Julius
Terra-cotta
 Rogers, John
Terra-cotta, redware
 Jones, George
White earthenware
 Bonin, Gousse
 Chelsea China Company
 Freytag, Daniel
 Jersey City Pottery Company
 Mead, Dr.
 Morris, George A.
White Granite
 Baum, J.H.
 Brearley, Stephens and Tams
 Eagle Pottery Company
 F. Haynes and Company
 Mayer Pottery Company
 Mayer, James
 Morley and Company
 Morley, Goodwin and Flentke
 New Jersey Pottery Company
 Plympton and Robertson Pottery Company
 Standard Pottery Company
 Warwick China Company
 Wylie, John
White Granite, cream-colored ware
 City Pottery Co.
White Granite, earthenware
 Summit China Company
Whiteware
 Allen, George
 Goodwin Pottery Company
 Haynes, Bennett and Company
 Rhodes, Strong and McGeron
 Smith, Alexander
Whiteware, Rockingham
 Pass, James
Yellow-ware
 Agner and Gaston
 Agner, Fouts and Company
 Behn, Andrew
 Bulger and Worcester
 Doane, James
 Foster and Rigby
 Graff, J.
 Greatbach, Hamlet
 Howson, John
 J. Patterson and Company
 Lewis, William

Pottery (Cont.)
 Yellow-ware (Cont.)
 Marks, A.H.
 Marks, Farmer, Manley and Riley
 Shepard, Elihu H.
 Simms and Ferguson
 Smith, A.F.
 Tempest, Brockman and Company
 Woodward and Vodrey
 Worchester, Samuel
 Yellow-ware, brownware
 Bennett Brothers
 Bennett, Daniel
 Bennett, James S.
 Bennett, William
 Marshall, Abner
 Moore, Enoch
 Vodrey, Jabez
 Yellow-ware, Rockingham
 Brewer and Tempest
 Burton, William
 C.C. Thompson Pottery Co.
 Elverson, Thomas
 Frederick, Schenkle, Allen and Company
 Goodwin, John
 Howson, Bernard
 John W. Croxall and Sons
 Knowles, Isaac W.
 Mappes, H.
 McCullough, William
 Miller, August
 New England Pottery Company
 Pollock, Samuel
 Pyatt, George
 Pyatt, J.G.
 Simms and Laughlin
 Simms and Starkey
 Speeler, Henry
 T. Rigby and Company
 Thomas Croxall and Brothers
 Thompson and Herbert
 Vodrey and Frost
 Woodward, Blakely and Company
 Wylie Brothers
 Yellow-ware, Rockingham, artware
 Coultry, P.L.
 Yellow-ware, white-ware, Rockingham
 Clark, Decius W.

Pottery, ceremonial scene paintings
 Clay, oil
 Martinez, Cresencio

Pottery, churns
 Clay, stoneware
 S. Hart Pottery

Pottery, election banners
 Clay, fabric, oil
 Knowles, Mrs. Henry L.

Pottery, especially decorative flower pots
 Redware
 Moll, Benjamin Franklin

Pottery, especially toys and modeled pieces
 Redware
 Henne, Daniel P.

Pottery, fanciful jugs
 Stoneware
 Kirkpatrick, Wallace (V.)

Pottery, fanciful jugs, pipes
 Clay
 Kirkpatrick, Cornwall E.

Pottery, glazes
 Clay
 Storer, Mrs. Bellamy (Maria Longworth)

Pottery, porcelain
 Clay
 Smith, William
 Union Porcelain Works

Pottery, sewer tile sculpture
 Stoneware
 Camp and Thompson
 Stoneware and Tile Company

Pottery, sgraffito plates
 Clay
 Bergey, Benjamin
 Paul, Samuel
 Redware
 Headman, Andrew

Powderhorns
 Bone
 Hutton, Christopher
 Rogers, W.H.
 Unidentified Media
 Ball, John

Printed floor cloths
 Fabric
 Perkins, Samuel

Printed handkerchiefs
 Fabric
 Gray and Todd

Pull toys
 Wood
 Green, John H.

Pulls
 Brass
 Parker, S.

Punchbowls, pottery
 Stoneware, clay
 Crolius, John

Puppets
 Wood
 Burris, J.C. "Jack"
 Diefendorter, John
 Irving, George

Puppets, carvings
 Clay, acrylic, poster paint
 Kinney, Charles

Pysanky-Easter eggs
 Beeswax, pencils, candles
 Schmitz, Gail

Quill work sconces
 Various materials
 Wendell, Elizabeth

Quilts
 Fabric
 Addison, E.A.
 Allcock, Cirendilla
 Anderson, Eleanor S.
 Anderson, Sarah Runyan
 Armstrong, Ann Johnson
 Arsworth, Cynthia
 Bacheller, Celestine
 Bailey, Mary
 Baker, Dorothy
 Barker, Harriett Petrie
 Barr, Eliza
 Batson, Mary Jane
 Beckham, Julia Wickliffe
 Benedict, Mary Canfield (Baker)
 Bergen, Johanna
 Bidwell, Elizabeth Sullivan
 Bontager, Mrs. Clara
 Bontrager, Mrs. Eli
 Bontrager, Mrs. Lydia
 Bontrager, Mrs. Rudy
 Bontrager, Polly
 Boucher, Doris
 Bradburg, Harriett
 Bready, Eliza Ely
 Brock, Harriet E.
 Bruce, Sophronia Ann
 Buckingham, Susannah
 Buell, S.J.
 Bulluck, Panthed Coleman
 Burkholder, Lydia
 Calvert, Margaret Younglove
 Carswell, Mrs. N.W.
 Catlett, Lucy Tucker
 Chance, A.I.
 Childs, Hannah
 Christner, Mrs. John
 Cleland, Jennie
 Cline, Elizabeth Ann
 Cona
 Cook, Eunice W.
 Cook, Phebe

Coon, Clara
Counts, Charles
Cree, Matilda
Cumberland, Mary Alexander
Dabney, Mrs. Charlotte
Darrow, Mrs. Newton
De Groot, Ann
Dean, Emeline
Degge, Mary Frances
Dennett, Olive
Dicus, Ellen
Dodson, Mrs. Priscilla
Duchamp, Helen
Dunn, Mary
Eash, Lydia
Eisenhower, Mrs. Ida Elizabeth Stover
Ely, Sarah Weir
Ernest, Mrs. Austin
Esputa, Susan Adel
Farrington, Anna Putney
Ferguson, Mrs.
Fink, Willie Sharpe
Fitzgerald, Mrs. Joshua
Flemings, Isabella
Ford, Saddie
Forman, Irene B.
Fortner, Myrtle M.
Foster, Rebecah
Frank, Mrs. Gustav
Frye, Mary
Garr, Sarah Crain
Gatewood, Jane Warwick
Gay, Pocahontas Virginia
Geiger, Margaret
Getty, Marshall
Gibson, Mary L.
Gillette, Susan Buckingham
Glover, Elizabeth
Godwin, Abigail
Gouverneur, Maria Monroe
Gray, Grace
Greenawalt, Katie
Grider, Nancy Miller
Gross, Catherine
Gurney, P. Thompson
Hailey, Molly (Mrs. George)
Hamilton, Rebexy Gray
Hardman, Mrs. Edwin
Hasson, Sallie E.
Heath, Mrs. John
Herschberger, Mrs. Manuel
Hieatt, Martha Tribble
Hochstetter, Katie
Hochstetter, Mrs. Manas (Mary)
Holcomb, Sarah
Hollinger, Lizzie
Hostetler, Nina D.
Howe, Louise
Hoyt, Mary Ann
Hubbard, Maria Cadman
Hubbard, Tryphena Martague
Ivy, Virginia Mason
Jefferson, Mannie Holland
Johnson, Fanny
Kenedy, Sarah

Kichline, Christine S.
Kingman, Mary Dunham
Kittle, Nellie
Knapp, Harriet
Knappenberger, G.
Koch, Ann Koenig
Kohler, Rebecca Leiby
Kretzinger, Rose
Lambright, Mrs. Elizabeth
Lambright, Mrs. Menno
Lambright, Mrs. Susan
Lantz, Mrs. Ed
Lapp, Lydia
Lathouse, Mrs. W.B.
Leggett, Julia
Lehman, Amanda
Lehn, Mrs. Mary
Leverett, Elizabeth
Leverett, Sarah Sedwick
Lilly, Emily Jane
Loehr, Elizabeth
Lucas, Martha Hobbs
Malcolm, Mrs.
Maran, Mrs. Mary Jane Green
Mast, Barbara
Mattingly, Eliza Ann
Maxwell, Ann
McCord, Susan (Nokes)
McCrea, Mrs. Mary Lawson Ruth
McNabb, Marcena Coffman
Midkiff, Mary Louisa Givens "Lula"
Milan, Nettie
Miller, Anna Viola
Miller, Eliza Armstead
Miller, Henry
Miller, Katie (Mrs. David J.L.)
Miller, Lydia Ann
Miller, Mary
Miller, Mrs. Nathaniel
Miller, Mrs. S.N.
Miller, Mrs. Susie
Miller, Mrs. William Snyder
Miller, Polly
Miller, Sarah
Mitchell, Catherine
Mitchell, Elizabeth Roseberry
Mize, Mahulda
Moore, "Aunt Eliza"
Moore, Mrs. Roy
Moran, Amanda Estill
Morris, Mattie Tooke
Mosely, Susanna Richards
Moseman, Elizabeth E.
Myers, Mary Rosalie Prestmen
Naguy, Mary Jane
Naughn, Martha Agry
Newberry, Frances
Nicely, M. Eva
Nichols, Margaret
Nowlan, Margaret
Parell, Sarah
Patterson Sisters
Patterson, Mary Ann "Polly" Tanner
Peale, Sophonisha

Perkins, Elizabeth Taylor Brawner
Petershime, Mrs. Samuel
Pierson, Martha
Port, Elizabeth
Power, Nancy Willcockson
Powers, Harriet
Poyner, Mrs. M.E.
Pryor, Nannie Elizabeth (Sutherlin, Nannie Pr
Quick, Sarah V.B.
Randall, Jane Spillman
Raper, Millie
Reasoner, Mrs. A.E.
Reed, Kate D.
Reynolds, Mrs. P.
Riffle, Martha Jane
Robinson, Ann
Ross, Abby F. Bell (Abby J. Ball)
Rounsville, Helen Mary
Rupp, Salinda W.
Russell, Lydia Keene McNutt
Savery, Rebecca Scattergood
Schenck, Cornelia Ann
Schmidt, Anna Marie
Schrock, Mrs. Sam
Schrock, Susan
Scofield, E.A.
Scott, Judy Ann
Scovill, Nancy Cooke
Sears, Adeline Harris
Shaffner, Jacob
Sikes, Bessie
Skarsten, Karee
Smallwood, Zibiah
Smith, Charlotte
Smith, Mary Caroline Wooley
Smith, Virginia Bland
Steinberger, Samuel
Stenge, Bertha
Stewart, Virginia
Stickler, Mary Royer
Stockton, Hannah
Stoltzfus, Mrs.
Sutherlin, Mary
Talbott, Emeline
Taylor, Mary Wilcox
Telfair, Jessie
Thomas, C. Susan
Throckmorton, Jeannette Dean, Dr.
Thurman, Mary Elizabeth Woods
Toomer, Lucinda
Totten, Mary (Betsy)
Toupe, Robert
Trabue, Fannie Sales
Troyer, Amanda S.
Troyer, Mary Ann D.
Tucker, Phoebe Parker
Tuels, Anna
Tweed, Susannah
Van Sicklen, Cornelia
Van Voorhis, Mary
Vanzant, Ellen Smith Tooke
Vaughn, Martha Agry
Waldron, Jane D.

Quilts (Cont.)
 Fabric (Cont.)
 Walker, Jane McKinney
 Warner, Ann Maria
 Warner, Pecolia
 Whetstone, Lydia S.
 White, Iva Martin
 White, Mrs. Cecil
 Whitehill, Mrs. Charlotte Jane
 Wilson, Amelia Emelina
 Wilson, Mrs. Russell
 Wing, Samantha R. Barto
 Wissler, Cornelia Everhart
 Wood, Mrs. Jonathan
 Woodhouse, Eulalie E.
 Wright, Kate Vaughan
 Yoder, Amanda Sunthimer
 Yoder, Amelia
 Yoder, Fanny
 Yoder, Lydia
 Yoder, Mrs. Daniel T.
 Yoder, Mrs. Menno
 Yoder, Mrs. Mose V.
 Yoder, Mrs. Yrias V. (Mrs. Urias V.) (Anna)
 Yost, Sallie
 Zaumzeil, Ernestine Eberhardt

Quilts, crewel embroidered bedspreads
 Fabric
 Fifield, Mary Thurston

Quilts, needlepoint seat cushions
 Fabric
 Washington, Martha

Quilts, needleworks
 Fabric
 Herbert(?)

Quilts, weavings
 Fabric
 Riddle, Hannah

Quilts, weavings, coverlets
 Fabric
 Young, John W.

Racing horse paintings
 Watercolor
 Pi, Aqwa

Railroad paintings
 Oil
 Chute, Bill

Relief carvings
 Wood
 Almon, Leroy
 Shelley, Mary

Religious and historic carvings
 Wood
 Farmer, Josephus, Reverend

Religious and landscape paintings
 Oil, collage, acrylic
 Cooper, Richard P., Reverend

Religious and mystic paintings
 Oil, housepaint
 Bochero, Peter "Charlie"

Religious carvings
 Wood
 Bereman, John

Religious carvings in an environment
 Wood, oil
 Lund, E.K.

Religious drawings
 Ink, watercolor
 Otis, Daniel
 Pen, ink
 Reed, Eldress Polly
 Watercolor, ink
 Cohoon, Hannah

Religious embroidered pictures
 Fabric
 Fish, Eliza R.
 Ridgeway, Caroline

Religious, fantasy and idealized drawings
 Pencil, crayon, ink
 Ramirez, Martin

Religious, other carvings
 Wood
 Christenson, Lars
 Patton, Ernest

Religious paintings
 Oil
 Baldwin, Frank
 Blayney, William Alvin
 Cervantes
 Kikoin, Aaron
 Miller, Anna G.
 Orr, Georgianna
 Paint
 Wilkerson, Lizzie
 Watercolor
 Spalding, Eliza Hart
 Watercolor, acrylic, ink
 Morgan, Sister Gertrude

Religious paintings, sculptures
 Wood, paint
 Ellis, Clarence

Religious portraits, paintings
 Oil
 Haidt, John Valentine

Religious scene paintings
 Oil
 Lieberman, Harry

Religious sculptures, carvings
 Wood
 Koenig, Joseph

Rifles
 Metal
 Weiss, William

River scene paintings
 Oil
 Medelli, Antonio

Roadrunner
 Wood
 Klippenstein, S.

Rock castle sculptures
 Coral
 Leedskalnin, Edward

Rocking chairs
 Wood
 Newman, Benjamin
 Raymond, J.

Romantic scene paintings
 Watercolor
 Murray, Elenor
 Nims, Mary Altha
 Swift, Ann Waterman
 Walker, Elizabeth L.

Romantic western paintings, sculptures, carvings
 Wood, oil, mixed media
 White, George

Room interior and overmantel paintings
 Oil
 Eaton, Moses, Sr.
 Scott, I.

Rugs
 Fabric
 Collins, Sister Sarah
 Hawks, Mary
 Hicks, Harriet
 Moore, Ann
 Moore, Sophie
 Wells, Arabella Stebbins Sheldon
 Wells, Sister Jennie

Rugs, carpets, coverlets
 Fabric
 Tyler, Harry

Saddles, box liners, boxes, canes
 Leather
 Smart, John

Saddles, harnesses
 Leather
 Ohnemus, Matthias

Sailboat paintings
Oil
- Lo, William A.

Sailor's bags
Fabric
- Opie, Warren

Saltboxes
Wood
- Plank, Samuel

Samplers
Fabric
- Adams, Abigail
- Allen, Abby (Abigail Crawford)
- Allison, Mary H.
- Andaries, Elizabeth
- Anderson, Maria
- Andrews, Jane Margaret
- Anthony, Anne
- Antrim, Mary
- Atkinson, Sarah Weber
- Baker, Nancy
- Balch, Clarissa
- Balch, Mary
- Baley, Sarah
- Baner, Barbara A.
- Barnhott, Margaret
- Barton, Philura
- Beidler, Mary Ann Yost
- Belcher, Mary
- Bennet, Cordelia Lathan
- Berry, Hans
- Bevier, Ellen Bange
- Bishop, Abby
- Blank, Elizabeth
- Bolen, Maria
- Border, Ann Amelia Mathilda
- Borton, Mary Ann
- Bowditch, Eunice
- Bowles, Amanda A.
- Boyd, Ann
- Bratton, Phebe
- Briggs, Martha
- Brinton, Eleanor
- Brown, Angeline
- Bulyn, Mary
- Burr, Cynthia
- Burrill, Hannah
- Burton, Rebecca
- Butler, Martha
- Butz, Mary
- Byles, Abgail
- Caldwell, Sarah S.
- Cameron, Mary Elizabeth
- Carr, Mary
- Carter, Achsah
- Carter, Rebecca
- Caseel, Hester
- Castles, Mrs. John W. (Elizabeth Eshleman)
- Church, Hannah
- Clark, Emily
- Clark, Mary Ann
- Coggeshall, Eliza
- Coggeshall, Esther
- Coggeshall, Patty
- Coggeshall, Polly
- Congdon, Catharine
- Cooper, Ann Eliza
- Cox, Susanna
- Cozzens, Eliza
- Crider, Susy A.
- Crygier, Ealli
- Culin, Elizabeth B.
- Cunning, Susan
- Cutts, Elizabeth
- Daggett, Clarissa
- Daman, Desire Ells
- Daman, Ruth Tilden
- Davidson, Betsy W.
- Davis, Betsy (Betsey?)
- Davis, Patty (Martha)
- Dean, Frances E.
- Demeriett, Elizabeth J.
- Dexter, Abby (Abigail G.)
- Dexter, Nabby (Abigail)
- Dinyes, Mary Ann
- Doggett, Lydia
- Dunlavey, Martha
- Dyer, Sophia
- Easton, Elizabeth (Rousmaniere)
- Easton, Mary
- Emmons, Mary
- England, Ann E.
- Engle, Sarah Ann
- Fabian, Caroline Broughton
- Feke, Sarah
- Ferguson, Adaline M.
- Field, Rebecca
- Finney, Elizabeth
- Fisher, Eleanor
- Fleetwood, Miles
- Fogg, Mercy (Mary)
- Follet, Mary
- Foot, Fanny
- Fothergill, Emily
- Fowler, Elizabeth Starr
- Fox, Anne Mary B.
- Franklin, Mary M.
- Frishmuth, Sarah
- Garrett, Mary Hibberd
- Gawthorn, Ann
- Gibbs, Sarah
- Gladding, Lydia
- Gladding, Susan Cary
- Goddard, Mary
- Godfrey, Mary Greene
- Gorham, Bethiah
- Gorham, Jemima
- Gove, Mary Breed
- Green, Virginia
- Greenwalt, Maria B.
- Griscom, Rachel Denn
- Hafline, Mary
- Haines, Rebecca M.
- Hall, Abija
- Hall, Margaret L. (Mrs. George)
- Hall, Nancy (Anna)
- Hamilton, Mary
- Hammatt, Fanny Rand
- Harding, Jane
- Harrison, Mary
- Hartman, Sarah Ann
- Hawkes, Elizabeth Jane
- Hawkes, Mary Lou
- Heebneren, Susanha
- Hellick, Ann
- Herr, Elizabeth R.
- Hessin, Christina
- Heuling, Martha
- Hewson, Martha N.
- Hext, Elizabeth
- Hiester, Catherine
- Higgs, Harriet W.
- Hill, Harriet
- Hobart, Abigail Adams
- Hobdy, Ann F.
- Hofmann, Anna
- Holden, Katharine
- Holingsworth, Mary
- Hollinshead, Mary Ann
- Holmes, Flora Virginia
- Holmes, Mrs. Christian R. (Bettie)
- Hoockey, Hannah
- Hoopes, Lydia
- Hooton, Martha C.
- Hopkins, Lucy M.
- Hortter, Amanda Malvina
- Hosmer, Elizabeth Janes
- Hough, Catharine Westcot
- Humphreys, Jane
- Hunt, Content
- Ingraham, Peggy
- Irving, Clarabelle
- Jackson, Mary
- James, Rachel
- James, Ruth
- James, Sarah H.
- Jennison, Mary
- Jones, Harriet Dunn
- Keen, Palmyra M.
- Kelly, Ann E.
- Kennedy, Mary
- Killeran, Rebecca
- Kimball, Mary Grove
- Kings, Martha Y.
- Lafon, Mary Virginia
- Laighton, Deborah
- Lancaster, Lydia
- Landes, Barbara
- Laycock, Eliza
- Lewis, Unity
- Lincoln, Eunice
- Lincoln, Martha
- Linstead, Mary
- Lippitt, Julia
- Little, Mary L.
- Locke, Ruth
- Loring, Hulda
- Low, Lucy
- Lyman, Narcissa
- Lynch, Ann
- Lyon, Sarah
- Macomber, Ann
- Malone, Mildred

Samplers

Samplers (Cont.)
 Fabric (Cont.)
 Marein, Mahala
 Marley, Mary Ann
 Marsh, Ann
 Martin, Nabby
 Meyer, Catharine
 Miles, Diana
 Miller, Mary
 Miller, Sarah Ann
 Mode, Amy
 Morrison, Catharine
 Morton, Mary
 Morton, Mary Ann
 Munro, Rebekah S.
 Munro, Sally
 Myric, Nancy
 Nenniger, Louisa
 Nichols, Hannah
 Niles, Jane
 Norton, Ann Eliza
 Paine, Diana
 Parker, Clarinda
 Parker, Temperance
 Parry, Eliza
 Paschal, Frances
 Paul, Judith
 Peck, Ann J.
 Peele, Mary Mason
 Perry, Eliza
 Pickney, Francis
 Pinniger, Abigail
 Pitman, Mary
 Platt, Lydia
 Pope, Sarah E.
 Potter, Lucy
 Price, Jane Wilder
 Purinton, Beulah
 Purintum, Abigail
 Putnam, Ruthey
 Ramsey, Margaret
 Randall, Amey
 Randall, Sarah Ann
 Reed, Dolly Hartwell
 Reese, Susannah S.
 Reid, Margaret
 Richards, Elizabeth
 Rider, Lydia
 Robinson, Faith
 Roes, Anna Eliza
 Rogers, Sarah
 Ross, Jane
 Rowland, Elizabeth
 Rugg, Lucy
 Rush, Elizabeth
 Russell, Mary
 Sacket, Harriot
 Sanders, Anna (Nancy)
 Sayre, Caroline Eliza
 Schmidt, Amalie August
 Schrack, Catharine
 Scott, Elizabeth
 Sharples, Elen T.
 Shearer, Jane
 Sheffield, Elizabeth
 Shindle, Catherine
 Silsbe(e), Sarah
 Sisson, Hannah
 Sisson, Sussanna
 Smith, LoAnn
 Smith, Rebecca
 Smith, Sophia Stevens
 Smith, Sukey Jarvis
 Smith, Susan
 Sowers, Rebecca
 Spofford, Salley
 Spurr, Polly
 Standish, Loara
 Staples, Hannah
 Stauffer, Mary Ann
 Stiles, Susan Piece
 Stivour, Sarah
 Stone, Sarah
 Sutherland, Charlotte
 Sweet, Sarah Foster
 Symme, Polly Thompson
 Taylor, Hannah
 Taylor, Sarah
 Thayer, Hannah F.
 Tillinghast, Mary
 Timberlake, Alcinda C.
 Toppan, Sarah
 Trout, Hannah
 Tuel, Sarah
 Turnbull, Eliza J.
 Turner, Polly
 Tuttle, Henrietta
 Vickery, Eliza
 Vogdes, Ann H.
 Waite, Sarah
 Waterman, Eliza
 Waterman, Sarah (Sally)
 Watson, Ann
 Weckerly, Eliza
 Wheeler, Cathrine
 Wheeler, Eveline Foleman
 Whitman, Eliza
 Whitmore, Susan
 Whitwell, Rebecca
 Williams, Mary
 Wiltz, Emilie
 Wing, Zelinda
 Winsor, Nancy
 Winterbotham, Mrs. John Humphrey
 Woodnutt, Martha
 Needlework
 Allen, Priscilla A.
 Braidt, Frohica
 Corbit, Mary Pennell
 Marlett, Eliza Ann

Sandstone works
 Sandstone
 Coon, Phillip

Santeros
 Wood
 Aragon, Rafael
 Rendon, Enrique

Santeros, other religious carvings
 Wood
 Aragon, Jose
 Aragon, Jose Rafael (Miguel)
 Aragon, Luis
 Atencio, Patricio
 Barela, Patrocinio
 Benabides, Jose Manuel
 Benavides, Rafael, Father
 Gallegos, Celso
 Garcia, Fray Andres
 Herrera, Antonio
 Herrera, Miguel
 Lopez, Felix A.
 Lopez, George T.
 Martinez de Pedro, Linda
 Martinez, Apolonio
 Martinez, Eluid Levi
 Mondragon, Jose
 Ortega, Benjamin
 Ortega, Jose Benito
 Rochas, Ramon
 Rodriguez, Jose Miguel
 Romero, Orlando
 Salazar, Leo G. (Leon)
 Silvia, Rafael
 Toledo, Father Juan Jose
 Valdez, Horacio E.
 Vigil, Francisco
 Villalpando, Monico

Saucepans
 Copper
 Crabb and Minshall
 J. Bentley Sons

Saws
 Metal, wood
 Campbell, Larry

Scales
 Brass
 Marden, J.

Scene and genre drawings
 Watercolor, pinpricks
 Parker, Sally

Scene and genre paintings
 Oil
 Smagoinsky, Helen Fabri

Scene drawings
 Pencil, crayon, gouache
 Wentworth, P(erley) M.
 Watercolor, ink
 Neffensperger, J.D.

Scene drawings, portraits, mythical paintings
 Pen, watercolor
 Morton, Charles

Type of Work Index — Sculptures

Scene paintings
 Loom-art
 Dunn, Helen (Helen Viana)
 Oil
 Achey, Mary E.
 Bannon, S.S.
 Boudro(u), Alexandr(e)
 Carey, Joseph
 Isroff, Lola K.
 Keegan, Marie
 Kozlowski, Karol
 Long, H.F.
 Mader, Louis
 McIntosh, Amanda
 Mercer, William
 Smith, David H.
 Snyder, Philip
 Spencer, Harry L.
 Stanwood, A.
 Stearns, E.
 Sterling, Mary E.
 Taylor, Charles Ryall
 Villeneuve
 Oil, acrylic
 Kane, Andy
 Oil, watercolor, pencil
 Litwak, Israel
 Paint
 Davis, George
 Isherwood, Henry
 Rasmussen, Charles
 Pastel
 Burke-Rand, Ravinia
 Unidentified Media
 Adelman, Joseph E.
 Watercolor
 Bliss, H.
 Burd, Eliza Howard
 Harrison, Benjamin J.
 Jacobi, J.C.
 Lefferts, M.F.
 Meysick, Mary Ann
 Morton, Emeline
 Pratt, Caroline H. Barrett
 Roberts, John M.
 Schulze, Lizzie J.
 Wagoner, Maria
 Ward, H.
 Weisel, W.C.
 Weston, Mary Pillsbury
 Whitcomb, Susan
 Watercolor, crayon
 Crispell, John H.
 Watercolor, pen
 Gleason, Mrs. L.

Scene paintings, embroidered wool carpets
 Oil, fabric
 Miner, Eliza(beth) Gratia Campbell

Scenery pictures
 Fabric
 Tipton, Vena

Scenes for the America Opera Company
 Oil
 Emens, Homer
 Graham, Charles
 Meaders, Caspard
 Schaeffer, William

Scenes, paintings
 Oil on glass
 Bond, Milton
 Oil?
 Ostner, Charles

Scenic and panoramic paintings
 Oil
 Smith, John Rowson

Scrimshaw
 Whalebone
 Abbott, Henry R.
 Albro, T.L.
 Bower, W.M.
 Bradford, Benjamin W.
 Burdett, Edward
 Butts, F.A.
 Delano, Milton
 Dodge, Ephraim J.
 Folger, David
 Foster, Washington
 Galloway, Lyle
 Greene, Samuel
 Harris, Albert
 Hewit, Charles
 Hord, Jacob
 Horgos, William "Bill"
 Howland, John
 Huggins, Samuel, Jr.
 Jacobs, A. Douglas
 Martin, James
 McKenzie, Daniel, Jr.
 Morgan, Charles W.
 Myrick, Fredrick
 Roanoke, Bart
 Robinson, Josiah
 Rogers, George H.
 Snow, Martin
 Stark, Mary E.
 Townsend, George
 Vardeman, Paul E., Judge
 White, Alvin A.
 Wilson, Steve
 Worth, D.J.
 Yager, Rick
 Whaletooth
 Healy, Nathaniel

Scrimshaw, genre pictures
 Whalebone, watercolor
 Smith, Fred

Scrimshaw sculptures
 Whalebones, wood
 Chappell, William

Scrimshaw, ship portraits
 Whalebone
 Spring, Rick

Scrimshaw, whaleships painting
 Whalebone
 Perry, William

Scrimshaw, whaling scene paintings
 Whalebone, paint
 Ashley, Clifford W.

Scrimshaw?
 Whalebone?
 White, Edwin

Scroll paintings
 Watercolor
 Spear, P.

Sculpture
 Wood, gourds
 Black, Minnie

Sculpture constructions
 Wood, various materials
 Blocksma, Dewey Douglas

Sculpture, landscape paintings
 Wood, oil
 Beichler, Ed

Sculpture, relief paintings
 Mixed media
 Jones, Arthur

Sculptures
 Cement
 Bailey, Eldren
 Domke, Paul
 Ehn, John
 Muhlbacher, Joe
 Terrillion, Veronica
 Clay
 Blizzard, Georgia
 French, Daniel Chester
 Fretz, J.
 Clay fixed to plywood
 Suddouth, Jimmy Lee
 Dirt, stone, wood
 Kasling, "Driftwood Charlie"
 Earthenware
 Schweinfurt, John George
 Fabric
 Echols, Alice
 Iron
 Mossy Creek Iron Works
 Taylor, S.F.
 Metal
 Clayton, Theodore
 Papio, Stanley
 Rosebrook, Rod
 Molded clay
 Thomas, James "Son Ford"

Sculptures (Cont.)
 Rock, granite
 Ratcliffe, M.T.
 Sandstone, paint
 Spencer, Lonnie
 Stone
 Sherman, M.L.
 Stoneware
 Boughner, Daniel
 James, D.C.
 Various materials
 Cortez, Maxine
 Davis, Ellsworth
 Goff, G.
 Hampton, John (James)
 McEntyre, Kent K.
 McGriff, Columbus
 Nelson, Cal
 Rolling Mountain Thunder, Chief
 Townsend, Ted
 Wood
 Aaron, Jesse
 Ackley, R.D.
 Anderson, James
 Bailey, James Bright
 Bohacket, Albert
 Cerere, Pete
 Chapman, T.A.
 Cote, Adelard
 Decker, Evan
 Finn, Marvin
 Greer, Exell
 Johnson, Philip
 Kahle, Mathew S., Captain
 Lopez, Ergencio
 Lopez, Sylvanita
 Payne, A.C.
 Schaffer, "Pop" "Poppsy"
 Seebeck, Walter
 Self, Bob
 Sincerbox, Keeler
 Vivolo, John
 Wibb, Ward
 Wilburn, Tom
 Willeto, Charles
 Williams, Jeff
 Wimmer, Mrs. Marie
 Wolfert, Frank
 Wood, enamel
 Webster, Derek
 Wood, various materials
 Herrera, Jose Inez (Ines)

Sculptures, carvings
 Stone
 Marshall, David George
 Stone, wood
 Tolson, Edgar
 Wood
 Albertson, Erick
 Ambrose, Edward
 Ames, Asa (Alexander)
 Amidon, Douglas
 Anderson, Jacob S.
 Archuleta, Felipe Benito
 Armijo, Frederico
 Ashby, Steve
 Baker, Tom
 Balzer, John
 Barber, A.H.
 Barta, Joseph Thomas
 Barton, Major
 Baurichter, Fritz
 Buyer, Alfred
 Carpenter, Miles B.
 Carroll, Tessie
 Caspori
 Chwalinski, Joe Moore
 Colclough, Jim "Suh Jim"
 Corbin
 Cordova, Gloria Lopez
 Cordova, Herminio
 Crow, S.N.
 Davis, Ed
 Davis, Ulysses
 Davis, Virgil
 Deady, Stephen
 DeWees, George M.
 Doyle, Sam "Uncle Sam"
 Duncan, O.P.
 Dyker, Henry
 Eyman, Earl
 Galloway, Ed
 Gilbert, Archie
 Golonko, Joe
 Guthrie, Elwood
 Harrop, James A., Jr.
 Hedges, Joe
 Jeffries, Theodore
 Jeliff, John
 Johnson, Sargent
 Jones, A.W.
 Kriner, Robert
 Landau, Sol
 Landry, Pierre Joseph
 Langlais, Bernard
 Leve, Henry
 Ligon, C.P.
 Lukatch, Edward
 McKillop, Edgar Alexander
 McNutt, Bryan
 Moran, Frank
 Nethery, Ned
 Norris, William
 Odio, Saturnino Portuondo Pucho
 Patete, Eliodoro
 Pierce, Elijah
 Polaha, Steven
 Price, Albert
 Reber, John Slatington Carver
 Ricalton, William
 Richards, Frank Pierson
 Savage, Charles K., Jr.
 Schaffner, Dexter L.
 Schermerhorn
 Scholl, John
 Schubert, John G.
 Shoenhut
 Simmons, Schtockschnitzler
 Spalding, Rueben
 Stingfield, Clarence
 Stuart, Nobil
 Teubner, William, Jr.
 Ward, M. Paul
 Ware, Dewey
 Weidinger, Joe
 Wesenberg, Carl
 Winter, Henry
 Wood, metal
 Coe, Clark

Sculptures, carvings of Key West scenes
 Wood
 Sanchez, Mario

Sculptures, carvings, paintings
 Wood, oil
 Gavrelos, John J.
 Mazur, Frank
 Pressley, Daniel

Sculptures, carvings, portraits
 Wood, oil
 German, Henry

Sculptures, carvings, scene paintings
 Wood, oil, cement
 Roeder, John "The Blind Man"
 scene-genre paintings

Sculptures, carvings, scene-genre paintings
 Wood, oil
 Wiener, Isador "Pop"

Sculptures, carvings, show wagons, biblical stories
 Wood
 Hoy, David

Sculptures, carvings, totem poles, paintings
 Wood, oil
 Dawson, William

Sculptures, cigar store Indians, ship figures
 Wood
 Brooks, T(homas) V.

Sculptures, constructions
 Wood, tin, paint, canvas
 Gilkerson, Robert

Sculptures, duck decoys, carvings
 Wood
 Holmes, Benjamin

Sculptures, environmental building
 Stone, wood
 Smolak, Stanley

Sculptures, figural carvings, paintings
 Wood, watercolor
 Jones, Shields Landon

Type of Work Index

Sculptures, landscape paintings
Wood, stone, oil
 Risley, Russell

Sculptures, paintings
Wood, granite, oil
 Washington, James

Sculptures, religious carvings
Wood
 Zahn, Albert

Sculptures, ship carvings, figures
Wood
 Skillin, Simeon, Sr.

Sculptures, toys
Wood
 Warren, Marvin

Sculptures, toys, canes
Wood
 Mann, Ed

Sculptures, wind toys in an environment
Wood, paint, fabric
 Van Zile, John

Seascape and landscape paintings
Oil
 Ropes, George

Seascape paintings
Oil
 Cunningham, Earl
 Perry, William
 Phindoodle, Captain
Watercolor
 Goram, J.
 Gould, George A.
 Lincoln, Daniel H.

Secretaries
Wood
 Joseph Meeks and Sons

Sewer tile sculpture
Clay
 Aetna Fire Brick Company
 Akron Porcelain Company
 American Sewer Pipe Company
 Baker, W(ilbur) A.
 Beaver Clay Manufacturing Company
 Biddle, Robert W.
 Bish, W.H.
 Bosio, Louie
 Cannelton Sewer Pipe Company
 Cramlet, C.
 Crockett, Otto
 Dee, William M.
 Dorsey, Miss Edith
 "El Diadlo"
 Evans Pipe Company
 Exley, F.
 Fouts, Edward
 Funk, Abraham
 Gudy, Ernest
 Hirzel, William
 Hutchinson, John A.
 Lamielle, E.
 Lesh, Jane Barrow
 Massillon Refractories Company
 Moore, J.W.
 National Fireproofing Company
 National Sewer Pipe Company
 Nelsonville Sewer Pipe Company
 Newport Sewer Pipe Plant
 Romig Clay
 Somerset Trading Company
 Spencer, Herman
 Staley, Louie
 Sterling Brick Company
 Stockes, L. (Ralph)
 "Windy"

Sewing boxes
Oil
 Miller, J.

Sewing cases
Embroidery
 Biddle, Beulah

Sewn buttons, quilts, canes
Various materials
 Tenebaum, Morris

Shaker boxes
Wood
 Wilson, Elder Delmar

Shaker chairs
Wood
 Andersen, Elder William
 Burlingame, Elder Philip
 Wagan, Robert

Shawls
Fabric
 Goodrich, Mahala

Shelf clocks
Wood
 Stow, Solomon

Ship and harbor paintings
Oil
 Gooding, William T.

Ship and marine paintings
Oil
 West, Benjamin Franklin

Ship and scene paintings
Oil
 Smith, Joseph B.

Ship and seascape paintings
Oil
 Plummer, William

Ship and townscape paintings
Watercolor
 Anderson, Peter

Ship carvings
Wood
 Benson, Frank

Ship carvings, cigarstore figures
Wood
 Proctor, David R.
 Sailor, Samuel H.

Ship carvings, figures
Wood
 Counce, Harvey P.
 Cushing, Levi L.
 Dellaway, Thomas
 Dodge and Anderson
 Fowle, Isaac
 Garmons, William
 Geggie, William W.
 Harris, Daniel, Captain
 Hastings and Gleason
 Mason, John W.
 McIntire, Samuel
 Sampson, C(harles) A.L., Captain
 Vanderbree, Kenneth

Ship carvings, ship figures
Wood
 Abbot, J.C.
 Abig, Adolphus
 Alback, John
 Allen, Calvin
 Allen, James
 Allin, William
 Allison, Walter
 Alt, Godfried
 Alt, William
 Amthor, John
 Anderson, Alonzo
 Anderson, James
 Anderson, Jane
 Antres, Charles
 Apple, Henry
 Appleton, Chris
 Appleton, Thomas
 Arend, Michael
 Armstrong, James L.
 Ashe, Thomas
 Ashmore, A.P.
 Ashmore, Abraham V.
 Aube, Peter R.
 Auld, Wilberforce
 Austin, Peter H.
 Backman, Henry G.
 Badger, Hiram
 Bailly, Alexis J.
 Baird, James
 Baker, William

Ship carvings, ship figures

Ship carvings, ship figures (Cont.)
 Wood (Cont.)
 Baldauf, Joseph
 Banta, John W.
 Banvard, David
 Barna, William
 Barnes, William
 Barrett and Debeet
 Barry and Losea
 Barry, Thomas
 Barth, Bartholomew
 Baumback, Theodore
 Bayer, Michael
 Beadle, Edward
 Beadle, Leaman
 Bean, W.P.
 Beatly, Spencer
 Beatty, Spencer
 Beaujoy, Dennis
 Beecher, Laban S.
 Beiber, C.G.
 Beiderlinden, Nicol
 Bellamy, John Hales
 Bennett, Thomas
 Bent, Everett
 Bering, Thomas G.
 Bias
 Bias, Joseph
 Bickel, George
 Bids
 Bird, Charles
 Black, James
 Black, Robert
 Blankensee, John
 Blythe, David
 Boize, Charles
 Bokee, John
 Bolden, Robert H.
 Bolland, Martin
 Bolton, William
 Boos, John
 Boston Fancy Wood Carving Company
 Boulanger, John F.
 Bourguianon and Britt
 Bowers, Ezekial
 Bowers, Joseph
 Bowles, Joshua
 Brieschaft, Joseph
 Briggs, Cornelius
 Brinckerhoff, John P.
 Brittin, Sanford
 Brooks and White
 Brooks, James A.
 Brotherton and North
 Brown and Tweadwell
 Brown, Caspar
 Brown, Charles
 Brown, George H.
 Brown, John
 Brown, Jon
 Brown, W.H.
 Brown, William H.
 Browne, John H.
 Browne, John S.
 Bryne and Company
 Bryne, Joseph
 Buck, George H.
 Buckley, Patrick
 Budd, Edward
 Bunn and Brother
 Burgess, Everard
 Burkfeldt, August
 Burman, Augustus
 Burnett, Henry
 Burnham, Aaron L.
 Burtis, Jacob H.
 Buschor, Charles
 Buttling, Avery
 Byerley and Ely
 Byerley, Edwin
 C.A. Jackson and Company
 Callaham, Richard
 Campbell and Colby
 Campbell and Greig
 Cannon, Hugh
 Capalano, Anthony
 Carroll, Thomas
 Carver, Jacob
 Cather, David
 Cellarinus, Ferdinand
 Ceutsch, J.H.
 Chaloner, Holman Waldron
 Chanceaulier, Martin
 Chapman and Hastings
 Chapman, A.
 Chapman, Nathan
 Charlton and Williams
 Charlton, F.
 Charlton, Frederic
 Chatterson and Higgins
 Chatterson, Joseph
 Chatterson, Joseph
 Choate and Silvester
 Choate, John C.
 Churchill, Lemuel
 Clark and Risely
 Clark Leonard and Company
 Clark, John W.
 Clark, Levin P.
 Clements, Seth
 Clinton, George H.
 Coffin, Henry
 Colby, Emery and Company
 Colby, John
 Cole, Dexter K.
 Coleman, Alvin
 Coleman, Hezekiah
 Collins and Brown
 Collins, Abraham
 Collins, Thomas
 Collyer, Thomas
 Concklin
 Conger, John
 Conian, P.T.
 Conner, William M.
 Cook, William
 Cooley, William H.
 Cooper, James
 Cooper, William
 Cordery, William
 Cornwell, Stephen
 Cotten and Statler
 Court, Lewis
 Coutis, T.W.
 Crane, Jacob B.
 Creiger, Augustus
 Crocker, Ephraim
 Croll, John
 Cromwell and Harold
 Cromwell, Stephen
 Crouch, Henry
 Currier, Alexander
 Cushing, Jere C.
 Cushing, Jeremiah C.
 Cutbush, Edward
 Cutbush, Samuel
 Daroche, Frank
 Davenport, William, Captain
 Davidson, William
 Davis, Charles
 Dean, Thomas
 Decker, Louis
 Decker, Robert M.
 Deene, John
 Deering, William
 Deering, William, Jr.
 Degrasse, Aug.
 Delano, Joseph
 Delmont, David
 Denman, David
 Derlom, Francis
 Desaville, William W.
 Dimond, C.C.
 Dippel, Ferdinand
 Dockum, S.M.
 Dockum, Samuel M.
 Dodge and Sharpe
 Dodge and Son
 Dodge, Jeremiah
 Dodge, Nathan
 Dodson, W.K.
 Doherty, Joseph J.
 Doherty, Joseph J.
 Dolan, James
 Donegan, James
 Door, Edward
 Doran and Miller
 Doran, John B.
 Dotterer, Charles
 Doughty, John H.
 Downes and Sargent
 Downes, Peter B.
 Downs, P.T.
 Doyle, John M.
 Drawbridge, William S.
 Drew
 Drew, Alvin
 DuPee, Isaac
 Dwinell, Hezekiah
 Earl, Tarleton B.
 Earle, James
 Easson, James
 Eberle, Mark
 Eckhart, L.
 Ehrler, Charles
 Eidenbries, John
 Eliaers, Augustus

Ship carvings, ship figures

Ellenbass, Theodore
Ellis, John
Ellis, John, Jr.
Elwell, Samuel, III
Ely, Abraham
Emery, Charles
Ernst, Carl
Eureka Steam Machine Carving Company
Evans, John
Farnham, Henry
Farnham, John D.
Farrand and Omensetter
Farrand and Stuart
Farrand, Stephen
Farrell, John
Farren and Edlefson
Fash, William B.
Ferg, Henry
Ferran, Joseph
Fewkes, J.
Fifield, Daniel
Finch, Nathaniel
Finnerard, M.T.
Fischer, Charles
Flandrow, Joseph B.
Foley, Theodore H.
Forg, P.
Fowle, John D.
Fowle, William H.
Fox, Francis
Foy, P.
Fraser, John
Frazer, Hiram
French, William B.
Fryer, James
Fuentes, Lucas
G.B. McLain and Company
Gallier, Edward
Gally, Thomas J.
Gantz, Frederick
Gardiner, John
Gardner, Andrew
Gardner, John
Gardner, William
Garing, Christian
Gastal, J.
Geidt, Anthony E.
Geiger, Jacob
Gendrot Gahery and Company
Gereau, William
Getty and Sapper
Getty, Robert
Gibbs, James
Gilbert and Worcester
Gilbert, Fitz W.
Glad, George H.
Gleason and Company
Gleason and Henderson
Gleason, Benjamin A.
Gleason, Henry (Herbert)
Gleason, W.G.
Gleason, William B.
Golding, John
Gooding, Charles Gustavus
Gorbut, Robert

Gossett, Henry
Gottier, Edward
Gracey, William
Graham, Thomas
Grant, William
Greeley, John
Green, George W.
Greer, James
Gridley, George
Griffin, Edward Souther
Griffin, John
Griffith, William
Guiterman, Gustave
Haberland, Benno
Haden Company
Haehnlen, Louis A.
Hahnle, Egidius
Hainsdorf, Henry
Haley, John C.
Halliday, Thomas
Hansbury, John
Hardcastle, Henry
Harding, John T.
Harding, Richard H.
Harding, Samuel
Harned, Henry
Harold and Randolph
Harris, George
Harrison, Henry
Harvey, Thomas
Hasslock, Charles
Hastings, E.W(arren) (Warren E.)
Hatch, Edbury
Hatfield, Joseph
Hausel, Martin
Hausel, William
Hauser, Joseph
Hawks, George W.
Hays and Morse
Hays, Robert
Heath, Samuel
Hedian, T.
Heiligmann and Brother
Hein, John
Heiss, Balthus
Henderson, Joseph
Henry, David H.
Henry, Samuel C.
Heron and Macy
Heron and Weeden
Heron, James
Herr, John
Herzog, James J.
Hetzell, George J.
Hey and Luckens
Hicks, Walter
Higgins, Stephen
Hild, Michael
Hindes, John M.
Hobbs, John E.
Hobbs, John, Jr.
Hoffman and Maurer
Hoffman, Alexander
Hoffman, Gustav
Hoffman, John
Hoffman, Leonard

Hoffmaster, Charles A.
Holden, Oliver
Holly, William
Holzer, Julius
Honey, John
Horton, Daniel
Horton, James
Hotz, Martin
How, Joseph
Howland, E.D.
Hubbard, Paul
Hubbard, Samuel
Hubbart, Samuel
Hunt, D.W. Lewis
Hunt, William
Hurley, George
Ingalls, C(yrus) A.
Irwin, Joseph
Ives, Chauncey B.
J(ohn) W. Banta and Company
J.S. Anderson and Son
Jackson, Joseph
Jackson, Joseph H.B.
Jacob Anderson and Company
James, Isaac
Jardalla, Joseph
Jeffers, James T.
Jewsson, George
Joe
Johnson, John
Johnson, Theodore
Jones, Anthony W.
Jones, Emery
Jones, Henry A.
Jones, Samuel D.
Jones, William
Kaufman, Jacob
Keebler, Julius
Keena, John
Kelley, Asahel A.
Kemmon, Joseph
Kemp, A.
Kemp, Frederick
Kennard, William J., Jr.
Kennedy, Samuel
Kertell, George
Kessel and Hartung
Kett, John F.
Killalea, Thomas
Klumbach, Jacob
Knight, Richard
Knoedler, Cyriak
Knost, Edward
Kohl, Peter
Krause, Oscar
Krause, William O.
Krieghoff, Philip E.
Kronauze, William
Kuehls, Theodore
Kurtz and Company
Kurz, Max
Kutz, Anthony
Labeyril, Constant
Lafleur, Charles
Lake, William
Lambert, Thomas

Ship carvings, ship figures (Cont.)
 Wood (Cont.)
 Langdon, Elias
 Lannuier, John
 Launsbury, John
 Leach, H.
 Leatherman, Gebhard
 Lebrecht, Frederick
 Leconey, James
 Lees and Preeble
 Lees, A.
 Lees, J. W(alter)
 Lerving, Samuel
 Lerving, Samuel
 Letourneau, Charles
 Lewin, Isaac
 Lex, Henry
 Lillagore, Theodore W.
 Lindsay, William
 Lingard, William
 Litchfield, E.
 Little, Thomas
 Littlefield Brothers
 Littlefield, Charles H.
 Littlefield, Francis A.
 Littlefield, Nahorn (Nahum)
 Littlefield, Nathan, Jr.
 Lockrow, William
 Lockwood, William
 Lokke, S.R.
 Long, Rufus
 Lord, T.M.
 Lovejoy, Edward Bell
 Lowery, Alexander
 Lucas, Thomas
 Luce, Benjamin
 Luff and Brother
 Luff and Monroe
 Luff, George W.
 Luff, John V.
 Luke, William
 Lundmark, Winter
 M. Barrett and Brother
 Mace, Richard
 Macy, Reuben
 Macy, Robert H.
 Maher, E.
 Main, William H.
 Manard, John B.
 Mannebach, Lewis
 Manning, John
 Marcellus, John
 Marcher, James
 Marsh, Joseph
 Marston, W.W.
 Mayer, Henry
 Mayer, Philip
 Mayo, Robert
 McAleese and Wyman
 McClain, G.B.
 McClellan Brothers
 McColley
 McColley, Charles
 McCully and Company
 McGrath, George
 McGuire, Dominick
 McIntire, James
 McIntire, Joseph
 McIntire, Joseph, Jr.
 McIntire, Samuel Field
 McIntyre and Gleason
 McLean, Hugh
 McMahon, Thomas
 McQuillen, James
 Mead, William
 Meaher, J.W.
 Mengen, Theodore
 Menges, Adam
 Merriam, John
 Merrill, Joseph P.
 Meyers and Hedian
 Miller and Browne
 Miller, Athanasias
 Miller, Edwin N.
 Miller, Ernest
 Miller, George A.
 Miller, Jacob
 Miller, John
 Miller, John F.
 Miller, John F., Jr.
 Milliard, Charles
 Milliard, James
 Milliard, Thomas
 Milliken, Robert
 Milliken, Thomas
 Milosh, Christian
 Milosh, William
 Minifie, James
 Minton, W.D.
 Mitchell, Robert
 Mon Hon
 Monroe, John
 Montgomery, William
 Montgomery, William M.
 Mooney, Michael
 More, Samuel
 More, Thomas
 Morgan, William H.
 Morrell and Morriss
 Morrell, Willett H.
 Morris, J.H.
 Morris, John
 Morrison, John C.
 Morton, Daniel O.
 Moss, Frederick
 Mott and Doran
 Mott and Pasman
 Mott, Dewitt C.
 Moulton Brothers
 Mullard, Robert
 Mullen, James
 Mulligan, Michael
 Naber, George
 Nantion, J.
 Neal, Joseph B.
 Newcomb
 Nicholson, Washington A.
 Nickols, John
 Noble, George
 Nodine, Alexander
 Northrop, Rodolphus E.
 Nye, Alfred
 Ochs, George N.
 Olson
 Omensetter, Elhanan
 Orr, Richard
 Orth, Adam
 Ostheimer, A.
 Otton, J. Hare
 Pappenberg, Henry
 Park, Thomas
 Parker, Clark
 Parkinson, John
 Pasman, Frances
 Pastor, James
 Patney, Peter
 Patterson
 Patterson and Read
 Paul, John
 Peirce, George W.
 Penn, Thomas
 Pepperrell, William
 Petrie, John
 Phelen, James
 Phillips, Felix
 Phillips, William S.
 Pickard, J.
 Pierre, F.J.
 Pifer, William
 Pinsonault, L.
 Piper, John C.
 Potter, W(oodbury) A(bner)
 Potts, Abram
 Power and Ferrell
 Pratt, Leon B.
 Priestman, James
 Primrose, Mordecai
 Primrose, Robert
 Prince, Henry M.
 Proctor, D.R.
 Purrington, Henry J.
 Pursell, John
 Pyfer, William
 Pyle, John W.
 Quest, Francis
 Quinn, C.F.
 R.C. Pringle and Company
 R.H. Counce and Company
 R.R. Thomas and Company
 Raeder, Hartman
 Raeder, Sebastian
 Ramsey, Joseph
 Randolph and Seward
 Raymond and Fowle
 Raymond, Edmund
 Reifsneider, Charles
 Renouf, Edward M.
 Reynell, John
 Rhode, Henry
 Richardson, John
 Richardson, R.
 Richardson, Thomas
 Riemann, George
 Risley, Charles
 Risley, Charles E.
 Roberts, George S.
 Robertson, Joseph
 Robertson, William A.

Robinson, George
Robinson, John L.
Roebel, George
Rogers, James
Rogerson, John
Roherge and Knoblock
Rollins, George W.S.
Romer, C.
Roosetter, Charles H.
Rouse, Richard
Rumney, George R.
Rumney, John
Rumney, William H.
Rusby, John
Rush, Benjamin
Rush, John
S. Merchant and Company
S.W. Gleason and Sons
Sailor, S.H.
Samson Cariss and Company
Sanbach, Herman
Sapper, William
Sargent, John B.
Scallon and Company
Scallon, L.
Schaeffer, Henry
Schaffert, Charles
Scheckel, Conrad
Schmidt, Peter
Schmitt, Ambrose
Schneider and Pachtmann
Schone, Robert
Schwager, William
Schwartz, Peter
Scott, John
Searing, George E.
Seavey, Thomas
Seavey, William L.
Seaward
Selman, William
Seward, William
Shannon, George W.
Sharp, Charles
Sharpe and Ellis
Sharpe, C(ornelius) N.
Shepherd, Jacob
Shoener, John
Shulz, Randolph
Simmons, W.A.
Simon, Martin
Sims and Shepherd
Sims, James
Skillin and Dodge
Skillin, Samuel
Skillin, Simeon, III
Skillin, Simeon, Jr.
Skinner, Edward
Skinner, John
Skinner, W. Hammond
Slote, Alexander
Smith and Crane
Smith, C.W.
Smith, Henry
Smith, Henry M.
Smith, R.

Smith, Thomas H.
Smith, Thomas H.
Smith, William W.
Solomon, John
Southwork, William
Southworth and Jones
Spalding, Frederick
Spaulding, Frederick D.
Spaulding, James
Spinney, Ivah W.
Starckloff and Decker
Statler, George
Stegagnini, L.
Stephen, John
Stephen, William
Stephens, Ebenezer
Stevens, E.A.
Steward, David
Stewart, James, Jr.
Stewart, William
Stewart, William
Stoddard and McLaughlin
Stoddard, N.
Stoddart, N.
Stone, George
Storey
Stow, Samuel E.
Stratton and Morrell
Stratton, Joseph
Stuart, Alexander W.
Stueler, Charles
Stumpf, Valentine
Stutchfield, Joseph T.
Sudbury and Schaefer
Sudbury, Joseph M.
Swam, George
Swan, Jonathan R.
Swasey, Alexander G.
Sweatland, Joel
T.J. White and Company
Tapp and Miller
Tapp, Edward
Taylor, Enoch
Taylor, George
Taylor, John
Taylor, John
Telan, W.A.
Telfer, James W.
Terhune, Nicholas
Theall, Isaac
Thomas Seavey and Sons
Thomas, Carl C.
Thomas, Robert D.
Thompson, John
Thompson, M.
Titcomb, James
Titus, Francis
Todd, James
Towson and Hines
Toy and Lingard
Toy, Nicholas, Jr.
Train and Collins
Train, Daniel N.
Trautz, August
Treadwell and Godbold

Treadwell, H.S.
Treat, S(amuel) L.
Trepner, William
Tryday, G.H.
Twing, George B.
Uhle, Herman
Umbrick, Gabriel
Van Horn, Fielding
Van Wymen and Brother
Van Wynen, Bernard
Vanderhoof, William H.
Vannorden, John G.
Vanzile, Ginge
Verill, J(oseph) E.
Verleger, C. Fred(ric)k
Vieille, Ludwig
Vogell, Charles
Voltheiser, Joseph
Voos, Robert
Vought, Samuel L.
Waddell, R.
Wadsworth, Charles
Walker, Peter
Warburton
Washburn, W.L.
Watson, Richard
Weaver, F.L.
Weeden, John
Weedon, J(ohn)
Weedon, John
Weiss, George
Welch, John
Wells, Henry
Wells, Henry
Welsh, John
Werner, Casper
West, Francis
Weston, Thomas
White and Company
White, Richard H.
Wightman, Thomas
Wilkinson, Anthony
Wilkinson, Bryant
Willard, Solomon
William Krafe and E.F. Teubner
Williams, E.
Williams, John
Willis, Edward
Wilson and Schaettler
Wilson, Alfred (Albert H.)
Wilson, James W.
Wilson, Joseph
Winnemore, Philip
Winsor and Brother
Winsor, Nathaniel
Winsor, Samuel L.
Witherstone, Phillip
Wittfield, Henry
Wooster, A.N.
Wooster, A.V.
Wright, Morrison
Wyman, Samuel D.
Young, William
Youngs, Icabod

Ship carvings, ship figures, cigar store Indians
Wood
 Campbell, James
 Lindmark, Winter

Ship carvings, ship figures, sculptures
Wood, marble
 Randolph, James T.

Ship drawings
Watercolor, pencil
 Robinson, Frank

Ship, harbor scene, seascape paintings
Oil
 Lane, Fitz Hugh

Ship models
Ivory
 Anderson, Lloyd, Captain

Ship paintings
Oil
 Bradford, William
 Cooke, Captain
 Dannenburg, C.F.
 Halsall, William Formsby
 Jacobsen, Antonio
 Luscomb, William Henry
 Marsh, William
 Moses, Thomas P.
 Pansing, Fred
 Smith, William S.
 Stancliff, J.W.
 Williams, A.
 Wright, J(ames) H(enry)
Oil, watercolor
 Bard, James
 Bard, John
 Robertson, John
Watercolor
 Bowen, Ashley
 Briggs, L.A.
 Phippen, John

Ship portraits
Oil
 Badger, S.F.M.
 Cluczs, H.
 Cornell, John V.
 Evans, James I.
 Johnson, R.
 Nissen, Charles
 Roath, H.A.
Pen, watercolor
 Chase, Elijah
 Chase, Joseph T., Captain
 Nivelet
Pencil, watercolor
 Akin, John F.
 Keith, Charles F.
 Luce, Shubael H.
Watercolor
 Camiletti, Edmund
 Parsons, Charles

Ship portraits, scene paintings
Oil, watercolor
 Huge, Jurgan Frederick
 (Friedrick; Fredrick)

Ship portraits, seascape paintings
Oil, oilcloth
 Crane, James

Ship, seascape, lighthouse paintings
Oil
 Drew, Clement

Shorebird decoys
Papermache
 Paine, Josiah
Wood
 Dilly, John
 Glover, John
 Verity, Nelson

Shorebird, duck decoys
Wood
 Osborne, Henry F.

Show towels
Fabric
 Gross, Magdalena
 Hosterman, Anna

Sign and decorative paintings
Unidentified Media
 Hillman, Richard S.

Sign and miniature paintings
Paint
 James, Webster

Sign and ornamental paintings
Oil
 Attwood, J.M.
 Cleveland and Company
 Cole, A.C.
 Oliver, John A.
 White, Alexander
Paint
 Mehrle, W.

Signs
Iron
 Mangin, John A.
Metal
 Dayton, B.
 Moore, Billy
Oil
 Freeland, Henry C.
Oil, wood
 Andross, Chester
 Angell, Richard
 Bouve, S.R.
 Carter, J.
 Rice, William
 Richardson
Paint, wood
 Blyderburg, S.
 Burkholder, J.P.
 Janes, Alfred
 Kinstler, W.
Unidentified Media
 Mason, J.
Wood
 Barrow, John Sutcliff
 Grimes, John
 Hoadley, David
 Knight, L.
 Knight, Stephanas
 Millard, Tom
 Noble, Clarke
 Norwich, Beatty and Company
 Page, H.
 Pelkey, J.E.
 Reed, Abner
 Sizer, Samuel
 White, William Fred
Wood, paint
 Schuman, E.

Signs, bible paintings
Oil
 Howard, Jesse

Signs, paintings
Wood
 Crossman, G.

Signs, portraits, miniatures, chaise paintings
Oil
 Sanford, Isaac

Signs, ship carvings, figures
Wood
 Skillin, John

Signs, ship carvings, figures, sculptures
Wood
 Rush, William

Silhouettes
Paper
 Ellis, Freeman
 Griffing, Martin
 Hankes, Master
 Honeywell, Martha Ann
 Hubard, William James
 Lindsey, Seymore S.

Silhouettes, collages
Paper, watercolor
 Brown, William Henry

Silhouettes, drawings, furniture
Pen, ink, wood
 King, William

Silverware
Silver
 Smith, John E.

Sketches

Pen, ink
- Castelnau, Francis
- Collot, George Henri Victor
- Hall, Basil, Captain
- Jackson, Anne Wakely
- Jackson, J.
- Lewis, Betsey
- Murphy, W.
- West, Benjamin

Unidentified Media
- Kinzie, Juliette M.

Sketches of Indians

Pencil
- Lewis, James Otto

Sleighbells

Metal
- Barton, William

Social and political genre carvings

Wood
- Cartledge, William Ned

Sofas

Wood
- Steinhagen, Christofer Friderich Carl

Spice boxes

Tin
- Dreese, Thomas

Wood
- Needhams, Mercy

Spinningwheels

Wood
- Stewart, William M.

Spirit drawings

Ink, watercolor
- Holy Mother Wisdom

Pen, ink
- Boler, Daniel

Unidentified Media
- Wright, Mother Lucy

Watercolor
- Hazard, Mary

Spoons

Pewter
- Hedderly and Riland
- Proby, Jacob

Silver
- Shepherd, Robert

Statues

Clay
- Hornaday, William T.

Steam boat models

Wood
- Storie, Harold

Stenciled bedcovers

Fabric
- Morton, Emily

Stenciled chairs

Wood
- Eaton, W.P.
- Johnson, Jarred

Stenciled overmantel paintings

Oil
- Pomroy, Lucinda

Stencils

Copper
- Collis, S.C.
- Zell, William D.

Tin
- Scripture, George

Still life and landscape paintings

Oil, acrylic
- Miles, Pamela

Still life drawings

Watercolor, pinpricks
- Knight, Belinda D.

Still life, landscape paintings

Oil
- Fellini, William

Still life, narrative historical, biblical paintings

Oil
- Pippin, Horace

Still life paintings

Charcoal
- Cobb, Anna C.

Oil
- Chipman
- Francis, John F.
- Kost
- Lawrie, Alexander
- Leach, R.
- Nuttman, I.W. Isaac
- Powers, Susan
- Randall, A.M.
- Regensburg, Sophy
- Roesen, Severin
- Ronalds, Elizabeth F.
- Smith, F.E.D.
- Wagguno

Oil, masonite
- Alberts, Sylvia

Pastel
- Bowers, J.

Unidentified Media
- Hubban, E.A.

Velvet
- Freleigh, Margaret Ann
- Hale, Eliza Camp Miller
- Pitkin, Elizabeth
- Shaw, Susan M.
- Stearns, Mary Ann H.
- Stearns, William
- Terry, Sarah F.
- Wilson, Isabella Maria

Watercolor
- Babcock, Amory L.
- Badger, Nancy
- Cady, Emma Jane
- Forney, Henry
- Gilpin, A.W.S.
- Holden, H.
- Morrill, M.L.
- Niles, Melinda
- Paxton, Eliza
- Peters, Joseph
- Sackett, Ester
- Sawin, Wealthy O.
- Sawyer, Belinda A.
- Sherman, Lucy McFarland
- Vaughan, N.J.
- Waters, Almira

Still life pictures

Embroidery
- Cheever, Miss Mary
- Platt, Mrs. Charles (Dorothy)
- Williams, Cynthia
- Winsor, Fanny (Francis)

Fabric, pencil, embroidery
- Bishop, Sally Foster

Stills

Copper
- Sanderson, Francis
- Stoehr, Daniel
- Weitel, J.

Stills, kettles

Copper
- Bruce, John M.

Stitched linens

Fabric
- Dille, Susann
- Kral, Kadharina
- Miller, Anna Mari
- Schaffer, Marea

Stitched poems

Fabric
- Way, Rebecca

Stools

Wood
- Roux, Alexander

Stove plates

Glass, iron
- Stiegel, Henry Wilhelm, Baron

Iron
- Barsto Furnace
- Stevenson, George

Stove plates, ironware
Iron
Rutter, Thomas

Street genre paintings
Acrylic
Brice, Bruce

Street scene paintings
Watercolor
Goodman, J. Reginald
Hyde de Neuville, Baroness

Striped woven blankets
Fabric
Winningham, Susan Elizabeth

Swan carvings
Wood, paint
Rust, David

Swan decoys
Wood
Williams, S.

Symbolic and mystic paintings
Oil
Newton, B.J(esus)

Symbolic and religious collages
Fabric
Martin, Don "Duke"

Symbolic paintings
Oil
Mitchell, Vernell

Symbolic scene paintings
Oil
Sullivan, Patrick J.

Table mats, pillow covers
Fabric
Neal, Mr.

Tablecloths
Fabric
Ellis, Lucebra

Tableware
Copper
Smith, James

Tea kettles
Brass
Harbeson, Benjamin
Copper
Reid, G.
Steinman, F.

Teapots, pottery
Clay
Binney and Ronaldson

Theater and sideshow scenes
Oil
Daugherty Brothers Tent and Awning Company
Enkeboll Art Company
Flagg, Edwin H.
Hoyt, Henry E.
Mahaffey Brothers Tent and Awning Company
Plaisted, T.J.
Seavey, Lafayette W.
Swift Studios

Theater, circus, and sideshow scenes
Oil
Voegtlin, William

Theatrical and banner art
Unidentified Media
Bianchi, John

Theodalites
Brass
Platt, Augustus

Theorems
Velvet
Hook, Susan
Watercolor
Bennett, Caroline
Ferguson, Sarah
Gernerick, Emelia Smith
Paris, Delphina
Paul, J.W.S.
Rotschafer, F.A.

Theorems, frakturs
Oil, watercolor, velvet
Ellinger, David

Three-footed tables
Wood
Foot, D.

Tile
Clay
Beaver Falls Art Tile Company

Tin mirrors
Tin, glass
Byington, Martin

Tin roof ornaments
Tin
Scheffer, Richard

Tinder boxes
Tin
Ives, Ira

Tinder boxes, scoops
Tin
Metcalf, Edward

Tinman signs
Wood
Krans, J.

Tinned sheet iron dishes
Iron
Osmon(d), (Anna) Maria

Tinned sheet iron toys
Iron
Spencer, James

Tinware
Tin
Ahrens, Otto
Ald, Henry
Alfred, Nabby
American Tea Tray Works
Andrews, Asa
Andrews, Burr
Andrews, H.
Angstad, E.
Babb, Conrad
Bacon, Nathaniel
Bailey, Abner
Baker, Joseph
Balsh, Conrad
Barber, James
Barber, Titus
Barnes, Blakeslee
Barnes, Edward
Barrett, Edward P.(T.)
Barth, Louis
Bartholomew, Jacob, Jr.
Bartholomew, Samuel
Beckley, John
Beeman, S.
Belden, Aziel
Belden, Joshua
Belden, Sylvester
Benton, Jared
Bidwell, Titus
Bierman, Fred
Bigger, Peacock
Bingman, Samuel Harrison
Bingman, Yost
Bishop, Nathaniel
Bishop, Uri
Black, Daniel (David)
Black, James
Blakeslee Stiles and Company
Boas, Jacob
Booth, Salmon
Boschert, Bernard
Bradford, Joseph
Bradley, Thomas
Brady, Hiram
Briggs, Amos
Briscoe, Thomas "Ol' Briscoe"
Bronson, Asahel
Bronson, Oliver
Bronson, Samuel
Bronson, Silas
Brown, Joseph, Jr.
Brown, Moses
Buckley, Justus

Type of Work Index — Tinware

Buckley, Mary Ann
Buckley, Moses
Buckley, Oliver
Buckley, Orrin
Buckley, William, Jr.
Buckman, John
Bulkeley, George
Burr, Jason
Buschman, Frederick
Butler, Aaron
Butler, Abel
Butler, Ann
Butler, Marilla
Butler, Minerva (Miller)
Butler, Thomas
Butler, Thomas C.
Butler, W. and L.
Butler, William
Byrne and Kiefer Company
Camp, Emily
Camp, Lucy
Carson, William
Carter, Thomas
Case, T.
Chalker, Walter H.
Clark, Charles
Clark, Elisha
Clark, Nathaniel
Clark, Patrick
Clark, Samuel
Clarke, S.S.
Clarke, Warren
Cloister, Ephrata
Commiller, Lewis
Corrigan, William
Cotton, Shubael Banks
Cowles, Josiah
Crane, Harry
Cross, J.E.
Curtis, Daniel
Curtiss, H.W.
Dash, John Baltus
Davis, S(amuel)
Day, Nathan
Degenhardt, Henry
Delgado, Francisco
Deming, Horace
Deming, Luther
Deshon, Thomas
Dickinson, Russel
Drinkhouse, John N.
Drinkhouse, William H.
Dunham, John
Dunham, Solomon
Dyer, Henry
Eddy, Jesse
Eicholtz, George
Eicholtz, Leonard
Elderkin, E.B.
Elliot, John
Elliot, Nathan
Endriss, George
Eno, Reuben
Erbest, John
Esterbrucks, Richard
Eveling, Frederick

Filley, Augustus
Filley, Giles
Filley, Harvey
Filley, Jay Humphrey
Filley, Marcus Lucius
Filley, Oliver
Filley, Oliver (Dwight)
Finchour, Joseph
Fischer, Charles
Flanagan, John
Florys, William
Foot, Lewis
Foote, Lewis
Frazer, Thomas
French, Asa
Frisbie
Fry, John
Gale, F.A.
Gilbert, Daniel
Gilbert, David
Gminder, Gottlieb
Goodrich, Asahel (Asohet)
Goodrich, Ives and Rutty Co.
Goodrich, John J.
Goodrich, Samuel
Goodrich, Seth
Goodrich, Walter
Graham, Francis
Graham, John
Griffith, Thomas
Gross, William
Hall, Joseph P.
Harrington, Lyman
Haywood, Thomas
Hennis, John
Henrie, John
Heye, Frederick
Hill, George
Hoffman, William
Holmes, Allen E.
Holmes, Eleazer
Hooker, Asahel
Hooker, Bryan, Captain
Hooker, Ira
Horn, John
Horsfield, Israel
Hubbard and Root
Hubbard, Enoch
Hubbard, John
Hull and Stafford
Humphrey, Hiram
Isaac Smith and Thomas Lee
Jabez Peck and Company
Johnson, Alfred
Johnson, Zachariah
Keller, Conrad
Kelsey, Samuel
Kempton, Samuel
Kentz, Joseph
Kepner, William
Killens, B.
Kilsey, Edward A.
Kingsbury, Mary
Kirtland, James
Klingman, C.L.
Kreider, Albert M.

Kreider, Maurice (Morris)
Lamb, James
Lamb, Lysis
Langdon, Barnabas
Larkin
Lathrop, James S.
Lawrence, Sherman B.
Lebkicker, Lewis
Lee, Jared
Lewis, A.N.
Lewis, Erastus
Lewis, Isaac
Lewis, Patrick
Lewis, Seth
Little, Joseph K.
Loercher, Everett R.
Loercher, Ronald
Logan, James
Lorenz, Frederick
Lowery, Daniel
Maertz, Charles
Marrott, Ted
Martin, John
Martin, William
Martinez, Angelina Delgado
McMinn, Charles Van Lineaus
Merriam, Lawrence T.
Messenger, Charles
Miller, Joseph
Minkimer, Frederick
Mitchell and Manross
Mitchell, Thomas
Mitchell, William Alton
Moore, Cyrus
Morse, Alvin
Morse, Asahel
Muensenmayer, Jacob
Naugle, James
Neumann
Newell, Isaac
North, Abijah
North, Alfred (Albert)
North, David
North, Elijah
North, Jedediah
North, John
North, Lemuel
North, Linus
North, Lucinda
North, Seth
North, Silas
North, Simeon
North, Stephen
Northford's Shop
Norton, Ezra
Norton, Samuel
Norton, Zachariah
Nott, Zebedee
Noyes, Morillo
Paine, Nelson
Parsons, Eli
Passmore, Thomas
Pattison, Edward
Pattison, Edward, Jr.
Pattison, Luther
Pattison, Samuel

Tinware (Cont.)
 Tin (Cont.)
 Pattison, Shubael
 Pattison, William
 Peck, Asahel
 Peck, David
 Peck, Pattison and Company
 Peck, Seth
 Philips, Solomon Alexander
 Phinney, Gould
 Plum, Seth
 Plumb, Seth
 Pomeroy, Charles
 Pomeroy, Noah
 Pond, Edward L.
 Porter, Abel
 Porter, John
 Porter, Moses
 Purchasem, Mark
 Putnam, N.B.
 Quade, Julius
 Quinn, John
 Raiser, Jacob
 Redman, Richard
 Redman, Thomas
 Reed, Luke
 Reichter, Frederick
 Resser, William W. "Will"
 Rhodes, Daniel
 Rich, John
 Richardson, Francis B.
 Ridley, Mary
 Rising, Lester
 Robbins, Lewis
 Roberts, Candace
 Romero, Emilio
 Romero, Senaida
 Root, Lewis
 Root, William
 Rose, Philip
 Roseumen, Richard
 Ross, Calvin
 Rowley, Jacob
 Rowley, Philander
 Roybal, Maria Luisa Delgado
 Saalmueler, Peter
 Schnure
 Shade, J.
 Shade, P.
 Shade, Willoughby
 Shepherd, Miss
 Silloway, Samuel
 Slade, John
 Smith, Henry E.
 Smith, Joseph C.
 Smith, Samuel
 Smith, Thomas
 Smith, William
 Snell, Charles K.
 Snell, John L.
 Speakman, Joseph
 Squires, Ansel
 Squires, Fred
 Stedman and Clark
 Steele, Horace
 Stern, S.
 Stevens, Alfred
 Stevens, Samuel
 Stoner, Albert
 Stoughton, Jonathan
 Stow, O.W.
 Strickland, Simon
 Thompson, James A.
 Thompson, Major
 Thomson, William
 Tisdale, Riley
 Truman, James
 Tryon, George
 Turner, Edward
 Upson, (James) Salmon
 Upson, Asahel
 Upson, James
 Wagenhurst, Charles
 Walls, Jack
 Waterman, Charles
 Weller, Benneville
 Wenfold and Stevens
 Weston, Loren
 Whiting, Calvin
 Wilcox, Allyn
 Wilcox, Benjamin
 Wilcox, Daniel
 Wilcox, Francis C.
 Wilcox, Lewis S.
 Wilcox, Richard
 Williams, Smith
 Witmer, Galen (Gale)
 Witmer, Henry
 Witmer, Peter
 Witmer, Philip
 Wright, Cruger
 Wright, Dan
 Wright, Malcolm
 Wrightman, John
 Yale, E.A.
 Yale, Edwin R.
 Yale, Hiram
 Yale, Samuel
 Zeitz, Frederick
 Zeitz, Louis

Tinware, clocks
 Tin
 Rich, Sheldon

Tinware, copperware
 Tin, copper
 Holmes, L.W.

Tinware, footstoves
 Tin
 Goodrich, Asaph

Tinware, footstoves etc.
 Tin
 Morse, Chauncey

Tinware, ironware
 Tin, iron
 Stevens, Zachariah Brackett

Tinware, pottery
 Tin, clay
 Weaver, Henry

Tinware, tin dollhouses
 Tin
 Reitz, Isaac Jones

Tinware, weathervanes
 Tin, metal
 Leonhard, August

Tinware?
 Tin?
 Allen, Pelotiah
 Barber, T.G.
 Barrett, Jonathan
 Barrows, Asahel
 Beach, Chauncey
 Beckwith, Israel
 Belden, Horace
 Bond, Caleb
 Brown, Nathan
 Buckley, Luther
 Burr, A.
 Burr, C.
 Burr, Charles H.
 Burr, Emerson
 Burr, M.
 Butler, Timothy
 Cadwell, A.
 Cadwell, I.
 Cadwell, L.
 Case, E.H.
 Case, H.H.
 Case, Robert
 Clark, Abna
 Cole, John
 Colton, S.
 Cornish, H.
 Cossett, M.
 Cowles, Elisha
 Cowles, Thomas
 Crofoot, Joseph
 Curtis, Emory
 Curtis, Thomas S.
 Deming, Levi
 Deming, Roger
 Dickerman, Edwin S.
 Dunbar, H.
 Ellis, John
 Ellsworth, James
 Eno, Chester
 Eno, Ira
 Eno, William
 Ensign, Moses
 Evans, Robert
 Farmington, Silas
 Filley, I.A.
 Flagg, Abijah
 Foster, Holloway, Bacon, and Company
 Frazier, Stephen
 Gibson, Page
 Goodman, Hezekiah
 Graham, B.

Holt, Elias
Merrimen, Ives
North, Joseph
Phelps, H.G.

Tobacco pipes
Clay
Creus, William
Frantz, Isaac
Redware
Eval and Zom
Gast, Henry
Seebold, Phillip
Sturgis, Samuel
Stoneware
Merrill, Earl

Tomahawks
Brass
Welshhans, J.

Totem poles
Wood
Kay, Edward A.

Towels
Fabric
Root, Lucy (Curtiss)

Towers, carvings
Wood
Van Hoecke, Allan

Townscape paintings
Oil
Britton, William
Watercolor
Henrill, Hermann
Tucker, Joshua

Townscapes, miniature portraits, paintings
Watercolor, oil
Walton, Henry

Toys
Tin
Smith, Eldad
Wood
Remmick, Joseph
Smith, W.A.

Toys, fish, flower bowls
Wood
Queor, William B.

Trapunto coverlets
Fabric
Foot, Lucy
Phares, Mary Anne

Trivets
Iron
Rimby, W.B.

Metal
Seller, James

Trompe l'oeil
Oil
Somerby, F.T.

Unidentified Type of Work
Fabric
Cochran, Hazel

Valentines
Paper
Mai, Thomas

Vases
Redware
Fox, Haag and Company
Stoneware
Eli La Fever Pottery
Owen, J.B.

Village scene paintings
Oil
Arnold, A.
Whitney, L.

Waffle irons
Iron
Cook, S.

Wall decorations, paintings
Stencils
Parker, Nathaniel

Wall murals
Paint
McKeller, Candy

Wallpaper
Paper
Fleeson, Plunket
Rugar, John

Wallpaper designs
Paper
Barkley, Hugh
Wood
Clough, Ebenezer

Wardrobes
Wood
Heckmann, John H.

Warming pans
Copper
Collier, Richard
Hunneman, William C.
Richmond, A.D.
Witherle, Joshua

Weathervanes
Copper
Cushing and White
Harris and Company

Iron
Fisher
Gould and Hazlett
Puritan Iron Works
Metal
Ames Plow Company
Baldwin, V.
Berger Manufacturing Company
Broad Gauge Iron Works
C. Foster and Company
C.G. Brunncknow Company
Clark, John
Crowell, Andrew (Andres)
Drowne, Thomas
E.E. Souther Iron Company
E.G. Washburne and Company
Gould Brothers and Diblee
H.L. Washburn and Company
Hallberg, Charles
Harvey, Bill
Hayes Brothers
Henis, William
Howard, J.
J.B. and G.L. Mesker and Company
J.E. Bolles and Company
J.L. Mott Iron Works
J.W. Fiske (Ironworks)
John A. Whim
Jonathan Howard and Company
Joseph Breck and Sons
Kennecott Copper Workshop
Kenneth Lynch and Sons
Kessler, Charles
L'Enfant, Pierre Charles
L.D. Berger Brothers Manufacturing
Leibo, Jacob
Loebig, George
Metal Stamping and Spinning Company
Miller Iron Company
National Iron Wire Company
Oakes Manufacturing Company
Parker and Gannett
Phoenix Wire Works
Rakestraw, Joseph
Reed, Kenneth
Rice, Ernest S.
Rochester Iron Works
Spokane Ornamental Iron and Wire Works
Thew, John Gerrett
Union Malleable Iron Company
Van Dorn Iron Works
W.A. Snow Company, Inc.
W.H. Mullins and Company
Walbridge and Company
Watkins, R.
Western Grille Manufacturing Company
White, Henry J.
Whitehall Metal Studio
Winn, John A.
Wyllie, Alexander

Weathervanes

Weathervanes (Cont.)
 Metal?
 Dorendorf, D.
 Scrap material
 Hirsch, Cliff
 Steel
 Norberg, Virgil
 Unidentified Media
 Wasey, Jane
 Wood
 Cook, Mr.
 Crane, Mr.
 Gray, Mr.
 Greene, E. De Chois
 Leach, Henry
 Lombard, James
 Roby, W(arren) G(ould)
 Wood, metal
 Townsend, Albert

Weathervanes, brassware
 Metal
 Hamlin, Samuel E.

Weathervanes, cast iron tea kettles
 Iron
 Savory and Company

Weathervanes, duck decoys, shore bird decoys, other carvings
 Wood
 Crowell, A.E(lmer)

Weathervanes, ornamental metal works
 Metal
 A.B. and W.T. Westervelt Company
 A.J. Harris and Company
 Barbee, W.T.
 Barnum, E.T.
 Bubier and Company
 Chelmsford Foundry Company
 M.D. Jones and Company
 Samuel Bent and Sons
 Samuel Yellin Company
 Yellin, Harvey

Weathervanes, sculptures, carvings
 Wood
 Ceeley, Lincoln J.
 Wood?
 Brasher, Rex

Weathervanes, ship figures, figureheads
 Wood
 Rogers, Bruce

Weathervanes, signs, ornamental metal works
 Metal
 A.L. Jewell and Company

Weathervanes, tinware
 Metal
 Drowne, Deacon Shem

Weathervanes, whirligigs
 Wood
 Bell, Joseph "Joe"

Weavings
 Fabric
 Adam
 Adolf, Charles
 Adolf, George
 Adolf, Henry
 Aikens, James
 Akin, Phebe
 Alexander, F.M.
 Alexander, Thomas M.
 Allabach, Philip
 Ambrouse
 Anderson, Sarah Runyan
 Andrews, Fanny
 Andrews, Jacob
 Angstad, Benjamin
 Angstadt, Nathaniel
 Apodaca, Manuelita
 Ardner, Jacob
 Ardner, Michael
 Armstrong, J.H.
 Arnold, Daniel
 Artman, Abraham
 Backus, Thaddeus
 Baden, C.
 Baird, James
 Baker, Daniel, Jr.
 Baker, David
 Baker, Eliza Jane
 Baker, John
 Balantyne
 Balantyne, Abraham
 Balantyne, John
 Balantyne, Samuel
 Ball, H.H.
 Barrett
 Barth, Andrew
 Bartlet, Jerusha
 Bazan, Ignacio Ricardo
 Bazan, Joaquin
 Beck, Augustus
 Beerbower, William
 Beil, B.
 Bellman, Henry
 Bender, David
 Bennett, R.
 Bennett, S.A.
 Berry
 Bichel, W.
 Bick, John
 Biesecker, Jacob, Jr.
 Bingham, David
 Bishop, P.
 Bisset, William
 Bivenouer, M.
 Black, G.
 Black, William
 Boalt, James
 Boeshor, Heinrich
 Bolton, Thomas
 Bone, Elihu
 Bordner, Daniel
 Brehm, Henry
 Brick, Zena
 Brosey, John, Jr.
 Brosey, W.
 Brown, David
 Brown, Isaac
 Brown, John
 Brown, W.W.
 Brubaker, A.
 Brubaker, Isaac
 Buchanan, Mrs. John
 Buchwalder, A.
 Bundy, Hiram
 Burkerd, Peter
 Burkhardt, P.H.
 Burkholder, Isaac
 Burns, James
 Burns, Martin
 Burrough, Mark
 Bury, Daniel
 Butterfield, J.
 Bysel, Phillip
 Calister, James C.
 Campbell, James
 Carmen, Elizabeth (Mrs. Caleb)
 Casebeer, Aaron
 Casebeer, Abraham
 Cass, David
 Cass, Nathan
 Cassel, Joseph H.
 Caswell, Zeruah Higley Guernsey
 Chappelear, Mary
 Chatham's Run Factory
 Chenne, Joseph
 Chester, Sarah Noyes
 Chew, Ada
 Christman, G.
 Clark, Jacob N.
 Cleever, John
 Cole, J.C.
 Coleman, Sarah Whinery
 Collings, S.
 Colman, Peter
 Conger, Daniel
 Conger, J.
 Conner, C.S.
 Conoly, David
 Cook, Harvey
 Cook, John
 Cooper, Teunis
 Corbin, Hannah
 Cordova, Alfredo
 Cordova, Grabielita
 Cordova, Harry
 Corick, Joshua
 Corwick, Andrew
 Cosley, Dennis
 Cosley, G(eorge)
 Cothead, Phoebe
 Coulter, George
 Covey, Harriet
 Cowam, Donald

Craig, James
Craig, Robert
Craig, William, Jr.
Craig, William, Sr.
Cranston, Thomas
Crossley, Robert
Crozier, John
Cumbie
Danhouse, F.
Danner, Philip
Dannert, Henry
Daron, Jacob
Darrow, J.M.
Deavler, Joseph
Deeds, William
Deitsch, Andrew
Dengler, John
Denholm, John
Detterick, George
Deuel, Elizabeth
Deyarmon, Abraham
Diller, P.
Dorward, John
Dorward, Joshua
Earnest, Joseph
Eckert, Gottlieb
Eckler, Henry
Eichman, Michael
Enders, Henry
Ettinger, Emanuel
Ettinger, William (Henry)
Fairbrothers, William
Fasig, Christian
Fatsinger, Adam
Favorite, Elias
Fernandez, Gilbert
Fernberg, Samuel
Flanigan, George
Fleck, Joseph
Fleck, William
Flocher, S.
Fogle, Lewis
Folk, John
Foltz, Harry
Forry, Rudolph
Forster, William
France, Joseph
Frances
Franklin Woolen Factory
Franz, Michael
Frazie, J.
French, B.
Fritzinger, Jerret (Jared)
G.W. Kimble Woolen Factory
Gabriel, Henry
Gamble, J.A.
Garber, C.
Garis, John
Geb, L.R. (John)
Gebhart, John R.
Geller, Adam
Gernand, J.B.
Gernand, Jacob B.
Gernand, W.H.
Getty, A.
Getty, J.A.

Getty, James
Getty, John
Gibbs, John
Gilbert, Samuel
Gilchrist, Hugh
Gilchrist, William
Ginn, Robert
Glen, Hugh
Globe Factory
Goebell, Henry
Good Intent Woolen Factory
Goodman, Daniel
Goodman, John S.
Goodman, Peter
Goodwin, Harmon
Gordon, L.
Gottfried Kappel and Company
Graham, John
Gramlyg, John
Granold, J. George
Grape
Graves, David Isaac
Greenwald, John W.
Griest Fulling Mill
Grube, Emanuel
Haag, Jacob
Hain, Peter L.
Haldeman, John M.
Hamas, Elias
Hamilton, John
Hammond, Denton
Hammond, John
Harch, J.
Haring, James A.
Hart
Hartman, John
Hartman, Peter
Hausman, Allen B.
Hausman, Ephrain
Hausman, G.
Hausman, Jacob, Jr.
Hausman, Jacob, Sr.
Hausman, Solomon
Hausman, Tilgham (Tilghman)
Hecht, Abslam
Heifner, J. Philip
Heilbronn, George
Herreter and Sweitzer
Herrmann, Charles A.
Hesse, F.E.
Hesse, L.
Hicks, Samuel
Hinshillwood, Robert
Hipp, Sebastian
Hippert, Samuel
Hoffman
Hohulin, Gottlich
Holland, James
Hoover, Andrew
Hoover, John
Hoover, M.
Hopeman
Hornbreaker, Henry
Hosfield, F
Housman
Howland, Lucinda

Huber, John
Hudders, J.S.
Hull, Lewis
Hull, Mathias
Humphreys, S.
Huntington, Edwin
Inger, J. Fritz
Ingham, David
Irvin, James
Irwin, L.
J.S. Hogeland and Son
Jackson, Thomas
Jessup, James
Jones, L.
Kachel, John
Kaley, John
Kapp, Christof
Keagy, Abraham, I
Keagy, Abraham, II
Keagy, John
Keagy, Samuel
Kean, Frederick A.
Keifer, Louis
Kell, D.
Kepner, Isaac
Kepners Woolen Mill
Kiehl, Benjamin
King, Daniel
King, Joseph
King, Martha Ellen
Kirst, John
Kisner and Company
Kisner, Benedict
Kisner, John A.
Kittinger, John
Klar, Francis Joseph
Klehl, J.
Klein, Andrew
Klein, Francis
Klein, Fredoline
Klein, Michael
Knirim, A.D.
Kostner, J.M.
Krebs, Philip, Jr.
Krebs, Philip, Sr.
Kuder, William
Lashel
Lashell, L.M.
Laughlin, M.
Lawson, David
Le Bar, Pamela
Lederman, Henry
Lehr, George
Leisey, Peter
Leitz
Leitz, J.
Leopold, Valentine
Lewis, Harvey
Lichy, Benjamin
Linderman, Jacob
Lochman, Christian L.
Lochman, William
Long, C.
Long, Jacob
Long, John
Long, John

Weavings (Cont.)
 Fabric (Cont.)
 Lovett, Rodman
 Lutz, E.
 Lutz, Jacob
 Mackeon, Abraham B.
 Mamn, Mathias
 Manning
 March, J(ohn) H(enry)
 Marion, Edward
 Mark, Matthew W.
 Marr, John
 Marsh, J.
 Marsteller, A.
 Martin, Robert
 Masters, Margaret
 Mater, William Henry
 Maurer, Johannes
 Maurer, John
 Maus, Philip
 McCann, George
 McClellan, J.
 McKinney, James
 McLaughlin, James
 Mealy
 Meiley, Charles S.
 Mellinger, Daniel
 Mellinger, Samuel
 Mench, E.
 Menser, David
 Merkle, Alexander
 Merkle, James
 Mesick, C.
 Metzger, F.
 Meyer, Johann Philip
 Michaels
 Miller, Henry
 Miller, Levi M.S.
 Miller, Robert
 Miller, Theodore H.
 Miller, Tobias
 Money
 Moon, Robert
 Moore, Robert
 Morrey
 Moser, Jacob
 Mount Pleasant Mills
 Moyers Woolen Mill
 Muir, Robert
 Muir, Thomas
 Muir, William
 Myer, P.
 Myers, Elizabeth
 Nagel, Philip
 Nash, Matilda
 Neely, Henry
 Netzley, Uriah
 Ney, William
 Nichols, Richard
 Nicklas, Peter
 Noll, William
 Nurre, Joseph
 Oertle, Joseph
 Orms
 Ortega, Nicacio
 Ortega, Robert James
 Osbon, Aaron C.
 Ott, C.
 Overholt, Henry O.
 Packer, J.
 Patten, P.C.
 Patterson, Thomas
 Peck
 Petna, George
 Petrie
 Petry, Peter
 Pierce, Merrily
 Pompey, L.W.
 Powder Valley Woolen Mill
 Prescott, Martha Abbott
 Randel, Martin
 Randell, Martha
 Rassweiler, H.
 Rauch, M.
 Reed, V.R.
 Reeve, Joseph H.
 Reiner, Georg
 Reiter, Nicholas
 Renner, George
 Renner, P.
 Ressler, Rudolph
 Rezinor, John
 Rich, John
 Richardson
 Risser, L.D.
 Roberts, Charles
 Rogers, John
 Rose, William Henry Harrison
 Rotzel, Mathias
 Rouser, Gabriel
 Royer, John
 Salazar, David
 Salisbury, Henry
 Salisbury, Mary
 Satler, Lewis
 Sawyer, Mrs.
 Sayels, J.M.
 Saylor, Jacob
 Scheelin, Conrad
 Schipper, Jacob
 Schmeck, John
 Schnee, William
 Schnell, Jacob
 Schrack, Joseph
 Schreffler, Henry
 Schriver, Jacob
 Schriver, John
 Schum, Philip
 Schwartz, Michael
 Seibert, John, Jr.
 Seibert, John, Sr.
 Seibert, Owen
 Seifert, Andrew
 Seifert, Emanuel
 Seigrist, Henry
 Setzer, Jacob
 Shalk, Jacob
 Shalk, Jacob
 Shaw, Robert
 Sheafer, Franklin D.
 Shearer, Henry
 Sherman, Jacob
 Sherman, John
 Shive, M.
 Shotwell
 Shouse, Nicholas
 Shreffler, Henry
 Simpson, Joseph
 Singer, John
 Slaybough, Charles
 Slaybough, Josiah
 Slaybough, William
 Slothower, P.
 Slusser, Eli M.
 Slusser, Jacob M.
 Smith, Daniel S.
 Smith, John
 Smith, Sarah Douglas
 Snider, J.
 Snider, Samuel
 Snyder, Daniel
 Snyder, Jacob
 Snyder, John
 Snyder, Mary
 Speck, Johan Ludwig
 Spencer, William
 Sperling, Louis
 Stager, Henry F.
 Staley, Andrew
 Staples, Waity
 Staudt, Simon
 Steier, W.
 Stephen, Jacob
 Stiebig, John
 Stierwalt, Moses
 Stinger, Samuel
 Stohl, F.
 Stoud, William
 Stracke, Barnhardt
 Strauser, Elias
 Striebig, John K.
 Strobel, Lorenz
 Strunks Mill
 Swan, Cyrus
 Swank, J.
 Sweeny, T.W.
 Synder, Jacob
 Talpey, J.M.
 Test Woolen Mills
 Thompson, George
 Thompson, Ritchie
 Tillman, Frances
 Trappe, Samuel J.
 Trujillo, John R.
 Tuttle, Miss Ann
 Umbarger, Michael, Jr.
 Van Gordon, William H.
 Varick
 Vergara-Wilson, Maria
 Verplank, Samuel
 Vogel, August
 Vogler, Milton
 Wagner, John
 Walhaus, Henry
 Walter, Jacob
 Warick, J.
 Warner, Ann Walgrave
 Weaver, Frederick

Weber, R.
White, Abel
Whitehead, L(iberty) N.
Whitmer, J.
Whittaker, James
Wiand, Charles
Wiand, David
Wiend, Michael
Wildin, John
Wilkison, Emily
William, Abram
Williams, H.R.
Williams, John T. (T.J.)
Williams, William T.
Wilson, Henry
Wilson, Hugh
Wilson, John
Wilson, Jonathan
Wingert, George S.
Wingert, Henry
Wirick, John
Wirick, William
Wise, H.
Wissler, John
Witmer, Jacob
Witt
Wohe, W. (Wolfe)
Wolf, Adam
Wolf, H.
Wolf, William
Wood, J.C.
Woolrich Woolen Mills
Worley, W.C.
Yardy, Christian
Yearous, Adam
Yergin, William K.
Yingst, David
Yordy, Benjamin
Young
Young, Charles
Young, Matthew
Zarn, George
Zelner, Aaron
Zoar Industries
Zufall, Moses

Weavings, coverlets
Fabric
 Hay Weaving Shop
 Pearsen, J.

Weavings, linens, coverlets
Fabric
 Seewald, John (John Philip)

Weavings, murals
Fabric, oil
 Jaramillo, Juanita

Weavings, quilts
Fabric
 Bradford, Esther S.
 Cook, Jermima Ann (Jermina)

Weavings?
Fabric?
 Andrews, M.
 Brand, D.
 C. Oppel and Company
 Hall
 Huber, Damus
 Jackson, John Hamilton
 Milroy
 Rossvilles

Wedding gowns, quilts
Fabric
 Johnson, Mary Myers

Wedding veils
Fabric
 Canfield, Caroline
 Harness, Martha
 Hustace, Maria
 Moser, Lucinda Vail

Welded horses
Metal
 Merchant, Richard

Western mural sculptures, carvings
Wood
 Grimes, Leslie

Whale stamp designs
Pen, ink
 Little, Charles

Whale stamps
Inked stamps
 Stinson, Henry

Whalebone, ivory art
Whalebone, ivory
 Kuzuguk, Bert

Whaling scene paintings
Chalk
 Coleman
Pen, watercolor
 Baker, Warren W.
 Bertoncini, John
 Clark, George S.
 Jones, Reuben, Captain
 Taylor, William W.

Whimsical decorated letters, paintings, wall murals
Oil, watercolor
 Shelby, George Cass

Whimsical figures
Wood
 Quiles, Manuel

Whirligigs
Wood
 Austin, Roy
 Fenimore, Janice
 Hinson, John
 Little, T.J.
 Marvin, Fay
 Reynolds, W.J., Dr.
Wood, metal, paint
 Ward, Edwin P.

Whirligigs, wind machines, paintings, drawings
Paint, wood, metal
 Young, John

Whirligigs, yard art
Wood
 Irvine, Eldon

Wind indicators, compasses
Wood, metal
 Jefferson, Thomas

Windsor chairs
Wood
 Fry, George

Windsor furniture
Wood
 Brown, G.

Windsor rockers
Wood
 Jackson, Samuel

Wood sculptures
Wood
 Blythe, David Gilmour

Wood sculptures, carvings
Wood
 Bernier
 Bickstead, A.E.
 Bixler, Absalom
 Blair, Fred

Woodenware
Wood
 Hersey, Edmond

Woodenware, buckets
Wood
 Hingham Wooden Ware

Woven and hooked bed rugs, coverlets
Fabric
 Williams, Amy

Wreaths
Hair
 Harper, Cassandra Stone
Seeds
 Banker, Martha Calista Larkin

Wrought ironworks
Iron
 Simmons, Peter

Yarn winders
　Various materials
　　Dominy, Nathaniel, V